The Genius

Sponsored at
the University of Connecticut
by
the Thomas J. Dodd Research Center,
the College of Liberal Arts and Sciences,
the University Research Foundation,
the Department of English,
and by
the University of Pennsylvania Library

GENERAL EDITOR
Thomas P. Riggio

TEXTUAL EDITORS
Lee Ann Draud
James L. W. West III

THEODORE DREISER

The Genius

Edited by
CLARE VIRGINIA EBY

University of Illinois Press
Urbana and Chicago

© 2008 by the Board of Trustees
of the University of Illinois
All rights reserved
Manufactured in the United States of America
C 5 4 3 2 1
∞ This book is printed on acid-free paper.

Library of Congress Cataloging-in-Publication Data
Dreiser, Theodore, 1871–1945.
The genius / Theodore Dreiser ; edited by
Clare Virginia Eby.
p. cm. — (The Dreiser edition)
Includes bibliographical references and index.
ISBN-13: 978-0-252-03100-7 (alk. paper)
ISBN-10: 0-252-03100-8 (alk. paper)
I. Eby, Clare Virginia. II. Title.
III. Series: Dreiser, Theodore, 1871–1945.
Selections. 1988.
PS3507.R55G46 2008
813'.52—dc22 2006017800

CONTENTS

ILLUSTRATIONS

Illustrations follow page 851.

By 1911 Theodore Dreiser had published only two modestly successful novels—*Sister Carrie* (1900) and *Jennie Gerhardt* (1911)—both inspired by unconventionally amorous events in the lives of his sisters. Sometime in late 1910 he began writing a third novel called *The Genius*. By April 1911 he had a complete holograph draft, which he continued to rework until he sent off a corrected manuscript to be typed in July 1911. He had shown it to various trusted readers and then put it aside to work on his next book and to prepare *Jennie Gerhardt* for publication. As he wrote to William C. Lengel, he was satisfied with the novel, and it was "lying on ice, all nicely typewritten, awaiting its turn [to be sent to the publisher, Harper's]" (Dreiser to Lengel, 15 October 1911). The publisher, however, was more interested in his work in progress, a novel based on the career of the railroad magnate Charles T. Yerkes. It took another four years for Dreiser to publish *The Genius*, and then only after he had revised it considerably. The present edition, based on the 1911 manuscript, offers a version of the book that differs in many ways from the long-established novel published (with quotation marks added) in 1915 as *The "Genius"*.

Readers have generally viewed *The "Genius"* of 1915 as a departure from the mode of Dreiser's first two novels. There was in fact a noticeable shift in Dreiser's writing after he published *Jennie Gerhardt*. In a 1912 interview for the *New York Times Review of Books*, Dreiser signaled his movement away from the subject matter of his early novels about young women adrift in the new American city. Speaking of the ruthless businessman of his new book *The Financier* (1912), Dreiser noted that "Jennie's temperament does not appeal to me any longer . . . in the new novel, the note of the plot will come from the man, and men shall be the center of the next three or four novels." For this and other reasons, *The "Genius"* has mainly been read within the context of his more starkly naturalistic writing of the 1910s, particularly *The Financier* and *The Titan* (1914). *The "Genius"* does in fact show the influence of an intense period of creativity that occurred between 1912 and 1915—a time in which Dreiser was reinventing himself with a strikingly new thematic and formal agenda. (In addition to the Cowperwood novels, he also was writing plays about what he called the "natural and supernatural," and he had begun exploring himself as a major subject of his writing in *A Traveler at Forty* (1913), a lengthy account of his European adventures.)

In contrast to the novel published in 1915, *The Genius* of 1911 (which was completed before the publication of *Jennie Gerhardt*) is the work of a writer who had not yet appreciably distanced himself from the ideas and specula-

tive concerns of his early fiction. No in-depth comparative study of the two texts exists, largely because the 1911 version has hitherto been unavailable to most readers. Whatever commentary exists focuses mainly on the radical difference between its ending and that of the published novel. There is general agreement that the "happy" denouement of the 1911 text—which concludes with Dreiser's hero Eugene Witla blissfully reunited with the object of his affections, Suzanne Dale—represents Dreiser's more romantic conception of his material. The differences between the endings have, however, obscured other equally important distinctions. For example, the absence of quotation marks in the 1911 title points more to the relatively amorphous idea of creative genius or temperament that defines Witla (as well as Carrie Meeber and Jennie Gerhardt) than to the more qualified and skeptical idea of artistic genius that marks Witla in the 1915 novel. In the present edition, the historical and textual essays examine many other such unique features of the 1911 novel as it existed before Dreiser revised it to meet the demands of his rapidly evolving philosophical, aesthetic, religious, and social ideals.

The volume editor's textual commentary offers an analysis of the tangled compositional history of the novel. It demonstrates, among other things, the ways in which the editorial contributions of numerous readers altered the novel Dreiser wrote in 1911. The editor has also provided the first systematic overview of the various artists and schools of painting Dreiser used in a novel set firmly in the art culture, as well as the business world, of turn-of-the-century America. In addition, the notes and the historical essay provide necessary information on the now obscure philosophical and religious ideas (particularly Christian Science) that were central to Dreiser's novel at its inception.

The holograph manuscript of 1911 that survives among the Dreiser papers at the University of Pennsylvania's Annenberg Rare Book and Manuscript Library makes possible this edition of a text lost to all but a few scholars robust enough to make their way through its thousands of handwritten sheets. In rescuing from the archives a manuscript that is part of the novelist's literary heritage, this edition makes available an important text in the Dreiser canon. It also offers the opportunity to compare the 1911 version of the novel with the historical text of 1915. In so doing, it provides an occasion to consider the dynamics of Dreiser's creative outlook and compositional habits at a critical time in his career.

Editorial Procedures

The Genius is part of an ongoing series in the Dreiser Edition. Each book is a product of cooperative efforts. The general editor appoints an editor

for each project. The general editor and the textual editors select the text for each edition and establish the project within the framework of current editorial theory. They approve the relevant documents, devise the historical and textual principles for the edition, and work with volume editors in determining the copy-text. The general editor verifies all transcriptions and assists the volume editor in gathering the textual, historical, and bibliographical documents pertinent to the edition. At each stage of preparation, the editorial staff proofreads the text and authenticates its contents.

The editorial principles formulated by W. W. Greg, Fredson Bowers, and G. Thomas Tanselle have guided the Dreiser Edition since its inception in 1981. These principles served as useful techniques in determining copy-text and methodology for early Dreiser Edition volumes. The Dreiser Edition remains committed to many of the basic procedures of these first volumes. Editors continue to be engaged in presenting critical texts that utilize pertinent documents among Dreiser's papers. Each edition takes into account the author's intentions for the work (insofar as they are knowable); each employs a system of emendation that considers all relevant prepublication and printed texts. There is no attempt to reproduce the text of a single historical document, nor is there any claim to be definitive. Although Dreiser Edition volumes are often dependent on unpublished manuscripts and typescripts, they do not aim to replace the published or historical texts of Dreiser's works.

The Dreiser Edition has long recognized that Dreiser's books are the products of collaborative efforts that began with his holograph manuscripts. Over time these manuscripts were subject to alterations, with varying degrees of authorial cooperation, by Dreiser's personal associates, publishers, professional editors, and typists. As the compositional history of Dreiser's works suggests, his intentions for publication were often problematic, even when he was cooperating with publishers and editors to take his works to print. In the case of *The Genius*, Dreiser's correspondence with various typists and readers indicates that he knew he could not submit the 1911 text without the sort of editorial revision he habitually expected for his work.

In employing the holograph manuscript as copy-text, it has been edited as a public document. Therefore the editor has emended unintelligible passages, misspellings, typographical errors, and hiatuses in the manuscript. Emendations have been based on collations from existing documents, including the first edition, that have authorial sanction. For instances in which there are no authorities beyond the copy-text for accidentals or for obscure matters of substance, the volume editor took an active role and made decisions consistent with Dreiser's known habits of composition. All emendations are fully recorded in two textual apparatuses: an abbreviated

or selected list of emendations included in this volume and a complete list of emendations that has been deposited at the Annenberg Rare Book and Manuscript Library.

In selecting the 1911 manuscript as the basis for this edition of *The Genius*, the editors recognize that this determination represents only one of a number of possible editorial choices of equal import. In this regard the Dreiser Edition has evolved naturally from its original formulations to take into account one of the central ideas common to the work of such diverse modern textual critics as Hans Zeller, Jerome J. McGann, and Donald H. Reiman. Accordingly, this edition of *The Genius* is presented as one of a number of possible versions in a continuum of composition. Viewed together with the version Dreiser published in 1915 and the various prepublication typescripts, as well as with the abridged serialization published in *Metropolitan Magazine*, this edition provides an opportunity to more fully examine the complex process of composition, editing, censorship, and revision that characterizes Dreiser's work throughout his career.

* * *

The Genius continues the Dreiser Edition's tradition of publishing texts that are not easily accessible, even to the specialist. Such an undertaking would be unimaginable without the sponsorship of two institutions: the University of Connecticut and the library of the University of Pennsylvania. Several individuals at the University of Connecticut deserve special mention for their initiatives and continuing generous support of this project: Robert Tilton, head of the English department; Ross D. MacKinnon, dean of the College of Liberal Arts and Sciences; Gregory Anderson, vice provost for Research and Graduate Education; and Thomas P. Wilsted, director of the Thomas J. Dodd Research Center, as well as his administrative assistant Linda Perrone. The goodwill and special training of the staff at the University of Pennsylvania's Annenberg Rare Book and Manuscript Library have been essential to the progress of the Dreiser Edition. Director Michael T. Ryan has generously devoted his own time and the resources of his staff to facilitating the work of the Dreiser Edition. Curator of manuscripts Nancy M. Shawcross continues to contribute her expertise and special service to the project. John Pollack has consistently and untiringly assisted Dreiser Edition editors in their work. Finally, Dr. Willis Regier, the director of the University of Illinois Press, continues against many odds to provide imaginative guidance and commitment to the project.

Thomas P. Riggio
General Editor
The Dreiser Edition

ACKNOWLEDGMENTS

In the course of editing *The Genius,* I have profited immeasurably from the work of several generations of Dreiser scholars and biographers. LaVerne Kennevan Maginnis transcribed the text of the holograph, making my labors infinitely easier. Nancy M. Shawcross, curator of manuscripts at University of Pennsylvania Library, and John Pollack, at the University of Pennsylvania Annenberg Rare Book and Manuscript Library, provided the best research environment I have ever enjoyed, as well as excellent company. The historical research for this project was made possible by the tireless efforts of the University of Connecticut Libraries, in particular the Inter-Library Loan Team at the Homer Babbidge Library and the staff at the Harleigh B. Trecker Library. The University of Connecticut awarded me a Provost's Fellowship for fall 2003, allowing me to devote uninterrupted time to art historical research, while the university's Research Foundation provided financial support for several trips to the University of Pennsylvania archives.

I am indebted to Toby Anita Appel, Bailey Van Hook, Hap Fairbanks, Brenda Murphy, Fred Roden, Tracey Rudnick, Michael Young, Louis J. Oldani, and especially to Richard Bleiler, for help in tracking down elusive references. Leonard Cassuto has been a necessary sounding board during all stages of my work on *The Genius*; he also provided helpful suggestions on the notes and commentaries. In addition to explaining many artistic terms and concepts, my husband John Lo Presti has helped me understand what is at stake in being an artist (and a businessman) in America; our marriage, much happier than that of the Witlas, has enriched my understanding of virtually every scene in *The Genius*. My interest in art originated in my parents' taking me to museums throughout my childhood, so thanks to Patsy Aldridge and Cecil Eby for opening up worlds to me. Tom Riggio prodded, instructed, challenged, and supervised my work on *The Genius* through every phase. It is an honor to have worked so closely with the leading Dreiser scholar of our generation. I have learned much from our association, and am lucky to count him as a friend.

The Genius

"Eugene Witla, wilt thou have this woman to thy wedded wife, to live together after God's ordinance in the holy estate of matrimony? Wilt thou love her, comfort her, honour and keep her in sickness and in health; and forsaking all others, keep thee only unto her, so long as ye both shall live?"

"I will."

CHAPTER I

This story has its origin in the town of Alexandria, Illinois, between 1884 and 1889, at the time when that place had a population of about seven to ten thousand. There was about it just enough of the air of a city to take away the sense of rural life which much smaller places suffer from. It had one street car line running from its environs on the west to its environs on the east, later connected with car lines from other towns and cities. There was a theatre or rather an opera house, so called (why, no one might say, for no opera was ever performed there), two railroads, with two stations, a business heart composing four brisk sides of a public square, the centre of which was occupied by the county court house and several newspapers, two morning and two evening, which made the population fairly aware of the fact that life was full of issues, local and national, and that there were many interesting and varied things to do outside the little issues of working and living in this place. One of its most pleasing aspects was the presence of several lakes and a pretty stream, all on the edge of the town, which gave it an atmosphere not unakin to that of a moderately priced summer resort. Architecturally the town was not new, being mostly built of wood, as all American towns were at this time, but laid out prettily in some sections, with houses that sat back in great yards, far from the streets, with flower beds and brick walks and great green trees as concomitants of a comfortable home life. It was, all told, as clean as it was ambitious and energetic. Alexandria was a city of young Americans. Its spirit was young. Life was all before almost everybody. It was really good to be alive.

In one part of this city there lived at this time a family of five people, father, mother, two daughters and a son, which in its character and composition might well have been considered typically American and middle western. It was not by any means poor—or at least did not consider itself so; it was in no sense rich. Thomas Jefferson Witla, the father, was a sewing machine agent with the general agency in that county of one of the best known and best selling sewing machines made. He had the right to sell machines anywhere in the city of Alexandria or its surrounding county, or to appoint agents under him so to do, and no one could interfere with him or take his trade away. From each twenty, thirty-five or sixty dollar machine which he sold, he took a profit of thirty-five per cent. The sale of machines was not great but it was enough to yield him nearly two thousand dollars a year, and on this he had managed to buy a house and lot, to furnish it comfortably, to send his children to school, and to maintain a local store on the public square where the latest styles of machines were displayed. He

also took old machines of other makes in exchange for his new ones, allow-ing ten to fifteen dollars on the purchase price of a new machine. He also repaired machines, and with that peculiar energy of the American mind, tried to do a little insurance business on the side. His first idea was that his son, Eugene Tennyson Witla, might take charge of this latter work once he became old enough and the insurance trade had developed sufficiently. He did not know what his son might turn out to be, but it was always well to have an anchor to the windward.

He was a quick, wiry, active man of no great stature, sandy haired, blue-eyed, with noticeable eye brows, an eagle nose and a rather radiant, ingrati-ating smile. Service as a canvassing salesman, endeavoring to persuade recal-citrant wives and indifferent or conservative husbands to realize that they really needed a new machine in their home, had taught him caution, tact, savoir faire. He knew how to approach people pleasantly—his wife thought too much so. Certainly he was honest, hard working, thrifty. They had been waiting a long time for the day they could say that they owned their own home and had a little something laid by for a rainy day. They were in that position now and it was not half bad. Their house was neat—white with green shutters, surrounded by a yard of perhaps 150 by 150 feet, with well kept flower beds, a smooth lawn and some few shapely and broad spreading trees. There was a front porch with rockers, a swing under one tree, a hammock under another, a buggy and several canvassing wagons in a nearby stable. Witla senior liked dogs, so there were two collies. Mrs. Witla also liked live things, so there was a cat, a canary bird, some chickens, and a bird house set aloft on a pole where a few bluebirds made their home. It was a nice little house all told, and Mr. and Mrs. Witla were rather proud of it.

Mrs. Miriam Witla was the daughter of a hay and grain dealer in Wooster, a small town near Alexandria in McLean County. She had never been farther out into the world than Springfield and Chicago. She had gone to Springfield as a very young girl, to see Lincoln buried, and once with her husband to see the state fair or exposition which was held annually in those days on the lake front in Chicago. She was well preserved, good looking, poetic under a marked outward reserve. It was she who had insisted on nam-ing her only son Eugene Tennyson, a tribute at once to a brother who was named Eugene and to the celebrated romanticist of verse, because she had been so impressed with his *Idylls of the King*. Eugene Tennyson seemed rather strong to Witla père, as the name of a middle-western American boy, but he loved his wife and gave her her way in most things. He rather liked the names of Sylvia and Myrtle with which she had christened the two girls. All three of the children were good looking—Sylvia, a girl of twenty-one, having black hair, blackish brown eyes, a smooth dark skin with a touch

of red in her cheeks, and red lips. She was full blown like a rose, healthy, active, smiling. Myrtle was of a less vigorous constitution, small, pale, shy but intensely sweet—like the flower she was named after, her mother said. She was inclined to be studious and reflective, to read verse and dream. Her hair was brown like her eyes; her face white as her hands. The young bloods of the high school were all crazy to talk to Myrtle and to walk with her but they could find no words. And she herself did not know what to say to them.

Eugene Witla was the apple of his family's eye, younger than either of his two sisters by two years. He had straight, smooth black hair which even at the age of sixteen he parted in the middle. He had dark, almond-shaped eyes, a straight nose, a shapely but not aggressive chin. His teeth were even and white, showing with a curious delicacy when he smiled, as if he were proud of them. He was not very strong to begin with, moody and to a notable extent artistic. Because he believed he had a weak stomach and a semi-anaemic condition, he did not appear as strong as he really was, though later in life he became intensely virile. He had emotion, fire, divine longings in a way, but they were concealed at this time behind a wall of reserve. He was shy, proud, sensitive and very uncertain of himself.

When at home he lounged about the house, reading Dickens, Thackeray, Scott, and Poe. He browsed idly through one book after another, wondering about life. The great cities appealed to him. He thought of travel as a wonderful thing. In school he would read Taine and Gibbon between recitation hours, wondering at the luxury and beauty of the great courts of the world. He cared nothing for grammar, nothing for mathematics, nothing for botany or physics, except odd bits here and there. Curious facts would strike him—the composition of clouds, the composition of water, the chemical elements of earth. He liked to lie in the hammock at home spring, summer, or fall, and look at the blue sky showing through the trees. A soaring buzzard poised in its speculative flight held his attention fixedly. The wonder of a snowy cloud, high piled like wool and drifting as an island, was like a song to him. He had wit, a keen sense of humor, a sense of pathos. Sometimes he thought he would draw; sometimes write. He had a little talent for both, he thought, but he did practically nothing with either. He would sketch now and then in a feeling, impressive way but only fragments—a small roof top with smoke curling from a chimney and birds flying; a bit of water with willows bending over it and perhaps a boat anchored; a mill pond with ducks afloat and a boy or woman on the bank. He really had no vast talent for interpretation at this time, only an intense sense of beauty. The beauty of a bird in flight, a rose in bloom, a tree swaying in the wind—these held him. He would walk the streets of his native town at night admiring the bright-

ness of the store windows, the sense of youth and enthusiasm that went with a crowd, the sense of love and comfort and home that spoke through the glowing windows of homes set among trees.

He admired girls—actually he was mad about them, but only about those who were truly beautiful. There were three or four in his school that reminded him of poetic phrases he had come across in his time—"beauty like a tightened bow"; "thy hyacinth hair, thy classic face"; "a dancing shape, an image gay"—but he could not talk to them with ease. They were beautiful yet so distant. Actually he invested them with more beauty than they really had because his was the sense of beauty. But he did not know that. One girl whose yellow hair lay upon her neck in great braids like ripe corn was constantly in his thoughts. He worshipped her from afar but she never knew. She never knew what solemn black eyes burned at her when she was not looking. She left Alexandria after a time, her family moving elsewhere, and then in time he recovered, for there is much of beauty. But the color of her hair and the wonder of her neck stayed with him always.

There was some plan on the part of Witla to send these children to college but none of them had any real leaning in the direction of definite, concrete knowledge. They were wiser than books, for they were living in the realm of imagination and feeling. Sylvia longed to be a mother and was married at twenty-one to Henry Burgess, the son of Benjamin C. Burgess, the editor of the Morning Appeal. There was a baby the first year. Myrtle was dreaming through algebra and trigonometry, wondering whether she would teach or get married, for the moderate prosperity of the family demanded that she do something. Eugene mooned through his studies learning nothing practical. He thought at times that he ought to write but his efforts at sixteen were puerile. He thought he might draw but there was no one to tell him whether or not there was any merit in the things he did. He was overawed also by the fact that the world apparently demanded practical service—buying and selling like his father, clerking in stores, running big businesses. It was a confusing maze and he wondered, even at this age, what was to become of him. He did not object to the kind of work his father was doing, but it did not interest him. For himself he knew it would be a pointless, dreary way of making a living and as for insurance, that was equally bad. He could hardly bring himself to read through the long rigmarole of specifications which each insurance paper itemized. There were times—evenings and Saturdays—when he clerked in his father's store, but it was mostly painful work. His mind was not on it.

As early as Eugene's twelfth year, his father had begun to see that Eugene was not much for business and by the time he was sixteen he was well convinced of it. From the trend of Eugene's reading and his percentage marks

at school, Witla was equally convinced that the boy was not much good at practical study. Myrtle, who was two classes ahead of him but sometimes in the same room—co-education was then in force—reported that he dreamed too much. He was always looking out the window.

"I think we ought to try to get Eugene into newspaper work or something like that," Witla senior suggested to his wife.

"It looks as though that's all he would be good for, at least now," replied Mrs. Witla, who was satisfied that her boy had not yet found himself. "I think he'll do something better later on. His health isn't very good, you know."

Witla half suspected that his boy was naturally lazy, but he wasn't sure. The boy had a great gift for lying in the hammock. Witla suggested that Benjamin C. Burgess, the prospective father-in-law of Sylvia and the editor and proprietor of the *Morning Appeal*, might give Eugene a place as a reporter or typesetter in order that he might learn the business from the ground up. The *Appeal* carried few employees, but Mr. Burgess might have no objection to starting Eugene as a reporter if he could write, or as a student of typesetting, or both. There was room for both—Witla knew that, for he had seen another young fellow go through very much the same process several years before. He appealed to Burgess one day on the street.

"Say, Burgess," he said, "you wouldn't have a place over in that shop of yours for that boy of mine would you, as a beginner? He likes to scribble a little, I notice. I think he pretends to draw, too, though I guess it doesn't amount to much. He ought to get into something. He isn't doing any good at school. Maybe he could learn typesetting. It wouldn't hurt him to begin at the bottom if he's ever going to follow that line. It wouldn't matter what you paid him to begin with."

Burgess thought. He had seen Eugene around town, knew no harm of him except that he was lackadaisical and rather moody.

"Send him in to see me some day," he replied noncommittally. "I might do something for him."

"I'd certainly be much obliged to you, if you would," said Witla. "He's not doing much good as it is, now," and the two men parted.

He went home and told both Eugene and his wife of this rather interesting opportunity but Eugene was not at all enthusiastic.

"Burgess says he might give you a place as a reporter or typesetter on the *Appeal* if you'd come in and see him some day," explained Witla, looking over to where his son was reading by the lamplight.

"Does he?" replied Eugene calmly. "Well, I can't write. I might set type. Did you ask him?"

"Yes," said Witla, "you'd better go in there some day."

Eugene bit his lip. He realized this was commentary on his loafing propensities. He wasn't doing very well, that was certain. Still typesetting was no bright field for a man of his temperament.

"I will," he concluded, "when school's over."

"Better speak for it before school ends. Some of the other fellows might ask for it around that time. It wouldn't hurt you to try your hand at it."

"I will," replied his son obediently.

So it was that he stopped in at Mr. Burgess's office on the ground floor of the three-story *Appeal* building one sunny April afternoon. Burgess looked at him quizzically when he stated his business. He was a fat man, slightly bald, with a round head, smooth shaven and with a short nose surmounted by a pair of steel rimmed spectacles. What little hair he had was gray.

"So you think you'd like to go into the newspaper business, do you?" queried Burgess.

"I'd like to try my hand at it," replied the boy. "I'd like to see whether I like it."

"I can tell you right now there's very little in it. Your father says you like to write?"

"I'd like to well enough, but I don't think I can. I wouldn't mind learning typesetting. If I ever could write I'd be perfectly willing to."

"When do you think you'd like to start?"

"At the end of school, if it's all the same to you."

"It doesn't make much difference. I'm not really in need of anybody, but I could use you. Would you be satisfied with five a week?"

"Yes, sir!"

"Well, come in when you're ready. I'll see what I can do."

He waved the prospective typesetter away with a movement of his fat hand and turned to his black walnut desk, dingy, covered with papers, and lit by a green shaded electric light. Eugene went out, the smell of fresh printing ink in his nose, and that equally aggressive smell of damp newspapers. It was going to be an interesting experience he thought, but perhaps a waste of time. He didn't think so much of Alexandria. Some time he was going to get out of it.

CHAPTER II

The office of the *Appeal* was not different from that of any other country newspaper office within the confines of our two hemispheres. The ground floor was given over to the business and cash office, with one flat

bed press and three job and printing presses lined up in a large and fairly well lighted room in the rear. On the second floor was the composing room with its rows of type cases on their high racks—for this newspaper was, like most other country newspapers, still set by hand—and in front was the one dingy office of the so-called editor, or managing editor, or city editor, for all three were the same person, Mr. Caleb Williams, whom Burgess had picked up in times past from heaven knows where. Williams was a small, lean, wiry, man with a black pointed beard and a glass eye which fixed you oddly with its black pupil. His other eye was black naturally and watered a great deal. His hair was black, curly, thick, and upright. He was talkative, skipped about from duty to duty, wore most of the time a green shade pulled low over his forehead, and smoked a brown briar pipe. He had a fund of knowledge, picked up apparently from metropolitan journalistic experience, but he was anchored here with a wife and three children after sailing, no doubt, a chartless sea of troubles, and was glad to talk life and experiences after office hours with almost anybody. It took him from eight in the morning until two in the afternoon to gather what local news there was, and either write it or edit it. He seemed to have a number of correspondents who sent him weekly batches of news from surrounding points. The Associated Press furnished him with a few minor items by telegraph, and there was a "patent insides"—two pages of fiction, household hints, medicine ads, and what not—which saved him considerable time and stress. Most of the news which came to him received short shrift in the matter of editing. "In Chicago we used to give a lot of attention to this sort of thing," he was wont to declare to anyone who was near, "but you can't do it down here. The readers really don't expect it. They're looking for local items pretty sharp."

Mr. Burgess took care of the advertising sections. In fact he personally solicited advertising, saw that it was properly set up as the advertiser wanted it, and properly placed according to the convenience of the day and the rights and demands of others. He was the politician of the concern, the handshaker, the guider of its policy. He wrote editorials now and then, or with Williams decided just what their sense must be, met the visitors who came to the office to see the editor, and arbitrated all known forms of difficulty. He was at the beck and call of certain Republican party leaders in the county, but that seemed natural, for he was a Republican himself by temperament and disposition. He was appointed postmaster once to pay him for some useful services, but he declined because he was really making more out of his paper than his postmastership would have brought. He received whatever city or county advertising it was in the power of the Republican leaders to give him, and so he did very well. The complications of his political relationship Williams knew in part, but they never troubled that industrious soul.

He was through with moralizing. "I have to make a living for my wife and three children. That's enough to keep me going without bothering my head about other people." So this office was really run very quietly, efficiently, and in almost every way pleasantly. It was a sunny place to work.

Witla, who came here at the end of his eleventh school year when he had just turned seventeen, was impressed with the personality of Mr. Williams. He liked him. He came to like a Jonas Lyle who worked at what might have been called the head desk of the composing room, and a certain John Summers who worked at odd times—whenever there was an extra rush of job printing. He learned very quickly that John Summers, who was fifty-five, gray, and comparatively silent, was troubled with weak lungs and drank. He would slip out of the office, Eugene would notice, at various times during the day and be gone from five to fifteen minutes. No one ever said anything, for there was no pressure here. What work was to be done was done. Jonas Lyle was of a more interesting nature. He was younger by ten years, stronger, better built, but still a character. He was semi-phlegmatic, philosophic, partially literary. He had worked, as Eugene found out in the course of time, in nearly every part of the United States—Denver, Portland, St. Paul, Cincinnati, St. Louis, what not—and had a fund of recollections of this proprietor and that. Whenever he saw a name of any distinction in the newspapers he was apt to bring the particular paragraph to Williams—and later, when they became familiar, to Eugene—and say, "I used to know that fellow out in ——. He was postmaster (or what not) at X——. He's come up considerably since I knew him." In most cases he did not know these celebrities personally at all, but he did know of them. And the echo of their fame sounding in this out-of-the-way corner of the world impressed him. He was a careful reader of proof when Williams was in a rush, a quick typesetter, a man who stayed by his tasks faithfully. But he hadn't gotten anywhere in the world, for after all, he was little more than a machine. Eugene could see that at a glance.

It was Lyle who taught him the art of typesetting. He demonstrated the first day the theory of the squares or pockets in a case, how some letters were placed more conveniently to the hand than others, why some letters were much less sparsely represented as to quantity, why capitals were used in certain offices for certain purposes, in others not. "Now on the Chicago *Tribune* we used to italicize the names of churches, boats, books, hotels, and things of that sort. That's the only paper I ever knew to do that," he sagely remarked. What slugs, sticks, galleys, turnovers were, came rapidly to the surface. That the fingers would come to recognize weights of leads by the touch, that a letter would almost instinctively find its way back to its proper pocket, even though you were not thinking, once you became expert, were

facts which he cheerfully communicated. He wanted his knowledge taken seriously, and this serious attention, Eugene, because of his innate respect for learning of any and all kinds, was only too glad to accord him. He did not know what he wanted to do, but he knew quite well that he wanted to see everything. This shop was interesting to him for some little time for this reason, for though he soon found that he did not want to be a typesetter, or a reporter, or indeed anything much in connection with a country newspaper, he was learning about life.

He worked at his desk cheerfully, smiling out upon the world which indicated its presence to him through an open window, read the curious bits of news or opinion or local advertising announcements as he composed them, and dreamed of what the world might have in store for him. He was not vastly ambitious as yet, but hopeful and yet, withal, a little melancholy. He could see boys and girls whom he knew, idling in the streets on the corner squares; he could see where Tad Martinwood was driving by in his father's buggy or George Anderson was going up the street with the air of some one who would never need to work. George's father owned the one and only hotel. There were thoughts in Eugene's mind of fishing, boating, lolling somewhere with some pretty girl, but alas, girls did not apparently take to him so very readily. He was too shy. If he were only rich—what a life he would lead—how happy he would be. So he dreamed.

Almost up to the time that Eugene was thus called to take his place in the world, his experience with girls had not been very wide. There were those very minor things that always occur in early youth—girls whom we furtively kiss or who equally furtively kiss us. The latter had been the way in Eugene's case, but he had had no notable interest in any one girl. At fourteen years of age he had been picked at a party by one little girl as her affinity, for the evening at least, and in a game of "post office" had enjoyed the wonder of a girl's arms around him in a dark room and of a girl's lips against his; but since then there had been no re-encounter of any kind. He had dreamed of love, with this one experience as a basis, but always in a shy, distant way. He was afraid of girls and they, to tell the truth, were afraid of him. They could not make him out.

The fall preceding his start with the *Morning Appeal*, however, he had come into contact and relationship with one girl who had made a profound impression on him. It was so astonishing to him, so much of an influence in shaping his ideals of womanhood, that it will have to be narrated in detail. Stella Appleton was the girl's name and she was a notably beautiful creature of a distinct type. She was very fair, Eugene's own age, with blue eyes, light hair, a slender sylph-like body. She was gay and debonair in an enticing way, without really realizing how dangerous she was to the average, susceptible

male heart. She liked to flirt with the boys, principally because it amused her and not because she cared for anyone in particular. There was no petty meanness in it, however, for she thought they were all rather nice, the less clever appealing to her almost more than the sophisticated. She may have liked Eugene from the first because of his rather retiring disposition.

He saw her first at the beginning of his last school year when she entered the second year high school class as a transfer from the first year high school class of Moline, Illinois. Her father had come to Alexandria the preceding spring to take a position as manager of a new pulley manufactory which was just starting, he being familiar with the details of that business. Eugene saw her in class first, and then later on Main Street with his sister Myrtle, for the two girls had made friends a few weeks after school opened. Being opposite in type and somewhat of a sympathetic turn, they were in a way attracted to each other. Stella met Myrtle one evening at a friend's house shortly after school began and they walked home together. The former was attracted by Myrtle's quiet ways, the latter by Stella's gayety. They met mornings on their way to school; at noon it was their custom to meet; in the evenings they walked home together. Eugene noted this with particular satisfaction, though he was not the one to intrude his presence on any girl.

One afternoon as the two of them were on Main Street, walking home from the post office, they encountered Eugene, who had been home and was going to visit a boy friend. He was really bashful and anxious to escape when he saw them a few hundred feet ahead, but there was no way. They saw him, and Stella approached confidently enough. Myrtle was anxious to intercept him, principally because she had her pretty companion with her.

"You haven't been home, have you?" she asked, stopping, for this was her chance to introduce Stella; Eugene could not escape. "Miss Appleton, this is my brother Eugene."

Stella gave him a sunny, encouraging smile and held out her hand, which he took gingerly. He was plainly nervous.

"I'm not very clean," he said apologetically. "I've been helping father fix a buggy."

"Oh, we don't mind," said Myrtle. "Where are you going?"

"Over to Harry Morris's," he explained.

"What for?"

"We're going for hickory nuts."

"Oh, I wish I had some," said Stella.

"I'll bring you some," he volunteered gallantly.

She smiled again. "I wish you would."

She was almost for proposing that they be taken along, but inexperience hindered her.

Eugene was struck with all her charms at once. She seemed like one of those unattainable creatures who had swam into his ken earlier and disappeared. There was something of the girl with the corn-colored hair about her, only she had been more voluptuous, more sensuous. This girl was fine, delicate, pink, like porcelain. She was fragile and yet virile. He half caught his breath, for his sense of beauty was exceedingly keen, but he was more or less afraid of her. He did not know what she might be thinking of him.

"Well, we're going out to the house," said Myrtle.

"I'd go along if I hadn't promised Harry I'd come over."

"Oh, that's all right," replied Myrtle. "We don't mind."

He withdrew, feeling as though he had made a very poor impression. Stella's eyes had been on him in an inquiring way. She looked after him when he had gone, thinking that he was interesting.

"Isn't he nice?" she said to Myrtle frankly.

"I think so," replied Myrtle, "kinda. He's too moody, though."

"What makes him?"

"He isn't very strong."

"I think he has a nice smile."

"I'll tell him," she said.

"No, please don't. You won't, will you?"

"No."

"But he has a nice smile."

"I'll let you come out to the house some evening and you can meet him again."

"I'd like to," said Stella. "It would be lots of fun."

"Come out Saturday evening and stay all night. He's home then."

"I will," said Stella. "Won't that be fine."

"I believe you like him," laughed Myrtle.

"I think he's awfully nice," replied Stella.

This second meeting between Eugene and Stella occurred on Saturday evening as arranged, when he came home at 5:30 from his father's store where he had been helping on what to him was the accursed insurance business. Stella had come to dinner, or supper, as it was called here. Eugene saw her from the hall through the open sitting room door as he bounded upstairs to his room to wash and change his clothes, for he had at this time a fire of youth which no sickness of stomach or weakness of lungs could overcome. A thrill of anticipation ran over his body. He took especial pains with his toilet, adjusting a red tie he had to a nicety, powdering his face, parting his hair carefully in the middle. He came down after a time, conscious that he had to say something smart, worthy of himself, or she would not see how attractive he was; and yet he was very much afraid of the result.

When he entered the sitting room she was sitting with his sister before an open fireplace, the glow of a table lamp with a red flowered shade warmly illuminating the room. It was a commonplace room with its blue cloth covered centre-table, its chairs of stereotyped factory design, and its bookcase of assorted cloth-bound novels and histories, but it was homey, and the sense of homeliness was strong.

Mrs. Witla was in and out occasionally, looking for something which appertained to her functions as a house-mother. Witla père came home at six-thirty, having been to some outlying town of the county trying to sell a machine. He was a wiry man with a fund of humor which extended to joking with his son and daughters when he was feeling good, to noting their budding interest in the opposite sex, to predicting some commonplace climax to their one grand passion when it should come. He was fond of telling Myrtle that she would some day marry a horse doctor. And as for Eugene, he predicted a certain Elsa Brown, who, his wife said, had greasy curls. This did not irritate either Myrtle or Eugene. It brought a wry smile to the latter's face, for he was fond of a jest. But even at this age Eugene saw his father pretty clearly. He saw the smallness of his business; the ridiculousness of any such profession or calling ever having any claim on him. He never wanted to say anything, but there was in him a burning opposition to the commonplace, a molten pit in a crater of reserve, which smoked ominously now and then for anyone who could have seen it. Neither his father nor his mother understood him. To them he was a peculiar boy, dreamy, sickly, unwitting as yet of what he really wanted.

"Oh, here you are," said Myrtle when he came in, "Come sit down."

Stella gave him an enticing smile.

Instead he walked to the mantle-piece and stood there, posing. He wanted to impress this girl and yet he did not know how. He was almost lost for anything to say.

"You can't guess what we've been doing," his sister chirped helpfully.

"Well, what?" he replied blankly.

"You ought to guess, I should say. Can't you be nice and guess?"

"Yes, one guess anyhow," put in Stella, who pretended to be gazing soulfully in the fire.

"Toasting pop-corn," he ventured with a half smile.

"Well, you're close anyhow." It was Myrtle talking.

Stella looked at him with round, blue eyes. "One more guess," she suggested.

"Chestnuts," he responded feelingly.

She nodded her head in agreement.

"What hair," was all he thought. Then—"Where are they?"

"Here's one," laughed his new acquaintance, holding out a dainty hand.

Under her laughing encouragement he was finding his voice. "Stingy," he said.

"Now, isn't that mean," she exclaimed. "I give him the only one I have and he calls me stingy. Don't you give him any of yours, Myrtle."

"I take it all back," he pleaded. "I didn't know it was the only one you had."

"I won't," exclaimed Myrtle, talking at the same time. "Here, Stella," and she held out a few nuts still in her possession, "you take these, and don't you give him any."

She put them in Stella's eager hands.

It was a bid for contest. He felt it. She wanted him to try to make her give him some.

"Here," he exclaimed, holding out his hand. "That's not right. I get some, don't I?"

She shook her golden head.

"Oh, yes, one, anyhow."

Her head moved back and forth sidewise.

"One," he pleaded, drawing near.

Again the golden negative. But her hand was at the side nearest him, where he could seize it. She started to pass its contents back of her to the other hand. He jumped and grabbed it.

"Myrtle! Quick!" she called, trying to put the chestnuts into the other hand.

Myrtle came. It was a three-handed struggle. In the contest, Stella twisted and got up. Her golden hair brushed his face. He held her little hand not roughly but firmly. Then for a moment he looked in her eyes. What was it? He could not say. Only he half let go and gave her the victory.

"There," she smiled. "Now I'll give you one."

He took it, laughing, but he yearned to take her in his arms.

During the rest of the evening it was much like this. His father came in a little while before supper and sat down, but finally took a Chicago paper and went into the dining room to read. His mother called them to table and he sat by Stella. They all had to talk generalities but he was intensely interested in what she did and said. If her lip moved, he noted how. If her teeth showed, he thought they were lovely. A little ringlet on her forehead beckoned like a golden finger. He felt the wonder of the poetic phrase, "the shining strands of her hair."

After dinner they went to the sitting room—he and Myrtle and Stella. His father stayed behind to read, his mother, to wash the dishes. Myrtle left

the room after a bit to help her mother, and then these two were alone. He hadn't much to say, now that they were together—he couldn't talk. Something about her beauty kept him silent.

"Do you like school?" she asked, after a time. She felt as if they must talk.

"Only fairly well," he replied. "I'm not much interested. I think I'll quit one of these days and go to work."

"What do you expect to do?"

"I don't know yet. I'd like to be an artist," he confessed for the first time in his life—why, he could not have said.

Stella took note of the peculiar confession.

"I was afraid they wouldn't let me enter second year high school, but they did. The superintendent at Moline had to write the superintendent here."

"They're mean about those things," he cogitated.

She got up and went to the bookcase to look at the books. He followed after a little while.

"Do you like Dickens?" she asked.

He nodded his head solemnly in approval. "Pretty much," he said.

"I can't like him. He's too long drawn out. I like Scott better."

"I like Scott," he said.

"I'll tell you a lovely book that I like." She paused, her lips parted, trying to remember the name. She lifted her hand as though to pick the title out of the air. "*The Fair God*," she exclaimed at last.

"Yes, it's fine," he approved. "I thought the scene in the old Aztec temple where they were going to sacrifice Ahwahee was so wonderful."

"Oh yes, I liked that," she added.

She pulled out *Ben Hur* and turned its leaves idly. "And this was so good."

"Wonderful!"

They paused and she went to the window, standing underneath the cheap lace curtains. It was a moonlit night. The rows of trees that lined the street on either side were leafless, the grass brown and dead. You could see through the thin, interlaced twigs that were like silver filigree, the lamps of other houses shining through half-drawn blinds. A man went by, a black shadow in the half-light.

"Oh, isn't it lovely," she said.

Eugene came near. "It's fine," he answered.

"I wish it was cold enough to skate. Do you skate?" She turned to him.

"Yes, indeed," he replied.

"My, it's so nice on a moonlit night. I used to skate a lot at Moline."

"We skate a lot here. There's two lakes, you know."

He thought of clear crystal nights when the ice on Green Lake had split every so often with a great resounding rumble. He thought of the crowds of boys and girls shouting. The distant shadows; the stars. Up to now he had never found any girl to skate with successfully. He had never felt just easy with anyone. He had tried it, but once he had fallen with a girl, and it had almost cured him of skating forever. He felt, though, as if he could skate with Stella. He felt as though she might like to skate with him.

"When it gets colder we might go," he ventured. "Myrtle skates."

"Oh, that'll be fine!" she applauded.

Still she looked out into the street.

After a bit she came back to the fire and stood before him, a few feet away, pensively gazing down.

"Do you think your father will stay here?" he asked.

"He says so. He likes it very much."

"Do you?"

"Yes, now."

"Why *now?*"

"Oh, I didn't like it at first."

"Why?"

"Oh, I guess it was because I didn't know anybody. I like it though, now." She lifted her eyes.

He drew a little nearer.

"It's a nice place," he said, "only there isn't much for me here. I think I'll leave next year."

"Where do you think you'll go?"

"To Chicago. I don't want to stay here."

She turned her body toward the fire and he moved to a chair behind her, leaning on its back. She felt him there, rather close, but did not move. He was surprising himself.

"Aren't you ever coming back?" she asked.

"Maybe. It all depends. I suppose so."

"I shouldn't think you'd want to leave yet."

"Why?"

"You say it's so nice."

He made no answer and she looked over her shoulder. He was leaning very much toward her.

"Will you skate with me this winter?" he asked meaningly.

She nodded her head.

Myrtle came in.

"What are you two talking about?" she asked.

"The fine skating we have here," he said.

"I love to skate," she exclaimed.

"So do I," added Stella. "It's heavenly."

CHAPTER III

It would be useless to chronicle the details of this courtship—passing as it was—except for the fact that some of its incidents left a profound impression on Eugene's mind. There was one scene not long after that when they met to skate, for the snow came and the ice and there was wonderful skating on Green Lake. The freeze was so heavy that men with hoses and ice-saws were cutting blocks a foot thick over at Miller's Point, where the ice houses were. Almost every day after Thanksgiving there were crowds of boys and girls from the schools scooting about like water skippers on their bright skates. Eugene could not always go on week evenings and Saturdays, because of having to assist his father at the store, but he could stand at his window and think about what those who did not have to work were doing. At regular intervals he could ask Myrtle to get Stella and let them all go together at night. At other times he would ask her to go alone. Not infrequently she did, but she was really not for love in any great sense yet. She was too young—younger than he in temperament and knowledge, though actually older by several months in the matter of life.

On one particular occasion they were below a group of houses which crept near the lake on high ground. The moon was high, its wooing rays reflected in the polished surface of the ice. Through the black masses of trees that lined the shore in spots could be seen the glow of windows, yellow and homey. They had slowed up to turn about, after having left the crowd of skaters some distance back. Her golden curls were ornamented by a bright blue French cap, her body, to below the hips, encased in a white wool Jersey, close-fitting and shapely. The skirt below was a gray mixture of thick wool threads, and the stockings covered by white wool leggings. She looked tempting and cute and knew it.

Suddenly as they turned, one of her skates came loose and she hobbled and exclaimed about it. "Wait," said Eugene, "I'll fix it."

She stood before him and he fell to his knees, undoing the twisted strap. When he had the skate off and ready for her foot he looked up, and she looked down on him, smiling. He dropped it and flung his arms about her hips, laying his head against her waist.

"You're a bad boy," she said.

For a few minutes she kept silent, for as the centre of this lovely scene she was divine. While he held her she pulled off his wool cap and laid her hand on his hair. It almost brought tears to his eyes, he was so happy. At the same time it awakened a tremendous passion. He clutched her significantly.

"Fix my skate now," she said wisely.

He got up to hug her but she would not let him.

"No, no," she protested. "You mustn't do like that. I won't come with you if you do."

"Oh, Stella," he pleaded.

"I mean it," she insisted. "You mustn't do like that."

He subsided, hurt, half angry. But he feared her will. She was really not as ready for love as he had thought.

There was another time when a sleighing party was given by some school girls, and Stella, Eugene, and Myrtle were invited. It was a lovely night of snow and stars, not too cold but bracing. A great box wagon had been dismantled of its body and the latter put on runners and filled with straw and warm robes. Eugene and Myrtle, like the others, had been picked up at their door after the sleigh had gone the rounds of some ten peaceful little homes. Stella was not in yet, but in a little while her house was reached.

"Get in here," called Myrtle, though she was half the length of the box away from Eugene. Her request made him angry. "Sit by me," he called, fearful that she would not. She climbed in by Myrtle, but finding the space not to her liking moved farther down. Eugene made a special effort to make room by him and she came there as though by accident. He drew a buffalo robe up about her and thrilled to think that she was really there. The sleigh went jingling about the town for others and finally struck out into the country. It passed great patches of dark woods silent in the snow, little white frame farm houses snuggled close to the ground and with windows that gleamed yellow in a vague romantic way. The stars were countless and keen. The whole scene made a tremendous impression on him, for he was in love and here beside him, in the shadow, her face palely outlined, was this girl. He could make out the sweetness of her cheek, her eyes, the softness of her hair.

There was considerable chatter and singing, and in the midst of these distractions he managed to slip an arm about her waist, to get her hand in his, to look close into her eyes, trying to divine their expression. She was always coy with him, not wholly yielding. Three or four times he kissed her cheek furtively and once her mouth. Then in a dark place he pulled her vigorously to him, planting a long, sensuous kiss on her lips that frightened her.

"No," she protested, nervously. "You mustn't."

He ceased for a time, feeling that he was pressing his advantage too keenly. But the night in all its beauty and she in hers made an enduring impression.

Eugene was at that age when he wished to express himself in ardent phrases. He was also at the age when bashfulness held him in reserve, even though he were in love, and intensely emotional. He could only say to Stella what seemed trivial things and then look his intensity, whereas it was the trivial things that were most pleasing to her—not the intensity. She was even then beginning to think he was a little strange, a little too intense for her disposition. Love did not mean much to her yet, but she liked him.

In the meantime the winter passed. He went to work in the office of the *Appeal*. It became generally understood around town that Stella was *his* girl. School day mating usually goes on in this manner in a small city or village. He was seen to go out with her. His father teased him. Her father and mother deemed this a manifestation of calf-love, more on his part than on hers, for they were aware of her tendency to hold lightly any budding manifestation of affection on the part of boys. He seemed a silly sentimentalist who would soon be wearisome to Stella. As a matter of fact it actually would work out this way, but he did not yet know it. On one occasion at a party given by various high school girls, a "country post office" was organized. That was one of those utterly daring games which mean kissing only. A system of guessing results in a series of forfeits. If you miss, you become the postmaster and must call someone for "mail." "*Mail*" means to be kissed in a dark room (where the postmaster stands) by someone whom you like or who likes you. You, as postmaster, have authority or compulsion—however you may be feeling about it—to call whom you please.

In this particular instance Stella, who was caught before Eugene, was under compulsion to call someone to kiss. Her first thought was of him, but on account of the open character of the deed and because there was a lurking fear in her of his eagerness, the name she felt impelled to speak was that of Harvey Rutter. He was a handsome boy whom Stella had met after her first encounter with Eugene. He was not as yet fascinating to her, but pleasing. She had a coquette's desire to see what he was like. This was her first direct chance.

He stepped gaily in and Eugene was at once insane with jealousy. He could not understand why she would treat him that way. When it came his turn, he called for Bertha Shoemaker, whom he admired and who was sweet enough in a dark way, but who was as nothing to Stella in his estimation. The pain of kissing her when he really wanted the other girl was great. When he came out, Stella saw moodiness in his eyes but chose to ignore it. He was obviously half-hearted and downcast in his simulation of joy.

A second chance came to her and this time she called him. He went but was in a semi-defiant mood. He wanted to punish her. When they met in the dark she expected him to put his arms around her. Her own hands were up to about where his shoulders would be. Instead he only took hold of one of her arms with his hand and planted a chilly kiss on her lips. If he had only asked, "Why did you?" or held her close and pleaded with her not to treat him so badly, the relationship might have lasted much longer instead of being doomed from the start. He said nothing and she flared with defiance. It made her angry and she went out gaily. There was a strain of reserve running between them until the party broke up and he took her home.

"You must be melancholy tonight," she remarked, after they had walked two blocks in comparative silence. The streets were dark and their feet sounded hollowly on the brick pavement.

"Oh, I'm feeling all right," he replied moodily.

"Wasn't Ada Renwick dressed cute?" she volunteered.

"Very," he said sullenly.

"I think it's awfully nice at the Weimers'—we always have so much fun there."

"Oh, lots of fun," he echoed contemptuously.

"Oh, don't be so cross," she flared. "You haven't any reason for fussing."

"Haven't I?"

"No, you haven't."

"Well, if that's the way you feel about it, I suppose I haven't. I don't see it that way."

"Well, anyhow, it doesn't make any difference to me what you think."

"Oh, doesn't it?"

"No, it doesn't." Her head was up and she was angry.

"Well, I'm sure then it doesn't to me."

There was another silence which endured until they were almost home.

"Are you coming to the sociable next Thursday?" he inquired. He was referring to a Methodist evening entertainment which, although he cared very little about it, was a convenient way to see her and a chance to take her home. He was prompted to ask by the fear that an open rupture was impending.

"No," she said. "I don't think I will."

"Why not?"

"I don't care to."

"I think you're mean," he said reprovingly.

"I don't care," she replied. "You're too bossy. I don't think I like you very much any more, anyhow."

His heart contracted ominously.

"You can do as you please," he persisted.

They reached her gate. It was his wont to kiss her here in the shadows—to hold her tight for a few moments in spite of her protests. Tonight he thought of doing it but she gave him no chance.

When they reached the gate she opened it quickly and slipped in. "Good night," she called.

"Good night," he said and then, as she reached her door, "Stella!"

It was open and she slipped in. He stood in the dark, hurt, sore, oppressed. What should he do? He strolled home, cudgeling his brains over whether never to speak to or look at her again until she came to him or to hunt her up and fight it all out with her. She was in the wrong, he knew that. When he went to bed he was grieving over it, and when he awoke it was with him all day.

Meanwhile he had been gaining rather rapidly as a student of typesetting and, to a certain extent, of the theory of reporting, though he was very poor at it. Yet he worked diligently and earnestly at his proposed trade. He still loved to look out the window and dream, though of late after knowing Stella so well and coming to quarrel with her because of her indifference there was a little hurt in it. This getting to the office at eight in the morning, putting on an apron and starting in on some local correspondence left over from the day before, or some telegraph copy which had been freshly filed on his hook, had its constructive value. Williams endeavored to use him on some local items of news as a reporter, but he was a slow worker and almost a failure at getting all the facts. He did not appear to know how to interview anybody, and would come back with a story which needed to be filled in from other sources. He really did not understand the theory of news, and Williams could only make it partially clear to him. Mostly he worked at his case, but he did learn some things.

For one thing, the theory of advertising began to dawn on him. These local merchants put in the same ads day after day, and many of them did not change them noticeably. He saw Lyle and Summers taking the same ads which had appeared unchangingly from month to month in so far as their main features were concerned, and alter only a few words before returning them to the forms. He wondered sometimes at the sameness of them, and when at last ads were given to him to revise, he often wished he could change them a little. The language seemed so dull.

"Why don't they ever put little drawings in these ads?" he asked Lyle one day. "Don't you think they'd look a little better?"

"Oh, I don't know," replied Jonas. "They look pretty good. These people around here wouldn't want anything like that. They'd think it was too fancy."

Eugene had seen and in a way studied the ads in the magazines. They seemed so much more fascinating to him. Why couldn't newspaper ads be different?

Still it was never given to him to trouble over this problem. Mr. Burgess dealt with the advertisers. He settled just how the ads were to be. He never talked to Eugene or Summers about them—not always to Lyle. He would sometimes have Williams explain just what their character and layout was to be.

Eugene was so young that Williams did not at first pay very much attention to him, but after a time he began to realize that there was a personality here, and then he would explain certain things—why space had to be short for some items and long for others, why county news, news of small towns around Alexandria and about people, was much more important financially to the paper than the correct reporting of the death of the sultan of Turkey. "The most important thing is to get local names right. Don't ever misspell them," he once cautioned him. "Don't ever leave out a part of a name if you can help it. People are awfully sensitive about that. They'll stop their subscription if you don't watch out, and you won't know what's the matter."

Eugene took all these things to heart. He wanted to know how the thing was done, though basically it seemed a little small. People seemed a little small, mostly.

One of the things that did interest him was to see the paper actually put on the press and run off. He liked to help lock up the forms and to see how they were imposed and registered. He liked to hear the press run, to help carry the wet papers to the mailing tables and the distributing counter out in front. The paper hadn't a very large circulation but there was a slight hum of life about that time, and he liked it. He liked the sense of getting his hands and face streaked and not caring, and of seeing his hair, tousled, in the mirror. He tried to be useful and the various people on the paper came to like him, though he was sometimes a little awkward and slow. He was not strong at this period and his stomach troubled him. He thought, too, the smell of the ink might affect his lungs, though he did not seriously fear it. In the main it was interesting but small; there was a much larger world outside, he knew that. He hoped to go to it some day. He really hoped to go to Chicago.

CHAPTER IV

The way this came about was interesting, though simple and common-place enough. Eugene grew more and more moody and restless under Stella's increasing independence. She grew steadily more indifferent because of his moods. The fact that other boys were crazy for her consideration was a great factor; the fact that one particular boy, Harvey Rutter, was persistently genial, not insistent, really better looking than Eugene, and notably bet-ter tempered, helped a great deal. Eugene saw her walk with him now and then, saw her go skating with him, or at least with a crowd of which he was a member. Eugene hated him heartily; he hated her at times for not yielding to him wholly, but he was nevertheless wild over her beauty. It fascinated and enthralled him. It stamped his brain with a type or ideal. Thereafter he knew in a very definite way what, to be really beautiful, womanhood ought to be. It gave him a standard.

Another thing it did for him was to bring home very definitely a sense of his position in the world. So far he had always been dependent on his parents for food, clothes, spending money, and what not, and his parents were not very liberal. He knew of other boys in town who had money wherewith to run up to Chicago or down to Springfield (the latter was nearer) to have a Saturday and Sunday lark. No such gaities were for him. His father would not allow it, or rather would not pay for it. There were other boys, who, because of spending money amply provided, were the town dandies. He saw them kicking their heels outside the corner book store, the principal loafing place of the elite, on Wednesdays and Saturdays and sometimes on Sunday evenings preparatory to going somewhere, dressed in a luxury of clothing which was beyond his wildest dreams. Tad Martinwood, the son of the principal dry goods man, had a frock coat in which he sometimes appeared when he came down to the barber shop for a shave before he went to call on his girl—be-powdered, be-perfumed, be-boutonniered to the point of exasperation. George Anderson, whose father had the one hotel, was pos-sessed of a dress suit and wore dancing pumps at all dances. There was Ed Waterbury, who was known to have a horse and runabout or driving cart of his own. These fellows were slightly older and went with girls in an older set, but the point was the same. Actually in matter of intellect Eugene was much older; only in the matter of years was he younger. But he saw these things and they hurt him.

Another thing which affected his temper was that he had no known avenue of progress which, so far as he could see, was going to bring him to any financial prosperity. His father was never going to be rich. Anybody could see that. He was making no practical progress in school work—he

knew that. He hated insurance, soliciting or writing, despised the sewing machine business when he began to see it in its true proportions, and did not know how he would ever get anything which he might like to do in literature or art. His drawing seemed a joke; his writing, or wish for writing, pointless. There were lots of people doing things in that way, but it did not occur to him then that he would ever be one of them or in any way remotely connected with them. So he was broodingly unhappy.

One day Williams, who had been watching him a long time, stopped at his desk.

"I say, Witla," he said, "why don't you go to Chicago? There's a lot more up there for a boy like you than there is down here. You'll never get anywhere working on a country newspaper."

"I know it," said Eugene.

"Now with me it's different," went on Williams. "I've had my rounds. I've got a wife and three children, and when a man's got a family he can't afford to take any chance. If I didn't, I wouldn't stay here. But you're young yet. You ought to get a good start. Why don't you go to Chicago and get on a paper? You could get something."

"What could I get?" asked Eugene.

"Well, you might get a job as a typesetter if you'd join the union. I don't know how good you'd be as a reporter—I hardly think that's your line. But you might study art and learn to draw. Newspaper artists make good money."

Eugene thought of his art. It wasn't much. He didn't do much with it. Still, the thought of Chicago—the world appealed to him. If he could only get out of here—if he could only make more than seven or eight dollars a week. He brooded about this. Certainly there was nothing more here for him—he was sick of it all.

One Sunday afternoon he and Stella went with Myrtle to Sylvia's home and after a three-quarters of an hour stay, Stella announced that she would have to be going. Her mother would be expecting her back. Myrtle was for going with her, but decided against it when Sylvia asked her to stay to tea. "Let Eugene take her home," Sylvia said. "You stay and he can come back when he's done." Eugene was delighted in his persistent, hopeless way. He was not yet convinced that she could not be won to love. When they walked out in the fresh, sweet air—it was nearing spring—he felt as if now he should have a chance of saying something which would be winning—which would lure her to him.

They strolled out a street next to the one she lived on, quite to the confines of the town. She had wanted to turn off at her street but he urged her not to. "Do you have to go home just yet?" he asked, pleadingly.

"No, I can walk a little way," she replied.

They reached a vacant place—the last house some little distance back—talking idly. In recent days a reserve had grown up. It was getting hard to make talk. In his efforts to be entertaining, he picked up three twigs to show her how a certain trick in balancing was performed. It consisted in laying two at right angles with each other and with a third, using the latter as an upright. She could not do it, of course. She was not really very much interested. He wanted her to try and when she did, he tried to take hold of her right hand to steady her efforts.

"No, don't," she said, drawing her hand away. "I can do it."

She trifled with the twigs unsuccessfully and was about to let them fall when he took hold of both her hands. It was so sudden that she could not resist, or rather get her hands away, and so she looked him straight in the eye.

"Let go, Eugene," she said. "Please let go."

He shook his head, gazing at her.

"Please let go," she went on. "You mustn't do this. I don't want you to."

"Why?" he asked.

"Because."

"Because why?"

"Well, because I don't."

"Don't you like me any more, Stella, really?" he asked.

"I don't think I do—not that way."

"But you did."

"I thought I did."

"Have you changed your mind?"

"Yes. I think I have."

He dropped her hands and looked at her fixedly and dramatically. The attitude did not appeal to her. They strolled back to her street, and when they neared her door he said, "Well, I suppose there's no use in my coming to see you any more."

"I think you'd better not," she said simply.

She walked in, never looking back, and instead of going back to his sister's, he went home. He was in a very gloomy mood and after sitting about awhile, went to his room. The night fell and he sat there looking out at the trees and grieving about what he had lost. Perhaps he was not good enough for her—he could not make her love him. Was it that he was not handsome enough—he did not really consider himself good looking—or not dashing enough, or what? Was it a lack of courage or strength?

He looked out of the window after a time, and there was the moon hanging like a bright shield in the sky. Two layers of thin fleecy clouds were

moving in different directions on different levels. He stopped in his cogita-
tions to think where these clouds came from. On sunny days when there
were great argosies of them he had seen them disappear before his eyes and
then, marvel of marvels, reappear out of nothingness. The first time he
ever saw this it astonished him greatly, for he had never known up to then
what clouds were. Afterward he read about them in his physical geography.
Tonight he thought of that, and of the great plains over which these winds
swept and of the grass and trees—great forests of them—miles and miles.
What a wonderful world! Poets wrote about these things. Longfellow and
Bryant and Tennyson. He thought of "Thanatopsis" and of the "Elegy," both
of which he had read and admired greatly. What was this thing, life?

Then he came back to Stella with an ache. She was gone. She was
actually gone, and she was so beautiful. She would never really talk to him
anymore. He would never get to hold her hand anymore or to kiss her. Oh,
that night on the ice; that night in the sleigh! How wonderful they were.
He clenched his hands, for he was really hurt, and then undressed and went
to bed. He wanted to be alone—to be lonely. On his clean white pillow
he lay and dreamed of the things that might have been, kisses, caresses, a
thousand joys—now they were all gone.

What would he do—stay here? He thought not. He wanted to quit work
and leave. If he could only go to Chicago. Maybe he could get out in the
world and be something. Maybe he could forget? Could he?

One Sunday afternoon not long after that, he was lying in his ham-
mock thinking of all this—thinking of what a dreary place Alexandria was,
anyhow, when he opened a Chicago Saturday afternoon paper, which was
something like a Sunday one because it had no Sunday edition, and went
gloomily through it. It was, as he always found, full of a subtle wonder—the
wonder of the city, which drew him like a magnet. Here was the drawing
of a big hotel someone was going to build; there was a sketch of a great
pianist who was coming to play. An account of a new comedy drama; of a
little romantic section of Goose Island in the Chicago River, with its old
decayed boats turned into houses and geese waddling about; an item about
a man falling through a coal hole on South Halsted Street fascinated him.
This last happened at sixty-two hundred and something, and the thought
of such a long street seized on his imagination. What a tremendous city
Chicago must be. The thought of car lines, crowds, trains, came to him with
almost a yearning appeal.

All at once the magnet got him. It gripped his very soul—this wonder,
this beauty, this life.

"I'm going to Chicago," he thought, and he got up.

There was his nice, quiet little home laid out before him. Inside were his

mother, his father, Myrtle. Still he was going. He could come back. "Sure I can come back," he thought. Propelled by this magnetic power, he went in and upstairs to his room, and got a little grip or portmanteau he had. He put in it the things he thought he would immediately need. In his pocket were nine dollars, money he had been saving for some time. His mother could send his trunk. Finally he came down stairs and stood in the door of the sitting room.

"What's the matter?" asked his mother, looking at his solemn introspective face.

"I'm going to Chicago," he said.

"When?" she asked, astonished, a little uncertain of just what he meant.

"Today," he said.

"No. You're joking." She smiled unbelievingly. This was a boyish prank.

"I'm going today," he said. "I'm going to catch that four o'clock train."

Her face saddened. "You're not?" she said.

"I can come back," he replied, "if I want to. I want to get something else to do."

His father came in at this time. He had a little work room out in the barn where he sometimes cleaned machines and repaired vehicles on Sundays. He was fresh from such a task now.

"What's up?" he asked, seeing his wife close to her boy.

"Eugene's going to Chicago."

"Since when?" he inquired amusedly.

"Today. He says he's going right now."

"You don't mean it," said Witla, astonished. He really did not believe it. "Why don't you take a little time and think it over? What are you going to live on?"

"I'll live," said Eugene. "I'm going. I've had enough of this place. I want to get out."

"All right," said his father, who, after all, believed in initiative. Evidently after all he hadn't quite understood this boy. "Got your trunk packed?"

"No, but mother can send me that."

"Don't go today, Eugene!" pleaded his mother. "Wait until you get something ready. Wait and do a little thinking about it. Wait until tomorrow, anyhow."

"I want to go today, ma." He slipped his arm around her. "Little ma." He was bigger than she was by now, and still growing.

"All right, Eugene," she said softly, "but I wish you wouldn't." Her boy was leaving her—her heart was hurt.

"I can come back, ma. It's only a hundred miles."

"Well, all right," she said finally, trying to brighten. "I'll pack your bag."

"I have already," he said.

She went to look.

"Well, it'll soon be time," said Witla, who was thinking that Eugene might back down. "I'm sorry. Still it may be a good thing for you. You're always welcome here, you know."

"I know," said Eugene.

They went finally to the train together, he and Witla and Myrtle. His mother couldn't go. She stayed to cry.

On the way to the depot they stopped at Sylvia's.

"Why, Eugene!" she exclaimed, "How ridiculous. Don't go."

"He's set," said Witla.

Eugene finally got loose. He seemed to be fighting love, home ties, everything, every step of the way. Finally he reached the depot. The train came. Witla grabbed his hand affectionately. "Be a good boy," he said, swallowing a gulp. Myrtle kissed him. "You're so funny, Eugene. Write me."

"I will."

He stepped on the train. The bell rang. Out the cars rolled—out and on. He looked out at the familiar scenes and then a real ache came to him—Stella, his mother, his father, Myrtle, the little home. They were all going out of his life.

"Hm," he half groaned, clearing his throat. "Gee!"

And then he sank back and tried, as usual, not to think. He must succeed. That's what the world was made for. That was what he was made for. That was what he would have to do.

CHAPTER V

The city of Chicago—who shall portray it? This vast ruck of life that had sprung suddenly into existence upon the dank marshes of a lake shore. Miles and miles of dreary little wooden houses; miles and miles of wooden block-paved streets with gas lamps placed and water mains laid and empty wooden walks set for pedestrians. The beat of a hundred thousand hammers; the ring of a hundred thousand trowels; how wonderful it all was. Long, converging lines of telegraph poles; thousands upon thousands of sentinel cottages, factory plants, towering smoke stacks, and here and there a lonely, shabby church steeple, sitting out pathetically upon vacant land. The raw

prairie stretch was covered with yellow grass; the great broad highways of the tracks of railroads, ten, fifteen, twenty, thirty, laid side by side and strung with thousands of shabby cars, like beads upon a string, were most impressive. These engines clanging, these trains moving, the people waiting at street crossings—pedestrians, wagon drivers, steel car drivers, drays of beer, trucks carrying brick, stone, sand, coal in great loads—a spectacle of new, raw, eager, necessary life!

As Eugene began to draw near it, he caught for the first time in his life the sense and significance of a great city. What were these newspaper shadows he had been dealing with in his reading compared to this vivid, articulate, eager thing? Here was the substance of a new world—fascinating, different, substantial. The handsome suburban station at South Chicago, the first of its kind he had ever seen, took his eye as his train rolled cityward at 5:30. He had never before seen a crowd of foreigners—working men—and here was one, Lithuanians, Poles, Czechs, waiting for a local train to take them somewhere. He had never seen a really large factory plant and here was one, and another, and another—steel works, potteries, soap factories, foundries, all gaunt and hard in the Sunday evening air. There seemed to be, for all it was Sunday, something youthful, energetic, and alive about the streets. He noted the street cars waiting; at one place a small river was crossed on a draw—dirty, gloomy, but crowded with boats and lined with great warehouses, grain elevators, coal pockets—that architecture of necessity and utility. His imagination was fired by this, for here was something that could be done brilliantly in black—a spot of red or green for ship and bridge lights. He wished now he were a great artist like Doré, who then held his fancy. There were some men on the magazines who did things like this, only not so vivid.

As the train rolled on he fairly thrilled, for somehow it seemed as though he could do something here. This city was big and sprawling—nearly eight hundred thousand people, the city claimed, and not too fine. Work was the thing. Everybody was working. He could see that. He could get work. He knew that.

The train threaded its way through long lines of cars where coal was stocked, grain spilled, ice allowed to drip. It came finally into an immense train shed where arc lights were sputtering—a score under a great curved steel and glass roof or dome, where people were hurrying to and fro. Engines were hissing; bells clanging raucously. He had no relatives, no soul to turn to, but somehow he did not feel lonely. This picture of life, this newness, fascinated him. He stepped down and strolled leisurely to the gate and outside, wondering which way he should go. As he walked he came to a corner where a lamp post already lit blazoned the name *Madison*. He looked out

and saw, as far as the eye could reach, two lines of stores, horse cars jingling, people walking. What a sight, he thought, and turned west. For three miles he walked, musing, and then as it was dark and he had arranged for neither bed nor board, he wondered where he should eat and sleep. A fat man sitting outside a livery stable door in a tilted, cane-seated chair offered a possibility of information.

"Do you know where I could get a room around here?" Eugene asked.

The lounger looked him over. He was the proprietor of the place.

"There's an old lady living over there at 732," he said, "who has a room, I think. She might take you in." He liked Eugene's looks.

Eugene crossed over and rang a downstairs doorbell. There was a bakery shop beneath with pies and cakes displayed in the window, though without a light. The door was opened shortly by a tall, kindly looking woman of a rather matriarchal turn. Her hair was gray.

"Yes?" she inquired.

"The gentleman at the livery stable over there said I might get a room here. I'm looking for one."

She smiled pleasantly. This boy looked his strangeness, his wide-eyed interest, his freshness from the country. "Come in," she said. "I have a room. You can look at it."

It was a front room—a little bedroom off the one main living room, clean, simple, convenient. "This looks all right," he said.

She smiled.

"You can have it for two dollars a week," she proffered.

"That's all right," he replied, putting down his grip. "I'll take it."

He took out his purse and started to take out a bill.

"You needn't pay me right away," she said. "You can pay me at the end of the week if you want to."

"Oh, I'll pay now," he answered. "I'd just as leave."

She took his money then, bringing him in shortly two towels, a pitcher of fresh water, and a glass.

"Have you had your supper?" she asked.

"No, but I'm going out shortly. I want to see the streets. I'll find some place to eat."

"I'll give you a little something," she said.

Eugene thanked her.

Again she smiled that sweet motherly smile. This was what Chicago did to the country. It took the boys.

He opened the closed shutters of his window and knelt down before it, leaning on the sill. He looked out idly, for it was all so wonderful. Bright lights were burning in store windows. Cars were jingling by. The horses

with little bells on their necks—how funny they were. These people hurrying—how their feet sounded—clap, clap, clap. And away east and away west it was all like this. It was all like this everywhere—a great big wonderful city. It was nice to be in a city. He felt that now. It was all worth while. How could he have ever stayed in Alexandria so long? He would get along here. Certainly he would. He was perfectly sure of that. He knew.

CHAPTER VI

The city of Chicago at this time certainly offered a world of hope and opportunity for the beginner. It was so new, so raw: everything was in the making. The long lines of streets were constructed of houses and stores which were mainly temporary makeshifts, but the auger of something very much better in the future. They were one and two story frame affairs, with here and there a three and four story brick building which spoke of better days to come. Down in the business heart which lay between the lake and the river, the North Side and the South Side, was a region which spoke of a tremendous future, for here were stores which represented the buying capacity not only of the local population but of the Middle West. There were great banks, great retail stores, great office buildings, great hotels. The section was running with a tide of people which represented the youth, the illusions, the untrained aspirations of millions of souls. When you walked into this area you could feel what Chicago meant—eagerness, hope, desire. It was a city that put vitality into almost every wavering heart: it made the beginner dream dreams; the aged to feel that misfortune was never so grim that it might not change. That was the surface atmosphere.

Underneath, of course, was a great struggle. Youth and hope and energy were setting a terrific pace. You had to work here, to move, to step lively. You had to have ideas. This city demanded of you your very best, or it would have little to do with you. Youth in its search for something—and age—were quickly made to feel this. It was no fool's paradise.

Eugene, once he was settled, was made to feel this. He had the notion, somehow, that the printer's trade was all over for him. He wanted no more of that. He wanted to be an artist or something like that, although he hardly knew how to begin. The papers offered one way, but he was not sure that they took on beginners. He had had no training whatsoever. No one ever told him if his drawings—little scribblings they were—were really good. His sister Myrtle had once said that some of those little thumb-nail scenes were pretty, but what did she know? If he could study somewhere, find someone who would teach him. Meanwhile though, he would have to work.

His experiences for four years, while he was trying to find himself, were varied. He had walked here and there, dreaming. He tried the newspapers first, of course, for these great institutions seemed the ideal resort for anyone who hoped to get up in the world, but those teeming offices with frowning art directors and critical newspaper workers frightened him. He did not know how anything in connection with them was done, outside of his typesetting and printing. His editorial writing had been a failure. And the city papers operated, apparently, on such a vast scale. Why should an inexperienced country boy who knew nothing about art fit in? One art director did see something in the three or four little sketches which he showed, but he happened to be in a crusty mood and did not want anybody anyway. He simply said no, there was nothing. Eugene conceived the notion that as an artist also, he might be a failure.

The trouble with this boy was that he was really not half awake yet. The beauty of life, its wonders, had cast a spell over him, but he was years away from effective interpretation of it. He walked about these wonderful streets, gazing in the store windows, looking at the boats on the river, looking at the ships on the lake. He had never before seen a ship in full sail and one day, while he was standing on the lake shore there came one in the offing. It gripped his sense of beauty. He clasped his hands nervously and thrilled to it. Then he sat down on the lake wall and looked, and looked, and looked until it gradually sunk below the horizon. So this was how the great lakes were; so this was how the great seas must be—the Atlantic and the Pacific and the Indian Ocean. Oh, the sea! Some day, perhaps, he would go to New York. That was where the sea was. But here it was also, in miniature, and it was wonderful.

One cannot moon by lake shores and before store windows and at bridge draws and live, unless one is provided with the means of living, and this Eugene was not. He had determined, when he left home, that he would be independent. He wanted to get a salary someway, anyway, that he could live on. He wanted to write back and be able to say that he was getting along nicely, but after a few days of applying he did not see how he was to do this. His trunk came and a loving letter from his mother with some money, but he sent that back. It was only ten dollars, but he objected to beginning by taking money from his mother. He thought he ought to earn his own way and he wanted to try, anyhow.

After ten days his funds were very low, a dollar and seventy-five cents, and he decided that any job would have to do. Never mind about art or typesetting now—he could not get the last without a union card—he must take anything, and so he applied from store to store. The cheap little shops in which he asked hurt his artistic sensibilities terribly but he laid that all aside. He asked for anything—to be made a clerk in a bakery, in a candy

store, in a dry-goods store. After a time a hardware store loomed up, and he asked there. The man looked at him curiously. "I might give you a place at storing stoves."

Eugene did not understand but he accepted gladly. It paid only six dollars a week, but he could live on that. He was shown to a loft in charge of two rough men—stove-fitters, polishers and repairers—who gruffly explained to him that his business was to brush the rust off decayed stoves, to help piece and screw things together, to polish and lift things, for this was a second-hand stove business which bought and repaired stoves from junk dealers all over the city. Eugene had a low bench near a window where he was supposed to do his polishing, but he very frequently wasted time here looking out into the great yards of some houses in a side street. The city was full of wonder to him—its every detail fascinating. When a rag picker would go by calling "rags, old iron," or a vegetable hawker crying "tomatoes, potatoes, green corn, peas," he would stop and listen, the musical patterns of the cries appealing to him. Alexandria had never had anything like this. It was all so strange. He saw himself making pen and ink sketches of them, and of these clothes lines in the back yards, and of the maids with baskets. A wonderful city, truly.

On one of the days when he thought he was doing fairly well (he had been there two weeks), one of the two men for whom he worked—he was under the impression that he was working with, not under them—said, "Hey, get a move on, you. You're not paid to look out the window."

Eugene stopped. He had not realized that he was loafing.

"What have you got to do with it?" he asked, hurt and half defiant.

"I'll show you, you fresh kid," said the older of the two, who was an individual built on the order of Dickens's Bill Sikes. "You're under me. You get a move on, and don't give me any of your lip."

Eugene could hardly believe his ears. It was a flash out of a clear sky, and so brutal. The man was such an animal—and yet Eugene had been scanning him as an artist would, as a type, out of the tail of his eye.

"You go to the devil," he said, only half awake to the grim reality of the situation.

"What's that?" exclaimed this big bear, making for him. He gave him a shove towards the wall and attempted to kick him with his big hob-nailed boot. Eugene grabbed a stove leg. His face was wax white.

"Don't you try that again," he said darkly. He fixed the leg in his hand firmly.

"Call it off, Jim," exclaimed the other man, who saw the uselessness of so much temper. "Don't hit him. Send him downstairs if you don't like him."

"You get the hell out of here, then," said his noble superior.

Eugene walked to a nail where his hat and coat were, carrying the stove leg. He edged past his assailant cautiously, fearing a second attack. The man was inclined to kick at him again because of his stubbornness but he forbore for some reason.

"You're too fresh, Willie," he said, as Eugene went. "You want to wake up, you dough face."

Eugene slipped out quietly. His nerves were torn to their uttermost threads. What a scene. He, Eugene Witla, kicked at, almost kicked out, and that for a job that paid six dollars a week. A great lump came up in his throat, but it went down again. He wanted to cry but he could not. He went downstairs, stove polish on his hands and face, and stepped up to the desk.

"I want to quit," he said to the man who had hired him.

"All right, what's the matter?"

"That big brute up there tried to kick me," he explained.

"They're pretty rough men," answered his employer. "I was afraid you wouldn't get along. I guess you're not strong enough. Here you are." And he laid out three dollars and a half. Eugene had worked for two weeks. He wondered at this queer interpretation of his complaint. Lack of strength made him unfit? He must get along with these men? They mustn't get along with him? So the city had that sort of brutality in it.

He went home and washed up and then struck out again, for it was no time now to be without a job. After a week he found one, as a house runner for a real estate concern, a young man to bring in the numbers of empty houses and to paste up the "for rent" signs in windows. It paid eight dollars and seemed, to this impressionable youth, to offer great opportunities. He would have stayed there a long time, only it failed after three months. He had reached the season for fall clothes then and needed a new winter overcoat, but he made no complaint to his family. He wanted to appear to be getting along nicely, whether he was or not.

One of the things which tended to sharpen and harden his impressions of life at this time was the show of luxury seen in some directions, for the city was by no means all commonplace. On Michigan Avenue and Prairie Avenue in the South Side, and on Ashland Avenue and Washington Boulevard in the West Side, were sections which were crowded with luxurious homes such as Eugene had never seen before. He was astonished at the magnificence of their appointments—the beauty of the lawns, the show of the windows, the distinction of the equipages which accompanied and served them. For the first time in his life he saw liveried footmen at doors; he saw girls and grown women who seemed, from a distance, marvels of beauty to him, they were so distinguished in their dress; he saw young men carrying

themselves with an air of distinction which he had never seen before. These must be the society people the newspapers were always talking about. His mind made no distinctions as yet. If there were fine clothes, fine trappings, of course social prestige went with them. It made him see for the first time what far reaches lay between the condition of a beginner coming from a country town to Chicago and what the world really had to offer—showered in fact on some who were at the top. It subdued and saddened him a little. Life was unfair: that in the main was what impressed him here. It made some rich, some poor by birth. What a bitter, hard thing to contemplate.

These fall days too, with their brown leaves, sharp winds, scudding smoke and whirls of dust showed him that the city could be cruel. He met shabby men, sunken eyed, gloomy, haggard, who looked at him apparently out of a deep despair. The creatures all seemed to have been brought where they were by difficult circumstances. If they begged at all, and they rarely did of him—he did not look prosperous enough—it was with the statement that unfortunate circumstances over which they had no control had brought them where they were. It was a sad world. You could fail easily. You could really starve if you didn't look sharp—the city quickly taught him that.

During these days he also got immensely lonely. He was, as has been pointed out, not very sociable to begin with, too introspective. He had no means of making friends or thought he had none. So he wandered about the streets at night when he was not working, marvelling at the sights that he saw, or stayed at home in his little room. Mrs. Woodruff, his landlady, was nice and motherly enough but she was not young and she could not enter into his fancies. He was thinking about girls and how sad it was that he had not one to say a word to him. Stella was gone—that dream was over. When would he find another like her?

After hunting about for nearly a month, during which time he was compelled to use some money his mother sent him and to buy a suit of clothes on an installment plan which he saw advertised in one of the papers, he secured a place as a driver for a laundry, which because it paid ten dollars a week seemed very good. His real place was in the art world but his early rebuffs had destroyed his faith. He sketched now and then, tentatively, when he was not tired, but what he did seemed pointless. So he worked here, driving a wagon, when he should have been applying for an art opening or taking art lessons. There was an art students' league in connection with the Art Institute, but he did not know of it. Later he would find out about it and take some lessons, but now he was drifting.

It was during this winter's work that several interesting things happened. For one thing, Myrtle wrote him that Stella Appleton had moved to Wichita, Kansas, whither her father had gone. For another, that his mother's health

was bad and that she did so want him to come home and stay awhile. For a third, he met a little Scotch girl, Margaret Duff by name, who worked in the laundry and was anything but an uplifting influence on him.

This relationship need not be described, for it was immoral, except that the effect needs to be indicated. For one thing it established a precedent as regards the sex relationship which hitherto had not existed in his life. Before this he had never physically known a girl. Now, and of a sudden, he was plunged into something which awakened a new and, if not evil, at least disrupting and disorganizing propensity of his character. He loved women, the beauty of the curves of their body. He loved beauty of feature and after a while he was to love beauty of mind—he did now, in a vague, unformed way, but his ideal was as yet not clear to him. This girl, representing some simplicity of attitude, some generosity of spirit, some shapeliness of form, some comeliness of feature—it was not more—drew him. And as our appetites grow upon what they feed, his sex appetite grew. In a few weeks it had almost mastered him. He burned to be with this girl daily—and she was perfectly willing that he should, so long as the relationship did not become too conspicuous. She was a little afraid of her parents although those two, being working people, retired early and slept soundly. They did not seem to mind her early philandering with boys, and she had had a number of them who had called Wednesdays and Sundays in times past. This latest one was no novelty. The relationship burned fiercely for three months. Eugene was eager, insatiable: the girl not so much so, but willing. She liked more this evidence of fire in him—the hard, burning flame she had aroused. He would seize her with an ardor that fairly worked her flesh and yet after a time she got a little tired. Then little personal differences arose—differences of taste, differences of judgement, differences of interest. He really could not talk to her of anything serious or uplifting—could not get a response for his delicate emotions. On her part she could not find an apt response to the little things she liked. Her conception of what was tasty in dress was good enough, but as for anything else—art, literature, public affairs—she knew nothing at all. Theatre jests, the bright remarks of other boys and girls, were more in her line. Eugene, for all his youth, was intensely alive as to what was going on. The sound of great names and fames was in his ears—Carlyle, Emerson, Thoreau, Whitman. He read of great theosophists, painters, musicians, as they sped across the intellectual sky of the western world, and wondered. He felt as though someday he would be called to do something—in his youthful enthusiasm he half-imagined it might be soon. Meanwhile he was living in a world of intellectual enthusiasm which had no relationship to any living human being—only to the world at large. And he knew that this poor little girl he was trifling with could not hold him. Of course she had lured him,

but once lured he was master, judge, critic. He was beginning to feel as if he could get along without her—as if he could find someone better.

Naturally such an attitude would make for the death of passion, as the satiation of passion would make for the development of such an attitude. Margaret became indifferent. She resented his superior chiding, his toplofty tone at times. They quarreled over little things. One night he suggested something that she ought to do—and did it in the haughty manner which was customary with him.

"Oh, don't be so smart," she said. "You always talk as though you owned me."

"I do," he said jestingly.

"Do you?" she flared. "Don't be so sure. There are others."

"Well, whenever you're ready you can have them. I'm willing."

The tone cut her, though actually he was only teasing in an ill-timed way. He was kinder then he sounded.

"Well, I'm ready now," she exclaimed. "You needn't come to see me unless you want to. I can get along."

She tossed her head.

"Don't be foolish, Margy," he said, seeing the ill will he had aroused. "You don't mean that."

"Don't I? Well, we'll see." She walked away from him to another corner of the room. He followed but her anger re-aroused his opposition. "Oh, all right," he said after a time. "I guess I'd better be going."

She made no response, neither plea or suggestion.

He went and secured his hat and coat and came back.

"Want to kiss me good-bye?" he inquired.

"No," she said simply.

"Good night," he called.

"Good night," she replied indifferently.

The relationship was never really amicably adjusted after this although it endured for some time.

CHAPTER VII

One of the notable things this particular encounter did for Eugene, and it did a number, was to stir to an almost unbridled degree his interest in the sex question. Most men are secretly proud of their triumphs with women—their ability to triumph—and any evidence of their ability to attract, entertain, hold, is one of those things which tends to give them an

air of superiority and self-sufficiency which is sometimes lacking in those who are not so victorious. This was, in its way, his first taste of victory in this respect and it pleased him mightily. He felt much more sure of himself instead of in any way ashamed. What, he thought, did the silly boys back in Alexandria know of life as compared to this? Nothing. He was in Chicago now. The world was different. He was finding himself to be a man; free, individual, of interest to other personalities. Margaret Duff had told him many pretty things about himself. She had complimented his looks, his total appearance, his taste in the selection of particular things. He had felt what it is to own a woman in an affectional sense. He strutted about for a time, the fact that he had been dismissed rather arbitrarily having little weight with him because he was so very ready to be dismissed.

Eugene's experience with Margaret also stirred up a sudden dissatisfaction with his job, for ten dollars a week was no sum wherewith any self-respecting youth could maintain himself—particularly with a view to sustaining himself in any such relationship as that which had just ended. He felt that he ought to get a better place and yet he did not see how. He thought he ought to study art but had no money, and he was under the impression that it would take considerable to do it right. He once thought of going around to the newspapers again but that was a pointless thing to do, he thought, without some study. After his quarrel with Margaret, he did not feel that his place with the laundry was quite as tenable. She was satisfied that he was slipping away. He knew the time would come when he would see her no more.

The end finally came about naturally enough one day when he was delivering a parcel to a woman who lived on Warren Avenue. She stopped him long enough to ask, "What do you drivers get a week for your work?"

"I get ten dollars," said Eugene. "I think some get more."

"You ought to make a good collector," she went on. She was a large, homely, incisive, straight-talking woman. "Would you like to change to that kind of work?"

Eugene was sick of the laundry business. The hours were killing—from seven to six or seven week-days, whenever you happened to get through, and from seven until eleven or twelve on Saturday nights. He had worked as late as one o'clock Sunday mornings!

"I think I would," he exclaimed. "I don't know anything about it, but this work is no fun."

"My husband is the manager of The People's Furniture Company," she went on. "He needs a good collector now and then. I think he's going to make a change pretty soon. I'll speak to him."

He smiled joyously and thanked her. This was surely a windfall. He was

anxious to know what collectors were paid but he thought it scarcely tact-
ful to ask.

"If he gives you a job you will probably get fourteen dollars to begin
with," she volunteered.

Eugene thrilled. That would be really a rise in the world. Four dollars
more. He could get some nice clothes out of that and have spending money
besides. He might get a chance to study art. His visions began to multiply.
One could get up in the world by trying. The energetic delivering he had
done for the laundry had brought him this. Further effort in the other field
might bring him more. And he was young yet.

This promise came after he had been working for the laundry company
six months. It was actually fulfilled six weeks later when Mr. Henry Mitchly,
manager of the People's Furniture, wrote him care of the laundry company
to call at his home any evening after eight and he would see him. "My wife
has spoken to me of you," he added.

Eugene complied the same day he received the note and was looked over
by a lean, brisk, unctuous looking man of forty, who asked him various ques-
tion as to his work, his home, how much money he took in as a driver, and
what not. Finally he said, "I need a bright young man as a collector down
in my place. It's a good job for one who is steady and honest and hardwork-
ing. My wife seems to think you work pretty well, so I'm willing to give you
trial. I want you to come in to see me a week from Monday. I can put you
to work at fourteen dollars."

Eugene thanked him. He decided on Mr. Mitchly's advice to give his
laundry manager a full week's notice. He notified Margaret at once that he
was leaving and she was apparently glad for his sake. Work at the laundry
had not brought them into much contact. His leaving really need not affect
their relationship if it were desirable to continue it, so she thought very
little about it. The management was slightly sorry, for Eugene was a good
driver, but they never asked resigning employees to remain, so he was free
to go. He helped break in a new man during the following week and on the
next Monday appeared before Mr. Mitchly, ready to begin.

Mr. Mitchly was glad to have him for he had conceived of Eugene as
someone who had energy and force. He explained the simple nature of the
work, which was to take bills for clocks, furniture, silver ware, rugs, any-
thing which the company sold, and go over the various routes (there were
six—one for each day in the week) and collect the money due. It would aver-
age from seventy-five to one hundred and twenty-five dollars a day. "Most
companies in our line require a bond," he explained, "but we haven't come
to that yet. I think I know honest young men when I see them. Anyhow,
we have a system of inspection. If a man's inclined to be dishonest he can't
get very far with us."

Eugene had never thought very much of this question of honesty. He had been raised where he did not have to worry about the matter of a little pocket change, and he had made enough at the *Appeal* to supply his immediate wants. Besides, among the people he had always associated with, it was considered a very right and necessary thing to be honest. Men were arrested for not being honest. He remembered one very sad case of a boy he knew being arrested at Alexandria for breaking into a store at night. That seemed a terrible thing to him at the time. Since then he had been speculating a great deal in a vague way as to what honesty was but he had not yet decided. He knew that it was expected of him to account for the last penny of anything that was placed in his keeping and he was perfectly willing to do so. The money he earned seemed enough if he had to live on it. There was no need for him to aid in supporting anyone else. So he slipped along rather easily and practically untested.

Eugene took the first day's package of bills as laid out for him and faithfully went from door to door. In some places money was paid him for which he gave a receipt; in others he was put off or refused because of previous difficulties with the company. In a number of cases the people had moved, leaving no trace of themselves and taking the unpaid for goods with them. It was his business, as Mr. Mitchly had explained to him, to try to get track of these people from the neighbors.

Eugene saw at once that he was going to like the work. The fresh air, the outdoor life, the walking, the quickness with which his task was accomplished—for by travelling fast he could wind up his labors by three o'clock—all pleased him. His routes took him into strange and new parts of the city where he had never been before and introduced him to types he had never met. His laundry work, taking him from door to door, had been one enlarging influence. This was another. He saw scenes that he felt sure he could make great things out of, once he developed his artistic skills—dark, towering factory sites, great stretches of railroad yards laid out like a puzzle in rain, snow, or bright sunlight; great smoke stacks throwing their black heights athwart morning or evening skies. He liked them best in the late afternoon when they stood out in a glow of red or fading purple. "Wonderful," he used to exclaim to himself, and think how the world would marvel if he could ever come to do great sketches like those of Doré. Of all the artists Doré alone appealed to him. He admired the man's tremendous imagination. He never thought of himself as doing anything in oils or water colors or chalks—only pen and ink, and that in great rude splotches of black and white. That was the way. That was the way force was achieved. But he could not do them. He could only think of them.

One of his pet joys was the Chicago River, its black, mucky waters churned by puffing tugs and its banks lined by great red grain elevators and black coal

chutes and yellow lumber yards. Here was real color and life—the thing to draw; and then there were the low, drab, gray, rain-soaked cottages standing in lonely shabby little rows out on flat prairie land, perhaps a scrubby tree somewhere near. He loved these. He used to take an envelope and try to get the sense of them—the feel, as he called it—but it wouldn't come. All he did seemed cheap and commonplace, mere pointless lines and stiff wooden masses. How did the great artists get their smoothness and ease?

He wondered.

CHAPTER VIII

E ugene had worked here awhile, reporting his collections faithfully every day, and had managed to save a little money. Margaret was now a thing of the past. Mrs. Woodruff had gone to live with a daughter in Sedalia, Missouri. Eugene had moved to the home of a shoe salesman in one of the big department stores who had a comparatively nice home in East Twenty-first Street on the South Side. He had come upon this place in one of his rounds. It had taken his eye because of a tree in a fifty foot space of ground before an old house. There was a card in the window reading "furnished room," and he entered and took it. Like his other room it cost him little, and he was with a family. He arranged a twenty-cent rate per meal for such meals as he took there and in this way he managed to hold his bare living expenses down to five dollars a week. The remaining nine he spent sparingly for clothes, car fare and amusements—almost nothing of the latter. When he saw he had a little money on the side he began to think of looking up the Art Institute, which had been looming up in his mind as an avenue of advancement, and find out on what conditions he could join a night class in drawing. They were very reasonable—he heard only fifteen dollars a quarter—and he decided to begin if the conditions were not too severe. He was beginning to be convinced that he was born to be an artist—how soon, he could not tell.

The old Art Institute which preceded the present impressive structure was located at Michigan Avenue and Monroe Street, and presented an atmosphere of distinction which was not present in most of the structures which ostensibly catered to public taste. It was large, six stories in height, of brown stone and red brick, and contained, besides exhibition rooms, a number of studios for painters, sculptors, teachers of music, and the like. In the basement were a number of rooms for the classes which endeavored to teach aspiring beginners who could not go abroad the mysteries of drawing, modeling, cos-

tuming, and composition in oils, water colors, crayons, and pen and ink, in accordance with the taste and leaning of the individual student. There were quite a number of classes, day and evening, and even at that time a large number of students. The Western soul to a certain extent was fired by the wonder of art. There was so little of it in the life of the people—and so the fame of those who could accomplish things in this field and live in a more refined atmosphere was great. To go to Paris! To be a student in anyone of the great ateliers of that city, or of Munich or of Rome; to know the character of the artistic treasures of Europe—the life of the art quarters—that was something. There was what might have been termed a wild desire in the breast of many an untutored boy and girl to get out of the ranks of the commonplace; to assume the character and the habiliments of the artistic temperament as they were then supposed to be; to have a refined, semi-languorous, semi-indifferent manner; to live in a studio; to have a certain freedom in morals and temperament not accorded the ordinary individual—these were the great things to do and to be. Of course, art composition was a part of this. You were supposed ultimately to paint great pictures or do noble sculptures, but meanwhile you could and should live the life of the artist. And that was beautiful and wonderful and free.

Eugene had long had some sense of this. He was aware that there were studios in Chicago; that certain men were supposed to be doing good work—he saw it in the papers. There were mentions now and then of exhibitions, mostly free, which the public attended but sparingly. Once there was an exhibition on loan of some of the war pictures of Verestchagin, a great Russian painter who had come West for some purpose. Eugene saw them one Sunday afternoon and was enthralled by the magnificence of their grasp of the elements of battle; the wonder of the coloring; the truthfulness of the portrayal of character; the dramatic quality of the composition and arrangement; the sense of force and danger and horror and suffering which was somehow around and in and through them all. This man seemed to him to have virility, insight, stupendous imagination and temperament. Eugene stood and stared, wondering how such things could be done. Ever afterward the name of Verestchagin was like a great call to his imagination; that was the kind of an artist to be, if you were going to be one.

There was another picture which came there once which appealed to another side of his nature, although the basis of its appeal was primarily artistic. It was a great, warm-tinted nude by Bouguereau, a notable French artist of the period, who was startling his day with his daring portrayal of the nude. The types he chose to set forth in this manner were not namby-pamby little slim-bodied women, with half formed intellects and spindling qualities of strength and passion, but great, full blown souls whose voluptuous

contour of neck and arms and torso and hip and thighs was enough to set the welling blood of youth and desire at fever heat. These women as Bouguereau painted them were the crowning expression of a great passion. The man obviously understood and had passion, love of form, love of desire, love of beauty—and this distinctly moulded flesh appealed to him. He painted with a sense of the bridal bed in the background; of motherhood and of fat, crowing babies, joyously nursed. These women stood up big in their sense of beauty and magnetism, the soft lure of desire in their eyes, their full lips parted, their cheeks naturally flushed with the blood of health. They were a notable call to motherhood and as such were anathema to the conservative and puritanical in mind; the religious in temperament; the cautious in training or taste. The very bringing of this picture to Chicago as a product for sale—it was in the hands of one of the most exclusive art agents—was enough to create a furor of objection. Such pictures should not be painted, was the cry of the press; or if painted, certainly not exhibited. Bouguereau was conceived of by many as one of those dastards of art, endeavoring to corrupt by his talent the morals of the world; there was a cry raised that the thing should be suppressed, and as was always the case in such outbursts of special or class opposition, the interest of the general public was aroused.

Eugene was one of those who noted the discussion. He had never seen a painting by Bouguereau, or as a matter of fact an original nude by any other artist. Being at liberty as a rule after three o'clock, he was free now to visit some of these exhibits, and having found it possible to do his work in good clothes he had come to wear his best business suit daily. He was a fairly presentable youth with a solemn mien, and his request to be shown anything in any art store would have met with favor. He looked as though he belonged to the intellectual and artistic classes.

Not being sure of what reception would be accorded one so young—he was now nearing twenty—he nevertheless ventured, at the height of the discussion, to stop at the gallery in Wabash Avenue and ask to see the picture in question. The attendant in charge eyed him curiously but led the way back to a room hung in dark red, and turning on a burst of incandescent bulbs set in the ceiling of a red plush hung cabinet, pulled back a curtain revealing the marvelous figure. Eugene had never seen such a figure and face. It was a dream of beauty—his ideal come to life. He studied the face and neck, the soft brown sensuous hair massed at the back of the head, the flowerlike lips and soft, dainty cheeks. He marveled at the suggestion of the breasts and the abdomen—that potentiality of motherhood that is so firing to the male. He could have stood there hours dreaming, luxuriating, but the attendant who had left him alone with it for a few moments returned.

"What is the price of this?" he asked critically.

"Ten thousand dollars," was the reply.

Eugene smiled solemnly. "It's a wonderful thing," he said, and turned to go. The attendant put out the light.

This picture, like those of Verestchagin, gave him a definite personal insight into the ramifications of art. He was not much for opinion or discussion, but anything he saw made a sharp impression on him. Curiously he had no longing to paint anything of this kind. He only rejoiced to look at it. It spoke to him of his present ideal of womanhood, of physical beauty, and he longed with all his heart to find a creature like that who would look on him with favor.

There were other exhibitions—one containing a genuine Rembrandt—which impressed him favorably, but none like either of these two which definitely stirred him. His interest in art was becoming eager. He wanted to find out all about it—to do something himself. So one day he ventured to call at the Art Institute building and consult with the secretary, who explained to him what the charges were. He learned from her, for she was a woman of a practical, clerical turn, that the classes ran from October to May, that he could enter a life or antique class or both, though only one was advisable at a time, and a class in illustration, where costumes of different periods were presented on different models. He found that each class had an instructor of supposed note, whom it was not necessary for him to see. Each class had a monitor and each student was supposed to work faithfully for his own benefit. He did not get to see the class rooms but he gained a sense of the art of it all nevertheless, for the halls and offices were decorated in an artistic way and there were many sketches of arms, legs, busts, thighs, and heads. It was as though one stood in an open door and looked out upon a new world. The one thing that gratified him was that he could study pen and ink or crayon or brush work in either the life or illustration evening class, and study illustration from five to six every afternoon without extra charge, if he wished to devote the evening hours to drawing in the life class. He was a little bit astonished to learn from a printed prospectus the secretary gave him that the life class meant a nude model to work from—one week a man, another week a woman. This was surely a different world that he was entering now. Think of being an artist and being permitted to do these things. It seemed necessary and natural enough, and yet there was a class atmosphere about it, something that smacked of the inner precincts of a shrine, to which only talent was admitted. Was he talented? Wait! He would show the world, even if he was a raw country boy.

The classes which he entered when the time came were, first, the life class, which convened every evening at seven in one of the half dozen study rooms and remained in session until ten o'clock and, second, the illustra-

tion or costume class, which met from five to six in the afternoon. The former was really a convenience for those who preferred it or who could not attend the longer sessions of the day classes. Eugene felt, and wisely, that he knew little or nothing about figure work or anatomy and that he had better brush up on it. Costume or illustration work would have to wait until he developed figural and anatomical ability, and as for the landscape or rather city-scape views of which he was so fond, he could afford to defer those until he learned the fundamentals of real art.

Heretofore he had rarely attempted the drawing of a face or figure except in miniature and as details of a larger scene. Now he was confronted with the necessity of modeling in crayon the head or the figure of a living person, and it frightened him a little. He knew that he would be in a class along with fifteen or twenty other male students. They would be able to see and comment on what he was doing. Twice a week a noted instructor would come around and pass upon his work. There were rewards for those who did the best work during any one week—namely, he learned from the prospectus, seats nearest the model at the beginning of the next week. The class instructor must be of considerable significance in the American art world, he thought, for they were N.A.'s, and that meant National Academicians. He little knew with what contempt this honor was received in certain quarters or he would not have attached so much significance to it.

The Monday evening in October when this, to him, wonderful class work began, he arrived armed with the several sheets of crayon board which he had been told to purchase by the secretary and by his informing prospectus. He ventured to approach the notable building and entered. He was a little nervous at the sight of the brightly lighted halls and class rooms, and the moving throng of young men and women did not tend to allay his fears. He was struck at once with the quality of gayety, determination, easy grace which went with these different members of this company. The boys struck him as interesting, virile, in many cases good looking. The girls as graceful, rather dashing, and confident. One or two whom he noted were beautiful in a dark way. This was a wonderful world.

The rooms, too, were exceptional. They were old enough for the walls to be completely covered with the accumulation of paint scraped from palettes and brushes. There were heads and arms and various parts of the anatomy indicated but mostly painted over. There were no easels or other paraphernalia but simply chairs and little camp stools—the former, as Eugene learned, to be turned upside down and used as easels, the latter for the students to sit on. In the front of the room was a platform the height of an ordinary table for the life model to pose on, and in one corner, a screen which, properly arranged, constituted his or her dressing room. There were no pictures or

statuary, just the bare walls, but curiously, in one corner, a piano. Out in the halls and in the members' rooms (a general lounging centre), were pictures of nude figures or parts of figures posed in all sorts of ways which Eugene, in his raw, youthful way, thought suggestive. He secretly rejoiced to look at them but he felt that he must not say anything about what he thought. An art student, he felt sure, must appear to be indifferent to such suggestion—to be above such desire. They came here to work, not to dream of women.

When the time came for the classes to assemble there was considerable scurrying to and fro, considerable conferring between different students, and then the men found themselves in one set of rooms, the women in another. Eugene saw a young girl in his room, sitting up near the screen idly gazing about. She was pretty, very, of a slightly Irish cast of countenance, with black hair and black eyes. She had on a dainty imitation of the Polish national head-dress and a red cape. Eugene assumed her to be the class model and secretly wondered if he was really to see her in the nude. What a wonderful thing that was! In a few minutes all the students were gathered and then there was a stir as there strolled in a rather vigorous and pictur-esque individual of thirty-six or thereabouts, who sauntered to the front of the room and called the class to order. He was clad in a shabby suit of gray tweed and crowned with a little brown hat shoved rakishly over one ear, which he did not trouble to take off. He wore a soft blue hickory shirt without collar or tie, and looked immensely self-sufficient. He was tall and lean and rather raw boned, with a face which was long and narrow. His eyes were large and wide-set, his mouth big and rather firm in its lines. He had big hands and feet, an almost rolling gait. Eugene assumed instinctively that this was Mr. Temple Boyle, N.A., the class instructor. He imagined there would be an opening address of some kind, but he was mistaken. The instructor merely asked, standing in the front of the room near the raised platform, that the class come to order. He announced that Mr. William Ray had been appointed monitor and he hoped that there would be no disorder or wasting of time for any reason. There would be regular criticism days by him, Wednesdays and Saturdays. He hoped that each pupil would be able to show marked improvement. The class would now begin work. Then he strolled out.

Eugene learned at once that the instructor really was Mr. Boyle—well known locally, one student told another. Mr. William Ray arose and asked the young Irish girl something. She had gone, after Mr. Boyle's remarks, behind the screen. Eugene could see partially, from where he was sitting, that she was disrobing. It shocked him a little but he kept his courage and countenance because of the presence of so many others. He had turned a chair upside down as had the others and was sitting on the little camp stool

provided. His crayons were lying in a little box on the floor beside him where he had put them. He straightened his crayon board and fidgeted, keeping as still as he could. A number of men were talking. Suddenly he saw this girl divesting herself of a thin gauze undershirt and the next moment she appeared, naked and composed, to step upon the platform and stand perfectly erect, her arms by her side, her head thrown back. Eugene tingled and blushed and was almost ashamed to look directly at her. Then he took his pencil and began feebly sketching, attempting to convey something of this personality and this pose to paper. It seemed a wonderful thing for him to be doing—to be in this room, to see this girl posing so, to be an art student. So this was what it was, a world absolutely different from anything he had ever known. And he was self-called to be a member of it.

CHAPTER IX

It was before entering the two art classes which he had fixed upon as useful to him that Eugene paid his first visit to his family. Although they were only a comparatively short distance away—one hundred and fifteen miles—he had never felt like going back, had never felt able. Now, it seemed to him he had something definite to offer, something to proclaim. He was going to be an artist and he was getting along fairly well in his work. Mr. Mitchly appeared to like him. He was Eugene's immediate superior, to whom he reported daily with his collections and his unsatisfied bills. The collections were checked by Mitchly with the cash and the unpaid bills certified. Sometimes Eugene made a mistake, having too much or too little, but the "too much" was always credited against the "too little" so that in the main he came out even. In money matters there was no tendency on Eugene's part to be dishonest. He thought of lots of things he wanted but he was fairly well content to wait and come by them legitimately. It was this note in him which appealed to Mitchly. He thought that possibly something could be made of Eugene in a trade way.

He left the Friday night preceding Labor Day, the first Monday in September, which was a holiday throughout the city. He had told Mr. Mitchly that he thought of leaving Saturday after work for a Sunday and Monday visit, but Mr. Mitchly suggested that he might double up his Saturday's work with Thursday's and Friday's if he wished, and go Friday evening after his cash was in. "Saturday's a short day anyhow," he said. "That would give you three days at home and you wouldn't be behind with your work."

Eugene thought this was a fine idea and thanked his employer. He did

as suggested and found himself free for the extra day. He packed a bag with the best he had in the way of clothes and journeyed homeward, wondering how he would find things. How different it all was. Stella was gone. His youthful unsophistication was passed. He could go home as a city man with some prospects. He had no idea of how boyish he looked, how much the idealist he was, how far removed from hard, practical judgement which the world values so highly.

When the train reached Alexandria, his father and Myrtle and Sylvia were at the depot to greet him—the latter with her two year old baby, a boy. They had all come down in the family carryall, which left one seat for Eugene. He greeted them warmly and received their encomiums on his looks with a befitting sense of humility.

"You're bigger," his father exclaimed. "You're going to be a tall man after all, Eugene. I was afraid you had stopped growing."

"I hadn't noticed that I had grown any," said Eugene.

"Oh, yes," put in Myrtle. "You're much bigger, Gene. It makes you look thinner. Are you good and strong?"

"I ought to be," explained Eugene. "I walk about fifteen or twenty miles a day, and I'm out in the air all the time. If I don't get strong now, I never will."

"How's your stomach trouble?" asked Sylvia.

"Oh, that's about the same. Sometimes I think it's better. Sometimes worse. A doctor told me to drink hot water in the morning but I don't like to do it. It's so hard to swallow the stuff."

While they were talking, asking questions, they reached the front gate of the house and Mrs. Witla came out on the front porch. Eugene, at the sight of her in the late dusk, jumped over the front wheel and ran to meet her.

"Little ma," he exclaimed. "Didn't expect me back so soon, did you?"

"So soon?" she said, her arms around his neck. Then she held him so, quite still for a few moments. "You're getting to be a big man," she said when she released him.

He went into the old sitting room and looked around. It was quite the same—no change. There were the same books, the same table, the same chairs, the same pulley lamp suspended from the middle of the ceiling, which you could raise and lower at will. In the parlor there was nothing new, nor in the bedrooms or the kitchen. His mother looked a little older for some reason—his father not. Sylvia had changed greatly—being slightly peaked in the face compared to her former plumpness, which was due no doubt, he thought, to motherhood. Myrtle was a little more calm and happy. She had a real "steady" now, Frank Bangs, the superintendent of the one big local furniture manufacturing company. He was quite young, good looking, going

to be well off some day, so they thought. "Old Bill," one of the bay horses, had been sold. Rover, one of the two collies, was dead. Old Jake, the cat, had been killed in a night brawl somewhere. He died under the porch. It was a typical Middle West home.

Somehow, as Eugene stood around in the kitchen and saw his mother frying a big steak and making biscuit and gravy in honor of his coming, he felt that he did not belong to this world any more. It was smaller, narrower than he had ever thought. The town seemed smaller as he came through its streets; the houses also, and yet he thought it was nice. The yards were nice and simple but countrified. His father, running a sewing machine business, seemed tremendously limited, and he was. He had a country or small town mind. It struck Eugene as curious now that they had never had a piano. And Myrtle liked music, too. As for himself, he had learned that he was passionately fond of it. There were organ recitals in the Central Music Hall of Chicago on Tuesday and Friday afternoons, and he had managed to attend some after his work. There were great preachers like Professor Swing and the Reverend H. W. Thomas and the Reverend F. W. Gunsaulus and Professor Saltus, liberal thinkers all, whose public services in the great city were always accompanied by lovely music. Eugene had found all these men and their services in his search for life and to avoid being lonely. Now they had taught him that his old world was no world at all. It was a small town. He would never come to this any more.

And yet in a way he thought it was sweet, if only it were not so barren of real mental life. The yards were nice. Nasturtiums and golden glow and yellow asters were still in bloom. He liked the porches that had vines on them, and the yards that had lovely flower beds. Some of these people had box hedges about their lawns. His father had never had sufficient taste, apparently, to have this done. And there were two or three homes of architectural distinction. Eugene realized now, though, that the best—the wealthiest people of the town, rather—had never been intimate with his father. He had never met Mr. Henry Woods, the biggest banker in the town, nor James H. Finch, who owned the big furniture company. He and his family were just middle-class here, nothing more, and Eugene had never quite realized it. Well, what did he care? Time would adjust all these things. He would be bigger than any of them.

After a sound night's rest in his old room, he went down the next day to see Mr. Caleb Williams at the *Appeal* office, and Mr. Burgess, and Jonas Lyle, and John Summers. On the way, on the court house square, he met Ed Mitchell and George Taps and Will Groniger and four or five others whom he had known in school. From them he learned how things were—what had become of Tad Martinwood and George Anderson and Ed Waterbury.

It appeared that one or two had married local girls. George Anderson was in Chicago, working out in the stockyards. Ed Waterbury had gone to San Francisco. The pretty Sampson girl, Bessie Sampson, who used to go with Tad Martinwood, had run away with a man from Anderson, Indiana. There was a lot of talk about it at the time. So he listened.

It all seemed less, though, than the world he had entered. None of these fellows knew the visions that were now surging in his brain. Paris no less—and New York—by what far route he could scarcely tell. And Will Groniger had gotten to be baggage clerk at one of the two depots and was proud of it. Good heavens!

At the office of the *Appeal* things were unchanged. Somehow Eugene had the feeling that two years would have made a lot of difference whereas the difference was all in him. He was the one who had suffered cataclysmic changes. He had been a stove polisher and a real-estate assistant and a driver and a collector. He had known Margaret Duff and Mr. Redwood of the laundry and Mr. Mitchly. The great city had dawned on him, Verestchagin and Bouguereau and the Art Institute. He was going on at one pace whereas the town was moving at another—a slower pace, but quite as fast as it had ever gone.

Caleb Williams was there, skipping about as of yore, cheerful, communicative, interested.

"I'm glad to see you back, Eugene," he declared, fixing him with the one good eye that watered. "I'm glad you're getting along—that's fine. Going to be an artist, eh! Well, I think that's what you're cut out for. This town is no place for a young fellow like you. It takes a place like Chicago to stir some people up. I wouldn't advise every young fellow to go there, but that's where you belong. I could see that from the first. If it wasn't for my wife and three children I never would have left it. When you got a wife and family though——." He paused and shook his head. "I gad! You got to do the best you can." Then he went to look up some missing copy.

Jonas Lyle was as portly, phlegmatic, and philosophic as ever. He greeted Eugene with a solemn, inquiring look.

"Well, how is it?" he asked.

Eugene smiled. "Oh, pretty good."

"Not going to be a printer then?"

"No, I think not."

"Well, it's just as well. There are an awful lot of them."

While they were talking, John Summers sidled up.

"How are you, Mr. Witla?" he inquired.

Eugene looked. John was certainly marked for the grave in the near future. He was thinner, of a bluish-gray color, bent at the shoulders.

"Why I'm fine, Mr. Summers," Eugene said.

"I'm not so good," said the old printer. He tapped his chest significantly. "This thing's getting the best of me."

"Don't you believe it," put in Lyle. "John's always gloomy. He's just as good as ever. I tell him he'll live twenty years yet."

"No, no," said Summers, shaking his head. "I know."

He left after a bit to go across the street—his customary drinking excuse.

"He can't last another year," Lyle observed the moment the door closed. "Burgess only keeps him because it would be a shame to turn him out. But he's done for."

"Anyone can see that," said Eugene. "He looks terrible."

So they talked.

At noon he went home and Myrtle announced that he was to come with her and Mr. Bangs to a party that evening. There were going to be games and refreshments. It never occurred to Eugene that in this town there had never been dancing among the girls and boys he had moved with, and scarcely any music. People did not have pianos—or at least only a few of them. He could not dance, so he did not realize what he was missing. Had he figured it all out he would have seen that convention, inexperience, and the lack of any but the most ordinary means of living had made most of these nice little families exceedingly simple and rather circumscribed in their pleasures.

After supper Mr. Bangs called, and the three of them attended a typical small town party. It was not much different from the ones he had attended with Stella except that the participants were, in the main, just that much older. Two years make a great deal of difference in youth—much more so than in age. There were some twenty-two young men and women all crowded into three fair sized rooms and on a porch, the windows and doors leading to which were open. Outside were grass and some fall flowers. Early crickets were chirping, and late jarflies. It was warm and pleasant.

As usual, the opening efforts to be sociable were a little stiff. There were introductions all around, much smart badinage among the town dandies, for most of them were here. There were a number of new faces—girls who had moved in from other towns or blossomed into maturity since Eugene had left.

"If you'll marry me, Madge," Eugene heard one of the young bloods remark, "I'll buy you a nice new pair of seal skin earrings."

Eugene grinned.

The girl laughed back. "He always thinks he's so cute."

Although there were games and banter, it was almost impossible for Eugene to break through the sense of reserve which clogged his actions at

everything in the way of social diversion. He was a little nervous because he was afraid of criticism. That was his vanity and deep egotism. He stood about, trying to get into the swing of the thing with a bright remark or two. Just as he was beginning to tremble, a girl came in from one of the other rooms. Eugene had not met her. She was with his prospective brother-in-law, Bangs, and was laughing in a sweet, joyous way which arrested his attention. She was dressed in white, he noticed, with a band of copper colored ribbon pulled through the loop above the flounces at the bottom of her dress. Her hair was a wonderful red—a great mass of it—and laid in big, thick braids above her forehead and ears. Her nose was straight, her lips thin and red, her cheek bone faintly but curiously noticeable. Somehow there was a sense of distinction to her—a faint aroma of personality which Eugene did not understand. It appealed to him.

Bangs brought her over. He was a tight, smiling youth, as sound as oak, as clear as good water.

"Here's Miss Blue, Eugene. She's from up in Wisconsin and comes down to Chicago occasionally. I told her you ought to know her. You might meet up there some time."

"Say, that's good luck, isn't it?" smiled Eugene. "I'm sure I'm glad to know you. What part of Wisconsin do you come from?"

"Black Wood," she laughed, her greenish-blue eyes dancing.

"Her hair is red, her eyes are blue, and she comes from Black Wood," commented Bangs. "How's that?" His big mouth, with its even teeth, was wide with a smile.

"Fine, only you left out the Blue name and the white dress. She ought to wear white all the time."

"Oh, it does harmonize with my name, doesn't it?" she cried. "At home I do wear white mostly. You see I'm just a simple country girl, and I make most of my things."

"Did you make that?" asked Eugene.

"Yes, of course I did."

"Well, that is really pretty," said Bangs, moving away and looking at her.

"Mr. Bangs is such a flatterer," she smiled at Eugene. "He doesn't mean anything he says. He just tells me one nice thing after another."

"He's right," said Eugene. "I agree as to the dress. And somehow it fits the hair."

"She wears it for that reason," added Bangs. "Look at that bronze ribbon down there." He talked familiarly in the genial, small town way.

"Now you hush," she pleaded. "You mustn't say I'm vain. I don't want to be."

"You're not," encouraged Eugene.

"You see, he's lost, too," laughed Bangs. "That's what happens to all of them. Well, I'm going to leave you two. I've got to get back. I left your sister in the hands of an enemy of mine."

Eugene turned to this girl who was clinging, subtle, emotional, passionate, but not ultimately big, and laughed his reserved laugh. "I was just thinking what was going to become of me. I've been away for two years and I've lost track of some of these people."

"I'm worse yet. I've only been here two weeks and I scarcely know anybody. Miss King just takes me around everywhere, but it's all so new I can't get hold of it. I think Alexandria is lovely."

"It is nice. I suppose you've been out on the lakes?"

"Oh, yes we've fished and rowed and camped. I have had a lovely time but I have to go back tomorrow."

"Do you?" said Eugene. "Why, so do I. I'm going to take that 4:15 train."

"So am I," she laughed. "Perhaps we can go together."

"Why, certainly. That'll be fine. I thought I'd have to go back alone. I only came down to stay over Sunday. I've been working up in Chicago for the past two years."

For some reason and in spite of the interests of the party, they fell into each other's histories. She was from Black Wood, only eighty-five miles from Chicago, had lived there all her life. There were eight brothers and sisters. Her father was evidently a farmer and politician and what not, and Eugene gleaned from stray remarks that they must be well thought of, though poor. One brother-in-law was spoken of as a banker; another as the owner of a grain elevator; she herself was a school teacher at Black Wood—had been for several years.

Eugene did not realize it, but she was all of five years older than himself, with the tact and superior advantage which so much difference in years brings. She was sick of school teaching, though he did not know that, and sick of caring for the babies of married sisters, sick of being left to work and stay at home when the ideal marrying age was rapidly passing. She was interested in able people, and silly village boys did not appeal to her. There was one up in Black Wood who was begging her to marry him at this moment but he was a slow soul, not actually worthy of her nor able to support her nicely. She was hopefully, sadly, vaguely, madly longing for something better but as yet nothing better had turned up. This meeting with Eugene was not anything which promised a way out to her. She was not seeking in any such urgent way—did not give introductions that sort of a twist in her consciousness—but this young man had an appeal for her,

beyond anyone who had been introduced to her recently. They were in sympathetic accord, apparently. She liked his clear, big eyes, his dark hair, his rather waxy complexion. He seemed something better than she had known and she hoped he would be nice to her.

CHAPTER X

The rest of that evening Eugene spent not exactly with but near Miss Blue—Miss Angela Blue, as he found her name to be. He was interested in her not so much from the point of view of looks, though she was charming enough, but because of some peculiarity of temperament which lingered with him as a grateful taste might dwell on the palate. He liked her; thought her young; was charmed by what he considered her innocence and unsophistication. As a matter of fact she was not so much young and unsophisticated as a clever simulator of simplicity without being conscious in any clear way that she was simulating. She was of that peculiar order of mind which is sly, imitative, and emotional without really knowing that it is so. In the conventional sense she was a thoroughly good woman, loyal, financially honest, truthful in all commonplace things, and thoroughly virtuous in that she deemed marriage and children the fate and duty of all women. Having had so much bother and trouble with other people's children she was not anxious to have any, or at least many, of her own. The women who love children will not understand this, but such is the case. Of course, she did not believe that she would escape with what seemed to her any such good fortune. There were physical reasons which made it impossible for her to have children, but this she did not know. She fancied she would be like her sisters—the wife of a good provider, a business or professional man; the mother of three or four or even five or six healthy children; the keeper of an ideal middle class home; the handmaiden of her husband's needs. There was a deep current of passion in her which she was already convinced would never be satisfied. No man would ever understand—no man at least whom she was likely to meet; but she deemed it her great capacity to love. If someone would only come along and arouse that—be worthy of it—what a whirlwind of affection she would return to him. How she would love, how sacrifice. These were dreams. But it seemed now that her dreams were destined never to be fulfilled, because so much time had slipped by and she had not been courted by the right one. So here she was at twenty-five, dreaming and longing—the object of her ideals thus accidentally brought before her, yet she had no immediate consciousness that such was the case.

It does not take affinity or chemical or sex attraction long to manifest itself once the objects of love's duality are brought within striking distance of each other, and this was a case in point. Eugene was older in certain forms of knowledge, broader in a sense; bigger really than she could ever possibly comprehend; but nevertheless a fool in the matter of the affections. He was swayed not by judgement and common sense but by emotion and sex desire, of which she had as much if not more. Her emotions were not aroused by the same things as his. The stars, the night, a lovely scene, any exquisite attribute of nature, could fascinate him to the point of melancholy, whereas with her, nature in its larger aspects passed practically unnoticed. She responded exquisitely to music, as did Eugene. In literature, only real-ism appealed to him; with her, sentiment which was to a certain extent strained (though not unreal) was apt to have the greater charm. Art in its purely aesthetic forms—"Ode on a Grecian Urn," for instance—would have meant nothing at all to her. To Eugene it was the last word in the matter of emotional perception. History, philosophy, logic, psychology, were sealed books to her. To Eugene they were already open doors, or better yet, flowery paths of joy, down which he was wandering. Yet in spite of these things, a chemical or sex affinity was already acting. They were being pulled toward each other and neither could have said exactly why.

It is a curious thing which may be jotted down here in passing that these two were destined not to like the same people, except up to a certain point. After that, their paths, or to be exact their tastes in character, diverged. Convention—a sense that some things were evil and other things were good—would have prevented Angela from liking some types of people. For Eugene, convention meant nothing at all, and his sense of evil and good was something which the conventional person would not have read-ily comprehended. As a matter of fact, he liked all sorts and conditions of human beings—the intellectual, the ignorant; the clean, the dirty; the gay, the sorrowful; white, yellow, red, black. The one thing he objected to was the cold and greedy person; the one he most admired was the generous and sympathetic type, when these characteristics were accompanied by a large understanding. As for Angela, she preferred the more circumspect class, those who conducted themselves according to given standards of propriety. She was raised to think of those people as best who worked the hardest, denied themselves the most, struggled to conform to the world's theory of what is proper and right. She did not question current standards. As it was written ethically and socially upon the tables of the law, so was it. There might be charming characters in all walks but it was only when they conformed faithfully to current standards that they were worthwhile. Negroes, Indians, foreign races generally except of the very superior classes,

were under suspicion. For instance, you could scarcely look upon a Negro as a human being. On the other hand Eugene found little difference in any race. A human being was a human being. The ruck of misfits and ne'er-do-wells he could laugh joyously with or at. He did not feel any malice toward life, nor any narrow binding criticism in regard to it—it was all wonderful, beautiful, amusing. Even its grimness and tragedy were worthwhile, although they hurt him terribly at times. He had already said to himself, as the artist naturally would, that everything needed light and shade.

Why, under these circumstances, he should have been so thoroughly attracted to Angela remains a mystery, except that there was this kinship in passion and love of nature and life up to a certain point. During this evening and the next day's ride back on the train to Chicago she caught fire from the warmth and geniality of his temperament. It is more than likely that they complemented each other at this time as a satellite complements a larger luminary. For actually, Eugene was your egoist or self-centered constructive personality requiring praise, sympathy, and feminine coddling to be really happy; Angela was your clinging sentimentalist requiring love and consideration of herself as an object of sex attraction. Anyhow, there was this blood propinquity which was working, drawing them sympathetically together.

On the train back to Chicago, Eugene had what he deemed nearly three hours of most delightful talk with her. They had not journeyed far before he had told her of how he had traveled this way, on this train, at this hour, two years before; how he had walked around the streets looking for a place to sleep, how he had gotten work and stayed away until he felt he had found himself. Now he was going to study art and then go to New York or Paris and do magazine illustration and maybe paint some pictures. He was truly your flamboyant youth of talent when he got started talking—when he had a truly sympathetic ear. He loved to boast to someone who really admired him, and he felt he had admiration here. Angela looked at him with swimming eyes. He was really different from anything she had ever known, young, ambitious, imaginative, artistic. He was going out into a world which she had longed for but never hoped to see—that of art. Here he was telling her of his prospective art studies, and talking of Paris. What a wonderful thing.

As the train neared Chicago, she explained that she would have to make an almost immediate connection, from the Chicago, Milwaukee, and St. Paul train, to the one for Black Wood. She was a little lonely, to tell the truth, a little sick at heart, for her summer vacation was over and she was going back to teach school. Alexandria, for the two weeks she had been there visiting Mrs. King (formerly a Black Wood girl and a schoolday

chum of hers), was lovely. Her girlhood friend had tried to make things most pleasant and now it was all over. Even Eugene was over, for he said nothing much of seeing her again, or had not so far. She was wishing she might see more of this world he painted in such glowing terms, when he said, "Mr. Bangs said you come down to Chicago every now and then."

"I do," she replied. "I sometimes come down to go to the theatres and shop." She did not say that there was an element of practical household commercialism in these trips, for she was considered one of the best buyers in the family, and that she was sent to buy in quantity for various members of the family. From a practical household point of view she was a thorough-bred, and was valued by her sisters and friends as someone who loved to do things. She might have been deemed an incipient family pack-horse, though the term is rough, solely because she loved to work. It was her instinct to do everything she did thoroughly but she worked almost exclusively in minor household matters.

"How soon do you expect to come down again?" he asked.

"Oh, I can't tell. I sometimes come down when Grand Opera is on in the winter. I may be here around Thanksgiving."

"Not before that?"

"I don't think so," she replied archly.

"Well, that's too bad. I thought maybe I'd see you a few times this fall. When you do come I wish you would let me know. I'd like to take you to the theatre."

Eugene spent precious little money on any entertainment but he thought he could venture this. She would not be down often. Then, too, he had the notion that he might get a raise one of these days—that would make a difference. When she came again he would be in art school—opening up another field for himself. Life looked hopeful.

"That's so nice of you," she replied. "And when I come, I'll let you know. I'm just a country girl," she added, with a toss of her head, "and I don't get to come to the city often."

Eugene liked what he deemed the guileless naivete of her confessions—the frankness with which she owned up to simplicity and poverty. Most girls didn't. She almost made a virtue out of these things—at least they were charming as confessed by her.

"Well, now. I'll hold you to that," he assured her.

"Oh, you needn't. I'll be glad to let you know."

They were nearing the station. He forgot for the moment that she was not as remote and delicate in her beauty as Stella, that she was apparently not as passionate temperamentally as Margaret. He saw her red hair and her

thin red lips and her peculiar blue eyes, and he admired her honesty and simplicity. He picked up her grip and his, and helped her to find her train. When they came to part he shook her hand warmly, for she had been very nice to him, so attentive and sympathetic and interested.

"Now remember," he said gaily, after he put her in her seat in the local.

"I won't forget."

"You wouldn't mind if I wrote you now and then?"

"Oh, not at all. I'd like it."

"Then I will," he said, and he went out.

He stood outside and looked at her through the train window as it pulled out. He was glad to have met her. This was the right sort of a girl, clean, honest, simple, attractive. That was the way the best women were—good and pure—not your wild firebrands like Margaret, nor your unconscious indifferent beauties like Stella, he was going to add, but he couldn't. There was a voice within that said that artistically, Stella was perfect, and even now it hurt him a little to remember—it actually did. But Stella was gone forever—there was no doubt of that.

During the days that followed he thought of Angela often. He wondered what sort of a town Black Wood was; what sort of a house she lived in, what sort of people she moved with. They must be nice simple people like his own back in Alexandria. These types of city bred people whom he saw—girls particularly, and those born to wealth—had no appeal for him as yet. They were too distant, too far removed from anything he could aspire to. A good woman, such as Miss Blue obviously was, must be a treasure anywhere in the world. He kept thinking he would write her—he had no other woman acquaintance now; and before he entered the art school he actually did, penning her a little note saying he remembered so pleasantly their ride and asking when was she coming. Her answer, after a week, was that she expected to be in the city in October, about the middle or later part, and that she would be glad to have him call. She gave him the house number of an aunt who lived out on the North Side in Ohio Street, and said she would notify him further. She was hard at work teaching school now and didn't ever have much time to think of the lovely summer she had had.

"Poor girl," thought Eugene. "She deserves a better fate." Still he thought of her as being equally well-placed socially as himself. "When she comes I'll surely look her up," he thought and there was a little thrill that went with the idea. Such wonderful hair. What did that much red hair on a woman mean, anyhow, as to temperament?

CHAPTER XI

T he succeeding days in the art school after his admission truly revealed a new world to Eugene. He understood now, or thought he did, why artists were different. This Art Institute atmosphere was something so refreshing after his days of rambling among shabby and poor neighborhoods collecting, that he could hardly believe that he, Eugene Witla, was entitled to enter it. These were exceptional young people—some of them, anyhow. If they weren't cut out to be good artists they still had a little imagination—the dream of being artists. They came from all parts of the west and south, from Chicago and St. Louis, as Eugene gradually learned—from Kansas and Nebraska and Iowa, from Texas and California and Minnesota. One boy was from Saskatchewan in the Canadian northwest and another from what was then the territory of New Mexico. Because his name was Gill they named him the Gila Monster—the difference in the pronunciation of the G's not troubling them at all. A boy who came down from Minnesota was a farmer's son, and talked about going back to help plow and sow and reap during the next spring and summer. Another boy was the son of a Kansas City millionaire. Facts of this kind appealed to Eugene, and he felt they gave the Art Institute an edge.

Another thing that interested him was what might be called the mechanics and physics of drawing. He learned on the first night that there was some hitch in his understanding of light and shade as it related to the human form. He could not get anything save a wooden hardness which had no relief of roundness or light.

"The darkest shadow is always closest to the highest light," observed his instructor laconically on Wednesday evening, looking over his shoulder. "You're making everything a dull, even tone. That's no way to draw."

Eugene could grasp this fact instantly. It cleared up a problem which he had thought and thought about. Before long, this trouble with his drawing had disappeared. Then by degrees other facts began to dawn on him. Thus, for one thing, he learned that the average beginner sees too much. Instead of seeing the subject as a whole and selecting only the salient features for illustration, he wants to draw in everything—legs, arms, hands, waist, head, feet, all in detail.

"You're drawing this figure as a bricklayer who isn't an architect might start to build a house. You're laying bricks without having a plan. Where's your plan?" The voice was that of his instructor looking over his shoulder.

Eugene looked up. He had begun to draw the head only.

"A plan! A plan!" said his instructor, making a peculiar motion with his

hand which described the outlines of the human form in a single motion. "Get your general lines first. Then you can put in the details afterward."

Eugene saw at once.

There were other little details relating to foreground, middle ground, and background perspective and points of diminution which he practiced but had not consciously known, details that stuck in his memory for years. Once his instructor was watching him draw the female breast. He was doing it woodenly—without much beauty of contour.

"They're round! They're round, I tell you!" exclaimed Boyle. "If you ever see any square ones, let me know."

This caught Eugene's sense of humor. It made him laugh, even though he flushed painfully, for he knew he had a lot to learn. Another time he heard this bear of a man say to a boy, "You call those legs? Hell, you wouldn't follow a girl very far who was walking on anything like that."

The class laughed. The boy flushed. It drove home to Eugene's consciousness the meaning of good drawing. You had to work here.

The cruelest thing he ever heard this man say was to a boy who was rather thick and fat but conscientious. "You can't draw," he said roughly. "Take my advice and go home. You'll make more money driving a wagon."

The class winced, but Boyle was ugly in his intolerance of futility. The idea of anybody wasting his time was obnoxious to him. He took art as a business man takes business, and he had no time for the misfit, the fool, or the failure. He wanted his class to know that art meant effort.

Aside from this brutal insistence on the significance of art, there was another side to the life which was not so hard and in a way more alluring. Between the twenty-five minute poses which the model took, there were some four or five five-minute rests during the course of evening in which the students smoked, talked, relighted their pipes, and did much as they pleased. Sometimes students from other classes came in for a few moments.

The thing that astonished Eugene, though, was the freedom of the model with the students and the freedom of the students with her. After the first few weeks, when the class was fairly organized and its spirit caught, he observed some of those who had been here the year before going up to the platform where the girl sat and talking with her. She had a little pink gauze veil which she drew around her shoulders or her waist that, instead of reducing the suggestiveness of her attitudes, heightened them.

"Say, ain't that enough to make everything go black in front of your eyes?" said a boy sitting next to Eugene.

"Well, I guess," he laughed. "There's some edge to that."

The boys would sit and laugh and jest with this girl, and she would laugh

and coquette in return. He saw her strolling about, looking over some of the students' shoulders at their drawings of her, standing face to face with others, talking—and so calmly. It always invariably aroused a strong desire in Eugene but he quelled and concealed it, for these things were not to be shown on the surface. Once while he was looking at some photos that some student had brought, she came and looked over his shoulder, this little flower of the streets, her body graced by this thin scarf; her lips and cheeks red with color. She came so close that she leaned against his shoulder and arm with her soft flesh. It pulled him tense, like a great current; but he made no sign, pretending as if it were the veriest commonplace. And several times, because the piano was there, and because in the interludes students would sing and play, she came over and sat on the piano stool herself, strumming out an accompaniment to which some one or some three or four would sing. Somehow this, of all things, seemed most sensuous to him—most oriental. It set him wild. He felt his teeth click without volition on his part; for he was intensely emotional in his sex moods. "Good lord," he thought, "if I could only have her now." When she resumed her pose his passion subsided, for the cold aesthetic value of her beauty then became uppermost. It was only these little things which upset him.

As a draughtsman and an artist, however, and in spite of these sex disturbances, Eugene was gradually showing improvement. He liked to draw—he found to his surprise that he liked to draw the figure. He was not as quick at that as he was at the more varied outlines of landscapes and building scapes but he could give lovely sensuous touches to the human form—particularly to the female form—which were impressive. He got past the place where Boyle ever had to say, "They're round." He gave a sensuous sweep to his lines which attracted the instructor's attention.

"You're getting the thing as a whole, I see," he said quietly once. Eugene thrilled with satisfaction. Another Wednesday he said, "A little colder my boy, a little colder. There's sex in that. It isn't in the figure." Eugene flushed. He was giving his work a touch of his own personal desire. "You ought to make a good mural decorator some day if you have the inclination," Boyle said another time. "You've got the sense of beauty." The roots of Eugene's hair tingled. So art was coming to him. This man saw his capacity. He really had art in him.

One evening he saw a paper sign pasted up bearing the significant legend, "Artists, Attention! We eat! We eat! Nov. 16th at Sofroni's. All those who want to get in, give their names to the monitors."

Eugene had heard nothing of this, but he judged it originated in one of the other life classes. He spoke to the monitor and found that only seventy-five cents was expected of him. Students could bring girls if they wished.

Most of them would. He decided that he would go. There was ample time to pay. But where would he get a girl? And where was Sofroni's? The last was quickly answered.

Sofroni's was an Italian restaurant in lower Clark Street which had originally started out as an eating place for Italian laborers because it was near an Italian boarding house section. By some fortuitous accident it was located in an old wooden house which was not exactly homey. A yard in the back had been set with plain wooden tables and benches for use in the summertime, and later this had been covered with a mouldy tent cloth to protect the diners from rain. Still later the area was enclosed in glass and could be used in winter. The place was clean and the food good. Some struggling craftsman in journalism and art had found it and by degrees Signor Sofroni had come to realize that he was dealing with a better element. He began to exchange greetings with these people—to set aside a little corner for them. Finally he entertained a small group of them at dinner, charging them hardly more than cost price, and so he was launched. One student told another. Sofroni now had his yard so protected that he could entertain a hundred at dinner even in winter. He could serve a meal with several kinds of wines and liquors for seventy-five cents a plate. So he was popular.

This dinner was the culmination of several other kinds of class treats. For instance it was the custom of a class, whenever a stranger appeared or even a new member, to yell, "Treat! Treat," at which the visitor or new member was supposed to produce two dollars and donate it as an opening contribution to a beer fund. If the money was not produced, the stranger was apt to be thrown out or some ridiculous trick played upon him; if it was forthcoming, work for the evening ceased. A collection was immediately taken up. At least two kegs of beer were sent for, and sandwiches and cheese. Drinking, singing, piano playing, jesting followed. Eugene once saw, to his utter astonishment, one of the most feral of the students—a big, good-natured, carousing boy from Omaha named Showalter—rush and grab the nude model during one of these treats, lift her to shoulders, set her astride his neck and march around the room, jigging as he went. The girl was pulling his black hair.

The other students fell in behind, shouting. Some of the girls in an adjoining room, studying in an evening life class, stopped their work to peep through a half dozen small holes which had been punched in the intervening partition. The sight of Showalter carrying the girl so astonished the eavesdroppers that the news of it was soon all over the building. The secretary was informed and the next day Showalter was dropped. But the marvellous Bacchic dance had been enacted, its impression remained.

There were other treats like this in which Eugene was urged to drink,

and he did—a very little. He had no taste for beer. He also tried to smoke, but he was not enthusiastic for it. He could become nervously intoxicated at times by the mere sight of such revelry, and then he grew witty, easy in his motions, quick to say bright things. On one of these occasions one of the models said to him, "why you're nicer than I thought. I imagined you were very solemn."

"Oh, no," he said. "Only at times. You don't know me."

He seized her about the waist, but she pushed him away. He wished now that he danced, for he saw that he might have whirled her about the room, then and there. He decided to learn at once.

This matter of the dinner, or really the girl for the dinner, troubled him. He knew of no one except Margaret and he did not know that she danced. Anyhow they were quits. There was Miss Blue, of Black Wood, who by the way had been to the city once, but the thought of her in connection with anything like this was to him sacrilegious. He wondered what she would think if she saw such scenes as he had witnessed. She was, in his judgement, exceedingly good and pure. He had the youth's unsophisticated belief in the extreme goodness and innocence of the other sex, particularly those members of the class known as refined and virtuous. No, Miss Blue would never know anything of this world. She was too nice. So he thought of looking elsewhere.

It so chanced that one day when he was in the members' room—he had stopped on his way out following the afternoon illustration class to see who might be there, for he had come to know a few boys and several girl art students—he met Miss Kenny, the girl whom he had seen posing the first night he had entered the class. She was passing out from a day life class, having lingered for some purpose in an illustration class. Eugene remembered her as fascinating, for she was the first nude model he had ever seen and she was pretty. She was also the one who had come and stood by him when she was posing in the altogether but she had left not long afterward, posing in private studios for artists being her preferred work. She had liked Eugene but he had seemed a little distant and, at first, a little commonplace. Since she had left he had taken to a loose flowing tie and a soft round hat which was very becoming to him. He roached his hair back loosely on purpose and enviously mimicked the independent swing of Mr. Temple Boyle. That man was a sort of god to him—strong and successful. If he could only be like that.

This girl saw a change for what she deemed the better. He was so nice now, she thought, so white skinned and clear eyed and keen.

She pretended to be looking at the drawing of a nude when she saw him.

"How are you?" he asked, smiling, venturing to speak to her because he was lonely and because he knew no other girl.

"Oh, about the same," she returned gaily, "How have you been?" She turned about and faced him with red smiling lips and genial bright eyes.

"Oh, so-so. I haven't seen you for some time. Are you back here now?"

"For this week," she said. "I'm doing studio work. I don't care for classes when I can get the other."

"I thought you liked them," he replied, recalling her gayety of mood.

"Oh, I don't dislike them. Only studio work is nicer, if you can get all you want of it."

"We've missed you," he said frankly. "The others haven't been near so nice."

"Aren't you complimentary," she laughed, her black eyes looking into his with a twinkle.

"No, it's so," he returned hopefully. "Are you going to the dinner on the 16th?"

"Maybe," she said. "I haven't made up my mind. It all depends."

"On what?"

"On how I feel and who asks me."

"I shouldn't think there'd be any trouble about that," he observed. She had been asked and had evaded several offers. "If I had a girl, I'd go," he said, making a terrific effort to reach the place where he could ask her. She caught his drift.

"Well?" she laughed.

"Would you go with me?" he ventured, thus so shamelessly assisted.

"Sure," she said, for she liked him.

"That's fine," he exclaimed. "Where do you live? I'll want to know that." He searched for a pencil.

"It's 346 West Fifty-seventh," she answered.

Because of his collecting he knew the neighborhood. It was a street of shabby frame houses far out on the South Side. He remembered great mazes of tracks near it and unpaved streets and open stretches of wet prairie land. Somehow it seemed fitting to him that this little flower of the muck and coalyard area should be a model.

"I'll be sure and get you," he laughed. "You won't forget, will you, Miss ——"

"Just Ruby," she interrupted. "Ruby Kenny. That's all right."

"That's a pretty name, isn't it?" he said. "It's so euphonious. You wouldn't let me come out some Sunday and see just where it is?"

"Yes, you may," she replied, pleased by his comment on her name. "I'm home most every Sunday. Come out next Sunday afternoon if you want to."

"I will," said Eugene.

He walked out to the street with her in a very buoyant mood.

CHAPTER XII

Ruby Kenny was the adopted child of an old Irish laborer and his wife who had taken her from a quarreling couple when they had practically deserted her at the age of four years. She was bright, good-natured, not at all informed as to the social organization of the world—just a simple little girl with a passion for adventure and no saving insight which would indicate beforehand where adventure might lead. She began life as a cash girl in The Fair and was spoiled of her virtue at fifteen. By reason of some defect of body she had escaped the consequences which usually flow from sex connection. And thus far also, because she attracted the rather superior, capable, self-protecting type of individual who is not afflicted with the horrors of sex contagion, she had also escaped disease. Ruby was of the kind which is not utterly promiscuous, her appetite waiting on strong likes and, in one or two cases, serious affection, and culminating only after a period of dalliance which made her as much a victim of her moods as were her lovers. Her foster parents had provided absolutely no intelligent guidance. They liked her, and since she was brighter than they were, submitted to her rule, her explanations of conduct, her taste. She waved aside with a laughing rejoinder any slight objections they might make, and always protested that she did not care what the neighbors thought.

The visits which Eugene paid, the companionship which ensued, the somewhat dramatic turn which it finally took, were of a piece with every other relationship of this character which he ever entered into—full of the worship of beauty as beauty and never wholly divested of a certain quality of mind and heart which he longed for and usually found in part. Eugene was always, or nearly always, choosing the girl who was good-natured and sympathetic, or partly so—but never startlingly brilliant, for he shunned criticism and coldness, and was never apt to choose anyone who could outshine him either in emotion or rapidity or distinction of ideas. He liked at this time simple things, simple homes, simple surroundings, the commonplace atmosphere of simple life, for the more elegant and imposing overawed him. Simple things seemed to him more natural—more worthwhile. The great mansions which he saw, the great trade structures, the great, significant personalities, seemed more or less artificial and cold. He liked little people—people who were not well known but who were sweet and kindly in their moods. If he could find female beauty with anything like that as a background, he was happy and settled down near it, if he could, in comfort. His drawing near to Miss Kenny was of a piece with this mood. She was friendly, good-natured, artistic in a small way, albeit variable, and he liked her.

The Sunday Eugene called it rained and the neighborhood in which she lived was exceedingly dreary. As he looked around here and there, he could see, in the open spaces between the houses, pools of water standing in the brown, dead grass. He crossed a great maze of black cindered car tracks where engines and cars stood in great masses, and speculated as usual on what magnificent, forceful drawings such scenes would make. After experimenting with charcoal, he had begun to think that maybe he could work these things out in crayon, with touches of color thrown in. These dreary car track scenes kept appealing to him as something wonderful—big black engines throwing up clouds of smoke and steam in gray, wet air; great mazes of parti-colored cars dank in the rain but lovely somehow. At night the switch-lights in these great masses of yards bloomed like flowers. He loved the sheer yellows, reds, greens, blues that burned like eyes. Here was the stuff that touched him magnificently, and somehow he was glad that this raw flowering girl lived near something like this. How poor was the mind that could not feel the beauty of these things. He did not condemn this poverty. All life was good, if you could only live. That was the question—how to live well.

When he reached the door and rang the bell he was greeted by an old stodgy Irish-American who seemed to him rather low in the scale of intelligence—the kind of a man who would make a good crossing guard, for instance. He had on common, characterful clothes, the kind that from long wear have taken the natural outlines of the body. In his fingers was a short pipe which he had been smoking.

"Is Miss Kenny in?" Eugene inquired.

"Yes," said the man. "Come in. I'll get her." He poked back through a typical working man's parlor to a rear room. Eugene sat down on a cheap, red plush divan and waited. Now that he was inside, the place looked rather good to him, for someone had seen to it that most everything in the room was red, the big silk shaded lamp, the family album, the carpet and the red flowered wall paper. The woodwork happened to be cherry stained and matched fairly well. He did not think of it as being calculatedly harmonized, but it was pleasant.

While he was waiting he ventured to open the album and look at what he supposed were her relatives—commonplace people all—clerks, salesmen, store-keepers, what not. They were exceedingly mediocre. Presently Ruby came and then his eye lighted, for there was about her a smartness of youth—she was not more than nineteen—which captivated his fancy. She had on a black cashmere dress with little bands of red velvet at the neck, the sleeves, and above the flounces at the hem, and she wore a loose red tie, much as a boy might. She looked gay and cheerful and held out her hand.

"Did you have much trouble in getting here?" she asked.

He shook his head. "I know this country pretty well. I collect all through here week days. I work for the People's Furniture Company, you know."

"Oh well, then it's all right," she said, enjoying his frankness. "I thought you'd have a hard time finding it. It's a pretty bad day, isn't it?"

Eugene admitted that it was, but commented on the car tracks he had seen and how much he admired them. "If I could paint at all, I'd like to paint those things. They're so big and wonderful to me."

He went to the window and gazed out at the neighborhood.

Ruby watched him interestedly. His every movement was pleasing to her. She felt so much at home in his company—as though she were going to like him very much. It was so easy to talk to him for there was a feeling of congeniality of soul. There were the classes, her studio work, his own career, this neighborhood.

"Are there many big studios in Chicago?" he asked when they finally got around to that phase of her work. He was curious to know what the art life of the city was, and he knew nothing.

"No, not so very many—not at least of the good ones. There are a lot of fellows who think they can paint."

"Who are the big ones?" he asked.

"Well, I only know by what I hear artists say. Mr. Rose is pretty good. Byam Jones is pretty fine on genre subjects, so they say. Walter Low is a good portrait painter. And so is Manson Steele. And let's see—there's Arthur Biggs—he does landscapes only; I've never been in his studio; and Finley Wood, he's another portrait man; and Wilson Brooks; he does figures—Oh! I don't know, there are quite a number."

Eugene listened, entranced. This patter of art talk was more in the way of definite information about personalities than he had heard during all the time he had been in the city. This girl knew these things. She got around. He wondered what her relationship to these various people was.

While she was talking, he was contemplating her face and figure, the smartness of her air. She was the first woman he had ever met who knew something about men. Would she be interested in him, then?

After they had talked a little more about the city's established artists, they changed the subject to the personality of Mr. Temple Boyle, whom Ruby did not like because he was so dictatorial. "He thinks he's so smart," she observed. "I wouldn't pose for him privately or in the class either if he had much to do with it." Eugene smiled. He liked Boyle. He could see of course why she would not and tactfully agreed with her point of view.

He got up after a time and looked out the window again. She came over also. "It's not very nice around here," she explained, "but papa and mama like to live here. It's near papa's work."

"Was that your father I met at the door?"

"They're not my real parents," she explained. "I'm an adopted child. They're just like real parents to me, though. I actually owe them a lot."

"You can't have been posing in art very long," said Eugene thoughtfully, thinking of her age.

"No, I only began about a year ago."

She told him how she had been a clerk in The Fair, and how she and another girl had gotten the idea from articles in the Sunday papers that it would be nice to pose in the studios and for the life class. There was once a picture in the *Tribune* of a model posing in the altogether before the local life class. This had taken her eye and she had consulted with the other girl as to whether they had not better try posing, too. Her friend, like herself, was still posing. She was coming to the dinner.

Eugene listened, entranced. It reminded him of how he was caught by the picture of Goose Island in the Chicago River, with the little tumble-down huts and upturned hulls of boats used for houses. He told her of that, and of how he had come to Chicago, and it touched her fancy. She thought he was sentimental but nice—and then he was big, too, and she was so much smaller.

"You play," he asked, "don't you?"

"Oh, just a little. But we haven't got a piano. I learned what I know by practicing at the different studios."

"Do you dance?" asked Eugene.

"Yes, indeed," she replied.

"I wish I did," he commented ruefully.

"Why don't you? It's easy. You could learn in no time. I could teach you in a lesson."

"I wish you would," he said, persuasively.

"It isn't hard," she went on, moving away from him. "I can show you the steps. They always begin with the waltz."

She lifted her skirts and exposed her cute little feet. She explained how you started backward with the left foot, drawing the right in a long sweep beyond it and then bringing the left to it again. He tried to do it alone, but failed; so she had him put his right hand to her back and placed her hand in his. "Now you follow me," she said.

It was so delightful to find her practically in his arms, and so quickly. And she was apparently in no hurry to conclude the lesson, for she worked with him quite a few minutes, explaining the steps, stopping and correcting him, laughing at her mistakes and his. "You're getting it, though," she said, after they had turned around a few times.

They had looked into each other's faces a number of times and she gave him frank smiles in return for his. He thought of the time when she stood

by him in the studio, looking over his shoulder. Surely, surely, this gap of formalities might be bridged at once if he tried—if he had the courage. He pulled her a little closer and when they stopped he did not let go.

"You're mighty sweet to me," he said with an effort.

"No, I'm just good-natured," she laughed, not endeavoring to break away.

He became emotionally tense, as usual.

She saw his drift, rather liked the superiority of his mood. It was different, stronger than was customary in the men she knew.

"Do you like me?" he asked, looking at her.

She studied his face and hair and eyes.

"I don't know," she returned calmly.

"Are you sure you don't?"

There was another pause in which she looked almost mockingly at him and then, sobering, away at the hall door.

"Yes, I think I do," she said.

He picked her up in his arms. "You're as cute as a doll," he said, and carried her to the red settee. He sat down, and the rest of the rainy afternoon was spent by her lying in his arms and enjoying his kisses. He was a new, peculiar kind of boy.

CHAPTER XIII

Before this understanding between Eugene and Ruby had been reached and before the dinner at Sofroni's had occurred, Angela Blue, at the earnest solicitation of Eugene, had paid her first fall visit to Chicago. She had made a special effort to come, lured by a certain poignancy of expression which he could give to any thought, particularly when it concerned his desires. In addition to the art of drawing he had the gift of writing—very slow in its development from a structural and interpretative point of view, but strongly developed already on its descriptive side. He could describe anything, people, horses, houses, dogs, landscapes, much as he could draw them and give a moving sense of tenderness and pathos in the bargain. He could describe in the most alluring fashion city scenes and the personal atmosphere which surrounded him. He had little time to write but he took time in this instance to tell Angela what he was doing. Naturally she was captivated by the quality of this world in which he was moving, the color of the city streets which he emphasized, and the distinction of his own personality which he indicated rather indirectly than otherwise. In the face of

his communications, her own little world began to look very shabby indeed, for this was a wider life he was talking about—beautiful, dramatic, important. Teaching school, minding babies, buying for relatives, sewing—these seemed nothing at all anymore, the commonplace drudgery of existence.

She came first shortly after the art school had opened and, at her invitation, he went out to the residence of her aunt on the North Side, a nice, pleasant brick house in a quiet side street which had all the airs of middle class peace and comfort. As a matter of fact, it was no more a happy household than any other, but that is neither here nor there in this story. Eugene was impressed with what seemed to him a sweet, conservative atmosphere—a fitting domicile, if temporary, for a girl so dainty and refined as Angela. He paid his respects early Saturday morning because her neighborhood happened to be in the direction of his work, and promised to call that night and take her to a theatre. He skipped his class for the occasion, arrayed himself in his best clothes, and made his evening appearance, shining and eager. He was full of the sense of his art prospects, for he had gone far in developing his talent in that direction and was consequently happy. He was happy to see her again, for he was satisfied that he was going to fall in love with her. She had a strong sympathetic attitude which allured him. She was attractive in a new way for him, for she was a natural born actor, highly emotional and temperamental, and could simulate or feel whatever it was necessary to feel at the time. She wanted to be nice to this youth— wanted him to like her—and so the atmosphere was right.

He found the house charming for the minutes he stayed in the morning. It was cheerful and bright because of a yard and some windows— not common in the great rows of bay windowed homes everywhere being erected—and there was a piano, as well as some pleasing engravings. Eugene discovered to his pleasure that Miss Blue played quite well—better than anyone he had ever known. It seemed a great accomplishment. Her deep, sympathetic, and emotional attitude led her to music of a high emotional order and to songs and instrumental compositions of indefinable sweetness. In the half hour he stayed in the morning, she played several pieces, her small, shapely body and wealth of red hair impressing him in a new way, for her hair was hung in two great braids far below her waist and her dress was of a very simple, close fitting design. She reminded him the least bit of Marguerite in *Faust*, only she was smaller than those he had seen interpret the role on stage. She was gay and coy and sweet.

That evening when he came she had changed her simple white dress of the morning for one of a soft gray, a color which did not become her as well as some others but which still looked attractive. They took a car and went to the Chicago Opera House where there was playing an extrava-

ganza of the order of *The Crystal Slipper*. This phantasy, so beautiful in its
stage craft, so gorgeous in its show of costumes and pretty girls, so idle in
its humor and sweet in its love songs, captivated both Eugene and Angela.
Neither had been to a show in some time; both were en rapport with some
such fantastic interpretation of existence. After the short acquaintance at
Alexandria, it was a nice coming together. It gave point to their reunion.

After the show he guided her through the surging crowds to a North
Division Street car—they had laid cables since he had arrived—and together
they went over the beauties and humor of the thing they had seen. Then
he asked permission to call the next afternoon and, having spent that time
with her, proposed that they go to hear a famous preacher who was speak-
ing at Central Music Hall evenings. There had been considerable stir in
the newspapers about the quality of these sermons, the young orator who
delivered them having built up a tremendous following of hearers. It was
necessary to lock the doors at 7:30 in order to keep the overflow crowds
from idly waiting to get in.

Angela was pleased at Eugene's resourcefulness. She wanted to be with
him. This was a good excuse; they went early and enjoyed it. The sermon
was one of those curious compounds of emotion, poetry of thought, beauty
of delivery, and little logic which go so well with the masses. Eugene liked
it as an expression of youth and beauty and power to command. He would
have liked to be an orator like that, he told Angela. And he confided more
and more of himself to her. She was impressed by his vivid interest in life and
his powers of discrimination, and felt that he was destined to be a notable
personality.

There were other meetings. She came again in early November and
before Christmas, and Eugene was fast becoming lost in the meshes of her
hair. Although he met Ruby in November and took up a tentative rela-
tionship on a less—as he would have said at the time—spiritual basis, he
nevertheless held this relationship with Angela in the background as a
superior and more significant thing. She was purer, he thought, than Ruby,
more spiritual. There was certainly a deeper vein of feeling, as expressed in
her thoughts and music. Moreover she represented a country home, some-
thing like his own, a nice simple country town, nice people. Why should
he part with her, or ever let her know anything of this other world that he
touched? He did not think he ought to. He was afraid that he would lose
her, and he knew that she would make any man an ideal wife. She came
again in December and he almost proposed to her—but then he realized
he must not be free with her or draw too near too rapidly. She made him
feel the sacredness of love and marriage. And he did propose in January.

It is useless to attempt the psychology of this sex disposition. The artistic

temperament is a blend of subtleties in emotion which is not classifiable. No one woman could have been sufficient to Eugene in the particular mood he was then in. Beauty was the point with him—beauty as represented by life and sex. Any girl who was young, emotional or sympathetic to the right degree, and beautiful would have attracted and held him for a while. He loved beauty—not a plan of life, not children. He was interested in an artistic career, not the founding of a family or the propagation of the race. The beauty of youth—girlhood—was artistic, hence he craved it. This weakness was destined to play a terrific trump in his life's drama.

On the other hand, Angela's mental and emotional composition was anything but variable. She had learned to believe from childhood that marriage, when it came, was a fixed and stable thing. She believed in one life and one love. When you found that, all other relationships which did not minister to it were ended. If children came, very good. If not, very good, but marriage was permanent anyhow. And if you did not marry happily, it was necessarily your duty to endure and suffer for whatever good might remain. You might suffer badly in such a union but it was unwise and dangerous and disgraceful to break it unless you could not stand it anymore. Then your life was a failure, to be endured as such.

Of course Eugene did not know what he was trifling with. He had no conception of the nature of the relationship he was building up. He went on blindly dreaming of this girl as an ideal, and contemplating eventual marriage with her. When that would be, he had no idea, for he was still only getting fifteen, or rather eighteen dollars a week (for his salary was raised at Christmas time), but he deemed marriage would come within a reasonable time. He did not figure what waiting meant to a woman of Angela's age, for he did not know her age, assuming it to be something about his own. It was ticklish situation but so it was.

Meanwhile, since visiting Ruby, he had become intimate with her. The very nature of the situation seemed to compel it. She was, as has been said, young, running strong with a love of adventure, admiring youth and strength in men. Eugene, with his pale face which had just a touch of melancholy about it, his sex magnetism, his love of beauty, appealed to her. Sex weakness was perhaps uppermost to begin with, but very shortly it was compounded with affection, for this girl could love. She was sweet, good-natured, ignorant of life from many points of view. Eugene represented the most of dramatic imagination she had yet seen. She confided to him about her relationship with her foster parents, how simple they were and how she could do about as she pleased. They did not know that she posed in the altogether. She confided to him her particular friendship for certain artists, but denied having sex relations with anyone at present. She admitted in a

roundabout way that she had in the past, but that was all over. Eugene really did not believe this. He suspected her of meeting other approaches in the spirit in which she had met his own. It aroused his jealousy, and he wished at once that she were not a model. He said as much and she laughed. She knew he would act like that. It was the first proof of real, definite interest in her on his part.

There were some lovely days and evenings spent in her company from then on. One Sunday she invited him over to breakfast. Her foster parents were going over to the West Side to visit some relatives and she was to have the house or rather flat, for it contained two apartments, to herself. She wanted to cook Eugene a breakfast—principally to show him she could cook, and then it was sort of cute and novel. She waited until he arrived at nine to begin operations and then, arrayed in a neat little lavender hued house dress which was close fitting and a ruffled white apron, went about her work, setting the table, making biscuit, preparing a kidney ragout with sherry, and boiling coffee. There was a plate of peach preserves and some fresh cream which she put on the table in a little pink flowered pitcher.

Eugene was beside himself with satisfaction. He followed her about, delaying her work by taking her in his arms and kissing her mouth. She got flour on her nose and he brushed it off with his lips. There was the customary culmination to this sort of thing, for it could not be otherwise with him. He could not restrain his passion long with anyone that he really cared for.

It was on this occasion that she showed him a very pleasing little dance she could do—a clog dance, which had a running sidewise motion, with frequent and rapid clicking of the heels. She would gather her skirts a little way above her ankles and twinkle her feet through a maze of motions. Eugene was beside himself with admiration. He told himself he had never met such a girl—to be so clever at posing, playing, dancing, and so young. He thought she would make a delightful creature to live with and he wished now he had money enough to do such a thing. At this high-flown moment and at some others he thought he might almost marry her—of such is the stuff of emotion.

On the night he took her to the dinner at Sofroni's, he was surprised to find that Ruby was arrayed in a dark red dress with a row of large black leather buttons cutting diagonally across the front. She had on red stockings and shoes and wore a red carnation in her hair. The bodice was cut low in the neck and the sleeves stopped short of the elbows. Eugene thought she looked stunning and told her so. She laughed. They went in a cab for she had warned him beforehand that they would have to. It cost him two dollars each way but he excused his extravagance on the ground of necessity. It was things like this which were beginning to make him think sharply of the problem of getting on.

This dinner at Sofroni's presented to Eugene another phase of art life which had not yet dawned on him. The jubilance of the artist's character had come to him in odd moments during the treats, but on this occasion he was destined to see a mass effect which was somewhat different from the smaller studio gatherings.

The students who had gotten up this dinner were from all the classes, day and night. There were over two hundred of them, all of them young, and there was a mixed collection of girl art students, artists' models, and girlfriends of various grades who were brought as companions. The big dining room was tempestuous from the outset with the rattling of dishes, the shouting of jests, the singing of songs, and the exchange of greetings. Eugene knew a few of these people outside of his own classes, enough to give him the chance to be sociable and not appear lonely or out of it.

It was a different story with Ruby from the outset. It was apparent that she was generally known and liked. Her costume, which was a little bold, made her conspicuous. There were cries from various directions when she came in of "Hey! Rube!" which was a familiar interpretation of her name.

Eugene was surprised at this—it shocked him a little. All sorts of boys he did not know came and talked to her, exchanging familiar gossip. She was called away from him a dozen times in as many minutes. He saw her laughing and chatting at the other end of the hall, surrounded by a half dozen boys. It made him jealous.

He was destined to severer shocks, however, for as the evening progressed the attitude of each toward the other and all toward anyone became more and more familiar. Eugene saw Ruby, and other girls quite as attractive and quite as distinctively garbed, being grabbed by the arms as they passed, and pulled down beside youths in order that something might be told them. After the courses had all been served, a space was cleared at one end and a screen of green cloth rigged up in one corner as a dressing room for *stunts*. Eugene saw one of the students called, with much applause, to do an Irish monologue, wearing green whiskers which he adjusted in the presence of the crowd. There was another youth who pretended to have with him an immense roll of verse—an epic, no less—wound in so tight a manner that it looked as though it might take all night to read it. The crowd groaned. With an amusing savoir faire he put up one hand for silence, dropped the roll, holding of course to the outer end, and began reading. It was not bad verse but the amusing part was that it was really short, not more than twenty lines. The rest of the paper had been covered with mere scribbling to deceive the crowd. The stunt secured a round of applause. There was one second year man who sang a song, "Down in the Lehigh Valley," and another who gave imitations of Temple Boyle and other instructors, criticising and painting for the benefit of the class. These were greatly enjoyed.

Finally one of the models, after much calling by the crowd of "Desmond, Desmond!" (her last name), went behind the green cloth screen and in a few moments reappeared in the short skirt of the Spanish dancer, with black and silver spangles and castanets. Some friendly student had brought a mandolin and "La Paloma" was danced.

Eugene had little of Ruby's company during all this. She was too much sought after. He felt a little out of it at times, for he had come with her and was holding back from mixing much with others because of her. He was thinking of this as the other girl was concluding her dance, when he heard the cry of "Hey, Rube!" She had been accosted by someone asking, "Why don't you do your turn?" Someone else, eager to see her dance, had called, "Come on, Ruby." The rest of the room, almost unthinkingly, took it up. Some boys surrounding her had started to push her toward the dancing space. Before Eugene knew it she was up in someone's arms, being passed from group to group for a joke. The crowd cheered.

Eugene, having become so close to her, was irritated by this familiarity. She did not appear to belong to him, but to the whole art student body. And she was laughing. When she was put down in the clear space she lifted her skirts as she had done for him and danced. A crowd of students got very close. He had to draw near to see her at all. And there she was, unconscious of him, doing her lovely clog dance. When she stopped, three or four of the more daring youth seized her by the hands and arms and urged her to do something else.

Someone cleared a table and someone else picked her up and put her on it. She did still other dances and kicked. Someone cried, "Hey, Kenny, do you need the red dress?" The inference was obvious. So this was his temporary sweetheart.

When she was finally ready to go home at four o'clock in the morning, or when the others were agreed to let her go, she hardly remembered that she had Eugene with her. She saw him waiting as two students were asking for the privilege of taking her home.

"No," she exclaimed, seeing him, "I have my escort. I'm going now. Good-bye," and came toward him. He felt rather frozen and out of it.

"Are you ready?" she asked.

He nodded gloomily, reproachfully.

Somehow there had been a lot taken out of this relationship and yet he still liked her. And on her part she did not realize how the very conditions which surrounded her were militating against her interest in him.

CHAPTER XIV

The following winter quite a number of things in connection with Eugene's life developed. From drawing from the nude, which he came to do very successfully, his interest switched to his work in the illustration class, where costumed figures were put up for copying. Here for the first time he tried his hand at wash drawings, the current medium for magazine work, and was complimented after a time on his execution. He was not always so praised, however, for the instructors, feeling that harsh criticism would make for steadier effort, pooh-poohed some of his best work. He had an abiding faith in what he was destined to do, however, and after sinking to depths of despair he would rise to great heights of self-confidence. He was not sure for some time as to how he was to get into the art world. His labor for the People's Furniture Company was becoming a rather dreary grind.

It is the habit of capable art instructors to take promising students in hand and make suggestions as to their future. Vincent Beers, the instructor in the illustration class, a small, magnetic, black-bearded man, while looking over his shoulder one Wednesday afternoon, said, "you ought to be able to make a little money by your work pretty soon, Witla."

"Do you think so?" questioned Eugene.

"It's pretty good. There ought to be a place on one of the newspapers here for a man like you—an afternoon newspaper, possibly. Did you ever try to get one?"

"I did when I first came to the city, but they didn't want anyone. I'm rather glad they didn't now. I guess they wouldn't have kept me very long."

"You draw in pen and ink pretty well, don't you?"

"I thought I liked that best of all at first."

"Well, then, they ought to be able to use you. I wouldn't stay very long at it, though. You ought to go to New York to get in the magazine illustration field—there's nothing out here—but a little newspaper work now wouldn't hurt you."

Eugene took this as an excellent cue. He needed urging. He decided to go around and see the editors of the afternoon papers for he knew that if he could connect with one of these he could still continue his night class. He could give the long evening session to the illustration class and take an occasional night off to work on the life studies. That would make an admirable arrangement. For several days he took an hour after his work to make inquiry, taking with him some samples of his pen and inks. Several of the men in charge of art departments liked what he had to show but there was no immediate opening. All their artists were on salary. There was only one paper, one of the poorest, that offered him any encouragement. The

editor-in-chief who hired all artists here said he might be in need of a man shortly. If Eugene would come in again in three or four weeks, he would tell him. They did not pay very much—twenty-five dollars to beginners.

Eugene thought of this as a great opportunity. If he could only make this connection he would be on a fair road to prosperity. Out of twenty-five dollars he could put five dollars in a bank and still have twelve or thirteen for art tuition fees, clothes, entertainment, and what not. He still figured his board and room at six dollars. Why a man could almost get married on that sum. He went back in three weeks and actually secured the place, a desk in a small back room on a fourth floor where there was accidentally west and north light. He was in a department which held two other men, both several years older than himself, one of whom posed as dean or head of the staff. As a matter of fact there was no head, the Managing Editor, City Editor, and Sunday Editor giving work to whomsoever of the three seemed least pressed for time or crowded with work. Eugene settled down in the hope of being as unobtrusive as he could and his companions in labor eyed him critically, of course.

The work here was peculiar in that it included not only pen and ink but also the chalk-plate process which was a method of drawing with a steel point upon a zinc plate covered with a deposit of chalk, which left a design which was easily reproduced. Eugene had never done this, so he had to be shown by the dean, but he soon picked it up. He found it hard on his lungs for he had constantly to keep blowing the chalk away as he scratched the surface of the plate, which blew it sometimes up into his nostrils. He hoped sincerely there would not be much of this work, but there was rather an undue proportion at first owing to the fact that it was shouldered on to him by the other two—he being the beginner. He suspected as much after a little while, but by that time he was beginning to make friends with his companions and things were not so bad.

These two men, although they did not figure vastly in his life, introduced Eugene to conditions and personalities in the Chicago newspaper world which broadened him and presented points of view which were helpful. They were clever men both—one of them a native of Illinois, the other of Iowa. Like so many other boys, they had come to the city to make their way and were forging along alone, without family surroundings. The elder of the two—the dean—was a young man of Eugene's own complexion but smaller, twenty-six years of age, dressy, rather superior in his manner, distinctly arty. He made Eugene look less like an artist because of his own greater lustre in that respect, and assumed at once and without self-analysis that of course Eugene was a less competent man than himself. His name was Horace Howe. The other youth, Jeremiah Mathews—Jerry for short, as

called by Howe—was short and fat with a round, cheerful, smiling counte-
nance and a Jovian wealth of coarse black hair. He had brown eyes, a well
formed but chubby nose, and a round, solid chin. He loved chewing tobacco,
was a little mussy about his clothes but self-contained, studious, generous,
and good-natured. Eugene quickly found that he had several passions, one
for good food, another for oriental curios, and a third for archaeology. He
appeared to be intensely alive to what was going on in the world, and was
absolutely without any prejudices, moral, religious, or what not. He liked to
work, whistled or talked over it; laughed heartily and got up and shook him-
self now and then in a fussy way which meant that he was ready for almost
anything. Eugene took a secret liking for him from the beginning, though
it was some time before they came to a right understanding of each other.

It was while working on this paper that Eugene first learned that he really
could write. It came about in a rather fortuitous way for he had quite aban-
doned the idea that he could ever do anything in newspaper work—which
was the writing field he originally contemplated—or in any other literary
realm. Here, however, there was great need for cheap Sunday specials of a
local character, and in reading some of those which were given to him for
illustration, he came to the conclusion that he could do much better him-
self. Some of them were so bad.

"Say," he once said to Mathews, "who writes these articles in here?" He
was looking over the Sunday issue in which there were quite a number.

"Oh, the reporters on the staff—anyone that wants to. I think they buy
some from outsiders. They only pay four dollars a column."

Eugene wondered if they would pay him, but anyhow, pay or no pay, he
was interested to do them. Maybe they would let him sign his name. He
saw that some were signed. He suggested he believed he could do that sort
of thing but Howe, as a writer himself, frowned on this. He wrote and drew.
Howe's opposition piqued Eugene, who decided to try when the opportunity
offered. He wanted to write about the Chicago River, which he thought he
could illustrate beautifully; Goose Island, because of the description he had
read of it several years before; the simple beauties of the city parks, where he
liked to stroll and watch the lovers on Sundays. There were many things to
draw, but these scenes stood as susceptible of delicious, feeling illustration
and he wanted to try his hand. He once suggested to the Sunday Editor—
Mitchell Goldfarb, with whom he became friendly—that he thought some-
thing nice in an illustrative way could be done on the Chicago River.

"Go ahead, try your hand," exclaimed that worthy, who was a vigor-
ous, robust, young American of about thirty-one, with a gaspy laugh that
sounded as if someone had thrown cold water down his back. "We need all
that stuff. Can you write?"

"I sometimes think I might if I practised a little."

"Why not," went on the other, who saw visions of a little free copy. "Try your hand. You might make a good thing of it. If your writing is anything like your drawing it will be all right. We don't pay people on the staff but you can sign your name to it."

This was enough for Eugene. He tried his hand at once. His art work had already begun to impress his companions. It was rough, daring, incisive, with a touch of soul to it. Howe was already secretly envious, Mathews full of admiration. Encouraged thus by Goldfarb, Eugene took a Sunday afternoon and followed up the branches of the Chicago River, noting its wonders and peculiarities, and finally made his drawings. Afterward he went to the Chicago library and looked up its history—accidentally coming across the reports of some government engineers who dwelt on the oddities of its traffic. He did not write an article so much as a panegyric on its beauty and littleness, finding the former where few would have believed it to exist. Goldfarb was oddly surprised when he read it. He had not thought Eugene could do it.

"That boy is all right," he said. "I'll get him to do some more stuff." He praised Eugene to his face and suggested to the managing editor that he ought to be allowed to send him out on that sort of thing now and then. There was no real objection and so for a time and at odd intervals Eugene had the pleasure of writing and illustrating his own pieces.

The charm of Eugene's writing was that his mind was full of color and poetry and yet he had the logic and desire for facts which gave everything he wrote stability. He liked to know the history of things and to comment on the current phases of life. He wrote of the parks, Goose Island, the Bridewell, whatever took his fancy, and wrote with real feeling. Of course his illustrations helped and really gained him his introduction, but if he had pursued literature singly he would have made a success of it.

His real passion was for art, however. It was a slightly easier medium for him—quicker. He thrilled to think sometimes that he could tell a thing in words and then actually draw it. It seemed a beautiful privilege and he loved the thought of making the commonplace dramatic. It was all dramatic to him—the wagons in the streets, the tall buildings, the street lamps—anything, everything.

"I don't know what there is about your stuff, Witla, that gets me," Mathews said to him one day, "but you do something to it. Now why did you put those birds flying above that smoke stack?"

"Oh, I don't know," replied Eugene. "It's just the way I feel about it. I've seen pigeons flying like that."

"It's all to the good," exclaimed Mathews. "And then you handle your masses right. I don't see anybody doing this sort of thing over here."

He meant in America, for these two art workers considered themselves connoisseurs of pen and ink and illustration generally. They were subscribers to *Jugend, Simplicissimus, Pick-Me-Up* and the radical European art journals. They were aware of Steinlen and Van Ile and Mucha and the whole rising young school of French poster workers. Eugene was surprised to hear of these men and these papers. He began to gain confidence in himself—to think of himself as somebody. If he could interest Mathews in this way, who knew of all these other people, his own work must be good. He began to think of his name, Eugene Witla, and how it sounded. He thought of Eugene Tennyson Witla as a variation and then of E. Tennyson Witla. For some time he wondered whether it would not be better to drop the Eugene entirely and sign himself Tennyson Witla but he did not have the courage yet. He wanted to be a little more sure of himself before he assumed anything so euphonious as that.

It was while he was gaining in this art knowledge—finding out who was who and what and why—that he followed up his relationship to Angela Blue to its logical conclusion—he became engaged to her. In spite of his connection with Ruby Kenny, which continued unbroken after the dinner, he nevertheless felt that he must have Angela, partially because she offered more resistance than any girl since Stella—she was loath to permit any liberties this side of an engagement—and partially because she appeared to be so innocent, simple, and good hearted. He was mistaken about this in part but she was altogether lovely anyhow. She had a beautiful form, which no crudity of country dressmaking could conceal. She had her wonderful wealth of hair and her large, luring, water clear blue eyes. She had colorful lips and cheeks, a natural grace in walking, could dance and play the piano. Eugene looked at her and came to the conclusion after a time that she was as beautiful as any girl he had seen—that she had more soul, more emotion, more sweetness. He tried to hold her hand, to kiss her, to take her in his arms, to hold her on his lap, but she eluded him in a careful, wary, and yet half yielding way. She wanted him to propose to her, not because she was anxious to trap him but because her conventional conscience told her these things were not right outside a definite engagement, and she wanted to be engaged first. She was already madly in love with him. When he pleaded she was anxious to throw herself in his arms in a mad embrace but she restrained herself, waiting. At last he threw his arms about her as she was sitting at the piano one evening and, holding her tight, pressed his lips to her cheek.

She struggled to her feet. "You mustn't," she said. "It isn't right. I can't let you do that."

"But I love you," he exclaimed, pursuing her. "I want to marry you. Will you have me, Angela? Will you be mine?"

She looked at him yearningly, for she realized that she had made him do things her way—this wild, impractical, artistic soul. She wanted to yield then and there, but something told her to wait.

"I won't tell you now," she said. "I want to talk to papa and mama. I haven't told them anything as yet. I want to ask them about you and then I'll tell you when I come again."

"Oh, Angela!" he pleaded.

"Now, please wait, Mr. Witla," she pleaded. She had never yet called him Eugene. "I'll come again in two or three weeks. I want to think it over. It's better."

He curbed his wild desire to fondle her and waited, but it made all the more vigorous and binding the illusion that she was the one woman in the world for him. She aroused more than any woman yet a sense of the necessity of concealing his eager sexuality—of pretending something higher. He even tried to deceive himself into the belief that this was a spiritual relationship, but underneath all was a burning sense of her beauty, her physical charm, her passion. She was sleeping as yet, bound in convention and a semi-religious interpretation of life. If she were aroused. He closed his eyes and dreamed.

CHAPTER XV

In two weeks Angela came back ready to plight her faith and Eugene was waiting, eager to receive it. He was planning to meet her under the smoky train shed of the Chicago, Milwaukee, and St. Paul depot, to escort her to Kinsley's for dinner, to buy her some flowers and candy, to give her a ring he had secured in anticipation—a ring which had cost him seventy-five dollars and consumed quite all of his savings—but she was too regardful of the dramatics of the situation to meet him anywhere but in the parlor of her aunt's house, where she could look as she wished. She wrote him that she must come down early, and when he arrived at eight of a Saturday evening, was wearing the dress that seemed most romantic to her, the one she had worn when she first met him in Alexandria. She half suspected he would bring flowers and so she wore none, and when he came with a dozen roses, added three to her corsage. She was a picture of rosy youth and trimness

and not unlike one of the historical characters he had christened her—the fair Jehane of Arthur's court. Her copper colored hair was done in a great mass that hung sensuously about her neck; her cheeks were rosy with the elation of the hour; her lips moist; her eyes bright. She fairly sparkled her welcome as he entered, but with a pretence of kindly social geniality only. He understood—for words mean so little anyhow. All the big things are deep currents, silent and swift.

At the sight of her Eugene was beside himself. He had the habit of keying himself up to the breaking point over any romantic situation such as this. The beauty of the idea did it—the beauty of love as love; the delight of youth; the lure of sex. He saw himself as an outsider might—a Romeo hanging at the balcony of a fair Juliet—and then felt himself in the part also, as the urgent participant of so much joy. It filled his mind as a song might, made him tense, feverish, enthusiastic.

"You're here at last, Angela," he said, trying to hold her hands. "What word?"

"Oh, you mustn't ask so soon," she replied. "I want to talk to you first. I'll play you something."

"No," he said, following her as she backed toward the piano. "I want to know. I must. I can't wait."

"I haven't made up my mind," she pleaded evasively. "Let me play. I want to think. You had better."

"Oh, no," he urged.

"Yes, let me play."

She broke away and sat down at the piano, sweeping the keys before beginning her favorite melody, the "Fifth Nocturne." Eugene watched her eagerly, standing close beside.

"You go over there and sit down," she urged gaily, speaking over her shoulder.

He shook his head.

She ignored him then and swept into the depths of the composition but all the while she was conscious of him hovering over her—a force. At the close, when she had become even more emotionally responsive to the suggestion of the piece, he slipped his arms about her as he had once before but she struggled away again, slipping to a corner and standing at bay. He liked her flushed face, her shaken hair, the roses awry at her waist. "You must tell me now," he said, standing before her. "Will you have me?"

She dropped her head down as though doubting and fearing familiarity. He slipped to one knee to see her eyes. Then looking up, he caught her about the waist. "Will you?" he asked.

She looked at his soft hair, dark and thick, his smooth, pale brow, his

black eyes and even chin. She wanted to yield dramatically and this was dramatic enough. She put her hands to his head, bent over and looked into his eyes, her hair falling forward about her face. "Will you be good to me?" she asked, yearning into his eyes.

"Yes, yes," he declared. "You know that. Oh, I love you so."

She put his head far back and laid her lips to his. There was fire, agony in it. She held him so, and then he stood up, heaping burning kisses upon her cheeks, her lips, her eyes, her neck.

"Good God!" he exclaimed. "How wonderful you are."

The expression shocked her. "You mustn't!" she said.

"I can't help it. You are so beautiful."

She forgave him for the compliment.

There were warm scenes after this, moments in which they clung to each other desperately, moments in which he carried her in his arms, moments in which he whispered his dreams of the future. He took the ring he had bought and put it on her finger. He was going to be a great artist; she was going to be an artist's bride; he was going to paint her lovely face, her hair, her form. If he wanted love scenes, he would paint these which they were now living together. They talked until one in the morning and then she begged him to go but he would not. He was intoxicated with what he considered his wonderful victory. At two he left, but only to come early the next morning in order to take her to church.

There ensued for Eugene a rather astonishing imaginative and emotional period in which he grew in perception of things literary and artistic and in dreams of what marriage with Angela would mean to him. There was a peculiar awareness about the man at this time which was leading him into an understanding of all sorts of things, the ridiculousness of some phases of dogma in the matter of religion; the depths of human perversion in the matter of morality; the fact that there were worlds within worlds of our social organism; that really basically and actually there was no fixed and definite understanding of anything by anybody. From Mathews he learned of philosophies—Kant, Hegel, Schlegel, Schopenhauer—faint inklings of what they believed. From association with Howe he heard of current authors who expressed new moods, Pierre Loti, Thomas Hardy, Maeterlinck, Tolstoy. Eugene was no person to read—he was too eager to live—but he gained much by conversation and he liked to talk. He began to feel as if he could do almost anything if he tried—write poems, write plays, write stories, paint, illustrate, act. He used to conceive of himself as a general, an orator, a politician—thinking how wonderful he would be if he set himself definitely to any one thing. Sometimes he would recite passages from great speeches he had composed in his imagination as he walked. The saving grace in his

whole makeup was that he really loved to work and he would work at the things he could do. He would not shirk his assignments or dodge his duties. He crowded into his long day eight hours for the *Daily Globe* from eight to five, with one hour for an exciting lunch with someone, Mathews or Howe or Goldfarb—anyone who would go with him. For two hours between five and seven, he would sometimes walk the streets, wondering at the night skies, the city scenes, the whirl of life and opportunity, then hurrying to his class after a fifteen or twenty cent lunch. He was beginning to think that what he wanted was to get out of Chicago, where he could only do newspaper work, and go to New York, where he could draw for the magazines and make some money. There was no chance here. He could never get married on this salary.

After his class he would sometimes go out to Ruby's house, getting there by eleven and being admitted per an arrangement with her by which she left the front door open so that he could enter quietly. More than once he found her sleeping in her little boudoir off the front room, arrayed in a red silk dressing gown and curled up like a little black-haired doll. She knew he liked her art instincts and strived to gratify them, doing the peculiar and the exceptional. She would place a candle under a red shade on a small table by her bed and pretend to have been reading, the book being usually tossed to one side on the coverlet where he would see it lying when he came. He would enter like a thief in the night, silently gathering her up in his arms as she dozed, kissing her lips to wake her, carrying her in his arms to the front room to spoon and whisper his passion. There was no cessation to this arrangement the while he was declaring his love for Angela, and he really did not see that the two interfered greatly. He loved Angela, he thought. He liked Ruby, thought she was sweet. He felt sorry for her at times because she was such a little thing, so unthinking. Who was going to marry her eventually? What was going to become of her?

Because of this very attitude he fascinated this girl, who was soon ready to do anything for him. Ruby thought of pretending to be enceinte by him in order to see if he would not marry her. She dreamed dreams of how nice it would be if they could live in just a little flat together—all alone. She would give up her art posing and just keep house for him. He talked to her of this—imagining at times that it might possibly come to pass, but realizing quite fully the remainder of the time that it probably wouldn't. He wanted Angela for his wife, but if he had money he thought Ruby and he might keep a separate apartment, somehow. It did not trouble him what Angela would think of this—only that she should not know. He never breathed anything to either of the other, but there were times when he wondered what they would think, each of the other, if they knew. Money, money,

that was the great deterrent for him. For the lack of money he could not marry anybody at present—neither Angela nor Ruby nor anyone else. His first duty, he thought, was to so place himself financially that he could talk seriously to any girl. That was what Angela expected of him, anyhow, he knew. That was what he would have to have if he wanted to take Ruby. So he carried on with these two.

There came a time when this situation began to grow irksome. He had reached the point where he began to understand how limited his life was. Mathews, who was making thirty-five dollars solely because he had been on the paper longer, and Howe, who drew forty for the same reason, were able to live better than Eugene. They went out to midnight suppers at Rector's and Kinsley's. They went in for theatre parties and expeditions to the section devoted to immoral women—the term *tenderloin* not having been invented at that time. They had time to browse about the sections of the city which had peculiar charm for them as Bohemians after dark—the levee, as a certain section of the Chicago River was called; Gamblers Row in South Clark Street; the Whitechapel Club, as a certain bohemian organization of newspaper men was called; and other places frequented by the literati and the more talented of the newspaper workers. Eugene, first because of a temperament which was introspective and reflective, and second because of his aesthetic taste which was offended by much that he thought was tawdry and cheap about these places, and third by what he considered his lack of means (he was not in any sense a liberal spender at this time), was comparatively removed from what he would have considered normal participation. While he worked in his class he heard of these things—usually the next day—and they were amplified and made more showy and interesting by the emotional and narrative powers of the participants. He hated coarse, vulgar women and ribald conduct, but he felt that he was not even permitted to see them at close range had he wanted to. It took money to carouse and he did not have it.

Curiously, because of his youth and a certain air of unsophistication and perhaps impracticability which went with him, his employers were not inclined to consider money matters in connection with him. They seemed to think he would work for little and would not mind. He was allowed to drift here six months without a sign of increase though he really deserved more than any one of those who worked with him during this period. He was never the one to push his claims personally but grew restless and slightly embittered under the strain and ached to be free, though his work was as effective as ever.

It was this indifference on the part of his employers which fixed his determination to leave Chicago, although Angela, his art career, his natu-

ral restlessness, and growing judgement of what he might possibly become, were deeper irritants. Angela haunted him as a dream of future peace. If he could marry her and settle down he would be happy. He felt now, having fairly satiated himself in the direction of Ruby, that he might abandon her. She would not really care so very much. Her sentiments were not deep enough. Still he knew she would care some, and when he began going less regularly to her home, really caring less what she did in the art world, he began also to feel ashamed of himself, for he knew that it was a cruel thing to do. He saw by her manner when he absented himself that she was hurt and that she knew he was growing cold.

"Are you coming out Sunday night?" she asked him once, wistfully.

"I can't," he apologized. "I have to work."

"Yes, I know how you have to work. But go on. I don't mind. I know."

"Oh, Ruby, how you talk. I can't always be here."

"I know what it is, Eugene," she replied. "You don't care any more. Oh, well, don't mind me."

"Now, sweet, don't talk like that," he would say, but after he was gone she would stand by her window and look out upon the shabby neighborhood and sigh sadly. He was more to her than anyone she had met yet, but she was not the kind that cried.

"He is going to leave me," was her one thought. "He is going to leave me."

It was Goldfarb who made an end to this situation, unconsciously of course. He had watched Eugene a long time, was interested in him, realized he had talent. He was leaving shortly to take a better Sunday editorship himself on a larger paper, and he thought Eugene was wasting his time here and ought to be told so.

"I think you ought to try to get on one of the bigger papers here, Witla," Goldfarb said to him one Saturday afternoon when things were easing up. "You'll never amount to anything on this paper. It isn't big enough. You ought to get on one of the big ones. Why don't you try the *Tribune*, or go to New York. I think you ought to do magazine work."

Eugene drank it all in. "I've been thinking of that," he said. "I think I'll go to New York. I'll be better off there."

"I would either do one or the other. If you stay too long in a place like this, it's apt to do you harm."

Eugene went back to his desk with the thought of change ringing in his ears. He would go. He would save up his money until he had one hundred and fifty or two hundred dollars and then try his luck in the East. He would leave Ruby and Angela—the latter only temporarily, the former for good very likely—though he only vaguely confessed this to himself. He would

make some money and then he would come back and marry this dream from Black Wood. Already his imaginative mind ran forward to a poetic wedding in a little country church, with Angela standing beside him in white, and then he would bring her back with him to New York—he, Eugene Witla—already famous in the East. Already the lure of the big eastern city was in his mind—its palaces, its wealth, its fame. It was the great world, he knew, this side of Paris and London. He would go to it now, shortly. What would he be there? How great? When? So he dreamed.

CHAPTER XVI

Once this idea of New York was thoroughly fixed in his mind as a necessary step in his career, it was no trouble for him to carry it out. He had already put aside sixty dollars in a savings bank since he had given Angela the ring, and he decided to treble it as quickly as possible and then start. He fancied that all he needed was just enough to live on for a little while until he could get a start. If he could not sell drawings to the magazines he might get a place on a newspaper and anyhow he felt confident that he could live. He communicated to Howe and Mathews his intention of going East pretty soon and aroused in their respective bosoms the emotions which were characteristic of each. Howe, envious from the start, was glad to have Eugene off the paper but resentful of the stellar career which his determination foreboded. He half suspected now that Eugene would do something exceptional—he was so free in his moods, so eccentric. Mathews was glad for Eugene and a little sorry for himself. He wished he had Eugene's courage, his fire, his talent.

"You'll make good when you get down there," Mathews said to him one afternoon when Howe was out of the room, for he realized that the latter was jealous. "You've got the stuff. Some of the work you have done here will give you a fine introduction. I wish I were going."

"Why don't you?" suggested Eugene.

"Who, me? What good would it do me? I'm not ready yet. I can't do that sort of stuff."

"I think you do good work," said Eugene generously. He really did not believe it was good art, but it was fair newspaper sketching.

"Oh, no, you don't mean that, Witla," replied Mathews. "I know what I can do."

Eugene was silent.

"I wish when you get down there," went on Mathews, "you would write us occasionally. I would like to know how you are getting along."

"Sure I'll write," replied Eugene, flattered by the interest which his determination had aroused. "Sure I will." But he never did.

In Ruby and Angela he had two emotional problems to adjust which were not so easy. In the former case he felt sympathy, regret, sorrow for her helplessness, her hopelessness. Ruby was so sweet and lovely in her way, but not quite big enough mentally or emotionally for him and a little loose morally, though that did not make so much difference to him. Could he really live with her if he wanted to? Could he substitute her for a girl like Angela, who was good and pure? Could he? And now he had involved Angela, for since her return to tell him that she accepted him as her affianced lover, there had been some big scenes between them—scenes in which a new standard of emotion had been set for him. This girl who looked so simple and innocent at times was burning with a wild fire. It snapped in her eyes when Eugene undid her wonderful hair once and ran his hands through its copper strands. "The Rhine Maiden!" he said soulfully. "Little Lorelei! You are like the mermaid waiting to catch the young lover in the strands of her hair. You are Marguerite and I Faust. You are a Dutch Gretchen. I love this wonderful hair when it is braided. Oh, sweet, you perfect creature. I will put you in a painting yet. I will make your hair famous."

Angela thrilled to this. She burned with a flame which was of his fanning. She put her lips to his in long, hot kisses, sat on his lap and twined her hair about his neck; rubbed his face with it as one might bathe a face in strands of red gold. Finding such a response he went wild, kissed her madly, and would have taken those customary liberties which were instinctive had she not, at the slightest suggestion of forwardness, leaped from his embrace—not opposition but self-protection in her eyes. She pretended to think better of his love—and Eugene, checked by his conception of her ideal of him, tried to restrain himself. He did manage to desist because he was sure that he could not do what he wanted to. Daring such as that would end her love. So they wrestled in affection.

It was the fall following his betrothal to Angela that he actually took his departure. He had drifted through the summer, pondering. Once he had thought to go up to Angela's home for a visit but his newspaper work was too exacting. He still trifled with Ruby in a half-hearted way, but the passion was all gone. He saw only the sadness of her liking for him and did not want to hurt her, but he stayed away more and more. When the time came he left without saying good-bye to her, though he thought up to the last that he intended to go out and see her and he wrote her immediately after he reached New York.

As for Angela, it was quite a different story. When it came time to say good-bye to her he was in a very different mood—depressed, downcast. He thought now that he really did not want to go to New York, but was being

driven by fate. There was no money for him in the West. They could not live on what he could earn there. Hence he must go and in doing so must lose her. It looked very tragic.

Out at her aunt's house, where she came for the Saturday and Sunday preceding his departure, he walked the floor with her gloomily, counted the lapse of the hours after which he would be with her no more, pictured the day when he would return successful to get her. Angela had a slight foreboding fear of the events that might intervene. She had read stories of artists who had gone to the city and had never come back. Eugene seemed such a wonderful person that she might not hold him; and yet he had given her his word and he was madly in love with her now—no doubt of that. That fixed, passionate, yearning look in his eyes—what did it mean if not enduring, eternal love? This was the thing she had dreamed of—this the love that poets wrote about. Life had brought her a great treasure—an artist for a lover, and a great love.

"Go, Eugene," she said at last, tragically and not without real pathos. His face was in her hands. "I will wait for you. You need never have one uneasy thought. When you are ready, I will be here, only come soon—you will, won't you?"

"Will I!" he declared, kissing her, "Will I! Look at me. Don't you know?"

"Yes! yes! yes!!" she exclaimed, "Of course I know. Oh, yes! yes!"

The rest was passionate embraces.

And then they parted.

He went out into the night brooding over the subtlety and tragedy of life. The sharp October stars saddened him. Here was he, Eugene Witla, come from middle Illinois and here was she, Angela Blue, come from southern Wisconsin, and now they were as unified in personality as two cups of water poured into one. They were the same thing emotionally, physically. She wanted him and he wanted her! What bliss! What mystery! How strangely the world was composed. Worlds and worlds without end, up yonder great binding forces controlling them, and then his own littleness, and now this love affair. How beautiful life was—how beautiful and how sad—death, separation, age. He shook his head. He clinched his hands. It was a wonderful world, but bitter to endure at times. Still it could be endured and there was happiness and peace in store for him probably. He and Angela would find it together living in each other's company, living in each other's embrace and by each other's kisses. It must be so. The whole world believed it—even he, after Stella and Margaret and Ruby and Angela. Even he.

The train which eventually bore him to New York bore a very meditative individual. The journey required twenty-four hours, the train leav-

ing Chicago at eight in the morning and arriving in New York the next morning at nine, allowing an hour for the difference in time. As the train pulled out through the great railroad yards of the city, past the shabby back yards of houses, the street crossings at grade, the great factories and elevators, he thought of that other time when he had first ventured in the city. How different! Then he was so green, so raw. Since then he had become a newspaper artist at least, could write, could find his tongue with women, could say he knew a little something about the organization of the world. He had not saved any real money, quite true, but he had gone through the art school, had given Angela a diamond ring, had this two hundred dollars with which he was venturing to reconnoitre the great social metropolis of the country. As he was passing Fifty-seventh Street he recognized the neighborhood he had traversed so often in visiting Ruby. There in the distance were the rows of commonplace two family frame dwellings, one of which she occupied with her foster parents. Poor little Ruby, and she liked him. It was a shame—but what was he to do about it? He didn't care for her. It really hurt him to think and then he tried not to remember. These tragedies of the world could not be healed by thinking.

The train passed out into the flat fields of northern Indiana and as little country towns flashed past he thought of Alexandria and how he had picked up and left it. What was Jonas Lyle doing, and John Summers? Myrtle wrote him she was going to be married in the spring. She had delayed solely because she wanted to delay. He thought sometimes that Myrtle was a little like himself, fickle in her moods. All the others were doing as they had done. He was sure he would never want to go back to Alexandria except for a short visit, and yet the thought of his father and his mother and his old home were sweet to him. His father! How little he knew of the real world!

As he looked out, he saw immense stretches of country and towns and cities. When they reached Columbus it was late afternoon and at Pittsburgh it was already night. He went into the dining car thinking of where he should go for a room in the morning—what move to make. The show of comfort on the part of well dressed strangers around him who were apparently well placed in the world was depressing to him. He felt now the smallness of his means, the largeness of his venture. He was approaching the great city alone and he might fail. That longing of youth to be something, to get somewhere, was strong in him.

As they passed out of Pittsburgh he saw for the first time the great mountains, raising their heads in solemn majesty in the dark, the great lines of coke ovens flaming red tongues of fire. He saw men working, and sleeping towns succeeding one another. What a great country America was, it

came to him. What a great thing to be an artist here. Millions of people and no vast artistic voice to portray these things—these simple dramatic things like these coke ovens in the night. If he could only do that. If he could only stir the whole country so that his name would be like that of Doré in France or Verestchagin in Russia. If he could but put fire into his work—the fire he felt.

He got into his berth after a time and looked out on the dark night and the stars, longing, and then he dozed. When he awoke again the train had already passed Philadelphia. It was morning and the cars were speeding across the flat meadows toward Trenton. He arose and dressed, watching the array of towns the while—Princeton, New Brunswick, Metuchen, Elizabeth. Somehow this country was like Illinois—flat. After Newark they rushed out upon a great meadow and he caught the sense of the sea. It was beyond this. There were tide water streams—the Passaic and the Hackensack, with small ships and coal and brick barges tied at the water side. The thrill of something big overtook him as the brakeman began to call "Jersey City," and as he stepped out into the vast train shed his heart misgave him a little. He was all alone in New York. It was wealthy, cold, critical. How should he prosper here? He walked out through the gates to where low arches concealed ferry boats, and in another moment it was before him—skyline, bay, the Hudson, the Statue of Liberty, ferry boats, steamers, liners, all in a gray mist of fine rain, and the tugs and liners blowing mournfully upon great whistles. It was something he could never have imagined without seeing it, and this swish of real salt water, rolling in heavy waves, spoke to him as music might, exalting his soul. What a wonderful thing this was, the sea—with ships and whales and great mysteries. What a wonderful thing New York was, set down by the sea, surrounded by it—this metropolis of the country, the world. Here was the sea; yonder the great docks for the vessels that sailed to the ports of all the world. He saw them, great gray and black hulls tied to long piers jutting out into the water. He listened to the whistles, the swish of the water, saw the wonderful circling gulls, grasped in an emotional way the meaning of this great mass of people. Here were Jay Gould and Russell Sage and the Vanderbilts and Morgan—all alive and all here. Wall Street, Fifth Avenue, Madison Square, Broadway—he knew of them all by reputation. How would he do here—how fare? Would the city ever proclaim him as it did some? He looked wide eyed, with an open heart, with intense and immense appreciation. Well, he was going to enter, going to try. He could do that—perhaps, perhaps. But he felt lonely. He wished now he were back with Angela where her soft arms could shut him safe. He wished he might feel her hands on his cheeks, his hair. He would not need to fight alone then, he did not want to. But he was alone, and the city was roaring about him a great noise like the sea. He must enter and do battle.

CHAPTER XVII

Whatever Chicago might be, it had made a tremendous impression on Eugene's youthful and vigorous fancy. New York was to affect it much more. Not knowing routes or directions, he took a Desbrosses Street ferry and coming into West Street, wandered along that curious thoroughfare staring at the dock entrances. Manhattan Island seemed a little shabby to him from this angle at first, and he thought that although physically perhaps it might not be distinguished, certainly there must be other things here which made it wonderful. Later when he saw the solidity of it, the massed houses, the persistent streams of people, the crush of traffic, it dawned on him that mere humanity in packed numbers makes a kind of greatness and this was the island's first characteristic. There were other prominent characteristics, like the prevailing lowness of the buildings in the old neighborhoods, the narrowness of the streets in certain areas, the shabbiness of brick and stone when they have seen a hundred years of weather, which struck him as curious or depressing. He was easily touched by exterior conditions.

In his wanderings he kept looking for some place that he might like to room, some house that had a yard or a tree, but he found none. He finally found a row of houses in lower Seventh Avenue which had a collective array of iron balconies in front which appealed to him. He applied here, and in one house found a room for four dollars which he thought he had better take for the present. It was cheaper than any hotel. His hostess was a shabby woman in black who made scarcely any impression on him as a personality, merely giving him a thought as to what a dreary thing it was to keep roomers. The room itself was nothing, a commonplace, but he had a new world before him and all his interests were outside. He wanted to see this city. He deposited his grip and sent for his trunk and then took to the streets hoping soon to see and hear things which would be of advantage to him.

Eugene went about this early relationship to the city in the right spirit. For a little while he did not try to think what he would do, but struck out and walked, here, there, and everywhere. He walked down Broadway to the City Hall the afternoon of this very first day and up Broadway from Fourteenth to Forty-second Street the same night. He came to see by degrees all of Third Avenue and the Bowery, the wonders of Fifth Avenue and Riverside Drive, the beauties of the East River, the Battery, Central Park, and the lower East Side. He sought out quickly the wonders of metropolitan life— its crowds at dinner and theatre time in Broadway, its tremendous throngs mornings and afternoons in the shopping district, its marvelous world of carriages in Fifth Avenue and Central Park. He had marveled at wealth and luxury in Chicago; here it took his breath away. It was obviously so much more fixed, so definite and understandable. You felt intuitively here the far

reaches which separated the ordinary man from the scions of wealth in the fashionable district. It rather curled him up like a frozen leaf. It dulled his very soul and gave him a clear sense of his position in the social scale. He had come here rather built up in his estimate of himself, but daily, as he looked, he felt himself crumbling. What was he? What was art? What did this city care? It was much more interested in other things—dressing, eating, visiting, riding about. There was no art atmosphere suggested except in some great sculptural or social way—the accidental artistry of nature and life. The lower half of the island was filled with a cold commercialism which frightened him; the upper half, which concerned mostly women and show, was filled with a voluptuous sybaritism which caused him envy. He had but two hundred dollars with which to fight his way and this was the world he must conquer.

Men of Eugene's artistic and poetic temperament are easily depressed. Because of the wideness of his vision and the breadth and depth of his emotions, he first gorged this spectacle of life and then suffered from mental indigestion afterward. He saw too much of it too quickly. He wandered about for weeks, looking in the shop windows, the libraries, the museums, the great streets, growing all the while more despondent. At night he would return to his bare room and indite long epistles to Angela, describing what he had seen and telling her of his undying love for her—its depth and force—largely because he had no other means of ridding himself of his superabundant vitality and moods. They were beautiful letters full of color and feeling, but to Angela they gave a false impression of emotion and sincerity because they appeared to be provoked by absence from her alone, which was not true. In part of course they were, but far more largely his letters were the result of loneliness and the desire for expression—literary if not artistic—which this vast spectacle and life itself incited. He also made some tentative sketches of things he had seen, which he sent her: a large crowd in the dock at Thirty-fourth Street; a boat off Eighty-sixth Street in the East River in a driving rain; a barge with cars being towed by a tug. He could not think exactly what to do with these things at this time, but he wanted to try his hand at illustrating for the magazines. He was a little afraid of these great publications, however, for now that he was on the ground where they were, his art did not appear so significant.

It was during these first few weeks that he received his first and last letter from Ruby, for she was not much for writing. His parting letter to her written from New York had been one of those makeshift affairs which faded passion indites, simulating an interest which it cannot honestly feel. He was so sorry he had to leave without seeing her. He had intended to come out but the rush of preparation at the last moment, and so forth. He hoped

to come back to Chicago one of these days and then he would look her up. He still loved her but it was necessary for him to leave—to come where the greatest possibilities were. "I remember how sweet you were when I first saw you," he added. "I shall never forget my first impressions, Little Ruby."

It was cruel to add this touch of remembrance, but the artist in him, the lover of the aesthetic, could not refrain. It cut Ruby as a double edged sword, for she understood that he cared well enough that way—aesthetically. It was not her but beauty that he loved. And her particular beauty had lost its appeal.

She wrote him after a time, intending to be defiant, indifferent, but she really could not be. She tried to think of something sharp to say but finally put down the simple truth.

> "Dear Eugene," she wrote. "I got your note several weeks ago but I could not bring myself to answer it before this. I know everything is over between us and that is all right for I suppose it has to be. You couldn't love any woman long, I think. I know what you say about your having to go to New York to broaden your field is true. You ought to, but I'm sorry you didn't come out. You might have. Still I don't blame you, Eugene. It isn't much different from what has been going on for some time. I have cared but I'll get over that I know, and I won't ever think hard of you. Won't you return me the notes I have sent you from time to time and my pictures? You won't want them now.

> "Ruby."

There was a little blank space on the paper and then,

> "I stood by the window last night and looked out on the street. The moon was shining and those dead trees were waving in the wind. I saw the moon on that pool of water over in the field. It looked like silver. Oh, Eugene, I wish I were dead."

He jumped up as he read these words and clenched the letter in his hand. The pathos of it all cut him to the quick, raised his estimate of her, made him feel as if he had made a mistake in leaving her. He really cared for her after all. She was sweet. If she were here now he could live with her. She might as well be a model in New York as in Chicago. He was on the verge of writing her this when one of the long, almost daily epistles from Angela arrived and changed his mood. He did not see how, in the face of so great and clean a love as hers, he could go on with Ruby. His affection had obviously been dying. Should he try to revive it now?

This conflict of emotions was so characteristic of Eugene's nature that had he been soundly introspective at this time he would have seen that he

was an idealist by temperament, in love with the aesthetic, in love with love, and that there was no permanent faith in him for anybody—certainly not of his willing. Some one woman might have held him but she would have had to have been swifter in her intellectual processes than he, more subtle in her emotions than he could readily perceive, elusive and yet fond of him in such a way as would have permitted her to pardon his idiosyncrasies and give him his freedom. If he had his absolute freedom under these conditions he might not have wanted it so much, might have stayed near the object of its origin out of sheer curiosity. But aesthetic beauty, youth, and love would always hold him spellbound. He would have run after them anywhere unless given his freedom by some such aesthetic object as the ideal woman in question. Then he would not have been so anxious.

As it was, he wrote Ruby a letter breathing regret and sorrow but not inviting her to come. He could not have supported her long if she had, he thought. Besides he was anxious to secure Angela. So the love affair lapsed.

In the meantime he visited the magazine offices. On leaving Chicago he had put in the bottom of his trunk a number of drawings which he had done for the *Globe*—his sketches of the Chicago River, of Blue Island Avenue, of which he had once made a study as a street, of Goose Island and of the lake front. There were some street scenes, too, all forceful in the peculiar massings of their blacks, the unexpected, almost flashing, use of a streak of white at times. There was emotion in them, a sense of life and movement. He should have been appreciated at once but oddly, there was just enough of the strange about what he did—the radical—to make his work seem crude, almost coarse. He drew a man's coat with a single dash of his pen. He indicated a face by a spot. If you looked close there was scarcely any detail, frequently none at all. From the praise he had received at the art school and from Mathews and Goldfarb, he was slowly coming to the conclusion that he had a way of his own. Being so individual, he was inclined to stick to it. He walked with an air of conviction which had nothing but his own belief in himself to back it up, and it was not an air which drew anybody to him. When he showed his pictures at the *Century*, *Harper's*, *Scribner's*, they were received with an air of weary consideration. Dozens of magnificent drawings were displayed on their walls, signed by men whom Eugene knew to be leaders in the illustration world. He had been studying the magazines at Brentano's. He returned to his room satisfied that he had made no impression at all. They must be familiar with artists a hundred times better than himself.

As a matter of fact Eugene was simply overawed by the material face of things. These men whose pictures he saw displayed on the walls of the art and editorial rooms of the magazines were really not, in many instances, any

better than himself, if as good. They had the advantage of solid wood frames and artistic acceptance. He was a long way as yet from magazine distinction but the work he did later had no more of the fire than had these early pieces. It was a little broader in treatment, a little less intolerant of detail, but no more vigorous, if as much so. The various art directors were weary of smart young artists showing drawings. A little suffering was good for them in the beginning. So Eugene was incontinently turned away with a little faint praise which was worse than opposition. He sank very low in spirits.

There were still the smaller magazines and the newspapers, however, and he hunted about faithfully trying to get something to do. From one or two of the smaller magazines, after a time, he secured commissions, three or four drawings for thirty-five dollars, and from that had to be extracted models' fees. He found that he would have to get a room where he could work as an artist, receiving models to pose, for his room was possessed of only an east light and no art privileges whatsoever. He finally found one in West Fourteenth Street, a back bedroom looking out over an open court and with a public stair which let all come who might without question. It cost him twenty-five dollars a month but he thought he had better risk it. If he could get a few commissions he could live.

CHAPTER XVIII

The art world of New York is peculiar. It was then, and to this day, broken up into spheres with scarcely any unity. There was a world of sculpture, for instance, in which some thirty or forty sculptors had part—perhaps more—but they knew each other slightly, criticized each other severely, and retired for the most part into a background of relatives and friends who were not necessarily artistic, but with whom they lived and had their being. There was a painting world, as distinguished from an illustrating world, in which perhaps a thousand alleged artists, perhaps more, took part. Most of these were men and women who had some ability—enough to have their pictures hung at the National Academy of Design exhibits, to sell some pictures, get some decorative work to do, paint some portraits, each according to his especial aptitude.

There were a number of distinct studio buildings scattered about various portions of the city—in Washington Square; in Ninth and Tenth Streets; in Twenty-third Street; in Fifty-fifth, Fifty-sixth, and Fifty-seventh Streets; and in addition, in odd places such as MacDougal Alley and the cross streets from Washington Square to Fifty-ninth, where lofts of stables were filled

with painters, illustrators, sculptors, and the interesting run of craftsmen in art generally. This painting world had more unity than the world of sculptors and, in a way, included the latter. There were several art clubs—the Salmagundi, the Kit-Kat, and the Lotos—and there were a number of annual exhibitions of oils, water colors, crayons, with their concomitant reception nights, where all manner of artists could meet and exchange courtesies and friendship. In addition there were little communal groups, such as those who resided in the Tenth Street studios, the Twenty-third Street Y.M.C.A., the Van Dyck Studios, and so on. It was possible to find little crowds now and then who harmonized well enough for a time and to get into a group, if, to use a colloquialism, you *belonged*. If you did not, art life in New York might be a very dreary thing and you might go a long time without finding just the particular crowd with which you could associate.

Besides the painting world there was the illustrating world, made up of young beginners in magazine illustration and those who had established themselves firmly in editorial favor who were not necessarily part of the painting or sculpture worlds and yet in spirit were allied with them. These individuals had their clubs also, and their studios were in the various neighborhoods where the painters and sculptors were. The only difference was that in the case of the beginning illustrators, they were to be found living three and four in one studio, partly because of the saving in expense, partly because of the love of companionship, and partly because they could hearten and correct each other in their work. A number of such interesting groups were in existence when Eugene arrived but of course he did not know of them.

It takes time for the beginner to get a hearing anywhere—to get in touch with the life of the profession he has chosen, and this is no less true of art than it is of trade. The world is not anxious to recognize youth, however talented. Age, which is usually in a position to command, is of the opinion that youth ought to wait and be willing to wait. We all have to serve an apprenticeship, whatever field we enter. Eugene had lots of talent and determination, but no experience, no savoir faire, no circle of friends and acquaintances. The whole city was strange and cold, and if he had not immediately fallen desperately in love with it as a spectacle he would have been unconscionably lonely and unhappy. As it was, the great fresh squares, such as Washington, Union, and Madison; the great streets, such as Broadway, Fifth Avenue, and Sixth Avenue; the great spectacles, such as the Bowery at night, the East River, the waterfront, the Battery; all fascinated him with an unchanging glamor. He was hypnotized by the wonder of this thing—the beauty of it. "Such seething masses of people! Such whirlpools of life!" he thought. The great hotels, the opera, the theatres,

the restaurants, all gripped him with a sense of beauty. These lovely women in magnificent gowns; these handsome men in evening suits; these swarms of cabs with golden eyes like bugs; this ebb and surge of life, morning and evening, thrilled him like a song. Though he had no money to spend, no immediate hope of a successful career, he could walk these streets, look in these windows, admire these beautiful women, thrill at the daily newspaper announcements of almost hourly successes in one field and another. Here and there in the news an author had made a great success with a book; a scientist with a discovery; a philosopher with a new theory; a financier with an investment. There was news of great plays being put on; great actors and actresses coming from abroad; great successes being made by debutantes in society; great movements forwarded generally. Youth and ambition had the call—he saw that. If you had talent, it was only a question of time when you would get your bearing. He longed ardently for his, but he had no feeling that it was coming to him quickly. He was not sure at times that it was ever coming for him—so he got the blues. It was a long road to travel.

One of his pet diversions these days and nights was to walk the streets in rain or fog or snow. The city appealed to him, wet or white, particularly the public squares. He saw Fifth Avenue once in a driving snow storm and under sputtering arc lights, and he hurried to his easel the next morning to see if he could not put it down in black and white. It was no go, or at least he felt so, for after an hour of trying he threw it aside in disgust. But these spectacles were drawing him. The Bowery by night; Fifth Avenue in a driving snow; a pilot tug with a tow of cars in the East River; Greeley Square in a wet drizzle—the pavements a glistening gray—all these things were fixing themselves in his brain as wonderful spectacles. He was wanting to do them—wanting to see them shown somewhere in color. The thought was a solace at a time when all he could pay for a meal was fifteen cents and when he had no place to go and not a soul with whom to talk.

It was an interesting phase of Eugene's character that he had a passion for financial independence. He might have written home from Chicago at times when he was hard pressed; he might have borrowed some money from his father now, but preferred to earn it—to appear to be farther along than he was. If anyone had asked him, he would have said he was doing fine. This he wrote Angela, giving as an excuse for further delay that he wanted to wait until he had ample means. He was trying all this time to make his two hundred dollars go as far as possible and to add to it by any little commissions he could get, however small. He figured his expenses down to ten dollars a week and managed to stay within that sum.

The particular building in which he had located was really not a studio building but an old run down boarding and rooming house turned partially

to trade. The landlord had rented the ground floor to a trunk delivery com-
pany; the second floor to a maker of uniforms for certain orders. The third
floor held a school of languages, with a lot of poor dolts studying French
and German, and the top floor contained three fair sized rooms and two
hall bedrooms, all occupied by lonely individuals plying some craft or other.
Eugene's next door neighbor chanced to be a hack illustrator who had had
his training in Boston and who had set up his easel here in the hope of mak-
ing a living. There were not many exchanges of courtesies between them at
first, although the door being open the second day he arrived, he saw that
an artist worked there, for an easel was visible. Since taking this room he
had purchased for himself the necessary working implements of his craft
and was prepared to do most anything, if he had known how, to dispose of
his work.

No models applying at first, he decided to appeal to the Art Students
League, for he had learned in Chicago that models were secured that way
and he had to have one. He called on the secretary and was given the names
of four, who replied to postal cards from him. One he selected, a young
Swedish-American by the name of Hedda Andersen, who looked something
like the character in the story he had in mind. She was neat and attractive,
with dark hair, a straight nose, and pointed chin, and Eugene immediately
conceived a liking for her. He was ashamed of his surroundings, however,
and consequently diffident. Despite his successes with women he was never
forward in his approach, preferring to be courted rather than courting. He
went only so far in his advances as he was encouraged or drawn by a state
of sympathy on the other side, and would work side by side with a model
without lifting an eyelash unless he felt a sympathetic response. He was
beginning to suspect that women were drawn to him, however, since Mar-
garet and Ruby and Angela had fallen victims to his pleasant and agree-
able attitude. This particular model was suitably distant, however, and he
finished his pictures with as much expedition and as little expense as he
possibly could.

It would be useless to follow the variations and details of a dreary first
year and a partially dreary second one, except to indicate some of the main
incidents. The pictures, in the case of the first two commissions, were satis-
factory although Eugene ran up against that terror to the artist's soul—criti-
cism from the incompetent. In the case of the minor magazines and weeklies,
he was not dealing with art directors but editors who knew little of art. He
was compelled to make certain changes which to him were pointless and
destructive of his best effects, but at this time, being very uncertain as to the
general outcome of his art venture, he was not inclined to be insistent. He
had to sell a few things to live, but he was determined to defy criticism as

soon as possible. It hurt him to think he had to do work for little unimport-
ant magazines and to meet silly objections in the bargain, but the attitude
of the large ones had discouraged him greatly.

Eugene was not much for scraping up odd acquaintances, though he
made friends fast enough where the balance of intellect was right. In Chi-
cago he had come to understand and appreciate several men in the Insti-
tute—William McConnell, Oren Benedict, Judson Cole, men with whom
he had become comparatively friendly—but here he knew no one, having
come without introductions. He did come to know Philip Shotmeyer, his
neighbor, who discussed local art life with him, but Shotmeyer was not
brilliant and could not supply him with more than minor details of what
Eugene wanted to know. Through Shotmeyer, Eugene did learn of studio
regions, art personalities, the fact that young beginners worked in groups.
Shotmeyer had been in such a group the year before, though why he was
alone now he did not say. He sold drawings to some of the minor magazines,
better ones than Eugene had yet had dealings with. One thing he did for
Eugene from the first which was very helpful was to admire his work. He
saw, as had others before him, something of the distinction which attended
everything Eugene did, and one day he gave him a bit of advice which was
the beginning of Eugene's successful magazine career. He was working on
one of his street scenes—a task which he invariably essayed when he had
nothing else to do. Shotmeyer had drifted in and was following the strokes
of Eugene's crayon as he attempted to portray a mass of East Side working
girls flooding the streets after six o'clock. There were dark walls of buildings,
a flaring gas lamp or two, some yellow shop windows, and many shaded,
half-seen faces—bare suggestions of souls and pulsing life.

"Say," said Shotmeyer at one point. "That kinda looks like the real thing
to me. I've seen a crowd like that."

"Have you?" replied Eugene.

"You ought to be able to get some magazine to use that as a frontispiece.
Why don't you try *Truth* with that?"

Truth was a weekly which Eugene, along with many others in the West,
had admired greatly because it ran a double-page color insert every week
and occasionally used scenes of this character. All the young artists and lit-
erary people throughout the country admired its spirit. Eugene had admired
many of the things that it had published in the past. Somehow he always
needed a shove of this kind to make him act when he was drifting. He put
more enthusiasm into his work because of Shotmeyer's remark and when
it was all done decided to carry it to the office of *Truth*. Before doing so he
decided to change a distant street lamp in the middle perspective from white
to red. It was a fortunate decision for it gave a touch of color to an other-

wise sombre whole and really carried the day for the picture though he did not know it. He took it to the office of *Truth* and the art director approved it on sight, though he said nothing. He carried it in to the editor.

"Here's a thing that I consider a find in its way."

He set it proudly upon the editorial desk.

"Say," said the editor, laying down a manuscript. "That's the real thing, isn't it? Who did that?"

"A young fellow by the name of Witla who has just blown in here. He looks like the real thing to me."

"Say," went on the editor. "Look at the suggestion of faces back there! What? Reminds me just a little of the masses in Doré. It's good, isn't it?"

"It's fine," echoed the art director. "I think he's a comer, if nothing happens to him. We ought to get a few centre pages out of him."

"How much does he want for this?"

"Oh, he doesn't know. He'll take almost anything. I'll give him seventy-five dollars."

"That's all right," said the editor as the art director took the drawing down. "There's something new there. You ought to hang on to him."

"I will," replied his associate. "He's young yet. He doesn't want to be encouraged too much."

He went out and pulled a solemn countenance.

"I like this fairly well," he said. "We may be able to find room for it. I'll send you a check shortly if you'll let me have your address."

Eugene gave it. His heart was beating a gay tattoo in his chest. He did not think anything of the price; in fact it did not occur to him. All that was in his mind was the picture of the drawing as a double-page spread. So he had really sold one after all, and to *Truth*. Now he could honestly say he had made some progress. Now he could write Angela and tell her. Now he could send home copies when it came out. He could really have something to point to after this and best of all, now he knew he could do street scenes. Some of the best illustrators contributed to this double-page spread series in *Truth*.

He went out into the street, treading not the gray stone pavement but air. He threw back his head and breathed deep. He thought of other scenes like this which he could do. His dreams were beginning to be realized—he, Eugene Witla, the painter of a double-page spread in *Truth*. Already he was doing a whole series in his imagination, all he had ever dreamed of. He wanted to run and tell Shotmeyer—to buy him a good meal. He almost loved him—commonplace hack that he was—because he had suggested to him the right thing to do.

"Say, Shotmeyer," he said, sticking his head in that worthy's door. "You and I eat tonight. *Truth* took that drawing."

"Isn't that fine!" said his floor mate without a trace of envy. "Well, I'm glad. I thought they'd like it."

Eugene could have cried. Poor Shotmeyer, he wasn't a good artist but he had a good heart. He would never forget him. He took him out at six o'clock and ventured to enter the best restaurant he had seen that looked anywhere close to what the slimness of his purse could accommodate. It was Shanley's, and the dinner cost in the neighborhood of three dollars. Eugene consoled himself with the thought that he would soon have a little additional cash. That night he went over his whole future. He saw himself successful in scores of ways. Angela was uppermost in his mind as being perceptibly nearer. When he went to sleep it was with the thought that he would soon be able to marry her if he sold many drawings.

CHAPTER XIX

This one significant sale with its subsequent check of seventy-five dollars, and later the appearance of the picture in color, gave Eugene such a lift in spirit that he felt for the time being as though his art career had achieved a substantial foundation. He concentrated his attention on several additional scenes, doing the view of Greeley Square in a sopping drizzle which he had contemplated and the picture of an L train speeding up the Bowery on its high, thin trestle of steel. He had an eye for contrasts, picking out lights and shadows sharply, making wonderful blurs that were like colors in precious stones, indistinct and suggestive. He took one of these drawings after a month to *Truth* and again the art director was his target. He tried to be indifferent but it was hard. This young man had something that he wanted.

"You might show me anything else you do in this line," he said. "I can use a few if they come up to these two."

Eugene went away with his head in the air. He was beginning to get the courage of his ability.

It takes quite a number of drawings at seventy-five and one hundred dollars each to make a living income, and artists were too numerous to make anyone's opportunity for immediate distinction easy. Eugene waited months to see his first drawing come out. He stayed away from the smaller magazines in the hope that he would soon be able to do business with the larger ones, but they were not eagerly seeking any new artists. He met through

Shotmeyer two artists who were living in one studio in Waverly Place and took a great fancy to them—Joseph Smite and Peter McHugh. Both were graduates of the New York Art Students League and were doing fairly well with the magazines. One of them, McHugh, was an importation from Wyoming with delicious stories of mountain farming and mining; the other, Smite, was a fisher lad from Nova Scotia. McHugh, tall and lean, with a face that looked like that of a raw yokel, but withal some gleam of insight and humor in the eyes which redeemed it instantly, was Eugene's favorite for his pleasing, genial personality. Joseph Smite came second, with a sense of the sea about him. He was short and stout, and rather solidly put together like a blacksmith. He had big hands and feet, a big mouth, big, bony eye sockets, and coarse brown hair. When he talked, ordinarily it was with a slow, halting air, and when he smiled or laughed it was with his whole face. When he became excited or gay something seemed to happen distinctly to every part of his body. His face became a curious cross-hatch of genial lines. His tongue loosened and he talked fast. He had a habit of emphasizing his language with oaths on these occasions, numerous and picturesque, for he had worked with sea-faring men and had accumulated a vast vocabulary of expressions. These oaths were vacant of evil intent so far as Smite was concerned, for there was no subtlety or guile in him. He was kindly and genial all through. Eugene wanted to be friendly and struck up a gay relationship with these two. He found that he got along excellently well with them and could swap humorous incidents and character sketches by the hour. It was some months before he could actually say that he was intimate with them, but he began to visit regularly and after a time they called on him.

It was during this year that he came to know several models passingly well, to visit the various art exhibits, to be taken up by Hudson Dula, the art director of *Truth*, and invited to two or three small dinners for artists and some girls. He did not find anyone whom he liked exceptionally well, barring one editor of a rather hopeless magazine called *Craft*, devoted to art subjects—a young blonde, of poetic temperament, who saw in Eugene an artistic spirit and tried to make friends with him. Eugene responded cheerfully and thereafter Richard Wheeler was a visitor at his studio from time to time. He was not making enough to house himself much better these days but he did manage to buy a few plaster casts and to pick up a few nice things in copper and brass which gave his studio an air of artistic selection and arrangement. His own drawings, his street scenes, were hung here and there. The way in which the exceptionally clever looked at them convinced him by degrees that he had something big to say.

It was while he was settling himself in this atmosphere—the spring of the second year—that he decided to go back and visit Angela and inci-

dentally Alexandria and Chicago. He had been away now sixteen months, had not seen anyone who had won his affections or alienated him from his love of Angela. He wrote her in March that he thought he would be coming in May or June. He did get away in July—a season when the city was suffering from a wave of intense heat. He had saved his money, as much as he could, having now five hundred dollars in his possession and he thought that he was entitled to a holiday. He had not done so much—illustrated eight or ten stories and drawn four double-page pictures for *Truth,* one of which had appeared, but he was getting along. Just as he was starting for Chicago and Black Wood, a second issue with his illustration was put on the newstands, and he proudly carried a copy of it with him on the train. It was of the Bowery by night, with the L train rushing overhead, and as reproduced, it had color and life. He felt intensely proud and knew that Angela would also. She had written him such a glowing appreciation of the East Side picture called "Six O'clock."

As he rode he dreamed, for somehow, in spite of his loneliness, he was very happy these days. He had found a book called *The Red Badge of Courage* by Stephen Crane and another, *Trilby,* by George du Maurier, which had swept him emotionally as a musician sweeps the strings of an instrument. He had recently come across Thomas Hardy and was revelling in that nature lover's sad romances of the out-of-doors. He was now deep in *The Woodlanders* and greatly stirred by the pathos of the spectacle of unrequited love. So this journey to see his lady-love was in the nature of a sweet romance and he went forward expectantly. His plan was to go directly to Black Wood where he was awaited by Angela and then out for a few days' visit to her house as the guest of her father and mother. She had warned him it was a very simple life they led and he was looking forward to green trees, yellow country roads, an old rambling house, perhaps, and stillness. What he had always loved about the country in summer was its profound peace. Now after the noise and rush of the city—nearly two years of it—he was to have peace. And with it love such as he had looked forward to unceasingly since he had left the West.

It came to him at last, the long stretch of earth between New York and Chicago traversed; he arrived in the lake city in the afternoon of the second day. Without pausing to revisit the scenes of his earlier efforts, he took a five o'clock train for Black Wood. It was sultry and on the way heavy thunder clouds gathered and broke in a short, splendid summer rain. The trees and grass were thoroughly wet and the dust on the roads settled. There was a refreshing coolness about the air which caressed the weary flesh. Little towns with white, yellow, and blue lumber cottages, nestling among green trees came into view and passed again as the train pursued its way. At last Black

Wood appeared, not nearly so large as Alexandria but not much different. Like the other it was marked by a church steeple, a saw mill, a pretty brick business street, and many broad, branching green trees. Eugene felt drawn to it on sight. It was such a place as Angela should live in.

It was seven and consequently almost dark when he arrived. He had not given her the definite hour of his arrival and so decided to stay over night at the little inn or so-called hotel he saw up the street. He had only troubled to bring a large suit case and a traveling bag. He made arrangements with the proprietor for his room, inquired the direction and distance of the Blue home from the town, found that he could get a vehicle any time in the morning which would "take him over," as the phrase ran, for a dollar. He ate his supper of fried steak and poor coffee and fried potatoes, and then sat out in a rocking chair on the front porch facing the street to see how the village of Black Wood wagged and to enjoy the cool of the evening. As he sat he thought of Angela's home and how nice it must be. This town was such a little place—so quiet. There would not be another train coming up from the city until after eleven.

It is curious how conditions which sometimes surround love will seize on the imagination and fix themselves as integral parts of the beauty, the pathos, and the sweetness of a relationship which, after all, has nothing to do with them. This summer night with its early rain, its wet trees, its smell of lush, wet, growing things, was impressing itself on Eugene as one might impress wet clay with a notable design. Eugene's mood was tender toward the little houses with their glowing windows, the occasional pedestrians with their "howdy, Jakes" and "evening, Henrys." He was touched by the noise of the jar flies, the chirp of the tree toads, the hang of the lucent suns and planets above the tree-tops. The whole night was quick with the richness of fertility, stirring subtly about some work which concerned man or of which at least he was a part.

After a time he rose up and took a short walk, breathing the wonderful night air. Later he came back and, throwing wide the windows of the stuffy room, sat looking out. His eyelids drooped after a time and he went to bed to sleep deep and dreamlessly.

The next morning he was up bright and early, eager for the hour to arrive when he might start. He did not think it advisable to leave before nine o'clock, and attracted considerable attention by strolling about, his tall, spare, artistic figure and forceful, shapely profile being an unusual sight to the natives. He had at this time a rapt, dreamy air which took in only the artistic whole of things—not their less lovely and unpretentious details. At nine o'clock a respectable carryall with a driver was placed at his disposal and he was driven out over a long yellow road, damp with the rain

of the night before and shaded in places by overhanging trees. There were so many lovely wild flowers growing in profusion in the angles of the rail fences—wild yellow and pink roses, elder flower, Queen Anne's lace, dozens of beautiful blooms—that Eugene was lost in admiration of them. His heart sang over the beauty of yellowing wheat fields, the young corn, already three feet high, the vistas of hay and clover, with patches of woods enclosing them, and over all, house martins and swallows scudding after insects, and, high up in the air, his boyhood dream of beauty, a soaring buzzard.

As he rode, the moods of his boyhood days came back to him—his love of winging butterflies and birds; his passion for the voice of the wood-dove (there was one crying in the still distance now); his admiration for what he deemed the virile strength of the men of the countryside—an illusion which was more of his reading than of his observation. He thought as he rode that he would like to paint a series of country scenes that would be as simple as these cottage dooryards that now and then appeared; this little stream that cut the road at right angles and made a drinking place for the horses; this skeleton of an old abandoned home, doorless and windowless, where the roof sagged and hollyhocks and morning glories grew high under the eaves. "We city dwellers do not know," he sighed, as though he had not taken the country in his heart and carried it to town as had every other boy and girl who had gone the way of the metropolis.

The Blue homestead was located in the centre of a rather wide, rolling stretch of country which lay between two gently rising ridges of hill covered with trees. One corner of the farm, and that not so far from the house, was cut by a stream, a little shallow thing singing over pebbles and making willows and hazel bushes grow in profusion along its banks. Within a mile of the house there was a little lake a quarter of a mile wide and perhaps two thirds of a mile long. In front of the house was a ten acre field of wheat, owned and cultivated by some neighbor. To the right of it looking south, for the house faced north, a grazing patch of five acres owned by Jotham P. Blue, Angela's father. To the left, a field of three acres sowed with clover, but occupied at the south extreme and nearest the house by a barn, a well, a pig pen, a corn crib, and some smaller sheds used for storing farming implements—a wagon, a buggy, a cider press, and so on. In front of the house was a long open lawn, two hundred feet wide and five hundred feet deep, down the centre of which came a gravel path, lined on either side by tall old elm trees. The immediate dooryard was shut from this noble lawn by a low picket fence, along the length of which grew lilac bushes and inside of which, facing the house, were simple beds of roses, sweet peas, calycanthus, and golden glow. Over an arbor leading from the back door to a rather distant summer kitchen flourished a grape vine, and there was a tall remnant

of a tree trunk covered completely with a yellow blooming trumpet vine. The dooryard's lawn was smooth enough, and the great lawn was a dream of green grass adorned by the shadows of a few great trees. The house was long in width and narrow in depth, the front a series of six rooms ranged in a row, without an upper story. There were two large rooms in the rear of the two middle rooms which had originally, perhaps seventy years before, been all there was to the house. Since then all the other rooms had been added and there was in addition to these eight rooms a lean-to, containing two more rooms—a winter kitchen and dining room—and to the west of the arbor leading to the summer kitchen an old unpainted frame storehouse. The house was shabby and run down but picturesque and quaint. It had been painted white some years before but badly needed a new coat. Because of the lawn, the flowers, the vines, and trees, it was sweet in its old fashioned homey appearance, and sheltered a family of such sterling simplicity and decency that it needs to be described fully to be understood.

Jotham P. Blue, the father of this family, was at the time Eugene arrived a man of sixty-five years of age, tall, strong, gray haired and gray bearded, a typical patriarch in appearance, manner, and method of thought. He was a native of southern Illinois who had moved to Wisconsin forty years before and established himself in this particular county as a farmer. He had brought with him from his native town of Pinckney, Illinois, a young girl, Grace Livingston, as his wife, who was possessed of as sterling a character as himself. Together they had made a home here and raised eleven children, three of whom had died after reaching maturity. At the outbreak of the Civil War, Jotham had raised a company of infantry and led them as captain through four years of vigorous fighting under several generals. He had come back to find his property badly deteriorated and himself somewhat out of the farming mood, his preliminary earnings spent to bring up the first three children to healthy adolescence. He took up his work again and was successful in making a living, but nothing more, for his family was added to by eight children. It was not a good living in the sense in which that term is used in the cities where the necessity for the children to work is obviated by an ample income, and where clothes, ornamental household comforts, and pleasures are provided as part of natural, joyous youth. These children had practically none of those comforts. After the three oldest of the brood died, there were four girls to be taken care of, followed by one boy, one additional girl, and then two young boys. Naturally the offspring had complicated the financial stability of the farm, for if the three oldest living children had been boys, they could have helped their father and made him more successful, for he obviously raised good children. As it was, the oldest girls could only teach school and later marry well, or fairly well, which they did. The boys, with

the exception of the eldest, were at the time of Eugene's visit just reaching the age of real usefulness, the eldest being twenty-four, the next eighteen, and the youngest sixteen—but their youth had precluded their having been of any real service to Jotham when he most needed them. Now he was old, scarcely the figure of a man he once was though still hearty and forceful.

Between the eldest boy, Samuel, and the second youngest, Benjamin, there was a girl, Marietta, twenty-two years old, who was as gay and joyous as her next oldest sister, Angela, was sober and in a way morbid. Marietta was as light souled as a kitten, looking always on the bright side of things, making hosts of friends everywhere she went, having a perfect swarm of lovers who wrote her eager notes but whom she rebuffed with good-natured sympathetic simplicity. Here on this farm there was not supposed to be so much opportunity for social life as in town, but beaux made their way here on one pretext and another. Marietta was the magnet and in the world of gayety which she created Angela shared somewhat.

The morning Eugene arrived he was surprised to find the place looking so charming. It appealed to him, the long, low front, with doors opening from the centre and end rooms directly upon the grass, with windows set in climbing vines and the lilac bushes forming a green wall between the house and the main lawn. The great rows of elm trees throwing a grateful shade seemed like sentinel files. As the carryall turned in at the wagon gate in front he thought, "What a place for love, and to think Angela should live here."

The carryall rattled down the pebble road to the left of the lawn and stopped at the garden gate. Marietta came out. Angela was in the dining room—easy to be called—but Marietta wanted to see for herself what sort of lover her sister had captured. She was surprised at his height, his presence, the keenness of his eyes. She hardly understood so fine a lover for Angela or herself, but held out her hand smilingly. "This is Mr. Witla, isn't it?" she asked.

"The same," he replied a little pompously. "Isn't it a lovely drive over here."

"We think so in nice weather," she laughed. "You wouldn't like it so much in winter. Won't you come in and put your grip here in the hall? I'll have David take it to your room."

Eugene obeyed but he was thinking of Angela and when she would appear and how she would look. He stepped into the large, low ceilinged, dark, cool parlor, and was delighted to see a piano and some music piled on a rack. Through an open window he saw several hammocks out on the main lawn, under the trees. It seemed a wonderful place to him, the substance of poetry, and then Angela appeared. As he had hoped, she was

dressed in plain white linen, with a small yellow leather belt at her waist and yellow shoes which somehow harmonized nicely with her hair. The latter was braided as he liked it in a great rope and lay as a band across her forehead. She had secured a big pink rose and put it in her waist. At sight of her Eugene held out his arms and she flew to them, laying her cheek upon his breast. He kissed her vigorously, for Marietta had discreetly retired and they were left purposely alone. Angela protested after a time but he was for biting her cheeks lightly and dreaming in her eyes indefinitely. "So I have you at last," he whispered, and kissed her again.

"Oh, yes, yes, and it has been so long," she sighed.

"You couldn't have suffered any more than I have," he consoled. "Every minute has been torture pretty near—waiting, waiting, waiting!"

"Let's not think of that now," she urged. "We have each other. You are here."

"Yes, here I am," he laughed, "all the virtues done up in one brown suit. Isn't it lovely—those great trees, that beautiful lawn?"

He paused from kissing to look out the window.

"I'm glad you like it," she replied joyously. "We think it's nice but this place is so old."

"I love it for that," he cried appreciatively. "Those bushes are so nice—those roses. Oh, dear, you don't know how sweet it all seems—and you—you are so nice."

He held her off at arm's length and surveyed her while she blushed becomingly. His eager, direct, vigorous onslaught confused her at times—caused her pulse to beat at a high rate.

They came out into the dooryard after a time and then Marietta appeared again and with her Mrs. Blue, a comfortable, round-bodied mother of sixty, with a round, plump, smiling face and smooth hair, who greeted Eugene cordially. He could feel in her what he felt in his own mother—in every good mother—love of order and peace, love of the well being of her children, love of public respect and private honor and morality. All of these things Eugene heartily respected in others. He was glad to see them, believed they had a place in society, but was uncertain as to whether they bore any fixed or important relationship to himself. He was always thinking in his private conscience that life was somehow bigger and subtler and darker than any given theory or order of living. It might well be worthwhile for a man or woman to be honest and moral within a given condition or quality of society, but it did not matter any in the ultimate substance or composition of the universe. Any form or order of society which hoped to endure must have individuals like Mrs. Blue, who would conform to the highest standards and theories of that society, and when found they were admirable,

but they meant nothing in the shifting, subtle forces of nature. They were just accidental harmonies blossoming out of something which meant everything here to this order, nothing to the universe at large. At twenty-two years of age he was thinking these things, wondering whether it would be possible ever to express them; wondering what people would think of him if they actually knew what he did think; wondering if there was anywhere anything which was really stable—a rock to cling to—and not mere shifting shadow and unreality.

Mrs. Blue looked at her daughter's young lover with a kindly eye. She had heard a great deal about him. Having raised her children to be honest, moral, and truthful, she trusted them to associate only with those who were so spiritually equipped. She assumed that Eugene was such a man, and his frank open countenance and smiling eyes and mouth convinced her that he was basically worthwhile. Also what to her were his wonderful drawings, sent to Angela in the form of proofs from time to time, particularly the one of the East Side crowd, had been enough to prejudice her in his favor. No other daughter of the family, and there were three married, had approximated this type of man in her choice. One son-in-law, the husband of the eldest, was a country banker; the second was owner of a small grain elevator connected with a hay and feed business; the third was a country lawyer and politician, at present the county clerk of the adjoining county. They were all nice, quiet, stable men, raised with some faith in current religious beliefs and with the idea that a home and a family were the fixed and necessary objects of every man's life and of civilization, and harnessed from youth to a sense of duty and obligation to their wives, their children, their parents, and so on. Eugene was looked upon as a prospective son-in-law who would fulfill these various obligations joyfully and as a matter of course.

"I'm very glad to meet you, Mrs. Blue," Eugene said pleasantly. "I've always wanted to come out here for a visit—I've heard so much of the family from Miss Angela."

"It's just a country home we have—not much to look at, but we like it," replied his hostess.

She smiled blandly, asked if he wouldn't make himself comfortable in one of the hammocks, wanted to know how he was getting along with his work in New York, and then returned to her cooking, for she was already preparing his first meal. Eugene strolled with Angela to the big lawn under the trees and sat down. He was experiencing the extreme and most supreme of human emotions—love in youth, accepted and requited; hope in youth, justified in action by his success in New York; peace in youth, for he had a well earned holiday in his grasp, was resting with the means to do so and

with love and beauty and admiration and joyous summer weather to comfort him.

"Life can really hold nothing finer than this," he thought, as he rocked to and fro in the hammock, gazing at the charming lawn, and he was reasonably correct in his deduction.

CHAPTER XX

The day revealed various interesting things about the family. Toward noon old Jotham Blue came in from a corn field where he had been turning the earth between the rows with a small plow. Although sixty-five and with snowy hair and beard he looked to be vigorous and good to live until ninety or a hundred. His eyes were blue and keen; his color rosy. He had great, broad shoulders set upon a spare waist, for he had been a handsome figure of a man in his youth. His feet were incased in high boots into which his jeans trouser legs were tucked and he had on a bluish-gray gingham shirt opened loosely at the neck. He wore neither coat nor vest and in lieu of suspenders a strap held his trousers to the waist. A big fan-brimmed straw hat crowned his curly white hair. It was shoved back carelessly above his high forehead, making a golden halo for his fine face. He had a big eagle-shaped nose, a wide, classic-lipped mouth. Plato and Socrates should have looked something like this man. Whitman, Bryant, Longfellow were his counterparts—all were typical Americans.

"How do you do, Mr. Witla," he inquired with easy grace as he strolled up, the yellow mud of the fields on his boots and trouser legs. He pulled a big jack-knife out of his trousers pocket and began whittling a fine twig he picked up. "I'm glad to see you. My daughter Angela has been telling me one thing and another about you."

His voice was so full and deep and resonant that Eugene was at once impressed with it as one might be by the opening tones of an orator. He smiled as he looked at Eugene. Angela, who was sitting beside him, rose and strolled toward the house.

"I'm glad to see you," said Eugene. "I like your country around here. It looks prosperous."

"It is prosperous," said the old patriarch, drawing up a chair which stood at the foot of a tree and seating himself. Eugene sank into the hammock.

"It's a soil that's rich in lime and carbon and sodium—the things which make plant life grow. We need very little fertilizer here—very little. The principal thing is to keep the ground thoroughly cultivated and to keep out the bugs and weeds." He cut at his stick meditatively.

Eugene noted the chemical and physical knowledge relative to farming. It pleased him to find brains coupled with knowledge of crop cultivation.

"I noticed some splendid fields of wheat as I came over," he observed.

"Yes, wheat does well here," Jotham went on, "when the weather is moderately favorable. Corn does well. We have a splendid apple crop and grapes are generally successful in this state. I have always thought that Wisconsin had a little the best of the other valley states, for we are blessed with a moderate climate, plenty of streams and rivers, and a fine, broken landscape. There are good mines up north and lots of lumber. We are a prosperous people, we Wisconsiners, decidedly prosperous. This state has a great future."

Eugene noted the wide space between his clear blue eyes as he talked. He liked the bigness of Jotham's conception of his state and of his country. No petty little ground-harnessed ploughman this, but a farmer in the big sense of the word—a cultivator of the soil with an understanding of it, an American who loved his state and his country.

"I have always thought of the Mississippi Valley as the country of the future," said Eugene. "We have had the Valley of the Nile and the Valley of the Euphrates with big populations, but this is something larger. I rather feel as though a great wave of population were coming here in the future."

"This Mississippi Valley," said his host, pausing in his whittling and holding up his right hand for emphasis, "is the new paradise of the world. It is the world's great grainery. We haven't come to realize its possibilities. The fruit, the corn, the wheat to feed the nations of the world can be raised here. I sometimes marvel at the productivity of the soil. It is so generous. It is like a great mother. It only asks to be treated kindly to give all that it has."

Eugene smiled. The bigness of his prospective father-in-law's feelings lured him. He felt as though he could love this man as an intellectual friend and brother. His yellow straw hat and top boots were just the things which a rugged, kingly intellect should wear.

They talked on about other things—the character of the surrounding population, the growth of Chicago, the recent threat of a war with Venezuela, the rise of a new leader in the Democratic party, a man whom Jotham admired very much. As he was telling of the latter's exploits—it appeared he had recently met him at Black Wood—Mrs. Blue appeared in the front door.

"Jotham!" she called.

He rose. "My wife must want a bucket of water," he said, and strolled away.

Eugene smiled. This was lovely. This was the way life should be—compounded of health, strength, good nature, understanding, simplicity. He wished he were a man like Jotham, as sound, as hearty, as clean and strong.

To think he had raised eight children. No wonder Angela was lovely. They all were, no doubt.

While he was rocking, Marietta came back, smiling, her blond hair blowing about her face. Like her father she had blue eyes, like him a sanguine temperament, warm and ruddy. Eugene felt drawn to her. She reminded him a little of Ruby—a little of Margaret. She was bursting with young health.

"You're stronger than Angela," he said, looking at her.

"Oh, yes, I can always out run Angel-face," she exclaimed. "We fight sometimes but I can get things away from her. She has to give in. Sometimes I feel older—I always take the lead."

Eugene rejoiced in the sobriquet of Angel-face. It suited Angela, he thought. She looked like pictures of angels in the old prints and in the stained-glass windows he had seen. He wondered in a vague way, however, whether Marietta did not have the sweeter temperament—were not really more lovable and cozy—but he put the thought forcefully out of his mind. He felt he must be loyal to Angela here.

While they were talking, the youngest boy, David, came up and sat down on the grass. He was short and stocky for his years—sixteen—with an intelligent face and an inquiring eye. Eugene noted stability and quiet force in his character at once. He began to see that these children had inherited character as well as strength from their parents. This was a home in which successful children were being reared. Benjamin came up after a while—a tall, overgrown puritanical youth with western modifications—and then Samuel, the oldest of the living boys and the most impressive. He was big and serene like his father, of brown complexion and hickory strength. Eugene learned in the conversation that he was a railroad man in St. Paul—home for a very brief vacation after three years' absence. He was with a road called the Great Northern, already a second assistant passenger agent and with great prospects, so the family thought. Eugene could see that all the boys and girls, like Angela, were ruggedly and honestly truthful. They were written all over with Christian precept—not church dogma, but Christian precept, lightly and good-naturedly applied. They obeyed the Ten Commandments insofar as possible and lived within the limits of what people considered sane and decent. Eugene wondered at this. His own moral laxity was a puzzle to him. He wondered whether he were not really all wrong and they all right. Yet the subtlety of the universe was always with him—the mystery of its chemistry. For a given order of society, no doubt, he was out of place—for life in general, well, he could not say.

Dinner was announced from the door by Mrs. Blue at 12:30 and they all arose. It was one of those simple home feasts common to every intelligent

farming family where good cooking is practised. There was a generous sup-
ply of fresh vegetables—green peas, new potatoes, new string beans. A steak
had been secured from the itinerant butcher who served these parts and
Mrs. Blue had made hot light biscuit and brown gravy. Eugene expressed a
predilection for fresh buttermilk and they brought him a pitcher full, say-
ing that as a rule it was given to the pigs. The children did not care for it.
They talked and jested and he heard odd bits of information concerning
people here and there—some farmer who had lost a horse by colic; some
other farmer who was preparing to cut his wheat. There were frequent refer-
ences to Ellen, Elizabeth, and Grace, the three oldest sisters. Their children
appeared to be numerous and fairly troublesome. Ellen lived in Black Bay,
Elizabeth in Wanhesba of this same county. Grace was a resident of Koosa,
a small town of Indian name some fifteen miles east. They all came home
frequently, it appeared, and were bound up closely with the interests of the
family as a whole.

"The more you know about the Blue family," observed Samuel to Eugene,
who expressed surprise at the solidarity of interest, "the more you'll realize
that they're a clan, not a family. They stick together like glue."

"That's a rather nice trait, I should say," laughed Eugene, who felt no
such keen interest in his relatives.

"Well, if you want to find out how the Blue family stick together just
do something to one of them," observed Jake Doll, a neighbor who had
entered.

"That's sure true, isn't it, Sis?" observed Samuel, who was sitting next
to Angela, putting his hand affectionately on his sister's arm. Eugene noted
the movement.

She nodded her head affectionately. "Yes, we Blues all hang together."

Eugene almost begrudged him his sister's apparent affection. Could such a
girl be cut out of such an atmosphere—separated from it completely, brought
into a radically different world, he wondered. Would she understand him;
would he stick by her? He smiled at Jotham and Mrs. Blue and thought he
ought to, but life was strange. You never could tell what might happen.

During the afternoon there were more lovely impressions. He and Angela
sat alone in the cool parlor for two hours after dinner while he restated his
impressions of her over and over. He told her how charming he thought her
home was, how nice her father and mother, what interesting brothers she
had. He made a pencil sketch from memory of Jotham as he had strolled up
to him at noon which pleased Angela and she kept it to show her father. He
had her pose in the window and sketched her head and her halo of hair. He
thought of his double-page illustration of the Bowery by night and went to
fetch it, looking for the first time at the sweet cool room at the end of the

house which he was to occupy. One window—a west one—had hollyhocks looking in, and the door to the north gave out on the cool, shady grass. He moved in beauty, he thought; was treading on showered happiness. It hurt him to think that such joy might not always be—as though beauty were not everywhere and forever present.

When Angela saw the picture which *Truth* had reproduced she was beside herself with joy and pride and happiness. It was such a testimony to her lover's ability. He had written her almost daily of the New York art world so she was familiar with it in an exaggerated form, but these actual things, like reproduced pictures, were different. Eugene moved in the New York art world and saw it, but the whole world saw this picture. He must be famous already, she imagined—a great many people must know about him. She wished deeply that he were able to take her back with him—that they could live in a studio together. She would be his model. He could sketch from her. She was afraid for herself of these other creatures who came to pose for him—of the ones who would pose in the altogether. She thought from what he said that he did not use that kind, but if he ever did it would be her, of course. She colored in her cheeks at the thought but after marriage, and with Eugene, of course it would be all right.

That evening and the next and the next, as they sat in the parlor alone, he drew nearer and nearer to that definite understanding which comes between two people when they love. Eugene was for making advances, always definitely and directly toward one end. He could never stop with mere kissing and caressing in a reserved way if not persistently restrained. It seemed natural to him that love should go on, that he should test the power of his control in love, that he should not necessarily wait for any ceremony before possessing his lady love. If he could make Angela go farther than she would normally go, yield herself to him possibly in some dramatic way, it would be the fine thing that should occur in love. It was not that in cold blood and with evil calculation he deliberately intended to destroy virtue but that he found his finest expression of delight in the sex relationship and its approach. Marriage was not such a distinguished and sacred thing in his eyes as to deter him. He had not been married. He did not know what its responsibilities were. He had never given a thought to what his parents had endured to make him worthwhile. There was no stable instinct in him to tell him. He had no yearning for parenthood, that normal instinct which builds visions of a home and the proper social conditions for rearing a family. All he thought of was the lovemaking period—the billing and cooing and the transports of delight which came with it. With Angela he felt that these would be extraordinary because she was so slow in yielding—so on the defensive against herself. He could look in her eyes at times and see a

swooning veil which prognosticated a storm of emotion. He would sit by her, rubbing her hands, touching her cheek, smoothing her hair, or at other times, holding her in his arms. It was hard for her to resist his significant pressures, to prevent him from taking the liberties he desired, for she herself was eager for the delights of love.

It was on the third night of his stay and in the face of his growing respect for every member of this family that he swept Angela to the danger line— would have carried her across it, had it not been for one of those fortuitous waves of emotion which was not of his creation but hers.

They had been to the little lake—Okoonee, a short way from the house during the afternoon to swim, he and Angela and Marietta and David, and they had taken a drive afterward. It was one of those lovely afternoons which come sometimes in summer and speak direct to the heart of love and beauty. It was so fair and warm, the shadows of the trees so comforting that they fairly made Eugene's soul ache. He was given to admiring nature and so these simple roads, the stretches of ragged woodland, the clear bosomed lake, all touched him as evidences of a perfect picture which might not come again in his life. He was young now, life was beautiful, but how would it be when he was old? A morbid anticipation of disaster seemed to harrow his soul.

They drove and drove, past sweet-scented fields of timothy, past hedges of scrub oak and wild flowers, past pleasant little farm yards, cattle grazing in fields, and always a hill or two rising gently and giving roundness of form to the bosom of the earth. It drew near to evening at last, the sun colored the west a golden hue, dying to a steely silver at the zenith. Insects hummed, a cow-bell tinkled now and then; a breath of cool air, those harbingers of approaching eve, swept their cheeks as they passed some hollow. In an ecstasy of emotion, Eugene clasped Angela's hand which lay beside him. Finally they came home to see a little curl of blue smoke rising from the chimney of the kitchen. Mrs. Blue was already about her evening meal.

Eugene did not want to eat—he wanted to dream. He sat out in the hammock with Angela as the dusk fell and watched the pretty scene which the house presented. Marietta lighted a lamp in the sitting room; Samuel, who had ridden to Black Wood on horseback, now returned, stabling his mare himself. Jotham and Benjamin came in from the fields, washing their hands in a tin basin outside the kitchen door. There was anticipatory stomping of horses' feet in the barn, the lowing of a distant cow, the hungry grunts of pigs. Eugene shook his head—it was so pastoral, so sweet. Angela finally left him alone for a little while to his meditations.

When she called him again he went in to supper, scarcely touching what was put before him, the group at the dining table holding his atten-

tion as a spectacle. Afterwards he sat with the family on the lawn outside the door, breathing the odors of flowers, watching the stars over the trees, listening to Jotham and Mrs. Blue, to Samuel, Benjamin, David, Marietta, and occasionally Angela. Because of his mood, which was sad in the face of exquisite beauty, hers was also, though she was naturally of a more morbid turn than himself. Beauty such as this, and where love was involved, touched her vastly. She said little, listening to Eugene and her father, but when she did talk her voice sounded sweet.

Jotham arose after a time and went to bed. Mrs. Blue followed. David and Marietta went into the sitting room and then Samuel and Benjamin left. They gave as an excuse hard work for the morning. Samuel was going to try his hand again at thrashing. Eugene took Angela by the hand and led her out where some hydrangeas were blooming, white as snow by day but pale and silvery in the dark. He took her face in his hands, telling her again of love.

"It's been such a wonderful day, I'm all wrought up," he said. "I'm beside myself. Life is so beautiful here. This place is so sweet and peaceful. And you! Oh, you!" Kisses ended his words.

They stood there a little while, then went back into the parlor where she lighted a lamp for the looks of things. It cast a soft yellow glow over the room, just enough to make it artistic, he thought. They first sat side by side on two rocking chairs and then later on a settee, he holding her in his arms. For caution's sake the shutters had been closed though she feared no one spying. Before supper she had changed from a close-fitting walking dress to a loose house gown of cream challis. He persuaded her to let her hair hang in the two braids which he so much admired.

Real passion is silent. It was so intense with him that he sat contemplating her as if in a spell. She leaned back against his shoulder, stroking his hair, but finally gave over, for her own feeling was too intense to make movement possible. She thought of him as a young god, strong, virile, beautiful—a brilliant future before him. All these years she had waited for someone to truly love her and now this splendid youth had apparently cast himself wholly at her feet. He stroked her hands, her neck, cheeks, then slowly gathered her close and buried his head against her bosom.

Angela was strong in convention, in the precepts of her parents, in the sense of her family and its attitude, but this situation was more than she could endure. She accepted first the pressure of his arms about her hips, then the slow subtlety with which he caressed her limbs outside her dress. Resistance seemed almost impossible now, for he held her close—tight within the range of his magnetism. When the expected and feared happened—when she felt the pressure of his hand upon her stocking, her knee—she threw herself back in a transport of agony and delight.

"No, no, Eugene," she begged, "not me. Save me from myself. Save me from myself. Oh, Eugene!"

He paused a moment to look at her face. It was wrought in lines of intense suffering—pale as though she were ill. Her body was quite limp. Only the hot, moist lips told the significant story. He could not help going further, stroking her thigh, feeling her bosom, doing as he had done with so many others.

She struggled lamely at this point and slipped to her knees, her dress open at the neck.

"Don't, Eugene," she begged, "don't. Think of my father, my mother, who have boasted so. I of whom they feel so sure. Oh, Eugene, I beg of you, save me from myself."

He stroked her hair, her cheek, looking into her face as Dante might have gazed into that of Beatrice; as Abélard into that of Héloïse.

"Oh, I know why it is," she exclaimed convulsively, explaining and palliating her deed to herself. "I am no better than any other, but I have waited so long, so long! But I mustn't! Oh, Eugene, I mustn't! Help me to save myself!"

Eugene vaguely understood. She had been without lovers. Why, he thought. She was beautiful. He got up, half intending to carry her to his room, but he paused, thinking. She was such a pathetic figure. Was he really as bad as this? Could he not be fair in this instance? Her father had been so nice to him—her mother. He saw Jotham before him, Mrs. Blue, her admiring brothers and sisters as they had been a little while before. He looked at her and still the prize lured him—almost swept him on in spite of himself, but he stayed.

"Stand up, Angela," he said at last, pulling himself together and looking at her intensely. She did so.

"Leave me now," he went on, "right away! I won't answer for myself if you don't. I am really trying. Please go!"

She paused, looking at him fearfully, regretfully.

"Oh, forgive me, Eugene," she pleaded.

"Forgive me," he said. "I'm the one. But you go now, sweet. You don't know how hard this is. Help me by going."

She moved away and he followed her with his eyes yearningly, burningly, until she reached the door. When she closed it softly he went into his room and sat down. His body was limp and weary. He ached from head to toe from the intensity of the mood he had experienced. He went over the recent incidents, almost stunned by his experience and then went outside and stood under the stars, listening. Tree toads were chirping, there were suspicious cracklings in the grass as of bugs stirring. A duck quacked somewhere feebly. The bell of the family cow tinkled—somewhere over near

the water of the little stream. He saw the great dipper in the sky, Sirius, Canopus, the vast galaxy of the Milky Way.

"What is life, anyway?" he asked himself. "What is the human body? What produces passion? Here we are for a few years surging with a fever of longing and then we burn out and die." He thought of some lines he might write, of pictures he might paint. All the while there was reiterating before his mind's eye like a cinematograph, views of Angela as she had been tonight in his arms, on her knees. He had seen her trim form. It was dainty. He had held her bosom in his arms. He had voluntarily resigned her charms for tonight, anyhow. No harm had come. It should never.

He wished sincerely that he might do her no further harm but marry her, and have this fever of longing over with.

CHAPTER XXI

It would be hard to say in what respect, if any, the experiences of this particular night altered Eugene's opinion of Angela. Not being bound by the customs and conventions of the world as currently conceived, he was not prone to attach much importance to the opinion of others in these matters. If anything, he was a little proud of his skill as a squire of dames and in a way he was probably inclined to like her better for what he would have called her humanness. To thus frankly confess her weakness and inability to save herself was splendid. That he was given this chance to do a noble deed was fortuitous and worthy. He knew now that he could take her, if he wished, but once calm again he resolved to be fair and not to insist. He could wait.

The state of Angela's mind, on the contrary, once she had come out of her paroxysm and gained the privacy of her own room, or rather the room she shared with Marietta at the other extreme of the house, was pitiable. She had for so long considered herself such an estimable and virtuous girl. There was in her just a faint trace of prudery which might readily have led to an unhappy old maid existence for her, if Eugene, with his superiority or non-understanding or indifference to conventional theories and to old maidish feelings, had not come along, and with his customary blindness to material prosperity, age limitations, in fact to everything but aesthetic and artistic appearances, seized upon and made love to her. He had filled her brain with a whirlwind of notions hitherto unfamiliar to her world and set himself up in her brain as a law unto himself. He was not like other men— she could see that. He was superior to them. He might not make much money being an artist, but he would achieve other things which seemed

more desirable to her. Fame, beautiful pictures, notable friends—were not these things far superior to money? She had had little enough money in all conscience, and if Eugene made anything at all it would be enough for her. He seemed to be under the notion that he needed a lot to get married, whereas she would have been glad to risk it on almost anything at all.

This latest development in her character, besides tearing from her mind a carefully nurtured belief in her own virtuous impregnability, raised at the same time a spectre of disaster insofar as Eugene's love for her was concerned. Would he, now that she had allowed him those precious liberties which should have been reserved for the marriage bed only, care for her as much as he had before? Would he not think of her as a light minded, easily spoiled creature who was waiting only for a propitious moment to yield herself? She had been lost to all sense of right and wrong in that hour, that she knew. Her father's character and what he stood for, her mother's virtue and love of decency, her cleanly-minded, right-living brothers and sisters—all had been forgotten and here she was, a tainted maiden, virtuous in a technical sense it is true, but tainted. Her convention-trained conscience smote her vigorously and she groaned soulfully. She went outside the door of her room and sat down on the damp grass in the early morning to think. It was so cool and calm everywhere but in her own soul. She held her face in her hands, feeling her hot cheeks, wondering what Eugene was thinking now. What would her father think, her mother? She wrung her hands more than once and finally went inside to see if she could not rest. She was not unconscious of the beauty involved in the whole thing, and the joy, but she was troubled by what she felt she ought to think, what the consequences to her future might be. How to hold Eugene now—that was a subtle question. To hold up her head in front of him as she had, could she? To keep him from going further? It was a difficult situation and she tossed restlessly all night, getting little sleep. In the morning she arose weary and disturbed but more desperately in love than ever. This wonderful youth had revealed an entirely new and dramatic world to her.

When they met on the lawn again before breakfast Angela was garbed in white linen, a favorite fabric with her. She looked waxen and delicate and her eyes showed dark rings as well as the dark thoughts that were troubling her. Eugene took her hand sympathetically.

"Don't worry," he said. "I know. It isn't as bad as you think." And he smiled tenderly.

"Oh, Eugene, I don't understand myself now," she said sorrowfully. "I thought I was better than that."

"We're none of us better than that," he replied simply. "We just think we are sometimes. You are not any different to me. You just think you are."

"Oh, are you sure?" she asked eagerly.

"Quite sure," he replied. "Love isn't a terrible thing between any two. It's just lovely. Why should I think worse of you?"

"Oh, because good girls don't do what I have done. I have been raised to know better—to do better."

"All a belief, my dear, which you get from what has been taught you. You think it's wrong. Why? Because your father and mother told you so. Isn't that it?"

"Oh, not that alone. Everybody thinks it's wrong. The Bible teaches that it is. Everybody turns his back on you when he finds out."

"Wait a minute," pleaded Eugene argumentatively. He was trying to solve this puzzle for himself. "Let's leave the Bible out of it, for I don't believe in the Bible—not as a law of action, anyhow. The fact that everybody thinks it's wrong wouldn't necessarily make it so, would it?"

He was ignoring completely the significance of *everybody* as a reflection of those principles which govern the universe.

"No-o-o," ventured Angela doubtfully.

"Listen," went on Eugene. "Everybody in Constantinople believes that Mahomet is the prophet of God. That doesn't make him so, does it?"

"No."

"Well then, everyone here might believe that what we did last night was wrong, without making it so. Isn't that true?"

"Yes," replied Angela confusedly. She really did not know. She could not argue with him. He was too subtle. But her innate principles and instincts were speaking plainly enough, nevertheless.

"Now what you're really thinking about is what people will do. They'll turn their back on you, you say. That is practical opposition. Your father might turn you out of doors——."

"I think he would," replied Angela, little understanding the bigness of the heart of her father.

"I think he wouldn't," said Eugene, "but that's neither here nor there. Men might refuse to marry you. Those are material considerations. You wouldn't say they had anything to do with real right or wrong, would you?"

Eugene had no convincing end to his argument. He did not know any more than anyone else what was right or wrong in this matter. He was merely talking to convince himself, but he had enough logic to confuse Angela.

"I don't know," she said vaguely.

"Right," he went on loftily, "is something which is supposed to be in accordance with a standard of truth and wrong, something which is in opposition to it. Now no one in all the world knows what the standard of truth

is—no one. There is no way of telling. You can only act wisely or unwisely as regards your personal welfare. If that's what you're worrying about, and it is, I can tell you that you're no worse off. There's nothing the matter with your welfare. I think you're better off, for I like you better."

Angela wondered at the subtlety of his brain. She was not sure—but what he said seemed true. She felt sure she had lost some of the bloom of her youth, anyhow. Could her fears be baseless? "How can you?" she asked.

"Easily enough," he replied. "I know more about you. I admire your frankness. You're lovely—altogether so. You are sweet beyond compare."

In a moment he was referring to her shapely form, her dainty limbs.

"Don't, Eugene," she pleaded, putting her fingers over her lips. The color was leaving her cheeks. "Please don't. I can't stand it."

"All right," he said, "I won't. But you're altogether lovely. Let's go sit in the hammock."

"No. I'm going to get you your breakfast. It's time you had something."

He took comfort in his privileges, for the others had all gone. Jotham, Samuel, Benjamin, and David were in the fields. Mrs. Blue was sewing and Marietta had gone to see a girl friend up the road. Angela, as Ruby before her, bestirred herself about this youth's meal, mixing biscuit, broiling him some bacon, cleaning a basket of fresh dewberries for him.

"I like your man," said her mother, coming out where she was working. "He looks to be good-natured. But don't spoil him. If you begin wrong now you'll be sorry."

"You spoiled papa, didn't you?" asked Angela sagely, recalling all the little humoring her father had received.

"Your father has a keen sense of duty," retorted her mother. "It didn't hurt him to be spoiled a little."

"Maybe Eugene has too," replied her daughter, turning her slices of bacon.

Her mother smiled. All her daughters had married well. Perhaps Angela was doing the best of all. Certainly her lover was the most distinguished. Yet—"Well, be careful," she suggested.

Angela thought. If her mother only knew, or her father. Dear heaven! And yet Eugene was altogether lovely. She wanted to wait on him—to spoil him. She wished she could be with him every day from now on—that they need not part anymore. "Oh, if he would only marry me," she sighed. It was the one divine event which would complete her life.

Eugene would have liked to linger in this atmosphere indefinitely. It was pleasant—so ideal. Old Jotham, he found, liked to talk to him. He took an interest in national and international affairs, was aware of distinguished and peculiar personalities, seemed to follow world currents everywhere. Eugene

began to think of him as a distinguished personality in himself—someone of whom the world should have heard more, but old Jotham waved the suggestion blandly aside.

"I'm a farmer," he said. "I've seen my greatest success in raising good children. My boys will do well, I know."

For the first time Eugene caught the sense of fatherhood, of what it means to live again in your children, but only vaguely. He was too young, too eager for a varied life, too lustful. So its true import was temporarily lost.

Sunday came and with it the necessity to leave. He had been here nine days, really two days more than he had intended to stay. It was farewell to Angela who had come so close, was so much in his grasp that she was like a child in his hands. It was farewell, moreover, to an ideal scene, a bit of bucolic poetry. When would he see again an old patriarch like Jotham, clean, kindly, intelligent, standing upright amid his rows of corn, proud to be a good father, not ashamed to be poor, not afraid to be old or to die? Eugene had drawn so much from him. It was like sitting at the feet of Isaiah. It was farewell to the lovely fields and the blue hills, the long rows of trees down the lawn walk, the white and red and blue flowers about the dooryard. He had slept so sweetly in his clean room; he had listened so joyously to the voices of birds, the wood dove and the poet thrush; he had heard the water in Blue's branch rippling over its clean pebbles. The pigs in the barnyard pen, the horses, the cows, all had appealed to him as Gray's family's country life had appealed to him. He thought of the latter's "Elegy"—of Goldsmith's "Deserted Village" and "The Traveller." This was something like the things those two men had loved. It touched him deeply.

He walked down the lawn with Angela when the time came, repeating how sorry he was to go. David had hitched up a little brown mare and was waiting at the extreme end of the lawn.

"Oh, sweet," he sighed. "I shall never be happy until I have you."

"I will wait," sighed Angela, although she was wishing to exclaim, "Oh, take me! take me!" When he was gone she went about her duties mechanically, for it was as if all the life and joy had gone out of her. Without this brilliant imagination of his to illuminate things, life seemed dull.

And he rode, parting in his mind with each lovely thing as he went—the fields of wheat, the little stream, Lake Okoosa, the pretty Blue farmhouse, all of it. "I shall never see anything finer than this," he said to himself. "Nothing more lovely will ever come again. Angela in my arms in her simple little parlor. Dear God. And there are only seventy years of life—not more than ten or fifteen of true youth, all told."

CHAPTER XXII

It would be hard to say what, definitely, this visit did to Eugene, although it made a profound impression on him. Despite his altered and now more familiar relationship to Angela, he grew in respect for the Blue family, and in a way more in his respect for her. Old Jotham was such a worthwhile figure of a man; his wife so kindly and earnest. Their relationship to their children and between themselves was so respectable. Another man, looking at the worldly side of life and having no insight into character or the emotions, might have been disgruntled or dissatisfied (according to the depths of his materialism or the narrowness of his conventional beliefs) with what he found in the way of material want or lack here. There was really so little of what the world looks upon as important—merely the bare necessities. But Eugene, never having experienced anything much better than this, was prone to see in these things all that was necessary.

In addition he had found character, poetry of location, poetry of ambition, youth, and prospects. These boys with their sturdy constitutions and thoroughly independent attitudes were sure to succeed. Obviously Marietta—a girl with so much charm—would marry well. Angela informed him that her father had been a local political leader in his day—was yet, and could hold a crowd spellbound by his oratory. Samuel was making $2200 in his present position. Benjamin was studying to be a lawyer. David was going into the army as an officer via West Point. She was teaching school and Marietta was going to in the fall, facts that seemed merely additional proof of the family's sterling worth. Eugene had visited around Black Wood with Angela and had been introduced to Mr. and Mrs. Stockwell (her sister Ellen and her husband Henry), who lived in a small, neat home already crowded with six children. Stockwell was one of the four or five leading citizens of Black Wood and carried himself with the conviction of that fact. He was small, lean, and brisk, but obviously forceful and a sterling father and husband. He talked to Eugene of local banking conditions, for he was president of one of the two small banks in Black Wood, and manipulated real estate deals on the side. He was a leader in the local Baptist church and a conductor of one of its Sunday school classes. He liked Eugene as a rather interesting specimen of eastern life, and Eugene liked him. Everyone seemed to take him as the sure-enough future husband of Angela, which had rather solidified and made more definite his own views on that important point. By the end of his stay he had become as en rapport with the family as if he had known them all his life.

The period of absence from New York was lengthened by a few days in Chicago, where he stopped to see Howe and Mathews, grinding away at

their old tasks, and four additional days in Alexandria, where he found his father busy about his old affairs. He was still delivering sewing machines in person, as briskly traversing the long roads of the county in his light machine-carrying buggy as in his earliest days. He seemed to Eugene now just a little futile and yet he admired him, his patience, his industry. The busy sewing machine agent was considerably wrought up by his son's success, and was actually trying to take an interest in art. One evening coming home from the post office, he pointed out a street scene in Alexandria as having something about it quite paintable. Eugene knew that art had only been called to his father's attention by his own efforts. He had noticed those things all his life, no doubt, but attached no significance to them until he had seen his son's work in the magazines.

"If you ever paint country things, you ought to paint Cook's Mill, over here by the falls. That's one of the prettiest things I know anywhere," he said to Eugene one evening, trying to make his son feel the interest he took. Eugene knew the place. It was attractive, a little branch of bright water running at the base of a forty foot wall of red sandstone and finally tumbling down a fifteen foot declivity of gray, mossy stones. It was close to a yellow road which carried considerable traffic and was surrounded by a company of trees which ornamented and sheltered it on all sides. Eugene recalled it well. He had admired it in his youth as beautiful and peaceful.

"It is nice," he replied to his father. "I'll take a look at it some day."

Witla senior felt set up. His son was doing him honor.

His mother, like his father, was showing the first notable traces of the flight of time. The crow's feet at the sides of her eyes were deeper, the wrinkles in her forehead longer. At the sight of Eugene the first night she fairly thrilled, for he was apparently so well developed now, so self-reliant. He had come through his experiences to a kind of poise which she realized was manhood. Her boy, requiring her careful guidance, was gone. This was someone who could guide her, tease her as a man would a child.

"You've got so big I hardly know you," she said as he folded her in his arms.

"No, you're just getting little, ma. I used to think I'd never get to the place where you couldn't shake me but that's all over, isn't it?"

"You never did need much shaking," she said fondly.

Myrtle, who had married Frank Bangs the preceding year, had gone with her husband to live in Ottumwa, Iowa, where he had taken charge of a mill, so Eugene did not see her, but he spent some little time with Sylvia who was now the mother of two children. Her husband was the same quiet, conservative plodder Eugene had first noted him to be. He revisited the office of the *Appeal* and found that John Summers had recently died. Otherwise

things were as they had been. Jonas Lyle and Caleb Williams were still in charge—quite the same as before.

As on the last visit, he was restless, cabined, without means of diversion. The town was too small. He was glad when his visit was up and he took the train back to Chicago, which was his starting point for New York, with a light heart.

One of the things which had touched him most keenly on his entrance into Chicago from the East, on his return to it from Black Wood, and again on his return to it from Alexandria, was the remembrance of Ruby. She had been so uniformly nice to him. His opening art experiences had in a way been centered about her. Now he was passing through and in spite of all that had been between them she did not mean enough to him to want to go out and see her—or did he? He asked himself this question with a pang of sorrow, for in a way he cared. He cared for her as one might care for a girl in a play or book. She had the quality of a tragedy about her. She—her life, her surroundings, her misfortune in loving him—constituted an artistic composition. He thought he might be able to write a book about it some time. He was already able to write rather charming verse which he kept to himself. He had the knack of saying things in a simple way and with feeling—making you see a picture. The trouble with his verse was that it lacked as yet true nobility of thought—was not as irrevocably logical as it might have been.

He did not go to see Ruby. The reason he assigned to himself was that it would not be wise. She might not want him to now. She might be trying to forget. And he had Angela. It really wasn't fair to her. But he looked over toward the region in which Ruby lived, as he travelled out of the city eastward and wished that some of those lovely moments he had spent with her might be again.

The following year in New York was a repetition of the one preceding, with some minor modifications. In the fall Eugene went to live with McHugh and Smite, the studio they had consisting of one big working room and three bedrooms which made a rather nice arrangement for three men. He was led to this by his own desires and by the wishes of both McHugh and Smite. They agreed that they could get along together nicely, and for a period it was a real benefit. The rooms were not so well furnished, so that his belongings could be added without much trouble. The criticism they furnished each other was of genuine value. All three found it pleasant to dine together on occasion and to walk, to see the exhibitions, and what not. They stimulated each other with argument, each having a special point of view. It was much as it had been with Howe and Mathews in Chicago.

It was during this winter that Eugene had his first set of pictures appear

in one of the leading publications of the time—*Harper's Magazine*. That, with the *Century* and *Scribner's*, was in the front rank of art significance, and Eugene considered this acceptance quite a triumph. He had gone to the art director with some of his previous work in proof and had been told that it was admirable—if some suitable story turned up he would be considered. Later a letter came asking him to call and a commission involving three pictures for $125 was given him. He worked them out successfully with models and was complimented on the result. His associates cheered him on also, for they truly admired what he was doing. He set out definitely to *make Scribner's* and the *Century*, as getting illustrations into those publications was called, and after a time he succeeded in making an impression on their respective art directors, though no notable commissions were given him. From one he secured a poem, rather out of his mood, to decorate, and from the other a short story, but somehow he could not feel that either was a real opportunity. He wanted an appropriate subject or to sell them some of his scenes.

Building up a paying reputation was slow work. Although he was being mentioned here and there among artists, his name was anything but a significant factor with the public or with the art directors. He was still a promising beginner—growing, but not yet arrived by a long distance.

It was during this winter that he met Miriam Finch and Christina Channing, two women of radically different temperaments and professions who opened for Eugene an entirely new world or rather two new worlds.

Miriam Finch was a sculptor by profession and a critic by temperament, with no great emotional capacity herself but an intense appreciation of its significance in others. To see her was to be immediately impressed with a vital force in womanhood. She was a woman who had never had a real youth or real love affair—a grand passion—but who clung to her ideal of both with a passionate, almost fatuous, faith that they still could be brought to pass. Eugene met her through Richard Wheeler, the editor of *Craft*, who invited him to go around to her studio with him one evening. Wheeler was interested to know what Eugene would think of her. Miriam was already thirty-two when Eugene met her, which was several years older than himself, petite, brown haired, brown eyed, with a slender, rather cat-like figure and a suavity of address and manner which was artistic to the finger-tips. She was not at all beautiful, with that budding beauty that is the glory of eighteen, but she had a total appearance which was artistic, pleasing, and in many respects delightful. Her hair encircled her head, a fluffy, cloudy mass; her eyes moved quickly, expressing intense intelligence, feeling, humor, sympathy—in fact any and all of her moods definitely and succinctly. Her lips were sweetly modeled after the pattern of a Cupid's bow, and her smile was

as ingratiating as it was alluring. Her complexion, while sallow, somehow matched her hair and her dress, for her preference was for brown or drab velvets and corduroys. There was a striking simplicity about the things she wore which gave her an air of distinction. They were not necessarily fashionable but they were intensely becoming. She saw herself as an artistic composition from head to foot, with a sense of fitness in regard to self and life which was a rather distinguished thing in itself.

There is something about an intelligent, artistic, self-regulating and self-poised human being, which to natures such as Eugene's, admiring art, composition, intelligence and artistic achievement, is intensely magnetic and gratifying. He turned to the capable person as naturally as a flower turns toward the light, and he found joy in contemplating the completeness and sufficiency of such a being. To have ideas of your own seemed to him a marvelous thing. To be able to definitely formulate your thoughts and reach positive and satisfying conclusions was a great and beautiful thing. When anyone could do this, Eugene was there, almost open mouthed with admiration, until he was full to running over with what they knew. He drew close to a person of this kind as another might to a table loaded with delectable viands, and when he was full he was apt to leave. If his hunger returned he was apt to return—not otherwise.

Hitherto all his relationships with personages of this character had been confined to the male sex, for he had not known any distinguished women. Beginning with Temple Boyle, N.A., instructor in the life class in Chicago, and Vincent Beers, instructor in the illustration class, he had encountered successively Jerry Mathews, Mitchell Goldfarb, Peter McHugh, David Smite, and Jotham Blue, all men of intense personal feeling and convictions, and men who had impressed him greatly. Now he was to encounter for the first time some forceful, really exceptional women of the same calibre who were to do likewise. Stella Appleton, Margaret Duff, Ruby Kenny, and Angela Blue were charming women or girls in their way but they did not think original, distinguished thoughts such as these others did. They were not organized, self-directed, self-controlled personalities in the way that Miriam Finch was. She would have recognized herself at once as being infinitely superior, intellectually and artistically, to any or all of them, while entertaining at the same time a sympathetic, appreciative understanding of their beauty, fitness, equality of value in the social scheme. Miriam was a student of life, a critic of emotions and understanding, with a grasping, appreciative intelligence and yet longing intensely for just what Stella and Margaret and Ruby and even Angela had—youth, beauty, sex interest for men, the power or magnetism or charm of face and form to compel the love and brainless passion of a man. She would have given anything if a young man

like Eugene had fallen madly and passionately in love with her. She wanted to be loved by someone who could love madly and passionately—beautifully, let us say—and this had never come to pass.

Miss Finch's home, or rather her studio, was with her family in East Twenty-sixth Street, where she occupied a north room on the third floor, but her presence in the bosom of her family did not prevent her from attaining an individuality and an exclusiveness which was most illuminating to Eugene. Her room was beautifully done in silver, brown, and gray; with a great wax-festooned candlestick fully five feet high standing in one corner and a magnificent brown carved chest of early Flemish origin standing in another. There was a brown combination writing desk and book shelf, which was arrayed with some of the most curious volumes—Pater's *Marius, the Epicurean*, Daudet's *Wives of Men of Genius*, Richard Jefferies's *Story of My Heart*, Stevenson's "Aes Triplex," "The Kasidah" by Richard Burton, *The House of Life* by Dante Gabrielle Rossetti, *Also sprach Zarathustra* by Friedrich Nietzsche—volumes of which Eugene had never heard. The fact that they were here, after he had taken one look at the woman and the room, was sufficient proof that they were distinguished. He handled them curiously, as was his way, nosing about, looking at pictures, reading odd paragraphs, making rapid-fire notes in his mental notebook. This was someone worth knowing, he felt that. He wanted to make a sufficiently favorable impression to be permitted to know her better.

On her part, Miriam Finch was at once taken with Eugene. She did not admit to herself at first that he was anything exceptional, but there was such an air of vigor, inquiry, appreciation, and understanding about him that she could not help being impressed. He seemed somewhat like a lighted lamp casting a soft, shaded, velvety glow. He went about her room, after his introduction, looking at her pictures, her bronzes and clays, asking after the creator of this, the painter of that, where a third thing came from.

"I never heard of one of these books," he said frankly when he looked over her small, specially selected collection.

"There are some very interesting things here," she volunteered, coming to his side, his simple confession appealing to her. He was like a breath of fresh air. Richard Wheeler, who was also present, made no objection to being neglected. He wanted her to admire his find.

"You know," said Eugene, looking up from Burton's "Kasidah" and into her brown eyes, "New York gets me dizzy. It's so wonderful."

"Just how?" she asked.

"It's so compact of wonderful things. I saw a shop the other day full of old jewelry and ornaments and quaint stones and clothes, and oh, heavens! I don't know what all—more things than I had ever seen in my whole life

before; and here in this quiet side street and this unpretentious house I find this room. Nothing seems to show on the outside. Everything seems to be crowded to suffocation with luxury or art value on the inside."

"Are you talking about this room, sir?" she ventured.

"Why, yes," he replied.

"Take note, Mr. Wheeler," she called over her shoulder to her young editor friend. "This is the first time in my life that I have been accused of possessing luxury. When you write me up again I want you to give me credit for luxury. I like it."

"I'll certainly do it," said Wheeler.

"And he said art values, too."

"Yes. Art values. I have it," said Wheeler.

Eugene smiled. He liked her vivacity.

"I know what you mean," she added. "I've felt the same thing about Paris. You go into little unpretentious places there and come across such wonderful things—heaps and heaps of fine clothes, antiques, jewels. Where was it I read such an interesting article about that?"

"Not in *Craft*, I hope," ventured Wheeler.

"No, I don't think so. *Harper's Bazar*, I believe."

"Ah, pshaw!" exclaimed Wheeler, crestfallen. "*Harper's Bazar*! Just my luck. What rot!"

"But that's just what you ought to have. Why don't you do it over for *Craft*?"

"I will," he said.

Eugene went to the piano and turned over a pile of music. Again he came across the unfamiliar, the strange, the obviously distinguished—"Arabian Dance," by Grieg; "Es war ein Traum," by Lassen; "Elegie," by Massenet; "Otidi," by Davydoff; "Nymphs and Shepherds," by Purcell—things that smacked of color and beauty by their very titles. Gluck, Sgambati, Rossini, Tschaikowsky; the Norseman, Grieg; the Pole, Wieniawski; the Italian, Scarlatti—he marveled at what he did not know about music.

"Play something," he pleaded, and with a smile Miriam stepped to the piano.

"Do you know 'Es war ein Traum'?" she inquired.

"No," he said.

"Oh, that's lovely," put in Wheeler. "Sing it."

He had assumed that possibly she sang, but he was not prepared for the burst of color that came with her voice. It was not great, but sweet, sympathetic, equal to the tasks she set herself. She selected her music as she selected her clothes—to suit her capacity. The poetic, sympathetic reminiscence of the song came home with real force. Eugene was delighted.

"Oh," he exclaimed hitching his chair close to the piano and looking in her face, "you sing beautifully."

She gave him a glittering smile. "Now I'll sing anything you want for you—if you go on like that."

"I'm crazy about music," he said. "I don't know anything about it, but I like this sort of thing."

"You like the really good things. I know. So do I."

He felt flattered and grateful. They went through "Otidi," "The Nightingale," "Elegie," "The Lost Spring"—music Eugene had never heard before. He knew at once that he was listening to music which represented a better intelligence, a keener selective judgement, a finer artistic impulse than anyone he had ever known had possessed. Ruby played and Angela, the latter much better than the former, but neither had ever heard of these things, he was sure. Ruby had only liked popular things; Angela, the standard melodies, beautiful but notably familiar. Here was someone who seemed to ignore popular taste—was far in advance of it. In all her music he had found nothing he knew. It grew on him as a significant fact. He wanted to be nice to her, to have her like him. So he drew close and smiled and she always smiled back. Like the others, she liked his face—his mouth, his eyes, his hair.

"He's charming," she thought, when he eventually left, and his impression of her was of a woman who was notably and significantly distinguished.

CHAPTER XXIII

It is a question as to what their mutual sympathetic admiration and understanding might not have led, if it had not been for the peculiarly conservative and at times reactionary temperament of Miss Finch. She had been raised in a family of middle western origin which did not understand or sympathize very much with the artistic temperament. Since her sixteenth year, when she had first begun to feel those definite strivings toward the artistic, her parents had guarded her jealously against what they considered the corrupting atmosphere of the art world. Her mother had first brought her to New York from Ohio and lived with her while she studied art in the local art school, chaperoning her everywhere. When it became advisable, as she thought, for Miriam to go to Paris and Rome, she went with her, accompanying her through the galleries of Rome, Florence, Venice, Munich, Dresden, and those of every other city of importance. She was permitted to see the art world from a distance, as it were—to partake of it under proper

supervision. When she lived in the Latin Quarter in Paris, her mother was with her; when she loitered in the atmosphere of the galleries and palaces in Rome, it was with her mother at her side. At Pompeii and Herculaneum, in London, in Berlin, her mother, an iron-willed little woman of forty-five at that time, was with her. She was convinced that she knew exactly what was good for her daughter and had more or less insisted on Miriam's accepting her theories. Later Miriam's personal judgement began to diverge slightly from that of her mother, and then the trouble began.

It was vague at first—hardly a definite, tangible thing in the daughter's mind—but later it grew to be a definite feeling that her life was being severely cramped. She had been warned off from association with this person and that; had been shown the pitfalls that surround the free, untrammelled life of the art studio. Marriage with the average artist was not to be considered. Modelling from the nude, particularly the nude of a man, seemed to her mother at first most painful. She insisted on being present and for a long time her daughter thought it was all right. Finally the presence, the viewpoint, the intellectual insistence of her mother became too irksome and an open rupture followed. It was one of those family tragedies which almost kill conservative parents. Mrs. Finch's heart was practically broken.

The trouble with this rupture was that it came a little too late for Miriam's heart happiness. In the stress of this insistent chaperonage she had lost her youth—the period during which she felt she should have had her natural freedom. She had lost the interest of several men who in her nineteenth, twentieth and twenty-first years had approached her longingly, but who could not stand the criticism of her mother. She had grown to be critical herself and now, at thirty-two, realized it. At twenty-eight, when the row came, the most delightful love period was over and she felt grieved and resentful.

At that time she had insisted on a complete and radical change for herself. She had managed to get, through one art house and another, commissions or rather orders for certain spirited clays which she did. There was a dancing girl, a visualization of one of the moods of Carmencita—a celebrated dancer of this period—which had caught the public fancy. At least the particular art dealer who was handling her work for her had managed to sell some eighteen replicas of it at $175 each. Miss Finch's share of this was $100 each. There was another little thing—a six-inch bronze called *Sleep* which had sold some twenty replicas in all at $150 each and was still selling. *The Wind,* a figure crouching and huddling as if from cold, was also selling. It looked as though she might be able to make from three to four thousand dollars a year steadily.

She demanded of her mother at this time the right to a private studio, to go and come when she pleased, to go alone where she pleased, to have men and women come to her private chamber and be entertained by her in her own manner. She objected to supervision in any form, cast aside criticism, and declared roundly that she would lead her own life. She realized sadly while she was doing it, however, that the best was gone—that she had not had the wit or the stamina or the individuality to do as she pleased at the time she had most wanted to do so. Now she would be almost automatically conservative. She could not help it.

Eugene, when he first met her, felt this. He felt the subtlety of her temperament, her philosophic conclusions, what might be called her emotional disappointment. She was eager for life, just why, he could not say for she appeared to have so much. By degrees he got it out of her, for they came to be quite friendly, and then he understood quite clearly just how things were.

By the end of three months and before Christina Channing appeared, Eugene had come to the sanest, cleanest understanding with Miss Finch that he had yet reached with any woman. She had moved back to her mother's home after three years of absence and quarreling, having come to a definite understanding as to her rights and privileges, and Eugene had dropped into the habit of calling there regularly, once and sometimes twice a week. He had learned to understand her point of view which was notably aesthetic and rather removed from the world of the sensuous. Love to her, if it ever came, meant happy marriage with children. She had long wished that she could get married but the right person had not appeared. Her ideal had been fixed to a certain extent by statues and poems of Greek youth—Hylas, Adonis, Perseus—and by those men of Arthur's court painted by G.F. Watts, Millais, Burne-Jones, Dante Gabriel Rossetti, and Ford Madox Brown. She had hoped for a youth with a classic outline of face, distinction of form, graciousness of demeanor, and an appreciative intellect. He must be manly but artistic and strong. It was a rather high ideal, not readily capable of fulfillment for a woman already turned thirty, but nevertheless worth dreaming about.

Although she had surrounded herself with talented youth as much as possible—both young men and young women—she had not come across *the one*. There had been a number of times when, for a very little while, she had imagined she had found him, but had been compelled to see her fancy fade into a cold reality. All the youths she knew had been inclined to fall in love with girls younger than themselves—some with the interesting maidens she introduced them to. It is hard to witness an ideal turning from you, who are intellectually and spiritually its counterpart, and fixing itself upon some mere fleshly vision of beauty which a few years will cause to fade. Such had been her fate, however, and she was at times inclined to

despair. When Eugene appeared she had almost concluded that love was not for her, and she did not flatter herself that he would fall in love with her. Nevertheless she could not help but be interested in him and look at times with a longing eye at his interesting head and body. It was so obvious that if he had loved at all it would be dramatically, and in all probability beautifully.

As time went on she laid herself out to be nice to him. He had, as it were, the freedom of her room. She knew of exhibitions, personalities, movements—in religion, art, government, literature—almost everything, in fact, that was going on. She was inclined to take a slight interest in socialism and believed in righting the wrongs of the people. Eugene thought he did, but he was so keenly interested in life as a spectacle that he hadn't as much time to sympathize as he thought he ought to have. She took him to see exhibitions and to meet people, being rather proud of a boy with so much talent, and she was pleased to find that he was so generally acceptable. People, particularly artistic people, writers, poets, musicians—beginners in every field—were inclined to remember him. He was an easy talker, witty, quick to make himself at home, and perfectly natural. He tried to be accurate in his judgements of things, and fair, but of course he was young and subject to strong prejudices. He could have proposed to Miriam any time after the third month and won her acceptance, but it would have had to have been a sincere and convincing proposal. Eugene did not, of course, care enough for her to do that. He felt himself well bound to Angela, and curiously he felt Miriam's age more keenly than he did Angela's. Her intellectual superiority made this difference, in all probability, more noticeable. At any rate, though he admired Miriam tremendously and was learning, through her in part, what his ideal ought to be, he was not drawn sufficiently to want to make love to her. She kept him affectionately at a distance and he realized clearly that he must make all the advances and do the promising or there would be no match. So he kept reasonably well aloof, but he admired her greatly.

On the other hand, with Christina Channing, whom he met shortly afterwards, he found a woman who was intrinsically of a more sensuous and lovable type, though hardly the less artistic. Miss Channing was a singer by profession, living also in New York with her mother, but not, as Miss Finch had been, dominated by her so thoroughly, although she was still at that age where her mother could and did have considerable influence with her. She was twenty-seven years of age and so far (and unfortunately, she thought) had not attained the eminence which subsequently was hers, though she was full of that buoyant self-confidence which makes for eventual triumph. So far she had studied ardently under various teachers, had had

several love affairs—none serious enough to win her away from her chosen profession—and had come through the various experiences of those who begin ignorantly to do something in art and eventually, through experience, achieve an understanding of how the world is organized and what they will have to do to succeed.

Although Miss Channing's artistic sense did not achieve that definite artistic expression in her material surroundings which characterized Miss Finch's studio atmosphere, it went much farther in her expression of joy in life. Her thoughts were beautiful and her ability to sing was a talent of great distinction. Her voice was a rich contralto, deep, full, colorful. What is more, it had a note of pathos and poignancy which gave a touch of emotion to the gayest things she rendered. She could play well enough to accompany herself with delicacy and emphasis. Her presence in America at this time was due to a profitable opportunity to sing in concert with the New York Symphony Orchestra. She was one of its soloists, with the privilege of accepting occasional outside engagements. The following fall she was preparing to make a final dash to Germany to see if she could not connect with a notable court opera company and so pave the way for an eventual debut in a New York opera. She was already quite well known in musical circles as a promising operatic candidate and her eventual arrival would be not so much a matter of talent as of luck.

It should be said here, in connection with these two women, that while they fascinated Eugene for the time being, diverting his attention from his recent enthusiasm for Angela, his feeling for the latter continued quite as strong, for while he saw her losing ground comparatively on the intellectual and artistic sides, he felt her to be more than holding her own emotionally. He had learned, as he thought, by observation of life that there were two kinds of greatness possible in an individual—intellectual and emotional. By making studies of such literary and art personalities as Sapho in Daudet's book of that name, Mademoiselle Marguerite Gautier in *La Dame aux camélias*, Manon Lescaut, Carmen, Fior d'Aliza, Trilby—to say nothing of the stories of Paul and Virginia, Abélard and Héloïse, Dante and Beatrice— he had come to the conclusion that there were women and men (women more suitably than men) who were, let us say, intellectually indifferent or even deficient while being emotionally marvellous. Sarah Bernhardt, for instance, he considered to be more emotionally than intellectually great, though she partook of both. Most successful actresses he considered to have more emotional capacity than intellectual force. Their art was intuitional. In ordinary life a woman like Carmen or Sapho or Trilby might come and pass without a chronicler and the world would be no wiser, but she would have been nonetheless great for being obscure. He was beginning to feel

that Angela was one such, for there was a poignancy about her love let-
ters, and intensity about her personal feelings when in his presence, which
moved him in spite of himself. He tried to keep sane but there was an ache
that went with her which evoked the traditions of Sapho and Mademoi-
selle Marguerite Gautier. It occurred to him now that if he threw her down
it might go seriously with her. He did not know what she would do—what
effect it would have on her life. He did not actually think of doing so at
present but he was seeing that there was a difference between Angela and
the women of intellectual and art capacity such as Miriam Finch. Besides
that, there was a whole world of society women swimming into his ken—
women whom as yet he only knew of through the newspapers and the smart
weeklies like *Town Topics* and *Vogue* who were presenting still a third order
of excellence—that of physical perfection. Vaguely he was beginning to see
that the world was immensely large and subtle, and that there was a lot to
learn about women that he had never dreamed of.

And then he met Christina Channing—a girl who was intrinsically of a
more sensuous and lovable type than Miriam Finch, hardly less artistic and
much more beautiful to look upon. She was as wonderful in her way from a
physical point of view as Angela Blue, having a perfectly rounded form of
perhaps five feet, ten inches in height, and 140 pounds in weight. She had
a lovely oval face, rounded, nut brown as to complexion, and with a rosy
glow of health showing through the cheeks and lips. Her eyes were large,
brown, lustrous, intelligent, and sympathetic. She had a mass of blue-black
hair which rivaled Angela's in volume and beauty, and her disposition was
sensitive, philosophic, and emotional.

Eugene met her through the good offices of Shotmeyer. It seems that
through some mutual friend in Boston he had been given a letter of intro-
duction to Miss Channing, who had received him socially in the spirit in
which he was sent. She did not think very much of Shotmeyer but he was
good-natured, full of current gossip, courteous, and always willing to be
useful, and so he was generally tolerated where one would have fancied he
would not be. He spoke of Eugene to Miss Channing and her mother as being
a very brilliant young artist and his friend, and wished that he might bring
him up some evening to hear her sing. Miss Channing acquiesced, for she
had seen some of his drawings and was struck by the poetic note in them.
Shotmeyer, vain of his notable acquaintances, described Miss Channing's
voice to Eugene and asked him if he did not want to call on her some eve-
ning. "Delighted," said Eugene.

An appointment was made and in a suite of three rooms in a supe-
rior Nineteenth Street boarding house he was received by Miss Channing,
arrayed in a smooth close-fitting dress of black velvet, touched with red at

the throat and the ends of the sleeves, and with a flowing red silk tie orna-menting her bosom. Eugene was reminded of the first costume in which he had seen Ruby. He was dazzled. As for her, she confessed to him afterwards, she was somehow aware of a peculiar subconscious perturbation—why, she could not say.

"When I put on my tie that night," she told him, "I was going to put on a dark blue silk one I had just bought and then I thought, 'no, he'll like me better in a red one.' Isn't that curious? I just felt as though you were going to like—as though we might know each other better. That young man—what's his name?—described you so accurately."

This confession came months afterward, the following summer in the Blue Ridge, but it serves to illuminate the condition of her mind on this evening.

When Eugene entered, it was with the grand air he had acquired since his life had broadened in the East. He took his relationship with talent, particularly female talent, seriously. He stood up very straight, walked with a notable stride, drove an examining glance into the very soul of the person he was looking at. He was quick to get impressions particularly of talent. He could feel ability in another. When he looked at Miss Channing he felt it—a strong wave of something came to him—the vibrating waves of an intense consciousness.

"Oh, how are you," she said, extending a soft white hand. "I'm glad to know you. Mr. Shotmeyer has been speaking of you."

"The pleasure is all the other way around," he replied. "I've been hearing of you. It sounds like an even break but it isn't. Music is the finer thing."

Her dark brown eyes swept his total composition. "Yes, this was a real man," she thought, "forceful, vigorous, enthusiastic. He was as good to look at as his art."

"My mother, Mr. Witla," she announced, as a little, wrinkled, gray-browed old lady came in the room.

Eugene shook hands with her. They sat down, conversing generally, and presently Miss Channing sang. She sang with vigor, passion, enthusiasm, and Eugene felt as if she were singing to him. Her cheeks were flushed and her lips red.

"You're in splendid voice this evening, Christina," her mother remarked after she had finished "Che faro senza Euridice."

"I feel particularly good," she replied.

"A wonderful voice," exclaimed Eugene. "Beautiful. It's like a big red poppy or a great yellow orchid."

Christina thrilled. The description caught her fancy. It seemed true. She felt something of that in the sounds to which she gave vent.

"Please sing 'Who is Sylvia,'" he begged a little while later. She complied gladly.

"That was written for such as you," he said softly as she ceased, for he had come close to the piano. "You remind me of her."

Her cheeks colored warmly.

"Thanks," she nodded. But her eyes spoke.

She welcomed his daring and she was glad to let him know it.

CHAPTER XXIV

The entrance of these two women into Eugene's life was at once an illuminating, a disturbing, and a fascinating thing. Warm as he was towards talent and ability in men, he was doubly so to the same thing in women. A talented woman, good looking, healthy, with a clear insight into the affairs of life, able to converse with him on his own plane, to match him, thought for thought, emotion for emotion—a woman with a sense of humor, that rare thing in the sex, and with the courage to think and talk of things as they were and not as the rank and file assumed them to be—he might have vaguely dreamed of such a one up to now but he had not found her. Ruby and Margaret had in their way been free from conventions but they had not possessed that mental outlook which would have lifted them out of the commonplace, made them fit companions for a man of intellect, and given them a place in the world. They were better than the rank and file of women at that, he thought. There was more freedom to their souls—more courage. At least they dared to do the things they wanted to do and were not mere chattels. As Eugene saw most women now, they were tied by a thousand ties; afraid to turn their heads, afraid to call their names their own. He accused them in his consciousness of not being able to think, of being mostly hacks, and he passed them by with utter indifference. He did not accuse the ideal mother-woman of being pointless, but somehow he did not class her with the average woman. In his judgement the ideal mother was not so very much more common than the woman of talent. But a real thinking woman—a woman of emotion or rare judgement, of transcendent beauty and talent combined—he was on his knees at once. They called forth the finest fire that was in him. He did his best to make them feel that he was a master equal to their finest fancy.

The trouble with this situation, and it was a most serious one to him, was that he was not making money commensurate with what he considered his needs, his tastes, or his talents. He had, as has been said, been able to earn

about $1200 the first year. The second he made a little over two thousand, and this third year he was apparently approaching this same mark, possibly doing a little better, but in view of what he saw around him and what he now knew of life, it was nothing. New York presented a spectacle of physical munificence such as he had never dreamed really existed. The carriages on Fifth Avenues, the notable dinners at the great hotels, the constant talk of society functions in the newspapers, made his brain dizzy. He was inclined to idle about upon the streets, to watch the handsomely dressed crowds, to study the evidences of show and refinement everywhere, and he came to the conclusion that he was not living at all, but existing. Art as he had first dreamed of it, art had seemed not only a road to tremendous distinction but also to affluence. Now as he studied those about him he found that it was not wholly so, not even partially so. Artists were never tremendously affluent, he learned. He remembered reading in Balzac's story *Cousin Betty* of a certain artist who had attained great distinction being allowed condescendingly by one of the rich families of Paris to marry a daughter, but it was considered a great come down for her. He could hardly credit the idea at the time, so exalted was his idea of the artist's life, but now, however, he was beginning to see that it must be so. There were certain artists who were tremendously popular in America—meretriciously so, he thought in certain cases—who were earning from ten to fifteen thousand a year, so report had it. Where would that put them, he asked himself, in that world of real luxury which was made up the so-called *four hundred*—the people of immense wealth and social position? Why, he read in the papers where it took from fifteen to twenty-five thousand dollars a year to clothe a single debutante. It was nothing uncommon, he heard, for a man to spend from fifteen to twenty dollars on a single restaurant dinner. The prices that he heard tailors demanded, that dressmakers commanded, the display of jewels and expensive garments at the opera, made the poor little income of any artist look like nothing at all. Miss Finch was constantly telling him of the show and swagger she met with in her circle of acquaintances, for she had managed by her tact and adaptability to make friends with a number of people in society. Miss Channing, when he came to know her better, made constant references to things she came in contact with—notable functions, great artists paid $1,000 a night for singing or playing, tremendous salaries commanded by the successful opera stars. He began, as he looked at his own meagre little income, to feel shabby again and run down, much as he had during those first days in Chicago. Why art, outside of its fame, was nothing. It did not make for actual living. It made for a kind of blooming mentally, which everybody recognized, but you could be a poor, sick, hungry, shabby genius—you actually could. Look at Verlaine, who had recently died in Paris.

A part of this feeling was due at this time to the opening of a golden age of luxury in New York and the effect the reiterated sight of it was having on Eugene. Tremendous fortunes had been amassed by various individuals in the preceding fifty years and now there were thousands of residents of the great new city who were worth anywhere from one to fifty and in some instances a hundred million dollars. The metropolitan area, outside of Manhattan Island and, particularly, Manhattan Island above Fifty-Ninth Street, was growing like a weed. Great hotels were being erected in various parts of the so-called "white light" district. There was beginning, just then, the first organized attempts of capital to supply a new need—the modern sumptuous eight, ten, and twelve story apartment houses which were to house the world of the newly rich middle class who were beginning to pour into New York from every location. Money was being made in the West, the South and the North by various individuals, and as fast as their capital permitted—as fast as they deemed they had sufficient to permit them to live in luxury for the rest of their days—they were moving East, occupying these expensive chambers on Manhattan Island, crowding the great hotels, patronizing the sumptuous restaurants, giving the city its air of spendthrift luxury. All the things which catered to showy material living were beginning to flourish tremendously: art curio shops, rug concerns, decorative companies dealing with either the old or the new in hangings, furniture, objects of art; dealers in paintings, jewelry stores, china and glassware houses—anything and everything, in short, which goes to make up a comfortable and brilliant spectacle of living. Eugene, as he strolled about the city, saw this, felt the impending change, realized that the drift was toward greater population, greater luxury, greater beauty. His mind was full of the sense of the necessity of living *now*. He was young *now*; he was vigorous *now*; he was keen *now*; in a few years he might not be—seventy years was the allotted span and twenty-five of his had already gone. How would it be if he never came into this luxury, was never allowed to enter society, was never permitted to live as wealth was now living? The thought hurt him. He felt an eager desire to tear wealth and fame from the bosom of the world. Life must give him his share. If it did not he would curse it to his dying day. So he felt when he was turning toward twenty-six.

The effect of Christina Channing's friendship for him was particularly to emphasize this. She was not so much older than he, was possessed of very much the same temperament, the same hopes and aspirations and she saw almost as clearly as he did the current drift of events. New York was to witness a golden age of luxury. It was already passing into it. Those who rose to distinction in any field, particularly painting or music or the stage, were apt to witness and share a most notable spectacle of luxury. Christina

hoped to. She was sure she would. After a few conversations with Eugene she was inclined to feel that he would. He was so brilliant, so incisive.

"You have such a way with you," she said, the second time he came. "You're so commanding. You make me think you can do almost anything you want to."

"Oh, no," he deprecated. "Not as bad as that. I have just as much trouble as anyone getting what I want."

"Oh, but you will, though. You have the ideas."

It did not take these two long to reach an understanding. They confided to each other their individual histories, with notable reservations of course, at first. She told him of her musical history beginning at Hagerstown, Maryland, and he went back to his earliest days in Alexandria. They discussed the differences in parental control to which they had been subject. He learned of her father's business, which was that of oyster farming, and confessed frankly on his part to being the son of a sewing machine agent. They talked of small town influences, early illusions, the different things they had tried to do. She had sung in the local Methodist church, had once thought she would like to be a milliner, had fallen in the hands of a hack teacher who tried to get her to marry him, and she had been on the verge. Something happened—she went away for the summer, or encountered a new man, or something of that sort, and had changed her mind.

After an evening at the theatre with her, a late supper one night, and a third call, to spend a quiet evening in her room, he took her by the hand. She was standing up by the piano near him and he was looking at her rounded cheeks, her large, inquiring eyes, her smooth, rounded neck and chin. "You like me," he said suddenly, apropos of nothing save the mutual attraction that was always running strong between them.

Without hesitation she nodded her head, though the bright blood mounted to her neck and cheeks.

"You are so lovely to me," he went on, "that words are of no value. I can paint you. Or you can sing me what you are, but mere words won't show it. I have been in love before but never with anyone like you."

"Are you in love?" she asked naively.

"What is this?" he asked, and slipped his arms about her, drawing her close.

She turned her head away, leaving her rosy cheek near his lips. He kissed that, then her mouth and her neck. He held her chin and looked into her eyes.

"Be careful," she said. "Mama may come in."

"Hang mama!" he laughed.

"She'll hang you if she sees you. Mama would never suspect me of anything like this."

"That shows how little mama knows of her Christina," he answered.

"She knows enough at that," she confessed gaily. "Oh, if we were only up in the mountains now," she added.

"What mountains?" he inquired curiously.

"The Blue Ridge. We have a bungalow up at Florizel. You want to come up there when we go there next summer."

"Will mama be there?" he asked.

"And papa," she laughed.

"And I suppose cousin Annie."

"No, but brother George will be."

"Nix, for the bungalow," he replied, using a slang word that had become immensely popular.

"Oh, but I know all that country around there. There are some lovely walks and drives."

She said this archly, naively, suggestively, her bright face lit with an intelligence that seemed perfection.

"Well, such being the case!" he smiled. "And meanwhile?"

"Oh, meanwhile we just have to wait. You see how things are." She nodded her head toward an inside room where Mrs. Channing was lying down with a slight headache. "Mama doesn't leave me very often."

Eugene did not know exactly how to take Christina. He had never encountered this attitude before. Her directness, coming in connection with so much talent, such real ability, rather took him by surprise. He did not expect it—did not think she would confess affection for him, did not know just what she meant by speaking in the way she did of the bungalow and Florizel. He was flattered, raised in his own self-esteem. If such a beautiful, talented creature as this could confess her love for him, what a personage he must be. And she was thinking of a freer love situation with him—just what?

He did not want to press the matter too closely then, and she was not anxious to have him do so—she preferred to be enigmatic. But there was a light of affection and admiration in her eye which made him intensely proud and happy just as things were.

As she said, there was little chance for lovemaking under the existing conditions. Her mother was with her most of the time. Christina invited Eugene to come and hear her sing at the Philharmonic concerts, and once in a great ball room at the Waldorf-Astoria, and once in the imposing auditorium of the Carnegie Hall, and a third time in the splendid auditorium of the Arion Society, where he had the pleasure of seeing her walk briskly to the footlights, the great orchestra waiting, the audience expectant, herself arch, assured, almost defiant, he thought, and so beautiful. She looked so shapely, budding, and distinguished in dark cream silk with a great train

caught up by a silken ribbon on her bare, rounded arm and a bunch of dark red roses at her waist. Her wealth of black hair was so smoothly laid over her distinguished brows. He could see that she was forceful, magnetic, a winning personality. When the great house thundered in applause he was basking in one delicious memory of her.

"Last night she had her arms about my neck. Tonight when I call and we are alone, she will kiss me. That beautiful, distinguished creature standing there bowing and smiling, loves me and no one else. If I wanted to ask her she would marry me—if I were in the position and had the means."

"If I were in the position"—that thought cut him, for he knew that he was not. He could not marry her. Really she would not have him, knowing how little he made, or would she? He wondered.

CHAPTER XXV

Toward the end of spring he concluded he would go up in the mountains near Christina's bungalow this summer rather than back, as he had promised himself, to see Angela. The memory of that precious creature was, under the stress and excitement of metropolitan life, becoming a little bit tarnished. His memories of her were as delightful as ever—they were as redolent of beauty—but he had seen another kind of woman and he was beginning to wonder whether he had not made a mistake. He was beginning to see so many and such varied angles to living. The smart crowd in New York was composed of a different type. Angela was sweet and lovely but would she fit in? How would she compare with Miriam Finch; how with Christina Channing? The former with her subtle, eclectic selections was a constant source of education and improvement to Eugene. She was as good as a school. He would sit and listen to her descriptions of plays, her appreciation of books, her summing up an analysis of current philosophies, and he could almost feel himself growing. She knew so many people, could tell him where to go to see just such and such an important thing. All the startling personalities, the worthwhile sermons, the new actors, somehow she knew about them.

"Now Eugene Witla," she would exclaim on seeing him, "you just must go and see Hayden Boyd in *The Signet*," or "see Elmina Deming in her new dances," or "look at the pictures of Winslow Homer that are being shown at Knoedler's." She would explain with exactness why she wanted him to see them, what points she thought they would make with him. She frankly confessed to him that she considered him a genius and always insisted on

knowing what new thing he was doing. When any work of his appeared and she liked it, she was frank and quick to express it. He almost felt as if he owned her room and herself; as if all that she was—her ideas, her friends, her experiences—belonged to him. He would go and draw on them by sitting at her feet or going with her somewhere. When spring came she liked to walk with him—to listen to his comments on nature and life.

"That's just fine," she would exclaim. "Now why don't you write that?" or "why don't you paint that?"

He showed her some of his minor poems once and she had copies made of them and pasted them in a book of what she called exceptional things. So he was coddled by her.

In another way Christina was equally nice. Having confessed her love, she was frank to tell Eugene how much she thought of him, how nice she thought he was. "You're so big and smarty," she said to him once, pinioning his arms and looking into his eyes. "I like the way you part your hair, too. You're kinda like an artist ought to be."

"That's the way to spoil me," he replied. "Let me tell you how nice you are. Want to know how nice you are?"

"Uh-huh," she smiled, shaking her head to mean "no."

"Say," he said, violently gripping her. "Wait till we get to the mountains. I'll tell you."

He sealed her lips with his, holding her until her breath was almost gone.

"Oh, you!" she exclaimed. "You're terrible. You're like steel."

"And you're like a big red rose—kiss me."

From Christina he learned all about the musical world and musical personalities. He gained a thorough insight into the different forms of music and just how they worked out in composition—operatic, symphonic, instrumental. He learned of all the different forms of composition, the terminology, the mystery of the vocal cords, the methods of training. He learned of the jealousies within the profession, what the best musical authorities thought of such and such composers, such and such singers, such and such virtuosi generally. He learned how difficult it was to gain a place in the operatic world, how bitterly singers fought each other, how quick the public was to desert a fading star. Christina took it all so matter-of-factly that he almost loved her for her courage. She was so wise and so good-natured.

She was industrious too, an omnivorous reader, a student of philosophy, interested in life. "You have to give up a lot of things to be a good artist," she said to Eugene one day. "You can't have the ordinary life and art too."

"Just what do you mean, Chrissy?" he asked, petting her hand, for they were alone together.

"Why, you can't get married very well and have children, and you can't do much in a social way. Oh, I know they do get married but sometimes I think it's a mistake. Most of the singers I know don't do so very well tied down by marriage."

"Don't you intend to get married?" asked Eugene curiously.

"Oh, I don't know," she replied, realizing what he was driving at. "I'd want to think about that. A woman artist is in a d—— of a position any way"—using the letter *d* only to indicate the real word, devil, she wanted to use. "She has so many things to think about."

"For instance?"

"Oh, what people think, like your family, and I don't know what all. They ought to get a new sex for artists—like they have for worker bees."

Eugene smiled. He knew what she was driving at. He did not know how long she had been debating the problem of her virginity as juxtaposed to her love of distinction in art. She was nearly sure that she did not want to complicate her art life with marriage. She was almost positive that success on the operatic stage—particularly the great opportunity for the beginner abroad—was complicated by any sex-liaison. Some escaped, but it was not many. She was wondering in her own mind whether she owed it to life, to current morality or rather the theory of it, and to conventional belief to remain absolutely pure. It was assumed generally that girls should remain virtuous and marry, but this did not necessarily apply to her—should it apply to the artistic temperament? Her mother and her family troubled her. They expected so much. She was virtuous but youth and desire had given her some bitter moments. And here was Eugene to emphasize it.

"It is a difficult problem," he said sympathetically, wondering what she would eventually do about it. He felt keenly that her attitude in regard to marriage affected his relationship to her. Was she wedded to her art at the expense of love?

"It's a big problem," she said and went to the piano to sing.

He half suspected for a little while after this that she might be contemplating some radical step—what, he did not care to say to himself, but he was intensely interested in her problem. This peculiar freedom of thought astonished him—broadened his horizon. He wondered what his sister Myrtle would think of a girl discussing marriage in this way—the to be or not to be of it—what Sylvia? He wondered if many girls did that. Most of the women he had known seemed to think more logically along these lines than he did. He remembered asking Ruby once whether she didn't think that illicit love was wrong and hearing her reply—No. That some people thought it was wrong but that didn't make it so to her. Here was another girl with another theory.

They talked more of love and he wondered why she wanted him to come up to Florizel in the summer. She could not be thinking of ——. She was too conservative. He began to suspect though that she would not marry him—would not marry anyone at present. She merely wanted to be loved for a while, no doubt.

May came and with it the end of Christina's concert work and voice study so far as New York was concerned. She had been in and out of the city all winter—to Pittsburgh, Buffalo, Chicago, St. Paul—and now after a winter's hard work, retired to Hagerstown with her mother for a few weeks prior to leaving for Florizel.

"You ought to come down here," she wrote to Eugene in early June. "There is a sickle moon that shines in my garden and the roses are in bloom. Oh, the odours are sweet and the dew! Some of our windows open out level with the grass and I sing! I sing!! I sing!!!"

He had a notion to run down but restrained himself for she told him that they were leaving in two weeks for the mountains. He had a set of three drawings to complete for a magazine for which they were in a hurry. So he decided to wait until that was done.

In late June he went up in the Blue Ridge, in Southern Pennsylvania, where Florizel was located. He thought at first he would be invited to stay at the Channing bungalow, but Christina warned him that it would be safer and nicer for him to stay at one of the adjoining hotels. There were several expensive ones on the slopes of adjacent hills ranging in price from five to ten dollars a day. Though it was high, Eugene decided to go. He wanted to be with this marvellous creature—to see just what she did mean by wishing they were in the mountains together.

He had saved some eight hundred dollars which was in a savings bank and he withdrew three hundred for this little outing. He took Christina a very handsomely bound copy of Villon, of whom she was very fond, and several volumes of new verse, for she liked poetry. The *Rubáiyát of Omar Khayyám* was comparatively new then—she had not seen it anyhow—and Eugene took that and *London Voluntaries* by W. E. Henley and *The House of Life* by Dante Gabriel Rossetti. All of these, sad in their poetic texture, were nevertheless so beautiful that Eugene was moved to intense philosophic despair. They all preached the nothingness of life, its sadness, albeit the perfection of its beauty.

It should be said of Eugene at this time that he had quite reached the conclusion that there was no hereafter—there was nothing save blind, dark forces moving aimlessly—where formerly he had believed vaguely in a heaven and had speculated some on the curiosity of a possible hell. His reading had led him through some main roads and some odd bypaths of

logic and philosophy. He was an omnivorous reader now and a fairly logical thinker. He had already come across Spencer's *First Principles,* the first volume of the well-known *Synthetic Philosophy,* which had literally torn him up by the roots and set him adrift, and later he had encountered Marcus Aurelius, Epictetus, Spinoza, and Schopenhauer—men who ripped out all his private theories and made him wonder what life really was. He had walked the streets for a long time after reading some of these things, speculating on the play of forces, the decay of matter, the fact that thought forms had no more stability than cloud forms. Philosophies came and went, religions came and went, governments came and went, races arose and disappeared. He walked into the great natural history museum of New York once to discover enormous skeletons of prehistoric animals—things said to have lived two to three millions of years before his day—and he marveled at the intelligence which produced them, the indifference, apparently, with which they had been allowed to die. Nature seemed lavish of types and of individuals and so utterly indifferent to the persistence of anything. He came to the conclusion that he was nothing, a mere shell, a sound, a leaf which had no general significance, and for the time being it almost broke his heart. It tended to smash his egotism, to tear away his intellectual pride. He wandered about dazed, hurt, moody, like a child without its mama. But he was thinking persistently.

Then came Darwin, Huxley, Tyndall, Lubbock—a whole string of British thinkers who fortified the original conclusions of the others but showed him a beauty, a formality, a lavishness of form and idea in nature's methods which fairly transfixed him. He was still reading—poets, naturalists, essayists, novelists—but he was still gloomy. Life was nothing save dark forces moving aimlessly.

The manner in which he applied this thinking to his life was characteristic and individual. To think that beauty should blossom this way for a little while, never to appear anymore, seemed sad. To think that his life should endure for but seventy years and then be no more was terrible. He and Angela were chance acquaintances—chemical affinities—never to meet again in all time. He and Christina, he and Ruby—he and anyone—a few bright hours were all they could have together and then would come the great silence, dissolution, pointless chemistry and physics, and he would never be anymore. It hurt him to think of this but it made him all the more eager to live, to be loved while he was here. If he would only have a lovely girl's arms to shut him safe always. One of his favorite poems was "Gather ye rosebuds while ye may."

It was while he was in this mood that he reached Florizel after a long night's ride and Christina, who was considerable of a philosopher and mel-

ancholy thinker herself at times, was the first to notice it. She was present at the depot with a dainty little trap of her own and advised him to have his bags sent to the nearest hotel which she suggested while he took a drive with her. She was dressed so neatly in a plaid walking shirt of dark blues, reds and greens and a dark maroon waist of silk that she changed his feelings. A dainty revolutionist's cap graced her black hair.

"I know you feel dusty," she said, "but the drive will do you good. I want to show you some of our pretty scenes."

"Our?" he said, climbing up beside her after arranging with a hotel porter for the transfer of his belongings, and they were off for a brisk jaunt along soft yellow dusty roads. The mountain dew was still in the earth though, and the dust was heavy with damp and not flying. Green branches of trees hung low over them, charming vistas came into view at every turn. Eugene fell to squeezing her waist and kissing her lips, for there was apparently no one to see. Neither houses nor pedestrians were numerous.

"Remember I have to see to navigate this trap," she said, as Eugene twisted her head to kiss her lips at leisure.

"That horse knows the way—let him jog," replied Eugene.

"It's a blessed thing he's tame or we'd happen to some accident. What makes you so moody?"

"I'm not moody—or am I? I've been thinking a lot of things of late—of you, principally."

"Do I make you sad?"

"From one point of view, yes."

"And what is that, sir?" she asked, mock-threateningly.

"You are so beautiful, so wonderful, and life is so short."

"You have only fifty years to love me in," she laughed, calculating his age. "Oh, Eugene, what a boy you are!—Wait a minute," she added after a pause, drawing the horse to a stop under some trees. "Hold these," she said, offering him the reins. He took them and she put her arms about his neck. "Now, you silly!" she exclaimed, "I love you, love you, love you! There was never anyone quite like you. Will that help now?" She smiled into his eyes.

"Yes," he answered. "But it isn't enough. Seventy years isn't enough. Eternity isn't enough of life as it is now."

"As it is now," she echoed and then took the reins, for she felt what he felt, the need of persistent youth and persistent beauty to keep it as it should be, and these things would not stay.

CHAPTER XXVI

The days spent in these mountains were seventeen exactly and during that time Eugene and Christina reached a curious spiritual exaltation different from anything he had ever experienced before. In the first place he had never known a girl like Christina, so beautiful, so perfect physically, so incisive mentally, so full of a fine, noble, artistic perception which was at once capable and not too insistently selfish. In fact she did not appear to be selfish at all with him. She was so quick in her ability to perceive exactly what he meant. She was so suggestive to him in her own thoughts and feelings. The mysteries of life employed her mind quite as fully as they did his. She thought constantly of the subtlety of the human body, of its mysterious emotions, of its conscious and subconscious activities and relationships. The passions, the desires, the necessities of life, wove as fine a tapestry for her mind to contemplate as for that of any other living being. She had no time to sit down and formulate her thoughts. She did not want to write—but she worked out, through her emotions and through her singing, the beautiful and pathetic things she felt. And she could talk in a fine, poetic, melancholy vein on occasion. Though there was so much courage and strength in her young blood, she was not afraid of any phase of life or what nature might do with the little substance which was her, when it should be ready to dissolve it.

"Time and chance happeneth to us all," she quoted to Eugene often, and he would gravely nod his head with a sympathetic, "Yes, yes."

The hotel he stopped at was more distinguished than any he had been privileged to enjoy before. He had never had so much money in his life before, to begin with, and he had never been able or felt called upon to spend it in such an easy and for him lavish manner. The room he took—because of what Christina might think—was one of the best. His meals were included in the rate of the room, and the other comforts of the place—the Turkish and Russian baths, the hotel conveyances and so on—were his for a slight increase. He had taken Christina's suggestion and invited her, her mother, and her brother to dinner on several occasions. The remainder of the family had not arrived yet. In return he was invited to breakfast, lunch, and dinner at the bungalow on different occasions.

Christina showed on his arrival that she had planned to be with him alone as much as possible, for she suggested that they go to High Hill and Bald Face and the Chimney—three surrounding mountains—on different days and at reasonable lengths apart. She knew of nice hotels at seven, ten, and fifteen miles distance, to which they could go by train, or drive and return by moonlight.

She had selected two or three secluded spots before he came, located in

thickets and groves where the trees gave way to little open spaces of grass, and here they strung a hammock, scattered their books of verse about, and sat down to enjoy the delights of love and perfect mental companionship.

It was because of these occasions under cloudless skies and in the heart of the late June weather that Christina finally yielded to an arrangement which need not be discussed here but which brought Eugene into a relationship which he had never deemed possible with her. They had progressed by degrees through all those subtleties of lovemaking which are so commonplace to those who know. By degrees they had discussed the nature of passion and emotion, had swept aside as pointless the conclusion that there was any basic evil in the sex relationship, and had decided for themselves that nothing save self-preservation was important. Eugene's task was to convince Christina that she was to come to no harm which he did successfully, but solely because of her intense desire.

She frankly confessed to him, "I don't want to get married. It isn't for me—not until I've thoroughly succeeded, anyhow. I'd rather wait——. If I could just have you and singleness, too."

"Why do you want to yield yourself to me?" asked Eugene curiously.

"I don't know that I exactly want to. I could do with just your love—if you were satisfied. It's you that I want to make happy. I want to give you anything you want."

"Curious girl," observed her lover, smoothing her high forehead with his hand. "I don't understand you, Christina. I don't know how your mind works. Why should you? You have everything to lose if worst came to worst."

"Oh, no," she smiled. "I'd marry you then."

"But to do this out of hand, because you love me, because you want me to be happy!"—he paused.

"I don't understand it either, honey boy," she offered. "I just do."

"But why, if you are willing to do this, you wouldn't prefer to live with me is what I don't understand."

She took his face between her hands. "I think I understand you better than you do yourself. I don't think you'd be happy married. You might not always love me. I might not always love you. You might come to regret. If we could be happy now you might come to the place where you wouldn't care anymore. Then, you see, I wouldn't be sorry that we had never been happy."

"What logic!" he exclaimed. "Do you mean to say you wouldn't care anymore?"

"Oh, I'd care, but not in the same way. Don't you see, Eugene, I would have the satisfaction of knowing that even if we did separate you had had the best of me."

It seemed astounding to Eugene that she should talk this way—reason this way. What a curious, sacrificial, fatalistic turn of mind. Could a young, beautiful, talented girl really be like this? Would anybody on earth really believe it if they knew? He looked at her and shook his head sorrowfully.

"To think that the quintessence of life should not stay with us always," he sighed.

"No, honey boy!" she replied, "You want too much. You think you want it to stay, but you don't. You want it to go. You wouldn't be satisfied to live with me always, I know it. Take what the gods provide and have no regrets. Refuse to think. You can, you know."

Eugene gathered her up in his arms. He kissed her over and over, forgetting in her embrace all the lovers he had ever known. She yielded herself to him gladly, joyously, telling him over and over that it made her happy.

"If you could only see how nice you are to me, you wouldn't wonder," she explained.

He concluded she was the most wonderful being he had ever known. No woman had ever revealed herself to him so unselfishly in love. No woman he had ever known appeared to have the courage and the insight to go thus simply and directly to that which she desired. To hear an artist discussing calmly whether she should sacrifice her virtue to love; whether marriage in the customary form was good for her art; whether she should take him now when they were young or bow to the conventions and let youth pass, was enough to shock his still trammeled soul. For after all, and despite his desire for personal freedom, his intellectual doubts, and mental exceptions, he still had a profound reverence for a home such as that maintained by Jotham Blue and his wife, and for its results in the form of normal, healthy, dutiful children. Nature had no doubt come to this form through a long series of difficulties and experiments and she would not readily relinquish it. Was it really necessary to abandon it entirely? Did he want to see a world in which a woman would take him for a little while as Christina was doing now and then leave him? Did he want Christina to leave him, even though he had had what formerly seemed to him to constitute the chief features of marriage? His experience here was making him think, throwing his theories and ideas up in the air, making a mess of all the notions he had ever formed about things. He almost came to perceive—not quite—that marriage might be based on compatibility of temper and not sex desire, though the latter, being so strong in him, seemed to make the other proposition rather ridiculous. Still, he was beginning to feel that he was glad to be with Christina because of her mental ability. He racked his brain over this proposition of sex and life, sitting on the great verandas of the hotel and wondering over and over just what the answer was and why

he could not be like other men, faithful to one woman—and be happy. He wondered whether this was really so and whether he could not. It seemed to him then, as at a much later period, that he might. He knew that he did not understand himself very clearly; that he had no grasp on himself at all as yet—his tendencies, his possibilities, nothing.

These days, spent as had been those with Angela under such halcyon conditions, made a profound impression on him. He was tremendously impressed with the perfection life could reach at odd moments. These great quiet hills, so uniform in their roundness, so green, so peaceful, rested his soul. He and Christina climbed two thousand feet one day to a ledge which jutted out over a valley and commanded what seemed to him the kingdoms and powers of the earth—vast stretches of green land and subdivided fields, little cottage settlements and towns, great hills that stood up like friendly brothers to this one in the distance.

"See that man down in that yard?" said Christina, pointing to a speck of a being chopping wood in a front space serving as a yard to a country cottage, fully a mile distant.

"Where?" asked Eugene.

"See where that red barn is, just this side of that clump of trees? Don't you see, there, where those cows are in that field."

"I don't see any cows."

"Oh, Eugene, what's the matter with your eyes? I know they're small but——"

"Oh, now I see," he replied, squeezing her fingers. "He looks like a cockroach, doesn't he?"

"Yes," she laughed.

"How wide the earth is and how small we are. Now think of that speck with all his hopes and ambitions—all the machinery of his brain and nerves—and tell me whether any God can care. How can He, Christina?"

"He can't care for any one particular speck much, sweet. He might care for the idea of man or a race of man as a whole. Still, I'm not sure, honey. All I know is that I'm happy now."

"And I," he echoed.

Still they dug at this race problem, the question of the origin of life—its why. The stratification of earth substances, the denuding power of frost and heat and rain, the tremendous and wearisome age of the earth, the veritable storms of birth and death that seem to have raged at different periods, all came up for discussion.

"We can't solve it, Eugene, mio," she laughed. "We might as well go home. Poor dear mama will be wondering where her Christina is. You know,

I think she suspects that I'm falling in love with you. She doesn't care how many men fall in love with me. But if I show the least sign of a strong preference she begins to worry."

"Have there been many preferences?" he inquired.

"No, but don't ask. What difference does it make? Oh, Eugene, what difference does it make? I love you now."

"I don't know what difference it makes," he replied, "only there is an ache that goes with the thought of previous experience. I can't tell you why it is. It just is."

She looked thoughtfully away. "Anyhow, no man ever had me before. Isn't that enough? Doesn't that testify?"

"Yes, yes, sweet, it does. Oh, yes, it does. Forgive me. I won't grieve any more."

"Don't, please," she said. "You hurt me as much as you hurt yourself."

There were evenings when he sat on some one of the great verandas and watched them trim and string the interspaces between the columns with soft, glowing Chinese lanterns, preparatory to the evening's dancing. He loved to see the girls and men of the summer colony arrive, the former treading the soft grass in filmy white gowns and white slippers, the latter in white ducks and flannels, gaily chatting as they came. Christina would come to these affairs with her mother and brother, beautifully clad in white linen or delicate lawns and laces, and he would be beside himself with chagrin that he had not practised dancing to the perfection of the art. He could dance now but not like her brother or scores of men he saw upon the waxen floor. It hurt him. At times he would sit all alone after his splendid evenings with his love, dreaming of the beauty of it all—mostly after midnight or two o'clock in the morning. The stars would be as a great wealth of diamond seed flung from the lavish hand of an aimless sower. The hills, dark and tall, echoed only with the faint cheep of birds. There was peace and quiet everywhere.

"Why may not life be always like this?" he would ask himself, and then he would answer out of his philosophy that it would become deadly after awhile, as all unchanging beauty does. The call of the soul is for motion, not peace. Peace after activity, for a little while, then activity again. So must it be. He understood that well enough.

Just before he left to return to New York, she said to him, "Now when you see me again I will be Miss Channing of New York. You will be Mr. Witla. We will almost forget that we were ever up here together. We will scarcely believe that we have seen what we have seen and done what we have done."

"Why, Christina, you talk as though everything were over. It isn't, is it?"

"We can't do anything like this in New York," she sighed. "I haven't time. And you must work."

There was a premonition of finality in her tone.

"Oh, Christina, don't talk so. I can't think that way. Please don't."

"I won't," she said. "We'll see. Wait till I get back."

He kissed her a dozen farewells and at her door held her close once more.

"Will you forsake me?" he asked.

"No, you will forsake me. But remember dear! Don't you see! You've had all. Let me be your wood nymph. The rest is commonplace."

He went back to his hotel with an ache in his heart, for he knew he had gone through all that he would with her. She had had her summer with him. She had given him of herself fully. She wanted to be free to work now. He could not understand it, but he knew it to be so.

CHAPTER XXVII

It is a rather dreary thing to come back to the hot city in the summer after such a period of beauty in the mountains. The quiet of the hills was in Eugene's mind, the glisten and babble of mountain streams, the soar and poise of hawks and buzzards and eagles sailing the empyrean—the crystal and blue. He felt lonely and sick for a while, out of touch with work and with practical life generally. There were little souvenirs of his recent happiness in the shape of letters and notes from Christina but he was full of the premonition of finality which had troubled him on leaving.

As for Angela, he had not thought of her all the time he had been gone. He had been in the habit of writing her every third or fourth day at the least in the past, and heretofore, while his letters had been growing less passionate, they had remained fairly long and interesting. But now this sudden break coming—it was all of three weeks—made her feel as if he were ill, although she had begun to feel also that he might be changing. His letters had grown steadily less reminiscent of the joys they had experienced together and of the happiness they were anticipating, and more inclined to deal with the color and character of city life and of what he hoped to achieve. Angela was inclined to excuse much of this on the grounds of the special effort he was making to achieve distinction and a living income for themselves. But it was hard to explain three weeks of silence without something quite serious having happened.

Eugene understood this. He tried to explain it on the grounds of illness,

stating that he was now up and feeling much better, but it had the hollow ring of insincerity. Angela wondered what it could be. Was he yielding to the temptation of that looser life which all artists were supposed to lead? She wondered and worried, for time was slipping away and he was setting no definite date for their much discussed nuptials.

The trouble with Angela's position was that this delay involved practically everything which was important in her life. She was getting so far along now in years—being five years older than Eugene—that each additional year or lesser fraction of time meant corresponding changes in that atmosphere of youth and buoyancy which is so characteristic of a girl between eighteen and twenty-two. Then, for a period of four years, the body of maidenhood blooms like a rose and there is about it the freshness and color of all rich, new, lush life. Afterwards the decline is persistent toward something harder, shrewder, and less beautiful. In the case of some persons the decline is slow and the fragrance of youth lingers for years, the artifices of the dressmaker, the chemist and the jeweler being but little needed. In others it is fast, and no artifice will stay the ravages of a restless, eager, dissatisfied soul. Sometimes art combines with slowness of decay to make a woman of almost perennial charm, loveliness of mind matching loveliness of body, and taste and tact supplementing both. Angela was fortunate in being slow to fade and she had much loveliness of imagination and emotion, but she had a restless, troublesome, worrying disposition which, unless it had been stayed to a certain extent by the kindly color of her home life and by the fortunate or unfortunate intervention of Eugene at a time when she considered her ideal of love to have fairly passed beyond the pale of possibility, would have resulted in signs of prospective old maidishness which would have been unmistakable. She was greatly afraid of this, as were her mother and father, and she was worrying about it now. She was not of the newer order of femininity, eager to get out in the world and follow some individual line of self-development and interest. Rather she was your ideal home woman wanting some one man to look after and love. Her ideal of a man was unfortunately high, and she had been spoiled in her attitude toward the joy and necessity of having children, as has been said, by the early and rather compulsory care of children—her sisters'—which were shouldered on to her as a part of family and sisterly consideration. She had had so much care and bother with them already that she was sick of them, and her opposition to the necessity of teaching school was equally bitter. She was waiting patiently to hear from Eugene that he was ready, and was dreaming dreams of the time when she should preside as mistress of a studio in New York—the wonder and beauty of it making the danger of it seem less and the possible compulsory continuance of a humdrum, underpaid, backwoods existence making her sick at heart.

The summer passed. Peter McHugh and Joseph Smite went their respective ways—one to Nova Scotia, the other to Wyoming. Eugene worked alone, lonely. The one significant thing he did was to encounter, in an editorial office in New York, Norma Whitmore, a dark, keen, temperamental, and moody but brilliant writer and editor who, like others before her, took a fancy to Eugene. She was introduced to him by Willis Jansen, art director of the paper.

"I warn you," he said in introducing her, "that you are now meeting the only living specimen of the female 'fan'" (the current baseball term for enthusiast) "now in captivity. She admires your work and has asked to meet you."

Eugene bowed and smiled.

"'Fan' is good," replied Miss Whitmore, who was well aware of the work Eugene was doing or was trying to do, "but I'm more impressed with what you say about captivity. That has a touch of realism to me. Captivity is the thing that describes my condition exactly."

"The bird in the gilded cage," said Eugene solemnly.

"I won't object to being called a bird but I do object to classifying this office as a gilded cage. It can't qualify. If you'll stop at my door as you go out, I'll show you what sort of a cage I do work in."

She led the way to a little room no larger than six by eight where she had her desk. Eugene noticed that she was lean and sallow, as old as himself at least, if not older, but brilliant and vivacious. Her hands took his attention for they were thin, shapely, and artistic. Her eyes burned with a peculiar lustre, and her clothes, though not close fitting, were somehow artistically draped about her. A conversation sprang up as to his work and he was invited to her apartment where she lived with her mother and sister.

Eugene also learned from chance encounters that Oren Benedict and Judson Cole were in New York and that William McConnell was coming. Christina Channing was not in the city again until October, and then for a few days only on her way to Europe. Miriam Finch had been out of the city most of the time. He had worked alone at his drawings, trying to build a series for an exhibition at some time.

It was while Eugene was bestirring himself about life in the city during the fall and winter—with his drawings, his friends (Miriam, Miss Whitmore—he rapidly became intimate with her—Oren Benedict, Judson Cole, Shotmeyer, Richard Wheeler, David Smite and Peter McHugh), and with the quality of its public life generally—that Angela was becoming constantly more restless and disturbed. Because of his recent infatuation for Christina he could not write Angela as heartily as he had before and he did not attempt it. He thought that she was charming, delightful, that he ought to write her regularly and that he ought to go back and marry her pretty soon—he

was getting to the place where he could support her in a studio if they lived economically—but he did not want to exactly. This newer life that he was finding was really much more interesting to him than anything he had ever known. And meanwhile her position was becoming untenable.

He had known her now for three years. It was all of a year and a half since he had seen her last. In the last year he had shown a decline of enthusiasm in his regular letters, growing more and more diffuse. He was finding it difficult to concentrate on love. At the same time he did not have sufficient cold practical wisdom to permit or compel him to take careful stock of his emotions, studying out just where he had reached in his present estimate of life and, finding himself changing and indifferent, writing her frankly that such was the case and asking to be released. Instead he parleyed, held by pity for her passing youth and her notable affection for him, held by his sense of the unfairness of taking up so much of her time to the exclusion of every other person who might have proposed to her, held by sorrow for the cruelty of her position in being left to explain to her family that she had been jilted after her hopes had run so high. It is but fair to say for Eugene, that in spite of his fickleness, he had a kindly, sympathetic, not ungenerous disposition. He hated to hurt any person's feelings. He preferred to save them their face, as the Chinese put it, whenever it was possible although by so doing he was probably doing them a greater ultimate harm. He did not want to be conscious of the grief of any person who had come to suffering through him and he could not very well make them suffer and not be conscious. He was too tender hearted, in short, to be wholly successful in anything save art and that of a purely idealistic character. He drifted in this instance, as he had in that of Ruby, though his qualms of conscience now were much more keen. Ruby, after all, was more or less of a fickle character to begin with. She was not moral. She had not really loved him in the first place but only afterward and then for what, he scarcely knew. He had never really definitely engaged himself to her. To Angela he had pledged himself, giving her a ring, begging her to wait, writing her fulsome letters of protest and desire. Now after three years he was trying to readjust this, shaming her in front of her charming family—old Jotham, her mother, her sisters and brothers. It seemed a bitter, cruel thing to do and he did not care to contemplate it.

On the other hand Angela, by reason of the morbid, passionate, apprehensive nature of her character, was inclined to see disaster looming up in the distance. She loved Eugene passionately and she had been waiting all these years for the privilege of expressing physically and within the confines of sacred matrimony the pent-up fires of her nature. Eugene, by the charm of his manner and the niceness of his body, no less than by the sen-

sual character of some of his moods and the subtleties and refinements of his references to the sex relationship, had stirred her to anticipate a perfect fruition of her dreams, and she was eager for that almost to the place where she would have been willing to discard virtue itself. Certainly her thoughts constituted a form of nymphomania at this time. The remembrance of the one significant scene between her and Eugene was enough to make her wish that, if her love affair was to terminate in indifference on his part, she had not attempted to save herself on that occasion but had yielded, the thought now being that perhaps if he had been permitted to take her, then he would have been involved with the more complicated problem of fatherhood and would have married her out of a sense of sympathy and duty. Anyhow she would have had that crowning glory of womanhood, ardent union with her lover, and if worst had come to worst, she could have died.

It is considerable to charge a girl like Angela with thoughts such as these but so she thought. She thought of the quiet little lake near her home, its glassy bosom a mirror to the sky, and how, in case of failure, she would have looked lying on its sandy bottom, her copper hair diffused by some aimless motion of the water, her eyes sealed by the end of consciousness, her hands pathetically folded. She was an emotionalist with a fancy which outran her daring. She would not have done this, but she could dream about it, and it made her love problem all the more intense. She had not read Sapho but she had long been familiar with Camille and the love problems of the operas.

As time went by and Eugene did not strengthen any in his enthusiasm, this problem of her failure became more harassing and she began to seriously wonder what she could do to win him back to her. He had expressed such a violent desire for her on his last visit, had painted his love in such glowing terms, that she felt convinced he must love her still, though absence and the excitements of city life had dimmed the memory of her temporarily. She remembered a line in a comic opera which she and Eugene had seen together which ran, "Absence is the dark room in which lovers develop negatives," and this seemed a case in point. If she could get him back, if he could be near her again, his old fever would develop and she would then find some way of making him take her perhaps. It did not occur to her quite clearly just how this could be done at this time but some vague notion of self-abasement in the way of a sex complication was already stirring vaguely and disturbingly in her brain.

To help this notion on effectually were the trying and in a way disheartening conditions of her home. Her sister Marietta was, as has been indicated already, surrounded by a score of suitors who were as eager for her love as a bee is for the honey of a flower, and Angela could see that they were already

looking upon her as an elderly chaperon at best who need not be taken into serious consideration, and who fortunately was concerned with a definite affair of the heart of her own. Her mother and father, watching her going about her work, grieved because so good a girl should be made to suffer for the want of a proper marriage arrangement. She could not conceal her feelings entirely and they could tell at times that she was unhappy. She could see that they saw it. It was hard to be explaining to her sisters and brothers, who occasionally asked after Eugene, that he was doing all right, and never be able to say that he was coming for her some day soon.

At first Marietta had been envious of her. She thought she would like to win Eugene for herself, and only consideration for Angela's age and the fact that she had not been so successful in love had deterred her. Now that Eugene was obviously neglecting her, or at least delaying beyond any reasonable period, she was sorry, very. Once, before she had grown into the age of courtship, she had said to Angela, "I'm not going to be like you when I grow up. I'm going to be nice to the men. You're too cold. You'll never get married," and Angela had realized that it was not a matter of "too cold" but an innate prejudice against most of the types she met up with. And then the average man did not take up with her. She could not abandon herself to pleasure in their company. It took a fire like Eugene's to stir her mightily, and once having known it she could brook no other. Now because of these three years she had cut herself off from other men, particularly the one who had been most attentive to her, most faithful—Victor Dean—and she had no one. Because of the lapse of time and her increasing judgement and criticism of life she was not as attractive to the average eligible man, perhaps, who preferred youth and beauty in its unsophistication to full blown womanhood with its keener insight. The thing that saved Angela from being outclassed entirely was a spirit of romance which kept her perennially young in looks and feelings—young enough at least to appear so to the not too critical and observing.

With the fear of desertion in her mind, Angela began to hint to Eugene that he come back to see her—to hope in her letters that their marriage need not, because of any difficulty of establishing himself, be postponed much longer. She said to him over and over that she could be happy with him in a cottage and that she so longed to see him again. Eugene felt that he was certainly badly placed if he really wished to break with her and he began to ask himself whether he did.

The fact that on her passional side Angela appealed to him more than any woman he had ever known was a saving point in her favor in this situation. There was a note in her make-up which was stronger, deeper, more suggestive of joy to come than anything he had found elsewhere. He remem-

bered keenly the wonderful days he had spent with her—the one significant night when she had begged him to save her against herself. All the beauty of the season with which she was surrounded at that time, the pleasing quality of her family, the odour of flowers and the shade of trees, served to make a setting for her charms which had endured with him as fresh as yesterday. Now, without having completed that romance—a very perfect flower—he was thinking of casting it aside. And besides, at this time, he was having no sex relationship with any woman.

Miriam Finch was too conservative and intellectual; Norma Whitmore not attractive enough. The rank and file of women meant nothing at all to him, and as for some other charming examples of femininity whom he had met here and there—he had not been drawn to them or they to him. Emotionally he was lonely and this was always a very susceptible state for him.

It so happened that Marietta, after watching her sister's love affair some time, reached the conclusion that she ought to try to help her. Angela was obviously concealing a weariness of heart which was telling on her peace of mind and her sweetness of disposition. She was unhappy and it grieved her sister greatly. The latter loved her in a whole-hearted way in spite of the fact that their affections might possibly have clashed over Eugene, and she thought once of writing him in a sweet way and telling him how things were. She thought he was good and kind, that he loved Angela, that perhaps he was delaying, as her sister said, until he should have sufficient means to marry right, and that if the right word were said now he would cease chasing a phantom fortune long enough to realize that it were better to take Angela while she was still attractive and he was young, rather than to wait until they were so old that marriage would not mean so much to them any more. She thought over this a long time, picturing to herself how sweet Angela really was and then she finally nerved herself to pen the following letter, which she sent.

"Dear Eugene:
"You will be surprised to get a letter from me and I want you to promise me that you will never say anything about it to anyone— above all never to Angela. Eugene, I have been watching her for a long time now and I know she is not happy. She is so desperately in love with you. I notice when a letter does not come promptly she is downcast and I can't help seeing that she is longing to have you with her. Eugene, why don't you marry Angela? She is lovely and attractive now and she is as good as she is beautiful. She doesn't want to wait for a fine home and luxuries—no girl wants to do that, Eugene, when she loves as I know Angela does you. She would rather have you now when you are both young and can enjoy life than any fine home or nice things

you might give her later. I haven't talked to her at all, Eugene—never one word—and I know it would hurt her terribly if she thought I had written you. She would never forgive me. But I can't help it. I can't bear to see her grieving and longing, and I know when you know that, you will come and get her. Don't ever indicate in any way, please, that I wrote you. Don't write to me unless you want to very much. I would rather you wouldn't. And tear up this letter. But do come for her soon, Eugene, please do. She wants you. And she will make you a perfectly wonderful wife, for she is a wonderful girl. We all love her so—papa and mama and all. I hope you will forgive me. I can't help it.

> "With love I am yours,
> "Marietta."

When Eugene received this letter he was not only surprised and aston-ished but grieved for himself and Angela and Marietta and indeed the whole situation. He saw in a way how things were drifting. He had not read Balzac and Hardy and Tolstoy for nothing. The tragedy of this situation appealed to him quite as much from the dramatic as from the personal point of view. He had a clear conception of what might be called the epic note in life. Little Angela with her bright copper hair and classic face. What a shame that he could not love her as she wished—as really, in a way, he wished. She was beautiful—no doubt of that. And there was a charm about her which was as alluring as that of any girl barring the intellectually exceptional. Her emotions in a way were deeper than those of Miriam Finch and Christina Channing. She could not reason about them—that was all. She could just feel them. He saw all phases of her anguish—the way her parents probably felt, the way she felt being looked at by them, the way her friends wondered. It was a shame, no doubt of that—a cruel situation. Perhaps he had better go back. He could be happy with her. They could live in a studio and no doubt things would work out all right. Had he better be cruel and not go? He hated to think of it.

Anyhow he did not answer Marietta's letter, and he did tear it up into a thousand bits as she requested. If Angela knew that, no doubt she would feel wretched, he thought, and to his credit it should be said that he did try to forget that he ever received it.

In the meanwhile Angela was thinking, and her brooding led her to the conclusion that while she had no means other than her expressions of devotion wherewith to allure her lover, if ever he came to her it might be advisable to yield herself in order that he might feel compelled to take her. She was no reasoner about life in any big sense. Her judgement of affairs was much more confused at this time than at a later period. She did not have a clear conception of how foolish any trickery of this sort in love really is. She

loved Eugene, felt that she must have him, felt that she would be willing to die rather than lose him, and this thought of compromising herself came only as a last resource. If he refused her then she was determined on one thing—the lake. She would quit this dreary world where love was crossed with despair in its finest moments, and forget it all. If only there were rest and silence on the other side, that would be enough.

It came on toward spring, and because of some note of this sentiment, reiterated in pathetic phrases, he came to feel that he must go back. Marietta's letter preyed on his mind. The intensity of Angela's attitude made him feel that something desperate would happen. He could not, in cold blood, sit down and write her that he would not see her any more. The impressions of Black Wood were too fresh in his mind; the summer incense and green beauty of the world in which she lived. He wrote her in April that he would come again in June, and Angela was beside herself with joy.

One of the things which helped Eugene reach this conclusion was the fact that Christina Channing was not coming back from Europe that year. She had written him a few times during the winter but very guardedly. The casual reader could not have drawn from what she said whether there had ever been anything between them or not. He had written her much more enthusiastically, of course, but she had chosen to ignore his eager references, making him feel by degrees that he was not to know much of her in the future. They were going to be good friends but not necessarily lovers nor eventually husband and wife. It irritated him to think she could be so calm about a thing which to him seemed so important. It hurt his pride to think she could so deliberately throw him over. Finally he began to be incensed and then Angela's fidelity appeared in a much finer light. There was a girl who would never treat him that way. She really loved him. She was faithful and true. So his promised trip began to look much more attractive, and by June he was in a fever to see her.

CHAPTER XXVIII

The beautiful June weather arrived and with it he took his departure once more for Black Wood. He was in a peculiar mood, for while he was anxious to see Angela again, it was with the thought that perhaps he was making a mistake. A notion of fatality was beginning to run through his mind, for he was of a brooding, introspective turn which was inclined to see character as fixed by fate. Perhaps he was destined to take her!—and yet could anything be more ridiculous? He could decide. He had deliberately

decided to go back here—or had he? He admitted to himself that his passion was drawing him—in fact he could not see that there was anything in love, much, outside of passion. Sex desire! Wasn't that all that pulled two people together? There was some little charm of personality above that, but in the main, as he reasoned at this time, desire was the keynote. And if the physical attraction were strong enough, wasn't that sufficient to hold two people together? Did you really need so much more? It was poor logic based on youth, enthusiasm and inexperience, but it was enough to hold him for the time being—to soothe him. He was not drawn by any of the things which drew him to Miriam Finch or Norma Whitmore, nor was there the wonderful art of Christina Channing. Still, he was going.

His interest in Norma Whitmore had increased greatly as the winter passed. In this woman he had found an intellect as broadening and refining as any he had encountered. Her taste for the exceptional in literature and art was as great as that of anyone he had ever known, and it was just as individual. She ran to big realistic fiction in literature and to the kind of fresh-from-the-soil art which Eugene represented. Her sense of just how big and fresh was the thing he was trying to do was very encouraging, and she was carrying the word about town to all her friends that he was doing it. She had even gone so far as to speak to two different art dealers, asking them why they had not looked into his, to her, perfectly wonderful drawings.

"Why they're astonishing in their newness," she told Eberhard Zang, one of the important picture dealers on Fifth Avenue. She knew him from having gone there to borrow pictures for reproduction.

"Witla! Witla!" he commented in his conservative German way, rubbing his chin, "I doaned remember seeing anything by him."

"Of course you don't," replied Norma, persistently. "He's new, I tell you. He hasn't been here so very long. You get *Truth* for some week in last March—I forget which one—and see that picture of Greeley Square. It will show you what I mean."

"Witla! Witla!" repeated Zang, much as a parrot might fix a sound in its memory. "Tell him to come in here and see me some day. I should like to see some of his things."

"I will," replied Norma genially. She was anxious to have Eugene go but he was more anxious to get a lot of things done. He had sense enough not to want to risk an impression with anything save a rather large showing. And his selection of views was not complete at that time. Besides he had a much more significant art dealer in mind.

He and Norma had reached the place by this time where they were like brother and sister, or better yet, two good men friends. He would slip his arm about her waist when entering her rooms and was free to hold her hands or

pat her on the arms and back. There was nothing more than strong good feeling on his part while on hers a burning affection might have been inspired, but his genial, brotherly attitude convinced her that it was useless. He had never told her of any of his other women friends and he was wondering as he rode west how she and Miriam Finch would take his marriage with Angela, supposing that he ever did marry her. As for Christina Channing, he did not want to think—really did not dare to think of her very much. Some sense of lost beauty came to him out of that experience—a touch of memory that had a pang in it.

Chicago in June was just a little dreary to him with its hurry of life, its breath of past experience—the Art Institute, the *Daily Globe* building, the street and house in which Ruby had lived. He wondered about her (as he had before) the moment he neared the city, and had a strong desire to go and look her up. She was so nice, after all. Then he visited the *Globe* offices, but Mathews had gone. Nice, genial, cheerful Jerry had moved to Philadelphia recently, taking a position on the Philadelphia *North American*, leaving Howe alone, more finicky and picayunish than ever. Goldfarb, of course, was gone and Eugene felt out of it. He was glad to take the train for Black Wood for, true to his impressionable disposition, he felt lonesome. He left the city with quite an ache for old times in his heart and the feeling that life was a jumble of meaningless, strange, and pathetic things.

"To think that we should grow old," he thought, "that things that were as real as these things were to me should become mere memories."

The time of his approach toward Black Wood constituted a period of great emotional stress for Angela. Now she was to learn whether he really loved her as much as he had. She was to feel the joy of his presence, the subtle influence of his, to her, splendid attitude. She was to find whether she could hold him or not. Marietta, who on hearing that he was coming, had rather plumed herself that her letter had had something to do with it, was afraid that her sister would not make good use of this opportune occasion. She was anxious that Angela should look her best and made suggestions as to things she might wear, games she might play (they had installed tennis and croquet as part of the home pleasures since he had been there last), and places they might go. Marietta was convinced that Angela was not artful enough—not sufficiently subtle in her presentation of her charms. He could be made to feel keen about her if she dressed right, acted right in the sense of posing and showing herself to the best advantage. Even Marietta was nervous, though, and after helping Angela she proposed to keep out of the way as much as possible and to appear at great disadvantage in the matter of dress and appearance when seen, for she had become a perfect beauty and was a breaker of hearts without conscious effort.

"You know that string of coral beads I have, Angel Face?" she asked Angela one morning some ten days before Eugene arrived. She was referring to a string of extra large beads given to her by her sister Ellen which matched Angela's hair and complexion beautifully. "Wear them with that tan linen dress of mine and your tan shoes some day for Eugene. You'll look stunning in those things and he'll like you. Why don't you take the new buggy and drive him over to Black Wood or meet him? That's it. You meet him."

"Oh, I don't think I want to, Babyette," she replied. She was afraid of this first impression. She did not want to appear to run after him. Babyette was a nickname which had been applied to Marietta in childhood and had never been dropped.

"Oh, pshaw, Angel Face, don't be so backward. You're the shyest thing I know. Why that's nothing. He'd like you all the better for treating him just a little smartly. You do that now, will you?"

"I can't," replied Angela. "I can't do it that way. Let him come over here first. Then I'll drive him over some afternoon."

"Oh, Angel Face! Well, anyhow, when he comes then you wear that little rose flowered house dress and put a wreath of green leaves in your hair."

"Oh, I won't do anything of the sort, Babyette," exclaimed Angela.

"Yes you will, too," replied her sister. "Now you just have to do what I tell you for once. That dress looks beautiful on you and the wreath will make it perfect."

"It isn't the dress. I know that's nice. It's the wreath."

The garment in question was a light, close fitting, faintly yellow-tinted house dress with a band of yellow roses at the ruffle line and a little band of yellow leaves worked about the neck, which was cut low. Angela wore a high lace collar with this because her neck was not all that it should be, but she would have looked quite as well with it cut low, and better if she had only thought so. Her objection to the filet of leaves was that it was out of place in the morning and a bit of affectation anyhow—rather far-fetched in Waukesha County.

Marietta was incensed by this bit of pointless conservatism. "Oh, Angel Face," she exclaimed, "don't be so silly. You're older than I am but I know more about men in a minute than you'll ever know. Don't you want him to like you? You'll have to be more daring—goodness, lots of girls would go a lot further than that."

She caught her sister about the waist and looked in her eyes. "Now you have to wear it," she added finally, and Angela understood that Marietta wanted her to entice Eugene by any means in her power—to make him declare himself finally and set a definite date or take her back to New York with him.

There were other conversations in which a trip to the lake was suggested, games of tennis, with Angela wearing her white tennis suit and shoes, a country dance which might be gotten up—there were rumors of one to be given in the new barn of a farmer by the name of Holtschlegel some seven miles away—and so on. Marietta was determined that Angela should appear youthful, gay, active; just the things which she knew instinctively would fascinate Eugene. It was a period of intense thought and feeling.

Finally Eugene came. He had left Chicago in the morning and arrived at Black Wood at noon. For all her objections and planning otherwise, Angela met him, dressed smartly and, as urged by Marietta, carrying herself with an air. She hoped to impress Eugene with a sense of independence but when she saw him stepping down from the train wearing a belted corduroy trav-eling suit, a gray English traveling cap, and carrying a green leather bag of the latest design, her heart misgave her. He was so worldly now—so expe-rienced. You could see by his manner that this country place meant little or nothing to him. He had tasted of the world at large.

Angela had stayed in her buggy, which was neat and attractive, at the end of the depot platform and she soon caught Eugene's eye and waved to him. He came briskly forward.

"Why, sweet!" he exclaimed, "Here you are. How nice you look." He was taken with her neat getup and the rather eastern way in which she received him. It reminded him of Christina's reception of him at Florizel. He jumped up beside her, surveying her critically, and she could feel his examining glance. After the first general impression he sensed the difference between his new world and hers and was a little depressed by it. She was a little older—no doubt of that. You cannot hope and long and worry for three years and not have something show. And yet she was fine and tender and sympathetic and emotional. He felt all this too. It hurt him a little for her sake and for his, too.

"Well, how have you been?" he asked. They were in the confines of the village and no demonstration could be made. Until the quiet of a country road could be reached, all had to be formal.

"Oh, just the same, Eugene, longing to see you."

She looked into his eyes with hers expressively and he felt the impact of that emotional force which governed her when she was near him. There was something in the chemistry of her being which roused to blazing the ordinarily dormant fires of his sympathies. She tried to conceal her real feeling—to sham gayety and enthusiasm—but her eyes spoke. Something roused in him now at her look—a combined sense of emotion and desire.

"It's so fine to be out in the country again," he said, pressing her hand, for he was letting her drive. "After the city, to see you and the green fields!"

He looked about at the little one story cottages, each with a small plot of grass, a few trees, a neat confining fence. After New York and Chicago, a village like this was quaint.

"Do you love me as much as ever?"

She nodded her head.

They reached a strip of yellow road, he asking after her father, her mother, her brothers and sisters, and when he saw that they were unobserved he slipped his arm about her and drew her head to his.

"Now we can," he said.

She felt a certain force of desire in what he was doing but she missed that note of adoration which had seemed to characterize his first lovemaking. How true it was he had changed! He must have. The city had made her seem less significant. It hurt her to think that life should treat her so. But perhaps she could win him back—could hold him anyhow.

They drove over toward Okoonee, which was the name of a little crossroads settlement near the small lake of that name which was so close to Angela's house, and which the Blues were wont to call home. On the way, Eugene learned that her youngest brother, David, was a cadet at West Point now and doing splendidly. Samuel had become western freight agent of the Great Northern and was in line for significant promotion. Benjamin had completed his law studies and was practicing in Racine. He was interested in politics and was going to run for the state legislature. Marietta was still the gay, carefree girl she had always been, not at all inclined to marry because she had so many anxious suitors. Eugene thought of her letter to him—wondered if she would look her thoughts into his eyes when he saw her.

"Oh, Marietta," Angela sighed when Eugene asked after her, "she's just as dangerous as ever. She makes all the men make love to her."

Eugene smiled. Marietta was always a pleasing thought to him. He wished for the moment that it was Marietta instead of Angela that he was coming to see.

Marietta was as shrewd as she was kind in this instance. Her appearance on meeting Eugene was purposely indifferent and her attitude anything but coaxing and gay. At the same time she suffered a genuine pang of feeling, for Eugene appealed to her. If it were anybody but Angela, she thought, how she would dress and how quickly she would be coquetting with him. Then she would win his love by her and she felt that she could hold it. She had great confidence in her ability to keep any man, and Eugene was a man she would have been delighted to have kept. As it was she kept out of his way, took sly glances at him here and there, wondered if Angela would truly win him. She was so anxious for Angela's sake. Never, never, she told herself, would she ever cross her sister's path.

It was so nice at the Blue homestead. This summer weather. He was greeted as cordially as before. Marietta greeted him as though there had never been a private word between them. An hour in the hammock with Angela quite brought back the feeling of three years before. Eugene was always a victim of natural beauty. It touched his heart and his fancy much as a song or a poem might. These open fields, this old house and its lovely lawn, all served to awaken the most poignant sensations. One of Marietta's beaus, who was over from Wankesha, appeared after Eugene had shaken hands with Mrs. Blue, and Marietta persuaded him to play a game of tennis with Angela. She invited Eugene to make it a four with her but, not knowing how, he refused at first although later in the day he played.

Angela changed to her tennis suit and Eugene opened his eyes to her charms. She was very attractive in the court, quick, flushed, laughing. And when she laughed she had a charming way of showing her even, small, white teeth. She quite awakened a feeling of interest in her on his part—she looked so dainty and frail. When he saw her afterwards in the dark, quiet parlor, he gathered her to his heart with much of the old enthusiasm. She felt the change of feeling. Marietta was right. Eugene loved gayety and color. Although on the way over she had despaired, this was something much better.

A peculiarity of Eugene's temperament was that he rarely entered on anything half heartedly. If he allowed himself to become interested at all it was usually to become greatly interested. He could yield himself to the glamour of a situation in such a way as to come finally to believe that he was something which he was not. Thus now he was beginning to yield himself to this situation as Angela and Marietta wished it should be and to see her in somewhat the old light. He overlooked things which, had he been in his New York studio, surrounded by the influences which there corrected his judgement, he would have seen. Angela was too old for him. She was not liberal enough in her views. She was charming, no doubt of that, but he could not bring her up to an understanding of his casual acceptance of life. She really knew nothing of his real disposition and he did not tell her. He played the part of a seemingly single-minded Romeo, and as such he was, from a woman's point of view, beautiful to contemplate. In his own mind he was beginning to see clearly enough that he was fickle but he still did not want to admit it to himself.

There was a night of stars after an evening of June perfection. At five old Jotham came in from the fields, as dignified and patriarchal as ever. He greeted Eugene with a hearty handshake, for he admired him. "I see some of your work now and then," he said, "in these monthly magazines. It's fine. I'm glad you're getting along so well. There's a young minister down here

near the lake that's very anxious to meet you. He likes to get hold of any-thing you do and I always send the books down when Angela gets through with them."

He used the words "books" and "magazines" interchangeably and spoke as if they were not much more important to him than the leaves of the trees, as indeed they were not. To a mind contemplating the rotation of crops and seasons, as did his, all life with its multitudinous interplay of shapes and forms seemed a passing jumble of nothingness. Even men were as the leaves of yesteryear.

Eugene took to old Jotham as a filing to a magnet. His was just the type of mind that appealed to him, and Angela gained by the radiated glory of her father. If he was so wonderful, she must be something above the aver-age of womanhood. Such a man could not help but produce exceptional children.

Being left alone, it was hardly possible for Eugene and Angela not to renew the old relationship on the old basis. Having gone as far as he had the first time, it was natural that he should wish to go as far, and farther. After dinner when she returned to him from the room, arrayed in a soft evening gown of clinging texture—her neck exposed some at Marietta's request, for she had helped dress her—Eugene was conscious of an emotional perturba-tion on her part. He himself was wrought up and drawing an occasional deep breath, for he did not know how far he would go—how far he would dare to trust himself. He was always troubled when dealing intellectually with his physical passion, for it was as a raging lion at times. It seemed to overcome him quite as a drug might or a soporific fume. He would say to himself that he would control himself but unless he instantly fled there was no hope and he did not seem able to do that. He would linger and parley, and in a few moments of contact his passion was master and he was following its behest blindly, desperately, to the point almost of exposure and destruction.

Tonight when Angela came back he was cogitating, thinking what it might mean. Should he? Would he marry her? Could he escape? They sat down to talk but presently he drew her to him. It was the old story—moment after moment of increasing feeling. Presently she, from the excess of longing and waiting, was lost to all sense of consideration. And he——

"I will have to leave, Eugene," she pleaded when he carried her reck-lessly into his room, "if anything happens. I cannot stay here."

"Don't talk," he said. "You can come to me."

"Surely, Eugene, surely?" she begged.

"As I'm holding you here," he replied. He thought in the excite-ment of the moment that he might as well take her. They could be happy together.

There was an hour in which the hymeneal sacrifice of this dark room was guarded by their watchful eyes and ears. At midnight Angela left, frightened, wondering, doubting, feeling herself the most depraved creature. Two pictures were in her mind alternately and with clocklike reiteration. One was a composite of a marriage altar and a charming New York studio with friends coming in to see them—such as he had often described to her. The other was of the still blue waters of Okoonee with her lying there, pale and still. Yes, she would die—if he did not marry her now. Life would not be worthwhile. She would not force him. She would slip out some night when it was too late and all hope had been abandoned—when exposure was near—and the next day they would find her.

Little Marietta—how she would cry. And old Jotham—she could see him, but he would never be really sure of the truth. And her mother. "Oh, God in heaven," she thought, "how life runs. How terrible it can be!"

CHAPTER XXIX

The atmosphere of this house after this night seemed charged with a form of reproach to Eugene, although it took on no semblance of reality in either look or sound. When he awoke in the morning and looked through the half closed shutter blades to the green world outside, he felt a sense of freshness and of shame. It was cruel to come into a home as nice as this and do a thing as mean as he had done. After all, philosophy or no philosophy, didn't a fine old citizen like Jotham, honest, upright, genuine in his moral point of view and his observance of the golden rule, deserve better from a man whom he so sincerely admired? Jotham had been so nice to him. Their conversations together were so broad, kindly, and sympathetic. Eugene felt that Jotham believed that he was an honest man. He looked it, he knew. He was frank, genial, considerate, not willing to condemn any one—but this sex question, that was where he was weak. And was not the whole world keyed to that? Did not the decencies and the sanities of life depend on right moral conduct? Was not the world dependent on how its homes were run? How could one be good if his mother and father had not been good before him? How could the children of the world expect to be anything if people rushed here and there holding illicit relations? Take his sister Myrtle, now—would he have wanted her rifled in this manner? In the face of this question he was not ready to say exactly what he wanted or was willing to countenance. Myrtle had been a free agent, as was every other girl. She could do as she pleased. It might not please him exactly

but——. He went round and round from one problem to another, trying to untie this Gordian knot. For one thing, this home had appeared sweet and clean when he came into it. Now it was just a little tarnished, and by him! Or, was it? His mind was always asking this question. There was not a thing that he just accepted as so any more. He was going around in a ring asking questions of this proposition and that. Are you so? And are you so? And all the while he was apparently not getting anywhere. It puzzled him, this life. Sometimes it shamed him. This deed shamed him. And he asked himself whether he was wrong to be ashamed or not. Perhaps he was just foolish. Was not life made for living, not worrying about? Had he made his passions and desires?

He threw open his shutters and there was the bright day. Everything was so green outside, the flowers in bloom, the trees casting a cool, lovely shade, the birds twittering. Bees were humming. He could smell the lilac.

"Dear God," he exclaimed, throwing his arms above his head, "How lovely life is! How beautiful. Oh!" He drew in a deep breath of the flower and fruit laden air. If only he could live always like this—forever and ever.

When he had sponged himself with cold water and dressed, putting on a soft negligee shirt, a clean, high, turn-down collar, and a dark brown, loose-flowing tie, he issued forth clean and fresh. Angela was there to greet him. Her face was pale but she looked intensely sweet because of her sadness.

"There, there," he said, touching her chin. "Less of that now."

"I told them that I have a headache," she said. "So I have, do you hear?"

"I have your headache," he laughed. "But everything is all right—very much all right. Isn't this a lovely day?"

"Beautiful," replied Angela sadly.

"Cheer up," he insisted. "The worst is yet to come. Don't worry. For heaven's sake, don't worry. Everything is coming out fine." He walked to the window and stared out.

"I'll have your breakfast ready in a minute," she said, and squeezing his hands, left him.

Eugene went out into the hammock. He was so deliciously contented and joyous now that he saw the green world about him that he felt that everything was all right again. The vigorous blooming forces of nature every-where present belied the sense of evil and decay to which mortal mind is so readily subject. He felt that everything was justified in youth and love, par-ticularly where mutual affection reigned. Why should he not take Angela? Why should they not be together? He went in to breakfast at her call, eating comfortably of the things she provided. He felt the easy familiarity and gra-ciousness of the conqueror. Angela on her part felt the fear and uncertainty

of one who has embarked upon a dangerous voyage. She had set sail—for where? At what port would she land? Was it the lake or the studio which Eugene had described to her? Would she live to be happy or die to face a black uncertainty? Was there a hell, as some ministers maintained? Was there a gloomy place of lost souls such as the poets described? She looked into the face of this same world which Eugene found so beautiful and its very beauty trembled with foreboding of danger.

And there were days and days yet to be lived of this. For all her fear, once having tasted of the forbidden fruit, it was sweet and inviting. She could not go near Eugene, nor he her, but what this flush of emotion would occur. Nothing could be done in the day—she was too fearful—but at night the possibilities of safe gratification were too obvious to be ignored.

When the night came with its stars, its fresh winds, its urge to desire, then it was as if fear could not detain her after all. She feared, truly enough, but Eugene was insatiable and she was yearning. The slightest touch was as fire to tow. She yielded saying she should not yield.

The Blue family were of course blissfully ignorant of what was transpiring. It seemed so astonishing to Angela at first that the very air did not register in some visible way the nature of her sin. That they should be able thus to be alone was not so remarkable, seeing that Eugene's courtship was being aided and abetted for her sake, but that her lack of morality should not be exposed by some sinister influence seemed strange—an accident subtly pending. Something would happen—that was her fear. She had not the courage of her desire or her need.

By the end of the week, though Eugene was partially satiated and more or less oppressed by the seeming completeness with which he had dethroned virtue, he was not ready to leave. He was sorry to go, for it ended a honeymoon of notable force and beauty—all the more wonderful and enchanting because so clandestine—yet, on the other hand, his indulgence was beginning to indicate to him that he was binding himself in chains of duty and responsibility. Angela had thrown herself on his mercy and his sense of honor to begin with. She had exacted a promise of marriage—not urgently and as one who sought to entrap him, but with the explanation that otherwise life must end in disaster for her. Eugene could look in her face and see that it would. And now that he had known her body—sensed the depths of her emotions and desires—he had a higher estimate of her personality. Despite the fact that she had yielded to him, that she was older than he was, there was a breath of youth and beauty here which held him. Her form was exquisite. Her feeling about life, about love, tender and beautiful. He wished he could make true her dreams of bliss without injury to himself. Already she was beginning to worry over the future.

It so transpired that as his visit was drawing to a close Angela decided that she ought to go to Chicago, for there were certain things in the way of purchases which required attention. Her mother wanted her to go and she decided she would go with Eugene. This made the separation easier, gave them more time to talk. Her usual plan was to stay at her aunt's and she was going there now.

On the way she asked over and over what he would think of her in the future; whether what had transpired would not lower her in his eyes. To his credit, because of the largeness of his nature, it may be said that he did not feel that it would. And in years afterward this was not held in his consciousness against her, but as a testimony to the genuineness of her affection—the sacrificial character of her feeling for him.

Once she said to him sadly, "only death or marriage can help me now."

"What do you mean?" he asked, her red head pillowed on his shoulder, her dark blue eyes looking sadly into his.

"That if you don't marry, me, I'll have to kill myself. I can't stay home."

He thought of her with her pretty form, her mass of bright hair all tarnished in death.

"You wouldn't do that?" he asked unbelievingly.

"Yes, I would," she said sadly. "I must. I will."

"Hush, Angel Face," he pleaded. "You won't do anything like that. You won't have to. I'll marry you. How would you take your life?"

"Oh, I've thought it all out," she continued gloomily. "You know that little lake. I will drown myself there."

"Don't, sweetheart," he pleaded. "Don't talk that way. It's terrible. You won't have to do anything like that."

To think of her under the clear waters of little Okoonee, with its green banks, the yellow sandy shores. All her love come to this! All her passion! That would be too bad. Her death would be upon his head and he could not stand the thought of that. It frightened him. Such tragedies occasionally appeared in the papers with all the pathetic details convincingly set forth, but this should not enter his life. He would marry her. She was lovely, after all. He would have to. He might as well make up his mind to that now. He began to speculate how soon it might be. For the sake of her family she wanted no secret marriage but one which, if they could not be present at it, they could at least know was taking place. She was willing to come East—that could be arranged, but nothing more than that. They must be married. Eugene realized the depths of her conventional feelings so keenly that it never occurred to him to suggest anything else. She would not consent, would scorn him for it. Death was the only alternative.

One evening—the last—when it was necessary for her to return to Black Wood and he had seen her off on the train, her face a study in the sad lines of the Madonna, he rode out gloomily to Jackson Park, where he had once seen the beautiful lake in the moonlight. It was a late sunset, for this was near the twenty-first of June, which is the longest day. The glow of a radiant western sky was still faintly perceptible at eight o'clock. When he reached there at seven, the waters of the lake were still suffused and tinged with lovely suggestions of lavender, pink, and silver. The trees to the east and west were dark, the sky in the west showing a last lingering flush of orange. Odours were about—warm June fragrances. He thought now, as he walked about the quiet paths where the sand and pebbles echoed lightly to his feet, of all the glory of this wonderful week. How dramatic was his life; how full of romance. This home of Angela's, how beautiful. Youth was with him—love. Would he go on to greater days of beauty or would he stumble, idling his time, wasting his substance in riotous living? Was this riotous living? Would there be evil fruition to his deeds? Would he really love Angela after he married her? Would they be happy?

Then he stood by the bank of this lake, studying the still water, marvelling at the subtleties of reflected radiance, feeling the artist's joy in perfect natural beauty; twining and intertwining it all with love, death, failure, fame. In such a lake, if he were unkind, would Angela be found. By such a dark as was now descending would all her bright dreams be submerged. It would be beautiful as a romance. He could imagine a novelist like Daudet or Balzac making a great story of it. It was even a subject for some form of romantic expression in art. Poor Angela. Most of Henner's maidens looked as she looked. His treatment of hair suggested hers. If he were a great portrait painter, he would paint her. He thought of some treatment of her in the nude with that mass of hair of hers falling about her neck and breasts. It would be beautiful. Should he marry her? Yes, though he was not now sure of the outcome, he must. It might be a mistake but——

He stared at the fading surface of the lake. Behold the silver, the lavender, the leaden gray. Overhead one translucent star was already shining. How would it be with her if she were below those still waters? How would it be with him? It couldn't be like that. It would be too desperate, too regretful. No, he must marry her. So it was in this mood that he returned to the city, the ache of life in his heart. It was in this mood that he secured his grip from the hotel and sought the midnight train for New York. For once Ruby, Christina, Miriam, were forgotten. He was involved in a love drama which meant life or death for Angela, peace or reproach of conscience for himself in the future. He could not guess what the outcome would be but he felt that he must marry her—how soon, he could not say. Circumstances

would dictate that. From what appeared to be transpiring now, it must be immediately. He must see about a studio, announce the news of his departure to Smite and McHugh; make a special effort to further his art ambitions so that he and Angela would have enough to live on. He had talked so glowingly of his art life that now, when the necessity for demonstrating it was at hand, he was troubled as to what the showing would be. The studio had to be attractive. He would need to introduce his friends. All the way back to New York he turned this over in his mind—Smite, McHugh, Miriam, Norma, Wheeler, Christina—what would Christina think if she ever returned to New York and found him married? There was no question there was a difference between Angela and these. It was something—a matter of courage perhaps—more soul, more daring, more awareness—something. When they saw her would they think he had made a mistake, would they put him down as a fool? McHugh was going with a girl but she was of a different type—intellectual, smart. He thought and thought, but he came back to the same conclusion always. He would have to marry her—there was no way out. He would have to.

CHAPTER XXX

The studio of Messrs. Smite, McHugh, and Witla in Waverly Place was concerned the following October with a rather picturesque event. The melancholy days had come when the leaves of the trees were beginning to yellow and fall. Those disturbing preliminaries of winter—gray, lowery days, with a scrap of paper, straws and bits of wood blown about by gusty currents of air through the city streets—were making it painful to be abroad on certain days. The fear of cold and storms and suffering among those who have little was also apparent. Yet the air of renewed vitality which comes with those who have seen an idle summer through and are anxious to work again was everywhere. Shopping and marketing and barter and sale were at high key. The art world, the social world, the manufacturing world, the professional worlds of law, medicine, finance, literature, were bubbling with that feeling of necessity to do and achieve. The whole city, stung by the apprehension of winter, had an atmosphere of emprise and distinction.

In this atmosphere, with a fairly clear comprehension of the elements which were at work making the color of the life about him, was Eugene, digging away at the task he had set himself. Since leaving Angela he had reached the conclusion that he must complete the drawings for the exhibit which had been running in his mind these last two years. There was no

other way for him to make a notable impression—he saw that. Since he had been back he had gone through various experiences and impressions: the experience of having Angela inform him that she was sure there was something wrong with her; an impression sincere enough, but based on an excited and overwrought imagination of evil to follow, and having no foundation in fact. Eugene was as yet, and in spite of his several experiences, not sufficiently informed in the affairs of sex to know. His lack of courage in these matters would have delayed him from asking even if he had known. In the next place, facing this crisis, he had declared that he would marry her, and because of her distressed condition he thought he might as well do it now. He had wanted time to do some of these pictures he was working on, to take in a little money for drawing, to find a suitable place to live. He had looked at various studios in various sections of the city and had found none, as yet, which answered to his taste or his purse. Anything with a proper light, a bath, a suitable sleeping room, and an inconspicuous chamber which might be turned into a kitchen, was difficult to find. Prices were high, ranging from fifty to one hundred and twenty-five and one hundred and fifty dollars a month. There were some new studio buildings being erected for the rich loungers and idlers in this world which commanded, so he understood, three and four thousand dollars. He wondered if he should ever attain to any such magnificence via his art.

In taking a studio for himself and Angela there was also the matter of furniture. The studio of himself, Smite, and McHugh was more or less of a camp. The two main rooms were bare of carpets or rugs. The folding beds which graced the rear of these two rooms were heirlooms from ancient predecessors—substantial but shabby. Outside of various drawings, three easels, a few chairs, and a dresser or chest of drawers for each, there was no suitable household equipment. A woman came twice a week to clean, send out the linen, make up the beds properly, and so forth.

To live with Angela required in Eugene's judgement many and much more significant things. His idea of a studio was some such one as that now occupied by Miriam Finch or Norma Whitmore. There ought to be furniture of a period—old Flemish or Colonial, Hepplewhite or Chippendale or Sheraton—such as he saw occasionally knocked about in curio shops and secondhand stores. It could be picked up if he had time. He was satisfied that Angela knew nothing of these things. There ought to be rugs, hangings of tapestry, bits of brass, pewter, copper, old silver, if he could afford it. He had an idea of obtaining some day a figure of the Christ in brass or plaster, hung upon a rough wooden cross of walnut or teak, which he could hang or stand up in some corner as one might a shrine and place before it two great candlesticks with immense candles smoked and dripping with wax.

These lighted in a dark studio, with the outlines of the Christ flickering in the shadows behind, would give what he considered tone to the chamber. Such an equipment as he dreamed of would have cost in the neighborhood of two thousand dollars.

Of course this was not to be thought of at this period. He had no more than that in ready cash. He was writing Angela of his difficulties in finding a suitable place when he heard from her that she was mistaken as to her condition. She was not enceinte. She hesitated to tell him when she discovered this, for it seemed to endanger her chances of speedy marriage, but she feared to lie to him. He would be sure to find it out later. He would think she had tricked him. Besides, his recent letters gave evidence of such interest and sympathy that she was inclined to think he was going to marry her anyhow. This very conversation about a studio proved it. The truth was that Eugene, excited by his carnal experiences with her and having found her of a temperament which answered his present mood, was eager for more of what had proved to be so delightful. She ran through his mind now not for any spiritual qualities, though these were dimly in the background, but unfortunately for her gross physical ones. Two natures being at war in him, one spiritual, the other carnal and fleshy, it was possible to appeal to either. He responded quickest at most times to the appeal of the flesh. Having no other intimacy which ranked with this one for quality at this time, it seemed all important, worthwhile, as though marriage could be based on it. He could marry Angela for this quality alone almost, he thought, and happiness in such a marriage would endure!

When he learned that her condition was not serious, however, he relaxed to a certain extent his energy in seeking a studio immediately, though having gone so far it was not possible to turn back. He did not feel for the time being that he wanted to. He had given his word to Angela anew. He had promised her by all that was good and holy that she should not be made to suffer, and he felt now that even though their misconduct had not led to compulsory union or disaster he ought not to turn back. The desire for her, in his physical loneliness, was pulling at him.

Eugene heard too, at this time, of a studio in Washington Square South, which the literary man who occupied it was going to quit for the winter. It was, as he understood it, handsomely furnished and was to be let so, for the rent of the studio. The owner wanted someone who would take care of it to occupy it for him until he should return the following fall. Eugene hurried about to look at it and, taken with the location, the appearance of the square from the windows, the beauty of the equipment, felt that he would like to live here. This would be the way to introduce Angela to New York. This would be the first and proper impression to give her. Here, as in every

well arranged studio he had yet seen, were books, pictures, bits of statuary, implements of copper and brass, and some few pieces of silver. There was a great fish net, dyed green, and spangled with small bits of mirror in imitation of scales which hung as a veil between the studio proper and an alcove. There was a piano done in black walnut, which matched the odd pieces of furniture—Mission, old Flemish, Venetian of the sixteenth and English of the seventeenth century—which nevertheless contrived a unity of appearance and a harmony of usefulness. There was one bedroom, a bath, and a small partitioned section which could be used as a kitchen. With a few of his pictures judiciously substituted he could see a perfect abode here for himself and his wife. The rent was fifty dollars. He decided that he would risk it.

Having gone so far as to indicate he would take it—he was partially persuaded to this matrimonial step by the very appearance of this place, for his own appearance and credentials were satisfactory to the owner—he decided that he would marry in October. Angela could come to New York or Buffalo—she had never seen Niagara Falls—and they could be married there. She had spoken recently of visiting her brother at West Point. Then they could come here and settle down. He decided that this must be so, wrote her to that effect, and vaguely hinted to Smite and McHugh that he might get married shortly.

This was a great blow to his partners in art, for Eugene was very popular with them. He had the habit, when he was with those whom he truly liked and could admire, of jesting constantly. "Say, look at the look of noble determination on Smite's brow this morning," he would comment cheerfully on getting up, or, "McHugh, you lazy lout, crawl out and earn your living."

McHugh's nose, eyes, and ears would be comfortably buried in the folds of a blanket.

"These hack artists," Eugene would sigh disconsolately. "There's not much to be made out of them. A pile of straw and a couple of boiled potatoes a day is about all they need."

"Aw, cut it out," McHugh would grunt.

"To hell, to hell, I yell, I yell," would come from somewhere in the voice of Smite.

"If it weren't for me," Eugene would go on, "God knows what would become of this place. A lot of farmers and fishermen trying to be artists."

"And laundry wagon drivers; don't forget that," McHugh would add, sitting up and rubbing his tousled head, for Eugene had retailed some of his experiences. "Don't forget the contribution made by the American Steam Laundry company to the world of true art."

"Collars and cuffs, I would have you know, is artistic," Eugene once declared with mock dignity. "Whereas plows and fish is trash!"

Sometimes this persiflage would continue for a quarter of an hour at a stretch, when some one jest brighter than any other would dissolve the whole in laughter. Work began after breakfast, to which they usually sallied forth together, and would continue unbroken save for necessary engagements or periods of entertainment, lunch, and so on, until five in the afternoon.

They had worked together now for several years and had been most gratified. They had, by experience, learned of each other's reliability, courtesy, kindliness, and liberality. Criticism was free, generous, and sincerely intended to be helpful. Pleasure trips such as walks on gray lowery days or in rain or brilliant sunshine, or trips to Coney Island, Far Rockaway, the theatres, the art exhibits, the odd and peculiar restaurants of different nationalities, were always undertaken in a spirit of joyous camaraderie. Jesting as to morality, their respective abilities, their tendencies and characteristics, were all taken and given in the best part. At one time it would be Joseph Smite who would come in for a united drubbing and excoriation on the part of Eugene and McHugh. On another day, Eugene or McHugh would be the victim, the remaining two joining forces vigorously. Art, literature, personalities, phases of life, philosophy were discussed and argued by turns. As with Jerry Mathews, Eugene had learned of new things from these individuals—the life of the fisher-folk and the characteristics of the ocean from Joseph Smite; the nature and spirit of the boundless West from McHugh. Each appeared to have an inexhaustible fund of experiences and reminiscences which entertained and refreshed the trio day by day and year in and year out. They were at their best strolling through some exhibit or preliminary view of an art collection offered for sale, when all their inmost convictions as to what was valuable and enduring in art would come to the surface. All three were intolerant of reputations as such but were strong for individual merit, whether it carried a great name or not. They were constantly finding some little known genius in the various dark passages of art and celebrating his talents, each to the other. Thus Monet, Manet, Ribera, Fortuny, Van Hooge, Fragonard, Watteau, and Ruisdael, Mesdag, Mancini came up by turns for examination and praise.

When Eugene then announced one day toward the end of September that he might be leaving them shortly, there was a united wail of opposition. Joseph Smite was working on a sea scene at the time, doing his best to get the proper color harmony between the worm-eaten deck of a Gold Coast trading ship, a half naked, West Coast negro handling a broken wheel, and a mass of blue-black undulations in the distance which represented the boundless sea.

"Gwan!" said Smite, incredulously, for he assumed of course that Eugene was jesting. There had been a steady stream of letters issuing from some-

where in the West and delivered here regularly week after week, as there had been for McHugh, but this by now was a commonplace and apparently meant nothing. "You marry! What the h— do you want to get married for? A fine specimen you will make. I'll come around and tell your wife."

"Sure," returned Eugene, "that's right. I may get married." He was amused at Smite's natural assumption that it must be a jest.

"Stow that," called McHugh, from his easel. He was working on a country-corner picture—a group of farmers before a country post office. "You don't want to break up this shack, do you?" Both of these men were fond of Eugene—they found him inspiring, helpful, always intensely vigorous, and apparently optimistic.

"I don't want to break up any shack. But haven't I a right to get married?"

"I vote no, by God!" said Smite, emphatically. "You'll never go out of here with my consent. Peter, are we going to stand for anything like that?"

"We are not," replied McHugh. "We'll call out the reserves if he tries any game like that on us. I'll prefer charges against him. Who's the lady, Eugene?"

"I'll bet I know," suggested Smite. "He's been running up here to Twenty-sixth Street pretty regularly." Joseph was thinking of Miriam Finch, to whom Eugene had introduced him, as he had McHugh.

"Nothing like that, surely," inquired McHugh, looking over at Eugene to see if possibly it could be so.

"It's all true, fellers," replied Eugene, "as God is my judge. I'm going to leave you soon."

"You're not really talking seriously are you, Witla?" inquired Joseph soberly.

"I am, Joe," said Eugene quietly. He was studying the perspective of his sixteenth New York view, a canvas twenty-four by sixty. It was of three engines coming abreast into a great yard of cars. The smoke, the barge, the dingy reds and yellows and greens of kicked-about box cars were showing with vigor and beauty—the vigor and beauty of raw reality.

"Soon?" asked McHugh, quietly. He was feeling that touch of pensiveness which comes with a sense of vanishing pleasures.

"Sometime in October, I think, very likely," replied Eugene.

"Jesus Christ, I'm sorry to hear that," put in Smite.

He laid down his brush and strolled over to the window. McHugh, less expressive, worked on meditatively.

"When'd you reach that conclusion, Witla?" he asked after a time.

"Oh, I've been thinking over a long time, Peter," he returned. "I should really have married before if I could have afforded it. I know how things are

here or I wouldn't spring this so suddenly. I'll hold up my end on the rent here until you get someone else".

"To hell with the rent," said Smite. "We don't want anyone else, do we Peter? We didn't have anyone else before."

Smite was rubbing his square chin and contemplating his partner as if they were facing a catastrophe.

"There's no use talking about that," said Peter. "You know we don't care about the rent. Do you mind telling us who you're going to marry? Do we know her?"

"You don't," returned Eugene. "She's out in Wisconsin. It's the one who writes the letters. Angela Blue is her name."

"Well here's to Angela Blue, by God, say I," said Smite, recovering his spirits and picking up the brush from his paint board to hold aloft. "Here's to Mrs. Eugene Witla, and may she never reef a sail to a storm or foul an anchor, as they say up Nova Scotia way."

"Right oh," added McHugh, catching the spirit of Smite's generous attitude. "Them's my sentiments. When'd you expect to get married really, Eugene?"

"Oh, I haven't fixed the time exactly. About November first, I should say. I hope you won't say anything about it though, either of you. I don't want to go through any explanations."

"We won't," said Smite, "but it's tough, you old Walrus. Why the hell didn't you give us time to think it over? You're a fine old jelly fish, you are."

He poked him reprimandingly in the ribs.

"There isn't anyone any more sorry than I am," said Eugene. "I hate to leave here. I do. But we won't lose track of each other. I'll still be around here."

"Where do you expect to live? Here in the city?" asked McHugh, still a little gloomy.

"Sure. Right over here in Washington Square. Remember that Dexter studio Weaver was telling us about? The one on the third floor at sixty-one. That's it."

"You don't say," exclaimed Smite. "You're in right. How'd you get that?"

Eugene explained.

"Well you're sure one lucky man," observed McHugh. "Your wife ought to like that. I suppose there'll be a cozy corner for an occasional strolling artist?"

"No farmers, no seafaring men, no artistic hacks—nothing," declared Eugene dramatically.

"You go to hell," said Smite. "When Mrs. Witla sees us——"

"She'll wish she'd never come to New York," put in Eugene.

"She'll wish she'd seen us first," said McHugh.

CHAPTER XXXI

The gayety in question, announced at the opening of the last chapter, which concerned the studio life of Messrs. Smite, Witla, and McHugh, related to a plan generated in the fertile mind of Mr. Joseph Smite to give Eugene, without his knowledge until the last moment, a parting send-off. The day of his nuptials was drawing near. He had explained to both McHugh and Smite that he was going to Buffalo to get married. It had been arranged between himself and Angela that she was to come with her sister Marietta as far as Buffalo where he would meet her, seek a minister, and after viewing the falls together, either idle a day or two or come on to West Point, where a dance and some other form of entertainment was scheduled and in which, because of their brother's presence, both Angela and Marietta could share. Eugene could either stay at West Point to share this, though he did not dance well, or come on to New York and await the arrival of Angela there. He preferred to stay with her, however, and was making plans for some further form of entertainment afterward. Marietta was coming to New York for a few days after she had visited her brother, and Eugene was pleased to think that the studio to which he could take Angela would prove so impressive.

The time came for his departure and the night before, while he and McHugh and Smite were sitting before the grate fire which graced the west wall of the studio—it was between five and six in the afternoon—Smite said to McHugh, "Let's stay inside tonight and have Gozzolo bring up the dinner." Gozzolo was a restauranteur of the Italian fifty cent variety whose place was around the corner in MacDougal Street.

"Sure," said McHugh. "I'm for that. How about Eugene?"

"It's a good idea."

It had been a custom of theirs from time to time to clear off the centre table, decorate it with several candelabra holding three candles each, turn out other lights and sometimes—as in winter, with the grate fire glowing, at other times as in summer with the windows open and the noise of cars and wagons and voices providing a not inharmonious symphonic accompaniment—eat what Signor Gozzolo would provide: macaroni, stewed meat, a salad of lettuce, tomatoes, and oil, some soggy Italian pastry, and red wine.

"Red ink, red ink," Eugene had apostrophized on one of these occasions, "the more you know the less you drink."

And of Gozzolo he had sung:

"He brings us raw spaghetti,
He serves us oil and wine,
Ten thousand dead attest the art
Of this dark Eye-tal-yine."

"Do you get the pronunciation of that last word?" inquired Eugene.

"Oh, my God!" was Smite's only comment.

On this occasion they sat down as usual and Peter telephoned to Gozzolo to bring the—as he called it—"customary layout." They were waiting comfortably when the bell rang and in strolled Richard Wheeler, smiling, his short, slender form encased in a new fall overcoat.

"Hey, Wheeler," called Smite, "draw up a chair. You can get in on this."

Wheeler strolled into the back room to deposit his coat and returned displaying a new suit.

"Say," observed McHugh, "there's something to this editorial business after all. Look at the new coffee sack he has on."

Wheeler grinned with an air of pride and satisfaction.

"We must be getting our salary quite regularly now," said Eugene.

"We are, we are," echoed Wheeler. "We expect to draw enough to get a new pair of shoes next week."

The bell rang again.

"It's Shotmeyer, as I live," exclaimed Eugene, as the door opened. "Where do you blow from?"

Shotmeyer, like Wheeler, was grinning. Eugene was so innocent. "Oh, I thought I'd look in on you people. How are you?"

"Fine as a swordfish asleep in the sea," said Smite, "sit down."

Shotmeyer had no talent but he was the soul of good nature. He drew up a chair and as he did so, again the bell rang.

"Say, this is going some," said McHugh, deceptively. "Our little private meal will become a banquet. We can't feed this bunch."

"We don't intend to," added Smite. "We'll go out first and they can come along and pay their way."

The door opened and this time entered Oren Benedict and Judson Cole, with whom Eugene had renewed the relationship begun in Chicago, and with whom Smite and McHugh had become acquainted through Eugene.

"Welcome to our city," called McHugh, as he saw them come in. "The more the merrier. It never rains but it pours."

"Well I'll be damned," exclaimed Eugene, "they're coming from every-where." He looked at Smite, who was grinning.

"What is this?" he asked, as the bell rang again.

"I don't know," replied Smite, evasively. Concealment was getting dif-ficult.

Eugene got up. Louis Deesa, with Hedda Andersen, the first model he had employed on coming to New York, was entering.

McHugh was busy greeting them.

Eugene sensed that it was for himself. It must be. He was going away.

"Is this for me?" he asked Smite.

"We wanted a little blowout for old time's sake," replied the latter. "They don't know. What difference does it make? It'll all come out anyhow."

"I won't stay here to be joked," said Eugene.

"They don't know, I tell you. We called it an appetizer for the winter's work. Sit down. We're going to have lots of fun."

Eugene was mollified. He was afraid that everyone knew—that he was to be the mark and butt of ribald wit.

"I promise you there won't be a word," assured McHugh, squeezing his arm.

Eugene went back to the table and began talking with Hedda Andersen, who had drawn near. She had grown taller, more interesting. "I haven't seen you in a long time," he said.

"Ha," she said, her teeth showing between red lips. "You've done well since I posed for you. I see your things in *Truth* and everywhere. Is that one of yours?" She went to his easel, drawn close to the wall tonight, to exam-ine the three engines and the car yard.

"I like your things," she commented. "They're so strong. They look just like things are."

She gave him another bewitching smile.

He wondered, because of this, why he hadn't seen her oftener.

It was a continued stream of newcomers from now on, for Smite and Shot-meyer and McHugh and Weaver had collaborated to make the thing a suc-cess. Word had been passed around that it would be clever. Gozzolo arrived with a basket of straw-packed bottles of what he said was wine grown on his own farm in Italy. It wasn't very good wine but it had an original flavor. Giuseppe, his assistant, carried in a hamper of sandwiches. Presently came Leonard Baker, the illustrator, and Mark McCarthy, the writer of magazine specials, and Owen Overman, the poet. There was a black eyed beauty, Isi-dora Crane, who came with Paynter Stone, the radical, and whom Eugene remembered as having seen at Norma Whitmore's. She was a beginner on the stage. William McConnell came and brought Anna Magruder, and Hud-

son Dula was a late arrival with Elizabeth Stein, a socialist agitator, beautiful and hence petted and made over out of all proportion to her talents.

Eugene had scarcely conceived he knew so many people. Four years in New York had, by introductions here and there, widened his circle until there were perhaps a hundred talented people whom he knew in a friendly way. By nine o'clock of this night there were forty of them present, chattering, smoking cigarettes, drinking Gozzolo's green colored wine, and trading experiences. They were getting to the place where diversion was being demanded, and Jack Bazenah, Owen Overman, and Paynter Stone had already joined hands to sing about "the beer at Monterey———"

> "And you don't have to pay!
> And you don't have to pay!!
> And you don't have to pay!!!"

"Say," called Leonard Baker, getting up on a chair. "I'll show you people something."

He had the eyes of all after a few moments, for he was pulling out a suit of false whiskers à la an East Side Jew and adjusting them, and was calling for a large derby hat which he pulled completely over his ears.

"Vy iss?" he inquired, when his disguise was complete, stretching out his hands palms up, "ven I do this nobody dooaned know me? Iss it for vy by illustrations I make me my living, no? Oi! Oi! By illustrations I make me only a bum living. Oi! Oi!"

The crowd laughed.

"I show you now wit how my drawings I go me by der art directors."

All the artists chuckled for there were several art directors present. Baker was seizing their familiar ground for caricature. He reached down for a bundle of drawings which some one was holding for him and began an animated argument with, supposedly, Mr. Hudson Dula of *Truth*. He had with him, as samples apparently, pictures by the best known illustrators present. "Here vass some ash-scows," he said of one Eugene's pictures, holding it up, "going dem by der night by der sea. You doaned vond it! It vass a frost!! It vass a lemon!! Oi! Oi! Vat for iss a frost? How you make him—do lemon? For vy he make me lemons I shall sell?"

The crowd roared. Eugene laughed with them. He enjoyed Jewish dialect caricature.

When Baker was through, his whiskers removed, Louis Deesa took the floor. His speciality was Negro dialect and he had one very popular turn, that of a Negro robbing a hen roost. It began with him slipping in, supposedly in the dark, and reaching cautiously up to a porch, a chorus of artists in the back ground imitating the squawking.

"Sh! Sh!" was his popular exclamation and a peculiarly humorous swinging movement of his right arm showed how he was wringing the respective necks of his prey. His face was a study in Negro expression. A constant mumbling of the type of advice which a poaching darky might give to a recalcitrant chicken was a part of his humor. His turn also won its applause.

While he was displaying his art, Norma Whitmore came in and sought Eugene to apologize for her lateness. She knew nothing of his approaching marriage, as her conversation indicated, and he was now convinced that Smite and McHugh were as good as their word. Miriam Finch did not come though she was invited. Absence from the city was her legitimate excuse.

While this gayety was in progress Eugene was thinking from time to time of how Angela would take to such an atmosphere as this. In many respects it was broad and noisy—in some of its phases a little coarse. Already many of the artists and their women friends were unduly gay. Cigarettes were between the lips of most of the girls and wine drinking was common to all. One of the models who was there as the guest of a writer and who was considerably enthused by what she had consumed and by the spirit of the crowd was endeavoring to persuade a handsome Swede propagandist of anarchism—Hjolmar Nordyen, twenty-six years of age—to come and talk to her. He was broad faced, tow headed, blue eyed with red cheeks and a big, smiling mouth. Already he was fairly well overcome by what he had consumed and was following Owen Overman about, insisting that he drink with him. As fast as the poet would condescend to drink one glass, Nordyen would run and get another, beginning his silly pleading all over again. To the pleading of his fair temptress he turned a deaf ear.

"No, no, you go way and talk to some one else. No, no, I got no time now. I haf to drink lots yet."

Because she stroked his hand and pulled at his arm he pushed her inconsiderately at the waist and shoulder. She took no offense, retiring and watching him at a distance with the thought of interesting him later.

Eugene understood this peculiar and decidedly unconventional attitude and conduct. He rather sympathized with it as being free and natural. It accorded with his own speedy adjustment of relationship with any member of the fair sex who interested him and who reciprocated his interest. A number of these girls were, let us say, not immoral but amoral. He knew that Miss Stein, for instance, would take up with any man according to her predilections but it was a phase of philosophic belief with her—a problem in individual liberty. Once at a socialist dance which he attended in company with McHugh he met her, talking to Thurland Chataway, a traveler and socialist light whom Eugene had met previously at Norma Whitmore's.

Chataway was known as a radical, a free thinker, a free lover after the anarchist fashion.

"Why don't you take Witla here, Elizabeth?" Chataway said familiarly to Miss Stein, "and teach him some of the freedom of life. He's too conventional. He's a fine artist but he hasn't come out of his shell yet."

Eugene laughed for he thought of course that he was broad enough, only cautious. He did not care for this open and aboveboard declaration of principles. It seemed too loose—at least for his personal practise.

Miss Stein looked him over critically. Her smooth black hair, laid in even plaits over her forehead, her charmingly moulded features—straight, thin, chiseled nose, low forehead, even red lips, slightly sunken cheeks, but with eyes and actions indicating great nervous strength—appealed to him. Her waxen pallor also had a fascination for him though he did not feel that true mental reciprocity could exist between them. "I don't think we'd get along," she said to Chataway. "He doesn't understand. You and I, though"—she stroked Chataway's cheek with her hand.

"You don't know what I understand," laughed Eugene good-naturedly.

"Huh-uh," she said, shaking her head, meaning that he really did not.

Eugene's lips curled with a superior smile. She need not be interested in him if she did not want to. Still this sort of thing made the status of life among the radicals and bohemians perfectly clear to him and he liked it. Though she did not care for him, this idea of intellectual and moral freedom seemed to have something back of it which was worthwhile. It might lead to the gutter, but he doubted it. He wondered however what became of these people—where they went or ended up in their old age.

Tonight, with much of this atmosphere characterizing this particular entertainment, he wondered how Angela would look upon it all. She would not be interested in most of these people, surely. She was not sufficiently sophisticated—not at all a woman of the world. He did not reason about it deeply, however, for if he had it would have worried him greatly. For after all, think what he would, this atmosphere appealed to him and Angela was utterly conventional. She still believed in the Methodist church, in going to church on Sundays, or at least sometimes. Despite her apparently immoral relations with him she was not immoral at all. Her distress and shame, indicating probable suicide unless her state was remedied—her love justified by matrimony—proved it. These girls—some of them at least—would not be worried by any such relationship as that. They would take it as a matter of course. Did it mean that he would have to give most of them up? Of course there were many who were eligible anywhere—in the strictest homes—McHugh and Smite, for instance, and Miss Finch and Miss DeZauche, who was now singing a song to the accompaniment of a

guitar, but the others—and they were almost the most remarkable ones of the lot—how would they fare? How would Angela receive a girl like Miss Stein—a radical like Nordyen? Would they come to a house presided over by such a woman as she? How would he teach Angela the quality of this life? How would she take to it? He let it go as something which time would adjust and turned his attention to a sailor song which Smite was beginning to sing by request—"When I Was a Lad I Went to Sea." The hearty square face and honest eyes of his mess mate always appealed to Eugene.

He got up and went over to stand beside him, joining in on the noisy refrain of "Sing tiddery I and an oary oh!" Nordyen was still pursuing Overman with requests to drink. Miss Stein was looking dreamily into the eyes of Louis Deesa, who had forsaken his original companion. McHugh and Norma Whitmore were engaged in a cheerful debate and some fourteen writers, artists, critics, and bohemians at large were tramping to and fro, single file, lockstep fashion, singing "tiddery i and an oary oh," with Eugene. It was gay and silly and good-natured and it was one of the things which reconciled Eugene to the art life. He was finding that there was not so much money in it—at least he had not made very much as yet—but this was color and youth and freedom and enthusiasm and it was worth something, truly it was. He was glad that McHugh and Smite had called these representatives of Bohemia together. He was glad to be a part of it—sorry that tonight was his last night under this roof. Tomorrow he would go to Buffalo and after that he would have to carve out a new form of existence for himself. Angela would have to be with him in everything.

Angela! Certainly delirious moments came back to him at the thought— at the knowledge that in a little over twenty-four hours more he would be with her. It was not the fine feeling of spiritual companionship which ought to elevate one in a moment of that kind but something lower. Alas, he did not see it. He did not see how useless it is to base hopes of happiness on anything save mental and spiritual compatibility. He was as blind in this hour as matter itself—he who could see so many phases of life with so truly a spiritual eye.

At two thirty in the morning the excitement began to wane and at four o'clock the last cheerful straggler had left.

"It was a great blowout, wasn't it?" declared Smite. "I God, Eugene, there was some jinks here, hey? Let's open the windows and get the smoke out. Phew!"

He threw open the windows. Eugene sat down and stretched his legs.

"McHugh, you old Ranchero, come to life, will you? Wasn't that Jensen girl a peach? Say, by God, I believe she likes me."

"Oh cut it out and let's crawl," said McHugh, pulling the pillows into

shape at the head of his bed. "Your last night, Eugene, remember that. You'll have an apartment of your own to run, from now on."

"Right-oh," said Smite. "It's all day with you now, Eugene, by God."

"Oh, that's all right," grinned Eugene cheerfully. "I'm sorry it's all over though—I really am. I've had a hell of a fine time in this place."

"Here, too," said Smite.

"Here, too," said McHugh. "Well you've gone and done it so we won't worry now, but I'm sorry you're going and I wish you didn't have to."

They turned in at last and soon Smite and McHugh were soundly sleeping, but Eugene was full of vague apprehensions of he knew not what. He wasn't going into this new relationship with a whole and enthusiastic heart as he should have been. In spite of this joyous windup he was not feeling quite right about it. Angela was a model girl—would make an ideal wife for some one, but would she fit in here—would she suit him? This crowd which had just left—how much of the life they represented could enter this new world of his? He turned it all over curiously and then fell to dozing, dreaming that he was on the train to Buffalo, that he was married, that he was back in his father's old barn fixing a machine which had a broken shuttle bar. It seemed scarcely an hour before someone shook him and then there was Smite saying, "Hey! Eugene, you have to get up some time today. You're leaving this afternoon, you know."

Eugene rubbed his eyes. It was after nine. "Well, I'll be plum cussed," he exclaimed. "I did sleep soundly, didn't I?"

And he rose and went to take his bath.

CHAPTER XXXII

The marriage ceremony between Eugene and Angela was solemnized at Buffalo on November second, the day following Eugene's departure from New York. Together with Marietta, after viewing the falls, they came as far east as West Point where Marietta, because of her personal charm and her brother David's popularity, was invited to stay a week with some friends of his, leaving Eugene and Angela free to come to New York together and have a little time to themselves. Naturally, under the circumstances, it was a very simple affair, for there were no congratulations to go through with and no gifts—at least immediately—to consider and acknowledge. Angela had explained to her parents and friends that it was absolutely impossible for Eugene to come West at this time—and besides he objected to a public ceremony where he would have to run the gauntlet of all her relatives—

so that he preferred that she meet him in the East and be married there. Eugene had not troubled to take his family into his confidence as yet. He had indicated on his last visit home that he might get married and that Angela was the girl in question, but since Myrtle was the only one of his family who had seen her and she was now in Ottumwa, Iowa, they could not recall anything about her. To tell the truth, Eugene's father was a little disappointed for he expected to hear some day that Eugene had made a brilliant match. His boy, whose pictures were in the magazines so frequently and whose appearance was so generally distinguished, ought in New York, where opportunities abounded, to marry an heiress at least. It was all right of course if Eugene wanted to marry a girl from the country, but it robbed the situation of its possible glory.

The spirit of this marriage celebration in so far as Eugene was concerned was not right, for of course he was not approaching it in the right spirit. There was the consciousness, always with him, of his possibly making a mistake; the feeling that he was being compelled by untoward circumstances and his own weakness to fulfill an agreement which might better remain, for his interests at least, unfulfilled; and lastly the dominant feeling of desire, the gratification of which he looked to for such compensation as might lie in saving Angela from an unhappy and possibly broken hearted spinsterhood. It was a thin reed to lean on; there could be no honest satisfaction in it. Angela was sweet, devoted, painstaking in her attitude toward life, toward him, toward everything with which she came in contact, but she was not what he had always fancied his true mate would be—the be all and the end all of his existence. Where was the divine fire which on this occasion should have animated him; the happy thoughts of future companionship; that intense feeling he had first felt about her when he had called on her at her aunt's house in Chicago? Something had happened. Was it that he had cheapened his ideal by too close contact with it? Had he taken a beautiful flower and trailed it in the dust? Was passion all there was to marriage? Or was it that true marriage was something higher—a union of fine thoughts and feelings? Did Angela share his with him? Did he have any real noble, beautiful thoughts which a woman of mental beauty could share with him? Angela had exalted feelings and moods at times. They were not sensibly intellectual or verbally expressible, but she seemed to respond to the better things in music and to some extent in literature. She knew nothing about art, was not progressive and intellectually grasping after the constructive fashion of Miriam Finch and Christina Channing, but she was emotionally responsive to many fine things. Why was not this enough to make life durable and comfortable between them? Was it not really enough?

After he had gone over all these points, there was still the thought that

there was something wrong in this union. Despite his supposedly laudable conduct in fulfilling an obligation which in a way he had helped create or created, he was not happy. He went to his marriage as a man goes to fulfill an uncomfortable social obligation. It might turn out that he would have an enjoyable and happy life and it might turn out very much otherwise. He could not feel the weight and significance of the public thought that this was for life—that if he married her today he would have to live with her all the rest of his days. He knew that this was the generally accepted interpretation of marriage but it did not appeal to him. Union ought, in his estimation, to be based on a keen desire to live together and on nothing else. He did not feel the obligation which attaches to children for he had never had any and did not feel the desire for any. A child in his estimation was a kind of nuisance. Marriage was a trick of nature's by which you were compelled to carry out her schemes for race continuance. Love was a lure, sex desire a scheme of propagation devised by the race spirit. Nature, the race spirit, used you as you would use a work horse to pull a load. The load in this case was race progress and man was the victim. He did not think he owed anything to nature or rather this race spirit. He had not asked to come here. He had not been treated as generously as he might have been since he arrived. Why should he do what nature bid?

When he met Angela he kissed her fondly, for of course the sight of her aroused the feeling of desire which had been running in his mind so keenly for some time. Since seeing Angela he had touched no woman, principally because the right one had not presented herself and because the memories and the anticipations in connection with Angela were so close. Now that he was with her again the old fire came over him and he was eager for the completion of the ceremony. They sought a Methodist minister—he had seen to the marriage license in the morning—and from the train on which Angela and Marietta arrived they proceeded directly in a carriage to the preacher. The ceremony which meant so much to Angela meant practically nothing to him. It seemed a silly formula—this piece of paper from the marriage clerk's office and this instructed phraseology concerning "love, honor, and cherish." Certainly he would love, honor, and cherish if it were possible—if not, then not.

Angela, with the marriage ring on her finger and with the words "with this ring I thee wed" echoing in her ears, felt that all her dreams had come true. Now she was really, truly, Mrs. Eugene Witla. She did not need to worry about drowning herself or being disgraced or enduring a lonely, rather commiserated old age. She was the wife of an artist—a rising one—and she was going to live in New York. What a future stretched before her. Eugene loved her after all. She imagined she could see that. His slowness in marry-

ing her was due to his difficulty of establishing himself properly. Otherwise he would have done it before. They drove to the Iroquois Hotel and registered as man and wife, securing a separate room for Marietta. The latter pretended an urgent desire to bathe and clean up and left them, promising to be ready in time for dinner. Eugene and Angela were finally left alone.

He saw now, how in spite of his fine theories, his previous experiences with Angela had deadened to an extent his joy in this occasion. He had her again, it was true. His desire that he had thought of so keenly was to be gratified but there was no mystery connected with it. His real nuptials had been celebrated at Black Wood months before. This was the commonplace of any marriage relation. It was intense and gratifying, but the original, wonderful mystery of unexplored character was absent. He eagerly undressed her and took her in his arms but there was more of crude desire than of refined affection in the whole proceeding.

Nevertheless Angela was sweet to him. She had obviously a loving disposition and anyhow he was the beginning and the end of her existence. His figure was of heroic proportions to her. His talent, divine fire. No one could know as much as Eugene of course! No one could be as artistic. To her he was not as obviously practical as some men—her brothers and brothers-in-law, for instance, but he was a man of talent, of genius. Why should he be practical? She was beginning to think already of how thoroughly she would help him shape his life toward success—what a good wife she would be to him. Her training as a teacher, her experience as a buyer, her practical judgement outside of matters relating to sex and the affections, would help him so much.

They spent the two hours up to dinner in renewed transports of gratification and then dressed and made their public appearance. Angela had designed a number of dresses for this occasion—the savings of years—and tonight she looked exceptional at dinner in a dress of black silk, set with a neck piece and half sleeves of mother-of-pearl silk. A joint arrangement of seed pearls and black beads, inset designs on the bodice and the hem of the skirt, gave it additional distinction. Marietta, in a pale pink china silk of peach blow softness of hue with short sleeves and a bodice cut low in the neck was, because of her youth and natural plumpness and gayety of soul, ravishing. Now that she had Angela safely married she was under no obligations to keep out of Eugene's way nor to modify her charms in order that her sister's might shine. She was particularly ebullient in her mood and Eugene could not help contrasting even in this hour the qualities of the two sisters. Marietta's smile, her humor, her unconscious courage, contrasted so markedly with Angela's moodiness and emotional gloom. To say that there was any comparison between the two women's emotional capacities would

be unjust to Angela. She had more of the fire of real affection and passion than anyone Eugene had ever known.

The luxuries of the modern hotel have become the commonplace of ordinary existence but to Eugene and Angela they were still strange enough to be impressive. To Eugene, because of his metropolitan experiences, they were somewhat dull but to Angela they were a foretaste of what was to be an enduring higher life. These carpets, hangings, elevators, waiters, seemed in their shabby materialism to speak of superior things. So mortal mind makes of clay its idols and bows obsequiously or reverently to wood and stone.

They spent one day in Buffalo with a view of the magnificent current at Niagara, and then came West Point with a dress parade coincidentally provided for a visiting general and a ball for the cadets. Angela and Eugene only stayed long enough to see Marietta safely housed and then came to the city and the apartment in Washington Square.

It was dark when they arrived and Angela was impressed with the glittering galaxy of light the city presented across the North River from Forty-second Street. She had no idea of the nature of the city and as the cab at Eugene's request turned into Broadway at Forty-second and clattered with interrupted progress south to Fifth Avenue, she had her first glimpse of that tawdry world which subsequently became known as the Great White Way. Already much of its make-believe and inherent cheapness was a factor in Eugene's judgement of the city and its life but it still held enough of the lure of the flesh and of clatter and of rushlight reputations to hold his attention. Here was where the dramatic critics were, and the most noted actors and actresses, and the chorus girls and the avid, inexperienced, unsatisfied, material elements of wealth. He showed Angela the different theatres, called her attention to the distinguished names, made much of restaurants and hotels and shops and stores that sell trifles and trash, and finally turned into lower Fifth Avenue, where the dignity of great homes and great conservative wealth still lingered. At Fourteenth Street Angela could already see Washington Arch glowing cream white in the glare of electric lights.

"What is that?" she asked interestedly.

"It's Washington Arch," he replied. "We live in sight of that on the south side of the square."

"Oh, isn't it beautiful," she exclaimed.

It seemed very wonderful to her, and as they passed under it and the whole square spread out before her, it seemed a perfect world in which to live.

"Is this where it is?" she asked as they stepped in front of the studio building.

"Yes, this is it. How do you like it?"

"I think it's beautiful," she said.

They went up the white stone steps of the old brick house in which was Eugene's leased studio, and up two flights of stairs carpeted nicely with red, and finally into the dark studio where he struck a match and lit, for the art of it, candles. A soft waxen glow irradiated the place as he proceeded and then Angela saw old Chippendale chairs, a Hepplewhite writing table, a Flemish strong box containing used and unused drawings, the green stained fish net studded with bits of looking glass in imitation of scales, a square, gold framed mirror over the mantel, and one of Eugene's drawings—the three engines in the gray, lowery weather, standing large and impressive up on an easel. It all seemed wonderful to Angela, the perfection of beauty. She saw the difference now between the tawdry gorgeousness of a commonplace hotel and this selection and arrangement of individual taste. The glowing candelabrum, one of seven candles on either side of the square mirror, impressed her deeply. The black walnut piano in the alcove behind the half draped net drew forth an exclamation of delight.

"Oh, how lovely it all is," she exclaimed and ran to Eugene to be kissed. He fondled her for a few minutes and then she left to examine in detail pictures, pieces of furniture, ornaments of brass and copper.

"When did you get all this?" she asked, for Eugene had not told her of his luck in finding the departing Dexter and leasing the apartment for the rent of the studio and its care. He was lighting the fire in the grate which had been prepared by the house attendant, Max Schindler.

"Oh, it isn't mine," he replied easily. "I leased this from Russell Dexter. He's going to be in Europe until next winter. I thought that would be easier than waiting around to fix up a place after you came. We can get our things together next fall."

He was thinking he would be able to have his exhibition in the spring and perhaps that would bring some notable sales. Anyhow it might bring a few, increase his repute, and give him a greater earning power.

Angela's heart sank just a little but she recovered in a moment, for after all it was very exceptional even to be able to lease a place of this character. She went to the window and looked out—the great square with its four walls of lighted houses, the spread of trees, still decorated with a few dusty leaves, and the dozens of arc lights sputtering their white radiance in between the graceful arch, cream white over at the entrance of Fifth Avenue.

"It's so beautiful," she exclaimed again, coming back to Eugene and putting her arms about him. "I didn't think it would be anything as fine as this. You're so good to me."

She put up her lips and he kissed her, pinching her cheeks. Together they walked to the kitchen they were to use, the bedroom they were to occupy, the bathroom. Then after a time they blew out the candles and retired for the night.

CHAPTER XXXIII

The social life which any condition offers depends of course on the individual primarily—his intelligence, magnetism, capacity for enjoyment, and the like. No condition where talent and magnetism prevail is absolutely bad; none without imagination, tact and judgement, is truly good. The individual is the answer.

After the quiet of a small town, the monotony and simplicity of country life, the dreary, reiterated weariness of teaching a country school, this new world into which Angela was plunged seemed to her astonished eyes and ears to be compounded of little save beauties, curiosities, and delights. The human senses which weary so quickly of repeated sensory impressions exaggerate as enthusiastically the beauty and charm of that which is not customary. It is new—therefore it must be better than that which we have had of old. The material details with which we are able to surround ourselves at times seem to remake our point of view. If we have been poor, wealth will temporarily make us happy; if we have been amid elements and personages apparently discordant to our thoughts, to be put among harmonious conditions seems for the time being to solve all our woes. It is because we lack the understanding of that peace which springs from the eternal principle of which we are a part—and which no material conditions can truly affect or disturb—that we alternate between happiness and unhappiness. "Lay not up for yourselves treasures upon earth where moths and rust doth corrupt and where thieves break through and steal" is not the aimless mouthing of ignorance but the profoundest expression of eternal truth.

When Angela awoke the next morning, this studio in which she was now to live seemed the most perfect habitation which could be devised by man. The artistry of the arrangement of the rooms, the charm of the conveniences—a bath room with hot and cold water next to the bed room; a kitchen with an array of necessary utensils, in the rear portion of the studio used as a dining room; a glimpse of the main studio set with several intricately carved pieces; the sense of art which dealt with nature, the beauty of the human form, colors, tones—how different from teaching school. To her semi-educated intelligence the difference between the long, low, rambling house at Black Wood with its vine ornamented windows, its somewhat haphazard arrangement of flowers and its great lawn, and this peculiarly compact and ornate studio apartment looking out upon Washington Square, was all in favor of the latter. In Angela's judgement there was no comparison.

She could not have understood, if she could have seen into Eugene's mind at this time, how her home town, her father's simple farm, the blue waters of the little lake near her door, the shadows of the tall trees on her

lawn, were somehow compounded for him not only with classic beauty itself but, what was much more to her advantage emotionally, with her very being in his eyes. Having seen her among these things, he felt she partook of their beauty and was dignified and made more charming thereby. They were not cheap and unimportant but beautiful. To her all these older elements of her life were shabby and unimportant—pointless and to be neglected. To him they were magnificent details of a great romance, like the caves and castles and forests of grand opera. Her father was as good as any hero in the Greek tragedies or character in romance. He was fine and dignified and noble. To Eugene her home surroundings, from which she had now been withdrawn, was the fine thing. This studio was charming surely but the simplicities of her early life were better. They were cleaner, more rugged, hence more essentially worthwhile. Angela would not have comprehended the drift of his poetic thought in this connection if she had known, but temporarily at least she was reaping the reward. He was too aerial for her understanding—too removed in cloudy drifts of artistic and poetic conception for her to know and follow where he led.

This new world was in its way for her, however, an Aladdin's cave of delight. When she looked out on the great square for the first time the next morning, seeing it bathed in sunlight, a dignified line of red brick dwellings to the north, a towering office building to the east, trucks, carts, cars, and vehicles clattering over the pavement below, it all seemed gay with youth and energy. Everything was apparently clean. Everything new.

"We'll have to dress and go out to breakfast," said Eugene. "I didn't think to lay anything in. As a matter of fact I wouldn't have known what to have bought if I had wanted to. I never tried housekeeping for myself."

"Oh that's all right," said Angela, fondling his hands, "only let's not go out to breakfast unless we have to. Let's see what's here," and she went back to the very small room devoted to cooking purposes to see what utensils for culinary work had been provided. She had been dreaming of housekeeping and cooking for Eugene—petting and spoiling him—and now the hour of her opportunity had arrived. She found that Mr. Dexter, their generous lessor, had provided himself with many conveniences—breakfast and dinner sets of brown and blue porcelain, a coffee percolator, a charming dark blue teapot with cups to match, a chafing dish, a set of waffle irons, griddles, spiders, skillets, stew and roasting pans, and knives and forks of steel and silver in abundance. Obviously he had entertained from time to time, for there were bread, cake, sugar, flour, and salt boxes, and a little chest containing in small drawers the various spices.

"Oh, it will be easy to get something here," said Angela, lighting the various burners of the gas stove to see whether it was in good working order.

"We can just go out to market if you'll come and show me once and get what we want. It won't take a minute. I'll know after that."

Eugene consented gladly. She had always fancied she would be an ideal housekeeper and now that she had her Eugene, she was anxious to begin. It would be such a pleasure to show him what a manager she was, how everything would go smoothly in her hands, how careful she could be of his earnings—their joint possessions.

She was sorry, now that she saw that art was no great producer of wealth, that she had no money to bring him but she knew that Eugene in the depths of his heart thought nothing of that. He was too impractical. He was a great artist, but when it came to practical affairs she felt instinctively that she was much the wiser. She had bought for so long—calculated so well for her sisters and brothers in the necessary buying.

Out of her bag (for her trunks had not arrived yet) she extracted a neat house dress of pale green linen, which she put on after she had done up her hair in a cosy coil, and together (with Eugene for a temporary guide) they set forth to find where the stores were. He had told her, looking out the window, that there were lines of Italian grocers, butchers, and vegetable men in the side streets leading south from the square, and into one of these they now ventured. The swarming, impressive life of the street almost took her breath away. It was so crowded. Potatoes, tomatoes, eggs, flour, butter, lamb chops, salt—a dozen little accessories were all purchased in small quantities and an eager return to the studio made. Angela was a little disgusted with the appearance of some of the stores but she was also convinced that some of them were notably clean. It seemed so strange to her to be buying in an Italian street, with Italian women and children all about, their swarthy or leathern faces set with bright, almost feverish eyes. Eugene, in his brown corduroy suit and soft green hat, watching and commenting at her side, presented such a contrast. He was so tall, so exceptional, so laconic.

"I like them when they wear rings in their ears," he said at one time.

"Get a coal man who looks like a bandit," he observed at another.

"This old woman here might do for the witch of Endor."

Angela tended strictly to her marketing. She was gay and smiling but practical. She was busy wondering in what quantities she should buy things, how she would keep fresh vegetables, whether the ice box was really clean, how much delicate dusting the various objects in the studio would require. The raw brick walls of the street, the dirt and slops in the gutter, the stray cats and dogs hungry and lean, the swarming stream of people, did not appeal to her as picturesque at all. Only when she heard Eugene expatiating gravely did she begin to realize that all this must have artistic possibilities. If Eugene said so, it did. But it was a fascinating world, whatever it was, and it was obvious that she was going to be very, very happy.

There was a breakfast in the studio then of hot biscuit, with fresh butter, an omelette with tomatoes, potatoes stewed in cream, and coffee. After the long period of commonplace restaurant dining which Eugene had endured, this seemed ideal. To sit in your own private apartment, furnished in comparative luxury, with a charming wife opposite you ready to render you any service, and with an array of food before you which revived the finest memories in your experience seemed perfect. Nothing could be nicer. He saw visions of a happy future if he could finance this. It would require considerable money, more than he had been making, and it was beginning already to give him serious cause for reflection, but he thought he could make out. After breakfast Angela played on the piano and then, Eugene wanting to work, she started housekeeping in earnest. The trunks arriving gave her the task of unpacking, and between that and lunch and dinner, to say nothing of love, she had sufficient to do.

It was a charming existence for a little while. Eugene suggested that they have Smite and McHugh to dinner to begin with, these being his closest friends. Angela agreed heartily, for she was only too anxious to meet the people he knew. She wanted to show him that she knew how to receive and entertain as well as anyone he knew. She made great preparation for the Wednesday evening following—the night set for dinner—and when it was come was on the qui vive to see what his friends were like and what they would think of her.

This particular dinner passed off smoothly enough and was the occasion of considerable jollity, for these two cheerful worthies were never without appreciation of honest merit, and never having been in the Dexter Studio were greatly impressed with its contents. They were quick to congratulate Eugene on his luck before Angela, and to compliment him on his good fortune in having married her. Angela, in the same dress in which she had appeared at dinner in Buffalo, was impressive. Her mass of Titian hair fascinated the gaze of both Smite and McHugh.

"Gee, what hair!" Smite observed secretly to McHugh when neither Angela nor Eugene were within hearing distance and later, more subtly, he complimented Angela directly, who was greatly pleased.

"You're right," returned McHugh. "She's not at all bad looking, is she?"

"I should say not," returned Smite, who admired Angela's simple, good-natured western manners.

Marietta, who had arrived late in the afternoon, had not appeared yet. She was in the one available studio bed room making her toilet. Angela, in spite of her fine raiment, was busy superintending the cooking, for although through Max Schindler, the janitor, she had managed to negotiate the loan of a girl to serve, she could not get anyone to cook. A soup, a fish, a chicken, and a salad were the order of procedure.

Marietta finally appeared, ravishing in close fitting pink silk, with short sleeves and a low cut waist. Both Smite and McHugh sat up, for Marietta knew no orders or distinctions in men. They were all slaves to her—victims to be stuck on the spit of her beauty and broiled at her leisure. In after years Eugene learned to speak of Marietta's smile as "the dagger." The moment she would appear smiling he would say, "Ah, we have it out again have we? Who gets the blade this evening? Poor victim!"

Being her brother-in-law now, he was free to slip his arm about her waist and she took this family connection as license to kiss him. There was something about Eugene which held her always. During these very first days she gratified her desire to be in his arms but always with a sense of reserve which kept him in check. She wondered secretly how much he liked her—how far he would venture to go if she would let him.

As for Smite and McHugh, now when she appeared, they both rose to do her service. McHugh, who was delightfully impressed, offered her his chair by the fire. Smite bestirred himself in an aimless fashion.

"I've just had such a dandy week up at West Point," began Marietta cheerfully, "dancing, seeing dress parades, walking with the soldier boys."

"I warn you two, here and now," began Eugene, who had already learned to tease Marietta, "that you're not safe. This woman here is dangerous. As artists in good standing, you had better look out for yourselves."

"Oh, Eugene, how you talk," laughed Marietta, her teeth showing effectively. "Mr. Smite, I leave it to you. Isn't that a mean way to introduce a sister-in-law—I'm here for just a few days, too, and have so little time. I think it cruel."

"It's a shame!" said Smite, who was plainly a willing victim. "You ought to have another kind of brother-in-law. If you had some people I know, now——"

"It's an outrage," commented McHugh. "There's one thing, though. You may not require so very much time."

"Now I think that's ungallant," Marietta laughed. (McHugh's look was as dry as a cowboy's.) "I see I'm all alone here except for Mr. Smite. Never mind. You all will be sorry when I'm gone."

"I believe that," replied McHugh, feelingly. He sensed how easy it would be to fall in love with her.

Smite simply stared. He was lost in admiration of her peaches and cream complexion, her fluffy, silky brown hair, her bright blue eyes and plump, rounded arms. Such radiant good nature would be heavenly to live with. He wondered what sort of a family this was that Eugene had become connected with. Angela, Marietta, a brother at West Point. They must be nice, conservative, well-to-do western people. Marietta left to help her sister and

Smite, in the absence of Eugene, said, "Say, he's in right, isn't he? She's a peach. She's got it a little on her sister."

McHugh merely stared at the room. He was taken with the complexion and arrangement of things generally. The old furniture, the rugs, the hangings, the pictures, Eugene's borrowed maid servant in a white apron and cap. Angela, Marietta, the bright table set with colored china and an arrangement of single silver candlesticks, with one of four branches in the center—Eugene had certainly changed the tenor of his life radically within the last ten days. Why he was really marvellously fortunate. This studio was a wonderful piece of luck. Some people—and he shook his head meditatively.

"Well," said Eugene, coming back after a final touch to his toilet, "what do you think of it, Peter?"

"You're certainly moving along, Eugene. I never expected to see it. You ought to praise God. You're plain lucky."

Eugene smiled enigmatically. He was wondering whether he was. Neither Smite nor McHugh nor anyone could dream of the conditions under which this came about. What a sham the world was anyhow, its surface appearances so ridiculously deceptive. If anyone had known of the apparent necessity when he first started to look for an apartment—of his own mood toward it!

Marietta came back, and Angela. The latter had taken kindly toward both these men or boys, as she deemed them, because one had come from the sea and one from the farm. Eugene had a talent for reducing rather grandiloquent personages to "simply folks," as he so often called them. He saw under every reputation the individual, like a small man hidden in a great overcoat. No one could be awesomely *grand* in his presence. Something about his own attitude prevented it. He took all reputations as a matter of course for he considered his own personality the peer of any. He did not want to appear self-opinionated or boastful but no one could condescend to him. He had to be accepted as an equal or not at all. So these two capable and talented men were mere country boys like himself—and Angela caught his attitude.

"I'd like to have you let me make a sketch of you some day, Mrs. Witla," McHugh said to Angela, when she came back to the fire. He was essaying portraiture as a sideline and every worthwhile opportunity was important in the matter of practise.

Angela thrilled at the invitation and the use of her new name, Mrs. Witla, by Eugene's old friends.

"I'd be delighted, I'm sure," she replied, flushing.

"My, won't you look nice, Angel Face," exclaimed Marietta, catching her

about the waist. "You paint her with her hair down in braids, Mr. McHugh. She makes a stunning Gretchen."

Angela flushed anew.

"I've been reserving that for myself, Peter," said Eugene, "but you try your hand at it. I'm not much on portraiture anyhow."

Smite smiled at Marietta. He wished he could paint her but he was poor at figure work except as incidental characters in sea scenes. He could *do* men better than he could women.

"If you were an old sea captain now, Miss Blue," he said to Marietta gallantly, "I could make a striking thing out of you."

"I'll try to be, if you want to paint me," she replied gaily. "I'd look fine in a big pair of boots and a raincoat, wouldn't I, Eugene?"

"You certainly would, if I'm any judge," replied Smite. "Come over to the studio and I'll rig you out. I have all those things on hand."

"I will," she replied, laughing. "You just say the word."

McHugh felt as if Smite were stealing a match on him. He wanted to be nice to Marietta—to have her take an interest in him.

"Now, looky, Joseph," he protested. "I was going to suggest making a study of Miss Blue myself."

"Well you're too late," replied Smite. "You didn't speak quick enough."

Marietta was notably impressed with this atmosphere in which Angela and Eugene were living. She expected to see something of an art atmosphere but nothing so nice as this particular studio. Angela explained to her that Eugene did not own it, but that made small difference in Marietta's estimate of its significance. Eugene had it. His art and social connections brought it about. They were beginning excellently well. If she could have as nice when she started on her married career, she would be satisfied.

They sat down about the round teak table which was a part of Dexter's prized possessions and were served by Angela's borrowed maid. The conversation was light and for the most part pointless, serving only to familiarize these people with each other. Both Angela and Marietta were taken with the two artists because they detected in them a note of homely conservatism. They spoke easily and naturally of the trials of art life, the difficulty of making a good living, its triumphs, and seemed to be at home with personages of repute in one world and another.

During this dinner Smite narrated experiences in his sea-faring life and McHugh of his mountain camping experiences in the West. Marietta described experiences with her beaus in Wisconsin and characteristics of her yokel neighbors at Black Wood, and Angela joined in. Finally McHugh drew a picture of Marietta followed by a long train of admiring yokels and showed her eyes turned up in a very shy, deceptive manner.

"Now I think that's mean," she declared, when Eugene laughed heartily. "I never look like that."

"That's just the way you look and do," he declared. "You're the broad and flowery path that leadeth to destruction."

"Never mind, Babyette," put in Angela. "I'll take your part if no one else will. You're a nice, demure, shrinking girl and you wouldn't look at anyone, would you?"

Angela got up and was holding Marietta's head mock sympathetically in her arms.

"Say, that's a dandy pet name," called Smite, moved by Marietta's beauty.

"Poor Marietta," observed Eugene. "Come over here to me and I'll sympathize with you."

"You don't take my drawing in the right spirit, Miss Blue," put in McHugh cheerfully. "That simply shows how popular you are."

Angela stood beside Eugene as his guests departed, her slender arm about his waist. Marietta was coquetting finally with McHugh. These two friends of his, thought Eugene, had the privilege of singleness—to be gay and alluring to her. With him, that was over now. He could not be that way to any girl any more. He had to behave—be calm and circumspect. It cut him, this thought. It was, he saw at once, not in accord with his nature. He wanted to do just as he had always done—make love to Marietta if she would let him—but he could not. He walked to the grate fire when the studio door was closed.

"They're such nice boys," exclaimed Marietta. "I think Mr. McHugh is as funny as he can be. He has such droll wit."

"Smite is nice too," replied Eugene, defensively.

"They're both lovely—just lovely," returned Marietta.

"I like Mr. McHugh a little the best—he's quainter," said Angela, "but I think Mr. Smite is just as nice as he could be. He's so old fashioned. There's not anyone as nice as my Eugene, though," she said affectionately, putting her arms about him.

"Oh, dear, you two!" exclaimed Marietta. "Well, I'm going to bed."

Eugene sighed.

They had arranged a couch for her which could be put behind the silver spangled fish net in the alcove when company was gone.

Eugene thought what a pity that already this affection of Angela's was old to him. It was not like it would be if he had taken Marietta or Christina. They went to their bed room to retire and then he saw that all he had was passion, not intellectual joy. Must he be satisfied with that? Could he be? It started a chain of thought which, while persistently interrupted or befogged,

was never really broken. Momentary sympathy, desire, admiration might obscure it but always basically it was there. He had made a mistake. He had put his head in a noose. He had subjected himself to conditions which he did not sincerely approve of. How was he going to remedy this—or could it ever be remedied?

CHAPTER XXXIV

The joint relationship into which Eugene and Angela had thus entered and which, in the minds of the vast majority of people at that time, was bound up and interlaced with emotions, obligations, and privileges which transcend written or unwritten social law, was to him merely a peculiar social custom or habit which had grown up through a long period of racial evolution. This in its turn was based on many fortuitous circumstances of climate, danger, race prosperity, race perversity, the lure of color, the lure of form—anything and everything save spiritual or divine command which, had he reasoned further, might have appeared to him absolutely unavoidable. He could not see that religion or religious emotions had anything to do with marriage, given that he believed in evolution and the survival of the fittest. His idea of matrimony was that it was based on accidental chemical affinity; that it represented nothing higher than a correlation of mutual emotions and desires. If these endured, marriage might well endure. If they altered or failed, it might well cease. It occurred to him that if children were born their presence might complicate matters, though he observed that children did well under almost any circumstances. According to the evolutionists, anyhow, coddling and care diminished strength. A child, to be successful, should be subject to trials. Eugene forgot or left out of his calculations the thought that any child needs a certain amount of nurture before it can endure trials—his own among others. He had read Jean Jacques Rousseau's *Confessions* and was inclined to think that the orphan asylum, under certain conditions, might not be a bad solution of the child problem. In all fairness it should be said of him, though, that his thoughts were far more revolutionary than his deeds. He really objected strenuously to certain orphan asylum conditions as he knew them to be and would not personally have subjected his own or any other child to these conditions. If he had had children, his natural sympathy would have led him to stand by and protect them. It was possibly both fortunate and unfortunate (looked at from one aspect and another) that in this case the rearing of children was not possible.

He began his marriage career, however, with the outward air of one who takes it seriously enough. Although he had felt all this time that he was making a mistake, now that he was established in the married state, was actually bound by legal ties, he felt that he might as well make the best of it. He had had the notion at one time that it might be possible to conceal his marriage, keeping Angela in the background, but this notion had been dispelled by the attitude of McHugh and Smite, to say nothing of Angela. He saw, when he thought of it, that this could not be. So he began to consider the necessity of notifying his friends—Miriam Finch and Norma Whitmore and possibly Christina Channing when she returned, if she ever did. These three women offered the largest difficulty, to his mind. He anticipated the commentary which their personal ties represented. What would they think of him? What of Angela? Now that she was right here in the city, he could see that she represented a different order of thought. She was not as artistic as they. He had opened the campaign by suggesting that they invite Smite and McHugh. The thing to do now was to go further in this matter.

The one thing that troubled him was breaking the news to Miriam Finch, for Christina Channing was away and Norma Whitmore was not of sufficient importance. He argued now that he should have done this beforehand, but having neglected to do so, it behooved him to act at once. He did so, finally, writing Norma Whitmore and saying, for he had no long explanation to make, "Yours truly is married. Can I bring my wife to see you?" Miss Whitmore was truly taken by surprise. She was sorry at first—very—because Eugene interested her greatly and she was afraid he would make a mistake in his marriage, but she hastened to make the best of a bad turn on the part of fate and wrote a note which ran as follows:

"Dear Eugene and Eugene's wife:
"This is news 'as is news.' Congratulations. And I am coming right down as soon as I get my breath. And then you two must come to see me.
"Norma Whitmore."

Eugene was pleased and grateful that she took it so nicely but Angela was the least bit chagrined secretly that he had not told her before. Why hadn't he? Was this someone that he was interested in? Those three years in which she had doubtingly waited for Eugene had whetted her suspicions and nurtured her fears. Still she tried to make little of it and to put on an air of joyousness. She would be so glad to meet Miss Whitmore. Eugene told her how kind she had been to him, how much she admired his art, how influential she was in bringing together young literary and artistic people. She could do him many a good turn. Angela listened patiently but she was

just the least bit resentful that he should think so much of any one woman, outside of herself. Why should he, Eugene Witla, be dependent on the favor of any woman? Of course she must be very nice, and they would be good friends, but——

Norma came one afternoon two days later with the atmosphere of enthusiasm trailing (it seemed to Eugene) like a cloud of glory about her. She was both fire and strength to him in her regard and sympathy even though she resented, ever so slightly, his affectional desertion.

"You piggy-wiggy, Eugene Witla," she exclaimed. "What do you mean by running off and getting married and never saying a word? I never even had a chance to get you a present, and now I have to bring it. Isn't this a charming location—why it's perfectly delightful," and as she laid her present down unopened she looked about to see where Mrs. Eugene Witla might be.

Angela was in the bedroom giving her toilet a last touch. She was expecting this descent and so was prepared, being suitably dressed in a light green house gown. When she heard Miss Whitmore's familiar mode of address she winced, for this spoke volumes for a boon companionship of long endurance. Eugene hadn't said so much of Miss Whitmore in the past as he had recently but she could see that they were very intimate. She looked out only to see this tall, not very shapely, but graceful woman, whose whole being represented dynamic energy, awareness, subtlety of perception. Eugene was shaking her hand and looking genially into her face. A thrill of jealousy passed over Angela, for she saw in his look genial enthusiasm, delight, appreciation—a sort of leaning toward her which was brotherly in the extreme and almost more than that.

"Why should Eugene like her so much?" she asked herself instantly. Why did his face shine with that light of intense enthusiasm? This "piggy-wiggy Eugene Witla" expression of hers irritated Angela. It sounded as though she might be in love with him. She came out after a moment with a gladsome smile on her face and approached with every show of good feeling but Miss Whitmore could sense opposition. She extended her a cordial and enthusiastic greeting, however.

"So this is Mrs. Witla," she exclaimed, kissing her. "I'm delighted to know you. I have always wondered what sort of a girl Mr. Witla would marry. You'll just have to pardon my calling him Eugene. I'll get over it after a bit, I suppose, now that he's married. But we've been such good friends and I admire his work so much. How do you like studio life—or are you used to it?"

Angela, who was taking in every detail of Eugene's old friend, gushed that no, she wasn't used to studio life. She was just from the country, you know—a regular farmer girl—Black Wood, Wisconsin, no less! She stopped to let Norma express friendly surprise and then went on to say that she sup-

posed Eugene had not said very much about her, but he wrote her often enough. She was rejoicing in the fact that whatever slight Eugene's previous silence seemed to put upon her, she had the satisfaction that she had won him after all and not Miss Whitmore. She fancied from Miss Whitmore's enthusiastic attitude that she must like Eugene very much and could see now what sort of women might have made him wish to delay. Who were the others, she wondered.

They talked of metropolitan experiences generally. Marietta came in from a shopping expedition with a Mrs. Link, wife of an army captain acting as an instructor at West Point, and tea was served immediately afterward. Miss Whitmore was insistent that they should come and take dinner with her some evening. Eugene confided that he was sending a picture to the Academy.

"They'll hang it, of course," assured Norma, "but you ought to have an exhibit of your own." Angela in a way resented this assurance. Marietta gushed about the wonder of the greater stores and so it came time finally for Miss Whitmore to go.

"Now you will come up, won't you?" she said to Angela, for in spite of a certain feeling of incompatibility and difference, she was determined to like her. She thought Angela a little inexperienced and presumptuous in marrying Eugene. She was afraid she was not up to his standard mentally and emotionally. Still she was quaint, piquant. Perhaps she would do very well. Angela was thinking all the while that Miss Whitmore was presuming on her old acquaintance with Eugene—that she was too gushing and affected and enthusiastic. Angela had never seen the enthusiastic art and literary type, and she felt as though there were no sincerity behind it. As a matter of fact, a more sincere and normally sympathetic soul than Norma Whitmore never lived.

There was another day on which Miriam Finch called. Richard Wheeler, having been to Smite and McHugh's studio and learning of Eugene's marriage and present whereabouts, hurried over and then immediately afterward up to Miriam Finch's studio—for being surprised himself, he knew that she would be more so.

"Witla's married!" he exclaimed, bursting into her room, and for the moment Miriam lost her self-possession sufficiently to reply almost dramatically, "Richard Wheeler, what are you talking about! You don't mean that, do you?"

"He's married," insisted Wheeler, "and he's living down in Washington Square—61 is the number. He has the cutest red haired wife you ever saw."

Angela had been nice to Wheeler and he liked her. He liked the whole

complexion of this domicile and thought it was going to be a fine, advantageous thing for Eugene. He needed to settle down and work hard.

Miriam winced mentally at the picture. She was hurt by this defection of Eugene—chagrined because he had not thought enough of her even to indicate that he was going to get married.

"He's been married ten days," communicated Wheeler, and this added force to her temporary anger or disappointment. The fact that Angela was "red haired and cute" was also disturbing.

"Well," she finally exclaimed cheerfully, "he might have said something to us, mightn't he?" and she covered her own original confusion by a gay nonchalance which showed nothing of what she was really thinking. This was certainly indifferent on Eugene's part and yet why shouldn't he be? He had never proposed to her. Still, they had been so intimate mentally. She felt as though she could never feel quite the same about him any more.

Still she was interested to see Angela. She wondered what sort of a woman she really was. Red haired! Cute! That sounded promising from a physical point of view, unquestionably. Like all men, Eugene had sacrificed intellect and mental charm for a dainty form and a pretty face. It seemed queer but she had fancied that he would not do that—that his wife, if he ever took one, would be tall perhaps, and gracious, and of a beautiful mind—someone distinguished. Why would men, intellectual men, artistic men, any kind of men, invariably make fools of themselves? Well, she would go and see her.

Because Wheeler informed him that he had told Miriam, Eugene wrote her, saying as briefly as possible that he was married and that he wanted to bring Angela to the studio. For reply she came herself, gay, smiling, immaculately dressed, anxious to hurt Angela because she had proved the victor. She wanted to show Eugene also that it all made so little difference to her.

"You certainly are a secretive young man, Mr. Eugene Witla," she exclaimed when she saw him. "Why didn't you make him tell us, Mrs. Witla?" she demanded archly of Angela, but with a secret dagger thrust in her eyes. "You'd think he didn't want us to know."

Angela felt the sting of this whip cord. Miriam made her feel as though Eugene had attempted to conceal his relationship to her in various ways— as though he was ashamed of her. How many more woman were there like Miriam and Norma Whitmore?

Eugene, gaily unconscious of the real animus in Miriam's conversation, and now that the first cruel moment was over, was talking glibly of things in general, anxious to make everything seem as simple and natural as possible. He was working at one of his pictures when Miriam came in and was

eager to obtain her critical opinion, seeing that it was nearly done. She squinted at it narrowly but said nothing when he asked. Ordinarily she would have applauded it vigorously. She thought it exceptional now but was determined to say nothing. She walked indifferently about, examining this and that object in a superior way, asking how he came to obtain the studio, congratulating him upon his good luck. Angela, she decided for herself, was interesting but not in Eugene's class mentally, and in a way decided to ignore her. Eugene had made a mistake, she decided—that was plain. Angela would not be of much help to him. And he with his high flown, emotional nature needed some one!

"Now you must bring Mrs. Witla up to see me," she cautioned on leaving. "I'll play and sing all my latest songs for you. I have made some of the daintiest discoveries in old Italian and Spanish pieces."

Angela, who had posed to Eugene as knowing something about music, resented this superior invitation, without inquiry as to her own possible ability or taste, as she did Miriam's entire attitude. Why was she so haughty—so superior? What was it to her whether Eugene had said anything about her presence or not? Angela said nothing to show that she played herself but wondered that Eugene said nothing. It seemed neglectful and inconsiderate on his part. He was busy wondering what Miriam thought of his picture. She took his hand warmly at parting, looked cheerfully into his eyes, said, "I know you two are going to be irrationally happy," and went out.

Eugene felt the irritation at last. He knew that Angela felt something. Miriam was resentful, that was it. She was angry at him for his seeming indifference. She had commented to herself on Angela's appearance, and to her disadvantage. In her manner had been the statement that his wife was not very important after all—not of the artistic and superior world to which she and he belonged.

"How do you like her?" he asked tentatively after Miriam had gone, feeling a strong current of opposition but not knowing on what it might be based exactly.

"I don't like her," returned Angela petulantly. "She thinks she's smart. She treats you as though she thought you were her personal property. She openly insulted me about your not telling her. Miss Whitmore did the same thing—they all do! They all will! Oh!!"

She suddenly burst into tears and ran crying toward their bedroom.

Eugene followed, astonished, ashamed, rebuked, guilty minded, almost terror stricken—he hardly knew what. He had never encountered such an outburst as this before in anyone.

"Why Angela," he urged pleadingly and in self-defense, leaning over her and attempting to pick her up. "How you talk. You know that isn't true."

"It is! It is!!" she insisted. "Don't touch me! Don't come near me! You know it's true! You don't love me. You haven't treated me right at all since I've been here. You haven't done anything that you should have done. She insulted me openly to my face."

She was shaking with sobs and Eugene was at once pained and terrorized by this persistent and unexpected display of emotion. He had never seen Angela like this before. He had never seen any woman so.

"Why, Angel Face," he urged, "how can you go on like this? You know what you say isn't true. What have I done?"

"You haven't told your friends—that's what you haven't done," she exclaimed between gasps. "They still think you're single. You keep me here hidden in the background as though I were a—were a—I don't know what. Your friends come and insult me openly to my face. They do! They do! Oh!" and she sobbed anew.

She knew very well what she was doing in her anger and rage. She felt that she was acting in the right way. Eugene needed a severe reproof. He had acted very badly and this was the way to administer it to him now, in the beginning. This conduct of his was indefensible, and only the fact that he was an artist, immersed in cloudy artistic thoughts and not really subject to the ordinary conventions of life, saved him in her estimation. It didn't matter that she had urged him to marry her. It didn't absolve him that he had done so generously. She thought he owed her that. Anyhow they were married now and he should do the proper thing. In her rage she was still proud of his state and hers but she felt he ought to be made to suffer for his indiscretions, and tears—a storm such as this—would do it. Even while she was crying she was listening thoughtfully to his pleadings, anxious for the moment to come when she could quit and smother him with her kisses and affectional blandishments.

Eugene stood there cut as with a knife by this to him terrific charge. He had not meant anything desperate by concealing her presence, he thought. He had only endeavored to protect himself very slightly, temporarily. There weren't many more people that didn't know of his marriage, not many anyhow whom he cared anything about. Shotmeyer perhaps, William McConnell, Hudson Dula, his mother and father, his two sisters—he could write them at once.

"You oughtn't say that, Angela," he pleaded. "There aren't any more that don't know—at least any more that I care anything about. I didn't think. I didn't mean to conceal anything. I'll write everybody that might be interested."

He still felt hurt that she should brutally attack him this way, even in her sorrow. He was wrong, no doubt, but she—was this a way to act—the nature of true love?

He writhed and twisted mentally, picking her up in his arms, smoothing her hair, asking her to forgive him. Finally when she thought she had punished him enough and that he was truly sorry and would make amends in the future she pretended to listen and then of a sudden threw her arms about his neck and began to hug and kiss him. Passion of course was the end of this, but the whole thing left a disagreeable taste in Eugene's mouth. He did not like scenes. He preferred the lofty indifference of Miriam, the gay subterfuge of Norma, the supreme stoicism of Christina Channing. This noisy, tempestuous, angry emotion was not quite the thing to have introduced into his life. He did not see that it would make for love between them.

Still Angela was sweet, he thought. She was a little girl—not as wise as Norma Whitmore, not as self-protective as Miriam Finch or Christina Channing. Perhaps, after all, she needed his care and affection. Maybe it was best for her and for him that he married her. Life could not always be lived for the strong and the perfect. The weak need us most.

So he rocked her in his arms, thinking, and Angela, lying there, was satisfied she had won a most important victory. She was starting right. She was starting Eugene right. She would get the moral, mental, and emotional upper hand of him and keep it. Then these women who thought themselves so superior could go their way. She would have Eugene and he would be a great man and she would be his wife. That was all she wanted.

CHAPTER XXXV

The result of Angela's outburst was that Eugene hastened to notify those whom he had not already informed—Shotmeyer, his father and mother, Sylvia, Myrtle, Hudson Dula—and received in return cards and letters of congratulation expressing surprise and interest, which he presented to Angela in a conciliatory spirit. She realized, after it was all over, that she had given him quite a surprise and shock and was anxious to make up to him in personal affection what she had apparently compelled him to suffer for policy's sake. Eugene did not understand at this time that in Angela, despite her smallness of body and her (to him) babyishness of spirit, he had a thinking woman who, outside of her inexperience in art, was quite wise as to ways and means of handling her personal affairs. She was, of course, whirled in the maelstrom of her affection for Eugene and this was confusing, and she did not understand the emotions and philosophic sweep of his intellect. But she did understand instinctively what was good for the preservation of public appearance and esteem, what made for a sane relationship between one married couple and another, and between any married

couple and the world, and she proposed to maintain this. To her the utterance of the marriage vow meant just what it said, that they would cleave each to the other and that there would be henceforth no thoughts, feelings, or emotions, and decidedly no actions, which would not be conformable with the letter and the spirit of the marriage vow. It did not make any difference what had gone on before marriage. Utterance of the marriage vow changed all that. She knew of course that men were, now and then, subject to the blandishment of some vile woman or other, and that they were occasionally hypnotized and seduced by the arts of a female sorceress, but a good man would resist such blandishments to the utmost—avoid even the appearance of evil—and a good woman would never think of glancing askance at a married man. She did not even perceive, much less understand, the emotions of her own sister.

Naturally such feelings and such an attitude meant that she would instinctively safeguard all her marriage rights and privileges, that she would expect Eugene to do the same for himself and her. She had no idea that he was on the moral side an eager, emotional sensualist, whose affectional feelings and desires were not at all confined to her alone. He might have leanings and admirations inspired by this particular type of beauty and that—what true man would not?—but aided by his affection and regard for her and his sense of what was right and proper in marriage, he would overcome them. There never would, or at least should be, any cause for sorrow or complaint between them. They were to be happy in each other and so it was to be until death ended this mortal existence.

Eugene, as has been shown, sensed something of this, but not accurately. He did not correctly estimate either the courage, the faith, or the rigidity of her beliefs and convictions. He thought, emotionalist that he was, that her character might possibly partake of some of his own easy tolerance and good nature. She must know that people—men, particularly—were more or less chemical and fluid in their makeup. Life could not be governed by hard and fast rules. Why, everybody knew that. You might try, and should hold yourself in check as much as possible for the sake of self-preservation and social appearances, but if you erred, and you might easily, it was no crime. Certainly it was no crime to look at another woman longingly. If you went astray, overbalanced by your desires, why, wasn't it after all in the scheme of things? Did we make our desires? Certainly we did not. And if we did not succeed completely in controlling them—well——

The drift of life into which they now settled was interesting enough, though for Eugene it was complicated with the thought of possible failure, for he was, as might well be expected, of so exalted and emotional a temperament, of a worrying nature, and inclined in his hours of ordinary effort

to look on the dark side of things. The fact that he had married Angela against his will; the fact that he had no definite art connections which produced him as yet anything more than $2,000 a year; the fact that he had assumed financial obligations which doubled the cost of food, clothing, entertainment, and practically rent—for this studio was costing him thirty dollars more than had his share of the Smite-McHugh chambers—weighed on him. This dinner which he had given to Smite and McHugh had cost in the neighborhood of eight dollars over and above the ordinary expenses of the week. Others of a similar character would cost as much and more. He would have to take Angela to the theatre occasionally. There would be the need of furnishing a new studio the following fall unless another such windfall as this manifested itself. Although Angela had equipped herself with a somewhat varied and serviceable trousseau her clothes would not last forever. Odd necessities began to crop up not long after they were married, and he began to see that if they lived with anything like the freedom and care with which he had before he was married, his income would have to be larger and surer. It came home to him now with considerable force that he had made no real financial progress in the art world and that in a way he had been shilly-shallying, making love when he should have been working and bettering his condition.

This necessity for energy at this time, becoming uppermost in his mind, resulted in several important moves on his part which brought about a considerable advance for him artistically and intellectually as well as practically. For one thing he sent the original of the East Side picture, "Six O'clock," to the National Academy of Design exhibit—a thing which he might have done long before but had failed to do.

"Are you going to try for the National Academy of Design this month, Eugene?" asked McHugh, the night he and Smite were dining in Eugene's studio. He was thinking of sending a picture of his own for exhibition purposes for the first time.

"No, I hadn't thought of it," replied Eugene, "but I believe I will. Some of these things might get through." He wondered now why he had not sent any before. Many of his things were as good and better than the things hung on the line. To be "hung on the line" was to have your picture in the lower tier or row where the light was excellent and the public could get a good view of it.

"Send that East Side picture. They'll take it. I always liked it."

Angela had long since heard from Eugene that the National Academy of Design was a forum for the display of art to which the public was invited or admitted for a charge. To have a picture accepted by this society and hung on the line was in its way a mark of merit and approval, though Eugene did

not think very highly of it, for all the pictures were passed on by a jury of artists which decided whether they should be admitted or rejected, and if admitted, whether they should be given a place of honor or hung in some inconspicuous position. Eugene had thought the first two years he was in New York that he was really not sufficiently experienced or meritorious, and the previous year he had thought that he would hold all that he was doing for his first appearance in some exhibit of his own, because the National Academy had been denounced to him as commonplace and retroactive and because he thought so himself. The exhibitions he had seen thus far had been full of commonplace dead-alive stuff, he thought. It was no great honor to be admitted to such a collection. Now, because McHugh was trying and because he was so near a full exhibit of what he could do at some private gallery he hoped to interest, Eugene thought he would see what the standard body of American artists thought of his work. They might reject him. If so, that would merely prove that they did not recognize a radical departure from accepted methods and subject matter as art. The Impressionists, he understood, were being so ignored now. Later the National Academy would accept him. If he were admitted now it would simply mean that they knew better than he thought.

"I believe I will do that," he replied. "I'd like to know what they think of my stuff anyhow."

Angela and Marietta listened to this impromptu discussion of the merits of the Academy as the clashing voices of a great world with which they were now connected. What Eugene said or thought fixed their opinion exactly. If he said the Academy was commonplace, it was. Still, they hoped that anything he troubled to send would be received with acclaim.

The picture was sent as he had planned and, to his immense satisfaction, it was accepted and hung. It did not, for some reason, attract as much attention as it might but it was not without its modicum of praise. Owen Overman, the poet, met him in the general reception entrance of the Academy on the opening night and congratulated him sincerely. "I remember seeing that in *Truth*," he said, "but it's much better in the original. It's fine. You ought to do a lot of those things."

"I am," replied Eugene. "I expect to have an exhibit of my own one of these days."

He called Angela, who had wandered away to look at a piece of statuary located near the east wall, and introduced her.

"I was just telling your husband how much I like his picture," Overman informed her.

Angela was flattered that her husband was so much of a personage that he could have his pictures hung in a great exhibition such as this, with its

walls crowded with what seemed to her magnificent canvases and its rooms filled with important and distinguished people. Eugene pointed out to her, as they strolled about, this distinguished artist and that writer, saying almost always that they were very able. He knew three or four of the celebrated collectors, prize givers, and art patrons by sight, though not personally, and told Angela who they were. There were a number of striking looking models present whom Eugene knew either by reputation, whispered comment of friends, or personally—Zelma Desmond, who had posed for Eugene, Hedda Andersen, Anna Magruder, and Laura Mathewson, among others. Angela was struck and in a way taken by the dash and beauty of these girls. They carried themselves with a consciousness of personal freedom and courage which surprised her. Hedda Andersen was bold in her appearance but immensely smart. Her manner seemed to comment on the ordinary woman as being indifferent and not worthwhile. She looked at Angela, walking with Eugene, and wondered who she was.

"Isn't she striking," observed Angela, not knowing she was anyone whom Eugene knew.

"I know her well," he replied, "she's a model."

Just then Miss Andersen, in return for his nod, gave him a fetching smile. Angela chilled. She did not like the idea of this type of maiden being too familiar with Eugene. It was the type he ought to guard himself against.

Elizabeth Stein passed by and he nodded to her.

"Who is she?" asked Angela.

"She's a socialist agitator and radical. She sometimes speaks from a soap-box on the East Side."

Angela studied her carefully. Her waxen complexion, smooth, black hair laid in even plaits over her forehead, her straight, thin, chiseled nose, even red lips, and low forehead indicated a daring, courageous, and very subtle soul. Angela did not understand her. She could not understand a girl as good looking as that doing any such thing as Eugene said, and yet she had a bold, rather free and easy air, she thought. Eugene certainly knew strange people. He introduced her by turn to William McConnell, Hudson Dula, who had not yet been to see them, Willis Jansen, Louis Deesa, Leonard Baker, and Paynter Stone. There were present also Richard Wheeler, Joseph Smite, Peter McHugh, and Philip Shotmeyer, who had called just before Marietta left for the West, and these men made the great exhibition seem rather homelike to Angela. They were so uniformly friendly and courteous. She marveled at Eugene's array of friends and acquaintances and the fact that they were all apparently so exceptional. She was glad to hear Eugene say, as he did one day, that he rarely used models. It took a great load off her mind, for ever since seeing the type of woman he knew she had become apprehensive.

In regard to Eugene's picture the papers with one exception had nothing to say, but this one in both Eugene's and Angela's minds made up for all the others. It was the *Evening Sun,* a most excellent medium for art opinion, and it was very definite in its conclusions in regard to this particular work.

"A new painter, Eugene Witla," it said, "has a pastel entitled 'Six O'clock' which for directness, virility, sympathy, faithfulness to detail, and what for want of a better term we may call totality of spirit, is quite the best thing in the exhibition. It looks rather out of place surrounded by the weak and spindling interpretations of scenery and water, which so readily find a place in the exhibitions of the Academy, but it is none the weaker for that. The artist has a new, crude, raw, and almost rough method but his canvas seems to say quite clearly what he sees and feels. He may have to wait—if this is not a single accidental burst of ability—but he will have a hearing. There is no question of that. Eugene Witla is an artist."

Eugene thrilled when he read this commentary. It was quite what he would have said himself if he had dared. Angela was beside herself with joy. Who was this critic who said this, they wondered. What was he like? He must be truly an intellectual personage. Eugene wanted to go and look him up. If one saw his talent now, others would see it later. It was for this reason—though the picture came back to him subsequently unsold and unmentioned, so far as merit or prizes were concerned, by the judges of the exhibition—that he decided to try for an art exhibit of his own. If one critic believed this, others would.

CHAPTER XXXVI

The hope of fame—what hours of speculation, what pulses of enthusiasm, what fevers of effort, are not based on that peculiarly subtle and mortal illusion. Although in the main it has no substance outside of envy and all uncharitableness, it is yet the lure, the ignis fatuus of almost every breathing heart. In the young particularly, it burns with the sweetness and perfume of spring fires. Then and then only the substance and not the shadow of fame is truly known—those deep, beautiful illusions which tremendous figures throw over the world. Somewhere, it seems, must be the peace and plenty and sweet content that fame means to indicate—that spell of bliss that never was on land or sea. Fame! To youth it partakes somewhat of the beauty and freshness of the morning. It has in it the odour of the rose, the feel of rich satin, the color of the cheeks of youth. If we could but be famous when we dream of fame and not when locks are tinged with gray, faces seamed with

the lines that speak of past struggles, and eyes wearied with the angers, the
longings, and the despairs of years. To bestride the world in the morning
of life; to walk amid the plaudits and the huzzahs, when love and faith are
young; to feel youth and the world's affection when youth, in health, is
sweet—what dream is that, of pure sunlight and moonlight compounded.
A sun-kissed breath of mist in the sky; the reflection of moonlight upon
water; the remembrance of dreams to the waking mind—of such is fame in
our youth, and never afterward.

By some such illusion as this was Eugene's mind possessed at the time. He
had no conception of what life would bring him for his efforts. He thought
if he could have his picture hung in a Fifth Avenue gallery, much as he had
seen Bouguereau's Venus in Chicago, with people coming as he had come
on that occasion—that would be of great comfort and satisfaction to him.
If he could paint something which would be purchased by and hung in the
Metropolitan Museum in New York, he would then be somewhat of a classic
figure, ranking with Corot and Daubigny and Detaille of the French or with
Millais and Watts and Rossetti of the English, the leading artistic figures
of his time. These men seemed to have something which he did not have,
though, he thought—a greater breadth of technique; a finer comprehen-
sion of color and character; a feeling for the subtleties back of life which
somehow showed through what they did. Larger experience, larger vision,
larger feeling—these things seemed to be immanent in the great pictures
that he saw exhibited here, and it made him a little uncertain of himself.
Only this criticism in the *Evening Sun* fortified him against all thought of
failure. *He was an artist.*

He gathered up the various pastels he had done—there were some
twenty-six all told now, scenes of the rivers, the streets, the night life, and
so forth—and went over them carefully, touching up details which in the
beginning he had merely sketched or indicated, adding to the force of a
spot of color here, modifying a tone or shade there, giving care to all the
minor details which mean so much to the artist, so little to the public at
large, and finally, after much brooding over the possible result, set forth to
find an exhibitor who would give them place and distinction.

Eugene's feeling was that they were a little raw and sketchy, that they
might not have sufficient human appeal, seeing that they concerned fac-
tory architecture at times, scows, tugs, engines, the elevated roads done in
raw reds, yellows, and blacks, but McHugh, Dula, Smite, Miss Finch, Chris-
tina, the *Evening Sun*, Norma Whitmore—all had praised them or some
of them. Was not the world really much more interested in the form and
spirit of classic beauty such as that represented by Sir John Millais? Would
it not prefer Rossetti's "Blessed Damozel," which was very distinguished at

that time, to any scow scene ever painted? He could never be sure. In the very hour of his triumph when the *Sun* praised his picture there lurked the spectre of possible intrinsic weakness. Did the world wish this sort of thing? Would it ever buy of him? Was he of any real value?

"No, artist heart!" one might have answered. "Of no more value than any other worker of existence and no less. The sunlight in the corn, the color of dawn in the maid's cheek, the moonlight on the water—these are of value and of no value, according to the soul for whom is the appeal. Fear not. Of dreams and the beauty of dreams is the world compounded."

The firm of M. Kellner and Son, to whom he now betook himself—purveyors of artistic treasures in the way of paintings, bronzes, marbles, by the masters both living and dead, but particularly the living—whose offices were located in Fifth Avenue near Twenty-eighth Street at this time, was the one truly distinguished art-trade organization in the city. The pictures in the windows of M. Kellner and Son, the exhibits in their very exclusive showrooms, the general approval which their discriminating taste evoked, had attracted the attention of artists and the lay public for all of thirty years. Eugene had followed their peculiar exhibits with interest ever since he had been here. He had seen, every now and then, a most astonishing picture of one school or another displayed in their imposing shop window, and he had heard artists comment with considerable enthusiasm from time to time on what M. Kellner and Son had to show. He had seen, for instance, the first distinguished picture of the Impressionistic school—a heavy spring rain in a grove of silver poplars by Winthrop—in the window of this concern, which gave him quite a clear understanding of what the new art was like, and fascinated him after he realized the theory of the technique involved. He had encountered here a complete interpretation of Aubrey Beardsley's decadent drawings; of Helleu's pen and inks; of Rodin's astonishing sculptures and Thaulow's solid Scandanavian eclecticism. This house appeared to have capable artistic connections all over the world, for the latest art force in Italy or Spain or Switzerland or Sweden was quite as apt to find its timely expression here as the more accredited work of England or Germany or France or Russia. M. Kellner and Son were art connoisseurs in the best sense of the word, and although the German founder of the house had died many years before, its management and taste had never deteriorated. Eugene had always hoped that some time, when he was ready, he would be able to induce M. Kellner and Son to take an interest in his work and make a suitable exhibition of it such as he had seen them make of the work of other men. It would be so distinguished to have his drawings shown here. The effect on his fellow artists, the magazine directors, the general public, would be so beneficial to him.

Eugene did not know at this time how very difficult it was to obtain an exhibition of anything in connection with M. Kellner and Son, for the simple reason that they were overcrowded with offers of art material and appeals for display from distinguished artists who were quite willing and able to pay for the space and time they occupied. A fixed charge was in vogue, never deviated from except in rare instances where the talent of the artist, his possible poverty, or the need of a real novelty was great. Two hundred dollars was considered little enough for the use of an art showroom for a period of ten days or less, and this price was being regularly paid by those who exhibited.

Eugene had no such sum to spare but one day in January, nevertheless, and without any real knowledge as to what the conditions were, he carried four of the reproductions which had been made from time to time in *Truth* to the office of M. Kellner, certain that he had something to show. Miss Whitmore had indicated to him that Eberhard Zang wanted him to come and see him, but Eugene thought if he was going anywhere he would prefer to go to M. Kellner and Son. He wanted to explain to M. Kellner, if there were such a person, that he had many more drawings which he considered much better—more expressive of his developing understanding of American life and of himself and his technique—and he was only taking four drawings because he did not want to give the idea that he was worn to a commonplace by magazine reproduction. He had already learned from hearing artists talk that this might be the case. He went timidly in (albeit with quite an air) for this adventure disturbed him much. He was like a knight reconnoitering a doubtful and frowning castle. Strategy was of little value here, however—only strength. Was his work really significant enough to command the interest of an art house of this character? Would they approve or condemn him, or damn him with faint praise? Where so often on days of exhibition he had entered here to praise or blame, now he was humbly seeking the opinion and criticism of others. He asked of the hall-porter who stood in stately attendance in a be-buttoned suit of dark maroon cloth where he would find the manager, and being told on the second floor, ascended to that sanctum of great criticism—to him, of almost final judgement.

The American manager of M. Kellner and Son, M. Anatole Charles, was a Frenchman by birth and training, familiar with the spirit and details of French art and with the drift and tendency of art in various other sections of the world. He had been sent here by the home office in Berlin not only because of his very thorough training in European art ways and because of his ability to select that type of picture which would attract attention and bring credit and distinction to the house here and abroad, but also because

of his ability to make friends among the rich and powerful wherever he was and to sell one type of important picture after another, having some knack or magnetic capacity for attracting to him those who cared for the truly exceptional in art and were willing to pay for it. His specialty of course was the canvases of the eminently successful artists in various parts of the world—the living successful. He was friendly with connoisseurs who were not engaged in any trade way with art and who could tell him in the mere process of conversation what were the distinctive art features and tendencies of the time. He knew by experience what sold—here, in France, in England, in Germany. He was convinced that there was practically nothing of value in American art as yet—certainly not from a commercial point of view, and very little from an artistic. Beyond a few canvases by Inness, Blum, Sargent, Abbey, Whistler—men who were more foreign or rather universal than American in their spirit—he considered that the American art spirit was as yet young and raw and crude. "They do not seem to be grown up as yet over here," he said to his intimate friends. "They paint little things in a forceful way but they do not seem as yet to see things as a whole. I miss that sense of the universe in miniature which we find in the canvases of so many of the great Europeans. They are better illustrators than artists over here—why, I don't know."

Those who knew how impossible it was to sell American canvases abroad agreed with him. Those who saw how clearly educated American taste distinguished between American and European canvases, taking only those which represented the larger European spirit, would have said the same thing. M. Charles had come to feel that American pictures—the work of any particular American artist—was a waste of time for exhibition purposes. Americans would not buy them even if they were good. The prejudice was strong in favor of the foreign workers. If now and then some man like Whistler, with an entirely new theory of treatment arose, it might be advisable, for purposes of local critical distinction and furore to make an exhibition of what he had to show. The name of the house had to be kept before the newspaper public. As for hope of profit, that was eliminated from the considerations entirely. American art, as a rule and with only rare exceptions, did not sell.

M. Anatole Charles spoke English perfectly. He was an example of your true man of the world—polished, dignified, immaculately dressed, conservative in thought, and of few words in expression. Critics and art enthusiasts were constantly running to him with this and that suggestion in regard to this and that artist, but he only lifted his sophisticated eyebrows, curled his superior mustachios, pulled at his highly artistic goatee, and exclaimed "Ah!" or "So!" He claimed always that he was most anxious to find tal-

ent—profitable talent—though on occasion (and he would demonstrate that by an outward wave of his hands and a shrug of his immaculate shoulders), the house of M. Kellner and Son was not averse to doing what it could for art—and that for art's sake, without any thought of profit whatsoever. "Where are your artists?" he would ask. "I look and look. Whistler, Abbey, Inness, Sargent—ah—they are old, where are the new ones?"

"Well, this one——" the critic would probably persist.

"Well, well, I will go. I shall look. But I have little hope—very, very little hope."

He was constantly appearing at this studio and that under such pressure—examining, criticising. Alas, he selected the work of but very few artists for purposes of public exhibition and usually charged them well for it.

It was this individual, polished man, artistically superb in his way, whom Eugene was destined to meet this morning. When he entered the sumptuously furnished office of M. Charles, the latter arose. He was seated at a little rosewood desk, lighted by a lamp carrying a green silk shade. One glance told him that Eugene was an artist—very likely of ability, more than likely of a sensitive, high-strung nature. He had long since learned that politeness and savoir faire cost nothing. It was the first essential so far as the good will of an artist was concerned. Eugene's card and message, brought by a uniformed attendant, had indicated the nature of his business. As he approached, M. Charles's raised eyebrows indicated that he would be very pleased to know what he could do for Mr. Witla.

"I should like to show you several reproductions of drawings of mine," began Eugene in his best and most courageous manner. "I have been working on a number with a view to making an exhibit of them and I thought that possibly you might be interested to look at them with a view to displaying them for me. I have twenty-six all told and——"

"Exhibit! Exhibit! That is a difficult thing to suggest," replied Mr. Charles cautiously. "We have a great many exhibits scheduled now—enough to carry us through two years if we considered nothing more. Obligations to artists with whom we have dealt in the past take up a great deal of our time. Contracts which our Berlin and Paris branches enter into sometimes crowd out our local exhibits entirely. Of course we are always anxious to make interesting exhibits. If opportunity should permit we might be very pleased. You know our charges?"

"No," said Eugene, surprised that there should be one.

"Two hundred dollars for two weeks. We do not take exhibitions for less than that time."

Eugene's countenance fell. He had expected quite a different reception. Nevertheless he spread the proofs out for M. Charles to see, since he had

brought them, and untied the tape of the portfolio in which they were laid. The latter looked at them curiously. He was much impressed with the picture of the East Side crowd at first, but looking at one of Fifth Avenue in a snow storm, the battered, shabby bus pulled by a team of lean, unkempt, bony horses, he paused, struck by its force. He liked the delineation of swirling, wind-driven snow. The emptiness of this thoroughfare, usually so crowded, the buttoned, huddled, hunched, withdrawn look of those who traversed it, the exceptional details of piles of snow sifted onto window sills and ledges and into doorways and onto the windows of the bus itself, attracted his attention.

"An effective detail," he said to Eugene, as one critic might say to another, pointing to a line of white snow on the windows of one side of the bus. Another dash of snow on a man's hat rim took his eye also. "I can feel the wind," he added.

Eugene smiled.

M. Charles passed on in silence to the steaming tug coming up the East River in the dark, hauling two great freight barges. He was saying to himself that after all, Eugene's art was that of merely seizing upon the obviously dramatic. It wasn't so much the art of color composition and life analysis as it was stage craft. This gentleman before him had the ability to see the dramatic side of life. Still——

He turned to the last reproduction, which was that of Greeley Square in a drizzling rain. Eugene by some mystery of his art had caught the exact texture of seeping water on gray stones in the glare of various electric lights. He had caught the values of various kinds of lights—those in cabs, those in cable cars, those in shop windows, those in the street lamp. The black shadows of the crowds and of the sky were excellent. The color work here was unmistakably good. It could not be the mere drama of the situation— night, crowd, and rain—for this surface of wet, light-struck stones was too difficult to handle without fine artistic perception. M. Charles studied this carefully.

"How large are the originals of these?" he asked thoughtfully.

"Nearly all of them are twenty-four by sixty."

Eugene could not tell by his manner whether he were merely curious or interested.

"All of them done in pastel, I fancy."

"Yes, all."

"They are not bad, I must say," he observed cautiously. "A little persistently dramatic but——"

"They're reproductions," began Eugene, hoping by criticizing the press work to interest him in the superior quality of the originals.

"Yes, I see," M. Charles interrupted, knowing full well what was coming. "They are very bad. Still they show well enough what the originals are like. Where is your studio?"

"61 Washington Square."

"As I say," went on M. Charles, noting the address on Eugene's card, "the opportunity for exhibition purposes is very limited and our charge is rather high. We have so many things we would like to exhibit—so many things we must exhibit. It is so hard to say when the situation would permit. If you are still interested I might come and see them sometime."

Eugene's countenance fell. Two hundred dollars! Two hundred dollars! Could he afford it? It would mean so much to him. And yet the man was not at all anxious to rent him the showroom even at this price. He needed an exhibition here, though.

"I will come," said M. Charles, seeing his mood, "if you wish. That is what you want me to do. We have to be careful of what we exhibit here. It isn't as if it were an ordinary showroom. I will drop you a card someday when occasion offers, if you wish, and you can let me know whether the time I suggest is all right. I am rather interested to see these drawings of yours. They are very good of their kind. It may be—one never can tell—an opportunity might offer—a week or ten days somewhere in between other things."

Eugene sighed inwardly. So this was how these things were done. It wasn't very flattering. Still, he must have an exhibit. He could afford two hundred if he had to. An exhibition elsewhere would not be so significant. He had expected to make a better impression than this.

"I wish you would come," he said at last meditatively. "I think I should like the space if I can get it. I would like to know what you think."

M. Charles raised his eyebrows.

"Very well," he said, "I will communicate with you."

Eugene went out.

What a poor thing this exhibiting business was, he thought. Here he had been dreaming of an exhibition at Kellner's which should be brought about without charge to him because they were tremendously impressed with his work. Now they did not even want his pictures—would charge him two hundred dollars to show them. It was a great comedown—very discouraging.

Still he went home thinking it would do him some good. The critics would discuss his work just as they did that of other artists. They would have to see what he could do. Could it be that at last this thing which he had dreamed of and so deliberately planned had come true? He had thought of an exhibition at Kellner's for the past four years as the last joyous thing to be attained in the world of rising art and now it looked as though he was

near it. It might actually be coming to pass. This man wanted to see the rest of his work. He was not opposed to looking at his pictures. What a triumph even that was!

CHAPTER XXXVII

It was some little time before M. Charles condescended to write him, saying that if it were agreeable he would call Wednesday morning, January sixteenth, at 10 a.m., but the letter finally did come and this dispelled all of Eugene's intermediary doubts and fears. At least he was to have a hearing! This man might see something in his work—possibly take a fancy to it. Who could tell. He showed the letter to Angela with an easy air, as though it were quite a matter of course, but he felt intensely hopeful. Because of this letter he could not work this morning but put on his great overcoat—a treasure on which he had spent $85 the preceding winter (it was in imitation of several he had seen worn by bankers and brokers at art exhibits in his time)—and strolled over to Smite and McHugh's studio to break the news. He could not keep it. He had to say something, he thought, if no more than to hint vaguely that M. Charles was coming.

"Well, fellows," he said, when he strolled in to where the two artists were working—they had not taken a third partner in their studio life—and stood rubbing his hands to warm them, "I think I'm going to have an exhibition of my drawings pretty soon. Anatole Charles, the manager up at Kellner's, is coming down to see them. He seems to think they're pretty good—those that I showed him."

"You don't say, Witla!" exclaimed McHugh, laying down his brush. "Now that's something like. That's the house. If you can get an exhibit there, you're made. You won't have to worry after that. They don't pick any failures to exhibit in their place. How much do they charge you? Or are they doing it because they like your work?"

"That isn't settled yet," said Eugene evasively. "I don't know. They may not charge me anything. He likes my stuff pretty much."

"Who? The manager?"

"Yes."

"I God!" said Smite "you're coming along, Eugene. Put 'er there. Your stuff'll make a sensation if you get it in that place. I God, that's the best house in the country, isn't it, McHugh?"

"It certainly is," replied the latter.

Eugene took off his coat and recited the details. He told how he had

gone and just what M. Charles had said. He had only seen four scenes but these had induced him to call. It wasn't settled, but if he liked the others as well as he did these four——

"You needn't worry about the outcome," observed McHugh, convincingly. "If he liked those four, he'll like the others. I tell you, you're doing great stuff. You should have had an exhibition long ago. What a man like you wants to be fiddling around with magazine illustration for, I don't know. You ought to be doing mural decoration. Some of those things would make great lunettes in the ceiling of a bank, or wall decorations for a depot. You can put that stuff of yours in any of our modern buildings once you let them know what you're doing. You haven't exhibited enough. I've been telling you that."

Eugene appreciated this generous praise. He thought McHugh was right—had always thought so—but somehow an artist who had not made his name yet could not prove to Eugene what the world would think of his work. M. Charles's cold, doubting attitude was much more convincing—his coming after he had hesitated, that was testimony.

They rejoiced together, though, Smite and McHugh hoping sincerely that their turn would come someday, and finally Eugene went back home. He had a mediocre story to illustrate but he felt as if he could throw it out of the window. Wait until his real hearing came. He might become a mural decorator—who knew. Temple Boyle had told him that a way back in the old art school days in Chicago. Temple Boyle, N.A. What a great figure he had become in art since then. He saw where he was painting some of the great ceilings in the new congressional library.

He worked on though, and finally M. Charles came. Angela had put the studio in perfect order for she knew what this visit meant to Eugene, and in her eager, faithful way was anxious to help him as much as possible. She bought flowers from the Italian florist at the corner and put them in several vases here and there. She swept and dusted, dressed herself immaculately in her most becoming house dress, and waited with nerves at high tension for the fateful ring of the door bell. Eugene pretended to work at one of his pictures which he had done long before—the raw jangling wall of an East Side street with its swarms of children, its shabby push carts, its mass of eager shuffling pushing mortals, the sense of rugged ground life, running all through it—but he had no heart for the work. He was asking himself over and over what M. Charles would think. Thank heaven this studio looked so charming! Thank heaven Angela was so dainty in her pale green house gown with a simple red coral pin at her throat. He walked to the window and stared out at Washington Square with its bare wind-shaken branches of trees, its snow, its antlike pedestrians hurrying here and there. If he were

only rich—how peacefully he would paint. M. Charles could go to the devil. He would paint and if the world didn't like it, it could leave it. But art was poor pay and he had no money and this new condition required at least three thousand a year to maintain. Damn life anyhow, with its pinch and grind. He had never seen the day, since he had started in the office of the Alexandria *Appeal,* when he knew what financial peace of mind was.

The door bell rang.

Angela clicked a button and up came M. Charles quietly. They could hear his steps in the hall. He knocked and Eugene answered, decidedly nervous in his mind but outwardly calm and dignified. M. Charles entered, clad in a fur-lined overcoat, fur cap, and yellow suede gloves.

"Ah, good morning!" greeted Mr. Charles. "A fine, bracing day, isn't it? What a charming view you have here. Mrs. Witla! I'm delighted to meet you, I'm sure. I am a little late but I was unavoidably detained. One of our German associates is in the city."

In answer to Eugene's request, he divested himself of his great coat, rubbed his hands before the grate fire, and tried, now that he had unbent so far, to be genial and considerate. If he and Eugene were to do any business in the future, it must be so. Besides, the picture on the easel before him, near the window which for the time being he pretended not to see, was an astonishingly virile thing. Of whose work did it remind him—anybody's? He confessed to himself as he stirred around among his numerous art memories that he recalled nothing exactly like it. Raw reds, raw greens, dirt gray paving stones—such faces! Why this thing fairly shouted its facts. It seemed to say, "I'm dirty, I am commonplace, I am grim, I am shabby, but I am life." And there was no apologizing for anything in it, no glossing anything over. Bang! Smash! Crack! came the facts one after another, with a bitter, brutal insistence on their so-ness. Why, on moody days when he felt sour and depressed, he had seen somewhere a street that looked like this, and here it was—dirty, sad, slovenly, immoral, drunken—anything, everything, but here it was. "Thank God for a realist," he said to himself as he looked, for he knew life, this cold connoisseur, but he made no sign. He looked at the tall, slim figure of Eugene, his cheeks slightly sunken, his eyes bright—an artist every inch of him—and then at Angela, small, eager, a sweet, loving, little woman, and he was glad that he was going to be able to say that he would exhibit these things. He felt that he would—he must—for the four things he had seen, and now this, convinced him.

"Well," he said, pretending to look at the picture on the easel for the first time, "we might as well begin to look at these things. I see you have one here. Very good, I think. Quite forceful. What others have you?"

Eugene was afraid this one hadn't appealed to him as much as he had

hoped it would and set it aside quickly, picking up the second in the stack which stood against the wall, covered by a green curtain. It was the three engines entering the great freight yard abreast, the smoke of the engines towering straight up like tall, whitish-gray plumes in the damp, cold air, the sky lowering with blackish-gray clouds, the red and yellow and blue cars standing out in sodden dankness because of the water. You could feel the cold, wet drizzle, the soppy tracks, the weariness of "throwing switches" as a brakeman here. There was a lone brakeman in the foreground, "throwing" a red brake signal. He was quite black and evidently wet.

"A symphony in gray," said M. Charles succinctly.

They came swiftly after this, without much comment from either, Eugene putting one drawing after another before him, leaving it for a few moments, and replacing it with another. His estimate of his own work did not rise very rapidly, for M. Charles was persistently distant, but the latter could not help voicing approval of "After the Theatre," a pastel which was full of the wonder and enthusiasm of a night crowd under sputtering electric lamps. He saw that Eugene had covered almost every phase of what might be called the dramatic spectacle in the public life of the city, and much that did not appear dramatic until he touched it—the empty canyon of Broadway at three o'clock in the morning; a long line of giant milk wagons, swinging curious lanterns, coming up from the docks at four o'clock in the morning; a plunging parade of fire vehicles, the engines steaming smoke, the people running or staring open-mouthed; a crowd of polite society figures emerging from the opera; the bread line; an Italian boy throwing pigeons in the air from a basket on his arm in a crowded lower West Side street. Everything he touched seemed to have romance and beauty and yet it was real and mostly grim and shabby.

"I congratulate you, Mr. Witla," finally exclaimed M. Charles, moved by the ability of the man and feeling that caution was no longer necessary. "To me this is wonderful material, much more effective than the reproductions show, dramatic and true. I question whether you will make any money out of it. There is very little sale for American art in this country. It might almost do better in Europe. It ought to sell, but that is another matter. The best things do not always sell readily. It takes time. Still I will do what I can. I will give these pictures a two weeks display early in April without any charge to you whatsoever." (Eugene started.) "I will call the attention of those who know to them. I will speak to those who buy. It is an honor, I assure you, to do this. I consider you an artist in every sense of the word—I might say a great artist. You ought, if you preserve your sanity and caution, go far—very far. I shall be glad to send for these when the time comes."

Eugene did not know how to reply to this. He did not quite understand

the European seriousness of method, its appreciation of genius, which was thus so easily and sincerely expressed in a formal way. M. Charles meant every word that he said. This was one of those rare and gratifying moments of his life when he was permitted to extend to waiting and unrecognized genius the assurance of the consideration and approval of the world. As a representative of the most distinguished art agency in existence, a judge himself of what was important and true and beautiful, he felt called upon to express himself so. It was not only a privilege but a duty—very important, very memorable. He stood there waiting to hear what Eugene would say, but the latter only flushed under his pale skin.

"I'm very glad," he said, in his rather commonplace, offhand, American way. "I thought they were pretty good but I wasn't sure. I'm very grateful to you."

"You need not feel gratitude toward me," returned M. Charles, modifying now his formal manner. "You can congratulate yourself—your art. I am honored, as I tell you. We will make a fine display of them. You have no frames for these—well, never mind, I will loan you frames."

He smiled and shook Eugene's hand and congratulated Angela. The latter, who was standing to one side, had listened to this address with astonishment, swelling pride, and enthusiasm. She had perceived, in spite of Eugene's manner, the anxiety he was feeling, the intense hope he was placing in the outcome of this meeting. M. Charles's early opening manner had deceived her. She had felt that he did not care so much after all and that Eugene was going to be disappointed. Now when this burst of approval came she hardly knew what to make of it. She looked at Eugene and saw that he was intensely moved by not only a sense of relief but pride and joy. His pale, dark face showed it. To see this load of care taken off of him whom she loved so deeply was enough to unsettle Angela. She found herself stirred in a pathetic way and now when M. Charles turned to her, tears welled to her eyelids.

"Don't cry, Mrs. Witla," he said grandly, on seeing this. "You have a right to be proud of your husband. He is a great artist. You should take care of him."

"Oh, I'm so happy," half laughed and half sobbed Angela, "I can't help it."

She went over to where Eugene was and put her face against his coat. Eugene slipped his arm about her and smiled sympathetically. M. Charles smiled also, proud of the effect of his words.

"You both have a right to feel very happy," he suggested.

"Little Angela!" thought Eugene. This was your true wife for you, your good woman. Her husband's success meant all to her. She had no life of her own—nothing outside of him and his good fortune.

M. Charles smiled. "Well, I will be going now," he said finally. "I will send for the pictures when the time comes. And meanwhile you two must come with me to dinner. I will let you know."

He bowed himself out with many assurances of good will and then Angela and Eugene looked at each other.

"Oh, isn't it lovely, honeybun," she cried, half giggling, half crying, for she had begun to call him honeybun the first day they were married. "My Eugene, a great artist! He said it was a great honor! Isn't that lovely. And all the world is going to know it now soon. Isn't that fine! Oh, dear, I'm so proud." And she threw her arms ecstatically about his neck.

Eugene kissed her affectionately. He was not thinking so much of her though as he was of M. Kellner and Son—their great plush covered exhibit room, the appearance of these twenty-seven or thirty great pictures in gold frames, the spectators who might come to see, the newspaper criticisms, the voices of approval. Now all his artist friends would know that he was considered a great artist; he was to have a chance to associate on equal terms with men like Sargent and Whistler if he ever met them. The world would hear of him widely. His fame might go to the uttermost parts of the earth.

He went to the window after a time and looked out. There came back to his mind Alexandria, the printing shop, the People's Furniture Company in Chicago, the *Daily Globe*. Surely he had come by devious paths. Surely his life had been commonplace and simple enough. Well, here he was at last—a great artist. M. Charles said so. Now the world would hear of him. "Gee!" he exclaimed at last simply, "Smite and McHugh will be glad to hear this. I'll have to go over and tell them."

And he decided that shortly after lunch he would go. They were waiting for just this news. It was so good not to have to report a failure. An exhibition at Kellner's! And without charge to him. Gee! That meant practically that he had that great art house behind him—standing sponsor for him in a way. It was truly an amazing development—a revelation. He was a great artist from now on. What a wonderful thing to be.

CHAPTER XXXVIII

The exhibition which followed in April was one of those distinguished things which happen to rare souls in art—a complete flowering out before the eyes of the world of the feelings, emotions, perceptions, and understanding of a given individual. We all have feelings and emotions to a greater or lesser degree, but not many have the power of self-expres-

sion. It is true that to a greater or lesser extent, the details and the works of all lives form an expression of character, but this is a different thing. The details of most lives are not held up for public examination at any given time. We do not see succinctly in any given place just what an individual thinks and feels. An artist shows himself forth in the utmost profusion at times and with soul-stirring virility. That one should come to a collected public expression under distinguished artistic auspices, such as this exhibition proved to be, does not necessarily follow. Some are so fortunate—many are not. Eugene realized that fortune was showering its favors upon him. He was suitably humble, for like many people of exceptional merit he was without vanity or ostentation. He liked to be recognized for what he was, but was not deeply chagrined if he was not; he was quick to recognize and speak for merit in others.

When the time came, M. Charles was so kind as to send for the pictures and to arrange all the details. He had decided with Eugene that because of the vigor of treatment and the prevailing color scheme, black frames would be the best. The principal exhibition room on the ground floor in which these pastels were to be hung was heavily draped in red velvet and against this background the different pictures stood out effectively. Eugene visited the show chamber at the time the pictures were being hung—with Angela, with Smite, McHugh, Shotmeyer, and others. He had long since notified Norma Whitmore and Miriam Finch, but not the latter until after Wheeler had had time to tell her. This chagrined her also, for she felt in this as she had about his marriage, that he was purposely neglecting her.

The exhibition finally materialized—a room eighteen by forty, hung with dark red velvet, irradiated with a soft, illuminating glow from hidden lamps—in which Eugene's pictures stood forth in all their rawness and reality, almost as vigorous as life itself. To some people, those who do not see life clearly and directly, but only through other people's eyes, the pictures seemed more so. There is a large element in this world which cannot stomach nature as it is, but must have it cabled off, set on a stage, or shadowed forth in a picture before they can see it. Put vice or sorrow or hunger or raw reality of any sort in a picture, edge it with a gold frame, irradiate it with a soft incandescence, and it is palatable and charming enough. Show it in its native habitat, where poverty is, or hunger or dirt, and it has no meaning. The mass is too much. Your average mortal can digest but a little of real life at a time. He has no capacity for its larger phases—no understanding of masses, either their artistic or spiritual significance.

For this reason Eugene's exhibition of pictures was an astonishing thing to most of those who saw it. It concerned phases of life which in the main they had but casually glanced at, things which, because they were com-

monplace and customary, were supposedly beyond the pale of artistic significance. One picture in particular, of a great, hulking, ungainly negro, a positive animal man, his ears thick and projecting, his lips fat, his nose flat, his cheek bones prominent, his whole body expressing brute strength and animal indifference to dirt and cold, illustrated this point. He was standing in a cheap, commonplace East Side street. The time evidently was a January or a February morning. His business was driving an ash cart, and his occupation at the moment illustrated by the picture was that of lifting a great can of mixed ashes, paper, and garbage to the edge of the ungainly iron wagon. His hands were immense and were covered with great, red-patched woolen and leather gloves—dirty, bulbous, inconvenient, one would have said. His head and ears were swaddled about by a red flannel shawl or strip of cloth which was knotted under his pugnacious chin and his forehead, shawl and all, surmounted by a brown canvas cap with his badge and number as a garbage driver on it. About his waist was tied a great piece of rough coffee sacking, and his arms and legs looked as though he might have on two or three pairs of trousers and as many vests. He was looking purblindly down the shabby street, its hard, crisp snow littered with tin cans, paper, bits of slop and offal. Dust, gray ash dust, was flying from his upturned can. In the distance back of him was a milk wagon, a few pedestrians, a little thinly clad girl coming out of a delicatessen store. Overhead were dull small-paned windows, some shutters with a few of their slats broken out, a frowsy headed man looking out evidently to see whether the day was cold.

Eugene was so cruel in his indictment of life. He seemed to lay on his details with bitter inconsiderateness. Like a slave driver lashing a slave, he spared no least stroke of his cutting brush. Thus, and thus, and thus (he seemed to say), is it! What do you think of this? and this? and this?

People came and stared. Young society matrons, art dealers, art critics, the literary element who were interested in art, some musicians, and because the newspapers made especial mention of it, quite a number of those who run wherever they imagine there is something interesting to see. It was quite a notable two weeks' display. Miriam Finch (though she never admitted to Eugene that she had seen it—she would not give him that satisfaction), Norma Whitmore, William McConnell, Louis Deesa, Owen Overman, Paynter Stone, the whole ruck and rubble of literary and artistic life called. There were artists there of great ability whom Eugene had never heard of. It would have pleased him immensely to have seen several of the city's most distinguished social leaders looking—at one time and another—at what he had to show. All of his observers were astonished at his virility, curious as to his personality, curious as to what motive or significance or point of view it might have. The more eclectically cultured turned to the newspa-

pers to see what the art critics would say of this—how they would label it. Because of the force of the work, the dignity and critical judgement of M. Kellner and Son, the fact that the public of its own instinct and volition was interested, most of the criticisms were favorable. One art publication, connected with and representative of the conservative tendencies of a great publishing house, denied the merit of the collection as a whole, ridiculed the artist's insistence on shabby details as having artistic merit, denied that he could draw accurately, denied that he was a lover of pure beauty, and accused him of having no higher ideal than that of desire to shock the current mass by painting brutal things brutally.

"Mr. Witla," exclaimed this medium, "would no doubt be flattered if he were referred to as an American Millet. The brutal exaggeration of that painter's art would probably testify to him of his own merit. He is mistaken. The great Frenchman was a lover of humanity, a reformer in spirit, a master of draughtsmanship and composition. There was nothing of this cheap desire to startle and offend by what he did. If we are to have ash cans and engines and broken down bus-horses thrust down our throats as art, heaven preserve us. We had better turn to commonplace photography at once and be done with it. Broken window shutters, dirty pavements, half-frozen ash cart drivers, overdrawn, heavily exaggerated figures of policeman, tenement harridans, beggars, panhandlers, sandwich men—of such is *Art* according to Eugene Witla."

Eugene winced when he read this. For the time being it seemed true enough. His art was shabby. And yet there were others like Luke Severas who went to the other extreme.

"A true sense of the pathetic, a true sense of the dramatic, the ability to endow color not with its photographic value—though to the current thought it may seem so—but with its higher spiritual significance; the ability to indict life with its own grossness, to charge it prophetically with its own meanness and cruelty in order that mayhap it may heal itself; the ability to see wherein is beauty, even in shame and pathos and degradation: of such is this man's work. He comes from the soil apparently, fresh to a great task. There is no fear here, no bowing to traditions, no recognition of any of the accepted methods. It is probable that he may not know what the accepted methods are. So much the better. We have a new method. The world is the richer for that. As we have said before, Mr. Witla may have to wait for his recognition. It is certain that these pictures will not be quickly purchased and hung in parlors. The average art lover does not take to a new thing so readily. But if he perseveres, if his art does not fail him, his turn will come. It cannot fail. He is a great artist. May he live to realize it consciously and in his own soul."

Tears leaped to Eugene's eyes when he read this. The thought that he was a medium for some noble and superhuman purpose thickened the cords in his throat until they felt as a lump. He wanted to be a great artist, he wanted to be worthy of the appreciation that was thus extended to him. He thought of all the writers and artists and musicians and connoisseurs of pictures who would read this and remember him. It was just possible that from now on some of his pictures would sell. He would be so glad to devote himself to this sort of thing—to quit magazine illustration entirely. How ridiculous the latter was, how confined and unimportant. From now on, unless he was driven by sheer necessity, he would do no more. And they would beg in vain. He was an artist in the best sense of the word—a great painter, ranking with Whistler and Sargent and Velázquez and Turner. Let the magazines with their little ephemeral circulation go their way. He was for the whole world.

He stood at the window of his studio one day while the exhibit was still in progress, Angela by his side, thinking of all the fine things which had been said. No pictures had been sold but M. Charles had told him that some might be taken before it was all over.

"I think if I make any money out of this," he said to Angela, "we will go to Paris, this summer. I have always wanted to see Paris. In the fall we'll come back and take a studio up town. They are building some dandy ones up in Sixty-fifth Street." He was thinking of the artist who could pay three and four thousand dollars a year for a studio. He was thinking of men who made four, five, six and even eight hundred dollars out of every picture they completed. If he could do that. Or if he could get a contract for a mural decoration for next winter. He had very little money laid up. He had spent most of his time this winter working with these pictures which were now so successful.

"Oh, Eugene," exclaimed Angela, "it seems so wonderful, I can hardly believe it. You, a really, truly, great artist. And us going to Paris. Oh, isn't that beautiful. It seems like a dream. I think and think, but it's hard to believe that I am here sometimes, and that your pictures are up at Kellner's, and oh!——" She clung to him in an ecstasy of delight.

Out in the park the leaves were just budding out. It looked as though the whole square were hung with a transparent green net, spangled, as was the net in his room, with tiny green leaves. Loungers were idling in the sun. Sparrows were flying noisily about in small clouds. Pigeons were picking lazily between the car tracks of the street below.

"I might get a group of pictures illustrative of Paris. You can't tell what we'll find. Charles says he'll have another exhibition for me next spring, if I'll get the material ready." He pushed his arms above his head and yawned deliciously.

He wondered what Miss Finch thought now. He wondered where Christina Channing was. There was never a word in the papers yet as to what had become of her. He knew what Norma Whitmore thought. She was apparently as happy as though the exhibition had been her own.

"Well I must go and get your lunch, honeybun!" exclaimed Angela. "I have to go to Mr. Zapinto, the grocer, and to Mr. Ruggiero, the vegetable man." She laughed, for the Italian names amused her.

Eugene went back to his easel. He was thinking of Christina—where was she? At that moment, if he had known, she was looking at his pictures. Only newly returned from Europe, she had seen a notice in the *Evening Post*.

"Such work," she thought, "such force. Oh, what a delightful artist. And he was with me."

Her mind went back to Florizel and the amphitheatre among the trees. "He called me 'Diana of the Mountains,'" she thought, "his 'hama-dryad,' his 'huntress of the moon.'" She knew he was married. An acquaintance of hers had written in December. The past was past with her—she wanted no more of it. But it was beautiful to think upon—a delicious memory.

"What a queer girl I am," she thought. "I'm not normal at all."

Still she wished she could see him again—not face to face but somewhere where he could not see her. She wondered if he was changing—if he would ever change. He was so beautiful then—to her.

CHAPTER XXXIX

The days following the exhibition were delightful ones for Eugene. Now that he had attained to the dignity of a public exhibition which had been notably commented upon by the newspapers and art journals and had been so widely attended by the elect, artists, critics, writers generally seemed to know of him. There were many who were anxious to meet and greet him, to speak approvingly of his work. It was generally understood, apparently, that he was a great artist, not exactly arrived to the fullness of his stature as yet, being so new, but on his way. By this one exhibition, among those who knew him, he was lifted almost in a day to a lonely height, far above the puny efforts of such men as Smite and McHugh, McConnell and Deesa, the whole world of small artists whose canvases packed the semi-annual exhibitions of the National Academy of Design and the Water Color Society and with whom, in a way, he had been associated. He was a great artist now—recognized as such by the very eminent critics who knew—and as such, from him now on would be expected the works of a great artist. One

phrase in the criticism of Luke Severas in the *Evening Sun* as it appeared during the run of his exhibition remained in his memory clearly—"if he perseveres; if his art does not fail him." Why should his art fail him?—he asked himself.

He was immensely pleased to learn from M. Charles at the close of the exhibition that three of his pictures had been sold—one for three hundred dollars to Henry McKenna, a banker; another, the East Side street scene which Mr. Charles so greatly admired, to Isaac Wertheim for five hundred dollars; a third, the pastel of the three engines and the railroad yard, went to Robert C. Winchom, a railroad man, first vice president of one of the great railroads entering New York, for five hundred dollars. Eugene had never heard of either Mr. McKenna or Mr. Winchom, but he was assured that they were men of wealth and refinement. At Angela's suggestion he asked M. Charles if he would not accept one of his pictures as a slight testimony of his appreciation for all he had done for him. Eugene would not have thought to do this, he was so careless, nebulous, and impractical. But Angela did, and saw that he did it. M. Charles was greatly pleased and took the picture of Greeley Square which he considered a masterpiece of color interpretation. This somehow sealed the friendship between these two and M. Charles was anxious to see Eugene's interests properly forwarded. He asked him to leave three of his scenes on sale for a time and he would see what he could do. Meanwhile Eugene, with thirteen hundred dollars added to the thousand and some odd he had left in his bank from previous earnings, was convinced that his career was made, and decided, as he had planned, to go to Paris for the summer at least.

This trip, so exceptional to him, so epoch making, was easily arranged. All the time he had been in New York he had heard more in his circle of Paris than of any other city. Its streets, its quarters, its museums, its theatres and opera, were almost already a commonplace to him. The cost of living, the ideal methods of living, the way to travel, what to see—how often he had sat and listened to descriptions of these things. Now he was going. Interestingly enough, Angela took the initiative in arranging all the practical details—such as looking up the steamship routes, deciding on the size of trunks required and what to take, buying the tickets, looking up the rates of the different hotels and pensions at which they might possibly stay. She was so dazed by this glory of distinction that had burst upon her husband's life, and that was so adequately reflected to her, that she scarcely knew what to do or what to make of it. It was quite as though the kingdom of God had come upon earth.

"That Mr. Bierdat," she said to Eugene, referring to one of the assistant steam-ship agents with whom she had taken counsel, "tells me that if we

are just going for the summer, it's foolish to take anything but the absolute necessities. He says we can buy so many nice little things to wear over there if we need them and then I can bring them back duty free in the fall."

Eugene approved of this. He thought Angela would like to see the shops. They finally decided to go via London, returning direct from Havre and on the tenth of May they departed, arriving in London a week later and in Paris on the first of June. Eugene was greatly impressed with London, much more so than he was with Paris, though he did not decide this until he had canvased the latter thoroughly. He had arrived in time to miss the British damp and cold and to see London through a golden haze which was entrancing. Angela objected to the shops which she described as "punk" and to the condition of the lower classes, who were so poor and wretchedly dressed. She and Eugene discussed the interesting fact that all Englishmen looked exactly alike, dressed, walked, and wore their hats and carried their canes exactly alike. Eugene was impressed with the apparent "go" of the men—their smartness and dapperness. The women he objected to as dowdy and homely and awkward.

"Gee!" he said to Angela one day in Oxford Circus, "if a real American girl were to suddenly confront me I think I'd drop." He thought to see some exceptional women, based on his American ideal of beauty, at the theatres, but outside of the actresses, he saw none. He spent most of his days walking with Angela or riding on the tops of buses—looking at the famous buildings, the crush of traffic, the winding streets of the older sections. What astonished him, gave him a sense of oceanic might, was the vast size of London, its immense areas of commonplace homes, block after block of little houses with fences and yards all alike, or walls that receded in squares until the brain was weary. "The ruck of living," thought Eugene, "the immense persistency and repetition of a single type! Why?"

In Paris on the other hand he found nothing of this oppressive bigness. It was comprehensible, and thoroughly governed artistically. He could see or rather feel instantly the moment he stepped out of the depot what it was that artists liked—the spirit of Paris. It was in the air. These little men, with their wide trousers, their to him odd shaped hats, their tight coats, their bright eyes and demonstrative activity, were immensely alive. Never, anywhere, had he seen anything like this. The police, the cab drivers, the soldiery, the pedestrians—what sense of activity, awareness, spirit went with all of them. They might be standing perfectly still, or sleeping for that matter, but the soul of them was intense. Everywhere, in the shops, in the theatres, the music halls, the parks, the windows, was this flowing tide of keen, excited, enthusiastic, good-natured people. It seemed to him the most powerful race temperamentally that possibly could be.

Angela, he noticed, was growing in confidence if not in mentality by leaps and bounds. From a certain dazed uncertainty which had character-ized her the preceding fall when she had first come to New York, heightened and increased for the time being by the rush of art life and strange person-alities she had encountered, she was blossoming out into a kind of assur-ance born of experience. Finding that Eugene's ideas, feelings, and interests were of the upper world of thought purely—concerned with types, crowds, the aspect of buildings, streets, skylines, the humors and pathetic aspects of living—she concerned herself solely with the managerial details. It did not take her long to discover that if anyone would relieve Eugene of all care for himself, he would let him do it. It was no satisfaction to him to buy himself anything. He objected to executive and commercial details. If tickets had to be bought, time tables consulted, inquiries made, any labor of argument or dispute engaged in, he was loathe to enter. "You get these, will you, Angela?" he would plead or, "you see him about that. I can't now. Will you?"

Angela would hurry to the task, whatever it was, anxious to show that she was of real use and necessity. She liked, at first, to find that he was this way—that he was willing to relinquish the management of things to her. To find him mooning like a baby, dreaming his great dreams, staring out of the window at the peculiar aspects of a neighborhood, drawing out his ever ready sketch book into which he would jot peculiarities of landscapes, skylines, lamp posts, faces, windows, shutters, carts, anything, seemed mar-vellous to her. She did not see how the human brain could do this. Under his pencil, before her very eyes, would grow lines of joy or sorrow in a face, the haggard aspects of age, the peculiar, sunken indifference of weariness, the gayety and vivacity of youth. He could make a thunder cloud over the city express a delicious sense of heat and impending rain. On the busses of London or Paris, as in New York, he was sketching, sketching, sketch-ing—cabs, little passenger boats of the Seine, characters in the cafés, parks, gardens, music halls, anywhere, anything, for he was practically tireless. All that he wanted was not to be bothered very much, to be left to his own devices. Sometimes Angela would pay all the bills for him for a day. She carried his purse, took charge of all the express orders into which their cash had been transferred, kept a list of all their expenditures, did the market-ing, shopping, buying, paying. Eugene was left to see the things he wanted to see, to think the things that he wanted to think. During all these early days Angela made a god of him and he was very willing to cross his legs, Buddha fashion, and act as one.

The way they had arranged their affairs on arriving in Paris was as fol-lows. Eugene had taken a number of letters from M. Charles, Hudson Dula, Louis Deesa, Leonard Baker, and others who, on hearing that he was going,

had volunteered to send him to friends who might help him. The principal thing, if he did not wish to maintain a studio of his own and did wish to learn French, was to get in with some pleasant French family where he would hear the language and pick it up quickly. If he did not wish to do this, the next best thing was to locate in the Montmartre district in some section or court where he could obtain a nice studio and where there were a number of Americans or English students. Some of these Americans to whom he had letters were already located here. With a small calling list of friends who spoke English he would do very well. As for the shops, English was almost invariably spoken by someone, and there were many people on the street who spoke his tongue.

"You will be surprised, Witla," said Deesa to him one day, "how much English you can get understood by making intelligent signs."

Eugene laughed at Deesa's descriptions of his own difficulties and successes, but he afterwards found that Deesa was right. Signs went very far and they were, as a rule, thoroughly intelligible.

The studio which they eventually took after a few days spent at the Hotel Métropole was a comfortable one on the third floor of a house which Eugene found ready to his hand, recommended by M. Arkquin, of the Paris branch of M. Kellner and Son. Another artist, Finley Wood, whom afterwards Eugene recalled as having been mentioned to him by Ruby Kenny in Chicago, was leaving Paris for the summer. Because of M. Charles's impressive letter, M. Arkquin was most anxious that Eugene should be comfortably located and suggested that he take this, the charge being anything he cared to pay—forty francs the month.

Eugene looked at it and was delighted. It was in the back of the house, looking out on a little garden. Because of a westward slope of the ground from this direction and an accidental breach in the building line, it commanded a view of a section of the city of Paris—the Gare du Nord, the twin towers of Notre Dame, the sheer rise of the Eiffel Tower, and other points of the city. It was interesting to see the lights of the city blinking of an evening. Eugene would invariably draw his chair close to his favorite window when he returned from anywhere, while Angela made lemonade or iced tea or practised her culinary art upon a chafing dish. In presenting to him an almost standard American menu she exhibited the executive ability and natural industry which were her chief characteristics. She would go to the neighboring groceries, rotisseries, patisseries, green vegetable stands, and get the few things she needed in the smallest quantities, always selecting the best and preparing them with the greatest care. She was an excellent cook and loved to set a dainty and shining table. The one trouble with her then,

and at all times, was that she saw no need of company to speak of, for she was perfectly happy with Eugene alone and felt that he must be with her. She had no desire to go anywhere alone—only with him—and would hang on his every thought and motion, waiting for him to say what his pleasure would be.

Eugene set up his easel in the studio, painted from nine to noon some days; on others, from two to five in the afternoon. If it were dark, he would walk or ride with Angela or visit the museums, the galleries and the public buildings, or stroll in the factory or railroad sections of the city, where he was pleased by the atmosphere of toil and effort. Eugene sympathized most with sombre types and was constantly drawing something which represented grim care. Aside from the dancers in the music halls, the toughs in what years later became known as the Apache district, the summer picnicking parties at Versailles and St. Cloud, the boat crowds on the Seine, he drew factory throngs, watchmen and railway crossings, people at market in the dark, street sweepers, newspaper vendors, flower merchants—always with a notable street scene in the background. Some of the most interesting bits of Paris, its towers, bridges, river views, notable facades, appeared as backgrounds to the grim or picturesque or pathetic character studies. It was his hope that he could interest America in these things—that his next exhibition would not only illustrate his versatility and persistence of talent but show an improvement in his genius, a surer sense of color values, a greater analytical power in the matter of character, a surer selective taste in the matter of composition, arrangement, and so forth.

Eugene did not realize that he was now doing the only thing that could seriously injure himself, rob talent of its finest flavor, discolor his world, take scope from imagination, and hamper art with nervous irritation. In the control or lack of control of his sex desire lay the key to his whole future, and he could not see that in giving free reign to his passions, lusting after the flesh, dreaming persistently of physical enjoyment, he was planting the seeds of an unconscionable crop of ills. He had not the faintest conception of what even the slightest physical deterioration can do to a perfect art—how it can distort the sense of color, weaken that balanced judgement of character which is so essential to a normal interpretation of life, make life look black, take from art its most joyous conceptions, make life itself seem unimportant and death a relief. It is so vast a condition to contemplate—the pathology of disease and weakness is so involved with the chemistry of life—that if one were given the pen of men and angels it would be impossible to indicate the miseries to which the sin of physical and mental immorality may not lead.

CHAPTER XL

U nfortunately Angela, who came to marriage through years of self-denial and the thought that she might never be married, saw in it—and in the rapidly imparted views of Eugene—the gate to licensed and respected gratification for a curbed up passion. Without succinct and definite training in either ethics, morals, or the organic arrangement of sex—and having only the hearsay of girls and the confessions of newly married women and the advice of her older sisters (conveyed by what process of conversation heaven only knows)—it seemed normal and excellent that this desire of years should now vent itself unrestrained. For weeks and weeks—in fact for months and years—following their union there ensued what might well be described as a storm of sex indulgence between them which bore no relationship to any necessity in nature, any rearing of children, any balancing of physical strength with the intellectual and artistic tasks which, on Eugene's part at least, should have commanded the full measure of his ability. Angela proved to be what her eyes and hair, and indeed her whole life, indicated: a creature of astonishing sex virility. Once the variations of passion had been measured for her, there was no end to her appetite. She saw in Eugene, or fancied she saw, a creature of inexhaustible strength, and she interpreted her ability to meet his utmost passionate desires as a kindness and duty to him. It scarcely occurred to her that this persistent, unwearied indulgence might possibly end in physical disaster for him.

The summer passed, and with it the freshness and novelty of Paris, though Eugene (much less Angela) never really wearied of it. The peculiarities of a different national life, the variations between this and his own country of national ideals, the obviously much more complaisant and human attitude toward morals, a matter-of-fact acceptance of the ills, weaknesses, and class differences, to say nothing of the general physical appearance of the dress, habitations, and amusements of the people, astonished as much as they entertained him. He was never weary of studying the differences between American and European architecture; noting the pacific manner in which the Frenchman appeared to take life; listening to Angela's unwearied comments on the cleanliness, economy, and thoroughness with which the French women kept house; rejoicing in the absence of the American drag to incessant activity. Angela was struck by the very moderate prices for laundry, the skill with which their concierge—who governed this quarter, and who knew sufficient English to talk to her—did her marketing, cooking, sewing, entertaining. The richness of supply and aimless waste of Americans were alike unknown. Because she was naturally of a domestic turn, Angela became very intimate with Madame Bourgoche

and learned of her a hundred and one little tricks of domestic economy and arrangement.

"You're a peculiar girl, Angela," Eugene once said to her. "I believe you would rather sit down stairs and talk to that Frenchwoman than meet the most interesting literary or artistic personage that ever was. What do you find that's so interesting to talk about?"

"Oh, nothing much," replied Angela, who was not unconscious of the implied slur on her artistic leanings. "She's such a smart woman. She's so practical. She knows more in a minute about saving and buying and making a little go a long way than any American woman I ever saw. I'm not interested in her any more than I am in anyone else. All the artistic people do, that I can see, is run around and pretend that they're a whole lot when they're not. I'd rather talk to her than some of these silly girls that are always running around to the studios here and in New York pretending they are so much."

Eugene saw that he had made an irritating reference, not wholly intended in the way it was being taken. He was afraid that it might result in an additional storm of feeling and hastened to modify his implied criticism.

"I'm not saying she isn't able," he went on. "One talent is as good as another, I suppose. She certainly looks clever enough to me. Where is her husband?"

"He was killed in the army," returned Angela dolefully.

"Well, I suppose you'll learn enough from her to run a hotel when you get back to New York. You don't know enough about housekeeping now, do you?"

Eugene smiled with this implied compliment. He was anxious to get Angela's mind off of this art topic and her suspected insufficiency. He hoped she would feel or see that he meant nothing but she was not so easily pacified.

"You don't think I'm so bad, Eugene, do you?" she asked after a moment. "You don't think it makes so much difference whether I talk to Madame Bourgoche? She isn't so dull. She's awfully smart. You just haven't talked to her. She says she can tell by looking at you that you're a great artist. You're different. You remind her of a Mister Gérôme that once lived here. Was he a great artist?"

"Was he!" said Eugene. "Well, I guess yes. Did he have this studio?"

"Oh, a long time ago—fifteen years ago."

Eugene smiled beatifically. This was a great compliment. He could not help liking Madame Bourgoche some for it. She was bright, no doubt of that, or she would not be able to make such a comparison. Angela drew from him, as before, that her domesticity and housekeeping skill were as

important as anything else in the world and having done this, was satisfied and cheerful once more. Eugene thought how little art or conditions or climate or country altered the basic characteristics of human nature. Here he was in Paris, comparatively well supplied with money, famous or in process of becoming so, and quarrelling with Angela over little domestic idiosyncrasies. What a joke.

It should be said here in connection with their social adjustment, one to the other, that during the time in which these various details in connection with this art exhibit and their subsequent removal to Paris were transpiring, there had occurred a number of things which made much clearer to Eugene and to Angela the problematic relationship between them, though it must be confessed the future was much clearer in perspective to Eugene than to Angela.

On one occasion shortly after Miss Finch's first visit, Eugene had suggested that after all, seeing that Miriam was an old friend of his, they ought to invite her to dinner along with Shotmeyer, Richard Wheeler, Norma Whitmore, and Miss Elaine DeZauche because the latter had a charming contralto voice and could help them entertain. Angela was willing to entertain both Miss Whitmore and Miss Finch, not because she liked either of them, but because she did not wish to appear arbitrary or especially contrary at this time. Eugene liked these people too much. They were friends of too long standing. She reluctantly wrote them to come, and because they liked Eugene and did not wish to countenance an open rupture so soon either, they came. There was no real friendship to be established between Angela and Miss Finch, however, for their outlooks on life were radically different. Miss Finch was as conservative as Angela in her attitude and as set in her convictions. But she had decided, partly because Eugene had neglected her, partly because Angela was the victor in this contest, that he had made a mistake. Miss Finch was convinced that Angela did not have sufficient artistic apprehension, sufficient breadth of outlook, to make a good wife for him. She was charming enough to look at, of course, but there was really not enough to her socially—she was not sufficiently trained in the ways of the world, sufficiently wise and interesting to make him an ideal companion. Miss Finch insisted on thinking this vigorously and, smile as she might and be as gracious as she might, it showed in her manner. Angela noticed it. Eugene did too. He did not dare to indicate to either what he thought but he felt there would be no peace here. It worried him for he liked Miriam very much, but alas Angela had no good to say of her. After every encounter there were fresh charges to be made.

Miss Finch didn't invite Angela to sit down sufficiently quickly when she called at her studio was one complaint; she didn't offer her a cup of

tea at the hour she called another afternoon, though it was quite time for it. She didn't invite her to sing or play on another occasion, though there were others there who were invited.

"I gave her one good shot, though," said Angela one day to Eugene in narrating her troubles. "She's always talking about her artistic friends. I as good as asked her why she didn't marry, if she is so much sought after."

Eugene did not understand the mental sword thrusts involved in these feminine bickerings. He could not grasp the airy geniality which sometimes accompanied the bitterest feeling. He could stand or sit by, listening to a conversation between Angela and Miss Finch or Angela and anyone else whom she did not like, and miss all the subtle stabs and cutting insinuations which were exchanged and of which Angela was so thoroughly capable. He did not blame her for fighting for herself if she thought that she was being injured but he did object to her creating fresh occasion and this, he saw, she was quite capable of doing. She was looking for new opportunities to fight with Miriam Finch and Miss Whitmore. Eugene thought that Miriam might be in a better business than creating fresh difficulties. Truly he had thought better of her. It seemed a sad commentary on the nature of friend- ship, and he was sorry.

As for Norma Whitmore, he was grateful to her for the genial manner in which she navigated between Scylla and Charybdis. She saw at once what Angela's trouble was and did her best to allay suspicions by treating Eugene quite formally in her presence. It was Mr. Witla here and Mr. Witla there after her first or second visit, with most of her remarks addressed to Angela, but she did not find it easy sailing after all. Angela was suspicious. There was none of the old freedom which had existed between Norma and Eugene anymore. He was afraid to slip his arm about her waist except in secret. He could not talk to her in the free and easy manner in which he always had. He saw by Angela's manner the moment he became the least enthusiastic and free that it would not do. One evening when Miss Whitmore called he said, forgetting himself, and because he had some interesting pictures to show her, "Hey, Norma, you skate, come over here. I want to show you something."

He forgot all about it afterward but Angela reminded him.

"Honeybun," she began when she was in his arms before the grate fire and he was least expecting it, "what makes you be so free with people when they call here? You're not the kind of man that can really afford to be free with anyone. Don't you know you can't? You're too big. You're too great. You just belittle yourself when you do it and make them think that they are your equals when they are not."

"Who has been going and acting free now?" he asked sourly on the instant,

and yet with a certain make-believe of manner, dreading the storm of feeling, the atmosphere of censure and control which the remark foreboded.

"Why, you have," she persisted correctively, and yet apparently mildly and innocently, "you always do. You don't exercise enough dignity, dearie. It isn't that you haven't it naturally. You just don't exercise it. I know how it is. You forget."

Eugene stirred with opposition at this for she was striking him on his tenderest spot, his pride. It was true that he did lack dignity at times. He knew it. Because of his affection for beautiful or interesting things—women, men, dramatic situations, songs, anything—he sometimes became very gay and free, talking loudly, using slang expressions, laughing boisterously. It was a failing with him, he knew. He carried it to excess at times. In his own heart he regretted these things afterward but he couldn't help them, apparently. He liked excitement, freedom, gayety, naturalness, as he called it—but it hurt him tremendously if he thought anyone else noticed it as unusual or out of the ordinary. He was exceedingly sensitive and this developing line of criticism of Angela's was something new to him. He had never noticed anything of that in her before marriage. Up to the time of the ceremony and for a little while afterward it appeared to him as if he were lord and master. She was so dependent on him, so anxious that he should take her. Why, her very life had been in his hands! And now—he tried to think back over the evening and see what it was he had done or said but he couldn't. Everything seemed innocent enough. He couldn't recall a single thing and yet——

"I don't know what you're talking about," he replied sourly, withdrawing into himself. "I haven't noticed that I lack dignity so much. I have a right to be cheerful, haven't I? You seem to be finding a lot that's wrong with me."

"Now please don't get angry, Eugene," she persisted, anxious to apply the corrective measure of her criticism, but willing to use the quickness of his sympathy for her obvious weakness and apparent helplessness to shield herself from him at the same time. "I can't ever tell you anything if you're going to get angry. You don't lack dignity generally, honeybun! You only forget at times. Don't you know how it is?"

She was cuddling up to him, her voice quavering, her hand stroking his cheek, in a curious effort to combine affection and punishment at the same time. Eugene felt nothing but wrath, resentment, discouragement, failure.

"No, I don't," he replied crossly. "What did I do? I don't recall doing anything that was so very much out of the way."

"It wasn't that it was so very much, honeybun! It was just the way you did it. You forget, I know. But it doesn't look right. It belittles you."

"What did I do?" he insisted, sourly.

"Why, it wasn't anything so very much. It was just when you had those pictures of those new sculptures which Mr. Wheeler loaned you and you were showing them to Miss Whitmore. Don't you remember when you were in the alcove there and called her over to you? Don't you remember what you said—how you called her over?"

"No," he replied. He was thinking that accidentally he might have slipped his arm about Norma or that he might have said something out of the way, jestingly, about the pictures—some of them were nudes—but Angela could not have heard. He was so careful these days anyway.

"Why, you said, 'hey, Norma, you skate! Come over here.' Now what a thing that is to say to a girl. Don't you see how ugly it sounds—how vulgar, kinda? She can't enjoy that sort of a remark, particularly in my presence, do you think? She must know that I can't like it—that I'd rather you wouldn't talk that way, particularly here. And if she were the right sort of girl she wouldn't want you to talk to her at all that way. Don't you know she wouldn't? She couldn't. No really no good woman would."

Eugene flushed angrily. This catechising, so new to his life, so different from anything he had ever endured in his youth or since, irritated him greatly. He could not recall anything that compared with it except the abuse and threats which had been heaped upon him by the hardware polisher the time he had worked for a few days in the stove-cleaning room in Chicago. It cut him to the core, and he got up, putting Angela away from him, for they were sitting in a large Morris chair before the fire, and walked to the window.

"I don't see that at all," he said stubbornly. "I don't see anything in that remark to raise a row about. Why, for goodness sake, I have known Norma Whitmore for years and years, it seems, although it's only been a little while at that. She's like a sister to me. I like her. She doesn't mind what I say. I'd stake my life that she never thought anything about it. No one would, that likes me as well as she does. Why do you pick on that to make a fuss about, for heaven's sake?"

"Please don't swear, Eugene," exclaimed Angela anxiously, using this expression as an occasion for criticizing him more. "It isn't nice in you and it doesn't sound right toward me. I'm your wife. It doesn't make any difference how long you've known her. I don't think it's nice to talk to her that way, particularly in my presence. You say you've known her so well and you like her so much. Don't you think you ought to consider me a little, now that I'm your wife? Don't you think you oughtn't to want to do anything like that any more, even if you have known her so well? Don't you think? You're married now and it doesn't look right to others, whatever you think of me. It can't look right to her if she's as nice as you say she is."

Disturbed, opposed, and irritated, Eugene listened to this semi-pleading, semi-chastising harangue. Certainly there was some truth in what she said but wasn't it an awfully small thing to raise a row about? Why should she quarrel with him for that? Couldn't he even be lightsome in his form of address any more? It was true that it did sound a little rough, now that he thought of it. Perhaps it wasn't exactly the thing to say in her presence. But Norma didn't care. He was sure it never occurred to her as being out of the way and here was Angela charging him with being vulgar and inconsiderate and Norma with being not the right sort of a girl and practically vulgar also on account of it. It was too much. It was too narrow. Too conventional. He wasn't going to stand for anything like that permanently. He was about to say something mean in reply, make some cutting commentary, when Angela came over to him. She saw that she had lashed him and Norma and his generally easy attitude pretty thoroughly and that he was getting angry. Perhaps, because of his sensitiveness, he would avoid this sort of thing in the future. Anyhow, now that she had lived with him four months she was beginning to understand him better, to see the quality of his moods, the strength of his passions, the nature of his weaknesses, how quickly he responded to the blandishments of sorrow, joy, pretended affection, or distress. She thought she could reform him at her leisure. She saw that he looked upon her in his superior way, as a little girl—largely because of the size of her body. He seemed to think that because she was little, she must be weak. Hence with any appeal to his sympathies, his superior strength almost invariably produced a reaction away from any antagonism which she or circumstances might have directed at him. She saw him now as a mother might see a great, overgrown, sulking boy needing only to be coaxed to be brought out of a very unsatisfactory condition, and she decided to bring him out of it. She had taught children in school for years and knew the incipient moods of the human race very well.

"Now, Eugene," she coaxed, "you're not really going to be angry with me, are you? You're not going to be 'mad to me'?" (imitating childish language).

"Oh, don't bother, Angela," he replied, distantly. "It's all right. No, I'm not angry. Only let's not talk about it any more."

"You are angry, though, Eugene," she wheedled, slipping her arm around him. "Please don't be 'mad to me.' I'm sorry now. I talk too much. I get mad. Please don't be mad at me, honeybun! I'll get over this after while. I'll do better. Please don't, will you?"

He could not stand this coaxing very long. He looked upon her just as she thought, and this pathetic baby talk was irresistible. He smiled grimly after awhile. She was so little. He ought to stand for her idiosyncrasies of

temperament. He had never treated her right. He had not been faithful to his engagement vows. If she only knew how bad he really was!

Angela slipped her arm through his and stood leaning against him. She loved this tall, distinguished looking man, and as M. Charles had suggested, she wanted to take care of him. He had told her that Eugene was a great man, that he was a wonderful artist, that she ought to take care of him, be proud of him. She thought that she was doing this now when she called his attention to his faults. Some day, by her persistent efforts maybe, he would overcome these silly, disagreeable, offensive traits. He would overcome not being dignified; he would see that he needed to show her more consideration than he now seemed to think he did. He would become a quiet, reserved, forceful man, weary of the silly women who were buzzing around him solely because he was an artist and talented and good looking, and then he would be truly great. She knew what they wanted, these nasty women. They would like to have him for themselves. Well they wouldn't. And they needn't think they would. She had him. He had married her. And she was going to keep him. They could just buzz all they pleased but they wouldn't get him. So there!

CHAPTER XLI

There were other spats which followed this and the one relating to Eugene's not having told his friends of his marriage, for Angela, having come to this estate by means of such a hardly-won victory, was anxious lest any germ of inattentiveness, lack of consideration, alien interest, or affection flourish and become a raging disease which would imperil or destroy the conditions on which her happiness was based. Because of Eugene's volatile, enthusiastic temperament, it was easy to see, now that she was with him constantly, that he could easily be led into one relationship and another which concerned her not at all. He was for running here, there, and everywhere, just as he had before marriage, and it was very hard for him to see that Angela should always be with him. As a matter of fact, it occurred to him as strange that she should want to be. She would not be interested in all the people he knew, he thought. Now that he was living with her and observing her more closely, he was quite sure that most of the people he had known in the past in an indifferent way would not appeal to her at all. Take Elizabeth Stein, for instance, or Hedda Andersen, or Isadora Crane, with her budding theatrical talent, or Laura Mathewson or Zelma Desmond—any of these women of the art studio world with their

radical ideas, their indifference to appearances, their semi-secret immorality. If Angela did not care for Norma Whitmore and Miriam Finch, who were still conventionally moral in their liberalism, what would she think of these? And yet any of these women would be glad to see him socially, unaccompanied by his wife, and he would be glad to see them. He liked them. Most of them had not seen Angela but if they had, he fancied they would feel about her much as he did—that is, that she did not like them, really did not fit in with their world. She could not understand their point of view, he saw that. She was for one life—one love. All this excitement about entertainment, this gathering in this studio and that; this meeting of radicals and models and artists and budding theatrical stars which she heard him and others talking about—she suspected it of no good results. It was too feverish, too far removed from the commonplace of living. She had been raised on a farm where, if she was not exactly a farmer's daughter, she had witnessed what an actual struggle for existence meant.

Out in Wisconsin in her neighborhood there were no artists, no models, no budding actresses, no incipient playwrights, such as she sensed here all about her. There people worked and worked hard. Her father was engaged at this minute in breaking the soil of his fields for the spring planting—an old man with a white beard, an honest kindly eye, a broad, kindly charity, a sense of duty. Her mother was bending daily over a cook stove preparing meals, washing dishes, sewing clothes, mending socks, doing the thousand and one chores which fall to the lot of every good housewife and mother. Her sister Marietta, for all her gayety and beauty, was helping her mother, teaching school, going to church, and taking the commonplace facts of midwestern country life in a simple, good-natured, unambitious way. But there was none of that toplofty sense of superiority which marked the manner of these eastern upstarts, such as she had seen at the one National Academy of Design opening exhibit which she had attended, at the several afternoon teas and evening entertainments which she had attended at Norma Whitmore's, Miriam Finch's, Elaine DeZauche's, and the Hudson Dulas'. Now that the particular art circle in which Eugene was moving had learned of his marriage, his exhibition, his undoubted talent he—or rather she, for him and her—was receiving numerous invitations to the more formal affairs of the studios. It was generally understood that he was a great artist and this had heightened his prestige immensely among all the art circles. New people sought him out. Artists whom he had only heard of vaguely as men of ability came to the studio to look at his pictures.

In New York, M. Charles, true to his word, had invited Eugene and Angela to a—for them—quite sumptuous dinner at the Plaza where they met Luke Severas, the art editor of the *Evening Sun*; Henry L. Tomlins, Cura-

tor of the Museum of Fine Arts, and his wife; Isaac Wertheim, one of the wealthy collectors of modern paintings, and Mrs. Wertheim. Neither Eugene nor Angela had ever seen a private dining room set in so distinguished a manner. It fairly glittered with Sèvres and Venetian tinted glass. The wine goblets were seven in number, set in an ascending row. The order of food was fixed, from Russian caviar to dessert, black coffee, nuts, liqueurs, and cigars. The conversation wandered its intense intellectual way from American art, European painters, discoveries of ancient pottery in the isles of the Aegean, to the manufacture of fine glass on Long Island, the character of certain collectors and collections in America, and the present state of the fine arts museum. Eugene listened dazedly, for as yet he was a little uncertain of himself. He did not know how to take these fine and able personages who seemed so powerful in the world's affairs. Isaac Wertheim, M. Charles calmly indicated to him, must be worth in the neighborhood of fifteen million dollars. He thought nothing of paying ten, fifteen, twenty, thirty thousand dollars even for a picture if it suited him. Mr. Tomlins was a graduate of Harvard, formerly curator of a western museum, the leader of one of the excavating expeditions to Milo in the Grecian Archipelago. Luke Severas was a student of art history who appeared to have a wide knowledge of art tendencies here and abroad, but who nevertheless wrote art criticism for a living. He was a little man of Greek extraction on his father's side, but as he laughingly admitted, was born and raised in McKeesport, Pennsylvania. He liked Eugene for his simple acknowledgement of the fact that he came from Alexandria and had worked in a printing business out in Illinois.

"It's curious how our nation brings able men from the ranks," Luke said to Eugene. "It is one of the great, joyous, hopeful facts about this country."

"Yes," said Eugene, "that's why I like it so much."

Eugene thought, as he dined here, how strange America was with its mixture of races, its unexpected sources of talent, its tremendous wealth and confidence. Mr. Wertheim and his wife were such solid, unemotional, practical looking people, and yet he could see that this solid looking Jew, whom some artists might possibly have sneered at for his self-complacency and curiously accented English, was as wise and sane and keen and kindly as anyone present, perhaps more so. The only difference between him and the average American was that he was exceptionally practical and not given to nervous enthusiasm. Angela liked him too.

It was at this particular dinner that the thought occurred to Angela that the real merit of the art world was not in the noisy studio palaver which she had heard at so many places already—Norma Whitmore's, Miriam Finch's and elsewhere—but in the solid commercial achievements of such men as Isaac Wertheim, Anatole Charles, Henry L. Tomlins, and Luke Severas. She

liked the laconic "yes, yes" of Mr. Wertheim when anything was said that suited him particularly well, and his "I haf seen that bardickular bigdure," with which he interrupted several times, when one of several pictures discussed was up for consideration. She was thinking if only a man like that would take an interest in Eugene—how much better it would be for him than all this enthusiasm of these silly, noisy beginners. She was glad to see that intellectually, Eugene could hold his own with any and all of these people. He was as much at ease here with Mr. Tomlins, talking about Greek excavation, as he was with Mr. Severas, discussing western conditions. She could not make out much what it was all about, but of course it must be very important if these men discussed it. Eugene was not sure as yet whether anyone knew much more about life than he did. He suspected not, but it might be that some of these eminent curators, art critics, bankers, and managers like M. Charles had a much wider insight into practical affairs. Practical affairs, he thought—if he only knew something about money! Somehow, though, his mind could not grasp how money was made. It seemed so easy for some people but for him a grim, dark mystery.

It was after this dinner that Angela began to feel that Eugene ought to be especially careful with whom he associated. She had talked with Mrs. Wertheim and Mrs. Tomlins and found them simple, natural people like herself. They were not puffed up with vanity and self-esteem as were those other women to whom Eugene had thus far introduced her. As compared to Norma Whitmore and Miriam Finch, or her own mother and sisters and her western friends, they were more like the latter. Mrs. Wertheim spoke of her two sons and three daughters as any good-natured, solicitous mother would. One of her sons was at Harvard, another at Yale. She asked Angela to come and see her some time, giving her her address. Mrs. Tomlins was more cultured apparently, more given to books and art, but even she was interested in what to Angela were the more important or at least more necessary things—the things on which all art and culture primarily based themselves—the commonplace and necessary details of the home. Cooking, housekeeping, shopping, sewing, were not beneath her nor Mrs. Wertheim's consideration. Mrs. Tomlins spoke of having to go and look for a spring bonnet in the morning, and how difficult it was to find the time.

Once when the men were getting especially enthused over European and American artistic standards, Angela asked. "Are you very much interested in art, Mrs. Tomlins?"

"Not so very much, to tell you the truth, Mrs. Witla. Oh, I like some pictures but as I so often tell my husband, when you have one baby two years old and another of five and another of seven, it takes considerable of your time attending to the art of raising them. I let him do the art for the family and I take care of the home."

This was sincere consolation for Angela. She appeared to be in danger of being swamped by this artistic storm which she had encountered. Her arts of cooking, sewing, shopping, housekeeping, appeared as nothing in this vast palaver about art. She knew nothing of Monet, Manet, Mancini, Rodin, Ibsen, Shaw, Rossetti, and Maeterlinck, with which the studios were apparently greatly concerned. And when people talked of these artists, singers, musicians, sculptors, playwrights, and so forth, she was compelled to keep silent.

Eugene could stand with his elbow on some mantel or piano and discuss by the half hour or hour individuals of whom she had never heard—Verlaine, Ibsen, Tschaikowsky (whose untimely death was still the sorrow of Russia), Tolstoy, Turgenieff, H. G. Wells, Madox Brown, George Inness, Vélazquez—anybody and everybody who appeared to interest the studio element of the time. Because of his desire to talk, his pleasure in meeting people, his joy in hearing of new things, his sense of the dramatic, he could catch quickly and retain vigorously anything which related to social, artistic, or intellectual development. He had no idea of what a full orbed, radiant, receptive thing his mind was. He only knew that life, things, intellect, anything and everything gave him joy when he was privileged to look into them—and he gave as freely as he received.

In this whirl of discussion, this lofty transcendentalism, Angela was lost, but she clung fast to the hope that somehow affection, regard for the material needs of her husband, the care of his clothes, the preparation of his meals, the serving of him quite as a faithful would, would bind him to her. At once and quickly, she hated and feared these artistically arrayed, artistically minded, vampirish looking maidens and women who appeared from this quarter and that to talk to Eugene at times. When she would see him standing or leaning somewhere, intent on the rendition of a song, the narration of some dramatic incident, the description of some book or picture or personage by this or that delicately chiselled Lorelei of the art or music or dramatic world, her heart contracted ominously and a nameless dread seized her. Somehow these creatures, however intent they might be on their work, or however indifferent actually to the artistic charms of her husband, seemed to Angela to be intent on taking him from her. She saw how easily and naturally he smiled, how very much at home he seemed to be in their company, how surely he gravitated to the type of girl who was beautifully and artistically dressed, who had ravishing eyes, fascinating hair, a sylphlike figure, and vivacity of manner—or how naturally they gravitated to him. In the rush of conversation and the exchange of greetings he was apt to forget her, to stroll about by himself, engaging in conversation first with one and then another, while she stood or sat somewhere gazing nervously or regretfully or unable to hold her own in the crossfire of conversation; unable to

retain the interest of most of the selfish, love-sick, sensation-seeking girls and men.

They always began talking about the opera, or the play, or the latest sensation in society, or some new singer or dancer or poet, and Angela, being new to this atmosphere and knowing so little of it, was compelled to confess that she did not know about any of them. It chagrined, dazed, and frightened her for a time. She longed to be able to grasp quickly and learn what this was all about. She wondered where she had been living—how—to have missed all this. Why, these things were enough to wreck her married life. Eugene would think so poorly of her—how could he help it? She watched these girls and women talking to him, and by turn she became envious, fearful, regretful, angry, charging first herself with unfitness, next Eugene with neglect, next these people with insincerity, immorality, vanity, and then lastly the whole world and life with a conspiracy to cheat her of what was rightfully her own. Why wouldn't these people be nice to her? Why didn't they give of their time and patience to make her comfortable and at home? Why did Eugene neglect her? Why did they hang on his words in their eager, seductive, alluring way? She hated them and, at moments, she hated him, only to be struck by a terrifying wave of remorse and fear a moment later. What if he should grow tired of her? What if his love should change?

On one of these occasions or rather after it, when they had returned from an evening at the Dulas' at which she imagined or rather realized that she had been neglected, she threw herself disconsolately in Eugene's arms and exclaimed: "What's the matter with me, Eugene? Why am I so dull? so uninteresting? so worthless?"

The sound of her voice was pathetic, hopeless, vibrant with the quality of an unuttered sob.

Eugene stirred nervously.

"Why, what's the matter with you now, Angel Face?" he asked sympathetically, sure that some new storm of some sort was coming. "What's come over you? There's nothing the matter with you! Who's been saying there is?"

"Oh, nothing! Nothing! Nobody! Everything! Everybody!" exclaimed Angela, dramatically and bursting into tears. "I see how it is! I see what's the matter with me. Oh! oh! It's because I don't know anything, I suppose. It's because I'm not fit to associate with you. It's because I haven't had the training that some people have had! It's because I'm dull! Oh! Oh!" and a torrent of heart-breaking sobs which shook her frame from head to toe followed this outburst and declamation.

Eugene gazed before him in startled sympathy, astonishment, pain, wonder, for he was seeing very clearly and keenly in these echoing sounds what the trouble was. She was feeling neglected, outclassed, unconsidered, help-

less, and because it was more or less true, it was frightening and wounding her. She was feeling the tragedy of life, its uncertainty, its pathos and injury, as he so often had. Of course she had been neglected. He remembered that now. It was partially his fault, partially the fault of incurable conditions. But what could he do about it? What say? People had conditions fixed for them in this world by their own ability. How should he comfort her in this crisis? How say something that would ease her soul?

"Why, Angela," he said seriously. "You know that's not true. You know you're not dull. Your manners and your taste and your style are as good as that of anybody. Who has indicated that they aren't? What has come over you? Who has been saying anything to you? Have I done something? If so, I'm sorry!"

"No, no," she exclaimed brokenly and without ceasing her tears, "it isn't you. It isn't anybody! It's me, just me! That's what's the matter with me! I'm dull! I'm not stylish. I'm not attractive! I don't know anything about music or books or people or anything. I sit and listen, but I don't know what to say. People talk to you—they hang on your words—but they haven't anything to say to me. They can't talk to me and I can't talk to them. It's because I don't know anything—because I haven't anything to say! Oh, dear! Oh, dear!" And she beat her thin, artistic little hands on the shoulders of his coat.

Eugene cuddled her close in his arms. He was extremely sorry. He could see how it was. She was hurt, she was neglected. He, among others, neglected her. These smart women whom he knew and liked to talk to neglected her. They couldn't see in her what he could. Wasn't life pathetic? They didn't know how sweet she was, how faithful, how glad she was to work for him. That really didn't make any difference in the art world. One must be clever—he knew that. Everybody knew it. And Angela was not clever—at least not in their way. She could not paint or sing or talk cleverly as they could. She did not really know what the world of music and art and literature were doing. She was only good and faithful and excellent as a housewife—a fine mender of clothes, a careful buyer, saving, considerate, dependable, but——

He thought of this depth of emotion of hers and then he realized that no woman that he had ever known had anything quite like this. He had known Stella and Margaret and Ruby and Christina intimately. He had associated with Miriam and Norma and Hedda Andersen and Zelma Desmond, and quite a number of interesting, attractive young women whom he had met here and there since, but outside of the stage—that art of Sarah Bernhardt and Clara Morris and some of the more talented English actresses—he had never seen anyone quite like Angela. This powerful upwelling of emotion which she was now exhibiting and which was so distinctive of her was not

to be found elsewhere. He had noted it in her the first time he had met her at Alexandria, for some reason. He felt it on the train going to Chicago; he felt it when she parted from him, going alone to Black Wood. He had felt it keenly the first days he had visited her in her aunt's house in North Chicago, at her father's home in Black Wood. Oh, those days with her in Black Wood! How wonderful they were! Those delirious nights. Flowers, moonlight, odours came back—the green fields, the open sky. Yes, she was powerful emotionally! She was compounded of many and all of these things. She knew nothing of art, it is true. Nothing of music—the great, new music. Nothing of books in the selective, eclectic sense, but she had real, sweet, deep, sad, stirring emotion. It was great emotion, effective, dramatic, powerful. Where did she get it? No really common soul could have it. Here was something of the loneliness of the prairies, the sad patience of the rocks and fields, the lonesomeness of the hush of night in the country, the aimless, monotonous, pathetic chirping of the crickets. Her father, following down a furrow in the twilight, behind straining toil-worn horses; her brothers, binding wheat in the July sun; the sadness of furrow scents and field fragrances in the twilight—there was something of all of these things in her sobs.

In his big way Eugene understood this—he felt it keenly.

"Why, Angela," he insisted, "you mustn't talk like that. You're better than they are; you're infinitely better than you say you are. You say you don't know anything about books or art or music. Why, that isn't all. There are things, many things, which are deeper than those. Emotion is a great thing in itself if you only knew. You have that. Sarah Bernhardt has it, Clara Morris has it. But who else? In Camille, Sapho, Carmen, Mademoiselle de Maupin, it is written about, but it is never commonplace. It's great. I'd rather have your deep, natural upwelling of emotion than all those cheap art songs and talk put together. For, sweet, don't you know," and he cuddled her more closely, "great art is based on great emotion. There is really no great art without it. You may not have the power to express yourself in music or books or pictures—though you play charmingly enough for me—but you have the thing on which these things are based—you have the power to feel them. Don't worry over yourself, dear. I see that. I know what you are, whether anyone else knows or not. Don't worry over me. I have to be nice to these people. I like them in their way, but I love you. I married you. Isn't that proof enough? What more do you want? Don't you understand, little Angel Face? Don't you see? Now, aren't you going to stop crying? Aren't you going to cheer up and be happy? You have me. Ain't I enough? Can't you be happy with just me? What more do you want, sweet? Just tell me."

"Nothing more, honeybun!" she went on, sobbing and cuddling close.

"Nothing more if I can have you. Just you! That's all I want—you! you! you!"

She hugged him tight.

Eugene sighed secretly.

"And am I emotionally great?" she cuddled and cooed after she had held him tight for a few moments. "Doesn't it make any difference whether I know anything about art or books or music? I do know something, don't I, honeybun? I'm not wholly ignorant, am I?"

"No, no, Angel Face, how you talk."

"And will you always love me, whether I know anything or not, honeybun?" she went on. "And won't it make any difference whether I can just cook and sew and do the marketing and keep house for you? And will you like me because I'm just pretty and not smart—I am a little pretty, ain't I, honeybun?"

"You're lovely," whispered Eugene, soothingly. "You're beautiful. Listen to me, sweet. I want to tell you something. Stop crying now and dry your eyes and I'll tell you something nice. Do you remember how we stood one night at the end of your father's field there, near the barn gate, and saw him coming down the path, singing to himself, driving that big gray team of horses, his big straw hat on the back of his head and his sleeves rolled up above his elbows?"

"Yes," said Angela.

"Do you remember how the air smelled of roses and honeysuckle and cut hay and oh, all those lovely scents of evening?"

"Yes," replied Angela, interestedly.

"And do you remember how lovely I said the cow bells sounded tinkling in the pasture near where the little river ran?"

"Yes."

"And the jar flies beginning to saw in the trees?"

"Yes."

"And that sad, deep red in the west, where the sun had gone done?"

"Yes, I remember," said Angela, crushing her cheek near to his neck.

"Now listen to me. That water running over the bright stones in that little river, the grass spreading out soft and green over the lawn, the cow bells tinkling, the smoke curling up from your mother's chimney, your father looking like a patriarch coming home out of the Bible days—all the soft sounds, all the sweet odours, all the babbling of birds—where do you suppose that all is now?"

"I don't know," replied Angela, anticipating something lovely.

"It's here," he replied easily, "done up in one little body in my arms. Your voice, your hair, your eyes, your cheeks. Your pretty body, your emotional

moods—where do you suppose they come from? Nature has a chemistry all her own. She's like a druggist sometimes, compounding things. She takes a little of the beauty of sunset, of the sky, of the fields, of the water, of the flowers, of goodness and virtue and honesty and patience, and she makes a girl. And some parents somewhere have her and then they name her Angela and they raise her nicely, and then a bold, bad man like Eugene comes along and takes her, and then she cries because she thinks he doesn't see anything in her. Now isn't that funny?"

"Ooh!" exclaimed Angela, melted by the fire of his feeling for beauty, the quaintness and sweetness of his diction, the subtlety of his compliment, the manner in which he coaxed her patiently out of herself.

"Oh, I love you, Eugene," she exclaimed. "I love you! love you! love you! Oh, you're wonderful! You won't stop loving me, will you? You'll always be true to me, won't you, Eugene? You'll never leave me, will you? I'll always be your little Angel Face, won't I? Oh, dear, I'm so happy." And she hugged him over and over.

"No, no," and "yes, yes," assured Eugene, as the occasion demanded.

He stared into the fire. This was not real passion with him—not real love in any sense, or at least he did not feel that it was. He was questioning himself at this time, as to what it was. Was it sympathy? love of beauty? power of poetic expression? delicacy of sentiment?—that and nothing more. Could he honestly say that he loved Angela? No. He liked her, sympathized with her, felt sorry for her. This ability of his to paint a picture was at the bottom of this last description. To Angela for the moment it seemed real enough, but he—he was thinking of the truth of the picture she had painted of herself—It was all *so*, every word she said. She was not really suited to these people, she did not understand them, she never would. He would always be soothing and coaxing her this way and she would be crying and worrying. Wasn't that too bad? Wasn't life sad at best? Why had he crossed her path? why followed her? why married her? Hadn't he made enough silly mistakes without making this one? What a pity!

Well he was married now. He would have to make the best of it—but, dear heaven, it was evident he was going to pay dearly.

He talked silly love talk with her for a while and finally they went to bed. There was just one outcome to these outbursts of feeling on her part. They spelled almost invariably renewed passion, eager, fiery, destroying. He wondered sometimes where her tremendous physical vitality came from. It was brutal, vampirish, destructive when aroused. And as for him, he yielded to it far too enthusiastically, he knew. It could not go on forever like that. It was not good for the body. It was not good for the brain. It was not good for the soul. He took it too seriously. It would do something to his imagi-

nation—it must. It might affect his art unfavorably. He told her this, but she did not quite understand. He did not understand. It was a case of the blind leading the blind. And the ditch they might fall into! It never really occurred to them seriously.

CHAPTER XLII

By late September Eugene had most of his sketches so well laid in that he could finish them anywhere. Some fifteen were as complete as they could be made. A number of others were nearly so. He decided that he had had a profitable summer. He had worked hard and here was the work to show for it—twenty-six canvases which were as good, in his judgement, as those he had painted in New York. They had not taken so long but he was surer of himself—surer of his method. He parted reluctantly with all the lovely things he had seen, believing that this collection of Parisian views would be as impressive to Americans as had his New York views. M. Arkquin for one, and many others including the friends of Deesa and Dula, were delighted with them. The former expressed the thought that some of them might be sold in France.

Eugene returned to America with Angela, and because he had advice that he might stay in the old studio until December first, settled down there to finish the work of his exhibit. After consultation with M. Charles, who had since sold two of his preceding exhibit pictures for four hundred dollars each, Eugene decided to hold his second exhibition in January, that time being most convenient for M. Kellner and Son. Because his pictures were not quite in shape, Eugene could not take advantage of an earlier occasion. He worked on diligently, but it was during this period that the first peculiar symptoms of an impending attack of neurasthenia began to appear.

To those who have never suffered from a physical ailment of any kind, who know nothing of the peculiar and subtle and harassing nature of nervous disorders, the following description of the ills, real and imaginary, which now began to afflict this man of genius will seem almost incomprehensible. The disease of his age, as he was subsequently able to reflect and as the physicians of his time described and apprehended it, was worry. The dominant mental and physical characteristic, looked at from a pathologic point of view, was *nerves*. A whole literature of a semi-metaphysical character had arisen on this subject, based on what were considered peculiarly American characteristics—haste, undue ambition, an insane desire for wealth, envy, malice—all the things that spring from an ungoverned desire for pleasure

and happiness. It was charged by most of the "nerve specialists" of the time that Americans did not know how to live; that they were scrambling unnaturally after "the dollar"; that they were killing themselves with over-work; gulping their food; cramming their minds with too much undigested knowledge. There was no specific attack on the sex morality of the time although on every hand neurasthenia, Saint Vitus' Dance, locomotor ataxia, paralysis—either of an arm, a hand, a leg, or a cheek—paresis, and insanity abounded. These things were charged to many and various causes: disease, worry over losses by death, business troubles, marital troubles, anything and everything save (in the majority of instances) to the right one. The one predominant characteristic tendency or weakness which, when combined with the other ills to which the flesh is heir, resulted in just these calami-ties which the science of the day so greatly deplored, was nothing more nor less than over-indulgence in the sex relationship, and it was from this that Eugene was suffering. It was considered immoral to speak of immoral-ity—to charge home graphically to its source the one ill to which so many other ills were due, and so physicians and religionists were equally silent. But the cause of this illness, as of so many other of the ailments previously mentioned, is precisely as described.

The first suggestion Eugene had that anything was wrong with him, out-side of a growing apprehensiveness as to what the American people would think of his French work, was in the fall when he began to imagine—or perhaps it was really true—that coffee did not agree with him. He had for several years now been free of his old time complaint, stomach trouble, but gradually it was beginning to reappear and he began to complain to Angela that he was feeling an irritation after his meals, that coffee came up in his throat. "I think I'll have to try tea or something else if this don't stop," he observed.

She suggested chocolate and he changed to that but this was merely shifting the ill to another quarter. He began to quarrel with his work—as not being able to get a certain effect, and when having sometimes altered and re-altered and re-re-altered a canvas until it bore little resemblance to the original arrangement, he would grow terribly discouraged, or believe that he had attained perfection at last only to change his mind the follow-ing morning.

"Now," he would say, "I think I have that thing right at last, thank heaven."

Angela would heave a sigh of relief, for she could feel instantly any dis-tress or inability that he felt, but the joy was of short duration. In a few hours she would find him working at the same canvas, changing something. He grew thinner and paler at this time and his apprehensions as to his future rapidly became morbid.

"By George! Angela," he said to her one day, "it would be a bad thing for me if I were to become sick now. It's just the time that I don't want to. I want to finish this exhibition up right and then go to London. If I could do London and Chicago as I did New York I would be just about made, but if I'm going to get sick——"

"Oh, you're not going to get sick, Eugene," replied Angela, "you just think you are. You want to remember that you've worked very hard this summer. And think how hard you worked last winter! You need a good rest, that's what you need. Why don't you stop after you get this exhibition ready and rest awhile. You have enough to live on for a little bit. M. Charles will probably sell a few more of those pictures, or some of these will sell and then you can wait. Don't try to go to London in the spring. Go on a walking tour or go down South or just rest awhile, anywhere—that's what you need."

Eugene realized vaguely that it wasn't rest that he needed so much as peace of mind. He was not tired. He was merely nervously excited and apprehensive. He began to sleep badly, to have terrifying dreams, to feel that his heart was failing him. At two o'clock in the morning, the hour when, for some reason, human vitality appears to undergo a peculiar disturbance, he would wake with a sense of sinking physically. His pulse would appear to be very low and he would feel his wrists nervously. Not infrequently he would break out in a cold perspiration and would get up and walk about to restore himself. Angela would rise and walk with him. One day at his easel he was seized with a peculiar, nervous disturbance—a sudden, glittering light before his eyes, a rumbling in his ears, and a sensation as though his body were being pricked with ten million scorching needles. It was as though his whole nervous system had given way at every minute point and division. For the time being he was intensely frightened, believing that he was going crazy, but he said nothing. It came to him as a staggering truth that the trouble with him was over-indulgence physically; that the remedy was abstinence, complete or at least partial; that he was probably so far weakened mentally and physically that it would be very difficult for him to recover; that his ability to paint might be seriously affected—his life blighted.

He stood before his canvas holding his brush, wondering. When the shock had completely gone, he laid the brush down with a trembling hand. He walked to the window, wiped his cold, damp forehead with his hand, and then turned to get his coat from the closet.

"Where are you going?" asked Angela.

"For a little walk. I'll be back soon. I don't feel just as fresh as I might."

She kissed him good-bye at the door and let him go but her heart troubled her. His eyes looked so apprehensive, his glance was so unsteady.

"I'm afraid Eugene is going to get sick," she thought. "He ought to stop work."

The vagaries of nervous disorders are too numerous either to permit or require specific or definite analysis in this connection. It may be said that for a period of five or six years following this alteration, Eugene was not himself again. He was not in any sense out of his mind—if power to reason clearly, jest sagely, argue and read intelligently are any evidence of sanity—particularly when in the presence and observation of others. But privately his mind was a maelstrom of contradictory doubts, feelings, and emotions. Always of a philosophic and introspective turn, this peculiar faculty of reasoning deeply and feeling emotionally were now turned upon himself and his own condition and, as in all such cases where we peer too closely into the subtleties of creation, confusion was the result. Previously he had been well satisfied that the world knew nothing. Neither in religion, philosophy, or science was there any answer to the riddle of existence. Above and below the little scintillating plane of man's thought was—what?

Once he had sat in a great hall and watched and heard a most famous electrical experimenter demonstrate and prognosticate concerning the wonders of his science. The man placed himself in an electric field where was moving a current of electricity calculated at 2,000,000 volts. In his hand was a vacuum tube of glass which blazed forth a brilliant white light. From his finger tips came sparks and yet he was unharmed. This had set Eugene speculating on the vast forces which govern the suns and fill the immensity of space. What were they? Who set them in motion? Why their incalculable strength and what of all this immensity could man hope to know? Puny man! Beyond the optic strength of the greatest telescope, far out upon the dim horizon of space, were clouds of stars. What were they doing out there? Who governed them? When were their sidereal motions calculated? He figured life as a grim, dark mystery, a sad, semi-conscious activity turning aimlessly in the dark. No one knew anything. God knew nothing—himself least of all. Malevolence, life living on death, plain violence—these were the chief characteristics of existence. If one failed of strength in any way, if life were not kind in its bestowal of gifts, if one were not born to fortune's pampering care—the rest was misery. In the days of his strength and prosperity the spectacle of existence had been sad enough: in the hours of threatened delay and defeat it seemed terrible. Why, if his art failed him now, what had he? Nothing. A little puny reputation which he could not sustain, no money, a wife to take care of, years of possible suffering and death. The abyss of death! When he looked into that after all the life and hope, how it shocked him, how it hurt. Here was life and happiness and love in health; there was death and nothingness—aeons and aeons of nothingness. Of such is morbidity and nerve-failure and material decay.

At the same time he did not immediately give up hope—immediately succumb to the evidences of a crumbling reality. For months and months he fancied each day that this was a temporary condition; that drugs and doctors could heal him. There were various remedies that were advertised in the papers, blood purifiers, nerve restorers, brain foods, which were announced at once as specifics and cures and while he did not think that the ordinary patent medicine had anything of value in it, he did imagine that some good could be had from tonics or *the* right tonic. A physician whom he consulted recommended rest and an excellent tonic which he knew of. He asked whether Eugene was subject to any wasting disease. Eugene told him no. He confessed to an over-indulgence in the sex relationship but the doctor did not believe that ordinarily this should bring about a nervous decline. Hard work must have something to do with over-anxiety. Some temperaments such as his were predisposed at birth to nervous breakdowns. They had to guard themselves. Eugene would have to be very careful. He should eat regularly, sleep as long as possible, observe regular hours. A system of exercises might not be a bad thing for him. He could get him a pair of Indian clubs or dumbbells or an exerciser and bring himself back to health that way. The doctor had learned that drugs were not of much value in such cases.

Eugene returned to his studio. He told Angela that he believed he would try exercising and joined a gymnasium. He took a tonic, walked with her a great deal, sought to ignore the fact that he was nervously depressed. These things were of practically no value, for the body had apparently been drawn a great distance below normal and all the hell of a subnormal state had to be endured before it could gradually come into its own again.

In the meantime he was not doing anything to overcome the one fault which was most destructive to him. If he had had the physique of a gladiator, the nerve-tensity and toughness of steel, the sex-energy of a satyr, he could not have withstood these persistent assaults. This incessant contact was out of all proportion to necessity or any normal desire. Because passions grow with what they feed upon, this grew, and each failure to restrain himself made it harder so to do. It was a customary remark of his that "he must quit this," but it was like the self-apologetic assurance of the drunkard that he must reform. There was no definite strength of will behind it—no real desire. In fact the full force of his desire was in the other direction. And there was not sufficient strength or judgement in Angela to overcome it.

In the meantime, now that he had stepped out into the lime-light of public observation—now that artists and critics and writers knew of him somewhat and in their occasional way were wondering what he was doing— it was necessary that he should bestir himself in especial effort in order to satisfy the public as to the enduring quality of his art. He was glad, once he realized that he was in for a siege of bad weather, that his Paris drawings

had been so nearly completed before the break came. By the day he suf-
fered the peculiar nervousness which seemed to mark the opening of his
real decline, he had completed twenty-two drawings which Angela begged
him not to touch, and by sheer strength of will, though he misdoubted
gravely, he managed to complete five more. All of these M. Charles came
to see on occasion and he approved of them highly. He was not so sure that
they would have the appeal of the American pictures for, after all, the city
of Paris had been pretty well done, over and over, in illustration and genre
work. It was not so new as New York, the things Eugene chose were not
as unconventional. Still, he could say truly they were exceptional. They
might try an exhibition of them later on in Paris if they did not take here.
He was very sorry to see that Eugene was in poor health and urged him to
take care of himself.

It would be useless to describe the details and difficulties of a persistent
decline. It was as if some malign planetary influence had swung into the ken
of the earth and unfavorably affected those born under a given star. Eugene
knew of astrology and palmistry and one day, in a spirit of curiosity and
vague apprehensiveness, consulted a practitioner of the former, receiving
for his dollar which was charged as a fee the statement that he was destined
to great fame in either art or literature but that he was entering a period
of stress which would endure for a number of years. Eugene's spirits sank
perceptibly. The musty old gentleman who essayed his books of astrologi-
cal lore shook his head. He had a rather noble growth of white hair and a
white beard but his coffee-stained vest was covered with tobacco leavings
and his collar and cuffs were dirty.

"It looks pretty bad between your twenty-eighth and your thirty-second
year but after that there is a notable period of prosperity. Somewhere around
your thirty-eighth or thirty-ninth year there is some more trouble, a little,
but you will come out of that—that is, it looks as though you would. Your
stars show you to be of a nervous, imaginative character, inclined to worry,
and I see that your kidneys are weak. You ought never to take much medi-
cine. Your sign is inclined to that but it is without benefit to you. You will
be married twice but I don't see any children."

He rambled on dolefully and Eugene left in great gloom. So it was writ-
ten in the stars that he was to suffer a period of decline and there was to
be more trouble for him in the future. But he did see a period of great suc-
cess for him between his thirty-second and thirty-eighth years. That was
some comfort. Who was the second woman he was to marry? Was Angela
going to die? He walked the streets this early December afternoon thinking,
thinking. He could not work. He could not make his impressions come out
right. He could only walk and think. How long was this to endure?

The Blue family had heard a great deal of Eugene's success since Angela had come to New York. There had never been a week that at least one letter and sometimes two had not gone the rounds of the various members of the family. It was written to Marietta primarily, but Mrs. Blue, Jotham, the boys, and the several sisters all received it by turns. Thus the whole regiment of Blue connections knew exactly how it was with Angela—and even better than it was; for although things had looked prosperous enough, Angela had not stayed within the limits of bare facts in describing her husband's success. She added atmosphere—not fictitious, but the seeming glory which dwelt in her mind—until the various connections of the Blue family, Marietta in particular, were convinced that there was nothing but dignity and bliss in store for the wife of so talented a man. The studio life which Angela had seen, here and in Paris, the picturesque descriptions which came home from London and Paris, the personalities of M. Charles, M. Arkquin, Isaac Wertheim, Henry L. Tomlins, Luke Severas—all the celebrities whom they met both in New York and abroad, had been described at length. There had not been a dinner, a luncheon, a reception, a tea party, which had not been pictured in all of its native colors, and more. Eugene had become somewhat of a demi-god to his western connections. The quality of his art was never questioned. It was only a matter of time now before he would be rich or at least well-to-do. All the relatives hoped that he would bring Angela home some day on a visit. To think that she should have married such a distinguished man.

In the Witla family it was quite the same. Eugene had not been home to see his parents since his last visit to Angela, but they had not been without news. For one thing, although Eugene had been so neglectful and somewhat because of this, Angela had taken it upon herself to open up a correspondence with his mother. She wrote her that of course she didn't know her, but that she was terribly fond of Eugene, that she hoped to make him a good wife, and that she hoped to make her a satisfactory daughter-in-law. Eugene was so dilatory about writing anyone. She would write for him now, and his mother should hear every week. She asked if she and her husband couldn't manage to come and see them some time. She would be so glad and it would do Eugene so much good. She asked if she couldn't have Myrtle's address—they had moved from Ottumwa—and if Sylvia wouldn't write her occasionally. She sent a picture of herself and Eugene, a sketch of the studio Eugene made one day, a sketch of herself looking pensively out of the window into Washington Square. Pictures from his first exhibit published in the newspapers, accounts of his work, criticisms—all reached the members of both families impartially and they were kept well aware of how things were going.

During the time that Eugene was feeling so badly and because if he were gong to lose his health it might be necessary to economize greatly, it occurred to Angela that it might be advisable for them to go home for a visit. While her family was not rich, it had sufficient means to live on. Eugene's mother also was constantly writing, wanting to know why they didn't come out there for awhile. She could not see why Eugene could not paint his pictures as well in Alexandria as in New York or Paris. Eugene listened to this willingly, for it occurred to him that instead of going to London he might do Chicago next, and he and Angela could stay awhile at Black Wood and another while at his own home. They would be welcome guests.

The condition of his finances at this time was not entirely bad but it was not very good. Of the thirteen hundred dollars he had received for the first three pictures sold, eleven hundred had been used on this foreign trip. He had since used three hundred dollars of his remaining capital of twelve hundred, but M. Charles's sale of two pictures at four hundred each had swelled his bank balance to seventeen hundred dollars. However, on this he had to live now until additional pictures were disposed of. He daily hoped to hear of additional sales but they did not materialize.

In addition, his exhibit in January did not produce quite the impression he thought it would. It was distinguished to look at; the critics and the public imagined that by now he must have created a following for himself, else why should M. Kellner go to this trouble of showing his work. But the former pointed out that these foreign studies could not hope to appeal to Americans as did American things. They indicated that they might take better in France. Eugene was depressed by the general tone of the opinions, but this was due more to his unhealthy state of mind than to any inherent reason for feeling so. There was still Paris to try and there might be some sales of his work here. Sales were slow in materializing, however, and because by February he had not been able to work, and because it was necessary that he should husband his resources as carefully as possible, he decided to accept Angela's family's invitation as well as that of his own parents and spend some time in Illinois and Wisconsin. Perhaps his health would become better. He decided also that, if his health permitted, he would work in Chicago.

CHAPTER XLIII

It was in packing the trunks and leaving the studio in Washington Square—for owing to the continued absence of Mr. Dexter they had never yet been compelled to vacate it—that Angela came across the first

evidence of duplicity on Eugene's part which she had hitherto encountered. Because of his peculiar indifference to everything except matters which related to his art, he had put the letters which he had received in times past from Christina Channing as well as the one and only from Ruby Kenny in a box which had formerly contained writing paper and which he threw carelessly in a corner of his trunk. He had by this time forgotten all about them, though his impression was that he had placed them somewhere where they would not be found. When Angela started to lay out the various things which occupied the trunk she came across this box and, opening it, took out the letters.

Curiosity as to things relative to Eugene was at this time the dominant characteristic of her life. She could neither think nor reason outside of this joint relationship which bound her to him. He and his affairs were truly the sum and substance of her existence. She looked at these oddly and then opened one—the first from Christina. It was dated Florizel, the summer of three years before, when she was waiting so patiently for him at Black Wood. It began conservatively enough, "Dear E," but it concerned itself immediately with references to an apparently affectionate relationship:

"I went this morning to see if by chance there were any tell-tale evidences of either Diana or Adonis in Arcady. There were none of importance. A hair pin or two, a broken mother-of-pearl button from a summer waist, the stub of a lead pencil wherewith a certain genius sketched. The trees seemed just as unconscious of any nymphs or hama-dryads as they could be. The smooth grass was quite unruffled of any feet. It is strange how much the trees and forest know and keep their counsel.

"And how is the hot city by now? Do you miss a certain evenly swung hammock? Oh, the odour of leaves and the dew! Don't work too hard. You have an easy future and almost too much vitality. More repose for you, sir, and considerable more optimism of thought. I send you good wishes.

"Diana."

Angela wondered at once who Diana was, for before she had begun the letter she had looked for the signature on the succeeding page. Then after reading this she hurried feverishly from letter to letter, seeking a name. There was none. "Diana of the Mountains," "the Hama-Dryad," "the Wood Nymph," "C," "See See"—so they ran, confusing, badgering, enraging her until—all at once it came to light, her first name at least. It was on the letter from Baltimore suggesting that he come to Florizel—"Christina."

"Ah," she thought, "Christina! That is her name." Then she hurried back to read the remaining epistles, hoping to find some clue to her sur-

name. They were all of the same character, in the manner of writing she despised, toplofty, make-believe, the nasty, hypocritical, cant and make-believe superiority of the studios. How she hated her, for the moment. How she could have taken her by the throat and beaten her head against the trees she described. Oh, the horrid creature! How dare she! And Eugene—how could he! What a way to reward her love! What an answer to make to all her devotion! At the very time when she was waiting so patiently, he was in the mountains with this Diana. And here she was packing his trunk for him like the little slave that she was when he cared so little, had apparently cared so little all this time. How could he ever have cared for her and done anything like this? He didn't! He never had! Dear heaven.

She began clinching and unclinching her hands dramatically, working herself into that frenzy of emotion and regret which was her most notable characteristic. All at once she stopped. There was another letter in another handwriting on cheaper paper. Ruby was the signature.

"Dear Eugene," she read:

> "I got your note several weeks ago but I could not bring myself to answer it before this. I know everything is over between us and that is all right for I suppose it has to be. You couldn't love any woman long, I think. I know what you say about your having to go to New York to broaden your field is true. You ought to, but I'm sorry you didn't come out. You might have. Still I don't blame you, Eugene. It isn't much different from what has been going on for some time. I have cared but I'll get over that I know, and I won't ever think hard of you. Won't you return me the notes I have sent you from time to time and my pictures? You won't want them now.
>
> <div align="right">"Ruby."</div>

> "I stood by the window last night and looked out on the street. The moon was shining and those dead trees were waving in the wind. I saw the moon on that pool of water over in the field. It looked like silver. Oh, Eugene, I wish I were dead."

Angela got up (as Eugene had) when she read this. The pathos struck home for somehow it matched her own. Ruby! Who was she? Where had she been concealed while she, Angela, was coming to Chicago? Was this the fall and winter of their engagement? It certainly was. Look at the date. And he had given her the diamond ring on her finger that fall! He had sworn eternal affection! He had sworn there was never another girl like her in all the world and yet, at that very time, he was apparently paying *court* to this woman, if nothing worse. Dear heaven! The dog! Could anything like this really be? He was telling her that he loved her, and making

love to Ruby at the same time. He was kissing and fondling her and Ruby too!! Dear heaven! Was there ever such a situation? He, Eugene Witla, to deceive her this way. No wonder he wanted to get rid of her when he came to New York. He would have treated her as he did this Ruby. And Christina! This Christina!! Where was she? Who was she? What was she doing now? She jumped up, prepared to go to Eugene and charge him with his iniquities but remembered that he was out of the studio—that he had gone for a walk. He was sick now, very sick. Would she dare to reproach him with these reprehensible episodes?

She came back to the trunk where she was working and sat down. Her eyes were hard and cold for the time, for she had a notable strain of selfishness in her, but at the same time there was a touch of terror and of agonized affection. A face that, in the ordinary lines of its repose, was very much like that of a Madonna, was now drawn and peaked and gray. The mere thought of Eugene having ever been loved by another was enough to upset her reason. She tried to think what she must do. Must she leave him? Must she turn on him now when he was in this wretched, sickly state and reproach him bitterly? Would it do her any good to make him explain? Through all her suffering was running a vein of eager curiosity. She wanted to know, oh, so much, who Ruby and Christina were. Apparently Christina had forsaken him, or it might be that they still corresponded secretly. She got up again at that thought. Still the letters were old. It looked as though all exchanging had ceased two years ago. What had he written to her—love notes. Letters full of wooing phrases such as he had written to her. Oh, the instability of men, the insincerity, the lack of responsibility and a sense of duty. Her father, what a different man he was; her brothers—their word was their bond. And here she was, married to a man who even in the days of his most ardent wooing had been deceiving her. She had let him lead her astray, too—disgrace her own home. Tears came after awhile, hot scalding tears that seared her cheeks. And now she was married to him and he was sick and she would have to make the best of it. She wanted to make the best of it, for after all she loved him.

But oh, the cruelty, the insincerity, the wickedness, the brutality of it all.

The fact that Eugene was out for several hours following her discovery gave her ample time to reflect as to a suitable course of action. Being so impressed by the genius of the man as imposed upon her by the opinion of others and her own affection, she could not readily think of anything save some method of ridding her soul of this misery and him of his evil tendencies: of making him ashamed of his wretched career, of making him see how badly he had treated her and how sorry he ought to be. She wanted

him to feel sorry, very sorry, so that he would be a long time repenting in suffering, but she feared at the same time that she could not make him do that. He was so ethereal, so indifferent, so lost in the contemplation of life, that he could not be made to think of her. That was her one complaint. He had other gods before her—the god of his art, the god of nature, the god of people as a spectacle. Frequently she had complained to him in this last year—"you don't love me! you don't love me!"—but he would answer, "oh, yes I do. I can't be talking to you all the time, Angel Face. I have work to do. My art has to be cultivated. I can't be making love all the time."

"Oh, it isn't that, it isn't that!" she would exclaim passionately. "You just don't love me, like you ought to. You just don't care. If you did I'd feel it."

"Oh, Angela," he answered, "why do you talk so? Why do you carry on so? You're the funniest girl I ever knew. Now be reasonable. Why don't you bring a little philosophy to bear. We can't be billing and cooing all the time!"

"Billing and cooing. That's the way you think of it. That's the way you talk of it! As though it were something you had to do. Oh, I hate love! I hate life! I hate philosophy! I wish I could die."

"Now, Angela, for heaven's sake, why will you take on so? I can't stand this. I can't stand these tantrums of yours. They're not reasonable. You know I love you. Why, haven't I shown it? Why should I have married you if I didn't? I didn't need to marry you!"

"Oh, dear! oh, dear!" Angela would sob on, wringing her hands. "Oh, you really don't love me! You don't care. And it will go on this way, getting worse and worse, with less and less of love and feeling until after awhile you won't even want to see me anymore—you'll hate me! Oh, dear! oh, dear!"

Eugene felt keenly the pathos involved in this picture of decaying love. This fear of disaster which might overtake her little bark of happiness was sufficiently well located in fact. It might be so that his affection would cease. It wasn't even affection now, in the true sense of the word—a passionate intellectual desire for her companionship. He never had really loved her for her mind, the beauty of her thoughts. As he meditated he realized that he had never reached an understanding with her by an intellectual process at all. It was emotional, subconscious, a natural drawing together which was not based on reason and spirituality of contemplation, apparently, but on grosser emotions and desires. Physical desire had been involved—strong, raging, incontrollable. And for some reason he had always felt sorry for her—he always had. She was so little, so conscious of disaster, so afraid of life and what it might do to her. It was a shame to wreck her hopes and desires. At the same time he was sorry now for this bondage he had let him-

self into—this yoke which he had put about his neck. He could have done so much better. He might have married a woman of wealth or a woman of the artistic perceptions and philosophic insight like Christina Channing, who would be peaceful and happy with him. Angela couldn't be. He really didn't admire her enough—couldn't make over her enough. Even while he was soothing her in these moments, trying to make her believe that there was no basis for her fears, sympathizing with her subconscious intuitions that all was not well, he was thinking of how different his life might have been. Poor Angela! He would try to be fair to her if he could—but oh the pathos of having to, for him and for her.

"It won't end that way," he would soothe. "Don't cry. Come now, don't cry. We're going to be very happy. I'm going to love you always, just as I'm loving you now, and you're going to love me. Won't that be all right? Come on, now. Cheer up. Don't be so pessimistic. Come on, Angela. Please do. Please!"

Angela would brighten after a time but these spells of apprehension and gloom were common—apt to burst forth like a summer storm when neither of them were really expecting it.

The finding of these letters simply confirmed the feeling that she had had all along that basically he did not care. Kind though he was—and he was kind, there was no question of that—he did not love her. It was kindness only. He showed the latter in various and sundry ways—by giving her his money to keep, insisting that she buy herself whatever she wanted within the limits of their means, telling her that she was pretty, that she was a good housekeeper, that she had emotional genius, pretending that he was fond of her company, bearing with her ill nature, her storms and rages of emotion patiently, soothing her so-called *fancied* ills. He never seemed to lose his temper, or rarely, and was always willing to forgive her assaults and charges of indifference, which were as frequent as her storms of emotion. At the same time he was something like a child in the matter of social observances, details of dress and personal adornment, yielding to whatever she suggested in these matters once he was convinced she was paying intelligent attention to them. She had to insist that he get himself new suits in season, new ties, collars, vests, shoes, otherwise he would dream along, working at his art, thinking that he was doing well enough. Angela did her best to school him in the niceties of conventional dress and observance as she understood them, for she was a stickler for these things. The selection and combination of the right colors and forms of clothing for particular occasions; the prompt answering of invitations which came to them; the paying of dinner calls and so on—things to which Eugene had paid small attention in the past—were of the greatest importance to her. She defined this as simply

being very nice—not inconsiderate. It was his idea that being an artist, he was quite above these petty little agreements of social life—that he could do as he pleased and that people would really like him better for ignoring proprieties. Since Angela insisted that they were important and was bent on observing them, he did not mind. He would do as she said, if she would take care of the details. So he came to give her the impression of sweetness and docility of temper, and she gathered the sense of great usefulness on her part. She was essential and valuable to him. She was helping him make his career.

The discovery of these letters now checked this feeling with which Angela had tried to delude herself at times that there might be anything more than kindness here. They confirmed her suspicions that there was not, brought on that sense of defeat and despair which so often and so tragically overcame her. It happened at a time, too, when Eugene needed her undivided consideration and feeling, for he was in a wretched state of mind. To have her quarrel with him now, lose her temper, fly into rages and moods, and compel him to console her, was very trying. He was in no mood for it; could not very well endure it without injury to himself. He was seeking for an atmosphere of joyousness; wishing to find a cheerful optimism somewhere which would pull him out of himself and make him whole. Not infrequently he dropped in to see Norma Whitmore; Isadora Crane, who was getting along very well on the stage; Hedda Andersen, who had a natural charm of intellect with much vivacity, even though she was a model; and now and then Miriam Finch. The latter was glad to see him alone, almost as a testimony against Angela, though she would not go out of her way to conceal from Angela the fact that he had been there. The others, though he said nothing, assumed that since Angela did not come with him he wanted nothing said and observed his wish. They were inclined to think that he had made a matrimonial mistake and was possibly artistically or intellectually lonely. All of them noted his decline in health with considerate apprehension and sorrow. It was too bad, they thought, if his health was going to fail him just at this time. Eugene lived in fear lest Angela should become aware of any of these visits. He thought he could not tell her because in the first place she would resent his not having taken her along and in the next, if he had proposed it, she would have objected or set another date or asked pointless questions. He liked the liberty of going where he pleased, saying nothing, not feeling it necessary to say anything. He longed for the feeling of his old prematrimonial days. Just at this time, because he could not work artistically and because he was in need of diversion and of joyous artistic palaver, he was especially miserable. Life seemed very dark and ugly.

Eugene, returning and feeling as usual depressed about his state, sought

to find consolation in her company. He came in at one o'clock, their usual lunch hour, and finding Angela still working, said, "George! but you like to keep at things when you get started, don't you? You're a regular little work-horse. Having much trouble?"

"No-o," replied Angela, dubiously.

Eugene noted the tone of her voice. He thought she was not very strong and this packing was getting on her nerves. Fortunately there were only some trunks to look after, for the vast mass of their housekeeping material belonged here. Still, no doubt she was weary.

"Are you very tired?" he asked.

"No-o," she replied.

"You look it," he said, slipping his arm about her. Her face, which he turned up with his hand, was pale and drawn.

"It isn't anything physical," she replied, looking away from him in a tragic way. "It's just my heart. It's here!" And she laid her hand over her heart.

"What's the matter now?" he asked, suspecting something emotional, though for the life of him he could not imagine what. "Does your heart hurt you?"

"It isn't my real heart," she returned, "it's just my mind, my feelings, though I don't suppose they ought to matter."

"What's the matter now, Angel Face?" he persisted, for he was sorry for her. This emotional ability of hers had the power to move him. It might have been acting or it might not have been. It might be either a real or a fancied woe—in either case it was real to her. "What's come up?" he continued. "Aren't you just tired? Suppose we quit this and go out somewhere and get something to eat. You'll feel better."

"No, I couldn't eat," she replied. "I'll stop now and get your lunch, but I don't want anything."

"Oh, what's the matter, Angela?" he begged. "I know there's something. Now what is it? You're tired or you're sick or something has happened. Is it anything that I have done? Look at me. Is it?"

Angela held away from him, looking down. She did not know how to begin this but she wanted to make him terribly sorry if she could, as sorry as she was for herself. She thought he ought to be; that if he had any true feeling of shame and sympathy in him he would be. Her own condition in the face of his shameless past was terrible. She had no one to love her. She had no one to turn to. Her own family did not understand her life any more—it had changed so. She was a different woman now, greater, more important, more distinguished. Her experiences with Eugene here in New York, in Paris, in London, and even before her marriage, in Chicago and Black Wood, had changed her point of view. She was no longer the same

in her ideas, she thought, and to find herself deserted in this way emotionally—not really loved, not ever having been really loved but just toyed with, made a doll and a play thing, was awful.

"Oh, dear!" she exclaimed in staccato, "I don't know what to do! I don't know what to say! I don't know what to think! If I only knew how to think or what to do!"

"What's the matter?" begged Eugene, releasing his hold and turning his thoughts partially to himself and his own condition as well as to hers. His nerves were put on edge by these emotional tantrums—his brain fairly ached. It made his hands tremble. In his days of physical and nervous soundness it did not matter but now when he was sick, when his own heart was weak, as he fancied, and his nerves set to jangling by the least discord, it was almost more than he could bear. "Why don't you speak," he insisted. "You know I can't stand this. I'm in no condition. What's the trouble? What's the use carrying on this way? Are you going to tell me?"

"There!" Angela said, pointing her finger at the box of letters she had laid aside on the window sill. She knew he would see them, would remember instantly what they were about.

Eugene looked. The box came to his memory instantly. He picked it up nervously, sheepishly, for this was like a blow in the face which he had no power to resist. The whole peculiar nature of his transactions with Ruby and with Christina came back to him, not as they had looked to him at the time but as they were appearing to Angela now. What must she think of him? Here he was protesting right along that he loved her, that he was happy and satisfied to live with her, that he was not interested in any of these other women whom she knew to be interested in him and of whom she was inordinately jealous, that he had always loved her and her only, and yet here were these letters suddenly come to light, giving the lie to all these protestations and asseverations—making him look like the coward, the blackguard, the moral thief that he knew himself to be. To be dragged out of the friendly darkness of lack of knowledge and understanding on her part, and set forth under the clear white light of positive proof—he stared helplessly, his nerves trembling, his brain aching, for truly he was in no condition for an emotional argument.

And yet Angela was crying now. She had walked away from him and was leaning against the mantle piece, sobbing as if her heart would break. There was a real convincing ache in the sound—the vibration expressing the sense of loss and defeat and despair which she felt. There was bitterness in it too, for he had nothing to say. He was staring at the box, wondering why he had been such an idiot as to leave them in his trunk, to have saved them at all. He might have known that she would come across them sometime.

"Well I don't know that there is anything to say to that," he observed finally, strolling over to where she was. There wasn't anything that he could say—that he knew. He was terribly sorry—sorry for her, sorry for himself. "Did you read them all?" he asked, curiously.

She nodded her head in the affirmative.

"Well, I didn't care so much for Christina Channing," he observed deprecatingly. He wanted to say something, anything which would relieve her depressed mood. He knew he couldn't say much. If he could only make her believe that there wasn't anything of vital affectional sincerity in either of these affairs, that his interest and protestations had been of a light, philandering character. Still the Ruby Kenny letter showed that she cared for him desperately. He could not say anything against Ruby.

Angela caught the name of Christina Channing clearly. It seared itself in her brain. She recalled now that it was she of whom she had heard him speak in a complimentary way from time to time. She had heard Eugene speak of her. He had told in studios of what a lovely voice she had, what a charming platform presence she had, how she could sing so feelingly, how intelligently she looked upon life, how good looking she was, how she was coming back to grand opera some day. And he had been in the mountains with her—had made love to her while she was out in Black Wood, waiting for him patiently. It aroused on the instant all of the fighting jealousy that was in her breast. It was the same jealousy that had determined her once before to hold him in spite of the plotting and scheming that appeared to her to be going on about her. They should not have him—these nasty studio superiorities—not any one of them, nor all of them combined, if they were to unite and try to get him. They had treated her shamefully since she had been in the East. They had almost uniformly ignored her. They would come to see Eugene, of course, and now that he was famous they could not be too nice to him, but as for her—well, they had no particular use for her. Hadn't she seen it. Hadn't she watched the critical, hypocritical, examining glances in their eyes. She wasn't smart enough! She wasn't literary enough or artistic enough. She knew as much about life as they did and more—ten times as much, and yet because she couldn't strut and pose and stare and talk in an affected voice, they thought themselves superior. And so did Eugene, the wretched creature. Superior! The cheap, mean, nasty, selfish upstarts. Why, the majority of them had nothing. Their clothes were mere rags and tags when you came to examine them closely, badly sewed, of poor material, merely slung together, and yet they wore them with such a grand air. She would show them. She would dress herself too, one of these days, when Eugene had the means. She was doing it now—a great deal more than when she first came, and she would do it a great deal more before long. The

nasty, mean, cheap, selfish, make-believe things. She would show them! Ooh! How she hated them.

Now as she cried she also thought of the fact that Eugene could write love letters to this horrible Christina Channing—one of the same kind, no doubt. Her letters showed it. Ooh, how she hated her. If she could only get at her to poison her. And yet her sobs sounded much more of the sorrow she felt than of the rage. She was helpless in a way and she knew it. She did not dare to show him exactly what she felt. She was afraid of him. He might possibly leave her. He really did not care for her enough to stand everything from her—or did he? This doubt was the one terrible, discouraging, annihilating feature of the whole thing—if he only cared.

"I wish you wouldn't cry, Angela," said Eugene appealingly after a time. "It isn't as bad as you think. It looks pretty bad, but I wasn't married then, and I didn't care so very much for these people—not as much as you think, really I didn't. It may look that way to you, but I didn't."

"Didn't care!" sneered Angela all at once, flaring up. "Didn't care! It looks as though you didn't care, with one of them calling you 'Honey Boy' and 'Adonis,' and the other saying she wishes she were dead. A fine time you'd have convincing anyone that you didn't care. And me out in Black Wood at that very time, longing and waiting for you to come, and you up in the mountains making love to another woman. Oh I know how much you cared. You showed how much you cared when you could leave me out there to wait for you, eating my heart out while you were off in the mountains having a good time with another woman. 'Dear E,' and 'Precious Honey Boy,' and 'Adonis.' That shows how much you cared, doesn't it?"

Eugene stared before him helplessly. Her bitterness and wrath surprised and irritated him. He did not know that she was capable of such an awful rage as showed itself in her face and words at this moment, and yet he did not know but that she was well justified. Why so bitter though—so almost brutal? He was sick. Had she no consideration for him?

"I tell you it wasn't as bad as you think," he said firmly, showing for the first time a trace of temper and opposition. "I wasn't married then. I did like Christina Channing. I did like Ruby Kenny. What of it? I can't help it now. What am I going to say about it? What do you want me to say? What do you want me to do?"

"Oh," whimpered Angela, changing her tone at once from helpless, accusing rage to pleading, self-commiserating misery. "And you can stand there and say to me what of it? What of it! What of it! What shall you say? What do you think you ought to say? And me believing that you were so honorable and faithful. Oh, if I had only known! If I had only known. I had better have drowned myself a hundred times over than to have waked and

found that I wasn't loved. Oh, dear, oh dear! I don't know what I ought to do! I don't know what I can do!"

"But I do love you," protested Eugene soothingly, anxious to say or do anything which would quiet this terrific storm. He could not imagine how he had been so foolish as to leave these letters laying around. Dear heaven! What a mess he had made of this. If only he had put them safely outside the home or destroyed them. Still he had hoped to keep Christina's letters for some reason. They were so charming.

"Yes, you love me!" flared Angela. "I see how you love me. Those letters show it! Oh, dear! Oh, dear! I wish I were dead."

"Listen to me, Angela," replied Eugene desperately. "I know this correspondence looks bad. I did make love to Miss Kenny and to Christina Channing, but you see I didn't care enough to marry either of them. If I had, I would have. I cared for you. Believe it or not. I married you. Why did I marry you? Answer me that. I needn't have married you. Why did I? Because I loved you, of course. What other reason could I have?"

"Because you couldn't get Christina Channing," snapped Angela, angrily, with the intuitive sense of one who reasons from one material fact to another—"that's why. If you could have, you would have. I know it. Her letters show it."

"Her letters don't show anything of the sort," returned Eugene angrily. "I couldn't get her! I could have had her, easily enough. I didn't want her. If I had wanted her, I would have married her—you can bet on that." He hated himself for lying in this way but he felt for the time being that he had to do it. He did not care to stand in the role of a jilted lover. He half fancied that he could have married Christina if he had really tried.

"Anyhow," he said, "I'm not going to argue that point with you. I didn't marry her, so there you are, and I didn't marry Ruby Kenny either. I suppose you think I couldn't have married her either? Well you can think all you want, but I know. I cared for them but I didn't marry them. I married you instead. I ought to get credit for something on that score. I married you because I didn't love you, I suppose? That's perfectly plain, isn't it?" He was half convincing himself that he had loved her some.

"Yes, I see how you love me," persisted Angela, cogitating this very peculiar fact which he was insisting on and which it was very hard intellectually to overcome. "You married me because you couldn't very well get out of it, that's why. Oh, I know. You didn't want to marry me. That's very plain. You wanted to marry someone else. Oh, dear! Oh, dear!"

"Oh, how you talk," replied Eugene defiantly. "Marry someone else! Who did I want to marry? I could have married often enough if I had wanted to. I didn't want to marry, that's all. Believe it or not. I wanted to marry you, and

I did. I don't think you have any right to stand there and argue so. What you say isn't so and you know it."

Angela cogitated this argument some more. He had married her! Why had he? He might have cared for Christina and Ruby but he must have cared for her too. Why hadn't she thought of that? There was something in it—something besides a mere desire to deceive her. Perhaps he did care for her a little. Anyway it was plain that she could not get very far by arguing with him—he was getting stubborn, argumentative, contentious. She had not seen him that way before.

"Oh," she sobbed, taking refuge from this very difficult realm of logic in the safer and more comfortable one of illogical tears. "I don't know what to do! I don't know what to think!" She was badly treated, no doubt of that. Her life was a failure, but even so there was some charm to him. As he stood there, looking aimlessly around, defiant at one moment, appealing at another, she could not help seeing that he was not wholly bad. He was just weak on this one point. He loved pretty women. They were always trying to win him to them. He was probably not wholly to blame. If he would only be repentant enough, this thing might be allowed to blow over. It couldn't be forgiven. She never could forgive him for the way he had deceived her. Her ideal of him had been more or less hopelessly shattered—but she might live with him probationally.

"Angela!" he said, while she was still sobbing, and feeling that he ought to apologize to her. "I'm awfully sorry. Really I am. Won't you believe me? Won't you forgive me? I don't like to hear you cry this way. There's no use saying that I didn't do anything. There's no use of my saying anything at all, really. You won't believe me. I don't want you to cry, and I'm sorry. Won't you believe that? Won't you forgive me?"

Angela listened to this curiously, her thoughts going around in a ring, for she was at once despairing, regretful, revengeful, critical, sympathetic toward him, desirous of retaining her state, desirous of obtaining and retaining his love, desirous of punishing him—desirous of doing any one of a hundred things. Oh, if he had only never done this. If he were only like her father, her brothers—a man with an indestructible, impeccable sense of honor. Oh, dear, she was so unhappy. And he was sick, too. He needed her sympathy.

"Won't you forgive me, Angela?" he pleaded softly, laying his hand on her own. "I'm not going to do anything like that any more. Won't you believe me? Come on now. Quit crying. Won't you?"

Angela hesitated for a while, lingering dolefully. She did not know what to do, what to say. It might be that he would not sin against her anymore. He had not thus far, in so far as she knew. Still, this was a terrible revelation. All at once, because he maneuvered himself into a suitable position,

and because she herself was weary of fighting and crying, and because she was longing for sympathy, she allowed herself to be pulled into his arms, her head to his shoulder, and then she cried more copiously than ever.

Eugene for the moment felt terribly grieved. He was really sorry for her. It wasn't right. He ought to be ashamed of himself. He should never have done anything like that. "I'm sorry," he whispered, "really I am. Won't you forgive me?"

"Oh, I don't know what to do! What to think!" moaned Angela after a time.

"Please do, Angela," he urged, holding her questioningly.

There was more of this pleading and emotional badgering until finally out of sheer exhaustion Angela said yes. Eugene's nerves were worn to a thread by the encounter. He was pale, exhausted, distraught. Many scenes like this, he thought, would set him crazy and still he had to go through a world of petting and love making even now. It was not easy to bring her back to her normal self. It was bad business, this philandering, he thought. It seemed to lead to all sorts of misery for him, and Angela was jealous. Dear heaven! What a wrathful, vicious, contentious nature she had when she was aroused. He had never suspected that. How could he truly love her when she acted like that? How could he sympathize with her? He recalled how she sneered at him—how she taunted him with Christina's having thrown him down. He was weary, excited, desirous of rest and sleep, but now he must make more love. He fondled her and by degrees she came out of her blackest mood but he was not really forgiven at that. He was just under-stood better. And she was not truly happy again but hopeful, inclined to take him on probation.

CHAPTER XLIV

Spring, summer, and fall came and went, with Eugene and Angela first in Alexandria and then in Black Wood. In suffering this nervous break-down and being compelled to leave New York, Eugene missed some of the finest fruits of his artistic efforts, for M. Charles, as well as a number of other people, were interested in him and were prepared to entertain him in an interesting and conspicuous way. He could have gone out a great deal but his mental state was such that he was poor company for anyone. He was exceedingly morbid, inclined to discuss gloomy subjects, to look on life as exceedingly sad, and to believe that people generally were evil. Lust, dishonesty, selfishness, envy, hypocrisy, slander, hate, theft, adultery,

murder, dementia, insanity, inanity—these and death and decay occupied his thoughts. There was no light anywhere. Only a storm of evil and death. These ideas, coupled with his troubles with Angela, the fact that he could not work, the fact that he felt he had made a matrimonial mistake, the fact that he feared that he might die or go crazy, made a terrible and anguishing winter for him. He was never able to forget it.

Angela's attitude, while sympathetic enough once the first storm of feeling was over, was nevertheless involved with a substratum of criticism. While she said nothing and agreed that she would forget, Eugene had the consciousness all the while that she wasn't forgetting, that she was secretly reproaching him, and that she was looking for new manifestations of weakness in this direction, expecting them, and on the alert to prevent them. One may feel the justification for such an attitude without enjoying it—while suffering keenly from it. Since Eugene was morbid anyhow, this thought was doubly irritating to him. He felt much as might a criminal in a pillory—exposed to the withering scorn of an observing public. How true it is that you shall not come out from evil until the last farthing is paid.

The springtime in Alexandria, opening as it did shortly after they reached there, was in a way a source of relief to Eugene. He had decided for the time being to give up trying to work, to give up his idea of going either to London or Chicago, and merely resting. Perhaps it was true that he was tired. He didn't feel that way. He couldn't sleep and he couldn't work, but he felt brisk enough. It was only because he couldn't work that he was miserable. Still, he decided to try sheer idleness. Perhaps that would revive his wonderful art for him. In the meantime he speculated ceaselessly on the time he was losing, the celebrities he was missing, the places he was not seeing. Oh, London, London! If he could only do that.

Mr. and Mrs. Witla were immensely pleased to have their boy back with them again. Being in their way simple, unsophisticated people, they could not understand how their son's health could have undergone such a sudden reversal. He must have been working extremely hard. Painting a picture must be very difficult. They did not understand that the delineation of a scene or a character was only the purest joy to Eugene. It was the inability to paint that was his chief misery.

"I never saw Gene looking so bad in all his life," observed Witla père to his wife the day Eugene arrived. "His eyes are so sunken. What in the world do you suppose is ailing him?"

"How should I know?" replied his wife, who was greatly distressed over her boy. "I suppose he's just tired out, that's all. He'll probably be all right after he rests awhile. Don't let on that you think he's looking out of sorts. Just pretend that he's all right. What do you think of his wife?"

"She appears to be a very nice little woman," replied Witla. "She's certainly devoted to him. I never thought Eugene would marry just that type, but he's the judge. I suppose people thought that I would never marry anybody like you, either," he added jokingly.

"Yes, you did make a terrible mistake," jested his wife in return. "You worked awfully hard to make it."

"I was young! I was young! You want to remember that," retorted Witla. "I didn't know much in those days."

"You don't appear to know much better yet," she replied, "do you?"

He smiled and patted her on the back. "Well, anyhow I'll have to make the best of it, won't I? It's too late now."

"It certainly is," replied his wife.

Eugene and Angela were given his old room on the second floor, which commanded a nice view of the yard and the street corner, and they settled down to spend what the Witla parents hoped would be months of peaceful days.

It was a curious sensation to Eugene to find himself back here in Alexandria, looking out upon the peaceful neighborhood in which he had been raised, the trees, the lawn, the hammock replaced several times since he had left, but still in its accustomed place. The thought of the little lakes and the small creek winding about the town was a comfort to him. He could go fishing now, and boating, and there were some interesting walks here and there. He began to amuse himself by going fishing the first week but it was still a little cold, and for the time being he decided to confine himself to walking. Angela made it a point to walk with him for she wanted to be as helpful and companionable as she could in these dark hours.

Days of this kind grow, as a rule, quickly monotonous. To a man of Eugene's turn of mind there was so little in Alexandria to entertain him. After London and Paris, Chicago and New York, the quiet streets of his old home town were a joke. He visited the office of the *Appeal* but both Jonas Lyle and Caleb Williams had gone, the former to St. Louis, the latter to Bloomington. Old Benjamin Burgess, his sister's husband's father, was unchanged except in the matter of years. He told Eugene that he was thinking of running for Congress in the next campaign—the Republican organization owed it to him. His son Henry, Sylvia's husband, had become treasurer of the local bank. He was working as patiently and quietly as ever, going to church Sundays, going to Chicago occasionally on business, consulting with farmers and business men about small loans. He was a close student of the several banking journals of the country, and seemed to be doing very well financially. Sylvia had little to say of how he was getting along. Having lived with him for eleven years she had become somewhat close-

mouthed like himself. Eugene could not help smiling at the lean, slippered subtlety of the man, young as he was. He was so quiet, so conservative, so intent on all the little things which make a conventionally successful life. Like a cabinet maker he was busy inlaying the little pieces which would eventually make the perfect whole.

Angela took up the household work, which Mrs. Witla grudgingly consented to share with her, with a will. She liked to work and would put the house in order while Mrs. Witla was washing the dishes after breakfast. She would make pies and cakes for Eugene when she could without giving offense, and she tried to conduct herself so that Mrs. Witla would like her. She did not think so much of the Witla household. It wasn't so much better than her own—hardly as good. Still it was Eugene's birthplace and for that reason important. There was a slight divergence of viewpoint though, between his mother and herself, over the nature of life and how to live it. Mrs. Witla was of an easier, more friendly outlook on life than Angela. She liked to take things as they came without much worry while Angela was of a naturally worrying disposition. The two had one very human failing in common—they could not work with anyone else at anything. Each preferred to do all that was to be done, rather than share it with anyone else. Both being so anxious to be conciliatory, for Eugene's sake and for permanent peace in the family, there was small chance for any disagreement, for neither was without tact. But there was just a vague hint of something in the air—that Angela was a little hard and selfish, on Mrs. Witla's part; that Mrs. Witla was just the least bit secretive or shy or distant, from Angela's point of view. All was serene and lovely on the surface, however, with many won't-you-let-me's and please-do-now's on both sides. Mrs. Witla, being so much older, was of course calmer and in the family seat of dignity and peace. She could not be flustered by any arrival. All of her wishes were naturally first in the matter of observance.

To be able to sit about in a chair, lie in a hammock, stroll in the woods and country fields, and be perfectly happy in idle contemplation and loneliness, requires an exceptional talent for just that sort of thing. Eugene once fancied he had it, as did his parents, but since he had heard the call of fame he could never be still anymore. And just at this time he was not in need of solitude and idle contemplation but of diversion and entertainment. He needed companionship of the right sort, gayety, sympathy, enthusiasm. Angela had some of this, when she was not troubled about anything; his parents, his sisters, his old acquaintances had a little more to offer. They could not, however, be forever talking to him or paying him attention, and beyond them there was nothing. The town had no resources. Eugene would walk the long country roads with Angela or go boating or fishing sometimes

alone, but these things made him lonely. He would sit on the porch or in the hammock and think of what he had seen in London and Paris—how he might be at work. St. Paul's in a mist, the Thames Embankment, Piccadilly, Blackfriars Bridge, the muck of Whitechapel and the East End—how he wished he was out of all this and painting them. He had begun working in oil since his first drawings and was doing splendidly. If he could only paint. He rigged up a studio in his father's barn, using a north loft door for light, and essayed certain things from memory but there was no making anything come out right. He had this fixed belief, which was a notion purely, that there was always something wrong. Angela, his mother, his father, whom he occasionally asked for an opinion, might protest that it was beautiful or wonderful but he did not believe it. After a few alternating ideas of this kind, under the influence of which he would change and change and change things, he would find himself becoming wild in his feelings, enraged at his condition, intensely despondent and sorry for himself.

"Well," he would say, throwing down his brush, "I shall simply have to wait until I come out of this. I can't do anything this way." Then he would walk or read or row on the lakes or play solitaire, or listen to Angela playing on the piano which his father had installed for Myrtle after he left. All the time, though, he was thinking of his condition, what he was missing, how the gay world was surging on rapidly elsewhere, how long it would be before he got well, if ever. He talked of going to Chicago and trying his hand at scenes there but Angela persuaded him to rest for awhile longer. In June, she promised him they would go to Black Wood for the summer, coming back here in the fall if he wished or going on to New York or staying in Chicago—just as he felt about it. Now he needed rest.

"Eugene will probably be all right by then," Angela volunteered to his mother, "and he can make up his mind whether he wants to go to Chicago or London."

She was very proud of her ability to talk of where they would go and what they would do. The Witlas were astounded at Eugene's position—his ability to rove here and there at will. If he would only get well again.

At Black Wood it was no different from Alexandria, however; for both were quiet, withdrawn from the world, and to a man in his condition, lonely. If it had not been for his besetting sin—the hope of some fresh exciting experience with a woman—he would have been unconscionably lonely. As it was, this thought with him—quite as the confirmed drunkards thought of whiskey—buoyed him up, kept him from despairing utterly, gave his mind the only diversion it had from the ever present thought of failure. If by chance he should meet some truly beautiful girl, gay, enticing, who would fall in love with him! That would be happiness. Only, Angela was

constantly watching him these days, and besides, more girls would simply mean that his present complaint would be aggravated. He was where he was because of over-indulgence, and yet so powerful is the illusion of sex, the sheer animal magnetism of beauty, that when it came near him in the form of a beautiful girl of his own temperamental inclinations he could not resist it. One look into an inviting eye, one glance at a face whose outlines were soft and delicate—full of that subtle suggestion of youth and health which is so characteristic of girlhood—and the spell was cast. It was as though the very form of the face, without will or intention on the part of the possessor, acted hypnotically upon its beholder. The Arabians believed in the magic power of the word *Abracadabra* to cast a spell. For Eugene the form of a woman's face and body was quite as powerful.

At Alexandria while he and Angela were there, from February to May inclusive, he met one night at his sister's house a girl who, from the point of view of the beauty which he admired and to which he was so susceptible, was extremely hypnotic, and who for the ease and convenience of a flirtation was very favorably located. She was the daughter of a traveling man, George Roth by name, whose wife, the child's mother, was dead. Roth lived with his sister in an old tree-shaded house on the edge of Green Lake not far from the spot where Eugene had once attempted to hug his first love, Stella Appleton, on the ice. Frieda was the girl's name, and her father's sister's name was Anna. Frieda was extremely attractive, not more than eighteen years of age, with large, clear blue eyes, a wealth of yellowish brown hair, and a plump but shapely figure. She was a graduate of the local high school, well developed for her years, bright, rosy cheeked, vivacious, and with a great deal of natural intelligence which attracted the attention of Eugene at once. Normally he was extremely fond of a natural, cheerful, laughing disposition. In his present state he was abnormally so. This girl and her foster mother had heard of him for a long time through his parents and his sister, whom they knew well and whom they visited frequently. George Roth had moved here since Eugene had first left for Chicago, and because he was so much on the road, Eugene had not seen him since. Frieda, on all his previous visits, had been too young to take an interest in men but now at this age when she was just blossoming into womanhood, her mind was fixed on men. She did not expect to be interested in Eugene because she knew he was married but, because of his reputation as an artist, she was curious about him. Everybody knew who he was. The local paper had written up his success and published his picture. The fact that he had had an exhibit in New York, had gone to London and Paris, and was just concluding a second exhibit in the metropolis, was of course common knowledge. Frieda expected to see a man of about forty years, stern and sober. Instead she met a smiling youth

of twenty-nine, rather gaunt and hollow eyed, but nonetheless attractive for that. He had the piercing eyes of an ardent but gloomy Romeo, "sicklied o'er by the pale cast of thought." Hamlet's brooding melancholy was quite akin to that from which he was suffering. Eugene, with Angela's approval, still affected a loose, flowing tie, a soft turn-down collar, brown corduroy suits as a rule, the coat cut with a belt, shooting jacket fashion, a black iron ring of very curious design upon one of his fingers, and a soft hat. His hands were very thin and white, his flesh pale. Frieda, rosy, as thoughtless as a butterfly, charmingly clothed in a dress of blue colored linen, afraid of him because of his reputation, attracted his attention at once. She was like all the young, healthy, laughing girls he had ever known—delightful. He wished he were single again, that he might fall into a jesting conversation with her. She seemed inclined to be friendly from the first.

Angela being present however, and Frieda's foster mother, it was necessary for him to be circumspect and distant. The latter, Sylvia, and Angela talked of art and listened to Angela's descriptions of Eugene's eccentricities, idiosyncrasies, and experiences, which were a never-failing source of interest to the common run of mortals whom they met. Eugene sat by in a comfortable chair with a weary, genial, or indifferent look on his face, as his mood happened to be. Tonight he was bored and a little indifferent in his manner. No one here interested him save this girl, the beauty of whose face fed his secret affections. He longed to have some such spirit of youth near him always. Why could not women remain young? Why would any man, particularly an artist, be such a fool as to go and marry, thus closing the door upon any reasonable enjoyment of life? Here he was, tied down to Angela, not satisfied to live with her, not happy in her company, wishing that he were free, pretending that he didn't, lying to her, lying to himself at times, watched over by her as a prisoner might be watched over by a jailer—and here was Frieda who would be interested in and delighted with him if he were single. Certainly life was a ridiculous tangle. How easy it was to make a costly mistake.

While they were laughing and talking Eugene picked up a copy of Howard Pyle's *Knights of the Round Table*, with its exquisite illustrations of the Arthurian heroes and heroines, and began to study the stately and exaggerated characteristics of the various characters. Sylvia had purchased it for her seven year old boy Jack, who was in bed, but Frieda had read it in her girlhood a few years before. She had been moving restlessly about, conscious of an interest in Eugene but not knowing how to make an opportunity for conversation. His smile, which he sometimes directed toward her, was entrancing.

"Oh, I read that," she said, when she saw him looking at it. She had

drifted to a position not far behind his chair and near one of the windows. She pretended to be looking out at first but now began to talk to him. "I used to be crazy about every one of the knights and ladies—Sir Launcelot, Sir Galahad, Sir Tristam, Sir Gawaine, Queen Guinevere."

"Did you ever hear of Sir Bluff?" he asked teasingly, "or Sir Stuff? or Sir Dub?" He was using slang words which had come into use at that time, each representative of a certain shallowness and pointlessness of spirit in the possessor. He looked at her with a mocking light of humor in his eyes.

"Oh, there aren't such people," laughed Frieda, surprised at the titles but tickled at the thought of them.

"Don't you let him mock you, Frieda," put in Angela, who was pleased at the girl's gayety and glad that Eugene had found someone in whom he could take an interest. She did not fear the simple western type of girl like Frieda and her own sister, Marietta. They were franker, more kindly, better intentioned than the eastern studio type. Besides, they did not consider themselves superior. Angela was playing the role of the condescending leader here.

"Certainly there are," replied Eugene solemnly, addressing Frieda. "They are the new Knights of the Round Table. Haven't you ever heard of that book?"

"No, I haven't," answered Frieda gaily, "and there isn't any such. You're just teasing me."

"Teasing you? Why, I wouldn't think of such a thing. And there is such a book. It's published by Harper and Brothers and it's called 'The New Knights of the Round Table.' You simply haven't heard of it, that's all."

Frieda was impressed. She didn't know whether to believe him or not. She opened her eyes in a curiously inquiring, girlish way which appealed to Eugene strongly. He wished he were free and could kiss her pretty, red, thoughtlessly parted lips. Angela herself was faintly doubtful as to whether he was speaking of a real book or not.

"Sir Stuff is a very famous knight," he went on, "and so is Sir Bluff. They're inseparable companions in the book. As for Sir Dub and Sir Hack, and the Lady Dope——"

"Oh, hush, Eugene," called Angela gaily. "Just listen to what he's telling Frieda," she remarked to Miss Roth. "You mustn't mind him, though. He's always teasing someone. Why didn't you raise him better, Sylvia?" she asked of Eugene's sister.

"Oh, don't ask me. We never could do anything with Gene. I never knew he had much jesting in him until he came back this time."

"They're very wonderful," they heard him telling Frieda. "All very fine gentlemen and ladies."

Frieda was impressed by this charming, good-natured man. His spirit was evidently as youthful and gay as her own. She sat before him, looking into his smiling eyes while he teased her about this, that, and the other foible of youth. Who were her sweethearts? How did she make love? How many boys lined up to see her come out of church on Sunday? He knew. "I'll bet they look like a line of soldiers on dress parade," he volunteered, "all with nice new ties and clean pocket handkerchiefs and their shoes polished and——"

"Oh, ha! ha!" laughed Frieda. The idea appealed to her immensely. She started giggling and bantering with him and their friendship was definitely sealed. She thought he was delightful.

CHAPTER XLV

The opportunity for further meetings was natural enough in a way, for the Witla boat house, where the family kept one small boat, was at the foot of the Roth lawn, reached by a street or rather a slightly used lane which came down that side of the house; and also by a grape-arbor, which concealed the lake from the lower floor of the house and made a sheltered walk to the water side, at the end of which was a weather-beaten wooden bench. Eugene came here some days to get the boat to row or to fish. On several occasions in the past Angela had accompanied him, though she did not care much for rowing or fishing and was perfectly willing that he should go alone if he wanted to. There was also the friendship of Miss Roth for Mr. and Mrs. Witla, which occasionally brought her and Frieda to the house. There was also his studio in the barn, to which Frieda came from time to time to see him paint. Angela thought very little of Frieda's presence there, because of her youth and innocence, but it struck Eugene as extremely fortunate. He was interested in her charms, anxious to make love to her in a philandering sort of way, without intending to do her any harm. It struck him as a little curious that he should find her living so near the spot where once upon a winter's night he had made love to Stella. There was something not unlike Stella about her, though she was softer, more whole-souledly genial and pliable to his mood.

He saw her one day when he went for his boat, standing out in the yard, and she came down to the waterside to greet him.

"Well," he said, smiling at her fresh morning appearance and addressing her with that easy familiarity with which he knew how to take youth and life generally. "We're looking as bright as a butterfly. I don't suppose we butterflies have to work very hard, do we?"

"Oh, don't we," replied Frieda. "That's all you know."

"Well I don't know, that's true, but perhaps one of these butterflies will tell me. Now you, for instance."

Frieda smiled. She scarcely knew how to take him but she thought he was delightful. She hadn't the faintest conception as to the depth and subtlety of his nature—the genial, kindly inconstancy of it. She only saw him as a handsome, smiling man, not at all too old, witty, good-natured, famous, here by the bright green waters of this lake pulling out his boat. He looked so cheerful to her, so carefree. She had him indissolubly mixed in her impressions with the freshness of the ground, the newness of the grass, the brightness of the sky, the chirping of the birds, and even the little scintillating ripples on the water.

"Butterflies never work, that I know," he said, refusing to take her seriously. "They just dance around in the sunlight and have a good time. Did you ever talk to a butterfly about that?"

Frieda merely smiled at him. He pushed his boat into the water, holding it lightly by a rope, got down a pair of oars from a rack, and stepped into it. Then he stood there looking at her.

"Have you lived in Alexandria long?" he asked.

"About five years now."

"Do you like it?"

"Sometimes. Not always. I wish we lived in Chicago. Ooh!" she sniffed, turning up her pretty nose, "isn't that lovely." She was smelling some odour of flowers blown from a garden.

"Yes, I get it too. Geraniums, isn't it? They're blooming here, I see. A day like this sets me crazy." He sat down in the boat and put his oars in place.

"Well, I have to go and try my luck for whales. Wouldn't you like to go fishing?"

"I would, all right," said Frieda, "only Anna wouldn't let me, I think. I'd just love to go. It's lots of fun, catching fish."

"Yes, *catching fish*," laughed Eugene. "Well, I'll bring you a nice little shark—one that bites. Would you like that? Down in the Atlantic Ocean they have sharks that bite and bark. They come up out of the water at night and bark like dogs."

"Oooh, dear! how funny!" giggled Frieda, and Eugene began slowly rowing his boat lakeward.

"Be sure you bring me a nice fish," she called.

"Be sure you're here to get it when I come back," he answered.

He saw her with the lattice of spring leaves behind her, the old house showing pleasantly on its rise of ground, some house-martins turning in the morning sky.

"What a lovely girl," he thought. "She's beautiful. As fresh as a flower. That is the one great thing in the world—the beauty of girlhood."

He came back after a time, expecting to find her, but her foster mother had sent her on an errand. He felt a keen sense of disappointment.

There were other meetings after this, once another day when he came back practically fishless and she laughed at him, once when he saw her sunning her hair on the back porch after she had washed it and she came down to stand under the trees near the water, looking like a naiad. He wished then he could take her in his arms but he was a little uncertain of her and of himself. Once she came to his studio in the barn to bring him a piece of leftover dough which his mother had turned on the top of the stove.

"Eugene used to be crazy about that when he was a boy," she had remarked.

"Oh, let me take it to him," said Frieda gaily, gleeful over the idea of the adventure.

"That's a good idea," said Angela innocently. "Wait, I'll put it on this saucer."

Frieda took it and ran. She found Eugene staring oddly at his canvas, his face curiously dark. When her head came above the loft floor, his expression changed immediately. His guileless, kindly smile returned.

"Guess what," she said, pulling a little white apron she had over the dish.

"Strawberries?" (They were in season.)

"Oh, no."

"Peaches and cream?"

"Where would we get peaches now?"

"At the grocery store."

"I'll give you one more guess."

"Angel cake!" He was fond of that and Angela occasionally made it.

"Your guesses are all gone. You can't have any."

He reached out his hand but she drew back. He followed and she laughed. "No, no, you can't have any now."

He caught her soft arm and drew her close to him. "Sure I can't?"

Their faces were close together.

She looked into his eyes for a moment, then dropped her lashes. Eugene's brain swirled with the sense of her beauty. It was hypnotism once more—the result of the old talisman. He covered her sweet lips with his own and she yielded feverishly.

"There now, eat your dough," she exclaimed when he let her go, pushing it shamefacedly toward him. She was flustered—so much so that she failed to jest about it. "What would Mrs. Witla think," she added, "if she could see us?"

Eugene paused solemnly and listened. He was afraid of Angela.

"I've always liked this stuff, ever since I was a boy," he said in an offhand way.

"So your mother said," replied Frieda, somewhat recovered. "Let me see what you're painting."

She came around to his side, and he took her hand.

"I'll have to go now," she said wisely. "They'll be expecting me back."

Eugene speculated on the intelligence of girls—at least on that of those he liked. Somehow they were all wise under these circumstances—cautious. He could see that, instinctively, Frieda was prepared to protect him and herself. She did not appear to be suffering from any shock from this revelation. Rather, she was inclined to make the best of it.

He folded her in his arms again.

"You're the angel cake and the strawberries and the peaches and cream," he said.

"Don't," she pleaded. "Don't. I have to go now."

And when he released her she ran quickly down the stairs, giving him a swift, parting smile.

So Frieda was added to the list of his conquests and he pondered over it gravely. If Angela could have seen this scene, what a storm there would have been. If she ever became conscious of what was going on, what a period of wrath there would be. It would be terrible. After her recent discovery of his letters he hated to think of that. Still, this bliss of caressing youth—was it not worth any price? To have a bright, joyous girl of eighteen put her arms about you—could you risk too much for it? The world said one life, one love. Could he accede to that? Could any one woman satisfy him? Could Frieda, if he had her? He did not know. He did not care to think about it. Only this walking in a garden of flowers—how delicious it was. This having a rose to your lips.

Angela saw nothing of this attraction for some time. She was not prepared yet to believe, poor little depender on the conventions as she understood them, that the world was full of plots and counter-plots, snares, pitfalls, and gins. The way of the faithful and well meaning woman in marriage should be simple. She should not be harassed by uncertainty of affection, infelicities of temper, indifference, or infidelity. If she worked hard, as Angela was trying to do—trying to be a good wife, saving, serving, making a sacrifice of her time and services and moods and wishes for her husband's sake—why shouldn't he do the same for her? She knew of no double standard of virtue. If she had, she wouldn't have believed in it. Her parents had raised her to see marriage in a different light. Her father was faithful to her mother. Eugene's father was faithful to his wife—that was perfectly plain. Her broth-

ers-in-law were faithful to her sisters, Eugene's brothers-in-law were faithful to his sisters. Why should not Eugene be to her?

So far, of course, she had no evidence to the contrary. He probably was faithful and would remain so. He had said so, but this pre-matrimonial philandering of his looked very curious. It was an astonishing thing that he could have deceived her so. She would never forget it. If he hadn't been such an ardent, beautiful lover, she would scarcely have known what to think now. But he had courted her so magnificently. It was a classic, their courtship, and she knew it. He was a genius to be sure. The world was waiting to hear what he had to say. She knew that she would have to make some allowance for a man with so much talent, but how much? Ah, there was the question! Share Eugene with any other woman? Never!! Allow him to dilly-dally and shilly-shally his time with studio superiorities? Why should he want to? His art was more important than this silly talking with women. Besides, all they wanted to do was to shine in the rays of his glory—to say that they knew him and talk familiarly about him. He oughtn't to want anything like that. He oughtn't to want to belittle himself, fritter away his time, listen to such silly chaff. He was a great man and should associate with great men, or failing that, should not want to associate with anyone at all. It was ridiculous for him to be running around after silly women. She thought of this and decided to do her best to prevent it. The seat of the mighty was, in her estimation, the place for Eugene—with her in the foreground as a faithful and conspicuous acolyte, swinging the censer of praise and delight.

The days went on and various little meetings—some accidental, some premeditated—took place between Eugene and Frieda. There was one afternoon when he was at his sister's and she came there to get a pattern for her foster-mother from Sylvia. She lingered for over an hour, during which time Eugene had opportunities to kiss her a dozen times. The beauty of her eyes and her smile haunted him after she was gone. There was another time when he saw her at dusk near his boat house and kissed her in the shadow of the sheltering grape-arbor. In his own home there were clandestine moments and in his studio (the barn loft), for Frieda made occasion a few times to come to him—a promise he made to make a sketch of her being the excuse. Angela resented this but she could not prevent it. In the main, Frieda exhibited that curious patience in love which women so customarily exhibit and which a man can never understand. She could wait for her own to come to her—for him to find her—while he, with that curious avidness of the male sex in love, burned as a fed fire to see her. He was jealous of the little innocent walks she took with boys she knew. The fact that it was necessary for her to be away from him was a great deprivation. The fact that he was

married to Angela was a horrible disaster. He would look at her when she was with him, preventing him from his freedom in love, with almost calculated hate in his eyes Why had he married her? As for Frieda, when she was near and he could not draw near her his eyes followed her movements with a yearning, devouring glance. He was fairly beside him with anguish under the spell of her beauty. Frieda had no notion of the consuming flame she had engendered.

It was a simple thing to walk home with her from the post office—quite accidentally on several occasions. It was a fortuitous thing that Anna Roth should invite Angela and himself, as well as his father and mother, to her house to dinner. On one occasion when Frieda was visiting at the Witla homestead, Angela thought Frieda stepped away from Eugene in a curiously disturbed manner when she came into the parlor. She was not sure. Frieda hung around him in a good-natured way most of the time when various members of the family were present. She wondered if by any chance he was making love to her but she could not prove it. She tried to watch them from then on but Eugene was so subtle, Frieda so circumspect, that she never did obtain any direct testimony. Nevertheless, before they left Alexandria there was a weeping scene over this, hysterical, tempestuous, in which she accused him of making love to Frieda, but he denied it stoutly.

"If it wasn't for your relatives' sake," she declared, "I would accuse her to her face, here before your eyes. She wouldn't dare deny it."

"Oh, you're crazy," said Eugene. "You're the most suspicious woman I ever knew. Good Lord, can't I look at a woman anymore? This little girl! Can't I even be nice to her?"

"Nice to her? Nice to her? I know how you're nice to her. I can see! I can feel! Oh, God! Why can't you give me a faithful husband!"

"Oh, cut it out!" demanded Eugene defiantly. "You give me pain. You're always watching. I can't turn around but you have your eye on me. I can tell. Well, you go ahead and watch. That's all the good it will do you. I'll give you some real reason for watching one of these days. You make me tired!"

"Oh, hear how he talks to me," moaned Angela, "and we only one year married. Oh, Eugene how can you? Have you no pity, no shame? Here in your own home, too! Oh! oh! oh!"

To Eugene such hysterics were maddening. He could not understand how anyone should want or find it possible to carry on in this fashion. He was lying out of the whole cloth about Frieda, but Angela didn't know and he knew she didn't know. All these tantrums were based on suspicion. If she would do this on a mere suspicion, what would she not do when she had a proved cause?

Still, by her tears as yet she had the power of rousing his sympathies and

awakening his sense of shame. Her sorrow made him slightly ashamed of his conduct, or rather sorry for the tangles nature was constantly presenting. Her suspicions made the further pursuit of this love quest practically impossible. Secretly, he already cursed the day he had married Angela, for Frieda's face was ever before him, a haunting lure to love and desire. In this hour life looked terribly sad to him. He could not help feeling that all the perfect things one might seek or find were doomed to the searing breath of an inimical fate. Ashes of roses—that was all life had to offer. Dead sea fruit, turning to ashes upon the lips. Oh, Frieda! Frieda! Oh, youth, youth! That these should dance before him, forevermore an unattainable desire—the holy grail of beauty. Oh life, oh death! Which was really better, waking or sleeping? If he could only have Frieda now it would be worth living but without her—it was plain hell.

CHAPTER XLVI

The weakness of Eugene was that in each of these new conquests, he was prone for the time being to see the sum and substance of bliss, to rise rapidly in the scale of uncontrollable and exaggerated affection, until he felt that here and nowhere else, now and in this particular form, was ideal happiness. He had been in love with Stella, with Margaret, with Ruby, with Angela, with Christina, and now with Frieda, quite in this way, and it had taught him nothing as yet concerning love except that it was utterly delightful. He wondered at times how it was that the formation of a particular face could work this spell. There was plain magic in the curl of a lock of hair, the whiteness or roundness of a forehead, the shapeliness of a nose or ear, the arched redness of full-blown petal lips. In combination with these, the cheek, the chin, the eye—how did they work this witchery? The tragedies to which he laid himself open by yielding to these spells—he never stopped to think of them.

It is a question whether the human will, of itself alone, ever has or ever can cure any human weakness. Tendencies are subtle things. They are involved in the chemistry of one's being, and those who delve in the mysteries of biology frequently find that curious anomaly, a form of minute animal life born to be the prey of another form of animal life—chemically and physically attracted to its own disaster. Thus to quote Gary Calkins, "some protozoa are apparently limited to special kinds of food. The 'slipper-animal' (Paramecium) and the 'bell-animal' (Vorticella) live on certain kinds of bacteria, and many others, which live upon smaller protozoa, seem

to have a marked affinity for certain kinds. I have watched one of these creatures (Actinobolus) lie perfectly quiet while hundreds of bacteria and smaller kinds of protozoa bumped against it, until a certain variety (Halteria grandinella) came near, when a minute dart, or 'trochocyst,' attached to a relatively long thread, was launched. The victim was invariably hit, and after a short struggle was drawn in and devoured. The results of many experiments indicate that the apparently *wilful* selection in these cases is the inevitable action of definite chemical and physical laws which the individual organism can no more change than it can change the course of gravitation. The killing dart mentioned above is called out by the particular kind of prey with the irresistible attraction of an iron filing for a magnet."

Eugene did not know of these curious biologic experiments at this time but he suspected that these attractions were deeper than human will. He thought at times that he ought to resist his impulses. At other times he asked himself why. If he lost his treasure by resistance, what had he? A sense of personal purity? It did not appeal to him. The respect of his fellow citizens? He believed that most of his fellow citizens were whited sepulchres. What good did their hypocritical respect do him? Justice to others? Others were not concerned, or should not be, in the natural affinity which might manifest itself between two people. That was for them to settle. Besides, there was very little justice in the world. As for his wife—well, he had given her his word but he had not done so willingly. Might one swear eternal fealty and abide by it when the very essence of nature was lack of fealty, inconsiderateness, destruction, change? A gloomy Hamlet to be sure, asking "can honor set a leg?" A subtle Machiavelli, believing that might made right, sure that it was a matter of careful planning, not ethics, which brought success in this world, and yet one of the poorest planners in it. An anarchistic manifestation of selfishness surely; but his additional plea was that he did not make his own mind, nor his emotions, nor anything else. And, worst of all, he counseled himself that he was not seizing anything ruthlessly. He was merely accepting that which was thrust temptingly before him by fate.

Hypnotic spells of this character, like contagions and fevers, have their period of duration, their beginning, climax, and end. It is written that love is deathless but this was not written of mortal mind, nor does it concern the fevers of sex desire. The marriage of true minds to which Shakespeare would admit no impediment is of a different texture and has little sex in it. The friendship of Damon and Pythias was a marriage in the best sense, though it concerned two men. The possibilities of intellectual union between a man and a woman are quite the same. This is deathless in so far as it reflects the spiritual ideals of the universe—not more so. All else is illusion of short duration and vanishes in thin air.

When the time came for Eugene to leave Alexandria as he had originally wanted to do he was not at all anxious to depart: rather it was an occasion of great suffering for him. He could not see any solution to the problem which confronted him in connection with Frieda's love for him. As a matter of fact when he thought about it at all, he was quite sure that she did not understand or appreciate the responsibilities engendered by her affection for him and his for her. It had no basis in responsibility. It was one of those things born of thin air—sunlight, bright waters, the reflections of a bright room—things which are intangible and insubstantial. Eugene was not one who, if he thought anything at all about it, would persuade a girl to immorality for the mere sake of sex sensation. His feelings were invariably compounded of finer things: love of companionship, love of beauty, a variable sense of the consequences which must ensue not so much to him as to her, though he took himself into consideration. If she were not already experienced and he had no method of protecting her; if he could not take her as his wife or give her the advantages of his presence and financial support secretly or openly; if he could not keep all their transactions a secret from the world, he was inclined to hesitate. He did not want to do anything rash—as much for her sake as for his. In this case the fact that he could not marry Frieda, that he could not reasonably run away with her, seeing that he was mentally sick and of uncertain financial condition, and the fact that he was surrounded by home conditions which made it of the greatest importance that he should conduct himself circumspectly, weighed greatly with him. Nevertheless tragedy could easily have eventuated here. If Frieda had been of a headstrong, unthinking nature; if Angela had been less watchful, morbid, appealing in her mood; if the family and town conditions had been less weighty; if Eugene had had health and ample means, he would probably have deserted Angela, taken Frieda to some European city—he dreamed of Paris in this connection—and found himself confronted later by an angry father, or a growing realization that Frieda's personal charms were not the sum and substance of his existence, or both. George Roth, for all he was a traveling salesman, was a man of considerable determination. He might readily have ended the life of his daughter's betrayer—art reputation or no. He worshipped Frieda as the living image of his dead wife and at best he would have been heartbroken.

As it was, there was not much chance of this, for Eugene was not rash. He was too philosophic. Conditions might have arisen in which he would have shown the most foolhardy bravado but not in his present state. There was not sufficient anguish in his own existence to drive him to action. He saw no clear way. So, in June, with Angela he took his departure for Black Wood, pretending to her outward indifference as to his departure, but

inwardly feeling as though his whole life were coming to nothing. Frieda was intensely sorry also. She had noted in her wise young way the subtle change in Angela's attitude. Frieda was no coward. If circumstances had been different and she had been persuaded by Eugene she would have defied Angela openly. She did not stop to think of Angela's rights in the matter, or if she did they did not trouble her much. She was too young, too inexperienced. Besides, she was fascinated by Eugene. In that argument Angela would have been beaten, for Frieda was the stronger fighting personality. Eugene had the power of attracting to him as a rule a peculiarly forceful, self-reliant type of woman.

When he reached Black Wood he was now, naturally, disgusted with the whole atmosphere of it. Frieda was not there. Alexandria, from having been the most wearisome side-pool of aimless inactivity, had suddenly taken on all the characteristics of paradise. The little lakes, the quiet streets, the court house square, his sister's home, Frieda's home, his own home, had been once more invested for him with the radiance of romance—that intangible glory of feeling which can have no existence outside the illusion of love. Frieda's face was everywhere in it, her form, the look of her eyes. He could see nothing there now save the glory of Frieda. It was as though the hard, weary face of a barren landscape were suddenly bathed in the soft effulgence of a midnight moon.

As for Black Wood, it was as lovely as ever but he could not see it. The fact that his attitude had changed toward Angela for the time being made all the difference. He did not really hate her—he told himself that. She was not any different from what she had been, that was perfectly plain. The difference was in him and the presence of Frieda, but it was here. What was he to do about it? He really could not be madly in love with two people at once. He had entertained joint affections for Angela and Ruby, and Angela and Christina, but those were not the dominating fevers which this seemed to be. He could not for the time get the face of this girl out of his mind. He was sorry for Angela at moments. At other times, because of her insistence on his presence with her, on her being in his company, "following him around" as he put it, he hated her. Dear heaven, if he could only be free without injuring her. If he could only get loose. Think, right now he might be with Frieda, walking in the sun somewhere, rowing on the lake at Alexandria, holding her in his arms. He would never forget how she looked the first morning she came into his barn studio at home—how cute and enticing she was the first night he saw her at Sylvia's. Damn! Hell! What a rotten mess living was, anyhow. And so he sat about in the hammock at the Blue homestead, or swung in a swing that old Jotham had since put up for Marietta's beaus, or dreamed in a chair in the shade of the house, reading. He was dreary and lonely with just one ambition in the world—Frieda.

Meanwhile, as might be expected, his health was not getting any better. Instead of curbing himself in those purely material displays of passion which characterized his life with Angela, the latter went on, unbroken. One would have thought that his passion for Frieda would have interrupted this, but the presence of Angela, the comparatively enforced contact, her insistence on affectional attention, broke down again and again the protecting barrier of refinement. Had he been alone he would have led a chaste life until some new and available infatuation seized him. As it was, there was no refuge either from himself or Angela, and the to him at times almost nauseating relationship went on and on.

The Blue family, or those members of it who were now in the home or near it, were delighted to see him. The fact that he had achieved such a great success with his first exhibition, as the papers had reported, and had not lost ground with the second—a very interesting letter had come from M. Charles saying that the Paris pictures would be shown in Paris in July—gave them a great estimate of him. Angela was a veritable queen in this home atmosphere and, as for Eugene, he was given the privilege of all geniuses to do as he pleased. He roamed about here and there, watched with curiosity by Mrs. Blue and Jotham who thought Eugene was an interesting figure; by Mrs. Stockwell, Angela's sister Ellen, who came over from Black Wood to stay a week; and later in July and August by Elizabeth (Mrs. John Kip of Wankesha) and Grace (Mrs. Alexander Hoover of Koosa), Angela's second and third oldest sisters, who were interested to look at Eugene, now that he was so famous. The natives knew nothing of his fame, of course, for this was mere family excitement, but it was nonetheless real to the latter. Henry Stockwell, John Kip, and Alexander Hoover, the three brothers-in-law outside of Eugene, together with Benjamin, the second oldest son, who had recently married a Miss Florence Koler of Racine, gathered at the request of their wives to share a grand Fourth of July dinner which Marietta had suggested. On this occasion Eugene was the centre of interest though he appeared not to be, for these four solid western brothers-in-law gave no indication that they thought he was unusual. He was not their type—banker, lawyer, grain merchant and real estate dealer as they were—but they felt proud of him just the same. He was different, and at the same time natural, genial, modest, inclined to appear far more interested in their affairs than he really was. He would listen by the hour to any of the details of their affairs, political, financial, agricultural, social. The world was a curious compost to Eugene and he was always anxious to find out how other people lived. He loved a good story and while he rarely told one he made a splendid audience for those who did. His eyes would sparkle and his whole face light with the joy of the humor he felt.

Through all this, though—the attention he was receiving, the welcome

he was made to feel, the fact that his art interests were not yet dead (the Paris exhibit being the expiring breath of his original burst of force)—he was feeling the downward trend of his affairs most keenly. His mind was not right. That was surely true. His money affairs were getting worse, not better, for while he could hope for a few sales yet (the Paris pictures sold not any in New York), he was not certain that this would be the case. This homeward trip had cost him two hundred of his seventeen hundred dollars and there would be additional expenses if he went to Chicago, as he planned in the fall. He could not live a single year on fifteen hundred dollars—scarcely more than six months—and he could not paint or illustrate anything new in his present state. Additional sales of the pictures of the two original exhibits must materialize in a reasonable length of time or he would find himself in hard straits.

Meanwhile Angela, who had obtained such a high estimate of his future by her experiences in New York and Paris, was beginning to enjoy herself again; for after all, in her judgement, she seemed to be able to manage Eugene very well. He might have had some slight understanding with Frieda Roth—it couldn't have been much or she would have seen it, she thought—and she had managed to break it up. Eugene was cross, naturally, but that was due more to her quarreling than anything else. These storms of feeling on her part, not always premeditated, seemed essential. Eugene must be made to understand that he was married now; that he could not look upon or run after girls as he had in the old days. She was well aware that he was considerably younger than she was in temperament, inclined to be exceedingly boyish, and this was apt to cause trouble anywhere. But if she watched over him, kept his attention fixed on her, everything would come out all right. And then here were all these other delightful qualities—his looks, his genial manner, his reputation, his talent. Dear, dear, what a delightful thing it had become to announce herself as Mrs. Eugene Witla, and how those who knew about him sat up. Big people were his friends, artists admired him, common, homely, everyday people thought he was nice and considerate and able and very much worthwhile. He was generally liked everywhere. What more could one want? If she could only get him restored to health now, quickly, by proper food and regular hours, everything would be fine.

It is curious, the character of the feminine mind, which at this time could thus reason in regard to the husband or children or both, in some instances, as property. Some women could see the fame, the labor, the mental capacity of the husband—the former historic lord and master—as chattels which appertained to the sacred institution of matrimony. Although Angela loved and admired Eugene and was willing to serve him, to do all

that was beholden of her either in love or duty, nevertheless she viewed him in this light. This was not the condition of every feminine mentality of that day and those who so reasoned were decreasing in number, but it certainly was a phase of the sociological thought of the time. The statement that "a husband is property to a wife and family and to win him away is nothing short of stealing" was a matter of court record in the state of New Jersey. It would have offended the average woman to have had this theory openly insisted upon as being the conscious thought of the time, but it was nevertheless true.

Angela shared it in common with others. Suits for non-support, alienation of affection, abandonment, and alimony were the commonest items of newspaper news, and the average woman read them in her boudoir or at the breakfast table or after the children were in bed with sentiments bordering upon hearty approval. The theory of duty in marriage was stringent and non-relaxing; and though it controverted the vaguely recalled serfdom imposed by man upon his domestic partner in earlier centuries, it was held to be nothing more than fair or right. He should provide well, whether the wife did little or much; he should demean himself as one who had no interest outside of the performance of these very important duties of making his family happy. The race spirit had established this condition clearly and Angela shared it to the letter. There is no contention here as to the ethics of this proposition pro or con. Its importance to this story is from another viewpoint entirely.

Angela was comfortable in this theory, and the fact that public opinion generally sustained her viewpoint made Eugene uncomfortable. Think as he might, the attitude in Angela, slowly developing with signs and portents, troubled him not a little. He felt as he had some time before, only more so: that he had put his head in a trap and that the spring had sprung. He was caught, and caught fast. How to get out was not so much a question with him at this time as how to make himself comfortable in it, for true to his cautious, philosophic nature he was inclined to consider the situation unsolvable. But he was already twisting and turning, worrying over his fate, worrying over his loss of freedom, studio privileges, Frieda, and whatnot. Without his art to employ him successfully, he was doubly restless.

For four years following this first year, this condition continued. Angela knew nothing of his real thoughts, for because of sympathy, a secret sense of injustice toward her on his part, a vigorous, morbid impression of the injustice of life as a whole, a desire to do things in a kindly or at least a secret and not brutal way, he was led to pretend at all times that he really cared for her; to pose as being comfortable and happy; to lay all his moods to his inability to work. Angela, who could not read him clearly, saw nothing of

this. He was too subtle for her understanding at times. She was living in a fool's paradise; playing over a sleeping volcano.

He grew no better, and by fall began to get the notion that he could do better by living in Chicago. His health would come back to him there, perhaps. He was terribly tired of Black Wood. The long, tree-shaded lawn was nothing to him now. The little lake, the stream, the fields that he had rejoiced in at first, were considerable of a commonplace. Old Jotham was a perpetual source of delight to him with his kindly, stable, enduring attitude toward things and his interesting comments on life; and Marietta entertained him with her wit, her good nature, her intuitive understanding; but he could not be happy just talking to everyday, normal, stable people, interesting and worthwhile as they might be. The doing of simple things, living a simple life, was just now becoming irritating. He wanted a wider outlook mentally in those he was associated with, a greater sense of drama, more of the noisy, swashbuckling air of proprietorship which characterized those who tried to do anything in the world. He thought of Chicago now with its noise, its traffic, its smoke, its tall buildings, as essential. He must get back into the swim of things and work. He must go to London, Paris—do things. He couldn't loaf this way. It mattered little that he could not work. He must try. This isolation was terrible.

There followed six months spent in Chicago in which he painted not one picture that was satisfactory to him, that was not messed into nothingness by changes and changes and changes. There were then three months in the mountains of Tennessee, because someone told him of a wonderfully curative spring in a delightful valley where the spring came as a dream of color and the living was next to nothing in so far as expense was concerned. There were four months of summer in southern Kentucky, on a ridge near a small town called Harkersberg, where the air was cool, and after that five months on the Gulf of Mexico, at Biloxi in Mississippi, because some comfortable people in Kentucky and Tennessee told Angela of this delightful winter resort further South. All this time Eugene's money, the fifteen hundred dollars he had when he left Black Wood—several sums of two hundred, one hundred and fifty, and two hundred and fifty, realized from pictures sold in New York and Paris during the fall and winter following his Paris exhibit, and two hundred which had come some months afterward from a fortuitous sale by M. Charles of one of his old New York views—had been largely dissipated. He still had five hundred dollars, but with no pictures being sold and none painted he was in a bad way financially insofar as the future was concerned. He could possibly return to Alexandria with Angela and live cheaply there for another six months, he figured, but because of the Frieda incident both he and she objected to it. Angela was afraid of Frieda and

was resolved that she would not go there so long as Frieda was in the town, and Eugene was ashamed because of the light a return would throw on his fading art prospects. Black Wood was out of the question to him. They had lived on her parents long enough. If he did not get better he must give up this art idea soon entirely, for he could not live on trying to paint.

He began to think that he was possessed—obsessed of a devil—and that some people were pursued by evil spirits, fated by stars, doomed from their birth to failure or accident. How did the astrologer in New York know that he was to have four years of bad luck? He had seen three of them already. Why did a man who read his palm in Chicago once say that his hand showed two periods of disaster, just as the New York astrologer had, and that he was apt to alter the course of his life radically in the middle portion of it? Were there any fixed laws of being? Did any of the so-called natural-istic school of philosophers and scientists about whom he had read know anything at all? They were always talking about the fixed laws of the uni-verse—the unalterable laws of chemistry and physics. Why didn't chemistry or physics throw some light for him on his peculiar physical condition, on the truthful prediction of the astrologer, on the signs and portents which he had come to observe for himself as foretelling trouble or good fortune for himself? If his left eye twitched, he had observed of late, he was going to have a quarrel with some one—invariably Angela. If he found a penny or any money he was going to get money, for every notification of a sale of a picture with the accompanying check had been preceded by the dis-covery of a coin somewhere: once a penny in State Street in Chicago on a rainy day—M. Charles wrote him that a Paris picture had been sold in Paris for two hundred; once a three cent piece of the old American issue in the dust of a road in Tennessee—M. Charles wrote him that one of his old American views had brought one hundred and fifty; once a penny in sands by the Gulf in Biloxi—another notification of a sale. So it went. He found that when doors squeaked, people were apt to get sick in the houses where they were, and a black dog howling in front of a house was a sure sign of death. He had seen this with his own eyes (this sign which his mother once told him of as having been verified in her experience) in connection with the case of a man who was sick in Biloxi. He was sick and a dog—a black dog—came running along the street and stopped in front of the man's house, and the man died. Eugene saw this with his own eyes—that is, the dog and the sick man's death notice. The dog howled at four o'clock in the afternoon and the next morning the man was dead. Eugene saw the crape on the door. Angela mocked at his superstition, but he was convinced. "There are more things in heaven and earth, Horatio, than are dreamt of in your philosophy."

CHAPTER XLVII

It is useless to follow all the vagaries and emotions of a temporarily embarrassed, morbid, and emotional disposition except to point out that finally, for the want of money, for the want of his ability to continue his art work, Eugene reached the place where he had no more funds and was compelled to think by what process he would continue to make a living in the future. Worry and a hypochondriacal despair had reduced his body to a comparatively gaunt condition. His eyes had a nervous, apprehensive look. He would walk about, speculating upon the mysteries of nature, wondering how he was to get out of this, what was to become of him, how soon, if ever, another picture would be sold, when? Angela, from having fancied that his illness was a mere temporary indisposition, had come to feel that he might be seriously affected for some time. He was not sick physically: he could walk and eat and talk vigorously enough, but he could not work and he was worrying, worrying, worrying.

At Black Wood he had tried working in the fields with old Jotham and his hired man, following the plow, helping mow, helping thrash, helping dig potatoes, doing anything and everything to divert his mind, but it was not work to Eugene. At that time he did not consider it important. His money was not gone yet. His art was a thing which had been apparently only temporarily eclipsed.

He was not taken seriously by those he worked with. Angela would bring a book and sit out under the trees or in a corner of the fence and watch him as he came by, binding sheaves, digging out potatoes, driving a hay-tedder, but it was all a kind of joke to her—Eugene farming! In a blue gingham shirt, old trousers and a wide-brim straw hat! Dear, dear. He looked so funny—like a stage farmer.

"How is my farmer boy?" she would call to him lovingly, when he came near. "Getting tired, honeybun?"

"Don't you want me to bring you a glass of water?"

"Wouldn't you like me to go up to the house and get you a nice glass of cold milk?"

"Hadn't you better stop and rest awhile now, sweet? You look so tired."

It was to an accompaniment of such inquiries—petting, caressing offers of service, and admiring remarks as to his courage, diligence, and ability to work—that his farming was done. Eugene strolled about, realizing that he was not getting much benefit from it. The beauty of the wind shaking the stalks of wheat in the great fields, the rustle of the trees as they stirred with every passing zephyr, the call of birds, the humming of bees, old Jotham

geehawing in some distant part of the near landscape—these were the things that were holding his mind—these and his own future and present troubles. But of course they did not help him to recover. The farming was not real to him and it made very little impression other than that which might work itself out in pictures at some time. He did not sleep any better, did not really feel any better mentally.

When they went to Chicago after leaving Black Wood in the fall and he tried to take up his art again, Angela had another long siege of watching, wondering, worrying on his account and her own. Being so infatuated with him, she was tremendously solicitous. There was no mood of his, morning, noon, or night, which she did not respect, and in the best way she could, seek to humor or relieve according to her understanding of what would be to his advantage. Did he want to walk—she would walk with him if he would let her; did he want to ride on a car—that suited her; was his mood for staying in the studio all day and working—she sat by a window silently sewing, waiting for him to ask for something, suggest something that she might do. Here as in New York and Paris she marketed and cooked in a careful, painstaking way, saving as much as she could, making every dollar go as far as possible. She was quite as well aware as Eugene that their finances were in a bad way or threatening to become so, though he said nothing at all about them. He was ashamed to confess at this day, after their very auspicious beginning in New York, that he was in fear of not doing well. How silly—he with all his ability. Surely he would get over this, and soon.

Angela's economical upbringing and naturally saving instinct stood her in good stead now, for she could market with the greatest care, purchase to the best advantage, make every scrap and penny count. She knew how to make her own clothes, as Eugene had found out when he first visited Black Wood, and was good at designing hats. Although she had thought in New York when Eugene first began to make money that now she would indulge in tailor-made garments and the art of an excellent dressmaker, she had never done so. With true frugality she had decided to wait a little while, and then Eugene's health having failed she had not the chance anymore. Fearing the possible long duration of this storm she had begun to mend and clean and press and make over whatever seemed to require it. Even when Eugene suggested that she get something new she would not do it. Her consideration for their future, the difficulty he might have in making a living, deterred her.

Eugene noted this, though he said nothing. He was not unaware of the fear that she felt, the patience she exhibited, the sacrifice she made of her own whims and desires to his, and he was not entirely unappreciative. It was becoming very apparent to him that she had no life outside of his own—no

interests. She was his shadow, his alter ego, his servant, his anything he wanted her to be. "Little Pigtail" was one of his jesting pet names for her because in the West as a boy they had always called anyone who ran errands for others a pigtailer. In playing "one old cat," if one wanted another to chase the struck balls he would say, "you pigtail for me, Willie, will you?" And Angela was his "little pigtail." She looked young at times—very young and cute in her close fitting little house-dresses. He remembered being flattered in his selection of her as his wife by an artist whose acquaintance he made in Chicago, and who called one morning only to find Eugene out, because the artist said to him when he met him again: "That's a charming little wife you have, Witla. I called and she wouldn't open the door entirely—just peeped out, but she looked like a Japanese doll to me—just as quaint. She has such a big mop of red hair."

"Angela is cunning," replied Eugene generously. "She's quite a little model in her way. And she's just as good as she looks."

Other people praised her for her looks, her faithfulness to him, the manner in which she sang his praises, the way she kept his studio for him—in fact everything about her. Eugene appreciated this as being true though he did not see that anything was to be done or said about it. She liked to wait on him. She liked to *pigtail* for him. Her interest was in what he was—not in anything she was herself or might be. Why worry? She wanted to be with him. She was having her wish. The only trouble was that *he* did not want to be with *her*. It might be true that now he had married her he ought to want to, but he did not believe that he could make himself want anything—was sure of it. Otherwise (and eliminating her insistence on his right conduct in so far as love for her was concerned) there was no cause for criticism.

There were no further grounds for jealousy during the months (almost two years) in which they were wandering around together, for the reason that she was always with him, almost his sole companion, and that they did not stay long enough in any one place and under sufficiently free social conditions to permit him to form those intimacies which might have resulted disastrously. Some girls did take his eye—the exceptional in youth and physical perfection were always doing that—but he had no chance, or very little, of meeting them socially. They were not living with people they knew, were not introduced in the local social worlds which they visited. Eugene could only look at these maidens whom he chanced to spy from time to time and wish that he might know them better. It was hard to be tied down to a conventional acceptance of matrimony—to pretend that he was interested in beauty only in a sociological way. He had to do it before Angela, though (and all conventional people for that matter), for she objected strenuously to the least interest he might manifest in any particular woman. All his

remarks had to be general and guarded in their character. At the least show of feeling or admiration Angela would begin to criticize his choice and to show wherein his admiration was ill-founded. If he were especially interested she would attempt to tear his latest ideal to pieces. She had no mercy and he could see plainly enough on what her criticism was based. It made him smile but he said nothing. He even admired her for her heroic efforts to hold her own, though every victory she seemed to win seemed only to strengthen the bars of his own cage.

It was during this time that he could not help learning and appreciating just how eager, patient, and genuine was her regard for his material and artistic welfare. To her he was obviously the greatest man in the world, a great painter, a great thinker, a great lover, a great personality in every way. It didn't make so much difference to her at this time that he wasn't making any money. He would sometime, surely, and wasn't she getting it all in fame anyhow, now? Why, to be Mrs. Eugene Witla after what she had seen of him in New York and Paris, what more could she want? Wasn't it all right for her to rake and scrape now, to make her own clothes and hats, save, mend, press, and patch? He would come out of all this silly feeling about other women once he became a little older and then he would be all right. Anyhow he appeared to love her now, and that was something. Because he was lonely, fearsome, uncertain of himself, uncertain of the future, he welcomed these unsparing attentions on her part, and this deceived her. Who else would give them to him, he thought; who else would be so faithful in times like these? He almost came to believe that he could love her again, be faithful to her, if he could keep out of the range of these other enticing personalities. If only he could stamp out this eager desire for other women, their praise and their beauty!

But this was more because he was sick and lonely than anything else. If he had been restored to health then and there, if prosperity had descended on him as he so eagerly dreamed, it would have been the same. He was as subtle as nature itself; as changeable as a chameleon. But two things were significant and real—two things to which he was as true and unvarying as the needle to the pole—his love of the beauty of life which was coupled with his desire to express it in color, and his love of beauty in the form of the face of a woman, or rather that of a girl at eighteen. That blossoming of life in womanhood at eighteen—there was no other thing under the sun like it to him. It was like the budding of the trees in spring; the blossoming of flowers in the early morning; the odour of roses and dews, the color of bright waters and clear jewels. He could not be faithless to that. He could not get away from it. It haunted him like a joyous vision, and the fact that the charms of Stella and Ruby and Angela and Christina and

Frieda, in whom it had been partially or wholly shadowed forth at one time or another, had come and gone made little difference. It remained clear and demanding. He could not escape it—the thought—he could not deny it. He was haunted by this, day after day and hour after hour. And when he said to himself that he was a fool, and that it would lure him as a will-o'-the-wisp to his destruction, and that he could find no profit in it ultimately, still it would not down. The beauty of youth; the beauty of eighteen. To him life without it was a joke, a shabby scramble, a workhorse job, with only silly material details like furniture and houses and steel cars and stores all involved—in a struggle for what? To make a habitation for mere shabby humanity? Never. To make a habitation for beauty? Certainly! What beauty? The beauty of old age?—how silly. The beauty of middle age? Nonsense! The beauty of maturity? No! The beauty of youth? Yes. The beauty of eighteen. Certainly! No more and no less. That was the standard, and the history of the world proved it. Art, literature, romance, history, poetry—if they did not concern this and the lure of this and the sins because of this, what did they concern? He was for beauty. The history of the world justified him. Who could deny it?

CHAPTER XLVIII

From Biloxi, because of the approach of summer when it would be unbearably warm there, and because his funds were so low that it was necessary to make a decisive move of some kind, whether it led to complete disaster or not, he decided to return to New York. In storage with M. Kellner and Son (M. Charles had kindly volunteered to take care of them for him) were a number of the pastels left over from the original exhibit and nearly all of the paintings and pastels of the Paris exhibit. The latter had not sold well. Eugene's idea was that he could slip into New York quietly, take a room in some side street or in Jersey City or Brooklyn where he could not be seen, have the pictures in the possession of M. Charles returned to him, and then see if he could not get some of the minor art dealers or speculators of whom he had heard to come and look at them and buy them outright. Failing that, he might take them himself, one by one, to different dealers here and there and dispose of them. He remembered now that Eberhard Zang, the art dealer, had, through Norma Whitmore, asked him to come and see him. He fancied that as M. Kellner and Son had been so interested and the newspaper critics had spoken of him so kindly, the smaller dealers would

be most eager to take up with him. Surely they would buy this material. It was exceptional—very. Why not?

Eugene forgot or did not know the metaphysical significance of the physical state of man, which has so much to do with our appearances of prosperity and failure. At that time chemistry and physics had not yet reached the conclusion that matter is nothing—no thing—and that mind is all. He did not realize that "as a man thinketh so is he," and so also is the estimate of the whole world at the time he is thinking of himself thus—not as he is but as he thinks he is. It is metaphysically true that if an electric light which has been blazing brightly suddenly burns out, it is no longer thought of as a blazing electric light. The sense of its change or conclusion is abroad—by what processes we know not, but so it is.

Eugene's mental state, so depressed, so helpless, so fearsome—a rudderless boat in the dark—was by reason of this very condition transmitting itself as an impression, a wireless message to all those who knew him or knew of him. His breakdown which had first astonished M. Charles, for instance, depressed and then weakened the latter's interest in him. Like all other capable, successful men in the commercial world, M. Charles was for strong men—men in the heyday of their success, the zenith of their ability. The least variation from this standard of force and interest was noticeable to him. If a man was going to fail, going to get sick and lose his interest in life or have his viewpoint affected, why, it might be very sad but there was just one thing to do under such circumstances—get away from him. Failures of any kind were dangerous things to countenance. One must not have anything to do with them. They were very unprofitable. Similarly, such people as Temple Boyle and Vincent Beers, who had been his instructors in the past and who had heard of him in Chicago at the time of his success, and Luke Severas, William McConnell, Oren Benedict, Hudson Dula, and others, wondered what had become of him. Why did he not paint any more? He was never seen in the New York haunts of art. It was rumored at the time of the Paris exhibition that he was going to London to do a similar group of views but the London exhibit never materialized. He had told Smite and McHugh the spring he left that he might do Chicago next, but that came to nothing. There was no evidence of it. There were rumors that he was very sick, that his art had failed him, that he had lost his mind even, and so the art world that knew him and was so interested in him was not very much interested any more. It was too bad but—so thought the rival artists—there was one less difficult star to contend with. As for his friends, they were sorry but such was life. He might recover. If not—well——

As time went on, one year, another year, another year, the strangeness

of his suddenly brilliant burst and disappearance became, to the talented in his field, a form of classic memory. He was a man of such promise. Why did he not go on painting? There was an occasional mention in conversation or in print, but Eugene, to all intents and purposes, was dead.

When he came to New York it was after his capital had been reduced to three hundred dollars, and he had given Angela one hundred and twenty-five of this to take her back to Black Wood and keep her there until he could make such arrangements as would permit her to come on to New York. After a long discussion they had finally agreed that this would be best, for seeing that he could neither paint nor illustrate, there was no certainty as to what he could do. To come here on so little money with her was not advisable. She had her home where she could stay, and gladly, for awhile anyhow. Meanwhile, alone he could weather any storm, he figured.

The appearance of the metropolis after somewhat over two years of absence, during which he had wandered everywhere, seemingly, was most impressive to Eugene. It was a relief after the mountains of Kentucky and Tennessee and the loneliness of the Biloxi coast, even though the latter coast was built with some pleasing residences, the comforts of which he had not shared, to get back to this swarming city where millions were hurrying to and fro, and where one's misery as well as one's prosperity was apparently swallowed up in an inconceivable mass of life. A subway was being built. The automobile, which only a few years before was having a vague, uncertain beginning, was now attaining a tremendous vogue. Magnificent cars of new design were everywhere. From the ferry house in Jersey City he could see notable changes in the skyline, and a single walk across Twenty-third Street and up Seventh Avenue showed him a changing world—great hotels, great apartment houses, a tremendous crush of vainglorious life which was moulding the city to its desires. It depressed him greatly for he had always hoped to be an integral part of this magnificence and display and now he was not—might never be again.

It was still raw and cold, for the spring was just beginning to break, and Eugene was compelled to buy a light overcoat, for his own imperishable great coat had been left behind and he had no other fit to wear. Appearances, he thought, demanded this. He had spent forty of his closely guarded one hundred and seventy-five dollars coming from Biloxi to New York, and now an additional fifteen was required for this coat, leaving him one hundred and twenty-five dollars with which to begin his career anew. He was greatly worried as to the outcome, but curiously also he had an abiding subconscious feeling that it could not be utterly destructive to him. Something was holding him back—what, he could not say, for he was not sure of any intelligent consciousness outside of this life, but he felt that it must

be something. This storm of passion which had seized him in connection with Angela and brought about this mental decline just at the time when he should have gone forward—was not this the hand of Providence? Why? Did he not deserve to succeed? Was there something wrong with his personal attitude? He asked himself this as he walked about the city, for this spectacle of life put the problems of ethics and success sharply before him.

He rented himself a cheap room in a semi-respectable neighborhood in West Twenty-fourth Street near Eleventh Avenue, solely because he wanted to keep out of the run of intellectual life and hide until he could get on his feet. It was an old and shabby residence in an old and shabby red brick neighborhood, such as he had drawn in one of his views, but it was not utterly bad. The people were poor but fairly intellectual. He chose this particular neighborhood with all its poverty because it was near the North River, where the great river traffic could be seen and where, because of some open lots in which were stored wagons, his one single west window gave him a view of all this life. About the corner in Twenty-third Street, in another somewhat decayed residence, was a moderate priced restaurant and boarding house. Here he could get a meal for twenty-five cents. He cared nothing for the life that was about him. It was cheap, poor from a money point of view, dingy, but he would not be here forever, he hoped. These people did not know him. Besides the number—552 West Twenty-fourth Street—did not sound bad. It might be one of the old neighborhoods with which New York was dotted and which artists were inclined to find and occupy.

After he had secured this room from a semi-respectable Irish landlady, a dock weigher's wife, he decided to call upon M. Charles. He knew that he looked very respectable as yet, despite his poverty and decline. His clothes were good, his overcoat new, his manner brisk and determined. But what he could not see was that his face in its thin sallowness, and his eyes with their semi-feverish lustre, bespoke a mind that was harassed by trouble of some kind. He stood outside the office of M. Kellner and Son in Fifth Avenue, a half block from the door, wondering whether he should go in, just what he should say. He had written M. Charles from time to time that his health was bad and that he couldn't work—always that he hoped to be better soon. He had always hoped that a reply would come that another of his pictures had been sold. One year had gone and then two and now a third was underway and still he was not any better. M. Charles would look at him searchingly. He would have to bear his unflinching gaze. In his present nervous state this was difficult and yet he was not without a kind of defiance even now. He would restore himself into the favor of life sometime.

He finally mustered up his courage and entered and M. Charles greeted him warmly:

"This certainly is good to see you again. I had almost given up hope that you would ever come back to New York. How is your health now? And how is Mrs. Witla? It doesn't seem as though it had been two years. You're looking excellent. And how is painting going now? Getting to the place where you can do something again?"

Eugene felt for the moment as though M. Charles believed him to be in excellent condition, whereas that shrewd observer of men was wondering what could have worked so great a change. Eugene appeared to be five years older. There were marked wrinkles between his eyes and an air of lassitude and weariness. He thought to himself, "Why, this man may possibly be done for artistically. Something has gone from him which I noted the first time I met him: that fire and intense enthusiasm which radiated force after the fashion of an arc light. Now he seems to be seeking to draw something in—to save himself from drowning, as it were—he is making a voiceless appeal for consideration. What a pity!"

And the worst of it all was that in his estimation nothing could be done in such a case. You couldn't do anything for an artist who could do nothing for himself. Eugene's art was gone. The sanest thing for him to do would be to quit trying, go at some other form of labor and forget all about it. It might be that he would recover, but it was a question. Nervous breakdowns were not infrequently permanent.

Eugene noticed something of this in his manner. He couldn't tell exactly what it was, but M. Charles seemed more than ordinarily preoccupied, careful, and distant. He wasn't exactly chilly in his manner, but conservative, as though he were afraid he might be asked to do something which he could not very well do.

"I noticed that the Paris drawings did not do very well either here or in Paris," observed Eugene with an air of nonchalance, as though it were a matter of small importance, at the same time hoping that he would hear some favorable word. "I had the idea that they would take better than they did. Still I don't suppose I ought to expect everything to sell. The New York drawings did all right."

"They did very well indeed, much better than I expected. I didn't think as many would be sold as were. They were very new and considerably outside the lines of current art interest. The Paris drawings on the other hand were foreign to Americans in the wrong sense. By that I mean they weren't to be included in that genre art which comes from abroad, but is not based on any locality and is universal in its appeal, thematically speaking. Your Paris pictures were, of course, pictures in the best sense to those who see art as color and composition and idea, but to the ordinary lay mind they were, I take it, merely Paris scenes. You get what I mean. In that sense they

were foreign and Paris has been done—illustratively anyhow. You might have done better with London or Chicago. Still you have every reason to congratulate yourself. Your work made a distinct impression both here and in France. When you feel able to return to it I have no doubt that you will find that time has done you no harm."

He tried to be polite and entertaining but he was glad when Eugene went away again.

The latter turned out into the street disconsolate. He could see how things were. He was down and out for the present and would have to wait.

CHAPTER XLIX

The next thing was to see what could be done with the other art dealers and the paintings that were left. There were quite a number of them. If he could get any reasonable price at all he ought to be able to live quite awhile—long enough anyhow to get on his feet again. When the pictures arrived at his quiet room and were unpacked by him in a rather shame-faced and disturbed manner and distributed about, they seemed wonderful things. Why, if the critics had raved over them and M. Charles had thought they were so fine, why could they not be sold? Art dealers would surely buy them! Still, now that he was on the ground again and could see the distinctive art shops from the sidewalks, his courage failed him. They were not running after pictures. Exceptional as he might be, there were artists in plenty—good ones. He could not run to other well known art dealers very well, for his work had become identified with the house of M. Kellner and Son. Some of the small dealers might buy them but they would not buy them all—probably one or two at the most, and that at a sacrifice. What a pass to come to—he, Eugene Witla, who three years before had been in the heyday of his approaching prosperity, wondering as he stood in the room of a gloomy side street house how he was going to raise money to live on for the summer, and how he was going to sell the paintings which had seemed the substance of his fortune but two years before. He decided that he would ask several of the middle class dealers whether they would not come and look at what he had to show. To a number of the smaller dealers in Fourth, Sixth, Eighth Avenues and elsewhere, he would offer to sell several outright when necessity pinched. Still he had to raise money soon. Angela could not be left at Black Wood indefinitely.

He went to Jacob Bergman, Henry La Rue, Pottle Frères and asked if they would be interested to see what he had. Jacob Bergman, who was his

own manager, recalled Eugene's name at once. He had seen the exhibition but was not eager. He asked curiously how the pictures of the first and second exhibitions had sold, how many there were of them, what prices they brought. Eugene told him.

"You might bring one or two here and leave them on sale. You know how that is. Someone might take a fancy to them. You never can tell."

He explained that his commission was twenty-five per cent and that he would report when a sale was made. He was not interested to come and see them. Eugene could select any two pictures he pleased. It was the same with Henry LaRue and Pottle Frères, though the latter had never heard of him. They asked him to show them one of his pictures. Eugene's pride was touched the least bit by this lack of knowledge on their part, though seeing how things were running with him, he felt as though he might expect as much and more.

Other art dealers he did not care to trust with selling his paintings, and he was now ashamed to start carrying them about to the magazines where, at best, one hundred and twenty-five to one hundred and fifty per picture might be expected for them if they were sold at all. He did not want the magazine art world to think that he had come to this. His best friend was Hudson Dula and he might no longer be art director of *Truth*. As a matter of fact Dula was no longer there, though Eugene did not know it. Then there was Willis Jansen and several others, but they were no doubt thinking of him now as a successful painter. It seemed as though his natural pride were building insurmountable barriers for him. How was he to live if he could not do this and could not paint? He decided on trying the small art dealers with a single picture, offering to sell it outright. They might not know him. If so they might buy it direct. He could accept, in such cases, without much shock to his pride anything which they might offer—if it were not too little.

He tried this one bright morning in May and though it was not without result, it spoiled the beautiful day for him. He took one picture, a New York scene, and carried it to a third rate art dealer whose place he had seen in upper Sixth Avenue, and without saying anything about himself, asked if he would like to buy it. The proprietor, a small, dark individual of Semitic extraction, looked at him curiously and at his picture. He could tell from a single look that Eugene was in trouble, that he needed money, and that he was anxious to sell this picture. He thought of course that he would take anything for it and he was not sure that he wanted the picture, at that. It was not very popular in theme, a view of a famous Sixth Avenue restaurant showing behind the track of the L road, with a driving rain pouring in between the interstices of light. Years after, this picture was picked up by

a collector from Kansas City at an old furniture sale and hung among his gems, but this morning its merits were not very much in evidence.

"I see that you occasionally exhibit a painting in your window for sale. Do you buy originals?"

"Now and again," said the man indifferently—"Not often. What have you?"

"I have a pastel here that I painted not so long ago. I occasionally do these things. I thought maybe you would like to buy it."

The proprietor stood by indifferently while Eugene untied the string, took off the paper, and sat the picture up for inspection. It was striking enough in its way but it did not appeal to him as being popular.

"I don't think it's anything that I could sell here," he remarked, shrugging his shoulders. "It's good, but we don't have much call for pictures of any kind. If it were a straight landscape or a marine or a figure of some kind——. Figures sell best—but this—I doubt if I could get rid of it. You might leave it on sale if you want to. Somebody might like it. I don't think I'd care to buy it."

"I don't care to leave it on sale," replied Eugene irritably. Leave one of his pictures in a cheap side street art store—and that on sale! He would not. He wanted to say something mean in reply but he curbed his welling wrath to ask: "how much do you think it would be worth if you did want it?"

"Oh," replied the proprietor, pursing his lips reflectively, "not more than ten dollars. We can't ask much for anything we have on view here. The Fifth Avenue stores take all the good trade."

Eugene winced. Ten dollars! Why what a ridiculous sum. What was the use of coming to a place like this anyhow? He could do better dealing with the art directors or the better stores. But where were they? Who would he deal with? Where were there any stores much better than this, outside of the large ones which he had already canvassed? He had better keep his pictures and go to work now at something else. He only had thirty-five of them, all told, and at this rate he would have just three hundred and fifty dollars when they were all gone. What good would that do him? He had better have left them in storage with M. Charles and struck out to find something to do. He wrapped up his picture and departed, consulting another small dealer, but the result was quite the same. This man, a Pacific American, explained also to Eugene just why it was that he could not sell that sort of thing. He had no customers for it. A third dealer, because of some personal predilection or knowledge of an avenue of opportunity, after much deliberation offered him fifteen dollars. It was high noon and Eugene was weary. He took it and left.

The sale of this picture, small as it was, was some relief in the face of what had preceded it; but viewed in light of what he must have to enter upon housekeeping with Angela again, to keep them in food and clothing, to maintain anything like the conditions they had been maintaining, it was nothing. If he sold one a week, or all of them quickly at this price, how long could he live? His mood and this preliminary experience convinced him that they could not be sold for any much greater sum. Fifteen dollars or less would probably be offered and he would be no better off at the end. His pictures would be gone and he would have nothing. He ought to get something to do and save his pictures. What?

To a man in Eugene's position—he was now thirty-one years of age, with no training outside of that which he had acquired in developing his artistic judgement and ability—this proposition of finding something else which he could do was very difficult. His mental sickness was, of course, the first great bar. It made him appear nervous and discouraged, and so more or less objectionable to anyone who was looking for vigorous, healthy manhood in the shape of an employee. In the next place, his look and manner had become decidedly that of an artist—refined, retiring, subtle. He also had an air at times of finicky standoffishness, particularly in the presence of those who appeared to him commonplace, or who by their look or manner appeared to be attempting to set themselves over him. In the last place, he could think of nothing that he really wanted to do—the idea that his art ability would come back to him, or that it ought to serve him in this crisis, haunting him all the time. Once he had thought he might like to be an art director—he was convinced that he would be a good one—and another time he had thought he would like to write, but that was long ago. He had never written anything since the Chicago newspaper specials, and several efforts at concentrating his mind for this quickly proved to him that writing was not for him now. It was hard for him to formulate an intelligent consecutive-idea'd letter to Angela. He harked back to his old Chicago days and remembering that he had been a collector and a driver of a laundry wagon, he decided that he might do something of that sort. Getting a position as a street car conductor or a dry goods clerk appealed to him as possibilities. The necessity of doing something within regular hours and in a routine way appealed to him as having curative properties. How should he get such a thing?

If it had not been for the bedeviled state of his mind, this would not have been such a difficult matter for Eugene, for he was physically active enough to hold any ordinary position. He might have appealed frankly and simply to M. Charles or Isaac Wertheim, and through influence obtained something which would have tided him over, but he was too sensitive to begin

with and his present weakness made him all the more fearsome and retiring. He had but one desire when he thought of doing anything outside of his creative gift, and that was to slink away from the gaze of men. How could he, with his appearance, his reputation, his tastes and refinement, hobnob with conductors, dry goods clerks, railroad hands or drivers? It wasn't possible—he hadn't the strength. Besides, all that was a thing of the past, or he thought it was. He had put it behind him in his art student days. Now to have to get out and look for a job! How could he? He walked the streets for days and days, coming back to his room to see if by any chance he could paint yet, and writing long, rambling, emotional letters to Angela. It was pitiful. In fits of gloom he would take out an occasional picture and sell it, parting with it for ten or fifteen dollars after he had carried it sometimes for miles. His one refuge was in walking, for somehow he could not walk and feel very bad. The beauty of nature, the activities of people, entertained and diverted his mind. He would come back to his room some evenings feeling as though a great change had come over him—as though he were going to do better now—but this did not last long. A little while and he would be back in his old mood again. He spent three months this way, drifting, before he realized that he must do something—that fall and winter would be coming on again in a little while and he would have nothing at all.

In his desperation he first attempted to get an art directorship, but two or three interviews with publishers of magazines indicated to him pretty quickly that positions of this character were not handed out to the inexperienced. It required an apprenticeship, just as anything else did, and those who had positions in this field elsewhere had the first call. His name or appearance did not appear to strike any of these gentleman as either familiar or important in any way. They had heard of him as an illustrator and a painter but his present appearance indicated that this was a refuge in ill-health which he was seeking, not a vigorous, constructive position, and so they would have none of him. He next tried at three of the principal publishing houses but they did not require anyone in that capacity. Truth to tell he knew very little of the details and responsibilities of the position though he thought he did. After that there was nothing save dry goods stores, street car registration offices, the employment offices of the great railroads and factories. He looked at sugar refineries, tobacco factories, express offices, railroad freight offices, wondering whether in any of these it would be possible for him to obtain a position which would give him a salary of ten dollars a week. If he could get that and any of the pictures now on show with Jacob Bergman, Henry LaRue, and Pottle Frères should be sold, he could get along. He might even live on this with Angela, if he could sell an occasional picture for ten or fifteen dollars. But this way he was living at the rate of seven dol-

lars a week, buying nothing at all save food and room, and he was scarcely managing to cling to the one hundred dollars which had remained of his original traveling fund after he paid all his opening expenses here in New York. He was afraid to let go of his pictures in this way for fear he would be sorry for it after a while.

To anyone who has ever tried to obtain a position under the most favorable conditions of health and youth and ambition, the difficulties of obtaining one under unfavorable ones need not be reiterated. Imagine if you can the crowds of men—forty, fifty, one hundred strong—that await at the door of every dry goods employment office, every street car registration bureau, on the special days set aside for considering applications, and at every factory, shop, or office when an advertisement calling for a certain type of man or woman was inserted in the newspapers. On the few occasions that Eugene tried or attempted to try, he found himself preceded by peculiar groups of individuals who eyed him curiously as he approached, wondering, as he thought, whether a man of his type could be coming to apply for a job. They seemed radically different from himself, to his mind, men with little education and a grim consciousness of the difficulties of life—young men, vapid looking men, shabby, stale, discouraged types—men who, like himself, looked as though they had seen something very much better, and men who looked as though they had seen things a great deal worse. The evidence which frightened him was the presence of groups of bright, healthy, eager looking boys of nineteen, twenty, twenty-one, and twenty-two who, like himself when he first went to Chicago years before, were everywhere he went. When he drew near he invariably found it impossible for him to indicate in any way that he was looking for anything. He couldn't. His courage failed him; he felt that he looked too superior, too different; self-consciousness and shame overcame him. He, Eugene Witla, standing in line with applicants for a clerk's or a driver's job. Invariably he drew himself up sensitively and passed on by, pretending other interests.

He learned now that men rose as early as four o'clock in the morning to buy a newspaper and run quickly to the place where the position was indicated, in order to get the place at the head of the line, thus getting first consideration as an applicant. He learned that some other men, such as waiters, cooks, hotel employees, and such, frequently stayed up all night in order to buy a paper at two in the morning, winter or summer, rain or snow, heat or cold, and hurry to the favorable addresses which they might find. He learned the crowds of applicants were apt to become surly or sarcastic or contentious as their individual chances were jeopardized by ever-increasing numbers. And all of this was going on all the time, in winter or summer, heat or cold, rain or snow. Pretending interest as a spectator, he

would sometimes stand and watch, hearing the ribald jests, the slurs cast upon life, fortune, individuals in particular and general by those who were wearily or hopelessly waiting. It was a horrible picture to him in his present condition. It was like the grinding of the millstones, upper and nether. These were the chaff. He was a part of the chaff at present, or in danger of becoming so. Life was winnowing him out. And he might go down, down, and there might be never any opportunity for his rising anymore.

It may be said here in this connection that few, if any, of us understand thoroughly the nature of the unconscious stratification which takes place in life, the layers and types and classes into which it assorts itself and the barriers which these offer to a free migration of individuals from one class to another. We take on so naturally the material habiliments of our temperaments, necessities, and opportunities. Priests, doctors, lawyers, merchants, appear to be born of their mental attitude and likewise the clerk, the ditch digger, the janitor. They have their codes, their guilds, and their class feelings. And while they may be spiritually closely related, they are physically far apart. Eugene, after hunting for a place for a month, knew a great deal more about this stratification than he had ever dreamed of knowing. He found, for instance, that he was naturally barred by temperament from some things; by strength and weight or the lack of them, from others; by inexperience from others; by age from others; and so on. And those who were different from him in any or all of these respects were inclined to look at him askance. "You are not as we are," their eyes seemed to say, "why do you come here?"

One day he approached a gang of men who were waiting outside a car barn and sought to find out where the registration office was. He did not lay off his natural manner of superiority—could not—but asked a man near him if he knew. It had taken all his courage to do this.

"He wouldn't be after lookin' for a place as a conductor, now, would he?" he heard someone say within his hearing. For some reason this remark took all his courage away. He went up the wooden stairs to the little office where the application blanks were handed out but did not even have the courage to apply for one. He pretended to be looking for someone and went out again.

It is a question how long this aimless, nervous wandering would have continued if it had not been for the accidental recollection of an experience which a fellow artist once related to him of a writer who had found himself nervously depressed and who, by application to the president of a railroad, had secured as a courtesy to the profession which he represented so ably, a position as an apprentice in a surveying corps, being given transportation to a distant section of the country and employed at a laborer's wages until he was well. Eugene now thought of this as quite an idea for himself. Why

it had not occurred to him before he did not know. He could as well apply as an artist—his appearance would bear him out—and being able to speak from the vantage point of his personal ability temporarily embarrassed by ill health, his chances of getting something would be so much better. It would not be the same as a position which he had secured for himself without fear or favor but it would be a position, different from farming with Angela's father because it would command a salary. If he could get that, and it paid anything at all, he and Angela might possibly take a small room somewhere, do light housekeeping perhaps, and when he was well again and could work, they could get something better. He had an idea that his work, whatever he secured, would be near New York. He did not see, though, now that he had had this rough experience, that art was such a great thing after all or that it held so much for him in the future. If it was so unsubstantial, so unprofitable, how much better was plain wealth founded on anything—manufacturing, speculation, trade. To have money. If he had had that, he would not have been worried all this time. If he had had that, he would probably have been well long ago. To see himself shoved about this way by a vagary of the mind was a terrible thing. Money would have saved his face before Angela: would have saved his face before the art world of New York. He would not have had to have hid away in this fashion, could have gone and seen those that he liked, telling them what his condition was, for he had seen no one except accidentally, and then to his confusion and embarrassment. He could have walked abroad openly, boasting that he was resting on his means while recovering. This way he was nothing, a recipient of charity at other people's hands, and really art would never provide him the income which would make him so vastly superior to this. He was chasing a will-o'-the-wisp. People who had money were happy. That was the thing he needed and that was the thing which, sincerely, he wished he might have.

CHAPTER L

The idea of appealing to the president of one of the great roads that entered into New York was not so difficult to execute. Eugene dressed himself very carefully the next morning, and going to the offices of the company in Forty-second Street, consulted the bulletin of officers posted in one of the halls, and finding the president to be on the third floor, ascended. He discovered, after compelling himself by sheer willpower to enter, that this so-called office was a mere anteroom to a force of assistants serving the president, and that no one could see him except by appointment.

"You might see his secretary, if he isn't busy," suggested the clerk who handled Eugene's card gingerly.

Eugene was for the moment undetermined what to do, but decided that maybe the secretary could help him. He asked that his card be taken to him and that no explanation be demanded of him except by the secretary in person. The latter came out after a while—an under-secretary of perhaps twenty-eight years of age, short and stout. He was bland and apparently good-natured.

"What is it I can do for you?" he asked.

Eugene had been formulating his request in his mind—some method of putting it briefly and simply.

"I came up to see Mr. Wilson," he said, "to see if he would not send me out as a day-laborer of some kind in connection with some department of the road. I am an artist by profession and I am suffering from neurasthenia. All the doctors I have consulted have recommended that I get a simple, manual position of some kind and work at it until I am well. I know of another case in which Mr. Wilson assisted Mr. Savin the author in this way, and I thought he might be willing to interest himself in my case."

At the sound of Henry Savin's name, the under-secretary pricked up his ears. He had, fortunately, read one of his books and this, together with Eugene's knowledge of this case, his personal appearance, and a certain ring of sincerity in what he was saying, caused him to be momentarily interested.

"There is no position in connection with any clerical force which the president could give you, I am sure," he replied. "All of these things are subject to a system of promotion. It might be that he could place you with one of the construction gangs in one of the departments under a foreman. I don't know. It's very hard work, though. He might consider your case." He smiled commiseratingly. "I question whether you're strong enough to do anything of that sort. It takes a pretty good man to wield a pick or a shovel."

"I don't think I had better worry about that now," replied Eugene in return, smiling wearily. "I'll take the work and see if it won't help me. I think I need it badly enough."

He was afraid the under-secretary would repent of his suggestion and refuse him entirely.

"Can you wait a little while?" asked the latter curiously. He had the idea that Eugene was someone of considerable importance, for he had suggested as a parting argument that he could give a number of notable references.

"Certainly," said Eugene, and the secretary went his way, coming back in half an hour with an enveloped letter which he handed Eugene.

"We have the idea," he said quite frankly, waiving away any suggestion of the president's influence in this matter and speaking for himself and

the secretary-in-chief, with whom he had agreed that Eugene ought to be assisted, "that you had best apply to the engineering department. Mr. Holsen, the chief-engineer, can arrange for you. This letter, I think, will get you what you want."

Eugene's heart bounded. He looked at the superscription and saw it addressed to Mr. Woodruff Holsen, Chief Engineer, and putting it in his pocket without stopping to read it, but thanking the under-secretary profusely, went out. In the hall at a safe distance he stopped and opened it, finding that it spoke of him familiarly as "Mr. Eugene Witla, an artist, temporarily incapacitated by neurasthenia," and went on to say that he was "desirous of being appointed to some manual task in some construction corps. The president's office recommends this request to your favor."

When he read this he knew it meant a position. It roused curious feelings as to the nature and value of stratification. As a laborer he was nothing: as an artist he could get a position as a laborer. After all, his ability as an artist was worth something. It obtained him this refuge. He hugged the letter joyously and a few moments later handed it to an under-secretary in the chief-engineer's office. Without being seen by anyone of authority he was, in return, given a letter to Mr. William Haverford, "Engineer of Maintainence of Way," a pale, anaemic gentleman of perhaps forty years of age, who, as Eugene learned from him when he was eventually ushered into his presence a half hour later, was a captain of 13,000 men. The latter read the letter from the engineer's office curiously. He was struck by Eugene's odd mission and his appearance as a man. Artists were queer. This was like one. Eugene reminded him of himself a little in his appearance.

"An artist," he said interestedly. "So you want to work as a day laborer?" He fixed Eugene with clear, coal-black eyes looking out of a long pear-shaped face. Eugene noticed that his hands were long and thin and white and that his high, pale forehead was crowned by a mop of black hair. "Neurasthenia. I've heard a great deal about that of late but have never been troubled that way myself. I find that I derive considerable benefit, when I am nervous, from the use of a rubber exerciser. You have seen them perhaps?"

"Yes," he replied, "I have. My case is much too severe for that I think. I have traveled a great deal. But it doesn't seem to do me any good. I must work at something manual, I fancy—something at which I have to work. Exercise in a room will not help me. I think I need a complete change of environment. I will be much obliged if you will place me in some capacity."

"Well this will very likely be it," suggested Mr. Haverford blandly. "Working as a day-laborer will certainly not strike you as play. To tell you the truth, I don't think you can stand it." He reached for a glass-framed map showing the various divisions of the railroad stretching from New England

to Chicago and St. Louis, and observed quietly, "I could send you to a great many places—Pennsylvania, New York, Ohio, Michigan, Canada." His finger roved idly about. "I have thirteen thousand men in my department and they are scattered far and wide."

Eugene marveled. Such a position! Such authority! This pale, dark man sitting as an engineer at a switchboard, directing so large a machine.

"You have a large force," he said simply. Mr. Haverford smiled wanly.

"I think if you will take my advice, you will not go in a construction corps right away. You can hardly do manual labor. There is a little carpenter shop which we have at Speonk, not very far outside the city, which I should think would answer your needs admirably. A little creek joins the Hudson there, and the shop is out on a point of land. It's summer now, and to put you in a broiling sun with a gang of Italians would be a little rough. Take my advice and go here. It will be hard enough. After you are broken in and you think you want a change I can easily arrange it for you. The money may not make so much difference to you but you may as well have it. It will be fifteen cents an hour. I will give you a letter to Mr. Fillebrown, our division engineer, and he will see that you are properly provided for."

Eugene bowed. Inwardly he smiled at the thought that the money would not be acceptable to him. Anything would be acceptable. Perhaps this would be best. It was near the city. His description of the little carpenter shop out on the neck of land appealed to him. It was, as he found out when he looked at the map of the immediate division to which this belonged, almost within the city limits. He could live in New York—the upper portion of it anyhow.

Again there was a letter, to Mr. Henry C. Fillebrown, a tall, meditative, philosophic man whom Eugene found two days later in the division offices at Yonkers, who in turn wrote a letter to Mr. Joseph Brooks, Superintendent of Buildings, at Mott Haven, whose secretary finally gave Eugene a letter to Mr. Jack Stix, Foreman Carpenter at Speonk. This letter, when presented on a bright Friday afternoon, brought him the advice to come Monday at seven a.m., and so Eugene saw a career as a day laborer stretching very conspicuously before him.

The "little shop" in question was located in the most charming manner possible. If it had been set as a stage scene for his especial artistic benefit it could not have been better. On a point of land between the river and the main line of the railroad and a little creek, which was east of the railroad and which the latter crossed on a trestle to get back to the mainland again, it stood—a long, low, two story structure, green as to its roof, red as to its body, full of windows which commanded picturesque views of passing yachts and steamers and little launches and row-boats anchored safely in the

waters of the cove which the creek formed. There was a veritable song of labor which arose from this shop, for it was occupied by planes, lathes, and wood-turning instruments of various kinds, to say nothing of a great group of carpenters who could make desks, chairs, tables—in short, office furniture of various kinds—and who kept the company's needs of these implements for its depots and offices well supplied. Each carpenter had a bench before a window on the second floor, and in the centre of them were the few necessary machines they were always using—small rip, crosscut, band, and jig saws, a plane, and four or five lathes. On the ground floor was the engine room, the blacksmith shop, the giant plane, and the great rip and crosscut saws, to say nothing of store rooms and supply closets. Out in the yard were piles of lumber with tracks in between and every day, twice a day, a local freight called "The Dinky" stopped to switch in or take out loaded cars of lumber or finished furniture and supplies. Eugene, as he came up on the day he presented his letter, stopped to admire the neatness of the low board fence which surrounded it all, the beauty of the water, the droning sweetness of the saws. "Why, the work here couldn't be very hard," he thought. He saw carpenters looking out of the upper windows, a couple of men in brown overalls and jumpers unloading a car. They were carrying great three-by-six joists on their shoulders. Would he be asked to do anything like that? He scarcely thought so. Mr. Haverford had distinctly indicated in his letter to Mr. Fillebrown that he was to be built up by degrees. Carrying great joists did not appeal to him as the right way, but he presented his letter.

He had previously looked about on the high ground which lay back of the river and which commanded this point of land to see if he could find a place to board and room, but had found nothing. The section was very exclusive, occupied by suburban New Yorkers of wealth, and they were not interested in his proposition, which he had formulated in his own mind, namely, his temporary reception somewhere as a paying guest. He had visions of a comfortable home somewhere now with nice people, for strangely, the securing of this very minor position had impressed him as the beginning of the end of his bad luck. He was probably going to get well now, in the course of time.

If he could only get in with some nice family for the summer. In the fall, if he were improving, and he thought he might be, Angela could come on. It might be that one of the dealers, Pottle Frères or Jacob Bergman or Henry La Rue, would have sold a picture. One hundred and fifty or two hundred dollars joined to his salary would go a long way towards making their living moderately comfortable. Besides, Angela's taste and economy coupled with his own art judgement could make any little place look respectable and attractive.

The problem of finding a room was not so easy to solve. He followed the track south to a settlement which was visible from the shop windows, a quarter of a mile away, and finding nothing there which suited his taste as to location, returned to Speonk proper and followed the little creek inland half a mile. The adventure delighted him for it revealed a semi-circle of charming cottages ranged upon a hill slope which had for its footstool the little silvery bosomed stream. Between the stream and the hill slope ran a semi-circular road and above that another road. Eugene could see at a glance that here was middle-class prosperity—smooth lawns, bright awnings, flower pots of blue and yellow and green upon the porches, doorsteps, and verandas. An auto standing in front of one house indicated a certain familiarity with the ways of the rich, and a summer road house, located at the intersection of a road leading out from New York and the little stream where it was crossed by a bridge, indicated that the charms of this village were not unknown to those who came touring and seeking for pleasure. The road house itself was hung with awnings, and one dining balcony sat out over the water. Eugene's desire was fixed on this village at once. He wanted to live here—anywhere in it, but here. He walked about under the cool shade of the trees, looking at first one door yard and then another, wishing that he might introduce himself by letter and be received. They ought to welcome an artist of his ability and refinement and would, he thought, if they knew. His working in a furniture factory or for the railroad as a day laborer for his health simply added to the picturesque character of his nature. In his wanderings he finally came upon a Methodist church quaintly built of red brick and gray stone trimmings, and the sight of its tall stained glass windows and square fortress-like bell-tower gave him an idea. Why not appeal to the minister? He could explain to him what he wanted, show him his credentials (for he had with him old letters from editors, publishers and art houses—a few) and give him a clear understanding as to why he wanted to come here at all. His ill health and distinction ought to appeal to this man, and he would probably direct him to someone who would gladly have him. At five in the afternoon he knocked at the door and was received in the pastor's study—a large, still room in which a few flies were buzzing in the shaded light. In a few moments the minister himself came in—a tall, gray-headed man, severely simple in his attire, and with the easy air of one who is used to public address. He was about to ask what he could do for him when Eugene interrupted him with his explanation.

"You don't know me at all. I am a stranger in this section. I am an artist by profession and I am coming to Speonk on Monday to work in the railroad shop there for my health. I have been suffering from a nervous breakdown and am going to try day labor for awhile. I want to find a convenient,

pleasant place to live, and I thought you might know of someone here or near here who might be willing to take me in for a little while, and that if you did, you might tell me. I can give excellent references. There doesn't appear to be anything in the immediate neighborhood of the shop."

"It is rather isolated there," replied the old minister, studying Eugene carefully. "I have often wondered how all of those men like it traveling so far. None of them live about here." He looked at Eugene solemnly, taking in his various characteristics. He was not badly impressed. He seemed to be a reserved, thoughtful, dignified young man and decidedly artistic. It struck him as very interesting that he should be trying so radical a thing as day labor for his nerves.

"Let me see," he said thoughtfully. He sat down in his chair near his table and put his hand over his eyes. "I don't think of anyone just at the moment. There are plenty of families who have the room to take you if they would, but I question very much whether they would. In fact I'm rather sure they wouldn't. Let me see now."

He thought again.

Eugene studied his big aquiline nose, his shaggy gray eye brows, his thick, crisp, gray hair. Already his mind was naturally sketching him, the desk, the dim walls, the whole atmosphere of the room.

"No, no," he said slowly. "I don't think of anyone. There is one family—Mrs. Hibberdell's. She lives in the, let me see, first, second, third, tenth house above here. She has one nephew with her at present, a young man of about your age, and I don't think anyone else. I don't know that she would consider taking you in, but she might. Her house is quite large. She did have her daughter with her at one time but I'm not sure that she's there now. I think not."

He talked as though he were reporting his own thoughts to himself audibly.

Eugene pricked up his ears at the mention of a daughter. During all the time he had been out of New York he had not, with the exception of Frieda, had a single opportunity to talk intimately and innocently with any girl. Angela had been with him all the time. Here in New York since he had been back, he had been living under such distressing conditions that he had not thought of either youth or love. He had no business to be thinking of it now, but this summer air, this tree-shaded village, the fact that he had a position, small as it was, on which he could depend and which would no doubt benefit him mentally, and that he was somehow feeling better about himself because he was going to work, made him feel that he might look more interestedly on life again. He was not going to die: he was going to

get well. Finding this position proved it. And he might go to this house now and find some charming girl who would like him very much. What a dream. After all this storm. Angela was away. He was alone. He had again the freedom of his youth. If he were only well and working.

He thanked the old minister very politely and went his way. He strolled up the evening street hoping for the best. Since he had secured this position, he had taken out of his trunk a dark blue summer suit left over from last year, a pair of low quarter shoes, and a pleated, soft-bosomed summer shirt. His suit had been cleaned and pressed, his shoes immaculately shined. He looked fresh and clean but very thin and pale. He recognized the house by certain details given him by the minister—a double balconied veranda, some red rockers, two yellow jardinières at the doorstep, a grayish white picket fence and gate. The house was a dark tan. He walked up smartly and rang the bell. A very intelligent woman of perhaps fifty-five or sixty with bright gray hair and clear light blue eyes was coming out with a book in her hand. Eugene stated his case. She listened with keen interest, looking him over the while. His appearance took her fancy for she was of a strong intellectual and literary turn of mind.

"I wouldn't ordinarily consider anything of the kind but I am alone here with my nephew and the house could easily accommodate a dozen. I don't want to do anything which will irritate him, but if you will come back in the morning I will let you know. It would not disturb me any to have you about. Do you happen to know of an artist by the name of Deesa?"

"I know him well," replied Eugene. "He's an old friend of mine."

"He is a friend of my daughter's, I think. Have you inquired anywhere else here in the village?"

"No," said Eugene.

"That is just as well," she replied.

He took the hint.

So there was no daughter here. Well, what matter? The view was beautiful. Of an evening he could sit out here in one of the rocking chairs and look at the water. The evening sun, already low in the west, was burnishing it a bright gold. The outline of the hill on the other side was dignified and peaceful. He could sleep and work as a day laborer and take life easy for awhile. He could get well now and this was the way to do it. Day labor. How fine, how original, how interesting. He felt somewhat like the knights-errant of old must have felt, he thought, reconnoitering a new and very strange world.

CHAPTER LI

The matter of securing admission to this house was quickly adjusted. The nephew, a genial, intelligent man of thirty-four as Eugene discovered later, had no objection. It appeared to Eugene that in some way he contributed to the support of this house, though Mrs. Hibberdell obviously had some money of her own. A charmingly furnished room on the second floor adjoining one of the several baths was assigned him and he was at once admitted to the freedom of the house. There were books, a piano (but no one to play it), a hammock, a maid of all work, and an atmosphere of content and peace. Mrs. Hibberdell, a widow, presumably, of some years of widowhood (how many or whether for certain Eugene never learned) was of that experience and judgement in life which gave her intellectual poise. She was not particularly inquisitive about anything in connection with him, and so far as he could see from surface indications was refined, silent, conservative. She could jest and did, in a subtle, understanding way. He told her quite frankly at the time he applied that he was married, that his wife was in the West, and that he expected her to return after his health was somewhat improved. She talked with him about art and books and life in general. Music appeared to be a thing apart for her. She did not care much for it. The nephew, Davis Simpson, was neither literary nor artistic. He apparently cared little for music. A slim, dapper, rather dandyish type of man with a lean, not thin but tight-muscled face and a short black mustache, he was a buyer for one of the large department stores and appeared to be interested only in the humors of character, trade, baseball, and methods of entertaining himself. The things that pleased Eugene about him were that he was clean, simple, direct, good-natured, and courteous. He had apparently no desire to infringe on anybody's privacy but was fond of stirring up light discussions and interpolating witty remarks. He liked also to grow flowers and to fish. The care of a border of flowers which glorified a short gravel path in the back yard received his especial attention evenings and mornings.

It was a great pleasure for Eugene to come into this atmosphere after the storm which had been assailing him for the past three years, and particularly for the past ninety days. He was only asked to pay eight dollars a week by Mrs. Hibberdell, though he realized that what he was obtaining in home atmosphere here was not ordinarily purchasable at any price in the public market. The maid saw to it that a little bouquet of flowers was put on his dresser daily. He was given fresh towels and linens in ample quantities. The bath he used was almost exclusively his own. He could sit out on the porch of an evening and look at the water uninterrupted or he could

stay in the library and read. Breakfast and dinner were invariably delightful occasions, for though he arose at five-forty-five in order to have his bath, breakfast, and be able to walk to the factory and reach it by seven, Mrs. Hibberdell was invariably up, and informed him that it was her habit to rise thus early—had been so for years. She liked it. Eugene in his weary mood could scarcely understand this. Davis came to the table some few minutes before he would be leaving. He invariably had some cheery remark to offer for he was never sullen or gloomy. His affairs, whatever they were, did not appear to oppress him. Mrs. Hibberdell would talk to Eugene genially about his work, this small social centre of which they were a part which was called Riverwood, the current movements in politics, religion, science, and so forth. There were occasionally references to her one daughter, who was married and living in New York. It appeared that she occasionally visited her mother here. Eugene was delighted to think he had been so fortunate as to find this place. He hoped to make himself so agreeable that there would be no question as to his welcome, and he was not disappointed.

Between themselves, Mrs. Hibberdell and Davis discussed him, agreeing that he was entirely charming, a good fellow, and well worth having about. At the factory where Eugene worked and where the conditions were radically different, he made for himself an atmosphere which was almost entirely agreeable to him, though he quarreled at times with specific details. On the first morning, for instance, he was put to work with two men, heavy clods of souls he thought at first, familiarly known about the yard as John and Bill. These two, to his artistic eye, appeared machines, more mechanical than human and self-directive. They were of medium height, not more than five feet, nine inches tall, and weighed in the neighborhood of 180 pounds each. One had a round, poorly modeled face very much the shape of a fat egg, to which was attached a heavy yellowish mustache. He had a glass eye, which was in addition complicated with a pair of glasses which were fastened over his large, protruding red ears by steel hooks. He wore a battered brown hat which had once been a fedora but which was now a limp shapeless mass. His name was Bill Jeffords and he responded sometimes to the sobriquet of "One Eye."

The other man was John alias "Jack" Duncan, an individual of the same height and build with but slightly more modeling to his face and with little if any greater intelligence. He looked somewhat the shrewder—Eugene fancied there might be lurking in him somewhere a spark of humor, but he was mistaken. Unquestionably in Jeffords there was none. Jack Stix, the foreman-carpenter, a tall, angular, ambling man with red hair, a red mustache, shifty, uncertain blue eyes and noticeably big hands and feet, had suggested to Eugene that he work with these men for a little while. It was

his idea to "try him out," as he told one of the associate foremen who was in charge of a gang of Italians working in the yard for the morning, and he was quite equal to doing it. He thought Eugene had no business here and might possibly be scared off by a little rough work.

"He's up here for his health," Stix told the associate foreman. "I don't know where he comes from. Mr. Brooks sent him up here with orders to put him on. I want to see how he takes to real work for awhile."

"Look out you don't hurt him," suggested the other. "He don't look very strong to me."

"He's strong enough to carry a few spiles, I guess. If Jimmy can carry 'em, he can. I don't intend to keep him at it long."

Eugene knew nothing of this but when he was told to "come along, new man," and shown a pile of round, rough, ash trunk cuttings, six inches in diameter and eight feet long, his courage failed him. He was suffered to carry some of these to the second floor, how many, he did not know.

"Take 'em to Thompson up there in the corner," said Jeffords dully.

Eugene grasped one uncertainly in the middle with his thin artistic hands. He did not know that there were ways of handling lumber quite as there were ways of handling a brush. He tried to lift it but could not. The rough bark scratched his fingers cruelly.

"Yuh gotta learn somepin' about that before yuh begin, I guess," said Jack Duncan, who had been standing by, eying him narrowly.

Jeffords had gone about some other work.

"I suppose I don't know very much about it," replied Eugene shame-facedly, stopping and waiting for further instructions.

"Lemme show you a trick," said his associate. "There's tricks in all these here trades. Take it by the end there and push it along until you can stand it up. Stoop down now and put your shoulder right next the middle. Gotta pad under your shirt? You oughtta have one. Now put your right arm out ahead o' yuh, on the spile. Now you're all right."

Eugene straightened up and the rough post balanced itself evenly but crushingly on his shoulder. It appeared to grind his muscles, and his back and legs ached instantly. He started bravely forward, straining to appear at ease, but within fifty feet he was suffering agony. He walked the length of the shop however, up the stairs and back again to the window where Thompson was, his forehead bursting out with perspiration and his ears red with blood. He fairly staggered as he neared the machine and dropped the post heavily.

"Look what you're doin'," said a voice behind him. It was Thompson, the lathe worker. "Can't you put that down easy?"

"No, I can't," replied Eugene angrily, his face tinged with a faint flush

from his extreme exertion. He was astonished and enraged to think they would put him to doing work like this, especially since Mr. Haverford had told him it would be easy. He suspected at once a plot to drive him away. He would have added, "These are too damned heavy for me," but he restrained himself. He went down the stairs, wondering how he was to get up the others. He fingered about the pile gingerly, hoping that the time stolen this way would ease his pain and give him strength for the next one. Finally he picked up another and staggered painfully to the loft again. The foreman was not without his eye on him but said nothing. It amused him a little to think Eugene was having such a hard time. It wouldn't hurt him, for a change, would do him good. "When he gets four carried up, let him go," he said to Thompson, however, feeling that he had best lighten the situation a little. The latter watched Eugene out of the tail of his eye, noting the grimaces he made and the strain he was undergoing, but he merely smiled. When four had been dropped on the floor he said, "That'll do for the present," and Eugene, heaving a groan of relief, went angrily away. In his nervous, fantastic, imaginative, and apprehensive frame of mind, he imagined he had been injured for life. He feared he had strained a muscle or broken a blood vessel somewhere.

"Good heavens, I can't stand anything like this," he thought. "If the work is going to be this hard I'll have to quit. I wonder what they mean by treating me this way. I didn't come here to do this."

Visions of days and weeks of back-breaking toil stretched before him. It would never do. He couldn't stand it. He saw his old search for work coming back, and this frightened him in another direction. "I mustn't give up so easily," he counseled himself in spite of his distress. "I have to stick this out a little while anyhow." It appeared to him in this first trying hour as though he were between the devil and the deep sea.

He went slowly down into the yard to find Jeffords and Duncan. When he came to them they were working at a car, one inside, receiving lumber to be piled, the other bringing it to him.

"Get down, Bill," said John, who was on the ground looking up at his partner indifferently. "You get up there, new man. What's your name?"

"Witla," said Eugene.

"Well, my name's Duncan. We'll bring this stuff to you and you pile it."

It was more heavy lumber, as Eugene apprehensively observed, quarter-cut joists for some building—"four by fours" they called them—but after he was shown the art of handling them they were not unmanageable. There were methods of sliding and balancing them which relieved him of a great quantity of labor. Eugene had not thought to provide himself with gloves though, and his hands were being cruelly torn. He stopped once to pick a

splinter out of his thumb and Jeffords, who was coming up, asked, "Ain't cha got no gloves?"

"No," said Eugene, "I didn't think to get any."

"Your hands'll get pretty well banged up, I'm afraid. Maybe Joseph'll let you have his for today. You might go in and ask him."

"Who's Joseph?" asked Eugene.

"He's inside there. He's taking from the plane."

Eugene did not understand this, quite. He knew what a plane was—had been listening to it sing mightily all morning, the shavings flying as it smoothed the boards, but *taking?*

"Where's Joseph?" he asked of the plane driver.

He nodded his head to a tall hump-shouldered boy of perhaps twenty-two. He was a big, simple, innocent looking fellow. His face was long and narrow, his mouth wide, his eyes a watery blue, his hair a shock of brown, loose, and wavy threads with a good sprinkling of saw-dust in it. About his waist was a big piece of hemp bagging, tied by a sisal grass rope. He wore an old, faded wool cap with a large visor in order to shield his eyes from flying chips and dust, and when Eugene came in, one hand was lifted protectingly to shield his eyes.

Eugene approached him deprecatingly.

"One of the men out in the yard said that you might have a pair of gloves you would lend me for today. I'm piling lumber and it's tearing my hands. I forgot to get a pair."

"Sure," said Joseph genially, waving his hand to the driver to stop. "They're over here in my locker. I know what that is. I been there. When I come here they rubbed it into me jist as they're doin' to you. Doncher mind. You'll come out all right. Up here for your health, are you? It ain't always like that. Somedays there ain't most nothin' to do here. Then some days again there's a whole lot. Well, it's good healthy work, I can say that. I ain't most never sick. Nice fresh air we git here and all that."

He rambled on, fumbling under his bagging apron for his keys, unlocking his locker, and producing a great pair of old yellow lumber gloves. He gave them to Eugene cheerfully and the latter thanked him. He liked Eugene at once and the latter liked him. "A nice fellow, that," he said as he went back to his car. Think of how genially he gave him these. Lovely! If only all men were genial and kindly disposed, as was this boy. How nice the world would be.

He put on the gloves and found his work instantly easier, for he could grab the joists firmly and without pain. He worked on until noon when the whistle blew and he ate a dreary lunch, sitting off by himself to one side, pondering. After one, he was called to carry shavings, one basket after another,

back through the blacksmith shop to the engine room in the rear, where was a big shaving bin. By four o'clock he had seen almost all the characters he was going to associate with for the time that he stayed here—Harry Fornes, the blacksmith or "the village smith," as Eugene came to call him later on; Jimmy Sudds, the blacksmith's helper or "maid of all work," as he promptly named him; John Peters, the engineer; Malachi Dempsey, the driver of the great plane; Joseph Mews; and in addition, carpenters, tin smiths, plumbers, painters, and those few exceptional cabinet workers who passed through the lower floor now and then, men who were about the place from time to time and away from it at others—all of whom took note of Eugene at first as a curiosity.

Eugene was himself intensely interested in the characters of the men. Harry Fornes and Jimmy Sudds attracted him especially. The former was an undersized American of distant Irish extraction on his mother's side who was so broad chested, swollen armed, square jawed, and generally self-reliant and forceful as to seem a minor Titan. He was remarkably industrious, turning out a great deal of work, and beating a piece of iron with a resounding lick which could be heard all about the hills and hollows outside. Jimmy Sudds, his assistant, like his master was equally undersized, dirty, gnarled, twisted, his teeth showing like a row of yellow snags, his ears standing out like small fans, his eye askew, but nevertheless with so genial a look in his face as to disarm criticism at once. Everybody liked Jimmy Sudds because he was honest, simple minded, and free of malicious intent. His coat was three and his trousers two times too large for him, and his shoes were obviously bought at a secondhand store, but he had the vast merit of being a picture. Eugene was fascinated with him. He learned shortly that Jimmy Sudds truly believed that buffalos were to be shot around Buffalo, New York.

John Peters, the engineer, was another character who fixed Eugene's attention. John was almost helplessly fat and was known for this reason as "Big John." He was a veritable whale of a man. Six feet tall, weighing over three hundred pounds, and standing these summer days in his hot engine room, his shirt off, his suspenders down, his great welts of fat showing through his thin cotton undershirt, he looked as though he might be suffering, but he was not. John, as Eugene soon found, did not take life emotionally. He stood mostly in his engine room door when the shade was there, staring out on the glistering water of the river, occasionally wishing that he didn't need to work but could lie and sleep indefinitely instead.

"Wouldja think them fellers would feel purty good sittin' out there on the poop deck of them there yachts smokin' their perfectos?" he once asked Eugene, apropos of the magnificent private vessels that passed up and down the river.

"I certainly would," laughed Eugene.

"Aw! Haw! That's the life fer yer uncle Dudley. I could do that there with any of 'em. Aw! Haw!"

Eugene laughed joyously.

"Yes, that's the life," he said. "We all could stand our share."

There was Malachi Dempsey—the driver of the great plane was dull, tight mouthed, silent more from lack of ideas than anything else, though oyster-wise, he had learned to recede from all manner of harm by closing the shell of material self tightly. He knew no way to avoid earthly harm save by being preternaturally silent, and Eugene saw this quickly. Eugene used to stare at him for long periods at a time, marvelling at the curiosity his attitude presented. Eugene himself though, as has been said, was a curiosity to the others—even more so than they were to him. He did not look like a workingman and could not be made to do so. His spirit was too high, his eye too flashing and incisive. He smiled at himself, carrying basketful after basketful of shavings from the planing room where it rained shavings, and from which, because of the lack of a shaving blower, they had to be removed back to the hot engine room where Big John presided. The latter took a great fancy to Eugene, but something after the fashion of a dog for a master. He did not have a single idea above his engine, his garden at home, his wife, his children, and his pipe. These and sleep—lots of it—were his joys, his recreations, the totality of his world.

CHAPTER LII

A chronicle of Eugene's experiences here would make a book itself, interesting and valuable, though they would have little place in this story. There were many days now, three months all told, in which he obtained an insight into the workaday world such as he had not previously had. It is true he had worked before in somewhat this fashion, but his Chicago experiences were without the broad philosophic insight which had come to him since. Formerly the hierarchies of powers in the universe and on earth were inexplicable to him—all out of order. But here, where he saw by degrees ignorant, almost animal intelligence being directed by greater, shrewder, and at times it seemed to him possibly malicious intelligences—he was not quite sure about that—who were so strong that the weaker ones must obey them, he began to imagine that, in a rough way, life might possibly be ordered to the best advantage even under this system. It was true that men quarreled here with each other as to who should be allowed to do the improving and

the leading. There was, here as elsewhere, great seeking for the privileges and honors of direction and leadership in such petty things as the ordering of the proper piling of lumber, the planing of boards, the making of desks and chairs—and men were grimly jealous of their talents and abilities in these respects—but in the main it was the jealousy that makes for ordered, intelligent control. All were striving to do the work of intelligence, not of unintelligence. Their pride, however ignorant it might be, was in the superior, not the inferior. They might complain of their work, snarl at each other, snarl at their bosses, but after all it was because they were not able or permitted to do the work and carry out the orders of the higher mind as it was revealed to them. All were striving to do something in a better way, in a superior way, and to obtain the honors and emoluments that come from doing anything in a superior way. If they were not rewarded according to their opinion of their works, there was wrath and opposition and complaint and self-pity, but the work of the superior intelligence was the thing which each, in his blind self-seeking way, was apparently trying to do.

Because Eugene was not so far out of his troubles that he could be forgetful of them, and because he was not at all certain that his talent to paint was ever coming back to him, he was not as cheerful at times as he might have been, but he managed to conceal it pretty well. This one thought with its attendant ills of probable poverty and obscurity was terrible to him: time was slipping away, and youth. But when he was not thinking of this he was cheerful enough. Besides, he had the ability to simulate cheerfulness even when he did not feel it. Because he did not permanently belong to this world of day labor, and because his position which had been given him as a favor was moderately secure, he felt superior to everything about him. He did not wish to show this feeling in any way—was very anxious as a matter of fact to conceal it—but his sense of superiority and ultimate indifference to all these petty details was an abiding thought with him. He went to and fro carrying a basket of shavings, jesting with "the village smith," making friends with "Big John," the engineer, with Joseph, Malachi Dempsey, little Jimmy Sudds, in fact anyone and everyone who came near him who would be friends. He took a pencil one day at the noon hour and made a sketch of Harry Fornes, the blacksmith, his arm upraised at the anvil, his helper, Jimmy Sudds standing behind him, the fire glowing in the forge. Fornes, who was standing beside him, looking over his shoulder, could scarcely believe his eyes.

"Watcha' doin'?" he asked Eugene curiously, looking over his shoulder, for it was at the blacksmith's table, in the sun of his window that he was sitting, looking out at the water. Eugene had bought a lunch box and was carrying with him daily a delectable lunch put up under Mrs. Hibberdell's

direction. He had eaten his noonday meal and was idling, thinking over the beauty of the scene, his peculiar position, the curiosities of this shop—anything and everything that came into his head.

"Wait a minute," he said genially, for he and the smith were already as thick as thieves.

The latter gazed interestedly and finally exclaimed, "W'y that's me, ain't it?"

"Yep," said Eugene.

"Wat are you goin' to do with that wen you get through it?" asked the latter avariciously.

"I'm going to give it to you, of course."

"Say, I'm much obliged for that," replied the smith, delightedly. "Gee, the wife'll be tickled to see that. You're a artist, ain'tcha? I heard a them fellers. I never saw one. Gee, that's good, that looks just like me, don't it?"

"Something," said Eugene quietly, still working.

The helper came in.

"Watcha' doin?" he asked.

"He's drawin' a pitcher, ya rube, wat d'ye suppose he's doin'?" informed the blacksmith authoritatively. "Don't get too close. He's gotta have room."

"Aw! who's crowdin'?" asked the helper irritably.

He realized at once that his superior was trying to shove him in the background, this being a momentous occasion. He did not propose that any such thing should happen.

The blacksmith glared at him irritably but the progress of the artwork was too exciting to permit of any immediate opportunities for hostilities. Jimmy was allowed to crowd close and see.

"Ho! ho! That's you, ain't it?" he asked the smith, curiously, indicating with a grimy thumb the exact position of that dignitary on the drawing.

"Don't," said the latter, loftily. "Sure! He's gotta have room."

"An' there's me. Ho! ho! Gee, I look swell, don't I? Ho! ho!"

The little helper's tushes were showing joyously—a smile that extended far about either side of his face. He was entirely unconscious of the rebuke administered by the smith.

"If you're perfectly good, Jimmy," observed Eugene cheerfully, still working, "I may make a sketch of you some time!"

"Na! Will you? Go on! Say, hully chee! Dat'll be fine, won't it? Say, ho! ho! De folks at home won't know me. I'd like to have a ting like dat, say!"

Eugene smiled. The smith was regretful. This dividing of honors was not quite all that it might be. Still his own picture was delightful. It looked exactly like the shop. Eugene worked until the whistle blew and the belts began to slap and the wheels to whirr. Then he got up.

"There you are, Fornes," he said. "Like it?"

"Gee, it's swell," said the latter and carried it to the locker. He took it out after a bit, though, and hung it up over his bench on the wall opposite his forge, for he wanted every one to see. It was one of the most significant events in his life.

This sketch was the subject immediately of a perfect storm of discussion. Eugene was an artist—could draw pictures—that was a revelation in itself. Then this picture was so life-like. It looked like Fornes and Sudds and the shop. Everyone was interested. Everyone jealous. They could not understand how God had favored the smith in this manner. Why hadn't Eugene sketched them before he did him? Why didn't he immediately offer to sketch them now? Big John came first—tipped off and piloted by Jimmy Sudds.

"Say!" he said, his big round eyes popping with surprise. "There's some class to that, what? That looks like you, Fornes. Jinged if it dont! An' Suddsy. Bless me if there ain't Suddsy. Say, there you are kid, natural as life, damned if you ain't. That's fine. You oughta keep that, smith."

"I intend to," said the latter proudly.

Big John went back to his engine room regretfully.

Next came Joseph Mews, his shoulders humped, his head bobbing like a duck, for he had this habit of nodding when he walked.

"Say, wot d'ye think a' that?" he asked. "Ain't that fine. He kin drawr jist as good as they do in them there magazines. I see them there things in them now an' then. Ain't that swell? Lookit Suddsy, back in there. Eh, Suddsy you're in right, all right. I wisht he'd make a picture a' us out there. We're just as good as you people. Wat's the matter with us, eh?"

"Oh, he ain't goin' to be bothered makin' pictures of you mokes," replied the smith jestingly. "He only draws real ones—you want to remember that, Mews. He's gotta have good people to make sketches of. None o' your half class plane drivers and rip-saw operators."

"Is that so? Is that so?" replied Joseph, contentiously, his love of humor spurred by the light imputation cast upon his ability. "Well, if he was lookin' for real ones he made a mistake w'en he come out here. They're all up front. You don't want to forget that, Smith. They don't live in no blacksmith shops as I ever seen it."

"Cut it out! Cut it out!" called little Suddsy from a position of vantage near the door. "Here comes the boss," and Joseph immediately pretended to be going to the engine room for a drink. The smith blew up his fire as though it were necessary to heat the iron he had laid in the coals. Jack Stix came ambling by.

"Who did that?" he asked, stopping after a single general glance and looking at the sketch on the wall.

"Mr. Witla, the new man," replied the smith, reverently.

"Say, that's pretty good, ain't it?" the foreman replied pleasantly. "He did that well. He must be an artist."

"I think he is," replied the Smith, cautiously. He was always eager to curry favor with the boss. He came near to his side and looked over his arm. "He done it here today at noon in about a half an hour."

"Say, that's pretty good now," and the foreman went on his way, thinking.

If Eugene could do that, why was he here? It must be his run-down condition, sure enough. And he must be the friend of some one high in authority. He had better be civil. Hitherto he had stood in suspicious awe of Eugene, not knowing what to make of him. He could not figure out just why he was here—a spy possibly. Now he thought that he might be mistaken. Eugene was all right, in all likelihood. He would be friendly with him. The next time he met him he exchanged a few words of friendly greeting, for he was thinking that some time Eugene might make a nice sketch of him. The whole shop was keyed up by degrees and from being a queer curiosity, Eugene became in some small measure a hero. He sketched Big John and Jimmy Sudds next, then Joseph Mews, and Malachi Dempsey. By degrees he did everybody of importance—the foreman, the yard foreman, "Bill," and "John," even a study of the shop itself which he gave to the foreman. The latter, having started out to be distant and secretly oppressive, relented entirely and while not daring to disorganize the discipline of the shop by showing Eugene any especial favor over the others in his work, was inclined to play up the need of consideration for him as a sick man.

"Don't let him work too hard," he told Bill and John. "He ain't any too strong yet. He came up here for his health."

He was obeyed in this respect, for there was no gainsaying the wishes of a foreman, but this open plea for consideration was the one thing, if any, which could have weakened Eugene's popularity. The men did not like the foreman. Eugene would have been stronger at any time in the affection of the men if the foreman had been less markedly considerate or against him entirely.

The days which followed were restful enough, though hard, for Eugene found that this constant whirl of work which went on here and of which he had naturally to do his share was beneficial to him. For the first time in several years he slept soundly. He would don his suit of blue overalls and jumper in the morning a few minutes before the whistle blew at seven and from then on until noon, and from one o'clock until six, he would carry shavings, pile lumber for one or several of the men in the yard, load or unload cars, help Big John stoke his boilers, or carry chips and shavings

from the second floor. He wore an old hat which he had found in a closet at Mrs. Hibberdell's—a faded, crumpled memory of a soft tan-colored stetson, which he punched jauntily to a peak and wore over one ear. He had big new yellow gloves which he kept on his hands all day, which were creased and frayed, but plenty good enough for this shop and yard. He learned to handle lumber nicely, to pile with skill, to "take" for Malachi Dempsey from the plane, to drive the rip-saw, and other curious arts. He was tireless in his energy because he was weary of thinking and hoped by sheer activity to beat down and overcome his notion of artistic inability—to forget that he believed he couldn't paint and so be able to paint again. He had surprised himself in these sketches he had made, for his first feeling under the old regime would have been that he could not make them. Here because the men were so eager and he was so much applauded he found it rather easy, and strange to say, he thought they were good.

At the home of Mrs. Hibberdell at night he would lay off all his working clothes before dinner, take a cold bath and don a new brown suit, which because of the assurance of this position he had bought for eighteen dollars, ready-made. He found it hard to get off to buy anything, for his pay ceased (fifteen cents an hour) the moment he left the shop. He had put his pictures in storage in New York and could not get off (or at least did not want to take the time off) to go and sell any. He found that he could leave without question if he wanted no pay, but if he wanted pay and had a good reason he could sometimes be excused. His appearance about the house and yard after six thirty in the evening and on Sundays was distinguished enough. He looked delicate, refined, conservative, and when not talking to someone, lonely and rather wistful. He was lonely and restless, for he felt terribly out of it. This house was lonely. As at Alexandria before he had met Frieda, he was wishing there were some girl about. He wondered where Frieda was, what she was doing, whether she had married. He hoped not. If life had only given him a girl like Frieda—so young, so beautiful.

He would sit and gaze at the water after dark in the moonlight, for this was his one consolation—the beauty of nature—thinking. How lovely it all was. How lovely life was—this village, the summer trees, the shop where he worked, the water, Joseph, little Jimmy, Big John, the stars. If he could only paint again; if he could only be in love again. In love! In love! Was there any other sensation in the world like that of being in love?

A spring evening, say, some soft sweet odours blowing as they were tonight, the dark trees bending down, or the twilight fading angelically— silver, hyacinth, orange; some soothing murmurs of the wind; some faint chirping of tree toads or frogs, and then your girl. Dear God! Could anything be finer than that? Was anything else in life worthwhile? Your girl,

her soft young arms about your neck, her lips to yours in pure love, her eyes speaking like twin pools of color here in the night.

So had it been only a little while ago with Frieda. So had it been once with Angela. So, long ago, with Stella! Dear, sweet Stella, how nice she was. And now here he was, sick and lonely and married, and Angela would be coming back soon—and———. He would get up frequently to shut out these thoughts, and either read or walk or go to bed. But he was lonely, almost irritably so. There was only one true place of comfort for Eugene anywhere, and that was in the springtime in love.

CHAPTER LIII

It was while he was mooning along in this mood, working, dreaming, wishing, that there came to her mother's house one day at Riverwood, Carlotta Wilson—Mrs. Norman Wilson, in the world in which she moved—a tall brunette of thirty-two, handsome after the English fashion of beauty, shapely, graceful, with a knowledge of the world which was not only compounded of natural intelligence and a sense of humor, but of experiences fortunate and unfortunate which had shown her both the showy and the seamy sides of life. To begin with she was the wife of a gambler—a professional gambler—of that peculiar order which essays the role of a gentleman, looks the part, and fleeces unmercifully the unwary partakers of his companionship. Carlotta Hibberdell, living with her mother at that time in Springfield, Massachusetts, had met him at a local series of races which she was attending with her father and mother, and where Wilson happened to be accidentally and upon another mission. Her father, a real estate dealer, and fairly successful at one time, was very much interested in racing horses, and owned several of worthy records, though of no great fame.

Norman Wilson had posed as a real estate speculator himself and had handled several fairly successful deals in land but his principal skills were in gambling. He knew, because of natural taste and intuition, all the tricks, calculations, and slight-of-hand feats that could be performed with cards. In his youth he amused various local gatherings greatly by the skill with which he could make the mystic numbers appear and disappear. Today, at thirty-nine, he never essayed a card trick of any kind, pretended but a passing interest in any game of cards or chance, avoided talk of racing, gambling, card playing as much as possible, and pretended an interest in books, pictures, social life and characteristics. As a matter of fact his principal interest in the city of New York where he lived was gambling. He was familiar with

all the gambling opportunities of the city, knew a large circle of those who liked to gamble, men and women in New York and elsewhere, and his luck or skill at times was phenomenal. At other times it was very bad. There were periods when he could afford to live in the most expensive apartment houses, dine at the best restaurants, visit the most expensive country plea- sure resorts, and otherwise disport himself in the companionship of friends. At other times because of bad luck he could not afford any of these things and though he held to his estate grimly, had to borrow money to do it. He was somewhat of a fatalist in his interpretation of affairs and would hang on with the faith that his luck would turn. It did turn invariably, of course, for when difficulties began to swarm too numerously he would think vigor- ously and would usually generate some idea which served to help him out. His plan was always to spin a web like a spider and await the blundering flight of some unwary fly.

At the time she married him, Carlotta Hibberdell did not know of the peculiar tendencies and subtle obsession of her ardent lover. Like all men of his type he was suave, persuasive, passionate, eager. There was a certain cat-like magnetism to him also which fascinated her. She could not under- stand him at that time and she never did afterwards. The license which he subsequently manifested, not only with her but with others, astonished and disgusted her. She found him selfish, domineering, outside of his own par- ticular field shallow, not at all artistic, emotional, or poetic. He was inclined to insist on the last touch of material refinement in surroundings as far as he understood them when he had money, but she found to her regret that he did not understand them. In his manner with her and everyone else he was toplofty, superior, condescending. His stilted language at times enraged and at other times amused her, and when her original passion passed and she began to see through his pretences to his motives and actions, she became indifferent and then weary. She was too big a woman mentally to quarrel with him much. She was too indifferent to really care. Her one passion was for an ideal lover of some type, and having been thoroughly mistaken in him she looked abroad, wondering whether there were any ideal men.

Various individuals came to their apartments. There were gamblers, blasé society men, mining experts, speculators, sometimes with, sometimes without a wife. From these and from her husband and her own observation she learned of all sorts of scandals, mésalliances, queer manifestations of incompatibility of temper, queer freaks of sex desire—things which would fit in well with the literary galleries compiled by De Maupassant and Zola. Because she was good looking, graceful, easy in her manners, there was no end of proposals, overtures, hints, and luring innuendos cast in her direction. She had long been accustomed to them. Because her husband deserted her

openly for other women and confessed it in a blasé way, she saw no valid reason for keeping herself from other men. She chose her lovers guardedly and with subtle taste, beginning, after mature deliberation, with one who pleased her greatly. As was natural she chose them from another world than that in which her husband moved—literary and art circles preferably, and from the medical, legal, educative, and scientific professions. She was seeking refinement, emotion, understanding, coupled with some ability, and these were not so easy to find. The long record of her liaisons is not for this story but their impress on her character was important.

She was indifferent in her manner at most times and to most people. A good jest or story drew from her a hearty laugh. She was not interested in books except those of a very exceptional character—the realistic school—and these she thought ought not to be permitted, except to private sub-scribers. Nevertheless she cared for no others. Art was fascinating—the really great art. She loved the pictures of Rembrandt, Frans Hals, Correggio, Tintoretto, Titian. *The Noble Slav* seemed a great portrait to her, as did some of the pictures of Whistler and Vélasquez. She sincerely admired Cabanel, Bouguereau, Daubigny, Corot, Gérôme, and Inness. To her there was reality in the works of these men, lightened by great imagination. Mostly people interested her, the vagaries of their minds, the idiosyncrasies of their characters, their lies, their subterfuges, their pretences, their fears. She knew that she was a dangerous woman and went softly, like a cat, wearing a half-smile not unlike that seen on the lips of *Mona Lisa,* but she did not worry about herself. She had too much courage. At the same time she was tolerant, generous to a fault, charitable. When someone suggested that she overdid the tolerance, she replied, "Why shouldn't I? I live in such a magnificent glass house."

The reason for her visit home on this occasion was that her husband had practically deserted her for the time being. He was in Chicago for some reason—principally because the atmosphere in New York was getting too hot for him, as she suspected. Because she hated Chicago and was weary of his company she refused to go with him. He was furious, for he suspected her of liaisons but he could not help himself. She was indifferent. Besides, she had other resources than those he represented, or could get them.

A certain wealthy Jew had been importuning her for years to get a divorce in order that he might marry her. His car and his resources were at her command but she condescended only the vaguest courtesies. It was within the ordinary possibilities of the day for him to call her up and ask if he could not come with his car or if she would not use it. He had three. She waved it all aside indifferently. "What's the use?" was her pet inquiry. Her husband was not without his car at times. She had means to drive where

she pleased, dress as she liked, and was invited to make one of many inter-esting outings. Her mother knew well of her peculiar attitude, her marital trouble, her quarrels, and her tendency to flirt. She did her best to keep her in check for she wanted to retain for her the privilege of obtaining a divorce and getting married in a distinguished manner. Norman Wilson would not readily give her a legal separation even though the preponder-ance of evidence was against him and if she compromised herself there would be no hope. Mrs. Hibberdell half suspected that her daughter might already have compromised herself, but she could not be sure. Carlotta was too subtle. Norman made open charges in their family quarrels but they were based largely on jealousy. He did not know for sure. He could prove some extended automobile tours and midnight suppers, in some cases under peculiar or suspicious circumstances, but there was no actual evidence of open immorality. So the situation stood.

Mrs. Wilson had heard of Eugene. She did not know of him by reputa-tion but her mother's guarded remarks in regard to him and his presence, the fact that he was an artist, that he was sick and working as a laborer for his health, aroused her interest. She had intended to spend the period of her husband's absence in Narragansett with some friends but before doing so she decided to come home for a few days just to see for herself. Instinctively her mother suspected curiosity on her part in regard to Eugene. She threw out the remark that he might not stay long, in the hope that her daughter would lose interest. His wife was coming back. Carlotta sensed this opposi-tion—this desire to keep her away. She decided she would come.

"I don't know that I want to go to Narragansett just now," she told her mother. "I'm tired. Norman has just worn my nerves to a frazzle. I think I'll come up home for a week or so."

"All right," said her mother, "but you be careful how you act, now. This Mr. Witla appears to be a very nice man and he's happily married. Don't you go casting any looks in his direction. If you do I won't let him stay there at all."

"Oh, how you talk," replied Carlotta irritably. "Do give me a little credit for something. I'm not going up there to see him. I'm tired, I tell you. If you don't want me to come, I won't."

"It isn't that, I do want you. But you know how you are. How do you ever expect to get free if you don't conduct yourself conservatively? You know that you——"

"Oh, for heaven's sake I hope you're not going to start that old argument again," exclaimed Carlotta defensively. "What's the use beginning on that? We've been all over it a thousand times. I can't go anywhere or do anything but what you want to fuss. You know whether I have a right to or not. Now

I'm not coming up there to do anything but rest. Why will you always start in to spoil everything?"

"Well now, you know well enough, Carlotta," reiterated her mother.

"Oh, chuck it. I'll not come. To hell with the house. I'll go to Narragansett. You make me tired!"

Her mother looked at her tall daughter, graceful, handsome, her black hair parted in rich folds after the simple manner of the Greeks, irritated and yet pleased with her force and ability. If she would only be conservative and careful, what a figure she might not yet become. Her complexion was like old rose-tinted ivory, her lips the color of dark raspberries, her eyes bluish gray, wide set, large, sympathetic, kindly. What a pity she had not married some big, worthy man to begin with. To be tied up to this gambler, even though they did live in Central Park West and had a comparatively sumptuous apartment, was a wretched thing. Still it was better than poverty or scandal and if she did not take care of herself, both might ensue. She wanted her to come to Riverwood for she liked her company, but she wanted her to behave herself. Perhaps Eugene would save the day. He was certainly conservative enough in his manner and remarks. She went back to Riverwood, and Carlotta, because the quarrel was smoothed over by her mother, came.

Eugene did not see her during the day she arrived, being at work, and she did not see him as he came in at night. He had on his old peaked hat and carried his handsome leather lunch box jauntily in one hand. He went to his room, bathed, dressed, and then out on the porch to await the call of the dinner gong. Mrs. Hibberdell was in her room on the second floor and "Cousin Dave," as Carlotta called Simpson, was in the back yard. It was a lovely twilight. Eugene was in the midst of deep thoughts about the beauty of the scene, his own loneliness, the characters at the shop, work, Angela, and what not, when the screen door opened and Carlotta stepped out. She had on a short sleeved house dress of dotted blue silk with a collarette of yellow lace set about the neck and the ends of the sleeves. Her shapely figure, beautifully harmonized to her height—she weighed 150 pounds and was five feet nine inches tall—was set in a smooth, close fitting corset. Her hair, laid in great braids at the back, was caught in a brown spangled net. She carried herself with great ease and simplicity, seeming naturally indifferent.

Eugene got up. "I'm in your way, I think. Won't you have this chair?"

"No, thanks. This one in the corner will do me. But I might as well introduce myself since there isn't anyone here to do it. I'm Mrs. Wilson, Mrs. Hibberdell's daughter. You're Mr. Witla."

"Yes, I answer to that," said Eugene, smiling.

He was not very much impressed at first. She seemed nice and, he fancied, intelligent—a little older than he cared to interest himself in. She sat down and looked at the water. He took his chair and held his peace. He was not even interested to talk to her. She was nice to look at, however. Her presence lightened the scene for him.

"I always like to come up here," she volunteered finally. "It's so warm in the city these days. I don't think many people know of this place. It's out of the beaten track."

"I enjoy it," said Eugene. "It's surely a rest for me. I don't know what I would have done if your mother hadn't taken me in. It's rather hard to find any place, doing what I am."

"You've taken a pretty strenuous way to get health, I should say," she observed. "Day labor sounds rough to me. Do you mind it?"

"Not at all. I like it. The work is interesting and not so very hard. It's all so new to me; that's what makes it easy. I like the idea of being a day laborer and associating with laborers. It's only because I'm run down in health that I worry any. I don't like to be sick."

"It is bad," she replied, "but this will probably put you on your feet. I think we're always inclined to look on our present troubles as the worst. I know I am."

"Thanks for the consolation," he said.

She did not look at him and he rocked to and fro silently. Finally the dinner gong struck, Mrs. Hibberdell came downstairs, and they went in.

* * *

The conversation at the first meal was pleasant enough—very entertaining to Eugene, for he was always interested in the wit of Davis Simpson and Mrs. Hibberdell's shrewd observations. The conversation turned on his work for a few moments and he described accurately the personalities of John and Bill and of Big John the engineer, and little Suddsy and Harry Fornes, the blacksmith. Carlotta listened attentively without appearing to, for everything about Eugene seemed singular and exceptional to her. She liked his tall, spare body, his lean hands, his dark hair and eyes. She liked the idea of his dressing as a laboring man in the morning, working all day in this, to her, grimy shop, and yet appearing so neat and trim at dinner. He was so easy in his manner, so apparently lethargic in his movements, and yet she could feel a certain swift force there that filled the room. It was richer for his presence. She understood at a glance that he was an artist, in all probability a good one. He said nothing of that, avoided carefully all reference to his art ability, and listened attentively to everyone else. She felt though as if he were studying her and everyone else and it made her gayer. At the same

time she had a strong leaning toward him because he was so nice. "What an ideal man to be associated with," was one of her repeated thoughts.

Although she was about the house for ten days and he met her, after the third morning, not only at dinner, which was natural enough, but at break-fast (which surprised him a little), he paid not so very much attention to her. She was nice, very, but Eugene was thinking of another type. He thought she was uncommonly pleasant and considerate and he admired her style of dressing and her beauty. "She seems to have a lot of clothes," he thought, for she appeared at breakfast in three styles of morning gowns and two differ-ent kimonos. At dinner she appeared to be invariably dressed in something new—becoming blues, blacks, white and black stripes, pearl grays—and she carried herself with infinite grace. Her chair was always near his and she served him attentively, anticipating his wishes with ease and security. She talked to him of art, books, people, listened to his descriptions of work, and smiled that curious non-interpretive smile which he had first noticed the night she sat down to dinner. If he went out on the porch after breakfast for a moment, she was apt to come out "to sniff the morning air," as she said. If he stayed in to read at night or sat in a corner of the porch, she came. She made no excuses or apologies for her presence—simply drew up a chair and sat down. He studied her interestedly, thinking of Frieda, wondering what sort of a life she led, for from the various bits of conversation he overheard not only at table but at other times he judged she was fairly well-to-do. There was an apartment in Central Park West, card parties, automobile parties, theatre parties, and a general sense of people—acquaintances anyhow—who were making money. He heard her talk of a mining engineer, Dr. Rowland; of a successful coal mining speculator, Gerald Woods; of a Mrs. Hale, who was heavily interested in copper mines and apparently very wealthy. "It's a pity Norman couldn't connect with something like that and make some real money," he heard her say to her mother one evening. He understood that Norman was her husband and that he would probably be back soon. So he kept his distance—interested and curious but little more.

Mrs. Wilson was not so easily baffled however. A car appeared one eve-ning at the door immediately after dinner, a great red touring car, and Mrs. Wilson announced easily, "We're going for a little spin after dinner, Mr. Witla; don't you want to come along?"

Eugene had never ridden in an automobile at that time. "I'd be very pleased," he said, for the thought of a lonely evening in an empty house had sprung up when he saw it appear.

There was a chauffeur in charge—a gallant figure in a brown straw cap and tan linen duster, but Mrs. Wilson maneuvered for place.

"You sit with the driver, coz," she said to Simpson, and when her mother stepped in she followed after, leaving Eugene the place to the right of her.

"There must be a coat and cap in the locker," she said to the chauffeur. "Let Mr. Witla have it."

The latter extracted a spare linen coat and straw cap which Eugene put on.

"I like automobiling, don't you?" she said to Eugene good-naturedly. "It's so refreshing. If there is any rest from care on this earth it's in traveling fast."

"I've never ridden before," replied Eugene simply.

Something about the way he said it touched her. She felt sorry for him because he appeared lonely and gloomy. His indifference to her piqued her curiosity and irritated her pride. Why shouldn't he take an interest in her? As they sped under leafy lanes, up hill and down dale, she made out his face in the starlight. It was pale, reflective, indifferent. "These deep thinkers!" she chided him. "It's terrible to be a philosopher."

Eugene smiled.

When they reached home he went to his room, as did all the others to theirs. He stepped out in the hall a few minutes later to go to the library for a book and found that her door, which he had to pass, was wide open. She was sitting back in a Morris chair, her feet upon another chair, her skirts slightly drawn up, revealing a trim foot and ankle. She did not stir but looked up and smiled winningly.

"Aren't you tired enough to sleep?" he asked.

"Not quite yet," she smiled.

He went downstairs and, turning on a light in the library, stood looking at a row of books, reading the titles. He heard a step and there she was, looking at the books also. "Don't you want a bottle of beer?" she asked. "I think there is some in the ice box. I forgot that you might be thirsty."

"I really don't care," he said. "I'm not much for drinks of any kind."

"That's not very sociable," she laughed.

"Let's have the beer then," he said.

She threw herself back languidly in one of the big dining room chairs when she had brought several bottles and some Swiss cheese and crackers and said, "I think you'll find some cigarettes on the table in the corner if you like. You don't smoke though, do you? You don't mind if I do?"

"Certainly not," said Eugene. "I rather like it. I don't like tobacco for myself but do for others."

He struck her a match and she puffed her cigarette comfortably. "I suppose you find it lonely up here—away from all your friends and companions," she volunteered.

"Oh, I've been sick so long I scarcely know whether I have any."

He described some of his imaginary ailments and experiences and she listened to him attentively. When the beer was gone she asked if he would

have more but he said no, he believed not. After a time, because he stirred wearily, she got up.

"Your mother will think we're running some sort of a midnight game down here," he volunteered.

"Mother can't hear," she said. "Her room is on the third floor and besides, she doesn't hear very well. Dave don't mind. He knows me well enough by now to know that I do as I please."

She stood close to Eugene but still he did not see. When he moved away she put out the lights and followed him to the stairs. "He's either the most bashful or the most indifferent of men," she thought, but she said softly, "Good night. Pleasant dreams to you," and went her way.

Eugene thought of her now as a good fellow, a little gay for a married woman, but probably conservative withal. She was simply being nice to him. All this was simply because, as yet, he was not very much interested.

There were other incidents. One morning he passed her door—her mother had already gone down to breakfast—and there was the spectacle of a smooth, shapely arm and shoulder, quite bare to his gaze, as she lay on her pillow, apparently unconscious that her door was open. It thrilled him as something sensuously beautiful for it was a perfect arm. Another time he saw her of an evening just before dinner, buttoning her shoes. Her dress was pulled three-quarters of the way to her knees, and her shoulders and arms were bare for she was still in her corset and short skirts. She seemed not to know that he was about the place. One night after dinner he started to whistle something and she went to the piano to keep him company. Another time he hummed on the porch and she started the same song, singing with him. He drew his chair near the window where there was a couch after her mother had retired for the night, and she came and threw herself on it. "You don't mind if I lie here," she said. "I'm tired tonight."

"Not at all. I'm glad to have you. I'm lonely."

She lay and stared at him, smiling. He hummed and she sang. "Let me see your palm," she said. "I want to learn something." He held it out. She fingered it temptingly. Even that did not wake him.

She left for five days, however, because of some necessity in connection with her engagements, and when she returned he was glad to see her. He had been lonesome and he knew now that she made the house gayer. He greeted her genially.

"I'm glad to see you back," he said.

"Are you really?" she replied. "I don't believe it."

"Why not?" he asked.

"Oh, signs, omens, and portents. You don't like women very well, I fancy."

"Don't I?"

"No, I think not," she replied.

She was charming in a soft grayish green satin. He noticed that her neck was beautiful and that her hair looped itself gracefully upon the back of it. Her nose was straight and fine, sensitive because of its thin partitioning walls. He followed her into the library and they went out on the porch. Presently he returned—it was ten o'clock—and she came also. Davis had gone to his room, Mrs. Hibberdell to hers.

"I think I'll read," he said, aimlessly.

"Why anything like that?" she jested. "Never read when you can do anything else."

"What else can I do?"

"Oh, lots of things. Play cards, tell fortunes, read palms, drink beer——." She looked at him willfully.

He went to his favorite chair near the window, side by side with the window-seat couch. She came and threw herself on it.

"Be gallant and fix my pillows for me, will you?" she asked.

"I surely will," he said.

He took one and raised her head, for she did not deign to move.

"Is that enough?" he inquired.

"One more."

He put his hand under the first pillow and lifted it up. She took hold of his free hand to raise herself. When she had it, she held it and laughed a curious excited laugh. It came over him all at once, the full meaning of all the things she had been doing. He dropped the pillow he was holding and looked at her steadfastly. She relaxed her hold and leaned languorously, smiling. He took her left hand, then her right, and sat down beside her. In a moment he slipped one arm under her waist and bending over, put his lips to hers. She twined her arms about his neck tightly and hugged him close. There was intense fondling and then, looking in his eyes, she heaved a great sigh.

"You love me, don't you?" he asked.

"I thought you never would," she sighed, and pulled him to her again.

CHAPTER LIV

The form of Carlotta Wilson was perfect, her passion eager, her subtlety a match for almost any situation. She had deliberately set out to win Eugene because he was attractive to her and because, by his early indiffer-

ence, he had piqued her vanity and self-love. She liked him though, every one of his characteristics, and was as proud of her triumph as a child with a new toy. When he had finally slipped his arm under her waist she had thrilled with a burning, vibrating thrill throughout her frame and when she came to him it was with the eagerness of one wild for his caresses. She threw herself on him, kissed him sensuously scores of times, whispered her desire and her affection. Eugene thought, now that he saw through the medium of an awakened passion, that he had never seen anything more lovely. For the time being he forgot Frieda, Angela, his loneliness, the fact that he was working in supposed conservative self-restraint to effect his recovery, and gave himself up to the full enjoyment of this situation.

Carlotta was tireless in her attentions. Once she saw that he really cared, or imagined he did, she dwelt in the atmosphere of her passion and affection. There was not a moment that she was not with or thinking of Eugene when either was possible. She lay in wait for him at every turn, gave him every opportunity for the display of his desire and her own which her skill could command. She knew the movements of her mother and cousin to the least fraction—could tell exactly where they were, how long they were apt to remain, how long it would take them to reach a certain door or spot from where they were standing. Her steps were noiseless, her motions and glances significant and interpretive. For a month or thereabouts she guided Eugene through the most perilous situations, keeping her arms about him to the last possible moment, kissing him silently and swiftly at the most unexpected times and in the most unexpected places. All her weary languor disappeared—her seeming indifference—and she was very much alive, except in the presence of others. Then her old manner remained, intensified even, for she was determined to throw a veil of darkness over her mother's and her cousin's eyes. She succeeded admirably for the time being, for she lied to her mother out of the whole cloth, pretending that Eugene was nice but a little slow so far as the ways of the world were concerned. "He may be a good artist," she volunteered, "but he isn't very much of a ladies' man. He hasn't the first trace of gallantry."

Mrs. Hibberdell was glad. At least there would be no disturbance here. She feared Carlotta, feared Eugene, but she saw no reason for complaint. In her presence all was seemingly formal and at times almost distant. She did not like to say to her daughter that she should not come to her own home. Now that Eugene was here she did not like to tell him to leave. Carlotta told her that she liked him fairly well but that was nothing. Any married woman might do that. Yet under her very eyes was going forward the most disconcerting license. She would have been astounded if she had known the manner in which the bath, Carlotta's chamber, and Eugene's room were being used. The hour never struck when they were alone but what they

were together, and Eugene's strength, instead of picking up as it had been for some little while now, began to fall back again.

Besides, he grew very indifferent in the matter of his work. From getting to the place where he was enjoying it because he looked upon it as a form of exercise which was benefitting him, and feeling that he might not have to work indefinitely if he kept up this physically constructive pace, he grew languid about it and moody over the time he had to give to it. Carlotta had the privilege of a certain automobile and besides she could afford to hire one of her own. She began by suggesting that he meet her at certain places and times for a little spin and this took him away from his work a good portion of the time.

"You don't have to work every day, do you?" she asked him one Sunday afternoon when they were alone together. Simpson and Mrs. Hibberdell had gone out for a walk and they were in her private room on the second floor.

"I don't have to," he said, "if I don't mind losing the money they pay. It's fifteen cents an hour and I need that. I'm not working at my regular profession, you want to remember."

"Oh, chuck that," she said. "What's fifteen cents an hour? I'll give you ten times that to come and be with me."

"No, you won't," he said. "You won't give me anything. We won't go anywhere on that basis."

"Oh, Eugene how you talk. Why won't you?" she asked. "I have lots of money—at least lots more than you have just now. And it might as well be spent this way as some other. It won't be spent right anyhow—that is, not for any exceptional purpose. Why shouldn't you have some of it? You can pay it back to me."

"I won't do it," said Eugene. "I'd rather go and work. It's all right, though. I can sell a picture, maybe. I expect to hear any day of something being sold. What is it you want to do?"

"I want you to come automobiling with me tomorrow. Ma is going over to her sister Ella's in Brooklyn. Has that shop of yours a phone?"

"Sure it has. I don't think you'd better call me up there though."

"Once wouldn't hurt."

"Well, perhaps not. But we'd better not begin that or at least not make a practice of it. These people are very strict. They have to be."

"I know," said Carlotta. "I won't. I was just thinking. I'll let you know. You know that river road that runs on the top of the hill over there?"

"Yes."

"You be walking along there tomorrow at one o'clock and I'll pick you up. You can come this once, can't you?"

"Sure," said Eugene. "I can come. I was just joking. I can get some

money." He had still his hundred dollars which he had not used when he first started looking for work. He had been clinging to it grimly, but now in this lightened atmosphere he thought he might spend some of it. He was going to get well. Everything was pointing that way. His luck was with him.

"Well, I'll get the car. You don't mind riding in that, do you?"

"No," he said, "I'll wear a good suit to the shop and change over there."

She laughed gaily for his scruples and simplicity amused her.

"You're a prince—my Prince Charming," she said, and she flung herself in his lap. "Oh, you angel man, heaven born! I've been waiting for you I don't know how long. Wise man! Prince Charming! I love you! I love you! I think you're the nicest thing that ever was."

Eugene caressed her gently.

"And you're my wise girl. But we are no good, neither you nor I. You're a wastrel and a stray. And I—I hesitate to think what I am."

"What is a wastrel?" she asked. "That's a new one on me. I don't remember."

"Something or someone that can be thrown away as useless. It was first applied to a child growing up in ignorance I think—a street arab. A stray is a pigeon that won't stay with the flock."

"That's me," said Carlotta, holding out her fine, smooth arms before her and grinning mischievously. "I won't stay with any flock. Nix for the flocks. I'd rather be off with my wise man. He's nice enough for me. He's better nor nine or ten flocks." (She was using corrupt English for the joy of it.) "Just me and you, Prince Charming. Am I your lovely little wastrel? Do you like strays? Say, do you? Listen? Do you like strays?"

Eugene had been turning his head away, saying, "Scandalous!" "Terrible," "You're the worst ever," but she stopped his mouth with her lips.

"Do you?"

"This wastrel, yes. This stray," he replied, smoothing her cheeks. "Ah, you're lovely, Carlotta, you're beautiful. What a wonderful woman you are."

She gave herself to him completely.

"Whatever I am, I'm yours, wise man," she went on. "You can have anything you want of me, do anything you please, with me. You're like an opiate to me, Eugene, sweet! You stop my mouth and close my eyes and seal my ears. You make me forget everything. I suppose I might think now and then, but I don't want to. I don't want to! And I don't care. I wish you were single. I wish I were free. I wish we had an island somewhere together. Oh, hell! Life is a wearisome tangle, isn't it? 'Take the cash and let the credit go.'" She was quoting Omar.

By this time Carlotta had heard enough of Eugene's life to understand what his present condition was. She knew he was sick, though not exactly why. She thought it was due to overwork. She knew he was out of funds except for certain pictures he had on sale but that he would regain his art ability and reestablish himself she did not doubt. She knew something of Angela and thought it was all right that she should be away from him, but now she wished it might be permanent. She went in to the city and, asking about at various art stores, learned something of Eugene's art history and his great promise. It made him all the more fascinating in her eyes. One of his pictures on exhibition at Pottle Frères was bought by her after a little while and the money sent to Eugene, for she had learned from him how these pictures, any pictures, were exhibited on sale and the painter paid, minus the commission, when the sale was made. She took good care to indicate to the manager at Pottle Frères that she was doing this so that Eugene could have the money and he saw to it that the check reached him promptly. If Eugene had been alone this check of three hundred dollars would have served to bring on Angela. As it was, it gave him funds to disport himself with in Carlotta's company. He did not know that she had been the means of his getting it or to whom the picture had been sold. A fictitious name was given. This sale somewhat restored Eugene's faith in his future, for if one of his pictures would sell at this late date for this price, others would.

There were days thereafter of the most curious composition. In the morning he would leave, dressed in his old working suit and carrying his lunch basket, Carlotta waving him a farewell from her window (or, if he had an engagement outside with Carlotta, wearing a good suit, and trusting to his overalls and jumper to protect it), and working all day with John and Bill, or Malachi Dempsey and Joseph—for there was a rivalry between these two groups as to which should have his company—or leaving the shop early and riding with her a part of the time and then coming home at night to be greeted by Carlotta as though she had not seen him at all. She watched for his coming as patiently as a wife and was eager to see if there was anything she could do for him. In the shop Malachi and Joseph, or John and Bill, and sometimes some of the carpenters upstairs, would complain of a rush of work in order that they might have his assistance or presence. Malachi and Joseph could always enter up the complaint that they were in danger of being hampered by shavings, for the latter were constantly piling up in great heaps, beautiful shavings of ash and yellow pine and walnut, which smelled like resin and frankincense and had the shapes of girls' curls or dry breakfast food, or rich damp sawdust. Or John and Bill would complain that they were being overworked and needed someone in the car to receive. Even Big John, the engineer, tried to figure out some scheme by which he could

utilize Eugene as a fireman, but that was impossible. There was no call for any such person. The foreman understood well enough what the point was but said nothing, placing Eugene with the particular group which seemed to need him most. Eugene was genial enough about the matter. Wherever he was, was right. He liked to be in the cars or on a lumber pile or in the plane room. He also liked to stand and talk to Big John or Harry Fornes, his basket under his arm—"kidding," as he called it. His progress to and fro was marked by endless quips and jests and he was never weary.

When his work was done at night he would hurry home, following the right bank of the little stream until he reached a path which led up to the street whereon was the Hibberdell home. On his way he would sometimes stop and study the water, its peaceful current bearing an occasional stick or straw upon its bosom, and contrasting the seeming peace of its movement with his own troubled life. The subtlety of nature as expressed in water appealed to him. The difference between this idyllic stream bank and his shop and all who were of it struck him forcefully. Malachi Dempsey had only the vaguest conception of the beauty of nature. Jack Stix was scarcely more artistic than the raw piles of lumber with which he dealt. Big John had no knowledge of the rich emotions of love of beauty which troubled Eugene's brain. They lived on another plane apparently.

And at the other end of the stream awaiting him was Carlotta, graceful, sophisticated, enthusiastic in her regard for him, luke-warm in her interest in morals, sybaritic in her moods, representing in a way a world which lived upon the fruits of this exploited toil at the bottom and caring nothing about it. If he said anything to Carlotta about the condition of Joseph Mews, who carried bundles of wood home to his sister of an evening to help save the expense of fuel, she merely smiled. If he talked of the poverty of the mass she said, "Don't be so doleful, Eugene." She wanted to talk of art and luxury and love, or think of them at least. Her love of the beauty of nature was keen. There were certain inns they could reach by automobile where they could sit and dine or drink, a bottle of sparkling burgundy or champagne or a pitcher of claret cup—any of these being favorite with her—and here she would muse on what they would do if they were only free.

Angela was frequently in Carlotta's thoughts, and persistently in Eugene's, for he could not help feeling that he was doing her a rank injustice. She had been so patient and affectionate all this long time past, had tended him as a mother, waited on him as a servant. Only recently he had been writing, in most affectionate terms, wishing she were with him. Now all that was dead again. It was hard work to write. Everything he said seemed a lie and he did not want to say it. He hated to pretend. Still if he did not write, Angela would be in a state of mortal agony, he thought, and would

shortly come on to look him up. It was only by writing her, protesting his affection, explaining why in his judgement it was inadvisable for her to come at present, that she could be made to stay where she was. And now that he was so infatuated with Carlotta this seemed very desirable. He did not delude himself that he would ever be able to marry her. He knew that he could not get a divorce, there being no grounds, and the injustice to Angela being such a bar to his conscience; and as for Carlotta, her future was very uncertain. Norman Wilson, for all that he disregarded her at times, did not want to give her up. He was writing her, threatening to come back to New York if she did not come to him, though the fact that she was in her mother's home where he considered her safe was some consolation to him. Angela was writing Eugene, begging him to let her come. They could get along, she argued, on whatever he got and he would be better off with her than alone. She pictured him living in some uncomfortable boarding house where he was not half attended to and intensely lonely. Her return meant the leaving of this lovely home, for Mrs. Hibberdell had indicated that she would not like to keep him and his wife, and the end of this perfect romance with Carlotta. An end to lovely country inns and summer balconies where they were dining together! An end to swift tours in her automobile which she guided skillfully herself, avoiding the presence of a chauffeur! An end to lovely trysts under trees and by pretty streams where he kissed and fondled her and where she lingered joyously in his arms!

"If ma could only see us now," she would jest, or,

"Do you suppose Bill and John would recognize you here if they saw you?"

Once she said: "This is better than the engine room, isn't it?"

"You're a bad lot, Carlotta," he would declare, and there would come to her lips the enigmatic smile of Mona Lisa.

"You like bad lots, don't you? Strays make fine hunting."

In her own philosophy, she was taking the cash and letting the credit go.

CHAPTER LV

Days like this could not go on forever. Because of the very fact that the seed of their destruction was in their beginning, Eugene was sad. He used to look his mood at times, and if Carlotta asked him what was the matter, would say, "We can't keep this thing up much longer. It must come to an end soon."

"You're certainly a gloomy philosopher, Genie," she would reproach, for she had hopes that it could be made to last a long while under any circumstance. Eugene had the feeling that no pretence would escape Angela's psychology. She was too sensitive to his unspoken moods and feelings. She would come soon willy-nilly, and then all this would be ended. As a matter of fact, change and conclusion eventuated from several sources.

For one thing Mrs. Hibberdell had been more and more impressed by the fact that Carlotta was not only interested or content to stay here all summer, but once having come, that she was fairly determined to remain. She had her own apartment in the city, ostensibly closed for the summer, for she had protested that it was too hot to live in town when she first proposed going to Narragansett. After seeing Eugene she figured out a possible use for it; though that use was dangerous, for Norman Wilson might return at any time. Nevertheless they had been there on occasion—and this with the double effect of deceiving her mother and entertaining Eugene. If she could remain away from Riverwood a percentage of the time, as she argued with Eugene, it would make her stay less suspicious and would not jeopardize their joy in companionship. So they did this. At the same time she could not stay away from Riverwood entirely, for Eugene was there necessarily morning and evening, and she had protested it was cooler. Besides she had managed her deceits so well that all appeared serene and lovely.

Nevertheless, toward the end of August, Mrs. Hibberdell was growing suspicious. She had seen an automobile entering Central Park once when Carlotta had phoned her that she had a sick headache and could not come up. It looked to Mrs. Hibberdell, who had gone downtown shopping on the strength of this ailment and who had phoned Carlotta that she was going to call at her apartment in the evening, as though Eugene and Carlotta were in it. Eugene had gone to work that morning, which made it seem doubtful, but it certainly looked very much like him. Still she did not believe it was he or Carlotta either. When she came to the latter's apartment Carlotta was there, feeling better but stating that she had not been out. Mrs. Hibberdell concluded thoughtfully that she might have been mistaken.

Another time coming home early in the afternoon from a shopping tour, she found Eugene home from work. He was in his room lying down, Carlotta said, for he was not feeling well and there was no evidence of anything out of the way. Nevertheless a certain nonchalance in Carlotta's attitude, assumed for the occasion and just the least bit nervously overdone, attracted Mrs. Hibberdell's attention. She attached no great significance to it at the time, however, for there was nothing else to connect it with, but afterward it was all plain enough. It fitted in well with other things which she discovered. Her own room was on the third floor and several times after all had retired and

she had come down to the kitchen or dining room or library for something, she had heard a peculiar noise as of someone walking lightly. She thought it was fancy on her part for invariably when she reached the second floor all was dark and still. Nevertheless she wondered whether Eugene and Carlotta could be visiting. Twice, between breakfast and the time Eugene departed, she thought she heard Eugene and Carlotta whispering on the second floor but there was no proof. Carlotta's readiness to rise frequently at six-thirty in order to be at the same table with Eugene was peculiar, and her giving up Narragansett for Riverwood was most significant. It remained for one real discovery to resolve all her suspicions into the substance of fact and convict Carlotta of being the most conscienceless of deceivers.

It came about in this fashion. One Sunday morning Davis and Mrs. Hibberdell had decided to go automobiling. Eugene and Carlotta, being invited, had refused, for Carlotta, hearing the discussion several days before, had warned Eugene and planned to have the day for herself and her lover. She cautioned him to pretend the need of making visits downtown. As for herself she had said she would go but on the day in question did not feel well enough. Davis and Mrs. Hibberdell departed, their destinaton being Long Island. It was an all day tour. After an hour their machine broke, however, and after sitting in it two hours waiting for repairs—long enough to spoil their plans—they came back by trolley. Eugene had not gone downtown. He was not even dressed when the door opened on the ground floor and Mrs. Hibberdell came in.

"Oh, Carlotta," she called, standing at the foot of the stairs and expecting Carlotta to appear from her own room or a sort of lounging and sewing room which occupied the front of the house on the second floor and where she frequently stayed. Carlotta, unfortunately, was in with Eugene and the door to this room was commanded from where Mrs. Hibberdell was standing. She did not dare to answer.

"Oh, Carlotta," called her mother again.

The latter's first thought was to go back in the kitchen and look there but on second thought she ascended the steps and started for the sewing room. Carlotta thought she had entered. In an instant she seized the opportunity to step into the bath which was next to Eugene's room but she was scarcely quick enough. Her mother had not gone in the room—only opened the door and looked in. She did not see Carlotta step out of Eugene's room but she did see her entering the bath, *en negligé*, and she could scarcely have come from anywhere else. Her own door which was between Eugene's room and the sewing room was ten feet away. It did not seem possible that she could have come from there; she had not had time enough and anyhow, why had she not answered?

The first impulse of Mrs. Hibberdell was to call to her. Her second thought was to let the ruse seem successful. She was convinced that Eugene was in his room and a few moments later a monitory cough on his part—coughed of a purpose—convinced her.

"Are you in the bath, Carlotta?" she called quietly, after looking into Carlotta's room.

"Yes," came the reply, easily enough now. "Did your machine break down?"

A few remarks were exchanged through the door and then Mrs. Hibberdell went to her room. She thought over this situation steadily for it irritated her greatly. It was not the same as the discovered irregularity of a trusted and virtuous daughter. No one had led Carlotta astray. She was a grown woman, married, experienced. In every way she knew as much about life as her mother—in some respects more. The difference between them was in ethical standards and the policy that aligns itself with common sense, decency, self-preservation. Carlotta had so much to look out for. Her future was in her own hands. Besides, Eugene's future, his wife's rights and interests, her mother's house, her mother's standards, were things which she ought to respect—ought to want to respect. To find her lying as she had been this long time, pretending indifference, pretending absence, and no doubt associating with Eugene all the while, was disgusting. She was angry, very, not so much at Eugene, though her respect for him was greatly lowered, artist though he was, as at Carlotta.

She ought to do better. She ought to be ashamed not to guard herself against a man like Eugene instead of luring him on. It was Carlotta's fault, and she decided to reproach her bitterly and to break up this wretched alliance at once.

There was an intense and bitter quarrel the next morning, for Mrs. Hibberdell decided to hold her peace until Eugene and Davis should be out of the house. She wanted to have this out with Carlotta alone, and the clash came shortly after breakfast when both the others had left. Carlotta had already warned Eugene that something might happen on account of this but under no circumstances was he to admit anything unless she told him to. The maid was in the kitchen out of earshot and Mrs. Hibberdell and Carlotta were in the library when the opening gun was fired. In a way Carlotta was prepared, for she fancied her mother might have seen other things—what or how much she could not guess. She was not without the dignity of a Circe for she had been through scenes like this before. Her own husband had charged her with infidelity more than once and she had been threatened with physical violence by him. Her face was pale but calm.

"Now Carlotta," observed her mother vigorously, "I saw what was going

on yesterday morning when I came home. You were in Mr. Witla's room with your clothes off. I saw you come out. Please don't deny it. I saw you come out. Aren't you ashamed of yourself? How can you treat me that way after your promise not to do anything out of the way here?"

"You didn't see me come out of his room and I wasn't in there," said Carlotta brazenly. Her face was pale, but she was giving a fair imitation of righteous surprise. "Why do you make any such statement as that?"

"Why, Carlotta Hibberdell, how dare you contradict me! How dare you lie! You came out of that room. You know you did. You know that you were in there. You know that I saw you. I should think you would be ashamed of yourself, slipping about this house like a street girl, and your own mother in it. Aren't you ashamed of yourself? Have you no sense of decency left? Oh, Carlotta, I know you are bad but why will you come here to be so? Why couldn't you let this man alone? He was doing well enough. It's a shame, the thing you have done. It's an outrage. Mrs. Witla ought to come here and whip you within an inch of your life."

"Oh, how you talk," said Carlotta irritably. "You make me tired. You didn't see me. It's the old story—suspicion. You're always full of suspicion. You didn't see me and I wasn't in there. Why do you start a fuss for nothing?"

"A fuss! A fuss for nothing—the idea, you evil woman. A fuss for nothing. How can you talk that way? I can hardly believe my senses. I can hardly believe you would dare to brazenly face me in this way. I saw you and now you deny it."

Mrs. Hibberdell had not seen her but she was convinced that what she said was true.

Carlotta brazened it out. "You didn't," she insisted.

Mrs. Hibberdell stared. The effrontery of it took her breath away.

"Carlotta," she exclaimed, "I honestly think you are the worst woman in the world. I can't think of you as my daughter—you're too brazen. You're the worst because you're calculating. You know what you're doing and you are deliberate in your method of doing it. You're evil minded. You know exactly what you want and you set out deliberately to get it. You have done it in this case. You started out to get this man and you have succeeded in doing it. You have no sense of shame, no pride, no honesty, no honor, no respect for me or anyone else. You have no hesitation in lying to me now here to my face. You have no dignity even. You come up in this little village where everyone can see if they have half an eye, and take up with a man whom you have never seen before, of whom you know nothing, whom you cannot possibly love, for you know that you can't love anyone. You're too selfish. You merely want to gratify your selfish passions, and you do not hesitate to use me or my house or anyone or anything to accomplish your purpose.

You do not love this man. You know you don't. If you did you would never degrade him and yourself and me as you have done. You've simply indulged in another vile relationship because you wanted to, and now when you're caught you brazen it out. You're evil, Carlotta. You're as low as a woman can be, even if you are my daughter."

"It isn't true," said Carlotta. "You're just talking to hear yourself talk."

"It is true and you know it," returned her mother. "You talk about Norman. He never did a thing worse in his life than you have done. He may be a gambler and immoral and inconsiderate and selfish. What are you? Can you stand there and tell me you're any better? Pah! If you only had a sense of shame something could be done for you but you haven't any. You're just vile, that's all."

Carlotta stared at her mother, thinking. She was not greatly disturbed. It was pretty bad, no doubt of that, but she was not thinking so much of that as of the folly of being found out. Her mother knew, even though she would not admit to her that she knew. Now all of this fine summer romance would end—the pleasant convenience of it, anyhow. Eugene would be put to the trouble of moving. Her mother might say something to him which would be so shabby, so coarse and unrefined. Besides, she knew she was better than Norman because she did not associate with the same evil type of people. She was not coarse, she was not thick-witted, she was not cruel, she was not a user of vile language or an expresser of vile ideas, and Norman was at times. She considered that she had a superior refinement of feeling. She might lie and she might be calculating, but not to anyone's disadvantage—she was simply a sex enthusiast, frankly so and only in this one thing, the matter of love or romance, was she evil. Her mother said she was evil. Well she was in one way; but her mother was angry, that was all. She did not mean all she said. She would come round. Still Carlotta did not propose to admit the truth of her mother's charges or to go through this situation without some argument. There were charges which her mother was making which were untenable—points which were excusable.

"How you talk, ma," she observed calmly, "how you carry on, and that on a mere suspicion. You didn't see me. I might have been in there but you didn't see me and I wasn't. You're making a storm just because you want to. I like Mr. Witla. I think he's very nice, but I'm not interested in him and I haven't done anything to harm him. You can throw him out if you want to. That's none of my affair. You're simply raging about as usual without any facts to go on."

"Carlotta Hibberdell, you're the most brazen creature I ever knew! You're a terrible liar. How can you stand there and look me in the eye and say that,

when you know that I know? Why lie in addition to everything else? Oh, Carlotta, the shame of it. If you only had some sense of honor! How can you lie like that? How can you?"

"I'm not lying," declared Carlotta, "and I wish you would quit fussing. You didn't see me. You know you didn't. I came out of my room and you were in the front room. Why do you say you weren't? You didn't see me. Supposing I am a liar? I'm your daughter. I may be vile. I didn't make myself so. Certainly I'm not in this instance. Whatever I am, I come by it honestly. My life hasn't been a bed of roses. Why do you start a silly fight? You haven't a thing to go on except suspicion, and now you want to raise a row. I don't care what you think of me. I'm not guilty in this case, and you can think what you please. You ought to be ashamed to charge me with something of which you are not sure."

She walked to the window and stared out.

Her mother shook her head. Such effrontery was beyond her. It was like her daughter, though. She took after her father and herself. Both were self-willed and determined when aroused. At the same time she was sorry for her girl for she was a big woman in her way and very much dissatisfied with life.

"I should think you would be ashamed of yourself, Carlotta, whether you admit it to me or not," she went on. "The truth's the truth, and it must hurt you a little. You were in that room. We won't argue that, though. You set out deliberately to do this and you have done it. Now what I have to say is this. You are going back to your apartment today and Mr. Witla is going to leave here as quick as he can get a room somewhere else. You're not going to continue this wretched relationship any longer if I can help it. I'm going to write to his wife and to Norman too if I can't do anything else to break this up. You're going to let this man alone. You have no right to break up this relationship between him and Mrs. Witla. It's an outrage and no one but a vile conscienceless woman would do it. I'm not going to say anything to him now but he's going to leave here and so are you. When it's all over you can come back if you want to. I'm ashamed for you. I'm ashamed for myself. If it hadn't been for my own feelings and those of Davis I would have ordered you both out of the house yesterday and you know it. It's consideration for myself that's made me smooth it over as much as I have. He, the vile thing, after all the courtesy I have shown him. Still, I don't blame him as much as I do you, for he would never have looked at you if you hadn't made him. My own daughter! My own house! Tch! Tch! Tch!"

There was more conversation—that fulgurous coruscating reiteration of charges. Eugene was no good. Carlotta was vile. Mrs. Hibberdell wouldn't

have believed it possible if she hadn't seen it with her own eyes. She was going to tell Norman if Carlotta didn't reform—over and over, one threat after another.

"Well," she said finally, "you're going to get your things ready and go into the city this afternoon. I'm not going to have you here another day."

"No I'm not," said Carlotta boldly, pondering over all that had been said. It was a terrible ordeal but she would not go today. "I'm going in the morning. I'm not going to pack that fast. It's too hot. I'm not going to be ordered out of here like a servant."

Her mother groaned but she gave in. Carlotta could not be made to do anything she did not want to. She went to her room and presently Mrs. Hibberdell heard her singing. She shook her head. Such a personality. No wonder Eugene succumbed to her blandishments. What man wouldn't?

CHAPTER LVI

The sequel of this stormy scene was not long in manifesting itself. At dinner time Mrs. Hibberdell announced in the presence of Carlotta and Davis that this house was going to be closed up for the present and that very quickly. She and Carlotta were going to Narragansett for the month of September and a part of October. Eugene, having been forewarned by Carlotta, took it with a show of polite surprise. He was sorry. He had spent such a pleasant time here. Mrs. Hibberdell could not be sure whether Carlotta had told him or not, he seemed so innocent, but she assumed that she had and that he, like Carlotta, was "putting on." She had informed Davis that for reasons of her own she wanted to do this. He suspected what they were for he had seen signs and slight demonstrations which convinced him that Carlotta and Eugene had reached an understanding. He did not consider it anything very much amiss, for Carlotta was a woman of the world, her own boss, and a "good fellow." She had always been nice to him. He did not want to put any obstacles in her way. In addition, he liked Eugene. Once he had said to Carlotta jestingly, "Well, his arms are almost as long as Norman's—not quite, maybe."

"You go to the devil," was her polite reply.

Tonight a storm came up, a brilliant, flashing summer storm. Eugene went out on the porch to watch it. Carlotta came also.

"Well, wise man," she said as the thunder rolled. "It's all over up here. Don't let on. I'll see you wherever you go, but this was so nice. It was fine to have you near me. Don't get the blues, will you? She says she may write

your wife but I don't think she will. If she thinks I'm behaving, she won't. I'll try and fool her. It's too bad though. I'm crazy about you, Genie."

She had coined this pet name for him out of his own name, saying the Arabian demon had no more power to produce happiness for others than he had for her. "You create all illusions for me, oh Genie," she insisted. "You can make everything come true for me."

Now that he was in danger of losing Carlotta, her beauty took on a special significance for Eugene. He had come into such close contact with her, had seen her, under such varied conditions, that he had come into a profound admiration for not only her beauty but her intellect and ability as well. One of his weaknesses was that he was inclined to see much more in those he admired than was really there. He endowed them with the romance of his own moods—saw in them the ability to do things which he only could do. In doing this of course he flattered their vanity, aroused their self-confidence, made them feel themselves the possessors of latent powers and forces which, before him, they had only dreamed of. Margaret, Ruby, Angela, Christina, and Carlotta had all gained this feeling from him. They had a better opinion of themselves for having known him. Now as he looked at Carlotta he was intensely sorry, for she was so calm, so affable, so seemingly efficient and self-reliant, and such a comfort to him in these days. Nothing disturbed her. She was ready to fight for him, as he had seen, for she had confessed to him some of the details of this scene with her mother. Her fine, straight, supple body, clear eyes, genial mouth with its enigmatic smile, and her smooth, high forehead bespoke to him a delightful personality and a big intellect.

"Circe," he said, "this is too bad. I'm sorry. I'm going to hate to lose you."

"You won't lose me," she replied. "You can't, I won't let you. I've found you now and I'm going to keep you. This don't mean anything. We can find places to meet. Get a place where they have a phone if you can. When do you think you'll go?"

"Right away," said Eugene. "I'll take tomorrow morning off and look."

"Poor Eugene!" she said, sympathetically. "It's too bad. Never mind though. Everything will come out right."

She was still not figuring on Angela. She thought that even if Angela came back, as Eugene told her she would soon, a joint arrangement might possibly be made. Angela could be here, but she, Carlotta, could share Eugene in some way. She thought she would rather live with him than any other man on earth.

It was only about noon the next morning when Eugene found another room, for in living here so long he had thought of several methods by which

he might have obtained a room in the first place. There was another church, a library, the postmaster, and the ticket agent at Speonk who lived in this village. He went first to the postmaster and learned of two families—one the home of a civil engineer, where he might be welcome, and it was with the latter that he eventually located. The view was not quite so attractive but it was charming and he had a good room and good meals. He told them that he might not stay long for his wife was coming back soon. The letters from Angela were becoming most importunate.

He gathered up his belongings at Mrs. Hibberdell's and took a polite departure. After he was gone Mrs. Hibberdell of course changed her mind, and Carlotta returned to her apartment in New York. She communicated with Eugene not only by phone but by special delivery and had him meet her at a convenient inn the second evening of his departure. She was planning some sort of a separate apartment for them when Eugene informed her that Angela was already on her way to New York and that nothing could be done at present.

Since Eugene had left her at Biloxi, the latter had spent a most miserable period of seven months. She had been grieving her heart out for she imagined him to be most lonely, and at the same time she was regretful that she had ever left him. She might as well have been with him. She figured afterward that she might have borrowed several hundred dollars from one of her brothers and carried out the fight for Eugene's mental recovery by his side. Once he had gone she fancied she might have made a mistake matrimonially, for he was so impressionable—but his condition was such that she did not deem him to be interested in anything save his recovery. Besides, his attitude toward her of late had been so affectionate and in a way dependent. All her letters since he had left had been most tender, speaking of his sorrow at this necessitated absence and hoping that the time would soon come when they could be together. The fact that he was lonely finally decided her and she wrote him that she was coming whether he wanted her to or not.

Her arrival would have made little difference except that by now he was thoroughly weaned away from her again, had obtained a new ideal, and was interested only to see and be with Carlotta. The latter's comfortable financial state, her nice clothes, her familiarity with comfortable and luxurious things—better things than Eugene had ever dreamed of enjoying—her use of the automobile, her freedom in the matter of expenditures, taking the purchase of champagnes and expensive meals as a matter of course, dazzled and fascinated him. It was rather an astonishing thing, he thought, to have so fine a woman fall in love with him. Besides, her tolerance, her indifference to petty conventions, her knowledge of life and literature and art, set

her off in marked contrast to Angela, he thought, and in all ways she seemed big and forceful to him. He wished from his heart again that he could be free and could have Carlotta.

Into this peculiar situation Angela precipitated herself one bright Saturday afternoon in September, for she was dying to see Eugene again. Full of grave thoughts for his future, she had come to share it, whatever it might be. Her one idea was that he was sick and depressed and lonely. None of his letters had been cheerful or optimistic, for of course he did not dare to confess the pleasure he was having in Carlotta's company. In order to keep her away he had to pretend that lack of funds made it inadvisable for her to be here. The fact that he was spending, and by the time she arrived had spent, nearly all of the three hundred dollars his picture sold to Carlotta had brought him had troubled him some—not unduly, of course, or he would not have done it. He had qualms of conscience, severe ones, but they passed with the presence of Carlotta or the reading of his letters from Angela.

"I don't know what's the matter with me," he said to himself from time to time. "I guess I'm no good." He thought it was a god's blessing for him that the world could not see him as he was.

One of the particular weaknesses of Eugene's which should be set forth here and which will help to illuminate the basis of his conduct was that he was troubled with a dual point of view—a condition based upon a peculiar power of analysis—self-analysis in particular, which was constantly permitting him to tear himself up by the roots in order to see how he was getting along. He would daily and hourly when not otherwise employed lift the veil from his inner mental processes as one might lift the covering from a well and peer into its dark depths. What he saw was not very inviting and vastly disconcerting: a piece of machinery that was going as a true man might go (clock fashion) but corresponding in none of its moral characteristics to the recognized standards of a man. He had concluded by now from watching various specimens that some men were honest, some moral, some regulated by a keen sense of duty, and that occasionally all of these virtues and others were bound up in one man. Angela's father was such an one. M. Charles appeared to be another. He had concluded from his association with Jerry Mathews, Philip Shotmeyer, Peter McHugh, and Joseph Smite, that they all were all rather decent in respect to morals.

He had never seen them under temptation, but he imagined they were. Such a man as William Haverford, the engineer of maintenance of way, and Henry C. Fillebrown, the division engineer of this immense road, struck him as men who must have stuck close to a sense of duty and the conventions of the life they represented, working hard all the time, to have attained the positions which they had. All this whole railroad system which he was

watching closely from day to day from his little vantage point of connection with it seemed a clear illustration of the need for a sense of duty and reliability. All of these men who worked for this company had to be in good health, all had to appear at their posts on the tick of the clock, all had to faithfully perform the duties assigned them, or there would be disaster. Most of them climbed by long, arduous years of work to very moderate positions of prominence, as conductors, engineers, foremen, division superintendents. Others more gifted or more blessed by fortune reached to be division engineers, superintendents, vice-presidents, and presidents. They were all slow climbers, however, rigid in their sense of duty, tireless in their energy, exact, thoughtful. What was he?

He looked into the well of his being and there he saw nothing but shifty and uncertain currents. It was very dark down in there. He was not honest, he said to himself, except in money matters—he often wondered why. He was not truthful. He was not moral. This love of beauty which haunted him seemed much more important than anything else in this world, and his pursuit of that seemed to fly in the face of everything else which was established and important. He found that men everywhere did not think much of a man who was crazy after women. They might joke about occasional lapses as the expression of an amiable vice which the world generally condoned, but they wanted little to do with a man who was overpowered by it. There was a case over in the railroad yard at Speonk recently, which he had noted, of a foreman who had left his wife and gone after some hoyden in White Plains, and because of this offense he was promptly discharged. It appeared though that before, occasionally, he had lapsed from virtue and that each time he had been discharged, but had been subsequently forgiven. This one weakness and no more had given him a bad reputation among his fellow railroad men—much as that a drunkard might have. Big John Peters, the engineer, had expressed it aptly to Eugene one day when he told him in confidence that "Ed Bowers would go to hell for his hide"—the latter being the local expression for women. Everybody seemed to pity him, and the man seemed in a way to pity himself. He had a hang-dog look when he was reinstated and yet everybody knew that outside of this he was a fairly competent foreman. Still, it was generally understood that he would never get anywhere.

From this Eugene argued to himself that a man who was cursed with this peculiar vice could not get anywhere—that he, if he kept it up, would not. It was like drinking and stealing, and the face of the world was against it. Very frequently it went hand in hand with those things—"birds of a feather," he thought. Still he was cursed with it and he no more than Ed Bowers appeared to be able to conquer it. At least he was yielding to it now as he

had before. It mattered not that the women he chose were exceptionally beautiful and fascinating. They were women, and ought he to want them? He had one. He had taken a solemn vow to love and cherish her, or at least gone through the formality of such a vow, and here he was running about with Carlotta as he had with Christina and Ruby before her. Was he not always looking for some such woman as this? Certainly he was. And as in fishing so in wishing: he gained what he sought for. Had he not far better be seeking for wealth, distinction, a reputation for probity, chastity, impeccable moral honor? Certainly he had better be. It was the way to distinction apparently (along with talent) and here he was doing anything but that. Shame upon himself! Shame upon his weak-kneed disposition—not to be able to recover from this illusion of beauty. Such were some of the thoughts which his moments of introspection brought him.

On the other hand, there came over him that other phase of his duality—the ability to turn his terrible searchlight of intelligence, which swept the heavens and the deep with a great white ray, upon the other side of the question. It revealed constantly the inexplicable subtleties and seeming injustices of nature. He could not help seeing how the big fish fed upon the little ones; the strong were constantly using the weak as pawns; the thieves, the grafters, the murderers were sometimes allowed to prey on society without let or hindrance. Good was not always rewarded—frequently was terribly ill rewarded. Evil was seen to flourish beautifully at times. It was all right to say that it would be punished, but would it? Carlotta did not think so. She did not think the thing she was doing with him was very evil. She had said to him over and over that it was an open question—that he was troubled with an ingrowing conscience. "I don't think it's so bad," she once told him. "It depends somewhat on how you are raised." There was a system apparently in society, but also apparently it did not work very well. Only fools were held by religion, which in the main was an imposition, a graft, and a lie. The honest man might be very fine but he wasn't very successful. There was a great to-do about morals but most people were immoral or unmoral. Why worry? Look to your health! Don't let a morbid conscience get the best of you. Thus she counseled, and he agreed with her. For the rest, the law of the survival of the fittest was the best. Why should he worry? He had talent.

It was thus that Eugene floundered to and fro and it was in this state, brooding and melancholy, that Angela found him on her return. He was as gay as ever at times, when he was not thinking, but he was very thin and hollow-eyed, and Angela fancied that it was overwork and worry which kept him in this state. Why had she left him? Poor Eugene! She had clung desperately to the money he had given her and had most of it with her,

ready to be expended now for his care. She was so anxious for his recovery and his peace of mind that she was ready to go to work herself at anything she could find in order to make his path easier. She was thinking that fate was terribly unjust to him, and when he had gone to sleep beside her the first night she lay awake and cried. Poor Eugene! To think he should be tried so by fate. Nevertheless he should not be tortured by anything which she could prevent. She was going to make him as comfortable and happy as she could. She set about to find some nice little apartment or rooms where they could live in peace and where she could cook Eugene's meals for him. She fancied that maybe his food had not been exactly right, and when she got him where she could manifest a pretence of self-confidence and cour-age, that he would take courage from her and grow better. So she set briskly about her task, honeying Eugene the while, for she was confident that this above all was the thing he needed.

She little suspected what a farce it all appeared to him—how mean and contemptible he appeared to himself. He did not care to be mean—to roughly disillusion her and go his way—and yet this dual existence sick-ened him. He could not help but feel that from some points of view Angela was better than Carlotta—from a great many points of view. On the other hand, the other woman was wider in her outlook, more gracious in her appearance, more commanding, more subtle. She was a princess of the world, subtle, deadly, Machiavellian, but a princess nevertheless. Angela was better described by that current and acceptable phrase of the time—a "thoroughly good woman," honest, energetic, resourceful, in all things obe-dient to the race spirit and the conventional feelings of the time. He knew that society would sustain her thoroughly and condemn Carlotta, and yet Carlotta interested him more. He wished that he might have both and no fussing. Then all would be beautiful.

So he thought.

CHAPTER LVII

The situation which here presented itself was subject to no such gracious and generous interpretation. Angela was the soul of watchfulness, insis-tence on duty, consideration for right conduct and the privileges, oppor-tunities, and emoluments which belonged to her as the wife of a talented, and if temporarily disabled, certain to be distinguished artist of the future. She was deluding herself that this recent experience of hardship had prob-ably broadened and sharpened Eugene's practical instincts, made him less

indifferent to the necessity of looking out for himself, given him keener instincts of self-protection and economy. He had done very well to live on so little, she thought, but they were going to do better—they were going to save. She was going to give up those silly dreams she had entertained of a magnificent studio and hosts of friends, and she was going to start out now, saving a fraction of whatever they made, however small it might be, if it were only ten cents a week. If Eugene could only make nine dollars a week by working every day, they were going to live on that. He still had ninety-seven of the hundred dollars he had brought with him, he told her—he did not tell her of the sale for $300 of one of his pictures by Pottle Frères and of its subsequent dissipation—and this was going in the bank. In the same bank they were going to put any money from subsequent sales until he was on his feet again. One of these days if they ever made any money they were going to buy a house somewhere in which they could live without paying rent. Some of the money in the bank, a very little of it, might go for clothes if worst came to worst, but it would not be touched unless absolutely necessary. She needed clothes now but that did not matter. To Eugene's ninety-seven was added Angela's two hundred and twenty-eight which she brought with her and this total sum of three hundred and twenty-five dollars was promptly deposited in the Bank of Riverwood.

Angela, by personal energy and explanation, found four rooms in the home of a furniture manufacturer which had been vacated by a daughter who had married and which the owners were glad to let to an artist and his wife for practically nothing so far as the real worth was concerned, for this was a private home on a lovely lawn. Twelve dollars per month was the charge. Mrs. Witla seemed very charming to Mrs. Desenas, who was the wife of the manufacturer in question, and for her especial benefit a little bedroom on the second floor adjoining a bath was turned into a kitchen, with a small gas stove, and Angela at once began housekeeping operations on the tiny basis necessitated by their income and the fact that there were only two to provide for. Some furniture had to be secured, for the flat was not completely furnished, but Angela, by haunting the secondhand stores in New York, looking through all the department stores, and visiting certain private sales, managed to find a few things which she could buy cheaply and which would fit in with the dressing stand, library table, dining table, and one bed which were already present. There were several chairs and a small table necessary for the combined kitchen and dining room, which she bought out of a secondhand store, and painted white with a snow white varnish applied by her own hands. There were certain curtains necessary for the bath and kitchen windows which she cut, decorated, and hung for herself. She went down to the storage company where the unsold and

undisplayed portion of Eugene's pictures were and brought up seven which she distributed in the general living room and dining room. All of Eugene's clothes—his underwear and socks particularly—received her immediate attention, and she soon had his rather attenuated wardrobe in good condition. From the local market she bought good vegetables and a little meat and made delightful stews, ragouts, combinations of eggs and tasty meat juices after the French fashion. All of her housekeeping art was employed to the utmost to make everything look clean and neat, to keep a bountiful supply of varied food on the table, and yet to hold the cost down so that they could not only live on nine dollars a week but set aside a dollar or more of that for what Angela called their private bank account. She had a little hollow brown pig, calculated to hold fifteen dollars in change, which could be opened when full, which she conscientiously endeavored to fill and refill. Her one desire was to rehabilitate her husband in the eyes of the world—this time to stay—and she was determined to do it.

For another thing, reflection and conversation with one person and another had taught her that it was not well for herself or for Eugene for her to encourage him in his animal passions. Some woman in Black Wood had pointed out a local case of locomotor-ataxia which had resulted from this, and Angela had learned that it was believed that many other nervous troubles sprang from this source. Perhaps Eugene's had. She had resolved, in so far as her own strength would permit and her control of him would guarantee, to protect him from himself. She did not believe she could be injured, but Eugene was so sensitive, so emotional. So this household was set up upon a new, clean, conservative basis and had there been no dissipating tendency on Eugene's part, it would have no doubt gone smoothly forward to an interesting and conservative success.

The trouble with this situation was that it was such a sharp alteration from his recent free, and to him delightful, mode of existence that it was almost painful. He could see that everything appeared to be satisfactory to her, that she thought all his days had been moral and full of hard work. Carlotta's presence in the background was not suspected. Angela's idea was that they would work hard together now, along simple, idealistic lines to the one end—success for him, and of course, by reflection, for her. The thought that he might want anything outside of this was not apparent in either her thoughts or actions. The simple life, conservatism, honest, everyday friends, hard work—such was the program before him, and it did not utterly appeal.

Eugene saw the charm of it well enough but it was only as a picture suitable for the intellect and attitude of others. He was an artist. The common laws of existence could not reasonably apply to an artist. The latter should

have intellectual freedom, the privilege of going where he pleased, associating with whom he chose. This marriage business was a galling yoke, cutting off all rational opportunity for enjoyment, and he was now after a brief period of freedom having that yoke heavily adjusted to his neck again. Gone were all the fine dreams of pleasure and happiness which so recently had been so real—the hope of living with or marrying Carlotta—the hope of associating with her on easy and natural terms in that superior world which she represented. Angela's insistence on the thought that he would work every day and bring home nine dollars a week or rather its equivalent, twenty-six or twenty-seven days' pay every month at one dollar and a half a day, made it necessary for him to think sharply of the change, to take care of the little money he had kept out of the remainder of the three hundred in order that he might supply any deficiency which would occur from his taking time off. For there was no opportunity now of seeing Carlotta of an evening, and it was necessary to take a regular number of afternoons or mornings off each week in order to satisfy her, and his own desire of seeing her.

He would leave this little apartment as usual at a quarter of seven in the morning, dressed suitably for possible outdoor expeditions, for in anticipation of difficulty he had told Angela that it was his custom to do this, and sometimes he would go to the factory and sometimes he would not. There was a car line there which carried him rapidly cityward to a rendezvous and he would either ride or walk with Carlotta as the case might be. There was constant thought on his and her part of the risk involved but still they persisted. By some stroke of ill or good fortune, Norman Wilson returned from Chicago so that Carlotta's movements had to be calculated to a nicety, but she did not care. She trusted most to the automobiles which she could hire at convenient garages and which would carry them rapidly away from the vicinities where they might be seen and recognized.

It was a tangled life; difficult and dangerous. There was no peace in it, for there is neither peace nor happiness in deception. A burning joy at one point was invariably followed by a disturbing remorse afterward. There was Carlotta's mother, Norman Wilson, and Angela to guard against, to say nothing of the constant pricking of his own conscience.

It is almost a forgone conclusion in any situation of this kind that it cannot endure indefinitely. The seed of its undoing is in itself. We think that our actions when unseen of mortal eyes resolve themselves into nothingness but this is not true. They are woven into that indefinable essence which constitutes our being, and shine forth ultimately as the real self in spite of all our pretenses. One could almost accept the Brahmanistic dogma of a psychic body which sees and is seen where we deem all to be darkness. There is no other supposition on which to explain the facts of intuition.

So many individuals have it acutely. They know so well without knowing why they know.

Angela had this intuitive power in connection with Eugene. Because her affection and admiration for him was great she divined or sensed many things in connection with him long before they occurred. All during her absence from him she was haunted by the idea that she ought to be with him and now that she was here and the first excitement of contact and adjustment was over, she was beginning to sense something. Eugene was not the same as he had been a little while before he had left her. His attitude, in spite of a hardly demonstrated show of affection, was distant and preoccupied. He had no real power of concealing anything. He appeared at times—at most times when he was with her—to be lost in a mist of speculation. He was lonely and a little love-sick because under the pressure of home affairs Carlotta was not able to see him quite so much. At the same time, now that the fall was coming on he was growing weary of the shop at Speonk, for the gray days and slight chill which settled upon the earth at times caused the shop windows to be closed and robbed the yard of that air of romance which had characterized it when he first came there. He could not take his way of an evening along the banks of the stream to the arms of Carlotta. The novelty of Big John and Joseph Mews and Malachi Dempsey and Little Suddsy had worn off. He was beginning now to see also that they were nothing but plain workingmen after all, worrying over the fact that they were not getting more than fifteen or seventeen and a half cents an hour; jealous of each other and their superiors, full of all the frailties and weaknesses to which the flesh is heir.

His coming had created a slight diversion for them, for he was very strange, but his strangeness was no longer a novelty. They were beginning to see him also as a relatively commonplace human being. He was an artist to be sure but his actions and intuitions were not so vastly different from those of other men. This fact might be illustrated by a hundred little incidents but one will be sufficient. Bill and John had worked with him at odd times all summer, or rather he had worked with them. Because of the fact that he was supposed to be not so very strong, he was given the easy end of the work—piling or unpiling the material in or from cars as a rule. If a lumber stack was being built, he was on top of it. If anything was being handed down which was difficult to receive, he was put where it was easy. Eugene had about him an easy way of jesting. He was as likely to make fun of himself as anyone else without thought of how it would be taken. His favorite reference to these two men with whom he worked was, because of the color of their clothes, "the sawdust brothers." This amused the smith and Big John and Joseph Mews very much but it did not amuse John and

Bill when they heard of it. Eugene was constantly referring to Joseph Mews as "Joe the duck," and Harry Fornes as "the village smith," and Big John as "the Cardiff Giant." These terms were amusing enough at first but later on when they became used to him, and his actions indicated that he might be making fun of them and that he considered himself secretly and in spite of all his jollity a superior being, it was not so pleasant. Malachi Dempsey was the first to resent it, calling Big John's attention to it, and later Joseph Smith and Harry Fornes began to think of him as "a little gay." Bill and John heard of his humorous name for them and took great offence. They did not trouble to ask him whether it was so and resent him openly, but secretly they began to despise him and to try to make his work with them hard. It was a simple thing for John or Bill to climb into a car or on a lumber pile and receive while he carried. His work was readily made very hard in this way and he resented it. He at once suspected a secret grudge but was too proud to inquire. It was easier for him to linger longer over his shavings and so make his yard work less arduous. He had long ago been told to take his time, and shown how, lingering first on one foot and then the other if he wished, but he had heretofore avoided this. Now in view of this changing attitude it became a very convenient thing to do.

A shop of this kind, like any other institution where people are compelled by force or circumstances to work together, whether the weather be fair or foul or the mood grave or gay, can readily, and frequently does, become a veritable hell. Human nature is a subtle, irritable, irrational thing. It is not governed so much by rules of ethics and conditions of understanding as by mood and temperament. Eugene could easily see, philosopher that he was, that these people would come here enveloped in some mist of home trouble or secret illness or grief, and would conceive that somehow it was not their state of mind but the things around them which were the cause of all this woe. Sour looks would sometimes, and very readily, breed sour looks; a gruff question would beget a gruff answer; there were long-standing grudges between one man and another based on nothing more than a grouchy observation at one time or other. Eugene thought by introducing gayety and persistent, if make-believe, geniality that he was tending to obviate and overcome this general condition but this was only relatively true. His own gayety was like to become as much of a weariness to those who were out of the spirit of it as was the sour brutality with which at times he was compelled to contend. So he wished that he might arrange to get well and get out of here or at least change his form of work, for it was plain to be seen that this condition would not readily improve. His presence was a commonplace. His power to entertain and charm was practically gone.

This situation coupled with Angela's spirit of honest conservatism was

bad, but it was destined to be much worse. From watching him and endeavoring to decipher his moods, Angela came to suspect something—she could not say what. He did not love her as much as he had. There was a coolness in his caresses which was not there when he had left her. What could have happened, she asked herself. Was it just absence or what?

One day when he had returned from an afternoon outing with Carlotta and was holding Angela in his arms in greeting, she asked him solemnly, "Do you love me, honeybun?"

"You know I do," he asseverated but without any feeling, for he could not feel his old original feeling for her. There was no trace of it—only sympathy, pity, and a kind of sorrow that she was being so badly treated after all her efforts. She was not like the other women he was interested in, but she had her good points.

"No, you don't," she replied, detecting the hollow ring in what he said. Her voice was sad and her eyes showed traces of that wistful despair into which she could so readily sink at times.

"Why yes I do, Angel Face," he insisted. "What makes you ask? What's come over you?"

He was wondering whether she had heard anything or seen anything and was concealing her knowledge behind this preliminary inquiry.

"Nothing," she replied. "Only you don't love me. I don't know what it is. I don't know why. But I can feel it right here," and she laid her hand on her heart.

The action was sincere, unstudied. It hurt him for it was like that of a little child.

"Oh, hush! Don't say that," he pleaded. "You know I do. Don't look so gloomy. I love you—don't you know I do?" and he kissed her lips.

"No, no," said Angela. "I know! You don't. Oh, dear, oh, dear, I feel so bad."

Eugene was dreading another show of the hysteria with which he was familiar but it did not come. She conquered her mood, seeing that she had no real basis of proof, and went about the work of getting him his dinner. She was depressed though and he was fearful. What if she should ever find out!

More days passed. Carlotta called him up at the shop occasionally for there was no phone where he lived, and she would not have risked it if there had been. She sent him registered notes to be signed for, addressed to Henry Kingsland and directed to the post office at Speonk. Eugene was not known there as Witla and easily secured these missives, which were usually very guarded in their expressions and concerned appointments—the vaguest,

most mysterious directions, which he understood. They made arrangements largely from meeting to meeting, saying, "If I can't keep it Thursday at two it will be Friday at the same time, and if not then, Saturday. If anything happens I'll send you a registered special." So it went.

One noontime Eugene walked down to the little post office at Speonk to look for a letter, for Carlotta had not been able to meet him the previous day and had phoned him instead to look for her letter the following day. He found it safely enough and after glancing at it—it contained but few words—decided to tear it up as usual and throw the pieces away. A mere expression, "Ashes of Roses," which she sometimes used to designate herself and the superscription, "Oh, Genii!" made it inexpressibly dear to him. He loved the art of it—of her. He thought he would hold it in his possession just a little while—a few hours longer. It was enigmatic enough to anyone but himself, he thought, even if found—"The bridge. Two. Wednesday." The bridge referred to was one over the Harlem at Morris Heights. He kept the appointment that day as requested but by some necromancy of fate he forgot the letter until he was within his own door. Then he took it out, tore it up into four or five pieces quickly, put it in his vest pocket, and went upstairs, intending at the first opportunity to throw it in the toilet.

Meanwhile Angela, for the first time since they had been living at Riverwood, had decided to walk over toward the factory about six o'clock and meet Eugene on his way home. She had heard him discourse on the loveliness of this stream and what a pleasure it was to stroll along its banks morning and evening. He was so fond of the smooth water and the overhanging leaves. She had walked with him there already on several Sundays. When she went this evening she thought what a pleasant surprise it would be for him, for she had prepared everything on leaving so that his supper would not be delayed when they reached home. She heard the whistle blow as she neared the shop, and standing behind a clump of bushes on the thither side of the stream she waited, expecting to pounce out on Eugene with a loving "Boo!" He did not come.

The forty or fifty men who worked here trickled out like a little stream of black ants and then, Eugene not appearing, Angela went over to the gate which Joseph Mews, in the official capacity of gateman, after the whistle blew, was closing.

"Is Mr. Witla here?" asked Angela, peering through the bars at him. Eugene had described Joseph so accurately to her that she quite recognized him on sight.

"No ma'am," replied Joseph, quite taken back by this attractive arrival, for good looking women were not common at the shop gate of this factory,

particularly at this hour. "He left four or five hours ago. I think he left at one o'clock, if I remember right. He wasn't working with us today. He was working out in the yard."

"You don't know where he went, do you?" asked Angela, who was surprised at this information. Eugene had not said anything about going anywhere. Where could he have gone?

"No-'m, I don't," replied Joseph volubly. "He sometimes goes off this way—quite frequent, ma'am. His wife calls him up—er—now, maybe you're his wife."

"I am," said Angela, but she was no longer thinking of what she was saying—her words, on the instant, were becoming mechanical. Eugene going away frequently? He had never said anything to her! His wife calling him up! Could there be another woman? Instantly all her old suspicions, jealousies, fears awoke and she was wondering why she had not fixed on this fact before. That explained Eugene's indifference, of course. That explained his air of abstraction. He was not thinking of her, the miserable creature. He was thinking of someone else. Still she could not be sure, for she had no proof. Two adroit questions elicited the fact that no one in the shop had ever seen his wife. He had just gone out. A woman had called up.

Angela took her way home amid a whirling fire of conjecture. When she reached it, Eugene was not there yet for he sometimes delayed his coming, lingering as he said to look at the water. It was natural enough in an artist. She went upstairs and hung the broad-brimmed straw hat she had worn in the closet and went into the kitchen to await his coming. Experience with him and the nature of her own temperament determined her to enact a role of subtlety. She would wait until he spoke, pretending that she had not been out; she would ask whether he had had a hard day and see whether he disclosed the fact that he had been away from the factory. That would show her positively what he was doing and whether he was deliberately deceiving her.

Eugene came up the stairs, gay enough but anxious to deposit the scraps of paper where they would not be seen. No opportunity came, for Angela was there to greet him.

"Did you have a hard job today?" she asked, noting that he made no preliminary announcement of any absence.

"Not very," he replied, "no. I don't look tired?"

"No," she said bitterly, but concealing her feelings for she wanted to see how thoroughly and deliberately he would lie, "but I thought maybe you might have. Did you stop to look at the water tonight?"

"Yes," he replied smoothly. "It's very lovely over there. I never get tired

of it. The sun in the leaves these days, now that they are turning yellow, is so beautiful. They look a little like stained glass at certain angles."

Her first impulse after hearing this was to exclaim, "Why do you lie to me, Eugene?" for her temper was fiery, almost incontrollable at times, but she restrained herself. She wanted to find out more—how, she did not know, but time, if she could only wait a little, would help her. Eugene went in the bath, congratulating himself on the ease of his escape—the comfortable fact that he was not catechized very much—but in this temporary feeling of satisfaction he forgot the scraps of paper in his vest pocket, though not for long. He went into the bath, hung his coat and vest on a hook, and started into the bedroom to get himself a fresh collar and a tie. While he was in there Angela passed the bathroom door. She was always interested in Eugene's clothes, how they were wearing, and this was one of his two good suits which he had worn to be with Carlotta, but tonight there were other thoughts in her mind. Hastily and by intuition she went through his pockets, finding the torn scraps, then for excuse took his coat and vest down to clean certain spots. At the same moment Eugene thought of his letter. He came hurrying out to get it, or the pieces rather, but Angela already had them and was looking at them curiously.

"What was that?" she asked, all her suspicious nature on the qui vive for additional proof. Why would he keep the torn fragments of a letter in his jacket? All these days she had been having a psychic sense of something impending. Everything about him seemed strange, worthy of investigation. Now it was all coming out.

"Nothing," he said nervously. "A memorandum. Throw it in the paper box."

Angela noted the peculiarity of his voice and manner. She was taken by the guilty expression of his eyes. Something was wrong. It concerned these scraps of paper. Maybe it was in these she would be able to read the riddle of his conduct. The woman's name might be in here. Like a flash it came to her that she might piece these scraps together but there was another thought, equally swift, which urged her to pretend indifference. That might help her. Pretend now and she would know more later. She threw them in the paper box as he requested, thinking to piece them together at her leisure. Eugene noted her hesitation, her suspicion. He was afraid she would do something, what, he could not guess. He breathed easier when the papers fluttered into the practically empty box, but he was nervous. If they were only burned. He did not think she would attempt to put them together but he was afraid. He would have given anything, he thought, if his sense of romance had not led him into this trap.

CHAPTER LVIII

Angela was quick to act upon her thought. No sooner had Eugene entered the bath than she gathered up the pieces, threw other bits of paper like them in their place, and tried quickly to piece them together where she was, on the ironing board. It was not difficult. The scraps were not small. On one triangular bit were the words "Oh, Genii!" with a colon after them. On another, the words "the Bridge," and on another, "roses." There was no doubt in her mind from this preliminary survey that this was a love note and every nerve in her body tingled to the, to her, terrible import of it. Could it really be true? Could Eugene have found someone else? Was this the cause of his coolness and his hypocritical pretence of affection and his absence? Oh, God! Would her earthly sufferings never cease? She hurried into the front room, her face white, her hand clinching the tell-tale bits, and there set to work to complete her difficult analysis. It did not take her long. In four minutes it was all together and then she saw it all. A love note! From some demon of a woman! No doubt of it! Some mysterious woman in the background. "Ashes of Roses!" Now God curse her for a siren, a love-thief, a hypnotizing snake, fascinating men with her evil eyes. And Eugene! The dog! The scoundrel! The vile coward! The traitor! Was there no decency, no morality, no kindness, no gratitude in his soul? After all her patience, all her suffering, all her loneliness, her poverty! To treat her like this! Writing that he was sick and lonely and unable to have her with him, and at the same time running around with a strange woman. "Ashes of Roses!" Oh curses, curses, curses on her harlot's heart and brain. Might God strike her dead for her cynical, brutal seizing upon that sacred something of marriage which belonged to another. She wrung her hands desperately.

Angela was fairly beside herself. Through her dainty little head ran a foaming torrent of rage, hate, envy, sorrow, self-commiseration, and a brutal, evil, desire for revenge. If she could only get at this woman! If she could only denounce Eugene now to his face! If she could only find them together and kill them! How she would like to strike her in the mouth! How tear her hair and her eyes out. Something of the forest cat's cruel rage shone in her gleaming eyes as she thought of her, for if she could have had Carlotta there alone she would have tortured her with hot irons, torn her tongue and teeth loose from their roots, beaten her into insensibility and an unrecognizable mass. She was a real tigress now, her eyes gleaming, her red lips wet. She would kill her! kill her!! kill her!!! As God was her judge, she would kill her if she could find her, and Eugene and herself. Yes, yes, she would. Better death than this agony of suffering. Better a thousand times to be dead with this beast of a woman dead beside her, and Eugene,

than to suffer this way. She didn't deserve it. Why did God torture her so? Why was she made to bleed at every step by this, her sacrificial love? Had she not been a good wife? Had she not laid every tribute of tenderness, patience, self-abnegation, self-sacrifice, and virtue on the altar of love? What more could God ask? What more could man want? Had she not waited on Eugene in sickness and health? She had gone without clothes, gone without friends, hidden herself away in Black Wood the seven months while he was here, frittering away his health and time in love and immorality, and what was her reward? In Chicago, in Tennessee, in Mississippi, had she not waited on him, sat up with him nights, walked the floor with him when he was nervous, consoled him in his fear of poverty and failure, and here she was now, after seven long months of patient waiting and watching—eating her lonely heart out—forsaken. Oh, the unconceivable inhumanity of the human heart. To think anybody could be so vile, so low, so unkind, so cruel. To think that Eugene, with his black eyes, his soft hair, his smiling face, could be so treacherous, so subtle, so dastardly mean. Could he really be as mean as this note proved him to be? Could he be as brutal, as selfish? Was she awake or asleep? Was this a dream? Oh God! No, no it was not a dream. It was a cold, bitter, agonizing reality. And the cause of all her suffering was there in the bathroom now, shaving himself.

For one moment she thought she could go in and strike him where he stood. She thought she could tear his heart out, cut him up, but then suddenly the picture of him bleeding and dead came to her and she recoiled. No, no, she could not do that. Oh, no, not Eugene—and yet—and yet.

"Oh, God, let me get my hands on that woman," she said to herself. "Let me get my hands on her. I'll kill her, I'll kill her! I'll kill her."

This torrent of fury and self-pity was still raging in her heart when the bathroom knob clicked and Eugene came out. He was in his undershirt, trousers, and shoes, looking for a clean white shirt. He was very nervous over the note which had been thrown in scraps into the box, but looking in the kitchen and seeing the pieces still there, he was slightly reassured. Angela was not there. He could come back and get them when he found out where she was. He went on into the bedroom, looking into the front room as he did so. She appeared to be at the window, waiting for him. After all, she was probably not as suspicious as he thought. It was his own imagination. He was too nervous and sensitive. Well he would get these pieces together now if he could and throw them out of the window. Angela should not get a chance to examine them if she wanted to. He slipped out in the kitchen, made a quick grab for the little heap, and sent the pieces flying. Then he felt much better. He would never bring another letter home from anybody, that was a certainty. Fate was too much against him.

Angela came out after bit, for the click of the bathroom knob had sobered her a little. Her rage was high, her pulse abnormal, her whole being shaken to its roots, but still she realized she must have time to think. She must see who this woman was first. She must have time to find her. Eugene mustn't know. This way if she reproached him he could refuse to tell, as he had of Frieda. He could deny that it was a woman or that he was at all intimate with her. He could refuse to talk at all and she would never know. He would warn her, the beast. Somehow there came to her mind's eye the kind of woman that Carlotta was. It was a psychic interpretation but it was fairly correct. Angela saw her tall, graceful, supple, dignified, dark, and she hated her all the more vigorously for this mental impression. Where was she now? Where was this bridge? Where did they meet? Where did she live? She wondered for the moment why she couldn't think it all out, why it didn't come to her in a flash, a revelation. If she could only know.

In a few minutes Eugene came out, clean shaven, smiling, his equanimity and piece of mind fairly well restored. The letter was gone. Angela could never know. She might suspect but this possible burst of jealousy had been nipped in the bud. He came over toward Angela to put his arm around her but she slipped away from him, pretending to need the sugar. He let this effort at lovemaking go—the will for the deed—and sat down at the snow white little table, set with pleasant dishes, and waited to be served. The day had been very pleasant, being very near the fifth of October, and he was pleased to see a last lingering ray of light falling on some red and yellow leaves. This yard was very beautiful; this little flat, for all their poverty, very charming. Angela was neat and trim in a dainty, close fitting house dress of mixed brown and green gingham. A dark blue studio apron of quaint design shielded her bosom and skirt. She was very pale and distraught looking but Eugene for the time was almost unconscious of it—he was so relieved.

"Are you very tired, Angela?" he finally asked sympathetically.

"Yes, I'm not feeling so well today," she replied.

"What have you been doing, ironing?"

"Oh, yes, and cleaning. I worked on the cupboard."

"You oughtn't to try to do so much," he said cheerfully. "You're not strong enough. You think you're a little horse, but you're only a colt. Better go slow, hadn't you?"

"I will after I get everything straightened out to suit me," she replied.

She was having the struggle of her life to conceal her real feelings. Never at any time had she undergone such an ordeal as this. Once in the studio when she discovered those two letters she thought she was suffering—but that, what was that to this? What were her suspicions concerning Frieda? What were her lonely longings at home, her grieving and worrying over his

illness? Nothing, nothing! Now he was actually faithless to her. Now she had the evidence. This woman was here. She was somewhere in the immediate background. After these years of marriage and close companionship he was deceiving her. It was possible that he had been with this woman today, yesterday, the day before. The letter was not dated. Could it be that she was related to Mrs. Hibberdell? Eugene had said that there was a married daughter but never that she was there. If she was there why would he have moved? He wouldn't have. Was it the wife of the man he was last living with? No, she was too homely. Angela had seen her. Eugene would never associate with her. There was a library here, a little one, with a good looking girl attendant—could it be she? Her mind ran like a hound on the scent first in this direction, then in that, sniffing, whining, eager. If she could only know. "Ashes of Roses." The world went red before her eyes.

There was no use bursting into a storm now, though, she thought. If she should only be calm it would be better. If she only had some one to talk to—if there were a minister or a bosom friend. She might run to a detective agency. They might help her. A detective could trail this woman and Eugene. Did she want to do this? It cost money. They were very poor now. Paugh! Why should she worry about their poverty, mending her dresses, going without hats, going without decent shoes, and he wasting his time and being upon some shameless strumpet. If he had money he would spend it on her. Still he had handed her almost all of the money he had brought East with him intact. How was that?

All the time Eugene was sitting opposite her, eating fairly heartily. If his note trouble had not come out so favorably he would have been without appetite, but now he felt pretty good. Angela said she was not hungry and could not eat. She passed him the bread, the butter, the hashed brown potatoes, the tea, and he ate cheerfully.

"I think I am going to try to get out of that shop over there," he volunteered affably.

"Why?" asked Angela mechanically.

"I'm tired of it. The men are not so interesting to me any more. I'm tired of them. I think Mr. Haverford will change me if I write him. He said he would. I'd rather be outside with some section gang if I could. It's going to be very dreary in that shop when they close it up."

"Well, if you're tired, you'd better," replied Angela. "Your mind needs diversion, I know that. Why don't you write Mr. Haverford?"

"I will," he said, but he did not immediately. He went in to the front room and lit the gas eventually, reading a paper, then a book, then yawning wearily. Angela came in after a time and sat down, pale and tired. She went and secured a little work basket in which were socks undarned and other

odds and ends and began on those but she despised the thought of doing anything for him and put them up. She got out a skirt of hers which she was making. Eugene watched her a little while lazily, his artistic eye measuring the various lengths of her features. She had a well balanced face, he finally concluded. He noted the effect of the light on her hair—the peculiar hue it gave it—and wondered if he could get that in oil. Night scenes were harder than those of the full daylight. In art, shadows were so very treacherous. He got up finally.

"Well I'm going to turn in," he said. "I'm tired. I have to get up at six. Oh, dear, this darn day labor business gives me a pain. I wish it were over."

Angela did not trust herself to speak. She was so full of pain and despair that she thought if she spoke she would cry. He went out, saying "coming soon?" She nodded her head. When he was gone she began the storm, breaking into a terrific burst of tears. They were not only tears of sorrow but of rage and helplessness. She went out on a little balcony and cried alone, the night lights shining wistfully about. After this first storm she began to harden and dry up again, for helpless tears were foreign to her in a rage. She dried her eyes and became white-faced and desperate as before.

The dog, the scoundrel, the brute, the hound! she thought. How could she have ever loved him? How could she love him now? Oh, the horror of life, its injustice, its cruelty, its shame. That she should be dragged through the mire with a man like this. The pity of it! The shame! If this was art, death take it. And yet hate him as she might, hate this hellish man-trap who signed herself "Ashes of Roses," she loved him too. She could not help it. She knew she loved him. Oh to be crossed by two fevers like this. Why might she not die? Why not die, right now?

CHAPTER LIX

The hells of love are bitter and complete. There were days after that when Angela watched him, followed him down the pleasant lane which led from the house to the water's edge, slipping out unceremoniously after he had gone not more than eight hundred feet. She watched the bridge at Riverwood at one and six, expecting that Eugene and his paramour might meet there. It just happened that Carlotta was compelled to leave town for ten days with her husband and so Eugene was safe, for he made no move. On two occasions he went downtown, into the heart of the great city, anxious to get a breath of the old life that so fascinated him, and Angela followed him only to lose track of him quickly. He did nothing evil however,

merely walked, wondering what Miriam Finch and Christina Channing and Norma Whitmore were doing these days and what they were thinking of him in his long absence. Of all the people he had known, he had only seen Norma Whitmore once and that was not long after he returned to New York. He had given her a garbled explanation of his illness, stated that he was going to work now, and proposed to come about and see her. He did his best to avoid observation, however, for he dreaded explaining the reason for his non-productive condition. Miriam Finch was almost glad that he had failed for he had treated her so badly. Christina Channing was in opera, as he quickly discovered, for he saw her name blazoned one day the following November in the newspapers. She was a star of whose talent great hopes were entertained and was interested almost exclusively in her career. She was to sing in *La Bohème* and *Rigoletto*.

Another thing, fortunate for Eugene at this time, was that he changed his work. There came to the shop one day an Irish foreman, Timothy Deegan, master of a score of "guineas," as he called the Italian day laborers who worked for him, who took Eugene's fancy greatly. He was of medium height, thick of body and neck, with a cheerful, healthy, red face, a keen, twinkling gray eye, and stiff, closely cropped gray hair and mustache. He had come to lay the foundation for a small dynamo in the engine room at Speonk, which was to supply the plant with light in case of night work, and a car of his had been backed in, a tool car, full of boards, barrows, mortar boards, picks, and shovels. Eugene was amused and astonished at his insistent, defiant attitude and the rapid fire manner in which he was handing out orders to his men.

"Come, Matt! Come, Jimmie! Get the shovels, now! Get the picks!" he heard him shout. "Bring some sand here! Bring some stone! Where's the cement, now? Where's the cement? Jasus Christ! I must have some cement. What arre ye all doing? Hurry, now, hurry! Bring the cement."

"Well he knows how to give orders," commented Eugene to Big John, who was standing near. "He certainly does," replied the latter. To himself Eugene observed, hearing only the calls at first, "the Irish brute." Later he discovered a subtle twinkle in Deegan's eye as he stood brazenly in the door, looking defiantly about. There was no brutality in it, only self-confidence and a hearty Irish insistence on the necessity of the hour.

"Well you're a dandy," commented Eugene boldly after a time and laughed.

"Ha! ha! ha!" mocked Deegan in return. "If you had to work as harred as these men you wouldn't laugh."

"I'm not laughing at them, I'm laughing at you," explained Eugene.

"Laugh," said Deegan. "Shure you're as funny to me as I am to you."

Eugene laughed some more. The Irishman agreed with himself that there

was some humor in it. He laughed. Eugene patted his big rough shoulder with his hands and they were friends immediately. It did not take Deegan long to find out from Big John why he was there and what he was doing.

"An arrtist!" he commented. "Shewer he'd better be outside than in. The likes of him packin' shavin's and him laughin' at me."

Big John smiled.

"I believe he wants to get outside," he said.

"Why don't he come with me then? He'd have a fine time workin' with the guineas. Shewer 'twould make a man 'av him—a few months of that"— and he pointed to Angelo Esposito shoveling clay.

Big John thought this worth reporting to Eugene. He did not think Eugene wanted to work with the guineas but he might like to be with Deegan. Eugene saw his opportunity. He liked Deegan.

"Would you like to have an artist who's looking for health come and work for you, Deegan?" he asked the latter genially. He thought Deegan might refuse but it didn't matter. It was worth the trial.

"Shewer!" replied the latter.

"Will I have to work with the Italians?"

"There'll be plinty av work for ye to do without ever layin' yer hand to pick er shovel unless ye want to. Shewer that's no work for a white man to do."

"And what do you call them, Deegan? Aren't they white?"

"Shewer they're naat."

"What are they then? They're not black."

"Nagurs of coorse."

"But they're not negroes."

"Will, begad, they're naat white. Any man kin tell that be lookin' at them."

Eugene smiled. He understood at once the solid Irish temperament which could draw this hearty conclusion. There was no malice in it. Deegan did not underestimate these Italians. He liked his men, but they weren't white. He didn't know what they were exactly, but they weren't white. He was standing over them a moment later shouting, "Up with it! Up with it! Down with it! Down with it!" as though his whole soul were intent on driving the last scrap of strength out of these poor underlings, when as a matter of fact they were not working very hard at all. His glance was roving about in a general way as he yelled, and they paid little attention to him. Once in a while he would interpolate a "Come Matt" in a softer key—a key so soft that it was entirely out of keeping with his other voice. Eugene saw it all clearly. He understood Deegan.

"I think I'll get Mr. Haverford to transfer me to you, if you'll let me

come," he said at the close of the day when Deegan was taking off his over-alls and the "Eyetalians," as he called them, were putting the things back in the car.

"Shewer!" said Deegan, impressed by the great name of Haverford. If Eugene could accomplish that through such a far off, wondrous personality, he must be a remarkable man himself. "Come along. I'll be glad to have ye. Ye can jist make out the o.k. blanks and the repoarts and watch over the min sich times as I'll naat be there and—will—aal told ye'll have enough to keep ye busy."

Eugene smiled. This was a pleasant prospect. Big John had told him dur-ing the morning that Deegan went up and down the road from Peekskill on the main line, Chatham on the Midland Division, and Mt. Kisco on a third branch to New York City. He built wells, culverts, coal bins, building piers, small brick buildings—anything and everything, in short, which a capable foreman-mason ought to be able to build—and in addition he was fairly content and happy in his task. Eugene could see it. The atmosphere of the man was wholesome. He was like a tonic—a revivifying dynamo to this sickly overwrought sentimentalist.

That night he went home to Angela full of the humor and romance of his new situation. He liked the idea. He wanted to tell her about Deegan—to make her laugh. He was destined, unfortunately, to another kind of a reception.

For Angela, by this time, had endured the agony of the discovery to the breaking point. She had listened to his pretences, knowing them to be lies, until she could endure it no longer. In following him she had discovered nothing, and the change in his work would make the chase more difficult. It was scarcely possible for anyone to follow him, for he himself did not know where he would be from day to day. He would be here, there, and every-where. His sense of security as well as of his unfairness made him sensitive about being nice to Angela in the unimportant things. When he thought at all he was ashamed of what he was doing—thoroughly ashamed. Like the drunkard, he appeared to be mastered by his weakness, and the psychology of his attitude is so best interpreted. He caressed her sympathetically, for he thought, owing to her drawn, weary look, that she was verging on some illness. She appeared to him to be suffering from worry for him, overwork, or approaching malady.

"Are you feeling just right?" he asked her one evening when he came home, looking into her sad, gloomy, and at times sulphurous eyes, though she concealed from him the latter quality. She did her best to conceal the terrible reproach which lay there. Her brain was flaming with anger half the time—her throat dry and choking.

"Oh, yes," she replied wearily, "I'm all right."

"You don't look it," he insisted. "You look awfully weary. What is it, Angel Face? Anything troubling you?"

"No, no," replied Angela irritably. "I'll be all right. Don't bother about me."

She wanted to get away from him, for fear she would burst out crying or break into a torrent of rage. He withdrew readily enough for he did not like to trifle with her when she was moody. His unfaithfulness need not be complicated with hypocritical pretence.

But Eugene, in spite of his unfaithfulness, did sympathize with Angela greatly. He appreciated her good qualities—her truthfulness, economy, devotion, and self-sacrifice in all things which related to him. He was sorry that his own yearning for freedom crossed with her desire for single-minded devotion on his part. He could not love her as she wanted him to, that he knew, and yet he was at times sorry for it, very. He would look at her when she was not looking at him, admiring her industry, her patience, her pretty figure, her geniality in the face of many difficulties and wish that she could have had a better fate than to have met or married him. At the same time he realized that as bad as he was she would probably rather have him than anybody else for she was fascinated by him.

Temperamentally they were suited in many ways—a mutual love of order, a mutual admiration for the odd in character, a sense of humor, a sense of pathos in themselves and life in general—many little things which made for a comfortable home life which is so important in any union. Only at this unfortunate juncture, where her conventional morality met his lawless artistic beauty worship, were they at odds—and then only in so far as Angela's desire to keep Eugene wholly for herself was concerned. She admired beauty in woman quite as much as he did, sympathized with the emotions which their charms evoked, but she wanted him to avoid the vicinity of temptation and to keep his sentiments and passions religiously for her. Hence this terrific storm.

Because of these feelings on his part for her he could not bear to see her suffer. When she appeared to be ill he could not help drawing near to her, wanting to know how she was, endeavoring to make her feel better by those sympathetic, emotional demonstrations which he knew meant so much to her. On this particular evening, noting the still, drawn agony of her face, he remarked, "What's the matter with you, Angel Face, these days? You look so tired. You're not right. What's troubling you?"

"Oh, nothing," replied Angela wearily.

"But I know there is," he replied. "You can't be feeling well. What's ailing you? You're not like yourself at all. Won't you tell me, sweet? What's the trouble?"

He was thinking because Angela said nothing that it must be a real physical illness. Any emotional complaint vented itself quickly.

"Why should you care?" she asked cautiously, breaking her self-imposed vow of silence. She was thinking that Eugene and this woman, whoever she was, were conspiring to defeat her and that they were succeeding. Her voice had changed from one of weary resignation to subtle semi-concealed complaint and offence, and Eugene noted it.

Before she could add any more he had observed, "Why shouldn't I? Why, how you talk. What's the matter now?"

Angela really did not intend to go on. Her query was dragged out of her by his obvious sympathy. He was sorry for her in some general way. It made her pain and wrath all the greater. And his additional inquiry irritated her the more.

"Why should you?" she asked, weepingly. "You don't want me. You don't like me. You pretend sympathy when I look a little bad, but that's all. But you don't care for me. If you could get rid of me you would. That is so plain."

"Why, what are you talking about?" he asked, astonished. Had she found out anything? Was the incident of the scraps of paper really closed? Had anybody been telling her anything about Carlotta? Instantly he was all at sea. Still he had to pretend.

"You know I care," he said. "How can you say that?"

"You don't. You know you don't!" she flamed up suddenly. "Why do you lie? You don't care. Don't touch me. Don't come near me. I'm sick of your hypocritical pretences. Oh!" And she straightened up, with her fingernails cutting into her palms.

Eugene, at the first expression of disbelief on her part, had laid his head soothingly on her arm. That was why she had jumped away from him. Now he drew back nonplussed, nervous, a little defiant. It was easier to combat rage than sorrow, but he did not want to do either.

"What's the matter with you?" he asked, though assuming a look of bewildered innocence. "What have I done now?"

"What haven't you done, you'd better ask, you dog! You coward!" flared Angela. "Leaving me to stay out in Wisconsin while you go running around with a shameless woman. Don't deny it! Don't dare to deny it!" (this apropos of a protesting movement on the part of Eugene's head) "I know all! I know more than I want to know. I know how you've been acting. I know what you've been doing! I know how you've been lying to me. You've been running around with a low, vile wretch of a woman while I have been staying out in Black Wood eating my heart out, that's what you've been doing. Oh, the horrible brutality of it all—the shamelessness, the cruelty. 'Dear Angela! Dear Angel Face! Dear Madonna Dolorosa!' Ha! What have you been calling her, you lying, hypocritical coward? What names have you for

her? Hypocrite! Brute! Liar! I know what you've been doing. Oh, how well I know! Oh, why was I ever born?—oh! Why? Why?"

Her voice trailed off in a wail of agony. Eugene stood there astonished to the point of aimless inefficiency. He could not think of a single thing to do or say. He had no idea upon what evidence she based her complaint. He fancied that it must be much more than had been contained in that little note which he had torn up. She had not seen that—of that he was reasonably sure—or was he? Could she have taken it out of the box while he was in the bath and then put it back again? This sounded like it. She had looked very bad that night. How much did she know? Where had she secured her information? Mrs. Hibberdell? Carlotta? No! Had she seen her? Where? When?

"You're talking through your hat," he said aimlessly and largely in order to get time, using a slang phrase of the day. "You're crazy! What's got into you, anyhow? I haven't been doing anything of the sort."

"Oh, haven't you?" she sneered. "You haven't been meeting her at bridges and road houses and street cars have you, you liar? You haven't been call-ing her 'Ashes of Roses' and 'River nymph' and 'Angel Girl.'" Angela was making up names and places out of her own mind. "I suppose you used some of the pet names on her that you gave to Christina Channing, didn't you? She'd like those, the vile strumpet. And you, you dog, pretending to me—pretending sympathy, pretending loneliness, pretending sorrow that I couldn't be here. A lot you cared what I was doing or thinking or suf-fering. Oh, I hate you, you horrible coward. I hate her. I hope something terrible happens to you. If I could get at her now, I would kill you and her both—and myself—I would. I wish I could die! I wish I could die!"

Eugene was beginning to get the measure of his iniquity as Angela inter-preted it. He could now see how cruelly he had hurt her. He could see now how vile what he was doing looked in her eyes. It was bad business—run-ning with other women—no doubt of it. It always ended in something like this—a terrible storm in which he had to sit by and hear himself called brutal names to which there was no legitimate answer. He had heard of this in connection with other people but he had never thought it would come to him. And the worst of it was that he was guilty and deserving of it. No doubt of that. It lowered him in his own estimation. It lowered her in his and her own because she had to fight this way. Why did he do it? Why did he drag her into such a situation? It was breaking down that sense of pride in himself which was the only sustaining power a man had before the gaze of the world. Why did he let himself get into these situations? Did he really love Carlotta? Did he want freedom enough to ensure such abuse as this? This was a terrible scene! And where would it end? His nerves were

tingling; his brain fairly aching. Still he felt that he was not utterly without justification, for after all, life was not giving him what he wanted. It had not brought his kindly intentions in marrying Angela to the best fruition. He really wanted another type of woman, sad as it might seem. Right here in the midst of this storm, and looking at Angela, as wronged as she was, he could truthfully say this to himself—and yet he did not want to be unkind to her. If he could only conquer this desire for another type and be faithful, and yet how dreadful that seemed. To confine himself in all his thoughts to just Angela! It was not possible. He thought of these things standing there, enduring the brunt of this storm. It was a terrible ordeal but it was not wholly cleansing, even at that.

"What's the use of your carrying on like that, Angela?" he said grimly after had listened to all this. "It isn't as bad as you think. I'm not a liar and I'm not a dog! You must have pieced together that note I threw in the paper box and read it. When did you do it?"

He was curious about that and about how much she knew. What were her intentions in regard to him? What in regard to Carlotta? What would she do next?

"When did I do it?" she replied. "When did I do it? What has that got to do with it? What right have you to ask? Where is this woman, that's what I want to know. I want to find her. I want to face her. I want to tell her what a wretched beast she is. I'll show her how to come and steal another woman's husband. I'll kill her. I'll kill her and I'll kill you too. Do you hear, I'll kill you." And she advanced on him defiantly, blazingly.

Eugene was astounded. He had never seen such a rage in any woman. It was wonderful, fascinating, something like a great lightning-riven storm. Angela was capable of hurling thunderbolts of wrath. He had not known that. It raised her in his estimation—made her really more attractive than she would otherwise have been, for power, however displayed, is fascinating. She was so little, so grim, so determined. It was, in its way, a test of great capability. And he liked her for it, even though he resented her abuse.

"No, no, Angela," he said sympathetically and with a keen wish to alleviate her sorrow. You wouldn't do anything like that. You couldn't."

"I will! I will!" she declared. "I'll kill her and you too!"

And then having reached this tremendous height, she suddenly broke. Eugene's big, sympathetic understanding was after all too much for her. His brooding patience in the midst of her wrath, his innate sorrow for what he could not or would not help (it was written all over his face), his very obvious presentation of the fact by his attitude that he knew that she loved him in spite of this, was too much for her. It was like beating her poor little hands against a stone. She might kill him and this woman, whoever she was, but

she would not have changed his attitude toward her and that was what she wanted. A great torrent of heart-breaking sobs broke from her, shaking her frame like a reed. She threw her arms and head upon the kitchen table, falling to her knees, and cried and cried. Eugene stood there, contemplating the wreck he had made of her dreams. Certainly it was hell, he said to himself, certainly it was. He was a liar, as she said, a dog, a scoundrel. Poor little Angela! Well, the damage had been done. What could he do now? Anything? Certainly not. Not a thing. She was broken—heart-broken. There was no earthly remedy for that. Priests might shrive for heaven and hell but for a broken heart what remedy was there?

"Angela!" he called gently, "Angela! I'm sorry! Don't cry! Angela!! Don't cry!"

But she did not hear him. She did not hear anything. Lost in the agony of her situation she could only sob convulsively until it seemed that her pretty little frame would break to pieces.

CHAPTER LX

The subtlety of the human mind, in its larger aspects and developments and when uncontrolled by a rigid will toward perfection and the beatitudes, is one of the most dangerous and terrible things. We partially view its ramifications and results in the courts and jails of the world, but the remainder which is not visible and goes unwhipped of justice is even more discouraging. Man is innately evil, declared St. Augustine, and mercy and salvation are by the grace of God alone. One is almost prepared to believe it when one contemplates the ramifications of evil, its fertile inventiveness, its seeming inability to turn from its ways except by the pressure of difficulties which it alone creates. The will to perfection! Beyond that is darkness and terror only.

Eugene's feelings on this occasion were of reasonable duration. It is always possible under such circumstances to take the victim of our brutalities in our arms and utter a few sympathetic or repentant words. The real kindness and repentance which consists in reformation is quite another matter. One must see with eyes too pure to behold evil to do that. Eugene was not to be reformed by one hour or many hours of agony on anyone's part. Angela was well within the range of his sympathetic interests. He suffered with her keenly but not enough to outrun or offset his own keen desire for what he considered his spiritual right to enjoy beauty. What harm did it do, he would have asked himself, if he secretly exchanged affectionate looks and

feelings with Carlotta or any other woman who fascinated him and in turn was fascinated by him? Could an affinity of this character really be called evil? He was not giving her any money which Angela ought to have, or very little. He did not want to marry her and she really did not want to marry him—there was no chance of that, anyhow. He wanted to associate with her. And what harm did that do Angela? None, if she did not know. Of course if she knew, it was very sad for her and for him. But if the shoe were on the other foot and Angela was the one who was acting as he was now, he would not care, he thought. He forgot to add that if he did not care it would be because he was not in love, and Angela was in love. Such reasoning runs in circles. Only it is not reasoning. It is sentimental and affectional anarchy. There is no will towards progress or perfection in it.

When Angela recovered from her first burst of rage and grief, it was only to continue it further though not quite in the same vein. There can only be one superlative climax in any field of endeavor. Beyond that may be mutterings and thunderings or a shining after-glow but no second superlative climax. The second is a contradiction in terms and cannot exist. Angela charged him with every weakness and evil tendency only to have him look at her in a solemn way, occasionally saying, "Oh, no. You know I'm not as bad as that," or "Why do you abuse me that way? That isn't true," or "Why do you say that?"

"Because it's so, and you know it's so," Angela would declare.

"Listen, Angela," he replied once, with a certain amount of logic, "there is no use in brow-beating me this way. It doesn't do any good to call me names. You want me to love you, don't you? That's all you want. You don't want anything else. Will calling me names make me do it? If I can't I can't, and if I can I can. How will fighting help that?"

She listened to him pitifully for she knew that her rage was useless, or practically so. He was in the position of power. She loved him. That was the sad part of it. To think that tears and pleading and wrath might not really avail after all. He could only love her out of a desire that was not self-generated. That was something she was beginning to see in a dim way as a grim truth.

Once she folded her hands and sat white and drawn, staring at the floor. "Well, I don't know what to do," she declared. "I suppose I ought to leave you. If it just weren't for my family! They all think so highly of the marriage state. They are so naturally faithful and decent. I suppose those qualities have to be born in people. They can't be acquired. You would have to be made over."

Eugene knew she would not leave him. He smiled at the superior condescension of the last remark, only it was not intended as such by her. To

think of his being made over after the model Angela and her relatives would lay down. Still, there was truth in what she said. He knew that.

"I don't know where I'd go or what I'd do," she observed. "I can't go back to my family. I don't want to go there. I haven't been trained in anything except school teaching and I hate to think of that again. If I could only study stenography or book-keeping." She was talking as much to clear her own mind as his. She really did not know what to do.

Eugene listened to this self-demonstrated situation with a shamed face. It was hard for him to think of Angela being thrown out on the world as a book keeper or a stenographer. He did not want to see her doing anything like that. In a way he wanted to live with her, if it could be done in his way—much as the Mormons might, perhaps. What a lonely life hers would be if she were away from him. And she was not suited to it. She was not suited to the commercial world—she was too homey—too housewifely. He wished he could assure her now that she would not have further cause for grief and mean it, but he was like a sick man wishing he could do the things a well man might. There was no self-conviction in his thoughts, only the idea that if he tried to do right in this matter he might succeed but he would be unhappy. So he drifted.

Days came and went after this but to no great immediate advantage or improvement. This storm, long continued with occasional bursts of hard words and gloomy looks and thoughts on his part and Angela's, had the advantage of clearing the atmosphere on one point only—the uselessness of further suspicion. Angela's grounds had been established, her rights made clear. She might not control him but she had convicted him of evil. He began to think that this relationship with Carlotta, much as he admired her, might not be tenable after all. He could scarcely expect to go on this way. It was causing too much suffering. She was lovely, of course, but so were other women, and anyhow this situation was hedged about by almost insurmountable difficulties. If he had her she would not in all probability make him any such wife as Angela. At least she would not do the things that Angela did. Her mind was fixed on the same thing his was—the joy of living. Angela would work for him. Carlotta would live with him. There was a great difference. Both had their advantages.

Carlotta saw the change which came over him when Angela came home. She saw how difficult it was for him to maintain the easy, summery mode of communication which had held when he was at Speonk. He was now travelling up and down the road for Deegan and could meet her in a great many places but he did not have so much time and he was not so keen about it. His conscience was troubling him.

Besides, Angela was doing her best to discover who it was that he was

associating with without exposing herself to ridicule. Also Angela's sense of duty, loyalty, pride, shame at exposure before her family, and hope of reformation, were constantly conflicting with her hatred, desire for revenge, sorrow, self-commiseration, and so on. At one time, in a sorrowful way, she would make up her mind to stick it out, thinking because of her own fighting ability and persistence she could win. At another time, because of his persistent refusal to tell of the whereabouts of his partner in crime and her inability to trace him, she would despair of her power of endurance. It couldn't be, she would say to herself. Her life from now on would be a hell. What was the use trying? So the storm raged.

In the meanwhile Eugene had taken up his work with Deegan and was going through a very curious experience. At the time Deegan had stated that he would take him he had written to Haverford, making a polite request for transfer, and was immediately informed that his wishes would be granted. Haverford remembered Eugene kindly. He hoped he was improving. He understood from inquiry of the superintendent of buildings that Deegan was in need of a capable assistant, anyhow, and that Eugene could well serve in that capacity. The foreman was always in trouble about his reports. An order was issued to Deegan commanding him to receive Eugene, and another to Eugene from the office of the superintendent of buildings ordering him to report to Deegan. Eugene went, finding him working on the problem of constructing a coal bin under the depot at Fords Centre and raising as much storm as ever. He was received with a grin of satisfaction.

"So here ye arre. Will, ye're jist in time. I want ye to go down to the ahffice."

Eugene laughed. "Sure," he said. Deegan was down in a freshly excavated hole, and his clothes were redolent of the freshly turned earth which surrounded him. He had a plum bob in his hand and a spirit level, but he laid them down. Under the neat train shed to which he crawled when Eugene appeared and where they stood, he fished from a pocket of his old gray coat a soiled and crumpled letter which he carefully unfolded with his thick and clumsy fingers. Then he held it up and looked at it defiantly.

"I want ye to go to Woodlawn," he continued, "an' look after some bolts that arre theyer—theres a keg av thim—an' sign the bill fer thim, an' ship thim down to me. They're not miny. An' thin I waant ye to go down to the ahffice an' take thim this o.k."—and here he fished around and produced another crumpled slip. "It's nonsinse!" he exclaimed when he saw it. "It's onraisonable! They're aalways yillen fer thim o.k. blanks. Ye'd think, b'gad, I was goin' to steal thim from thim. Ye'd think I lived on thim things. O.k. blanks. O.k. blanks. From mornin' till night. O.k. blanks. It's nonsinse! It's onraisonable." And his face flushed a defiant red.

Eugene could see that some infraction of the railroad's rules had occurred and that Deegan had been "called down" or "jacked up" about it, as the railroad men expressed it. He was in a high state of dudgeon—as defiant and pugnacious as his royal Irish temper would allow.

"I'll fix it," said Eugene. "That's all right. Leave it to me."

Deegan showed some signs of approaching relief. At last he had a man of "intilligence," as he would have expressed it. He flung a parting shot, though, at his superior as Eugene departed.

"Tell thim I'll sign fer thim when I git thim and naat before," he rumbled.

Eugene laughed. He knew no such message would be accepted but he was glad to give Deegan an opportunity to blow off steam. He entered upon his new tasks with vim, pleased with the out-of-doors, the sunshine, the opportunity for brief trips up and down the road like this. It was delightful. He would be soon all right now, that he knew.

He went to Woodlawn and signed for the bolts; went to the office and met the chief clerk (delivering the desired o.k. blank in person), who informed him of the chief difficulty in Deegan's life. It appeared that there were some twenty-five of these reports to be made out monthly, to say nothing of endless o.k. blanks to be filled in with acknowledgements of material received. Everything had to be signed for in this way; it mattered not whether it was a section of a bridge or a single bolt or a pound of putty. It was the only way the superintendent of buildings had of compiling his report. It appeared that Deegan was not skilful in these matters and in consequence was in a bad way at times with his superiors. He was an A-1 workman but that did not help him much since the chief clerk's very existence as a chief clerk depended on the accuracy with which he could survey for his superior the nature and progress of the work in hand. If a man could sit down and reel off a graphic report of what he was doing he was the pride of the chief clerk's heart. His doing the work properly was taken as a matter of course. Deegan was not efficient at this, though he was assisted at times by his wife and all three of his children, a boy and two girls. He was constantly in hot water.

"My God!" exclaimed the chief clerk when Eugene explained that Deegan had thought he might leave the bolts at the station where they would be safe until he needed them and then sign for them when he took them out. He ran his hands distractedly through his hair. "What do you think of that," he exclaimed. "He'll leave them there until he needs them, will he? What becomes of my reports? I've got to have those o.k.'s. You tell Deegan he ought to know better than that. He's been long enough on the road. You tell him that I said that I want a signed form for everything consigned to him the moment he learns that it's waiting for him. And I want

it without fail. Let him go and get it. The gall! He's got to come to time about this or something's going to drop. I'm not going to stand it any longer. You'd better help him in this. I've got to make out my reports on time."

Eugene agreed that he would. This was his field. He could help Deegan. He could be really useful. This was the most ideal request for assistance that had ever come to him. He was delighted to be able to help.

Time passed. The weather grew colder and while the work was interesting at first, like all other things it began after a time to grow monotonous. It was nice enough when the weather was fine to stand out under the trees, where some culvert was being built to bridge a small rivulet, or some well to supply the freight engines with water, and survey the surrounding landscape; but when the weather grew colder it was not so nice. Deegan was always interesting. He was forever raising a ruction. He lived a life of hard, narrow activity laid among boards, wheelbarrows, cement, stone, a life which concerned construction and had no particular joy in fruition. The moment a thing was nicely finished they had to leave it and go where everything, because of their work, would be torn up again. He used to look at the wounded ground, the piles of yellow mud, the dirty Italians, clean enough in their spirit but soiled and gnarled by their labor, and wonder how long he could stand it. To think that he, of all men, should be here working with Deegan and the *guineas*. He became lonesome at times—terribly—and sad. He longed for Carlotta, longed for a beautiful studio, longed for a luxurious, artistic life. It seemed that life had wronged him terribly and yet he could do nothing about it. He had no money-making capacity.

About this time the construction of a rather pretentious machine shop, 200 by 200 feet and four stories high, was assigned to Deegan largely because of the efficiency which Eugene contributed to the work which Deegan could do so well. Eugene handled his reports and accounts with rapidity and preciseness, and this so soothed the division management that they had an opportunity to see Deegan's real worth. The latter was beside himself with excitement, anticipating great credit and distinction for the work he was now going to be permitted to do.

"'Tis the fine time we'll have, Eugene, me bye," he exclaimed, "puttin' up that buildin'. 'Tis no culvert we'll be afther buildin' now. Nor no coal bin. Wait till the masons come. Thin ye'll see somethin.'"

Eugene was pleased that their work was eventuating so successfully, but of course there was no future in it for him. He was lonely and disheartened.

Besides, Angela was complaining, and rightfully enough, that they were leading a difficult life and to what end, so far as she was concerned? He might recover his health and his art (by reason of his dramatic shake-ups and changes he appeared to be doing so), but what would that avail her? He

did not love her. If he became prosperous again it might be to forsake her. And at best he could only give her money and position, if he ever attained these, and how would that help? It was love that she wanted, his love. And she did not have that, or only a mere shadow of it. He had made up his mind after this last fatal argument that he would not pretend to anything he did not feel in regard to her, and this made it even harder. She did believe that he sympathized with her in his way but it was an intellectual sympathy and had very little to do with the heart. He was sorry for her. Sorry! Sorry! How she hated the thought of that. If he could not do any better than that, what was there in all the years to come but misery?

A curious fact to be noted about this period was that suspicion had so keyed up Angela's perceptions that she could almost tell, and that without knowing how or why, when Eugene was with Carlotta—or had been. There was something about his manner when he came in of an evening, to say nothing of those subtler thought waves which passed from him to her when he was with Carlotta, which told her instantly where he had been and what he had been doing. She would ask him where he had been and he would say, "Oh, up to White Plains," or "out to Scarborough," but nearly always when he had been with Carlotta, Angela would flare up with, "Yes, I know where you've been. You've been out again with that miserable beast of a woman. Oh, God will punish her yet! You will be punished! Wait and see."

Tears would flood her eyes and she would berate him roundly.

Eugene stood in profound awe before the subtle outbreaks. He could not understand how it was that Angela came to know or suspect so accurately. To a certain extent he was a believer in spiritualism and the mysteries of a subconscious mind or self. He fancied that there must be some way of this subconscious self seeing or apprehending what was going on and of communicating its knowledge in the form of fear and suspicion to Angela's mind. If the very subtleties of nature were in league against him, how was he to continue or profit in this career? Obviously it could not be done. He would probably be severely punished for it. He was half terrified by the vague suspicion that there might be some laws, determined by a superior mind, which tended to correct in this way all the abuses in nature. There might be much vice and crime going on seemingly unpunished but there might also be much correction going on, as the suicides and deaths and cases of insanity seemed to attest. Was this true? Was there no escape from the results of evil except by abandoning it entirely? He pondered over this gravely. It was something to think about, even though it did not immediately cure him of his evil tendencies.

Getting on his feet again financially was not such an easy thing. He had been out of touch now so long with things artistic—the magazine world

and the art agencies—that he felt as if he might not readily be able to get in touch again. Besides, he was not at all sure of himself. He had made sketches of men and things at Speonk, and of Deegan and his gang on the road, and of Carlotta and Angela, but he felt that they were weak in their import—lacking in the force and feeling which had once characterized his work. He thought of trying his hand at newspaper work if he could make any sort of a connection—working in some obscure newspaper art department until he should feel himself able to do better—but he did not feel at all confident that he could get that. His severe breakdown had made him afraid of life—made him yearn for the sympathy of a woman like Carlotta or of a larger, more hopeful, more tender attitude, and he dreaded looking for anything anywhere. Besides, he hated to spare the time unless he was going to get somewhere. His work was so pressing. He thought about it wearily, wishing he were better placed in this world, and finally screwed up his courage to leave, though it was not until something else was quite safely in his hands.

CHAPTER LXI

Those who are following the development of this character will fail to grasp it entirely unless they understand clearly that Eugene, in spite of his seeming hardness, his subtlety, his moral irresponsibility, was seeking in an eager, almost pathetic way the realization of an ideal which one might say may never have been on land or sea, but which he dreamed of for himself—the possession of a lovely girl of eighteen or thereabouts who would be at once wife, mother, mentor, friend—a paragon of beauty, sympathy, and force, on whom he could lean and who would share all his moods and fully comprehend his peculiar point of view. Of course he was looking for a very remarkable woman. Angela was not one such. She had many of the qualities which he needed—but not the last ones—largeness of sympathy and unseeking generosity. Angela, while faithful, thrifty, good looking, ambitious for his welfare, was at the same time seeing through his talent and ability the means to an end. She wanted him to love her ever much more than she craved the privilege of loving him. She wanted him to realize how good and fine and faithful she was—how much she craved his success and had his interests at heart. She was always telling him these things—never letting him forget them. He did not want to be loved that way, but rather unselfishly. He did not want to be made to love, but to be allowed to do it. He wanted it to be a desire in him, but where was the

woman who would truly inspire it? Looking back over all the women he had known, Frieda seemed nearest to one who would understand his moods and emotions because she herself was apparently an embodiment of these things, but he was not sure. She was so young. She seemed truly a wonderful girl even yet—a phantom of delight—"a dancing shape, an image gay, to haunt, to startle and waylay"—but he could not have her. Angela was here and Angela had a legal claim on him, and apparently a moral one. It seemed a terrible thing to him to be thus whipped at the tail of the cart of convention but how was he to do—how get loose? It would have been better for him then, so long as he was as he was, to have left her deliberately and ceased this mutual agony (since he could not well be corrected) rather than go on groaning, complaining, and feeling deeply injured by life. His was not, however, the constructive, executive temperament. He did not see how essential it is to cut away from all binding claims, ruthlessly if one must, rather than go on aimlessly living in unrest and misery.

Angela was equally unwise. Instead of giving him up sensibly when she saw how irreconciled was his attitude toward her, she went on pursuing this phantom of his affection. She could make him love her. She could make him settle down and behave himself if she tried hard enough. All her sisters' marriages were successful—why not hers? It might be agonizing to her now that he was unfaithful, but after awhile, when he was older, when he had more experience of the world, when perhaps he was old and poor, he would see how essential it was to have a woman of her type about. Where would he find anyone who would do for him what she had done? Where could he? Most women were selfish, self-seeking, not looking after their husbands' interests. She was not one such. All her life was for him—all her thoughts—but she forgot that in giving everything she was demanding everything in return, which was where the scratch came.

It was only after a considerable lapse of time, when trying to live on nine dollars a week and seeing Angela struggle almost helplessly in her determination to live on what he earned and put a little aside, that he came to his senses and made a sincere effort to find something better. During all this time he had been watching her narrowly, seeing how systematically she did all her own house work, even under these adverse and trying circumstances cooking, cleaning, marketing. She went over her old clothes, reshaping them so they would last longer and still look stylish. She made her own hats, doing everything, in short, that she could to make the money in the bank endure until Eugene should be on his feet. She was willing that he should take money and buy himself clothes when she was not willing to spend it on herself. She was living in the hope that somehow he would reform. Consciousness of what she was worth to him might some day strike

him. Still she did not feel that things could ever be quite the same again. She could never forget and neither could he.

The affair between Eugene and Carlotta, because of the various forces that were militating against it, was slowly drawing to a close. It had not been able to endure all the storm and stress which followed its discovery. For one thing, Carlotta's mother, without telling her husband, made him feel that he had good cause to stay about, which made it difficult for Carlotta to act. Besides she charged her daughter constantly, much as Angela was charging Eugene, with the utmost dissoluteness of character and was as constantly putting her on the defensive. In spite of the fact that Carlotta resented her mother's interference, nevertheless she respected and in her way admired her, for her mother was doing it for her own good. She had to listen to these pleas and persuasions in patience, for her mother could tell her husband—though she knew she wouldn't, unless she were pushed too far. Besides, the winter which had come on was proving exceptionally severe and Carlotta did not love the out-of-doors. She was too hedged about to risk a separate apartment and Eugene would not accept money from her to pay for expensive indoor entertainment. She wanted to see Eugene but she kept hoping he would get to the place where he would have a studio again and she could see him as a star in his own field. That would be so much nicer. By degrees those once exciting engagements began to lapse and despite his grief Eugene was not altogether sorry.

To tell the truth, great physical discomforts recently had painted his romantic tendencies in a very sorry light for him. He saw in a way where they were leading him. That there was no money in them was obvious. That the affairs of the world were put in the hands of those who were content to get their life's happiness out of their management, was quite plain. Idlers had nothing—as a rule not even the respect of their fellow men. Sex enthusiasts were worn threadbare and disgraced by their ridiculous and psychologically diseased propensities. Women and men who indulged in these ungoverned flirtations were sickly sentimentalists as a rule and were thrown out or ignored by all forceful society. One had to be strong, eager, determined, and abstemious if wealth came and then it had to be held by much the same qualities. One could not relax. Otherwise one became much what he was now, a brooding sentimentalist—diseased in mind and body. How was he to get up in the world again? he asked himself. By gaining health first and strength and then by gaining the respect of others? Certainly. And that could only be gained by hard work, abstemiousness, and the self-confidence which comes of self-respect. And he could only respect himself when he found himself in line with what the world deemed essential and important.

So out of love-excitement and poverty and ill health and abuse, he was coming to see this one fact clearly: that he must behave himself if he truly wished to succeed. Did he want to? He could not say that. But he had to—that was the sad part of it, and since apparently he had to, he would do the best he could. It was grim but it was essential.

At this time Eugene still retained that rather ultra-artistic appearance which had characterized his earlier years but he began to suspect that on this score he was a little bizarre and out of keeping with the spirit of the times. Certain artists whom he met in times past and recently were quite commercial in their appearance—the very successful ones—and he decided that it was because they put the emphasis upon the hard facts of life and not upon the romance connected with their work. It impressed him and he decided to do likewise, abandoning the flowing tie and the rather indiscriminate manner he had of combing his hair, and affecting severe simplicity. He still wore a soft hat because he thought it became him best but otherwise he toned himself down greatly. His work with Deegan had given him a sharp impression of what hard, earnest labor meant, for Deegan was nothing but a worker. There was no romance in him. He knew nothing about romance. Picks and shovels and mortar boards and concrete forms—such was his life, and he never complained. Eugene remembered commiserating with him once on having to get up at four a.m. in order to make a train which would get him to work by seven. Darkness and cold made no difference to him, however.

"Shewer I have to be theyre," he had replied with his quizzical Irish grin. "They're not payin' me me wages fer lyin' in bed. If ye were to get up that way every day fer a year it would make a man av ye!"

"Oh, no," said Eugene teasingly.

"Oh, yis," said Deegan, "it would. An' ye're the man that's needin' it. I can tell that by the cut av ye."

Eugene resented this but it stayed by him.

Deegan had the habit of driving home salutary lessons in regard to work and abstemiousness without really meaning to. The two qualities were wholly representative of him—just those two things and nothing more.

One day Eugene went down into Printing House Square to see if he could not make up his mind to apply at one of the newspaper art departments, when he ran into Hudson Dula, whom he had not seen for a long while. The latter was delighted to see him.

"Why, hello, Witla," he exclaimed, shocked to see that he was exceptionally thin and pale. "Where have you been all these years? I'm delighted to see you. What have you been doing? Let's go over here to Hahn's and you tell me all about yourself."

"I've been sick, Dula," said Eugene frankly. "I had a severe case of nervous breakdown and I've been working on the railroad for a change. I tried all sorts of specialists but they couldn't help me. So I decided to go to work by the day and see what that would do. I got all out of sorts with myself and I've been pretty near four years getting back. I think I am getting better, though. I'm going to knock off on the road one of these days and try my hand at painting again. I think I can do it."

"Isn't that curious," replied Dula reminiscently, "I was just thinking of you the other day and wondering where you were. You know I've quit the art director game. *Truth* failed and I went into the lithographic business. I have a small interest in a plant that I'm managing down in West Street. I wish you'd come in and see me some day."

"I certainly will," said Eugene.

"Now this nervousness of yours," said Dula, as they strolled into the restaurant where they were dining. "I have a brother-in-law that was hit that way. He's still doctoring around. I'm going to tell him about your case. You don't look so bad."

"I'm feeling much better," said Eugene. "I really am. But I've had a bad spell of it. I'm going to come back in the game, though. I feel sure of it. When I do, I'll know better how to take care of myself. I overworked on that first burst of pictures."

"I must say that was the best stuff of that kind I ever saw done in this country," said Dula. "I saw both your exhibits, as you remember. They were splendid. What became of all those pictures?"

"Oh, some were sold and the rest are in storage," replied Eugene.

"Curious, isn't it," said Dula. "I should have thought all of those things would have been purchased. They were so new and forceful in treatment. You want to pull yourself together and stay pulled. You're going to have a great future in that field."

"Oh, I don't know," replied Eugene pessimistically. "It's all right to obtain a big reputation but you can't live on that, you know. Pictures don't sell very well over here. I have most of mine left. A commonplace grocer with one delivery wagon has the best artist that ever lived backed right off the board for financial results."

"Oh, not quite as bad as that," said Dula, smilingly. "An artist has something which a tradesman can never have—you want to remember that. His point of view is worth something. He lives in a different world spiritually. And then financially you can do well enough—you can live, and what more do you want? You're received everywhere. You have what the tradesman cannot possibly attain—distinction; and you leave the world a standard of merit—*you* will, at least. If I had your ability I would never sit about envy-

ing any butcher or baker. Why, all the artists know you now—the good ones anyhow. It only remains for you to do more, to obtain more. There are lots of things you can do."

"What, for instance?" asked Eugene.

"Why ceilings, mural decorations. I was saying to someone the other day what a mistake it was the Boston Library did not assign some of their panels to you. You would make splendid things of them."

"You certainly have a world of faith in me," replied Eugene, tingling warmly. It was like a glowing fire to hear this after all the dreary days. Then the world still remembered him. He was worthwhile.

"Do you remember Oren Benedict—you used to know him out in Chicago, didn't you?"

"I certainly did," replied Eugene. "I worked with him."

"He's down on the *World* now, in charge of the art department there. He's just gone there." Then as Eugene exclaimed over the curious shifts of time, he suddenly added, "Why wouldn't that be a good idea for you? You say you're just about to knock off. Why don't you go down and do some pen work to get your hand in? You're not known. It would be a good experience for you. Benedict would be glad to put you on, I'm sure."

Dula suspected that Eugene might be out of funds and this would be an easy way for him to slip into something which would lead back to studio work. He liked Eugene. He was anxious to see him get along. It flattered him to think he was the first to publish his work in color.

"That isn't a bad idea," said Eugene. "I was really thinking of doing something like that if I could. I'll go and see him, maybe today. It would be just the thing I need now—a little preliminary practice. I feel rather rusty and uncertain."

"I'll call him up if you want," said Dula generously. "I know him well. He was asking me the other day if I knew one or two exceptional men. You wait here a minute."

Eugene leaned back in his chair as Dula left. Could it be that he was going to be restored thus easily to something better? He had thought it would be so hard. Now this chance was coming to lift him out of his sufferings at the right time.

Dula came back. "He says sure," he exclaimed. "Come right down. You'd better go down there this afternoon. That'll be just the thing for you. And when you're located again, come around and see me. Where are you living?"

Eugene gave him his address.

"That's right, you're married," he added, when Eugene spoke of himself and Angela having a small place. "How is Mrs. Witla? I remember her as a very

charming woman. Mrs. Dula and I have an apartment in Gramercy Place. You didn't know I had tied up, did you? Well I have. Bring your wife and come to see us—we'll be delighted. I'll make a dinner date for you two."

Eugene was greatly pleased and elated. He knew Angela would be. They had seen so little of artistic life lately. He hurried down to see Benedict and was greeted as an old acquaintance. They had never been very chummy but always friendly. Benedict had heard of Eugene's nervous breakdown.

"Well, I'll tell you," he said after greetings and reminiscences were over. "I can't pay very much—fifty dollars is high here just at present, and I have just one vacancy now at twenty-five which you can have if you want to try your hand. There's a good deal of hurry up about it at times, but you don't mind that. When I get things straightened around here I may have something better."

"Oh, that's all right," replied Eugene cheerfully. "I'm glad to get that" (he was very glad indeed), "and I don't mind the hurry. It will be good for a change."

Benedict gave him a friendly handshake in farewell. He was glad to have him for he knew what he could do.

"I don't think I can come before Monday. I have to give a few days' notice. Is that all right?"

"I could use you earlier but Monday will do," said Benedict, and they parted genially.

Eugene hurried back to Port Morris, the neighborhood into which he and Angela had moved after he went with Deegan. He was delighted to tell Angela, for this would rob their condition of part of its gloom. It was no great comfort to him to be starting in as a newspaper artist again at twenty-five dollars a week but it couldn't be helped and it was better than nothing. At least it was putting him back on the track again. He was sure to do still better after this. He could hold this newspaper job, he felt, and outside of that he didn't care very much for the time being. It was vastly better than day labor and his pride had received a severe jolt. He hurried up the four flights of stairs to the cheap little quarters they occupied, saying when he saw Angela at the gas range, "Well I guess our railroad days are over."

"What's the trouble?" asked Angela apprehensively.

"No trouble," he replied, "I have a better job."

"What is it?"

"I'm going to be a newspaper artist for awhile on the *World*."

"When did you find that out?" she asked, brightening, for she had been terribly depressed over their state.

"This afternoon. I'm going to work Monday. Twenty-five dollars will be some better than nine, won't it?"

Angela smiled. "It certainly will," she said, and tears of thanksgiving filled her eyes.

Eugene knew what those tears stood for. He was anxious to avoid painful reminiscences.

"Don't cry," he said. "Things are going to be much better from now on."

"Oh, I hope so, I hope so," she murmured, and he patted her head affectionately as it rested on his shoulder.

"There now. Cheer up, girlie, will you? We're going to be all right from now on."

They both felt that their burden was being lifted a little and were thankful.

Angela smiled through her tears. She set the table exceedingly cheerfully.

"That certainly is good news," she laughed, afterward. "Well, we're not going to spend any more money for a long while, anyhow. We're going to save something. We don't want to get in this place again."

"No more of this for me and mine," replied Eugene gaily, "not if I know my business," and he went into the one little combination parlor, sitting room, reception room, and general room of all work to open his evening newspaper and whistle. In his excitement he almost forgot his woes over Carlotta and the love question in general. He was going to climb again in the world and be happy with Angela. He was going to be an artist or a business man or something. Look at Hudson Dula. Doing a lithographic business and living in Gramercy Place. Could any artist he knew do that? Scarcely. He would see about this. He would think this art business over. Maybe he could be an art director or a lithographer or something. He had often thought while he was out on the road that he could be a good superintendent of buildings if he could only give it time enough.

Angela for her part was wondering what this change really spelled for her. Would he behave now? Would he set himself to the task of climbing slowly and surely? He was getting along in life. He ought to begin to place himself securely in the world if he ever was going to. Her love was not the same as it had formerly been. It was crossed with dislike and opposition at times but she felt that he needed her to help him. Poor Eugene—if he only were not cursed with this weakness. Perhaps he would overcome it? So she mused.

CHAPTER LXII

The work which Eugene undertook in connection with the art depart-
ment of the *World* was not different from that which he had done ten
years before in Chicago. It seemed no less difficult for all his experience—
more so, if anything, for he felt above it these days and consequently out of
place. He wished at once that he could get something which would pay him
commensurately with his ability. To be set down among mere boys—there
were a lot of men there as old as himself and older, though of course he
did not pay so much attention to them—was galling. He thought Benedict
should have had more respect for his talent than to have offered him so
little though at the same time he was grateful for what he had received. He
undertook energetically to carry out all the suggestions given him and sur-
prised his superior with the speed and imagination with which he developed
everything. He surprised Benedict the second day with a splendid imagina-
tive interpretation of the "Black Death," which was to accompany a Sunday
newspaper article upon the modern possibilities of plagues. Benedict saw at
once that Eugene could probably not be retained but a very little while at
the figure he had given him but he had made the mistake of starting him low.
He had been thinking that Eugene's talent after so severe an illness might
be at a very low ebb. He did not know, being new to the art directorship of
a newspaper, how very difficult it was to get proper increases. An advance
of ten dollars to anyone meant earnest representation and an argument with
the business manager, and to double and treble the salary—which should
have been done in this case—was out of the question. Six months was a
reasonable length of time for anyone to wait for an increase—such was the
dictum of the business management, and in Eugene's case it was ridiculous
and unfair. However, being still sick and apprehensive, he was content to
abide by the situation, hoping with returning strength and the saving of a
little money to put himself right eventually.

Angela, of course, was pleased with the turn of affairs. Having suffered so
long with only prospects of something worse in store, it was a great relief to
go to the bank every Tuesday—Eugene was paid on Monday—and deposit
ten dollars against a rainy day. It was agreed between them that they might
use the additional six for clothing, which Angela and Eugene very much
needed, and some slight entertainment. It was not long before Eugene began
to bring an occasional newspaper artist friend up to dinner, and they were
invited out. They had gone without much clothing, with scarcely a single
visit to the theatre, without friends—everything. Now the tide began slowly
to change and in a little while, because they were more free to go places,
they began to encounter people whom they knew. Once they called on the

art dealers to learn how Eugene's pictures were getting along and another time to see the Dulas. There they re-encountered some of the other people they had known and were able to give a reasonable account of themselves. Eugene's health had been so bad they had been traveling. In a little while Eugene began to feel as though he might climb upward again—they had a thousand dollars in the bank and so he took on a much more cheerful attitude toward life.

There was six months of this drifting journalistic work, in which as in his railroad work he grew more and more restless, and then there came a time when he felt as if he could not stand that for another minute. He had been raised to thirty-five dollars and then fifty, but it was a terrific grind of exaggerated and, to him, thoroughly meretricious art. The only valuable results in connection with it were that for the first time in his life he was drawing a moderately secure living salary and that his mind was fully occupied with details which gave him no time to think about himself. He was in a large room surrounded by other men who were as sharp as knives in their thrusts of wit and were restless and greedy in their attitude toward the world. They wanted to live brilliantly, just as he did, only they had more self-confidence and in many cases that extreme poise which comes of rare good health. They were inclined to think he was somewhat of a poseur at first but later they came to like him, all of them. He had a winning smile and his love of a joke, so keen, so body-shaking, drew to him all of those who had a good story to tell.

"Tell that to Witla," was a common phrase about the office, and Eugene was always listening smilingly to some one. He got to going out to lunch with first one and then another—then three or four at a time—and by degrees Angela was compelled to entertain Eugene and two or three of his friends twice and sometimes three times a week. She objected greatly and there was some feeling over that, for she had no maid and she did not think that Eugene ought to begin so soon to put the burden of entertainment upon their slender income. She wanted him to make these things very formal and by appointment but Eugene would stroll in, genially explaining that he had Irving Nelson with him or Henry Hare or George Beers, and asking nervously at the last minute whether it was all right. Angela would say, "Certainly, to be sure," in front of the guest but when they were alone there would be tears and reproaches and firm declarations that she could not stand it.

"Well I won't do it anymore," Eugene would apologize. "I forgot, you know."

Still, he wanted Angela to get a maid and let him bring all who would come. It was a great relief to get back into the swim of things and see life broadening out once more.

It was not so long after he had grown exceedingly weary of his under-paid relationship to the *World* that he heard of something which promised a much better avenue of advancement. Eugene had been hearing for some time from one source and another of the development of art in advertising. He had read one or two articles on the subjects in the smaller magazines, had seen from time to time curious and some times beautiful series of ads running by first one corporation and then another advertising some product. He had always fancied in looking at these things that he could get up a notable series on almost any subject and he wondered how it was done—who handled these things. He asked Benedict one night, going up on the car with him, what he knew about it.

"Why, so far as I know," said Benedict, "that is coming to be quite a business. There is a man out in Chicago, Soljerian, an American Syrian—his father was a Syrian but he was born over here—who has built a tremendous business out of designing series of ads like that for big corporations. He got up that Molly Maguire series for the new cleaning fluid. I don't think he does any of the work himself. He hires artists to do it. Some of the best men, I understand, have done work for him. He gets splendid prices. Then some of the big advertising agencies are taking up that work. One of them I know. The Summerfield Company has a big art department in connection with it. They employ fifteen to eighteen men all the time, sometimes more. They turn out some fine ads too, to my way of thinking. Do you remember that Korno series?" Benedict was referring to a breakfast food which had been advertised by a succession of ten very beautiful and very clever pictures.

"Yes," replied Eugene.

"Well, they did that."

Eugene thought of this as a most interesting development. Since the days in which he had worked in the Alexandria *Appeal* he had been interested in ads. The thought of an ad department took his fancy. It was newer than anything else he had encountered recently. He wondered if there would not be some chance in that field for him. His paintings were not selling. He did not have the courage to start a new series. If he could make some money first, say ten thousand dollars, so that he could get an interest income of say six or seven hundred dollars a year, he might be willing to risk art for art's sake. He had suffered so much—poverty had scared him so that he was very anxious to lean on a salary or a business income of some kind for the time being.

It was while he was speculating over this almost daily that there came to him one day a young artist who had formerly worked on the *World*—a youth by the name of Morgenbau, Adolph Morgenbau—who admired Eugene and his work greatly and who had since gone to another paper. He was very anx-

ious to tell Eugene something, for he had heard of a change coming in the art directorship of the Summerfield Company and he fancied for one reason and another that Eugene might be glad to know of it. The latter had never looked to Morgenbau like a man who ought to be working in a newspaper art department. He was too self-poised, too superior, too wise. Morgenbau had conceived the idea that Eugene was destined to make a great strike of some kind and with that kindling intuition that sometimes saves us whole, he was anxious to help Eugene in some way and so gain his favor.

"I have something I'd like to tell you, Mr. Witla," he observed.

"Well, what is it?" smiled Eugene.

"Are you going out to lunch?"

"Certainly, come along."

They went out together and Morgenbau communicated to Eugene what he had heard—that the Summerfield Company had just dismissed, or parted company with, or lost, a very capable director by the name of Freeman and that they were looking for a new man. "Why don't you apply for that?" asked Morgenbau. "You could hold it. You're doing just the sort of work that would make great ads. You know how to handle men, too. They like you. All the young fellows around here do. Why don't you go and see Mr. Summerfield? He's up in Thirty-fourth Street. You might be just the man he's looking for, and then you'd have a department of your own."

Eugene looked at this boy, wondering what had put this idea in his head. He was intensely superstitious. He believed that, more or less, his life was fated. He seemed always to be guided—not always favorably, apparently, but favorably or unfavorably, guided nevertheless. Benedict had mentioned the name of this firm not so long before. He had been thinking of something like this for himself. Now the idea was put up to him direct to act upon. He turned it over in his mind, thanking Morgenbau warmly, and studying how best to proceed. Dula could help him in this perhaps, and Richard Wheeler, who he understood, though he had not seen him in a long time, was in charge of the American Art Publishing Society, a large concern, as manager. He decided to call up Dula and did so at once, asking him what he thought would be the best move to make. The latter did not know Summerfield but he knew someone who did.

"I'll tell you what to do, Eugene," he said. "You go and see Baker Bates of the Satina Company. That's at the corner of Broadway and Fourth Streets. We do a big business with the Satina Company, and they do a big business with Summerfield. I'll send a letter over to you by a boy and you take that. Then I'll call Bates up on the phone and if he's favorable he can speak to Summerfield. He'll want to see you, though."

Eugene was very grateful and eagerly awaited the arrival of the letter.

He asked Benedict for a little time off and presented it to Mr. Baker Bates. The latter had heard enough from Dula to be friendly. He had been told by Dula that Eugene was potentially a great artist, slightly down on his luck, but that he was doing exceedingly well where he was and would do better in the new place. He was impressed by Eugene's appearance, for the latter had changed his style from the semi-artistic to the practical. He thought Eugene looked capable. He was certainly pleasant.

"I'll talk to Mr. Summerfield for you," he said, "though I wouldn't put much hope in what will come of it if I were you. He's a difficult man and it's best not to appear too eager in this matter. If he can be induced to send for you it will be much better. You let this rest until tomorrow. I'll call him up on another matter and take him out to lunch and then I'll see how he stands and who he has in mind, if he has anyone. He may have, you know. If there is a real opening I'll speak of you. We'll see."

Eugene went away, once more very grateful. He was thinking that Dula had always meant good luck to him. He had taken his first important drawing. The drawings he had published for him had brought him the favor of M. Charles. Dula had secured him the position that he now had. Would he be the cause of his getting this one?

On the way downtown on the car, he encountered a cross-eyed boy. He had understood from someone recently that cross-eyed boys were good luck—cross-eyed women bad luck. A thrill of hopeful prognostication passed over him. In all likelihood he was going to get this place. If this sign came true this time he would believe in signs. They had come true before but this would be a real test. He stared cheerfully at the boy and the latter looked him full in the eyes and grinned.

"That settles it," said Eugene, "I'm going to get it."

Still he was far from being absolutely sure.

CHAPTER LXIII

The Summerfield Advertising Agency, of which Mr. Daniel C. Summerfield was president, was one of those curious exfoliations or efflorescences of the personality of a single individual which is so often met with in the business world and which always mean a remarkable individual behind them. The ideas, the enthusiasm, the strength of Mr. Daniel C. Summerfield was all there was to the Summerfield Advertising Agency. It was true there was a large force of men working for him—advertising solicitors, advertising writers, financial accountants, artists, stenographers, book-keepers, and

the like—but they were all, as it were, an emanation or irradiation of the personality of Mr. Daniel C. Summerfield. He was small, wiry, black-haired, black-eyed, black-mustached, with an olive complexion and even, pleasing, albeit at times wolfish, white teeth which indicated a disposition as avid and hungry as a disposition well might be.

Mr. Summerfield had come up into his present state of affluence or comparative affluence from the direst poverty and by the directest route—his personal efforts. In the state in which he had originated, Alabama, his family had been known (in the small circle to which they were known at all) as poor white trash. His father had been a rather lackadaiscal, half-starved cotton planter who had been satisfied with a single bale or less of cotton to the acre on the ground which he leased, and who drove a lean mule very much the worse for age and wear up and down the furrows of his leaner fields the while he complained of "the misery" in his breast. He was afflicted with slow consumption or thought he was, which was just as effective, and in addition had hook worm.

Daniel Christopher, his eldest son, named after the one important grandfather on the wife's side; Thomas Jefferson, the second boy; and Andrew Jackson, the third, were the only children of a very unimportant and rather miserable marriage. Daniel C. had been raised with scarcely any education, having been put in a cotton mill at the age of seven. Thomas Jefferson had run away at eleven years and bestirred himself about various tasks. Andrew Jackson, who was seven years younger than his eldest brother, had stayed at home and gone to school, for by the time he was ten the very forceful brain of Daniel Christopher had begun to show itself in the family's miserable home life and they were beginning to do better.

Daniel C. for the first four years of his business career had worked in the cotton mill to which his father had apprenticed him. Later, because of his unusual brightness he had been given a place in the printing shop of the Wickham *Union* where, because he was attractive to the slow-going proprietor, he soon became foreman of the printing department and then manager. He knew nothing of printing or newspapers at the time but the little contact he obtained here soon cleared his vision. He saw instantly what the newspaper business was and decided to enter it. Later as he grew older he suspected that no one knew very much about advertising as yet, or very little, and that he was called by God to revise it. He had visions of a still wider field of usefulness in that direction and began at once to prepare himself for it, reading all manner of advertising literature and practising the art of display and statement. He had been through such bitter things as personal fights with his own employees, or rather those who worked under him, knocking one man down with a heavy iron form key; personal altercations

with his own father and mother, in which he frankly told them that they were failures and that they had better let him show them something about regulating their hopeless lives; he had quarreled with his younger brothers, trying to dominate them and had succeeded in controlling the youngest, principally for the very good reason that he had become foolishly fond of him. This youngest brother was later introduced into his advertising business. He had religiously saved the little he had earned thus far, invested a part of it in the further development of the Wickham *Union*, bought his father an eight acre farm which he showed him how to work, and finally decided to come to New York to see if he could not connect himself with some important advertising concern where he could learn something more about the one thing that interested him. At the time he was married and brought his young wife with him from the South.

He soon connected himself as a solicitor with one of the great agencies and advanced rapidly. He was so smiling, so bland, so insistent, so magnetic, that business came to him rapidly. He became the star man in this New York concern and Alfred Cookman, who was its owner and manager, was soon pondering what he could do to retain him. No individual or concern could long retain Daniel C. Summerfield, however, once he understood his personal capabilities. In two years he had learned all that Alfred Cookman had to teach him and more than he could teach him. He knew his customers and what their needs were and where the lack was in the service which Mr. Cookman rendered them. He foresaw the drift toward perfect art representation of saleable products and decided to go into that side of it. He would start an agency which would render a service so complete and dramatic that anyone who could afford to use his service would make money. He believed that each particular ad which a house put out could be made to say something so forcefully that everyone would stop and notice it. That was the ideal he was striving for, and he was thinking of geniuses in art and humor and caricature who could help him realize this ideal.

When Eugene first heard of this agency, the Summerfield concern was six years old and rapidly growing. It was already very large and profitable, and as hard and forceful as its owner. Daniel C. Summerfield, sitting in his private office, was absolutely ruthless in his calculations as to men. He had studied the life of Napoleon and had come to the conclusion that no individual life was important. Mercy was a joke to be eliminated from business. Sentiment was silly twaddle. The thing to do was to hire men as cheaply as possible, to drive them as vigorously as possible, and to dispose of them quickly when they showed signs of weakening under the strain. He had already had five art directors in as many years, had hired and "fired" as he termed it innumerable solicitors, ad writers, book keepers, stenographers,

artists—in short anyone and everyone who showed the least sign of inca-pacity or inefficiency. The great office floor which he maintained was a model of cleanliness, order—one might almost say beauty of a commercial sort—but it was the cleanliness, order, and beauty of a hard, polished and well-oiled machine. Daniel C. Summerfield was not much more than that, but he had long ago decided that was what he must be in order not to be a failure and as he called it "a mark," and he admired himself for being so.

When Mr. Baker Bates, at Hudson Dula's request, went to Mr. Summer-field in regard to the rumored vacancy, the latter was in a most receptive frame of mind. He had just come into two very important advertising con-tracts which required considerable imagination and artistic skill to execute, and he had lost his art director because of a row over an old contract. It was true that in very many cases—in most cases in fact—his customers had very definite ideas as to what they wanted to say and how they wanted to say it, but not always. They were almost always open to suggestions as to modifications and improvements and in a number of very important cases they were willing to leave the entire theory of procedure to the Summerfield Advertising Company. This called for rare good judgement not only in the preparation but in the placing of these ads and it was in the matter of their preparation—the many striking ideas which they should embody—that the judgement and assistance of a capable art director of real imagination was most valuable.

As has already been said, Mr. Summerfield had had five art directors in almost as many years. In each case he had used the Napoleonic method of throwing a fresh, unwearied mind into the breach of difficulty and when it wearied or broke under the strain, tossing it briskly out. There was no compunction or pity connected with any detail of this method. "I hire good men and I pay them good wages," was his favorite comment. "Why shouldn't I expect good results?" If he was wearied or angered by failure he was prone to exclaim, "These God damned cattle of artists! What can you expect of them? They don't know anything outside of their little theory of how things ought to look. They don't know anything about life. Why, God damn it, they're like a lot of children. Why should anybody pay any attention to what they think? Who cares what they think? They give me a pain in the neck."

It should be explained here that Mr. Daniel C. Summerfield was very much given to swearing more as a matter of habit than of foul intention and that no picture of him would be complete without the interpolation of his favorite expressions.

When Eugene appeared on the horizon as a possible applicant for this delightful position Mr. Daniel C. Summerfield was debating with himself just

what he should do in connection with the two contracts in question. The advertisers were awaiting his suggestions eagerly. One was for the nationwide advertising of a new brand of sugar, the second for the international display of ideas in connection with a series of French perfumes, the sale of which depended largely upon the beauty with which they could be interpreted to the lay mind. The latter were not only to be advertised in the United States and Canada but in Mexico also, and the fulfillment of the contracts in either case was dependent upon the approval given by the advertisers to the designs for newspaper, car, and billboard advertising which he should submit. It was a ticklish business, worth two hundred thousand dollars in ultimate profits, and naturally he was anxious that the man who should sit in the seat of authority in his art department should be one of real force and talent—genius if possible—who should help win, through his ideas, this golden harvest.

Such men were, naturally, hard to find. The last man had been only fairly capable. He was dignified, meditative, thoughtful, with considerable taste and apprehension as to what the material situation required in driving home simple ideas, but he had no great, imaginative grasp of life. In fact no man who had ever sat in the director's chair had ever really suited Mr. Summerfield. According to him they had all been weaklings. "Dubs," "fakes," "hot air artists," were some of his descriptions of them. Their problem, however, was a hard one for they had to think very vigorously in connection with any product which he might be trying to market and to offer him endless suggestions as to what would be the next best thing which this man could say or do which would attract attention to what he had. It might be a catch phrase such as "Have You Seen This New Soap?" or "Do You Know Soresda?—It's Red." It might be that a novelty in the way of a hand or a finger or an eye or a mouth was all that was required, carrying some appropriate explanation in type. Sometimes, as in the case of very practical products, their very practicable display, in some clear, interesting, attractive way, was all that was needed. In most cases, though, something radically new was required, for it was the theory of Mr. Summerfield that his ads must not only arrest the eye but fix themselves in memory and convey a fact which was or at least could be made to seem important to the reader. So he was struggling with one of the deepest and most interesting phases of human psychology, and the task was difficult.

The last man, Older Freeman, had been of considerable use to him in his day. He had collected about him a number of fairly capable artists—men temporarily down on their luck—who like Eugene were willing to take a working position of this character, and from them he had extracted by dint of pleading, cajoling, demonstrating, and the like, a number of inter-

esting ideas. Their working hours were from nine to five-thirty, their pay meagre—eighteen to thirty-five, with experts drawing in several instances fifty and sixty dollars—and their tasks innumerable and really never ending. Their output was regulated by a tabulated record system which kept account of just how much they succeeded in accomplishing in a week and how much it was worth to the concern. The ideas on which they worked were more or less products of the brains of the art director and his superior, though occasionally they themselves made important suggestions, but for their proper execution, the amount of time spent on them, the failures suffered, the art director was more or less responsible. He could not carry to his superior a poor drawing of a poor idea, or a poor idea for something which required a superior thought, and long hope to retain his position. Mr. Daniel C. Summerfield was too shrewd and too exacting. He was really tireless in his energy. It was his art director's business, he thought, to get him good ideas for good drawings and then to see that they were properly and speedily executed.

Anything less than this was sickening failure in the eyes of Mr. Summerfield and he was not at all bashful in expressing himself. As a matter of fact he was at times terribly brutal. "Why the hell do you show me a thing like that?" he once exclaimed to Freeman. "Jesus Christ, I could hire an ash man and get better results. Why, God damn it, look at the drawing of the arm of that woman. Look at her ear. Who's going to take a thing like that? It's tame! It's punk! It's a joke! What sort of cattle have you got out there working for you anyhow? Why, if the Summerfield Advertising Company can't do better than that, I might as well shut up the place and go fishing. We'll be a joke in six weeks. Don't try to hand me any such God dammed tripe as that, Freeman. You know better. You ought to know our advertisers wouldn't stand for anything like that. Wake up. I'm paying you five thousand a year. How do you expect I'm going to get my money back out of any such arrangement as that? You're simply wasting my money and your time letting a man draw a thing like that. Hell!"

The art director, whoever he was—having been by degrees initiated into the brutalities of the situation, and having by reason of the time he had been employed and the privileges he had permitted himself on account of his comfortable and probably never before experienced salary, sold himself into bondage to his now fancied necessities—was usually humble and tractable under the most galling fire. Where could he go and get five thousand dollars a year for his services? How could he live at the rate he was living if he lost this place? Art directorships were not numerous. Men who could fill them fairly acceptably were not impossible to find. If he thought at all and were not a heaven-born genius, serene in the knowledge of his God-given powers, he was very apt to hesitate, to worry, to be humble, and to

endure a good deal. Most men, under similar circumstances, do the same thing. They think before they fling back into the teeth of their oppressors some of the slurs and brutal characterizations which so frequently issue therefrom. Most men do. Besides, there is almost always a high percentage of truth in the charges made. Usually the storm is for the betterment of the men. Mr. Summerfield knew this. He knew also the yoke of poverty and the bondage of fear which most, if not all, of his men were under. He had no compunction about using these weapons, much as a strong man might use a club. He had had a hard life himself. No one had sympathized with him very much. Besides, you couldn't sympathize and succeed. Better look the facts in the face, deal only with infinite capacity, roughly weed out the incompetents, and proceed along the line of least resistance, in so far as your powerful enemies were concerned. Men might theorize and theorize until the crack of doom but this was the way the thing had to be done and this was the way he proposed to do it.

Eugene had never heard of any of these facts in connection with the Summerfield Company. The idea had been flung at him so quickly he had no time to think, and besides if he had, it would have made no difference. A little experience of life had taught him, as it teaches everyone else, to mistrust rumor. He had applied for the place on hearsay and he was hoping to get it. At noon the day following his visit to Mr. Baker Bates, the latter was speaking for him to Mr. Summerfield, but only very casually.

"Say," he asked, quite apropos of nothing apparently, for they were discussing the chances of his introducing his product into South America, "do you ever have need of an art director over in your place?"

"Occasionally," replied Summerfield guardedly, for his impression was that Mr. Baker Bates knew very little of art directors or anything else in connection with the artistic or advertising life. He might have heard of his present need and be trying to palm off some friend of his—an incompetent of course—on him. "What makes you ask?"

"Why, Hudson Dula, the manager of the Tripos Lithographic Company, was telling me of a man who is connected with the *World* who might make a good one for you. I know something of him. He's painted some rather remarkable views of New York and Paris here a few years ago. Dula tells me they were very good."

"Is he young?" interrupted Summerfield, calculating.

"Yes, comparatively. Thirty-one or two, I should say."

"And he wants to be an art director, does he? Where is he?"

"He's down on the *World* and I understand he wants to get out of there. I heard you say last year you were looking for a man and I thought this might interest you."

"What's he doing down on the *World?*"

"He's been sick, I understand, and is just getting on his feet again."
The exposition sounded sincere enough to Summerfield.

"What's his name?" he asked.

"Witla. Eugene Witla. He had an exhibit at one of the galleries here a few years ago."

"I'm afraid of these regular highbrow artists," observed Summerfield suspiciously. "They're usually so set up about their art that there is no living with them. I have to have someone with hard, practical sense in my work. Someone that isn't a plain damn fool. He has to be good manager—a good executive. Mere talent for drawing won't do—though he has to have that, or know it. You might send this fellow around sometime if you know him. I wouldn't mind looking at him. I may need a man pretty soon. I'm thinking of making certain changes."

"If I see him, I will," said Bates indifferently and dropped the matter. Summerfield, however, for some psychological reason, was impressed with the name. Where had he heard it? Somewhere, apparently. Perhaps he had better find out something about him.

"If you send him, you'd better give him a letter of introduction," he added thoughtfully, before Bates should have forgotten the matter. "So many people try to get in to see me, and I may forget."

Bates knew at once that Summerfield wished to look at Witla. He dictated a letter of introduction that afternoon to his stenographer and mailed it to Eugene.

"I find Mr. Summerfield apparently interested to see you," he wrote. "You had better go and see him if you are interested. Present this letter. Very truly yours."

Eugene looked at it with astonishment and a sense of destiny so far as what was to follow. Fate was fixing this for him. He was going to get it. How strange life was. Here he was down on the *World* working for fifty dollars a week and suddenly an art directorship—a thing he had thought of for years—was coming to him out of nowhere! Then he decided to telephone Mr. Daniel C. Summerfield, saying that he had a letter from Mr. Baker Bates and asking when he could see him. Later he decided to waste no time but to present the letter direct without phoning. At three in the afternoon he received permission from Benedict to be away from the office between three and five, and at three-thirty he was in the anteroom of the general office room of the Summerfield Advertising Company, waiting for a much desired permission to enter.

CHAPTER LXIV

W̶hen Eugene called, Mr. Daniel C. Summerfield was in no great rush about any particular matter but he had decided in this case, as he had in many others, that it was very important that anyone who wanted anything from him should be made to wait. Eugene was made to wait a solid hour before he was informed by an underling that he was very sorry but that other matters had so detained Mr. Summerfield that it was now impossible for him to see him at all this day, but that tomorrow at twelve he would be glad to see him. Eugene was finally admitted on the morrow and then, at the first glance, Mr. Summerfield liked him. "A man of intelligence," he thought, as he leaned back in his chair and stared at him. "A man of force. Young, still, wide eyed, quick, clean looking. Perhaps I have found someone in this man who will make a good art director." He smiled, for Summerfield was good natured in his opening relationships—usually so in all of them—and took most people (his employees and prospective employees particularly) with an air of superior but genial condescension.

"Sit down! Sit down!" he exclaimed cheerfully, and Eugene did so, looking about at the handsomely decorated walls, the floor which was laid with a wide, soft, light brown rug, and at the mahogany desk, flat topped, glass covered, on which lay handsome ornaments of silver, ivory, and bronze. This man looked so keen, so dynamic to him, like a polished Japanese carving, hard and smooth.

"Now tell me all about yourself," began Summerfield. "Where do you come from? Who are you? What have you done?"

"Hold! Hold!" said Eugene easily and tolerantly. "Not so fast. My history isn't much. The short and simple annals of the poor. I'll tell you in two or three sentences."

Summerfield was a little taken back at this poise, which was rather new to him and generated by Summerfield's own attitude, but he liked it. His applicant wasn't frightened or apparently even nervous, so far as he could judge. "He is droll," he thought, "drily so—a man who had seen a number of things, evidently. He is sweet in his mood, too, and kindly."

"Well," he said, smilingly, for Eugene's slowness appealed to him. His humor was something new in art directors. So far as Summerfield could recall, his predecessors had never had any to speak of.

"Well, I'm an artist," said Eugene, "working on the *World*. Let's hope that don't militate against me very much."

"It don't," said Summerfield.

"And I want to become an art director because I think I'd make a good one."

"Why?" asked Summerfield, his even teeth showing amiably.

"Well, because I like to manage men, or I think I do. And they take to me."

"You know that?"

"I do. In the next place, I know too much about art to want to do the little things that I'm doing. I can do bigger things."

"I like that also," applauded Summerfield.

He was thinking that Eugene was nice and good looking, a little pale and thin to be wholly forceful perhaps; he wasn't sure. His hair a little too long. His manner perhaps a bit too deliberate. Still he was nice. Why would he wear a soft hat? Why would artists always insist on wearing soft hats, most of them? It was so ridiculous, so unbusinesslike.

"How much do you get," he added, "if it's a fair question?"

"Less than I'm worth," said Eugene. "Only fifty dollars. But I took it as a sort of a health cure. I had a nervous breakdown several years ago—better now, as Mulvaney used to say—and I don't want to stay at that. I'm an art director by temperament, or I think I am. Anyhow, here I am."

"You mean," said Summerfield, "you never ran an art department then?"

"Never."

"Know anything about advertising?"

"I used to think so."

"How long ago was that?"

"When I worked on the Alexandria, Illinois *Morning Appeal*."

Summerfield smiled. He couldn't help it.

"That's almost as important as the Wickham *Union*, I fancy. It sounds as though it might have the same wide influence."

"Oh, much more, much more," returned Eugene quietly. "The Alexandria *Appeal* had the largest exclusively country circulation of any county south of the Sangamon."

"I see! I see!" replied Summerfield. "It's all day with the Wickham *Union*. Well, how was it you came to change your mind?"

"Well, I got a few years older, for one thing," said Eugene. "And then I decided that I was cut out to be the greatest living artist, and then I came to New York, and in the excitement I almost lost the idea."

"I see."

"But I have it again, thank heaven, tied up back of the house, and here I am."

"Well, Witla, to tell you the truth you don't look like a real, live, every day, sure enough art director, but you might make good. You're not quite art-y enough according to the standards that prevail around this office. Still

I might be willing to take one gosh-awful chance. I suppose if I do it I'll get stung as usual, but I've been stung so often that I ought to begin to get used to it by now. I feel sort of spotted at times from the hornets I've hired in the past. But be that as it may, what do you think you could do with a real live art directorship if you had it?"

Eugene mused. The persiflage entertained him much. He thought Summerfield would like him better for his wit and hire him now that they were together.

"Oh, I'd draw my salary first and then I'd see that I had the proper entry system so that any one who came to see me would think I was the King of England and then I'd——"

"I was really busy yesterday," interpolated Summerfield, apologetically.

"I'm satisfied of that," replied Eugene gaily. "And finally I might condescend, if I were coaxed enough, to do a little work."

This speech at once irritated and amused the fancy of Mr. Summerfield. He liked a man of spirit. You could do something with someone who wasn't afraid, even if he didn't know so much to begin with. And Eugene knew a good deal, he fancied. Besides, his talk was precisely in his own sarcastic, semi-humorous vein. Coming from Eugene it did not sound so hard as it would have, coming from himself, but it had his own gay, bantering attitude of mind in it. He believed Eugene could make good. He wanted to try him, instanter, anyhow.

"Well I'll tell you what, Witla," he finally observed. "I don't know whether you can run this thing or not—the probabilities are all against you, as I have said—but you seem to have some ideas, or what might be made good ones under my direction, and I think I'll give you a chance. Mind you, I haven't much confidence. My personal likes usually prove very fatal to me. Still, you're here and I like your looks and I haven't seen anyone else and so——"

"Thanks," said Eugene.

"Don't thank me. You have a hard job ahead of you if I take you. It's no child's play. You'd better come with me first and look over the place," and he led the way out into the great central room where, because it was still noon time there were few people working, but where one could see just how imposing this business really was.

"Seventy-two stenographers, book keepers, solicitors, ad writers, and trade-aid people at these desks," he observed with an easy wave of his hand and moved on into the art department which was in another wing of the building, where a north and east light could be secured.

"Here's where you come in," he observed, throwing open the door where thirty-two artists' desks and easels were ranged. Eugene was astonished.

"You don't employ that many, do you?" he asked, interestedly. Most of the men were out to lunch.

"From twenty to twenty-five all the time, sometimes more," he said. "Some on the outside. It depends on the condition of business."

"And how much do you pay them as a rule?"

"Well, that depends. I think I'll give you seventy-five dollars a week to begin with, if we come to an understanding. If you make good I'll make it a hundred dollars a week inside of three months. It all depends. The others we don't pay so much. The business manager can tell you."

Eugene noticed the evasion. His eyes narrowed. Still there was a good chance here. Seventy-five dollars was considerably better than fifty and it might lead to more. He was his own boss—a man of some consequence. He could not help stiffening with pride a little as he looked at the room which Summerfield pointed out to him as his own if he came—a room where a large, highly polished oak desk was located and where some of the Summerfield Advertising Company's art products were hung on the walls. There was a nice rug on the floor and some leather backed chairs.

"Here's where you will be if you come here," said Summerfield.

Eugene looked. Certainly life was looking up. How was he to get this place? On what did it depend? His mind was running forward to various improvements in his affairs, a better apartment for Angela, better clothes for her, more entertainment for both of them, freedom from worry over the future—for a little bank account would soon eventuate from a place like this.

"Do you do much business a year?" Eugene asked curiously.

"Oh, about two million dollars' worth."

"And you have to make drawings for every ad?"

"Exactly. Not one but six or eight sometimes. It depends on the ability of the art director. If he does his work right I save money."

Eugene saw the point.

"What became of the other man?" he asked, noting the name of Older Freeman on the door.

"Oh, he quit," said Summerfield, "or rather he saw what was coming and got out of the way. He was no good. He was too weak. He was turning out work here which was a joke—some things had to be done over eight and nine times."

Eugene sensed the wrath and difficulties and opposition which went with this. Summerfield was a hard man, plainly. He might smile and joke now, but anyone who took that chair would hear from him constantly. For a moment Eugene felt as though he could not do it, as though he had better not try it, and then he thought, "Why shouldn't I? It can't hurt me. If worst comes to worst, I have my art to fall back on."

"Well so it goes," he said. "If I don't make good, the door for mine, I suppose?"

"No, no, nothing so easy," chuckled Summerfield, "the coal chute."

Eugene noticed that he champed his teeth like a nervous horse and that he seemed fairly to radiate waves of energy. For himself he winced the least bit. This was a grim, fighting atmosphere he was coming into. He would have to fight for his life here—no doubt of that—and it was all new to him.

"Now," said Summerfield, when they were strolling back to his own office, "I'll tell you what you might do. I have two propositions, one from the Sand Perfume Company and another from the American Crystal Sugar Refining Company, which may mean big contracts for me if I can present them the right line of ideas for advertising as they want to advertise. The Sand Company wants suggestions for bottles, labels, car ads, newspaper ads, posters, and so on. The American Crystal company wants to sell its sugar in small packages, powdered, grained, cubed, hexagoned. We want package forms, labels, posters, ads, and so on for that. It's a question of how much novelty, simplicity, and force we can put in the smallest possible space. Now I depend on my art director to tell me something about those things. I don't expect him to do everything. I'm here and I'll help him. I have men in the trade aid department out there who are wonders at making suggestions along this line, but the art director is supposed to help. He's the man that is supposed to have the taste and can execute the proposition in its last form. Now suppose you take these two ideas and see what you can do with them. Bring me some suggestions. If they suit me and I think you have the right note, I'll hire you. If not, well then I won't, and no harm done. Is that all right?"

"That's all right," said Eugene.

Mr. Summerfield handed him a bundle of papers—catalogues, prospectuses, communications. "You can look these over if you want to. Take them along and then bring them back."

Eugene arose.

"I'd like to have two or three days for this," he said. "It's a new proposition to me. I think I can give you some ideas—I'm not sure. Anyhow, I'd like to try."

"Go ahead! go ahead!" said Summerfield, "the more the merrier. And I'll see you any time you're ready. I have a man out there—Freeman's assistant—who's running things for me temporarily. Here's luck," and he waved his hand indifferently.

Eugene went out. Was there ever such a man, so hard, so cold, so practical? It was a new note to him but he was simply astonished, largely because he was inexperienced. He had not yet gone up against the business world as those who try to do anything in a big way commercially must. This man was

getting on his nerves already, making him feel that he had a tremendous prob-
lem before him, making him think that the quiet realms of art were merely
the back waters of oblivion. Those who did anything, who were out in the
front row of effort, were fighters such as this man was, raw products of the
soil, ruthless, superior, indifferent. If only he could be that way, he thought.
If he could be strong, defiant, commanding, what a thing it would be. Not
to wince, not to quail, but to stand up four square to the world and make
people obey. Ah, what a splendid vision of empire was here before him.

CHAPTER LXV

The designs or suggestions which Eugene offered his prospective employer
for the advertising of the products of M. Sand et Cie and the Ameri-
can Crystal Sugar Refining Company were peculiar. As has been indicated,
Eugene had one of those large, tropic, effervescent intelligences which,
when he was in good physical condition, fairly bubbled ideas. His imagin-
ings, without any effort on his part, naturally took all forms and shapes. The
call of Mr. Summerfield was for street car cards, posters, and newspaper ads
of various sizes and what he wanted Eugene specifically to supply was not
so much the lettering or rather wording of the ads, as it was their artistic
appearance and illustrative point. What one particular suggestion in the
form of a picture or drawing or design could be made in each case which
would arrest public attention? Eugene went home and took the sugar propo-
sition under advisement first. He did not say anything of what he was really
doing to Angela because he did not want to disappoint her. He pretended
that he was making sketches which he might offer to some company for a
little money and because it amused him. By the light of his green-shaded
working lamp at home he sketched designs of hands holding squares of sugar
either in the fingers or by silver and gold sugar tongs; urns, piled high with
crystalline concoctions; a blue and gold after dinner cup with one lump of
the new form on the side against a section of snow white table cloth; and
things of that character. He worked rapidly and with ease until he had some
thirty-five suggestions on this one proposition alone, and then he turned
his attention to the matter of the perfumery.

His first thought was that he did not know all the designs of the com-
pany's bottles, but he originated peculiar and delightful shapes of his own,
some of which were afterwards adopted by the company as holding forms.
He designed boxes and labels to amuse himself and then made various still
life compositions such as a box, a bottle, a dainty handkerchief, and a small

white hand all showing in a row. His mind slipped to the manufacture of perfume, the growing of flowers, the gathering of blossoms, the types of girls and men that might possibly be employed, and then he hurried to the great public library the next day to see if he could find a book or magazine article which would tell him something about it. He found this, and several articles on sugar raising and refining, which gave him new ideas in that direction. He decided that in each case he could take a beautifully designed bottle of perfume or a handsome package of sugar, put its picture say in the upper right or lower left hand corner of the design, and then for the rest show some scene in the process of its manufacture. He began to think of men who could carry out his ideas brilliantly if they were not already on his staff, letterers, character artists, men with a keen sense of color combination whom he might possibly hire cheaply. He thought of Jerry Mathews of the old Chicago *Globe* days—where was he now?—and Philip Shotmeyer, who would be almost ideal to work under his direction, for he was a splendid letterer, and Henry Hare, still of the *World,* with whom he had frequently talked of car ads and posters. Then there was young Morgenbau, who was a most excellent character man, looking to him for some opportunity, and eight or ten men whose work he had admired in the magazines—the less known ones. He decided first to see what could be done with the staff that he had, and then to eliminate and fill in as rapidly as possible until he had a capable working staff. He caught by mere contact with Summerfield some of that eager personage's ruthlessness and began to manifest it in his own attitude. He was most impressionable to things advantageous to himself and this chance to rise to a higher level out of the slough of poverty in which he had so greatly suffered nerved him to the utmost effort. In two days he had a most impressive mass of material to show his prospective employer and he returned to his presence with considerable confidence. The latter looked over his ideas carefully and then began to warm to his attitude of mind.

"I should say," he said generously, "there's some life to this stuff. I can see you getting that five thousand a year all right if you keep on. You're a little new but you've caught the drift." And he sat down to show him where some improvements from a practical point of view could be made.

"Now, professor," he said finally, when he was satisfied that Eugene was the man he wanted, "you and I might as well call this a deal. It's pretty plain to me that you've got something that I want. Some of these things are fine. I don't know how you're going to make out as a master of men but you might as well take that desk out there and we'll begin right now. I wish you luck. I really do. You're a live wire, I think."

Eugene thrilled with satisfaction. This was the result he wanted. No half-hearted commendation but enthusiastic praise. He must have it. He

always felt that he could command it. People naturally ran after him. He was getting used to it by now—taking it as a matter of course. If he hadn't broken down, curse the luck, think where he could have been today. He had lost five years and he was not quite well yet, but thank God he was getting steadily better and he would try and hold himself in check from now on. The world demanded it.

He went out with Summerfield into the art room and was there introduced by him to the various men employed. "Mr. Davis, Mr. Witla; Mr. Hart, Mr. Witla; Mr. Clemens, Mr. Witla"—so it went, and the staff was soon aware of who he was. Summerfield then took him into the next room and introduced him to the various heads of departments, the business manager who fixed his and his artists' salaries, the cashier who paid him, the manager of the ad writing department, the manager of the trade aid department, the head of the stenographic department, a woman. Eugene was a little disgusted with what he considered the crassness of these people. After the quality of the art atmosphere in which he had moved, these people seemed to him somewhat raw and voracious, like fish. They had no refinement. Their looks and manners were unduly aggressive. He resented particularly the fact that one solicitor with whom he shook hands wore a bright red tie and had on yellow shoes. The insistence on department store models for suits and floor walker manners pained him.

"To hell with such cattle," he thought, but on the surface he smiled and shook hands and said how glad he would be to work with them. Finally when all the introductions were over he went back to his own department to take up the work which rushed through here like a living stream, pellmell.

His own sanctum was of course much more agreeable to him. These artists who worked for him interested him, for they were, as he suspected, men very much like himself, in poor health probably or down on their luck, and compelled to do this. He called for his assistant, Mr. Davis, whom Summerfield had introduced to him as such and asked him to let him see how the work stood.

"Have you a schedule of the work in hand?" he asked, easily.

"Yes, sir," said his new attendant.

"Let me see it."

The latter brought what he called his order book and showed him just how things worked. Each particular piece of work, or order as it was called, was given a number when it came in, the time of its entry marked on the slip, the name of the artist to whom it was assigned, the time taken to execute it, and so forth. If one artist only put two hours on it and another took it and put four, this was noted. If the first drawing was a failure and a second begun, this was also noted. It was plain that the records would show all the

slips and errors of the office as well as its speed and capacity. Eugene perceived that he must see to it that his men did not make many mistakes.

After this order book had been carefully inspected by him he arose and strolled about among the men to see how they were getting along. He wanted to familiarize himself at once with the styles and methods of his men. Some were working on clothing ads, some on designs illustrative of the beef industry, some on a railroad travel series for the street cars, and so forth. Eugene bent over each one graciously, for he wanted to make friends with these people and win their confidence. He knew from experience how sensitive artists were—how they could be bound by feelings of good fellowship. He had a soft, easy, smiling manner which he hoped would smooth his way for him. He leaned over this and that man's shoulder, asking what the point was, how long a piece of work of that character ought to take, suggesting where a man appeared to be in doubt what he thought would be advisable. He was not at all certain of himself—this line of work being so new—but he was hopeful and eager. It was a fine sensation, this being a boss, if one could only triumph at it. He hoped to help these men to help themselves; to make them good in ways which would bring them and him more money. He wanted more money—that five thousand, no less.

"I think you have the right idea there," he said to one pale, anaemic worker who looked as though he might have a lot of talent.

The man, whose name was Dillon, responded to the soothing, caressing tone of his voice. He liked Eugene's appearance though he was not at all prone to pass favorable judgement as yet. It was already rumored about that he had had an exceptional career as an artist. Summerfield had attended to that. He looked up and smiled and said, "Do you think so?"

"I certainly do," said Eugene cheerfully. "Try a touch of yellow next to that blue. See if you don't like that."

The artist did as requested and squinted at it narrowly. "It helps it a lot, don't it," he observed, as though the idea were his own.

"It certainly does," said Eugene, "that's a good idea," and somehow Dillon felt as though he had thought of it. Inside of twenty minutes the whole staff was agreeing that he was a nice man to all outward appearances and that he might make good. He appeared to be so sure. They little knew how perturbed he was inwardly, how anxious he was to get all the threads of this in his hand and to see that everything came to an ideal fruition. He dreaded the hour when he might have something to contend with which was not quite right.

Days passed at this new work and then weeks, and by degrees he grew moderately sure of himself and comparatively easy in his seat, though he realized that he had not stepped into a bed of roses. He found this a most

tempestuous office to work in, for Summerfield was, as he expressed it, "on the job" early and late, and tireless in his insistence and enthusiasm. He came down from his residence in the upper portion of the city at 8:00 in the morning and remained almost invariably until six-thirty and seven and not infrequently until eight and nine in the evening. He had an inconsiderate habit of keeping such of his staff as happened to be working upon the thing in which he was interested until all hours of the night, sometimes transferring his deliberations to his own home and that without dinner or the proffer of it to those whom he made to work. He would talk advertising with one big merchant or another until it was time to go home and would call in the weary members of his staff before they had time to escape and begin a long and important discussion of something he wanted done. At times when anything went wrong he would fly into an insane fury, rave and curse, and finally perhaps discharge someone who was really not to blame. There was no end of labored and irritating conferences in which hard words and sarcastic references would fly about, for he had no respect for the ability or personality of anyone who worked for him. They were all more or less machines in his estimation, and rather poorly constructed ones at that. Their ideas were not good enough by far in any particular instance, unless for the time being they happened to be new or, as in Eugene's case, predominantly blessed with talent.

He could not fathom Eugene so readily for he had never met anyone of his kind. He was looking closely in his case, as he was in that of all the others, to see if he could not find some weakness in his ideas. He had a gleaming, insistent, almost demoniac eye, a habit of chewing incessantly and even violently the stub end of a cigar, the habit of twitching about, getting up and walking about, stirring things on his desk, doing anything and everything to give his restless, generative energy a chance to escape.

"Now, professor," he would say when Eugene came in and seated himself quietly and unobtrusively in some corner, "we have a very difficult thing here to solve today. I want to know what you think could be done in such and such a case," describing a particular condition.

Eugene would brace himself up and begin to consider, but rumination was not what Summerfield wanted from anyone.

"Well, professor! Well! Well!" he would exclaim.

Eugene would stir irritably. This was so embarrassing—in a way so degrading to him.

"Come to life, professor," Summerfield would go on.

He seemed to have concluded long before that the gad was the most effective commercial weapon.

Eugene would then make some polite suggestion, wishing instead that he

could tell him to go to the devil, but that was not the end of it. Before all the ad writers, solicitors, trade aid men—sometimes one or two of his own artists who might be working upon the particular task in question—Summerfield would exclaim, "Lord! what a poor suggestion!" or, "Can't you do any better than that, professor?" or, "Good heavens, I have three or four ideas better than that myself." The best he would ever say in conference was, "Well, there may be something in that," though privately, afterwards, he might possibly express great pleasure. Past achievements counted for nothing; that was so plain. One might bring in gold and silver all day long. The next day there must be more gold and silver and in larger quantities. There was no end to the man's appetite. There was no limit to the speed at which he wished to drive his men. There was no limit to the venomous commercial idea as an idea. Summerfield set an example of nagging and irritating insistence and he urged all of his employees to same policy. The result was a bear garden, a den of prize fighters, liars, cutthroats, and thieves, in which every man was for himself, openly and avowedly, and the devil take the hindmost.

CHAPTER LXVI

Time went by, and although things did not improve very much in his office over the standards which he saw prevailing when he came there, he was obviously getting things much better arranged in his private life. In the first place, Angela's attitude was getting much better. The old agony which had possessed her so keenly in the days when he was acting so badly had modified as, day by day, she saw him working and conducting himself with reasonable circumspection. She did not trust him as yet. She was not sure that he had utterly broken with Carlotta Wilson (she had never found out who his paramour was), but all the evidence seemed to attest it. There was a telephone down stairs in a drug store by which, during his days on the *World*, she could call him up at any time and whenever she had called him up he was always in the office. He seemed to have plenty of time to take her to the theatre evenings if she wished to go and to have no especial desire to avoid her company. He had once told her frankly that he did not propose to pretend to love her any more, though he did care for her, and this frightened her. In spite of her wrath and suffering she cared for him and she believed that he still sympathized with her and might come to care for her again—that he ought to.

She decided to play the role of the affectionate wife whether it was true

or not, and to hug and kiss him and make over him if he would let her, just as though nothing had happened. Eugene did not understand this. He did not see how Angela could. He thought she must hate him, having such just grounds, for having by dint of hard work and absence come out of his vast excitement about Carlotta he was beginning to see the terrific injustice he had done Angela and to wish to make amends. He did not want to love her, he did not feel that he could, but he was perfectly willing to behave himself, to try to earn a good living, to take her to the theatre and the opera as opportunity permitted, and to build up and renew a social relationship with others which should act as a substitute for love. He was beginning to think that there was no honest or happy solution to any affair of the heart in this world. Most people in so far as he could see were unhappily married. It seemed to be the lot of mankind to make mistakes in its matrimonial selections. He was probably no less happy than others. Let the world wag as it would for a time. He would try to make some money now and restore himself in the eyes of the world. Later, life might bring him something—who could tell?

In the next place, their financial condition, even before he left the *World*, was so much better than it had been. By dint of saving and scraping, refusing to increase their expenses more than was absolutely necessary, Angela had succeeded by the time he left the *World* in laying by over one thousand dollars, and since then it had gone up to two thousand five hundred. They had relaxed sufficiently so that now they were wearing reasonably good clothes, were going out some, and were receiving company regularly. It was not possible in this little apartment which they still occupied to entertain more than three or four at the outside, and two was all that Angela ever cared to consider as either pleasurable or comfortable, but they entertained this number all the while. There were some slight recoveries of friendships out of the old life—Hudson Dula, Jerry Mathews, who had moved from Philadelphia, where he had gone on leaving Chicago, to Newark, and with whom Eugene and occasionally Eugene and Angela exchanged visits. Willam McConnell, who met Eugene in the street one day and learning where he was, invited him and Angela out to dinner. Philip Shotmeyer came to life when Eugene was on the *World*, greatly surprised to find Eugene there but glad to know that he was recovering himself again. McHugh and Smite had parted company, Eugene learned, one returning to Nova Scotia to paint, the other working at present in Chicago. As for the old art crowd, socialists and radicals included, Eugene attempted to avoid them as much as possible. He knew nothing of the present whereabouts of Miriam Finch and Norma Whitmore except that in all likelihood they were in New York. Of Christina Channing he heard much for she was singing in Grand Opera,

her pictures displayed in the papers and upon the bill boards when she did concert work. There were many new friends, principally young newspaper artists like Adolph Morgenbau, who took to Eugene and acted as disciples might to any fascinating leader.

Angela's relatives showed up from time to time. John Kip, Angela's brother-in-law from Wankesha who came to New York with his wife on a sight-seeing trip; Alexander Hoover, her sister Grace's husband from Koosa; and David Blue, now a sub-lieutenant in the army, with all the army officer's pride of place and station. There were women friends whom Angela made and retained and whom she occasionally visited but for whom Eugene cared little—Mrs. Desmas, the wife of the furniture manufacturer at Riverwood from whom they had rented their four rooms there; Mrs. Wertheim, the wife of the multimillionaire whom M. Charles had introduced to them and whom Angela liked and was liked by in return; Mrs. Link, the wife of the West Point Army Captain who had come to the old Washington Square Studio with Marietta and who was now stationed at Fort Hamilton, in Brooklyn; and a Mrs. Juergens, living in a neighboring apartment at Port Morris. As long as they were very poor Angela was very careful how she revived acquaintances, but when they began to have a little money she decided that she might indulge her predilections and so make life less lonesome for herself. She had always been anxious to build up solid social connections for Eugene but as yet she did not see how it was to be done.

When Eugene's new connection with the Summerfield Company was consummated, Angela was greatly astonished and rather delighted to think that if he had to work in this practical field for long it was to be under such comforting auspices—that is, as a superior and not as an underling. Long ago she had come to feel that Eugene would never make any money in a commercial way. To see him mounting in this manner was curious but not wholly reassuring. They must save money, that was her one cry. They had to move soon, that was very plain, but they mustn't spend any more than they had to. She delayed on this until the attitude of Summerfield, upon an accidental visit to their flat, made it commercially advisable.

Summerfield was a great admirer of Eugene's artistic ability. He had never seen any of his pictures but he was rather keen to, and once when Eugene told him that they were still on display—one or two of them at Pottle Frères, Jacob Bergman's, and Henry La Rue's—he decided to visit these places, but put it off. One night when he was riding up town on the L road with Eugene—who had the habit of coming up on the Sixth Avenue line and taking a cross-town car—he decided because he was in a vagrom mood to accompany him and see his pictures there. Eugene did not want this. He was chagrined to be compelled to take him into their very little apartment

but there was apparently no way of escaping it. He tried to persuade him to visit Pottle Frères instead, where there was one picture still on view, but Summerfield would none of that.

"I don't like you to see this place," he finally said, apologetically, as they were going up the steps of the five story apartment house. "We are going to get out of here pretty soon. I came over here when I worked on the road."

Summerfield looked about at the poor neighborhood, the inlet of a canal some two blocks east where a series of black coal pockets were, and to the north, where there was flat open country and a railroad yard.

"Why, that's all right," he said in his direct, practical way. "It doesn't make any difference to me. It does to you, though, Witla, of course. You know that. I believe in spending money, everybody spending money. Nobody gets anywhere by saving anything. Pay out, pay out—that's the idea. I found that out for myself long ago. You better move when you get a chance, soon, and surround yourself with clever people."

Eugene considered this easy talk for a man who was successful and lucky but he still thought there was much in it. Summerfield came in and viewed the pictures. He liked them and he liked Angela, whom he met, though he wondered how Eugene ever came to marry her. She was such a quiet little homebody. Eugene looked more like a Bohemian or a club man now that he had been worked upon by Summerfield. The soft hat had long since been discarded for a stiff derby, and Eugene's clothes were of the most practical business type he could find. He looked more like a young merchant than an artist. Summerfield invited them over to dinner at his house, refusing to stay to dinner here, and went his way.

Before long, because of his advice, they moved. They had practically four thousand by now and because of his salary, Angela figured that they could increase their living expenses to, say, two thousand five hundred or even three thousand dollars. She wanted Eugene to save two thousand each year against that day when he should decide to return to art. They sought about together Saturday afternoons and Sundays, and finally found a charming apartment in Central Park West, overlooking the park, where they thought they could live and entertain beautifully. It had a nice large dining room and living room, located side by side and when the table was cleared away forming one great room. There was a handsomely equipped bathroom, a nice kitchen with ample pantry room, three bedrooms, one of which Angela turned into a sewing room, and a square hall or entry way which answered as a temporary reception room. There were plenty of closets, gas and electricity, elevator service with nicely uniformed elevator men, and a house telephone. It was very different from the Port Morris house where they only had a long, dark hall, stairways to climb, gas only, and no

phone. The neighborhood, too, was so much finer. Here were automobiles and people walking in the park or promenading on a Sunday afternoon, and obsequious consideration or polite indifference to your affairs from everyone who had accidentally or deliberately anything to do with you.

"Well, the tide is certainly turning," said Eugene as they entered it the first day.

He had this apartment redecorated in white and delft blue and dark blue, getting a set of library and dining room furniture in imitation rosewood to match it. He bought a few choice pictures such as he had seen at the various exhibits to mix in with his own and set a cut glass bowl in the ceiling where formerly the commonplace chandelier had been. There were books enough, accumulated during a period of years, to fill the attractive white book case with its lead-paned windows. Attractive sets of bedroom furniture in bird's-eye maple and white lacquer were secured, and the whole apartment given a very cozy and tasteful appearance. A piano was purchased outright and dinner and breakfast sets of Haviland china. There were many other dainty accessories such as rugs, curtains, portières, and so forth, the hanging of which Angela supervised. In this they settled down to a comparatively new and attractive life.

Angela had never really forgiven him his indiscretions of the past, his radical brutality in the last instance, but she was not holding them up insistently against him. There were occasional scenes, even yet, the echoes of a far off storm, but as long as they were making money and friends were beginning to come back, she did not propose to quarrel. Eugene was very considerate. He was very, very hard-working. Why should she nag him? He would sit by a window overlooking the park at night and toil over his sketches and ideas until midnight. He was up and dressed by seven, down to his office by 8:30, and out to lunch at one or later, and only back home at eight or nine o'clock at night. Sometimes Angela would be cross at him for this, sometimes rail at Summerfield for an inhuman brute, but seeing that the apartment was so lovely and that Eugene was getting along so well, how could she quarrel? It appeared to be for her benefit as much as for his that he was working. He did not think to spend money. He did not seem to care. He would work, work, work, until she actually felt sorry for him.

"Certainly Mr. Summerfield ought to like you," she said to him one day, half in compliment, half in rage at a man who would exact so much from him. "You're valuable enough to him. I never saw a man who could work like you can. Don't you ever want to stop?"

"Don't bother about me, Angel Face," he said. "I have to do it. I don't mind. It's better than walking the streets and wondering how I'm going to get along"—and he fell to his ideas again.

Angela shook her head. Poor Eugene. If ever a man deserved success for working, he certainly did. And he was really getting nice again—getting conservative. Perhaps it was because he was getting a little older. It might turn out that he would become a splendid man after all.

CHAPTER LXVII

The two years that Eugene spent with the Summerfield Advertising Company did several notable things for him. For one thing, it introduced him to a form of commercial prosperity seen at close range which was new in his experience. In the beginning, Daniel C. Summerfield took a great fancy to him. He was subject to these rather spasmodic likes and dislikes. Eugene had a dry humor and a laconic sarcasm, sharpened to a certain extent by his recent period of suffering, which appealed to Summerfield. He found that they could talk together on a simple unostentatious plane, for they were both rather simple and direct—to outward appearances. Inwardly they were of course exceedingly complex, but they had very much the same sort of complexity and subtlety. Neither had any fixed convictions concerning anything. Neither had any desire to seem other than he was. Both were very proud of their personal worth and their personal achievements. Summerfield was convinced that he was one of the greatest advertising men that ever lived; Eugene was convinced that no artist had power to surpass him in his interpretation of life. Summerfield, in spite of all his ravings against artists, was temperamentally a sincere admirer of art—and Eugene was an admirer of business acumen such as he found in this man. He was astonished by the speed, accuracy, and virility with which this man's mind worked, and Summerfield was impressed with the keenness of Eugene's understanding and appreciation, with the business of his artistic judgement and taste.

He found himself telling Eugene of his early life the very first day they met—where he came from, how poor his family was, the fact that he had worked in a cotton mill, the fact that he had knocked a poor hireling down with an iron form key. It was true that he told these things, or most of them, to people who came close to him sympathetically, after they had been with him a long time, but rarely to anyone on the first day. There had been one other man—a man who had come into great prominence as a manufacturer of shoes—who had won this confession from him on sight, but this man was also a genius in his way and had told Summerfield things about himself which had enlisted his interest and enthusiasm. Eugene seemed to him to understand naturally just how everything could be—all crime, all poverty,

all degradation—and to think nothing of it. He told Summerfield of his own early life, his art student days, his collecting experiences, and some other things, and the two frequently laughed heartily together.

Summerfield came bounding into Eugene's room one day after he had been there three months and exclaimed—Eugene was alone at the time— "Witla, you're worth five thousand a year to this house; there isn't any question about it. I've asked Chipman, the business manager, to give it to you and you'll get it. That last idea of yours is great."

It was something in connection with a series of tobacco ads.

Eugene smiled comfortably.

"What's the point?" he asked.

"Nothing, except you have a note in your system that I've been wanting to find for a long time. You'll be worth more if you keep on this way. Painting mere pictures is no game for a man like you. Why, you'll be making ten thousand a year if you stay with me a few years and keep up this pace."

Eugene's chest swelled. Instantly he saw visions of empire. My, he was coming up fast with this man. It was a great thing to make a big hit like this.

He went home and told Angela, who hailed these prospects with joy. After the long years of deprivation this was like sunshine bursting through dark clouds.

For another thing, Summerfield took him upon trips to see prominent manufacturers whose advertising the company was handling—accounts, they were called—and thus Eugene came to know by sight and exchange of thought a number of distinguished men in the manufacturing field—William Butler, of the Butler Shoe Company; Andrew Gillette, of the Gillette Soap Manufacturing Company; Mark Gorthwaite, of the Gorthwaite Ready-to-Wear Clothing System. These men, all of them in the heyday of their prosperity, newly coming into great fortunes because of their own efforts, fighting desperate fights for trade supremacy with innumerable rivals and competitors, and disporting themselves in exceptional clothing, fine houses, automobiles, and palatial offices, fairly took Eugene's breath away. He had studied the executive type when he had been on the railroad, men who were marvellous lieutenants and captains under other men, but these individuals who were making their own way in a great manufacturing concern were different and new. He had never seen such strength, such physical force, such crass egotism, such dynamic insistence on the value of their own intuitions. They had a habit—any one of these men whose accounts were sufficiently large—of telegraphing Summerfield to come to their offices or homes for a conference, and he was expected to bring with him to Boston, to Philadelphia, to Rochester, to Chicago, not only his art director and chief

copy writer—men who could take and give suggestions as to vague theories which might be in the master's mind as to possible improvements in his battle lines of advertising—but also his business manager and his lawyer, in order that new contracts might be drawn. Small delegations were apt to leave for distant cities on two hours' notice and Eugene, after he had been initiated into the mysteries of this ad-composition and placing business, was invariably called to accompany him. Angela began to think that Eugene was getting to be a man of considerable consequence.

In these trips he was introduced into a world of autos, Pullmans, important restaurants, great manufactories, private residences of great beauty, country clubs, and what not. Summerfield found relief in Eugene's company from the ordinary affairs of his life and liked to get him off in the corner of a Pullman or parlor car en route, where the others could not disturb them, and complain to him of the brutal necessities of his life, the crassness of commercial life generally, the hardness and insistence of the men—the big men with whom he was compelled to do business.

"These God damned business men, Witla," he once said to Eugene, "make me sick. You'd think I had nothing to do but run after them. They're the damndest lot of hogs that ever lived. They haven't an idea above the thing they're doing. This fellow Gorthwaite smokes, eats, drinks and sleeps ready-made clothing. You'd think his mind was a pair of ready-made pants. Why, Witla, he'll sometimes get in my office and sit there with a big cigar between his teeth, and talk suits, and overcoats, and styles, and ways of displaying them until I'm ready to puke, damned if I ain't. I sometimes think I'll have to get out of this business—I'm too refined. I've got too many ideas that don't concern shoes and soap and automobiles and safety razors. Why, my God! I've heard so much about automobiles—spark plugs and ignition fuses and double gear, high speed triple expansion engines—that I could take every damned automobile and throw it in the East River. These fellows don't know anything outside of their business. They don't know a single God damned thing. They're all egotists. They're all crazy about themselves. They think I haven't anything else to do but sit and listen to them. Why, it's the God damndest farce that was ever staged. There isn't anything like it in any play. If you put one of these fellows in a play the public wouldn't believe it. They'd think you were lying. Take this fellow Butler now——." So he would rave.

Eugene would listen patiently to all this palaver. He knew at the very first conversation that Summerfield did not mean half nor the fourth of what he said. He was irritated by these men but he was flattered also. Their accounts brought him good money. Their telegraphing for him showed their confidence in him. He was not anxious to get out of this business as yet for he

was getting rich in it—had pulled himself out of poverty and insignificance into comparative prominence. To be sure there was a great deal of truth in what he said, but his wrath was more than three-quarters due to the fact that he was a rank egotist himself and that he liked to boast. He liked to get in the limelight and hear himself expatiate. When he was back in the office or here on this train he was quite as much of a pooh-bah in his small way as any manufacturer or general that ever lived. He hated opposition, he hated competition. He could not brook rivalry in any form. He liked Eugene because he fancied there could be no rivalry between them and because, since Eugene was an artist, he could patronize him. It was something—a mark of distinction to have an artist of Eugene's capability at his beck and call. To sit here with him at his elbow, knowing that he was a fountain of original ideas, that he could help him solve some of his most difficult problems with the greatest ease, and yet to be able to say to him to do thus and so was real pleasure. He liked Eugene personally and for the first six or eight months, while he was entirely new, found great joy in his company.

There came a time though when dancing attendance on this eccentric genius palled on Eugene a little—and then later a great deal—for he was, of course, the rankest of egotists himself, proud of his own superiority, eternally conscious of it, dissembling smoothly because of necessity's sake, but wishing for the day when he could make people run and do as he said. The trouble with him was that he was not sufficiently brutal to be a real master. He could not easily say cruel, bitter, cutting things. He could not utterly forget the other fellow and make him work at six, eight, and nine o'clock in the evening, whether he wanted to or not. He could not "fire" people out of hand, at a moment's notice, as Summerfield could, and as he fancied from looking at them, that these other men whose accounts he carried also could. They all seemed exceptionally hard and ruthless to him, single- or rather narrow-minded. The range of their interests was too small. They seemed to know only the one thing they worked in, nothing more. But they waked his mind to new worlds.

Gorthwaite he found to be a stout, florid striding dynamo of perhaps forty-three years of age, whose reddish brown hair, blue eyes, and a self conscious presence seemed to say over and over, "You don't know who I am, do you?" Butler, of the Butler Shoe Company, was a lean, cold, insistent individual whose eyes looked exactly like those of a crow. Like Summerfield he had small, even, brilliantly white teeth. His ears were small, but stood out something like a bat's, straight from his head. As a matter of fact he did not look unlike a bat or vampire. He talked in a short, jerky, clicking way, as though his teeth were coming to an audible snap. His little white hands, pale and yet sinewy, sometimes beat a perpetual tattoo. He would rise,

shove his hands in his pockets, stare insistently in the eyes of his listener, and then suddenly sit down and begin drumming on his desk or table with his fingers. He was as cold as an icicle, as narrow as his finest shoes, and as tough as leather.

The first time Eugene saw him he said, "Good heavens, can that little man run all this big business?"

"One of the shrewdest men I ever knew," Summerfield told him afterward. "His foresight is positively uncanny. And he'd turn his own mother out of doors if she didn't pay her rent."

Eugene laughed. "They're a great bunch of citizens you deal with, aren't they?"

"They're not human beings," replied Summerfield. "They're machines. If I were a woman I would just as leave live with a printing press as that man."

This raw coming up against them in a trade way made an astonishing impression on Eugene. He was just at that particular point in his life when conditions made it a little uncertain just what he wanted to do. He had been so distressed and discomfited by his temporary art failure that he had almost lost faith in that as a means of livelihood or distinction. Art, at apparently the great, critical moment of his life, had failed him. After that came nervousness, gloom, depression, despair, one might almost say hunger, certainly hunger of the soul. It made little difference that he had been temporarily comforted by the appearance of such charming figures as Frieda Roth and Carlotta Wilson. They had come and gone and left a trail of comparative disaster in their wake. Love was no refuge. Strength, great physical and mental strength, was his only hope, and this for years he had been dissipating and wasting. Did he want to try to go back to art, as Angela was constantly saying he ought, when they had five or ten thousand dollars, and try again—or did he want to stick to this field now where he could make five thousand a year—or later go into some business of his own? Couldn't he be an advertising manager? Couldn't he get into some business like this or the shoe business or the clothing business where there was real money?

Look at these people. It was said by Summerfield that William Butler was making $800,000 a year clear; Andrew Gillette was making $500,000. Mark Gorthwaite was making $300,000 at forty-three years of age. Summerfield, at thirty-six or -seven, boasted that he was making thirty-five thousand a year out of his little business, as he called it. What pikers artists were alongside of these men. How shabby they looked. Take the poor little staff in his department, for instance, twenty-two men at this time, some of them very good ones, and what did they amount to? Seventy-five dollars was the highest he was paying any one—that to a new man by the name

of Derkman—and he himself drawing only $5000. Derkman, on his puny salary, carried himself with the air of a millionaire. What a pitiful spectacle the rest of this immediate art element presented—Morgenbau at fifty dollars, young Hare at forty-five, George Beer at forty, others at thirty-five, thirty, twenty-five, twenty, and some of these men occasionally illustrated stories in the magazines. As for the great artists, he heard what they received. Ten thousand was high for the best of them—their earnings for any year. Why follow a profession or craft in which there was nothing, in which all your days you would be tolerated for your genius with a kindly smile, used as an ornament at receptions but never taken seriously as a factor in the commercial affairs of the world? Good heavens! What a fate.

CHAPTER LXVIII

There came a time, however, when all this excitement and wrath and quarreling began to pall on Eugene and to make him feel that he could not, indefinitely, stand this strain. After all, his was the artistic temperament, not that of a commercial or financial genius. He was too nervous and restless. For one thing, he was first astonished, then embittered, then amused by the continual travesty on justice, truth, beauty, sympathy, which he saw enacted before his eyes. Life stripped of its illusions and its seemings becomes a rather deadly thing to contemplate. Because of the ruthless, insistent, inconsiderate attitude of this employer, all of the employees of this place followed in his wake and there was neither kindness nor courtesy—nor even raw justice anywhere. Eugene was compelled to see himself looked upon from the beginning not so much by his own staff as by the other employees of the company as a man who could not last long. He was disliked forsooth because Summerfield displayed some liking for him and because his manners did not coincide exactly with the prevailing standard of the office. Summerfield did not intend to allow his interest in Eugene to infringe in any way upon his commercial exactions but this was not enough to save or aid him in any way. The others disliked him, some because he was a true artist to begin with, a man with a rather distant air, and because in spite of himself, he could not take them all as seriously as he should.

Most of them seemed little manikins to him—little second, third, and fourth editions or copies of Summerfield. They all copied that worthy's insistent air. They all attempted to imitate his briskness. Like children, they were inclined to try to imitate his bitter persiflage and be smart, and they demanded, as he said they should, the last ounce of consideration and

duty from their neighbors. Eugene was too much of a philosopher not to take much of this with a grain of salt but, after all, his position depended on his activity and his ability to get results, and it was a pity, he thought, that he could expect neither courtesy nor favor from anyone. Department chiefs stormed his room daily, demanding this, that, and the other work immediately. Artists complained that they were not getting enough pay. The business manager railed because expenses were not kept low, saying that Eugene might be an improvement in the matter of the quality of the results obtained and the speed of execution but that he was lavish in his expenditures. Others cursed openly in his presence at times, and about him to his employer, charging that the execution of certain ideas was rotten or that certain work was delayed or that he was slow or discourteous. There was little in these things as Summerfield well knew from watching Eugene, but he was too much a lover of quarrels and excitement as being productive of the best results in the long run to wish to interfere. Eugene was soon accused of delaying work generally, of having incompetent men, which was not true, of being slow, of being an artistic snob. He stood it all calmly because of his recent experience with poverty, but he was determined to fight ultimately. He was no longer or at least was not going to be, he thought, the ambling, cowardly, dreaming Witla he had been. He was going to stand up, and he did begin to.

"Remember, you are the last word here, Witla," Summerfield had told him on one occasion. "If anything goes wrong here, you're to blame. Don't make any mistakes. Don't let anyone accuse you falsely. Don't run to me. I won't help you."

It was such a ruthless attitude that it shocked Eugene into an attitude of defiance. In time he became hardened and a changed man—aggressive, contentious, bitter.

"They can all go to hell," he said one day to Summerfield, after a terrific row about some delayed pictures in which one man who was animated by personal animosity more than anything else had lied about him. "The thing that's been stated here isn't so. My work is up and beyond the mark. This individual here" (pointing to the man in question) "simply doesn't like me. The next time he comes into my room nosing about I'll throw him out. He's a damned fakir and you know it. He lied here today and you know that."

"Good for you, Witla," exclaimed Summerfield joyously. The idea of a fighting attitude on Eugene's part pleased him. "You're coming to life. You'll get somewhere now. You've got the ideas but if you let these wolves run over you they'll do it and they'll eat you. I can't help it. They're all no good. I wouldn't trust a single God-damned man in the place."

So it went. Eugene smiled. Could he ever get used to such a life? Could

he ever learn to live with such cheap, inconsiderate, indecent little pups? Summerfield might like them, but he didn't. This might be a marvellous business policy but he couldn't see it. Somehow it seemed to reflect the mental attitude and temperament of Mr. Daniel C. Summerfield and nothing more. Human nature ought to be better than that.

It is curious how fortune sometimes binds up the wounds of the past, covers over the broken places as with clinging vines, gives to the miseries and mental wearinesses of life a look of sweetness and comfort. An illusion of perfect joy is sometimes created where still, underneath, are cracks and scars. Here were Angela and Eugene living together now, beginning to be visited by first one and then the other of those they had known in the past, and seemingly as happy as though no storm had ever beset the calm of their present sailing. Eugene was interested in his new work. He liked to think of himself as the captain of a score of men, having a handsome office desk, being hailed as chief by obsequious subordinates, and invited here and there by Summerfield, who still liked him. The work was hard but it was so much more profitable than anything he had ever had before. Angela was happier, too, he thought, than she had ever been in a long time, for she did not need to worry about money and his prospects were broadening. Friends were coming back to them in a steady stream and they were creating new ones. It was possible to go to a seaside resort occasionally, winter or summer, or to entertain three or four friends at dinner. Angela had a maid. The meals were served with considerable distinction under her supervision. She was flattered to hear nice things said about her husband in her presence, for it was whispered abroad in art circles with which they were now slightly in touch again that half the effectiveness of the Summerfield ads was due to Eugene's presence and innate talent. It was no shame for him to come out now and say where he was, for he was getting a good salary and was a department chief. He or rather the house through him had made several great strikes, issuing series of ads which attracted the attention of the public to the products which they advertised. Experts in the advertising world first, and then later the public generally, were beginning to wonder who it was that was primarily responsible for the strikes.

The Summerfield Company had not had them during the previous six years of its history. There were too many of them coming close together not to mark a new era in the history of the house. Summerfield himself, it was understood about the office, was becoming a little jealous of Eugene, for he could not brook the presence of a man with a reputation, and Eugene, with his five thousand dollars in cash in two savings banks, with practically two thousand five hundred dollars' worth of interesting furniture in his apartment, and with a ten thousand dollar life insurance policy carried in favor

of Angela, was carrying himself with quite an air. He was not feeling so anxious about his future.

Angela noted it. Summerfield also. The latter felt that Eugene was beginning to show his innate sense of artistic superiority in a way which was not entirely pleasant. Eugene was coming to have a direct, insistent, sometimes dictatorial manner. All the driving Summerfield had been able to do had not succeeded in breaking his spirit. Instead it had developed him. From a lean, pale, artistic soul wearing a soft hat he had straightened up and filled out until now he looked more like a business man than an artist, wearing a derby hat, clothes of the latest design, a ring of oriental design on his middle finger, and pins and ties which reflected the prevailing modes.

Eugene's attitude had not as yet changed completely, but it was changing. He was not nearly so fearsome as he had been. He was beginning to see that he had talent in more directions than one and to have the confidence of this fact. Five thousand dollars in cash, with two to three hundred dollars being added monthly, and interest at four per cent being paid upon it, gave him considerable poise. He began to joke Summerfield himself, for he began to realize that other advertising concerns might be glad to have him. Word had been brought to him once that the Alfred Cookman Company, of which Summerfield was a graduate, was considering making him an offer, and the Trine-Campbell Company—the largest in the field—was also interested in what he was doing. His own artists, mostly faithful because he had sought to pay them well and to help them succeed, had spread his fame greatly. According to them he was the sole cause of all the recent successes which had come to the house, which was not true at all.

A number—perhaps the majority—of things recently had started with him; but they had been amplified by Summerfield, worked over by the ad writing department, revised by the advertisers themselves, and so on and so forth, until notable changes had been effected and success achieved. There was no doubt in the world that Eugene was directly responsible for a share of this. His presence was inspirational and constructive. He keyed up the whole tone of the Summerfield Company merely by being around; but he was not all there was to it by many a long step. He realized this himself. He was simply surer, calmer, more genial, less easily ruffled, but even this was too much for Summerfield. He wanted a frightened man, and seeing that Eugene might be getting strong enough to slip away from him he began to think how he should either circumvent his possible sudden flight or discredit his fame so that if he did leave he would gain nothing by it. Neither of them was directly manifesting any ill will or indicating his true feelings, but such was the situation just the same.

The things which Summerfield thought he might do were not easy to

do under any circumstances. It was particularly hard in Eugene's case. The man was beginning to have an air. People liked him. Advertisers who met him, the big manufacturers, took note of him. They did not understand him as a trade figure but they thought he must have real force. One man, a great real estate plunger in New York who saw him once in Summerfield's office, spoke to the latter about him.

"That's a most interesting man you have there, that man Witla," he said when they were out to lunch together. "Where does he come from?"

"Oh, the West somewhere," replied Summerfield evasively. "I don't know. I've had so many art directors I don't pay much attention to them."

Winfield (ex-Senator Kenyon C. Winfield, of Brooklyn) sensed a slight under-current of opposition and belittling. "He looks like a bright fellow," he said, intending to drop the subject.

"He is, he is," returned Summerfield, "but like all artists, he's flighty. They're the most unstable people in the world. You can't depend on them. Good for one idea today—worth nothing tomorrow. I have to handle them like a lot of children. The weather sometimes makes all the difference in the world."

Winfield fancied this was true. Artists generally were worth nothing in business. Still, he remembered Eugene pleasantly.

As Summerfield talked here, so was it in the office and elsewhere. He began to say in the office and out that Eugene was really not doing as well as he might and that in all likelihood he would have to drop him. It was sad; but all directors, even the best of them, had their little day of ability and usefulness and then ran to seed. Eugene was so running. He did not see why it was that all these directors failed so, but they did. They never really made good in the long run. By this method, his own undiminished ability was made to stand out free and clear and Eugene was not able to appear so important.

No one who knew anything about Eugene, however, at this time believed this; but they did believe—in the office—that he might lose his position. He was too bright—too much of a leader not to become a real money accumulator and have a business of his own. They felt that this condition could not continue in a one-man concern; and this made his work harder, for it bred disloyalty in certain quarters. Some of his men were apt to counsel with the enemy.

But as time passed, and in spite of the change of attitude which was coming over Summerfield, Eugene became even stronger in his own self-esteem. He was not getting vain-glorious as yet—merely sure. Because of his art work, his art connections had revived considerably and he had heard again from such men as Louis Deesa, M. Charles, Luke Severas and oth-

ers, who now knew where he was and wondered why he did not come back to painting proper. It was always spoken of him to others as a great loss. Strange to relate, one of his pictures was sold the spring following his entry into the Summerfield Company, and another the following winter. Each netted him two hundred and fifty dollars, Pottle Frères being the agent in one case, Jacob Bergman in the other. These sales with their consequent calls for additional canvases to show cheered him greatly. He felt satisfied now that if anything happened to him he could go back to his art and that he could make a living, anyhow.

There came a time when he was sent for by Mr. Alfred Cookman, the advertising agent for whom Summerfield had worked; but nothing came of that, for the latter did not care to pay more than six thousand a year and Summerfield had once told Eugene that he would eventually pay him ten thousand if he stayed with him. He did not think it was fair to leave him at this time, anyhow, and besides, Cookman's firm had not the force and go and prestige which Summerfield's had at this time. It was more of a distinction to remain with the latter. He was afraid to say anything to Summerfield, however, for fear that the latter would say some mean, sarcastic thing which would make him want to quit anyhow. He had come to the conclusion that he ought to hold this until something really exceptional were offered him, when he could speak to Summerfield about a raise and see what he would say. Besides, no good offer would ever come to him if he were out of a position. He must go from here to something much better. Doing the work that he was, he was satisfied that Summerfield would never let him go until he had someone better in mind or until he gave him just cause for offense. There was no reason for anyone to quarrel with him at present, however, and there was no other man in sight.

His real chance came some six months later when one of the publishing houses of Philadelphia, having an important weekly to market, began looking for an advertising manager. It was the policy of this house to select young men and to find among all the available candidates just the one particular one who would suit the fancy of its owner and who had a record of successful effort behind him. Now Eugene was not any more an advertising manager by nature or experience than he was an art director, but having worked for Summerfield for nearly two years he had come to know a great deal about it and the public thought he knew a great deal more. He knew by now just how Summerfield had his business organized. He knew how he specialized his forces, giving this line to one and that line to another. He had been able to learn by sitting in conferences and consultations what it was that advertisers wanted, how they wanted their goods displayed, what they wanted said. He had learned that novelty, force, and beauty were the

keynotes and he had to work these elements out under the most galling fire so often that he knew how it ought to be done. He knew also about commissions, rebates, long time contracts, and so forth. He had fancied more than once that he might run a little advertising business of his own to great profit if he only could find an honest and capable business manager or partner. Since this person was not forthcoming, he was content to bide his time.

But the Kalvin Publishing Company of Philadelphia had heard of him. In his search for a man, Obadiah Kalvin, the founder of this company, had examined many individuals through agents in Chicago, in St. Louis, in Baltimore, Boston, and New York, but he had not yet made up his mind to act. He was slow in his decisions and always flattered himself that once he made a selection he was reasonably sure of a good result. He had not heard of Eugene until along toward the end of his search, but one day in the Union League in Philadelphia, listening to a big advertising agent with whom he did considerable business, the latter said:

"I hear you are looking for an advertising manager for your weekly."

"I am," he said.

"I heard of a man the other day who might suit you. He's with the Summerfield Company in New York. They've been getting up some very striking ads of late, as you may have noticed."

"I think I have seen some of them," replied Kalvin.

"I'm not sure of this man's name—Witla or Gitla or some such thing as that—but anyhow he's over there and they say he's pretty good. Just what he is in the house, I don't know. You might look him up."

"Thanks, I will," replied Kalvin. He was really quite grateful for he was not truly satisfied with any of those he had seen or heard of. He was an old man, extremely sensitive to ability, wanting to combine force with refinement if he could, for he was a good Christian and was running Christian, or rather, their happy correlatives, decidedly conservative publications. When he went back to his office he consulted with his business partner, a man by the name of Fredericks, who held but a minor share in the company, and asked him if he couldn't find out something about this promising individual. Fredericks did so. He called up Cookman, in New York, who was delighted to injure his old employee Summerfield to the extent of taking away his best man if he could. He told Fredericks that he thought Eugene was very capable, probably the most capable young man in the field, and in all likelihood the man he was looking for—a hustler.

"I thought once of hiring him myself here not long ago," he told Fredericks. "He has ideas. You can see that."

The next thing was a private letter from Mr. Fredericks to Mr. Witla,

asking if by any chance he could come over to Philadelphia the following Saturday afternoon and indicating that there was a business proposition of considerable importance which he wished to lay before him.

From the paper on which it was written Eugene could see that there was something important in the wind and laid the matter before Angela. The latter's eyes glistened.

"I'd certainly go if I were you," she advised. "He may want to make you business manager or art director or something. You can be sure they don't intend to offer you less than you're getting now, and Mr. Summerfield certainly hasn't treated you very well anyhow. You've worked like a slave for him and he's never kept his agreement to raise your salary as he said he would. It may mean our having to leave New York for awhile, but that doesn't make any difference. You don't intend to stay in this field anyhow. You only want to stay long enough to get a good sound income of your own."

Angela's longings for Eugene's art career were being slightly stilled these days by the presence and dangled lure of money. It was a great thing to be able to go down town and buy dresses and hats to suit the seasons. It was a fine thing to be taken by Eugene Saturday afternoons and Sundays in season to Atlantic City, to Spring Lake and Shelter Island. They had been in a cab more than once since those eventful days when they bemoaned life in each other's presence, putting little or nothing in the bank each week. There had come a circle of friendly acquaintances about them now, all comfortable, all admiring Eugene, all basing their admiration on his present position and achievements. As at the time when he was making his art success, Angela's relatives had heard of his accomplishments and so had Eugene's. Mrs. Bangs (Eugene's sister Myrtle) and her husband Frank had been to New York once from Boston, where they had recently moved, and had congratulated Eugene and Angela on being so well placed. Angela's sister Marietta was with them at this time, still single. She had been very anxious to see how nicely they were placed, as Angela had written her, and had finally come on at their urgent solicitation. Marietta was as attractive as ever to Eugene. She had never married because, in the first place, she was a born coquette with scores of followers, and secondly because she felt that someone ought to be at home with her father and mother.

The whole new regime appeared to depend on a nice, comfortable salary, and Eugene's art work, if he turned to that, would not provide it.

"I think I will go over," Eugene decided, and he wrote Mr. Fredericks a favorable reply.

The latter met him at the central station in Philadelphia with his auto and took him out to his country place in the Haverford district. On the way he talked of everything but business—the state of the weather, the con-

dition of the territory through which they were traveling, the day's news, the nature and interest of Eugene's present work. When they were in Mr. Fredericks's house, where they arrived in time for dinner, and while they were getting ready for it, Mr. Obadiah Kalvin dropped in—ostensibly to see his partner, but really to look at Eugene without committing himself. He was introduced to Eugene and shook hands with him cordially. During the meal he talked with Eugene some, though not upon business, and Eugene wondered why he had been called. He suspected, knowing as he did that Kalvin was the president of the company, that the latter was there to look at him. After dinner Mr. Kalvin left and Eugene noted that Mr. Fredericks was then quite ready to talk with him.

"The thing that I wanted you to come over and see me about is in regard to our weekly and the advertising department. We have a great paper over here, as you know," he said. "We are intending to do much more with it in the future than we have in the past even. Mr. Kalvin is anxious to get just the man to take charge of the advertising department. We have been looking for someone for quite a little while. Several people have suggested your name and I'm rather inclined to think that Mr. Kalvin would be pleased to see you take it. His visit here today was purely accidental but it was fortunate. He had a chance to look at you so that if I should propose your name he will know just who you are. I think you would find this company a fine background for your efforts. We have no penny-wise and pound-foolish policy over here. We know that any successful thing is made by the man behind it and we are willing to pay good money for good men. I don't know what you're getting where you are and I don't care very much. If you are interested I should like to talk to Mr. Kalvin about you, and if he is interested I should like to bring you two together for a final conference. The salary will be made right; you needn't worry about that. Mr. Kalvin isn't a small man. If he likes a man, and I think he might like you, he'll offer you what he thinks you're worth and you can take it or leave it. I never heard anyone complain about the salary he offered."

Eugene listened with extreme self-gratification. He was thrilling from head to toe. This was the message he had been expecting to hear for so long. He was getting five thousand now, he had been offered six. Mr. Kalvin could do no less than offer him seven or eight—possibly ten. He could easily ask seven thousand five hundred.

"I must say," he said innocently, "the proposition sounds attractive to me. It's a different kind of thing—somewhat—from what I have been doing but I think I could handle it successfully. Of course the salary will determine the whole proposition. I'm not at all badly located where I am. I've just gotten comfortably settled in New York and I'm not anxious to move. But I would

not be opposed to coming. I have no contract with Mr. Summerfield. He has never been willing to give me one."

"Well, we are not long upon contracts ourselves," said Mr. Fredericks. "It's not a very strong reed to lean upon, anyhow, as you know. Still, a contract might be arranged if you wish it. Supposing we talk a little further to Mr. Kalvin today. He doesn't live so far from here"—and with Eugene's consent he went to the phone.

The latter had supposed that the conversation with Mr. Kalvin was something which would necessarily have to take place at some future date; but from the conversation then and there held over the phone it appeared not. Mr. Fredericks explained elaborately over the phone—as though it were necessary—that he had been about the work of finding an advertising manager for some time, as Mr. Kalvin knew, and that he had had some difficulty in finding the right man.

"I have been talking to Mr. Witla, whom you met here today, and he is interested in what I have been telling him about the weekly. He strikes me from my talk with him here as being possibly the man you are looking for. I thought that you might like to talk to him further."

Mr. Kalvin evidently signified his assent, for the machine was called out and they traveled to his house, perhaps a mile away. On the way, Eugene's mind was busy with the possibilities of the future. It was all so nebulous, this talk of a connection with the famous Kalvin Publishing Company, but at the same time it was so significant, so potential. Could it be possible that he was going to leave Summerfield after all, and under such advantageous circumstances? It seemed like a dream.

Mr. Kalvin met them in the library of his house, which sat in a spacious lawn and which, barring the lights in the latter's room, was apparently quite dark and lonely, and here the conversation was continued. Kalvin was a quiet man, small, gray haired, searching in his gaze. He had, as Eugene noted then, little hands and small feet, and appeared as still and composed as a pool in dull weather. He said slowly and quietly that he was glad that Eugene and Mr. Fredericks had had this talk. He had heard a little something of Eugene in the past. Not much. He wanted to know what Eugene thought of advertising in general; whether trade aid could not be greatly amplified in connection with a weekly publication, whether the drift in his judgement was towards absolute accuracy in statement, and so on. His final observation was that the answer to success lay in the personality of the man. What that was, was hard to define, but one could only discover his man by trying.

"So you think you might like to come with us," he observed drily toward the end, as though Eugene had proposed coming.

"I don't think I would object to coming under certain conditions," he replied.

"And what are those conditions?"

"Well, I would rather hear what you have to suggest, Mr. Kalvin. I really am not sure that I would want to leave where I am. I'm doing pretty well as it is."

"Well, you seem like a rather likely young man to me," said Mr. Kalvin. "You have certain qualities which I think I need. I'll say eight thousand for this year and if everything is satisfactory one year from this time, I'll make it ten. After that we'll let the future take care of itself."

Eight thousand! Ten next year! thought Eugene. The title of advertising manager of a great publication. This was certainly a step forward.

"Well, that isn't so bad," he said after a moment of apparent reflection. "I'd be willing to take that, I think."

"I thought you would," said Mr. Kalvin with a dry smile. "Well, you and Mr. Fredericks can arrange the rest of the details, then. Let me wish you luck," and he extended his hand cordially.

Eugene took it.

It did not seem, as he rode back in the machine to Mr. Fredericks's house—for he was invited to stay for the night—that it could really be true. Eight thousand a year! Was he eventually going to become a great business man instead of an artist? He could scarcely flatter himself that this was true but the drift was strange. Eight thousand this year. Ten the next, if he made good—twelve, fifteen, eighteen—he had heard of such salaries in the advertising field alone, and how much more would his investments bring him? He foresaw coming toward him out of the future an apartment on Riverside Drive in New York, a house in the country perhaps, for he fancied he would not always want to live in the city. An automobile of his own perhaps; a grand piano for Angela; Sheraton or Chippendale furniture; friends, fame—what artist's career could compare to this? Did any artist he knew enjoy what he was enjoying now even? Why should he worry about being an artist? Did they ever get anywhere? Would the approval of posterity let him ride in an automobile now? He smiled as he recalled Dula's talk about class superiority—the distinction of being an artist even though poor. Poverty be hanged. Posterity could go to the devil. He wanted to live—now—not in the approval of posterity.

So he dreamed as he rode, and Mr. Fredericks was most affable. He assured Eugene that he was certain to make a big success and he was so glad to see him coming.

CHAPTER LXIX

The best positions are not always free from the most disturbing difficulties, for great responsibility goes with great opportunity; but Eugene went gaily to this new task for he knew that it could not possibly be much more difficult than the one he was leaving. Truly Summerfield had been a terrible man to work for. He had done his best by petty nagging, insisting on endless variations, the most frank and brutal criticism, to break down Eugene's imperturbable good nature and make him feel that he could not reasonably hope to handle the situation without Summerfield's co-operation and assistance, but he had only been able by so doing to bring out Eugene's better resources. His self-reliance, coolness under fire, ability to work long and ardently, even when at times his heart was scarcely in it, were all strengthened and developed.

"Well, luck to you Witla," he said, when Eugene informed him one morning that he was going to leave and wished to give him notice. "You needn't take me into consideration. I don't want you to stay if you're going to go. The quicker, the better. These long drawn-out agonies over leaving don't interest me. There's nothing in them. Chuck the job today if you want to. I'll find someone."

Eugene resented his indifference but he only smiled a cordial smile in reply. "I'll stay a little while if you want me to—one or two weeks—I don't want to tie up your work in any way."

"Oh, no, no. You won't tie up my work. On your way, and good luck."

"The little devil," thought Eugene, but he shook hands and said he was sorry. Summerfield grinned imperturbably. He wound up his affairs quickly and got out. "Thank God," he said the day he left, "I'm out of that hell hole," but he came to realize afterward that Summerfield had rendered him a great service. He had forced him to do his best and utmost, which no one had ever done before. It had told in his character, his spiritual makeup, his very appearance. He was no longer timid and nervous, but rather bold and determined looking. He had lost that fear of very little things, for he had been sailing through stormy seas. Little storms did not—could never again—really frighten him. He had learned to fight. That was the one great thing Summerfield had done for him.

In the offices of the Kalvin Company it was radically different. Here was comparative peace and quiet. Kalvin had not fought his way up by clubbing little people through little difficulties but had devoted himself to thinking out a few things and letting them, because of their very bigness and newness, make their own way and his. He believed in big men, honest men—the biggest and most honest he could find. He saw something in Eugene, a tendency toward perfection perhaps, which attracted him.

Anyhow he was pleased with his choice and said so to Fredericks. "I'm not exactly sure of that man but he's the best I have seen yet. He has imagination. He may make a few mistakes, for he's young yet, but we'll have to watch him. I want you to see that he has every chance to make good. Don't let the other people start fighting him until they have a chance to know him. Introduce him around right and tell everybody to be nice to him."

Fredericks agreed that he would.

The formalities of this new arrangement were soon concluded and Eugene came into his new and beautiful offices, heralded by the word secretly passed about that he was a most charming man. He was greeted by the editor, Townsend Miller, in the most cordial manner. He was met by his assembled staff in the most friendly spirit. It quite took Eugene's breath away to realize that he was the responsible head of some fifteen capable advertising men here in Philadelphia alone, to say nothing of eight more in a branch office in Chicago and traveling solicitors in different parts of the country—the far West, the South, the Southwest, the Canadian Northwest, and so on. His material surroundings were distinguished much more than they had been with the Summerfield Company. The idea of all of these men was to follow up business, to lay interesting propositions before successful merchants and manufacturers who had not yet tried the columns of the *North American Weekly*, to make contracts which should be mutually advantageous to the advertiser and the *Weekly*, and to gain and retain good will according to the results rendered. It was no very difficult task in connection with the *North American Weekly* to do this because, owing to a novel and distinguished editorial policy, it was already in possession of a circulation of 500,000 the week and was rapidly gaining more. It was not difficult, as Eugene soon found, to show advertisers in most cases that this was a proposition in which worthwhile results could be obtained, and what with Eugene's fertility in suggesting new methods of advertising, his suaveness of approach, and geniality in laying before the most recalcitrant his very desirable schemes, his ability to get ideas and suggestions out of his men in conference, he was really in no danger of not being able to hold his own and indeed to make a rather remarkable showing.

Kalvin, as has been said, liked his appearance. He was glad to make suggestions wherever he could, for he realized that Eugene would need assistance. He talked to him daily for awhile of the policy of the paper, showed him where in his judgement his best ammunition lay, gave him letters of introduction to various individuals and advertising houses that he thought might be useful to him. Eugene was most pleased. Here was a better man than Summerfield, he thought—a kinder man. He was broad and charitable and sympathetic.

"I don't want you to think you're alone here, fighting a lone battle. You're

not. Your battle is mine. This is the Kalvin Publishing Company fighting through you, do you understand? And we're not really fighting—we're teaching. I fancy, from one or two things I've heard about you, that you come from a very rough school. You've been used to hard knocks. Well, there are many handed about here but not *so* many, I think. Take your time, be easy, be gentlemanly. Easy does it—remember that. And I'll help you all I can."

"I thank you," he said, almost emotionally, to Mr. Kalvin. "I really do. It's a very different place, I assure you. I can see that. I'll do my best. That's all I can say."

"I know you will," said Kalvin. "You can't help it. You're that kind." And he smiled at him in a fatherly way.

Eugene returned to his office in a softened spirit. He wanted to come up to this man's ideal of him as a gentleman, and he did his best. He was soft, smiling, pliable—as easy as he could be. It made him a number of friends from the start.

Angela came over with him from New York the first few days, for she never wanted to let Eugene out of her sight any more, and she wanted to see that everything went well with him. It was their plan to take rooms at a good hotel first while she looked about for a suitable living place and later saw that their furniture was removed from New York. It was no hardship for her to work in connection with so pleasing an enterprise, and they were soon comfortably settled in a charming house in West Philadelphia, where, because of the comparative cheapness of rents as measured against New York and the plentitude of ground, it was deemed advisable to have one. They had never had a house before and it was pleasant to try one. The grounds in which the house was located were 150 by 125, with room for a pretty tennis court which had been arranged by an earlier occupant but had been let run somewhat to grass. A porch, a handsome bay window with lead-set diamond-shaped panes, a mass of clematis covering one side of the house, and a number of trees and bushes, gave it a most attractive appearance. It was not old fashioned but new and bright, with three handsome porcelain-lined bath rooms on the two floors, four charmingly decorated bedrooms, a library, dining room, sewing room, charming reception hall, and handsome stair case, all attractively finished in ash stained to imitate cherry. There were beautiful hanging electroliers in the library, parlor, dining room, and sitting rooms. It was such a house as the well-to-do middle class pride themselves on everywhere, and well suited to the small social functions which Angela fancied she would shortly have to indulge in.

For Eugene would have to be built up socially. He had said it more than once and she had heard Mr. Summerfield say it of her husband. Friends were worth something. They get one known in financial circles. Still, Eugene real-

ized that by so doing he was tying himself hand and foot finally in this marriage contract with Angela, for friends and acquaintances are like so many threads which make up the social net or fabric in which one finds oneself eventually enmeshed. He had given over the idea now of ever regaining his freedom and had come in a way to be reconciled to Angela. He appreciated her devotion. He sympathized with her affection for him and her sorrow at having it so brutally lacerated. He had come to the place where he would take her in his arms now and rock her occasionally and he was always jesting with her, chucking her under the chin, and kissing her affectionately. She was nice enough in her way—charming. When he was alone with her a little while, she seemed ideal. It was only when he got outside and looked at others—but that, as Mulvaney said, was another story.

It would be useless to incorporate here a disquisition upon Eugene's duties as an advertising manager during the several years in which he was connected with the Kalvin Company. It involved travel to Chicago, to New York, to Boston, and frequently to places of intermediate importance. It involved the frequent use of an automobile, and his self-introduction to many manufacturers and merchants of great importance. Eugene came to know in an easy way a hundred men of great wealth, but for the reason that he was constantly seeking the advantage of his paper and must be combatted on that score, they were more commercial relationships than anything else. Many men liked him. They all thought he was doing very well indeed and needed no help from them.

On the social side of his life, however, there were corresponding changes which, from a mental point of view, were much more significant. Hitherto in New York, Eugene and Angela had been expanding slowly. Angela, because of her natural tendency toward conservatism, had selected first one and then another of women who, in Eugene's eyes, were nice enough from a domestic and home living point of view, but who had no talent for what he called *living*. They weren't socially clever. She liked Mrs. Summerfield, for instance, who was a nice enough woman but who was thoroughly domesticated and subservient to her lord. She liked Mrs. Henry L. Tomkins, wife of the curator of the Museum of Fine Arts, who was another nice woman but in no wise brilliant. She did take up again with Miss Elaine DeZauche, the singer whom they had known in their studio days, because, as it developed in Eugene's observation, the latter was practical-minded and, having failed as a singer, was now teaching singing.

It seemed to Eugene as he watched Angela that she would always be for conservatism in this manner, the more so since he was radical and naturally gravitated to that lightness of spirit and uncontrolled camaraderie which made for such things as his easy friendships with Christina Chan-

ning, Miriam Finch, and Carlotta Wilson. He thought he was all over that sort of thing by now, though—or hoped he was anyhow—though the pangs of desire for true beauty would never quite down. But as he blossomed out financially again and began to look at the attractive women he saw he began to wish that he and Angela at least could have those smarter friendships which other people possessed. Why was she so? In the days of his youth and freedom he had been so happy. There were so many talented people, too, men and women whom they could "get in" with if Angela were only different. But alas, what a pity it was that she wasn't. Hang it all, life was never right.

Here in Philadelphia where, because of his connection with the Kalvin Company, his social life was broadening, he found that there were worlds within worlds. Townsend Miller, the editor, who was destined to play an important part in Eugene's affairs, socially and otherwise, was a man of considerable breadth and discernment. He was of Eugene's own age and height, though of a much more robust and florid appearance, and was of an immensely better station socially. His experiences had been those of comfort and refinement from his birth. His father was a banker, a resident of Baltimore, and young Miller, after having had fourteen years not of coddling but of decent social experience, was sent to Harvard, where he was graduated with honors. He was instinctively broadminded, intelligent, good natured, and after he had been at college two years and noted the struggles of men who were making their own way under the most discouraging circumstances and in contradistinction to the most silly and affected extravagance on the part of others, had decided that he ought to do something for himself. It was all right for his father to have helped him so far and to see him through to the end of his course, since he did not want to take the bread out of the mouths of men who needed it very much more than he did, but after he graduated he proposed to go to work and earn his own living. His father, an intelligent, conservative but kindly and humanitarian man, had vigorously applauded this stand.

Young Miller selected journalism, getting a position as reporter on the *Boston Herald* first, coming later to the *New York Sun* as a staff man, and finally becoming an exceedingly vigorous editorial writer on the *Baltimore Sun*. His style and mental attitude generally were so fresh, invigorating, and full of natural sense, that he was soon heard of in various quarters. He was invited to come to Philadelphia as a reader of manuscripts for the Kalvin Company and later, when the *Weekly* was started, was put in charge of it. When he was on the *Baltimore Sun* he had married a Baltimore society girl with money, but he had let neither his own nor his wife's prospects stand in the way of what he considered his personal debt to society—his duty to

work. He had one child, a boy two years old, whose antics were at present affording him intense satisfaction. He and his wife were exceedingly well connected socially in Philadelphia, were members of the Philadelphia Country Club, the Merion Cricket Club, the Tennis Club. He was a member of the Rittenhouse and Markham Clubs. Mrs. Miller was fond of riding, golfing, and dancing. Miller's chief amusements, outside of teasing his baby, were automobiling and playing tennis. Together, because of ample house service, they visited a great deal and were the bright, particular lights of a young, wealthy, married set.

Because Eugene was artistic, witty, and agreeable, Miller at once conceived an honest liking for him. He thought Eugene was decent clear through, and they soon became friendly. Angela and Mrs. Miller met, though because of a slight air of hauteur on the part of the latter—more a leftover manner than a thing of substance—Angela did not care for her very much. She liked Mr. Miller exceedingly, and hoped Eugene would become very friendly with him. For this reason she did her best to conceal her true feelings in connection with Mrs. Miller and to simulate a regard which she did not feel. Mrs. Miller was young, handsome, as solid as though she had been cut out of ivory, and exceedingly gay. That air of make-believe which Eugene liked and which Angela disliked was with her.

"Oh, Townsend, he is such a muss of a man," she exclaimed the very first day Angela had been introduced to her. "He just leaves everything out."

Eugene and Angela had come to pay an afternoon call, and Miller had strewn his porch and library with Sunday newspapers and weeklies. "Marie," she called to a maid. "Do come gather up this trash."

Angela recoiled the least bit. The tone of voice was a little lofty. It was so plain to her that this little woman was inexperienced in the world—bright enough, but without having tasted suffering or disappointment. Because of her own bitter experiences, Angela resented this. She wanted understanding of life as it is to be evident in other people, and she resented a haughty lack of knowledge of it. This visit and others passed pleasantly enough, but Angela felt that she and Eugene were really bigger than Mr. and Mrs. Miller and that they deserved more of life.

It will be hard to indicate clearly just what the two years following brought to Angela and Eugene, but there were changes temperamental, social, and financial which gradually tore Eugene loose from his old reserved sense of nervous conservatism and brought him back to that attitude of gay enthusiasm and carefree assurance which had characterized him before ever he married and before he suffered the nervous breakdown which had caused him so much distress. Angela was not so easily dislodged, for her mind was of another type entirely—fearsome, practical, intensely critical, suspicious.

Away from her, Eugene had little practical wisdom and few suspicions. He was easy, smiling, brilliant, full of happy suggestions—very much like an overgrown boy. Mrs. Miller liked him and praised him to her husband. The latter found him suggestive editorially and artistically and was soon leaning on him for advice in the latter field. Eugene was generous. The *Weekly* had no art director, the latter's duty being assigned to an assistant editor. Eugene came forward with interesting ideas for decorative schemes when solicited, and indicated men and means which Mr. Miller found most helpful. In a spirit of gratitude and goodwill, he introduced Angela and Eugene into his own social circle, inviting them to the golf links, the tennis courts, to go riding, automobiling, and so forth. There were card parties, automobile tours, dances, teas, lunches for Angela and the like, the spirit of which was well undertaken and sustained by Eugene.

Angela was not so keen. She felt just the least bit out of key with these people, though they were rather far removed in their attitude from that of the studio favorites whom she had first encountered on coming East. It was fascinating to her to see the nice homes to which they were admitted, the styles and airs which were naturally maintained. She was entertained by the talk of marriages and matches which was constantly uppermost in the minds of those she met, but after all this was not of her world. She liked simpler things—people like Mr. and Mrs. Wertheim, Captain and Mrs. Link of the army, Mrs. Henry L. Tomkins, and her own quiet, unpretentious, serious-minded relatives. It might well enough be fine to belong to this decidedly comfortable albeit conservative social world, but it was never in keeping with her mood. These people were, after all, not doing much of anything. Like a score of other people they met, Mr. Miller and Mr. Fredericks were holding comfortable positions but it was at best innocuous. It had no deep ambition involved in it anywhere, such as Eugene's—only the desire to be comfortable and elite. Why should Eugene pride himself on his connection with them? He was greater than these people. His true ideas were beyond them. He really belonged with such men as Luke Serveras, who was now attaining a great critical reputation, lecturing here and everywhere; M. Charles, who was a representative of great art connoisseurship; Mr. Wertheim, who had amassed a tremendous fortune and other such celebrities in New York. Mr. Miller was all right—he was the most forceful of this group—and Mr. Kalvin, who was in another class entirely, but as for these others, what did they amount to?

CHAPTER LXX

The significance of this attitude on her part was that somehow it kept Angela and Eugene temperamentally separated, or indicated rather that they were so. How different was Marietta, he thought, when life first began to brighten and broaden for them. She would surround herself with the sort of people whom he admired if she had the chance, although she was not to the manner born either. When Marietta had been in New York she had shown the same feeling for the artistic life which she had seen manifested before her and which Eugene had always wished that Angela would possess. It was not so much for art in the concrete—pictures, statuary, public buildings, and so forth—as it was for art in one's surroundings, companionship, adornment and personal appearance, and for that spirit of make-believe which appeals to the younger artistic impulse so thoroughly.

"Oh, Angela is a stay-at-home," Marietta had exclaimed one day in the presence of Eugene. "She has everything she needs now and she doesn't want to do anything."

Eugene and Marietta would have liked to hire an automobile and go motoring out to Woodside Manor some twenty miles away. Angela, who had seen the poverty of the days at Port Morris, would be satisfied with a diversion less expensive.

"Now, Babyette, you hush!" she exclaimed severely. "You don't know what you're talking about. I'm not a stay-at-home at all. Eugene and I have seen some pretty hard times and I think Manhattan Beach is plenty good enough. When he gets something better, we'll do better."

Marietta agreed well enough, but it was this conservative fearsomeness which gave to Eugene the sense of tameness which he was constantly experiencing in his life. What did he do but rise at six-thirty, exercise, bathe, breakfast, and go to work, only to come home again at seven or eight or nine and rise at 6:30 again? Good Lord! He was a human shuttle, and his talent was the bobbin of thread in it, being paid out wearisomely. To what end? He never saw anybody. His mind went back to the old studio days in Washington Square and he thought of such handsome girls as Hedda Andersen, Isadora Crane, Elizabeth Stein, Laura Mathews, who had blossomed into his life for a little while and then disappeared. There was none the less of that atmosphere in this world over here—he could see that by the daily papers—but he was out of it. It was all passing him by in a great gay babbling stream. He was reformed and leading a sedate and quiet life, and even that youthful attitude which expresses itself in make-believe talk and a smart attitude was beyond him, or at least Angela hoped so. The magnificent places which he saw the rich frequenting—the airs and liberties

which they gave themselves—would he ever be able to share that as he had once been able to share its companion world, that of the studios? Angela was opposed to it. She was for a world in which she could share everything equally with him, or if not, then she was for sedateness and saving. He was young in spirit, restless, eager, and growing apparently more so every day.

The days passed and Eugene and Angela settled into what might have been deemed a fixed atmosphere of comfort and refinement. Without much inconvenience to himself and with little friction among those about him, he had succeeded in reorganizing his staff along lines which were eminently satisfactory to himself. Some men who were formerly with the Summerfield Company were now with him. He had brought them because he found he could inculcate in them the spirit of sympathetic relationship and good understanding such as Kalvin desired. He was not making the progress which Summerfield was making with really less means at his command but then, this was a rich company which did not ask or expect any such struggle as that which Summerfield had been, and was still, compelled to make for himself. The business ethics of this company were high. It endorsed clean methods, good salaries, honest service.

Kalvin liked Eugene and he had one memorable conversation with him some time after he came there—almost a year—which stuck in his memory and did him much good in his struggle to maintain a conservative attitude. Kalvin saw clearly wherein both Eugene's strength and his weakness lay and once said to Fredericks, his business manger, "The one thing I like about that man is his readiness with ideas. He always has one and he's the most willing man to try I ever knew. He has imagination. He needs to be steadied in the direction of conservative thought so that he doesn't promise more than he can fulfill. Outside of this, I see nothing the matter with him."

Fredericks agreed. He liked Eugene also. He did as much as he could to make things smooth, but of course Eugene's task was personal and to be found out by him solely.

Kalvin said to him when it became necessary to raise his salary: "I've watched your work for a year now and I'm going to keep my word and raise your salary. You're a good man. You have many excellent qualities which I want and need in the man who sits at that desk, but you have also some failings. I don't want you to get offended. A man in my position is always like a father who sits at the head of a family, and my lieutenants are like my sons. I have to take an interest in them because they take an interest in me. Now you've done your work well—very well—but you're subject to one fault which may sometime lead into trouble. You're a little too enthusiastic. I don't think you stop to think enough. You have a lot of ideas. They swarm in your head like bees and sometimes you let them all out at once and they

buzz around you and confuse you and everyone else connected with you. You would really be a better man if you had, not less ideas—I won't say that—but better control of them. You want to do too many things at once. Go slow. Take your time. You have lots of time. You're young yet. Think! If you're in doubt, come down and consult with me. I'm older in this business than you are and I'll help you all I can."

Eugene smiled and said, "I think that's true."

"It is true," said Kalvin, "and now I want to speak of another thing which is a little more a personal matter, and I don't want you to take offense, for I'm saying it for your benefit. If I'm any judge of men, and I flatter myself sometimes that I am, you're a man whose greatest weakness lies—and mind you, I have no actual evidence to go by, not one scrap—your greatest weakness lies perhaps not so much in the direction of women as in a love of luxury generally, of which women might become, and usually are, a very conspicuous part."

Eugene flushed the least bit nervously and resentfully, for he thought he had conducted himself in the most circumspect manner here—in fact everywhere since the days he had begun to come out of the Riverwood incident.

"Now I suppose you wonder why I say that. Well, I raised two boys, both dead now, and one was just a little like you. You have so much imagination that it runs not only to ideas in business but ideas in dress and comfort and friends and entertainment. Be careful of the kind of people you get in with, Witla. Stick to the conservative element. You're the kind of man, if my observations and intuitions are correct, who is apt to be carried away by his ideals of anything—beauty, principally, I fancy. At bottom, I don't think you have the making of a real cold business man in you, but you're a splendid lieutenant. I'll tell you frankly I don't think a better man than you has ever sat or could sit in that chair. You are very exceptional. But your very ability makes you an uncertain quantity. You're just on the threshold of your career. This additional two thousand dollars is going to open up new opportunities to you. Keep cool. Keep out of the hands of clever people. Don't let subtle women come near. You're married and for your sake I hope you love your wife. If you don't, pretend to and stay within the bounds of conservatism. Don't let any scandal ever attach to you. If you do, it will be absolutely fatal so far as I am concerned. I have had to part with a number of excellent men in my time because a little money turned their heads and they went wild over some one woman, or many women. Don't you be that way. I like you. I'd like to see you get along. Be cold if you can. Be conservative. Think. That's the best advice I can give you and I wish you luck."

He waved him a dismissal and Eugene arose. He wondered how this man

had seen so clearly into his character. It was the truth, and he knew it was. His inmost thoughts and feelings were evidently written where this man could see them. Fittingly was he president of a great company. He could read men.

He went back into his office and decided to take this lesson to heart. He must keep cool and sane always. "I guess I've had enough experience to know that, though, by now," he said, and dismissed the idea from his mind.

For this year and the year following, when his salary was raised to twelve thousand, Eugene flourished prodigiously. He and Miller, instead of wearying of each other, became better friends than ever. Miller had advertising ideas which were of value to Eugene. Eugene had art and editorial ideas which were of value to Miller. They traveled together a great deal at social functions and were sometimes hailed by their companions as the "Kalvin Kids" and the "Limelight Twins." Eugene learned to play golf with Miller, though he was a slow student and never good, and also tennis. He and Mrs. Miller, Angela, and Townsend frequently made a set on their own court or over at Miller's. They automobiled and rode a great deal. Eugene met some charming women, particularly young ones, at dances of which he was now very fond, and at dinners and receptions. He and Miller, with Angela and Mrs. Miller, were invited to a great many affairs but by degrees it became apparent to him, as it did to Miller and Mrs. Miller, that his presence was much more desired by a certain type of smart woman than was that of his wife.

"Oh, he is so clever," was an observation which might have been heard in the making in various quarters. Frequently the compliment stopped there and nothing was said of Angela, or later on it would come up that she was not quite so nice. Not that she was not charming and worthy and all that, "But you know, my dear, she isn't quite so available. You can't use her as you can some women."

These hostesses wanted someone who could talk rapidly, make clever remarks, be nice to the men and entertain them in a gay way, and Angela could not do this. She was too conservative. By degrees, as in the old studio days, she began to resent the manner in which she was neglected at times, to wish to visit only those who were interested in her for herself, to accept invitations from people who did not discriminate between her and Eugene, except to praise her for having so clever a husband. Eugene was extended invitations when Angela was not, and these under the present state of things had to be religiously ignored. He found himself courted, as in times past, by charming debutantes. And he had to say to himself that the days of lovemaking were over for him. If it had only been possible for him to have raised a family at this period everything would have worked out well, for he might have become sufficiently interested in his children to have turned

his mind from the vanities of beauty. As it was, the world was flaunting its old lure of beauty before his eyes in its most tantalizing form, for the wives and daughters he saw now were superior in physical composition, in the stage setting amid which they appeared, against the background of wealth and middle class refinement, from which they stood forth. The friendship of Miller had certainly stood him in good stead. It brought him, quite accidentally, opportunities he could not easily have otherwise obtained.

It would be hard to say in just what little details this modified the recent comparative good feeling or revivified the old sense of difference between him and Angela, but it did. Eugene was inclined at times to be moody—to sit and think by himself—and when he did, Angela sometimes suspected that it was of things which did not concern her. He was inclined to become, as he had been in his studio days, enthusiastic over some particular type of beauty, between whom and himself Angela was quick to intervene. She had learned or come to believe that Eugene needed to be shielded from temptation and when a woman showed too much interest in Eugene, that woman received no more invitations to her house. She fought his going with certain groups because they were gay and she warned him openly.

"Now you know your weakness," she said to him one day openly. "You're inclined to take an interest in some one woman just because she happens to be nice to you. It's not you they're interested in. It's your station. They'd run after anyone in your position and you're so foolish you think it's you."

"I wish you'd cut out this constant nagging," he replied resentfully. "You're always watching and you're so suspicious. I can't be nice to anyone. You're always grumbling and you won't go here and you won't do this or that for fear somebody will take an interest in me. I'm all right. I know what I'm doing. And it don't make any difference to me whether it's me or the position they're looking after. I have a right to the sort of companionship I like and you're not going to stop me."

He did nothing desperate but weariness of this enforced conservative existence was on him.

"As though I wanted to stop him from the right sort of companionship," thought Angela resentfully afterwards. "He knows well enough what I want to stop him from." If he would only be careful. He was doing so nicely now.

"Oh, good Lord," he exclaimed once when she expressed this thought, rising angrily and throwing some papers aside. "As though I were doing anything that was not careful. Good God, what do I do? Get up at six every day. Work until five every afternoon. Work until nine, ten, and eleven here almost every night. What more do you want? Aren't you satisfied? Do you think I can do any more and not resent it? Well I can't. I'm getting tired and I wish you'd let me alone."

"Oh," sighed Angela wearily. "If you'd only see. If you'd only be careful. Just be careful, Eugene, that's all I ask. When you're ten years older you'll thank me from the bottom of your heart."

He walked upstairs grumbling—weary of lectures, weary of sameness, weary of conservatism. He could stand it, but what profit was there in it—work, work, work, like a horse. Oh, the devil. The truth was that Eugene was not intrinsically tired of Angela—he really cared for her in a very sympathetic way—but not for sameness of life, monotony under simple, homelike conditions, which were now constantly about him. He wanted to wander—to be free. He was restless. Besides there was, ever flaunted before his hedonistic temperament by an unkind providence, the beauty of womanhood in youth, and above all the beauty of the youthful temperament in love. Angela had, of late years, become severe and critical. She had seen so much of suffering that she had become embittered. In spite of the fact that Eugene caressed her she could see that he did not love her, and this was a terrible setback. All her life she had wanted love—such love as she had seen first manifested by him—and now, when that was gone, what was there left? It was all right to surround themselves with friends, to have money, to dress well and smile and laugh, but love was, after all, the keynote of life. To be left alone this way, to see Eugene looking after other women wistfully, even though he did nothing more than that, was bitterness. And he did do that. He could never forget that something in lovely girlhood which was soft, yielding, uncritical.

It was at this time that Angela first conceived the notion seriously that a child might have a sobering effect on Eugene. She had, in spite of the fact that for some time now they had been well able to support one or more and in spite also of the fact that Eugene's various emotional errors indicated that he needed a sobering weight of some kind, steadily objected in her mind to the idea of subjecting herself to this ordeal. To tell the truth, aside from the care and worry which always, owing to her early experiences with her sisters' children, had been associated in her mind with the presence of them, she was decidedly afraid of the result. She had heard her mother say that most girls in their infancy showed very clearly whether they were to be good, healthy mothers or not—whether they were to have children—and her recollection was that her mother had once said that she would not have any children. She half believed it to be impossible in her case though she had never told this to Eugene and she had guarded herself jealously against the danger of having any.

Now, however, after watching Eugene all these years, seeing the drift of his present mood, fearing the influence of prosperity on him, she wished sincerely that she might have one, without great danger or discomfort to

herself, in order that she might influence and control him. He might learn to love a child. The sense of responsibility involved would be significant. People would look to him to conduct himself soberly under those circumstances, and he probably would—he was so subject to public opinion now. She thought of this a long time, wondering, for fear and annoyance were quite strong weights with her, but she did nothing immediately. She listened to various women who talked with her from time to time about the child question, and decided that perhaps it was very wrong not to have children—at least one or two—that it was probably possible that she could have one, if she wanted to. A Mrs. Sanifore who called on her quite frequently in Philadelphia—Angela met her at the Millers'—told her that she was sure she could have one even if she was past the usual age, for she had known so many women who had.

"If I were you, Mrs. Witla, I would see a doctor," she suggested one day. "He can tell you. I'm sure you can if you want to. They have so many ways of exercising and dieting you which make all the difference in the world. I'd like to have you come some day and see my doctor, if you will."

Angela decided that she would, for curiosity's sake, and in case she wished to act on the matter some time; and was informed by the wiseacre who examined her that in his opinion there was no doubt that she could. She would have to subject herself to a strict regimen. Her muscles would have to be softened by some form of manipulation. Otherwise she was apparently in a healthy, normal condition and would suffer no intolerable hardship. This pleased and soothed Angela greatly. It gave her a club wherewith to strike her lord—a chain wherewith to bind him. She did not want to act at once. It was too serious a matter. She wanted time to think. But it was pleasant to know that she could do this. Unless Eugene sobered down now——

During the time in which he had been working for the Summerfield Company, and since then for the Kalvin Company here in Philadelphia, Eugene, in spite of the larger salary he was receiving—more each year—really had not saved so much money. Angela had seen to it that some of his earnings were invested in Pennsylvania Railroad stocks which seemed to her safe enough, and in a plot of ground 200 by 200 at Upper Montclair, New Jersey, near New York, where she and Eugene, she thought, might some day want to live. His business engagements had necessitated considerable personal expenditure—his opportunity to enter the Baltusrol Golf Club, the Yere Tennis Club, the Philadelphia Country Club, and similar organizations had taken annual sums not previously considered, and the need of having a modest automobile, not a touring car, was obvious. His short experience with that served as a lesson, however, for it was found to be a terrific expense, entirely disproportionate to his income. After paying

for endless repairs, wearisomely salarying a chauffeur, and meeting with an accident which permanently damaged the looks of his machine, he decided to give it up. They could rent autos for all the uses they would have. And so that luxury ended there.

It was curious, too, how during this time their western relatives fell rather shadowily into the background. Eugene had not been home now in nearly two years and Angela had seen only David, of all her family, since she had been in Philadelphia. In the fall of the third year of their presence there, Angela's mother died and she returned to Black Wood for a short time. The following spring, Eugene's father passed on. Myrtle and her husband Frank Bangs moved to New York. He was connected with a western furniture company which was maintaining important showrooms in New York. Myrtle had broken down nervously and gone in to Christian Science, as Eugene heard. Henry Burgess, Sylvia's husband, had become president of the bank with which he had been so long connected and had sold his father's paper, the Alexandria *Appeal*, when the latter suddenly died. Marietta was promising to come to Philadelphia the next year, in order, as she said, that Eugene might get her a rich husband but Angela informed him privately that Marietta was now irrevocably engaged and would, the next year, marry a Wisconsin lumber man of wealth. Everyone was delighted to hear that Eugene was doing so well, though all regretted the lapse of his career as an artist. His fame as an advertising man was growing and he was thought to have considerable weight in the editorial direction of the *North American Weekly*. So he flourished.

CHAPTER LXXI

It was in the fall of the third year that the most flattering offer of any was made to him, and that without any seeking on his part, for he was convinced that he had found a fairly permanent berth and was happy among his associates. To understand why so large an offer should have been made to him it must be explained what the publishing and other trade conditions were at this time, and how lieutenants of any importance in any field are called to positions of prominence and trust. Most of the great organizations of Eugene's day were already reaching the place where they were no longer controlled by the individuals who had founded and constructed them but had passed into the hands of sons or holding companies, or groups of stockholders, few of whom knew much if anything of the businesses which they were called to engineer and protect. In the publishing world there

were already several like this: for one, a great magazine and book house; for another, an immense fashion publication corporation; for a third, a great engineering and technical trade paper concern, each of which was capitalized at millions and managed by officers elected by directors for the benefit of the stockholders. All of the corporations were located in New York. In each case the founders were long since dead. In two cases, sons, as principal stockholders, were engineering through dummy directors the affairs of these concerns of which they practically knew nothing. In the case of the magazine and book concern, a young man—comparatively young as the world counts it, for at the time this offer was made to Eugene, the man was but forty-four—was newly come into charge of something which he knew little about and cared about intrinsically less.

Hiram C. Colfax was not a publisher at all at heart. He had come into control of the Swinton-Scudder-Davis Company by one of those curious manipulations of finance which sometimes gives the care of sheep into the hands of anything but competent or interested shepherds. Colfax was sufficiently competent to handle anything to the end that it would eventually make money for him, even if that result were finally attained by parting with it. In other words, he was a financier. His father had been a New England soap manufacturer who, having accumulated more or less radical ideas along with his wealth, had decided to propagandize in favor of various causes, the Single Tax theory of Henry George for one, Socialism for another, the promotion of reform ideas in politics generally. Colfax Senior had tried in various ways to get his ideas before the public but had not succeeded very well. He was not a good speaker, nor yet a good writer, simply a good money maker and fairly capable thinker, and this irritated him. He thought once of buying or starting a newspaper in Boston but investigation soon showed him that this was a rather hazardous undertaking. He next began subsidizing small weeklies which should advocate his reforms but this resulted in little. His interest in pamphleteering did bring his name to the attention of Martin W. Davis of the Swinton-Scudder-Davis Company, whose imprint on books, magazines, and weeklies was as common throughout the length and breadth of the land as that of Oxford is upon the English bible.

The Swinton-Scudder-Davis Company was in sad financial straits. Intellectually, for various reasons, it had run to seed. John Jacob Swinton and Oren V. Scudder, the men with book, magazine, and true literary instincts, were long since dead. Mr. Davis had tried, for the various heirs and assigns involved, to run it intelligently and honestly, but intelligence and honesty were of little value in this instance without great critical judgement. This he had not. The house had become filled up with editors, readers, critics, foremen of manufacturing and printing departments, business managers, art

directors, traveling salesman, and so on without end, each of whom might
be reasonably efficient if left alone but none of whom worked well together
and all of whom used up a great deal of money.

The principal literary publication, a magazine of great distinction, was
in the hands of an old man who had been editor for nearly forty years. A
weekly was being run by a boy, comparatively, a youth of twenty-nine. A
second literary magazine devoted to adventure fiction was in the hands of
another young man of twenty-six, and a national critical monthly was in the
hands of a salaried critic of great distinction and uncompromising attitude.
The book department was divided into the hands of a juvenile editor, a fic-
tion editor, a scientific and educational editor, and so on. It was Mr. Davis's
task to see that competent overseers were maintained over all departments
so that they might flourish and work harmoniously under him, but he was
neither sufficiently wise nor forceful to fill the role. He was old and was
sculled about first by one theory and another, and within the house were
rings and cliques.

One of the most influential of these—the most influential in fact—was
that which was captained and led by Florence J. White, an Irish-Ameri-
can, who as business manager (and really more than that, general manager
under Davis) was in charge of manufacturing and printing departments,
and who because of his immense budgets for paper, ink, printing, mailing,
and distribution generally, was in practical control of the business. He it
was who, with Davis's approval, said how much was to be paid for paper,
ink, composition, press work, and salaries generally; he it was who, through
his henchman, the head of the printing department, arranged the work-
ing schedules by which the magazines and books were to reach the presses,
and so whether they were to be on time or not. He it was who, through
another superintendent, supervised the mailing and the stock room, and
by reason of his great executive ability was coming to have a threatening
control over the advertising and circulation departments. Before White's
day these had been all more or less independent bodies or departments but
since his ascension to power they began to look at him fearsomely for advice
and direction, for his business acumen was tremendous.

The one trouble with White—as it was with any man who was to come
in through Davis's solicitation—was that he knew nothing of art, literature,
or science, and cared less, and that his chief interest was in manufacture.
He had risen so rapidly as an executive that his strength in that direction
had outrun his financial means. He was still poor. Davis, the present head
above him, had no means beyond his own depreciated share. Because of
poor editorial judgement, the books and magazines were tottering through
a serious loss of prestige to eventual failure. Something had to be done, for

at that time the expenditures for three years past had been much greater than the receipts.

Marshall P. Colfax, the father of Hiram, was appealed to at this particular time because of his interest in reform ideas—which might be to a certain extent looked upon as related to literature—and because he was reported to be a man of great wealth. Rumor reported his fortune as being anywhere between six and eight millions. The proposition which Davis had to put before him was that he buy from the various heirs and assigns the totality of the stock outside of his (Davis's) own, which amounted to somewhere in the neighborhood of sixty-five per cent, and then come in as managing director and reorganize the company to suit himself. Davis was old. He did not want to trouble himself about the future of this company or risk his own holdings outside. He realized as well as anyone that what the company needed was new blood. A receivership at this juncture would injure the value of the house imprint very much indeed. White had no money, and besides, he was so new and different that Davis scarcely understood what his ambitions or his true importance might be. There was no real intellectual sympathy between them. In the main he did not like White's temperament and so, in considering what might be done for the company, he passed him by.

Various consultations were held. Colfax was greatly flattered to think that this proposition should be brought to his attention at all. He had three sons, only one of whom was interested in the soap business. Edward and Hiram, the two youngest, were radically opposed to it. He thought this might be an outlet for the energies for one or both of them, preferably Hiram, who was of more of an intellectual and scientific turn than the others, though his chief interests were financial—and besides, these books and publications would give Colfax Senior that opportunity which he had long been seeking. His personal prestige might be immensely heightened thereby. He examined carefully all the financial phases of the situation, using his son Hiram, whose financial judgement he greatly admired, as an accountant and mouthpiece, and finally after seeing that he could secure the stock on a long time consideration for a very moderate valuation—$1,500,000 when it was worth $3,000,000—he had Hiram elected director and president and proceeded to see what could be done with the company.

In this approaching transaction Florence J. White had seen his opportunity and seized it. He had realized on sight that Hiram would need and possibly appreciate all the information and assistance he could get, and being in a position to know, he had laid all the facts in connection with the house plainly before him. He saw clearly what the matter was—the warring factions, the lack of editorial judgement, the poor financial manipulation. He knew exactly where the stock was, and by what representations it could

be best frightened and made to release itself cheaply. He worked vigorously for Hiram because he liked him and the latter reciprocated his regard.

"You've been a prince in this transaction, White," he said to that individual one day. "You've put things practically in my hands. I'm not going to forget it."

"Don't mention it," said White. "It's to my interest to see a real live man come in here."

"When I become president, you become vice-president and that means twenty-five thousand a year." White was then getting twelve.

"When I become vice-president nothing will ever happen to your interests," returned the other man grimly. White was six feet tall, lean, savage, only semi-articulate. Colfax was small, wiry, excitable, with enough energy to explode a cartridge by yelling at it. He was eager, avid, vainglorious, in many respects brilliant. He wanted to shine in the world and he did not know how to do it as yet exactly. This man White and this business looked like an opportunity to him. His father was giving him his first real chance.

The two shook hands firmly.

Some three months later, Colfax was truly elected director and president, and the same meeting that elected him president elected Florence J. White vice-president. The latter was for clearing out all the old elements and letting in new blood. Colfax was for going slow, until he could see for himself what he wanted to do. One or two men were eliminated at once, an old circulation man and an old advertising man. In six months, while they were still contemplating additional changes and looking for new men, Colfax senior died, and the Swinton-Scudder-Davis Company, or at least Mr. Colfax's control of it, was willed to Hiram. So he sat there, president and in full charge, wondering how he should make it a great success, and Florence J. White was his henchman and sworn ally.

At the time that Colfax first heard of Eugene he had been in charge of the Swinton-Scudder-Davis Company (which he was planning to reincorporate as the United Magazines Corporation) for three years. He had made a number of changes, some radical, some conservative. He had put in an advertising man who he was now finding was not satisfactory to him and had made changes in the art and editorial departments which were more the result of the suggestions of others, principally Florence J. White, than the thoughts of his own brain. Martin W. Davis, on the ascension of these two as the chief officers of the company, had retired. He was old and sick and unwilling to ruminate in a back room position. Such men as the editor of the *National Review, Swinton's Magazine,* and *Scudder's Weekly* were the only figures of importance about the place, and these of course were now subsidiary to Hiram Colfax and Florence White.

White had introduced a rather hard, bitter atmosphere into the place. He had been raised under difficult conditions himself in a back street in Brooklyn and had no sympathy with the airs and intellectual niceties which characterized the editorial and literary element which filled the place. He had an Irishman's love of organization and politics but far and away, above that, he had an Irishman's love of power. Because of the trick he had turned in winning the favor of Hiram Colfax at the time when the tremendous affairs of the concern were in a state of transition, he had become immensely ambitious. He wanted to be not nominally but actually dictator of the affairs of this house under Colfax, and he saw his way clear to do it by getting editors, art directors, department heads, and assistants generally put in who were agreeable to him. He could not do this directly, for while Colfax cared little about the details of the business, his hobby was just this one thing—men. Like Obadiah Kalvin, of the Kalvin Publishing Company—who by the way was now his one great rival—Colfax prided himself on his ability to select men. His general idea was that if he could find one more man as good as Florence White to take charge of the art, editorial, and book end of the business, not from the manufacturing and commercial but from the intellectual and spiritual end—a man with ideas who could draw to him authors, editors, scientific writers and capable assistants generally, the fortune of the house would be made. He thought, sanely enough from some points of view, that this publishing world could be divided in this way: White bringing the inside manufacturing, purchasing and selling interests to a state of perfection, the new man bringing the ideas of the house and their literary and artistic representation up to such a state of efficiency that the whole country would know that it was, once more, powerful and successful. He wanted to be called the foremost publisher of his day and then he could retire gracefully or devote himself to other financial matters as he pleased.

He did not really understand Florence J. White. White was a past master at dissembling. He had no desire to see any such thing as Colfax was now planning come to pass. He could not do the things intellectually and spiritually which Colfax wanted done—nevertheless, he wanted to be king under this emperor, the real power behind the throne, and he did not propose to brook any interference if he could help it. It was in his power, having the printing and composing room in his hands, to cause any man whom he greatly disliked to suffer severely. Forms could be delayed, material lost, complaints rendered as to inefficiency in the matter of meeting schedules. He had the Irishman's love of chicanery in the matter of morals. If he could get an enemy's record and there was a flaw in it, the facts were apt to become mysteriously known at the most inconvenient times. He demanded the utmost loyalty, secrecy, tact, and subservience on the part of

those who worked under him. If a man did not know enough instinctively to work intelligently for his interests, while at the same time appearing to serve the interests of the house at large only, he was soon dismissed on one pretext and another. Intelligent department heads, not sure of their own strength, and seeing which way the wind was blowing, soon lined up in his cause. Those whom he liked and who did his will prospered. Those whom he disliked suffered greatly in their duties and were forever explaining or complaining. To Colfax, who was not aware of White's subtlety, things seemed to be running in the most fair and openhanded manner. And so they were, among White's associates. What he did not see was the manner in which good men were being interfered with and crippled, and there was no satisfactory way of proving this to him.

When Colfax first heard of Eugene, he was still cherishing this dream of a literary and artistic primate who should rank in power with White. He had not found him as yet, for all of the men he sincerely admired and thought fitted for the position were in business for themselves. He had sounded out one man after another but to no satisfactory end. Then it became necessary to fill the position of advertising manager with someone who would make a conspicuous success of it and he began to sound out various authorities. Naturally he looked at the different advertising men working for various publications and quickly came to the name of Eugene Witla. The latter was rumored to be making a shining success of his work. He was well liked where he was. Two different business men stated to Colfax that they had met him and that he was exceptionally clever. A third told him of his record with Summerfield. Through a fourth man, who knew Eugene and who was having him to lunch at the Hardware Club a few weeks later, Colfax had a chance to meet him without appearing to be interested in him in any way.

Not knowing who Colfax was, or rather very little other than that he was president of this great rival publishing concern, Eugene was perfectly free and easy in his manner. He was never affected at any time, decidedly eager to learn things from anybody, and supremely good natured.

"So you're Swinton, Scudder, and Davis, are you?" he said to Colfax on introduction. "That trinity must have shrunk some to get condensed into you, but I suppose the power is all there."

"I don't know about that! I don't know about that!" exclaimed Colfax electrically. He was always ready, like a greyhound to run another a race. "They tell me Swinton and Scudder were exceptionally big men. If you have as much force as you have length there's nothing the matter with you, though."

"Oh, I'm all right," said Eugene, "when I'm by myself. These little men always worry me though. They are so darned smart."

Colfax cackled ecstatically. He liked Eugene's looks. The latter's manner, easy and not in any way nervous or irritable but coupled with a heavenly alertness of eye, took his fancy. It was a fit companion for his own terrific energy, and it was not unduly soft or yielding.

"So you're the advertising manager of the *North American*. How'd they ever come to tie you down like that?"

"They didn't tie me," said Eugene. "I just laid down. But they put a nice fat salary on top of me to keep me there. I wouldn't lie down for anything except a salary."

He grinned smartly.

Colfax cackled.

"Well, my boy, it doesn't seem to be hurting your ribs, does it? They're not caved in yet—Ha! Ha!—Ha! Ha! They're not, are they, ha! ha!"

Eugene studied this little man with great interest. He was taken by his sharp, fierce, examining eye. He was so different from Kalvin, who was about his size but so much more quiet, peaceful, dignified. Colfax was electric, noisy, insistent, like a pert jack-in-the box, and he seemed to be nothing but energy. Eugene thought of him as having an electric body coated over with some thin veneer of skin. He seemed as direct as a flash of lightning.

"Doing pretty good over there, are you?" he asked. "I've heard a little something about you from time to time. Not much. Not much. Just a little. Not unfavorable though. Not unfavorable."

"I hope not," said Eugene easily. He wondered why Colfax was so interested in him. The latter kept looking him over much as one might examine a prize animal. Their eyes would meet and Colfax's would gleam with a savage but friendly fire.

"Well?" said Eugene to him finally.

"I'm just thinking, my boy! I'm just thinking!" he returned, and that was all Eugene could get out of him.

It was not long after this very peculiar meeting, which stuck in Eugene's mind, that Colfax invited him over to his house in New York to dinner. "I wish," he wrote him one day not long after this meeting, "that the next time you are in New York you would let me know. I would like to have you come up to my house to dine. You and I ought to be pretty good friends. There are a number of things I would like to talk to you about."

This was written on the stationery of the United Magazines Corporation, which had just been organized to take over the old company of Swinton, Scudder, and Davis, and was labeled "The Office of the President."

Eugene thought this was significant. Could Colfax be going to make him an offer of some kind? Well, the more the merrier. He was doing very well indeed and liked Mr. Kalvin very much—in fact all his surroundings—but

as an offer was a testimonial to merit and could be shown as such, he would not be opposed to receive one. It might strengthen him with Kalvin if it did nothing else. He made an occasion to go over, first talking the letter over with Angela, who was simply curious about the whole thing. He told her how much interested Colfax appeared to be the first time they met and that he fancied it might mean an offer from the United Magazines Corporation at some time or other.

"I'm not particularly anxious about it," said Eugene, "but I'd like to see what is there."

Angela was not sure that it was wise to bother with it. "It's a big firm," she said, "but it isn't bigger than Mr. Kalvin's and he's been mighty nice to you. You'd better not do anything to injure yourself with him."

Eugene thought of this. It was sound advice. Still he wanted to hear.

"I won't do anything," he said. "I would like to hear what he has to say, though."

A little later he wrote him that he was coming on the twentieth and that he would be glad to take dinner with him.

The first meeting between Eugene and Colfax had been fatal so far as future friendship was concerned. These two, like Eugene and Summerfield, were temperamentally in accord though Colfax was very much superior to Summerfield in his ability to command men. Summerfield could command a certain type of man easily enough. But he had never been able to win or hold Eugene's respect from the start. Admire his subtlety and resourcefulness Eugene might, or rather marvel at it—but respect it? Never.

On the other hand, Colfax was the first man who from the first hour drew Eugene with a form of magnetic attraction. He could not help thinking, after he left him at the Hardware Club that day, of the sheer, raw energy of the man, which was, nevertheless, complicated with something vast in the way of intellectual perception. They had been talking of waterways and canals in connection with America and Colfax had pointed out so clearly how much they depended on the population of the areas they served and how useless it was to dream of fixing up the long stretches of American rivers and streams without a sufficiently large body of traffic to make them profitable. "Here and there you'll find a river where that can be done—short ones, like the Schuylkill, and the Monongahela. But the long ones!—we are years and years away from it."

This had been Eugene's own thought for some time, for he had been following the newspaper discussion of this with interest. Then the subject turned to water power.

"Do you want me to tell you something," Colfax had declared emphatically, his eye aglow with a sort of prophetic light. "Do you want me to tell

you something? The next big money combination that will be made in the country will be one that will be looking after water power interests. Why, it's the greatest dream of the age—to lease and sell power—think of it."

Eugene's mind ran out to where Colfax's was already placed, on that eminence where it could command the situation. He saw it all. Colfax was a financier. If a few men like him could get together they could do many such things. Perhaps he was dreaming of it. The idea seized his fancy. What a big man he was. And they said he was worth now about four millions.

This night when they met at dinner at Colfax's house the latter was most cordial. Colfax had invited him to come to his office and together they went uptown in his automobile. His residence was in upper Fifth Avenue, a new, white marble-front building with great iron gates at the door and a splendid entry way set with small palms and dwarf cedars. Eugene saw at once that this man was living in that intense atmosphere of commercial and financial rivalry which makes living in New York so keen. You could feel the air of hard, cold order about the place, the insistence on perfection of appointment, the compulsion toward material display which was held in check only by that sense of fitness which knowledge of current taste and *the mode* in everything demanded. His automobile was very large and very new, the latest model, a great dark blue affair which ran as silently as a sewing machine. His footman who opened the door was six feet tall, dressed in knee trousers and a swallow-tailed coat. His valet was a Japanese, silent, polite, intuitive. Eugene was introduced to his Mrs. Colfax, a most graceful but somewhat self-conscious woman. A French maid later presented two children, a boy and a girl.

The appointments of this house were most superior. It consisted of four floors with an elevator, of which an attendant was in charge. There was a library, a drawing room, an art gallery with a number of excellent pictures, a nursery, fitted with play appliances and scattered with toys. The rugs, the hangings, the knickknacks and objects of art were profuse and valuable. In the dining room a splendid service of silver was displayed and some rare Chinese porcelain.

Eugene by now had become used to refinement in various forms and this house was not superior to many he had seen, but it ranked with the best. Colfax was most free in it. He threw his overcoat to the valet carelessly and tossed his babies in the air by turns when they were presented to him by the French maid. His wife, slightly taller than himself, received a resounding smack.

"There, Ceta," he exclaimed (a diminutive for Cecile, as Eugene subsequently learned), "how do you like that, eh? Meet Mr. Witla. He's an artist and an art director and an advertising manager and——"

"A most humble person," put in Eugene smilingly. "Not half as bad as you think. His report is greatly exaggerated."

Mrs. Colfax smiled sweetly. "I discount much that he says at once," she returned. "More later. Won't you come up into the library?"

They ascended together, jesting, and then the small change of conversational politeness began. Eugene was pleased with what he saw. Mrs. Colfax liked him. She excused herself after a little while and Colfax talked of life in general. "I'm going to show you my house now and after dinner I'm going to talk a little business to you. You interest me. I may as well tell you that."

"Well, you interest me, Colfax," said Eugene genially. "I like you."

"You don't like me any more than I like you—that's a sure thing," replied the latter.

CHAPTER LXXII

The results of this evening were most pleasant but in some ways disconcerting. It became perfectly plain that Colfax was anxious to have Eugene desert the Kalvin Company and come over to him.

"You people over there," Colfax said to him at one stage of the conversation, "have an excellent company but it doesn't compare with this organization which we are revising. Why, what are your two publications to our seven? You have one eminently successful one—the one you're on—and no book business whatsoever. We have seven publications, all doing excellently well, and a book business that is second to none in the country. You know that. If it hadn't been that the business had been horribly mismanaged it would never have come into my hands at all. Why, Witla, I want to tell you one little fact in connection with that organization which will illustrate everything else which might be said in connection with it before I came there. They were wasting twenty thousand dollars a year on ink alone. We were publishing a hundred absolutely useless books that did not sell enough to pay for the cost of printing, let alone the paper, plates, typework, and cost of distribution. I think it's safe to say we lost over a hundred thousand dollars a year that way. The magazines were running down. They haven't waked up sufficiently yet to suit me. But I'm looking for men. I'm really looking for one man who will eventually take charge of all that editorial and art world and make it into something exceptional. He wants to be a man who can handle men. If I can get the right man I will even include the advertising department, for that really belongs with the literary and art sections. It depends on the man."

He looked significantly at Eugene, who sat there stroking his upper lip with his hand. It was after dinner, and Mrs. Colfax and a young lady guest of theirs had withdrawn while Eugene and Colfax lingered over their coffee and cigars. The dining table was spread with a litter of silver and cut glass in the process of being removed.

"Well," Eugene said thoughtfully, "that ought to make a very nice place for some one. Who have you in mind?"

"No one as yet that I'm absolutely sure of. I have one man in mind who I think might come to fill the position after he had had a chance to look about the organization and study its needs a little. It's a hard position to hold. It requires a man with imagination, tact, judgement. He would have to be a sort of vice-Colfax, for I can't give my attention permanently to that business. I don't want to. I have bigger fish to fry. But I want someone who will eventually be my other self in these departments, who can get along with Florence White and the men under him and hold his own in his own world. I want a sort of bi-partisan commissionship—each man supreme in his own realm."

"It sounds interesting," said Eugene thoughtfully. "Who's your man?"

"As I say, he isn't quite ready yet, in my judgement, but he's near it, and he's the right man! He's in this room now. You're the man I'm thinking about, Witla."

"Me," said Eugene quietly.

"Yes, you," replied Colfax.

"You flatter me," he said with a deprecating wave of his hand. "I'm not so sure that he is."

"Oh yes he is, if he thinks he is," replied Colfax emphatically. "Opportunity doesn't knock in vain at a real man's door. At least I don't believe it will knock here and not be admitted. Why, the advertising end of this business alone is worth $18,000 a year to begin with."

Eugene sat up. He was getting twelve. Could he afford to ignore that offer? Could the Kalvin Company afford to pay him that much? They were paying him pretty well as it was. Could the Kalvin Company offer him the prospects which this company was offering him?

"What is more, I might say," went on Colfax, "that the general publishing control of this organization—the position of managing publisher which I am going to create and which, when you're fitted for it, you can have—will be worth twenty-five thousand dollars a year and that oughtn't to be so very far away, either."

Eugene turned that over in his mind without saying anything. This presentation of fate coming so emphatically and definitely at this time actually made him nervous and fearsome. It was such a tremendous thing to talk about—the literary, art, and advertising control of the United Magazines

Corporation. Who was this man White? What was he like? Would he be able to agree with him? This man beside him was so hard, so brilliant, so dynamic. He would expect so much. Still, he was like the tempter speaking to Jesus, saying, "Behold the principalities and powers of this world. These will I give you if you will fall down and worship me." Should he drop the Kalvin Company, his comfortable hold on the advertising department, and seize this more brilliant opportunity? He was certainly better fitted to be a general director of art, literature, and advertising than he was advertising alone. Art was his specialty, his perfection he might say. Advertising was his avocation. He had made good at it but why, he hardly knew. He had never really liked it. Summerfield had given him such a vigorous push in that direction, though, that after him it had not seemed so hard. How much he really owed that man after all, with his hard, bitter, driving disposition. Summerfield had literally, as he saw it now, kicked and lashed him out of moody poverty. Queer, self-bedeviling Summerfield, with his constantly reiterated "I won't stand for any such God damned truck as that."

And then his work with Townsend Miller and under Mr. Kalvin. How much he had learned of the editorial game by merely talking and planning with those two men. He had got the whole idea of timely topics, of big, progressive, national forecasts and features, of odd departments and interesting pieces of fiction and personality studies from talking with Miller alone. Kalvin had made clear to him what constituted great features. Of course, long before, he had suspected just how it was, but in Philadelphia he had sat in conference with Miller and Kalvin, and knew. He had practically managed the former's little art department for him, without paying much attention to it either. Couldn't he really handle this greater thing if he tried? If he didn't, some one else would. Would *the man who did* be so much greater than he? He had had the same fears when Summerfield talked to him, and he had made good. He had felt equally nervous when Kalvin talked to him. He had succeeded there. Wasn't it sheer cowardice to imagine that he could not succeed here?

"I'm not anxious that you should act hastily," said Colfax soothingly after a little bit, for he saw that Eugene was debating this solemnly and that this was a severe problem for him. "I know how you feel. You have gone into the Kalvin Company and you've made good. They've been nice to you. It's only natural that they should be. You hate to leave. Well, think it over. I won't tempt you beyond your best judgement. Think it over. There's a splendid chance here, just as I tell you, and I think you're the man to get away with it. Come down to my place tomorrow and let me show you what we have. I want to show our resources. I don't think you know how big this thing really is."

"Yes, I do," replied Eugene, smiling. "It certainly is a fascinating propo-sition," he said, "but I can't make up my mind about it now. It's something I want to think about. I'd like to take my time and I'll let you know."

"Take all the time you want, my boy! Take all the time you want," exclaimed Colfax. "I'll wait for you a little while. I'm in no absolute life or death hurry. This position can't be filled satisfactorily in a minute. When you're ready, let me know what you decide. And now let's go to the the-atre—what do you say?"

The automobile was called; Mrs. Colfax and her guest Miss Genier appeared. There was an interesting evening in a box, with Eugene talking gaily and entertainingly to all, and then an after-theatre bite at Sherry's. The next morning (for he stayed all night at Colfax's) they visited the United Magazines Corporation building, and at noon Eugene returned to Phila-delphia. His head was fairly seething and ringing with all he had seen and heard. Colfax was a great man, he thought, greater in some respects than Kalvin. He was more forceful, more enthusiastic, younger, like himself. He could never fail—he was too rich. He would make a success of this great corporation—a tremendous success—and if he came, he might help make it with him. What a thing that would be, very different from working for a corporation with whose success he had never had anything to do. Should he ignore this offer? New York, a true art and literary standing, a great executive and social standing, fame, money—all these were talking. Why, on eighteen or twenty-five thousand he could have a splendid studio-apartment of his own, say on Riverside Drive, he could entertain magnificently, he could keep an automobile without worrying about it. Angela would cease feeling that they had to be careful. It would be the apex of lieutenantship for him. Beyond that would be stock in the company or a business of his own. What a long distance he had come from the days when, here as a boy, he had walked the streets wondering where he would find a three dollar room, and as an art failure when he carried his paintings about and sold them for ten and fifteen dollars. Dear heaven, what peculiar tricks fortune could play.

The discussion with Angela of this proposition led to some additional uncertainty, for although she was greatly impressed with what Colfax offered, she was afraid Eugene might be making a mistake in leaving Kalvin. The latter had been so nice to Eugene. He had never associated with him in any intimate way but he and Angela had been invited to his home on several formal occasions, and Eugene had reported that Kalvin was constantly giv-ing him good advice. His attitude in the office was not critical but analytic and considerate.

"He's been mighty nice to me," Eugene said to her one morning at break-fast. "They all have. It's a shame to leave him. And yet, now that I look at

it I can see very plainly that there is never going to be the field here that there will be with the United Company. They have the publications and the book business, and the Kalvin Company doesn't and won't. Kalvin is too old. They're in New York, too; that's one thing I like about it. I'd like to live in New York again. Wouldn't you?"

"It would be fine," said Angela, who had never really cared for Philadelphia and who saw visions of tremendous superiority in this situation. The latter place had always seemed a little out of the way of things after New York and Paris. Only Eugene's good salary and the comforts they had experienced here had made it tolerable.

"Why don't you speak to Mr. Kalvin and tell him just what Mr. Colfax says," she asked. "It may be that he'll want to raise your salary so much that you'll want to stay when he hears of this."

"No danger," replied Eugene. "He may raise it some but he never can pay me $25,000 a year. There isn't any reason in the place for paying it. It takes some corporation like the United to do it. There's isn't a man in our place gets that unless it is Fredericks. Besides, I could never be anything more here, or much more, than advertising manager. Miller has that editorial job sewed up. He ought to have it, too—he's a good man. This thing that Colfax offers lets me out into a new field. I don't want to be an advertising manager all my days if I can help it."

"And I don't want you to be either, Eugene," sighed Angela. "It's a shame you can't quit entirely and take up your art work. I've always thought that if you were to stop now and go to painting you would make a success of it. There's nothing the matter with your nerves now. It's just a question of whether we want to live more simply for awhile and let you work at that. I'm sure you'd make a big success of it."

"Art don't appeal to me so much as it once did," replied Eugene. "I've lived too well and I know a lot more about living than I once did. Where could I make twelve thousand a year painting? If I had a hundred thousand or a couple of hundred thousand laid aside it would be a different thing, but I haven't. All we have is Pennsylvania Railroad stock and those lots in Montclair eating their merry little heads off in taxes and that steel common stock. If we go back to New York we ought to build on that Montclair property and rent it if we don't want to live in it. If I quit now we wouldn't have more than $2000 a year outside of what I could earn, and what sort of a life can you live on that?"

Angela saw, disappearing under these circumstances, the rather pleasant world of entertainment in which they were disporting themselves. Art distinction might be delightful but would it furnish such a table as they were sitting at this morning? Would they have as nice a home and as many

friends? Art was glorious but would they have as many rides and auto trips as they had now? Would she be able to dress as nicely? It took money to produce a variety of clothing—house, street, evening, morning, and other wear. Hats at thirty-five and forty dollars were not in the range of artists' wives, as a rule. Did she want to go back to a simpler life for his art's sake? Wouldn't it be better to have him go with Mr. Colfax and make $25,000 a year for awhile and then have him retire? He could possibly save up to a hundred or two hundred thousand by that process and then he would have enough to keep up their present state without worrying whether his pictures paid or not. He could paint for painting's sake—just the things that he wanted to do.

"You'd better talk with Mr. Kalvin," she counseled. "You'll have to do that anyhow. See what he says. After that you can decide what you want to do."

Eugene hesitated but after thinking it all over he decided that he would. The lure was too great not to do something about it. The stimulus of ambition was working in his veins. Like every man of an imaginative turn, his mind painted possibilities in rosier hues than they could normally sustain. All his years and experiences had not taught him that hope is a liar. His recent upward flight had slightly turned his head and made all things seem possible.

One morning not long after, when he met Mr. Kalvin in the main hall on the editorial floor, he said, "I'd like to talk to you for a few moments sometime today, alone, Mr. Kalvin, if you can spare me the time."

"Certainly, I'm not busy now," returned the president. "Come right down. What is it you want to see me about?"

"Well, I'll tell you," said Eugene when they had reached the former's office and he had closed the door. "I've had an offer that I feel that I ought to talk to you about. It's a pretty fascinating proposition and it's troubling me. I owe it to you as well as to myself to speak about it."

"Yes, what is it?" said Kalvin considerately. He had fancied for some time that something of this sort might come to Eugene. There were several growing publishing companies in the field which he understood were looking for good men. He did not look upon Eugene as utterly indispensable but as someone who was very valuable and who might well hope to rise a little higher somewhere. Eugene was not a business man, he thought. He never would be—he was too flighty and unstable. But he was a good advertising and art man under supervision and might well be worth $15,000 a year to him, which was $3,000 a year more than he was now getting. He did not want to stand in the way of any legitimate ambition he might have but he wanted Eugene to stay within the bounds of his own reasonable prospects

and not to waste his life upon idle dreams. He fancied that he was doing very well as he was and ought to be pretty well satisfied.

"Mr. Colfax of the United Magazines Corporation came to me not long ago and wanted to know if I would not come with him. He offers me $18,000 a year as advertising manager to begin with, and a chance to take charge of all the art and editorial ends, as well, a little later at $25,000. He calls it the managing-publishing end of the business. I've been thinking of it seriously for I've handled the art and advertising ends here and at the Summerfield Company and I have always imagined that I knew something of the book and magazine business. I know it's a rather large proposition but I'm not at all sure that I couldn't handle it."

Mr. Kalvin listened quietly. He saw what Colfax's scheme was and liked it as a proposition. It was a good idea but he needed an exceptional man for the position. Was Eugene his man? He wasn't sure of that and yet, perchance, he might be. Colfax was a man of excellent financial if not publishing judgement. He might, if he could get the proper person, make an excellent success of his business. Eugene interested him—perhaps more at first blush than he would later. This man before him had a most promising appearance. He was clean, quiet, quick, with an alert mind and eye. Kalvin could see how, because of Eugene's success here, Colfax was thinking of him as being even more exceptional than he was. He was a good man—a fine man—under direction. Would Colfax have the patience, the interest, the sympathy to work with and understand him? Kalvin thought he understood Eugene. He was a great, easy, brilliant boy, always tugging at the leash of conservatism, wanting to do the impossible. It was a fine trait—a splendid one, but it needed the guarding eye of someone like himself who knew that the impossible was the impossible on sight, so that Eugene might not be wasting his time pursuing chimeras. Kalvin thought he was such a man. Should he advise Eugene to go? Was it best for Eugene? Was it best for the Kalvin Company? He disliked losing him very much for, all said and done, he was decidedly an inspirational character about the place, lively, hopeful, good natured, pleasant.

"Now let's think about that a little Witla," he said quietly. "It's a flattering offer. You'd be foolish if you didn't give it careful consideration. Do you know anything about the organization of that place over there?"

"No," replied Eugene, "nothing except what I learned by casually going over it with Mr. Colfax."

"Do you know much about Colfax as a man?"

"Very little. I've only met him twice. He's forceful, dramatic, a man with lots of ideas. I understand he's very rich—three or four millions, someone told me."

Kalvin's hand moved indifferently. "Do you like him?"

"Well, I can't say yet absolutely whether I do or don't. He interests me a lot. He's wonderfully dynamic. I'm sure I'm favorably impressed with him."

"And he wants to give you charge eventually of all the magazines and books—the publishing end."

"So he says," said Eugene.

"I'd go a little slow if I were you, in saddling myself with that responsibility, if you go there. I'd want to be sure that I knew all about it. You want to remember, Witla, that running one department under the direction and with the sympathetic assistance and consideration of someone over you is very different from running four or five departments on your own responsibility and with no one over you except someone who wants intelligent guidance from you. Colfax, as I understand him, isn't a publisher either by tendency or training or education. He's a financier. He'll want you, if you take that position, to tell him how it shall be done. Now unless you know a great deal about the publishing business you have a very difficult task in that. I don't want to appear to be throwing cold water on your natural ambition to get up in the world. You're entitled to go higher if you can. No one in your circle of acquaintances would wish you more luck than I will, if you decide to go. I want you to think carefully of what you are doing. Where you are here you are perfectly safe—or as nearly safe as any man who behaves himself and maintains his natural force and energy can be. It's only natural that you should expect more money in the face of this offer, and I will be perfectly willing to give it to you. I intended, as you possibly expected, to do somewhat better by you, by January. I'll say now that if you want to stay here you can have fifteen thousand now and possibly eighteen thousand in a year, or a year and a half from now. I don't want to overload this department with what I consider an undue salary. I think $18,000, when it is paid, will be high for the work that is done there but you're a good man and I'm perfectly willing to pay it to you. I don't know that the time will ever come when I would be willing to pay you more than that. I don't know that we will ever enlarge the company in such a way as to permit of larger opportunities and salaries than are now paid. Anyhow there is no advantage in capitalizing the future, and besides it wouldn't be honest. The thing for you to do is to make up your mind whether this proposition which I now make you is safer and more in accord with your desires than the one Mr. Colfax makes you. With him, your eighteen thousand begins at once. With me it is a year away, anyhow. With him, you have the promise of an outlook which is much more glittering than any you can reasonably hope for here, but you want to remember that the difficulties will be, of course, proportionately

greater. You know something about me by now. You still—and don't think I want to do him any injustice, I don't—have to learn about Mr. Colfax. Now I'd advise you to think carefully before you act. Study the situation over there before you accept it. The United Magazines Corporation is a great concern. I have no doubt that under Mr. Colfax's management it has a brilliant future in store for it. He is an able man. If you finally decide to go, come and tell me, and there will be no hard feelings one way or the other. If you decide to stay the new salary arrangement goes into effect at once. As a matter of fact I might as well have Mr. Fredericks credit that up to you so that you can say that you have drawn that sum here. It won't do you any harm. Then we can run along as before. I know it isn't good business as a rule to try to keep a man who has been poisoned by a bigger offer, and because I know it isn't is the reason why I am only offering you $15,000 this year. I want to be sure that you are sure that you want to stay. See!"

He smiled.

Eugene arose. "I see," he said. "You are one of the finest men I have ever known, Mr. Kalvin. You have constantly treated me with more consideration than I ever expected to receive anywhere. It has been a pleasure and a privilege to work for you. If I stay it will be because I want to—because I value your friendship."

"Well," said Kalvin quietly, "That's very nice, I'm sure, and I appreciate it. But don't let your friendship for me or your sense of gratitude stop you from doing something that you think you ought to do. Go ahead if you feel like it. I won't feel the least bit angry with you. I'll feel sorry, but that's neither here nor there. Life is a constant condition of re-adjustment and every good business man knows it."

He took Eugene's extended hand.

"Good luck," he said, "whatever you do"—his favorite expression.

CHAPTER LXXIII

The upshot of Eugene's final speculations was that he accepted the offer of the United Magazines Corporation and left Mr. Kalvin. Colfax had written one day to his house asking him what he thought he would do about it. The more he had turned it over in his mind the more it had grown in beauty. The Colfax Company was building a tremendous building eighteen stories high in the heart of the middle business district in New York, near Union Square, to house all their departments. Colfax had said at the time Eugene took dinner with him that the sixteenth, seventeenth, and eigh-

teenth floors would be devoted to the editorial, publication, circulation, art, and advertising departments. He had asked Eugene what he had thought would be a good floor arrangement and the latter, with his usual facility for scheming such things, had scratched on a piece of paper a tentative layout for the various departments. He had put the editorial and art departments on the topmost floor, giving the publisher, whoever he might eventually prove to be, a commanding position in a central room on the western side of the building which overlooked all the buildings between the square and the Hudson River, and showed that magnificent body of water as a panorama for the eye to feast upon. He had put the advertising and some overflow editorial rooms on the seventeenth floor, and the circulation with its attendant mailing and cabinet record rooms on the sixteenth. The publisher's and editor's rooms he laid out after an old Flemish theory he had long had in mind in which green, dark blue, blood red, and black walnut shades contrasted richly with the flood of light which would be available.

"You might as well do this thing right if you do it at all," he had said to Colfax. "Most all the editorial offices I have ever seen have been the flimsiest makeshifts. A rich-looking editorial, art, and advertising department would help your company a great deal. It has advertising value."

He recalled as he said it Summerfield's theory that a look of prosperity was about the most valuable asset a house could have.

Colfax agreed with him and said when the time came that he wished Eugene would do him the favor to come over and look the thing over. "I have two good architects on the job," he explained, "but I would rather trust your ideas as to how those rooms should be laid out."

Now when he was considering this final call for a decision, he was thinking how this floor would look—how rich it would be. Eventually, if he succeeded, his office would be the most sumptuous thing in it. He would be the most conspicuous figure in the great, new building, outside of Colfax himself.

Thoughts of this kind, which ought to have but very little part in any commercial speculation, were nevertheless uppermost in Eugene's mind, for he was not a business man—he was primarily an artist—and for all his floundering around in the commercial world, he remained an artist still. His sense of his coming dignity and standing before the world was almost greater than his sense of the terrifying responsibility which it involved. Colfax was a hard man, he knew, harder even than Summerfield, for he talked less and acted more, but this did not sink into Eugene's consciousness sufficiently to worry him any. He fancied he was a strong man, able to hold his own anywhere. When difficulties arose, if they did, his fertile imagination would get him out of them. So he decided in favor of the new proposition.

Angela was really not very much opposed to the change though her natural conservatism made her worry and hesitate to approve. It was a great step forward if Eugene succeeded but if he failed it would be such a loss. Still, he said that Colfax was very much impressed with him, that he believed he would do better with him than with anyone yet.

"Colfax has so much faith in me," he told her. "He's convinced that I can do it, and faith like that is a great help. I'd like to try it anyhow. It can't do me any harm. If I think I can't handle the publishing proposition I'll stick to the advertising end."

"All right," said Angela, "but I scarcely know what to advise. They've been so nice to you over here."

"I'll try it," said Eugene determinedly. "Nothing venture, nothing have," and he informed Kalvin the same day.

The latter looked at him solemnly, his keen gray eyes contemplating the situation from all points of view. "Well, Eugene," he said "you're shoulder-ing a great responsibility. It's difficult. Think carefully of everything that you do. I'm sorry to see you go. Good-bye."

He had the feeling that Eugene was making a mistake—that he would do better to rest awhile where he was—but persuasion was useless. It would only give Eugene the notion that he was more important than he was—make it more difficult to deal with him in the future.

Kalvin had heard a number of things concerning Colfax recently and he fancied that Eugene might find it hard to deal with him later. The general impression was that he was subject to sudden likes and dislikes which did not bear the test of time. He was said to be scarcely human enough to be the effective head of a great working corporation.

The truth was that this general opinion was quite correct. Colfax was as hard as steel but of a smiling and delightful presence to those he fancied. Vanity was his other name and ambition with him knew no bounds. He hoped to make a tremendous success of his life, to be looked up to as an imposing financier, and he wanted *men*—only strong men about him.

Eugene seemed to Colfax to be a strong man and the day he finally com-municated with him, saying that he thought that he would accept his offer but that he wished to talk to him some more, Colfax threw his hat up in the air, slapped his partner White on the back, and exclaimed, "Whee! Flor-rie! There's a trick I've turned for this corporation. There's a man, unless I am greatly mistaken, will do something here. He's young but he's all right. He's got the looks on you and me, Florrie, but we can stand that, can't we? He'll make the magazine people around this town sit up and take notice or I miss my guess. I've picked a prize, I tell you."

White eyed him, with a show of joy and satisfaction which was purely

simulated. He had seen many editors and many advertising men in his time. In his judgement they were nearly all lightweights, men who were easily satisfied with the little toys wherewith he or anyone might decide to gratify their vanity. This was probably another case in point but if a real publisher were coming in here it would not be so well with him. He might attempt to crowd in on his authority or at least divide it with him. That did not appeal to his personal vanity. It really put a stumbling block in White's path, for he hoped to rule here someday alone. Why was it that Colfax was so eager to have the authority in this house divided? Was it because he was somewhat afraid of him? He thought so and he was exceedingly close to the truth when he thought so.

As has been said, Colfax was the soul of vanity. He could not brook the idea that anyone was doing or could do anything for him which he could not better do for himself if he were to give the matter his close attention. Florence White had helped him to come into control of this institution quickly and effectively, and had since displayed wonderful acumen in handling the various problems which confronted them—in advertising, circulation, manufacture—but Colfax did not propose to sit by and see White dictate the entire policy of the house. He did not believe, for instance, that White was as a good a judge of talent and the ultimate intellectual force which was necessary to make a house of this kind important, as he was. White was really not big enough mentally. He was a Roman Catholic, more or less set in the tenets of that faith, and as such, in Colfax's judgement, more or less out of step with the true intellectual progress of the time. He was too narrow, rough, and hard in his methods and procedure. He was given to quick judgements and brutal expressions. At the same time, Colfax valued him for just these qualities, as one might value a tool of roughness and force. He was a fine sledge hammer or axe to wield when the services of such an implement were needed.

"Florrie's a good lieutenant," he said to himself, "but he needs to be counter-balanced here by someone who will represent the refinement and that intellectual superiority which the world respects."

He wanted this refinement and intellectual superiority to be popular with the public and to produce results in the shape of increased circulation for his magazines and books. These two would then act as foils each to the other, thus preventing the house from becoming top-heavy in either direction. Then he could drive this team as a grand master—the man who had selected both, whose ideas they represented and whose judgement they respected. The world of finance and trade would know they were nothing without him.

What Eugene thought and what White thought of this prospective sit-

uation was that the other would naturally be the minor figure and that he, under Colfax, would be the shining light. Eugene was convinced that the house without proper artistic and intellectual dominance was nothing. White was convinced that without some commercial management it was a failure and that this was the thing to look to. Money could buy brains. One could hire by the hundreds and thousands, editors, book judges, art directors, advertising men. Where could one find a commercial genius and hire him? So the new arrangement began under these peculiar conditions.

Colfax introduced Eugene to White on the morning he arrived to take charge, for on the previous occasions when he had been there White was absent. The two looked at each other and immediately suspended judgement, for both were able men. Eugene saw White as an interesting type, tall, leathery, swaggering, a backstreet bully evolved into the semblance of a gentleman. White saw in Eugene a nervous, refined, semi-emotional literary and artistic type who had, however, a curious versatility and virility not common among those whom he had previously encountered. He was exceedingly forceful but not poised. That he could eventually undermine him if he could not dominate him White did not doubt. Still he was coming in with the backing of Colfax and a great reputation and it might not be easy. Eugene made him feel nervous. He wondered as he looked at him whether Colfax would really make him general literary, artistic, and advertising executive, or whether he would remain simply advertising manager, as he now entered. Colfax had not accepted Eugene for more than that.

"Here he is, Florrie," Colfax had said of Eugene on introducing him to White. "This is the man I've been talking about. Witla, Mr. White. White, Mr. Witla. You two want to get together for the good of this house in the future. What do you think of each other?"

Eugene had previously noted the peculiarity of this rowdy, rah! rah! attitude on the part of Colfax. He seemed to have no sense of the conventions of social address and conference at any time. In this respect he was a law unto himself, kicking methods of procedure out of doors and going after anything that he wanted roughshod. Eugene had noted this in him the first time he met him at the Hardware Club, but because of his own free, untrammeled attitude, it pleased rather than offended him. He hated circumlocution. He liked to see people come directly to the point and Colfax did this more vigorously than almost anyone he had ever seen, not even excluding Summerfield.

"Now, by God," Colfax exclaimed, striking his right fist against his left palm, "unless I am greatly mistaken, this house is going to begin to move. I'm not positive that I have the man I want, but I think I have. White, let's stroll around and introduce him."

White swaggered to the office door.

"Sure," he said quietly.

Eugene bristled with the force that had been called into action by this comment. His personality, under stress, was electric. He radiated ideas and suggestions much as an electric generator radiates sparks. A psychometrist and delineator once told him that she could see waves of energy radiating from him in the shape of a great oval aura, and no doubt it was true. Even White, phlegmatic, solid, poised, and contentious, was penetrated by it.

"An exceptional man," he said to himself.

Colfax was almost beside himself with satisfaction, for he was subject to emotional flushes which, however, related to self-aggrandizement only. He walked with a great stride (little as he was) which was his wont when he was feeling particularly good. He talked in a loud voice for he wanted everyone to know that he, Hiram Colfax, was about, and as forceful as the lord of so great an institution should be. He could yell and scream sometimes, like a woman in a paroxysm of rage, when he was thwarted or irritated. Eugene did not know that as yet. However Colfax was full of great ideas which were inspirational in their character. He was in many ways a fit superior to men of talent.

"Here's one of the printing floors," he said to Eugene, throwing open a door which revealed a room full of thundering presses of giant size. "Where's Dodson, boy? Where's Dodson? Tell him to come here. He's foreman of our printing department," he added, turning to Eugene as the printer's devil who had been working at a press scurried away to find his master. "I told you, I guess, that we have thirty of these presses. There are four more floors just like this."

"So you did," replied Eugene. "It certainly is a great institution. I can see how the possibilities of a thing like this are almost limitless."

"Limitless! I should say. It depends on what you can do with this," and he tapped Eugene's forehead. "If you do your part right and he does his" (turning to White), "there won't be any limit to what this house can do. That remains to be seen."

Just then Dodson came bustling up, a shrewd, keen henchman of White's, who looked at Eugene curiously.

"Dodson, Mr. Witla, the new advertising manager. He's going to try to help pay for all this wasteful press work you're doing. Witla, Mr. Dodson, manager of the printing department."

The two men shook hands. Eugene felt in a way as though he were talking to an underling and did not pay very definite attention to him. Dodson resented his attitude somewhat but gave no sign. His loyalty was to White and he felt himself perfectly safe under that man's supervision.

The next visit was to the composing room where a vast army of men, apparently, were working away at type racks and linotype machines. A short, fat, ink-streaked foreman in a green striped apron that looked as though it might have been made of bed ticking came forward to greet them ingratiatingly. He was plainly nervous at their presence and withdrew his hand when Eugene offered to take it.

"It's too dirty," he said. "I'll take the will for the deed, Mr. Witla."

More explanations and laudations of the extent of the business followed.

There came the circulation department with its head, a tall, dark man who looked solemnly at Eugene, uncertain as to what place he was to have in the organization and uncertain as to what attitude he should ultimately have to take. White was "butting into his affairs," as he told his wife, and he did not know where it would end. He had heard rumors to the effect that there was to be a new man soon who was to have great authority over various departments. Was this he?

There came next the editors of the various magazines who viewed this triumphant procession with more or less contempt, for to them both Colfax and White were raw, uncouth upstarts blazoning their material superiority in loud-mouthed phrases. Colfax talked too loud and was too vainglorious. White was too hard, bitter, and unreasoning. They hated them both with a secret hate but there was no escaping their domination. The need of living salaries held all in obsequious subjection.

"Here's Mr. Marchwood," Colfax said, inconsiderately, of the editor of the *International Review*. "He thinks he's making a significant publication of that, but we don't know whether he is yet or not."

Eugene winced for Marchwood. He was so calm, so refined, so professorial.

"I suppose we can only go by the circulation department," he replied simply, attracted by Eugene's sympathetic smile.

"That's all! That's all!" exclaimed Colfax.

"That is probably true," said Eugene, "but a good thing ought to be as easily circulated as a poor one. At least it's worth trying."

Mr. Marchwood smiled. It was a bit of intellectual kindness in a world of cruel comment.

"It's a great institution," said Eugene finally, on reaching the president's office again. "I'll begin now and see what I can do."

"Good luck, my boy, good luck!" called Colfax loudly. "I'm laying great stress on what you're going to do, you know."

"Don't lean too hard," returned Eugene. "Remember I'm just one in a great organization."

"I know, I know, but the *one* is all I need up there—the *one*, see?"

"Yes, yes," laughed Eugene, "cheer up. We'll be able to do a little something, I'm sure."

"A great man, that," Colfax declared to White as he went away. "The real stuff in that fellow, no flinching there, you notice. He knows how to think. Now, Florrie, unless I miss my guess, you and I are going to get somewhere with this thing."

White smiled gloomily, almost cynically. He was not so sure. Eugene was pretty good but he was obviously too independent, too artistic to be really stable and dependable. Eugene would never run to him for advice but he would probably make mistakes. He might lose his head. What must he do to offset this new invasion of authority? Discredit him? Certainly. But he needn't worry about that. Eugene would do something. He would make mistakes of some kind. He felt sure of it. He was almost positive of it.

CHAPTER LXXIV

The assumption of his new duties here, as at Summerfield's and at Philadelphia, was accompanied by corresponding changes in his social environment. During the three years in which he and Angela had lived in Philadelphia, they had managed to pick up a host of acquaintances—one could scarcely call them friends, for they belonged to that strata of society which quite frankly seeks companionship in prosperity and is not concerned with those who are not doing so well or who may, perchance, of a sudden, cease doing very well. The Townsend Millers were sincere enough friends, or at least Miller was of Eugene, for there was marked compatibility in temper there, but with Angela and Mrs. Miller the case was somewhat different. They had really never agreed. Angela had never been able to overcome her opposition to Mrs. Miller's rather lofty—albeit innocent—method of expressing herself, and Mrs. Miller had felt in Angela an unnecessary tendency toward criticism. They were nice to each other, almost noticeably so, but not based on anything deep and keen. There was a long list of others whose mere names would mean nothing to the reader, and yet whose personalities should be understood as representing that class type which goes with refined prosperity. Not really rich, not very poor—writers, artists, authors, a few society people of literary and artistic inclinations, and many well domesticated wives and husbands whose incomes ranged from five to seven thousand a year.

Eugene, in spite of the fact that he was an advertising manager, which

of itself alone would have been more or less of a drawback, was welcomed and made much of because, first of all, he was an artist with a record for distinguished achievement in that field which would not down. In spite of the considerable lapse of time since he had done anything directly—it was nearly eight years and he was drawing near to the end of his thirty-seventh year—he was much better known now for the work he had done at that time than for anything he had achieved since. His fame in trade circles as art director in an advertising house, and later as an advertising manager and an art director in a publishing house of such prominence as the Kalvin Company, had simply tended to enhance his reputation as a real artist, for success called attention to his personality. Who was he? Where did he come from? Why did he seem to be so popular with illustrators, advertising men, the publishing world generally? Was he a great advertising man? Yes. Was he an exceptional art director? All the magazine artists and illustrators thought so. Did he display good business judgement? It was said so. Why did he want to leave the field in which he had first distinguished himself? Because of ill health and poverty. He had deserted art, as he himself confessed, because there was practically nothing in it.

And yet artists and illustrators as much as advertising men and others were constantly running to him because in him they found a sympathetic audience. He understood what they were trying to do, sympathized with their ambitions, was glad to direct their efforts toward right channels wherever possible. No one who applied to him—not even the youngest or rawest—was turned roughly away, though as he grew more and more successful it became constantly more and more difficult to see him. He rarely had the time any longer to sit and commiserate with beginners, though when he had the time he was not at all prone to refuse it. He was surrounded at the Kalvin Company by obsequious assistants, who saw to it, almost in spite of himself, that he was not very much disturbed. They made a fetich of his personality, as office assistants are inclined to do, and were only too pleased to shoo away necessitous applicants without his ever seeing them, thus adding to their own sense of authority and the dignity of working for so important a man.

Eugene came to have an easy, gracious, superior air which had something of Machiavelli's undisturbed and gracious savoir faire and Mona Lisa's elusive smile. He was considered cold by some who knew him only slightly, hard by others who had business dealings with him and who came in contact with him when he was sitting in the seat of authority. He was not either hard or cold except in spots and under certain circumstances. His sympathies were easily aroused. His sense of the unfairness of life to many was intensely keen. He was sorry for the truly poor, the inefficient, the

hopeless. All the reforms which were advocated in his day were heartily sanctioned by him. He wanted to see the world grow better. He did not, however, paradoxically, want its improvement to conflict too much with his personal desires.

Angela, on the other hand, was not broadening as rapidly with her opportunities as she might have. She was not seeing the radical development of his nature—the fact that he could not be governed by any theories which might govern the surface conditions of a town like Black Wood. She was still hypnotized by what people thought, or what they said they thought, in regard to morals, social ethics, dress, appearances, public conduct, without taking sufficiently into consideration what they did. If she had opened her eyes and balanced words with performances she would have seen that a hard and fast attitude was untenable. Eugene was not to be controlled that way. She was holding the reins too tight.

And there were such splendid opportunities for gaining that knowledge of the world that comes rapidly to some people when they have the occasion of mixing and mingling with the so-called cultivated classes. She understood the drift of their tendencies well enough but she did not accept them wholeheartedly as worthwhile, only as endurable and in some respects even enjoyable. She either could not or would not put on the mask and mouth and mum with the rest of them. The superior airs of the intellectuals were still an abomination to her. To Eugene they were a source of entertainment, if not of personal satisfaction. He liked clever people—"classy" he called them—and it was a source of great joy to him to see women of presence and distinction and a sense of superiority take an interest in him. Angela thought they were vain, silly, self-seeking, in a number of cases evil-minded. She thought she had so harried Eugene five or six years before that he would not soon again allow them to affect him by their blandishments. His own period of ill health and poverty, in spite of the fact that Frieda and Carlotta had appeared in that period, seemed to have sobered him. He was no longer, apparently, so easily disturbed from a passional point of view.

He worked hard, eagerly, fast at times, took trains to Chicago, Pittsburgh, Boston, and New York on a moment's notice. Food did not seem to interest him when work was in the way. He would give up any entertainment gladly for a cause. His one objection was to Angela's constant supervision, which he sometimes took with an amused smile, at other times with open opposition. "Oh, don't make such a fuss," was his constant comment, for he continually felt as if she were attempting to put him under heavy obligation to her. At the same time they quarreled occasionally over the fact that he did not appear to love her. He had said once that he would not pretend anymore but he had allowed himself to be coaxed into an atmosphere of

affection, half simulated, half real, which was a fair substitute for the original passion of years before. Angela was still very attractive. She appeared quite young to most people, exceedingly so, and learning this, began emphatically to simulate the manners of youth. She dressed in the most becoming style, with close fitting dresses that set off her attractive form to perfection, and wore hats which were dreams of artistic configuration. Eugene had made various portraits of her in the last few years which showed her in various poses and charming gowns, and these were occasionally exhibited in public at art exhibits and commented upon. Because of these and her watchfulness, and her pretence of great affection for him, which was still partially grounded in fact, those who came to know them at all imagined that here was an ideal love match.

"There's one couple," said a Mrs. Wakeman of Philadelphia, a woman who moved easily in the circle in which Eugene and Angela were now disporting themselves, "that appear to be happily married. I don't think there is any question of that. She adores him and there isn't any doubt that he is dependent on her. It's Angela here and Angela there. It's a comforting thing to see a married couple that has grown into each other's graces, and that time hasn't estranged. Dear me, when we see all the fighting and fussing that goes on behind doors and in public!"

Eugene occasionally heard these things—remarks of this character—and they made him smile, for he really did not consider himself happily married—he considered himself mismated. It was his thought, almost ever present in his mind, that he should have had someone who was more in accord, mentally and spiritually, with his deepest and inmost spiritual convictions, and the thought irritated him. He hated the sense of loss and failure in this respect which was ever with him. He wanted someone who understood the subtlety of life better and who could laugh with him at the curious depths and twists which life was constantly presenting. Angela could not. He constantly felt that she did not see the things that he saw. They talked of practical things in quite an effective way. To anything which concerned commercial, art, or social interests, Angela was as alive and keen as anyone could be—in a great many ways much more so than most people would have been. She was shrewd and subtle herself but she did not seem to realize the basic subtlety of nature itself. People must be honest, truthful, frank, open, unchanging in their principles, according to her—particularly Eugene. Eugene knew, or thought that he knew, that being a part of nature, he actually could not be. Nature was not in any way frank, open, truthful, unchanging. It was constantly simulating something, as for instance the bugs which simulate sticks and leaves, the spiders that set traps to catch flies, the men who use knives and forks instead of claws. Life

was innately subtle, brutal, and cruel. Life was living on death—the great slaughter houses at Chicago proved that. Why should anyone talk about innate beauty, honesty, truthfulness, virtue, perfection? People were lying or make-believing or mis-understanding—that was all. They were subject to silly illusions in regard to life and he wanted someone who wasn't and who knew that she wasn't.

Besides, Angela was getting old—forty-three to his thirty-seven—and it was beginning to show in small and subtle ways which he alone could see. He did not wish to reproach her with this. He did not think that it was anything which he should consciously take advantage of. It was too bad, for her and for him, but she was getting old just the same. Little lines about the eyes, mouth, and on the neck were indicative. Her manners were much more placid than those of a girl. She had the critical wisdom of a woman of her years in spite of her youthful appearance and makeup. Eugene, in spite of his age and experiences, had the manner, the enthusiasm, the almost aimless emotions of a boy. Angela had the air, when she was not watching herself, of a woman of forty.

They were not seeing life from the same angle at all. Eugene was looking at it from the viewpoint of the love time, when the world is green, the open road is before the heart, and there may be a maiden of great beauty somewhere waiting for him—dancing upon the grass, let us say. Angela was looking at it from the sober viewpoint of the prudent housewife whose ardent love period is over but who has saved enough out of that glorious bonfire of spring to warm the kitchen hearth. A nice house, a nice income, plenty of pleasing friends, good clothes, stability, the dignity and comfort that comes from being the loved and honored wife of a prosperous man— these were the things that she wanted and that she felt to be her right. She had never relaxed one jot, or little, of what she considered to be the laws of right conduct in marriage and she wanted Eugene to look neither to the right nor the left. If he did there was still argument, reproach, warning. She did not even want infidelity in others discussed except, perchance, to reproach it bitterly. God would punish the nasty men who were unfaithful to their wives. There was but one place for lechers, wife beaters, wife deserters, and so on—the public jail. Men, ever weak and fickle, should be compelled by law to conform to the principles which they accepted at marriage. Everything said at the altar must be literally fulfilled. Who failed in this was a liar, a dog, and a scoundrel. These convictions did not all come out in daily conversation but it was very easy for some item of news, some expression of opinion, some volunteered sympathy to tap the wellspring of conviction, and then her ideas and feelings on these subjects came forth free and clear.

"Oh, the devil," Eugene would say to himself, or at other times he would combat her fiercely, particularly in the presence of others, in order to gain testimony against her.

Most of the people whom they knew were much less fixed in their convictions than Angela, but in the main a great many of them agreed with her. All the men sided with Eugene, of course—Angela fancied because he naturally gravitated to men of his own stripe. There were times when their private arguments led back to Riverwood and Christina and then he was very sorry that he had ever said anything at all. Angela would sometimes burst into tears and sob bitterly at the memory of it. He would take her in his arms and attempt to console her. On several occasions she shoved him angrily, only to repent the next moment, for he was doing so much better now and it was useless to rake up bygones in the face of present prosperity. Nevertheless, he was never allowed to forget utterly that she had not forgotten. He was made to feel that he had good reason to try and behave himself for the rest of his natural life. Eugene resented this thought, but it was useless to contend, he fancied. She was married to him. The world would have it that divorce was a horrible evil. He had no grounds in the eyes of society for any action or complaint against her. Obviously she was the model wife. All he could do was to drift on and dream. And so he did.

The opening days of this, their second return to New York, was a period of great joy to Angela. Unlike the first time when she was returning after seven months of loneliness and unhappiness to a sick husband and a gloomy outlook, she was now looking forward to what, in spite of her previous doubts, was a glorious career of dignity, prosperity, and abundance. Eugene was such an important man now. His career was so well marked and in a way almost certified. They had considerable money in the bank. Their investments in stocks, on which they obtained a uniform rate of interest of about seven percent, aggregated $30,000. They had two lots, two hundred by two hundred, in Upper Montclair which were said to be slowly increasing in value and which Eugene now estimated to be worth about six thousand. He was talking about investing what additional money he might save in better interest-bearing stocks or some sound commercial venture.

When the proper time came a little later he might even abandon the publishing field entirely and renew his interest in art. He was certainly getting near to the place where he could do this.

The place which they selected for their residence in New York was in a new and very sumptuous studio apartment building on Riverside Drive near Seventy-ninth Street, where Eugene had long fancied he would like to live. This famous thoroughfare and showplace with its restricted park atmosphere, its magnificent and commanding view of the lordly Hudson, its

wondrous woods of color and magnificent sunsets, had long taken his eye. When he had first come to New York it had been his delight to stroll here, watching the stream of fashionable equipages pour out towards Grant's Tomb and return. He had sat on a park bench many an afternoon at this very spot or farther up and watched the gay company of horsemen and horsewomen riding cheerfully by, nodding to their social acquaintances, speaking to the park keepers and road scavengers in a condescending and superior way, taking their leisure in a comfortable fashion, and looking idly at the river. It seemed a wonderful world to him at that time. Only millionaires could afford to live there, he thought—so ignorant was he of the financial tricks of the world. These handsomely garbed men in riding coats and breeches; the distinguished looking girls in stiff black hats, trailing black riding skirts, yellow gloves, and disporting short whips which looked more like dainty canes than anything else, took his fancy greatly. It was his idea at that time that this was almost the apex of social glory—to be permitted to ride here of an afternoon. What important people these must be—how wealthy, how refined. To his ignorant, unsophisticated western mind, the type of woman who disported herself here must of course be superior, mentally, physically, emotionally, artistically. To be of that world—oh! oh!

Since then he had come a long way and learned a great deal but he still fancied this street as one of the few perfect expressions of the elegance and luxury of metropolitan life and he wanted to live on it. Angela was given authority, after discussion, to see what she could find in the way of an apartment of, say, nine or eleven rooms with two baths or more which should not cost more than three thousand or three thousand five hundred. As a matter of fact, a very handsome apartment of nine rooms and two baths, one of which was a studio room eighteen feet high, forty feet long, and twenty-two feet wide, was found at the now, to them, comparatively moderate sum of three thousand two hundred. The chambers were beautifully finished in old English oak, carved and stained after a very distinguished fifteenth century model, and the walls were left to the discretion of the incoming tenant. Whatever was desired in the way of tapestries, silks, or cloth wall finishings would be supplied.

Eugene chose green-brown tapestries representing old Rhine castles for his studio, and blue and brown silks for his wall finishings elsewhere. He now realized a long cherished dream of having a great wooden cross of brown stained oak, ornamented with a figure of the bleeding Christ, which he set in a dark shaded corner behind two immense wax candles set in tall heavy bronze candle sticks, the size of small bed posts. These, when lighted in an otherwise darkened room and flickering ruefully, cast a peculiar spell of beauty over the gay throngs which sometimes assembled here. A three-

quarter, triangular grand piano in old English oak occupying one corner, a magnificent music cabinet in French burnt woodwork stood near by. There were a number of carved and fluted high back chairs, a carved easel with one of his best pictures displayed, a black marble pedestal bearing a yellow stained marble bust of Nero, with his lascivious, degenerate face, scowling grimly at the world, and two gold plated candelabra, of eleven branches each, brought from the Appian Way and hung solidly upon the north wall, which ran at right angles to the river.

Two wide, tall windows with storm sashes, which reached from the floor to the ceiling, commanded the west view of the Hudson. Outside of one was a small stone balcony, wide enough to accommodate four chairs, which gave a beautiful, cool view of the drive. It was shielded by an awning in summer and was nine stories above the ground. Over the waters of the more or less peaceful stream were the stacks and outlines of a great factory, and in the roadstead lay boats always—war vessels, tramp freighters, sail boats, and up and down passed the endless traffic of small craft always so pleasant to look upon in fair or foul weather. It was a beautiful apartment, beautifully finished, in which most of their furniture brought from Philadelphia fitted admirably. It was here that at last they settled down to enjoy the fruit of that long struggle and comparative victory which brought them so near their much desired goal—an indestructible and unchangeable competence which no winds of ill fortune could readily destroy.

Eugene was quite beside himself with joy and satisfaction at thus finding himself and Angela eventually surrounded by those tokens of luxury, comfort, and distinction which had so long haunted his brain. Most of us go through life with the furniture of our prospective castle well outlined in mind but with never the privilege of seeing it realized. We have our pictures, our hangings, our servitors well and ably selected. Eugene's were real at last. His Riverside apartment was before him. He was in it at last, beautifully finished. One of the rooms had been turned into a card, billiard, and smoking room. Another had been devoted exclusively to books and magazines with a handsomely carved reading table and beautifully wrought stained glass lamp. There were pictures in plenty, handsome bedroom sets, a cook, a maid, a joint valet and chauffeur for himself. He reasoned that since he was going upward in the world, he would live for a little while as he had long dreamed and wished he might live. Now he proposed to entertain and rightly, for here he could do it.

CHAPTER LXXV

The affairs of the United Magazines Corporation, so far as the advertising, commercial, and manufacturing ends at least were concerned, were not in such an unfortunate condition by any means as to preclude that they could not be quickly restored by tact, good business judgement, and hard work. Since the accession to power in the commercial and financial ends of Florence White, things in that quarter at least had slowly begun to take a turn for the better. Although he had no judgement whatsoever as to what constituted a timely article, an important book, or a distinguished art feature, he had that peculiar intuition for right methods of manufacture, right buying and right selling of stock, right handling of labor from the cost and efficiency point of view, which made him a power to be reckoned with. He knew a good manufacturing man or employee on sight. He knew where books could be sold and how. He knew how to buy paper in large quantities and at the cheapest rates and how to print and manufacture at a cost which was as low as could possibly be figured. All waste was eliminated. He used his machines to their utmost capacity via a series of schedules which saved an immense amount of waste and permitted the least possible help. He was constantly having trouble with the labor unions on this score for they objected to a policy which cut out duplication of effort and so eliminated their men. He was an iron master, however, coarse, brutal, foul when dealing with them, and they properly feared and respected him.

In the advertising end of the business things had been going rather badly, for the reason that the magazines for which this department was supposed to get business had not been doing so well editorially. They were out of step with the times to a certain extent—not in advance of the feelings and emotions of the period—and so the public was beginning to be inclined to look elsewhere for its mental pabulum. They had had great circulations and great prestige. That was when they were younger and the original publishers and editors were in their prime. Since then, days of weariness, indifference, and confusion had ensued. Only with the accession of Colfax to power had hope begun to return.

As has been said, he was looking for strong men in every quarter of this field, but in particular was he looking for the one man who would tell him how to govern them after he had them. Who was to dream out the things which would interest the public in each particular magazine proposition? Who was to draw great and successful authors to the book end of the house? Who was to inspire the men who were directing these various departments with the spirit which would bring public interest and success? Eugene might

be the man eventually, he hoped, but how soon? He was anxious to hurry his progress now that he had him.

It was not long after Eugene was seated in his advertising managerial chair that he saw how things lay. His men, when he gathered them in conference, complained that they were fighting against falling circulations.

"You can talk all you want, Mr. Witla," said one of his men gloomily, "but circulation and circulation only is the answer. They have to key up the magazines here. All these manufacturers know when they get results. We go out and get new business all the time but we don't keep it. We can't keep it. The magazines don't bring results. What are you going to do about that?"

"I'll tell you what we're going to do," replied Eugene calmly, "we're going to key up the magazines. I understand that a number of changes are coming in that direction. They are doing better right now. The manufacturing department, for one thing, is in splendid shape. I know that. In a short time the editorial departments will be. I want you people to put up, at this time, the best fight you know how under the conditions as they are. I'm not going to make any changes here if I can help it. I'm going to show you how it can be done—each one separately. I want you to believe that we have the greatest organization in the world, and it can be made to sweep everything before it. Take a look at Mr. Colfax. Do you think he is ever going to fail? We may, but he won't."

The men liked Eugene's manner and confidence. They liked his faith in them and it was not more than ten days before he had won their confidence completely. He took home to his hotel where he and Angela were stopping temporarily all the magazines and examined them carefully. He took home a number of the latest books issued and asked Angela to read them. He tried to think just what it was each magazine should represent and who and where was the man who would give to each its proper life and vigor. At once, for the adventure magazine, he thought of a man whom he had met years before and who had since being making considerable of a success editing a Sunday newspaper magazine supplement, Jack Bezenah. He had started out to be a radical writer but had tamed down and become a most efficient newspaper man. Eugene had met him several times in the last few years and each time had been impressed with the force and subtlety of his judgement of life. Once he had said to him, "Jack, you ought to be editing a magazine of your own."

"I will be, I will be," returned that worthy gaily, and Eugene admired his courage and self-confidence. Now as he looked at this particular proposition, Bezenah stuck in his mind as the man who should be employed. He had seen the present editor but he seemed to have no force at all.

The weekly needed a man like Townsend Miller—where would he find

him? The present man was interesting but not universal in his conceptions. Eugene went about among the various editors, looking at them, ostensibly making their acquaintance, but he was not satisfied with any one of them. After knowing Summerfield, Kalvin, Miller, and Colfax intimately, he only wanted to do with strong men.

He waited to see that his own department was not needing any vast effort on his part before he said to Colfax one day:

"Things are not right with your editorial departments. I've looked into my particular job to see that there is nothing so radically behindhand there but what it can be remedied, but your magazines are not right. I wish, aside from salary propositions entirely, that you would let me begin to make a few changes. You haven't the right sort of people upstairs. I'll try not to move too fast, but you couldn't be worse off than you are now in some instances."

"I know it!" said Colfax, "I know it! What do you suggest?"

"Simply better men, that's all," replied Eugene. "Better men with newer ideas. It may cost you a little more money at present but it will bring you more back in the long run."

"You're right! You're right!" insisted Colfax enthusiastically. "I've been waiting for someone whose judgement I thought was worth two whoops to come and tell me that for a long time. So far as I'm concerned, you can take charge right now. I want to tell you something, though! I want to tell you something! You're going in there now with full authority but don't you fall or stub your toe or get sick or make any mistakes. If you do, God help you. If you do, I'll eat you alive. I'm a good employer, Witla. I'll pay any price for good men, within reason, but if I think I'm being done or made a fool of, or a man is making a mistake, there's no mercy in me—not a single bit. I'm a plain, everyday blank, blank, blank" (and he used a term so foul that it would not bear repetition in print), "and that's all there is to me. Now we understand each other."

Eugene looked at the man in astonishment. There was a hard, cold gleam in his blue eyes which he had seen there before. His presence was electric—his look demoniac.

"I've had a remark somewhat of that nature made to me before," commented Eugene. He was thinking of Summerfield's "the coal chute for yours." He had hardly expected to hear so cold and definite a proposition laid down so soon after his entry upon his new duties but it was here and he had to face it. He was sorry for the moment that he had ever left Kalvin. That individual's commercial instincts were different. He was more refined. Here he had come into a hard, strenuous, bitter atmosphere, something akin to the Summerfield Company only much more important. The salary might make up for the difference. The opportunity might repay one for the brutal

slaps to one's sense of refinement and niceness, but it was a terrible thing to hear, nevertheless.

"I'm not at all afraid of responsibility," replied Eugene grimly. "I'm not going to fall down or stub my toe or make any mistakes if I can help it. And if I do, I won't complain to you."

"Well, I'm only telling you," said Colfax, smiling and good natured again. The cold light was gone. "And I mean it in the best way in the world. I'll back you up with all power and authority but if you fail, God help you! I can't."

He went back to his desk and Eugene went upstairs. Eugene felt as though the red cap of a cardinal had been put upon his head and at the same time an axe suspended over him. He would have to think carefully of what he was doing from now on. He would have to go slow, but he would have to *go*. All power had been given him—all authority. He could go upstairs now and discharge everybody in the place. Colfax would probably back him up but he would have to replace them. And that quickly and effectively. It was a trying hour, notable but grim.

His first move was to send for Bezenah. He had not seen him in some time but his stationery, which he now had engraved, headed "The United Magazines Corporation," and in one corner, "Office of the Managing Publisher," brought him fast enough. It was a daring thing to do in a way, thus to style himself managing publisher when so many able men were concerned in the work but this fact did not disturb him any. He was bound and determined to begin and this stationery—the mere engraving of it—was as good a way as any of serving notice that he was in the saddle. The news flew like wild fire about the building, for there were many in his office, even his private stenographer, to carry the news. All the editors and assistants wondered what it could mean but they asked no questions except among themselves. No general announcement had been made. On the same stationery he sent for Adolph Morgenbau, who had exhibited considerable skill at Summerfield's as his assistant and who had since become art editor of the *Sphere*, a magazine of rising importance. He thought that Morgenbau might by now be fitted to handle the art work under him, and he was not mistaken. Morgenbau had developed into a man of considerable force and intelligence, and was only too glad to be connected with Eugene again. He also talked with various advertising men, artists, and writers as to just who were the significant editorial men in the field at the time, and those he wrote to ask if they would come and see him. One by one they came, for the fact that he came to New York to take charge not only of the advertising but the editorial ends of the United Magazines Corporation spread rapidly over the city. All those interested in art, writing, editing, and advertising heard of it.

Those who had known something of him in the past could scarcely believe their ears. Where did he get the skill?

Eugene now stated to Colfax that he deemed it advisable that a general announcement be made to the staff that he was in charge. "I have been looking about," he said, "and I think I know what I want to do."

The various editors, art directors, advertising men, and book workers were called to the main office and Colfax announced that he wished to make a statement which affected all those present:

"Mr. Witla here will be in charge of all the publishing ends of this business from now on. I am withdrawing from any say in the matter, for I am satisfied that I do not know as much about it as he does. I want you, all, to look to him for advice and counsel just as you have to me in the past. Mr. White will continue in charge of the manufacturing and distributing end of the business. Mr. White and Mr. Witla will work together. That's all I have to say."

The company departed and once more Eugene returned to his office. He decided at once to find an advertising man who could work under him and do things as well as he would. He spent some time looking for this man and finally found him working for the Hays-Rickert company, a man whom he had known something of in the past as an exceptional worker. He was a strong, forceful individual of thirty-two, Carter Hayes by name, who was very anxious to rise in his chosen work and who saw a great opportunity here. He did not like Eugene so very well—he thought that he was overestimated—but he decided to work for him. The latter put him in at ten thousand a year and then turned his attention to his new duties completely.

The editorial and publishing world was entirely new to Eugene from the executive side. He did not understand it as well as he did the art and advertising worlds, and because it was in a way comparatively new and strange to him he made a number of initial mistakes. His first was in concluding that all the men about him were more or less weak and inefficient, principally because the magazines were weak when, as a matter of fact, there were a number of excellent men whom conditions had repressed and who were only waiting for some slight recognition to be of great value. In the next place, he was not clear as to the exact policies to be followed in the case of each publication, and he was not inclined to listen humbly to those who could tell him. His best plan would have been to have gone slowly, watching the men who were in charge, getting their theories and supplementing their efforts with genial suggestions. Instead he decided on sweeping changes, and not long after he had been in charge, began to make them. Marchwood, the editor of the *Review,* was removed, as was Gailer, of the *Weekly.* The editorship of *Adventure Story Magazine* was given to Bezenah.

In any organization of this kind, however, great improvements cannot be effected in a moment, and weeks and months must elapse before any noticeable change can be shown. Instead of throwing the burden of responsibility on each of his assistants and leaving it there, making occasional criticisms, Eugene undertook to work with each and all of them, endeavoring to direct the policy intimately in each particular case. It was not easy, and to him at times it was confusing. He had a great deal to learn. Still he did have helpful ideas in a score of directions daily, and these told. The magazines were improved. The first issues which were affected by his judgement and those of his men were inspected closely by Colfax, White, and others. White was particularly anxious to see what improvement had been made, and while he could not judge well himself, he had the means of getting opinions. Nearly all of these were favorable, much to his disappointment, for he hoped to find things to criticize.

In the meantime Colfax, who had been watching Eugene's determined air, the energy with which he went about his work, and the manner in which he freely accepted responsibility, came to admire him even more than he had before. He liked him socially—his companionship after business hours—and began to invite him up to the house to dinner. Unlike Kalvin, on most of these occasions he did not take Angela into consideration, for having met her he was not so very much impressed with her. She was nice but not of the same coruscating calibre as her husband. Mrs. Colfax expressed a derogatory opinion, and this also made it difficult. He sincerely wished that Eugene were single.

Time passed, and as Eugene worked more and more with the various propositions which this situation involved, he became more and more at his ease. Those who have ever held an executive position of any importance know how easy it is, given a certain degree of talent, to attract men and women of ability and force according to that talent. Like seeks like and those who are looking for advancement in this world according to their talents naturally drift to those who are higher placed and who are much like themselves. Advertising men, artists, circulation men, editors, book critics, authors, and all those who were of his calibre sufficiently to understand or appreciate him sought him out, and by degrees he was compelled to learn to refer all applicants to the heads of departments. He was compelled to learn to rely to a certain degree on his men, and having learned this he was inclined to go to the other extreme and rely too much. In the case of Carter Hayes, in the advertising department, he was particularly impressed with that man's efficiency and rested on him heavily for all the details of that work, merely inspecting his programs of procedure and advising him in difficult situations. The latter appreciated this for he was egotistic to the roots,

but it did develop a sense of loyalty in him. He saw in Eugene a man who had risen by some fluke of fortune and who was really not an advertising man at heart. He hoped some day that circumstances would bring it about that he could be advertising manager in fact, dealing directly with Colfax and White, whom he considered Eugene's superiors because of their greater interest in the business. There were others in the other departments who felt this same way.

The one great difficulty with Eugene was that he had no great power of commanding the loyalty of his assistants. He had the power of inspiring them—of giving them ideas which would be helpful to themselves—but these they used as a rule merely to further their own interests, to cause them to grow to the place where they deemed themselves beyond him. Because in his manner he was not hard, distant, bitter, he was considered as a rule rather easy. The men whom he employed—and he had talent for picking men of very exceptional ability, sometimes much greater than his own in their particular specialties—looked upon him not so much as a superior after a time as someone who was in their path and to whose shoes they might properly aspire. He seemed so good natured about the whole work—so easy going. Now and then he took the trouble to tell a man that he was getting too officious but in the main he did not care much. Things were going smoothly, the magazines were improving, the advertising and circulation departments were showing marked gains, and altogether his life seemed to have blossomed out into comparative perfection. There were storms and daily difficulties but they were not serious. Colfax advised with him genially when he was in doubt, and White pretended a friendship which he did not feel.

CHAPTER LXXVI

The trouble with this situation was that it involved more power, comfort, ease, and luxury than Eugene had ever experienced before and made him a sort of oriental potentate not only among his large company of assistants but in his own home. Angela, who had been watching his career all these years with curiosity, began to conceive of him at last as a genius in every respect—not one whose talent was confined to art alone but who was destined to some great pre-eminence somewhere, perhaps in art and finance or the publishing world, or one or two of these fields, or all three. She did not relax her attitude in regard to his conduct but was, if anything, more convinced than ever that to maintain the dizzy eminence to which he was now so rapidly ascending he must be even more circumspect. People

were watching him so closely now, she thought. They were so obsequious to him but still so dangerous. A man in his position must be so careful how he dressed, talked, walked, was seen, anywhere and at any time.

"Don't make so much fuss," he used to say to her irritably. "For heaven's sake, let me alone." This merely produced more quarrels, for Angela was determined to regulate him in spite of his wishes and in his best interests.

Grave men and women in various walks of life—art, literature, philanthropy, trade—began to seek him out, because in the first place he had an understanding mind and because in the next place, which was much more important, he had something to give. There are always those in all walks of life who are seeking something which a successful person represents—whatever that may be, and these, together with those who are intensely eager to bask in the reflected glory of a rising luminary, make a retinue for every successful man. Eugene had his retinue, men and women of his own station or beneath it who would eagerly shake his hand with an "Oh, yes, indeed. Managing Publisher of the United Magazines Corporation! Oh, yes! yes!" Women, particularly, were prone to smile, showing him even white teeth, and regret that all good looking and successful men were married. He was introduced by Colfax and his wife to scores of people they knew in the financial and social worlds, and to a certain extent Angela shared in this. His assistants were always bringing him celebrities who happened to be visiting the building for one purpose and another.

In July, following his coming from Philadelphia, the United Magazines Corporation moved into its new building and then he was installed into the most distinguished office of his career. A subtle assistant wishing to ingratiate the staff in Eugene's good graces suggested that a collection be taken up for flowers. His room, which was done in white, blue, and gold with rosewood furniture to set it apart from the prevailing decorative scheme and so make it more impressive, was scattered with great bouquets of roses, sweet peas, and pinks in beautiful and ornate vases of different qualities, countries, colors, and schools. His great rosewood flat-top desk, covered with a thick plate of leveled glass through which the polished wood shone beautifully, was decorated with flowers. On the morning of his entry he held an impromptu reception, on which occasion he was visited by Colfax and White after going to look at their new rooms. A general reception which followed some three weeks later, and in which the successful representatives of various walks of life in the metropolis took part, drew to the building a great crowd—artists, writers, editors, publishers, authors, and advertising men who saw him in all his glory. On this occasion Eugene, with White and Colfax, did the receiving. He was admired at a distance by striplings who wondered how he had ever accomplished such great results. His rise had

been so meteoric. It seemed so impossible that a man who had started out to be an artist should change so and become a dominant fact in literature and art from a publishing point of view.

In his own home he was equally distinguished—equally as much of a figure as he was now in his office. When he was alone now with Angela, which was not so often, for naturally they did a great deal of entertaining, he was, as has been said, a figure even to her. Long ago she had come to think of him as someone who would some day dominate in the art world; but to see him an imposing factor in the city's commercial life—its principal publisher's representative—having a valet and automobile, riding freely in cabs, lunching at the most exclusive restaurants and clubs, and associating constantly with someone who was of importance, was a different matter. Think what she would of art, the new giant building with Eugene's office so imposingly arranged and this beautiful apartment so richly and delightfully decorated overawed her and made her respect the power of money and the force of her husband. She was no longer so sure of herself with him—not so certain of her power to control him. They quarreled over little things but she was not so ready to begin these disagreements. He seemed stronger now, and deeper. Still she was afraid, even yet, that he might make a mistake and lose it all—that the forces of ill will, envy, and jealousy which were everywhere apparent in life and which blow about so easily like gusts of wind would work him harm—but he was apparently at ease.

He trembled at times for his own safety, when he thought of it, for he had no stock in this company and was as beholden to Colfax as any hall boy, but he did not see how he could easily be dispensed with. He was *making good*. Colfax was friendly to him. He was surprised at times to see how badly the manufacturing arrangements could go awry, affecting his dates of issue, but White invariably had a good excuse. Colfax took him to his house in the country, his lodge in the mountains, on short yachting and fishing trips, for he liked to talk to him, but he rarely if ever invited Angela. He did not seem to think it was necessary to do this and Eugene was afraid to impress the slight upon his attention, much as he dreaded the thoughts which Angela must be thinking. It was Eugene here and Eugene there, with constant calls of, "Where are you, old man?" from Colfax, who appeared not to want to be away from him. He reminded Eugene somewhat of Summerfield in this respect—he was so insistent, so excitable, so persistent in his comments on life and in his dogmatic attitude. Eugene finally began to weary of him but he could not say anything for Colfax was his superior, the creator of his fortune, and he had to endure it. At the same time it was rather a distinguished thing to have Colfax so taken with him.

"Well, old man," he would say, looking him over much as one might a

blooded horse or a fancy dog, "you're getting on. This new job agrees with you. You didn't look like that when you came to me," and he would feel the latest suit Eugene might be wearing or comment on some pin or tie he had on or tell him that his shoes were not as good as he could get if he wanted to be really perfect in dress. Colfax was for grooming his new prize much as one might groom a blooded horse, and he was always telling Eugene little details of social life—the right things to do, the right places to be seen, the right places to go—as though Eugene knew little or nothing.

"Now when we go down to Mrs. Davage's Friday afternoon, you get a Truxton portmanteau. Have you seen them? Well, they're the thing. Got a London coat? Well, you ought to have one. Those servants down there go through your things and they size you up accordingly. Nothing less than two dollars each goes, and five dollars to the butler—remember that."

He assumed an insistent, dogmatic attitude which Eugene resented quite as much as he did his persistent ignoring of Angela, but he did not dare comment on it for fear of him. He could see that Colfax was variable, that he could hate as well as love, and that he rarely took any intermediate ground. Eugene was his favorite boy now and he wanted him with him all the time.

"I'll send my car around for you at two Friday," he would say, as though Eugene did not have a car, when he was planning one of his weekend excursions. "You be ready."

At two on that day, Colfax's big blue touring car would come speeding up to the entrance of the apartment house, and Eugene's valet would carry down his bags, golf sticks, tennis racket, and the various paraphernalia that makes a weekend's entertainment, and off the car would roll. At times Angela would be left behind—at other times taken when Eugene could arrange it—but he found that he had to be tactful and accede to this indifference. Eugene would always explain to her how it was. He was sorry for her in a way and yet he felt there was some force or truth in the distinction. She was not exactly suited to that topmost world in which he was now beginning to move. These people were colder, sharper, shrewder than Angela, he thought. They had more of that intense sophistication of manner and experience than she could achieve. As a matter of fact, Angela had as much grace and more than many of those who flourished as representatives of the four hundred but she did lack that quickness of wit or that shallow self sufficiency and assurance which is the almost invariable concomitant of those who shine as members of the smart set. Eugene was able to assume this manner whether he felt it or not.

"Oh, that's all right," she would say, "as long as you're doing it for business reasons."

She resented it nevertheless, bitterly, for it seemed such an uncalled for slur. Colfax had no compunction in adjusting his companionship to suit his moods. He thought Eugene was well suited to this high life. He thought Angela was not. He made the distinction roughly and went his way.

It was in this manner that Eugene learned a curious fact about the social world, and that was that frequently in the highest circles a man would be received where his wife would not and vice versa, and that nothing very much was thought of it, if it could be managed. He had heard comments in times past in Philadelphia which led him to believe this—and later in New York it was clearly demonstrated to him.

"Oh, is that Birkwood?" he heard a young swell once remark, concerning an individual in Philadelphia. "Why do they let him in? His wife is charming but he won't do."

Once in New York he heard a daughter ask a mother, of a certain wife who was announced—and her husband was then at the table—"who invited her?"

"I'm sure I don't know," replied her mother. "I didn't. She must have come of her own accord."

"She certainly has her nerve with her," replied the daughter and when the wife entered Eugene could see why. She was not good looking and not harmoniously and tastefully dressed. It gave Eugene a shock but in a way he could understand. There were no such grounds of complaint against Angela. She was attractive and shapely. Her one weakness was that she lacked the blasé social air. It was too bad, he thought.

In his own home and circle, however, he thought to make up for this by a series of entertainments which grew more and more significant as time went on. At first when he came back from Philadelphia these entertainments consisted of a few people in to dinner—old friends, for he was not quite sure of himself and did not know how many would come to share his new distinction with him. Eugene had never gotten over his love for those he had known in his youth. He was not snobbish. It was true that now he was taking naturally to big people, but the little ones, the old time ones, he liked for auld lang syne's sake as well as for themselves. You would have been surprised to see how friends of five, ten, fifteen, and even twenty years' standing looked him up and how joyously he received them. No one came to borrow money for he had never associated with that kind but many were attracted by his fame. He came to have a distinguished and easy air with celebrities, the greater the easier, so much so that people remarked it.

"He makes you feel so much at home," said Sir Thomas Wood, a famous English physicist, who was brought to the office by the editor of the *Review*. "Quite a charming personality. Very able, I should judge."

"He is remarkable considering his age," observed the editor, almost as a necessary tribute. "The management here thinks quite highly of him. He has done so well with the various publications."

"I should judge so! I should judge so! A very interesting young man."

Eugene knew intimately and pleasantly such men as William Dean Howells, Mark Twain, Prof. William James, Sir A. Conan Doyle, and other interesting figures of his time.

In his own home there appeared at his table such old friends and acquaintances as Mitchell Goldfarb, now one of the able Sunday editors of New York; William McConnell and Judson Cole of his student days; Jerry Mathews, now a noted cartoonist; Philip Shotmeyer, Hudson Dula, Richard Wheeler, Joseph Smite, Louis Deesa, Russell Dexter, Leonard Baker, Peter McHugh, and Luke Severas, all representative of his early struggles. Later, as he grew more secure in his position, such men as M. Anatole Charles, Isaac Wertheim, Henry McKenna, Robert C. Winchom, and great artists, publishers, grand opera stars, actors, actresses, and playwrights gathered about him in friendly understanding. His large salary, for one thing—still only $18,000 a year, however—his beautiful apartment and its location, his magnificent office and his friendly manner, all conspired to assist him. It was his self-conscious boast that he had not changed. He liked nice people, simple people, natural people, he said, these were the really great ones, but he could not see how far he had come in class selection. Now he naturally gravitated to the wealthy, the distinguished, the beautiful, the strong and able, for no others interested him. He hardly saw them. If he did, it was to pity or give alms.

He rode in cabs, autos, had suitable clothes for every occasion, changed his linen at the slightest speck, and threw good shoes, hats, gloves, ties, suits, and other articles of his daily apparel into the limbo of disuse at the slightest sign of wear. Silk gloves, silk hose, silk underwear, the softest and choicest fabrics, were his selection at every turn. He wanted elegance only, for he was beginning to understand elegance and why people would pay almost any price for perfection. Years before it had seemed almost insane. Now it seemed natural enough. One hundred and fifty dollars for a suit of clothes, fourteen dollars for a silk muffler, sixteen dollars for a pair of shoes—as against sixteen, one-fifty and three in his early youth—were now natural enough. Elegance, luxury, taste, perfection of fit and harmony—these meant everything or nearly so to him now, and he was anxious to have them.

It is difficult to indicate to those who have never come out of poverty into luxury or out of comparative uncouthness into refinement, the veil or spell which the latter comes eventually to cast over the mind, coloring the world anew. Life is apparently striving, constantly, to perfect its illusions

and to create spells. There are, as a matter of fact, nothing but these, out-side of that ultimate substance or principle which underlies it all. To those who have come out of inharmony, harmony is a spell and to those who have come out of poverty, luxury is as a dream of delight. Eugene, being princi-pally a lover of beauty, keenly responsive to all those subtleties of perfec-tion and arrangement which mortal mind can devise, was taken vastly by the nature of this greater world into which, step by step apparently, he was almost insensibly passing. Each new fact which met his eye or soothed his sensibilities was quickly correlated to all that had gone before. It seemed to him as though all his life he had naturally—by temperament—belonged to this perfect world of country houses, city mansions, city and country clubs, notable hotels and inns, cars, resorts, beautiful women, refined manners, subtlety of appreciation and perfection of appointment generally. This was the true heaven—the material and spiritual perfection on earth of which the world was dreaming—and to which out of toil, disorder, shabby ideas, mixed opinions, non-understanding, and all the ills to which the flesh is heir, it was constantly aspiring. Here was no sickness, no weariness appar-ently, no ill health or untoward circumstance. All the troubles, disorders, and imperfections of existence were here carefully swept aside and one saw only niceness, health, and strength of being.

Eugene was more and more impressed, as he came farther and farther along in the scale of comfort, with the force and eagerness with which life seems to minister to the refinements of the human mind. He learned of so many, to him, lovely things—large, well kept, magnificent country places, beautiful and expensive rural inns, scenes of exquisite beauty where country clubs, hotels, seaside resorts of all descriptions had been placed. He found sport, amusement, exercise were tremendously well organized and that there were thousands of people who were practically devoting their lives to them. Such a state of social ease was not for him yet, but he could sip at the plea-sures so amply spread, between his hours of work, and dream of the time to come when possibly he might do nothing at all. Yachting, motoring, golfing, fishing, hunting, riding, playing at tennis and at polo—there were experts in all of these fields. Card playing, dancing, dining, lounging—these seemed to occupy many people's days constantly. He could only look in upon it all as upon a passing show, but that was better than nothing. It was more than he had ever done before. He was beginning to see clearly how the world was organized; how far were its reaches of wealth, its depths of poverty. From the lowest beggar to the topmost scene—what a distance. Dives and Lazarus surely brought close together in one little world, the one at his table, the other looking vainly upward for alms.

Angela scarcely kept pace with Eugene in all these mental peregrina-

tions. It was true that now she went to the best dressmakers only, bought charming hats, the most expensive shoes, or had them made, and rode in cabs and her husband's auto, but she did not feel about it as he did. It seemed very much like a dream to her—like something which had come so suddenly and so ornately that it could not be permanent. There was running in her mind all the time the thought that Eugene was neither a publisher nor an editor nor a financier at heart but an artist, and that an artist he would remain. He might attain great fame and make much money out of his adopted profession, but someday, in all likelihood, he would leave it and return to art. He seemed to be making sound investments—at least they seemed sound to her, and their stocks and bank accounts, principally convertible stocks, seemed a safe enough margin for the future to guarantee peace of mind, but they were not saving so much after all. It was costing them something over eight thousand dollars a year to live and their expenses were constantly growing larger rather than smaller. Eugene appeared to be growing more and more extravagant.

"I think we are doing too much entertaining," Angela had once protested, but he waved the complaint aside.

"I can't do what I'm doing and not entertain. It's building me up. People in our position have to."

He threw open the doors finally to really notable crowds and most of the cleverest people in all walks of life—the really exceptionally clever—came to eat his meals, to drink his wines, to envy his comfort and wish that they were in his shoes. Most of them pretended not to understand it, but they enjoyed themselves just the same.

During all this time Eugene and Angela, instead of growing closer together, were really growing farther and farther apart. She had never either forgotten or utterly forgiven that one terrific lapse and she had never believed that Eugene was utterly cured of his hedonistic tendencies. Crowds of beautiful women came to Angela's teas, lunches, and their joint joyous evening parties and receptions. They got up together, under Eugene's direction, interesting programmes, for it was no trouble now for him to command musical, theatrical, literary, and artistic talent. He knew men and women who could make rapid charcoal or crayon sketches of people, could do feats in legerdemain and character representation, could sing, dance, play, recite, and tell humorous stories in a droll and offhand way. He insisted that only exceptionally beautiful women be invited, for he did not care to look at the homely ones, and curiously, he found dozens who were not only extremely beautiful but singers, dancers, composers, authors, actors and playwrights in the bargain. Nearly all of them were brilliant conversationalists and they helped to entertain themselves—made their own entertainment, in fact. His table very frequently was a glittering spectacle.

One of his "stunts," as he called it, was to bundle a large party of fifteen or twenty people into three or four automobiles after they had lingered in his rooms until three o'clock in the morning and motor out to some out-of-town inn for breakfast and "to see the sun rise." A small matter like a bill for seventy-five dollars, or thirty-five dollars for a crowd for breakfast, did not trouble him. It was a glorious sensation to go down into his pocket, draw forth his purse, and remove four or five or six yellow backed ten dollar bills, knowing that it made little real difference. More money was coming to him from where this came. He could send down to the cashier at any time and draw from five hundred to a thousand dollars. He always had from one hundred and fifty to three hundred dollars in his purse in denominations of five, ten, and twenty dollar bills. He carried a small check book in the bargain, and not infrequently wrote out a check. For the first time in his life he was feeling free, easy, natural, not cribbed, cabined, or confined. The world was beginning to look beautiful to him, its rewards proportionate to his ability. By degrees he was beginning to forget that he had ever been poor. The scars were nearly all healed over.

"Eugene Witla! Eugene Witla! George! He's a nice fellow"; or, "It's remarkable how he has come up, isn't it?"; or, "I was to the Witlas' the other night. Did you ever see such a beautiful apartment? It's perfect! That view!"

People commented on the interesting people he entertained, the clever people you met there, the beautiful women, the beautiful view.

"And Mrs. Witla is so charming."

But down at the bottom of all this talk there was some envy and disparagement, and never so much enthusiasm for the personality of Mrs. Witla. She was not as brilliant as Eugene—or rather the comment was divided. Those who liked clever people, show, wit, brilliance, ease, liked Eugene and not Angela quite so much. Those who liked sedateness, solidity, sincerity, the commoner virtues of faithfulness and effort, admired Angela. All saw that she was a faithful handmaiden to her husband, that she adored the ground he walked on, or appeared to.

"Such a nice little woman—so homelike. It's curious that he should have married her though, isn't it? They are so different. And yet they appear to have lots of things in common too. It's strange—isn't it?"

CHAPTER LXXVII

It was in the course of his final upward progress that Eugene came once more into contact with Kenyon C. Winfield, ex-state senator of New York, President of the Long Island Realty Company, land developer, real etate

plunger, financier, artist, whatnot—a man very much of Eugene's own type and temperament, who at this time was doing rather remarkable things in a land speculative way. Winfield was tall and thin, black haired, black eyed, slightly but not offensively hook nosed, dignified, gracious, intellectual, magnetic, optimistic. He was forty-eight years of age. Winfield was a very fair sample of your man of the world who has ideas, dreams, fancies, executive ability, a certain amount of reserve, and judgement sufficient to hold his own in this very complicated mortal struggle. He was not really a great man in the last analysis of the word but he was so near it that he gave the impression to many of being so. His deep-sunken black eyes burned with a peculiar lustre—one might almost have fancied a tint of red in them. His pale, slightly sunken-cheeked face had some of the characteristics of your polished Mephisto, though not too many. He was not at all devilish looking in the true sense of that word, but keen, subtle, artistic. His method was to ingratiate himself with men who had money, in order to have them loan him the vast sums which he found it necessary to borrow so as to carry out the schemes or rather dreams he was constantly generating. His fancies were always too big for his purse, but he had such lovely fancies that it was a joy to work with them and him.

Primarily Winfield was a real estate speculator but secondarily he was a dreamer of dreams and seer of visions. His visions consisted of lovely country suburbs studded with charming country homes, cut up with well paved, tree shaded roads, provided with sewers, gas, electricity, suitable railway service, street cars, and all the comforts of a well organized living district which should be at once retired, exclusive, pleasing, conservative, and yet bound up tightly with the great metropolitan heart of New York which he so greatly admired. Winfield had been born and raised in Brooklyn. He had been a politician, orator, insurance dealer, contractor, and so on, until the world had taught him that great schemes were most profitable where natural wisdom and magnetism naturally drew talent to you. He had succeeded in organizing various suburban schemes—Winfield, Sunnyside, Ruritania, The Beeches—little forty, fifty, one hundred, and two hundred acre plots which, with the help of "O.P.M." as he always called other people's money, he had succeeded into dividing up into blocks, laying out charmingly with trees and sometimes a strip of green grass running down the centre, nice sidewalks, a set of noble restrictions, and so forth. Anyone who ever came to look at a lot in one of Winfield's perfect suburbs always found the choicest piece of property in the centre of the burst of improvements set aside for the magnificent house which Mr. Kenyon C. Winfield, the president of the company, intended to build and live in. He had been around the world and seen a great many things and places but Winfield or Sunnyside or Ruri-

tania or The Beeches had been finally selected by him deliberately as the one spot in all the world in which he hoped to spend the remainder of his days. Here he would round out his much traveled existence, surrounded by these peaceful, home-loving commuters who should establish their homes here. Naturally this had a very comforting and reassuring effect on those who might be thinking that the property was nice—but——. Meanwhile, Kenyon C. was off in some other section of Long Island, planning some other improvement which in time, equally with the others, should become his last resting place.

At the time Eugene met Winfield, he was planning Minetta Water on the shores of Gravesend Bay, which was the most ambitious of all his projects so far. He was being followed financially by a certain number of Brooklyn politicians and financiers who had seen him succeed in small things—taking a profit out of ten, twenty, and thirty acre plots of from three to four hundred per cent—but it had been slow work for all his brilliance. He was now worth between three and four hundred thousand dollars and for the first time in his life was beginning to feel that freedom in financial matters which made him think that he could do most anything. He had met all sorts of people—lawyers, bankers, doctors, merchants, the "easy classes" he called them, all with a little money to invest, and he had succeeded in hornswaggling hundreds of worthwhile people into his projects. His great dreams had never really been realized, however, for he saw visions of a great warehouse and shipping system to be located on Jamaica Bay, out of which he was to make millions if it ever came to pass, and a magnificent summer resort of some kind, somewhere, which was not yet clearly evolved in his mind. His ads were scattered freely through the newspapers. His signs, or rather the signs of his towns, were scattered broadcast over Long Island. He had worked long and enthusiastically, for he liked real estate improvements, but he had learned that humanity as a whole was a grimy proposition to deal with and that people were not as anxious to be beautifully surrounded as one might, at first blush, imagine.

Eugene had met Winfield first when he was working with the Summerfield Company, but he met him this time quite anew at the home of the W. W. Willebrands on the North Shore of Long Island, near Hempstead. He had gone down there one Saturday afternoon at the invitation of Mrs. Willebrand, whom he had met at another house party and with whom he had danced. She had been pleased with his gay, vivacious manner and had asked him then if he wouldn't come. Winfield was here as a guest—he was a widower—and Eugene had the pleasure of renewing their acquaintance.

"Oh, yes," said Winfield, pleasantly. "I recall you very well. You are now with the United Magazines Corporation, I understand—someone was telling

me—a most imposing company. I know Mr. Colfax very well. I once spoke to Summerfield about you. A most astonishing fellow, that—tremendously able. You were doing that series of sugar plantation ads for them, or having them done, I think. I copied the spirit of those things in advertising Ruritania, as you may have noticed. Well, you certainly have improved your condition since then. I once tried to tell Summerfield that he had an exceptional man in you but he would have nothing of it. He's too much of an individualist. He doesn't know how to work with men on equal terms."

Eugene smiled at the thought of Summerfield. He could see him now bustling about, turning the force of his revivifying energy into all dark and slow places.

"An able man," he said simply. "He did a great deal for me."

Winfield liked that. He thought Eugene would criticize him. He liked Eugene's genial manner and intelligent, expressive face. It came back to him that it had occurred to him that when he wanted to advertise one of his big development projects he intended to go to Eugene, or to the man who had done the sugar plantation series of pictures, and get him to give him the right idea for advertising.

Affinity is such a peculiar thing. It draws people so easily, outside of their volition or consciousness.

In a few moments Eugene and Winfield, sitting side by side on this morning veranda, looking at the greensward before them, the long stretch of open sound dotted with white sails, and the dim, distant shore of Connecticut, were talking of real estate ventures in general, what land was worth, how speculations of this kind turned out as a rule. Winfield was anxious to take Eugene seriously for he felt drawn to him, and Eugene studied Winfield's pale face, his thin, immaculate hands, his suit of soft, imported gray cloth. He looked as able as his public reputation made him out to be—in fact he looked better than anything he had ever done. Eugene had seen Ruritania and The Beeches. They did not impress him vastly as territorial improvements but they were pretty nevertheless. For middle class people they were quite the thing, he thought.

"I should think that it would be a pleasure to you to scheme out a new section," Eugene said to him at one time. "The idea of a virgin piece of land to be done over into streets and houses or a village scheme appeals to me immensely. The idea of laying it out and sketching houses to fit certain locations suits my temperament exactly. I wish sometimes I had been born an architect."

"It is pleasant and if that were all that there were to it, it would be ideal," returned Winfield. "The thing is more a matter of financing than anything else. You have to raise money for land and improvements. If you make exceptional improvements, they are expensive. You really can't expect to

get much, if any, of your money back until your work is done. Then you have to wait. If you put up houses you can't rent them, for the moment you rent them you can't sell them as new. When you make your improvements, your taxes go up immediately. If you sell a piece of property to a man or woman who isn't exactly in accord with your scheme, he or she may put up a house which destroys the value of a whole neighborhood for you. You can't fix the details of a design in a contract too closely—you can only specify the minimum price the house is to cost and the nature of the materials to be used. Some people's idea of beauty will vary vastly from that of others. Taste in sections may change. A whole city like New York may suddenly decide that it wants to build west when you are figuring on its building east. So—well, all these things have to be taken into consideration."

"That sounds logical enough," said Eugene, "but wouldn't the right sort of scheme just naturally draw to itself the right sort of people if it is presented in the right way? Don't you fix the conditions by your own attitude?"

"You do, you do," replied Winfield, easily. "If you can give the matter sufficient care and attention, it can be done. The thing is, you can be too fine at times. I have seen attempts at perfection come to nothing. People with taste and tradition and money behind them are not moving into new additions and suburbs as a rule. You are dealing with the new rich and financial beginners. Most people strain their resources to the breaking point to better their living conditions and they don't always know. If they have the money it doesn't always follow that they have the taste to grasp what you are striving for, and if they have the taste they haven't the money. They would do better if they could, but they can't. You are like an artist and a teacher and a father confessor and a financier and everything all rolled into one when you start to be a real estate developer on a big scale. I have had some successes and some notable failures. Winfield is one of the worst. It's disgusting to me now. I've been trying to get them to change the name. Still, if you can do anything at all it's a source of satisfaction, and there is some pleasure in scheming the thing out."

"I have always wished that I could lay out a seaside resort or a suburb," said Eugene dreamily. "I've never been to but one or two of the resorts abroad but it strikes me that none of the resorts here—certainly none near New York—are right. The opportunities, it strikes me, are so wonderful. The things that have been done are horrible. There is no plan, no detail anywhere. It's all haphazard building and patchwork."

"My views exactly," said Winfield. "I've been thinking of it for years. Some such place could be built and I suppose if it were done right it would be successful. It would be expensive though, very, and those who came in would have a long wait for their money."

"It would be a great opportunity to do something really worthwhile,

though," said Eugene. "No one seems to realize how beautiful a thing like that could be made."

Winfield said nothing but the thought stuck in his mind. He was dreaming a seaside improvement which should be the most perfect thing of its kind in the world—a monument to himself if he did it. If Eugene had this idea of beauty he might help. At least he might talk to him about it when the time came. Perhaps Eugene might have a little money to invest. It would take millions to put such a scheme through, but every little bit would help. Besides, Eugene might have ideas which would make money for himself and for Winfield. It was worth thinking about. So they parted, not to meet again for weeks and months, but they did not forget each other. All Winfield's real estate dreams stuck in Eugene's mind, and Eugene's artistic and apparent financial ability remained with Winfield.

In the meantime another meeting took place between himself and a certain Mrs. Emily Dale, who was to interest him greatly in various ways. Mrs. Dale was a strikingly beautiful and intelligent widow of thirty-eight, the daughter of a well-to-do and somewhat famous New York family of Dutch extraction—the widow of an eminent banker of considerable wealth who had been killed in an automobile accident near Paris some four years before. She was the mother of four children—Suzanne, eighteen; Kinroy, fifteen; Adele, twelve; and Ninette, nine—but the size of her family in no way affected the subtlety of her social personality and the delicacy of her charm and manner. She was tall, graceful, willowy, with a wealth of dark hair which was used in the most subtle manner to adorn the beauty of her face. She was calm, placid, apparently, while really running deep with emotion and fancies, with manners which were the perfection of kindly courtesy and good breeding and with those airs of superiority which come so naturally to those who are raised in a reserved, exclusive atmosphere. She did not consider herself passionate in a notable way but freely admitted to herself that she was vain and coquettish. She was keen and observing, with an eye single to the main chance socially but with a genuine love for literature and art and a propensity to write. Eugene met her through Colfax, who introduced him to her in the house of a third party. He learned from Colfax that she was rather unfortunate in her marriage except from a money point of view and that her husband's death was no irreparable loss. He also learned from the same source that she was a good mother, trying to bring up her children in the manner most suitable to their station and opportunities. Her husband had been of a much poorer social origin than herself but her own standing was of the very best. She was a gay social figure, being invited much, entertaining freely, preferring the company of younger men to those of her own age or older, and being followed ardently by one fortune hunter

and another, who saw in her beauty, wealth, and station an easy door to the heaven of social supremacy. Mrs. Dale was very wary, however, half-satis-fied that her day was over, not anxious to complicate her present social and financial peace with anything so disturbing as a husband.

The Dale home, or homes rather, were located in several different places—one at Morristown, New Jersey, another on fashionable Grymes Hill on Staten Island, a third, a city residence which at the time Eugene met them was leased for a term of years was in Sixty-seventh Street, near Fifth Avenue in New York City, and a fourth, a small lodge, at Lenox, Mas-sachusetts, which was also rented. Shortly after he met her the house at Morristown was closed and the lodge at Lenox reoccupied.

For the most part Mrs. Dale preferred to dwell in her ancestral home on Staten Island, which because of its commanding position on what was known as Grimes Hill, controlled a magnificent view of the bay and harbor of New York. Manhattan—its lower wall of buildings lay like a cloud at the north. The rocking floor of the sea, blue and gray and slate black by turns, spread to the east. In the west were visible the Kill von Kull with its mass of shipping, and the Orange Hills. In a boat club at Tompkinsville she had her motor boat, used mostly by her boy; in her garage at Grimes Hill, several automobiles. She owned several riding horses, retained four family servants permanently, and in other ways possessed all those niceties of appointment which make up the comfortable life of wealth and ease.

The two youngest of her girls were in a fashionable boarding school at Tarrytown; the boy, Kinroy, was preparing for Harvard; Suzanne, the eldest, was at home, fresh from boarding school experiences, beginning to go out socially. Her debut had already been made. She was a peculiar girl, plump, beautiful, moody, with at times a dreamy air of indifference and a smile that ran like a breath of air over water. Her eyes were large, of a vague blue-gray, her lips rosy and arched, her cheeks full and pink. She had a crown of light chestnut hair, a body at once innocent and voluptuous in its outlines. When she laughed it was a rippling gurgle and her sense of humor was perfect, if not exaggerated. She was one of these naturally wise but as yet vague and formless artistic types, which suspects, without education, nearly all the subtleties of the world, and burst forth full winged and beautiful but oh so fragile, like a butterfly from its chrysalis, the radiance of the morning upon its body. Eugene did not see her for a long time after he met Mrs. Dale but when he did, he was greatly impressed with her beauty.

His friendship with Mrs. Dale, as has been said, began at a house party on Long Island one Saturday afternoon. She was introduced to him by Colfax and because of the latter's brusque, jesting spirit, was under no illusions as to his social state.

"You needn't look at him closely," he observed gaily, "he's married."

"That simply makes him all the more interesting," she rippled, and extended her hand.

Eugene took it. "I'm glad a poor married man can find shelter some-where," he said, smartly.

"You should rejoice," she replied. "It's at once your liberty and your pro-tection. Think how safe you are!"

"I know, I know," he said. "All the slings and arrows of Miss Fortune hurtling by."

"And you in no danger of being hurtled."

"Yes, yes," he exclaimed, taking the cue.

He offered her his arm and they strolled through a window onto a veranda.

The day was just the least bit dull for Mrs. Dale. Whist was in progress in the card room, a company of women and girls gambling feverishly. Eugene was not good at whist—not quick enough mentally—and Mrs. Dale did not care so much for it. Her interests were more speculative, literary, studious of character.

"I have been trying to stir up enough interest to bring to pass a motor ride, but it doesn't work," she said. "They all have the gambling fever today. Are you as greedy as the others?"

"I'm greedy, I assure you, but I can't play. The greediest thing I can do is to stay away from the tables. I save most. That sharp Faraday has cleaned me and two others out of four hundred dollars. It's astonishing the way some people can play. They just look at the cards or make mystic signs and the wretched things range themselves in serried ranks to suit them. It's a crime. It ought to be a penitentiary offense—particularly to beat me. I'm such an inoffensive specimen of the non-bridge playing family."

"A burnt child, you know. Stay away. Let's sit here. They can't come out here and rob you."

They sat down in green stained willow chairs and after a time a servant offered them coffee. Mrs. Dale accepted. They drifted conversationally from bridge to characters in society—a certain climber by the name of Bristol, a man who had made a fortune in trunks, and from trunks to travel, and from travel to Mrs. Dale's experience with fortune hunters. The automobile materialized through the intervention of others, but Eugene found great sat-isfaction in this woman's company and sat beside her. They talked books, art, magazines, the making of fortunes and reputations. Because he was or seemed to be in a position to assist her in a literary way she was particularly nice to him. When he was leaving her she asked, "Where are you in New York?"

"Riverside Drive is our present abode," he said.

"Why don't you bring Mrs. Witla and come down to see us some weekend. I usually have a few people there and the room is ample. I'll name you a special day if you wish."

"Do. We'll be delighted. Mrs. Witla will enjoy it, I'm sure."

Mrs. Dale wrote Angela ten days later concerning a particular date and in this way the social intimacy began.

This intimacy, however, was never of a very definite character. When Mrs. Dale met Angela she liked her quite well as an individual, whatever she may have thought of her as a social figure. Neither Eugene nor Angela saw Suzanne nor any of the other children on this occasion, all being away. Eugene admired the view tremendously and hinted at being invited again. Mrs. Dale was delighted. She liked him as a man of genius, obviously someone who was going to succeed greatly, and particularly because of his publishing position. She was ambitious to write. Others had told her that he was the most conspicuous of the rising figures in the publishing world. Being friendly with him would give her, she thought, exceptional standing with all his editors. She was only too pleased to be gracious to him. He was invited again, and a third time with Angela, and it seemed as though they were reaching, or might at least, something much more definite than a mere social acquaintance. She liked him. He was so very gracious, witty, good-natured.

It was about six months after Eugene had first met Mrs. Dale that Angela gave a tea and Eugene, in assisting her to prepare the list of invitations, had suggested that those who were to serve the tea and cakes should be two exceptionally pretty girls who were accustomed to come to the Witla apartment—Florence Reel, the daughter of a well known author of that name, and Marjorie MacLennan, the daughter of a well known editor, both beautiful and talented, one with singing and the other with art ambitions. Angela had seen a picture of Suzanne Dale in her mother's room at Dalewood on Grimes Hill, and had been particularly taken with her girlish charm and beauty.

"I wonder," she said, "if Mrs. Dale would object to having Suzanne come and help serve that day. She would like it, I'm sure, there are going to be so many clever people here. We haven't seen her, but that doesn't matter. It would be a nice way to introduce herself."

"That's a good idea, I should say," observed Eugene judicially. He had seen the photo of Suzanne and liked it, though he was not over-impressed. Photos to him were usually the worst of deceivers. He looked at them always with notable reservations. Angela forthwith wrote Mrs. Dale, who replied to be sure she would be glad to come herself. She had seen the Witla apart-

ment and had been very much impressed with it. The reception day came and Angela begged Eugene to come home early.

"I know you don't like to be alone with a whole roomful of people, but Mr. Goodrich is coming, and Frederick Allen" (one of the social figures who had taken a fancy to Eugene). "Arturo Scalchero is going to sing and Bonavita to play." Scalchero was none other than Arthur Skalger of Port Jarvis, New Jersey, but he assumed this corruption of his name in Italy to help him to success. Bonavita was truly a Spanish pianist of distinction who was flattered to be invited to Eugene's home.

"Well, I don't care much about it," replied Eugene, "but I will come."

He frequently felt that afternoon teas and receptions were ridiculous affairs and that he had far better be in his office attending to his multitudinous duties. Still, he did leave early, and at five-thirty was ushered into a great room full of chattering, gesticulating, laughing people. A song by Florence Reel had just been concluded. Like all girls of ambition, vivacity, and imagination, she took an interest in Eugene, for in his smiling face she found a responsive gleam.

"Oh, Mr. Witla," she exclaimed. "Now here you are and you just missed my song. And I wanted you to hear it, too."

"Don't grieve, Florrie," he said familiarly, holding her hand and looking momentarily in her eyes. "You're going to sing it again for me. I heard part of it as I came up on the elevator." He relinquished her hand. "Why Mrs. Dale! Delighted, I'm sure. So nice of you. And Arturo Scalchero—hello Skalger, you old frost. Where'd you get the Italian name? Bonavita! Fine! Do I get to hear you play? All over? My loss. Marjorie MacLennan! Gee, but you look sweet! If Mrs. Witla weren't watching me, I'd kiss you. Ooh! The pretty bonnet! And Frederick Allen! My word! What are you trying to grab off, Allen? I'm on to you. No bluffs! Nix! Nix! Why Mrs. Schenck—delighted. Angela, why didn't you tell me Mrs. Schenck was coming? I'd have been home at three——"

By this time he had reached the east end of the great studio room, farthest from the river. In one corner was the great cross, illuminated by its immense candle. To the south of it was a tea table with a silver service and behind it a girl, oval faced, radiantly healthy, her full lips parted in a ripe smile, her blue-gray eyes talking pleasure and satisfaction, her forehead laid about by a silver filigree band, beneath which her brown chestnut curls protruded. Her hands, Eugene noted, were plump and fair. She stood erect, fulsome, assured, with the least touch of a quizzical light in her eye. A white, pink-bordered dress draped her girlish figure.

"I don't know," he said easily, "but I wager a guess that this is—this is—this is Suzanne Dale—what?"

"Gee, this is me," she replied laughingly. "Can I give you a cup of tea, Mr. Witla? I know you are Mr. Witla from mamá's description and the way in which you talk to everybody."

"And how do I talk to every body, may I ask, pleasum?"

"Oh, I can't tell you so easily. I mean, I can't find the words, you know. I know how it is, though. Familiarly, I suppose I mean. Will you have one lump or two?"

"Three, and thou pleasest. Didn't your mother tell me you sang or played?"

"Oh, you mustn't believe anything mamá says about me. She's apt to say anything. Tee! Hee! It makes me laugh" (she pronounced it laaf) "to think of my playing. My teacher says he would like to strike my knuckles. Oh, dear!" (She went off into a gale of giggles.) "And sing! Oh, dear! Oh dear! That is too good."

Eugene watched her pretty face intently. Her mouth and nose and eyes fascinated him. She was so sweet. He noted the configuration of her lips and cheeks and chin. The nose was delicate, beautifully formed, but not sensitive. The ears were small, the eyes large and wide set, the forehead naturally high, but so concealed by curls that it seemed low. She had a few freckles and a very small dimple in her chin.

"Now you mustn't laugh like that," he said mock solemnly. "It's very serious business, this laughing. In the first place it's against the rules of this apartment. No one is ever, ever, ever supposed to laugh here, particularly young ladies who pour tea. Tea, as Epictetus well says, involves the most serious conceptions of one's privileges and duties. It is the high born prerogative of tea servers to grin occasionally, but never, never, never, under any circumstances whatsoever———." Suzanne's lips were beginning to part ravishingly in anticipation of a burst of laughter.

"What's all the excitement, Witla?" asked Skalger, who drifted to his side. "Why this sudden cessation of progress?"

"Tea, my son, tea!" said Eugene. "Have a cup with me."

"I will."

"He's trying to tell me, Mr. Skalger, that I should never laaf. I must only grin." Her lips parted and she laughed joyously. Eugene laughed with her. He could not help it. "Mamá says I giggle all the time. I wouldn't do very well here, would I?"

She turned to Eugene again with big smiling eyes. He took their full beauty at a gulp.

"Exceptions, exceptions. I might make exceptions—one exception—but not more."

"Why one?" she asked archly.

"Oh, just to hear a natural laugh," he said a little plaintively. "Just to hear a real joyous laugh. Can you laugh joyously?"

She giggled again at this and he was about to tell her how joyously she did laugh, when Angela called him away to hear Florence Reel, who was going to sing again for his especial benefit. He parted from Miss Dale reluctantly, for she seemed some delicious figure as delicately colorful as Royal Dresden, as perfect in her moods as a spring evening, as soft, soulful, enticing as a strain of music heard through the night at a distance or over the water. He went over to where Florence Reel was standing, listening in a sympathetic, melancholy vein to a delightful rendition of "The Summer Winds Are Blowing, Blowing." All the while he could not help thinking of Suzanne—of letting his eyes stray in that direction. He talked to Mrs. Dale, to Henrietta Tenman, to Luke Severas, Mr. and Mrs. Dula, Paynter Stone, now a writer of special articles, and others, but he couldn't help longing to go back to her. How sweet she was. How very delightful. If he could only, once more in his life, have the love of a girl like that.

The guests began to depart. Angela and Eugene bustled about the farewells. Because of the duties of her daughter which endured to the last Mrs. Dale stayed, talking to Arthur Skalger. Eugene was in and out between the studio and the cloak room off the entry way. Now and then he caught glimpses of Suzanne demurely standing by her tea urn and samovar. Never in years had he seen anything so fresh and young as her body. She was like a new grown wet white lily pad in the spring. She seemed to have the texture of water chestnut and the lush, fat vegetables of the spring. Her eyes were as clear as water; her skin as radiant new ivory. There was no sign of weariness about her, nor any care, nor any thought of evil nor anything except health and happiness. "Such a face," he thought casually in passing. "She is as sweet as any girl could be. As radiant as light itself."

Incidentally the personality of Frieda Roth came back and—long before her—Stella Appleton.

Youth! youth! What in this world could be finer—more acceptable. Where would you find its equal? After all the dust of the streets and the spectacle of age and weariness—the crow's feet about people's eyes, the wrinkles in their necks, the make-believe of rouge and massage, and powder and cosmetics—to see real youth, not of the body but of the soul also—the eyes, the smile, the voice, the movements, all young. Why try to duplicate that miracle? Who could? Who ever had?

He went on shaking hands, bowing, smiling, laughing, jesting, making-believe himself, but all the while the miracle of the youth and beauty of Suzanne Dale was running in his mind.

"What are you thinking about, Eugene?" asked Angela, coming to the

window where he had drawn a rocking chair and was sitting, gazing out on the silver and lavender and gray of the river surface in the fading light. Some belated gulls were still flying about. Across the river, the great manufactory was sending up a spiral of black smoke from one of its tall chimneys. Lamps were beginning to twinkle in its hundred-windowed wall. A great siren cry broke from its whistle as six o'clock tolled from a neighboring clock tower. It was still late February, and cold.

"Oh, I was thinking of the beauty of this scene," he said warily.

Angela did not believe it. She was conscious of something but they never quarreled about what he was thinking anymore. They had come too far along in comfort and solidity. What was it, though, she wondered, that he was thinking about?

Suzanne Dale had no particular thoughts of him at all. She thought he was nice—pleasant, good looking. Mrs. Witla was quite nice and young.

"Mamá," she said, "did you look out the window at Mr. Witla's?"

"Yes, my dear!"

"Wasn't that a beautiful view?"

"Charming."

"I should think you might like to live on the drive sometime, Mamá."

"We may sometime."

Mrs. Dale fell to musing. Certainly Eugene was an attractive man, young, brilliant, able. What a mistake all the young men made, marrying so early. Here he was successful, introduced to society, attractive, the world really before him, and he was married to someone who, though a charming little woman, was not up to his possibilities.

"Oh well," she thought, "So goes the world. Why worry? Everyone must do the best they can."

Then she thought of a story she might write along this line and get Eugene to publish it in one of his magazines.

CHAPTER LXXVIII

It had been while he was first perfecting his understanding with Winfield as to what his relationship to the new Sea Island Construction Company was to be that Eugene had been dwelling more and more fondly upon the impression which Suzanne Dale had originally made upon him. It was six weeks before they met again and then it was on the occasion of a dance that Mrs. Dale was giving in honor of Suzanne to which Eugene and Angela were invited. Mrs. Dale admired Angela's sterling qualities as a wife, and while

there might be temperamental and social differences, she did not think they were sufficient to warrant any discrimination between them, at least not on her part. Angela was a good woman—not a society figure at all—but interesting in her way. Mrs. Dale was much more interested in Eugene because, in the first place, they were very much alike temperamentally, and the next place, because Eugene was a successful and brilliant person. She liked to see the easy manner in which he took life, the air with which he assumed that talent should naturally open all doors to him. He was not conscious apparently of any inferiority in anything but rather of a splendid superiority. She heard it from so many that he was rapidly rising in his publishing world and that he was interested in many things, the latest this project to create a magnificent summer resort. Winfield was a personal friend of hers. He had never attempted to sell her any property but he had once said that he might someday take her Staten Island holdings and divide them up into town lots. He had never done anything about this, for the tide of suburban travel was not in that direction. But she knew him as an able real-estate manipulator and he admired her as a charming society figure.

The evening in question, Eugene and Angela went down to Dalewood in their automobile. Eugene always admired this location for it gave him a sense of height and scope which was not easily attainable elsewhere about New York. It was still late winter and the night was cold but clear. The great house with its verandas encased in glass was brightly lit. There were a number of people there, men and women whom Eugene had met at various places, and quite a number of young people whom he did not know. Angela had to be introduced to a great many and Eugene felt that peculiar sensation which he so often felt, of a certain incongruity in his matrimonial standing. Angela was nice but to him she was not like these other women who carried themselves with such an air. There was a statuesqueness and a sufficiency about so many of them, to say nothing of their superb beauty and sophistication, which made him feel, when the contrast was forced upon him closely, that he had made a terrible mistake. Why had he been so silly as to have married? He could have told Angela frankly at that time that he would not, and all would have been well. He forgot how badly he had entangled himself emotionally at that time—but scenes like these made him dreadfully unhappy. Why his life, if he were single, would but now be beginning. As it was, socially, he was quite all over. He could never do this social whirl right—either with Angela with him or in the background. With him, she was not all the situation demanded. In the background, she was a living commentary on his own silly indifference to duty, or worse. Life had dealt with him badly, he thought—terribly.

As he walked around tonight he was glad to be free socially even for a

few minutes at a time. He was glad that first this person and that took the trouble to talk to Angela. It relieved him of the necessity of staying near her, for if he neglected her or she felt neglected by others she was apt to reproach him. He did not show her any attention! She would complain that he was conspicuous in his indifference. If others refused to talk to her, it was his place. He should. Eugene objected to this necessity with all his soul, but he did not see what he was to do about it. As she so often said, even if he had made a mistake in marrying her, it was his place to stick by her now that he had. A real man would.

One of the things that interested him was the number of beautiful young women. He was interested to see how full and complete mentally and physically so many girls appeared to be at eighteen. Why, in their taste, shrewdness, completeness, they were fit mates for a man of almost any period of years up to forty. Some of them looked so wonderful to him—so fresh and ruddy with the fires of ambition and desire burning briskly in their veins. Beautiful girls—real flowers, like roses, light and dark. And to think the love period was all over for him—completely over. It actually hurt him, so keen was his desire for youth and life once more—that wondrous experience of new love.

Suzanne came down with others after awhile from some room upstairs, and once more at the sight of her Eugene was impressed with her, to him, simple, natural, frank, good-natured attitude. Her light chestnut colored hair was tied with a wide band of light blue ribbon which matched her eyes and contrasted well with her complexion. Again her dress was some light filmy thing, the color of peach blossoms, girdled with ribbons, and hemmed with flowers like a wreath in some twining design. Soft white dancing sandals held her feet.

"Oh, Mr. Witla," she said gaily, holding out her smooth white arm on a level with her eyes and naturally drooping her hand in an artistic manner. Her red lips were parted, showing even white teeth, and arching themselves in a radiant smile. Her eyes were quite wide, as he remembered, with an innocent surprised look in them, which was wholly unconscious with her. If red wet roses could outrival a maiden in all her freshness, he thought he would like to see it. Nothing could equal the beauty of a young woman in her eighteenth or nineteenth year.

"Yes, quite Mr. Witla," he said, beaming. "I thought you had forgotten. My, we look charming this evening. We look like roses and cut flowers and stained glass windows and boxes of jewels, and, and, and——"

He pretended to be lost for words and looked quizzically up at the ceiling.

Suzanne began to laugh. Like Eugene, she had a notable sense of the

comic and the ridiculous. She was not in the least vain, and the idea of being like roses and boxes of jewels and stained glass windows tickled her fancy.

"Why that's quite a collection of things to be, isn't it?" she laughed, her lips parted. "I wouldn't mind being all those things if I could, particularly the jewels. Mamá won't give me any. I can't even get a broach for my throat."

"Mamá is real mean, apparently," said Eugene vigorously. "We'll have to talk to mamá, but she knows, you know, that you don't need any jewels, see. She knows that you have something which is just as good or better. But we won't talk about that, will we?"

Suzanne had been afraid that he was going to begin complimenting her but seeing how easily he avoided this course she liked him for it. She was a little overawed by his dignity and mental force, but attracted by his gayety and lightness of manner.

"Do you know, Mr. Witla," she said, "I believe you like to tease people."

"Oh, no!" said Eugene. "Oh, never! never! Nothing like that! How could I? Tease people! Far be it from me! That's the very last thing I ever think of doing. I always approach people in a very solemn manner and tell them the dark, sad truth. It's the only way. They need it. The more truth I tell the better I feel. And then they like me so much better for it. So many people just love me for telling the truth and the truth only."

At the first rush of this quizzical tirade, Suzanne's eyes opened quaintly, inquiringly. Then she began to smile and in a moment after he ceased she exclaimed, "Oh, ha! ha! Oh dear, oh dear, how you talk." A ripple of laughter spread outward and Eugene frowned darkly.

"How dare you laugh?" he said. "Don't you think it's rather mean to laugh at me? It's against the rules to laugh, anyhow. Don't you remember? Young girls should never laugh. Solemnity is the first rule of beauty. Never smile. Keep perfectly solemn. Look wise. Hence. Therefore. If. And——"

He lifted a finger solemnly and Suzanne stared. He had fixed her eye with his and was admiring her pretty chin and nose and lips while she puzzled quizzically, not knowing what to make of him. He was very different, very much like a boy, and yet very much like a solemn, dark master of some kind.

"You almost frighten me," she said.

"Now, now. Listen! It's all over. Come to. I'm just a silly-billy. Are you going to dance with me some this evening?"

"Why, certainly, if you want me to. Oh, that reminds me. We have cards. Did you get one?"

"No."

"Well, they're over here, I think."

She led the way toward the reception hall and Eugene took from the footman who was stationed there two of the little books.

"Let's see," he said, writing. "How greedy dare I be?"

Suzanne made no reply.

"If I took the third and the sixth and the tenth—would that be too many?"

"No-o," said Suzanne doubtfully.

He wrote in hers and his and then they went back to the drawing room where so many were now moving. "Will you be sure and save me these?"

"Why certainly," she replied. "To be sure I will."

"That's nice of you. And now here comes your mother. Remember—you mustn't ever, ever, ever, laugh. It's against the rules."

Suzanne went away thinking. She was pleased at the gayety of this man who seemed so light hearted and self-sufficient. He seemed like someone who took her as a little girl, so different from the boys she knew who were so very solemn in her presence and rather love-sickly. He was the kind of man one could have lots of fun with without subjecting herself to undue attention or having to explain to her mother. Her mother liked him. But Suzanne soon forgot him in the chatter of other people.

Eugene was thinking again of the indefinable something in the spirit of this girl which was attracting him so vigorously. What was it? He had seen hundreds of girls in the last few years, all charming, but somehow this one——. She seemed so strong, albeit so new and young. There was a poise there—a substantial quality to her soul which could laugh at life and think no ill of it. That was it or something of it, for of course her beauty was impressive, but this courageous optimism was shining out through her eyes. It was in her laugh, her mood. She would never be afraid. Life would do wonders for her. Oh, if he only had a big, courageous, optimistic woman—a girl as beautiful as that.

The dance began after ten and Eugene danced with first one and then another—Angela, Mrs. Dale, Mrs. Stevens, Miss Willy. When the third set came he went looking for Suzanne and found her talking with another young girl and two society men.

"Mine, you know," he said smilingly.

She came out to him laughing, stretching out her arm in a sinuous way quite unconscious of the charming figure she made. She had a way of throwing back her head which revealed her neck in beautiful lines of grace. She looked into Eugene's eyes simply and unaffectedly, returning his smile with one of her own. And when they began to dance he felt as though he had never really danced before.

What was it the poet said of the poetry of motion? This was it. This girl could dance wonderfully, sweetly, as a fine voice sings. She seemed to move like the air, with the sound of the two-step coming from an ambush of flowers, and Eugene yielded himself instinctively to the charm—the hypnotism of it. He danced, and in dancing forgot everything except this vision leaning upon his arm and the sweetness of it all. Nothing could equal this emotion, he said to himself. It was finer than anything he had ever experienced. There was joy in it, pure delight, an exquisite sense of harmony, and even while he was congratulating himself, the music seemed to hurry to a finish. Suzanne had looked up curiously into his eyes. He had said, "this is perfect"; "you dance divinely"; "there could be nothing more delicious than this."

"You like to dance, don't you," she said.

"I do, but I don't do it very well."

"Oh, I think so," she replied. "You dance so easily."

"It's because of you," he said simply. "You have the soul of the dance in you. Most people dance poorly, like myself."

"I don't think so," she said, hanging onto his arm as they walked toward a seat. "Oh, there's Kinroy. He has the next with me."

Eugene looked at her brother almost angrily. Why should circumstances rob him of her company in this way? Kinroy looked like her, he noted—he was very handsome for a boy.

"Well, then I have to give you up. I wish there were more."

He left her, only to wait impatiently for the sixth and the tenth. He knew it was silly to be interested in her in this way, for nothing could come of it. She was a young girl, hedged about by all the conventions and safeguards which go to make for the perfect upbringing of girlhood. He was a man past the period of her interest, watched over by conventions and interests also. There could be absolutely nothing between them and yet he longed for her just the same, for just this little sip of the nectar of make-believe. For a few minutes in her company, married or not, so many years older or not, he could be happy in her company, teasing her. That sense of dancing: that sense of perfect harmony with beauty—when had he ever experienced that before?

This night went by and at one o'clock he and Angela went home. She had been entertained by some young officer in the army stationed at Fort Wadsworth who had been there and knew her brother David. That had made the evening pleasant for her. She commented on Mrs. Dale and Suzanne, what a charming hostess the former was and how pretty and gay Suzanne looked, but Eugene manifested little interest. He did not want it to appear that he had been interested in Suzanne above any of the others.

"Yes, she's right nice," he said. "Rather pretty, but she's like all the girls of that age. I like to tease them."

Angela wondered whether Eugene had really changed for good. He seemed saner in all his talk concerning women. Perhaps big affairs had cured him completely, though she could not help feeling that he must be charmed and delighted by the beauty of some of the women whom he saw.

Five weeks more went by and then he saw Suzanne one day with her mother in Fifth Avenue coming out of an antique shop. Mrs. Dale explained that she was looking after the repair of a rare piece of furniture. Eugene and Suzanne were enabled to exchange but a few gay words. Four weeks later he met them at the Brentwood Hadleys', in Westchester. Suzanne and her mother were enjoying a season of spring riding. Eugene was there for only a Saturday afternoon and Sunday. On this occasion he saw her coming in at half past four, wearing a divided riding skirt and looking flushed and buoy-ant. Her lovely hair was blowing lightly about her temples.

"Oh, how are you?" she asked, with that same inconsequential air, her hand held out to him at a high angle. "I saw you last in Fifth Avenue, didn't I. Mamá was having her chair fixed. Ha ha! She's such a slow rider. I've left her miles behind. Are you going to be here long?"

"Just today and tomorrow."

He looked at her, pretending gayety and indifference.

"Is Mrs. Witla here?"

"No, she couldn't come. A relative of hers is in the city."

"I need a bath terribly," said the desire of his eyes and passed on, calling back, "I'll see you again before dinner, very likely."

Eugene sighed.

There went the perfection of beauty. Why should he look after her, though? What good did it do him?

She came down after an hour dressed in a pierced linen suit, a black silk tie bunched on her throat, a low collar showing her pretty neck. She picked up a magazine, passing a wicker table, and came down the veranda where Eugene was sitting alone. Her easy manner interested him, and her friendliness. She liked him well enough to be perfectly natural with him and to seek him out where he was sitting once she saw he was there.

"Oh, here you are," she said, and sat down, taking a chair which was near him.

Eugene forgot his solemn meditations. A sense of comfort and happiness settled upon him.

"Yes, here I am," he said, and began teasing her as usual, for it was the only way in which he knew how to approach her. Suzanne responded viva-ciously, for Eugene's teasing delighted her. It was the one kind of humor she really enjoyed.

"You know, Mr. Witla," she said to him once, "I'm not going to laugh at any of your jokes anymore. They're all at my expense."

"That makes it all the nicer," he said. "You wouldn't want me to make jokes at my expense, would you? That would be a terrible joke."

She laughed and he smiled. They looked at a golden sunset filtering through a grove of yellow maples. The spring was new and the leaves just budding.

"Isn't it lovely tonight?" he asked.

"Oh, yes," she exclaimed, in a mellow, meditative voice, the first ring of deep sincerity in it he had ever noticed there.

"Do you like nature?" he asked.

"Do I?" she returned. "I can't get enough of the woods these days. I feel so queer sometimes, Mr. Witla. As though I were not really alive at all, you know. Just a sound or a color in the woods."

He stopped and looked at her. The simile caught him quite as any notable characteristic in anyone would have caught him. What was the color and complexity of this girl's mind? Was she so subtle, so big, that nature appealed to her in a deep way? Was this wonderful charm that he felt the shadow or radiance of something finer still? She was so beautiful—like the shadows and sounds in the woods of which she was talking. A still, dull pool with the clouds of heaven reflected in its face.

"So that's the way it is, is it?" he asked.

"Yes," she said quietly.

He sat and looked at her and she eyed him as solemnly.

"Why do you look at me so?" she asked.

"Why do you say such curious things?" he answered.

"What did I say?"

"I don't believe you really know, at that. Well, never mind. Let us walk, will you? Do you mind? It's still an hour to dinner. I'd like to go over and see what's beyond those trees."

They went down a little path bordered with grass and under green budding twigs. It came to a stile finally and looked out upon a stony green field where some cows were pastured.

"Oh, the spring! the spring!" exclaimed Eugene, and Suzanne answered, "You know, Mr. Witla, I think we must be something alike in some ways. That's just the way I feel."

"How do you know how I feel?"

"I can tell by your voice," she said.

"Can you really?"

"Why, yes. Why shouldn't I?"

"What a strange girl you are," he said thoughtfully. "I don't think I understand you, quite."

"Why, why, am I so different from everyone else?"

"Quite, quite," he said, "at least to me. I have never seen anyone quite like you before."

CHAPTER LXXIX

It was after this meeting that a vague consciousness came to Suzanne that Mr. Witla (as she always thought of him to herself) was just a little more than very nice to her. He was so gentle, she thought, so meditative, and withal so gay when he was near her. He seemed fairly to bubble whenever he came into her presence, never to have any cause for depression or gloom such as sometimes seized on her when she was alone. He was always immaculately dressed, and had great affairs, so her mother said. They discussed him once at table at Dalewood, and Mrs. Dale said she thought he was charming.

"He's one of the nicest fellows that comes here, I know," said Kinroy. "I don't like that stick Woodward."

He was referring to another man of about Eugene's age who liked his mother.

"Mrs. Witla is such a queer little woman," said Suzanne. "She's so different from Mr. Witla. He's so gay and good-natured and she's so reserved. Is she as old as he is, mamá?"

"I don't think so," said Mrs. Dale, who was deceived by Angela's apparent youth. "What makes you ask?"

"Oh, I just wondered," said Suzanne, who was vaguely curious concerning things in connection with Eugene.

There were several other meetings, one of which Eugene engineered, once when he persuaded Angela to invite Suzanne and her mother to a spring night revel they were having at the studio, and the other when he and Angela were invited to the Willebrands' where the Dales were also. On each occasion Eugene saw Suzanne as moving in a realm of ineffable beauty, but he knew no way of reaching her. Angela was always with him. Mrs. Dale almost always with Suzanne. There were a few conversations but they were merely gay, inconsequential make-believe talks, in which Suzanne saw Eugene as one who was forever happy. She little sensed the brooding depths of longing that lay beneath his gay exterior.

The climax was brought about, however, when one July day after a short visit to one of the summer resorts, Angela was taken ill. She had always been subject to colds and sore throats, and these peculiar signs, which are associated by medical men with latent rheumatism, finally culminated in

this complaint. Angela had also been passed upon as having a weak heart and this, combined with a sudden, severe rheumatic attack, completely prostrated her. A trained nurse had to be called, and Angela's sister Marietta was sent for. Eugene's sister Myrtle, who now lived in New York, was asked by him to come over and take charge, and under her supervision pending Marietta's arrival, his household went forward smoothly enough. The former, being a full fledged Christian Scientist, having been instantly cured, as she claimed, of a long standing nervous complaint, was for calling a Christian Science practitioner, but Eugene would have none of it. He could not believe that there was anything to this new religious theory and thought Angela needed a doctor. He sent for a specialist in this complaint. It was said by the doctor that six weeks at the earliest, perhaps two months, must elapse before Angela would be able to sit up again.

"Her system is full of rheumatism," said her physician. "She is in a very bad way. Rest and quiet and constant medication will bring her around."

Eugene was sorry. He did not want to see her suffer, but her sickness did not for one minute alter his mental attitude. In fact he did not see how it could. It did not change their relative mental states in any way. Their peculiar relationship each to the other, one of guardian, the other of restless ward, was quite the same.

The doctor stated that there was, in his judgement, no fear of death.

All social gyrations of every kind now were abandoned by Eugene and he stayed at home every evening, curious to see what the outcome would be. He wanted to see how the trained nurse did her work and what the doctor thought would be the next step. He had a great deal to do at all times, reading, consulting, and he had many of those who wished to confer with him come to the apartment of an evening. All those who knew them at all intimately socially now called or sent messages of condolence, and among those who came were Mrs. Dale and Suzanne. The former—because Eugene had been so nice to her in a publishing way and was shortly going to bring out a novel by her, her first attempt—was most considerate. She sent flowers and came often, proffering the services of Suzanne for any day that the nurse might wish to leave or Mrs. Bangs (Myrtle) could not be present. She thought Angela might like to have Suzanne read to her. At least the offer sounded courteous and was made in good faith.

Suzanne did not come alone at first, but she did after a time when Angela had been ill four weeks and Eugene had stood the heat of the town apartment nightly for the reason that Angela could not be moved. Mrs. Dale suggested that he be allowed to run down to her place over Saturday and Sunday. It was not far. They were in close telephone communication. It would rest him.

Eugene, though Angela had suggested it a number of times before, had refused to go to any seaside resort or hotel, even for Saturday and Sunday, his statement being that he did not care to go alone at this time. The truth was, he was becoming so interested in Suzanne that he did not care to go anywhere save somewhere where he might see her again. He was not as interested in the large social circle he had known, for the reason that heretofore he had also been expecting to find some such soul as Suzanne, and now she was come. Why search when the search was over? She was always in his mind now as his ideal of earthly beauty.

This offer of Mrs. Dale's was welcome enough, but having dissembled so much he had to dissemble more. Mrs. Dale insisted. Angela added her plea. Myrtle thought he ought to go. He finally had his car take him down one Friday afternoon and leave him. Suzanne was out somewhere but he sat on the veranda and basked in the magnificent view it gave of the lower bay. Kinroy and some young friend, together with two girl friends, were playing tennis on one of the courts. Eugene went out to watch them and presently Suzanne returned, ruddy from a walk she had taken to a neighbor's house. At the sight of her every nerve in Eugene's body tingled—he felt a great exaltation and it seemed as though she responded in kind, for she was particularly gay and laughing.

"They have a four," she called to him, her white duck skirts blowing. "Let's you and I get rackets and play single."

"I'm not very good, you know," he said.

"You couldn't be worse than I am," she replied. "I'm so bad Kinroy won't let me play in any game with him. Ha! Ha!"

"Such being the case——," Eugene said lightly and followed her to where the rackets were. They went to the second court where they played practically unheeded. Every hit was a signal for congratulation on the part of one or the other, every miss for a burst of laughter or a jest. Eugene devoured Suzanne with his eyes, and she looked at him, over and over, directly, in wide-eyed sweetness, scarcely knowing what she was doing. Her own enthusiasm on this occasion was almost inexplicable to her. It seemed as if she were possessed of some spirit of enthusiasm which she could not control. She confessed to him afterward that she had been wildly glad, exalted, and played with a freedom and an abandon at the same time that she was frightened and nervous. To Eugene, she was of course ravishing to behold. She could not play, as she truly said, but it made no difference. Her motions were beautiful.

Mrs. Dale had long admired Eugene's youthful spirit. She watched him now from one of the windows and thought of him much as one might of a boy. He and Suzanne looking charming, playing together. It occurred to her

that if he were single he would not make a bad match for her daughter. Fortunately he was sane, conservative, charming, more like a guardian to Suzanne than anything else. Her friendship for him was rather a healthy sign.

After dinner it was proposed by Kinroy that he and his friends and Suzanne go to a dance which was being given at a neighboring club house, which was located near the government fortifications at The Narrows, where they spread out into the lower bay. Mrs. Dale, not to exclude Eugene, who was depressed at the thought of Suzanne's going and leaving him behind, suggested that they all go. She did not care so much for dancing herself, but Suzanne had no partner and Kinroy and his friend were very much interested in the girls they were taking. A car was called and they sped to the club to find it dimly lighted with Chinese lanterns, an orchestra playing somewhere softly in the gloom.

"Now you go ahead and dance," said her mother to Suzanne. "I want to sit out here and look at the water awhile. I'll walk you through the door."

Eugene held out his hand to Suzanne who took it and in a moment they were whirling about. A kind of madness seized them both, for without word or look they drew close to each other and danced furiously in a clinging ecstasy of joy.

"Oh! how lovely," Suzanne exclaimed at one turn of the room, where when passing an open door they looked out and saw a full lighted ship passing silently by in the distant dark. A sail boat, its one great sail enveloped in a shadowy mist, floated, wraith-like, nearer still.

"Do scenes like that appeal to you so?" asked Eugene.

"Oh, do they," she pulsated, "they take my breath away. This does too, it's—so lovely."

Eugene sighed. He understood now. Here was the soul of an artist, akin to his own, enveloped in beauty. This same thirst for beauty that was in him was in her, and it was pulling her to him. Only, her soul was so exquisitely set in youth and beauty and maidenhood that it overawed and frightened him. It seemed impossible that she should ever love him. These eyes, this face of hers—how they enchanted him. He was drawn as by a strong cord and so was she—by an immense, terrible magnetism. He had felt it all afternoon, keenly. He was feeling it intensely now. He pressed her to his bosom, and she yielded, yearningly, suiting her motions to his subtlest moods. He wanted to exclaim, "Oh Suzanne! oh, Suzanne!" but he was afraid. If he said anything to her it would frighten her. She did not really dream as yet what it all meant, but oh, oh, oh! The exquisite wonder of it. Here by the waterside, in the summer-scented wind, the stars over the sea, the boats slipping by in the dim, starlit radiance of the world outside. The candle-lit lantern blew delicately in the breeze.

"You know," he said, when the music stopped, "I'm quite beside myself. It's narcotic. I feel like a boy."

"Oh, if they would only go on," was all she said. And together they went out on the veranda, where there were no lights but only chairs and the countless stars.

"Well," said Mrs. Dale.

"It's divine here tonight," said Suzanne. "The air is so cool. Isn't the music lovely, mamá. Smell the salt water." She sniffed divinely.

"Exquisite. I don't know which is nicer, to be out here or in there. I rather think out here for me."

"I'm afraid you don't love to dance as well as I do?" observed Eugene calmly, sitting down beside her.

"I'm afraid I don't, seeing how joyously you do it. I've been watching you. You two dance well together. Kinroy, won't you have them bring us ices?"

"Dancing throws me into a lively perspiration, I'm sorry to state," said Eugene. "I don't do enough of it. I wish I did more."

Suzanne had slipped away to the side of her brother's friends. She talked to them cheerily the while Eugene was watching her, but she was intensely conscious of his presence and charm. She tried to think what she was doing but somehow she could not—she could only feel. The music struck up again but for looks' sake he had to let her dance with her brother's friend. The next was his and the next, for Kinroy preferred to sit out one and his friend also. Suzanne and Eugene danced the major portion of the dances together, growing into a wild exaltation which, however, was wordless despite a certain eagerness which might have been read into what they said. Their hands spoke when they touched and their eyes when they met. Suzanne was intensely shy and fearsome. She was really half terrified by what she was doing—afraid lest some word or thought would escape Eugene, and yet she wanted to dwell in the joy of this. He went once, between two dances when she was hanging over the rail looking at the dark, gurgling water below, and leaned over beside her.

"How wonderful this night is," he said.

"Yes, yes," she exclaimed and looked away.

"Do you wonder at all at the mystery of life?"

"Oh, yes, oh yes. All the time."

"And you are so young!" he said passionately, intensely.

"Sometimes, you know, Mr. Witla," she sighed, "I do not like to think."

"Why?"

"Oh, I don't know. I just can't tell you. I can't find words. I don't know."

There was an intense pathos in her phrasing which meant everything to his understanding. He understood how voiceless a great soul really might be, new born but without an earth-manufactured vocabulary. It gave him a clearer insight into a thought he had had for a long while, and that was that we come, as Wordsworth expressed it, "trailing clouds of glory," "from God, who is our home." Her soul might be intensely big—else why his yearning to her? But oh, the pathos of her voicelessness.

They went home in the car and late that night, while he was sitting on the veranda smoking to soothe his fevered brain, there was one other scene. The night was intensely warm everywhere except here on this hill where a cool breeze was blowing. The ships on the sea and bay were many—twinkling little lights—and the stars in the sky were as a great army. "See how the floor of heaven is inlaid with patines of bright gold," he quoted to himself. A door opened and Suzanne came out of the library which opened onto the veranda. He had not expected to see her again nor she him. The beauty of the night had drawn her.

"Suzanne!" he said when the door opened.

She looked at him, poised in uncertainty, her lovely white face glowing like a pale phosphorescent light in the dark.

"Isn't it beautiful out here? Come sit down."

"No," she said. "I mustn't stay. It is so beautiful." She looked about her vaguely and then at him. "Oh, that breeze." She turned up her nose and sniffed eagerly.

"The music is still whirling in my head," he said, coming to her. "I cannot get over tonight." He spoke softly—almost in a whisper—and threw his cigar away. Suzanne's voice was low.

She looked at him and filled her deep broad chest with air. "Oh," she sighed, throwing back her head, her neck showing divinely.

"One more dance," he said, taking her right hand and putting his left upon her waist.

She did not retreat from him but looked half distraught, half entranced, into his eyes.

"Without music?" she asked. She was almost trembling.

"You are music," he replied, an intense sense of suffocation seizing him.

They moved a few paces to the left where there were no windows and where no one could see. He drew her close to him and looked into her face but still he did not dare say what he thought. They moved about softly and then she gurgled that soft laugh that had entranced him from the first. "What would people think?" she asked.

They walked to the railing, he still holding her hand, and then she withdrew it. He was conscious of great danger—of jeopardizing a wonderfully blissful relationship—and finally said, "Perhaps we had better go."

"Yes," she said. "Mamá would be greatly disturbed if she knew this."
She walked ahead of him to the door.

"Good night," she whispered.

"Good night," he sighed.

He went back to his chair and meditated the course he was pursuing.
This was a terrible risk. Should he go on? The flower-like face of Suzanne
came back to him—her supple body, her wondrous grace and beauty. Oh,
perhaps not, but what a loss, what a lure to have flaunted in front of his
eyes. Were there ever thoughts and feelings like these in so young a body?
Never, never, never, had he seen her like. Never, in all his experiences, had
he seen anything so exquisite. She was like the budding woods in spring,
like little white and blue flowers growing. She was like rippling water and
faint whispering and spring sounds. She was exquisite, perfect, the flower of
God in earth. If life now, for once, would only be kind and give him her.

"Oh Suzanne, Suzanne," he breathed to himself, lingering over the
name.

For a fourth or a fifth time Eugene was imagining himself to be terribly,
eagerly, fearsomely in love.

CHAPTER LXXX

It had been while these various events were transpiring that the work of
the United Magazines Corporation proceeded apace. By the end of the
first year after Eugene's arrival, it had cleared up so many of its editorial and
advertising troubles that he was no longer greatly worried about them, and
by the end of the second year it was well on the way toward real success.
Eugene had become so much of a figure about the place that everyone in
the great building in which there were over a thousand employed knew him
on sight. The attendants were most courteous and obsequious—as much so
almost as they were to Colfax and White—though the latter twain, with
the improvement of the general condition of the company, had become
more forceful and imposing than ever. White, with his very large salary of
twenty-five thousand a year and his title of vice-president, was most anx-
ious that Eugene should not become more powerful than he had already.
It irritated him greatly to see the airs Eugene gave himself, for the latter
had little real tact in matters of great import such as these were that now
concerned him, and instead of dissembling his power and ability in front
of his superiors, was inclined to flaunt it. He was forever retailing to Colfax
some new achievement in the advertising, circulation, and editorial fields,
and that in White's presence (for he did not take the latter very seriously),

telling of a new author of import captured for the book department; a new manuscript feature secured for one or other of the magazines; a new circulation scheme or connection devised; or a new advertising contract of significance manipulated. His presence in Colfax's office was almost invariably a signal for congratulation or interest, for he was driving things hard and Colfax knew it.

"Well, what's the latest great thing you've done?" the latter said once, jovially, to Eugene, for he knew that Eugene was as fond of praise as a child and so could be bantered with impunity.

"No latest great thing, only Hayes has turned that Hammond Packing Company trick. That means eighteen thousand dollars' more worth of new business for next year. That'll help a little, won't it?"

"Hayes! Hayes! I'll be switched if I don't think he comes pretty near being a better advertising man than you are, Witla. You picked him—I'll have to admit that—but he certainly knows all about that game. If anything ever happened to you, I think I'd like to keep him right there."

Eugene's face fell, for this sudden twisting of the thread of interest from his to his assistant's achievements dampened his enthusiasm. It wasn't pleasant to have his inspirational leadership questioned or made secondary to the work of those whom he was managing. He had brought all of these men here and keyed the situation up. Was Colfax going to turn on him?

"Don't look so hurt," said the latter easily. "I know what you're thinking. I'm not going to turn on you. You hired this man. I'm simply telling you that if anything should happen to you, I'd like to keep him right where he is."

Eugene thought this remark over seriously. It was tantamount to serving notice on him, he thought, that he could not discharge Hayes. Colfax did not actually mean it this way at this time, though this was the seed of such a thought. He simply left the situation open for consideration and Eugene went away thinking what an extremely unfavorable twist this gave to everything. If he was to go on finding good men and bringing them in here but could not discharge them and if then later they became offensive to him, where would he be? Why, if they found that out, they could turn on him almost as lions on a tamer and tear him to pieces. This was a bad and unexpected twist to things and he did not like it.

While it had never occurred to Colfax before in this particular connection, for he liked Eugene, it fitted in well with certain warnings and suggestions which had been issuing from White, who was malevolently opposed to Eugene for his success in reorganizing the place on the intellectual and artistic sides. The latter work was giving Eugene a dignity and a repute, he thought, which was entirely disproportionate to what he was actually doing and which was threatening to overshadow and put in the limbo of indiffer-

ence that of every other person connected with the institution. White had not liked this from the start any more than he liked Eugene personally but he did not see what he was to do about it.

Colfax, for the time being, was enrapt by what he considered Eugene's shining intellectual and commercial qualities. It was a rare thing to find a man who could pick good men, even if you did have to keep them, possibly, at the expense of your own pride. Still, he did not want to be overshadowed in any way. He did not feel that he was. He did not care so much about the publishing world though now that he was in it and was seeing that it could be made profitable, he was rather flattered by the situation. His wife liked it, though, and people were always talking to her about the United Magazines Corporation, its periodicals, its books, its art products. While publishing might not be as profitable as soaps and woolens and railway stocks with which her husband was identified, it was somewhat more distinguished. She wanted him to keep it directly under his thumb and to shine in the glory of its power. So he was continuing to give publishing much more attention than he had originally anticipated he would, and this was White's main cue and lever.

White, in looking about for a club wherewith to strike Eugene, had thought of Colfax's vanity in this respect. If White could not reach Eugene's advertising, circulation, and editorial men directly and influence them to look to him instead of Eugene, he might reach and control them through Colfax. He might humble Eugene by curbing his power, making him see that he, White, was still the power behind the throne. He wanted Eugene subservient or at least subsidiary to him, and the only way to accomplish this was to make Colfax feel that Eugene was gaining too much of a supremacy—overshadowing Colfax himself—or making notable mistakes. So far, Eugene had not made many important mistakes. The only other weapon was the pride of Colfax.

"What do you think of this fellow Witla?" Colfax asked him from time to time, and when these occasions offered he was not slow to drive in an entering wedge.

"He's an able fellow," he said once, apparently most open mindedly. "It's plain that he's doing pretty well with those departments but I think you want to look out for his vanity. He's just the least bit in danger of getting a swelled head. You want to remember that he's still pretty young for the job he holds." (White was eight years older.) "These literary and artistic people are all alike. The one objection that I have to them is that they never seem to have any real, practical judgement. They make splendid second men when well governed, and you can do almost anything with them if you know how to handle them, but you have to govern them. This fellow,

as I see him, is just the man you want. He's picking some good people and he's getting some good results, but unless you watch him he's apt to throw them all out of here sometime or go away and take them all with him. I shouldn't let him do that if I were you. I should let him get just the men you think are right and then I should insist that he keep them. Of course a man has got to have authority in his own department but it can be carried too far. You're treating him pretty liberally, you know. I notice for one thing that he's always making some change somewhere but that process ought to stop sometime. You ought to be able to judge when. I don't want to influence your judgement against the man in any way, and I know that I won't be able to, but if I were you, I'd keep a sharp eye on him. He'll need all the direction you can give him to hold that job."

This sounded very sincere and logical to Colfax, for in spite of the fact that he admired Eugene greatly and went about with him a great deal, he did not exactly trust him. The man was in a way too brilliant, he thought. He was a little too airy and light on his feet. He had seen that in going around with him and talking in long stretches upon various subjects, Eugene had talent but he needed to be governed. White, for all his duller artistic perceptions, was perhaps sounder commercially. He was a good foil to Eugene.

Under pretext of helping his work and directing his policy without actually interfering so that it might not eventually prove a failure, White was constantly making suggestions. He made suggestions which, he told Colfax, Eugene ought to try out in the circulation department. He made suggestions which he thought he might find advisable to try out in the advertising department. He had suggestions, gathered from heaven knows where, for the magazines and books even, and these he invariably sent through Colfax, taking good care, however, that the various department heads knew from what source they had originally issued. It was no trick to speak to Hayes or Gillmore, who was in charge of circulation, or one of the editors, about some thought that was in his mind and then have that same thought come as an order via Eugene. The latter was so anxious to make good, so good natured in his interpretation of suggestions, that it did not occur to him for a long time that he was being played. The men under him, however, realized that something was happening, for White was close to Colfax and the two were not always with Eugene. He was not quite as powerful as White, was the first impression, and later the idea got about that Eugene and White did not agree temperamentally and that White was the stronger and would win.

It is not possible to go into the long, slow, multitudinous incidents and details which go to make up office politics, but anyone who has ever worked in a large or small organization anywhere will understand. Eugene was not a politician. He knew nothing of the delicate art of misrepresentation as it

was practised by White and those who were of his peculiarly subtle mental tendencies. He did not like Eugene and he proposed to have his power curbed. Some of his editors after a time began to find it difficult to get things as they wanted from the printing department, and when they complained it was explained that they were of a disorderly and quarrelsome temperament. Some of his advertising men made mistakes in statement or representation, and curiously these errors almost invariably came to light. Eugene found that his strong men were most quickly relieved of their difficulties if they approached White or Colfax directly to complain, but that if they came to him it was not quite so easy. Instead of ignoring these petty annoyances and going his way about the big things, he stopped occasionally to fight these petty battles and complain, and these simply put him in the light of one who was not able to maintain profound peace and order in his domain. White was always bland, helpful, ready with a suave explanation. He suggested to Colfax that perhaps Eugene was getting a little nervous, for the strain was great.

"It's just possible that he may not know how to handle these fellows after all," he once said to Colfax—and then if anyone was discharged it was a sign of of an unstable policy.

Colfax cautioned Eugene occasionally in line with White's suggestions, but Eugene was now so well aware of what was going on that he could see where they came from. He thought once of accusing White openly in front of Colfax, but he knew this would not be of any advantage for he had no real evidence to go on. All White's protestations to Colfax were that he was trying to help him. So the battle lay.

In the meantime Eugene, because of the thought that he might not always remain as powerful as he was, having no stock in the concern, and not being able to buy any, had been interesting himself in a proposition which had since been brought to him by Mr. Kenyon C. Winfield, who, since that memorable conversation at the home of the Willebrands' on Long Island, had not forgotten him. Winfield had thought of him for a long time in connection with a plan he had of establishing on the South Shore of Long Island, some thirty-five miles from New York, a magnificent seaside resort of some description which should outrival Palm Beach and the better phases of Atlantic City and give to New York, close at hand, such a dream of beauty and luxury as would turn the vast tide of luxury-loving idlers and successful money grubbers from the former resorts and others like them to this. Considerable thought had been given by Winfield as to just what its principal characteristics should be, but he had not worked it out to suit himself exactly, and he thought Eugene might be interested from the outlining point of view. Winfield wanted so fine a plan of beauty and

luxury, capable at the same time of so great a profit yielding capacity, that capitalists and monied men of a sybaritic turn would be interested. New York had no such resort as yet. It would be the crowning work of any man's life who undertook and successfully carried it to an issue.

Unfortunately, on the face of it, this was just the sort of scheme which would appeal to Eugene from all points of view, in spite of the fact that he already had his hands as full as they could be. Nothing interested him quite so much as beauty and luxury in some artistic combination. A summer resort of really imposing proportions, with hotels, casinos, pagodas, residence sections, club houses, a notable board or stone walk along the ocean, and possibly a gambling centre which should outrival Monte Carlo, had long since occurred to him as something which might well spring up near New York. He and Angela had visited Palm Beach, Old Point Comfort, Virginia Hot Springs, Newport, Shelter Island, Atlantic City, and Tuxedo, and his impressions of what constituted true luxury and beauty had long since widened to magnificent proportions. He liked the interiors of the Chamberlain at Old Point Comfort and the Royal Poinciana at Palm Beach. He had studied with artistic curiosity the development of the more imposing hotel features at Atlantic City and elsewhere. It had occurred to him that a restricted territory might be laid out on the Atlantic Ocean near Gravesend Bay, possibly, which would include, among other things, islands, canals or inland waterways, a mighty sea beach, two or three great hotels, a casino for dancing, dining, gambling, a great stone or concrete walk to be laid out on a new plan parallel with the ocean, and back of all these things and between the islands and the ocean a magnificent seaside city where the lots should sell at so expensive a rate that only the well-to-do could afford to live there. His thought was of something so fine that it would attract all the notable pleasure lovers he had recently met. If they could be made to understand, he thought, that such a place really existed; that it was beautiful, showy, exclusive in a money sense, they would come there by thousands. He could see them in his mind's eye as he had seen them actually about the casino at Newport, at Bar Harbor, at Tuxedo, and at Palm Beach, automobiles crowding each other in long gaudy rows, the beach strewn with bright-colored covered chairs, the casino and boardwalk promenaded by beautifully dressed women carrying handsomely designed and colored parasols. With Colfax and Mrs. Dale and Mrs. Willebrand and scores of others, he had already been to so many beautiful spots, but this would be *the* spot.

"Nothing is so profitable as a luxury, if the luxury-loving public want it," Colfax had once said to him; and he believed it. He judged this truth by the things he had recently seen. Why, people literally spent millions to

make themselves comfortable. He had seen gardens, lawns, walks, pavilions, pergolas, laid out at the expense of thousands and hundreds of thousands of dollars, where few would ever see them. In St. Louis he had seen a mausoleum built after the theory of the Taj Mahal, the lawn about which was undermined by a steam heating plant in order that the flowers and shrubs displayed there might bloom all winter long. It had never occurred to him that the day would ever come when he would ever have anything to do with any such dream as this or its ultimate fruition, but his was the kind of mind that loved to dwell on things of this sort. He was always dreaming of something beautiful. As though the task he had undertaken in connection with the United Magazines Corporation was not large enough, he had to dream some more. And this was one of his dreams—one of many, very many.

The proposition which Winfield now genially laid before him one day was simple enough. Winfield had heard that Eugene was making considerable money these days, that his salary was twenty-five thousand a year, if not more, that he had houses and lots and some nice stock investments, and it occurred to him, as it would have anyone, that Eugene might be able to shoulder a comfortable investment in some kind of a land proposition, particularly if he could see where he was going to make much more money in the long run. The idea Winfield had was as follows. He was going to organize a corporation to be known as the Sea Island Development Company, to be capitalized at ten millions of dollars, some two or three hundred thousand dollars of which was to be laid down or paid into the treasury at the start. Against this latter sum, stock to the value of one million dollars, or five shares of one hundred dollars par value each, was to be issued. That is, whoever laid down one hundred dollars in cash was to receive in return three shares of common stock valued at one hundred dollars each and two of preferred, bearing eight per cent interest, each worth one hundred dollars also. The ratio was to be continued until $200,000 in cash was in the treasury. Then those who came afterward and were willing to buy were only to receive two shares of common and one of preferred, until one million in cash was in the treasury. After that the stock was to be sold at its face value, or more, as the situation might dictate.

The original sum of two hundred thousand dollars was to go to purchase for the corporation a magnificent tract of land, half swamp, half islands, and facing the Atlantic Ocean beyond Gravesend Bay, now owned by Winfield himself, where a beautiful rolling beach of white sand some five miles in length and without flaw or interruption was encountered. This would clear Winfield of a piece of property which was worth say $60,000, which was unusable, and give him magnificent holdings in the new company besides. He proposed to take a mortgage on this and all improvements the company

might make in order to protect himself. Here, at the west end, was a beautiful bay, which, though shallow, gave access to a series of inlets and a network of waterways embracing nine small islands. These waterways when dredged would be amply deep enough for yachts and small craft of all descriptions, and the first important thought which occurred to Mr. Winfield was that the mud and sand so dredged could be used to fill in the low, mucky levels of the soil and so make it all into high, dry, and very valuable land. The next thing was to devise a beautiful scheme of improvement and it was for this that he wished to talk to Eugene.

The latter, when Winfield first phoned him from his club, asking if they could not get together for lunch in a day or two, was curious as to what it might mean. Since talking with Winfield, Eugene had seen that his latest venture, "The Beaches," had been proving quite successful. At least it was advertised a great deal and he heard talk from one person and another that it was attractive residential property. Winfield had no doubt in his own mind about being able to put through this latest venture, which was to be the one great thing in his life. He was anxious to call to his aid the finest talent architecturally and commercially, and he had no thought but that he would be able to interest in various ways financiers, railroad men, hotel men, small merchants who would want concessions, society people, and so forth. His aim in talking to Eugene was first to get a scheme of artistic procedure, second to get an investment out of him which would insure his continued interest, and third, once he was financially interested, to get him to use his influence socially among those he knew, and to suggest worthwhile schemes of advertising the proposition. He sincerely believed that Eugene would be a good man to have identified with him if possible and he proposed to get him.

CHAPTER LXXXI

The matter was not so very difficult to arrange. Eugene liked Winfield personally, and admired what he stood for in the commercial world. It seemed a rather refined and artistic thing that he was doing—laying out new suburbs of real physical charm—and he had more than once wished that he might be identified with some such delightful thing, providing only it would be profitable. Here was a man, as he soon found, a leader in his field and a gentleman of artistic proclivities, coming to him with an idea which was perfection itself. A great summer resort—such as had never before existed in America! A beautiful beach such as now was not accessible to New York

under three or four hours! Winfield began to explain to him at length just what the nature of the proposed work was, but before he had gone ten sentences, Eugene began to take the ideas out of his mind.

"I know something of that property," he said, studying a little outline map which Winfield had prepared. "I've been out there duck shooting with Colfax and some others. It's fine property, there's no doubt of it. How much do they want for it?"

"Well, as a matter of fact, I already own it," said Winfield. "It cost me sixty thousand dollars five years ago when it was a vast, inaccessible swamp. Nothing has been done to it since but I will turn it over to the company for what it is worth now—$200,000—and take a mortgage for my protection. Then the company can do what it pleases with it; but as president, of course, I will be directing the line of development. If you want to make a fortune and have fifty thousand dollars to spare, here is your chance. This land has increased in value from sixty to two hundred thousand dollars in five years. What do you fancy it will be worth ten years from now, the way New York is growing? It has pretty near four million people now. In twenty-five years it is safe to say that there will be fourteen or fifteen million scattered over this territory which lies within twenty-five miles. Of course this is thirty-two miles on a direct line, but what of it? The Long Island Railroad will be glad to put a spur in there which would bring this territory within one hour of the city. Think of it—one of the finest beaches on the Atlantic Ocean within one hour of New York. I expect to interest Mr. Wiltsie, the president of the Long Island, very heavily in this property. I come to you now because I think your advertising and artistic advice are worth something. You can take it or leave it. But before you do anything I want you to come out and look over the property with me."

All told, in stocks, land, free money in the banks, and what he might save in a year or two, Eugene had about fifty thousand dollars of good hard cash which he could lay his hands on in a pinch. He was well satisfied that Winfield was putting before him one of those golden opportunities which, conservatively managed, would make him a rich man. Nevertheless his fifty thousand was fifty thousand, and he had it. Never again, however, once this other thing were under way, if it were true, would he ever have to worry about a position or whether he would be able to maintain his present place in society. One could not possibly say what an investment like this might not lead to. Winfield, so he told Eugene, expected eventually to clear six or eight million dollars himself. He was going to take stock in some of the hotels, casinos, and various other enterprises which would be organized. He could clearly see where lots, once this land was properly drained and laid out, would be worth from three to fifteen thousand dollars each—100

by 100 being the smallest portions to be sold. There were islands which, for clubs or estates, should bring splendid revenues. Think of the leases to yacht and boat clubs alone. The company would own all the land.

"I would develop this myself if I had the capital," said Winfield, "but I want to see it done on a gigantic scale and I haven't the means. I want something here which will be a monument to me and to all connected with it. I am willing to take my chances pro-rata with those who now enter, and to prove my good faith I am going to buy as many shares as I possibly can on the five-for-one basis. You or any one else can do the same thing. What do you think?"

"It's a great idea," said Eugene. "It seems as though a dream which had been floating about in the back of my head for years had suddenly come to life. I can scarcely believe that it is true and yet I know that it is and that you will get away with it just as you are outlining it here. You want to be very careful how you lay out this property, though. You have the chance of a lifetime. For goodness' sake, don't make any mistakes. Let's have one resort that is truly, beautifully right."

"That's precisely the way I feel about it," answered Winfield, "and that's why I'm talking to you. I want you to come in on this, for I think your imagination will be worth something. You can help me lay this thing out right and advertise it right."

They talked on about one detail and another until finally Eugene, in spite of all his caution, saw all his dreams maturing in this particular proposition. Fifty thousand dollars invested here would give him two thousand five hundred shares, one thousand preferred and fifteen hundred common, whose face value, guaranteed by this magnificent piece of property, would be worth $250,000. Think of it, $250,000—a quarter of a million—and that subject to a natural increase which might readily carry him into the millionaire class. His own brains would be of some value here, for Winfield was anxious to have him help lay this out, and this would also bring him in touch with not only one of the best real estate men in the city but would bring him into contact later with a whole host of financiers in business—people who would certainly become interested in this venture. Winfield talked easily of architects, contractors, railroad men, presidents of construction companies, all of whom would take stock for the business opportunities it would bring to them later, and also of the many strings to be pulled which later would bring great gains to the company and save it from expenditures which would otherwise mean millions in outlay. Thus this proposed extension by the Long Island which would cost that railroad two hundred thousand dollars, would cost the Sea Island Company nothing and would bring thousands of lovers of beauty there the moment there were conveniences established

to receive them. This was true of hotels to be built. Each would bring business for everything else. The company could lease the ground. The great hotel men could do their own building according to restrictions and plans laid down by the Sea Island Company. The only real expenditures would be for streets, sewers, lights, water, walks, trees, and the great one hundred foot wide boardwalk with concrete ornaments which should be the finest sea stroll in the world.

Eugene saw it all. It was a vision of empire.

"I don't know about this," he said cautiously. "It's a great thing but I may not have the means to dip into it. I want to think it over. Meanwhile I'll be glad to go out there and look over the ground with you."

Winfield could see that he had Eugene fascinated. It would be an easy matter to land him once he had his plans perfected. Eugene would be the type of man who would build a house and come and live there in the summer. He would interest many people whom he knew. He went away feeling that he had made a good start, and he was not mistaken.

Eugene talked the matter over with Angela—his one recourse in these matters—and as usual she was doubtful but not exactly opposed. Angela had considerable business caution but no great business vision. She could not really tell him what he ought to do in these matters. Thus far his judgement, or rather his moves, had been obviously successful. He had been going up, apparently because he was valuable as an assistant, not because he was a born leader. The fact that Mr. Winfield wanted him to assist him was one of the best recommendations this whole scheme had in Angela's eyes. She had not met Winfield as yet, but from Eugene's description and from the published accounts of his ventures from time to time in the papers, she knew he must be of considerable financial responsibility. Many people seemed to know of him by reputation.

"You'll have to judge for yourself, Eugene," Angela finally said. "I don't know. It looks fine. You certainly won't want to work for Mr. Colfax all your life, and if, as you say, they are beginning to plot against you, you had better prepare to get out sometime. We have enough now, really, to live on, if you want to return to your art."

Eugene smiled. "My art. My poor old art. A lot I've done to develop my art."

"I don't think it needs developing. You have it. I'm sorry sometimes I ever let you leave it. We have lived better but your work hasn't counted for as much. What good has it done you, outside of the money, to become a successful publisher? You were as distinguished as you are now before you ever started in on this line, and more so. More people know you now as Eugene Witla the artist than as Eugene Witla the magazine man."

544 • The Genius

Eugene knew this to be so. His art achievements had never forsaken him. They had grown in fame in a way, those two exhibitions. Pictures that he had sold for two hundred had gone up to five hundred and a thousand in value, and he was occasionally approached by an art dealer to know if he ever intended to paint any more. In social circles it was a constant cry among the mentally elect——

"Why don't you ever paint any more?"

"What a shame you ever left the art world!"

"Those pictures of yours—I can never forget them."

"My dear," Eugene once said solemnly to one woman who reproached him, "I can't live by painting pictures as I am living by directing magazines. Art is very lovely. I am satisfied to believe that I am a great painter. Nevertheless I made little out of it and since then, I have learned to live. It's sad but it's true. If I could see my way to living in half the distinguished way I am doing now and not run the risk of padding the streets with a picture under my arm I would gladly return to art. The trouble is, the world is always so delightfully ready to see the other fellow make the sacrifice for art or literature's sake. Selah! I won't do it. So there."

"It's a pity! It's a pity," said this observer, but Eugene was not vastly distressed.

Similarly Mrs. Dale had reproached him, for she had seen and heard of his work.

"Sometime! Sometime!" he said grandly, "Wait."

Now this land proposition seemed to clear the way for everything. If Eugene embarked upon it, he might gradually come to the place where he could take some position in connection with it. Anyhow, think of a swelling income from $250,000. Think of the independence, the freedom. Surely then he could paint or travel or do as he pleased. He told Angela of Winfield's scheme to divide up the land between the inland islands and the beach into building plots for homes and that they might someday have a magnificent bungalow there. Visions of cool breezes, clear blue seas, bright awnings, gay sun shades, a happy, smiling company of idlers, came to Angela and Eugene. It could be designed so beautifully. Eugene was planning to design the whole water city so magnificently.

As a matter of fact, after two automobile rides to the nearest available position on the site of the future resort and a careful study of the islands and the beach, Eugene devised a scheme which included four hotels of varying sizes, one dining and dancing casino, one gambling resort after the pattern of Monte Carlo, a summer theatre, a music pavilion, three lovely water piers, a club house for one of the motor clubs which would centre here, a club house for one of the yacht clubs which would centre here, a park with

radiating streets, and other streets arranged in concentric rings to cross them. There was a grand plaza about which the four hotels were ranged, a noble promenade, three miles in length to begin with, a handsome railway station, plots for five thousand summer houses, ranging from 100 by 100 to 200 by 200. There were islands for residences, islands for clubs, islands for parks. One of the hotels sat close to an inlet over which a dining veranda was to be built. Stairs were to lead down to the water so that one could step into gondolas or launches and be carried quickly to one of the music pavilions on one of the islands. Everything that money wanted was to be eventually available here and all was to be gone about slowly but beautifully so that each step would only make more sure each additional step.

Eugene did not enter on this grand scheme until ten men, himself included, had pledged themselves to take stock up to $50,000 each. Included in these were Mr. Wiltsie, president of the Long Island, Mr. Kenyon C. Winfield, and Milton Willebrand, the very wealthy society man at whose house he had originally met Winfield. The Sea Island Company was then incorporated and on a series of dates agreed upon between them, and which were dependent upon a certain amount of work being accomplished by each date, the stock was issued to them in ten thousand dollar lots and then cash taken and deposited in the treasury. By the end of two years after Eugene had first been approached by Winfield, he had a choice collection of gold colored certificates of stock in the Sea Island Realty and Construction Company, which was building a now widely heralded seaside resort—"Blue Sea"—which according to those interested was to be the most perfect resort of its kind in the world. His certificates stated that they were worth $250,000, and potentially they were. Eugene and Angela looking at them, thinking of the initiative and strength of Mr. Kenyon C. Winfield and the men he was associated with, felt sure that someday, and that not so very far distant, they would yield their face value and much more.

Oh, to feel that you were worth $250,000. To understand some day, as they well might, that come what may, no harm could betide them financially. To be independent of a salary, however large, and not have to worry over what this man or that might do or say. It was a wonderfully inspiring thought and with this before him, Eugene was dreaming such dreams of opulence as had never before entered his brain. He was fairly drugged, intoxicated. Now, now he might actually become a millionaire. He might live like a prince. Good heavens, what dreams of beauty and delight were not within the range of his possibilities. There was just one flaw in it all—he was not happily married. Behave as he might, the vision of beauty in youth was ever before him and he was debarred from it for fear of what the world might do to him. He had to behave now. His position was treacherous. He

must. And yet what scenes of loveliness he was seeing—what perfection of womanhood at times. Take Suzanne Dale! If a man in his position could have a girl like Suzanne Dale—what a perfect, delicious, idyllic thing that would be.

CHAPTER LXXXII

This burst of emotion with its tentative understanding so subtly reached changed radically and completely the whole complexion of life for Eugene. Once more now the spirit of youth returned to him. He had been dreading all this while, in spite of his success, the lapse of time, for he was daily and hourly growing older and what had he really achieved? The more Eugene had looked at life through the medium of his experiences, the more it had dawned on him that somehow all effort was pointless. To where or what did one attain when one attained success? Was it for houses and lands and fine furnishings and friends that one was really striving? Was there any such thing as real friendship in life, and what were its fruits—intense satisfaction? In some few instances, perhaps, but in the main what a sorry jest most so-called friendships veiled! How often they were coupled with self-interest, self-seeking, self-everything. We associate in friendship mostly only with those who were of our own social station. A poor friend! Did he have one? An inefficient friend? Would one such long be his friend? Life ran in schools of those who could run a certain pace, maintain a certain standard of appearances, compel a certain grade of respect and efficiency in others. Colfax was his friend—for the present. So was Winfield. About him were scores and hundreds who were apparently delighted to grasp his hand, but for what? His fame? Certainly. His efficiency? Yes. Only by the measure of his personal power and strength could he measure his friends—no more.

And as for love—what had he ever had of love before? When he went back in his mind it seemed now that all, each and every one, had been combined in some way with lust and evil thinking. Could he say that he had ever been in love, truly? Certainly not with Margaret Duff or Ruby Kenny or Angela Blue (though that was the nearest he came to true love) or Christina Channing. He had liked all of these women very much, as he had Carlotta Wilson, but had he ever loved one? Never. Angela had won him through his sympathy for her, he told himself now. He had been induced to marry out of sorrow. And here he was now, having lived all these years and come all this way without having truly loved. Now, behold Suzanne Dale with her perfection of soul and body, and he was wild about her—not for lust

but for love. He wanted to be with her, to hold her hands, to kiss her lips, to watch her smile, but nothing more. He was not eager for her body. He was in love with her mind. It was true her body had its charm. In extremes it would draw him, but the beauty of her mind and appearance—there lay the fascination. He was heartsick at being compelled to be absent from her and yet he did not know that he would ever be able to attain her at all.

As he thought of this condition it rather terrified and nauseated him. To think, having known this one hour of wonder and superlative bliss, to be compelled to come back into this work-a-day world. Things were not improving at the office of the United Magazines Corporation. Instead of growing better they were grown worse. With the diversity of his interests, particularly the interest he held in the Sea Island Realty and Construction Company, he had grown rather lackadaisical in his attitude toward all magazine interests with which he was connected. He had put in strong men wherever he could find them, but these had come to be very secure in their places, working without very much regard to him, for he could not give them much attention. White and Colfax had come to know many of them personally. Some of them such as Hayes, the advertising man; Garfield, the circulation manager; Thompson, the editor of the review; and Campbell, the editor in charge of books, were so very able that it was practically settled that they could not be removed. Colfax and White came by degrees to understand that Eugene was a personality who, however brilliant he might be in selecting men, was really not a detail man for any position. He could not bring his mind down to small practical points. If he had been an owner such as Colfax was, or a practical henchman such as White, he would have been perfectly safe, but being a natural born leader or rather organizer, he was, unless he secured control in the beginning, rather hopeless and helpless when he had it all completed. Others could do the work better than he could. Colfax came to know his men and like them. In absences which had become more frequent as he became more secure and as he took up with Winfield, they had first gone to Colfax for advice and later, in Colfax's absence, to White. These two men had discussed Eugene secretly and agreed that he had done his great work organizing or rather re-organizing the place. He might be worth twenty-five thousand a year doing that, but hardly as a man to sit about and cool his heels after the work was done.

White had consistently whispered thoughts of Eugene's artistic inefficiency for the task he was essaying. "He's really trying to do up there what you ought to be doing," he told Colfax, "and that you can do better. You want to remember that you've learned a lot since you came in here, and so has he. Only he has become a little less practical and you have become more so. These men of his look more to you right now than they do to

him. That's the way it should be. I wouldn't disturb him there if I were you. Things are all right so long as he behaves himself but I can tell you frankly that you really don't need him, and anyone else who knows anything about the house will tell you the same thing. You dispense with him tomorrow, or he might die, and you would never know that he had gone."

Colfax rejoiced in this thought. He liked Eugene but he liked the idea better that his business interests were perfectly safe. He did not like to think that any one man was becoming so strong that his going would injure him, and this thought for a long time during Eugene's ascendancy had troubled him. The latter had carried himself with such an air. He fancied that Colfax needed to be impressed with his importance and this, in addition to his very thorough work, was one way to do it. This manner had palled on Colfax after a time, for he was the soul of vainglory himself and he wanted no other gods in the place beside himself. White, on the contrary, was constantly subservient and advisory in his manner. It made a great difference.

By degrees, through one process and another Eugene had lost ground but it was only in a nebulous mental state as yet, and not in any grounded fact. If he had never turned his attention to anything else, had never wearied of any details, had kept close to Colfax and to his own staff, he would have been safe. As it was, he began now to neglect them more than ever and this could not fail to tell rather effectively in the long run.

In the first place, the prospects in connection with the Sea Island Construction Company were apparently growing brighter and brighter. It was one of those schemes which would take years and years to develop—Eugene had not realized that at first—but it was showing tangible evidences of accomplishment. The first year after considerable money had been invested, considerable dredging was done and dry land appeared in many places—a long stretch of good earth back of the main beach on which hotels and resorts of all sorts could be constructed. The boardwalk was started after a model proposed by Eugene and approved by the architects engaged—with modifications—and a part of the future great dining and dancing casinos were begun and completed, a beautiful building done after the Moorish, Spanish, and Old Mission styles of architecture. A notable improvement in design had been effected in this scheme, for the color of Blue Sea, according to Eugene's theory, was to be red, white, yellow, blue, and green, done in spirited and yet simple outlines. The walls of all buildings were to be mostly white and yellow, latticed with green. The roofs, porticos, lintels, piers, and steps were to be red, yellow, green, and blue. There were to be round, shallow Italian pools of concrete in many of the courts and interiors of the houses. The hotels were to be brilliant modifications of the Giralda in Spain, each one a size smaller or larger than the other. Green spear pines and tall cone-

shaped poplars were to be the prevailing tree decorations. The railroad, as per Winfield's promise, had already completed its spur and Spanish depot, which was beautiful. It looked truly as though Blue Sea would become what Winfield said it would become, *the* seaside resort of America.

The actuality of this progress fascinated Eugene so much that he gave— until Suzanne appeared—much more time than he really should have to the development of this scheme. As in the days when he first went with Summerfield, he worked nights on exterior and interior *layouts*, as he called them, facades, ground arrangements, island improvements, and so on. He went frequently with Winfield and his architects in his auto to see how Blue Sea was getting along, and to visit monied men who might be interested. He drew up plans for ads and booklets, making many little delightful sketches and originating catch lines. Naturally he could not give as much attention to his own work as he should have, and it began to tell.

In the next place, after Suzanne appeared, he began to pay attention almost exclusively in his thoughts to her. He could not get her out of his mind, night or day. She haunted his thoughts in the office, at home, and in his dreams. He began actually to burn with a strange fever, which gave him no rest. When would he see her again? When would he see her again? When would he see her again? He could see her only as he danced with her at the boat club, at South Beach, as he sat with her in the swing at Dale-wood. It was a wild, aching desire which gave him no peace any more than any other fever of the brain ever does.

Once not long after he and she had visited South Beach, she came with her mother to see how Angela was, and Eugene had a chance to say a few words to her in the studio, for they came after five in the afternoon when he was at home. Suzanne gazed at him, wide eyed, scarcely knowing what to think, though she was fascinated. He asked her eagerly where she had been, where she was going to be.

"Why," she said gracefully, her pretty lips parted, "we're going to the Bentwood Hadleys' tomorrow. We'll be there for a week, I fancy. Maybe longer."

"Have you thought of me much, Suzanne?"

"Yes! yes! But you mustn't, Mr. Witla. No, no. I don't know what to think."

"If I came to the Bentwood Hadleys', would you be glad?"

"Oh, yes," she said hesitatingly. "But you mustn't come."

Eugene was there that weekend. It was not difficult to manage.

"I'm awfully tired," he wrote Mrs. Hadley. "Why don't you invite me out?"

"Come," came a telegram, and he went.

On this occasion he was more fortunate than ever. Suzanne was there, out riding when he came, but as he learned from Mrs. Hadley, a dance was scheduled at a nearby country club. Suzanne, with a number of others, was going. Mrs. Dale decided to go and invited Eugene. He seized the offer, for he knew he would get a chance to dance with his ideal. When they were going in to dinner he met Suzanne in the hall.

"I am going," he said eagerly. "Will you save a few dances for me?"

"Yes," she said, inhaling her breath in a gasp.

They went and he filled in her dancing card in five places.

"We must be careful," she pleaded. "Mamá won't like it."

He saw by this that she was beginning to understand and would work with him. Why was he luring her on? Why would she let him?

When he slipped his arm about her in the first dance he said, "At last," and then, "I have waited for this so long."

Suzanne made no reply.

"Look at me, Suzanne," he pleaded.

"I can't," she said.

"Oh, look at me," he urged, "once, please. Look in my eyes."

"No, no," she begged, "I can't."

"Oh, Suzanne," he exclaimed, "I am crazy about you. I am mad. I have lost all reason. Your face is like a flower to me. Your eyes—I can't tell you about your eyes. Look at me!"

"No," she pleaded.

"It seems as though the days will never end in which I do not see you. I wait and wait. Suzanne, do I seem like a silly boy to you?"

"No."

"I am counted strong and able. They tell me I am brilliant. You are the most perfect thing that I have ever known. I think of you awake and asleep. I could paint a thousand pictures of you. My art seems to come back to me through you. If I live I will paint you in a hundred ways. Have you ever heard of the Rossetti gallery in London?"

"No."

"It contains a score of portraits of the same woman. There shall be one with a hundred of you."

She lifted her eyes to look at him shyly, wonderingly, drawn by this terrific passion. His own blazed into her. "Oh, look at me again," he whispered when she dropped her eyes under the fire of his glance.

"I can't," she pleaded.

"Oh, yes! Once more!"

She lifted her eyes and it seemed as though their souls would blend. He felt dizzy, and Suzanne reeled.

"Do you love me, Suzanne?" he asked.

"I don't know," she trembled.

"Do you love me?"

"Don't ask me now."

The music ceased and Suzanne was gone.

He did not see her until much later, for she slipped away to think. Her soul was stirred as with a raging storm. It seemed as though her very soul were being torn up. She was tremulous, unsettled, yearning, eager. She came back after a time and they danced again, but she was calmer, apparently. They went out on a balcony and he contrived to say a few words there.

"You mustn't," she pleaded. "I think we are being watched."

He left her and on the way home in the auto he whispered, "I shall be on west veranda tonight. Will you come?"

"I don't know. I'll try."

He walked leisurely to that place later when all was still and sat down to wait. Gradually the great house quieted. It was one and one thirty and then nearly two before the door opened. A figure slipped out—the lovely form of Suzanne, dressed as she had been at the ball, a veil of lace over her hair.

"I'm so afraid," she said. "I scarcely know what I'm doing. Are you sure no one will see us?"

"Let us walk down that path to the field." It was the same they had taken in the early spring when he had met her here before. In the west hung low a waning moon, yellow, sickle shaped, very large because of the hour.

"Do you remember when we were here before?"

"Yes."

"I loved you then. Did you care for me?"

"No."

They walked on, under the trees, he holding her hand.

"Oh, this night! This night!" he said, the strain of his intense emotion almost wearing him. "Will I ever forget it?"

They came out from under the trees at the end of the path. There was a sense of August dryness in the air. It was warm, sensuous. About were the sounds of insects, faint bumblings, cracklings. A tree toad chirped or a bird cried.

"Come to me, Suzanne," he said at last when they came into the full light of the moon at the end of the path and paused. "Come to me." He slipped his arms about her.

"No!" she said, "no."

"Look at me, Suzanne," he pleaded. "I want to tell you how much I love you. Oh, I have no words. It seems ridiculous to try to tell you. Tell me that you love me, Suzanne. Tell me now. I am crazy with love of you. Tell me."

"No," she said, "I can't."

"Kiss me!"

"No."

He drew her to him and turned her face up by her chin in spite of her. "Open your eyes," he pleaded. "Oh, God! that this should come to me! Now, I could die. Life can hold no more. Oh, Flower Face! Oh, Silver Feet! Oh, Myrtle Bloom! Divine Fire! How perfect you are! How perfect! And to think you love me!"

He kissed her eagerly.

"Kiss me, Suzanne. Tell me that you love me. Tell me! Oh, how I love that name—Suzanne. Whisper to me, you love me."

"No."

"But you do."

"No."

"Look at me, Suzanne. Flower Face—Myrtle Bloom—For God's sake! Look at me. You love me."

"Oh, yes, yes, yes," she sobbed of a sudden, throwing her arms about his neck. "Oh, yes, yes."

"Don't cry," he pleaded. "Oh, sweet, don't cry. I am mad for love of you, mad. Kiss me now—one kiss. I am staking my soul on your love. Kiss me."

He pressed his lips to hers but she burst away, terror stricken.

"Oh, I am so frightened," she exclaimed all at once. "Oh, what shall I do? I am so afraid. Oh, please, please. Something terrifies me. Something scares me. Oh, what am I going to do? Let me go back."

She was white and trembling. Her hands were nervously clasping and unclasping.

Eugene smoothed her arm soberly. "Be still, Suzanne," he said. "Be still. I shall say no more. You are all right. I have frightened you. We will go back. Be calm. You are all right."

He recovered his own equipoise with an effort because of her obvious terror, and led her back under the trees. To reassure her, he drew his cigar case from his pocket and pretended to select a cigar. When he saw her calming he put it back.

"Are you quieter now, sweet?" he asked, tenderly.

"Yes, but let us go back."

"Listen. I will only go as far as the edge. You go alone. I will watch you safely to the door."

"Yes," she said peacefully.

"And you really love me, Suzanne?"

"Oh, yes, but don't speak of it. Not tonight. You will frighten me again. Let me go back."

They strolled on: then he said—"One kiss, sweet, in parting. One. Life has opened anew for me. You are the solvent of my whole being. You are making me over into something different. I feel as though I had never lived until now. Oh, this experience! This experience. It is such a wonderful thing to have done—to have lived through."

She let him kiss her but she was too frightened and wrought to even breathe right. She was intense, emotional, strange.

"Tomorrow," he said, at the wood's edge. "Tomorrow. Sweet dreams. I shall never know peace anymore without your love."

And he watched her eagerly, sadly, bitterly, ecstatically, as she walked lightly from him, disappearing like a shadow through the dark and silent door.

CHAPTER LXXXIII

It would be impossible to describe even in so detailed an account as this the subtleties, vagaries, beauties, and terrors of the emotions which seized upon him and which by degrees began also to possess Suzanne once he had become wholly infatuated with her. Mrs. Dale was, after a social fashion, one of Eugene's best friends. She had, since she had first come to know him, spread his fame far and wide as an immensely clever publisher and editor, an artist of the greatest power, and a man of lovely and delightful ideas and personal worth. He knew from various conversations with her that Suzanne was the apple of her eye. He had heard her talk—had discussed with her, in fact—of the difficulties of rearing a simple mannered, innocent minded girl in present day society. She had confided to him that it had been her policy to give Suzanne the widest liberty consistent with good breeding and current social theories. She did not want to make her bold or unduly self-reliant and yet she wanted her to be free and natural. Suzanne, she suspected from long observation and many frank conversations, was innately honest, truthful, and clean minded. She did not understand her exactly, for what mother can clearly understand any child; but she thought she knew enough about her to know that she was in some uncertain way forceful and able, like her father in the bargain, and that she would naturally gravitate to what was worthwhile in life.

Had she any talent? Mrs. Dale really did not know. The girl had vague yearnings toward something which was anything but social in its quality. She did not care anything at all for most of the young men and women she met. She went about a great deal but it was to ride and drive. Games of chance did not interest her. Drawing room conversations were amusing to her but

not gripping. She liked interesting characters, able books, striking pictures. She had been particularly impressed with those of Eugene's she had seen and had told her mother that they were wonderful. She loved poetry of a high order and was possessed of a boundless appetite for the ridiculous and the comic. An unexpected faux pas was apt to throw her into uncontrollable fits of laughter and the funny pages sketches of the current newspaper artists, when she could obtain them, amused her intensely. She was a student of character, and of her own mother, and was beginning to see clearly what were the motives which were prompting her mother in her attitude toward herself, quite as clearly as that person did herself and better. At bottom she was a bigger woman than her mother, mentally and spiritually, but she was not as yet as self controlled or as understanding of current theories and beliefs. She was truly large-minded, but young—artistic, emotional, excitable in an intellectual way, capable of high flights of fancy and of intense and fine appreciations. Her really sensuous beauty was nothing to her. She did not value it highly. She knew she was beautiful and that men and boys were apt to go wild about her but she did not care. They must not be so silly, she thought. She did not attempt to attract them in any way—on the contrary, she avoided every occasion of possible provocation. Her mother had told her plainly how susceptible men were, how little their promises meant, how careful she must be of her looks and actions. In consequence, she went her way as gaily and yet as inoffensively as she could, trying to avoid the sadness of entrancing anyone hopelessly and wondering what her career was to be. Then Eugene appeared.

With his arrival, Suzanne had almost unconsciously entered upon a new phase of her existence. She had seen all sorts of men in society but those who were exclusively social were exceedingly wearisome to her. She had heard her mother say that it was an important thing to marry money and some man of distinguished social standing but who this man was to be and what he was to be like she did not know. She did not look upon the typical society men she had encountered as answering suitably to the term distinguished. She had seen some celebrated moneyed men of reigning families but they did not seem to her to be really human enough to be worthwhile. Most of them were cold, self-opinionated, over refined for her easy, poetic spirit. In the realm of real distinction were many men whom the papers constantly talked about, financiers, politicians, authors, editors, scientists, some of whom were in society, she understood, but most of whom were not. She had met a few of them as a girl might. Most of those she met or saw were old and cold and paid no attention to her whatsoever. Eugene had appeared, trailing an atmosphere of distinction and acknowledged ability, and he was young. He was good looking too—laughing and gay. It seemed

almost impossible at first to her that one so young and smiling should be so able, as her mother said. Afterwards, when she came to know him, she began to feel that he was more than able—that he could do anything he pleased. She had seen him once in his office, accompanied by her mother, and she had been vastly impressed by the great building, its artistic finish, Eugene's palatial surroundings. Surely he was the most remarkable young man she had ever known. Then came his incandescent attentions to her—his glowing radiant presence and then——

Eugene speculated deeply on how he should proceed. All at once, after this night, the whole problem of his life came before him. He was married; he was highly placed socially, better than he had ever been before. He was connected closely with Colfax—so closely that he feared him, for Colfax, in spite of certain emotional variations of which Eugene knew, was intensely conventional. Whatever he did was managed in the most offhand way and with no intention of allowing his home life to be affected or disrupted. Winfield, whom also Mrs. Dale knew, was also conventional, to outward appearances. He had a mistress but she was held tightly in check, he understood. Eugene had seen her at the new casino, or a portion of it—the East Wing, recently erected at Blue Sea—and he had been greatly impressed with her beauty. She was chic, distingué, dashing, daring. Eugene looked at her then, wondering if the time would ever come when he could dare an intimacy of that character. So many monied men did. Would he ever attempt it and succeed?

Now that he had met Suzanne, however, he had a different notion of all this and it had come over him all at once. Heretofore in his dreams he had fancied he might strike up an emotional relationship somewhere which would be something like Winfield's toward Miss DeKalb, as she was known, and so satisfy the weary longing that was in him for something fine and delightful in the way of a sympathetic relationship toward beauty. Since seeing Suzanne he wanted nothing of this but only some readjustment or rearrangement of his life whereby he could have Suzanne and Suzanne only. Suzanne! Suzanne! Oh, that dream of beauty. How was he to obtain her—how free his life of all save a beautiful relationship to her? He could live with her forever and ever. He could! He could! Oh, the vision, the dream!

It was the Sunday morning following the dance that Suzanne and Eugene managed, or devised, another day together. It was one of those semi-accidental, semi-voiceless series of coincidences and mutual acceptances which were not wholly agreed upon or understood at the beginning, but were nevertheless seized upon, accepted silently and semi-consciously, semi-unconsiously worked out together. Had they had not been strongly drawn to each other, this would never have happened at all. To begin

with, Mrs. Dale was suffering from a sick headache the morning after. In the next place, Kinroy suggested that he and his friends go for a lark to South Beach, which was one of the poorest and scrubbiest of all beaches on Staten Island. In the next place, Mrs. Dale suggested that Suzanne be allowed to go and that perhaps Eugene would be amused. She rather trusted him as a guide and mentor.

Eugene stated calmly that he did not object. He was eager to be anywhere alone with Suzanne, and he fancied that some opportunity would present itself whereby, once they were there, they could be together, but he did not want to show it. Once more the car was called and they departed, being let off at one end of the silly panorama which stretched its shabby length for a mile along the shore. The chauffeur took the car back to the house, it having been agreed that they could reach him by phone. The crowd started down the plank walk but almost immediately, because of different interests, divided. Eugene and Suzanne stopped to shoot at a shooting gallery. Next they stopped at a cane rack to ring canes. Anything was delightful to Eugene which gave him an opportunity to observe his inamorata, to see her pretty face, her smile, and hear her, to him, heavenly voice. She rung a cane for him. Every gesture of hers was perfection; every look a thrill of delight. He was walking in some elysian realm which had nothing to do with the tawdry evidence of life about him.

They followed the boardwalk southward after a ride in the Devil's Whirlpool, for by now Suzanne was caught in the persuasive subtlety of his emotion and could no more do as her honest judgement would have dictated than she could have flown. It needed some shock, some discovery, to show her whether she was drifting, and this was absent. They came to a raw dance hall where a few servant girls and their sweethearts were dancing, and for a lark Eugene proposed that they enter. They danced together again, and though the surroundings were so poor and the music wretched, Eugene was in heaven.

"Let's run away and go down to the Terra Marine," he suggested. "It's so much nicer there. It's so beautiful. This is all so bad."

"Where is it?" asked Suzanne.

"Oh, about three miles south of here. We could almost walk there."

He looked down the long hot beach, but changed his mind.

"I don't mind this," said Suzanne. "It's so very bad that it's good, you know. I like to see how shabby life can be."

"But it is *so* bad," argued Eugene. "I wish I had your fine, healthy attitude toward things. Still, we won't go if you don't want to."

Suzanne paused, thinking. Should she run away with him? The others would be looking for them, no doubt—had wondered where they had gone

already. Still, it didn't make so much difference. Her mother trusted her with Eugene. They could go.

"Well," she said finally, "I don't care. Let's."

"What will the others think?" he asked doubtfully.

"Oh, they won't mind," she said. "When they're ready, they'll call the car. They know that I am with you. They know I can get the car when I want it. Mamá won't mind."

Eugene led the way back to a train connection which made for Huguenot—their destination. He was beside himself with the thought of a day all alone with Suzanne. He did not stop to think or give ear to the thoughts concerning Angela at home or what Mrs. Dale would think. Nothing would come of it. It was a plausible adventure. They took the train south and in a little while were in another world—on the veranda of a hotel that overlooked the sea. There were numerous autos of idlers like themselves in a court before the hotel. There was a great grassy lawn with swings covered by striped awnings of red and blue and green, and beyond that a pier with many little white launches anchored near. The sea was as smooth as glass, and great steamers rode in the distance, trailing lovely plumes of smoke. The sun was blazing hot—brilliant—but here on the cool porch, waiters were serving pleasure lovers with food and drink. A quartette of negroes was singing. Suzanne and Eugene sat down in rockers at first to view the perfect day, and later went and sat in a swing.

Unthinkingly, without words, these two were gradually gravitating toward each other in some spell which had no relationship to everyday life. Suzanne looked at him in the double seated swing where they sat facing each other and they smiled or jested aimlessly, voicing nothing of all the upward-welling deep that was stirring within.

"Was there ever such a day?" said Eugene finally and in a voice that was filled with intense yearning. "See that steamer out there? It looks like a little toy."

"Yes," said Suzanne with a little gasp. She inhaled her breath as she pronounced this word, which gave it an airy breathlessness which had a touch of divine pathos in it. "Oh, it is perfect."

"Your hair," he said. "You don't know how nice you look. You fit this scene exactly."

"Don't speak of me," she pleaded. "I look so badly. The wind on the train blew my hair so. I ought to go to the ladies' dressing room and hunt up a maid."

"Stay here," said Eugene "Don't go. It is all so lovely."

"I won't, now. I wish we might always sit here, you just as you are there, and I here."

"Did you ever read the 'Ode on a Grecian Urn'?"

"Yes."

"Do you remember the line, 'Fair youth beneath the trees thou canst not leave'?"

"Yes, yes," she answered ecstatically.

> "'Bold Lover, never, never canst thou kiss,
> Though winning near the goal—yet, do not grieve;
> She cannot fade, though thou hast not thy bliss,
> For ever wilt thou love and she be fair!'"

"Don't, don't," she pleaded.

He understood. The pathos of that great thought was too much for her. It hurt her as it did him. What a mind.

They rocked and he sang idly and she joined him at times. They strolled up the beach and sat down on a green clump of grass overlooking the sea. Idlers approached at times and passed. He laid his arm to her waist and held her hand but something in her mood staid him from any expression. Through dinner at the hotel it was the same and on the way to the train, for she wanted to walk through the dark. Under some tall trees though, in the rich moonlight, prevailing, he pressed her hand.

"Oh, Suzanne," he said.

"No, no," she breathed, drawing back.

"Oh, Suzanne," he repeated, "may I tell you?"

"No, no," she answered. "Don't speak to me. Please don't. Let's just walk, you and I."

He hushed, for her voice, though sad and fearsome, was imperious. He could not do less than obey this mood.

They went to a little country platform which ranged along the track in lieu of a depot, and sang a quaint air from some old time comic opera.

"Do you remember yesterday when we were playing?" he asked.

"Yes."

"Do you know, I felt a strange vibration before your coming and all during your playing. Did you?"

"Yes."

"What is that, Suzanne?"

"I don't know."

"Do you want to know?"

"No, no, Mr. Witla, not now."

"Mr. Witla?"

"It must be so."

"Oh, Suzanne!"

"Let's just think," she pleaded. "It is so beautiful."

They came to a station near Dalewood and walked over. On the way he slipped his arm about her waist but oh, so lightly.

"Suzanne," he asked, with a terrible yearning ache in his heart, "do you blame me? Can you?"

"Don't ask me," she pleaded. "Not now. No, no" (he tried to press her a little more closely), "not now. I don't blame you."

He stopped as they neared her lawn and entered the house with a jesting air. Explanations about a mix up in the crowd were so easy. Mrs. Dale smiled good naturedly. Suzanne went to her room and he saw her no more. The next morning when he arose he dined with Mrs. Dale alone. Kinroy and Suzanne had departed early for White Plains.

CHAPTER LXXXIV

Having involved himself thus far, seized upon and made his own this perfect flower of life, Eugene had but one thought and that was to retain it. Now, of a sudden, had fallen from him all the weariness of years. To be in love again. To be involved in such a love—so wonderful, so perfect, so exquisite—it did not seem that life could really be so gracious as to have yielded him so much. What did it all mean—his upward rise during all these recent years? There had been seemingly but one triumph after another since those bitter days in Riverwood and after. The *World*, Summerfield's, The Kalvin Company, The United Magazines Corporation, Winfield, his beautiful apartment on the Drive. Surely the gods were good. What did they mean? To give him fame, fortune, and Suzanne into the bargain? Could such a thing really be? How could it be worked out? Would fate conspire and assist him so that he should be free of Angela—or——

The thought of Angela to him these days was a great pain. At bottom Eugene really did not dislike her—he never had. Years of living with her had produced an understanding and a relationship as strong and as keen as it might be, in some respects. Angela had always fancied since the Riverwood days that she really did not love Eugene truly any more—could not; that he was too self centered and selfish; but this on her part was more of an illusion than a reality. She did care for him in an unselfish way from one point of view, in that she would sacrifice everything to his interests. From another point of view it was wholly selfish, for she wanted him to sacrifice everything for her in return. This he was not willing to do and had never been. He considered that his life was a bigger thing than could be encom-

passed by any single matrimonial relationship. He wanted freedom of action and companionship but he was afraid of Angela, afraid of society, in a way afraid of himself and what positive liberty might do to him. He felt sorry for Angela—the intense suffering she would endure if he forced her in some way to release him—and at the same time he felt sorry for himself. This lure of beauty had never for one moment during all these years of upward mounting effort been stilled.

It is curious how things seem to conspire at times to produce a climax. One would think that tragedies are somewhat like plants and flowers which are planted as a seed and grow by various means and aids to a terrible maturity. Roses of hell are some lives, and they shine with all the lustre of infernal fires.

In the first place, Eugene now began to neglect his office work thoroughly for he could not fix his mind upon it any more than he could upon the affairs of the Sea Isle Company, as it was known among the stock holders, or upon his own home and Angela's illness. The morning after his dramatic love declaration to Suzanne and her equally dramatic love confession to him, he saw her for a little while upon the veranda of the Hadleys' country place. She was not seemingly depressed or at least not noticeably so, and yet there was a gravity about her which indicated that a marked impression of some kind had been made upon her soul. She looked at him with wide frank eyes as she came out to him purposely to tell him that she was going with her mother and some friends to Tarrytown for the day.

"I have to go," she said. "Mamá has arranged it by phone."

"Then I won't see you any more here?"

"No."

"Do you love me, Suzanne?"

"Oh, yes, yes!" she declared and walked warily to an angle of the wall where they could not be seen.

He followed her quickly—cautiously.

"Kiss me," he said, and she put her lips to his in a distraught, frightened way. Then she turned and walked briskly off and he admired the robust swinging charm of her body. She was not tall like he was, nor small like Angela, but middle sized, full bodied, vigorous. He imagined now that she had a powerful soul in her capable of great things—full of courage and strength. Once she were a little older she would be very forceful and full of able, notable thoughts.

He did not see her again for nearly ten days and by that time he was nearly desperate. He was wondering all the time how he was to arrange this. He could not go on in this haphazard way, seeing her occasionally. Why, she might leave town for the fall a little later and then what would he do? If her

mother heard, she would pack her off to Europe and then would Suzanne forget? What a tragedy that would be! No, before that should happen he would run away with her. He would cash in all his means and leave. He could not live without her, he thought—he must have her; at any cost. What did the United Magazines Corporation amount to anyhow? He was tired of that work. Angela might have the Sea Island Realty Company's stock if he could not cash it, or if he could, he would make provision for her out of what he should receive. He had some ready money—a few thousand dollars. This and his art—he could still paint—would sustain them. He would go to England with Suzanne, or France. They would be happy if she really loved him and he thought she did. All this old life could go its way. It was a dreary thing anyhow without love. These were his first thoughts.

Later he came to have saner ones but this was after he had talked to Suzanne again. It was a difficult matter to arrange. In a fit of desperation he called up Dalewood one day and asked if Miss Suzanne Dale were there. A servant answered, and in answer to the "Who shall I say?" he gave the name of a young man that he knew Suzanne knew. When she answered, he said, "Listen, Suzanne. Can you hear me very well?"

"Yes."

"Do you recognize my voice?"

"Yes."

"Please don't pronounce my name, will you?"

"No."

"Suzanne, I am crazy to see you. It has been ten days now. Are you going to be in town long?"

"I don't know. I think so."

"If anyone comes near you, Suzanne, simply hang up the receiver and I will understand."

"Yes."

"If I come anywhere near your house in a car could you come out and see me?"

"I don't know."

"Oh, Suzanne."

"I'm not sure. I'll try. What time?"

"Do you know where the old fort road is, at Crystal Lake, just below you?"

"Yes."

"Do you know where the ice house is near the road there?"

"Yes."

"Could you come there?"

"What time?"

"At eleven tomorrow morning, or two this afternoon, or three."

"I might at two today."

"Oh, thank God for that. I'll wait for you anyhow."

"All right. Good-bye."

And she hung up the receiver.

Eugene rejoiced, without thinking at first, at the fortunate outcome of this effort and then later began to wonder at the capable manner in which she had handled this situation or rather unexpected conversation which must have been very trying to her. This love of his was so new to her. Her situation was so very difficult. And yet on this first call when she had been suddenly put in touch with him she had shown no signs of trepidation. Her voice had been firm and even, much more so than his, for he was nervously excited. She had taken in the situation at once and fallen into the ruse quite readily. Was she as simple as she seemed? Yes and no. She was simply capable, he thought, and her capability had acted through her natural simplicity instantly.

At two that same day Eugene was there. He gave as an excuse to his secretary that he was going out for a business conference with a well known author whose book he wished to obtain and, calling a closed auto, but one not his own, journeyed to the rendezvous. He asked the man to drive down the road, making two and fro trips of a half mile each, while he sat in the shade of a clump of trees out of view of the road. Presently Suzanne came, bright, as fresh as the morning, beautiful in a light purple walking suit, exquisitely designed. She had on a large, soft-brimmed hat of the same shade with feathers to match, which became her exquisitely. She walked, he thought, with such an air of grace and freedom and yet when he looked into her eyes he saw a touch of trouble there.

"At last," he said, signalling her and smiling. "Come in here. My car is just up the road. Don't you think we had better get in that? It's closed. We might be seen. How long can you stay?"

He took her in his arms and kissed her eagerly while she explained that she could not stay long. She had said she was going to the library, which her mother had endowed, for a book. She must be there by half past three or four at the latest.

"Oh, we can talk a great deal by then," he said gaily. "Here comes the car. Let's get in."

He looked cautiously about, hailed it, and they stepped in quickly as it drew up. "Perth Amboy," said Eugene, and they were off at high speed.

Once in the car all was perfect for they could not be seen. He drew the shades partially and gathered her in his arms.

"Oh, Suzanne," he said, "how long it has seemed. How very long. Do you love me?"

"Yes. You know I do."

"Suzanne, how shall we arrange this? Are you going away soon? I must see you oftener."

"I don't know," she said. "I don't know what mamá is thinking of doing. I know she wants to go up to Lenox in the fall."

"Oh, pshaw!" commented Eugene wearily.

"Listen, Mr. Witla," said Suzanne thoughtfully. "You know we are running a terrible risk. What if Mrs. Witla should find out, or mamá? It would be terrible."

"I know it," said Eugene. "I suppose I ought not be acting this way. But, oh, Suzanne, I am wild about you. I am not myself anymore. I don't know what I am. I only know that I love you, love you, love you."

He gathered her in his arms and kissed her ecstatically. "How sweet you look! How beautiful you are. Oh, Flower Face! Myrtle Bloom! Angel Eyes! Divine Fire!" He hugged her in a long silent embrace, the while the car sped on.

"But what about us?" she asked, wide eyed. "You know we are running a terrible risk. I was just thinking this morning when you called me up. It's dangerous, you know."

"Are you becoming sorry, Suzanne?"

"No."

"Do you love me?"

"You know I do!"

"Then you will help me figure this out."

"I want to. But listen, Mr. Witla—now listen to me. I want to tell you something." She was very solemn and quaint and sweet in this mood.

"I'll listen to anything, baby mine, but don't call me Mr. Witla. Call me Eugene, will you?"

"Well now, listen to me, mister—mister Eugene."

"Not Mr. Eugene. Just Eugene. Now say it! 'Eugene'"—he quoted his own name to her.

"Now listen to me—Mister—now listen to me, Eugene," she at last forced herself to say, and Eugene stopped her lips with his mouth.

"There," he said.

"Now listen to me," she went on urgently. "You know, I'm afraid. Mamá will be terribly angry if she finds this out."

"Oh, will she?" interrupted Eugene jocosely.

Suzanne paid no attention to him.

"We have to be very careful. She likes you so much now that if she doesn't come across anything direct, she will never think of anything. She was talking about you only this morning."

"What was she saying?"

"Oh, what a nice man you are, and how able you are."

"Oh, nothing like that," replied Eugene jestingly.

"Yes, she did. And I think Mrs. Witla likes me. I can meet you sometimes when I'm here, but we must be so careful. I mustn't stay out long today. I want to think some more, too. You know I'm having a real hard time thinking about this."

Eugene smiled. Her innocence was so delightful to him—so naive.

"What do you mean by thinking some more, too, Suzanne?" asked Eugene curiously. He was interested in the workings of her young mind, which seemed so fresh and wonderful to him. It was so delightful to find this paragon of beauty so responsive, so affectionate and helpful, and withal, so thoughtful. She was somewhat like a delightful toy to him and he held her as reverently in awe as though she were a priceless vase.

"You know I want to think what I'm doing. I have to. It seems so terrible to me at times and yet you know, you know——"

"I know what?" he asked, when she paused.

"I don't know why I shouldn't if I want to—if I love you."

Eugene looked at her curiously. This subtle analysis of life, particularly in relation to so trying and daring a situation as this, astonished him. He had fancied Suzanne more or less thoughtless and formless as yet—big potentially, but uncertain and vague. Here she was thinking about this most difficult problem almost more directly than he was, and apparently with more courage. He was astounded but, more than that, intensely interested. What had become of her terrific fright of ten days before? What was it she was thinking about exactly?

"What a curious girl you are," he said.

"Why am I?" she asked.

"Because you are. I didn't think you could think so keenly yet. I thought you would—but—how have you reasoned this out?"

"Did you read *Anna Karenina?*" she asked him, meditatively.

"Yes," he said, wondering that she should have read it at her age.

"What did you think of that?"

"Oh, it shows what happens as a rule, when you fly in the face of convention," he said easily, wondering at the ability of her brain.

"Do you think things must happen that way?"

"No, I don't think they must happen that way. There are lots of cases where people do go against the conventions and succeed. I don't know. It appears to be all a matter of time and chance. Some do and some don't. If you are big enough to 'get away with it,' as they say, you will. If you aren't, you won't. What makes you ask?"

"Well," she said pausing, her lips parted, her eyes fixed on the floor, "I

was thinking that it needn't necessarily be like that, do you think? It could be different?"

"Yes, it could be," he said, thoughtfully, wondering if it really could.

"Because if it couldn't," she went on, "the price would be too high. It isn't worthwhile."

"You mean—you mean," he said, looking at her, "that you would——." He was thinking that she was deliberately contemplating making a sacrifice of herself for him. Something in her thoughtful, self-debating, meditative manner made him think so.

Suzanne looked out of the window and slowly nodded her head. "Yes," she said, solemnly. "If it could be arranged. Why not? I don't see why."

Her face was a perfect blossom of beauty as she spoke. Eugene wondered whether he was waking or sleeping. Suzanne reasoning so! Suzanne reading *Anna Karenina* and philosophizing so! Basing a course of action on theorizing in connection with books and life! And in the face of such terrible evidence as Anna Karenina presented, to the contrary of Suzanne's proposition. Would wonders never cease?

"You know," she said after a time, "I think mamá wouldn't mind, Eugene. She likes you. I've heard her say so lots of times. Besides, I've heard her talk this way about other people. She thinks people oughtn't to marry unless they love each other very much—I don't think she thinks it's necessary for people to marry at all unless they want to. We might live together if we wished, you know."

Eugene himself had heard Mrs. Dale question the marriage system but only in a philosophic way. He did not take much stock in her social maunderings. He did not know what she might be privately saying to Suzanne but he did not believe it could be very radical—or at least seriously so.

"Don't you take any stock in what your mother says, Suzanne," he observed, studying her pretty face. "She doesn't mean it—at least she doesn't mean it so far as you are concerned. She's merely talking. If she thought anything were going to happen to you, she'd change her tune pretty quick."

"No, I don't think so," replied Suzanne thoughtfully. "You know, I think I know mamá better than she knows herself—I know her better than you do. She always talks of me as a little girl but I can rule her in lots of things. I've done it."

Eugene stared at Suzanne in amazement. He could scarcely believe his ears. She was beginning so early to think so deeply on the social and executive sides of life. Why should her mind be trying to dominate that of her mother?

"Suzanne," he observed, "you must be careful what you do or say. Don't you rush into talking of this, pell mell. It's dangerous. I love you but we will

have to go slow. If Mrs. Witla should learn of this she would be crazy. If your mother should suspect she would take you away to Europe somewhere, very likely. Then I wouldn't get to see you at all."

"Oh no, she wouldn't," replied Suzanne determinedly. "You know, I know mamá better than you think I do. I can rule her, I tell you. I know I can. I've done it."

She tossed her head in an exquisitely pretty way which upset Eugene's reasoning faculties. He could not think and look at her.

"Suzanne," he said, drawing her to him, "you are exquisite, extreme. You are the last word in womanhood to me. To think of your reasoning so—you, Suzanne."

"Why, why," she asked with pretty parted lips and uplifted eyebrows, "why shouldn't I? I think."

"Oh, yes, certainly, we all do, but not so deeply, necessarily, Flower Face."

"Well, we must think now," she said swiftly.

"Yes, we must think now," he replied. "Would you really share a studio with me if I were to take one? I don't know of any other way quite at present."

"I would if I knew how," she replied. "Mamá is queer. She's so watchful. She thinks I'm a child and you know I'm not at all. I don't understand mamá. She talks one thing and does another. Still, I think I can fix it. You leave it to me."

"And if you can, you'll come to me."

"Oh, yes, yes," exclaimed Suzanne ecstatically, turning to him all at once and catching his face between her hands. "Oh!" She looked into his eyes and dreamed.

"But we must be careful," he cautioned. "We mustn't do anything rash."

"I won't," said Suzanne.

"And I won't, of course," he replied.

They paused again while he watched her.

"I might make friends with Mrs. Witla," she observed after a time. "She likes me, doesn't she?"

"Yes," said Eugene.

"Mamá doesn't object to my going up there and I could let you know."

"That's all right. Do that," said Eugene. "Oh, please do, if you can. Did you notice whose name I used today?"

"Yes," she said. "You know Mr. Witla—Eugene—I thought you might call me up."

"Did you?" he asked, smiling.

"Yes."

"You give me courage, Suzanne," he said, drawing close to her. "You're so confident, so apparently carefree. The world hasn't touched your spirits!"

"When I'm away from you, though, I'm not so courageous," she replied. "I've been thinking terrible things. I get frightened sometimes."

"But you mustn't, sweet—I need you so. Oh, how I need you."

She looked at him and for the first time smoothed his hair with her hand.

"You know—Eugene—you're just like a boy to me."

"Do I seem so?" he asked, comforted greatly.

"I couldn't love you as I do, if you weren't."

He drew her to him again and kissed her more.

"Can't we repeat these rides, every few days?" he asked.

"Yes, if I'm here, maybe."

"Is it all right to call you up, if I use another name?"

"Yes, I think so."

"Let's choose new names for each other so that we'll know who's calling." They agreed on Jenny Lind and Allen Poe. Then they fell to ardent lovemaking until the time came when they had to return. For him, so far as work was concerned, the afternoon was gone.

CHAPTER LXXXV

There followed now a series of meetings contrived with difficulty, fraught with danger, destructive of his peace of mind, of his recently acquired sense of moral and commercial responsibility, of his sense of singleness of purpose and interest in his editorial and publishing world, which had helped him so much recently. The meetings nevertheless were full of such intense bliss for him that it seemed as though he were a thousand times repaid for all the subtlety, evil, and folly he was practising. There were times when he came to the ice house in a hired car, others when she notified him by phone or note to his office of times when she was coming in town to shop. He took her in his car one afternoon to Blue Sea when he was sure no one would encounter him. He persuaded Suzanne to carry a heavy veil which could be adjusted at odd moments. Another time, several in fact, she came to the apartment in Riverside Drive, ostensibly to see how Mrs. Witla was getting along but really, of course, to see Eugene. Suzanne did not really care so much for Angela, though she did not dislike her. She thought she was an interesting woman, though perhaps not a happy mate for Eugene.

The latter had told her not so much that he was unhappy as that he was out of love. He loved her now, Suzanne, and only her.

The problem as to where this relationship was to lead was complicated by another problem which Eugene knew nothing of but which was exceedingly important. For Angela, following the career of Eugene with extreme pleasure, satisfaction, and enthusiasm on the commercial side, and with fear and distrust on the social and emotional sides, had finally decided to risk the uncertain outcome of a child in connection with Eugene and herself and to give him something which would steady his life, make him realize his responsibilities, and give him something to take joy in besides social entertainment and the lure of beauty in youth. She had never forgotten the advice which Mrs. Sanifore and her physician had given her in Philadelphia, nor had she ever ceased her cogitations as to what the probable effect of a child would be. Eugene needed something of this sort to balance him. His position in the world was too tenuous; his temperament too variable. A child—a little girl, she hoped, for he always liked very little girls and made much of them—would quiet him. If she could only have a little girl now!

Some two months before, while Eugene was becoming (all unwitting to her) so enthusiastic about Suzanne, Angela had relaxed or rather abandoned her old time precautions entirely and had recently begun to suspect that her fears or hopes or both were about to be realized. She was not very happy from her own personal point of view and very uncertain as to how Eugene would take it—he had never expressed a desire for a child. She had no thought of telling him as yet for she wanted to be absolutely sure. If she were not correct in her suspicions, he would attempt to dissuade her for the future. If she were, he could not help himself. Like all women in that condition, she was beginning to long for sympathy and consideration and to note more keenly the drift of Eugene's mind toward a world which did not very much concern her. His interest in Suzanne had puzzled her a little, though she was not greatly concerned about her because Mrs. Dale appeared to be so thoughtful about her daughter. Times were changed. Eugene had so much more to do. His responsibilities were in a way safeguards. Nevertheless she was intensely suspicious and this one interest attracted her attention. A child would help. It was high time it came.

Eugene and Suzanne, however, planned so very badly, or rather it must be said that they scarcely planned at all, that when Angela was ready to play her card it was complicated with much which she little anticipated. When Suzanne had first begun coming with her mother, Angela thought nothing of it, but on the several occasions when Suzanne called during her illness and Eugene had been present, she felt as though there might eas-

ily spring up something between them. Suzanne was so charming. Once as she lay thinking after Suzanne had left the room to go into the studio for a few moments, she heard Eugene jesting with her and laughing keenly. Suzanne's laugh, or gurgling giggle, was most infectious. It was so easy, too, for Eugene to make her laugh, for his type of jesting was to her the essence of fun. It seemed to Angela that there was something almost overly gay in the way they carried on. On each occasion, too, Eugene proposed that he take Suzanne home in his car, and this set her thinking.

There came a time when, Angela being well enough from her rheumatic attack, Eugene invited a famous singer—a tenor who had a charming repertoire of songs—to come to his apartment and sing. He had met him at a social affair in Brooklyn with which Winfield had something to do. A number of people were invited in. Mrs. Dale, Suzanne, and Kinroy were invited, but Mrs. Dale could not come and as Suzanne had an appointment for the next morning, Sunday, in the city, she decided to stay at the Witlas'. This pleased Eugene immensely. He had bought a sketching book which he had begun to fill with artistic sketches of Suzanne from memory and these he wanted to show her. Besides, he wanted her to hear this, to him, beautiful voice.

The company was interesting. Kinroy brought Suzanne early and left. Eugene and Suzanne, after she had exchanged greetings with Angela, sat out on the little stone balcony overlooking the river and exchanged loving thoughts. He was constantly holding her hand when no one was looking and stealing kisses. After a time the company began to arrive and finally the singer himself. The trained nurse, with Eugene's assistance, helped Angela forward, who listened enraptured to the songs. Suzanne and Eugene, swept by the charm of such songs as "Oh, That We Two Were Maying," "Obstination," "Es War Ein Traum," looked at each other with that burning gaze which love alone understands. To Eugene, Suzanne's face was a perfect flower of hypnotic influence. He could scarcely keep his eyes off her for a moment at a time. The singer ceased, the company departed. Angela was left crying over the beauty of "The Erlking," the last song rendered. She went back to her room and Suzanne ostensibly departed for hers. She came out to say a few final words to Mrs. Witla, then came through the studio to go to her own room again. Eugene was there waiting. He caught her in his arms, kissing her silently. They pretended to strike up a conventional conversation and he invited her to sit out on the stone balcony for a few last moments. The moon was so beautiful over the river.

"Don't," she said when he gathered her in arms in the shadow of the night outside. "She might come."

"No," he said eagerly.

They listened but there was no sound. He began an easy pretence of talk, the while stroking her pretty arm which was bare. Insanity over her beauty, the loveliness of the night, the charm of the music, had put him beside himself. He drew her into his arms in spite of her protest, only to have Angela suddenly appear at the other end of the room where the door was. There was no concealing anything—she saw. She came rapidly forward, even as Suzanne jumped up, a sickening rage in her heart, a sense of her personal condition strong in her mind, a sense of something terrible and climacteric in the very air, but she was still too ill to risk a great demonstration or to declare herself fully. It seemed now as though, once more, the world had fallen about her ears, for because of her plans and in spite of all her suspicions, she had not been ready to believe that Eugene would really trespass again. She had come to surprise him if possible, but she had not actually expected it—had hoped not to. Here was this beautiful girl, the victim of his wiles, and here was she, involved by her own planning, while Eugene, shamefaced she supposed, stood by ready to have this ridiculous liaison nipped in the bud. She did not propose to expose herself to Suzanne if she could help it, but sorrow for herself, shame for him, pity for Suzanne in a way, the desire to preserve the shell of appearances which was now, after this, so utterly empty for her though so important for the child, caused her to swell with her old-time rage and yet to hold it in check. Six years before she would have raged to his face—but time had softened her in this respect. She did not see the value of brutal words.

"Suzanne!" she said, standing erect in the filtered gloom of the room which was still irradiated by the light of the moon in the west. "How could you? I thought so much better of you!"

Her face, thinned by her long illness and her brooding over her present condition, was still beautiful in a spiritual way. She wore a pale yellow and white flowered dressing gown of filmy, lacy texture, and her long hair, done in braids by the nurse, was hanging down her back, making her look like the Gretchen she was to him years before. Her hands were thin and pale but artistic and her face drawn in all the wearisome agony of a mater dolorosa.

"Why, why," exclaimed Suzanne, terribly shaken out of her natural poise for the moment but not forgetful of the dominating thought in her mind. "I love him, that's why, Mrs. Witla."

"Oh, no you don't. You only think you love him, as so many women have before you, Suzanne," said Angela frozenly, the thought of the coming child always with her. If she had only told him before. "Oh, shame, in my house, and you a young, supposedly innocent girl. What do you suppose your mother would think if I should call her up and tell her now? Or your brother?

You know Mr. Witla is a married man. I might excuse you if it weren't for that—if you hadn't known me and hadn't accepted my hospitality. As for him—there is no need of my talking to him. This is an old story with him, Suzanne. He has done this with other women before you and he will do it with other women after you. It is one of the things I have to bear for having married a man of so-called talent. Don't think, Suzanne, when you tell me you love him, that you tell me anything new. I have heard that story before from other women. You are not the first and you will not be the last."

Suzanne looked at Eugene inquiringly, vaguely, helplessly, wondering if all this were so.

Eugene hardened under Angela's cutting accusation but he was not at all sure at first what he ought to do. He wondered for the moment whether he ought to abandon Suzanne and fall back into his old state, dreary as it might seem to him, but the sight of her pretty face, the sound of Angela's cutting voice, determined him quickly.

"Angela," he began, recovering his composure the while Suzanne contemplated him. "Why do you talk that way? You know that what you say isn't true. There was one other woman. I will tell Suzanne about her. There were several before I married you. I will tell her about them. But my life is a shell, and you know it. This apartment is a shell. Absolutely it means nothing at all to me. There has been no love between us, certainly not on my part, for years, and you know that. You have practically confessed to me from time to time that you do not care for me. I haven't deceived this girl—I am glad to tell her now how things stand."

"How things stand! How things stand!" exclaimed Angela, blazing and forgetting herself for the moment. "Will you tell her what an excellent, faithful husband you have made me? Will you tell her how honestly you have kept your word pledged me at the altar? Will you tell her how I have worked and sacrificed for you through all these years? How I have been repaid by just such things as this? I'm sorry for you, Suzanne, more than anything else," went on Angela, wondering whether she should tell Eugene here and now of her condition but fearing he would not believe it. It seemed so much like melodrama. "You are just a silly little girl duped by an expert man, who thinks he loves you for a little while but who really doesn't. He will get over it. Tell me frankly what do you expect to get out of it all? You can't marry him. I won't give him a divorce. I can't, as he will know later, and he has no grounds for obtaining one. Do you expect to be his mistress? You have no hope of ever being anything else. Isn't that a nice ambition for a girl of your standing? And you are supposed to be virtuous. Oh, I am ashamed for you, if you are not. I am sorry for your mother. I am astonished to think that you would so belittle yourself."

Suzanne had heard the "I can't," but she really did not know how to interpret it. It had never occurred to her that there could ever be a child here to complicate matters. Eugene had told her that he was unhappy, that there was nothing between him and Angela, and never could be.

"But I love him, Mrs. Witla," said Suzanne simply, and rather dramatically. She was tense, erect, pale, and decidedly beautiful. It was a great problem to have so quickly laid upon her shoulders.

"Don't talk nonsense, Suzanne," said Angela, angrily and desperately. "Don't deceive yourself and strike a silly pose. You are acting now. You are talking as you think you ought to talk, as you have seen people talk in books. This is my husband. You are in my house. Come get your things. I will call up your mother and tell her how things stand and she will send her auto for you."

"Oh, no," said Suzanne, "you can't do that. I can't go back there if you tell her. I must go out in the world and get something to do until I can straighten out my affairs. I won't be able to go home anymore. Oh, what shall I do?"

"Be calm, Suzanne," said Eugene determinedly, taking her hand and looking at Angela defiantly. "She isn't going to call your mother. You are going to stay right here as you intended and tomorrow you are going where you thought you were going."

"Oh, no she isn't," said Angela angrily, starting for the phone. "I'm going to call her mother."

Suzanne stirred nervously. Eugene put his hand on hers to reassure her.

"Oh, no you aren't," he said determinedly. "She isn't going home and you are not going to touch that phone. If you do, a number of things are going to happen and they are going to happen quick."

He moved between her and the telephone receiver, which hung in the hall outside the studio and toward which she was edging.

Angela paused at the ominous note in his voice—the determined quality of his attitude. She was surprised and amazed at the almost rough manner in which he put her aside. He had taken Suzanne's hand—he, her husband—and was begging her to be calm.

"Oh, Eugene," said Angela desperately, frightened and horrified, her anger half melted in her fears, "you don't know what you are doing. Suzanne doesn't. She won't want anything to do with you when she does. Young as she is, she will have too much womanhood."

"What are you talking about?" asked Eugene desperately. He had no idea what Angela was driving at—not the faintest suspicion. "What are you talking about?" he repeated grimly.

"Let me say just one word to you alone—not here before Suzanne—just one, and then perhaps you will be willing to let her go home tonight."

Angela was subtle in this—a little bit wicked. She was not using her advantage in exactly the right spirit.

"What is it?" said Eugene sourly, expecting some trick. He had so long gnawed at the chains which bound him that the thought of any additional lengths which might be forged irritated him greatly. "Why can't you tell it here? What difference can it make?"

"It ought to make all the difference in the world. Let me say it to you alone."

Suzanne, who wondered what it could be, walked away. She was wondering what it was Angela had to tell. The latter's manner was not exactly suggestive of the weighty secret she bore. When Suzanne was gone, Angela whispered to him.

"It's a lie!" said Eugene vigorously, desperately, hopelessly. "It's something you've trumped up for this occasion. It's just like you to say that—to do it. Pah! I don't believe it. It's a lie! It's a lie! You know it's a lie!"

"It's the truth," said Angela, angrily, pathetically—outraged in her every nerve and thought by the reception which this fact had received, and desperate to think that the announcement of a coming child by him should be received in this manner, under such circumstances—that it should be forced from her as a last resort only to be received with derision and scorn. "It's the truth, and you ought to be ashamed to say that to me. What can I expect of a man, though, who would introduce another woman into his own home as you have tonight?"

To think that she should be reduced to such a situation as this, so suddenly. It was impossible to argue it with him here. She was ashamed now that she had introduced it at this time. He would not believe her anyhow—now she saw that. It only enraged him and her. He was too wild. This seemed to infuriate him—to condemn her in his mind as a trickster and a sharper—someone who was using unfair means to hold him. He almost jumped away from her in disgust and she realized that she had struck an awful blow which apparently to him had some elements of unfairness in it.

"Won't you have the decency after this to send her away?" she pleaded aloud, angrily, eagerly, bitterly.

Eugene was absolutely in a fury of feeling. If ever he thoroughly hated and despised Angela, he did so at that moment. To think that she should have done anything like this. To think that she should have complicated this problem of weariness of her with a thing like this. How cheap it was—how shabby. It showed the measure of the woman—to bring a child in the world, regardless of the interests of the child, in order to hold him against his will. Damn! Hell! God damn such a complicated, rotten world. No, she was lying. She could not hold him that way. It was a horrible, low, vile trick. He would have nothing to do with her. He would show her. He would leave her. He

would show her that this sort of thing would not work with him. It was like every other petty thing she had ever done. Never, never, never, would he let this stand in the way. Oh, what a mean, cruel, wretched thing to do.

Suzanne came back while they were arguing. She half suspected what it was all about but she did not dare to act or think clearly. The events of this night were too numerous—too complicated. Eugene had said so forcibly it was a lie, whatever it was, that she half believed him. His response was a sign surely of the affection that existed between him and Angela. Angela was not crying. Her face was hard, white, drawn.

"I can't stay here," said Suzanne dramatically to Eugene. "I must go somewhere. I had better go to a hotel for the night. Would you call a car?"

"Listen to me, Suzanne," said Eugene vigorously and determinedly. "You love me, don't you?"

"You know I do," she replied.

Angela stirred sneeringly.

"Then you will stay right here. I want you to pay no attention to anything she may say or declare. She has told me a lie tonight. I know why. Don't let her deceive you. Go to your room and your bed. I want to talk to you tomorrow. There is no need of your leaving tonight. There is plenty of room here. It's silly. You're here now. Stay. I will go to my room. You go to yours. She will go to hers."

"But I don't think I'd better stay," said Suzanne nervously.

Eugene took her hand reassuringly.

"Listen to me—" he began.

"But she won't stay," said Angela.

"But she will," said Eugene, "and if she don't stay, she goes with me. I will take her home."

"Oh, no you won't," replied Angela.

"Listen," said Eugene angrily. "This isn't six years ago, but now. I'm master of this situation and she stays right here. She stays here, or she goes with me and you look to the future as best you may. I love her. I'm not going to give her up, and if you want to make trouble, you begin right now. The house comes down on your head, not mine."

"Oh," said Angela, half terrified, "what do I hear?"

"Just that. Now you go to your room. Suzanne will go to hers. I will go to mine. We will not have any more fighting here tonight. The jig is up. The die is cast. I'm through. Suzanne comes to me, if she will."

Angela walked to her room, through the studio, stricken by the turn things had taken, horrified by the thoughts that were in her mind—unable to convince Eugene, unable to depose Suzanne, her throat dry and hot, her hands shaking, her heart beating fitfully. She felt as if her brain would burst,

her heart break actually—not emotionally. She thought Eugene had gone crazy and yet now, for the first time in her married life, she realized what a terrible mistake she had made in always trying to drive him. It hadn't worked tonight—her rage, her domineering, critical attitude. It had failed her completely and also this scheme—this beautiful plan, her trump card, on which she had placed so much reliance for a happy life, this child, which she had hoped to play so effectively. He didn't believe her. He didn't admire her for it. He despised her! He looked on it as a trick! Oh, what an unfortunate thing it had been to mention it. And yet Suzanne must understand, she must know, she would never countenance anything like this! But what would he do? He was positively livid with rage. What fine auspices these were under which to usher a child into the world. She stared feverishly before her and finally began to cry hopelessly.

Eugene stood in the hall beside Suzanne after Angela had gone. His face was drawn, his eyes hunted, his hair tousled. He looked grim and wonderful in his way—stronger than he had ever looked before.

"Suzanne," he said, taking the latter by her two arms and staring into her eyes, "she has told me a lie, a lie—a cold, cruel, mean lie. She'll tell it you shortly. She says she is with child by me. It isn't so. She couldn't have one. If she did it would kill her. She would have had one long ago if she could have. I know her. She thinks this will frighten me. She thinks it will drive you away. Will it? It's a lie, do you hear me—whatever she says. It's a lie and she knows it. Ough!" He dropped her left arm and pulled at his neck. "I can't stand this. You won't leave me—you won't believe her, will you?"

Suzanne stared into his distraught face—his handsome, desperate, significant eyes. She saw the woe here—the agony—and was sympathetic. He seemed wonderfully worthy of love—unhappy, unfortunately pursued—and yet she was frightened. Still she had promised to love him—she did love him.

"No," she said, fixedly, her eyes speaking a dramatic confidence.

"You won't leave here tonight?"

"No."

She smoothed his cheek with her hand.

"You'll come and walk with me in the morning? I have to talk with you."

"Yes."

"Don't be afraid. Just lock your door if you are. She won't bother you. She won't do anything. She is afraid of me. She may want to talk to you but I am right here. Do you still love me?"

"Yes."

"Will you come to me if I can arrange it?"

"Yes."

"Even in the face of what she says?"

"Yes. I don't believe her. I believe you. What difference could it make anyhow? You don't love her."

"No," he said, "No, no, no. I never have."

He drew her into his arms wearily, relievedly. "Oh, Flower Face," he said. "Don't give me up. Don't grieve. Try not to, anyhow. I have been bad, as she says, but I love you. I love you and I will stake all on that. If this must come down, then down it comes. I love you."

Suzanne stroked his cheek with her hands, nervously. She was deathly pale, frightened, but somehow courageous through it all. She caught strength from his love.

"I love you," she said.

"Yes," he replied. "You won't give me up?"

"No I won't," she said, not really understanding the depth of his own mood. "I will be true."

"Things will be better tomorrow," he said somewhat more quietly. "We will be calmer. We will walk and talk. You won't leave without me?"

"No."

"Please don't, for I love you and we must talk and plan."

CHAPTER LXXXVI

The introduction of this astonishing fact in connection with Angela was so unexpected, so morally diverting and peculiar, that though Eugene denied it, half believed she was lying, he was harassed by the thought that she might be telling the truth. It was so unfair, though, was all he could think—so unkind. It never occurred to him that it was accidental (as indeed it was not), but only that it was a trick, sharp, cunning, ill-timed for him, just the thing calculated to blast his career and tie him down to the old regime when he wanted so much to be free. A new life was dawning for him now, he thought. For the first time in his life he was to have a woman after his own heart, so young, so beautiful, so intellectual, so artistic. With Suzanne by his side, he was about to plumb the depths of all the joys of living. Without her, life was to be dark and dreary. Here was Angela, coming forward at the critical moment, disrupting this dream as best she could by the introduction of a child or the promise of one, that she did not want and he did not want—and all to hold him against his will. If ever he hated her for trickery and sharp dealing, as he considered this to be, he did so

now. What would the effect on Suzanne be? How would he convince her that it was a trick? She must understand—she would! She would not let this miserable piece of chicanery stand between him and her. He turned on his bed wearily after he had gone to it but he could not sleep. He had to say something—do something. So he arose, slipped on a dressing gown, and went to Angela's room.

That poor little soul, for all her determined, fighting capacity, was enduring for the second time in her life the fires of hell. To think that in spite of all her work, her dreams, this recent effort to bring about peace and happiness almost at the expense of her own life, she was compelled to witness a scene like this. Eugene was trying to get free. He was obviously determined to do so. This scandalous relationship—when had it begun? Would her effort to hold him fail? It looked that way, and yet surely Suzanne, when she knew—when she understood—would leave him. Any woman would. Her head ached, her hands were hot, she fancied she might be suffering a terrible nightmare, she was so sick and weak, but no, this was her room. A little while ago she was sitting in her husband's studio surrounded by friends, the object of much solicitation, Eugene apparently considerate and thoughtful of her, a beautiful programme being rendered for their especial benefit. Now she was lying here in her room, a despised wife, an outcast from affection and happiness, the victim of some horrible sorcery of fate whereby another woman stood in her place in Eugene's affections. To see Suzanne, proud in her young beauty, confronting her with bold eyes, holding her husband's hand, saying in what seemed to her to be brutal, or insane, or silly, melodramatic make-believe, "But I love him, Mrs. Witla," was maddening. Oh, God, oh, God, would her tortures never cease? Must all her beautiful dreams come to nothing? Would Eugene leave her, as he had so forcefully said a little while ago? She had never seen him like this. It was terrible to see him so convinced—so cold and brutal. His voice had actually been harsh and guttural, something she had never known before in him.

She trembled as she thought, and then great flashes of rage swept her, only to be replaced by rushes of fear. He was in such a terrific position. The woman was with him—young, defiant, beautiful. She had heard him call to her; had heard them talking. Once, she thought, now would be the time to murder him, Suzanne, herself, the coming life, and end it all; but at this critical moment, having been sick and having grown so much older, with this problem of the coming life before her, she had no chart to go by. She tried to console herself with the thought that he must come out of it—that he would when the true force of what she had revealed had time to sink home; but it had not had time yet. Would it before he would do anything rash? Would it before he had completely compromised himself and Suzanne?

Judging from her talk and his, he had not as yet or she thought not. What was he going to do? What was she going to do?

Angela feared as she lay there that, in spite of her revelation, he might really leave her immediately. There might readily spring a terrible public scandal out of all of this. The mockery of their lives laid bare; the fate of the child jeopardized; Eugene, Suzanne, and herself disgraced, though she had little thought for Suzanne. Suzanne might get him after all. She might accidentally be just hard and cold enough. The world might possibly forgive him. She herself might die! What an end after all her dreams of something bigger, better, surer. Oh, the pity! The agony of this! The terror and horror of a wrecked life! To think that Eugene, in his position, at his age, at the topmost turning point in his career, when the last reaches of success were close within his grasp—and she was trying to help him with the one thing which would and should have assisted him most to adjust himself—should turn on her in this way and risk and jeopardize his whole career. What would Mr. Colfax think if he heard of it? What would Mr. Winfield think? Both of these men were conservative. She had met them more than once—Mr. Winfield a number of times recently, and he had liked her. Wouldn't they turn on Eugene if he scandalized himself and them in this fashion? Certainly they would. Mr. Colfax would no doubt remove him from his position. Mr. Winfield might want to part company with him as an active factor, at least in the Blue Sea Corporation. And here was Eugene, knowing all this, seeing the dangers and the opportunities of his position, deliberately telling her that he would leave her. It was terrible! It was incomprehensible! Oh, she could not stand this exposure, this disaster, this ultimate failure!

And then Eugene came into the room.

He was haggard, stormy-eyed, thoughtful, melancholy as he entered. He stood in the doorway first, intent, then clicked a little night lamp button which threw on a very small incandescent light near the head of Angela's bed, and sat down in a rocking chair which the nurse had placed near the medicine table. Angela had so much improved in these days that no night nurse was needed—only a twelve hour one.

"Well," he said solemnly but coldly, when he saw her pale and distraught, much of her old youthful beauty still with her. "You think you have turned a splendid trick, don't you? You think you have sprung a trap? I simply came in here to tell you that you haven't—that you have only seen the beginning of the end. You say you are in a delicate condition. I don't believe it. It's a lie and you know it's a lie. You saw that there was an end coming to all this state of weariness sometime, and this is your answer. Well, you've played one trick too many and you've played it in vain. You lose. I win this time. I'm going to be free now, I want to say to you, and I am going to be free, if I have to turn everything upside down. I don't care if there were seventeen

prospective children instead of one. It's a lie in the first place, but if it isn't a lie it's a trick, and I'm not going to be tricked any longer. I've had all I want of domination and trickery and cheap ideas. I'm through now, do you hear me, I'm through."

He felt his forehead with a nervous hand. His head ached—he felt half sick. This was such a dreary pit to find himself in, this pit of matrimony, chained by a domineering wife and a trickily manoeuvred child. His child— what a mockery at this stage of his life. How he hated the thought of that sort of thing—how cheap it all seemed.

Angela, who was wide eyed, flushed, exhausted, lying staring on her pillow, asked in a weary, indifferent voice, "What do you want me to do Eugene—leave you?"

"I'll tell you, Angela," he said sepulchrally, "I don't know what I want you to do just at this moment—the old life is over. It's as dead as dead can be. For eleven or twelve years now I have lived with you, knowing all the while that I was living a lie. I have never really loved you since we have been married. You know that. I may have loved you some in the begin- ning—yes, I did, out at Black Wood, but that was a long, long while ago. I never should have married you. I never should have! It was a mistake but I did and I've paid for it, inch by inch. You have too! You have insisted all along that I ought to love you. You have brow-beaten and abused me for something I could do no more than I could fly to Guinea. Now at this last minute you introduce a child to hold me, or say you have. I know why you have done it. You imagine that in some way you have been appointed by God to be my mentor and guardian. Well, I tell you now that you haven't. It's all over. If there were fifty children, it's all over. Suzanne isn't going to believe any such cock and bull story as that and if she did, she wouldn't leave me. She knows why you did it. All the days of weariness are over for me: all the days of being afraid. I'm not an ordinary man and I am not going to live an ordinary life. You have always insisted on holding me down to the little, cheap conventions as you have understood them out in Wisconsin—out in Black Wood. Nothing doing! It's all over from now on. Everything's over. This house, my job, my real estate deal, everything, anything. I don't care what your condition is. I love this girl in there and I'm going to have her. Do you hear me! I—love—her—and—I'm—going—to—have—her! She's mine! She suits me. I love her and no power under God is going to stop me. Now you may think this child proposition you have fixed up is going to stop me but you are going to find out that it can't—that it won't. It's a trick, and I know it, and you know it. It's too late. It might have last year or two years ago or three, but it won't work now. You have played your last card. That girl in there belongs to me and I'm going to have her."

Again he smoothed his face in a weary way, pausing to sway the least bit

in his chair. His teeth were set, his eyes hard. Consciously he realized it was a terrible situation that confronted him—hard to wrestle with. Matrimony is such a bond, and this one was particularly difficult.

Angela gazed at him with the eyes of one who is not quite sure that she even sees aright. She knew that Eugene had developed. He had become stronger, more urgent, more defiant, all during these years in which he had been going upward. He was no more like the Eugene who had clung to her for companionship in the dark days at Biloxi and elsewhere than a child is like a grown man. He was harder, easier in his manner, more indifferent, and yet until now there had never been a want of traces of the old Eugene. What had become of them so suddenly? Why was he so raging, so bitter? This girl! This foolish, silly, selfish girl, with her Circe gift of beauty. She, by her tolerance, her yielding, her throwing herself at her husband's head, had done this thing. She had drawn him away from her in spite of the fact that they had appeared to be happily mated. Suzanne did not know that they were not. In this mood he might actually leave her, enceinte as she was. It depended on the girl. Unless she could influence her, unless she could bring pressure to bear in some way, Eugene might readily be lost to her and then what a tragedy. She could not afford to have him go now. Why in eight months——! She shivered at the thought of all the misery a separation would entail: his position, this child, society, this apartment. Dear God, it would drive her crazy if he were to desert her now.

"Oh, Eugene," she said quite sadly and without any wrath in her voice at this moment, for she was too torn, terrified, and disheveled in spirit to feel anything save a haunting sense of fear, "you don't know what a terrible mistake you are making. I did do this thing on purpose, Eugene. It is true. Long ago in Philadelphia with Mrs. Sanifore, I went to see a physician to see if it were possible that I might have a child. You know that I always thought that I couldn't. Well, he told me that I could. I went because I thought that you needed something like that, Eugene, to balance you. I knew you didn't want one. I thought you would be angry when I told you. I didn't act on it for a long while. I didn't want one myself. I hoped it might be a little girl if ever there was one, because I know that you like little girls. It seems silly now in the face of what has happened tonight. I see what a mistake I have made. I see what the matter is, but I didn't mean it evilly, Eugene; honestly I didn't. I wanted to hold you—to bind you to me in some way. Do you utterly blame me, Eugene? I'm your wife, you know."

He stirred irritably and she paused, scarcely knowing how to go on. She could see how terribly irritated he was, how sick at heart, and yet she resented this attitude on his part. It was so hard to endure when all along she had fancied that she had so many just claims on him—moral, social, otherwise—

which he dare not ignore. Here she was now, sick, weary, pleading with him for something that ought justly be hers—and this coming child's.

"Oh, Eugene," she said, quite sadly and still without any wrath in her voice, "please think before you make a mistake. You don't really love this girl—you only think you do. You think she is beautiful and good and sweet and you are going to tear everything up and leave me, but you don't love her and you are going to find it out. You don't love anyone, Eugene, you can't. You are too selfish. If you had any real love in you some of it would have come out to me, for I have tried to be all that a good wife should but it has been all in vain. I've known you haven't liked me all these years. I've seen it in your eyes, Eugene. You have never come very close to me as a lover should, unless you had to or you couldn't avoid me. You have been cold and indifferent and now that I look at it, I see that it has made me so. I have been cold and hard. I've tried to steel myself to match what I thought was your steeliness, and now I see what it has done for me. I'm sorry. But as for her, you don't love her and you won't. She's too young. She hasn't any ideas that agree with yours. You think she's soft and gentle and yet big and wise, but do you think if she had been that she could have stood up there as she did tonight and looked me in the eyes—me, your wife—and told me that she loved you—you, my husband? Do you think if she had any shame she would be in there now, knowing what she does, for I suppose you have told her. What kind of girl is that, anyway? You call her good. Good! Would a good girl do anything like that?"

"What is the use of arguing by appearances?" asked Eugene, who had interrupted her with exclamations of opposition and bitter comment all through the previous address. "The situation is one which makes anything look bad. She didn't intend to be put in a position where she would have to tell you that she loved me. She didn't come here to let me make love to her in this apartment. I made love to her. She's in love with me and I made her love me. I didn't know of this other thing. If I had, it wouldn't have made any difference. However, let that be as it will. So it is. I'm in love with her and that's all there is to it."

Angela stared at the wall. She was half propped up on a pillow and had no courage now to speak of and no fighting strength.

"I know what it is with you, Eugene," she said after a time. "It's the yoke that galls. It isn't me only—it's anyone. It's marriage. You don't want to be married. It would be the same with any woman who might ever have loved and married you, or with any number of children. You would want to get rid of her and them. It's the yoke that galls you, Eugene. You want your freedom and you won't be satisfied until you have it. A child wouldn't make any difference. I can see that now."

"I want my freedom," he exclaimed bitterly and inconsiderately, "and what's more, I'm going to have it. I don't care. I'm sick of lying and pretending—sick of common little piffling notions of what you consider right and wrong. For eleven or twelve years now I have stood it. I have sat with you every morning at breakfast and every evening at dinner, most of the time when I didn't want to. I've listened to your theories of life when I didn't believe a word of what you said and didn't care anything about what you thought. I've done it because I thought I ought to do it so as not to hurt your feelings, but I'm through with all that. What have I had? Spying on me, opposition, searching my pockets for letters, complaining if I dared to stay out a single evening and did not give an account of myself. Why didn't you leave me after that affair at Riverwood? Why do you hang on to me when I don't love you? You'd think I was a prisoner and you my keeper. Good Christ, when I think of it, it makes me sick. Well, there's no use worrying over that any more. It's all over. It's all beautifully over and I'm done with it. I'm going to live a life of my own hereafter. I'm going to carve out some sort of a career that suits me. I'm going to live with someone that I can really love and that's the end of it. Now you run and do anything you want to."

He was like a young horse that had broken rein and thinks that by tearing and plunging he shall become forever free. He was thinking of green fields and delightful pastures. He was free now, in spite of what she had told him. This night had made him so and he was going to remain free. Suzanne would stand by him. He felt it. He was going to make it perfectly plain to Angela that never again, come what may, would things be as they were.

"Yes, Eugene," she replied sadly, after listening to his protestations on this score, "I think that you do want your freedom, now that I see you. I'm beginning to see what it means to you. But I have made such a terrible mistake. Are you thinking about me at all? What shall I do? It is true that there will be a child unless we both die. I'm afraid of that, or I was. I am not now. The only reason I would care to live would be to take care of it. I didn't think I was going to be ill with rheumatism. I didn't think my heart was going to be affected in this way. I didn't think that you were going to do as you have done but now that you have, nothing matters. Oh!" she said sadly, hot tears welling to her eyes, "it is all such a mistake. If I only hadn't done this."

Eugene stared at the floor. He wasn't softened one bit. He was thinking that this merely complicated things, or that she might be acting, but that it could not stand in his way. Why had she tried to trick him in this way? It was her fault. Now she was crying, but that was the old hypocrisy of emotion that she had used so often. He did not intend to desert her absolutely.

She would have plenty to live on. Merely he did not propose to live with her, if he could help it, or only nominally, anyhow. The major portion of his time should be given to Suzanne.

"I don't care what it costs," he said finally. "I don't propose to live with you. I didn't ask you to have a child. It was none of my doing."

He stirred again and Angela stared, hot cheeked. The hardness of the man enraged her for the moment.

"Yes, yes, I understand," she pleaded with an effort at controlling herself, "but I am not the only one to be considered. Are you thinking of Mrs. Dale and what she may do and say? She isn't going to let you take Suzanne without doing something about it. She is an able woman. She loves Suzanne, however self-willed she may be. She likes you now. But how long do you think she is going to like you when she learns what you want to do with her daughter? What are you going to do with her? You can't marry her under a year, even if I were willing to give you a divorce. You could scarcely get a divorce in that time."

"I'm going to live with her—that's what I'm going to do," declared Eugene. "She loves me. She's willing to take me just as I am. She doesn't need marriage ceremonies and rings and vows and chains. She doesn't believe in them. As long as I love her, all right. When I cease to love her, she doesn't want me any more. Some difference in that, isn't there," he added bitterly. "It doesn't sound exactly like Black Wood, does it?"

Angela bridled. His taunts were cruel.

"She says that, Eugene," she replied quietly, "but she hasn't had time to think. You've hypnotized her for the moment—she's fascinated. When she stops to think later, if she has any sense—any pride———. But oh, why should I talk, you won't listen. You won't think. What do you want to do with Mrs. Dale? Don't you suppose she will fight you, even if I do not? This is a terrible thing you are doing!"

"Think! think!" he exclaimed savagely and bitterly. "As though I had not been thinking all these years. Think! Hell, I haven't done anything but think. I've thought until the soul within me is sick. I've thought until I wish to God I could stop. I've thought about Mrs. Dale. Don't you worry about her. I'll settle this with her later. Just now I want to convince you of what I am going to do—and that is, I'm going to have Suzanne and you're not going to stop me."

"Oh, Eugene," sighed Angela, "if something would only make you see. It is partially my fault. I have been hard and suspicious and jealous but you have given me some cause to be, don't you think? I see now that I have made a mistake. I have been too hard and too jealous. But I could reform if you would let me try." (She was thinking now of living, not dying.) "I know I

could. You have so much to lose. Is this change worth it? You know so well how the world looks at these things. Why, even if you should obtain your freedom from me under the circumstances, what do you suppose the world would think? You couldn't desert your child. Why not wait and see what happens. I might die. There have been such cases. Then you would be free to do as you please. That is only a little way off."

It was a specious plea, calculated to hold him, but he saw through it.

"Nothing doing," he exclaimed in the slang of the day. "I know all about that. I know what you're thinking. In the first place, I don't think you're in the condition you say you are. In the next place, you're not going to die. I don't propose to wait to be free. I know you and I have no faith in you. What I do needn't affect your condition. You're not going to starve. No one need know unless you start a row about it. Suzanne and I can arrange this between ourselves. I know what you're thinking but you're not going to interfere. If you do, I'll smash everything in sight—you, this apartment, my job——" he clinched his hands desperately, determinedly.

Angela's hands were tingling with nervous pains while Eugene talked. Her eyes ached and her heart fluttered. She could not understand this dark, determined man, so savage and so resolute in his manner. Was this Eugene who was always moving about quietly when he was near her, getting angry at times but always feeling sorry and apologizing? She had boasted to some of her friends, and particularly to Marietta, in a friendly, jesting way that she could wind Eugene around her little finger. He was so easy going in the main, so quiet. Here he was, a raging demon almost—possessed of an evil spirit of desire and tearing up his and her and Suzanne's life, for that matter, by the roots. She did not care for Suzanne, though, now, or Mrs. Dale. Her own blighted life, looming so straight ahead of her, and Eugene's, terrified her.

"What do you suppose Mr. Colfax will do when he hears of this?" she asked desperately, hoping to frighten him.

"I don't give a damn what Mr. Colfax will or can do," he replied sententiously. "I don't give a damn what anybody does or says or thinks. I love Suzanne Dale. She loves me. She wants me. There's an end of that. I'm going to her. Now you stop me if you can!"

Suzanne Dale! Suzanne Dale! Now that name enraged and frightened Angela. Never before had she witnessed quite so clearly the power of beauty. Suzanne Dale was young and beautiful. She was looking at her only tonight, thinking how fascinating she was—how fair her face—and here was Eugene bewitched by it, completely undone. Oh, the terror of beauty! The terror of social life generally. Why had she entertained? Why become friendly with the Dales? But then there were other personalities almost as lovely and

quite as young—Marjorie MacLennan, Florence Reel, Henrietta Tenman, Annette Kean—it might have been any one of these. She couldn't have been expected to shut out all young women from Eugene's life. No. It was Eugene. It was his attitude toward life, his craze for the beautiful, particularly in woman. She could see it now. He really was not strong enough. Beauty would always upset him at critical moments. She had seen it in relation to herself—the beauty of her form which he admired so—or had.

"God," she prayed silently, "give me wisdom now. Give me strength. I don't deserve it, but help me. Help me save him. Help me save myself."

"Oh, Eugene," she said aloud hopelessly, "I wish you would stop and think. I wish you would let Suzanne go her way in the morning and you stay sane and calm. I won't care about myself. I can forgive and forget. I'll promise you, I'll never mention it. If a child comes, I'll do my best not to let it annoy you. I'll try yet not to have one. It may not be too late. I'll change from this day forth and, oh———." She began to cry.

"No! By God!" he said, getting up. "No! No!! No!!! I'm through now! I'm through! I've had enough of fake hysterics and tears. Tears one minute and wrath and hate the next! Subtlety! Subtlety!! Subtlety!!! Nothing doing. You've been taskmaster and jailer long enough. It's my turn now. I'll do a little jailing and task setting for a change. I'm in the saddle and I'm going to stay there. You can cry if you want to—you can do what you please about the child. I'm through. I'm tired and I'm going to bed but this thing is going to stand just as it does. I'm through and that's all there is to it."

He strode out of the room angrily and fiercely, but nevertheless, when he reached it, he sat in his own room, which was on the other side of the studio from Angela's, and did not sleep. His mind was on fire with the thought of Suzanne; the thought of the old order which had been so quickly and so terribly broken. Now if he could remain master—and he could—he proposed to take Suzanne. She would come to him secretly, no doubt, if necessary. They would open a studio—a second establishment. Angela might not give him a divorce if what she said was true. She couldn't—he wouldn't want her to—but he fancied from this conversation that she was so afraid of him, she would not stir up any trouble. There was nothing she could really do. He was in the saddle truly and would stay there. He would take Suzanne, would provide amply for Angela, would visit all those lovely public resorts he had so frequently seen, and he and Suzanne would be happy together.

Suzanne! Suzanne! Oh, how beautiful she was. And to think how beautifully and courageously she had stood by him tonight! How she had slipped her hand into his so sweetly and had said, "But I love him, Mrs. Witla." Yes, she loved him—no doubt of that. She was young, exquisite, beautifully rounded in her budding emotions and feelings. She was going to develop

into a wonderful woman—a real one. And she was so young. What a pity it was he was not free now. Well, wait. Time would right all things and meanwhile he would have her. He must talk to Suzanne. He must tell her how things stood. Poor little Suzanne. There she was in her room, wondering what was to become of her, and here was he. Well, he couldn't go to her tonight. It did not look right, and besides, Angela might fight still. But tomorrow! Tomorrow! Oh, tomorrow, he would walk and talk with her and they would plan. Tomorrow he would show her just what he wanted to do and find out what she could do.

CHAPTER LXXXVII

It is useless to speculate upon the ethics of a situation of this kind. The passions are bound up with morals only when they are under control. Passions have nothing to do with them when unloosed; like the fury of the sea, they rage and tear. Of what avail are ethical compasses and charts then? If the boat does not sink—if lives do not fail—ah, then, we may have use for ethics again, not otherwise.

This night was not without additional scenes, for in a way it was the most astonishing and tremendous in all Eugene's experience. He had not, up to the time Angela walked into the room, really expected anything so dramatic and climacteric to happen, though what he did expect was really never very clear to him. At times he fancied that he might eventually have to give Suzanne up, though how or when or why, he could not say. He was literally crazy over her and could not think that such a thing could really be. At other times he fancied that powers outside of this visible life—the life attested by the five senses—had arranged this beautiful finish to his career for him so that he might be perfectly happy. All his life he had fancied that he was leading a more or less fated life—principally more. He thought that his art was a gift—that he had been sent to revolutionize art in America, or carry it one step farther forward. He thought nature was thus constantly sending its avatars or special representatives, over whom it kept watch and in whom it was well pleased. At other times he fancied he might be the sport or toy of untoward and malicious powers, such as those which surrounded and accomplished Macbeth's tragic end, and which might be intending to make an illustration of him. As he looked at life, at times it seemed to do this to or with certain people. The fates lied. Lovely, blandishing lures were held out, only to lead man to destruction. He had seen other men who seemed to have been undone in this way. Was he to be so treated?

Angela's unexpected and peculiar announcement made it look that way. Still, he did not believe it. Life had sent Suzanne across his path for a purpose. The fates or powers had seen that he was miserable and unhappy. Being a favorite child of heaven, he was to be rewarded for his sufferings by having her. She was here now—quickly, forcefully thrust into his arms, so to speak—so that, perhaps, he might have her all the more quickly. How silly it seemed to him now to have brought her into his own apartment to make love to her and get caught, and yet how fortunate, too—the hand of fate. No doubt it was intended. Anyhow, the shame to him, the shame to Angela and Suzanne, the terrific moments and hours that each was enduring right now, himself and they—had endured, would endure—these were things which were unfortunately involved in any necessarily great readjustment. It probably had to come about this way. It was better so than to go on living an unhappy life. He was really fitted for something better, he thought—a great career. He would have to adjust this thing with Angela in some way now, either leave her or make some arrangement whereby he could enjoy the company of Suzanne uninterrupted. There must be no interference. He did not propose to give her up. The child might come. Well and good. He would provide for it—that would be all. He recalled now the conversation he had had with Suzanne, in which she had said that she would live with him if she could. The time had come. Their plan for a studio should now be put into effect. It must be secret. Angela would not care. She could not help herself. If only the events of this night would not terrorize Suzanne into retracing her steps. He had not explained to her how he was to get rid of Angela, other than what she had heard this night. Suzanne seemed to think in some foolish way that they could go on loving each other in this tentative fashion, occupying a studio together, perhaps, not caring what the world thought, not caring what her mother thought, ignoring her brother and sister and Angela, and being happy with Eugene only. He never tried to disillusion her. He was not thinking clearly himself. He was rushing forward in an aimless way, desiring the companionship of her, to him, beautiful mind and body. Now he saw he must act or lose her. He must convince her in the face of what Angela had said or let her go. She would probably be willing to come to him rather than leave him entirely. He must talk, explain, make her understand just what a trick this all was.

He sat and brooded, going back in the gray of the dawn because he heard Angela stirring and coughing fitfully, to see if there was anything he could do for her. In spite of his rage and his affection for Suzanne, his love or at least sympathy for Angela was not utterly dead. She had her good qualities; he could not forget that. She had worked and slaved for him willingly when they had little and had never complained of anything so very much save

his lack of appreciation. Unquestionably she loved him. There could be no denying that. He tried to make himself believe at times that she didn't, but there were so many little things which showed that she did, and any blank refusal of this testimony was simply unfair. She loved him and now she was seeing come to nothing all the hopeless devotion of years. Why should he be so savage, he asked himself at odd moments, and then the thought of Suzanne would return and he would become hard again. He could not help it. That lovely vision of happiness bewitched his fancy, bewrayed his brain. He was not normal, but wild, a man possessed of an evil spirit. If he had read the story in Matthew of the father who brought the son possessed of an evil spirit to Jesus, he would have found something which concerned him: "These come not out save by prayer and fasting."

When the morning came they were no farther along in their conclusions save to know, each separately and distinctly, that a great tragedy was at hand. Eugene heard Suzanne stirring after a time and went to her room and knocked. She opened the door almost fully dressed.

"Will you wait for me," he asked, "just a little bit? I want to change my clothes."

"Yes," she said, softly.

"You won't go without me?"

"No. Why do you ask?"

"Oh, I love you so," he replied, and slipped his arms about her.

She took his face between her hands and studied his eyes. She was so enrapt by him in this first burst of affection that she could see nothing but him. It did not matter that she was in the house of his wife or that his love was complicated with so much that was apparently evil. She loved him. She had thought all night about him, not sleeping. Being so young, it was hard for her to reason clearly as yet, but somehow it seemed to her that he was very unhappily placed, terribly mismated, and that he needed her. He was so fine, so clean, so capable. If he did not want Angela, why should she want him? She would not be suffering for anything save his company and why should she want to hold him? She, Suzanne, would not if she were in Angela's place. If there were a child involved, would that make any real difference? He did not love her.

"Don't worry about me," she said reassuringly. "I love you. Don't you know I do? I have to talk to you. We have to talk. How is Mrs. Witla?"

She was thinking about what Mrs. Witla would do—whether she would call up her mother, whether her struggle to have Eugene would have to begin at once.

"Oh, she's about the same," he said wearily. "We've had a long argument. I've told her just what I propose to do, but I'll tell you about that later."

He went back to a second bathroom which was between his and Angela's and bathed and changed his clothes.

"I'm going for a walk with Suzanne," he said dominantly when he was ready.

"All right," said Angela, who was so tired she could have fainted. "Will you be back for dinner?"

"I don't know," he replied. "What difference does it make?"

"Only this, that the maid and cook need not stay unless you are coming. I want nothing."

"When will the nurse be here?"

"At seven."

"Well, you can prepare dinner if you wish," he said. "I will try and be back by four."

He walked toward the studio where Suzanne was and found her waiting, white faced, slightly hollow eyed, but strong and confident at that. Now, as so often before, he noticed that spirit of self sufficiency and reliance about her young body which had impressed him so forcefully and delightfully in the past. She was a wonderful girl, this Suzanne, full of grit and ability although raised under what might have been deemed enervating circumstances. Her statement made under pressure the night before, that she must go to a hotel and not go home until she could straighten out her affairs, had impressed him greatly. Why had she thought of going out in the world to work for herself unless there were something really fine about her? She was heir to a fortune under her father's will. He had heard her mother say so. This morning her glance was so assured. He did not use the phone to call a car but strolled out into the drive with her, walking along the stone wall which commands the river northward toward Grant's Tomb. It occurred to him that they might go to the Claremont Inn for breakfast and afterwards take a car somewhere—he did not know quite where. Suzanne might be recognized. So might he.

"What shall we do, sweet?" he asked, as the cool air brushed their faces. It was a glorious day.

"I don't care," replied Suzanne. "I promised to be at the Almerdings' some time today but I didn't say when. They won't think anything of it if I don't get there till after dinner. Will Mrs. Witla call up mamá?"

"I don't think so. In fact I'm sure she won't." He was thinking of a last hour conversation in which Angela said she would do nothing. "Is your mother apt to call you up?"

"I think not. Mamá doesn't usually bother when she knows where I am going. If she does—they'll simply say I haven't come yet. Will Mrs. Witla tell her if she calls up there?"

"I think not," he said. "No, I'm sure she won't. Angela wants time to think. She isn't going to do anything. She told me that this morning. She's going to wait until she sees what I am going to do. It all depends now on how we play our cards."

He strolled onward, looking at the river and holding Suzanne's hand. It was only a quarter of seven and the drive was comparatively empty.

"If she tells mamá it will make things very bad," said Suzanne thoughtfully. "Do you really think she won't?"

"I'm sure she won't. I'm positive. She doesn't want to do anything yet. It's too dangerous. I think she thinks that maybe I will come round. Oh, what a life I've led. It seems like a dream, now that I have your love. You are so different, so generous. Your attitude is so unselfish. To have been ruled all these years in every little thing. This last trick of hers!"

He shook his head woefully. Suzanne looked at his weary face, her own as fresh as the morning.

"Oh, if I might only have had you to begin with," he added.

"Listen, Eugene," said Suzanne. "You know I feel sorry for Mrs. Witla. We shouldn't have done what we did last night but you made me. You know you will never listen to me, until it's too late. You're so headstrong. I don't want you to leave Mrs. Witla unless you want to. You needn't for me. I don't want to marry you—not now, anyhow. I'd rather just give myself to you if you want me to. I want time, though, to think and plan. If mamá should hear today, there would be a terrible time. If we have time to think we might bring her round. I don't care anything about what Mrs. Witla told you last night. I don't want you to leave her. If we could just arrange some way. It's mamá, you know."

She swung his hand softly in hers, pressing his fingers. She was deep in thought, for her mother presented a real problem.

"You know," she went on, "mamá isn't narrow. She doesn't believe much in marriage unless it's ideal. Mrs. Witla's condition wouldn't make so much difference if only the child were here. I've been thinking about that. Mamá might sanction some arrangement if she thought it would make me happy and there were no scandal. But I'll have to have time to talk to her. It can't be done right away."

Eugene listened to this with considerable surprise, as he did to everything Suzanne volunteered. She seemed to have been thinking about this sex and marriage question a long time. She was not free with her opinions. She hesitated, and halted between words and in her cogitations, but when they were out these were what they came to. He wondered how sound they were.

"Suzanne," he said, "you take my breath away. How you think! Do you know what you're talking about? Do you know your mother at all well?"

"Mamá? Oh, yes, I think I understand mamá. You know she's very peculiar. Mamá is literary and romantic. She talks a great deal about liberty but I don't take in everything she says. I think mamá is different from most women—she's exceptional. She likes me not so much as a daughter as a personality. She's curious about me. You know, I think I'm stronger than mamá. I think I could dominate her if I tried. She leans on me now a lot and she can't make me do anything unless I want to. I can make her come to my way of thinking, though. I have—lots of times. That's what makes me think I might now, if I have time. It will take time to get her to do what I want."

"How much time?" asked Eugene thoughtfully.

"Oh, I don't know. Three months. Six months. I can't tell. I would like to try, though."

"And if you can't—then what?"

"Why then—why then—why I'll defy her, that's all. I'm not sure, you know. But I think I can."

"And if you can't?"

"But I can. I'm sure I can." She tossed her head gaily.

"And come to me?"

"And come to you."

They were near One Hundredth Street, under the trees. There was a lone man, some distance away, walking away from them. Eugene caught Suzanne in his arms and implanted a kiss upon her mouth. "Oh, you divinity!" he exclaimed. "Helen! Circe! Dianeme!"

"No," she replied with smiling eyes. "No. Not here. Wait till we get a car."

"Shall we go to the Claremont?"

"I'm not hungry."

"Then we might as well call a car and ride."

They hunted a garage and sped northward, the wonderful wind of the morning cooling and refreshing their fevered senses. Both he and Suzanne were unnaturally depressed at moments, at other moments preternaturally gay, for he was varying between joy and fear, and she was buoying him up. Her attitude was calmer, surer, braver than his. She was like a strong mother to him.

"You know," he said, "I don't know what to think at times. I haven't any particular charge against Mrs. Witla except that I don't love her. I have been so unhappy. What do you think of a case of this kind, Suzanne? You heard what she said about me."

"Yes, I heard."

"It all comes from that. I don't love her. I never have, really, from the beginning. What do you think—where there is no love? It is true, part

of what she said. I have been in love with other women but it has always been because I have been longing for some sort of temperament that was congenial to me. I have, Suzanne—two since I have been married. I can't say that I was really in love with Carlotta Wilson, but I liked her. She was very much like I am. The other was a girl somewhat like you. Not as wise. That was years ago. Oh, I could tell you why. I love you, I love beauty. I want someone who is my companion mentally. You are that one, Suzanne, and yet see what a hell it is creating. Do you think it is so bad, where I am so very unhappy? Tell me, what do you think?"

"Why, why," said Suzanne, "I don't think anyone ought to stick by a bad bargain, Eugene."

"Just what do you mean by that, Suzanne?"

"Well, you say you don't love her. You're not happy with her. I shouldn't think it would be good for her or you to have you stay with her. She can live. I wouldn't want you to stay with me if you didn't love me. I wouldn't want you at all if you didn't. I wouldn't want to stay with you if I didn't love you, and I wouldn't. I think marriage ought to be a happy bargain and if it isn't, you oughtn't to try to stay together just because you thought you could stay together once."

"What if there were children?"

"Well, that might be different. Even then, one or the other could take them, wouldn't you think? The children could be made very unhappy in such a case."

Eugene looked at Suzanne's lovely face. It seemed so strange to hear her reasoning so solemnly—this girl.

"But you heard what she said about me, Suzanne, and about her condition?"

"I know," she said. "I've thought about it. I don't see that it makes so very much difference. You can take care of her."

"You love me just as much?"

"Yes."

"Even if all she says is true?"

"Yes."

"Why, Suzanne?"

"That was years ago, and then isn't now. And I know you love me now. I don't care about the past. You know, Eugene, I don't care about the future either. I want you to love me only so long as you want to love me. When you are tired of me, I want you to leave me. I wouldn't want you to live with me if you didn't love me. I wouldn't want to live with you if I didn't love you."

Eugene looked into her face, astonished, pleased, invigorated, and heartened by this philosophy. It was so like Suzanne, he thought. She seemed to

have reached definite and effective conclusions so early. Her young mind seemed a solvent for all life's difficulties.

"Oh, you wonderful girl," he said. "You know you are bigger than I am, stronger. I draw to you, Suzanne, like a cold man to a fire. You are so kindly, so temperate, so understanding."

They rode on toward Tarrytown and Scarborough, and on the way Eugene told Suzanne some of his plans. He was willing not to leave Angela, if that was agreeable to her. He was willing to maintain this outward show if that were satisfactory. The only point was, could he stay and have her too? He did not understand quite how she could want to share him with anybody but he could not fathom her from any particular point of view and he was fascinated. She seemed the dearest, the subtlest, the strangest and most lovable girl. He tried to find out by what process she proposed to overcome the objections of her mother but Suzanne seemed to have no plan save that of her ability to gradually get the upper hand mentally and dominate her.

"You know," she said at one point, "I have money coming to me. Papa set aside $200,000 for each of us children when we should come of age, and I am of age now. It is to be held in trust but I shall have twelve thousand or maybe more from that. We can use that. I am of age now but I have never said anything about it. Mamá has managed all those things."

Here was another thought which heartened Eugene. With Suzanne he should have this additional income, if ever they should come into a joint relationship, which might be used, whatever else might betide. If only Angela could be made to accept a joint relationship from now on and Suzanne could win in her contest with her mother, all would be well. His position need not be jeopardized. Mrs. Dale need hear nothing of it at present. He and Suzanne could go on associating in this way until an understanding had been reached. It was all like a delightful courtship which was to end in a still more delightful marriage.

The day passed in assurances of affection. Suzanne told Eugene of a book she had read in the French—*The Bluebird*—which was some time afterward translated and dramatized. The allegory touched Eugene to the quick—its quest for happiness—and he named Suzanne then and there, "the Bluebird." She had him stop the car once and go back and get her an exquisite lavender hued blossom growing wild on a tall stalk which she saw in a field as they sped by. Eugene objected genially because it was beyond a wire fence and set among thorns, but she said, "Yes, you must. You know you must obey me now. I'm going to begin to train you right now. You've been spoiled. You're a bad boy. Mamá says that. I'm going to reform you."

"A sweet time you'll have, Flower Face. I'm a bad lot. Have you noticed that?"

"A little."

"And you still like me?"

"I don't mind. I think I can change you by loving you."

Eugene went gladly. He plucked the magnificent bloom and handed it to her "as a sceptre," he said. "It looks like you, you know," he added. "It's regal."

Suzanne accepted the compliment without thought of its flattering import. She loved Eugene, and words had scarcely any meaning to her. She was as happy as a child and as wise in many things as a woman of twice her years. She was as foolish as Eugene over the beauty of nature, dwelling in an ecstasy upon morning and evening skies, the feel of winds, and the sigh of leaves. The beauties of nature at every turn caught her eye and she spoke to him of things she felt in such a simple way that he was entranced.

Once when they had left the car and were walking about the grounds of an inn, she found that one of her silk stockings had worn through at the heel. She lifted up her foot and looked at it meditatively.

"Now, if I had some ink I could fix that quickly," she said, laughing.

"What would you do?" he asked

"I would black it," she replied referring to her pink heel, "or you could paint it."

He laughed and she giggled. It was these little, idle simplicities which amused and fascinated him.

"Suzanne," he said dramatically at this time, "you are taking me back into fairyland."

"I want to make you happy," she said, "as happy as I am."

"If it could be. If it could only be."

"Wait," she said. "Be cheerful. Don't worry. Everything will come out right. I know it will. Things always come out right for me. I want you and you will come to me. You will have me just as I will have you. Oh, it is all so beautiful."

She squeezed his hand in an ecstasy of delight and then gave him her lips.

"What if someone might see?" he asked.

"I don't care! I don't care!" she cried. "I love you."

CHAPTER LXXXVIII

The days passed and with them came peculiar developments in this situation. For instance, on this particular day, after dining joyously, these two returned to the city. Suzanne, as she neared New York proper,

was nervous as to what Angela might have done, for she wanted, in case Angela told her mother, to be present in order to defend herself. She had reached a rather logical conclusion for her and that was, in the event her mother objected too vigorously, to elope with Eugene. She wanted to see just how her mother would take the intelligence, in order that she might see clearly what to do. Curiously, she had the feeling that she could persuade her mother to do nothing, even in the face of all that had been revealed. Nevertheless, she was nervous and her fears were bred to a certain extent by Eugene's own attitude.

In spite of all his bravado he really did not feel at all secure. He was not afraid of what he might lose materially so much as he was of losing Suzanne. The thought of the coming child had not affected him at all as yet. He could see clearly that conditions might come about whereby he could not have Suzanne but they were not in evidence as yet. Besides, Angela might be lying. Still at odd moments his conscience troubled him, for in the midst of his most intense satisfaction, his keenest thrills of joy, he could see Angela lying in bed, the thought of her wrecked future before her, the thought of the coming life troubling her, or hear the echo of some of the pleas she had made. It was useless to attempt to shut them out. This was a terrible situation he was undergoing—a ruthless thing he was doing. All the laws of life and public sentiment were against him. If the world knew, it would accuse him bitterly: he could not forget that. He despaired at moments of ever being able to solve the tangle in which he had involved himself and yet he was determined to go on. He thought to deliver Suzanne at her friends', the Almerdings', but she changed her mind and decided to go home. "I want to see whether mamá has heard anything," she insisted.

Eugene had to escort her to Staten Island and then have the chauffeur speed the machine in order to reach Riverside by four. He was somewhat remorseful but he argued that his love life was so long over with, in so far as Angela was concerned, that it could not really make so very much difference. Since Suzanne wanted to wait a little time and proceed slowly, it was not going to be as bad for Angela as he had anticipated. He was going to give her a choice of going her way and leaving him entirely, either now or after the child was born, giving her the half of his property—stocks, ready money, and anything else that might be divisible, and all the furniture—or staying and tacitly ignoring the thing she would know he was going to do— that is, maintain a separate ménage or secret rendezvous for Suzanne. Since Suzanne was so generous, he proposed to insist, not to argue this point. He must have her, and Angela must yield.

When he came to the house a great change had come over Angela. In the morning when he left she was hard and bitter in her mood. This afternoon

she was as soft and melting, albeit extremely sad, as he had ever seen her, and much more so. Her hard spirit was temporarily broken but in addition she had tried to resign herself to the inevitable and to look upon it as the will of God. Perhaps she had been, as Eugene had so often accused her of being, hard and cold. Perhaps she had held him in too tight leading strings. She had meant it for the best. She had tried to pray for light and guidance, and after awhile something softly sad, like a benediction, settled upon her. She must not fight any more, she thought. She must yield. God would guide her. Her smile, kindly and wan when Eugene entered the room, took him unawares.

Her explanation of her mood, her prayers, her willingness to give him up if need be even in the face of what was coming to her, moved him more than anything that had ever passed between them before. He sat opposite her at dinner, looking at her thin hands and face and her sad eyes, trying to be cheerful and considerate; and then, going back into her room and hearing her say she would do whatever he deemed best, Eugene burst into tears. He cried from an excess of involuntary and uncontrolled emotion. He hardly knew why he cried, but the sadness of everything—life, the tangle of human emotions, the proximity of death to all, old age, Suzanne, Angela, all—touched him and he shook as though he would rend his sides. Angela, in turn, was astonished and grieved for him. She could scarcely believe her eyes. Was he repenting?

"Come to me, Eugene," she pleaded. "Oh, I'm so sorry. Are you as much in love as that? Oh, dear, dear—if I could only do something. Don't cry like that, Eugene. If it means so much to you, I will give you up. It tears my heart to hear you. Oh, dear, please don't cry."

He laid his head on his knees and shook—then seeing her getting up, came over to the bed to prevent her.

"No, no," he said, "it will pass. I can't help it. I'm sorry for you. I'm sorry for myself. I'm sorry for life. God will punish me for this. I can't help it, but you are a good woman."

He laid his head down beside her and sobbed longer—great, aching sobs. After a time he recovered himself only to find that he had given Angela courage anew. His love might be recovered to her, she thought, if he were so sympathetic—Suzanne displaced. He knew that could not be, and so he was sorry that he had cried.

They went on from that to discussion, to argument, to ill feeling, to sympathetic agreement again by degrees, only to fall out anew. Angela could not resign herself to the thought of giving him up. Eugene could not see that he was called upon to do anything save divide this kingdom. He was most anxious to have nothing to do with Angela anymore in any way. He

might live in the same house but that would be all. He was going to have Suzanne. He was going to live for her only. He threatened Angela with dire results if she tried to interfere in any way. If she communicated with Mrs. Dale or said anything to Suzanne or attempted to injure him commercially, he would leave her.

"Here is the situation," he would insist. "You can maintain it as I say or break it. If you break it you lose me and everything that I represent. If you maintain it I may stay here. I think I will. I am perfectly willing to keep up appearances, but I want my freedom."

Angela thought and thought of this. She thought once of sending for Mrs. Dale and communicating with her secretly, urging her to get Suzanne out of the way without saying anything to her or to Eugene, but she did not do this. It was the one thing she should have done and the one thing Mrs. Dale should have agreed to, but fear and confusion deterred her. The next thing was to write or talk to Suzanne, and because she mistrusted her mood in Suzanne's presence, she decided to write her. She lay in bed on Monday when Eugene was away at the office and composed a long letter in which she practically gave the history of Eugene's life, reiterating her own condition and stating what she thought Suzanne ought to do.

"How can you think, Suzanne," she asked in one place, "that he will be true to you when he can ignore me in this condition? He has not been to anyone else. Are you going to throw your life away? Your station is assured now. What can he add to you that you have not already? If you take him it is sure to become known. You are the one who will be injured, not he. Men recover from these things—particularly from an infatuation of this character—and the world thinks nothing of it. But the world will not forgive you. You will be a bad woman after this, trebly so if a child is introduced. You think you love him. Do you really love him this much? Read this and stop and think. Think of his character. I am used to him. I made my mistake in the beginning and it is too late for me to change. The world can give me nothing. I may have sorrow and disgust but at least I will not be an outcast and our friends and the world will not be scandalized. But you—you have everything before you. Some man will come to you whom you will love and who will not ask and willingly make a sacrifice of you. Oh, I beg you to think. You do not need him. After all—sorry as I am to confess it—I do. It is as I tell you. Can you really afford to ignore this appeal?"

Suzanne read this and was greatly shocked. Angela painted him in a wretched light as fickle, deceitful, dishonest in sex matters. She debated this matter in her own room, for it could not help but give her pause, but after a time Eugene's face came back to her, his beautiful mind, the atmosphere of delight and perfection that seemed to envelop all that surrounded him. It

was as though Eugene were a mirage of beauty, so soft, so sweet, so delightful. Oh, to be with him; to hear his beautiful voice; to feel his intense caresses. What could life offer her equal to that? And besides, he needed her. She decided to talk it out with him, show him the letter, and then decide.

Eugene came in a day or two, having phoned Monday and Tuesday mornings. He made a rendezvous for the ice house, and then appeared as eager and smiling as ever. Since returning to the office and seeing no immediate signs of a destructive attitude on Angela's part, he had recovered his courage. He was hopeful of a perfect denouement to all this—of a studio and his lovely Suzanne. When they were seated in the auto she immediately produced Angela's letter and handed it to him without comment. Eugene read it quietly.

He was greatly schocked at what he read for he thought that Angela was more kindly disposed toward him. Still he knew it to be true, all of it, though he was not sure that Suzanne would suffer for his attentions. The fates might be kind. They might be happy together. Anyhow he wanted her now.

"Well," he said, giving it back, "what of it? Do you want to keep it?"

"No."

"Do you believe all she says?"

"It may be so but somehow when I am with you I don't seem to care. When I am away from you it's different. I'm not so sure."

"You can't tell whether I am as good as you think I am."

"I don't know what to think. I suppose all she says about you is true. I'm not sure. When you're away it's different. When you're here I feel as though everything must come out right. I love you so. Oh, I know it will." She threw her arms around him.

"Then the letter doesn't really make any difference?"

"No."

She looked at him with big round eyes and it was the old story, bliss in affection without thought. They rode miles, stopped at an inn for something to eat, looked at the sea where the return road skirted it, and kissed and kissed each other. Suzanne grew so ecstatic that she could see exactly how it was all coming out.

"Now you leave it to me," she said. "I will sound mamá out. If she is at all logical I think I can convince her. I would so much rather do it that way. I hate deception. I would rather just tell her and then, if I have to, defy her. I don't think I will have to, though. She can't do anything."

"I don't know about that," said Eugene cautiously. He had come to have great respect for Suzanne's courage, and he was rather relying on Mrs. Dale's affection for him to stay her from any desperate course, but he did not see how their end was to be achieved. He was for entering upon an illicit rela-

tionship after a time without saying anything at all. He was in no hurry, for his feeling for Suzanne was not purely physical, though he wanted her. Because of her strange reading and philosophy, she was for defying the world. She insisted that she did not see how it would hurt her.

"But, my dear, you don't know life," said Eugene. "It will hurt you. It will grind you to pieces in all places outside of New York. This is the metropolis. It is a world city. Things are not quite the same here. But you will have to pretend, anyhow. It is so much easier."

"Can you protect me?" she asked significantly, referring to the condition Angela pleaded. "I wouldn't want—I couldn't, you know, not now—not yet."

"I understand," he said. "Yes, I can. Absolutely."

"Well, I want to think about it," she said again. "I prefer so much to be honest about it. I would so much rather just tell mamá and then go and do it. It would be so much nicer. My life is my own to do with as I please. It doesn't concern anybody, not even mamá. You know, if I want to waste it, I may, only I don't think that I am. I want to live as I choose. I don't want to get married yet."

Eugene listened to her with the feeling that this was the most curious experience of his life. He had never heard, never seen, never experienced anything like it. The case of Christina Channing was different. She had her art to consider. Suzanne had nothing of the sort. She had a lovely home, a social future, money, the chance for a happy, stable, normal life. This was love, surely, and yet he was quite at sea. Still so many favorable things had happened, consciously favorable, that he was ready to believe that all this was intended for his benefit by a kind, governing providence. Angela had practically given in already. Why not Suzanne's mother? Angela would not tell her anything. Mrs. Dale was not any stronger than Angela, apparently. Suzanne might be able to control her, as she said. If she was so determined to try, could he really stop her? She was headstrong in a way and willful, but developing rapidly and reasoning tremendously. Perhaps she could do this thing. Who could tell?

They came flying back along lovely lanes, where the trees almost swept their faces, past green stretches of marsh where the wind stirred in ripples the tall green cut grass, past pretty farm yards with chickens and ducks in the foreground, beautiful mansions, playing children, sauntering laborers. All the while they were reassuring each other, vowing perfect affection, holding each other close. Suzanne, as Angela had, loved to take Eugene's face between her hands and look into his eyes.

"Look at me," she said once, when he had dolefully commented upon the possibility of change. "Look straight into my eyes. What do you see?"

"Courage and determination," he said.

"What else?"

"Love."

"Do you think I will change?"

"No."

"Surely?"

"No."

"Well, look at me straight, Eugene. I won't. I won't, do you hear? I'm yours until you don't want me any more. Now will you be happy?"

"Yes," he said.

"And when we get our studio," she went on.

"When we get our studio," he said, "we'll furnish it beautifully and entertain a little after a while, maybe. You'll be my lovely Suzanne, my Flower Face, My Myrtle Bloom! Helen! Circe! Dianeme!"

"I'll be your week-end bride," she laughed. "Your odd or even girl—whichever way the days fall."

"If it only comes true," he exclaimed when they parted. "If it only does."

"Wait and see," she said. "It will! It will! Now you wait and see."

The days passed and Suzanne began what she called her campaign. Her first move was to begin to talk about the marriage question at the dinner table or whenever she and her mother were alone and to sound her out on this important question, putting her on record. Mrs. Dale was one of those empirical thinkers who loves to philosophize generally but who makes no specific application of anything to herself and hers. On this marriage question she held most liberal and philosophic views for all outside of her immediate family. It was her idea (outside of her own family, of course) that if a girl, having reached maturity, and what she considered a sound intellectual majority, and who was not by then satisfied with the conditions which matrimony offered, if she loved no man desperately enough to want to marry him and could arrange some way whereby she could satisfy her craving for love without jeopardizing her reputation, that was her lookout. So far as Mrs. Dale was concerned, she had no particular objection. She knew women in society who were like that. She knew many women who, having made unfortunate marriages, or marriages of convenience, entertained some such relationship to a man or men whom they admired. There was a subtle, subsurface understanding, outside of the society circles, of the most rigid morality in regard to this, and there was the fast set, of which she was at times a welcome member, which laughed at the severe conventions of the older school. One must be careful—very. One must not be caught. But otherwise—well, every person's life was a law unto him or herself.

Suzanne was never figured into any of these theories, for Suzanne was a beautiful girl, capable of a high connection. Mrs. Dale did not care to marry

her off to any wretched possessor of great wealth or title solely for wealth or a title's sake, but she was hoping that some eligible young man of excellent social standing or wealth or real personal ability—such, for instance, as Eugene possessed—would come along and marry Suzanne. There would be a grand wedding at a public edifice of some character, St. Bartholomew's, very likely; a splendid wedding dinner; oceans of presents; a beautiful honeymoon. She used to look at Suzanne and think what a delightful mother she would make—she was so young, robust, vigorous, able, and in a quiet way, passionate. She could tell when Suzanne danced how eagerly she took life. The young man would come. It would not be long. These lovely springtimes would do their work one of these days. As it was, there were a score of men already who would have given an eye to have attracted Suzanne's attention, but Suzanne would have none of them. She seemed sly, coy, elusive, but above all, shy. Her mother had no more idea of the iron will (but moderately developed) all this concealed, than she had of the anarchist, unsocial thoughts that were then surging in her daughter's brain.

"Do you think a girl ought to marry at all, mamá," Suzanne asked her one evening when they were alone together, "if she isn't interested in marriage as something she would like to be in all her days?"

"No-o," replied her mother. "What makes you ask?"

"Well we see so much trouble among married people that we know. They're not very happy together. Wouldn't it be better if a person just stayed single, and if they found someone that they really loved—well, they needn't necessarily marry to be happy, need they?"

"What have you been reading lately, Suzanne?" asked her mother, looking up with a touch of surprise in her eyes.

"Nothing lately. What makes you ask?" said Suzanne wisely, noting the change in her mother's voice.

"With whom have you been talking?"

"Why? What difference does that make, mamá? I've heard you express precisely the same views."

"Quite so. I may have. But don't you think you're rather young to be thinking of things like that? I don't say all that I really think when I am arguing things philosophically. There are conditions which govern everything. If it were impossible for a girl to marry well, or if looks or lack of money interfered—there are plenty of reasons—a thing like that might possibly be excusable, but why should you be thinking of that?"

"Why, it doesn't necessarily follow, mamá, that because I am good looking or have a little money or am socially eligible that I should want to get married. I may not want to get married at all. I see just as well as you do how things are with most people. Why should I? Do I have to keep away from every man then?"

"Why, Suzanne, how you talk. I never heard you argue like this before. You must having been talking with someone or reading some outré book of late. I wish you wouldn't. You are too young and too good looking to entertain any such ideas. Why, you can have nearly any young man you wish. Surely you can find someone with whom you can live happily or with whom you would be willing to try. It's time enough to think about the other thing when you've tried and failed. At least you can give yourself ample time to learn something about life before you begin to talk such nonsense. You're too young. Why, it's ridiculous!"

"Mamá," said Suzanne, with the least touch of temper, "I wish you wouldn't talk to me like that. I'm not a child anymore. I'm a woman. I think like a woman—not like a girl. You forget that I have a mind of my own, and some thoughts. I may not want to get married. I don't think I do. Certainly not to any of the silly creatures that are running after me now. Why shouldn't I take some man in an independent way, if I wish? Other women have before me. Even if they hadn't it would be no reason why I shouldn't. My life is my own."

"Suzanne Dale!" exclaimed her mother, rising, a thrill of terror passing along her heart strings. "What are you talking about? Are you basing these ideas on anything I have said in the past? Then certainly my chickens are coming home to roost early. You certainly are in no position to consider whether you want to get married or not. You have seen practically nothing of men. Why should you reach any such conclusions now? For goodness' sake, Suzanne, don't begin so early to meditate on these terrible things. Give yourself a few years in which to see the world. I don't ask you to marry, but you may meet some man whom you could love very much and who would love you. If you were to go and throw yourself away under any such silly theory as you entertain now without stopping to see, or waiting for life to show you what it has in store, what will you have to offer him? Suzanne, Suzanne" (Suzanne was turning impatiently to a window), "you frighten me. There isn't—there couldn't be! Oh, Suzanne, I beg of you, be careful what you think, what you say, what you do! I can't know all your thoughts—no mother can—but, oh, if you will stop and think and wait awhile."

She looked at Suzanne, who walked to a mirror and began to fix a bow in her hair.

"Mamá," she said calmly, "really you amuse me. When you are out with people at dinner you talk one way and when you are here with me you talk another. I haven't done anything desperate yet. I don't know what I may want to do. I'm not a child anymore, mamá. Please remember that. I'm a woman grown and I certainly can lay out my life for myself. I'm sure I don't want to do what you are doing—talk one thing and do another."

Mrs. Dale recoiled intensely from this stab. Suzanne had suddenly developed in the line of her argument a note of determination, frank force, and serenity of logic which appalled her. Where had her girl gotten all this? With whom had she been associating? She went over in her mind the girls and men she had met and known. Who were her intimate companions—Vera Almerding, Lizette Woodworth, Cora TenEyck—a half dozen girls who were smart and clever and socially experienced. Were they talking such things among themselves? Was there some man or men unduly close to them? There was one remedy for all this. It must be acted on quickly if Suzanne were going to fall in with and imbibe any such ideas as these. Travel—two or three years of incessant travel with her, which would cover this dangerous period in which girls were so susceptible to undue influence, was the necessary thing. Oh! Her own miserable tongue! Her silly ideas! No doubt all she had said was true. Generally it was so. But Suzanne! Her Suzanne! Never! She would take her away until she had time to grow older and wiser through experience. Never should she be permitted to stay where girls and men were talking and advocating any such thing. She would scan Suzanne's literature more closely from now on. She would visé her friendships. What a pity that so lovely a girl must be corrupted by such wretched, unsocial, anarchistic notions. Why, what would become of the girl? Where would she be? Dear Heaven!

She looked down in the social abyss yawning at her feet and recoiled with horror.

Never, never, never! Suzanne should be saved from herself, from any such ideas now and at once.

And she began to think how she could introduce the thought of travel easily and nicely. She must lure Suzanne to go without alarming her—without making her think that she was bringing pressure to bear. But from now on there must be a new order established. She must talk differently; she must do differently. Suzanne and all her children must be protected against themselves—and others also. That was the lesson which this conversation taught her.

CHAPTER LXXXIX

The denouement which this conversation portended was not long in manifesting itself. Eugene and Angela had been quarreling between themselves most bitterly; at other times Angela was attempting to appeal to his sense of justice and fair play, if not to his old time affection, in the

subtletest of ways. She was completely thrown out of her old methods of calculation, and having lost those, had really no means wherewith to proceed. Eugene had always heretofore apparently feared her wrath; now he cared nothing for that. He had been subject to a certain extent to the blandishments of her body, which those in married life understand well enough, but these were as ashes. Her body meant nothing to him. She had hoped that this thought of a coming child would move him—but no, it was apparently without avail. Suzanne seemed a monster to her now that she did not desert him, and Eugene a raving maniac almost, and yet she could see how human and natural it all was. He was hypnotized, possessed. He had one thought—Suzanne, Suzanne—and he would fight her at every turn for that. He told her so. He told her he had read and destroyed her letter to Suzanne. It did not help her cause any, she knew, that she had abused him. He stood his ground solidly, awaiting the will of Suzanne, and he saw Suzanne frequently, telling her that he had won completely and that the fulfillment of their desires now depended upon her.

As has been said, Suzanne was not without passion. The longer she associated with Eugene the more eager she became for that joyous fulfillment which his words, his looks, his emotions indicated. In her foolish, girlish way, she had built up a fancy which was capable of realization only by the most ruthless and desperate conduct. Her theory of telling her mother and overcoming her by argument or defiance was really vain, for it could not be settled so easily or so quickly. Because of her mother's appeal to her in this first conversation, she fancied she had won a substantial victory. Her mother was subject to her control and could not defeat her in argument. By the latter token, she felt, she was certain to win. Besides, she was counting heavily on her mother's regard for Eugene and her deep affection for her. Hitherto her mother had really refused her nothing.

The fact that Eugene did not take her outright at this time (postponing until a more desperate occasion an adjustment of the difficulties which must necessarily flow from their attempted union without marriage) was due to the fact that he was really not as villainous as he appeared to be. He was not truly ruthless ever, but good natured and easy going. He was no subtle schemer and planner but rather an easy natured soul who drifted here and there with all the tides and favorable or unfavorable winds of circumstance. He might have been ruthless if he had been eager enough for any one particular thing on this earth—money, fame, affection—but at bottom he really did not care as much as he thought he did. Anything was really worth fighting for if you had to have it, but it was not worth fighting for to the bitter end if you could possibly get along without it. Besides, there was nothing really one could not do without if it were necessary. He might

long intensely, but he could survive. He was more involved in this desire than in anything else in his history but he was not willing to be hard and grasping. He wanted Suzanne but he wanted her to come to him willingly and voluntarily. It was so much more beautiful.

When Mrs. Dale quite casually within a few days began to suggest they leave New York for the fall and winter—she, Suzanne and Kinroy, and visit first England and then southern France and then Egypt—Suzanne immediately detected something intentional in it, or at best a very malicious notion on the part of fate which was intended to destroy her happiness. She had been conjecturing how, temporarily, she could avoid distant and long drawn out engagements which her mother not infrequently accepted for them about New York, but she had not even figured that out. Mrs. Dale was very popular and well liked. This easy suggestion, made with considerable assurance by her mother and as though it would be just the thing, frightened and then irritated Suzanne. Why should her mother think of this just at this time?

"I don't want to go to Europe," she said warily. "We were only over there three years ago. I'd rather stay over here this winter and see what's going on in New York."

"But this trip will be so delightful, Suzanne," her mother insisted. "The Camerons are to be at Callendar in Scotland for the fall. They have taken a cottage there. I had a note from Louise Tuesday. I thought we might run up there and see them and then go to the Isle of Wight."

"I don't care to go, mamá," replied Suzanne, determinedly. "We're settled here comfortably. Why do you always want to be running somewhere?"

"Why, I'm not running—how you talk, Suzanne. I never heard you object very much to going anywhere before. I should think Egypt and the Riviera would interest you very much. You haven't been to either of those places."

"I know they're delightful but I don't care to go this fall. I'd rather stay here. Why should you suddenly decide that you want to go away for a year?"

"I haven't suddenly decided," insisted her mother. "I've been thinking of it for some time, as you know. Haven't I said that we would spend a winter in Europe soon? The last time I mentioned it you were very keen for it."

"Oh, I know, mamá, but that was nearly a year ago. I don't want to go now. I would rather stay here."

"Why would you? More of your friends go away than remain. I think a particularly large number of them are going this winter."

"Ha! Ha! Ho! Ho!" laughed Suzanne. "A particularly large number. How you exaggerate, mamá, when you want anything. You always amuse

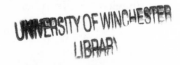

me. It's a particularly large number now, just because you want to go," and she laughed again.

Suzanne's defiance irritated her mother. Why should she suddenly take this notion to stay here? It must be this group of girls she was in with and yet Suzanne appeared to have so few intimate girl friends. The Almerdings were not going to stay in town all winter. They were here now because of a fire at their country place but it would only be for a little while. Neither were the TenEycks. It couldn't be that Suzanne was interested in some man. The only person she cared anything much about was Eugene Witla, and he was married and only friendly in a brotherly, guardian-like way.

"Now, Suzanne," she said determinedly, "I'm not going to have you talk nonsense. This trip will be a delightful thing for you once you have started. It's useless for you to let silly notions about not wanting to go stand in your way. You are just at the time when you ought to travel. Now you better begin to prepare yourself, for we're going."

"Oh, no I'm not, mamá," said Suzanne. "Why, you talk as though I were a very little girl. I don't want to go this fall, and I'm not going. You may go if you want to but I'm not going."

"Why, Suzanne Dale," exclaimed her mother, "whatever has come over you? Of course you'll go. Where would you stay if I went? Do you think I would walk off and leave you? Have I ever before?"

"You did when I was in boarding school," interrupted Suzanne.

"That was a very different matter. There you were under proper supervision. Mrs. Hill was answerable to me for your care. Here you would be alone. What do you think I would be doing?"

"There you go, mamá, talking as though I were a little girl again. Will you please remember that I am nearly nineteen? I know how to look after myself. Besides, there are plenty of people with whom I might stay if I chose."

"Suzanne Dale, you talk like one possessed. I'll listen to nothing of the sort. You are my daughter and as such subject to my guardianship. Of what are you thinking? What have you been reading? There's some silly thing at the bottom of all this. I'll not go away and leave you, and you will come with me. I should think that after all these years of devotion on my part, you would take my feelings into consideration. How can you stand there and argue with me in this way?"

"Arguing, mamá?" asked Suzanne loftily. "I'm not arguing. I'm just not going. I have my reasons for not wanting to go and I'm not going. That's all. Now you may go if you want to."

Mrs. Dale looked into Suzanne's eyes and saw for the first time a gleam of real defiance in them. What had brought this about? Why was her daughter so set—of a sudden, so stubborn and hard? Fear, anger, astonishment, mingled equally in her feelings.

"What do you mean by reasons?" asked her mother. "What reasons have you?"

"A very good one," said Suzanne quietly, twisting it to the singular.

"Well, what is it then, pray?"

Suzanne debated swiftly and yet a little vaguely in her own mind. She had hoped for a longer process of philosophic discussion in which to entrap her mother into some moral and intellectual position from which she could not well recede and by reason of which she would have to grant her the license she desired. From one remark and another dropped in this and the preceding conversation, she realized that her mother had no logical arrangement in her mind whereby she included her in her philosophical calculations at all. She might favor any and every theory and conclusion under the sun, but it would mean nothing in connection with Suzanne. The only thing that remained, therefore, was to defy her or run away, and Suzanne did not want to do the latter. She was of age. She could adjust her own affairs. She had money. Her mental point of view was as good and sound as her mother's. As a matter of fact the latter's attitude, in view of her own (Suzanne's) recent experiences and feelings, seemed weak and futile. What did her mother know of life any more than she? They were both in the world and Suzanne felt herself to be the stronger—the bigger of the two. Why not tell her now and defy her? She could win. She must. She could dominate her mother and this was the time to do it.

"Because I want to stay near the man I love," she finally volunteered quietly.

Mrs. Dale's hands, which had been elevated to a position of gesticulation before her, dropped limp, involuntarily to her side. Her mouth opened the least bit. She stared in a surprised, anguished, semi-foolish, and yet dangerous way.

"The man you love, Suzanne?" she asked, swept completely from her moorings and lost upon a boundless sea. "Who is he?"

"Mr. Witla. Eugene. I love him and he loves me. Don't stare, mamá. Mrs. Witla knows. She is willing that we should have each other. We love each other. I am going to stay here where I can be near him. He needs me!"

"Eugene Witla!" exclaimed her mother, breathless, a look of horror in her eyes, cold fright expressed by her tense hands. "You love Eugene Witla—a married man? He loves you? Are you talking to me? Eugene Witla! You love him! Why, I can't believe this! I'm not in my right mind. Suzanne Dale, don't stand there! Don't look at me like that! Are you talking to me? Your mother! Tell me it isn't so! Tell me it isn't so before you drive me mad. Oh, God, what am I coming to? What have I done? Eugene Witla—of all men! Oh, God, oh, God, oh, God!"

"Why do you carry on so, mamá?" asked Suzanne calmly. She had

expected some such scene as this—not quite so intense or hysterical, but something like it—and was in a way prepared for it. A selfish love was her animating, governing impulse—a love also that stilled self, and put aside as nothing all the world and its consideration. Suzanne really did not know what she was doing. She was hypnotized by this sense of perfection in her lover—the beauty of their love. Not practical facts but the beauty of the summer, the feel of cool winds, the glory of skies and sunlight and moon-light, were in her mind. Eugene's arms about her—his lips to hers meant more than all the world beside. "I love him. Of course I love him. What is there so strange about that?"

"What is there strange? Are you in your right mind? Oh, my poor dear, little girl! My Suzanne! Oh, that villain! That scoundrel! To come into my house and make love to you—my darling child! How should you know? How could I expect you to understand? Oh, Suzanne! For my sake, for the love of heaven, hush! Never breathe it! Never say that terrible thing to me again. Oh, dear! Oh, dear!! Oh dear!!! That I should live to see this! My child! My Suzanne! My lovely, beautiful Suzanne. I shall die unless I can stop this. I shall die! I shall die!"

Suzanne stared at her mother, quite astonished at this emotional state into which she had cast her. Her pretty eyes were opened wide, her eyebrows elevated, her lips parted sweetly. She was a picture of intense classic beauty, chiseled, peaceful, self possessed. Her brow was as smooth as marble, her lips as arched as though they had never known one emotion outside of joy. Her look was of a quizzical, slightly amused but not supercilious character, which made her more striking than ever, if possible.

"Why, mamá, how you talk. You think I am a child, don't you? All that I say to you is true. I love Eugene. He loves me. I am going to live with him as soon as it can be quietly arranged. I wanted to tell you because I don't want to do anything secretly, but I propose to do it. I wish you wouldn't insist on looking on me as a baby, mamá. I know what I am doing. I have thought it all out this long time."

"Thought it all out," thought Mrs. Dale. "Going to live with him when it can be arranged. Is she talking of living with a married man without a wedding ceremony being performed? Is the child stark mad? Something has turned her brain. Surely something has. This is not my Suzanne—my dear, lovely, entrancing Suzanne."

To Suzanne she exclaimed aloud:

"Are you talking of living with this—with this—oh, I don't dare to name him—I'll die if I don't get this matter straightened out—of living with him without a marriage ceremony and without his being divorced? I can't believe that I am awake! I can't! I can't!"

"Certainly I am," replied Suzanne. "It is all arranged between us. Mrs. Witla knows. She has given her consent. I expect you to give yours if you expect me to stay here, mamá."

"Give my consent?! As God is my witness! Am I alive? Is this my daughter talking to me? Am—I—in—this—room—here—with—you? I——" she stopped, her mouth wide open. "If it weren't so horribly tragic, I should laugh! I will. I will become hysterical! My brain is whirling like a wheel now. Suzanne Dale, you are insane. You are madly, foolishly insane. If you do not hush and cease this terrible palaver, I will have you locked up. I will have an inquiry made into your sanity. This is the wildest, most horrible, most unimaginable thing ever proposed to a mother. To think that I should have lived with you eighteen long years, carried you in my arms, nursed you at my breast, and then have you stand there and tell me that you will go and live unsanctioned with a man who has a good, true woman now living as his wife. This is the most astounding thing I have ever heard of. It is unbelievable. You will not do it. You will no more do it than you will fly. I will kill him! I will kill you. I would rather see you dead at my feet this minute than to even think that you could have stood there and proposed such a thing to me. It will never be! It will never be! I will give you poison first. I will do anything, everything, but you shall never see this man again. If he dares to cross this threshold, I will kill him on sight. I love you. I think you are a wonderful girl, but this thing shall never be. And don't you dare to attempt to dissuade me. I will kill you, I tell you. I would rather see you dead a thousand times. To think! To think! To think! Oh, that beast! That villain! That unconscionable cur! To think he would come into my house after all my courtesy to him and do this thing to me. Wait! He has position! He has distinction. I will drive him out of New York! I will ruin him! I will make it impossible for him to show his face among decent people! Wait and see!"

Her face was white, her hands clenched, her teeth set. She had a keen, savage beauty, much like that of a tigress when it shows its teeth. Her eyes were hard and cruel and flashing. Suzanne had never imagined her mother capable of such a burst of rage as this.

"Why, mamá," she said calmly and quite unmoved. "You talk as though you ruled my life completely. You would like to make me feel, I suppose, that I do not dare to do what I choose. I do, mamá. My life is my own—not yours. You cannot frighten me. I have made up my mind what I am going to do in this matter, and I am going to do it. You cannot stop me. You might as well not try. If I don't do it now, I will later. I love Eugene. I am going to live with him. If you don't let me, I will go away. But I propose to live with him and you might as well stop now trying to frighten me, for you can't."

"Frighten you! Frighten you! Suzanne Dale, you haven't the faintest, weakest conception of what you are talking about or of what I mean to do. If a breath of this, the faintest intimation of your intention, were to get abroad, you would be socially ostracized. Do you realize that you would not have a friend left in the world—that all the people you know now and are friendly with would go across the street to avoid you? If you didn't have independent means you couldn't even get a position in an ordinary shop. Going to live with him? You are going to die first, right here in my charge and in my arms. I love you too much not to kill you. I would a thousand times rather die with you myself. You are not going to see that man anymore—not once, and if he dares to show his face here, I will kill him. I have said it. I mean it. Now you provoke me to action if you dare."

Suzanne merely smiled. "How you talk, mamá. You make me laugh."

Mrs. Dale stared.

"Oh, Suzanne! Suzanne!" she suddenly exclaimed, "before it is too late! Before I learn to hate you! Before you break my heart, come to my arms and tell me that you are sorry—that it is all over—that it is all a vile, dark, hateful dream. Oh, my Suzanne! My Suzanne!"

"No, mamá! No! Don't come near! Don't touch me," said Suzanne, drawing back. You haven't any idea of what you are talking about, of what I am or what I mean to do. You don't understand me! You never did, mamá. You have always looked down on me in some superior way as though you knew a great deal and I very little. It isn't that way at all. It isn't true. I know what I am about. I know what I am doing. I love Mr. Witla and I am going to live with him. Mrs. Witla understands. She knows how it is. You will. I don't care anything at all about what people think. I don't care what any society friends do. They are not making my life. They are all just as narrow and selfish as they can be, anyhow. Love is something different from that. You don't understand me. I love Eugene and he is going to have me and I am going to have him. If you want to try to wreck my life and his you may, but it won't make any difference. I will have him anyhow. We just might as well quit talking about it now."

"Quit talking about it? Quit talking about it? Indeed! I haven't even begun talking yet. I am just trying to collect my wits, that's all. You are raging in insanity. This thing will never be! It will never be! You are just a poor, deluded slip of girl whom I have failed to watch sufficiently. From now on I will do my duty by you, if God spares me. You need me. Oh, how you need me. Poor, little Suzanne."

"Oh, hush, mamá! Stop the hysterics!" interrupted Suzanne.

"I will call up Mr. Colfax. I will call up Mr. Winfield. I will have him discharged. I will expose him in the newspapers. The scoundrel, the villain,

the thief. Oh, that I should ever have lived to see this day. That I should ever have lived to have seen this day."

"That's right, mamá!" said Suzanne wearily. "Go on. You are just talking, you know, and I know that you are. You cannot change me. Talking cannot. It is silly to rave like this, I think. Why won't you be quiet? We may talk, but needn't scream."

Mrs. Dale put her hands to her temples. Her brain seemed to be whirling.

"Never mind now," she said. "Never mind! I must have time to think. But this thing you are thinking will never be. It never will be. Oh! Oh! Oh!" and she turned, sobbing, to the window.

Suzanne merely stared. What a peculiar thing emotions were in people— these emotions over morals. Here was her mother weeping, and she was looking upon the thing her mother was crying about as the most essential and delightful and worthwhile thing. Certainly life was revealing itself to her rapidly these days. Did she really love Eugene so much? Yes, yes, yes, indeed. A thousand times yes. This was not a tearful emotion for her but a great, consuming, embracing joy.

CHAPTER XC

Pages and pages of this book might be devoted to just such tirades as this. For hours that night—until one, two, and three o'clock in the morning; from five, six, and seven on until noon and night of the next day, and the next day after that, and the fourth day, and the fifth day, the storm continued. It was a terrible siege, heart burning, heart breaking, brain wracking. Mrs. Dale lost weight rapidly. The color left her cheeks; a haggard look settled in her eyes. She was terrified, nonplussed, driven to extremities for means wherewith to overcome Suzanne's opposition and suddenly but terribly developed will. No one would have dreamed that this quiet, sweet mannered, introspective girl could be so positive, convinced, and unbending when in action. She was as a fluid body that has become adamant. She was a creature made of iron, a girl with a heart of stone. Nothing moved her—her mother's tears, her threats of social ostracism, of lost distinction, of physical and moral destruction for Eugene and herself, her threats of public exposure in the newspapers, of incarceration in an asylum. Suzanne had watched her mother a long time and had concluded that she loved to talk imposingly in an easy, philosophic, at times pompous way, but that really there was very little in what she said. She did not believe

that her mother had true courage—that she would risk incarcerating her in an asylum or exposing Eugene to her own disadvantage, let alone poisoning or killing her. Her mother loved her. She would rage terribly for a time this way, and then she would give in. It was Suzanne's plan to wear her down—to stand her ground firmly until her mother wearied and broke under the strain. Then she would begin to say a few words for Eugene, and eventually, by much arguing and blustering, her mother would come round. Eugene would be admitted to the family councils again. He and Suzanne would argue it all out together in her mother's presence. They would probably agree to disagree in a secret way but she would get Eugene and he her. Oh, the wonder of that joyous denouement. It was so near now, and all for a little courageous fighting. She would fight, fight until her mother broke and then—oh, Eugene! Eugene!

Mrs. Dale was not to be so easily overcome as Suzanne imagined. She was far from yielding, as haggard and worn as she was. There was an actual physical conflict between them once when Suzanne, in the height of an argument, decided that she would call up Eugene on the phone and ask him to come down and help her settle the discussion. Mrs. Dale was determined that she should not. The servants were in the house listening, unable to catch at first the drift of the situation but knowing almost by intuition that there was desperate discussion going on. Suzanne decided to go down in the library where the phone was. Mrs. Dale put her back to the door and attempted to deter her. Suzanne tried to open it by pulling. Her mother unloosed Suzanne's hands desperately, but it was very difficult. Suzanne was so strong.

"For shame," she said, "for shame! To make your own mother contest with you. Oh, the degradation" (this while she was struggling). Finally angry, hysteric tears coursed involuntarily down her cheeks, and Suzanne was moved at last. It was so obvious that this was real, bitter heart burning on her mother's part. Her hair was shaken loose on one side—her sleeve torn.

"Oh, my goodness, my goodness!" Mrs. Dale gasped at last, throwing herself in a chair and sobbing bitterly. "I shall never lift my head again! I shall never lift my head again!"

Suzanne looked at her somewhat sorrowfully. "I'm sorry, mamá," she said, "but you have brought it all on yourself. I needn't call him now. He will call me and I will answer. It all comes from your trying to rule me in your way. You won't realize that I am a personality also—quite as much as you are. I have my life to live. It is mine, to do with as I please. You are not going to prevent me in the long run. You might as well stop fighting with me now. I don't want to quarrel with you. I don't want to argue, but I am a grown woman, mamá. Why won't you listen to reason? Why won't you

let me show you how I feel about this? Two people really loving each other have a right to be with each other. It isn't anyone else's concern."

"Anyone else's concern! Anyone else's concern!" replied her mother viciously. "How you talk. What nonsense! What silly, love-sick drivel. If you had any idea of life, of how the world is organized, you would laugh at yourself. Ten years from now—one year even—you will begin to see what a terrible mistake you are trying to make. You will scarcely believe that you could have done or said what you are doing or saying now. Anyone else's concern! Oh, merciful heaven—will nothing put even a suggestion of the wild, foolish reckless character of the thing you are trying to do in your mind?"

"But I love him, mamá," said Suzanne.

"Love! Love! You talk about love," said her mother, bitterly and hysterically. "What do you know about it? Do you think he can be loving you when he wants to come here and take you out of a good home and a virtuous social condition and wreck your life and bring you down into the mire—your life and mine and that of your sisters and brother, forever and ever? What does he know of love? What do you? Think of Adele and Ninette and Kinroy. Have you no regard for them? Where is your love for me and for them? Oh, I have been so afraid that Kinroy might hear something of this. He would go and kill him. I know he would. I couldn't prevent it. Oh, the shame, the scandal, the wreck it would involve us all in. Have you no conscience, Suzanne, no heart?"

Suzanne stared before her calmly. The thought of Kinroy moved her a little. He might kill Eugene—she couldn't tell—he was a courageous boy. Still, there was no need for any killing or exposure or excitement of any kind if her mother would only behave herself. What difference did it make to her or Kinroy or anybody anywhere what she did? Why couldn't she, if she wanted to? The risk was on her head. She was willing. She couldn't see what harm it would do.

She expressed this thought to her mother once who answered in an impassioned plea for her to look at the facts. "How many evil women of the kind and character you would like to make of yourself do you know? How many would you like to know? How many do you suppose there are in good society? Look at this situation from Mrs. Witla's point of view. How would you like to be in her place? How would like to be in mine? Suppose you were Mrs. Witla and Mrs. Witla were the other woman? Then what?"

"I would let him go," said Suzanne.

"Yes! yes! yes! You would let him go. You might. But how would you feel? How would anyone feel? Can't you see the shame in all this, the disgrace? Have you no comprehension at all? No feeling?"

"Oh, how you talk, mamá. How silly you talk. You don't know the facts.

Mrs. Witla doesn't love him any more. She told me so. She has written me so. I had the letter and gave it back to Eugene. He doesn't care for her. She knows it. She knows he cares for me. What difference does it make, if she doesn't love him? He's entitled to love somebody. Now I love him. I want him. He wants me. Why shouldn't we have each other?"

In spite of all her threats, Mrs. Dale was not without subsidiary thoughts of what any public move on her part would certainly—not probably, but immediately—involve. Eugene was well known. To kill him, which was really very far from her thoughts, in any save a very secret way, would create a tremendous sensation and involve no end of examination, discussion, excited publicity. To expose him to either Colfax or Winfield meant in reality exposing Suzanne to them and possibly to members of her own social set or nearly so, for these men were of it and might talk. Eugene's sudden resignation would cause comment. If he left, Suzanne might run away with him—then what? There was the thought on her part that the least discussion or whisper of this to anybody might produce the most disastrous results. What capital the so-called "yellow" newspapers of the time would make out of a story of this character—Eugene and Suzanne. How they would gloat over the details. It was a most terrible and dangerous situation and yet it was plain that something had to be done and that immediately. What?

In this crisis it occurred to her that several things might be done, and without great danger of climacteric results, if she could only have a little time in which Suzanne would promise to remain quiescent. If she could get her to say that she would do nothing for ten days or five days, all might be well, for then she could go to see Angela, Eugene, Mr. Colfax if necessary, and Dr. Woolley, her old family physician. The latter was a most exalted personage of great age and perspicacity who had doctored her, her mother before her, and Suzanne after her. His advice would be most valuable. She wanted to have time to do these things—to leave Suzanne in order to go on these various errands—and in order to do this she had to obtain Suzanne's word, which she knew she could respect absolutely, that she would make no move of any kind until the time was up. Under pretence that Suzanne herself needed time to think or should take it, she pleaded and pleaded until finally the girl, on condition that she be allowed to phone Eugene and state how things stood, consented. Eugene had called her up the second day after the quarrel began and had been informed by the butler, at Mrs. Dale's request, that she was out of town. He called the second day and got the same answer. He wrote her, and Mrs. Dale hid this letter, but on the fourth day Suzanne called him up and explained. The moment she did so he was sorry that she had been so hasty in telling her mother, terribly so, but there was nothing to be done now save to stand by his guns. He was ready, in a grim way, to

rise or fall in this situation, so long as, in doing either, he could obtain his heart's desire.

"Shan't I come and help you argue?" he asked.

"No, not for five days. I have given my word."

"Shan't I see you?"

"No. Not for five days, Eugene."

"Mayn't I even call you up?"

"No. Not for five days. After that, yes."

"All right, Flower Face—Divine Fire. I'll obey. I'm yours to command. But, oh, sweet, it's a long time."

"I know, but it will pass."

"And you won't change?"

"No."

"They can't make you?"

"No. You know they can't, dearest. Why do you ask?"

"Oh, I can't help feeling a little fearful, sweet—you are so young—so new to love."

"I won't change! I won't change. I don't need to swear. I won't."

"Well, then, Myrtle Bloom."

She hung up the receiver, and Mrs. Dale knew now that her greatest struggle was before her.

Her several contemplated moves consisted first in going to Mrs. Witla, unbeknown to Suzanne or Eugene, and seeing what she knew of how things were and what she would advise. The next was in going to see Eugene himself at his office and either threatening or cajoling him into withdrawing. She half fancied because of his big interests and critical position she could make him do this. The third was in sending for the old, confidential family physician here in New York, to see what he would advise. She fancied that Suzanne, in case she refused to listen to the doctor's counsel, could be, forcefully or by some ruse, with his assistance spirited away to some private sanitarium or guarded hiding place where she could be detained, forcefully if necessary, until she had time to come to her senses. Three weeks, a month, six months, a year might be necessary to bring her to a realization of the terrible nature of the thing she was contemplating doing, but time certainly would produce a change of heart. As it was, she was too fresh from the presence of Eugene. His voice was practically in her ear. Nothing could be hoped for as long as he could call her up, or see her, or both, and whisper his insidious counsels, but once away she would have time to think. Then her mother's love and affection might hope to prevail. Anyhow she was determined to try.

Visiting Angela really did no great good, unless the fact that it fomented

anew the rage and grief of Angela and gave Mrs. Dale additional material wherewith to belabor Eugene could be said to be of advantage. Angela, who had been arguing and pleading with Eugene all these days, endeavoring by one thought and another to awaken him to a sense of the enormity of the offense he was contemplating, was practically in despair. She had reached the place where she had become rather savage again and he also. In spite of her condition, in spite of all she could say, he was cold and bitter—so insistent that he was through with the old order that he made her angry. Instead of leaving him as she might well have done, trusting to time to alter his attitude or to make her see the wisdom of releasing him entirely, she preferred to cling to him for there was still affection left. She was used to him. He was the father of her coming child, unwelcome as it was. He represented her social position to her—her station in the world. Why should she leave him? Then too, there was this fear of the outcome, which would come over her like a chill. She might die. What would become of the child?

It was useless—really the worst thing that could be done, for Eugene was in no mood to listen to overtures—but Angela could not see it. She thought wildly of going or writing to Colfax and Mr. Winfield, of appealing to Mrs. Dale, Suzanne, anyone, everyone, but alas, this could not be straightened out this way. Angela was in no frame of mind to think logically. All her little system had gone to pieces. She fancied, having no means of knowing, that Eugene was with Suzanne daily. If she could only make her understand, how quickly that would settle it. It filled her heart with a great rage to think that she should ever be compelled to think of appealing to Suzanne. What a brute Eugene was. What a dog!

And then Mrs. Dale came. She came in excited, nervous, bursting into tears at the sight of Angela, convinced now, though it had never occurred to her before, that she was terribly wronged. Angela foolishly told her all her woes, charging Eugene with everything from inconsiderateness to his most evil deeds, and revealing her own condition without saying, however, why she was so. Mrs. Dale listened, all ears, terribly shocked at what she heard—shocked at Eugene's seeming hardness of heart, his wretched record, the shame of his proposition in regard to Suzanne. She had great sympathy for her own daughter and considerable for Angela—though not so much, for after all, she could see a certain degree of incompatibility here. Angela's readiness to attack her husband surprised Mrs. Dale in the face of Angela's statement that she loved him. It did not seem quite natural, but of course she did not understand either Eugene or Angela. She was looking primarily for the salvation of her own daughter, and that was all.

Angela tried as much as possible to avoid any reference to Suzanne, for she had no love for her. Suzanne had come in her eyes to be the living

embodiment of personal deviltry. She now considered her hard, coarse, vulgar. No girl of any refinement would enter on any such misalliance as this. She must be evil innately, and Mrs. Dale's reference occasionally to her "poor, dear hypnotized Suzanne" irritated her greatly.

"You know, Mrs. Dale," she said at one point significantly, "I don't hold Suzanne absolutely guiltless. She is old enough to know better. She has been out in society long enough to know that a married man is sacred property to another woman."

"I know, I know," replied Mrs. Dale resentfully but cautiously, "but Suzanne is so young. You really don't know how much of a child she is. And she has this silly, idealistic, emotional disposition. I suspected something of it but I did not know it was so strong. I'm sure I don't know where she gets it. Her father was most practical. But she was all right until your husband persuaded her."

"That may be all true," went on Angela. "But she is not guiltless. I know Eugene. He is weak. But he will not follow where he is not led and no girl need be tempted unless she wants to."

"Suzanne is so young," again pleaded Mrs. Dale.

"Well, I'm sure if she knew Mr. Witla's record accurately," went on Angela foolishly, "she wouldn't want him. I have written her. She ought to know. He isn't honest and he isn't moral, as this thing shows. If this were the first time he had fallen in love with another woman I could forgive him, but it isn't. He did something quite as bad six or seven years ago and only two years before that there was another woman. He wouldn't be faithful to Suzanne if he had her. It would be a case of a blazing affection for a little while and then he would tire of her and cast her aside. Why, you can tell what sort of a man he is when he would propose to me, as he did here, that I should let him maintain a separate establishment for Suzanne and say nothing of it. The idea!"

Mrs. Dale clicked her lips significantly. She considered Angela foolish for talking this way, but it could not be helped now. Possibly Eugene had made a mistake in marrying her. This did not excuse him, however, in her eyes for wanting to take Suzanne under the conditions he proposed. If he were free, it would be an entirely different matter. His standing, his mind, and his manners were not entirely objectionable though he was not to the manner born.

Mrs. Dale went away toward evening, greatly nonplussed by what she had seen and heard but convinced that no possible good could come of this situation. Angela would never give him a divorce. Eugene was not a fit man morally for her daughter anyhow. There was great scandal on the verge of exposure here in which her beloved daughter would be irretriev-

ably smirched. In her desperation, she decided if she could do no better she would try to dissuade Eugene from seeking Suzanne until he could obtain a divorce, in which case, to avoid something worse, she would agree to a marriage. But this was only to be a lip promise if possible. The one thing she wanted to do was to get Suzanne to give him up entirely. If Suzanne could be spirited away or dissuaded from throwing herself away on Eugene—that would be the thing. Still she proposed to see what a conversation with Eugene would do.

The next morning as he was sitting in his office wondering what the delay of five days portended and what Suzanne was doing, as well as trying to fix his mind on the multitudinous details which required his constant attention and were now being rather markedly neglected, the card of Mrs. Emily Dale was laid on his table and a few moments later, after his secretary had been dismissed and word given that no one else was to be allowed to enter, Mrs. Dale was shown in.

She was pale and weary but exquisitely dressed in a greenish blue-gray striped silk and picture hat of black straw and feathers. She looked quite young and handsome herself, not too old for Eugene, and indeed once she had fancied he might well fall in love with her. What her thoughts had been at that time she did not now recall, but nevertheless they had been only partially nebulous for they had involved the probable desertion or divorce or death of Angela and Eugene's enthusiastic infatuation for her. All that was over now, of course, and in the excitement and distress almost completely forgotten. Eugene had not forgotten that he had had similar sensations or imaginations at the time, and that Mrs. Dale had always drawn to him in a sympathetic and friendly way. Here she was, though, this morning, coming upon a desperate mission, no doubt, and he would have to contend with her as best he could.

The conversation opened by his looking into her set face as she approached and smiling blandly though it was a considerable effort.

"Well, Suzanne phoned me that she told you," he began defiantly.

"Yes," she replied in a low, tense voice, "and I ought to kill you where you stand. To think that I should have ever harbored such a monster as you in my home and near my dear, innocent daughter. It seems incredible now. I can't believe it. That you should dare. And you with a dear, sweet wife at home, sick and in the condition she is in! I should think if you had any manhood at all—any sense of shame! When I think of that poor, dear little woman and what you have been doing or trying to do—I—if it weren't for the scandal of this, you would never leave this office alive."

"Oh, bother! Oh, don't talk rot, Mrs. Dale," said Eugene quietly, though irritably. He did not care for her melodramatic attitude. "The dear, dar-

ling little woman you speak of is not as bad off as you think, and I don't think she needs as much of your sympathy as you are so anxious to give. She is pretty well able to take care of herself, as sick as she is. As for killing me—you or anyone else—well, that wouldn't be such a bad idea. I'm not so much in love with life. This is not fifty years ago, though, but the twentieth century, and this is New York City. I love Suzanne. She loves me. We want each other desperately. Now an arrangement can be made which will not interfere with you in any way and which will adjust things for us. Suzanne is anxious to make that arrangement. It is as much her proposition as it is mine. Why should you be so vastly disturbed? You know a great deal about life."

"Why should I be disturbed? Why should I—can you sit in this office— you, a man in charge of all this vast public work, and ask me in cold blood why I should become disturbed? And my daughter's very life at stake. Why should I come disturbed, and my daughter only out of her short dresses a little while ago and practically innocent of the world. You dare to tell me that she proposed. Oh, you impervious scoundrel. To think I could be so mistaken in any human being. You, with your bland manners and your inconsistent talk of happy family life. I might have understood, though, when I saw you so often without your wife. I should have known. I did, God help me, but I didn't act upon it. I was taken by your bland, gentlemanly attitude. I don't blame poor, dear little Suzanne. I blame you, you utterly deceiving villain, and myself for being so silly. I am being justly rewarded, however."

Eugene merely looked at her and drummed with his fingers.

"But I did not come here to bandy words with you," she went on. "I came to say that you must never see my daughter again, or speak of her, or appear where she might chance to be, though she won't be where you may appear if I have my way, for you won't have a chance to appear anywhere in decent society very much longer. I shall go, unless you agree here and now never to see or communicate with her anymore, to Mr. Colfax, whom I know personally, as you well know, and lay the whole matter before him. I'm sure with what I know now of your record and what you have attempted to do in connection with my daughter, and the condition of your wife, that he will not require your services very much longer. I shall go to Mr. Winfield, who is also an old friend, and lay the matter before him. Privately you will be drummed out of society, and my daughter will be none the worse for it. She is so very young that when the facts are known you are the only one who will bear the odium of this. Your wife has given me your wretched record only yesterday. You would like to make my Suzanne your fourth or fifth. Well, you will not. I will show you something you have not previously known. You are dealing with a desperate mother. Defy me if you dare.

I demand that you write your farewell to Suzanne here and now and let me take it to her."

Eugene smiled sardonically. Mrs. Dale's reference to Angela made him bitter. So she had been there and Angela had talked of him—his past—to her. What a mean thing to do. After all, Angela was his wife. Only the morning before, she had been appealing to him on the grounds of love. And she had not told him of Mrs. Dale's appearance. Love! Love! What sort of love was this? He had done enough for her to make her generous in a crisis like this, even if she did not want to be.

"Write you a statement of release to Suzanne?" he observed, his lips curling, "How silly. Of course I won't. And as for your threat to run to Mr. Colfax, I have heard that before from Mrs. Witla. There is the door. His office is twelve flights down. I'll call a boy, if you wish. You tell it to Mr. Colfax and see how much farther it goes before you are much older. Run to Mr. Winfield also. A lot I care about him or Mr. Colfax. If you want a grand, interesting discussion of this thing, just begin. It will go far and wide, I assure you. I love your daughter. I'm desperate about her. I'm literally crazy about her." He got up. "She loves me, or I think does. Anyhow, I'm banking all on that thought. My life from an affectional point of view has been a failure. I have never really been in love before. But I am crazy about Suzanne Dale. I am wild about her. If you had any sympathy for an unhappy, sympathetic, emotional mortal, who has never yet been satisfied in a woman, you would give her to me. I love her, I love her. By God!" (He smashed the desk with his fist.) "I will do anything for her. If she will come to me, Colfax can have his position. Winfield can have his Blue Sea Corporation. You can have her money if she wants to give it to you. I can make a living abroad by my art, and I will. Other Americans have done it before me. I love her! I love her! Do you hear me, I love her, and what's more, I am going to have her. You can't stop me. You haven't the brains; you haven't the strength; you haven't the resources to match that girl. She's brighter than you are. She's bigger! She's finer. She's finer than the whole, current-day conception of society and life. She loves me and she wants to give herself to me—willingly, freely, joyously. Match that, in your petty society circles, if you can. Society. You say you will have me drummed out of it, will you? A lot I care about your society. Hacks! Poseurs, mental lightweights, money grubbers, gamblers, thieves, lechers—a fine lot, and a lot I care. To see you sitting there and talking to me with your grand air makes me laugh. A lot I care for you. I was thinking of another kind of woman when I met you—not a narrow, conventional fool. I thought I saw one in you. I did, didn't I—not? You are like all the rest, a narrow, petty, slavish follower after fashion and convention. Well"—he snapped his fingers in her face—"go on and do your

worst. I will get Suzanne in the long run. She will come to me. She will dominate you. Run to Colfax. Run to Winfield. I will get her just the same. She's mine. She belongs to me. She is big enough for me. The gods have given her to me. And I'll have her, if I have to smash you and your home and myself and everyone else connected with me. I'll have her! I'll have her!! She's mine! She's mine!" He lifted a tense hand. "Now you run and do anything you want to. Thank God, I've found one woman who knows how to live and to love. She's mine!"

Mrs. Dale stared at him in amazement, scarcely believing her ears. Was he crazy? Was he really so much in love? Had Suzanne turned his brain? What an astonishing thing. She had never seen him anything like this—never imagined him capable of anything like it. He was always so quiet, smiling, bland, witty. Here he was dramatic, impassioned, fiery, hungry. There was a terrible light in his eye and he was desperate. He must be in love.

"Oh, why will you do this to me?" she whimpered, all at once the terror of his mood conveying itself to her for the moment and arousing a sympathy which she had not previously felt. "Why will you come into my home and attempt to destroy it? There are lots of women who will love you. There are lots more suited to your years and temperament than Suzanne. She doesn't understand you. She doesn't understand herself. She's just young and foolish and hypnotized. You have hypnotized her. Oh, why will you do this to me? You are so much older than her; so much more schooled in life. Why not give her up? I don't want to go to Mr. Colfax. I don't want to speak to Mr. Winfield. I will if I have to, but I don't want to. I have always thought so well of you. I know you are not an ordinary man. Restore my respect for you, my confidence in you. I can forgive, if I can't forget. You may not be happily married—I am sorry for you. I don't want to do anything desperate. I only want to save poor little Suzanne. Oh, please, please! I love her so. I don't think you understand how I feel. You may be in love, but you ought to be willing to consider others. True love would. I know she is hard and wilful and desperate now, but she will change if you will help her. Why, if you really love her, if you have any sympathy for me or regard for her future or your own, you will come out of this and release her. Tell her you made a mistake. Write her now. Tell her you can't do this and not socially ruin her and me and yourself, and so you won't do it. Tell her that you have decided to wait until time has made you a free man, if that is to be, and then let her go to see if she will not be happy in a moral life. You don't want to ruin her at this age, do you? She is so young, so innocent. Oh, if you have any judgement of life at all, any regard, any consideration, anything. I beg of you; I beg as her mother, for I love her—oh!——." Tears came in her eyes again and she cried weakly in her handkerchief.

Eugene stared at her. What was he doing? Where was he going? Was he really as bad as he appeared to be here? Was he possessed? Was he really so hard hearted? Through her grief and Angela's and the threats concerning Colfax and Winfield, he caught a glimpse of the real heart of this situation. It was as if there had been a great flash of lightning illuminating a black landscape. He saw sympathetically—sorrow, folly, a number of things that were involved—and then the next moment it was gone. Suzanne's face came back, smooth, classic, chiseled, beautifully modeled, her beauty like a tightened bow; her eyes, her lips, her hair, the gayety and buoyancy of her motions and her smile. Give her up! Give up Suzanne and that dream of the studio and of joyous, continuous delicious companionship? Did Suzanne want him to? What had she said over the phone? No! No! No! Quit now, and her clinging to him? No! No! No! Never!! He would fight first. He would go down fighting. Never! Never! Never!

His brain seethed.

"I can't do it," he said, getting up again, for he had sat down after his previous tirade. "I can't do it. You are asking something that is utterly impossible. It can never be done. God help me, I'm insane, I'm wild over her. Go do anything you want to, but I must have her and I will. She's mine! She's mine! She's mine!"

His thin, lean hands clinched and he clicked his teeth.

"Mine, mine, mine!" he muttered, and one would have thought him a villain in a cheap melodrama.

Mrs. Dale shook her head.

"God help us both," she said. "You shall never have her. You are not worthy of her. You are not right in your mind. I will fight you with all the means in my power. I am desperate; I am wealthy; I know how to fight. You shall not have her. Now we will see which will win." She rose to go and Eugene followed her.

"Go ahead," he said calmly, "but in the end you lose. Suzanne comes to me. I know it. I feel it. I may lose many others things but I get her. She's mine."

"Oh!" sighed Mrs. Dale wearily, moving toward the door. "Is this your last word?"

"It is, positively."

"Then I must be going."

"Good-bye," he said solemnly.

"Good-bye," she answered, white faced, her eyes staring.

She went out and Eugene took up the telephone but he remembered that Suzanne had warned him not to call but to depend on her.

So he put it down again.

CHAPTER XCI

The fire and pathos of Mrs. Dale's appeal should have given Eugene pause. He thought once of going after her and making a further appeal, saying that he would try and get a divorce eventually and marry Suzanne, but he remembered that peculiar insistency of Suzanne on the fact that she did not want to get married. Somehow, somewhere, somewhy, she had formulated this peculiar ideal or attitude which, whatever the world might think of it, was possible of execution, providing she and he were tactful enough. It was not such a wild thing for two people to want to come together in this way, if they chose, he thought. Why was it? Heaven could witness there were enough illicit and peculiar relationships in this world to prevent society from becoming excited about one more, particularly when it was to be conducted in so circumspect and subtle a way. He and Suzanne did not intend to blazon their relationship to the world. As a distinguished artist—not active, but acknowledged and accomplished—he was entitled to a studio life. He and Suzanne could meet there. Nothing would be thought of it. Why had she insisted on telling her mother? It could have all been done without that. There was another peculiar ideal of hers—her determination to tell the truth under all circumstances. And yet she had really not told it. She had deceived her mother a long time about him, simply by saying nothing. Was this some untoward trick of fate's merely concocted to harm him? Surely not! And yet Suzanne's headstrong determination seemed almost a fatal mistake now. He sat down brooding over it. Was this a terrific mistake? Would he be sorry? All his life was in the balance. Should he turn back?

No! No! No! Never! It was not to be. He must go on. He must have Suzanne! He must! He must! So he brooded.

The third of Mrs. Dale's resources was not quite so unavailing as the others, though it was almost so. She had sent for Dr. Latson Woolley, the old school practitioner of great repute previously mentioned, who was of rigid honor and rather Christian principles himself, but who was of wide intellectual and moral attitude so far as others were concerned. In spite of all his social and medical experience (or rather because of it) and his Christian leanings, he was not so sure that the so-called collective wisdom of the world really represented anything of what might be called ultimate wisdom. He had seen so much of sin, sickness, shame, and degradation. People were always in so much secret trouble and always apparently wearing such a gay social exterior. He had no faith in this joyous mask anymore. It was almost universally, in so far as individuals were concerned, a mockery and a lie. Children were happy, sometimes. All people were happy for a little while, in spells and spots. But there were so many dark places in almost every home.

Oh, if the world only knew what he knew. But now he was old and tired and slightly rheumatic at times, and occasionally a little cross and crusty, but courteous, sympathetic, considerate, and liberal withal. If he could have given the world one bit of advice out of all his wealth of experience it would have been, "Bear ye one another's burdens," or as Christ also put it, "Love one another." The world was not looking for advice from him, however. It was looking for shows and gew-gaws and gayeties, and anyhow he would soon be dead. What difference did it make?

Dr. Woolley was not by any means a typical society physician. He was not dressy and well set up as are some of the old men of this order, and he was rather indifferent and shabby about himself. He affected black broadcloth because it was smooth and soft and apparently appropriate and easy to get into, but it was always loose and baggy in the legs and sleeves and the collar was a little dandruffy. The lapels of his coat and the front of his waistcoat were apt to be stained at times. He liked snuff, when he was alone, and if he had dared he would have chewed, but the memory of what his dead wife thought of the habit was sufficient to deter him. Mrs. Dale had relied on him in times of trouble, as had many another society woman whose mothers before them had been looked after by him. He knew Suzanne very well—was present when she came into the world and had watched her growth with interest, as he had watched that of many another society child. He understood the society type very well, Mrs. Dale particularly, and looked on it much as one might look on a blooded horse. There was no accounting for its vagaries. One needed either to humor or ignore them. There was no happy middle ground.

"Well, Mrs. Dale," he observed when he was ushered into her presence in the library on the ground floor, and extending his hand cordially, though wearily, "what can I do for you this morning?"

"Oh, Dr. Woolley," she began directly. "I am in so much trouble. It isn't a case of sickness. I wish it were. It is something so much worse. I have sent for you because I know I can rely on your judgement and sympathy. It concerns my daughter, Suzanne."

"Yes, yes," he grunted in a rather crusty voice, for his vocal chords were old, and his eyes looked out from under shaggy gray eyebrows which somehow bespoke a world of silent observation. "What's the matter with her? What has she done now that she ought not to do?"

"Oh, Dr. Woolley," exclaimed Mrs. Dale nervously, for the experiences of the last few days had almost completely dispelled her normal composure, "I don't know how to tell you, really. I don't know how to begin. Suzanne, my dear, precious Suzanne, in whom I have placed so much faith and reliance, has, has—oh, how shall I tell you? How can anyone believe it?"

"Well, tell me," interrupted Dr. Woolley laconically.

"Has fallen in love with a married man—a man twice her years in age, and of terrible tendencies, I find—and I am not able to do the first thing with her. She seems like one possessed. She is bound and determined to go and live with him—without marriage, she says, without waiting for a divorce, and I am almost mad. Think of it, my Suzanne! Without a marriage ceremony and without any regard for the conventions or public opinion! And when I try to argue with her she simply refuses to listen to me. She seems for some reason to think that I am trying to control her against her best interests, and nothing that I can say or do will apparently move her. Oh, doctor, I have almost been driven mad in these last few days. I have no one, practically, to whom I can turn in a crisis like this outside of yourself. I am desperate—heart broken. If only her father were alive or her brother old enough. I am so afraid of something being done or said by her or someone which will cause it to get to the public and the newspapers. Oh, if it should, I shall be irreparably ruined. Oh, do advise me, doctor. Tell me what I shall do in this crisis. I really do not know how to think any more. I am so nervous and upset."

"Calm yourself! Calm yourself!" he said, walking to a window and looking out as he rubbed his chin meditatively the while. "These things are not adjusted by growing frightened and hysterical. You will not get anywhere that way. It is probable this thing can be adjusted without any trouble or exposure if you will keep perfectly calm and think. Who is the man? If I may ask."

"His name is Witla, doctor, Eugene Witla, but you probably have never heard of him. He is the managing publisher of the United Magazines Corporation and he holds a rather prominent place in society and elsewhere. He has a charming wife entirely suited to his temperament who loves him dearly but he is determined to desert her now for Suzanne, and that at a time when his wife is about to become a mother." (Mrs. Dale was shortening the time frame greatly.) "She is sick and heart broken, lying up in their apartment on Riverside Drive. My daughter is like one possessed about him and you can imagine my state of mind. She will not listen to me; she refuses to even discuss any arrangement outside of the one she has in mind. She wants to go to him now and he wants to take her. Think of it. Think of my Suzanne, anxious to throw herself away in that fashion. I saw him yesterday and he positively refuses to give her up. Oh, I can't believe it, doctor! I can't realize it. I feel sometimes as though I should go raving, staring mad!"

"Be calm! Be calm! Don't talk nonsense!" said the old physician irritably. "What is the value of hysterics? This isn't a case in which nervous excitement is at all necessary. She hasn't given herself to him yet, then?"

"No."

"Well, I am thinking you have considerable to be grateful for. She might have yielded without your knowledge and told you afterwards—or not at all."

"Oh, doctor! My Suzanne!"

"Mrs. Dale, I looked after you, and your mother before you, and Suzanne. I know something about human nature and your family characteristics. Your husband was a very determined man, as you will remember. Suzanne may have some of his traits in her. She is a very young girl, you want to remember, very robust and vigorous. She is just at that time of life when she is apt to be taken with a passion of this kind. It is like scarlet fever or small pox or diphtheria or any other curable disease, however. Sometimes it leaves disagreeable marks and sometimes it doesn't. It may prove fatal as any of these cases may, but it may not. It depends very much on how it is handled. How old is this Witla man?"

"About thirty-eight or nine, doctor."

"Um! I suspected as much. The fatal age. It's a wonder you came through that period as safely as you did. You're nearly forty, aren't you?"

"Yes, doctor, but you're the only one that knows it."

"I know, I know. It's the fatal age. You say he is in charge of the United Magazines Corporation. I have probably heard of him. I know of Mr. Colfax of that company. Is he very emotional in his temperament?"

"I had never thought so before this."

"Um! Well he probably is. Thirty-eight or thirty-nine and eighteen or nineteen—a bad combination. Where is Suzanne?"

"Upstairs in her room, I fancy."

"It might not be a bad thing if I talked to her myself a little, though I don't believe it will do any good. A young woman in that state of mind isn't subject to argument. She is bound by something which hasn't anything to do with reason. It's a disease. Still I would like to talk to her. See if you can persuade her to come down."

Mrs. Dale disappeared and was gone for nearly three-quarters of an hour. Suzanne was stubborn, irritable, and to all preliminary entreaties insisted that she would not. Why should her mother call in outsiders, particularly Dr. Woolley, whom she knew and liked? She suspected at once when her mother said that Dr. Woolley wanted to see her that it had something to do with her case, and demanded to know why. Finally after much pleading she consented to come down, though it was with the intention of showing her mother how ridiculous all her excitement was.

The old doctor who had been meditating upon the inexplicable tangle of chemical and physical variations in life—the blowing hither and thither,

apparently aimlessly, like the winds of heaven, of diseases, affections, emotions, and hates of all kinds—looked up quizzically at Suzanne as she entered. Viewing her as a man would, aside from his convictions as a moralist and without thought of the necessity of divine guidance in all these matters, he could readily see how Eugene or any other healthy, normal, imaginative man might well be attracted to her and unless safely controlled by a nearly perfect will, become terribly infatuated with her. She was sweet, buoyant, delightful to look upon, with a fresh complexion, a clear eye, an intelligent, serene, and noticeably self-confident countenance. Her light brown hair was blowing about her eyes in dainty, wavy strands, and her figure was of those perfect proportions which naturally appeal strongly to the sex instincts.

"Well, Suzanne," he said genially, rising and walking slowly toward her, "I'm glad to see you again. How are you this morning?"

"Pretty well, doctor—how are you?"

"Oh, as you see! As you see! A little older and a little fussier, Suzanne, making other people's troubles my own. Your mother tells me you have fallen in love. That's an interesting thing to do, isn't it? Well, it's a very natural thing anyhow, particularly when we're young and thoughtless. I suppose you are satisfied that you have made the best choice in the world."

"You know, doctor," said Suzanne defiantly, "I told mamá that I don't care to discuss this, and I don't think she has any right to try to make me. I don't want to, and I won't. I think it is all in rather poor taste."

"Poor taste, Suzanne?" asked Mrs. Dale. "Do you call our discussion of what you want to do poor taste, when the world will think that what you want to do is terrible when you do it? I——"

"I told you, mamá, that I was not coming down here to discuss this thing, and I'm not," said Suzanne, turning to her mother and ignoring Dr. Woolley. "I'm not going to stay. I don't want to offend Dr. Woolley, but I'm not going to stay and have you argue this all over again. We have been arguing for days now. My mind is made up. You can discuss it all you please with anyone you please, but I'm not going to."

She turned to go.

"There, there, Mrs. Dale, don't interrupt," observed Dr. Woolley, holding Suzanne by the very tone of his voice. "I think myself that very little is to be gained by argument. Suzanne is convinced that what she is planning to do is to her best interests. It may be. We can't always tell, as someone has said. I think the best thing that could be discussed, if anything at all in this matter can be discussed, is the matter of time. It is my opinion that before doing this thing that Suzanne wants to do, and which may be all right, for all I know, it would be best if she would take a little time. I know nothing of Mr. Witla. He may be a most able and worthwhile man. Suzanne

ought to give herself a little time to think, though, I should say—three months or six months. A great many aftereffects hang on this decision, as you know," he said, turning to Suzanne. "It may involve responsibilities you are not quite ready to share. You are only eighteen or nineteen, you know. You might have to give up dancing and society and travel and a great many things and devote yourself to being a mother and ministering to your husband's needs. You expect to live with him permanently, don't you?"

"I don't want to discuss this, Dr. Woolley."

"But you do, don't you?"

"Only so long as we love each other."

"Um! Well, you might love him for some little time yet. You rather expect to do that, don't you?"

"Why, yes—but what is the good of this, anyhow? My mind is made up."

"Just the matter of thinking!" said Dr. Woolley very soothingly and in a voice which charmed Suzanne and held her. "Just a little time in which to be absolutely sure. Your mother is anxious not to have you do it at all. You, as I understand it, want to do this thing right away. Your mother loves you and at bottom, in spite of this little difference, I know you love her. It just occurred to me that for the sake of good feeling all around, you might like to strike a balance. You might be willing to take, say, six months or a year and think about it. Mr. Witla would probably not object. You won't be any the less delightful to him at the end of that time, and as for your mother, she would feel a great deal better if she thought that after all, what you decided to do you had done after mature deliberation. It is so much better to think awhile in all cases. Love isn't just kisses and billing and cooing, you know. It has a lot of just plain ordinary living together in it, Suzanne. You're a sensible girl. Don't you think a little time would be worthwhile in this case?"

"Yes," exclaimed Mrs. Dale impulsively, "do take time to think, Suzanne. A year won't hurt you. Wait. You can live that long without him."

"I won't agree to do anything of the kind," said Suzanne desperately. "I have thought it all over. Six months or a year won't make any difference. Why should I wait?"

"Your mother's feelings, my dear—your own future liberty. It's something to think about, anyhow. I wouldn't try to settle it now, neither of you. I'd talk along these lines, however, if you talk at all. As you see, your mother is vitally opposed. Your own mind is fully made up. Now before you break everything into pieces here, why not talk along the lines of a reasonable delay? It won't do any harm. Your happiness will be just as great six months

from now as it will now. You don't suppose that you cannot live for six months longer as you have lived during the past six months, do you?"

"No," said Suzanne, unguardedly. "It is all a matter of whether I want to or not. I don't want to."

"Precisely. Still this is something you might take into consideration. The situation from all outside points of view is serious. I haven't said so but I feel that you would be making a great mistake. Still, that is only my opinion. You are entitled to yours. I know how you feel about it but the public is not likely to feel quite the same way. The public is a wearisome thing, Suzanne, but we have to take it into consideration. We live in it—by it. You have no doubt thought of that yourself. Well, a little time to study it out wouldn't hurt. I would advise you to do that. If you were engaged in the ordinary way you would be perfectly willing to take that much time, I am sure."

Suzanne stared stubbornly and wearily at her tormentors. Their logic did not appeal to her at all. She was thinking of Eugene and their plan. It could be worked. What did she care about the world? During all this talk she drew nearer and nearer the door and finally opened it.

"Well, that is all," said Dr. Woolley when he saw she was determined to go. "Good morning, Suzanne. I am glad to have seen you again."

"Good morning, Dr. Woolley," she replied.

She went out and Mrs. Dale wrung her hands. "I wish I knew what was to be done," she exclaimed, gazing at her counsellor.

Dr. Woolley brooded over the folly of undesired human counsel.

"There is no need for excitement," he observed after a time. "It is obvious to me that if she is handled rightly she will wait. She is in a state of high strung opposition and emotion, for some reason, at present. You have driven her too hard. Relax! Let her think this thing out for herself. Counsel for delay but don't irritate. You cannot control her by driving. She has too stern a will. Tears won't help. Emotion seems a little silly to her. Ask her to think, or better yet let her think, and plead only for delay. If she can get two or three weeks or months off by herself, undisturbed by your pleadings and uninfluenced by his, if she would ask him of her own accord to let her alone for that time, all will be well. I don't think she will ever go to him. She thinks she will, but I have the feeling that she won't. However, be calm. If you can, get her to go away. I will come again if I can do any good. I don't think I can, but I will try. Be calm. Handle it as I say."

"Would it be possible to lock her up in some sanatorium or asylum, doctor, until she has had time to think?"

"All things are possible but I should say it would be the most inadvisable thing you could do. Force accomplishes nothing in these cases. It should

be a last recourse, if any. It might alienate her affections from you entirely, which would be most dangerous. Better try moral suasion and a peaceful atmosphere. She is in love. Remember that is not an attitude of mind, but a lack of one. It is a disease—a spell."

"I know, but suppose she won't listen to reason?"

"You really haven't come to that bridge yet. You haven't talked calmly to her yet. You are quarrelling with her. See if you can't win her sympathy again in some way. You can do more with her that way than by trying to drive her. There is very little in that. You two will simply grow further and further apart."

"How practical you are, Doctor," observed Mrs. Dale in a mollified and complimenting vein.

"Not practical but intuitional. If I were practical I would never have taken up medicine."

He walked to the door, his old body sinking in somewhat upon itself. His old, gray, sad-gay eyes twinkled slightly as he turned.

"You were in love once, Mrs. Dale?" he said.

"Yes," she replied.

"You remember how you felt then?"

"Yes."

"Be reasonable. Remember your own sensations—your own attitude. You probably weren't crossed in your affair. She is. She has made a mistake. Be patient. Be calm. We want to stop it and no doubt can. Do unto others as you would be done by."

He ambled shufflingly across the piazza and down the wide wooden steps to his car.

CHAPTER XCII

The counsel of Dr. Woolley, however sound it might have appeared to Mrs. Dale under ordinary circumstances and however much it appealed to her now as an ideal method of procedure, lacked that immediate saving quality of strategy which she thought this situation demanded. Suzanne was too stubborn, too set in her mood, to be appealed to by soft phrases. The truth was, Mrs. Dale, by giving way to one form of emotion and another, both in words and action, had lost her daughter's confidence. She could not very well appeal to her now. Her mother's actions seemed silly to Suzanne; her excitement unwarranted. She herself was calm and determined—why shouldn't her mother be, or at least conservative in her procedures? Why

should she run to Dr. Woolley? Why threaten to kill her? It was impossible, intolerable, laughable.

"Mamá," she said, when, after Doctor Woolley had gone and her mother came to her room to see if she might not be in a mellower mood and to plead with her further for delay, "it seems to me you are making a ridiculous mess of all this. Why should you go and tell Dr. Woolley about me? I will never forgive you for that, mamá. You have done something I never thought you would do. I thought you had more pride—more individuality."

To understand Suzanne's fascination for Eugene, one should have seen her, in her large private boudoir, her back to her oval mirrored bird's-eye dressing table, her face fronting her mother, who stood with one hand upon the squared bars of the foot of the heavily but ornately constructed brass bed. Bird's-eye maple panels, painted with pretty pictures of flying blue birds and pink cherry blooms, had been let into the head of the bed. The walls were covered with a pinkish-cream colored paper upon which had been worked, at intervals, gay, hanging streamers of wild yellow roses and their attendant thorny stems and leaves. It was a lovely, sunny, many windowed chamber, large, protected with bright pink and white striped awnings, a plain but thick and soft green and gray rug upon the floor, and willow chairs, a willow breakfast table, set with a polished panel of bird's-eye maple, a willow bound lamp with a tremendous shade of pink and white silk scattered about it. On the walls were original paintings in light, sunny colors by E. L. Henry, F. Luis Mora, and F. S. Church, contemporaries of that day. Suzanne, in a white and blue morning dress, was the prettiest object in it. She contrasted with the gay and soothing atmosphere of the room. She was as shapely, ornate, and perfect as any object in it.

Mrs. Dale felt the force of the picture which Suzanne presented, but it only heightened her feeling concerning the awful devastation life was threatening to this perfect flower. Suzanne was as set in her look as chiseled marble—not hard but firm and pink hued.

"Well, Suzanne, you know," Mrs. Dale said rather despondently, "I just couldn't help it. I had to go to someone. I am quite alone outside of you and Kinroy and the children" (she referred to Adele and Ninette as "the children" when talking to either Suzanne or Kinroy), "and I didn't want to say anything to them. You have been my only confidant up to now, and since you have turned against me——"

"I haven't turned against you, mamá."

"Oh, yes you have. Let's not talk about it, Suzanne. You have broken my heart. You are killing me. I just had to go to someone. We have known Doctor Woolley so long. He is so good and kind."

"Oh, I know, mamá, but what good will it do? How can anything he

might say help matters? He isn't going to change me. You're only telling it to somebody who oughtn't to know anything about it."

"But I thought he might influence you," pleaded Mrs. Dale. "I thought you would listen to him. Oh, dear, oh, dear. I'm so tired of it all. I wish I were dead. I wish I had never lived to see this."

"Now there you go, mamá," said Suzanne, confidently. "I can't see why you are so distressed about what I am going to do. It is my life that I am planning to arrange, not yours. I have to live my life, mamá, not you!"

"Oh yes, but it is just that that distresses me. What will it be after you do this—after you throw it away? Oh, if you could only see what you are contemplating doing—what a wretched thing it will be when it is all over with. You will never live with him—he is too old for you, too fickle, too insincere. He will not care for you after a little while, and then there you will be, unmarried, possibly with a child on your hands, a social outcast! Where will you go? All your present day acquaintances will have nothing to do with you. Think of Adele. Think of Ninette! Think of Kinroy! Have you no regard for them? Think how they will feel. They will have nothing to do with you—they can't. I would be expected to shun you openly or retire from society if I clung to you. The shame, the talk, the general exposure! Oh, the thought of it is maddening."

"Mamá," said Suzanne calmly, her lips parted in a rosy, babyish way. "I have thought of all this. I see how it is. But I think you and everybody else make too much ado about these things. You think of everything that could happen but it doesn't all happen that way. People do these things, I'm sure, and nothing much is thought of it."

"Yes, in books," put in Mrs. Dale. "I know where you get all this from. It's your reading."

"Anyhow, I am going to. I have made up my mind," added Suzanne. "I have decided that by September fifteenth I will go to Mr. Witla, and you might just as well make up your mind to it now." (This was August 10th.) "I propose to tell him so and when the time comes, I am going. Now if you want to be friends with me and help me, all right. If not, I am going anyhow."

"Suzanne," said her mother, staring at her, "I never imagined you could talk this way to me. You will do nothing of the kind. How can you be so hard? I did not know that you had such a terrible will in you. Doesn't anything I have said about Adele and Ninette or Kinroy appeal to you? Have you no heart in you? Why don't you wait, as Dr. Woolley suggests, six months or a year? Why do you talk about jumping into this without giving yourself time to think? It is such a wild, rash experiment. You haven't thought anything about it. You haven't had time."

"Oh, yes I have, mamá," replied Suzanne. "I've thought a great deal about it. I'm fully convinced. I want to do it then because I told Eugene that I would not keep him waiting long, and I won't. I want to go to him. It will be all of two months since we first talked of this."

Mrs. Dale winced. She had no idea of yielding to her daughter or letting her do this, but this definite conclusion as to the time brought matters finally to a head. Her daughter was out of her mind, that was all. It gave her not any too much time to turn around in. She must get Suzanne out of the city—out of the country if possible—or lock her up, and she must do it without antagonizing her too much. She hated the thought of violence. It could not be done very well that way. It must be done by strategy. Could she do it alone? Could she do it without aid of, say, Kinroy at least? Her servants were not to be trusted. Dr. Woolley had counselled against violence or enforced incarceration, and he would probably not assist her in that. Kinroy could help, but would he make a mess of it by attempting to kill Eugene? That would not help. The more she thought of the latter, the more she thought of him as being under a spell—hypnotized, like Suzanne. How, otherwise, could he make such a fool of himself? He had so much to lose. His wife was not at all unsatisfactory to him. She could not be. Why should he leave her as, from what he said about Europe, she fancied he was contemplating doing, taking Suzanne? His career was here—just now all before him. If he were single she would not object to his having Suzanne so much, though he was much too old. If it were possible and he could get a divorce, and if Suzanne would wait, she would consent to a marriage on that basis rather than see Suzanne go this way. But this—this—it must not be.

Her next step in this terrific struggle was to tell Kinroy, who wanted, of course, in a fit of boyish chivalry, to go immediately and kill Eugene. This was prevented by Mrs. Dale, who had much more control of his mentality than she did over Suzanne's, by pointing out to him what a terrific, destructive scandal would ensue, and urging subtlety and patience. Kinroy had a sincere affection for his sisters, particularly Suzanne and Adele, and he wanted to protect all of them. He decided in a pompous, ultra-chivalrous spirit that he must help his mother plan, and together they talked of chloroforming Suzanne some night, of carrying her thus as a sick girl in a private car to Maine or the Adirondacks or somewhere in Canada—the Thousand Islands or, better yet, the country between Montreal and Québec, where they had gone one summer with friends to hunt and fish. There was an old lodge on the side of Mont Cecile fifteen miles from Three Rivers which belonged to the Cathcarts and which could be leased, where, if her mother went with her, Suzanne could be easily detained. Mrs. Dale was perfectly willing to spend three, six, eight, or ten months alone with Suzanne, if by so

doing she could prevent her from seeing Eugene, and so giving her time to recover. She could get horses, snow shoes, a gun, and hire guards to watch the place, saying Suzanne was temporarily out of her mind. There would be no lack of creature comforts, but Eugene might not be able to find her and both would have time to meditate upon the extent of their folly. If he persisted after this—or Suzanne in going to him—she proposed to go to Mr. Colfax first and see what could be done there.

It would be useless to follow all of these strategic details in their order. There were, after the five days agreed upon by Suzanne, attempted phone messages by Eugene which were frustrated by Kinroy, who was now fulfilling the role of a private detective. Suzanne decided to have Eugene brought to the house for a discussion, but to this her mother objected. She felt that additional meetings would simply strengthen this bond of union. Kinroy wrote Eugene of his own accord that he knew all and that if he attempted to come near the place he would kill him on sight. Suzanne, finding herself blocked and detained by her mother, wrote Eugene a letter which Elizabeth, her maid, secretly conveyed to the mail for her, telling him how things stood. Her mother had told Dr. Woolley and Kinroy. Suzanne had decided that September fifteenth was the time she would leave home unless their companionship was quietly sanctioned. Kinroy had threatened to kill him to her but she did not think Eugene had anything to fear. Kinroy was just excited. Her mother wanted her to go to Europe for six months and think it over, but this she would not do. She was not going to leave the city and he need not fear, if he did not hear anything for a few days at a time, that anything was wrong with her. They must wait until the storm subsided a little. "I will be right here but perhaps it is best for you not to try to see me right now. When the time comes I will come to you. And if I get a chance I will see you before."

Eugene was both pained and surprised at the turn things had taken but still encouraged to hope for the best by the attitude which Suzanne took toward it all. Her courage strengthened him. She was so calm, he thought—so forceful. What a treasure she was. The mention of delay pained him greatly, though. Not to see her! Not to hear her voice! How could he stand it? She had warned him that any letters from him would probably now be intercepted, but knowing the government rule in regard to registered letters—personal delivery and personal signature of the person addressed where demanded—he risked one this way and found that she received it. Mrs. Dale was afraid of a postal inquiry which might be instigated by Eugene. She was afraid of stirring up too much opposition in Suzanne.

So began a series of daily love notes for a few days until Suzanne advised him to cease. There were constant arguments between her, her mother, and

Kinroy. Because she was being so obviously frustrated, she began to grow bitter and hard, and short, contradicting phrases passed between her and her mother, principally originating in Suzanne.

"No! no! no!" were her constantly reiterated statements. "I won't do it! I don't care! What of it! No! It's silly! Let me alone! I won't talk!"

So it went.

Mrs. Dale was figuring hourly how to abduct her. Chloroforming and secret removal after the fashion she had planned was not so easy of accomplishment. It was such a desperate thing to do to Suzanne. She was afraid she might die under its influence. It could not be administered without a doctor. The servants would think it strange. She fancied there were whispered suspicions already. Finally she thought of pretending to agree with Suzanne, removing all barriers, asking her to come to Albany to confer with her guardian, or rather the legal representative of the Marquardt Trust Company, which held her share of her father the late Westfield Dale's estate in trust for her, in regard to some property in western New York which belonged to her. Mrs. Dale decided to pretend to have to go to Albany in order to have Suzanne sign a waiver of right to any share in her mother's private estate, after which she would release and legally disinherit her in her will. Suzanne, according to this scheme, was to then come back to New York and go her way and her mother was not to see her any more.

To make this ruse more effective, Kinroy was sent to tell her of her mother's plan and beg her for her own and her family's sake not to let this final separation come about. Mrs. Dale changed her manner. Kinroy acted his part so effectively that, what with her mother's resigned look and indifferent method of address, Suzanne was completely deceived. She imagined her mother had experienced a complete change of heart and might be going to do what Kinroy said. Anyhow she was resigned to whatever she did, for in this crisis Eugene was more to her than father or mother, sister or brother, or the whole social atmosphere in which she was living. Her mother would not try to injure Eugene and they could live happily ever afterwards. What more could she want?

"No," she replied to Kinroy's pleadings. "I don't care whether she cuts me off. I'll be very glad to sign the papers. If she wants me to go away, I'll go. I think she has acted very foolish through all and so have you."

"I wish you wouldn't let her do that," observed Kinroy, who was rather exulting over the satisfactory manner in which this bait was being swallowed. "Mamá is broken hearted. She wants you to stay here—to wait six months or a year before you do anything at all, but if you won't, she's going to ask you to do this. I've tried to persuade her not to. I'd hate like anything to see you go. Won't you change your mind?"

"I told you I wouldn't, Kinroy. Don't ask me. I'm going to do just what I told mamá. My mind's made up. There's no use trying to change me. It can't be done. I'm going to leave at the time I said."

Kinroy went back to his mother and reported that Suzanne was stubborn as ever but that the trick would in all probability work. She would go aboard the train, thinking she was going to Albany. Once aboard, inside a leased car, she would scarcely suspect until the next morning and then they would be far north in the Adirondack Mountains. By two the same day they would be at Three Rivers, between Montreal and Québec. From there it would be easy to drive or motor to the mountain next to the Cathcarts' lodge. Without money or clothes, except what was in their charge, Suzanne would be compelled to come with them to Mont Cecile. Once there, she could scarcely leave without clothes or means, and the servants would be told she was insane.

The scheme worked in part. Her mother, as had Kinroy, went through this prearranged scene as well as though she were on the stage. Suzanne fancied she saw her freedom near at hand. Only a traveling bag was packed, and Suzanne went willingly enough into the auto and the train, only stipulating one thing—that she be allowed to call up Eugene and explain. Both Kinroy and his mother objected but when finally she refused flatly to go without it, they acceded. She called him at the office—it was four o'clock in the afternoon and they were leaving at five-thirty—and told him. He fancied at once it was a ruse and told her so, but she thought not. Mrs. Dale had never lied to her before. Neither had her brother. Their words were as bonds.

"Eugene says this is a trap, mamá," said Suzanne, turning from the phone to her mother who was near by. "Is it?"

"You know it isn't," replied her mother, lying shamefully. She felt that she was justified in this instance.

"If it is, it will come to nothing," she replied, and Eugene heard her. He was strengthened into acquiescence by the tone of her voice. Surely she was a wonderful girl—a master of men and women in her way.

"Very well, if you think it's all right," said Eugene, "but I'll be very lonely. I've been so already. I shall be more so, Flower Face, unless I see you soon. Oh, if the time were only up."

"It will be, Eugene," she replied, "in a very few days now. I'll be back Thursday and then you can come down and see me."

"Thursday afternoon?"

"Yes. We're to be back Thursday morning."

She finally hung up the receiver and they entered the automobile, and an hour later, the train.

CHAPTER XCIII

It was a Montreal, Ottawa, and Québec express, and it ran without stopping to Albany. By the time it was nearing there Suzanne was going to bed. It was a private car and so Mrs. Dale explained the president of the road had loaned it to her because it was being taken to Albany to meet some friends of his. Because it was a private car no announcement was made by porters of the arrival. When it stopped there shortly after ten o'clock it was the last car at the south end of the train and you could hear voices calling but just what, it was not possible to say. Suzanne, who had already gone to bed, fancied it might be Poughkeepsie or some way station. Her mother's statement was that, since they arrived so late, the car would be switched to a siding and they would stay aboard until morning. Nevertheless, she and Kinroy were alert to prevent any untoward demonstration or decision on Suzanne's part. As the train went on she slept soundly until Burlington, in the far northern part of Vermont, was reached the next morning. When she awoke and saw that the train was still speeding she wondered vaguely but not clearly what it could mean. There were mountains about, or rather tall, pine-covered hills. Mountain streams were passed on high trestles and sections of burned woodlands were passed where forest fires had left lonely, sad stretches of charred tree trunks towering high in the air. Suddenly it occurred to Suzanne that this was peculiar and she came out of the bath to ask why.

"Where are we, mamá?" she asked Mrs. Dale, who was leaning back in a comfortable willow chair reading, or pretending to read, a book. Kinroy was out on the observation platform for a moment. He came back through shortly, for he was nervous as to what Suzanne would do when she discovered her whereabouts. A hamper of food had been put aboard the night before, unknown to Suzanne, and Mrs. Dale was going shortly to provide breakfast. She had not risked a maid on this journey.

"I don't know," replied her mother indifferently, looking out at a stretch of green fields. Even in the car one could feel that early autumn tang or chill which in northern New York makes its appearance in late August.

"I thought we were to be in Albany a little after midnight?" said Suzanne.

"So we were," replied Mrs. Dale, preparing to confess. Kinroy came back into the car.

"Well then," said Suzanne, pausing, looking first out of the windows and then fixedly at her mother. It came to her as she saw the unsettled, somewhat nervous expression in her mother's face and eyes, and in Kinroy's, that this was a trick and that she was being taken somewhere—where?—against her will.

"This is a trick, mamá," she said to her mother grandly. "You have lied to me—you and Kinroy. We are not going to Albany at all. Where are we going?"

"I don't want to tell you now, Suzanne," replied Mrs. Dale quietly. "Have your bath and we'll talk about it afterwards. It doesn't matter. We're going up into Canada, if you must know. We are nearly there now. You'll know fast enough when we get there."

"Mamá," replied Suzanne, "this is a despicable trick. You are going to be sorry for this. You have lied to me—you and Kinroy. I see it now. I might have known. But I didn't believe you would lie to me, mamá. I can't do anything right now. I see that very plainly. But when the time comes, you are going to be sorry. You can't control me this way. You ought to know better. You yourself are going to take me back to New York." And she fixed her mother with a steady look which betokened a mastership which her mother felt nervously and wearily that she might eventually be compelled to acknowledge. Her mother could not control her. She could not dominate her intellectually at present, and there was no use trying.

"Now, Suzanne, what's the use of talking that way?" pleaded Kinroy. "Mamá is almost crazy as it is. She couldn't think of any other way or thing to do."

"You hush, Kinroy," replied Suzanne. "I don't care to talk to you. You have lied to me and that is more than I ever did to you. Mamá, I am astonished at you," she returned to her mother. "My mother lying to me! Very well, mamá. You have things in your hands today. I will have them in mine later. You have taken just the wrong course. Now you wait and see."

Mrs. Dale winced and quailed. This girl was the most unterrified, determined fighter she had ever known. She wondered where she got her courage—from her late husband, probably. She could actually feel the quietness, grit, lack of fear, which had grown up in her during the last few weeks under the provocation which antagonism had provided.

"Please don't talk that way, Suzanne," she pleaded. "I have done it all for your own good. You know I have. Why will you torture me? You know I won't give you up to that man. I won't. I'll move heaven and earth first. I'll die in this struggle, but I won't give you up."

"Then you'll die, mamá, for I'm going to do what I said. You can take me to where this car stops but you can't take me out of it. I'm going back to New York. Now a lot you have accomplished, haven't you?"

"Suzanne, I am convinced, almost, that you are out of your mind. You have almost driven me out of mine, but I am still sane enough to see what is right. If anyone had told me a month ago that anything like this could have come to me, I never would have believed it. To think that you can carry on in this way—to think that you can defy me so."

"Mamá, I don't propose to talk to you any more, or to Kinroy. You can take me back to New York or you can leave me, but you will not get me out of this car. I am through listening to nonsense and pretences. You have lied to me once. You will not get a chance to do it again."

"I don't care, Suzanne," replied her mother as the train clicked solemnly along. "You have forced me to this. It is your own attitude that is causing all the trouble. If you would be reasonable and take some time to think this all over you would not be where you are now. I won't let you do this thing that you want to do. You can stay in the car if you wish but you will not be taken back to New York without money. I will speak to the station agent about that."

Suzanne thought of this. She had no money, no clothes other than those she had on. She was in a strange country and not so very used to travelling alone. She had really gone very few places in times past by herself. It took the edge off of her determination to resist, but she was not conquered by any means.

"How are you going to get back?" asked her mother after a time, when Suzanne paid no attention to her. "You have no money. Surely, Suzanne, you are not going to make a scene? I only want you to come up here for a few weeks so that you will have time to think away from that man. I don't want you to go to him September fifteenth. I just won't let you do that. Why won't you be reasonable? You can have a pleasant time up here. You like to ride. You are welcome to do that. I will ride with you. You can invite some of your friends up here if you choose. I will send for your clothes. Only stay here awhile and think over what you are going to do. I know if I can just get you to postpone this for awhile you will change your mind. You are so impetuous. And you're so young."

Suzanne refused to talk. She was thinking what she could do. Eugene was back in New York. He would expect her Thursday.

Her mother talked on at her. At one point Kinroy interrupted and managed to extract a comment from her. He was a slender youth of the clean cut, even featured, well mannered, and well set up society type. Quite unlike his sister he was very dark—dark brown hair, dark eyes, a sallow complexion in spite of his constant exercise. He was a dreamy lad and not nearly as efficient as his sister.

"Yes, Suzanne," put in Kinroy. "Why not take ma's advice? She's trying to do the best thing by you. This is a terrible thing you're trying to do. Why not listen to common sense and stay up here three or four months?"

"Don't talk like a parrot, Kinroy. I'm hearing all this from mamá."

When her mother reproached her, she said, "Oh, hush mamá, I don't care to hear anything more. I won't do anything of the sort. You lied to me. You said you were going to Albany. You brought me out here under a

pretence. Now you can take me back. I won't go to any lodge. I won't go anywhere except to New York. You might just as well not argue with me."

The train rolled on. Breakfast was served. The private car was switched to the tracks of the Canadian Pacific at Montreal. Her mother's pleas continued. Suzanne refused to eat. She sat and looked out the window, meditating on this strange denouement. Where was Eugene? What was he doing? What would he think when she did not come back? She was not enraged at her mother. She was merely contemptuous of her. This trick irritated and disgusted her. She was not thinking of Eugene in any wild way, but merely that she would get back to him. She conceived of him much as she did of herself, though her conception of her real self was still vague—as strong, patient, resourceful, able to live without her a little while if he had to. She was eager to see him but really more eager that he should see her if he wanted to. What a creature he must take her mother to be.

By now they had reached Juinata, by two o'clock they were fifty miles west of Québec. At first Suzanne thought she would not eat at all to spite her mother. Later she reasoned that that was silly, and ate with both Kinroy and Mrs. Dale. She made it exceedingly unpleasant for them by her manner, and they realized that by bringing her away from New York they had merely transferred their troubles. Her spirit was not broken as yet. It filled the car with a disturbing vibration.

"Suzanne," questioned her mother at one point, "won't you talk to me? Won't you see I'm trying to do this for your own good? I want to give you time to think. I don't really want to coerce you, but you must see."

Suzanne merely stared out of the window at the green fields speeding by.

"Suzanne? Don't you see this will never do? Can't you see how terrible it all is?"

"Mamá, I want you to let me alone. You have done what you thought was the right thing to do. Now let me alone. You lied to me, mamá. I don't want to talk to you. I want you to take me back to New York. You have nothing else to do. Don't try to explain. You haven't any explanation."

Mrs. Dale's spirit fairly raged but it was impotent in the presence of this, her daughter's. She could do nothing. She felt helpless. What was it that made her stratagem seem so utterly vain? She had gotten her away from New York but she had not conquered her.

Still more hours. At one small town, Suzanne decided to get off but both Mrs. Dale and Kinroy offered actual physical opposition. They felt intensely silly and ashamed, though, for they could not break the spirit of the girl. She ignored their minds—their mental attitude—in the most contemptuous way. Mrs. Dale cried. Then her face hardened. Then she pleaded. Her

daughter merely looked loftily away. The mother's nerves were being worn almost to a thread. She felt as though she could not survive this contest.

At Three Rivers, Suzanne stayed in the car and refused to move. Mrs. Dale pleaded, threatened to call aid, stated that she would charge her with insanity. It was all without avail. The car was uncoupled after the conductor had asked Mrs. Dale if she did not intend to leave it. She was beside herself—frantic with rage, shame, baffled opposition.

"I think you are terrible," she exclaimed to Suzanne. "You are a little demon. We will live in this car then. We will see."

She knew that this could not be, for the car was only leased for the outward trip and had to be returned the next day.

The car was pushed onto a siding.

"I beg of you, Suzanne. Please don't make a mockery of us. This is terrible! What will people think?"

"I don't care what they think," said Suzanne.

"But you can't stay here."

"Oh, yes I can."

"Come, get off—please do. We won't stay up here indefinitely. I'll take you back. Promise me to stay a month and I'll give you my solemn word I'll take you back at the end of that time. I'm getting sick of this. I can't stand it. Do what you like after that; only stay a month now."

"No, mamá," replied Suzanne. "No, you won't. You lied to me. You're lying to me now just as you did before."

"I swear to you I'm not. I lied that once, but I was frantic. Oh, Suzanne, please. Please! Be reasonable. Have some consideration. I will take you back, but wait for some clothes to arrive. We can't go this way."

She sent Kinroy for the station master, to whom was explained the need of a carriage to take them to Mont Cecile, and also for a doctor—this was Mrs. Dale's latest thought—to whom she proposed to accuse Suzanne of insanity. Help to remove her was to be called. She told this to Suzanne, who simply glared at her.

"Get the doctor, mamá," she said. "I will go that way if I have to, but you will rue every step of this. You will be thoroughly sorry for every silly step you have taken."

When the carriage arrived, Suzanne got out without waiting for the doctor. The country driver, a French habitant, reported its presence at the car. Kinroy tried to soothe his sister by saying that he would help straighten matters out if she would only go peaceably.

"I tell you, Susie, if it isn't all arranged to suit you within a month and you still want to go back, I'll send you the money. I have to go back tomorrow or next day for ma, but I'll give you my word. You know I never lied to

you before. I never will again. I promise you. I think you're making a terrible mistake but I think we made one bringing you up here. I wouldn't do it again if I had it to do over. I'll talk to ma tonight. Please come. Let's go over there. We can be comfortable anyhow."

Mrs. Dale had leased the lodge from the Cathcarts by phone. It was all furnished, ready to live in—even wood fires prepared for lighting in the fireplaces. It had hot and cold water controlled by a hot water furnace system, acetylene gas, a supply of staples in the kitchen. The service to take care of it was to be called together by the caretaker, who could be reached by phone from the depot. Mrs. Dale had already communicated with him by the time the carriage or country carryall arrived. The roads were so poor that the use of an automobile was impossible. The station agent, seeing a fat fee in sight, was most obliging.

Suzanne listened to Kinroy, but she did not believe him. She did not believe anyone now save Eugene, and he was nowhere near to advise her. Still, since she was without money and they were threatening to call a doctor, she thought that it might be best perhaps to go peaceably. Her mother was most distracted. Her face was white and thin and nervous, and Kinroy was apparently strained to the breaking point.

"Do you promise me faithfully," she asked her mother, who had begun her pleadings anew, corroborating Kinroy in a way, "that you will take me back to New York in two weeks if I promise to stay that long?" This was still within the date in which she had promised to go to Eugene, and as long as she got back by that time she really did not care, so long as she could write her lover. It was a silly, arbitrary thing for her mother to have done but it could be endured.

Her mother, seeing no reasonable way to obtain peace, promised. If she could only keep her these two weeks quietly, perhaps that would help. Suzanne could think here under different conditions. New York was so exciting. Out at this lodge all would be so still. There was more argument and finally Suzanne agreed to enter the hack and they drove over toward Mont Cecile and the Cathcarts' lodge, now vacant and lonely, which was known as While-a-Way.

CHAPTER XCIV

The Cathcart lodge, which was a long, two story affair situated half way up a pine covered mountain slope, was one of those summer conveniences of the rich which was located just near enough the primeval wilds to give one a sense of the unexplored and dangerous in raw nature, and yet

near enough the comforts of civilization such as were represented by the cities of Québec and Montreal, to make one feel secure in the possession of those material joys which otherwise could be so easily interrupted. It was full of great rooms, tastefully furnished with simple, summery things—willow chairs, box window-seats, built-in book shelves, great open fireplaces surmounted by handsome mantels, outward swinging lead paned windows, settees, pillow strewn rustic couches, great fur rugs and robes, and things of that character. The walls were ornamented with trophies of the chase—antlers, raw fox skins, mounted loons and eagles, some skins of bears and other animals. Loomis Cathcart, to whom it all belonged, was a fair hunter and a good fisherman. From this point, when he was in this country, he was wont to indulge in short expeditions which resulted in considerable pleasure to him. This year the Cathcarts were elsewhere and the lodge was to be had by a woman of Mrs. Dale's standing for the asking.

The more Mrs. Dale thought of her expedition now that it was under way, the less she really cared for it. It was not a definite solution. It took her and Suzanne out of New York but it really did not solve anything. If she were really going to restrain Suzanne, she would require guards or the co-operation of some physician who would enter with her on some scheme to charge her with insanity and have her committed to some institution. Suzanne would never forgive her for this. It would simply widen the breach. She would probably find means of communicating with Eugene. There would be all the days of bitter antagonism, days that were now already wearing her down to the point of nervous prostration.

As they rode along through this rather scrubby country, set with open, rocky fields and clumps of pine forest, the cold air of an August night carrying already all the chill of approaching autumn, her heart was exceedingly bitter toward the man who had caused her all this trouble. She was convinced that if it had not been for Eugene's early attitude, Suzanne would never have been mastered by this wild hallucination which now possessed her. And to think that she, her mother, should be put to all this useless trouble for nothing. Why should any such terrible freaks of disposition be possible in life? If one could only appeal to the law and have it all settled, but the law—the wretched law of which she already knew something—was no avenue of escape. It simply contained miseries within miseries—courts, judges, jails, law offices, lawyers—that whole wretched army of difficulties which beset the applicant for justice. Conditions such as prevailed in this case made appeal to anyone or anything most dangerous. It looked as though one could be compelled to suffer aimlessly, hopelessly. She felt as though she really could kill Eugene and herself, if only so many things did not depend on her.

When they reached While-a-Way, the caretaker, Pierre, an old habi-

tant of a musty, log-hut origin, who spoke a broken pidgin English and was dressed in earth brown khaki, over heaven knows what combination of clothes underneath, had lighted the fires and was bestirring himself about, warming the house generally via the furnace.

His wife, a small, broad skirted, solid bodied woman, was in the kitchen preparing something to eat. There was plenty of meat to be had from the larder of the habitant himself, to say nothing of flour, jellies, butter, and the like. A girl to serve was called from the family of a neighboring trapper. She had worked in this very house as maid to the Cathcarts. The Dales settled down to make themselves comfortable, but the old discussion continued. There was no peace in it and through it all, actually, Suzanne was having her way.

Meanwhile, Eugene, back in New York, was expecting word from Suzanne on Thursday, and none came. He called up the house only to learn that Mrs. Dale was out of the city and was not expected back soon. Friday came and no word, and Saturday. He tried a registered letter "for personal delivery only—return signature demanded," but it came back marked "not there." Then he realized that his suspicions were correct and that Suzanne had fallen into a trap. He was gloomy, fearful, impatient, and nervous by turns, and all at the same time. He drummed on his desk at the office, tried almost in vain to fix his mind on the scores of details which were ever before him, wandered aimlessly about the streets at times, thinking. He was asked for his opinion on art plans, and books and advertising and circulation propositions, but he could not fix his mind closely on what was being said.

"The chief has certainly got something on his mind which is troubling him these days," said Carter Hayes, the advertising man, to the circulation head. "He's not himself. I don't believe he hears what I'm telling him."

"I've noticed that," replied the latter. They were in the reception room outside Eugene's door and strolled, arm in arm, down the richly carpeted hall to the elevator. "There's certainly something wrong. He ought to take a rest. He's trying to do too much."

Hayes did not believe Eugene was trying to do too much. In the last four or five months it had been almost impossible to get near him. He came down at ten or ten-thirty in the morning, left frequently at two or three, had lunch engagements which had nothing to do with office work, and at night went out into the social world to dinner or elsewhere, where he could not be found. Colfax had sent for him on a number of occasions when he was not present, and on several other occasions, when he called on his floor and at his office, Eugene was out. It struck Colfax as something not very bad so far as he was concerned—Eugene had a right to be absent—but as inadvisable from Eugene's point of view. Colfax knew that he had a vast number

of things to take care of. It would take an exceptionally efficient man to manage them and not give up all of his time to them. He would not have thought this if Eugene had been a partner with himself, as were other men in other ventures in which he was interested, but Eugene not being so, he could not help viewing him as an employee—one who ought to give all of his time to his work. Besides, Eugene had men who, while excellent executives, were not of his inspirational calibre, and when he was not there they were compelled to run to White and Colfax with their problems, which was not good for Eugene. It pleased White and it gave Colfax a clear insight into the situation, but this did not help Eugene. Colfax got the idea that Eugene was strong, but *so* strong that when he was absent things went wrong. He found that he had to take an interest in those things himself, or should, and he decided that while he might always have to have a man like Eugene, he would prefer one not so powerful. It would be better to have a man like White, for instance—strong, but intensely loyal and confidential.

White never asked anything much save the privilege of working, and was always about the place, alert, enthusiastic for his particular duties, not haughty but calm and absolutely efficient in every way. He was never weary of consulting with Colfax, whereas Eugene was indifferent, not at all desirous of running with every little proposition but preferring to act on his own initiative, and carrying himself constantly with very much of an air. So long as things ran smoothly, what difference did it make to Colfax or anyone how they were being done? This was very true and interesting from one point of view, but had its disadvantages from others. It ran counter to Colfax's domineering, egotistic disposition and could not help Eugene in the long run.

There were other things which were and had been militating against him. By degrees it had come to be rumored about the office that Eugene was interested in the Blue Sea or Sea Island Development and Construction Company, of which there was considerable talk about the city, particularly in financial and social circles. Colfax had heard of the corporation. He had been interested in the theory of it because it promised so much in the way of luxury. Not so noticeably much of the total panoramic whole—which was beautifully set forth in a thirty-two page literary prospectus, with inserts in color which Eugene had fathered editorially—was accomplished, but there was enough to indicate that it was going to be a great thing. Already somewhat over a mile and a quarter of the magnificent sea walk and wall were in place. A dining and dancing pavilion had been built, and one of the smaller hotels, all in keeping with the original architectural scheme. There were a number of houses—something like twenty or thirty—on plots of 150 by 150, built in the most ornate fashion on ground which had formerly been

dank marsh, grown high with grass, and which represented investments on the part of individuals of from fifteen to thirty thousand dollars each. Streets were laid out, three or four islands filled in. A club house for a minor yacht club had been constructed, but still the Sea Island Development Company had a long way to go before even a third of its total perfection could be said to be in place. Some business was coming to it via the Long Island Railroad, but it was a tremendous investment with much more money to be poured in before a sufficient presence would have been created to attract vast and sufficiently elite audiences to make it highly profitable. It had already occurred to Mr. Kenyon C. Winfield that, as mortgagee covering his original sale of 600 acres of the best waterfront property to the corporation, he might find it necessary to foreclose and take it over. The hotel might not pay for some time. The casino might readily not show a profit. It was to be slow work, he knew, but he had started it in the right direction and he personally would be perfectly safe so far as the financial outcome was concerned. Some of the small investors like Eugene might lose all they had put in it but the big ones like himself, Willebrand, Wiltsie, the president of the Long Island Railroad, and others could reorganize it under a new name and proceed. Yet it hurt a great proposition like this to reorganize once or twice.

Eugene did not know the drift of the company's financial affairs except in a very general way. He had tried to keep out of it so far as public notice of him was concerned, though he was constantly lunching with Winfield, Willebrand, and others, and endeavoring to direct as much attention to the wonders and prospects of the new resort as was possible for him to do. It was an easy thing for him to say to one person and another whom he met that Blue Sea was rapidly becoming the most perfect thing in the way of a summer resort that he had ever seen, and this did good, as did the comments of all the other people who were interested in it, but it did not make it anything of a success as yet. As a matter of fact, the true success of Blue Sea depended on the investment of much more than the original ten millions for which it had been capitalized. It depended on a truly solid growth which could never be rapid. So far, not more than one million had been subscribed. So the chances for any return from that proposition were a long way off, to say nothing of a possible receivership and reorganization which did not disturb Winfield at all.

The news which came to the United Magazines Corporation, and eventually to Colfax and White, was that Eugene was heavily interested in this venture, that he was secretary or some other officer in connection with it, that he was giving a great deal of his time to its development which might better be employed in furthering the interests of the United Magazines Corporation, and that this might eventually lead to his retirement

from the United Magazines Corporation, a wealthy man, to take care of his interests in that direction. Colfax, who had not heard anything of it before, was chagrined. He had hoped to retain Eugene's undivided attention in his own affairs, giving him possibly a small interest at some time, but this enthusiastic branching out in another direction gave Colfax small hope of retaining him. It was as White had said; Eugene was an uncertain quantity. White, while outwardly indifferent, was inwardly delighted. This would now prove to Colfax what he had always contended—that Eugene was not a stable person to rely upon in so far as this particular work was concerned. He might stay and he might not.

"What do you think of that?" Colfax asked White, on hearing the news one morning. It had come via the head of the printing department under White, who had mentioned it to Colfax by White's direction.

"It's just what I've been telling you all along," said the latter blandly. "He isn't interested in this business any more than he is in any other. He's using it as a stepping stone and when he's through with it—good-bye. Now that's all right from his point of view. Every man has a right to climb up, but it isn't so good from yours. You'd be better off if you had a man who wanted to stay here. You'd be better off really if you were handling it yourself. You may not want to do that, but with what you know now you can get someone who will manage. That's the one satisfactory thing about it—you really can get along without him if it comes right down to it now. With a good man in there it can be handled from your office."

This was really a very gratifying thought to Colfax. He had first started out with the thought that he wanted two lieutenants, and he still wanted them, but the man he wanted must be somewhat more like White—catering to him and taking direction from him. Eugene was too indefinite in his reports. He was too sensitive about his prerogatives. This thought that Eugene might be intending to leave him one of these days in the bargain merely strengthened his feeling that he ought to get a firmer grip on the details Eugene was now handling, or find some man who could take his place. He decided—this was some time before Eugene had become so vastly excited about Suzanne—to cast about for an experienced man who could take Eugene's place.

It was about this time that the most ardent phase of Eugene's love affair with Suzanne began. All through the spring and summer, Eugene had been busy with thoughts of Suzanne, ways of meeting her, pleasurable rides with her, thinking of things she had done and said. As a rule now, his thoughts were very far from the interests of his position and in the main it bored him greatly. He began to wish earnestly that his investment in the Sea Island Corporation would eventuate into something tangible—begin to bear inter-

est—so that he could have means to turn around with. It struck him as a most unfortunate thing, after his discovery with Suzanne by Angela, that he had tied up all his means in this Blue Sea investment. If it had been fated that he was to go on living with Angela, it would have been all right. Then he could have waited in patience and thought nothing of it. Now it simply meant that if he wanted to realize it, it would all be tied up in the courts, or possibly so, for Angela might sue him, or at the least he would want to make reasonable provision for her, and that would require a legal adjustment. Outside of this investment, he had nothing now save his salary, and that was not accumulating fast enough to do him much good in case Mrs. Dale went to Colfax soon and the latter broke with him.

Eugene wondered whether Colfax really would break with him. Would he ask him to give up Suzanne or simply force him to resign? He had noticed that for some time Colfax had not been as cordial to and enthusiastic about him as he had formerly been but this might be due to other things besides opposition. Moreover, it was natural for them to become a little tired of each other. They did not go about so much together, scarcely any, and when they did, Colfax was not as high flown and boyish in his spirits as he had formerly been. Eugene fancied it was White who was counselling against him, but he thought if Colfax was going to change, he was going to change, and there was no help for it. There were no grounds, he fancied, insofar as the affairs of the corporation were concerned. His work was successful.

If Eugene had been a partner, nothing ever would have been said or thought of his manner, his absenteeism, or his outside investments. As it was, his lack of an interest and his conscience rife with feelings of unrest and discord created this atmosphere about him. He was discordant and unhappy, and he radiated that everywhere. His assistants noticed it. Colfax thought that something was the matter. White was sure of it. The latter fancied that Eugene might be losing money in his Blue Sea investment and was having trouble at home.

The storm broke one day out of a clear sky in so far as the office was concerned, but not until there had been considerable heartache and misery in various directions—with the Dales, with Angela, and with Eugene himself.

Suzanne's action was the lightning bolt which precipitated this storm. It could only come from that quarter. Eugene was frantic to hear from her and for the first time in his life began to experience those excruciating and gnawing pangs which are the concomitants of uncertain and distraught love. It manifested itself as an actual pain in his vitals—in the region of the solar plexus or what is commonly known as the pit of the stomach. He hurt there very much, as the Spartan boy who was gnawed by the fox concealed

under his belt must have hurt. He would wonder where Suzanne was, what she was doing, and then, being unable to work, would call his car and ride or take his hat and walk. It did him no good to ride, for the agony was in sitting still. At night he would go home and sit by one or the other of his studio windows, principally out on the little stone balcony, and watch the changing panorama of the Hudson, yearning and wondering where she was. Would he ever see her again? Would he be able to win this battle if he did? Oh, her beautiful face; her lovely voice; her exquisite lips and eyes; the marvel of her touch and beautiful fancy.

He tried to compose poetry and wrote a series of sonnets to his beloved which were not at all bad. He worked on his sketch book of pencil portraits of her, seeking a hundred significant and delightful expressions and positions which could afterwards be elaborated into his gallery of paintings of her which he proposed to paint at some time. It did not matter to him that Angela was about but he had the graciousness to conceal these things from her. He was ashamed in a way of his treatment of her and yet the sight of her now was not so much pitiable as objectionable and unsatisfactory. Why had he married her? He kept asking himself that. Why had he tangled himself up so that he could not now get loose? For all that she was willing, apparently, to back down in this terrible crisis and share him with another, or at least pretend to (for she was not able to make any effectual protest for the present anyhow), he felt that she did not intend really to sit by and see him carry on as he planned. She would protest some time and that would be bad, and anyhow, the thought of living with her now was intolerable. He wanted to be free—not to see her any more unless he wanted to—to have Suzanne and Suzanne only. He would gladly give Angela this apartment and maintain it, or another equally as good, if he could—if she would only let him go. He wanted to get out of here as soon as Suzanne returned and go with her. Since she had been spirited away, he felt convinced now that Mrs. Dale would never give in. She would probably return to New York and expose him and if he pursued Suzanne he must be ready to fly with her. He decided in case of emergency to go and take nothing, simply notifying Angela afterwards that he had gone. He would not stay here—he would not stay anywhere without Suzanne.

They sat in the studio one night, Angela's face a picture of despair, for the horror of her situation was only by degrees coming to her, and she said, seeing him so moody and despondent:

"Eugene, don't you think you can get over this? You say Suzanne has been spirited away: why not let her go? Think of your career, Eugene. Think of me. What will become of me? You can get over it if you try. Won't you try? Surely you won't throw me down after all the years I have been with you.

Think how I have tried. I have been a pretty good wife to you, haven't I? I haven't annoyed you so terribly much, have I? Oh, I feel all the time as though we were on the brink of some terrible catastrophe. If only I could do something; if only I could say something. I know I have been hard and irritable at times, but that is all over now. I am a changed woman. I would never be that way any more."

"It can't be done, Angela," he replied calmly. "It can't be done. I don't love you—I've told you that. I don't want to live with you. I can't. I want to get free in some way, either by divorce or a quiet separation, and go my way. I'm not happy. I never will be as long as I am here. I want my freedom and then I will decide what I want to do."

Angela shook her head and sighed. She could scarcely believe that this was she, wandering around in her own apartment, wondering what she was going to do in connection with her own husband. Marietta had gone back to Wisconsin before the storm broke. Myrtle was here in New York but she hated to confess to her. She did not dare write to any member of her own family outside of Marietta, and she did not want to confess to her. Marietta had fancied, while she was here, that they were getting along so nicely. Angela had fits of crying which alternated with fits of anger but the latter were growing weak. Fear, despondency, and grief were becoming uppermost in her soul again—the fear and despondency that had animated her in those lonely days before she married Eugene, and the grief that she was now actually and finally to lose the one man whom, in spite of her iron determination to rule and make better, she had actually loved, and did love still.

CHAPTER XCV

It was three days later, while he was at his office, that a telegram came from Mrs. Dale which read, "I depend on you, on the honor of a gentleman, to ignore any message which may come from my daughter until I see you."

Eugene was puzzled but fancied that there must be a desperate quarrel on between Suzanne and her mother, wherever they were, and that it was probable that he would hear from her now. It was his first inkling as to her whereabouts, for the telegram was labelled from Three Rivers, in Canada, and he fancied they must be near there somewhere. The place of filing did him no good from a material point of view, for he could neither write nor pursue Suzanne on the strength of this. He would not know where to find her. He could only wait, conscious that she was having a struggle, perhaps as severe or possibly more so than his own. He wandered about with this

telegram in his pocket, wondering when he should hear—what a day should bring forth—and all those who came in contact with him noticed that there was something wrong.

Colfax, who saw him and asked, "What's the matter, old man? You're not looking as chipper as you might," fancied it might be something in connection with the Blue Sea Corporation. He had heard, after he had learned that Eugene was in it, that it would take much more money than had been invested to date to make it a really significant seaside proposition according to the outlines laid down, and that it would be years before it could possibly yield a suitable return. If Eugene had put much money in it, he had probably lost it or tied it up in a most unsatisfactory way. Well, it served him right for trifling with things he knew nothing about. He was not a business man or promoter and should not trifle with such things.

"Oh, nothing," replied Eugene abstractly, "I'm all right. I'm just a little run down physically. I'll come round."

"You'd better take a month or so off and brace up if you're not in shape."

"Oh, not at all. Not now, anyhow."

It occurred to Eugene that he might use this time to advantage a little later, and that he would claim it.

They proceeded to business but Colfax noticed that Eugene's eyes were especially hollow and weary and that he was noticeably restless. He wondered whether he might be going to break down physically.

Suzanne had drifted along peacefully enough, considering the nature of the feeling between her and her mother at this time, but after a few days of disturbing discussion along the lines now so familiar she began to see that her mother had no intention of terminating their stay at the time agreed upon, particularly since their return to New York meant, so far as Suzanne was concerned, her immediate departure to Eugene. Mrs. Dale began at first to plead for additional delay, and later that Suzanne should agree not to go to New York but to Lenox for a season. It was cold up here already now, quite so, though there were still bright, warm, summery or autumn periods between ten and four in the day and sometimes in the evening. The nights, though, usually were cold. Mrs. Dale would have gladly welcomed a compromise, for it was terribly lonely—just herself and Suzanne—after the gayeties of New York. There was no one to talk to save the old caretaker and his wife and two young French Canadian girls who had been inducted into service. Suzanne had wormed her way into the graces of one, Gabrielle, after their first conversation, and she was depending on using her, in case Mrs. Dale was obstinate, to help convey information to the outside world and to help her escape possibly, if necessary. Gabrielle confided to

her that André, who brought the mail, was a friend of hers. This was carried on horseback from St. Jacques nearby and occasionally from Three Rivers. If her mother continued obstinate for a day or two more, she proposed to write Eugene as to her whereabouts and see if he could not help her to escape. If he came she would go with him wherever he wanted to go, and she knew he would come.

Four days before the time of her proposed departure, Mrs. Dale was still obdurate or parleying in a diplomatic way, and Suzanne, disgusted, made the threat which caused Mrs. Dale to distractedly wire Eugene. Later she composed the following which she gave to Gabrielle.

> "Dear Eugene:
> "If you love me come and get me. I have told mamá that if she did not keep her word to return with me to New York by the fourteenth I would write you, and she is still obstinate. I am at the Cathcart cottage, While-a-Way, eighteen miles north of Three Rivers here in Canada. Anyone can show you. I will be here when you come. Do not try to write me as I am afraid I will not get it. But I will be at the lodge.
> "With love,
> "Suzanne."

Eugene had never before received a love appeal nor indeed any such appeal from any woman in his life. He had had letters from Suzanne, but they had been in a way perfunctory affairs which he had answered ardently enough. This letter reached him thirty-six hours after the telegram arrived and set him to planning at once. The hour had struck. He must act. Perhaps this old world was now behind him forever. Could he really get Suzanne if he went to Canada to find her? How was she surrounded? He thrilled with delight when he realized that it was Suzanne who was calling him and that he was going to find her. "If you love me come and get me"! Would he? Watch.

He called for his car; telephoned his valet to pack his bag and bring it to the Grand Central Station, first ascertaining for himself the time of departure; asked to talk to Angela, who had gone to Myrtle's apartment in upper Seventh Avenue, ready at last to confess her woes to Eugene's sister. Her condition did not appeal to Eugene in this situation. The inevitable result which he thought of frequently was still too far away. He notified Colfax that he was going to take a few days rest, went to the bank where he had over four thousand dollars on deposit, and drew it all. He then went to a ticket office and purchased a one way ticket, uncertain where his actions would take him once he saw Suzanne. He tried once more to get Angela, intending boldly to tell her that he was going to seek Suzanne, and to tell

her not to worry, that he would communicate with her, but she had not returned. Curiously, through all this he was intensely sorry for her and wondered how she would take it if he did not return. How would the child be arranged for? He was desperate and uncertain but he felt he must go. Angela was heartsick—he knew that—and frightened. Still, he could not resist this call. He could not resist anything in connection with this love affair. He was like a man possessed of a devil or wandering in a dream. He knew that his whole career was at stake but it did not make any difference. He must get her. The whole world could go hang if he could only obtain her—her, the beautiful, the perfect.

At five-thirty the train departed and then he sat there as it rolled northward, speculating on what he was to do when he got there. If Three Rivers were much of a place he could probably hire an automobile. With this in his possession and a suitable tip to the chauffeur, he could station it some distance from the lodge and then see if he could not approach unobserved and signal Suzanne. If she were about she would no doubt be on the lookout. At a sign she would run to him. They would hurry to the automobile. The pursuit might quickly follow but he would arrange it so that his pursuers would not know which railroad station he was going to. Québec was the nearest big city, he found by studying the map, though he might return to Montreal and New York or Buffalo if he chose to go west—he would see how the train ran. He would get Suzanne. They would spend the night together. Then they would openly defy her mother and bid her to do her worst.

It is curious what vagaries the human mind is subject to under conditions of this kind. Up to the time of Eugene's arrival in Three Rivers and after, he had no plan of campaign or of future conduct beyond that of obtaining Suzanne. He did not know that he would return to New York—he did not know that he would not. If Suzanne wished and it were best and they could, they would go to England from Montreal, or France. If necessary, they could go to Portland and sail. Mrs. Dale, on the evidence that he had Suzanne, and that of her own free will and volition, might see she was no longer available as a normal matrimonial candidate, and yield and say nothing. In this case he could return to New York and resume his position. This courageous stand on his part might solve the whole problem quickly; it might be the sword that would cut this Gordian knot. On the train was a heavy black-bearded man, which was always good luck to him. At Three Rivers, when he dismounted from the train he found a horse shoe, which was also a lucky sign. He did not stop to think what he could do if he really lost his position and had to live on the sum he had with him. He was really not thinking logically. He was dreaming. He fancied that he would get Suzanne

and have his salary and that somehow things would be much as they were. Of such is the logic of dreams.

When he arrived at Three Rivers, of course the conditions were not what he anticipated. There had been a short period of cold rain and the roads were practically impassable save for horses and carryalls. There was a carryall which went as far as St. Jacques, four miles from While-a-Way, where, the driver told him, he could get a horse if he wanted one. The owner of this hack line had a stable there.

This was gratifying to him and he decided to make arrangements for two horses at St. Jacques, which he would take to within a reasonable distance of the lodge and tie them in some spot where they would not be seen. Then he could consider the situation and signal Suzanne. If she were there on the lookout, how dramatic the end would be. How happy they would be, flying together. Judge then his astonishment on reaching St. Jacques to find Mrs. Dale waiting for him. Word had been telephoned by her faithful representative, the station agent at Three Rivers, that a man of Eugene's description had arrived and departed for While-a-Way. A telegram had come from Kinroy in New York to the effect that Eugene had gone somewhere. His daily custom, morning and afternoon, since Mrs. Dale had gone away and he had returned, was to call up the United Magazines Corporation and ask if Eugene was in the city. Heretofore he had been reported in. When on this day he was reported as having gone, Kinroy called up Angela to inquire. She also stated that he had left the city. He then wired his mother and she, calculating the time of his arrival and hearing from the station agent of his taking the carryall, had gone down to meet him. She had decided to fight every inch of the way with all the strategy at her command. She did not want to kill him—did not really have the courage to do that—but she still hoped to dissuade him. She had not been able to bring herself to resort to guards and detectives as yet. He could not be as hard as he looked and acted. Suzanne was bedeviling him by her support and communications. She had not been able to govern these, she saw. Her one hope was to talk him out of it or into an additional delay. If necessary they would all go back to New York together and she would appeal to Colfax and Winfield. She hoped they could persuade him to reason. Anyhow she would never leave Suzanne for one moment until this thing had been settled in her favor or brutally against her.

When Eugene appeared, she greeted him with her old social smile and called to him affably, "Come get in."

He looked at her grimly and obeyed, but changed his manner when he saw that she was really kindly in her tone, and greeted her sociably.

"How have you been?" he asked.

"Oh, quite well, thank you."

"And how is Suzanne?"

"All right, I fancy. She isn't here, you know."

"Where is she?" asked Eugene, his face a study in defeat.

"She went with some friends to visit Québec for ten days. Then she's going from there to New York. I don't expect to see her here anymore."

Eugene choked with a sense of opposition and distaste for her smart pretence. He did not believe what she was saying—saw at once that she was parleying with him.

"That's a lie," he said roughly, "and it's out of the whole cloth. She's here and you know it. Anyhow I'm going to see for myself."

"How polite you are," she laughed diplomatically. "That isn't the way you usually talk. Anyhow, she isn't here. You'll find that out, if you insist. I wouldn't advise you to insist, for I've sent for counsel since I heard you were coming and you will find detectives as well as guards waiting to receive you. She isn't there, though, even at that, and you might just as well turn around and go back. I will drive you over to Three Rivers if you wish. Why not be reasonable now and avoid a scene? She isn't there. You couldn't have her if she were. The people I have employed will prevent that. If you make trouble you will simply be arrested and then the newspapers will have it. Why not be reasonable now, Mr. Witla, and go on back? You have everything to lose. There is a train through Three Rivers from Québec for New York at eleven tonight. We can make it. Don't you want to do that? I will agree, if you come to your senses now and cause me no trouble here, to bring Suzanne back to New York within a month. I won't let you marry unless you get a divorce and straighten things out with your wife, but if you can do that within six months or a year and she still wants you, you can have her. I will promise in writing to withdraw all objection and see that her full share of her property comes to her uncontested. I will help you and her socially all I can, and you know I have considerable influence."

"I want to see her first," replied Eugene grimly and disbelievingly.

"I won't say that I will forget everything," went on Mrs. Dale, ignoring his interpolated remarks, "I can't, but I will pretend to. You can have the use of my country place at Lenox. I will buy out the lease at Morristown or the New York house and you can live in either place. I will set aside a sum of money for your wife, if you wish. That may help you to obtain your release. Surely you do not want to take Suzanne under the illegal condition which you propose when you can have her outright in this brilliant manner by waiting a little while. She says she does not want to get married but that is silly talk, based on nothing except erratic reading. She does or she will the moment she comes to think about it seriously. Why not help her? Why

not go back now and let me bring her back to New York a little later and then we will talk this all over? I will be very glad to have you in my family. You are a brilliant man. I have always liked you. Why not be reasonable? Come now and let's drive back over to Three Rivers and you take the train back to New York, will you?"

While Mrs. Dale had been talking, Eugene had been surveying her calmly. What a clever talker she was. How she could lie. He did not believe her. He did not believe one word that she said. She was fighting to keep him from Suzanne, why, he could readily understand. Suzanne was somewhere here, he fancied, though as in the case of her recent trip to Albany, she might have been spirited away. Still, he did not propose to be led into any such compromise as this. Mrs. Dale had outwitted him thus far by meeting him at St. Jacques but there must be other things he could do. Suzanne was here—he felt it.

"How you talk," said Eugene easily, defiantly, indifferently. "I'll not do anything of the sort. In the first place, I don't believe you. If you are so anxious to be nice to me, let me see her and then you say all this in front of her. I've come up here to see her and I'm going to. She's here. I know she is. You needn't lie. You needn't talk. I know she's here. Now I'm going to see her if I have to stay here a month and search."

Mrs. Dale stirred nervously. She knew that Eugene was desperate. She knew that Suzanne had written him. Talk might be useless. Strategy might not avail, but she could not help using it.

"Listen to me," she said excitedly. "I tell you, Suzanne is not here. She's gone. There are guards up there—lots of them. They know who you are. They have your description. They have orders to kill you if you try to break in. Kinroy is there. He is desperate. I have been having a struggle not to have him kill you already. The place is watched. We are watched right now. Won't you be reasonable? You can't see her. She's gone. Why make all this fuss? Why take your life in your hands?"

"Don't talk," said Eugene, "you're lying. I can see it in your face. Why talk? She's here. I'm going to see her."

He stared before him and Mrs. Dale ruminated as to what she was to do. There were no guards or detectives as she said. Kinroy was not there. Suzanne was not away. This was all palaver, as Eugene suspected, for she was too anxious to avoid publicity to make any move before absolutely she had to. She was not really willing to have Eugene in her family now but she was hoping by lies to deceive him. Vaguely, she fancied if worst came to worst and there were no other way, she might be willing to fulfill the terms of this last agreement, providing Suzanne made her. If Suzanne had really gone with Eugene all would have been adjusted to his satisfaction.

She would have yielded. As it was, she had everything still to fight for and she hoped to win.

It was a rather halcyon evening after some days of exceeding chill. A bright moon was coming up in the east, already discernable in the twilight, but which later would shine brilliantly. It was not cold, but really pleasantly warm, and the rough road along which they were driving was richly odourous. Eugene was not unconscious of its beauty but depressed by the possibility of Suzanne's absence.

"That's all very fine," he said. "I would believe it or put some faith in it anyhow if I didn't know that Suzanne is here. She wrote me that she would be and I know she is. She's up at While-a-Way and that's where I'm going, guards or no guards. If you want a scene, you will create it. But I came to see Suzanne and I'm going to see her. We'll talk about this other thing when she is present—not otherwise."

"Oh, do be generous," pleaded Mrs. Dale, who feared that once they saw each other reason would disappear. Suzanne would demand, as she had been continually demanding, that she be taken back to New York. Eugene, with or without Suzanne's consent or plea, would ignore her overtures of compromise and there would be immediate departure or defiant union here. She thought she would kill them if need be, but in the face of Eugene's defiant persistence on one side and Suzanne's on the other, her courage was failing. She was frightened by the daring of this man. "I will keep my word," she observed distractedly. "Honestly, she isn't here. She's in Québec, I tell you. Wait a month. I will bring her back then. We will arrange things together. Why can't you be generous?"

"I could be," said Eugene, who was considering all the brilliant prospects which her proposal involved and being moved by them, "but I can't believe you. You're not telling me the truth. You didn't tell the truth to Suzanne when you took her from New York. That was a trick and this is another. I know she isn't away. She's right up there in the lodge, wherever it is. You take me to her and then we will talk this thing out together. By the way, where are you going?"

Mrs. Dale had turned into a bypath or half formed road closely lined with small trees and looking as though it might be a wood chopper's path.

"To the lodge."

"I don't believe it," replied Eugene, who was intensely suspicious. "This isn't a main road to any such place as that."

"I tell you it is."

Mrs. Dale was nearing the precincts of the lodge and wanted more time to talk and plead.

"Well," said Eugene, "you can go this way if you want to. I'm going to

get out and walk. You can't throw me off by driving me around in some general way. I'm going to stay here a week, a month, two months if necessary, but I'm not going back without seeing Suzanne. She's right here and I know it. I'll go up alone and find her. I'm not afraid of your guards."

He jumped out and Mrs. Dale gave up in despair. "Wait," she pleaded, "it's over two miles yet. I'll take you there. She isn't home tonight anyhow. She's over at the cottage of the caretaker. Oh, why won't you be reasonable? I'll bring her to New York, I tell you. Are you going to throw aside all those fine prospects and wreck your life and hers and mine? Oh, if Mr. Dale were only alive. If I had a man on whom I could rely. Come get in and I'll drive you up there, but promise me you won't ask to see her tonight. She isn't there anyway. She's over at the caretaker's. Oh, dear, if only something would happen to solve this."

"I thought you said she was in Québec?"

"Oh, I only said that to gain time. I'm so unstrung. It wasn't true, but she isn't at the lodge, truly. She's away tonight. I can't let you stay there. Let me take you back to St. Jacques and you can stay with old Pierre Gaine. You can come up in the morning. The servants will think it so strange. I promise you, you shall see Suzanne. I give you my word."

"Your word. Why, Mrs. Dale you're going around in a ring. I can't believe anything you say," replied Eugene calmly. He was very much collected and elated now since he knew that Suzanne was here. He was going to see her— he felt it. He had Mrs. Dale badly worsted and he proposed to drive her until, in the presence of Suzanne, he and his beloved dictated terms. Oh, Suzanne, if he could be with her now. Quick, quick—he must urge this thing to a brilliant finish. In a few more minutes now—a half hour or so—he could win his way to his beloved. Oh, the joy, the bliss. No wonder the fates cast a horseshoe down before him as a sign. No wonder he saw a black, full-bearded man coming up on the train. It was all true—all his dreams. He was going to win, he and Suzanne. He was going to have her. Dear God, supposing he did get a divorce, offered Angela a large sum in settlement, and was introduced into society as Suzanne's husband, with her wealth and his own behind them. Why should he worry about any publishing position then? He would have Suzanne, his Blue Sea interest, a distinguished position. Ah!

"I'm going there tonight and you are going to bring her to me. If she isn't there, you know where to find her. She's here and I'm going to see her tonight. We'll talk of all this you're proposing in front of her. It's silly to twist things around this way. The girl is with me and you know it. She's mine. You can't control her. Now we two will talk to you together."

He sat back in the light vehicle and began to hum a tune. The moon was getting clearer.

"Promise me just one thing," urged Mrs. Dale despairingly. "Promise me that you will urge Suzanne to accept my proposition. A few months won't hurt. You can see her in New York as usual. Go about getting a divorce. You are the only one who has any influence with her. I admit it. She won't believe me. She won't listen to me. You tell her. Your future is in it. Persuade her to wait. Persuade her to stay up here or at Lenox for a little while and then come down. She will obey you. She will believe anything you say. I have lied—I have lied terribly all through this, but you can't blame me. Put yourself in my place. Think of my position. Please use your influence. I will do all that I say and more. You will never regret. You will be happy in this. Suzanne loves you. She will make you a charming wife. You will have a beautiful home. You can have lovely children. I think maybe one reason why you have been so unstable is that you haven't had any children. Start your life from right now. Build it up in a stable way. You have a great future. I will help you get a divorce."

"Will you bring Suzanne to me tonight?"

"Yes, if you promise."

"Will you bring her to me tonight, promise or no promise? I don't want to say anything to you which I can't say in front of her."

"Won't you promise me that you will accept my proposition and urge her to?"

"I think I will but I won't say. I want her to hear what you have to say. I think I will."

Mrs. Dale shook her head despondently.

"You might as well acquiesce," went on Eugene. "I'm going to see her anyhow, whether you will or no. She's there and I'll find her, if I have to search the house room by room. She can hear my voice."

He was carrying things with a high hand.

"Well," replied Mrs. Dale, "I suppose I must. Please don't let on to the servants. Pretend you're my guest. Let me take you back to St. Jacques tonight after you see her. Don't stay with her more than half an hour."

She was absolutely frightened out of her wits at this terrific denouement.

Eugene sat grimly congratulating himself as they jogged on in the moonlight. He actually squeezed her arm cheerfully and told her not to be so despairing—that all would come out all right. They would talk to Suzanne. He would see what she would have to say.

"You stay here," she said as they reached a little wooded knoll in a bend of the road—a high spot commanding a vast stretch of territory not lit by a glistening northern moon. "I'll go inside and get her. I don't know whether she's there, but if she isn't she's over at the caretaker's and we'll go

over there. I don't want the servants to see you meet her. Please don't be demonstrative. Oh, be careful."

Eugene smiled. How excited she was. How pointless after all her threats. So this was victory. What a fight he had made. Here he was outside this beautiful lodge, the lights of which—some of them—he could see gleaming like yellow gold through the silvery shadows. The air was full of field fragrances. You could smell the dewy earth, soon to be hard and covered deep in snow. There was still a bird's voice here and there and faint stirrings of the wind in the leaves. "On such a night" came back, Shakespeare's lines. How fitting that Suzanne should come to him under such conditions. Oh, the wonder of this romance—the beauty of it. From the very beginning it had been set about with perfections of scenery and material environment. Obviously nature had intended this as the crowning event of his life. Life recognized him as a genius—the fates—it was heaping posies in his lap, laying a crown of victory upon his brow.

He waited while Mrs. Dale went to the lodge and then after a time, true enough, there appeared in the distance the swinging buoyant, girlish form of Suzanne. She was plump, healthful, vigorous. He could detect her in the shadow under the trees and behind her a little way, Mrs. Dale. Yes, it was Suzanne and her mother. The former came eagerly on—youthful, buoyant, determined, beautiful. Her skirts were swinging about her body in ripples as she strode. She looked all Eugene had ever thought her—Hebe, a young Diana, a Venus at nineteen. Her lips were parted in a welcoming smile as she drew near, and her eyes were as placid as those dull opals which still burn with a hidden lustre of gold and flame.

She held out her arms to him as she came.

"Suzanne!" called her mother. "For shame!"

"Hush, mamá!" declared Suzanne defiantly. "I don't care. I don't care. It's your fault. You shouldn't have lied to me." He could hear her talk as she came. "I'm going back to New York. I told you I was."

She did not say, "Oh, Eugene," as she came close but gathered his face in her hands and looked eagerly into his eyes. His burned into hers. She stepped back and opened wide her arms only to fold them tightly about him.

"At last, at last," he said, kissing her feverishly. "Oh, Suzanne. Oh, Flower Face!"

"I knew you would come," she said. "I warned mamá. I told her you would. I'll go back with you!"

"Yes, yes," said Eugene. "Oh, this wonderful night. This wonderful climax. Oh, to have you in my arms again."

Mrs. Dale stood by, white, tense. To think a daughter of hers should act

like this, confound her so, make her a helpless spectator of her iniquity! What an astounding, terrible, impossible thing!

"Suzanne," she cried. "Oh, that I should ever have lived to see this day."

"I told you, mamá, that you would regret bringing me up here," declared Suzanne. "I told you I would write him. I knew you would come," she said to Eugene, and she squeezed his hand affectionately.

Eugene inhaled a deep breath and stared at her. The night, the stars swung round him in a gorgeous orbit. Thus it was to be victorious. It was too beautiful! Too wonderful! To think he should have triumphed in this way. Could any other man anywhere ever have enjoyed such a victory?

"Oh, Suzanne," he said eagerly, "this is like a dream. It's like heaven. I can scarcely believe I am alive."

"Yes, yes," she replied, "it is beautiful, perfect." And together they strolled away from her mother, hand in hand.

CHAPTER XCVI

It is useless to attempt a solution of the vagaries of passion and sex attraction which are forever astonishing the world anew. They are bound up in those subtleties and mysteries of personality—seeming matter—which Carlyle, and after him, Wallace, insisted were a product of mind, and which Mrs. Eddy, the founder of Christian Science, interpreting Christ's words, saw as spirit coated over with illusion—a shield rusted. Evil, according to the founder of Christian Science, had no existence. It is nothing—a belief—something outside the real and eternal, which is spirit and good. All this storm of sex, this duality of personality, male and female, was merely a product of mortal mind, something created out of nothing and therefore itself nothing. If one, according to Eddy, became conscious for a single moment that life and intelligence are purely spiritual, neither in nor of matter because matter is a creation of mind, all this clash of wills and desires would disappear. There would exist no longer this illusion of sex. Peace would follow, for only divine principle would exist. Beyond this, what explanation is there for the vagaries of sex?

The aftermath of the meeting was that Eugene stayed that night at the Cathcart lodge, with Mrs. Dale guarding over her daughter with a sleepless eye. He refused to leave. A truce had been declared between them, for in walking and talking with Suzanne in Mrs. Dale's presence, the whole proposition as she had outlined it to Eugene was gone over and Suzanne's

opinion secured. The truth was that she had none, for she had been swept along to this great length by her desire to be with Eugene. It had seemed to her in the beginning that it was not possible for him to get a divorce. It had seemed also from her reading and youthful philosophizing that it was really not necessary. She did not want to be mean to Angela. She did not want Eugene to cause her intense suffering by leaving her. She had fancied since Eugene had said that Angela was not satisfactory to him and that there was no real love between them that Angela really did not care—she had practically admitted as much in her letter to her—that it would not make so much difference if she shared him with her. Angela ought not to care if there was no public discussion of it. Her mother ought not to mind if she, Suzanne, did not. His presenting an alternative confused her a little—she did not know how it was that Eugene did not want to leave at once—but having gone so far, she did not think it mattered so much what he wanted now. Anything he wanted to do was satisfactory to her. No thought of quarreling arose here—only a sense of something different—though as she felt it then, whatever Eugene wanted, she wanted.

The truth was, after getting her in his arms again, and that in the presence of her mother, Eugene did not feel that he was quite so much the victor as he had imagined, for he had the whole problem of his life still to face. He could not very well ignore what Mrs. Dale had to offer if she was offering it seriously. She had said to him again in the presence of himself and Suzanne that unless he accepted these terms, she would go on fighting—that she would telegraph Colfax and ask him to come up here. Suzanne asked Eugene this same evening—as though she had not asked him before—whether he thought her mother could really injure him with Colfax.

"I don't know," he replied. "Yes, I think she could. I don't know what he'd do."

Suzanne puzzled.

"If you want to wait, it's all right. I want to do whatever you do. If you think we ought to wait, all right."

"Not if I am not to be with you regularly," replied Eugene, who was puzzling, wavering. He was really not your true executive in victory—your administrator and leader. He was figuring foolishly on an arrangement, if he waited at all, whereby he would see her twice a week at least, be able to dine with her, be able to ride with her, to dance with her where she was dancing. Mrs. Dale, now that she saw first sign of reason was manifesting itself, was not so despondent but began to try to limit this understanding as to how often he should see her—to fight for better terms.

The trouble was that Eugene, by the very nature of his speculative, impractical temperament, had been completely undone already in the proper fruition of his scheme by Mrs. Dale's strategy in meeting him. If she had not

been aware of his coming, if he had been able to signal Suzanne secretly or gotten word to her privately and flown, the thing would have been in better shape for a proper denouement. As it was, he was in a way compromising his own climax by listening to any terms which Mrs. Dale might have to offer. He had come ostensibly at Suzanne's call to get her. He had fought his way to her presence over what he considered great obstacles. He should have gone with her then and there, somewhere, to freedom. As it was, he listened to Mrs. Dale's Machiavellian pleas and it was undoing him.

Suzanne felt something—she scarcely knew what—a lack of point to the whole procedure. It was beautiful to have him with her again. It was wonderful to feel his caresses. But he was not flying with her. They were not defying the world: they were not doing what she fancied they would be doing, rushing to victory, and that was what she had sent for him for. Mrs. Dale was going to help Eugene get a divorce, so she said. She was going to help subsidize Angela if necessary. Suzanne was going to get married and actually settle down after a time. What a curious thought. Why, that was not what she had wanted to do. She had wanted to flout convention in some way—to do an original thing as she had planned, as she had dreamed. It might be disastrous but she did not think so. Her mother would have yielded. Why was Eugene compromising?

It is curious but such thoughts as these formulated in her mind at this time were the most disastrous things which could happen to this romance. Union should have followed his presence. Flight should have been a portion of it. As it was, she was in his arms but she was turning over vague, nebulous thoughts. Something—a rack of mist before the otherwise brilliant moon, a bit of spindrift, a speck of cloud no bigger than a man's hand, that might possibly portend something and might not—had come over or into this situation. Eugene was as lovely as ever but he was not flying with her. They were talking about going back to New York after, but they were not going to go together at once. How was this?

"I said to her," he said, speaking of her mother who was nearby in this walk on this night, "that I would decide nothing. She wanted me to say that I would do this but I insisted that it must be left to you. If you want to go back to New York we will go—tonight or tomorrow. If you want to accept this plan of your mother's it's all right so far as I am concerned. I would rather have you right away but if I can see you, as I say, I am willing to wait."

He was calm now—logical, foolishly speculative in this matter. Suzanne vaguely wondered why he did not sweep her defiantly, irresistibly away.

"Well, I don't know. Whatever you think," she said. "If you want me to stay here another month——?"

"No, no, I don't. I don't mean that. You come back with me. Or come

as far as Lenox for two weeks, if your mother insists, and then come. If she keeps her promise to let us be together, all well and good. If she doesn't, we'll run away together. Is that satisfactory?"

Suzanne thought.

"Yes," she said.

"Will you return with me tomorrow?"

"Yes."

"As far as Lenox or New York?"

"We'll see what mamá says. If you can agree with her—anything you want—I am willing."

Eugene felt that there was something wrong with this situation. Mrs. Dale felt as if the worst was over. If she could only make him wait, she could change his mind. Colfax could now surely be introduced to advantage. Winfield's pressure could be brought to bear. She smiled at this talk of delay. After a time, Eugene and Suzanne parted for the night. It was agreed that they should see each other in the morning. It was agreed that they should go back as far as Lenox together. Mrs. Dale was to help Eugene get a divorce. It was a delightfully affectionate and beautiful situation but somehow Eugene felt that he was not handling it right. He went to bed in one part of the house, Suzanne in another—Mrs. Dale fearful and watchful, staying nearby, but there was no need. He was not desperate. He went to sleep thinking that the near future was going to adjust all this for him nicely and that he and Suzanne were eventually going to get married.

The next day, after wavering whether they would not spend a few days here in billing and cooing, and listening to Mrs. Dale's veiled pleas as to what the servants might think or what they might know already or suspect from what the station master at Three Rivers might say, they decided to return—Eugene to New York, Suzanne to Lenox. All the way back to Albany, Eugene and Suzanne sat together in one seat in the Pullman like two children rejoicing in each other's company. Mrs. Dale sat one seat away, pondering over her promises and whether, after all, she had not yet better go at once and try to end this by appealing to Colfax, or whether she had better wait a little while and see if it might not die down of its own accord.

At Albany the following morning, Suzanne and Mrs. Dale transferred to the Boston and Albany, Eugene going on to New York. He went to the office because he was feeling much relieved, and later in the day to his apartment. Angela, who had been under a terrific strain, stared at him as if he were a ghost or one come back alive from the dead. She had not known where he had gone. She had not known whether he would ever come back. There was no value in reproaching him—she had realized that long since. The best she could do was to make an appeal. She waited until after dinner, at

which they had discussed the mere commonplaces of life, and then came to his room where he was unpacking his grip.

"Did you go to find Suzanne?" she asked.

"Yes."

"Is she with you?"

"No."

"Oh, Eugene, do you know where I have spent the last three days?" she asked.

He did not answer.

"On my knees! On my knees!!" she declared, "asking God to save you from yourself."

"Don't talk rot, Angela," he returned coldly. "You know how I feel about this thing. How much worse am I now than I was before? I tried to get you on the phone to tell you. I went to find her and bring her back, and I did—as far as Lenox. I am going to win this fight. I am going to get Suzanne, either legally or otherwise. If you want to give me a divorce, you can. I will provide amply for you. If you don't, I'm going to take her anyhow. That's understood between me and her. Now what's the use of hysterics, anyhow?"

Angela looked at him tearfully. Could this be the Eugene she had known? In each scene with him, after each plea, or through it, she came to this adamantine wall. Was he really so frantic about this girl? Was he going to do what he said? He outlined to her quite calmly his plans as recently revised, and at one place Angela, speaking of Mrs. Dale, interrupted him—"She will never give her up to you—you will see. You think she will. She says she will. She is only fooling you. She is fighting for time. Think what you are doing. You can't win."

"Oh, yes I can," said Eugene. "I practically have already. She will come to me."

"She may—she may—but at what a cost? Look at me, Eugene. Am I not enough? I am still good looking. You have declared to me time and again that I have a beautiful form. See, see"—she tore open her dressing gown and her *robe de nuit*, in which she had come in. She had arranged this plea, especially thought it out, and she hoped it would move him. "Am I not enough? Am I not still all that you desire?"

Eugene turned his head away wearily, somewhat disgusted. This was the last plea Angela should have made. It was the most ineffectual—the least appropriate at this time. It was dramatic, striking, but without force under the present circumstances.

"There is no use in your talking that way to me, Angela," he said. "I'm no longer moved in that way in connection with you. This affectional life between us is dead—terribly so. Why appeal to me with something

that has no appeal? I can't help it. It's dead. Now what are we going to do about it?"

Once more Angela turned wearily. Although she was nerve-worn and despairing, she was still fascinated by this tragedy which was being played out under her eyes. Would nothing make him see?

They went their separate ways for the night, and the next day he was at his desk again. Word came from Suzanne that she was still in Lenox, and then that her mother had gone to Boston for a day or two on a visit. The fifth day Colfax stepped into his office and, hailing him pleasantly, sat down.

"Well, how are things with you, old man?" he asked.

"Oh, about the same," said Eugene. "I can't complain."

"Everything going all right with you?"

"Yes, moderately so."

"People don't usually butt in on you here when I'm here, do they?" he asked curiously.

"I've given order against anything like that, but I'll make it doubly sure in this case," said Eugene interestedly. Could Colfax be going to talk to him about anything in connection with his case? He paled a little. He rang for the door boy to warn him.

Colfax looked out of the window at the distant panorama of the Hudson. He took out a cigar and cut the end of it but did not light it.

"I asked you about not being interrupted," he began thoughtfully, "because I have a little something I want to ask you about which I would rather no one else would hear. Mrs. Dale came to me the other day," he said quietly (Eugene started at the mention of her name and paled still more, but gave no other outward sign), "and told me a long story about something that you were trying to do in connection with her daughter—run away with her, or go and live with her without a license or a divorce, or desert your wife, or something to that effect, which I didn't pay much attention to, but which I have to talk to you about just the same. Now I never like to mix in with a man's personal affairs. I don't think that they concern me. I don't think they concern this business except in so far as they are apt to affect this business. But I would like to know if that is true. Is it?"

"Yes," said Eugene.

"Mrs. Dale is an old friend of mine. I've known her for years. I know Mrs. Witla, of course, but not quite in the same way. I haven't seen as much of her as I have of you. I didn't know that you were unhappily married but that is neither here nor there. The point is that Mrs. Dale seems to be on the verge of making a great scandal out of this—she seems a little distracted to me—and I thought I better come up and have a little talk with you before

anything serious really happened. You know it would be a rather serious thing for business if anything scandalous were started in connection with you just at present."

He paused, expecting Eugene to make some protest or explanation, but Eugene merely held his peace, speculating. He was tense, pale, harried. So she had gone to Colfax after all. Instead of going to Boston, instead of keeping her word, she had come down here to New York and gone to Colfax. Had she told him the full story? Very likely. Colfax, in spite of all his smooth words, would be inclined to sympathize with her. What must he think of him? He was rather conservative in a social way. He had never seen Colfax quite so cool and deliberate as he was now. He seemed to be trying to maintain an exceedingly judical and impartial tone, which was not characteristic.

"You have always been an interesting study to me, Witla, ever since I first met you," he went on after a time. "You're a genius, I fancy, if there ever was one, but like all geniuses you are afflicted with tendencies which are erratic. I used to think, for a little while, that maybe you sat down and planned the things which you carried through so successfully but I have since concluded that you don't. You have various faculties—it would be hard for me to say just what they are. One is vision—I know you have that. Another is appreciation of ability. I know you have. I have seen you pick some exceptional people. You plan in a way, but you don't plan logically or deliberately, unless I am greatly mistaken. The matter of this Dale girl now is an interesting case in point, I think."

"Let's not talk of her," said Eugene, bridling slightly. Suzanne was a sore point with him, a dangerous subject. Colfax saw it. "That's something I can't talk about very well."

"Well, we won't," put in the other calmly, "but the point can be established in other ways. You'll admit, I think, that you haven't been planning very well in connection with this present situation, for if you had been, you would see that in doing what you have been doing you have been riding straight for a fall. If you were going to take the girl and she was willing, as she appears to be, to be taken, you should have taken her without her mother's knowledge, old man. She might have been able to adjust things afterward. If not, you would have had her, and I suppose you would have been willing to suffer the consequences if you had been caught. As it is, you have let Mrs. Dale in on it and she has powerful friends. You can't ignore her. I can't. She is in a fighting mood and it looks as though she were going to bring considerable pressure to bear to make you let go."

He paused again waiting to see if Eugene would say something but the latter made no comment.

"I want to ask one question and I don't want you to take any offense at it for I don't mean anything by it, but it will help me to clear this matter up in my own mind, and perhaps in yours later if you will answer—have you had anything to do in a compromising way with Miss ——?"

"No," said Eugene before he could finish.

"How long has this fight been going on?"

"Oh, about four weeks, or a little less."

Colfax bit at the end of his cigar.

"You have powerful enemies here, you know, Witla. Your rule hasn't been very lenient. One of the things I have noticed about you is your utter inability to play politics. You have picked men who would be very glad to have your shoes if they could. If they could get the details of this predicament, your situation wouldn't be tenable more than fifteen minutes. You know that, of course. In spite of anything I might do you would have to resign. You couldn't maintain yourself here. I couldn't let you. You haven't thought of that in this connection, I suppose. No man in love does. I know just how you feel. From having seen Mrs. Witla, I can tell in a way just what the trouble is. You have been reined in too close. You haven't been master in your own home. It's irritated you. Life has appeared to be a failure. You have lost your chance, or thought you had, on this matrimonial game and it's made you restless. I know this girl. She's beautiful. But just as I say, old man, you haven't counted the cost—you haven't calculated right—you haven't planned. If anything could prove to me what I have always faintly suspected about you, it is this. You don't plan carefully enough"—and he looked out of the window.

Eugene sat staring at the floor. He couldn't make out just what it was that Colfax intended to do about this. He was calmer in his thinking than he had ever seen him before—less dramatic. As a rule, Colfax yelled things—demonstrated, performed, made excited motions. This morning he was slow, thoughtful, possibly emotional.

"In spite of the fact that I like you personally, Witla—and every man owes a little something to friendship, though it can't be worked out in business—I have been slowly coming to the conclusion that perhaps, after all, you aren't just the ideal man for this place. You're too emotional, I fancy—too erratic. White has been trying to tell me that for a long time but I wouldn't believe it. I'm not taking his judgement now. I don't know that I would have ever acted on that feeling or idea if this thing hadn't come up. I don't know that I am going to do so finally, but it strikes me that you are in a very ticklish position—one rather dangerous to this house, and you know this house could never brook a scandal. Why, the newspapers would never get over it. It would do us infinite harm. I think, viewing it all in all, that you had

better take a year off and see if you can't straighten this out quietly. I don't think you had better try to take this girl unless you can get a divorce and marry her, and I don't think you had better try to get a divorce unless you can do it quietly—I mean only so far as this position is concerned. Outside of that, you can do what you please, for of course a scandal would affect your usefulness here. If things can be patched up—well and good. If not—well, then they can't. If this thing gets talked around much, you know that there will be no hope of your coming back here. I don't suppose you would be willing to give her up?"

"No," said Eugene.

"I thought as much. I know just how you take a thing of this kind. It hits your type hard. Can you get a divorce from Mrs. Witla?"

"I'm not so sure," said Eugene. "I haven't any suitable grounds. We simply don't agree, that's all—my life has been a shell."

"Well," said Colfax, "it's a bad mix up all around. I know how you feel about the girl. She's very beautiful. She's just the kind to bring about a situation of this kind. I don't want to tell you what to do. You are your own best judge, but if you will take my advice, you won't try to live with her without first marrying her. A man in your position can't afford to do it. You're too much in the public eye. You know you have become fairly conspicuous in New York during the last few years, don't you?"

"Yes," said Eugene. "I thought I had arranged that matter with Mrs. Dale."

"It appears not. She tells me that you are trying to persuade her daughter to live with you, that you have no means of obtaining a divorce within a reasonable time, that your wife is in a—pardon me—and that you insist on associating with her daughter meanwhile, which isn't possible, according to her. I'm inclined to think she's right. It's hard, but it can't be helped. She says that you say that if you are not allowed to do that, you will take her and live with her."

He paused again. "Will you?"

"Yes," said Eugene.

Colfax twisted slowly in his chair and looked out of the window. What a man. What a curious thing love was.

"When is it," he asked finally, "that you think you might do this?"

"Oh, I don't know. I'm all tangled up now. I'll have to think."

Colfax meditated.

"It's a peculiar business. Few people would understand this as well as I do. Few people would understand you, Witla, as I do. You haven't calculated right, old man, and you'll have to pay the price. We all do. I can't let you stay here. I wish I could, but I can't. You'll have to take a year off and think

this thing out. If nothing happens—if no scandal arises—well, I won't say what I'll do. I might make a berth for you here somewhere—not exactly in the same position, perhaps, but somewhere. I'll have to think about that. Meanwhile——," he stopped and thought again.

Eugene was seeing clearly how it was with him. All this talk about coming back meant nothing. The thing that was uppermost in Colfax's mind was that he would have to go, and the reason that he would have to go was not Mrs. Dale or Suzanne or the moral issue involved, but the fact that he had lost Colfax's confidence in him. Somehow through White, through Mrs. Dale, through his own actions day in and day out, Colfax had come to the conclusion that he was erratic, uncertain, and for that reason, nothing else, he was being dispensed with now. It was Suzanne, it was fate, his own unfortunate temperament. He brooded pathetically and then he said: "When do you want this to happen?"

"Oh, anytime, the quicker, the better, if a public scandal is to grow out of it. If not, you can take your time—three weeks, a month, six weeks. You had better make it a matter of health and resign for your own good—I mean the looks of the thing. That won't make any difference in my subsequent conclusions. This place is arranged so well now that it can run nicely for a year without much trouble. We might fix this up again—it depends——"

Eugene wished he had not added the last hypocritical phrase.

"Well, I see nothing for it but that," he said sadly. "I suppose a week or ten days will be soon enough."

"Oh, certainly, certainly. I don't think you need to be in any rush about the matter as all that. Take your time. Fix it up any way that looks best to you. I don't want to see you injured in any way if I can help it."

"Well," said Eugene, getting up. "I'm sorry—very. You've been mighty nice to me on the whole, Colfax—fine. I can't help doing this thing. Truly I can't. I may say to you that I don't even want to. I'm crazy about this girl and I have no other object in life half so important. I'm sorry."

"So am I, old man," said Colfax feelingly—the first touch of real feeling that he had thus far manifested. "Damned sorry. It may work out for the best. Take a year off. You can probably straighten it all out in that time. If you do, come and talk to me. Come and see me anyhow. See if you can't keep it all under cover, whatever you do. It will be so much better for you. Don't sacrifice your life. You're too good a man."

He shook hands and went to the door and Eugene strolled to the window. Here was all this magnificent foundation cut from under him at one fell stroke as if by a sword. He had lost this truly magnificent position—$25,000 a year. Where would he get another like it? Who else—what other company could pay any such salary? How could he maintain the Riverside Drive apart-

ment now unless he married Suzanne? How could he have his automobile, his valet? Colfax said nothing about continuing his income—why should he? He really owed him nothing. He had been exceedingly well paid, better paid than he would have been anywhere else.

He regretted his fanciful dreams about Blue Sea—his silly enthusiasm in tying up all his money in that. Would Mrs. Dale go to Winfield? Would her talk do him any real harm there? Winfield had always been a good friend to him, had manifested a high regard. This charge—this talk of abduction. What a pity it all was. It might change Winfield's attitude. And still, why should it? He had women—no wife, however. He hadn't, as Colfax said, planned this thing quite right. That was plain now. His magnificent world of dreams was beginning to come down like a house of cards. It might be that he had been chasing a will-o'-the-wisp after all. Could this really be possible? Could it be?

CHAPTER XCVII

One would have thought this terrific blow would have given Eugene pause in a way, and it did. It frightened him. Mrs. Dale had gone to Colfax in order to persuade him to use his influence to make Eugene behave, and having done so much, she was actually prepared to go further. She was figuring on some scheme whereby she could blacken Eugene, have his true character become known without in any way involving Suzanne. Having been so relentlessly pursued and harried by Eugene, she was now as relentless in her own attitude. She wanted him to let go now—entirely, if she could make him—not to see Suzanne any more. She went first to Winfield and then back to Lenox with the hope of preventing any further communication, or at least action on Suzanne's part, or Eugene's possible presence there.

In so far as her visit to Winfield was concerned, it did not amount to so much morally or emotionally in that quarter, for Winfield did not feel that he was called upon to act in this matter. He was not Eugene's guardian nor yet a public censor of morals. In consequence, he waived the whole question grandly to one side, though in a way he was glad to know this, for it gave him a line on Eugene. He was sorry for him, a little—what man would not be?—nevertheless, in his thought that he might be compelled to reorganize the Blue Sea Corporation, he did not feel so bad over what might become of Eugene's interests. When the latter approached him, as he did sometime afterward with the idea that he might be able to dispose of his holdings,

he saw no way to do it. The company was really not in good shape. More money would have to be put in. All of the treasury stock would have to be quickly disposed of or a reorganization would have to be effected. The best that could be promised under those circumstances was that Eugene's holdings might be exchanged for a fraction of their value in a new issue by a new group of directors. So Eugene later saw the end of his dreams in that direction looming up quite clearly.

When he saw what Mrs. Dale had done, he saw also that it was necessary to communicate the situation clearly to Suzanne. The whole thing gave him pause and he began to wonder what was to become of him. With his twenty-five thousand a year in salary cut off; his prospect of an independent fortune in Blue Sea annihilated; the old life closed to him for want of cash—for who can travel in society without money?—the thought that he was in danger of complete social and commercial extinction dawned upon him and it was very well founded. If by any chance a discussion of the moral relations between him and Suzanne arose, or his unconscionable attitude toward Angela—if White heard of it, for instance—what would become of him? The latter would spread the fact. It would close every publishing house in the city to him. He did not believe Colfax would talk; he fancied that Mrs. Dale had not, after all, spoken to Winfield, but if she had, how much farther would it go? Would White hear of it through Colfax? Would he keep it a secret if he knew? Never. There was real danger and it began to dawn upon him dimly what it was that he had been doing. He was like a man who had been cast into a deep sleep by a powerful opiate and was slowly waking to a dim, wondering sense of where he was. He was in New York. He had no position. He had little ready money—perhaps five or six thousand, all told. He had the love of Suzanne, but her mother was still fighting him and he had Angela on his hands, undivorced. How was he to arrange things now? How could he think of going back to her? Never.

He sat down and composed the following letter to Suzanne, which he thought would make clear to her just how things stood and give her pause, if she wished opportunity for pause, for he thought he owed that much to her now.

"Flower Face:
"I had a talk with Mr. Colfax this morning and what I feared might happen has. Your mother, instead of going to Boston as you thought, came to New York and saw him—and, I fancy, my friend Winfield also. She cannot do me any harm in that direction for my relationship with that company does not depend on a salary or fixed income of any kind, but she has done me infinite harm here. Frankly, I have lost my position. I do not think that would have come about except for other

forces with which she had nothing to do, but her charges and complaints, coming on top of opposition here on the part of someone else and some conditions" (he was thinking of his own temperament) "has done what she couldn't have done alone.

"Flower Face, do you know what that means? I told you once that I had bound up all my spare cash in Blue Sea, which I hoped would come to so much. It may, but this cutting off of my salary here means great changes for me unless I can make other connections immediately. I will probably have to give up my apartment in Riverside Drive and my automobile and in other ways trim my sails to meet the bad weather. It means that if you come to me we should have to live on what I can earn as an artist unless I should decide or be able to find something else. When I came to Canada for you I had some such idea in mind but since this thing has actually happened you may think differently. If nothing happens to my Blue Sea investment, there may be an independent fortune some day in that. I can't tell. But that is a long way off and meanwhile there is only this, and I don't know what else your mother may do to my reputation. She appears to be in a very savage frame of mind. You heard what she said at While-a-Way. She has evidently gone back on that completely.

"Flower Face! Honeypot! I lay this all before you so that you may see how things are. If you come to me it may be in the face of a faded reputation. You must realize that there is a great difference between Eugene Witla, Managing-Publisher of the United Magazines Corporation, and Eugene Witla, artist. I have been very reckless and defiant in my love of you. Because you are so lovely—the most perfect thing that I have ever known—I have laid all on the altar of my affection. I would do it again gladly, a thousand times, if I could have you or if I could only have so much as I have had. Before you came, my life was a gloomy thing. I thought I was living but I knew in my heart that it was all a dusty shell—a lie. Then you came and oh, how I have lived! The nights, the days, of beautiful fancy! Shall I ever forget White Wood, or Blue Sea, or Briarcliff, or that wonderful first day at South Beach? Little girl, our ways have been the ways of perfectness and peace. This has been an intensely desperate thing to do, but for my sake I am not sorry. I have been dreaming a wonderfully sweet and perfect dream. It may be when you know all and see how things stand and stop and think, as I now ask you to do, you may be sorry and want to change your mind. Don't hesitate to do so if you feel that way. You know I told you to think calmly long before you told your mother. This is a bold, original thing we have been planning. It is not to be expected that the world would see it as we have. It is quite to be expected that trouble would follow in the wake of it. But it seemed possible to me and still seems so. If you want to come to me, say so. If you want me to come to you,

speak the word. We will go to England or Italy and I will try my hand at painting again. I can do that, I am sure. Or we can stay here and I can see if some connection cannot be made.

"You want to remember, though, that your mother may not be through fighting. She may go to much greater lengths than she has gone. You thought you might control her, but it seems not. I thought we had won in Canada, but it appears not. If she attempts to restrain you from using your share of your father's estate, she may be able to cause you trouble there. If she attempts to incarcerate you she might be successful. I wish I could talk to you. Can't I see you at Lenox? Are you coming home next week? We ought to think and plan and act now, if at all. Don't let any consideration for me stand in your way, though, if you are doubtful. Remember that conditions are different now. Your whole future hangs on your decision. I should have talked this way long ago, perhaps, but I did not think your mother could do what she has succeeded in doing. I did not think my financial means would play any part in it.

"Flower Face, this is the day of a real trial for me. I am unhappy, but only at the possible prospect of losing you. Nothing of all those other things really matters. With you, everything would be perfect, whatever my condition might be. Without you, it will be as dark as night. The decision is in your hands and you must act. Whatever you decide, that I will do. Don't, as I say, let consideration for me stand in the way. You are young. You have a social career before you. After all, I am twice your age. I talk thus sanely because if you come to me now, I want you to understand clearly how you come.

"Oh, honeypot! I wonder sometimes if you really understand. I wonder if I have been dreaming a dream. You are so beautiful. You have been such an inspiration to me. Has this been a lure—a will-o'-the-wisp? I wonder! I wonder! And yet I love you, love you, love you. A thousand kisses, Divine Fire, and I wait for your word.

<div align="right">"Eugene."</div>

Suzanne read this letter at Lenox and for the first time in her life she began to think and ponder seriously. What had she been doing? What was Eugene doing? These developments frightened her. Her mother was more forceful than she imagined. To think of her going to Colfax—of her lying and turning so in her moods. She had not thought this possible of her mother, had not thought it possible that Eugene could lose his position. He had always seemed so powerful to her; so much a law unto himself. Once when they were out in an automobile together, he had asked why she loved him and she said, "Because you are a genius and can do anything you please."

"Oh, no," he answered. "Nothing like that. I can't really do very much of anything. You just have an exaggerated notion of me."

"Oh, no, I haven't," she replied. "You can paint and you can write" (she was judging by some of the booklets about Blue Sea and verses about herself and clippings of articles done in his old Chicago newspaper days which he showed her once in a scrap-book in his apartment) "and you can run that office and you were an advertising manager and an art director."

She lifted up her face and looked into his eyes admiringly.

"My, what a list of accomplishments," he replied. "Well, whom the gods would destroy they first make mad." He gathered her in his arms and kissed her.

"And you love so beautifully," she added by way of climax.

Since then she had thought of this often but now, somehow, the idea received a severe setback. He was not quite so powerful. He could not prevent her mother from doing this. And could she really conquer her mother? Whatever Suzanne might think of her deceit, she was moving heaven and earth to prevent this. Was she wholly wrong? After that climacteric night at St. Jacques when somehow the expected did not happen, she had been thinking. Did she really want to leave home and go with Eugene to England or Italy? Did she want to fight her mother in regard to her estate? She might have to do that. Her original idea had been that she and Eugene would meet in some lovely studio and that she would have her home and he would have his. It was something very different, this talk of poverty and not having an automobile and being far away from home. Still she loved him. Maybe she could force her mother to terms yet.

There were more struggles in the two or three succeeding days in which the guardian of her estate—Mr. Herbert Pitcairn of the Marquardt Trust Company—and, once more, Dr. Woolley, were called in to argue with her. Suzanne, unable to make up her mind, listened to her mother's insidious plea that if she would wait a year and then say she really wanted him she could have him; listened to Mr. Pitcairn tell her mother that he believed any court would, on application, adjudge her incompetent and tie up her estate; heard Dr. Woolley say in her presence to her mother that he did not deem a commission in lunacy advisable, but if her mother insisted, no doubt a jury would adjudge her insane, if no more than to prevent this unhallowed consummation. Suzanne became frightened. Her iron nerve, after Eugene's letter, was weakening. She was terribly incensed against her mother but she began now, for the first time, to think what her friends would think. Supposing her mother did lock her up. Where would they think she was? All these days and weeks of strain which had worn her mother threadbare had told something on her own strength, or rather nerve. It was too intense, and she began to wonder whether she had not better pause, as Eugene suggested, and possibly wait a little while. He had agreed up at St. Jacques to

wait if she were willing. Only the provision was that they were to see each other. Now her mother had changed front again, pleading danger, undue influence, that she ought to have at least a year of her old kind of life undisturbed to see whether she really cared.

"How can you tell?" she insisted to Suzanne in spite of her desire not to talk. "You have been swept into this and you haven't given yourself time to think. A year won't hurt. What harm will it do you or him?"

"But mamá," asked Suzanne over and over at different times and in different places, "why did you go and tell Mr. Colfax? What a mean, cruel thing that was to do."

"Because I think he needs something like that to make him pause and think. He isn't going to starve. He is a man of talent. He needs something like that to bring him to his senses. Mr. Colfax hasn't discharged him. He told me he wouldn't. He said he would make him take a year off and think about it and that's just what he has done. It won't hurt him. I don't care if it does. Look at the way he has made me suffer."

She felt exceedingly bitter toward Eugene and was rejoicing that at least she was beginning to have her innings.

"Mamá," said Suzanne, "I am never going to forgive you for this. You are acting horribly. I may wait, but it will come to the same thing in the end. I am going to have him."

"I don't care what you do after a year," said Mrs. Dale cheerfully and subtly. "If you will just wait that long and give yourself time to think and still want to marry him, you can do so. He can probably get a divorce in that time anyhow." She did not mean what she was saying but any argument was good for the situation, if it helped any.

"But I don't know that I want to marry him," insisted Suzanne doggedly, harking back to her original ideal. "That isn't my theory of it."

"Oh, well," replied Mrs. Dale complaisantly, "you will know better what to think of that after a year. I don't want to coerce you but I'm not going to have our home and happiness broken up in this way without turning a hand and without your stopping to think about it. You owe it to me—to all these years I have cared for you—to show me some consideration. A year won't hurt you. It won't hurt him. You will find out that way whether he really loves you or not. This may just be a passing fancy. He has had other women before you. He may have others after you. He may go back to Mrs. Witla. It doesn't make any difference what he tells you. You ought to test him before you break up his home and mine. If he really loves you he will agree readily enough. Do this for me, Suzanne, and I will never cross your path anymore. If you will wait a year you can do anything you choose. I can only hope you won't go to him without going as his wife but if you insist

I will hush the matter up as best I can. Write him and tell him that you have decided that you both ought to wait a year. You don't need to see him anymore. It will just stir things all up afresh. If you don't see him, but just write him, it will be better for him too. He won't feel so badly as he will if you see him again and go all over the ground once more."

Mrs. Dale was terribly afraid of Eugene's influence but she could not accomplish this.

"I won't do that," said Suzanne. "I won't do it. I'm going back to New York. That's all there is to it." Mrs. Dale finally yielded that much.

There was a letter from Suzanne after three days, saying that she couldn't answer his letter in full but that she was coming back to New York and would see him, and subsequently a meeting between Suzanne and Eugene at Dalewood in her mother's presence (Dr. Woolley and Mr. Pitcairn were in another part of the house at the time), in which this proposition was gone over anew. Mrs. Dale stared at Eugene defiantly when he came but Suzanne welcomed him to her embrace. "Oh," she exclaimed, holding him close for a few moments and breathing feverishly. There was complete silence for a time.

"Mamá insists, Eugene," she said after a time, "that we ought to wait a year and I think, since there is such a fuss about it, that perhaps it might be as well. We may have been just a little hasty, don't you think? I have told mamá what I think about her action in going to Mr. Colfax but she doesn't seem to care. She is threatening now to have me adjudged insane. A year won't make any real difference since I am coming to you anyhow, will it? But I thought I ought to tell you this in person—to ask you about it." She paused, looking into his eyes.

"I thought we settled all this up in St. Jacques?" said Eugene, turning to Mrs. Dale, but experiencing a sinking sensation of fear.

"We did—all except the matter of not seeing her. I think it is highly inadvisable that you two should be together. It isn't possible the way things stand. People will talk. Your wife's condition has to be adjusted. You can't be running around with Suzanne, and a child coming to you. I want Suzanne to go away for a year where she can be calm and think it all out, and I want you to let her. If she still insists that she wants you after that and will not listen to the logic of the situation in regard to marriage, then I propose to wash my hands of the whole thing. She may have her inheritance. She may have you if she wants you. If you have come to your senses by that time, as I hope you will have, you will get a divorce or go back to Mrs. Witla or do whatever you do in a sensible way."

She did not want to incense Eugene here, but she was very bitter.

Eugene merely frowned.

"Is this your decision, Suzanne, too?" he asked wearily.

"I think mamá is terrible, Eugene," replied Suzanne evasively, or perhaps as a reply to her mother. "You and I have planned our lives and we will work them out. We have been a little selfish, I guess, now that I think of it. I think a year won't do any harm, perhaps, if it will stop all this fussing. I can wait if you can."

An inexpressible sense of despair fell upon Eugene at the sound of this, a sadness so deep that he could scarcely speak. He could not believe that it was really Suzanne who was saying that to him. Willing to wait a year! She who had declared so defiantly that she would not. It would do no harm? To think that life, fate, her mother, were triumphing over him in this fashion after all. What then was the significance of the black-bearded men he had seen so often of late? Why had he been finding horse shoes? Was fate such a liar? Did life in its dark subtle chambers lay lures and traps for men? His position gone. His Blue Sea venture involved in an indefinite delay out of which might come nothing. Suzanne going for a whole year—perhaps forever, most likely so, for what could not her mother do with her in a whole year, having her alone? Angela alienated—a child approaching. What a climax.

"Is this really your decision, Suzanne?" he asked sadly, a mist of woe clouding his whole being.

"I think it ought to be, perhaps, Eugene," she replied, still evasively. Somehow she was not feeling about it as he did—she was not able. "It's very trying. I will be faithful to you, though. I will not change. Don't you think we can wait a year? We can, can't we?"

"A whole year without seeing you, Suzanne?"

"Ye-e-s. It will pass, Eugene."

"A whole year?"

"Yes, Eugene."

"I have nothing more to say, Mrs. Dale," he said, turning to her mother solemnly, a sombre, gloomy light in his eye. "You win. It has been a terrible experience for me. A terrible passion. I love this girl. I love her with my whole heart. Sometimes I vaguely suspected that she might not know. But my life, my life."

He turned to Suzanne and for the first time he thought that he did not see there that true understanding which he had fancied had been there all the time. Could fate have been lying to him in this also? Was he mistaken in this and had been following a phantom lure of beauty? Was Suzanne but another trap to drag him down to his old nothingness? God! The prediction of the astrologer of a second period of defeat after seven or eight years came back.

"Oh, Suzanne," he said simply and unconsciously dramatically, "Do you really love me?"

"Yes, Eugene," she replied.

"Really?"

"Yes."

He held out his arms and she came, but for the life of him he could not dispel this terrible doubt. It took the joy out of his kiss—as if he had been dreaming a dream of something perfect in his arms and had awaked to find it nothing—as if life had sent him a Judas in the shape of a girl to betray him.

"Do let us end this, Mr. Witla," said Mrs. Dale coldly. "There is nothing to be gained by delaying. Let us end it for a year, and then talk."

"Oh, Suzanne," he continued, as mournful as a bell, "come to the door with me."

"No, the servants are there," put in Mrs. Dale. "Please make your farewells here."

"Mamá," said Suzanne, angrily and definitely moved by the pity of it. "I won't have you talk this way. Leave the room or I shall go to the door with him, and further. Leave it, please."

Mrs. Dale went out.

"Oh, Flower Face," said Eugene pathetically. "I can't believe it. I can't! I can't! This has been managed wrong. I should have taken you long ago. So it is to end this way. A year. A whole year—and how much longer?"

"Only a year," she insisted. "Only a year, believe me. Can't you? I won't change. I won't."

He shook his head and Suzanne, as before, took his face in her hands. She kissed his cheeks, his lips, his hair.

"Believe me, Eugene. I seem cold. You don't know what I have gone through. It is nothing but trouble everywhere. Let us wait a year. I promise you I will come to you. I swear. One year. Can't we wait one year?"

"A year!" he said. "A year! I can't believe it. Where will we all be in a year? Oh, Flower Face, Myrtle Bloom, Divine Fire. I can't stand this. I can't. It's too much. I'm the one who's paying now. Yes. I pay."

He held her face and looked at it—all its soft enticing features. Her eyes, her lips, her cheeks, her hair.

"I thought, I thought," he murmured.

Suzanne only stroked the back of his head with her hands.

"Well, if I must, I must," he said.

He turned—turned back to embrace her—turned again, and then without looking back, walked out into the hall. Mrs. Dale was there waiting.

"Good night, Mrs. Dale," he said gloomily.

"Good night, Mr. Witla," she replied frigidly but with a sense of something tragic in her victory at that.

He took his hat and walked out.

Outside, the bright October stars were in evidence by millions. The bay and harbor of New York were as wonderfully lit as on that night when Suzanne came to him on her own porch after the evening at Fort Wadsworth. He recalled the spring odours, the wonderful feel of youth and love—the hope that was springing then. Now it was five or six months later and all that romance was gone. Suzanne, sweet voice, accomplished shape, light whisper, delicate touch. Gone!

> "Faded the flower and all its budded charms,
> Faded the sight of beauty from my eyes,
> Faded the shape of beauty from my arms,
> Faded the voice, warmth, whiteness, paradise."

Gone were those bright days in which they had ridden together, dined together, walked in sylvan places beside their car. A little way from here he had come so often to meet her clandestinely. Here he first played tennis with her. Now she was gone—gone.

He had come in his car but he really did not want it. Life was accursed. His own was a failure. To think that all his fine dreams should crumble this way. Shortly he would have no car, no home on Riverside Drive, no position, no anything.

"God, I can't stand this," he exclaimed, and a little later, "By God, I can't! I can't!"

He dismissed his car at the Battery, telling his chauffeur to take it to the garage, and walked gloomily through all the tall dark streets of lower New York. Here was Broadway, where he had often been with Colfax and Winfield. Here was this great world of finance about Wall Street in which he had vaguely hoped to share. Now these buildings were high and silent, receding from him in a way. Overhead were the clear bright stars, cool and refreshing, but without meaning to him now. How was he to settle it? How adjust it? A year! She would never come back, never. It was all gone. A bright cloud faded! A mirage dissolved into its native nothingness. Position! Distinction! Love! Home! Where were they? Yet a little while and all these things would be as though they had never been. Hell! Damn! Curse the brooding fates that could thus plot to destroy him.

Back in her room in Dalewood, Suzanne had locked herself in. She was not without a growing sense of the tragedy of it. She stared at the floor, recalled his face.

"Oh, oh," she said, and for the first time in her life felt as though she could cry from a great heartache—but she could not.

And in Riverside Drive was another woman brooding, lonely, despondently, desperately over the nature of the tragedy that was upon her. How were things to be adjusted? How was she to be saved? Oh! Oh! Her life, her child! If Eugene could be made to understand. If he could only be made to see!

CHAPTER XCVIII

The hells of love are bitter and complete. One might have imagined that past experiences in the matter of affections—or rather their evil simulations, physical and emotional desire—would have taught Eugene to doubt the stability and duration of those fevers of the brain; to note or suspect their brevity and insecurity as well as the destructive nature of their continued indulgence; but for the first time in his life there was involved in this particular relationship a seeming affinity of temperament such as had never before existed between him and any woman. It drew him like a magnet to the bosom of Suzanne. She had seemed most innocent in her mood toward him—so free from guile and self seeking. She wanted to give him everything, make him happy.

He and Angela were truly not well mated. He did not understand this clearly at first, although in the latter years of their relationship he began to think that she really did not understand him and that truly he did not understand her. He had never been offended very much by the fact that she was so much older than he was, though he understood clearly that this might make a difference in their point of view. She was young enough in spirit and appearance to deceive him at the time they met and to make the difference on this score a negligible quantity. Afterward, though, he found out that she was much older through his sister Myrtle, who learned it accidentally through a talk with Marietta who once visited her while she was still at Alexandria. Angela was bright enough in a practical way. She could see the essential greatness of Eugene's moods without really following them or being able to, but where she lacked, and lacked woefully for the harmonious development of their joint idiosyncrasies and tastes, was in her inability to match him mood for mood, in understanding, perception, and feeling, and in her inability to give without wishing to receive in turn. Their tastes were not really alike in any save the practical things. He admired her order and economy because he was orderly and economical in small things, though a lavish spender when it came to anything which involved his love of beauty or refinement. Where Eugene's affections were concerned, he had no money sense at all. He could not resist the desire or temptation to give his beloved, whoever she might be, anything that he

had. Fortunately he was of the temperament or mood which unconsciously selected big minded and, as a rule, generous minded women.

From the very beginning, all of his female companions, save Angela and Miriam Finch, had really wanted nothing of him. Margaret Duff, Ruby Kenny, Christina Channing, Frieda Roth, Carlotta Wilson, and now after her, Suzanne Dale, had really thought of nothing in connection with him save the delight of his companionship. Money, position, the thought of making something out of him, either financially or socially, had never occurred to any of them. In every one of these instances they were really the soul of generosity so far as he was concerned, but with Angela and Miriam Finch it was different. And curiously these two had been possessed of the most innate opposition to each other. Both Miriam Finch and Angela had always hoped to rise by association with his personality. They saw in him an exceptional figure, mentally and artistically, and they believed firmly that the world would recognize him in some distinguished way. It had been delightful to Miriam Finch to dream of being Mrs. Eugene Witla and how she would capitalize his worth.

Angela, once she crossed his path, had the same sensations. Instinctively she recognized the able and exceptional in him, the thing or things that made him different, though she could not share them in the really sympathetic and understanding way which would have been best for him. She was always most anxious to see that his house was in order, that the things which he needed and which were most useful to him were ready to his hand. She wanted him to have the best friends for him—that is, the most useful, though she was not averse to minor relationships where they were delightful. It was, or had been, a great satisfaction to her to see him climbing steadily upward, even though it were in a field on which she had previously looked with contempt, for his art had been to her the one great thing to which he should have devoted himself. Still, she poorly brooked the ills of poverty—and that only because at the time there was a suggestion of effulgent dawn in the east, where his future lay. She wanted him to succeed, and all his weakness of character so far as the fair sex was concerned, with its attendant commentary on her own inefficiency as a lure to his emotional capabilities and desires, did not quite deaden her feelings so far as the satisfaction of being Mrs. Eugene Witla was concerned. She thought, and this was due to her ultimate lack of understanding, that whether there was any lure in her or not, and of course she did not admit for one moment that there was not, that he, having made a verbal agreement under the law and convention of the time to love and cherish her, he should continue to do so. Love and cherish he must, or pretend to do so in such a way that she would not suspect that it was a pretence. He must fulfill the spirit of the

agreement, whatever his personal feelings might be, and to this rule she was satisfied that there could be no honest or honorable objection. Any man who failed in this was simply weak, dishonest, and unprincipled. He might have other excellent qualities—notable ones such as Eugene had—but these were no palliatives, or only slight ones, for his real inherent and most degrading sin. Temperamentally and philosophically, Eugene did not agree with this at all. Hence——

Now, insofar as Suzanne was concerned, in her Eugene might have found, had he been able to take her at the time he found her, a woman who was in many ways suited to his fancies and subtlest emotions. Here was someone who was radically different from Angela. In the first place, she was really young enough and beautiful enough to satisfy him; and in the next place, her intelligence, moods, emotions, and theories were peculiar and radical enough to appeal to him constantly. She had no desire to profit by, hold, or exact from him anything which he did not freely and joyously wish to give. She had told him more than once that she did not want to come to him unless she could come freely, giving herself wholly and joyously without conditions and without price. How or by what process this idea had been formulated in her mind it would be difficult to say but it was there and, after Angela, it made a tremendous impression on his mind. What a difference in attitude! What a difference in temperament! Not to want to hold him to any verbal agreement! Not to care whether he ceased to love her or not!

"If I keep you, Eugene," Suzanne once said to him, "I know it must be something in me that you want. If I don't, I haven't what you want, and I don't want you to want me."

She had fairly taken Eugene's breath away. He had not seen or heard of anything quite so wonderful in all his days. Ruby had been nice and generous but she was not Suzanne's mental or social equal and she had not near so much to give. Christina Channing was something like this, only he had felt of Christina that she was seeking selfishly after joy, much as he was, and without great regard for individuality. Frieda Roth had been quite too young to express herself in this way, and Carlotta Wilson had been too experienced. She had not so much to give and really did not care except in a joyous, platonic way. Suzanne Dale loved him in a dramatic, artistic, subtle way. It was a new way—beautiful. He could feel it. There was some subtle aroma attaching to her, not only intellectually but spiritually, which fed his very soul. The bread of her giving was not made of human hands. She touched his face with her fingers and he thrilled from head to toe; she looked into his eyes and something flashed or rather soothingly flowed out to him which caused him to reel in an ecstasy of joy. There were no words

wherewith he could tell her of the things that he felt. It was something as subtle as tone in music, a hue in color, a benediction in spirit. She made him feel wonderful, she was exquisitely and unconsciously beautiful, and she loved him.

Now she was gone and he was too despondent to believe that she would ever come to him anymore. All the fine things that he had cherished as somehow a part of her—contemporaneous with and by right of the atmosphere in which she belonged—were going also. His machine, his beautiful apartment; his freedom of expenditure and action; his commanding position; the beauty of his office; the pretentious obsequiousness of his hirelings and those who were constantly seeking favors of him. No more those joyous rides to exquisite country places in which the thought of expenditure was nothing to be considered, any more than grips and material belongings. No more those delicious tête-à-tête conversations in obscure but lovely country eating places with her, where his machine and manner guaranteed him every courtesy, and where the former's speed made it possible for him to go and return undetected. He recalled hours when they sat on balconies overlooking the sea, seeing flowers—red geraniums, particularly, and green swards flourishing about them—hearing the sound of the waves, hearing music, stringed or vocal, seeing Suzanne looking so exquisite seated beside him, and caressing her fingers softly when she was not observed.

"You know, Eugene," she had said to him so often, "it is all like a dream to me. It doesn't seem to be like anything I have ever seen or felt before. It's soft—so sweet—everything is, with you. You just take to the beautiful, don't you?"

"Witness," he replied once, touching her lips, "a case in point."

And her eyes dreamed a dream of a smile in return.

Now all this was gone, finally, irrevocably. It and so many other things were gone that it was as if he stood in a house of falling timbers. An earthquake had transpired. All was chaos. In a few weeks, a few days, a few hours practically, he would be out of all this. What was he to do?

It should be said here that at one time Suzanne truly imagined she loved Eugene. It must be remembered, however, that she was overborne toward affection for him by the wonder of a personality that was hypnotic to her. There was something about the personality of Eugene that was subversive of conventionality. He approached, apparently a lamb of conventional feelings and appearances, whereas inwardly he was a ravening wolf of indifference to convention. All these organized modes and methods of life were a joke to him. He saw through to something that was not material life at all but spiritual, or say immaterial, of which all material things were a shadow. What did the great forces of life care whether this system which was main-

tained here with so much show and fuss was really maintained at all or not? How could they care? He once stood in a morgue and saw human bodies dissolving into a kind of chemical mush and he had said to himself then how ridiculous it was to assume that life meant anything much to the forces which were doing these things. Great chemical and physical forces were at work which permitted, accidentally perhaps, some little shadow play which would soon pass. But, oh, its presence, how sweet it all was.

Vaguely Suzanne was beginning, at her age, to feel these same things about life. The mysteries of things were holding her, in all her beauty, quite as much as they were him. She had not reached his subtle state of comprehension as yet but she would—or nearly so. She had, in addition, a sterling desire to tell the truth and stand her ground, which was not so much a characteristic of his, but with her to aid him—sympathetically, understandingly—he might have achieved it. Anyhow, they were in blissful accord as to these things and it was, or had been, an intense source of delight to him to watch her finding her way to his own observations—making them, sharing them with him.

"Oh, you sweet!" he used to exclaim, "how you think. How divinely you think. You are coming to me through your own moods."

It was as if this mystery of life and the love of it had been embodied in her beauty for him. He could gather it up in his arms, hold it, kiss it, feel a warm sense of response.

Suzanne, however, like himself, was uncertain what to do. Having gone so far as she had, she found herself at the limit of her resources. Her mother, having achieved one victory over Eugene, was growing aggressive—force and subtle pretense on one side, love and affection on the other. She had Suzanne in her power from one point of view, for she could tie up her fortune and have her incarcerated. At the same time, Suzanne suddenly felt that Eugene was impotent to do more than he had. Without his fortune or hers he could not very well take her. Without position, with Angela fighting him as her mother insisted she would, with society arrayed against them—perhaps, perhaps, the subtle thought crept in—perhaps they had been a little hasty. Would it do any real harm to wait awhile? This was a terrific storm. Why not let it subside. They could wait—she could. She was passionate and yearning but not in the vigorous sense that he was. She wanted to give herself to him but one time would not be vastly much more important than another—and then here were Kinroy and Adele and Ninette constantly being held up before her. The more time she had to think, to argue with her mother, to be away from Eugene, the less certain she became that she was not in a way vastly selfish. Her rushing into Eugene's arms seemed wonderfully beautiful but unconsidered—headstrong. Perhaps she had done Angela

an injustice! She remembered her intensely weary white face on that night. How would she feel if she were her? Still it was done now and over, but a year or six months might not make so much difference. It would give them both time to think. It was by this curious process that she had arrived at her decision, or doubt rather, and it was in this doubt that her decision, not very positive, to wait had been made.

Naturally Suzanne was cast down for the time being, for she was capable of suffering just as Eugene was, but having given her word to wait, she decided to stick to that although she had not stuck to her other. She was between nineteen and twenty now; Eugene was nearing forty. The influence of life on each was in inverse proportions. Life could still soothe her in spite of herself. In Eugene's case it could only hurt the more. What was he to do now, how live, was his constant thought. Go into a wee, small apartment in some back street with Angela, where he and she, if he decided to stay with her, could find a pretty outlook for a little money and live? Never! Admit that he lost Suzanne for a year at least, if not permanently, in this sudden, brusque way? Impossible! Go and confess that he had made a mistake, which he still did not feel to be true, or that he was sorry and would like to patch things up as before? Never! He was not sorry. He did not propose to live with Angela in the old way anymore. He was sick of her, or rather of that atmosphere of repression and convention in which he had spent so many years. He was sick of the idea of having a child thrust on him against his will. He would not do it. She had no business to put herself in this position. He would die first. His insurance was paid up to date. He had carried, during the last five years, something over eighteen thousand in her favor, and if he died she would get that. He wished he would. It would be some atonement for the hard knocks which fate had recently given her, but he did not wish to live with her anymore. Never! Never! Child or no child. Go back to the apartment after this night—how could he? If he did, he must pretend that nothing had happened—at least nothing untoward between him and Suzanne. She might come back! Might! Might!! Ah, the mockery of it—to leave him in this way when she really could have come to him, should have—oh, the bitterness of this thrust of fate!

He had now that new pain in his groin which had come to him first when her mother carried her off to Canada a little while ago and he was afraid that he should never see her anymore. It was a real pain—sharp, physical, like a cut with a knife. He wondered how it was that it could be physical and down there. His eyes hurt him and his finger tips. Wasn't that queer, too?

He decided after a time that he would go home, though, and tell Angela just how things stood and what he was going to do. He would not make any pretence about this. She ought to know. He had lost his position; he was

not going to Suzanne soon; he wanted her to leave him or he would leave her. She should go to Wisconsin or Europe or anywhere for the time being and leave him to fight this thing out alone. She needn't have him in her condition. There were nurses she could hire, maternity hospitals where she could stay. He would be willing to pay for that. He would never live with her anymore if he could help it—he did not want to. The sight of her in the face of his longing for Suzanne would be a wretched commentary—a reproach and a sore shame. No, he would leave her and perhaps, possibly, sometime when she obtained more real, fighting courage, Suzanne might come to him. She ought to. Angela might die. Yes, brutal as it may seem, he thought this. She might die and then—and then——. No thought of the child that might possibly live even if she died held him. He could not understand that—could not grasp it as yet. It was a mere abstraction.

There were long arguments over this situation between him and Angela— pleas, tears, a crashing downward of everything which was worthwhile in life to Angela, and then, in spite of her pathetic situation, separation. Because it was October and the landlord hearing of Eugene's financial straits or rather reversal of fortune, it was possible to relinquish the lease which had several years to run, and the apartment was given up. Angela, distraught, scarcely knew which way to turn. It was one of those pitiless, scandalous situations in life which sicken us of humanity. She ran helplessly to Eugene's sister Myrtle, who first tried to conceal the scandal and tragedy from her husband, but afterwards confessed and deliberated as to what should be done. Frank Bangs, who was a practical man, as well as firm believer in Christian Science because of his wife's, to him, miraculous healing from an ovarian tumor several years before, endeavored to apply his understanding of divine science—the omnipresence of good—to this situation.

"There is no use worrying about it, Myrtie," he said to his wife, who, in spite her faith, was temporarily shaken and frightened by the calamities which seemingly had overtaken her brother. "It's another evidence of the workings of mortal mind. It is real enough in its idea of itself, but nothing in God's grace. It will come out all right if we think right. Angela can go to a maternity hospital for the time being or whenever she's ready. We may be able to persuade Eugene to do the right thing."

Angela was persuaded to consult a Christian Science practitioner, and Myrtle went to the woman who had cured her and begged her to use her influence, or rather her knowledge of Science, to effect a rehabilitation for her brother. She was told that this could not be done without his wish but that she would pray for him. If he could be persuaded to come of his own accord, seeking spiritual guidance or divine aid, it would be a different matter. In spite of his errors, and to her they seemed palpable and terrible enough at

present, Myrtle's faith would not allow her to reproach him, and besides, she loved him. He was a strong man, she said, always strange. He and Angela might not have been well mated. But all could be righted in *Science*.

There was a dreary period of packing and storing for Angela, in which she stood about amid the ruins of her previous comfort and distinction and cried over the things that had seemed so lovely to her. Here were all of Eugene's things, his paintings, his canes, his pipes, his clothes. She cried over a handsome silk dressing gown in which he had been wont to lounge about—it smacked so much, curiously, of older and happier days. There were hard, cold, and determined conferences also, in which some of Angela's old fighting, ruling spirit would come back, but not for long. She was beaten now, and she knew it—wrecked. The roll of a cold and threatening sea was in her ears.

"I don't know what to do," she cried one day in his presence, wringing her hands. "I don't know where to go." There was a sob in her voice. "It will be all right for me for the time being in a maternity hospital when the time comes—I hope I die—but what shall I do afterwards if I live? I have no trade or profession."

"Well now, Angela," he insisted, "you're not so bad off. I'm giving you all this furniture. You're welcome to the two lots over in Upper Montclair. They are worth at least eight thousand now. I'll pay you twenty-five dollars a week as long as I can out of what I have. I don't want to be mean about anything. As long as I have anything you can have half but I don't want to live with you, and I won't. I can't. I told you that the first time this thing came up. I haven't changed my mind. If anything, I'm more convinced now than I ever was. We two were not suitably mated to begin with. You aren't suited to me and I'm not suited to you. There's no use crying about it. I'm sorry—I'm as sorry as I can be, but you can live away from me just as well as you can with me. Look at me. Do you think I'm happy? I have a fight to put up. You can study law or trained nursing or domestic science——"

"I hate law," sobbed Angela "and I'm too old to be a trained nurse. They won't take me. I don't want to study domestic science. I wouldn't want to keep house for anyone else."

"I can't help it," he insisted. "I don't want to live with you. I won't."

There were flashes of impotent reproachfulness which showed themselves from time to time, coupled with a morbid fear as to her future and an unconquerable yearning toward her lord and master in spite of his misdeeds. She could get no line on his temperament now. Her thoughts concerning him were chaotic. At one moment there were feelings of intense hate, at another a terrible desire to throw herself at his feet and beg for mercy.

"If you will only live with me," she begged at one time, "I will ask noth-

ing of you. I'll go and come and not be seen. You needn't pay any attention
to me. If you love Suzanne, I can't help it. Only don't cast me off this way.
I don't know where to go. I don't know what to do. I won't know how to
act after the child comes."

"Why not go abroad for awhile, if you don't want to go back home?"
suggested Eugene. He was thinking of the period when the child should
be sufficiently developed to permit this. "We have friends in England and
Italy. Why not visit the Wakemans? They're over in Venice now. We've
been nice enough to them, in all conscience. Why not see the MacLen-
nans? They're in London. They've been asking you to come over there.
There's the Tenmans in Paris. What's the matter with them? You needn't
say anything about our separation right away. Give yourself time to think.
I wish you'd go over to New Jersey, though, before you go, and establish a
legal residence there so you can sue me for a divorce. You can get one over
there in six months on the grounds of desertion."

"I'll not do it," declared Angela savagely, but later she half agreed that
she would if he would live with her a few years longer.

It may seem unreal to some that such conversation could go amid the
crash of falling fortunes and the desperate ache of tangled affections, but life
works precisely in this dreary, commonplace way. On the eve of a great battle
the commanding general undresses and goes to bed. Though our hearts be
breaking and our fortunes dissolving, life itself disappearing piecemeal, we
wash our faces and comb our hair and straighten the furniture about and say
little, cheap, commonplace things. Life is not dramatic in essential working
details. It is commonplace. Only the angle, the glimpse, the moment gives
the great effect. There were great moments here. Any of these, at any time,
while they were talking so, were peculiar, striking, strange, if you could have
known all. They were like ghosts wandering about among the realities of a
world from which they had departed. All the material details were still here
in this apartment at the time these conversations were going on, but the
spirit had departed. There was no hope in words. It had to break up and be
dissolved into its native nothingness—the thing from which it had been
called by the idea or spirit which originally animated them. Alas, alas, for
the phantasies of mortal mind which have their root in nothing and return
from whence they came.

There was a day when the furniture was sent away and Angela went to
live with Myrtle for the time being. There was another tearful hour when she
left New York to visit her sister Marietta at Racine, where they now were,
intending to tell her, before she came away, as a profound secret the terrible
tragedy which had overtaken her. Eugene went to the train with her but
with no desire to be there. Angela's one thought in all this was that some-

how time would affect a reconciliation. If she could just wait long enough; if she could keep her peace and live and not die and not give him a divorce he might eventually recover his sanity and come to think of her as at least worth living with. The child might do it. Its coming would be something that would affect him, surely. He was bound to see her through it. She told herself that she was willing and delighted to go through this ordeal if only it brought him back to her. This child—what a reception it was to receive. Unwanted, dishonored before its arrival, ignored—if by any chance she should die, what would he do about it? Surely he would not desert it. Already in her nervous, melancholy way she was yearning toward it.

"Tell me," she said to Eugene one day when they were alternately quarreling and planning. "If the baby comes and I—and I—die, you won't absolutely desert it. You'll take it, won't you?"

"I'll take it," he replied. "Don't worry. I'm not an absolute dog. I didn't want it. It's a trick on your part, but I'll take it. I don't want you to die. You know that."

Angela thought if she lived that she would be willing to go through a period of poverty and depression with him again if only she could live to see him sane and moral and semi-successful. The baby might do it. He had never had a child. As much as he disliked the idea now, still, when it was here, he might change his mind. If only she could get through that ordeal. She was so old, her muscles so set. Meanwhile she consulted a lawyer, a doctor, a fortune teller, an astrologer, and the Christian Science practitioner to whom Myrtle had recommended her. It was an aimless, ridiculous combination, but she was badly torn up and any port seemed worthwhile in this storm.

The doctor told her that her muscles were rather set but with the regimen he prescribed he was satisfied she would be all right. The astrologer told her that she and Eugene were fated for this storm by the stars, Eugene particularly, and that he might recover, in which case he would be successful again in a measure. As for herself, he shook his head. Yes, she would be all right. He was lying. The fortune teller laid the cards to see if Eugene would ever marry Suzanne, and Angela was momentarily gratified to learn that she would never enter his life—this from a semi-cadaverous but richly dressed and bejeweled lady whose ante-room was filled with women whose troubles were of the heart or the loss of money or the enmity of rivals or the dangers of childbirth. The Christian Science practitioner declared all to be divine mind—omnipotent, omnipresent, omniscient good, and that evil could not exist in it—only the illusion of it. "It is real enough to those who give it their faith and believe," said her counsellor, "but without substance or meaning to those who know themselves to be a perfect indestruc-

tible reflection of an idea in God. God is a principle. When the nature of that principle is realized and yourself as a part of it, evil falls away as the troublesome dream that it is. It has no reality." She assured Angela that no evil could befall her in the true understanding of Science. God is Love.

The lawyer told her, after listening to a heated story of Eugene's misconduct, that under the laws of the state of New York in which these misdeeds were committed, she was not entitled to anything more than a very small fraction of her husband's estate, if he had any. Two years was the shortest time in which a divorce could be secured. He would advise her to sue if she could establish a suitable condition of affluence on Eugene's part, not otherwise. Then he charged her twenty-five dollars for this advice.

CHAPTER XCIX

It seems pitiful to have to follow so dreary a progress as now succeeded but so it must be. During the two weeks which followed Colfax's talk with him and Suzanne's decision, which amounted practically to a dismissal, Eugene tried to wind up his affairs at the United Magazines Corporation as well as straighten out his relationship to Angela. It was no easy task. Colfax helped him considerably by suggesting that he say he was going abroad for the company, for the time being, and make it appear imperative that he go at once. Eugene called in his department heads and told them as Colfax suggested, but added that his own interests elsewhere, of which they knew or suspected, were now so involved that he might possibly not return or only for a little while at best. He put forward an air of great sufficiency and self-satisfaction, considering the difficulties he was encountering, and the thing passed off as a great wonder but with no suspicion of any immediate misfortune attaching to him. As a matter of fact it was assumed that he was going to a much higher estate—the control of his private interests.

It was only some two months later, when the truth began to leak out via White, and after him, others, that the significance and reason for his sudden departure began to appear. It was a greater wonder then than ever, for in spite of the precautions taken by Mrs. Dale to shield her daughter, it could not be wholly done. Suzanne's name was coupled with that of Eugene's to the extent that he was involved in a love affair with her and that—taken in connection with his sudden departure from the United Magazines Corporation, his giving up of the apartment in Riverside Drive, Angela's temporary departure for the West, and his disappearance from his old time social haunts, clubs, and commercial and financial connections—all served to

lend zest to the fact that a great romance had been enacted in connection with a very significant personage and that there had been a tragic conclusion to it. Eugene retired completely from the public eye. Mrs. Dale went abroad with Suzanne and the other children, hobnobbing with people who could not possibly have heard or ever would, except in a vague, uncertain way. If it became evident, she thought, that there was to be a scandal, Mrs. Dale proposed to say that Eugene had attempted an affectional relationship without sense or honor and that she had promptly broken it up, shielding Suzanne almost without the latter's knowledge. It was plausible enough.

Eugene took a room in an apartment house in Kingsbridge, where he was not known for the time being, and where he was not apt to be seen. Then there was witnessed that dreary spectacle of a man whose life has apparently come down in a heap: whose notions, emotions, tendencies and feelings are confused and disappointed by some untoward result. If Eugene had been ten or fifteen years older the result might have been suicide. A shade of difference in temperament might have resulted in death, murder, anything! As it was, he sat blankly at times, among the ruins of his dreams, speculating on what Suzanne was doing; on what Angela was doing; on what people were saying and thinking; on how he could gather up the broken pieces of his life and make anything out of them at all.

The one saving element in it all was his natural desire to work, which, although it did not manifest itself at first, by degrees later on began to come back. He must do something, if it was not anything more than to try to paint again. He could not be running around looking for a position. There was nothing for him in connection with Blue Sea. He had to work to support Angela, of whom he was now free, if he did not want to be mean—and as he viewed it all in the light of what had happened, he realized that he had been bad enough. She had not been temperamentally suited to him, but she had tried to be. Basically it was not her fault. How was he to work and live and be anything at all from now on?

To those who have followed a routine or system of living in this world— who have, by slow degrees and persistent effort, built up a series of habits, tastes, refinements, emotions, and methods of conduct, and have, in addition, achieved a certain distinction and position, so that they have said to one, "Go," and he goes; and to another, "Come," and he comes; who have enjoyed without stint or reserve, let or hindrance, those joys of perfect freedom of action, and that ease and deliberation which comes with the presence of comparative wealth and social position and comforts—the narrowing that comes with the lack of means, the fear of public opinion, or the shame of public disclosure, is one of the most pathetic, discouraging, and terrifying things that can be imagined. These are the times that

try men's souls. The man who sits in a seat of the mighty and observes a world that is ruled by a superior power, a superior force, of which he by some miraculous generosity of fate has been chosen, apparently, a glittering instrument, has no conception of the feelings of the man who, cast out of his dignities and emoluments, sits in the dark places of the earth among the ashes of his splendor and meditates upon the glory of his bygone days. There is a pathos here which passes the conception of the average man. The prophets of the Old Testament discerned it clearly enough, for they were forever pronouncing the fate of those whose follies were in opposition to the course of righteousness and who were made examples of by a beneficent and yet awful power. "Thus saith the Lord: Because thou hast lifted thyself up against the Lord of Heaven; and they have brought the vessels of his house before thee; and thou and thy lords, thy wives and thy concubines, have drunk wine in them; and thou hast praised the gods of silver and gold, of brass, iron, wood and stone. . . . God hath numbered thy kingdom and finished it; thou art weighed in the balance and found wanting; thy kingdom is divided and given to the Medes and the Persians."

Eugene was in a minor way an exemplification of this course of righteousness. His kingdom, small as it was, was truly at an end. Our social life is so organized, so closely knit upon a warp of instinct, that we instinctively flee that which does not accord with custom, usage, preconceived notions and tendencies. Who does not run from the man who may, because of his deeds, be condemned by the public? Walk he ever so proudly; carry himself with what circumspectness he may; at the first breath of suspicion all are off—friends, relatives, business acquaintances, the whole social fabric in toto. Unclean, is the cry. Unclean! Unclean! And it does not matter how inwardly shabby we may be—what whited sepulchres shining to the sun—we run quickly. It is our tribute to that providence which shapes our ends—which runs perfect in tendency, however vilely we may overlay its brightness with the rust of our mortal corruption.

A few letters which were written at this time will illuminate this period.

"Oct. 6th 19—

"Hiram Colfax, Esq.
The United Magazines Corporation,
Union Square, New York

"Dear Mr. Colfax:
"After our talk of the 27th I do not think it is really necessary for me to see you again but I feel that I must write and thank you for the many courtesies you have extended to me. I have spent now somewhat

more than three years in your company and during that time I must say I experienced the utmost liberty of thought and action. You have been in your way a kindly employer and a good leader. You sought a man who could act intelligently for himself and then you left him to his own devices. It has been a great experience.

"I am sorry—how much I cannot say—that anything should have come up which should have so radically altered our relations, but let that stand. The thing that I want to say is that I bear you no ill will. The result as it now stands is inevitable. I may not see you again but I hope you will remember me kindly, as I surely will you.

"Sincerely,

"Eugene Witla"

"The United Magazines Corporation
Union Square, New York
Office of the President

"Oct. 7th 19—

"My Dear Witla:
"I have your note and thank you for it. You are an able man. This is one of these things which come about through peculiarity of temperament over which, sometimes, I think we have no control. If you will take my advice and can arrange it, you will go abroad for a season. Your career is not closed, certainly not if you will give this thing time to blow over. You can still make a success as an artist, I am sure, in which, if you will trust the opinion of a layman, your greatest capability lies. However, do not accept my judgement as impertinent. I do not mean it that way. There are many who will welcome you later in the publishing field, I am sure.

"Hiram Colfax"

"To Suzanne Dale,
Dalewood,
New York.
New York, Oct. 26th

"Flower Face:
"I have risen in the night to write you this because I cannot sleep. Oh, Flower Face, what a peculiar state am I in when I have nothing to do all day but sit and think of you. I cannot collect my thoughts for any other purpose: I can not pull my energies together for any other effort. I had thought, since it was all over between us—I cannot but feel that a year will change your mood—that I could paint, or work at something, but I have no heart. I cannot paint. Life has lost all its glamour

for me. I have an actual, physical pain all the while. You have heard of the Greek boy and the fox. Love of you is gnawing at my vitals. I have walked the streets night and day. I have thought of you hour after hour. I can think of nothing else. Morning and evening, noon and night, it is the same. Do you remember the song, 'Obstination'? It was sung to us together on that wonderful night in Riverside Drive—'For her face is ever before me and her smile.'

"Oh, Flower Face, I cannot understand this thing that has come over me. It may be a dream, an illusion, but it is so deep, so deep. I turn and toss in my sleep of love so restlessly: and there are so many visions. Do you recall the day at Huguenot—the little balconies open to the sky? The sea, the sunshine, the distant sails. You cannot see what I saw, for I saw you. You were more than the ship and the bright waters and the perfect beauty of the day. You were the spirit of that beauty, without which it was nothing. And then there was the night at Dalewood—the late hour when you came out to me after the dance at Fort Wadsworth. Shall I ever forget it? Oh, how sweet you were—how sweet! And the night when you told me you loved me. Those hours! Those hours!

"Honey pot! Your mother has won. After Huguenot and Tenafly and Ridgewood and St. Jacques, she has actually won. You are gone. I may never see you again. I may never mail this letter. But the ache! The ache! Will it never end? Sometimes I can see your face as in a vision— as it was that night in the moonlight at While-a-Way. It is like a lily in the dark to me; it is like a white rose that I can see dimly. Honey pot! Divine Fire! After all our protestations, how could you? How could you struggle so hard and yield so easily? You are gone. It is all over. I will never see you any more. Dear God, I can't stand this! I can't! I can't!

"But, honeypot, of what avail is this? I write but it will do nothing. The things of which you are a part are gone—my social connections, my position, my income. I do not care, but you are gone with them. It is perhaps as well. Let all the glories subside at once. I shall have to fight this through somehow but it will change my life. From now on all things will be different. I, who have caused love, have been bitten by it. I know its sting. Let that misery cease forever for me. I shall not love or be loved. I do not want to be. Let me be still and at peace, for God's sake.

"But in the end of all this, sweet, let me pay you this tribute. You came into my life when it seemed that love was over for me. I had expected no more either of freedom or joy in beauty. Then you came. For a few short weeks, months, my soul expanded into some realm which was not of this earth. It was compounded of sunlight and moon-light, of dew and flowers and odours and tones. I saw—I saw as in a vision—beauty etherealized. The gates of heaven opened. There appeared before my enraptured eyes the spirit of perfection. Sweet, you

may not understand. Let it go without understanding. You are the love-
liest thing that ever came into my life.

"What more can I say? What more? Nothing. If you see me again I
will be different. This is burning something away. Good-bye, Flower
Face. Good-bye. Oh, how that hurts!

<div align="right">"Eugene."</div>

"Mrs. Eugene Witla:

c/o Mrs.——
Racine, Wisconsin.
Nov. 1, 19—

"Dear Angela:
"I am enclosing a check for $200. There is nothing to say. As long
as I have any means I will do my best to provide for you. Beyond that
there is nothing.

<div align="right">"Eugene."</div>

"Mr. Eugene Witla,

Kingsbridge, N.Y.
Nov. 3rd 19—

"Dear Eugene:
"I have your November 1 letter, and also your check, which is also
all right, though you needn't send me so much if you need it yourself.
I wish you would be careful of what you have so that it may carry you
over what may be a difficult period for awhile. I know things must look
bad to you now but they will get better later because you are too tal-
ented not to do something worthwhile. It is I who am out of my ele-
ment, wandering around, for as I told you I have really nothing to do
and nowhere to go. It does not interest me to come out here to Mari-
etta's for, although she is very thoughtful and considerate and speaks
so very delightfully of you (I have told her nothing as yet and don't
intend to if I can help it), she has her own interest now—her two chil-
dren and husband.

"Eugene, when I look at this home here and see how things are, and
what binding influences children are, I'm sorry that we never had any
though I am sorry now that at this period I should have tried to intro-
duce one. You might not have cared so much years ago, for you have
seemed to like children at times, but I was always afraid you wouldn't.
I always fancied that I did not want any, that I could not have any, but
when I see how much entertainment and what a keen interest they
provide I feel that it might have been better this way. I blame myself
and fate for many things and I see to a certain extent how if I had been
different, you might have been. I have been trying so hard of late to

get Christian Science. Your sister Myrtle was so anxious that I should, and I have always thought that had I clung closer to my religious beliefs and given less thought to the worldly things that have held me, I would not now be forsaken. I dimly understand the theory of Christian Science now—that there is no evil, only good, and that what we call evil and suffering is something which we can forsake by not believing it, or rather realizing our unity with God—good—but I have for so long had this sense of materiality, as they call it, that I can scarcely realize the other. This sounds sermony, doesn't it? Well I don't mean it to be, but I want you to realize that I am trying to make an effort to meet the most terrible thing that has happened to me in a philosophic or religious way. I am trying to save my reason, to do something for our child. I am so nervous at times, so fearful; I go to a practitioner almost every day now. I have the thought that if I can only live long enough—if I can endure this—that sometime you may take me back. I know that this seems impossible to you now. I marvel that, after all that has happened, I can ask. I have no pride apparently, no shame, but somehow now that it is all over and everything has gone, the rage that I felt has died out and I see that there was something else that I have craved, beside the show of love that I thought I wanted and your success, and that is your presence. It is for the baby's sake, too, as much as mine. I know you think I pretended a good deal to something I did not feel. You have accused me of acting and perhaps I did, but I am not acting now. I am lonely and heartsick and my life is worth nothing. If it weren't for this coming life I do not know what I would do. I do not want to do anything desperate. Honestly, Eugene, I want to die, and I think maybe God will grant me that yet so that you will be free. I do not begrudge you years of happiness. I will not. The child might not interfere with you so much if it lives. If I die no curse will follow me, and I don't want you to think that I want one to. You will not have me with you so long even if I get through with this, which I doubt if I can, judging by the feelings that haunt me. I have been told by a fortune teller that I am going to die in three years anyhow.

"What more is there to say, Eugene? I might write of the little things that occur here but they do not interest me and I know that they would bore you. I don't know how long I can reasonably stay here and not tell. My condition will begin to show pretty soon. They want you to come on for a visit. I don't suppose you would consider that, would you? If you won't, I must leave by December first, and I think if you will not take me back that I will go into the hospital. It will be time. I cannot come back to New York without explaining to so many and I don't want to yet. I can't, but there are good institutions in Chicago and I can stay there. I keep hoping against hope that your attitude will change toward me. Let me hear from you if you will, from time to time.

It can't make any difference in your course. A word won't hurt. And I am so lonely. Oh, Eugene, if I could only die—if I *only could.*

<div align="right">"Angela"</div>

CHAPTER C

L etters like this were common in various directions. Angela wrote Myrtle how bad she was feeling. She went home to see her father who was now quite old and feeble, and down to Alexandria to see Eugene's mother, who was also badly deteriorated in health. No word as to the true state of things was given to either side. Angela pretended that Eugene had long been sick of his commercial career and was, owing to untoward conditions in the Colfax company, glad to return to his art for a period. He might come home but he was very busy. So she lied.

There were a number of conferences between Eugene and Myrtle, for the latter, because of their early companionship, was very fond of him. His traits, the innocent ones, were as sweet to her as when they were boy and girl together. She sought him at Kingsbridge and begged him to come and see her.

"Why don't you come and stay with us, Eugene?" she pleaded. "We have a comfortable apartment. You can have that big room next to ours. It has a nice view. Frank likes you. We have listened to Angela and I think you are wrong, but you are my brother and I want you to come. Everything is coming out right. God will straighten it out. Frank and I are praying for you. There is no evil, you know, according to the way we think now," and she smiled her old time girlish smile. "Don't stay up here alone. Wouldn't you rather be with me?"

"Oh, I'd like to be there well enough, Myrtie, but I can't do it now. I don't want to. I have to think. I want to be alone. I haven't settled what I want to do. I think I will try my hand at some pictures. I have a little money, and all the time I want now. I see where there are some nice houses over there on the hill that might have a room with a north window that would serve as a studio. I want to think this thing out first. I don't know what I'll do."

"Why don't you go and see a Christian Science practitioner?" asked Myrtle. "It won't do you any harm. You don't need to believe. Let me get you the book and you read it. See if you don't think there is something in it. There you go smiling sarcastically, but Eugene, I can't tell what it hasn't done for us. It's done everything—that's just all. I'm a different person from what I was five years ago, and so is Frank. You know how sick I was?"

"Yes, I know."

"Why don't you go and see Mrs. Johns? You needn't tell her anything unless you want to. She has performed some perfectly wonderful cures."

"What can Mrs. Johns do for me?" asked Eugene bitterly, his lips set in an ironic mould. "Cure me of gloom? Make my heart quit aching? What's the use of talking? I ought to chuck the whole thing." He stared at the floor.

"She can't, but God can. Oh, Eugene I know how you feel. Please go. It can't do you any harm. I'll bring you the book tomorrow. Will you read it if I bring it to you?"

"No."

"Oh, Eugene, please do for my sake."

"What good will it do? I don't believe in it. I can't. I'm too intelligent to take any stock in that rot."

"Eugene, how you talk. You'll change your mind sometime. I know how you think. But read it anyhow. Will you please? Promise me you will. I shouldn't ask. It isn't the way. But I want you to look into it. Go and see Mrs. Johns."

Eugene refused. Of asinine things this seemed the silliest. Christian Science! Christian rot! He knew what to do. His conscience was dictating that he give up Suzanne and return to Angela in her hour of need, to his coming child, for the time being anyhow, but this awful lure of beauty, of personality, of love—how it tugged at his soul. Oh, those days with Suzanne in the pretty watering and dining places about New York: those hours of bliss when she looked so beautiful. How could he get over that? How give up the memory? She was so sweet! Her beauty so rare! Every thought of her hurt. It hurt so badly that most of the time he dared not think—must perforce walk or work or stir restlessly about, agonized for fear he should think too much. Oh, life! Oh, hell!

The injection of Christian Science into this proposition at this time was due, of course, to the belief in and enthusiasm for this religious idea on the part of Myrtle and her husband. As at Lourdes and St. Anne de Beaupré and other miracle-working centres where hope and desire and religious enthusiasm for the efficacious intervention of a superior and nonmalicious force intervenes, there had occurred in her case an actual cure from a very difficult and complicated physical condition. She had been suffering from an ovarian tumor, nervous insomnia, indigestion, constipation and a host of allied ills which had apparently refused to yield to ordinary medical treatment. She was in a very bad way mentally and physically at the time the Christian Science textbook, *Science and Health with Key to the Scriptures* by Mrs. Eddy, was put into her hands. While attempting to read it in a hopeless, helpless spirit, she was instantly cured—that is, the idea that she was

well took possession of her, and not so very long after she really was so. She threw all her medicines, of which there was quite a store, into the garbage pail, eschewed doctors, began to read the Christian Science literature and attend the Christian Science church nearest her apartment, and was soon involved in all its subtleties and metaphysical interpretation of mortal life. Into this faith her husband, who loved her very much, had followed her, for what was good enough for her and would cure her was good enough for him. He soon seized on its spiritual significance with great vigor and became, if anything, a better exponent and interpreter of its significant thought than was she herself.

Those who know anything of Christian Science know that its main tenet is that God is a principle, not a personality understandable or conceivable from the mortal or sensory side of life (which latter is an illusion), and that man (spiritually speaking) is His image and likeness. Man is not God or any part of Him. He is an idea in God and, as such, as perfect and indestructible and as undisturbedly harmonious as an idea in God or principle must be. To those not metaphysically inclined this is usually dark and without significance, but to those spiritually or metaphysically minded it comes as a great light. Matter becomes a built-up set or combination of illusions which may have evolved or not, as one chooses, but which unquestionably have been built up from nothing or an invisible, intangible idea, and have no significance beyond the faith or credence which those who are basically spiritual give them. Deny them—know them to be what they are—and they are gone.

To Eugene, who at this time was in a great state of mental doldrums—blue, dispirited, disheartened, inclined to see only evil and destructive forces—this might well come with peculiar significance if it came at all. He was one of those men who from their birth are metaphysically inclined. All his life he had been speculating on the subtleties of this mortal existence, reading Spencer, Kant, Spinoza at odd moments, and particularly such men as Darwin, Huxley, Tyndall, Lord Avebury, Alfred Russel Wallace, and latterly Sir Oliver Lodge and Sir William Crookes, trying to find out by the inductive, naturalistic method just what life was. He had secured inklings at times, he thought, by reading such things as Emerson's "Over-Soul," Carl Snyder's *World Machine*, Johnston's translation of the *Bhagavad Gita, The Meditations of Marcus Aurelius*, and Plato and Socrates. God was a spirit, he thought, as Christ had said to the woman at the well in Samaria, but whether this spirit concerned itself with mortal affairs where was so much suffering and contention was another matter. Personally he had never believed so—or been at all sure. He had always been moved by the Sermon on the Mount, the beauty of Christ's attitude toward the trouble

of the world, the wonder of the faith of the old prophets in insisting that God is God, that there are no other gods before Him, and that He would repay iniquity with his disfavor. Whether He did or not was an open question with Eugene. This question of sin had always puzzled him—original sin. Were these laws which antedated human experience, which were in God—The Word—before it was made flesh? If so, what were these laws? Did they concern matrimony—some spiritual union which was older than life itself? Did they concern stealing? What was stealing outside of life? Where was it before man began? Or did it only begin with man? Ridiculous! It must relate to something in chemistry and physics which had worked out in life. A sociologist, a great professor in one of the colleges, had once told him that he did not believe in success or failure, sin, or a sense of self righteousness except as they were related to built-up instincts in the race—instincts related solely to the self preservation and the evolution of the race. Beyond that was nothing. Spiritual morality? Bah! He knew nothing about it.

Such rank agnosticism could not but have had its weight with Eugene. He was a doubter ever. All life, as said before, went to pieces under his scalpel and he could not put it together again logically once he had it cut up. People talked about the sanctity of marriage. But heavens, marriage was an evolution; he knew that. Someone had written a two volume treatise on it—*The History of Human Marriage* or something like that—and in it animals were shown to have mated only for so long as it took to rear the young—to get them to the place where they could take care of themselves. And wasn't this really what was at the basis of modern marriage? He had read in this history, if he recalled aright, that the only reason marriage had come to be looked upon as sacred and "for life" was the length of time it took to rear the human young. It took so long that the parents were old, safely so, before the children were launched into the world! Then why separate?

But was it the duty of everyone to raise children? Ah, there had been the trouble. He had been bothered by that. The home centred around that. Children! Race reproduction! Pulling this wagon of evolution! Was every man who did not inevitably damned? Was the race spirit against him? Look at the men and women who didn't—who couldn't! Thousands and thousands. And those who did always thought those who didn't were wrong. The whole American spirit he had always felt to be intensely set in this direction—the idea of having children and rearing them, a conservative, workaday spirit. Look at his father. And yet other men were so shrewd that they preyed on this spirit, moving factories to where this race spirit was the most active so that they could hire the children cheaply. And nothing happened to them. Or did something happen?

However, Myrtle continued to plead with him to look into this new

interpretation of the scriptures, claiming that it was true, that it would bring him into an understanding of spirit which would drive away all these mortal ills, that it was above all mortal conception—spiritual over all—and so he thought about that. She told him that if it was right that he should cease to live with Angela, it would come to pass, and that if it was not, it would not; but anyhow and in any event in this truth there would be peace and happiness to him. He should do what was right ("Seek ye first the Kingdom of God") and then all these things would be added unto him.

It seemed terribly silly at first to Eugene to be listening at all to any such talk, but later it was not so much so. There were long arguments and appeals, breakfast and midweek or Sunday dinners at Myrtle's apartment, arguments with Bangs and Myrtle concerning every phase of the Science proposition, some visits to the Wednesday experience and testimony meetings of their church, at which Eugene heard statements concerning marvellous cures which he could scarcely believe, and so on. So long as these testimonies confined themselves to complaints which might be due to nervous imagination, he was satisfied that their cures were possible, due to religious enthusiasm which dispelled their belief in something which they did not have; but when they said they were cured of cancer, consumption, locomotor-ataxia, goitres, shortened limbs, hernia—he did not wish to say they were liars, they seemed too sincere to do that, but he fancied they were simply mistaken. How could they, or this belief, or whatever it was, cure cancer? Good Lord! He went on disbelieving in this way and refusing also to read the book until one Wednesday evening when he happened to be at the Fourth Church of Christ Scientist in New York, and a man stood up beside him in his own pew and said:

"I wish to testify to the love and mercy of God in my case, for I was hopelessly afflicted not so very long ago and one of the vilest men I think it is possible to be. I was raised in a family where the Bible was read night and morning—my father was a hidebound Presbyterian—and I was so sickened by the manner in which it was forced down my throat, and the inconsistencies which I thought I saw existing between Christian principle and practice, even in my own home, that I said to myself I would conform as long as I was in my father's house and eating his bread, but when I got out I would do as I pleased. I was in my father's house after that a number of years, until I was seventeen, and then I went to a large city, Cincinnati. But the moment I was away and free I threw aside all my so-called religious training and set out to do what I thought was the most pleasant and gratifying thing for me to do. I wanted to drink, and I did—though I was really never a successful drinker." (Eugene smiled.) "I wanted to gamble and I did but I was never a very clever gambler. Still I did gamble some. My great weak-

ness was women, and here I hope none will be offended—I know they will not be, for there may be others who need my testimony badly—I pursued women as I would any other lure. They were really all that I desired—their bodies. My lust was terrible. It was such a dominant thought with me that I could not look at any good-looking woman except, as the Bible says, to lust after her. I was vile. I became diseased. I was carried into the First Church of Christ Scientist in Chicago, after I had spent all of my money and five years of my time on physicians and specialists, suffering from locomotor ataxia, dropsy, and kidney trouble. I had previously been healed of some other things by ordinary medicine.

"If there is anyone within the sound of my voice who is afflicted as I was, I want him to listen to me. So far as the affairs of this world were concerned I was practically dead. I think now that my so-called mind was diseased. It could scarcely think, even then, of anything that was not low and mean, but fear and suffering were driving me. This was a last straw.

"I want to say to you tonight that I am a well man—not well physically only but well mentally, and what is better yet, in so far as I can see the truth, spiritually. I was healed after six months' treatment by a Christian Science practitioner in Chicago, who took my case on my appealing to her, and I stand before you absolutely sound and whole. God is good. The lust that haunted me as a fire is gone. The weakness or belief that kept me prone on my back and made my body so soft and watery that the impression of any chair I lay or sat in was left upon my body has been completely overcome. I know now that the God of my ignorance and misunderstanding—a distant, intangible, unrealizable indifferent personage—is not 'he who doeth his will in the army of the heavens,' who is omnipotent, omniscient, omnipresent, supreme. My God is here and now. He is a spirit, a principle, an ever present help in trouble. He is the only Life. If there is anywhere such a one as I, he can be healed. He does not need to seek further than the biblical word which says to us, 'He that believeth in me shall never die.' I never understood that. My God was some far off, distant personage, seated on a cloud perhaps, or a throne. I understand Him now as a principle, present—a rule of conduct, infinite wisdom, infinite mercy, of which all that is, is an image, a shadow, an idea. He is here and silent is His tread, not perceptible to the senses but to be discerned spiritually. He will heal. There is no sickness and no evil in Him. 'He is of eyes too pure to behold evil.' If mere thanks to God and Mrs. Eddy would express what I mean when I say that I am grateful, I would say it over and over. But they cannot. I can only live my gratitude and I give my testimony now in that spirit."

He sat down.

While he had been talking, Eugene had been studying him closely,

observing every line of his features. He was tall, lean, sandy haired and sandy bearded. He was not bad looking, with long straight nose, clear blue eyes, a light pinkish color to his complexion, and a sense of vigor and health about him. The thing that Eugene noted most was that he was calm, cool, serene, vital. He said exactly what he wanted to say and he said it vigorously. His voice was clear and with good carrying power. His clothes were shapely, new, well made. He was no beggar or tramp but a man of some profession—an engineer, very likely. Eugene wished that he might talk to him and yet he felt ashamed. Somehow this man's cases paralleled his own, not exactly but closely. He personally was never diseased, but how often had he looked after a perfectly charming woman to lust after her? Was the thing this man was saying really true? Could he be lying? How ridiculous! Could he be mistaken? *This man!* Impossible. He was too strong, too keen, too sincere, too earnest, to be any of these things. Still——. But this testimony might had been given for his benefit. Some strange, helpful power, that kindly fate that had always pursued him, might be trying to reach him here. Could it be? He felt a little strange about it, as he had when he saw the black-bearded man entering the train that took him to Three Rivers—the time he went at the call of Suzanne—as he did when horseshoes were laid before him by supernatural forces to warn him of coming prosperity. He went home thinking. And that night he seriously tried to read *Science and Health* for the first time.

CHAPTER CI

Those who have ever tried to read that very peculiar and, to many, very significant document know what an apparent jumble of contradictions and metaphysical balderdash it appears to be. The statement concerning the rapid multiplication and increased violence of diseases since the flood which appears in the introduction is enough to shock any believer in definite, material, established natural science; and when Eugene came upon this in the outset it irritated him, of course, greatly. Why would anybody make such a silly statement as this? Everybody knew that there had never been a flood. Why quote a myth as a fact? It irritated and, from a critical point of view, amused him. Then he came upon what he deemed to be a jumble of confusion in regard to matter and spirit. The author talked of the evidences of the five physical senses as being worthless and yet was constantly referring to and using similes based upon those evidences to illustrate her spiritual meanings. He threw the book down a number of times, for the biblical

references irritated him. He did not believe in the Bible. The very word "Christianity" was a sickening jest, as sickening as it had been to the man in the church. To say that the miracle of Christ could be repeated today—could that be so? Still, the man had testified. Was not that so? A certain vein of sincerity running through it all—that profound evidence of faith and sympathy which are the characteristics of all great reformers—appealed to him. Some little thoughts here and there—a profound acceptance of the spiritual understanding of Jesus, which he himself accepted, stayed with him. He recalled one sentence or paragraph which somehow stuck in his mind because he himself was of a metaphysical turn:

"Become conscious for a single moment that Life and intelligence are purely spiritual—neither in nor of matter—and the body will then utter no complaints. If suffering from a belief in sickness, you will find yourself suddenly well. Sorrow is turned into joy when the body is controlled by spiritual Life, Truth, and Love."

"God is a spirit," he recalled Jesus as saying. "They that worship him must worship in spirit and in truth."

"You will find yourself suddenly well," thought Eugene. "Sorrow is turned into joy."

"Sorrow? What kind of sorrow? Love, sorrow? This probably meant the end of earthly love, for that was mortal."

He read on, discovering that Scientists believed in the immaculate conception of the Virgin Mary, which struck him as silly; also that they believed in the ultimate abolition of marriage as representing a mortal illusion of self-creation and perpetuation and of course the having of children via the agency of the sexes; also in the dematerialization of the body—its chemicalization into its native spirituality, wherein there can be neither sin, sickness, disease, decay or death, were a part of their belief or understanding. It seemed to him to be a wild advance and yet at the time, because of his natural metaphysical turn, it accorded with his sense of the mystery of life.

It should be remembered as a factor in this reading that Eugene was particularly fitted by temperament—introspective, imaginative, psychical—and by a momentarily despairing attitude in which any straw was worth grasping at which promised relief from sorrow, despair, defeat, to make a study of this apparently radical theory of human existence. He had heard a great deal of Science, seeing recently its churches built, its adherents multiplying (particularly in New York) and enthusiastically claiming freedom from every human ill. The newspapers were wildly asseverating that the Christian Scientists believed or rather suspected that Mrs. Eddy, their leader and its founder, would never die. There was a great hubbub in New York at the time over the thought that all Christian Scientists were uniformly success-

ful—that somehow the mere clinging to it produced not only mental peace but material success. These highly material notions, characteristic of the selfish tendencies which pervade mortal thought generally and having no basis in the thought of the founder perhaps, were nevertheless uppermost in current thought and might be said to have constituted one of the main items in the news interest of the day. It could not influence Eugene in this grossly practical way, for he was naturally of an idealistic turn, but it had long since sufficed to arrest his attention. Now that he was lonely, idle, without entertainment or diversion, and intensely introspective, it was natural that these curious statements should hold him.

He was not unaware also from past reading and scientific speculating that Carlyle had once said that "matter itself—the outer world of mat-ter—was either nothing or else a product due to man's mind" (Carlyle's journal; from Froude's *Life of Carlyle*); and that Kant had held the whole universe to be something in the eye or mind—neither more nor less than a thought. Marcus Aurelius, he recalled, had said somewhere in his *Meditations* that the Soul of the universe was kind and merciful; that it had no evil in it and was not harmed by evil. This latter thought stuck in Eugene's mind as peculiar because it was so diametrically opposed to his own feelings that the universe (the spirit of it) was subtle, cruel, crafty and malicious. He wondered how a man who could come to be emperor of Rome could have thought otherwise. Christ's Sermon on the Mount had always appealed to him as the lovely speculations of an idealist who had no real knowledge of life. Yet he had always wondered why "Lay not up for yourselves treasures upon earth, where moth and rust doth corrupt, and where thieves break through and steal" had thrilled him as something so beautiful that it must be true. "For where your treasure is there will your heart be also."

Keats had said "beauty is truth—truth beauty," and yet another, "truth is what is."

"And what is?" he had asked himself in answer to that.

"Beauty," was his reply to himself, for life at bottom, in spite of all its teeming terrors, was beautiful.

Only those of a meta-physical or naturally religious turn of mind would care to follow the slow process of alteration or rather attempted alteration which took place during the series of months which followed Angela's departure from Racine, her return to New York at Myrtle's solicitation, the time she spent in the maternity hospital, whither she was escorted on her arrival by Eugene, and after. These are the deeps of being which only the more able intellectually essay, but Eugene wandered in them far and wide. There were long talks with Myrtle and Bangs—arguments upon all phases of mortal thought, real and unreal, with which Angela's situation

had nothing to do. Eugene frankly confessed that he did not love her, that he did not want to live with her. He insisted that he could scarcely live without Suzanne. There was the taking up and reading or re-reading of odd philosophic and religious volumes, for he had nothing else to do. He did not care at first to go and sit with Angela, as sorry as he was for her. He read or re-read Kent's *History of the Hebrews;* Weininger's *Sex and Character,* Carl Snyder's *The World Machine;* Muzzey's *Spiritual Heroes;* Johnston's translation of the *Bhaghavad Ghita,* Emerson's essay on the Over-Soul and Huxley's *Science and Hebrew Tradition* and *Science and Christian Tradition.* He learned from these things some curious facts which relate to religion which he had either not known before or forgotten: that the Jews were almost the only race or nation which developed a consecutive line of religious thinkers or prophets; that their ideal was first and last a single God or divinity, tribal at first, but later on, whose scope and significance was widened until He embraced the whole Universe (was in fact the Universe, a governing principle), one God, however, belief in whom—His power to heal, to build up and overthrow—had never been relinquished. The Old Testament was full of that—was that. The old prophets, he learned to his astonishment, were little more than whirling dervishes when they are first encountered historically, working themselves up into wild transports and frenzies, lying on the ground and writhing, cutting themselves as the Persian zealots do to this day in their feast of the tenth month and resorting to the most curious devices for nurturing their fanatic spirit, but always setting forth something that was astonishingly spiritual and great. They usually frequented the holy places and were to be distinguished by their wild looks and queer clothing. Isaiah eschewed clothing for three years (Is. 22:21); Jeremiah appeared in the streets of the capital (according to Muzzey) with a wooden yoke on his neck, saying, "Thus shalt Judah's neck be bent under bondage to the Babylonian" (Jer. 27:2 ff.); Zedekiah came to King Ahab, wearing horns of iron like a steer, and saying, "Thus shalt thou push the Syrians" (1 Kings 22:11). The prophet was called mad because he acted like a madman. Elisha dashed in on the gruff captain, Jehu, in his camp and broke a vial of oil on his head, saying, "Thus saith the Lord God of Israel, I have made thee king over the people of the Lord"; then he opened the door and fled. Somehow, though, these things accorded with Eugene's sense of prophecy. They were not cheap but great—wildly dramatic like the word of a Lord-God might be.

Another thing that fascinated him was to find that the evolutionary hypothesis did not after all shut out the conception of a ruling, ordaining divinity as he had supposed, for he came across several things in the papers which, now that he was thinking about this so keenly, held him spellbound.

One was quoted from a biological work by a man by the name of George M. Gould, and read:

"Life reaches control of physical forces by the cell-mechanism, and, so far as we know, by it solely." From reading Mrs. Eddy and arguing with Bangs, Eugene was not prepared to admit this but he was fascinated to see how it led ultimately to an acknowledgement of an active divinity which shapes our ends. "No inorganic molecule shows any evidence of intellect, design or purpose. It is the product solely of mathematically determinate and invariable physical forces. Life becomes conscious of itself through specialized cellular activity, and human personality, therefore, can only be a unity of greater differentiations of function, a higher and fuller incarnation than the single cell incarnation. Life, or God, is in the cell." (And everywhere outside of it, quite as active and more so, perhaps, Eugene reserved mentally.) "The cell's intelligence is His." (From reading Mrs. Eddy, Eugene could not quite agree with this. According to her it was an illusion.) "The human personality is also at last Himself and only Himself." "If you wish to say 'Biologos' or 'God' instead of 'Life' I heartily agree, and we are face to face with the sublime fact of biology: The cell is God's instrument and mediator in materiality; it is the mechanism of incarnation, the word made flesh and dwelling among us."

The other was a quotation in a Sunday newspaper from some man who appeared to be a working physicist of the time—Edgar Lucien Larkin.

"With the discovery and recent perfection of the new ultra-violet light micro-scope, and the companion apparatus, the micro-photographic camera, with rapidly moving sensitive films, it seems that the extreme limit of vision of the human eye has been reached. Inorganic and organic particles have been seen, and these so minute that [the smallest] objects visible in the most powerful old-style instruments are as huge chunks in comparison. An entire microscopic universe as wonderful as the sidereal universe, the stellar structure, has been revealed. This complexity actually exists; but exploration has scarcely com-menced. Within a hundred years, devoted to this research, the micro-universe may be partially understood. Laws of micro-movements may be detected and published in textbooks like those of the gigantic universe of suns and their concentric planets and moons.

"I cannot look into these minute moving and living deeps without instantly believing that they are mental—every motion is controlled by mind. The lon-ger I look at the amazing things, the deeper is this conviction. This micro-uni-verse is rooted and grounded in a mental base. Positively and without hope of overthrow, this assertion is made—the flying particles know where to go. Coarse particles, those visible in old-time microscopes, when suspended in liq-uids, were observed to be in rapid motion, darting to all geometrical directions with high speed. But the ultra-violet microscope reveals moving trillions of far

smaller bodies, and these rush on geometric lines and cut out angles with the most incredible speed, specific for each kind and type."

What were these angles? Eugene asked himself. Who made them? Who or what arranged the geometric lines? The "Divine Mind" of Mrs. Eddy? Had this woman really found the truth? He pondered this, reading on, and then one day, in a paper, he came upon this reflection in regard to the universe and its government by Alfred Russel Wallace which interested him as a proof that there might be, as Jesus said and as Mrs. Eddy contended, a Divine Mind or central thought in which there was no evil intent but only good. The quotation was from Mr. Wallace's book:

"Life is that power which, from air and water and the substances dissolved therein, builds up organized and highly complex structures possessing definite forms and functions; these are presented in a continuous state of decay and repair by internal circulation of fluids and gases; they 'reproduce their like,' go through various phases of youth, maturity and age, die and quickly decompose into their constituent elements. They thus form continuous series of similar individuals and so long as external conditions render their existence possible seem to possess a potential immortality.

"Many chapters might be written on the processes of life and the manifest adaptations of living things to environments, but when all this is said and done we are face to face with that which most authorities now admit, the necessity of some mind—some organizing and directive power—in nature, which can and does govern these manifestations. It is not enough to contemplate or admit as some may do some unknown forces or some innate rudimentary mind in cell or atom. Such powers would be wholly inadequate. It is necessary to presuppose some vast intelligence, some pervading spirit, to explain the guidance of the lower forces in accordance with the preordained system of evolution we see prevailing. Nothing less will do. The skill of arrangement and construction is too subtle. Fleshly mind at its best has not been able to duplicate in any minute way the subtleties of organization which are the commonplaces of nature.

"If, however, we go as far as this, we must go further. If there is a ruling and creative power to which the existence of our cosmos is due, and if we are its one and unique highest outcome, able to understand and make use of the forces and products of nature in a way that no other animal has been able to do; if, further, there is any reasonable probability of a continuous life for us to still further develop that higher spiritual nature which we possess, then we have a perfect right, on logical and scientific grounds, to see in all the infinitely varied products of the animal and vegetable kingdoms, which we alone can make use of, a preparation for ourselves, to assist in our mental development, and to fit us for a progressively higher state of existence as spiritual beings.

"My first point should be that the organizing mind which actually carries

out the development of the life world need not be infinite in any of its attributes—need not be what is usually meant by the terms God or Deity. The main cause of the antagonism between religion and science seems to me to be the assumption by both that there are no existences capable of taking part in the work of creation other than blind forces on one hand and the infinite, eternal, omnipotent God on the other. The apparently gratuitous creation by theologians of a hierarchy of angels and arch-angels, with no defined duties but that of attendants and messengers of the Deity, perhaps increases this antagonism, but it seems to me that both ideas are irrational.

"If, as I contend, we are forced to the assumption of an infinite God, by the fact that our earth has developed life, and mind, and ourselves, it seems only logical to assume that the vast, the infinite chasm between ourselves and the Deity is to some extent occupied by an almost infinite series of grades of beings, each successive grade having higher and higher powers in regard to the origination, the development and the control of the universe.

"If, as I here suggest, the whole purport of the material universe (our universe) is the development of spiritual beings who, in the infinite variety of their natures—what we term their characters—shall to some extent reflect that infinite variety of the whole inorganic and organic worlds through which they have been developed; and if we further suppose (as we must suppose if we owe our existence to Deity) that such variety of character could have been produced in no other way, then we may reasonably suppose that there may have been a vast system of co-operation of such grades of being, from a very high grade of power and intelligence down to those unconscious or almost unconscious 'cell souls' posited by Haeckel, and which I quite admit, seem to be essential co-adaptors in the process of life development.

"Now, granting all this, and granting further that each grade of being would be, for such a purpose as this, supreme over all beings of lower grade, who would carry out their orders or ideas with the most delighted and intelligent obedience, I can imagine the supreme, the Infinite Being, foreseeing and determining the broad outlines of a universe which would, in due course and with efficient guidance, produce the required result.

"He might, for instance, impress a sufficient number of his highest angels to create by their will power the primal universe of ether, with all those inherent properties and forces necessary for what was to follow. Using as a vehicle, the next subordinate association of angels would so act upon the ether as to develop from it, in suitable masses and at suitable distances, the various elements of matter, which, under the influence of such laws and forces as gravitation, heat and electricity, would thenceforth begin to form those vast systems of nebulae and suns which constitute our stellar universe.

"Then we may imagine these hosts of angels, to whom a thousand years are as one day, watching the development of this vast system of suns and planets until some one or more of them combined in itself all those conditions of size, of elementary constitution, of atmosphere, of mass of water and requisite distance

from its source of heat as to insure a stability of constitution and uniformity of temperature for a given minimum of millions of years, or of ages, as would be required for the full development of a life world from amoeba to man, with a surplus of a few hundreds of millions for his adequate development.

"In my *Man's Place in the Universe* I have pointed out the very narrow range of the quantitative and qualitative conditions which such a world must possess; and the next step in the process of what may be well termed 'creation' would be the initiation of life by the same or a subordinate body of spirit workers, whose duty would be, when the waters of the cooling earth had reached a proper temperature and were sufficiently saturated with gases and carbon compounds, to infuse into it suitable life centres to begin the process of organization, which, as Huxley acknowledged, implies life as its course. How this was done it is impossible for us to know and useless to speculate; but there are certain guides. . . .

"We are led, therefore, to postulate a body of what we may term organizing spirits, who would be charged with the duty of so influencing the myriads of cell souls as to carry out their part of the work with accuracy and certainty. In the power of 'thought transference' or mental impression, now generally admitted to be a vera causa, possessed by many, perhaps by all of us, we can understand how the higher intelligences are able to so act upon the lower and that the work of the latter soon becomes automatic. The work of the organizers is then devoted to keeping up the supply of life material to enable the cell souls to perform their duties while the cells are rapidly increasing.

"At successive stages of the development of the life-world more and perhaps higher intelligences might be required to direct the main lines of variation in definite directions, in accordance with the general design to be worked out, and to guard against a break in the particular line which alone could lead ultimately to the production of the human form. Some such conception as this—of delegated powers to beings of a very high and to others of a very low grade of life and intellect—seems to me less grossly improbable than that the Infinite Deity not only designed the whole of the cosmos but that Himself alone is the consciously acting power in every cell of every living thing that is or ever has been upon the earth. . . .

"To claim the Infinite and Eternal Being as the one and only direct agent in every detail of the universe seems too absurd. If there is such an Infinite Being and if (as our existence should teach us) His will and purpose is the increase of conscious beings, then we can hardly be the first result of this purpose. We conclude therefore, that there are now in the universe infinite grades of power, infinite grades of knowledge and wisdom, infinite grades of influence of higher beings upon lower. Holding this opinion, I have suggested that this vast and wonderful universe, with its almost infinite variety of forms, motions and reactions of part upon part, from suns and systems up to planet life, animal life and the human, living soul, has ever required and requires the continuous co-ordinated agency of myriads of such intelligences.

"This speculative suggestion, I venture to hope, will appeal to some of my

readers as the very best approximation we are now able to formulate as to the deeper, the more fundamental causes of matter and force of life and conscious- ness, and of man himself; at his best, already 'a little lower than the angels' and, like them, destined to a permanent progressive existence in a world of spirit."

This very peculiar and apparently progressive statement in regard to the conclusion which naturalistic science had revealed about the universe held Eugene as pretty fair confirmation of Mrs. Eddy's contention that all was mind and its infinite variety. The only difference between her and the Brit- ish scientific naturalists was that they contended for an ordered hierarchy which could only rule and manifest itself according to its own ordered or self-imposed laws, which they could perceive or detect, whereas she con- tended for a governing spirit which was everywhere and would act through ordered laws and powers, of its own arrangement or otherwise. God was a principle, like a rule in mathematics—two times two is four for instance— and was as manifest daily and hourly and momentarily in a hall bedroom as well as in the circling motions of suns and system. God was a principle. He had that now. A principle could be and was of course anywhere and everywhere at one and the same time. One could not imagine a place, for instance, where two times two would not be four, or where that rule would not be. So, likewise, with the omnipotent, omniscient, omnipresent mind of God.

CHAPTER CII

The most dangerous thing to possess a man to the extent of dominating him is an idea. It can and does ride him to destruction. Eugene's idea of the perfection of eighteen was one of the most dangerous things in his nature. In a way, combined with the inability of Angela to command his interest and loyalty, it had been his destruction or undoing to date. A reli- gious idea, followed in a narrow sense, would have diverted this other, but it might have completed his mental destruction also if he had been able to follow it. Fortunately the theory he was now interesting himself in was not a narrow dogmatic one in any sense, but religion in its larger aspects— a comprehensive résumé and spiritual co-ordination of the meta-physical speculations of the time which were worthy of anyone's intelligent inquiry. Christian Science as a cult or religion was shunned by current religions and religionists as something outré, impossible, uncanny: as necromancy, imagi- nation, hypnotism, mesmerism, spiritism, everything, in short, that it was

not and little if anything that it really was. Mrs. Eddy had formulated or rather restated a fact that was to have been found in the sacred writings of India; in the Hebrew testaments, old and new; in Socrates, Marcus Aurelius, St. Augustine, Emerson, and Carlyle. The one variation notable between her and the moderns was that her *ruling unity* was not malicious, as Eugene and so many others fancied, but helpful. Her *unity* was a *unity* of love. God was everything but the father of evil, which was an illusion—neither fact nor substance—sound and fury, signifying nothing.

It must be remembered that during all this time Eugene was doing this painful and religious speculation he was living in the extreme northern portion of the city, working desultorily at some paintings which he thought he might sell, visiting Angela occasionally, who was safely hidden away in the maternity hospital in 110th Street, thinking hourly and momentarily of Suzanne and wondering if by any chance he should ever see her any more. His mind had been so inflamed by the beauty and the disposition of this girl that he was really not normal any more. He needed some shock, some catastrophe greater than any he had previously experienced to bring him to his senses. The loss of his position had done something. The loss of Suzanne had only heightened his affection for her. The condition of Angela had given him pause, for it was an interesting question what would become of her. If she would only die, he said to himself—for we have the happy faculty of hating most joyously on this earth the thing we have wronged the most. He could scarcely go and see her, so obsessed was he with the idea that she was a handicap to his career. The idea of her introducing a child into his life only made him savage. Now if she should die he would have that, and Suzanne, because of it, might never come to him.

His one idea at this time was not to be observed too much, or rather not at all, for he considered himself to be in great disfavor and only liable to do himself injury by a public appearance. For this reason he had selected this quiet neighborhood where the line of current city traffic was as nothing, for here he could brood in peace. The family that he moved in with, taking a comfortable room and bath with a north light, knew nothing about him. Winter was setting in. Because of the cold and snow and high winds, he was not apt to see many people hereabouts, particularly those celebrities who had known him in the past. There was a great deal of correspondence that followed him via his old address, for his name had been used on many committees, he was in *Who's Who*, and he had many friends less distinguished than those whose companionship would have required the expenditure of much money who would have been glad to have looked him up. He ignored all invitations, however; refused to indicate by return mail where he was for the present; walked largely at night; read, painted, or sat and brooded dur-

ing the day. He was thinking all the time of Suzanne and how disastrously fate had trapped him, apparently, through her. He was thinking that she might come back—that she ought. Lovely, hurtful pictures came to him of re-encounters with her in which she would rush into his arms never to part from him any more. Angela, in her room in the hospital, received little thought from him. She was there. She was receiving expert medical attention. He was paying all her bills. Her serious time had not yet really come. Myrtle was seeing her. He caught glimpses of himself at times as a cruel, hard intellect, driving the most serviceable thing his life had known from him with blows, but somehow it seemed justifiable. Angela was not suited to him. Why could she not live away from him? Christian Science set aside marriage entirely as a human illusion, conflicting with the indestructible unity of the individual with God. Why shouldn't she let him go?

He wrote poems to Suzanne and consoled himself by reading things which seemed to apply to his case. One poem in particular by William Butler Yeats, which he found in a current magazine, appealed to him greatly. It seemed to speak volumes for the nature of Suzanne:

"Helen

"Why should I blame her that she filled my days
 With misery, or that she would of late
 Have taught ignorant men most violent ways,
 And hurled the little streets upon the great,
 Had they but courage equal to desire.
 What could have made her peaceful with a mind
 That nobleness made simple as a fire,
 Beauty like a tightened bow, a kind
 That is not natural in an age like this:
 Being high, and solitary, and most stern?
 Why, what could she have done, being what she is?
 Was there another Troy for her to burn?"

And then this by Shakespeare, to which he turned again and again in his solitude:

"When in Disgrace

"When in disgrace with fortune and men's eyes,
 I all alone beweep my outcast state,
 And trouble deaf heaven with my bootless cries,
 And look upon myself and curse my fate,
 Wishing me like to one more rich in hope,
 Featured like him, like him with friends possessed,
 Desiring this man's art, and that man's scope,

With what I most enjoy contented least;
Yet in these thoughts myself almost despising,
Haply I think on thee, and then my state,
Like to the lark at break of day arising
From sullen earth, sings hymns at heaven's gate:
For thy sweet love remembered such wealth brings
That then I scorn to change my state with kings."

There were other poems he found—in a small library of books which the family with which he lived possessed, and in the trunk full of books he had brought away with him from the Drive—which interested him in some of his moods: Keats's "The Day is Gone"; Alice Meynell's "Renouncement"; "Endurance" by Elizabeth Akers Allen; "Tears" by Lizette Woodworth Reese; "The Eve of St. Agnes" by Keats; and so on. He was not quite as bad as he was when he had broken down eight years before, but he was very bad. His mind was once more riveted upon the uncertainty of life, its changes, its follies. He was studying those things only which deal with the abstrusities of nature and this began to breed again a morbid fear of life itself. Myrtle was greatly distressed about him. She worried that he might lose his mind.

"Why don't you go to see a practitioner, Eugene?" she begged of him one day. "You will get help—really you will. You think you won't, but you will. There is something about them—I don't know what. They are spiritually at rest. You will feel better. Do go."

"Oh, why do you bother me, Myrtle? Please don't. I don't want to go. I think there is something in the idea, metaphysically speaking, but why should I go to a practitioner? God is as near me as He is anyone, if there is a God."

Myrtle wrung her hands and, because she felt so badly, more than anything else, he finally decided to go.

There might be something hypnotic or physically contagious about these people—some old alchemy of the mortal body which could reach and soothe him. He believed in hypnotism, hypnotic suggestion, etc. He finally called upon one practitioner, an old lady, highly recommended to Myrtle by others, who lived farther south on Broadway, somewhere in the neighborhood of Myrtle's home. Mrs. Althea Johns was her name—a woman who had performed wonderful cures. Why should he, Eugene Witla, he asked himself as he took down the receiver—why should he, Eugene Witla, ex-managing publisher of the United Magazines Corporation, ex-artist (in a way he felt that he was no longer an artist in the best sense) be going to a woman in Christian Science to be healed—of what? Gloom? Yes. Failure? Yes. Heartache? Yes. His evil tendencies in regard to women such as the stranger who had sat beside him had testified to? Yes. How strange. And yet he was curi-

ous. It interested him a little to speculate as to whether this could be really done. Could he be healed of failure? Could this pain of longing be made to cease? Did he want it to cease? No. Certainly not. He wanted Suzanne. Myrtle's idea, he knew, was that somehow this treatment would reunite him and Angela, and make him forget Suzanne, but he knew that could not be. He was going—but he was going because he was unhappy and idle and aimless. He was going because he really did not know what else to do.

The apartment of Mrs. Johns—Mrs. Althea Johns—was in an apartment house of conventional design, of which there were in New York hundreds at the time. There was a spacious areaway between two wings of cream-colored pressed brick leading back to an entrance way which was protected by a handsome wrought iron door, on either side of which was placed an electric lamp support of handsome design holding lovely cream-colored globes, shedding a soft lustre. Inside was the usual lobby, elevator, uniformed negro elevator man, indifferent and impertinent, and the telephone switchboard. The building was seven stories high.

Eugene went one snowy, blustery March night. The great wet flakes were spinning in huge whorls and the streets were covered with a soft, slushy carpet of snow. He was interested as usual, in spite of his gloom, in the picture of beauty the world presented—the city wrapped in a handsome mantle of white. Here were cars rumbling, people hunched in great coats facing the driving wind. He liked the snow, the flakes, the wonder of material living. It eased his mind of his misery and made him think of his painting again.

Mrs. Johns was on the seventh floor. Eugene knocked and was admitted by a maid. He was shown to a waiting room, for he was a little ahead of his time, and there were others—healthy looking men and women who did not appear to have an ache or pain—ahead of him. Was not this a sign, he thought as he sat down, that this was something which dealt with imaginary ills? Then why had the man he had heard in the church once beside him testified so forcefully and sincerely to his healing? Well, he would wait and see. He did not see what it could do for him now. He had to work. He sat there, in one corner, his hands folded and braced under his chin, thinking. The room was not artistic but rather nondescript; the furniture cheap or rather tasteless in design. Didn't Divine Mind know any better than to present its representatives in such a guise as this? Could a person called to assist in representing the majesty of God on earth be left so unintelligent artistically as to live in a house like this? Surely this was a poor manifestation of divinity—but——

Mrs. Johns came—a short, stout, homely woman, gray, wrinkled, dowdy in her clothing, a small wen on one side of her mouth, a nose slightly too big to be pleasing—all the mortal deficiencies as to an attractive appear-

ance—and looking like an old print of Mrs. Micawber that he had seen somewhere. She had on a black skirt, good as to material but shapeless and commonplace, and a dark blue gray waist. Her eye was clear and gray, though, he noticed, and she had a pleasing smile.

"This is Mr. Witla, I believe," she said, coming across the room to him, for he had gotten into a corner near the window, and speaking with an accent which sounded a little Scotch. "I'm so glad to see you. Won't you come in," she said, giving him precedence over some others because of his appointment, and recrossed the room preceding him down the hall to her practice room. She stood to one side to take his hand as he passed.

He touched it gingerly.

So this was Mrs. Johns, he thought as he entered, looking about him. Bangs and Myrtle had insisted that she had performed wonderful cures—or rather that Divine Mind had through her. Her hands were wrinkled, her face old. Why didn't she make herself young if she could perform these wonderful cures? Why was this room so mussy? It was actually stuffy with chromos and etchings of the Christ and Bible scenes on the walls, a cheap red carpet or rug on the floor, inartistic leather covered chairs, a table or desk too full of books, a pale picture of Mrs. Eddy and silly mottos of which he was sick and tired hung here and there. People were such hacks when it came to the art of living. How could they pretend to a sense of divinity who knew nothing of life here? He was weary and the room offended him. Mrs. Johns did. Besides, her voice was slightly falsetto. Could *she* cure cancer, and consumption, and all these horrible human ills, as Myrtle insisted she had? He didn't believe it!

He sat down wearily and yet contentiously in the chair she pointed out to him and stared at her while she quietly seated herself opposite him, looking at him with kindly, smiling eyes.

"And now," she said easily, "what does God's child think is the matter with him?"

Eugene stirred irritably.

God's child! he thought. What cant! What right had he to claim to be a child of God! What was the use of beginning that way? It was silly, so asinine. Why not ask plainly what was the matter with him? Still he answered:

"Oh, a number of things. So many that I am pretty sure they can never be remedied."

"As bad as that? Surely not. It is good to know, anyhow, that nothing is impossible to God. We can believe that, anyhow, can't we?" she replied, smiling. "You believe in a God or ruling power, don't you?"

"I don't know whether I do or not. In the main I guess I do. I'm sure I ought to. Yes, I guess I do."

"Is He a malicious God to you?"

"I have always thought so," he replied, thinking of Angela.

"Mortal mind! Mortal mind!" she asseverated to herself. "What delusions it will not harbor."

And then to him:

"One has to be cured almost against one's will to know that God is a God of love. So you believe you are sinful, do you, and that He is malicious? It is not necessary that you should tell me how. We are all alike in the mortal state. I would like to call your attention to Isaiah's words: 'Though your sins be as scarlet they shall be as white as snow; though they be red like crimson, they shall be as wool.'"

Eugene had not heard this quotation in years. It was only a dim thing in his memory. It flashed out simply now and appealed, as had all these Hebraic bursts of prophetic imagery in the past. Mrs. Johns, for all her wen and her nose and dowdy clothes, was a little better for having been able to quote this so aptly. It raised her in his estimation. It showed a vigorous mind—at least a tactful mind.

"Can you cure sorrow?" he asked grimly, and with a touch of sarcasm in his voice. "Can you cure heartache or fear?"

"I can do nothing of myself," she said, perceiving his mood. "All things are possible to God, however. If you believe in a Supreme Intelligence, He will cure you. St. Paul says, 'I can do all things through Christ which strengtheneth me.' Have you read Mrs. Eddy's book?"

"Most of it. I'm still reading it."

"Do you understand it?"

"No. Not quite. It seems a bundle of contradictions to me."

"To those who are first coming into Science, it nearly always seems so. But don't let that worry you. You would like to be cured of your troubles. St. Paul says, 'for the wisdom of this world is foolishness with God'; 'The Lord knoweth the thoughts of the wise—that they are in vain.' Do not think of me as a woman, or as having anything to do with this. I would rather have you think of me as St. Paul describes anyone who works for truth: 'Now then we are ambassadors for Christ, as though God did beseech you by us: we pray you in Christ's stead, be ye reconciled to God.'"

"You know your Bible, don't you?" said Eugene.

"It is the only knowledge I have," she replied.

There followed one of those peculiar religious demonstrations so common in Christian Science—so peculiar to the uninitiated—in which she asked Eugene to fix his mind in meditation on the Lord's Prayer. "Never mind if it seems pointless to you now. You have come here seeking aid. You are God's perfect image and likeness. He will not send you away empty

handed. Let me read you first, though, this one psalm which I think is always so helpful to the beginner." She opened her bible which was on the table near her and began:

> "'He that dwelleth in the secret place of the most high shall abide under the shadow of the Almighty.
> 'I will say of the Lord, He is my refuge and my fortress; my God; in him will I trust.
> 'Surely he shall deliver thee from the snare of the fowler, and from the noisome pestilence.
> 'He shall cover thee with his feathers, and under his wings shalt thou trust; his truth shall be thy shield and thy buckler.
> 'Thou shalt not be afraid for the terror by night; nor for the arrow that flieth by day;
> 'Nor for the pestilence that walketh in the darkness; nor for destruction that wasteth at noonday.
> 'A thousand shall fall at thy side, and ten thousand at thy right hand; but it shall not come nigh thee.
> 'Only with thine eyes shalt thou behold and see the reward of the wicked.
> 'Because thou hast made the Lord, which is my refuge, even the most High, thy habitation;
> 'There shall no evil befall thee, neither shall any plague come nigh thy dwelling.
> 'For he shall give his angels charge over thee, to keep thee in all thy ways.
> 'They shall bear thee up in their hands, lest thou dash thy foot against a stone.
> 'Thou shalt tread upon the lion and the adder; the young lion and the dragon shalt thou trample under feet.
> 'Because he hath set his love upon me, therefore will I deliver him; I will set him on high, because he hath known my name.
> 'He shall call upon me, and I will answer him: I will be with him in trouble; I will deliver him in trouble; I will deliver him and honour him.
> 'With long life will I satisfy him, and show him my salvation.'"

During this most exquisite pronunciamento of divine favor, Eugene was sitting with his eyes closed, his thoughts wandering over all his recent ills. For the first time in years he was trying to fix his mind upon an all-wise, omnipresent, omnipotent generosity. It was hard, and he could not reconcile the beauty of this expression of divine favor with the nature of the world as he knew it. What was the use of saying, "They shall bear thee up in their hands lest thou dash thy foot against a stone," when he had seen

Angela and himself suffering so much recently? Wasn't he dwelling in the secret place of the most High when he was alive? How could one get out of it? Still——. "Because he hath set his love on me, therefore will I deliver him." Was that the answer? Was Angela's love set on *Him?* Was his own? Might not all their woes have sprung from that?

"He shall call upon me and I will answer. I will deliver him in trouble. I will deliver him and honour him."

Had he ever really called on *Him?* Had Angela? Hadn't they been left in the slough of their own despond? Still, Angela was not suited to him. Why did not God straighten that out? He didn't want to live with her.

He wandered through this philosophically, critically, until Mrs. Johns stopped. What if, he asked himself, in spite of all his doubts, this seeming clamor and reality and pain and care were an illusion? Angela was suffering. So were many other people. How could this thing be true? Did not these facts exclude the possibility of illusion? Could they possibly be a part of it?

"Now we are going to try to realize that we are God's perfect child," she said, stopping and looking at him. "We think we are so big and strong and real. We are real enough, but only as a thought in God—that is all. No harm can happen to us there, no evil come nigh us. For God is infinite: all power, all life. Truth, Love, over all, and all."

She closed her eyes and began, as she said, to try to realize for him the perfectness of his spirit in God. Eugene sat there trying to think of the Lord's Prayer but in reality thinking of the room, the cheap prints, the homely furniture, her ugliness, the curiosity of his being there. He, Eugene Witla, being prayed for. What would Angela think? Why was this woman old, if spirit could do all these other things? Why didn't she make herself beautiful? What was it she was doing now? Was this hypnotism, mesmerism, she was practicing? He remembered where Mrs. Eddy had especially said that these were not to be practised—could not be in Science. No, Mrs. Johns was no doubt sincere. She looked it—talked it. She believed in this beneficent spirit. Would it act as the psalm said? Would it heal this ache? Would it make him not want Suzanne, ever, anymore? Perhaps that was evil? Yes, no doubt it was. Still——perhaps he had better fix his mind on the Lord's Prayer. Divinity could aid him if it would. Certainly it could. No doubt of it. There was nothing impossible to this vast force ruling the universe. Look at the telephone, wireless telegraphy. How about the stars and suns? "He shall give his angels charge over thee."

"Now," said Mrs. Johns after some fifteen minutes of silent meditation had passed, and she opened her eyes smilingly, "we are going to see whether we are not going to be better. We are going to feel better because we are going to do better and because we are going to realize that nothing can hurt

an idea in God. All the rest is illusion. It cannot hold us for it is not real. Think good—God—and you are good. Think evil and you are evil, but it has no reality outside of your own thought. Remember that." She talked to him as though he were a little child.

He went out into the snowy night where the wind was whirling the snow in picturesque whirls, buttoning his coat about him. The cars were running up Broadway as usual. Taxicabs were scuttling by. There were people forging their way through the snow, that ever present company of a great city. There were arc lights burning cleanly blue through the flying flakes. He wondered as he walked whether this would do him any good. Mrs. Eddy insisted that all these were unreal, he thought, that mortal mind had evolved something which was not in accord with spirit—mortal mind, "a liar and the father of it"—he recalled that quotation. Could it be so? Was evil unreal? Was misery only a belief? Could he come out of his sense of fear and shame and once more face the world? He boarded a car to go north. At Kingsbridge he made his way thoughtfully to his room. How could life ever be restored to him as it had been? He was nearly forty years of age.

He went home to Myrtle's and sat down in his chair near his lamp and took up his book, *Science and Health,* and opened it aimlessly. Then he thought for curiosity's sake he would see where he had opened it—what the particular page or paragraph his eye fell on had to say to him. He was still intensely superstitious. He looked and here was this paragraph growing under his eyes:

"When mortal man blends his thoughts of existence with the spiritual, and works only as God works, he will no longer grope in the dark and cling to earth because he has not tasted heaven. Carnal beliefs defraud us. They make man an involuntary hypocrite—producing evil when he would create good, forming deformity when he would outline grace and beauty, injuring those whom he would bless. He becomes a general mis-creator, who believes he is a semi-god. His 'touch turns hope to dust, the dust we all have trod.' He might say in Bible language: 'The good that I would, I do not: but the evil which I would not, that I do.'"

He closed the book and meditated. He wondered at the curious aptness of the paragraph, though it was no more apt than hundreds of other things in the book. He wished he might realize this thing if this were so. Still he did not want to become a religionist—a religious enthusiast. How silly they were. He picked up his daily paper, the *Evening Post,* and there on an inside page, quoted in an obscure corner was a poem, or an excerpt from one, by the late Francis Thompson, which was entitled "The Hound of Heaven." It ran:

"I fled Him, down the nights and down the days;
I fled Him, down the arches of the years,
I fled Him, down the labyrinthine ways
Of my own mind; and in the mist of tears
I hid from him, and under running laughter.
Up vistaed hopes I sped;
And shot, precipitated,
Adown Titanic glooms of chasmèd fears,
From those strong Feet that followed, followed after.
But with unhurrying chase,
And unperturbèd pace,
Deliberate speech, majestic instancy,
They beat—and a Voice beat
More instant than the Feet
'All things betray thee, who betrayest Me.'"
"I pleaded, outlaw-wise,
By many a hearted casement, curtained red,
Trellised with intertwining charities;
(For though I knew His love Who followèd,
Yet was I sore adread
Lest, having Him, I must have naught beside.)
But, if one little casement parted wide,
The gust of His approach would clash it to:
Fear wist not to evade, as Love wist to pursue.
Across the margent of the world I fled,
And troubled the gold gateways of the stars,
Smiting for shelter on their changèd bars;
Fretted to dulcet jars
And silvern chatter the pale parts o' the moon.
I said to Dawn: Be sudden—to Eve: Be soon;
With thy young skiey blossoms heap me over
From this tremendous lover!
Float thy vague veil about me, lest He see!
I tempted all His servitors, but to find
My own betrayal in their constancy,
In faith to Him their fickleness to me,
Their traitrous trueness and their loyal deceit,
To all swift things for swiftness did I sue;
Clung to the whistling mane of every wind. . . .
Still with unhurrying chase,
And unperturbèd pace,
Deliberate speed, majestic instancy.
Came on the following Feet,
And a Voice above their beat—
'Naught shelters thee, who will not shelter Me.'"

The latter really moved Eugene. It was large enough in its poetic appeal, dignified enough, beautiful enough to make him think. Did this man really believe this? Was it so?

He turned back to his book and read on, and by degrees he came half to believe that sin and evil and sickness might possibly be illusions—that they could be cured by aligning oneself intellectually and spiritually with this Divine Principle. He wasn't sure. It might be so. If he could only get this. If he could only recover from this terrible sense of defeat which pervaded him. This terrible sense of wrong. Could he give up Suzanne? Did he want to? No! No!! No!!! Never that! Never!

He got up and went to the window and looked out. The snow was still blowing, the electrics burning artistically, making strange pale blurs of dotted white where they stood.

Give her up! Give her up! And Angela in such a precarious condition. What a devil of a hole he was in anyway. Well, he would go and see her in the morning. He would at least be kind. He would see her through this thing. He lay down and tried to sleep but somehow sleep never came to him right any more. He was too wearied, too distressed, too wrought up! Still he slept a little and that was all he could hope for in these days.

CHAPTER CIII

It was while he was in this state some two months later that the great event so far as Angela was concerned transpired, and in which, of necessity, he was compelled to take part. At this time as yet he had no faith in Christian Science and was thinking against it, and Angela, in spite of her continued reception of a practitioner, had concluded that it could be of little service to her. She could not grasp its significance. She was sitting in her room, cosily and hygienically furnished, overlooking the cathedral grounds at Morningside Heights, and speculating hourly what her fate was to be. She had never wholly recovered from the severe attack of rheumatism which she had endured the preceding summer, and because of her worries since, and in her present condition, was pale and weak though she was not ill. The head visiting obstetrical surgeon, Dr. Lambert, a lean, gray man of sixty-five years of age with grizzled cheeks, whose curly gray hair, wide, humped nose, and keen gray eyes told of the energy and insight and ability that had placed him where he was, took a slight passing fancy to her for she seemed to him one of those good, patient little women whose lives are laid in sacrificial lines. He liked her brisk, practical, cheery disposition

in the face of her condition, which was serious, and which was so notice-able to strangers. Angela had naturally a bright, cheery face when she was not depressed or quarrelsome. It was the outward sign of her ability to say witty and clever things and she had never lost the desire to have things done efficiently and intelligently about her, wherever she was. The nurse, Miss De Sale, a solid, phlegmatic person of thirty-five, admired her spunk and courage and took a great fancy to her also because she was lightsome, so buoyant and hopeful in the face of what was really a very serious situa-tion. The general impression of the head operating surgeon, the house sur-geon, and the nurse was that her heart was weak and her kidneys might be affected by her condition. Angela had somehow concluded after talks with Myrtle that Christian Science, as demonstrated by its practitioners, would help her through this crisis. Eugene would come about, she thought also, for Myrtle was having him treated absently, and he was trying to read the book, she said. There would be a reconciliation between them when the baby came, because—because—well, because children were so winning. Eugene was really not hard hearted—he was just infatuated. He had been ensnared by a siren. He would get over it.

Miss De Sale let Angela's hair down in braids, Gretchen style, and fas-tened great, pink, youthful bows of ribbon in them. As her condition became more involved, only the lightest morning gowns were given her, soft, comfort-able things in which she sat about speculating about the future—practically. She had changed from a lean shapeliness to a swollen, somewhat objection-able condition, but she made the best of a bad situation. Eugene saw her and felt sorry. It was the dead of winter now, with snow blowing gaily or fiercely about the windows, and the park grounds opposite were snow white.

She could see the leafless line of sentinel poplars that bordered the upper edge of Morningside. She was calm, patient, hopeful, while the old obste-trician shook his head gravely to the house surgeon.

"We shall have to be very careful. I shall take charge of the actual birth myself. See if you can't build up her strength. We can only hope that the head is small."

Angela's littleness and courage appealed to him. For once, in a great many cases, he felt really sorry.

The house surgeon did as directed. Angela was given especially prepared food and drink. She was fed frequently. She was made to keep perfectly quiet.

"Her heart," the house surgeon reported to his superior, "I don't like that. It's weak and irregular. I think there's a slight lesion."

"We can only hope for the best," said the other solemnly. "We'll try and do without ether."

Eugene in his peculiar mental state was not capable of realizing the pathos of all this. He was alienated temperamentally and emotionally. Thinking that he cared for his wife dearly, the nurse and the house surgeon were for not warning him. They did not want to frighten him. He asked several times whether he could be present during the delivery, but they stated that it would be dangerous and trying. The nurse asked Angela if she had not better advise him to stay away. Angela did, but Eugene felt that in spite of his opposition she needed him. Besides, he was curious. He thought Angela could stand it better if he were near and now that the ordeal was drawing nigh he was beginning to understand how desperate it might be and to think it was only fair that he should assist her. Some of the old pathetic charm of her littleness was coming back to him. She might not live. She would have to suffer much. She had meant no real evil to him—only to hold him. Oh, the bitterness and pathos of this welter of earthly emotions. Why should they be so tangled?

The time grew very near and Angela was beginning to suffer severe pains. Those wonderful processes of the all-mother, which bind the coming life in a cradle of muscles and ligaments, were practically completed and were now relaxing their tendencies in one direction to enforce them in another. Angela suffered, at times severely, from straining ligaments. Her hands would clinch desperately, her face would become deathly pale. She would cry.

Eugene was with her on a number of these occasions and it drove home to his consciousness the subtlety and terror of this great scheme of reproduction which took all women to the door of the grave in order that this mortal scheme of things might be continued. He began to think that there might be something to the assertion of the Christian Science teachers that it was a lie and an illusion, a terrible fitful fever outside the rational consciousness of God. He went to the library one day and got down a book on obstetrics which covered the principles and practice of surgical delivery. He saw here scores of pictures drawn very carefully of the child in various positions in the womb—all the strange, peculiar, flower-like positions it could take, folded in upon itself like a little half-formed petal. The pictures were attractive, some of them beautiful, practical as they were. They appealed to his fancy. They showed the coming baby perfect, but so small, its head now in one position, now in another, its little arms twisted about in odd places, but always delightfully, suggestively appealing. From reading here and there in the volume—it was by an eminent surgeon—he learned that the great difficulty was the head—the delivery of that. It appeared that no other difficulty really confronted the obstetrician. How was that to be got out? If the head were large, the mother old, the walls of the peritoneal cavity

tight or hard, it might be impossible to get it out. There were whole chap-
ters on Craniotomy, Cephalotripsy, which in plain English means crushing
the head with an instrument known as the cephalotribe, and decapitation,
the art of severing the head in order that the body may be gotten out in
sections. Think of that, chapters showing how to kill the child and get it
out without killing the mother. There were pictures of cutting off its head
and breaking it up—poor little thing—in order that the mother might not
die. The hemostatic clamps, the forceps, high and low, the scalpels, all were
referred to as essential implements—hard cold pieces of steel with which the
surgeon had to work. One chapter was devoted to the Caesarian operation,
with a description of its tremendous difficulties and a long disquisition on
the ethics of killing the child to save the mother, or the mother to save the
child, with their relative values to society indicated. Think of it, a surgeon
sitting in the seat of judge and executioner at the critical moment. Ah, life
with its petty laws did not extend here. Here we came back to the con-
science of man which Mrs. Eddy maintained was a reflection of imminent
mind. If God were good He would speak through that—He was speaking
through it. This surgeon referred to that inmost consciousness of supreme
moral law which alone could guide the practitioner in this dreadful hour.

Then he told of what implements were necessary, how many assistants
(two), how many nurses (one), the kinds of bandages, needles, silk and
catgut thread, knives, clamps, dilators, rubber gloves. He showed how the
cut was to be made—when, where. Eugene closed the book, frightened. He
got up and walked out in the air, a desire to hurry up to Angela impelling
him. She was weak, he knew that. She had complained of her heart. Her
muscles were probably set. Supposing these problems, any one of them,
should come up in connection with her. He did not wish her to die.

He had said he had—yes, but he did not want to be a murderer. No, no!
Angela had been good to him. She had worked for him. Why, God damn
it, she had actually suffered for him in times past. He had treated her badly,
very badly, and now in her pathetic little way she had put herself in this
terrific position. It was her fault—sure it was. She had been trying, as she
always had, to hold him against his will, but then could he really blame
her? It wasn't a crime for her to want him to love her. They were just mis-
mated, that was all—sadly, tragically unsuited. He had tried to be kind in
marrying her and he hadn't been kind at all. It had merely produced unrest,
dissatisfaction, unhappiness for him and for her and now this—this—this
danger of death through pain, a weak heart, defective kidneys, a Caesarean
operation. Why, she couldn't stand anything like that. There was no use
talking about it. She wasn't strong enough—she was too old! He thought
of Christian Science practitioners and of how they might save her—of

some eminent surgeon who would know how without the knife. How? How? If these Christian Scientists could only think her through a thing like this—he wouldn't be sorry. He would be glad for her sake, if not his own. He might give up Suzanne—he might—he might. Oh, why should that thought intrude on him now?

When he reached the hospital it was three o'clock in the afternoon, and he had been there for a little while in the morning when she was comparatively all right. Now she was much worse. The straining pains in her sides which she had complained of were worse, and her face was alternately flushed and pale, sometimes convulsed a little, though not much. Myrtle was there, talking with her, and Eugene stood about nervously, wondering what he should do—what he could do. Angela saw his worry. In spite of her own condition she was sorry for him. She knew that this would cause him pain, for he was not hard hearted, and it was his first sign of relenting. She smiled at him, thinking that maybe he would come round and change his attitude entirely. Myrtle kept reassuring her that all would be well with her. The nurse said to her and to the house doctor who came in, a young man of twenty-eight years of age, with keen, quizzical eyes, whose sandy hair and ruddy complexion bespoke a fighting disposition, that she was doing nicely.

"No bearing down pains," he said, laughing at Angela, his even, white teeth showing in two gleaming rows.

"I don't know what kind they are, doctor," she replied. "I've had every other kind."

"You'll know them fast enough," he replied mock cheerfully. "They're not like any other kind."

He went away and Eugene followed him.

"How is she doing?" he asked when they were out in the hall.

"Well enough, considering. She's not very strong, you know. I have an idea she is going to be all right. Dr. Lambert will be here in a little while. You had better talk to him."

The house surgeon did not want to lie. He thought Eugene ought to be told. Dr. Lambert was of the same opinion but he wanted to wait until the last, until he could judge approximately correctly.

He came at five when it was already dark outside and looked at Angela with his grave, kindly eyes. He felt her pulse, listened to her heart with his stethoscope.

"Do you think I will be all right, doctor?" asked Angela faintly.

"Yes, I think so," he replied softly. "Little woman, big courage." He smoothed her hand.

He walked out and Eugene followed him.

"Well, doctor," he said. For the first time in months Eugene was thinking of something besides his lost fortune and Suzanne.

"I think it is advisable to tell you, Mr. Witla," said the old surgeon, "that your wife is in a serious condition. I don't want to alarm you unnecessarily—it may all come out very satisfactory: I have no positive reason to be sure that it will not. She is pretty old to have a child. Her muscles are set. The principal thing we have to fear in her case is some untoward complication with her kidneys. There is always difficulty in the delivery of the head in women of her age. It may be necessary to sacrifice the child. I can't be sure. The Caesarian operation is something I never care to think about. It is rarely used and it isn't always successful. Every care that can be taken, will be taken. I should like to have you understand the conditions. Your consent will be asked before any serious steps are taken. Your decision will have to be quick, however, if it is necessary at all, when the time comes."

"I can tell you now, doctor, what my decision will be," said Eugene, realizing fully the gravity of the situation. For the time being his old force and dignity were restored. "Save her life if you can, by any means that you can. I have no other wish."

"Thanks," said the surgeon, "we will do the best we can."

There were hours after that when Eugene, sitting by Angela, saw her endure pain which he never deemed it was possible for any human being to endure. He saw her draw herself up rigid, time and again, the color leaving her face, the perspiration breaking out on her forehead, only to relax and flush and groan without really crying out. He saw, strange to relate, that she was no baby like he was, whimpering over every little ill, but a representative of some great creative force which gave her power to suffer at once greatly and to endure greatly. She could not smile any more. That was not possible. She was in a welter of suffering, unbroken, astonishing. Myrtle had gone home to her dinner but promised to return later. Miss De Sale came, bringing another nurse, and while Eugene was out of the room Angela was prepared for the final ordeal. She was arrayed in the usual open-back hospital slip and white linen leggings. Under Doctor Lambert's orders, an operating table was gotten ready in the operating room on the top floor and a wheel table stationed outside the door, ready to remove her if necessary. He had left word that at the first evidence of the genuine child-bearing pains, which the nurse understood so well, he was to be called. The house surgeon was to be in immediate charge of the case.

Eugene wondered in this final hour at the mechanical, practical, business-like manner in which all these tragedies—the hospital was full of women—were taken. Miss De Sale went about her duties, calm, smiling, changing the pillows occasionally for Angela, straightening the disordered bedclothes,

adjusting the window curtains, fixing her own little lace cap or apron before the mirror which attached to the dresser, or before the one that was set in the closet door, and doing other little things without number. She took no interest in Eugene's tense attitude or Myrtle's, when she was there, but went in and out, talking, jesting with other nurses, doing whatever she had to do, quite undisturbed.

"Isn't there anything that can be done to relieve her of this pain?" Eugene asked wearily at one point. His own nerves were torn. "She can't stand anything like that. She hasn't the strength."

She shook her head placidly. "There isn't a thing that anyone can do. We can't give her an opiate. It stops the process. She just has to bear it. All women do."

All women, thought Eugene. Good God. Did all women go through a siege like this every time a child was born? There were two billion people on the earth now. Had there been two billion such scenes? Had he come this way? Angela? Every child? What a terrible mistake she had made—so unnecessary, so foolish. It was too late now, though, to speculate concerning this. She was suffering. She was agonizing.

The house surgeon came back after a time to look at her condition but was not at all alarmed, apparently. He nodded his head rather reassuringly to Miss De Sale, who stood beside him. "I think she's doing all right," he said.

"I think so too," she replied.

Eugene wondered how they could say this. She was suffering horribly.

"I'm going into A Ward," he said, "for an hour. If any change comes you get me there."

What change could come, asked Eugene of himself, any worse than had already appeared? He was thinking of the drawing, though, he had seen in the book, wondering if Angela would have to be assisted in some of the grim, mechanical ways indicated there. They illustrated to him the deadly possibilities of what might follow.

About midnight the expected change which Eugene, in agonized sympathy was awaiting, arrived. Myrtle had not returned. She had been waiting to hear from Eugene. Although Angela had been groaning before, pulling herself tense at times, twisting in an aimless, unhappy fashion, now she seemed to spring up and fall as though she had fainted. A shriek accompanied the movement, and then another and another. He rushed to the door but the nurse was there to meet him.

"It's here," she said quietly. She went to a phone outside and called for Doctor Willetts. A second nurse from some other room came in and stood beside her. In spite of the knotted cords on Angela's face, the swollen veins,

the purple hue, they were calm. Eugene could scarcely believe it but he made an intense effort to appear calm himself. So this was childbirth.

In a few moments Dr. Willetts came in. He also was calm, businesslike, energetic. He was dressed in a black suit and white linen jacket, but took that off, leaving the room as he did so, and returned with his sleeves rolled up and his body encased in a long white apron such as Eugene had seen butchers wear. He went over to Angela and began working with her, saying something to the nurse beside him which Eugene did not hear. He could not look—he dared not at first.

At the fourth or fifth convulsive shriek, a second doctor came in, a young man of Willets's age, dressed as he was, who also took his place beside him. Eugene had never seen him before. "Is it a case of forceps?" he asked.

"I can't tell," said the other. "Dr. Lambert is handling this personally. He ought to be here by now."

There was a step in the hall and the senior physician or obstetrician had entered. In the lower hall he had removed his great coat and fur gloves. He was dressed in his street clothes, but after looking at Angela, feeling her heart and temples, he went out and changed his coat for an apron like the others. His sleeves were rolled up but he did not immediately do anything, but stopped to watch the house surgeon, whose hands were bloody.

"Can't they give her chloroform?" asked Eugene, to whom no one was paying any attention, of Miss De Sale.

She scarcely heard but shook her head. She was busy dancing attendance on her very far removed superiors, the physicians.

"I would advise you to leave the room," said Dr. Lambert to Eugene, coming over near him. "You can do nothing here. You will be of no assistance whatsoever. You may be in the way."

Eugene left but it was only to pace agonizedly up and down the hall. He thought of all the things that had passed between him and Angela—the years, the struggles. All at once he thought of Myrtle and decided to call her up—she wanted to be there. Then he decided for the moment that he would not—she could do nothing. Then he thought of the Christian Science practitioner. Myrtle could get her to give Angela absent treatment. Anything, anything—it was a shame that she should suffer so.

"Myrtle," he said nervously over the phone when he reached her. "This is Eugene. Angela is suffering terribly. The birth is on. Can't you get Mrs. Johns to help her? It's terrible."

"Certainly, Eugene. I'll come right down. Don't worry. She'll be all right."

He hung up the receiver and walked up and down the hall again. He could hear mumbled voices—he could hear muffled screams. A nurse, not Miss De Sale, came out and wheeled in the operating table.

"Are they going to operate?" he asked feverishly. "I'm Mr. Witla."

"I don't think so. I don't know. Dr. Lambert wants it to be taken to the operating room in case it is necessary."

They wheeled her out after a few moments and on to the elevator which led to the floor above. Her face was slightly covered while she was being so transferred and those who were around prevented him from seeing just how it was with her, but because of her stillness he wondered, and the nurse said that a very slight, temporary opiate had been administered—not enough to affect the operation if it were found necessary. Eugene stood by dumbly, terrified. He stood in the hall outside the operating room, half afraid to enter. The head surgeon's warning came back to him and anyhow, what good could he do? He walked far down the dimly lit length of the hall before him, wondering, and looked out on a space where was nothing but snow. In the distance, a long, lighted train was winding about a high trestle like a golden serpent. There were automobiles honking and pedestrians laboring along in the snow. What a tangle life was, he thought. What a pity. Here, a little while ago, he wanted Angela to die, and now—God Almighty, that was her voice. He would be punished for his evil thoughts—yes, he would. His sins, all these terrible deeds would be coming home to him. They were coming home to him now. What a tragedy his career was: what a failure! Hot tears welled up into his eyes. His lower lip trembled, not for himself but for Angela. He was so sorry. All at once he shut it all back. No, by God, he wouldn't cry. What good were tears? It was for Angela—his pain was and tears would not help her now.

Thoughts of Suzanne came to him, Mrs. Dale, Colfax, but he shut them out. If they could see him now. Then another muffled scream and he walked quickly back. He couldn't stand this.

He didn't go in, however. Instead he listened intently, hearing something which sounded like gurgling, choking breathing. Was that Angela?

"The low forceps!" It was Dr. Lambert's voice.

"The high forceps." It was his voice again. Something clinked like metal in a bowl.

"It can't be done this way, I'm afraid." It was Dr. Lambert's voice again. "We'll have to operate. I hate to do it, too."

A nurse came out to see if Eugene were near. "You had better go down into the waiting room, Mr. Witla," she cautioned. "They'll be bringing her out pretty soon. It won't be long now."

"No," he said, all at once, "I want to see for myself."

He walked into the room where Angela was now lying on the operating table in the centre of the room. A six globed electrolier blazed close overhead.

On the right side was Dr. Lambert, his hands bloody, totally unconscious

of Eugene. To his right again was Dr. Willetts, holding a scalpel. One of the two nurses was near Angela's feet, officiating at a little table of knives, bowls, water, sponges, bandages. On the left of the table was the second young doctor, whose name Eugene did not know. His hands were arranging some clothes at the side of Angela's body. Miss De Sale was at her head holding a cone near Angela's head, but not over it. An ether bottle was in her hand. Angela was breathing stertorously. She appeared to have fainted or become unconscious. Her mouth was twisted into a pathetic, terrible grimace. Eugene cut his palms with his nails.

So, they have to operate after all, he thought. She is as bad as that. The Caesarean operation. Then they couldn't even get the child from her by killing it. Seventy-five per cent of the cases recorded were successful, so the book said. But how many cases were not recorded? Was Dr. Lambert a great surgeon? Could Angela stand ether with her heart?

He stood there looking at this wonderful picture while Dr. Lambert quickly washed his hands. He saw him taking a small gleaming steel knife— as bright as polished silver. The old man's hands were encased in rubber gloves, which looked bluish white under the light. Angela's exposed flesh was the color of a candle. He bent over her.

"Keep her breathing normal if you can," he said to Miss De Sale. "If she wakes, give her ether. Doctor, you'd better look after the arteries."

He cut softly a little cut just below the centre of the abdomen, apparently, and Eugene saw little trickling streams of blood spring where his blade touched. It did not seem a great cut. A nurse was sponging away the blood as fast as it flowed. As he cut again the membrane that underlies the muscles of the abdomen and protects the intestines seemed to spring into view.

"I don't want to cut too much," said the surgeon calmly—almost as though he were talking to himself. "These intestines are apt to become unmanageable. If you'll just lift up the ends, doctor. That's right. The sponge, Miss Wood. Now, if we can just cut here, enough." He was cutting again like an honest carpenter or cabinet worker.

He dropped the knife he held into Miss Wood's bowl of water. He reached into the bleeding wound, constantly sponged by the nurse, exposing something. What was that? Eugene's heart jerked. He was reaching down now in there with his middle finger—his fore and middle finger afterwards—and saying, "I don't find the leg. Let's see. Ah, yes. Here we have it."

"Can I move the head a little for you, doctor?" It was the young doctor at his left talking.

"Careful! Careful! It's bent under in the region of the coccyx. I have it now, though. Slowly, doctor, look out for the placenta."

Something was coming up out of this horrible cavity which was trickling with blood from the cut. It was queer—a little foot, a leg, a body, a head.

"As God is my judge," said Eugene to himself, his eyes brimming again.

"The placenta, doctor. Look after the peritoneum, Miss Wood. It's alive, all right. How is her pulse, Miss De Sale?"

"A little weak, doctor."

"Use less ether. There, now we have it. We'll put that back. Sponge! We'll have to sew this afterwards, Willets. I won't trust this to heal alone. Some surgeons think it will, but I mistrust her recuperative power. Three or four stitches, anyhow."

They were working like carpenters, cabinet workers, electricians. Angela might have been a lay figure for all they seemed to care. And yet there was a tenseness here, a great hurry, through slow, sure motion. "The less haste, the more speed," popped into Eugene's mind—the old saw. He stared as if this were all a dream—a nightmare. It might have been a great picture like Rembrandt's *The Night Watch*. One young doctor, the one he did not know, was holding aloft a purple object by the foot. It might have been a skinned rabbit, but Eugene's horrified eyes realized that it was his child—Angela's child—the thing all this horrible struggle and suffering was about. It was discolored, impossible, a myth, a monster. He could scarcely believe his eyes and yet the doctor was striking it on the back with his hand, looking at it curiously. At the same moment came a faint cry—not a cry either, only a faint, queer sound.

"She's awfully little, but I guess she'll make out." It was Dr. Willets talking of the baby. A girl baby! Now the nurse had it. That was Angela's flesh they had been cutting. That was Angela's wound they were sewing. This wasn't life. It was a nightmare. He was insane and being bedeviled by spirits.

"Now, doctor, I guess that will keep. The blankets, Miss De Sale. You can take her away."

They were doing lots of things to Angela, fastening bandages about her, removing the cone from her mouth, changing her position back to one of lying flat, moving her to the rolling table, wheeling her out while she moaned, unconscious in her ether. Eugene could barely stand the sickening, stertorous breathing. It was such a strange sound to come from her—as if her unconscious soul were crying.

Oh, God, what a life, what a life! he thought. To think that things should have to come this way. Death! Incisions! Unconsciousness! Pain! Could she live? Would she? And now he was a father.

He turned and there was the nurse holding this littlest girl on a white gauze blanket or cushion. She was doing something to it—rubbing oil on it.

"That isn't so bad is it?" she asked consolingly. She wanted to restore Eugene to a sense of the commonplace. He was so distracted looking.

Eugene stared at it. A strange feeling came over him. Something went up and down his body from head to toe, doing something to him. It was a nervous, titillating, prickling feeling. He touched the child. He looked at its hands, its face. It looked like Angela. Yes, it did. It was his child. It was hers. Would she live? Would he do better? Oh, God, to have this thrust at him now—and yet it was his child. How could he? Poor little thing. If Angela died—if Angela died, he would have this and nothing else—this little girl. Out of all her long, dramatic struggle, if she died, came this—to do what to him? To guide? To strengthen? To change? He could not say. Only, somehow, in spite of himself, it was beginning to appeal to him. It was so little. Yes, it was. He was so sorry for it, for Angela, for the pathetic tragedy that had brought it about. It was the child of a storm. And Angela—so near him now—would she ever live to see it? There she was unconscious, numb, horribly cut. Dr. Lambert was taking a last look at her before leaving.

"Do you think she will live, doctor?" he asked the famous surgeon feverishly.

The latter looked grave.

"I can't say. I can't say. Her strength isn't all that it ought to be. Her heart and kidneys make a bad combination. However, it was a last chance. We had to take it. I'm sorry. I'm glad we were able to save the child. The nurse will give her the best of care."

He went out into his practical world as a laborer leaves his work. So may we all. Eugene went over and stood by Angela. He was tremendously sorry for the long years of mistrust that had brought this about. She was so little, so pale, so worn. Yes, he had done this. He had brought her here by his lying, his instability, his uncertain temperament. It was fairly murder from one point of view and up to this last hour he had scarcely relented. Now, now—oh hell! Oh, God damn! If she would only recover. He would try and do better. Yes, he would. It sounded so silly coming from him, but he would try. Love wasn't worth the agony it cost. Let it go. Let it go. He could live. Truly there were hierarchies and powers, as Alfred Russell Wallace had pointed out. There was a God somewhere. He was on his throne. These large, dark, immutable forces—they were not for nothing. If she would only not die, he would try—he would behave. He would! he would!!

He looked at her but she looked so weak, so pale now, he did not think she could come round.

"Don't you want to come home with me, Eugene?" said Myrtle, who had come back sometime before, at his elbow. "We can't do anything here right now. The nurse says she may not come out for several hours. The baby is all right in their care."

The baby, the baby! He had forgotten it, forgotten Myrtle! He was thinking of the long, dark tragedy of his life—the miasma of it.

"Yes," he said wearily. It was nearly morning.

He went out and got in a taxi and went to his sister's house but in spite of his weariness he could scarcely sleep. He rolled feverishly. In the morning he was up again early anxious to go back and see how Angela was—and the child.

CHAPTER CIV

The trouble with Angela's system, in addition to a weak heart, was that it was complicated at the time of her delivery by that peculiar manifestation of nervous distortion or convulsion known as eclampsia. Once in every five hundred mothers (or at least such was the statistical calculation at that time) some such malady occurred to reduce the number of the newborn. In every two such terminations one mother also died, no matter what the anticipatory preparations were on the part of the most skilled surgeon. Though not caused by, it was diagnosed by certain kidney changes. What Eugene had been spared when he was out in the hall was the sight of Angela staring, her mouth pulled to one side in a horrible grimace, her body bent back, canoe shape, the arms flexed, the fingers and thumb bending over each other to and fro, in and out, slowly, not unlike a mechanical figure that is running down. Stupor and unconsciousness had quickly followed, and unless the child had been immediately brought into the world and the womb emptied, she and it would have died a horrible death.

As it was she had no real strength to fight her way back to life and health. A Christian Science practitioner was trying to "realize her identity with good" for her, but Angela had no faith before and no consciousness now. The ether had affected her heart. She came to long enough to vomit terribly—then sunk into a fever. In it she talked of Eugene. She was in Racine evidently, and wanted him to come back to her. He held her hand and cried, for he knew that there was never any recompense for that pain. What a dog he had been. He bit his lip and stared out of the window.

Once he said, "Oh, I'm no damned good. I should have died."

That whole day went without consciousness and most of that night. At two in the morning Angela awoke and asked to see the baby. The nurse brought it. Eugene held her hand. It was put down beside her and she cried for joy, but it was a weak, soundless cry. Eugene cried also.

"It's a girl, isn't it?" she said.

"Yes," said Eugene. "Angela, I want to tell you something. I'm so sorry. I'm ashamed. I want you to get well. I'll do better. Really I will."

She caressed his hand. "Don't cry," she said. "I'll be all right. I'm going to get well. We'll both do better. It's as much my fault as it is yours. I've been too hard." She worked at his fingers but he only choked. His vocal chords hurt him.

"I'm so sorry. I'm so sorry," he finally managed to say.

The child was taken away after a little while and Angela was feverish again. She grew very weak—so weak that although she was conscious later, she could not speak. She tried to make some sign. Eugene, the nurse, Myrtle understood. The baby! It was brought and held up before her. She smiled a weak yearning smile and looked at Eugene.

"I'll take care of her," he said, bending over her. He swore a great oath to himself. He would be decent—he would be clean henceforth and forever. The child was put beside her for a little while but she could not move. She sank steadily and died.

Eugene sat by the bed, holding his head in his hands. So, he had his wish. She was really dead. Now he had been taught what it was to fly in the face of conscience, instinct, immutable law. He sat there an hour while Myrtle begged him to come away.

"Please, Eugene," she said, "Please."

"No, no," he replied. "Where shall I go? I'm well enough here."

After a time he did go, wondering how he should adjust his life from now on. Who would take care of—of——

"Angela," came the name to his mind.

Yes, he would call her Angela. He had heard some one say she was going to have red hair.

* * *

The rest of this story is a record of philosophic doubt and speculation with a slow return to a normal point. As a matter of fact, he reached a metaphysical basis of peace. For a time that spring and summer, while Myrtle looked after little Angela—he went to live with Bangs and his wife—Eugene visited his old Christian Science practitioner. He had not been much impressed with the result in Angela's case, but Myrtle explained the difficulty of the situation in a plausible way. He was in a terrific state of depression, and it was while he was so that Myrtle persuaded him to go again. She insisted that Mrs. Johns would overcome his morbid gloom, anyhow, and make him feel better. "You want to come out of this, Eugene," she pleaded. "You will never do anything until you do. You are a big man. Your life isn't over. It's just begun. You're going to get strong and well again. Don't worry. Everything that is, is for the best."

He had thought of Suzanne since, but only with the feeling that he must give her up. There was no decency in that record. No manhood. He had little Angela now. He could work at his art.

He went once, quarreling with himself for doing so, for in spite of his great shocks, or rather because of them, he had no faith in religious conclusions of any kind. Angela had not been saved. Why should he?

A period of nearly four years will have to be added here, during which time all the vagaries and alterations which can possibly afflict a groping mind were his. He went from what might be described as almost belief in Christian Science to what might well be called quite the contrary. The mystery of life still puzzled him and it did not help him any that clear theories were laid down as to its interpretation. Still some things remained out of the debris. His metaphysical tendencies were strengthened by reading, and this in itself was a gain. Altogether he was changed notably and it is unquestionable that he was stronger and broader for what he had suffered, seen, and endured. His eyes were sadder—notably so. Angela second was very sweet. She was a bright little thing whom Myrtle raised for him with great care. She took a great fancy to the child because of its bright eyes and red hair. "She's going to be a little tartar, Eugene," she said to him often and Eugene replied, "I'll manage her. I owe her some attention."

He was painting these days, trying to assemble material for another exhibit which he thought would restore him in the eyes of the world. A good collection of pictures was always a notable thing. It would be distinguished coming from him, for he was very virile. He worked hard because he was lonely and because when he thought, remorse and some old longings were apt to seize on him.

It was while this was going on, month in and month out, during the time mentioned, that Suzanne was travelling abroad with her mother. She was in England, Scotland, France, by turns—Egypt, Italy, Greece. Eugene heard nothing from her. She heard nothing from him. He was satisfied, now that he had seen what had resulted, that that lure was properly over—or ought to be at least; he was not absolutely sure. There were so many sweet phases to think about, though, that it was difficult to overcome them, but he tried. He must give his thoughts to something better and higher, he thought, but what was higher and better than those two eyes of hers which haunted him at times?

Suzanne, on her part, was thinking of him—his affection—as the most astonishing thing in her life. She had never met anyone like him before and no one since. Gentlemen of title and military training, of countries abroad, and Americans of the first, second, and third generation of wealth assailed her for the purpose of winning her heart, but she was not interested. She had been too much impressed to recover quickly. By the end of the first

year the news of Angela's death was conveyed to her accidentally and then, unknown to her mother, she sat down and wrote him the following letter:

"Dear Eugene:

"I can still call you that, I suppose. Today, for the first time, I learned of Mrs. Witla's death. I am very sorry. I know that you must feel greatly depressed. Since we have been apart I have had time to think and I feel now that we were hasty and rather selfish. I have regretted my share in your troubles—not my affection for you though—and I suppose you have also. Still, I want you to know that I am sorry and that I wish you from now on every happiness in life.

"Suzanne Dale.

"The Villa Szenza
"Peruggia, Italy."

Eugene thought for a long time on receipt of this what he should do about it. It stirred up sharp memories and aches and longings, but somehow the worst of the fire was gone out of them. At least he could endure them better. Midst all his burning longings in the past, he had been resentful toward Suzanne for having abandoned him. There seemed a touch of heartlessness in it which even her youth and the pressure put upon her could not excuse. This reference to regret did not modify that. Besides, there was little Angela to look after. Would Suzanne make a good mother to her? Did he want to complicate his life with a union with her now? He had wanted so much to share that high social world with her to which she belonged but now somehow the salt had lost its savor. His old longing for country inns, showy friends, a lavish expenditure of money, was not so keen. Since Angela's death some of his affairs were looking better—his Blue Sea interests, for one thing—and he was expecting to make some little money as a painter. He was satisfied that he was going to strengthen his reputation in that field.

He meditated a week and then wrote her as follows:

"Dear Suzanne:

"I have your letter which you so kindly wrote me and for which I am sincerely grateful. Suzanne, so many things have happened in my life since last we met and before, that I can scarcely look on life as I did, or feel as I once felt. Mrs. Witla's death was a great blow to me, strange as it may seem. It opened my eyes to a number of things, not the least of which was my own selfishness, of which you spoke. I was selfish—terribly so. I see it now. I am still—not so much better, but, Suzanne, I am different. Life does not look the same. Once I thought love was all—desire. I see other qualities now which I have hitherto ignored.

"You did not know perhaps—your letter does not mention it—that

Mrs. Witla left me a little girl, also named Angela. I am very fond of her. I hope to make her a good father. I am painting again; expect to give an exhibition in the fall. I have not tried to venture into commercial affairs again—I have not had the heart—but I may. Up to this time my pictures have kept me busy. I hope you are well and happy. I truly wish you every joy through time to come. I hope we shall be friends. You have some letters of mine. If you have not destroyed them, will you, and I will return or destroy yours as you suggest.

<div style="text-align:right">"With sincere affection,
"Eugene."</div>

He mailed this to her Italian address, wondering how it would impress her. He had honestly tried to say what he felt.

Suzanne read this weeks later, marvelling at the change. No doubt it was best. They had been wild, impractical. Still—still. Someday they would probably meet again. The fact that he had become so stable, so calm, made him even more interesting. He was returning to art. She would probably hear of his pictures. As he requested, she sent him his letters.

During the next two years there was still more of his continued interest in Christian Science, though in a way it was a waning force. His was a peculiar personality. He saw, or thought he saw, the significance of the truth emphasized by Mrs. Eddy but it seemed as time went on as though it had merely served to call his attention to or emphasize a truth which he had known or suspected all his life. God was a spirit, certainly. Our instincts to live and fulfill certain laws were probably bound up with an immutable destiny which was from everlasting to everlasting and had no more proper representation in one religion than another. Whatsoever things were of good report, whatsoever things were pure, were probably best in accord with immutable law. He recurred to Alfred Russel Wallace's hypothesis with more interest, and although he occasionally went to church, sometimes quite frequently, he held strongly to this semi-religious agnosticism.

And curiously, for a time, even while he was changing this way, he went back to see Mrs. Johns, principally because he liked her. She seemed to be a motherly soul to him, contributing some of the old atmosphere that he had enjoyed in his own home at Alexandria. This woman, from working constantly in the esoteric depths which Mrs. Eddy's book suggests, demonstrating for herself, as she thought, through her belief in an understanding of the oneness of the universe (its non-malicious, affectionate control, the non-existence of fear, pain, disease and death itself), had become so grounded in her faith that evil positively did not exist, save in the belief of mortals, that she almost convinced Eugene that it was so. He speculated long and deeply along these lines with her.

The universe was to her, as Mrs. Eddy said, spiritual, not material, and no wretched condition, however seemingly powerful, could hold against the truth—could gainsay divine harmony. She looked at Eugene's case as she had at many another similar thing, being sure in her earnest way that she, by realizing his ultimate, basic spirituality, could bring him out of his mortal illusions and make him see the real spirituality of things, in which the world of flesh and desires had no part.

"'Beloved,'" she loved to quote to him, "'now are we the sons of God, and it doth not yet appear what we shall be, but we know that, when he shall appear'" (and she explained that *he* was this universal spirit of perfection of which we are a part), "'we shall be like him, for we shall see him as he is.

"'And every man that has this hope in him purifieth himself even as he is pure.'"

She once explained to him that this did not mean that the man must purify himself by some hopeless mortal struggle, but rather that the fact that he had this hope of something better in him would purify him in spite of himself.

"You laugh at me," she said to him one day, for in spite of all her physical defects he had come to like her very much, leaning on her in his misery quite as a boy might on his mother, "but I tell you you are a child of God. There is a divine spark in you. It must come out. I know it will. All this other will fall away as a bad dream. It has no reality."

She would sit and discuss Christian Science with him, arguing about its tenets, demonstrating her beliefs by her experiences. "Whatever you may say," she would reply to his cutting criticism, "I know what I have done by the will of God—not mine, but God's. I have seen cancer healed in this room in thirty minutes. I have known a seemingly terrible goitre to pass away in a day. There is no use arguing about these things. My God—your God—our God acts. He will act for you when you let him."

She even went so far in a sweet, motherly way as to sing hymns and now, strange to relate, her thin voice was no longer irritating to him, and her spirit made her apparently beautiful in his eyes. He did not try to adjust the curiosities and anomalies of material defects that presented themselves. The fact that her rooms were anything but artistically perfect; that her body was shapeless or comparatively so when contrasted with that standard of which he had always been so conscious; the fact that whales were accounted by her in some weird way as spiritual, and bugs and torturesome insects of all kinds as emanations of mortal mind, did not trouble him at all. There was something in this thought of a spiritual universe. The five senses certainly did not indicate its totality: beyond them must be depths upon depths of wonder and power. Why might not this act? Why might it not be good?

That book that he had once read, *The World Machine,* had indicated this planetary life as being so infinitesimally small that from the point of view of infinity it was not even thinkable—and yet here it appeared to be so large. Why might it not be, as Carlyle had said, a state of mind, and as such so easily dissolvable? These thoughts grew by degrees in force and power.

It is not possible to indicate just when or how he came to realize within himself the significance of this. It was a matter of intellectual evolution or devolution, and it had after all no close relation with Christian Science as a revealed religion. The scientific statement of being as laid down by Mrs. Eddy—"There is no life, truth, intelligence, nor substance in matter. All is infinite Mind and its infinite manifestation, for God is All-in-All"—gripped him firmly. He quoted the remainder of this to himself often: "Spirit is immortal truth; matter is mortal error. Spirit is the real and eternal; matter is the unreal and temporal. Spirit is God, and man is His image and likeness. Therefore man is not material; he is spiritual."

This last pleased him immensely. It accorded with his understanding of life, his idealism. He thought of Francis Thompson's poem and of Wallace's theory of the universe, as demonstrating scientifically his faith.

Meanwhile, time was drifting by and he was regaining much of his old form as a painter. He gave one exhibition at Kellner's which was notably received and commented on, and undertook the decoration of a bank building at M. Charles's suggestion, for the latter was back in New York and glad to see Eugene so much interested in art again. He predicted a notable career for him if he still persisted. Eugene spent much of his time with his sister Myrtle, occupying a studio in the daytime in Fifty-fifth Street, but later he decided to build himself a bungalow studio on his lot in Upper Montclair, where some other artists whom he knew were located. He needed better working facilities for the execution of his large panels, which he sometimes did on canvas, than he could obtain where he was.

He was walking one day in Fifth Avenue some two years later, speculating on life and its vicissitudes as exemplified by his particular career, when, as he neared Thirty-fourth Street, a voice greeted him.

"Why Mr. Witla!" He recognized it instantly. It was Suzanne's. A strange thrill ran down his spine. She was crossing from a shop to an automobile.

"Suzanne!" was all he said.

He looked at her, trying to find the old expression of half awake girlhood that had entranced him. It was gone, or almost so. Four years of travel, observations, friendships, had taken away that uncertain understanding of things and replaced it with a kind of sophistication that was still sweet but not so sweet. He added, after his first searching glance,

"This is a surprise! I *am* glad to see you. And how have you been?"

"Oh, practically the same."

"Quite the same?" he looked into her eyes.

"Yes, I think so."

"And where is your mother?"

"At Lenox today. Mamá trusts me more than she used to. She has given me a wider range of freedom." She laughed her old girlish laugh, but not so gaily. There was the least bit of restraint in it now.

Suzanne was a little nervous, for somehow she expected something tense or significant to manifest itself, but Eugene was only cool now and smiling. He had himself well in hand.

"I am glad of that." His tone was almost fatherly. "You are wise enough, in all conscience. And where are you staying?"

"Oh, down at Dalewood for the time being. I am hostess in mamá's absence."

Eugene smiled a little at the mention of the name. Dalewood! But the word did not hurt him.

"I have been working rather hard since I saw you, Suzanne," he explained, because he thought she would wish to know. "I had a great deal of work to do, preparing the pictures I exhibited last year, and I have been busy ever since on public buildings—theatres and a bank. I'm going in for state capitols and libraries, I think. I appear to be drifting that way—it sounds odd for me, doesn't it?"

"No, I don't think so at all, Mr. Witla," Suzanne replied warmly. She was looking shyly at his eyes and his hair. He was still attractive to her. "It sounds just like you. I saw some of your pictures in London. They are beautiful."

"Thank you, Suzanne."

"Is your little girl well?"

"Oh, she's fine. She's beautiful. I wish you might see her sometime. She has the most wonderful red hair!"

Suzanne smiled.

"I have a studio out at Montclair. People drop in occasionally to see me. If it weren't for the old feeling which I fancy your mother may retain, I would ask you to come out sometime—bring some of your friends."

Suzanne felt that there was no unbridled passion in this, only friendship. And it was a little sad. Could it really be that all was over between them?

"I'll be very pleased," she replied. "I surely will."

She extended her hand.

He took it easily and shook her a genial farewell. She went her way, entering quickly into her machine, and he continued his walk. So this was Suzanne, as beautiful as ever, or nearly so—not quite the same sweet, girlish soul, but nearly so. And it was four years! What was she thinking? What

ought he, in honor, be thinking? He ached a little in spite of himself, but did his best to keep sane and calm as he had so long promised himself he would.

Suzanne in her machine was thinking also. What a change, not so much physically as spiritually. He was a little gray now about the temples—he had not been so when they had parted—and his eyes were sadder, she thought, deeper set. He was quieter, too; more subdued. But why shouldn't he be? Angela was dead. She recalled that terrible night when they had been discovered together by her and she trembled a little for shame and fear—for the tragic outcome of it all. It was terrible, truly. Still, this re-encounter would give her no peace. Where was his studio? He had asked her to come. Sometime she would go, surely. She could find it. And he—would he really be very glad to see her? She wondered.

It was almost a month later that chance gave her the desired opportunity. She was in Montclair and she inquired of a drug man, stepping out of her machine, whether there were a directory which would help her to find what she wanted. He brought her one quickly. Yes, there it was. Eugene Witla. 125 South Maywood. She gave her driver the number. The machine (a bright purple body) sped away, and soon they were there. It was a sunny fall afternoon. The leaves were already turning a lovely combination of yellows, reds, browns, and golds. Some of them looked like pretty golden lamps or chalices glowing with a soft radiance.

"So here it is," she said, looking up as the driver turned into a blue gravel roadway which ran under drooping branches to a brown and gray bungalow structure, obviously of studio proportions and arrangement. A great, slanting, many-paneled north window told of the necessary north light.

When the machine stopped she stepped out and knocked lightly.

"*Entrez!*"

The voice thrilled her.

She knocked a little less vigorously.

"*Entrez!*"

Seeing that he was not coming, she opened the door.

"Oh!" he exclaimed, for he was up on a swinging bridge before a high panel representing a tower of the Brooklyn Bridge with a vision of the bay beyond. His palette was under his thumb, his corduroy trousers streaked with many colored paints. His coatless torso was encased in a light brown wool shirt, open at the neck, with the sleeves rolled up. His hair was tousled and dusty. He threw down his palette and leaped to the floor.

"I didn't think it could be anyone but Henry, my assistant. He comes about this time of day." He held out his hands—both of them.

"You expected Henry," she said nervously.

She was a little pale now and her adventure seemed quite too much of one. She had only given him one hand but he still waited for the other—holding it hopefully toward her.

"Suzanne!"

"Yes?"

Her eyes opened in their old, wide, unsophisticated way.

"You came!"

"Yes—but——!"

"Oh, I'm so glad!"

He still held the idle left hand extended, studying her pretty, nervous, quizzical face eagerly, and as he did so she put her uncertainty right into it. Her eyes were agaze with half an inquiry, half a fear.

"Suzanne!"

"Yes."

"You love me then?"

"Oh, yes! yes! yes!"

And with that old time cry that brought back a lost paradise to him, she yielded herself to his eager, unregenerate, and love-tortured arms.

L' ENVOI.

There appears to be in metaphysics, for those so temperamentally inclined, a basis for ethical and moral reflection. It may seem rather beside the mark that Eugene, in his peculiar moral and physical depression, should have inclined to these religious abstrusities—but any port in the storm. It was a refuge from himself, his own doubts and despairs. As he grew stronger and calmer, these metaphysical depths did not lure him so much from the point of view of refuge as from the point of view of beauty. It was beautiful now to think of the universe as being good, not evil; of this visible scene as being an idea, a notion, an illusion having no basis in fact. It is so easy to prove so many things to be illusions anyhow. It is so easy to point to a tree or a stone or house or and art and say, "it evolved from what?" "Natural selection," answers the scientist. Aye! Aye! "And what provides that?"

"A will to live!"

So we are back to thought, and space, and illimitable mind, and we shall stay there, attributing to it those things that we feel (some would have it subconsciously know) to be true. You saw an artist here now enjoying to read the Bible—following Kant and Spinoza, Maeterlinck and Bergson with

great interest. Those metaphysical poems which one person and another will persistently write always appealed to him, and once he and Suzanne were married, which had occurred six months later, he would walk with her, brooding over the mutations of time and force, and finding for the time being the keynote of joy for him in the beauty of her face and body and the sweetness of her temperament. Curiously, in spite of their strange and rather extended estrangement, there was a basic unity of soul here which held them together. She was like him and he was like her, meditative, philosophic, introspective. She had thought definitely to forget him, but it was not to be. They talked and talked of their estrangement—of all its peculiar ramifications—and their conclusion was that they were made for each other.

"Honey pot," he said once, "it was to be, after all."

"Yes. I'm sure of it. I always felt so. I always felt things would come out right. I don't know why."

He found great aid in the subtleties of her mood, for though she could not express herself as well, she would stumble upon thoughts and expressions which aided him greatly. Her criticism of his art was most valuable.

There was one incident which showed his intellectual drift clearly, and then this story is over. It has no connection with Christian Science as a belief, though practically it was an outgrowth of that and his long, dark speculations.

He was stirring around in his books one night before going to bed seeking something to read when in passing from volume to volume he came across Spencer's *Facts and Comments*, which, because of his one time fondness for it and its great depth of philosophic insight, he took down. In turning the pages idly, he happened on these paragraphs among others which he read, which interested him because he felt it expressed something which in his case had been superseded by something better:

"Beyond the reach of our intelligence as are the mysteries of the objects known by our senses, those presented in this universal matrix are, if we may so say, still further beyond the reach of our intelligence; for whereas those of the one kind may be, and are, thought of by many as explicable on the hypothesis of Creation, and by the rest on the hypothesis of Evolution, those of the other kind cannot by either be regarded as thus explicable. Theist and Agnostic must agree in recognizing the properties of Space as inherent, eternal, uncreated—as anteceding all creation, if creation has taken place, and all evolution, if evolution has taken place.

"Hence, could we penetrate the mysteries of existence, there would still remain more transcendent mysteries. That which can be thought of neither as made nor evolved presents us with facts, the origin of which is even more

remote from conceivability than is the origin of the facts presented by visible and tangible things. . . .

"The thought of this blank form of existence which, explored in all directions as far as imagination can reach, has, beyond that, an unexplored region compared with which the part which imagination has traversed is but infinitesimal—the thought of a space compared with which our immeasurable sidereal system dwindles to a point, is a thought too overwhelming to be dwelt upon. Of late years the consciousness that without origin or cause infinite Space has ever existed and must ever exist, produces in me a feeling from which I shrink."

"Well," he said, "that thought could never trouble me anymore. I think it is full of kindly wisdom," and he closed the book. He arose and stirred the fire in the fireplace which had been lit for him, for it was a chilly night. He sat before the blaze, thinking back over his life and his youth. Yes, he was truly changed. Life was no longer the thing it once had seemed. It was calmer, sweeter. "There is a ruling power," he said. "It rules all—is all, and it is not malicious."

He went out on his porch and looked up at the stars. It was a clear night, cool, brilliant. The autumn leaves were not all down yet.

"Somewhere in that—in *this*," he corrected himself, thinking of space, "is Angela—an idea in this universal, circumambient, intelligent control. She is as safe as I am—no more so, no less so." "He that doeth His will in the army of the heavens," he quoted.

Then turned after a time and went in.

"Eugene?" called Suzanne.

"Yes, I'm coming, sweet."

Historical Commentary

ABBREVIATIONS

DPCU Theodore Dreiser Papers, Special Manuscript
Collection, Columbia University Libraries

DPUP Theodore Dreiser Papers, University of
Pennsylvania

TD Theodore Dreiser

TSA Typescript A, in Theodore Dreiser Papers,
University of Pennsylvania

TSB Typescript B, in Theodore Dreiser Papers,
University of Pennsylvania

THE COMPOSITION OF THE GENIUS:
THE 1911 VERSION TO PRINT

The composition of *The Genius* was a defining moment in Dreiser's development as a writer. Dreiser's correspondence in 1910 and 1911 indicates that he began organizing the novel in late 1910. In later years, however, he complicated the issue of the novel's origins. In a 1943 letter to H. L. Mencken, Dreiser claimed to have begun *The Genius* in 1903, writing thirty-two chapters before burning them "in order to do *Jennie Gerhardt*."[1] It is impossible to know exactly when the idea for the novel originated; what is clear, however, is that Dreiser began writing a novel called *The Genius* between late 1910 and the early summer of 1911. In December 1910 he related the plot to his friend Mary Fanton Roberts, then the editor of the art and design magazine *Craftsman*.[2] Dreiser probably began writing the novel in December or January, after he finished the first draft of *Jennie Gerhardt*. He worked on the manuscript steadily, apparently without any writer's block such as had plagued him with *Sister Carrie* and *Jennie Gerhardt*.

The holograph, which serves as the basis for this edition, is written in Dreiser's hand in black ink, on unlined nine-by-eleven sheets of paper, and consists of approximately 3,500 pages. Chapters I through CIV appear to have been composed steadily with no interruption.[3] Some corrections and additions were made on the holograph, in ink, pencil, and occasionally blue crayon, mainly in Dreiser's hand in the process of reviewing his holograph as he wrote. An occasional penciled-in note appears from typists, but the manuscript is otherwise continuous and clear.

By the end of February 1911, Dreiser wrote Mencken that he was "half through" the novel, and in April informed him it would be called *The Genius* and published by Harper & Brothers. A week later, he reported that the novel "draws to a close. It's grim, I'm sorry to state, but life-like."[4] This assessment suggests that by April, Dreiser was working on the episode of Angela's death during childbirth, though this climactic scene remained a work in progress for some time. In June, the book reviewer Eleanora O'Neill, one of the first to read *The Genius* in manuscript, praised the novel but urged Dreiser, "Don't hurry with Angela. . . . That's a tremendous possibility in art you are handling. Do it carefully. Get some Doctor to let you in to some such case in town." Dreiser apparently followed her advice. In late June, he received two letters from a friend who had written articles on infant care for him at the *The Delineator*. Dr. Leonard Keene Hirshberg provided detailed information about the birth process, which he referred to

as the "foetus [entering] into this Dreiserian vale of wailing and gnashing of coin." Hirshberg also offered constructive criticism after reading the chapter detailing Angela's difficult labor: "Are you kidding me or yourself about that 'probang'. That damn thing is used at the other end, to wit the esophagus. It is used to push back, not to pull out; savez? It is thus the antithesis of the obstetrical forceps." Dreiser crossed off "pro-bang" from holograph Chapter CIII and rewrote the passage, also changing the "essential implements" to read as they do in the present edition (726).[5]

Dreiser also took Hirshberg's advice in crafting the scene of Angela's death. A second letter from the doctor in late June provides further instruction in obstetrics, this time presented in narrative form. Hirshberg invents a doctor named "Pullemowt" (Pull 'em out). This fictitious doctor explains eclampsia (an attack of convulsions during the birth process) to a medical student: "Though not caused by it, yet we diagnose eclampsia by certain kidney changes." Dreiser uses this explanation, practically verbatim, to account for Angela's impending death (735). That example marks only one of several passages from the beginning of Chapter CIV that Dreiser lifted from Hirshberg's letter. The doctor opined that "[i]t would be more dramatic possibly to describe the heroine, than to recite it this way to the medical student. I leave that to your superior art."[6] Dreiser, however, evidently felt he could not improve on his friend's medical descriptions.

By July 1911, Dreiser had completed the manuscript and mailed it to his typist, Decima Vivian. In August, it was still "being typewritten slowly," but by the middle of October, Dreiser could report that "*The Genius* . . . is now lying on ice, all nicely typewritten, awaiting its turn."[7] He had by this point completed a novel that would undergo substantial transformation during the four years before its publication as The "*Genius*" in October 1915.

The subsequent history of the novel is as tangled as are Dreiser's reasons for delaying revision of the 1911 text until 1914–1915. Many factors contributed to his not pressing for publication in 1911. For one thing, typescripts and carbons were lost, necessitating a complete retyping of the manuscript at least once, and possibly twice. In the process, the text went through many hands, most of them introducing substantial editorial changes or recommending detailed alterations that conflicted with each other. As was his habit, Dreiser had circulated copies among various readers to elicit responses and editorial suggestions. During December 1912, he visited Chicago and gave a carbon copy to William Lengel, his former secretary and devoted admirer from *The Delineator* days. Lengel passed the carbon on to several other readers, including Ray Long, editor of *Red Book*, and the poet Edgar Lee Masters, before mailing it back to Dreiser in New York in May

1912. This copy was lost in the mail, or perhaps (as Dreiser later maintained) destroyed by his estranged wife Sara, who had intercepted it.[8] How often the manuscript had to be retyped is uncertain. In the summer of 1913, Dreiser reported to Mencken that the novel needed retyping at a cost of $135. Almost a year later, Dreiser told Mencken the retyping was nearly complete, now complaining of a cost of $175. Furthermore, letters from a typist suggest that chapters were lost along the way and had to be replaced.[9]

Whatever problems such mishaps may have produced, the vagaries of mail service and bad luck were not the chief causes of the delay in publication. W. A. Swanberg speculates that Harper & Brothers, then Dreiser's publisher, was not inclined to take the novel because of its dubious moral content, but that seems less likely for the 1911 text than for the 1915 version. Moreover, there is some question as to whether a typescript was ever submitted to Harper's. Robert Elias maintains that Harper's wanted to publish the Cowperwood books, rather than The "Genius", as the sequel to *Jennie Gerhardt*,[10] and Dreiser's correspondence with Harper's corroborates that the publisher was more interested in publishing a historical novel about a financial tycoon than a book centered on the career of an artist.[11]

While Harper's editors likely voiced their opinion about what Dreiser's next book should be, the novelist himself seems to have had reasons for withholding publication.[12] In 1913 he told Lengel that The Genius "can't be published for two years anyhow—possibly three." Because the roots of the novel lay partially in recent personal scandals, Dreiser likely felt the novel could be too revealing—or perhaps that in its initial incarnation, The Genius might reveal aspects of his personality that he would prefer to conceal. As Dreiser would advise Ludwig Lewisohn when he sought to publish his own autobiographical novel well more than a decade later, "It is hard for any of us to stand on the sidelines and view ourselves with impartiality, but is that not necessary in transcribing our temperaments to fiction?" Dreiser then exaggerated his own patience: "I myself waited eight years before The 'Genius'."[13] In addition to wanting to achieve an impartial perspective on his autobiographical novel, Dreiser was sensitive about exposing people he knew, especially women, in his writings. (For the same reasons, he held up publication of his autobiography *Dawn* until 1931, although he had completed the text in 1914.) Moreover, Dreiser's depiction of Eugene's sexual encounters with numerous women made a delay in publication advisable, lest Dreiser face the wrath of his estranged wife Sara (the model for Angela Blue) or other women.

Perhaps the most important factor that contributed to Dreiser's hesitation to publish The Genius as he composed it in 1911 was his understanding

that the novel would draw comment for its autobiographical revelations, thus assuming a major role in defining his reputation. Still unsure whether he wanted to check his growing reputation as an "immoral" novelist or to court it, Dreiser was obsessive in his need to gather critical scrutiny of the novel. A flurry of effort to garner readers' reactions occurred in 1913. Dreiser told Lengel that he had accumulated "six or seven or eight reviews," enough to marvel at "how easy it is for people to disagree utterly."[14] He asked Lengel's advice about how to interpret the contradictory readings: might Floyd Dell, an editor of *The Masses*, and Lucian Cary, a Chicago newspaper critic, both of whom had responded negatively, be influenced by earlier reviews of his novels? And what did Lengel anticipate Mencken would think of *The Genius*? Recalling positive reactions (particularly by women readers, such as Eleanora O'Neill or, more recently, Anna P. Tatum), Dreiser reminded Lengel that others had urged him not to make any major alterations. Downplaying his own concerns that the novel might be too self-revelatory, Dreiser chided his former assistant for interpreting the manuscript autobiographically: "I have to smile when I read of 'the pain it caused' me. You don't know how practically I went about it or how cheerfully it was executed."[15]

Dreiser's indecision about his manuscript is most clearly reflected in his hesitation to show *The Genius* to H. L. Mencken, the critic whose word could most influence public opinion and whose judgment Dreiser especially respected. Mencken did not see the manuscript until November 1914, when Dreiser sent the first of two installments, the second to follow in the next month. Dreiser had long before promised Mencken (in October 1911) that he would soon mail *The Genius,* and the Baltimore critic offered several times to cast his "strange eye" over the novel, but Dreiser held it back for three years. As it turned out, Dreiser was correct in anticipating what would become their legendary disagreement over the merits of the novel.[16]

The history of the novel published in 1915 as *The "Genius"* is worth rehearsing because it sheds light on how that edition differs from the version Dreiser completed in 1911. How *The Genius* progressed from handwritten manuscript to first edition was explored first by Joseph Katz in 1971 and more fully by Louis Oldani in 1994. Both Katz and Oldani speculated, however, about documents that are not extant, including page proofs and missing typescripts.[17] The following stemma reflects what can be ascertained from the surviving documents about the composition of the historical novel:

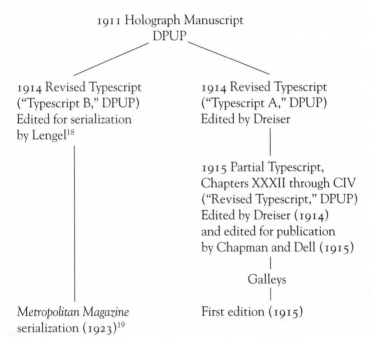

1911 Holograph Manuscript
DPUP

1914 Revised Typescript
("Typescript B," DPUP)
Edited for serialization
by Lengel[18]

1914 Revised Typescript
("Typescript A," DPUP)
Edited by Dreiser

1915 Partial Typescript,
Chapters XXXII through CIV
("Revised Typescript," DPUP)
Edited by Dreiser (1914)
and edited for publication
by Chapman and Dell (1915)

Galleys

Metropolitan Magazine
serialization (1923)[19]

First edition (1915)

In addition to the first edition published by John Lane in 1915, five texts in
various stages of completion survive, all of them held by the Dreiser Collec-
tion at the University of Pennsylvania. The 1911 holograph is a complete
document, representing Dreiser's original conception of the novel. In addi-
tion, three typescripts exist, all of them showing revisions and postdating
the period of the 1911 holograph.[20] (Correspondence makes clear that there
were typescripts and carbons from the 1911 period, but none of these sur-
vive.) Two of the extant typescripts have been catalogued as Typescript A
and Typescript B. From Chapter I through LXXVII, most of the sheets in
Typescript A and Typescript B are identical, including the same typographi-
cal errors; they were evidently prepared by the same typist or typists.[21]

From Chapter LXXVIII to the end of the novel, the relationship between
Typescript A and Typescript B becomes more complicated. The typescripts
were no longer produced by the same typewriter (and likely not by the same
typist), and the divergence becomes substantive in Chapter LXXIX. More-
over, the sheets of Typescript A and Typescript B consist of interspersed
ribbon and carbon copies. A third typescript (catalogued as Revised Type-
script) is a partial document, beginning with chapter XXXII and running
through Chapter CIV. In addition to these typescripts and the holograph,
the revised galleys survive.[22]

Typescripts A and B and the Revised Typescript all have the final chapter with the ending as it would appear in the 1915 edition, in which Eugene snubs Suzanne. However, the original happy ending as it appears in the 1911 holograph, in which Eugene and Suzanne marry, is also found in Typescript B.[23] The presence of these two different concluding chapters in typescript form presents a further challenge to reconstructing the compositional history of the novel.

While it is impossible to present a definitive account, the surviving documents and Dreiser's compositional habits permit informed speculation as to why these different endings exist in typescript. Correspondence verifies that Dreiser was having a typescript produced during the spring and summer of 1914.[24] In September 1914, typist Edna H. Westervelt returned some of the original chapters (I–XX and XXXI–LXI) from which she had prepared the typescript.[25] Since it is unlikely that she would have held on to Dreiser's originals after completing her work, it is unlikely that he had the completed typescript before September. It would also have been implausible for Dreiser to have sent the novel out for typing with two different endings. The most likely scenario is that Dreiser had the 1914 typescript prepared with the novel's original ending, then decided, after getting the complete typescript in fall 1914, to change it, at which point he sent out the new concluding chapter for typing. The hypothesis that Dreiser revised the ending of *The Genius* only after seeing the entire typescript is consistent with his known compositional habits as seen in the Dreiser Editions of *Sister Carrie* and *Jennie Gerhardt*.[26] In those instances, as with *The Genius*, it is only after revising the final chapter that Dreiser incorporates other changes to prepare for the new conclusion.

The next round of significant alterations was done by Dreiser after the production of the 1914 typescripts. Dreiser probably made these changes in the fall of 1914 before sending Mencken his first installment that November. Dreiser entered identical changes—both cutting and pasting and inking in interlinear revisions—on Typescript A and the Revised Typescript. These changes do not carry over into Typescript B but do, for the most part, appear in the 1915 edition. By this time Dreiser had committed to the revised ending, for he now made changes in earlier sections of the novel to prepare for the harsher denouement.[27] He apparently kept Typescript A for himself and sent Typescript B to William Lengel, who made cuts for a planned serialization of the novel.[28]

After making the same changes he had entered onto Typescript A, Dreiser sent the Revised Typescript to Frederic Chapman and Floyd Dell to prepare the book for publication. A note in Dreiser's hand on the first page of the Revised Typescript reads "(Chapters 1 to 31—missing)" and it is unclear

what happened to the first thirty-one chapters. This first page, a nine-by-eleven cardboard sheet, reads, in Dreiser's hand, "The 'Genius'—/By Theodore Dreiser/Revised Typewritten Copy from which 1st Edition was printed/Chapters 32 to 104 inc." Much of the rewriting that would make it into the first edition of 1915 was introduced at this stage. Frederic Chapman, adviser to John Lane, the British publisher of the novel, worked in red ink; Floyd Dell in green ink and in pencil. When Chapman returned the first half of the edited chapters to Dreiser in July 1915, he explained that while he had let stand the speech of characters, he had regularized narrative passages into "traditional English" and "toned down" the many times where Dreiser had "'call[ed] a spade a spade'. . . . You must remember that in the particular plot you have set out to cultivate spades have hitherto not even been called 'agricultural implements'—they have been politely ignored altogether." Chapman eliminated many instances of the word "sex" (insisting the word was "wholly unnecessary to the elucidation of your meaning.")[29] Chapman also toned down Dreiser's Christian Science terminology and changed the medium in which Eugene typically works from pastel to oil. Dell took on the next round of editing. As he recalls in *Homecoming*, "Dreiser was publishing his long novel, 'The Genius', at last, but the publisher wanted it cut; and he hired me to cut it. I would take a large hunk of that mountainous manuscript, and go through it, crossing out with a light lead pencil such sentences, paragraphs and pages as I thought could be spared; and when I returned for more, there sat Dreiser, with a large eraser, rescuing from oblivion such pages, paragraphs and sentences as he felt could not be spared."[30] Despite Dreiser's re-revisions, Dell and Chapman succeeded in changing many phrases, altering numerous details, and making substantial cuts and modifications, particularly of Dreiser's discursive philosophizing. In addition, the actress Kirah Markham, Dreiser's lover at the time, had a hand in editing the manuscript.[31]

Finally, comparison of the galleys that survive at the University of Pennsylvania with the 1915 printed edition indicates that further significant revisions were introduced after the galleys. Chapters were combined, long passages were deleted, and the 104 chapters were divided into three books entitled "Youth," "Struggle," and "Revolt." It cannot be determined who made these final alterations, but they were likely motivated by, in Donald Pizer's words, the desire "to divide a very long novel into shorter parts."[32]

Although there is disagreement about the details of the book's composition, there is little argument about the extent of the changes between the 1911 holograph and the published text of 1915. Joseph Katz asserts that Dreiser "rewrote the book in 1914," and the novelist approached this task, according to Robert Elias, with "a new perspective."[33] In addition to its dra-

matically different ending, the 1915 text would alter the characterization of the protagonists, making Eugene more decisive and Angela less empathetic, thereby polarizing their differences along gender lines. The 1915 text would also subordinate the sexual autonomy of female characters to Eugene's erotic appetites and reconstruct the narrator's moralizing into a more defiant posture.

In summary, the history of the text after 1911 reveals many changes in overall conception, characterization, structure, and thematic emphases, both by Dreiser and by a host of editors and readers. The text Dreiser wrote in 1911 was thus substantially altered by the time it went to press in 1915. The present edition provides an opportunity to read Dreiser's 1911 version of the novel, the product of a different creative and compositional process by an author who had not yet fully evolved from the ideological and thematic concerns of his earliest writing.

Notes

1. Theodore Dreiser (hereafter TD) to H. L. Mencken, 8 March 1943, *Dreiser-Mencken Letters: The Correspondence of Theodore Dreiser and H. L. Mencken, 1907–1945*, ed. Thomas P. Riggio. 2 vols. (Philadelphia: University of Pennsylvania Press, 1986), 2: 684.

For speculation that the origins of *The Genius* go back to 1900, see Louis J. Oldani, "Dreiser's '*Genius*' in the Making: Composition and Revision," *Studies in Bibliography* XLVII (1994), 230–35. Noting that the name "Eugene" appears in some of the holograph pages of *A Book about Myself*, Robert H. Elias, in "Bibliography and the Biographer," *Theodore Dreiser Centenary* (Philadelphia: The Library Chronicle, University of Pennsylvania, 1971), 43–44, speculates that these sheets were part of the original *The Genius*, evidently not destroyed as Dreiser claimed in his 1943 letter to Mencken. Thomas P. Riggio argues that these pages are instead part of the 1900 manuscript "The Rake," autobiographical fragments that cannot be considered "an early version of *The 'Genius*'," as W. A. Swanberg argues in *Theodore Dreiser* (New York: Charles Scribner's Sons, 1965), 543, n. 7, "except in the broadest sense of its being an autobiographical novel which may have dealt with Dreiser as artist" (Introduction to *Theodore Dreiser, American Diaries*, ed. Thomas P. Riggio [Philadelphia: University of Pennsylvania Press, 1982], 8, n. 5). In *The Novels of Theodore Dreiser: A Critical Study* (Minneapolis: University of Minnesota Press, 1976), 137, Donald Pizer makes the similar point that "the significance of this early attempt at an autobiographical novel does not lie in its role as a source for *The 'Genius'*" but rather in that both writings reflect Dreiser crafting accounts in response to crises in his career.

Further complicating matters is another incomplete manuscript in the DPUP titled "The Rake." Unlike the 1900 manuscript of that name, this manuscript has nothing to do with *The Genius* but rather delineates a crime story based on the Roland Molineaux murder case. Edited by Kathryn M. Plank, this unfinished manuscript has been published in *Papers on Language and Literature* (Spring 1991).

2. See Mary Fanton Roberts to TD, 13 December 1910, DPUP; see also Mary Fanton Roberts to TD, 22 June 1911, DPUP.

3. Chapter CV—the alternate ending, which corresponds with the ending as published in 1915 and which is printed here as Appendix 3—was written at a later point. The paper on which Dreiser composed Chapter CV is a different bond, and the ink appears more delicate. Early readers' reactions confirm that what they saw was the ending as Dreiser originally composed it (Chapter CIV), philosophically upbeat and romantically happy, not the grimmer ending that he would later compose. See especially Eleanora O'Neill to TD, 14 June 1911, DPUP.

4. TD to H. L. Mencken, 24 February 1911, *Dreiser-Mencken Letters*, 1: 63; TD to H. L. Mencken, 10 April 1911, *Dreiser-Mencken Letters*, 1:67; TD to H. L. Mencken, 17 April 1911, *Dreiser-Mencken Letters*, 1:67.

5. Eleanora O'Neill to TD, [June 1911], DPUP; Leonard Keene Hirshberg to TD, 25 June 1911, DPUP; holograph of *The Genius*, Chapter CIII, p. 11, DPUP.
Eleanora O'Neill rarely dated her mail, and some of her handwritten letters were subsequently typed by Dreiser's secretary with a date added; the added date may or may not be accurate. Some of O'Neill's letters about *The Genius* have been dated 1911 and others 1913; while she may have reread the manuscript at the later date, the date could be in error. In the case of such letters that appear in both handwritten and typed versions, reference is made here to the handwritten letter. Ranking the novel with *Anna Karenina, Les Miserables,* and *Vanity Fair,* O'Neill marveled over the "horrors and Blue Beard Chambers of soul analysis" (Eleanora O'Neill to TD [July? 1911], DPUP). Although O'Neill told Dreiser that *The Genius* "will always be your apogee of art," she disliked the ending: "somehow I don't like the idea of his [Eugene's] adjusting himself to any fixed dogma" (Eleanora O'Neill to TD [August? 1911], DPUP; Eleanora O'Neill to TD [July? 1911], DPUP).

6. Leonard Keene Hirshberg to TD [22 June 1911], DPUP.

7. See Decima Vivian to TD, 13 July 1911, DPUP; TD to H. L. Mencken, 8 August 1911, *Dreiser-Mencken Letters*, 1:73; TD to William Lengel, October 15, 1911, *The Letters of Theodore Dreiser,* ed. Robert Elias. 3 volumes. (Philadelphia: University of Pennsylvania Press, 1959), 1: 121–2.

8. Swanberg, *Dreiser,* 167.

9. TD to H. L. Mencken, [before 18 July 1913], *Dreiser-Mencken Letters*, 120–22; TD to H. L. Mencken, 22 June 1914, *Dreiser-Mencken Letters*, 144; on lost chapters, see Edna H. Westervelt to TD, 18 September 1914, DPUP.

10. Swanberg, *Dreiser,* 187; see TD to Major F. T. Leigh as noted in n. 12, below; Robert H. Elias, *Theodore Dreiser: Apostle of Nature,* Emended Edition (Ithaca, N.Y.: Cornell University Press, 1970), 158; Elias, "Bibliography," 31.

11. See Folder 2535, Harper & Brothers, 1912, DPUP; Folder 2536, Harper & Brothers, 1913–1915, DPUP.

12. In February of 1913, Dreiser wrote Major F. T. Leigh, vice president at Harper's, that he would turn over the manuscript of *The Genius*, still circulating in Chicago, when he got it back. Harper's could retain the manuscript as security, and "if my general indebtedness has not, say by Sept or Oct 1914, been cleaned up," they could publish it. But, Dreiser insisted, "I reserve the right even under these conditions however to withdraw *The Genius* and substitute for it some completed work (novel) which I may then be anxious to see published first." Further suggesting that Dreiser's priorities lay elsewhere, he wrote Lengel in April 1913 that he had not read *The Genius* "from end to end consecutively . . . in two years" (TD to William Lengel, 14 April 1913; DPCU).

13. TD to William Lengel, undated [presumably 1913] DPCU; TD to Ludwig Lewisohn, 6 January 1927, *Letters of TD,* 2:452.

14. TD to William Lengel, 14 April 1913, DPCU. See also Anna P. Tatum to TD, 12 April 1913, DPUP; Ray Long to TD, 9 April 1913 (Folder: *Red Book* Magazine), DPUP; Floyd Dell to TD, undated [before April 1913], DPUP.

15. TD to William Lengel, 14 April 1913, DPCU; TD to William Lengel, undated [1913?], TD to William Lengel, 14 April 1913, DPCU.

In 1929 Dreiser told Kathryn D. Sayre, who was writing a master's thesis on his work, that Dell had been one of the first to read *The Genius* and that he later retracted his initial harsh criticism: "when asked to edit it [Dell] was completely unable to 'cut anything of this splendid story'" (Folder 5463, Kathryn D. Sayre 1929–30, DPUP).

16. TD to H. L. Mencken, 30 November 1914, *Dreiser-Mencken Letters*, 1: 166; TD to H. L. Mencken, 17 October 1911, *Dreiser-Mencken Letters*, 1:78; H. L. Mencken to TD, 26 June 1914, *Dreiser-Mencken Letters*, 1:144. The 30 November letter also contains Dreiser's first known reference to the title with quotation marks: *The "Genius"*.

Upon reading the manuscript, Mencken reported two criticisms: "Witla's artistic progress is under-described in the first part," and "[t]here is no such word as alright" (H. L. Mencken to TD, 9 December 1914, *Dreiser-Mencken Letters*, 1:168–69). Unfortunately for literary history, Mencken never provided his complete reaction by letter. As Thomas P. Riggio explains, "Mencken broke his routine of sending one of his letters of criticism and instead asked for a private meeting to discuss the book." The discussion, in January 1915, was heated and would remain, according to Riggio, "a sore spot in the relationship for years after" (Thomas P. Riggio in *Dreiser-Mencken Letters*, 176–77). The unwelcome opinion Mencken delivered to Dreiser on *The Genius* can, however, be inferred by the review he would publish in the December 1915 *Smart Set*, "A Literary Behemoth," reprinted in *Dreiser-Mencken Letters*, 2: 754–759.

In a later letter, Mencken speculates that "[t]he real cause of the Comstockian attack upon 'The "Genius"' [sic], I have always thought, is not that Witla works his wicked will upon the girls, but that you make him insert his thumb into Angela's (as yet) virgin person" (H. L. Mencken to TD, 16 December 1916, *Dreiser-Mencken Letters*, 1: 281). None of the surviving documents includes this tantalizing description. The attribution may be the product of Mencken's characteristic exaggeration, or it may accurately refer to something that Dreiser wrote and then discarded. There is evidence that Dreiser eliminated pages from the holograph when the sexuality became especially explicit; see for instance Textual Note XXVI, 156.35.

17. Oldani, "Dreiser's 'Genius'," 230–252; Joseph Katz, "Dummy: *The 'Genius,'* by Theodore Dreiser," *Proof* 1 (1971), 330–41. Also see Louis J. Oldani, "Frederic Chapman," *A Theodore Dreiser Encyclopedia*, ed. Keith Newlin (Westport, Conn.: Greenwood Press, 2003), 60–61; Louis J. Oldani, "Floyd James Dell," *A Theodore Dreiser Encyclopedia*, 87–89.

18. According to Oldani, "Dreiser's 'Genius'," 236, Lengel had abridged the novel in 1914. He tried for years to interest a magazine in the serialization.

19. This radically condensed serialization of the entire novel consisted of three installments, published in *Metropolitan* 56 (February–March 1923); *Metropolitan* 57 (April–September 1923); *Metropolitan* 58 (October–November 1923).

20. The holograph contains, in addition to penciled-in comments by Decima Vivian, Dreiser's typist in 1911, a typed note attached by a clip from typist Edna H. Westervelt, who worked for the Century Company. Vivian's handwriting and Westervelt's note suggest that both prepared their typescripts from the original holograph.

21. There are some accidental exceptions in the two documents. Typescript A lacks

some of the prefatory pages; Typescript B is missing several chapters and features new, penciled-in chapter numbers.

22. The Dreiser papers also contain a publisher's dummy for *The "Genius"*, the significance of which is discussed in Katz, "Dummy."

23. The surviving happy ending is catalogued as "First TSB, discarded pages from CIV" (Folder 7977, DPUP).

24. See Edna H. Westervelt to TD, 12 May 1914, DPUP; Edna H. Westervelt to TD, 23 May 1914, DPUP; Edna H. Westervelt to TD, 22 June 1914, DPUP; Edna H. Westervelt to TD, 8 September 1914, DPUP.

25. Edna H. Westervelt to TD, 8 September 1914, DPUP.

26. James L. W. West III, "The Composition and Publication of *Jennie Gerhardt*," *Jennie Gerhardt* by Theodore Dreiser. Dreiser Edition (Philadelphia: University of Pennsylvania Press, 1992), 431–34; John C. Berkey, Alice M. Winters, and James L. W. West III, "*Sister Carrie*: Manuscript to Print," *Sister Carrie* by Theodore Dreiser. Dreiser Edition (Philadelphia: University of Pennsylvania Press, 1981), 514–19.

27. Several other changes at this stage in Dreiser's hand are also evident in Typescript A and the Revised Typescript, including Witla's reactions to Paris (presumably revised as a consequence of Dreiser's own first trip to Europe from November 1911 to April 1912) and elimination of a passage asserting Eugene and Angela's temperamental compatibility. Dreiser also made modest cuts and revisions in the prose at this stage.

28. In preparing the serial version, large blocks of material were cut from Typescript B, some entire chapters eliminated, and many chapter numbers changed in pencil. Both before and after publication of the first edition, Lengel attempted for years to line up a serial publication of *The "Genius."* See Henry J. [name illegible] to William C. Lengel, 3 February 1915, DPUP; William Lengel to TD, 26 July 1922, William C. Lengel Collection, DPUP.

29. Frederic Chapman to TD, 8 July 1915, DPUP.

30. Floyd Dell, *Homecoming* (New York: Holt and Rinehart, 1933), 269.

Vrest Orton estimates that Chapman cut 50,000 words and Dell another 100 pages in proof (*Dreiseriana: A Book about His Books* [New York: Chocorua Bibliographies, 1929], 35). Oldani is probably closer to the mark in estimating that Chapman's and Dell's cuts shaved 20,000 words ("Frederic Chapman," 61). Dreiser estimated the 1911 version as having 425,000 words (TD to Mary Fanton Roberts, 26 June 1911, DPUP), but the actual count is closer to 380,000 words. Pizer estimates that the 1915 edition contains 350,000 words (*Novels* 358, n. 17).

31. Markham's handwriting is clearly evident in Chapters XCVII and LXXVII of Typescript A.

32. Pizer, *Novels*, 136.

33. Katz, "Dummy," 331; Elias, *Theodore*, 176.

THE INTELLECTUAL AND CULTURAL
BACKGROUND TO THE GENIUS:
THE 1911 VERSION TO PRINT

Although Theodore Dreiser often defended *The "Genius"* (1915) as the
best of his novels,[1] and biographers have routinely mined it for information
about his life, its place in the trajectory of his career has never been fully
understood. Publication dates, as well as thematic similarities, have led crit-
ics to group *The "Genius"* with *The Financier* (1912) and *The Titan* (1914).
Eugene Witla and Frank Cowperwood are usually seen as case studies in
the sometimes competing, sometimes overlapping lures of art and business;
they are also typically defined by their extensive sexual conquests. Rich-
ard Lehan voices the consensus when he calls *The Financier* and *The Titan*
"merely less personal accounts of the same kind of story" as *The "Genius"*.
The assumption, moreover, has been that *The "Genius"* illustrates Dreiser's
view of himself, if not as a Cowperwood, then at least as a defiant artist
stripped of youthful illusions. Thus Ellen Moers describes *The "Genius"* as
an "account of the troubles of the artist from the vantage point of a man
who has conquered them."[2]

When Dreiser initially composed the novel in 1911, however, con-
quest was far from assured and his vantage point anything but secure. The
novel had a different title—*The Genius*, without the qualifying quotation
marks—and a very different ending.[3] The two versions, in fact, diverge
in structure, characterization of primary and incidental figures, thematic
emphasis, sensibility, and style. These differences have literary and bio-
graphical implications. Whereas the Eugene of 1915 suggests the assured,
amoral Cowperwood who "satisfies himself," the Eugene of 1911 has more
in common with the wavering protagonists of *Sister Carrie* and *Jennie Ger-
hardt*, who crave domestic stability and worry about breaching conventions.
The Genius of 1911 allows us to glimpse a younger, less assertive Dreiser
struggling between conservatism and rebellion. It reveals a Dreiser whose
mature ideas of self, masculinity, artistic achievement, and worldly success
were still in the process of formation.

The sensational history of the 1915 edition has eclipsed the 1911 ver-
sion of the text. The publication of *The "Genius"* became an overnight cel-
ebrated cause, a benchmark event in the period's struggle for artistic free-
dom. Its reputation as a defiant, rebellious book hindered critical inquiry
into Dreiser's initial conception of the story. In 1916, the New York Society
for the Suppression of Vice successfully campaigned to remove *The "Genius"*

from bookstores due to charges of lewdness and profanity. H. L. Mencken launched a defense of the novel, and nearly 500 writers signed a petition urging that the ban be lifted, but the novel languished until 1923, when Boni & Liveright reissued it. Although Dreiser had made much of the supposed "suppression" of *Sister Carrie*,[4] in fact *The "Genius"* holds the peculiar honor of being his first novel to be actually suppressed, and censorship of the book quickly assumed the aura of cultural myth. As Dorothy Dudley, who wrote the first book-length study of Dreiser, put it, "*The 'Genius'* was the first powerful American novel threatened by the vice crusaders. . . . *The 'Genius'* case became a rallying point for the rebels." The controversy confirmed what readers—both advocates and detractors—assumed about Dreiser, consolidating his public image as a rebel. And as Mencken astutely told Dreiser several years later, the attack on *The "Genius"* "in the long run was very profitable to you."[5]

This remarkable chapter in the chronicle of Dreiser's reception has obscured the equally charged atmosphere from which the first version of *The Genius* emerged. According to Floyd Dell, an early reader of the novel in manuscript, 1911 was a year during which change was palpable: "Something was in the air. Something was happening, about to happen—in politics, in literature, in art. The atmosphere became electric with it."[6] It was certainly a time of upheaval in Dreiser's personal and professional life. The impetus for *The Genius* was a scandal in 1910 at *The Delineator*, where Dreiser had been working successfully as editor since 1907. This halcyon period ended when he fell in love with Thelma Cudlipp, an aspiring painter studying at the Art Students League and the eighteen-year-old daughter of Dreiser's coworker, Anne Ericsson Cudlipp. The relationship was intense but unconsummated. Mrs. Cudlipp threatened to go to the papers if Dreiser continued pursuing Thelma, and he was forced to resign. Deprived of a steady income and estranged from his wife Sara, Dreiser had plenty of time, and apparently also motivation, to return to fiction; after finishing *Jennie Gerhardt*, he turned to *The Genius*, completing it in approximately six months.[7]

The most discussed difference between the 1911 novel and the first edition of 1915 is Dreiser's treatment of the outcome of the romance. In the concluding chapters of the published novel, Eugene Witla's young girlfriend, Suzanne Dale, under pressure from her mother, loses her nerve and leaves him for Europe. Eugene gives up both romantic illusions and Christian Science, returns to reading Herbert Spencer and pursuing a string of unidentified women, and concludes there is no rational, much less divine, order to the universe. When he later runs into Suzanne, he snubs her. The 1915 ending thus supports the image of Dreiser as a hard-headed, uncompromising realist. In the 1911 version, however, Eugene and Suzanne's chance

encounter at the end of the novel leads to a different outcome. Suzanne finds the matured Eugene more attractive than before and manufactures an excuse to drop by his studio. She finds him painting, confesses her love, and they return to their "lost paradise" (744). As the narrator explains, "there was a basic unity of soul which held them together." Happily concluding "they were made for each other" (745), Eugene and Suzanne marry. The original ending suggests a Dreiser attracted to conventional solutions and sentimental outcomes.

This denouement of the 1911 text corresponds to an equally fundamental difference in the protagonist's understanding of the world. Many of Dreiser's characters seek—as did the novelist himself—to discern "how life is organized." In 1911, Dreiser imagined Eugene uncovering a harmonious order to the universe. Such philosophical optimism is best seen in Eugene's final view of Christian Science: "As he grew stronger and calmer, these metaphysical depths did not lure him so much from the point of view of refuge as from the point of view of beauty. It was beautiful now to think of the universe as being good, not evil" (744). This view is consistent with the trajectory of the 1911 version of the novel: the artist finds aesthetic satisfaction in a benevolent world. And so, when Eugene picks up a volume of Herbert Spencer, he concludes the book "is full of kindly wisdom" but sets it aside, determining that Spencer's premise of unfathomable mystery "could never trouble [him] anymore" (746). "Altogether [Eugene] was changed notably," the narrator remarks, "and it is unquestionable that he was stronger and broader for what he had suffered, seen, and endured" (737). Eugene is not simply happily married at novel's end; he is at peace with the universe, his metaphysical conflicts resolved.

The endings of the texts have been discussed in isolation, and no critical attention has been paid to the numerous other differences between the two versions. *The Genius* of 1911 contains more discursive philosophical and social commentary. It also contains more topical references to issues large and small—fashions such as the powdered faces sported by perfumed dandies, theosophy, Brentano's bookstore, birth control, dining at the Plaza, Angela's similarity to Sarah Bernhardt and Clara Morris, divorce law, a Darwinian critique of marriage, the Cardiff Giant, and an extended discussion of the "peculiarly American" disease of neurasthenia—all of which provide rich cultural context. There are more detailed technical descriptions of contemporary art, as, for example, passages on the nature of instruction at the Chicago Art Institute. Eugene even works in a different medium: pastels rather than the oils he would favor in 1915.

The 1911 text also has more references to books, thus providing an index to the sources of Dreiser's ideas at the time. When the narrator quotes

from literary, scientific, biblical, and philosophical sources, the excerpts are more substantial. He provides greater detail on Eugene's reading (and Dreiser's): George du Maurier's *Trilby*, Keats's "Ode on a Grecian Urn," Stephen Crane's *Maggie*, Rousseau's *Confessions*, William Ernest Henley's *London Voluntaries*, among others. The narrator invokes far more literary allusions—Dante, Abélard and Héloïse, and, especially, allusions to the Bible and Shakespeare—which shed considerable light on Dreiser's intellectual influences.

A bookish book, *The Genius* of 1911 shows the extent to which Eugene's reactions to people and events are shaped by his reading—whether it is Spencer, Mary Baker Eddy, or W. B. Yeats. The first time Eugene visits Angela at her home in Black Wood, Wisconsin, Thomas Hardy sets the tone:

He was now deep in *The Woodlanders* and greatly stirred by the pathos of the spectacle of unrequited love. So this journey to see his lady-love was in the nature of a sweet romance. . . . She had warned him it was a very simple life they led and he was looking forward to green trees, yellow country roads, an old rambling house, perhaps, and stillness. (107)

Hardy's pastoral novel provides Eugene a perspective which defines his reunion with Angela. Eugene's tendency to view Angela through a literary lens reveals more about him—particularly his romanticism—than it does about her. For Eugene, Angela's origins illustrate the "magnificent details of a great romance, like the caves and castles and forests of grand opera. Her father was as good as any hero in the Greek tragedies or character in romance" (199).

This continual referencing of literature in order to understand life, even more extensive than in the 1911 edition, is one of several ways in which the Eugene of 1911 appears more impressionable and less decisive. When Eugene first arrives in Riverwood, where he will live while working as a day laborer for the railroad, he imagines himself "like the knights-errant of old must have felt, . . . reconnoitering a new and very strange world" (325). Dreiser's initial conception of Eugene also has him less sexually confident, more reactive to and dependent on women. Romantic encounters occur because female characters have libidos that match and often exceed Eugene's. The idyll in Florizel with singer Christina Channing unfolds, we hear, "solely because of her intense desire" (153). Even the shy sculptor, Miriam Finch, cannot resist "look[ing] at times with a longing eye at his interesting head and body" (137; toned down in 1915 to her examining Eugene's "face and figure" ["G" 144]). Correspondingly, Eugene's sex drive appears less indiscriminate. The narrator editorializes while Chicago model Ruby Kenny is making breakfast for Eugene that "[t]here was the customary

culmination to this sort of thing, for it could not be otherwise with him. He could not restrain his passion long with anyone that he really cared for" (76). Eugene's sexuality, even more insistent in 1911 than it would become in 1915, manifests his intense emotion, not just his enjoyment of an amiably carnal act.

As women in the 1911 version are more forthright sexually than they would become in the first edition, they are also more independent, as emphasized toward the end of a paragraph that begins Chapter XXIV. Eugene, reflecting on the attractions of Ruby Kenny and laundress Margaret Duff, concludes, "They were better than the rank and file of women. . . . There was more freedom to their souls—more courage. At least they dared to do the things they wanted to do and were not mere chattels. As Eugene saw most women now, they were tied by a thousand ties; afraid to turn their heads, afraid to call their names their own. . . . But a real thinking woman—a woman of emotion or rare judgement, of transcendent beauty and talent combined—he was on his knees at once" (141). Indifferent to "mere chattels," Eugene pines for what the text calls the "newer order of femininity, eager to get out in the world and follow some individual line of self-development and interest" (158). In other words, Eugene favors New Women, the self-directed, independent women who emerged on the American scene in the 1880s and 1890s.[8]

Dreiser's sympathetic treatment of women highlights the affinities of the 1911 version to *Sister Carrie* and *Jennie Gerhardt* and distinguishes this text from the 1915 edition, which more clearly brings the reader into the hypermasculine world of *The Financier*. For example, although the Angela Blue of 1911 is not a New Woman, she is nevertheless an imposing figure, even if not a fully autonomous one. Eugene learns from observation "that there were two kinds of greatness possible in an individual—intellectual and emotional" (138), and that his wife embodies the latter. Like Carrie Meeber, Angela has "emotional genius"—a significant quality given the title of the novel and Dreiser's interest in the temperament of the artist (271). Even Angela's tendency to morbidity (as in her suicide fantasy after entering into a sexual relationship with Eugene) becomes resonant and intelligible as Dreiser draws her character more fully. Angela is characterized by "moodiness and emotional gloom," unlike the sunny disposition of her sister Marietta. Yet "[t]o say that there was any comparison between the two women's emotional capacities would be unjust to Angela. She had more of the fire of real affection and passion than anyone Eugene had ever known" (195–96). The 1915 edition eliminates all these details about Angela's personality.

The treatment of Angela's sexuality marks another important register of how Dreiser initially conceived the character. When it comes to "emotion and sex desire," Angela has "as much if not more" than Eugene (58). Before their marriage, she daydreams about posing nude for him. Her fantasies, the narrator remarks, "constituted a form of nymphomania" (161). But Angela's sexual conflicts and pleasures are important in the novel in their own right, not simply as they affect her husband. Her flaming red hair suggests her passionate and vibrant nature—a feature toned down in 1915 to a "wonderfully dull" blonde ("G" 67).

More background on Angela's family appears here, and there are more times when Dreiser explores her subjectivity: when, as a new bride, she reflects on how marriage will change her life (213–14); when, as a pregnant and discarded wife, she is terrified over the prospect of losing her husband (578). Angela remains appealing to the reader after Eugene has cast her off, as when she writes a letter explaining the attractions that Christian Science, with its claim that suffering is illusory, holds for an abandoned wife. Angela ends her brief epistolary recitation of the faith's doctrine with the self-reflexive comment, "This sounds sermony, doesn't it?" one of many times when the 1911 text invites readers' empathy (697).

Dreiser's attention to female characters' interior lives, their passions, sexual and otherwise, renders them more comprehensible and sympathetic in the 1911 text. His depiction of gender is also less polarized here, and his treatment of the Witla marriage more balanced. Even after severe marital problems develop, the narrator remarks, "Temperamentally they were suited in many ways—a mutual love of order, a mutual admiration for the odd in character, a sense of humor, a sense of pathos in themselves and life in general—many little things which made for a comfortable home life which is so important in any union" (384). Eugene admits that "[o]bviously [Angela] was the model wife" (490). *The Genius* of 1911 makes it easier to discern that Eugene's problem lies less with Angela than with the institution of marriage.

The marital conflicts in the 1911 version appear in a different light not only because the wife is more appealing but also because the husband is more conventional. Eugene's conservative tendencies become especially visible in his sexual anxieties. After he and Angela start having intercourse before their marriage, the young man is, initially, simply aroused: "Eugene, excited by his carnal experiences with her and having found her of a temperament which answered his present mood, was eager for more of what had proved to be so delightful." But then his traditional pieties surface: "She ran through his mind now not for any spiritual qualities, . . . but for her gross physical ones. Two natures being at war in him, one spiritual, the other carnal and

fleshy, it was possible to appeal to either" (180). Later in the same scene Eugene reveals the continuing pull of traditional moral categories (as well as his substantial confusion) when he promises Angela "by all that was good and holy that she should not be made to suffer" (180). On the basis of this dubious reasoning he decides to marry her.

It is not only Eugene but also the narrator who stakes out orthodox moral positions. When discussing Eugene's first sexual intercourse, with laundress Margaret Duff, the narrator prudishly remarks, "This relationship need not be described, for it was immoral" (39). At Eugene's bachelor party (a chapter eliminated from the first edition), the groom reflects upon his upcoming marriage, and the narrator censoriously explores his state of mind: "It was not the fine feeling of spiritual companionship which ought to elevate one in a moment of that kind but something lower. Alas, he did not see it. He did not see how useless it is to base hopes of happiness on anything save mental and spiritual compatibility" (191). Biblical allusions throughout *The Genius* point to a Christian ideal of marriage. In addition to citing Saint Paul and endorsing the concept of sin, the narrator examines Eugene's sexual and romantic problems in light of the beatitudes and Augustine's belief in man's innate evil (388). Much as Dreiser dooms the Witla marriage by characterizing it as too carnal, he commends Eugene's relationship with Suzanne by noting, "He was not eager for her body. He was in love with her mind" (547). What Thomas Riggio describes as "Dreiser's residual puritanism" in *The Genius* is more pronounced throughout the 1911 edition.[9]

The narrator also turns to Christian Science to explain the couple's marital problems, noting that Eugene's carnality shows him "as blind . . . as matter itself" (191). Later the narrator will adopt the Christian Science notion of "mortal mind" (as distinct from "divine mind") to explain the failure of the marriage: "It had to break up and be dissolved into its native nothingness—the thing from which it had been called by the idea or spirit which originally animated them. Alas, alas, for the phantasies of mortal mind which have their root in nothing and return from whence they came" (689). Along with more traditional variants of Christianity, Christian Science sits more comfortably in *The Genius* of 1911, where the faith offers a reliable index of judgment and value.

Founded in 1879 by Mary Baker Eddy, Christian Science had entered the mainstream of American religious practices by the 1890s. Based on the premises that God is good, God is all, God is spirit, and hence evil and sickness are unreal, Christian Science holds out the promise of overcoming pain, unhappiness, even death. The faith's metaphysical basis underwrites extravagant tenets: according to Eddy, mind alone is real; matter is illusory. Exalting mind over matter provides the believer with extraordinary

power and agency. Not surprisingly, these views are especially attractive to people who suffer from depression, nervousness, and physical ailments—as did Dreiser. In one of many discursive segments published for the first time here, Dreiser endorses the metaphysics of Christian Science, citing Eddy in his exaltation of mind over matter, spirit over illusion. The ostensible subject, once again, is "the vagaries of passion and sex attraction" (661). For Dreiser in 1911, so preoccupied with both the material world and with the disruptions of sexuality, Christian Science provided an absorbing explanation of how life was organized.

The Genius of 1911 also refers extensively to the broader current of New Thought, which exalted the powers of the mind. The popular magazine *Success,* for which Dreiser had interviewed celebrated Americans in 1898, embraced New Thought tenets. The motto of the White City, the centerpiece of the 1893 World's Fair in Chicago, was "Not Matter, but Mind: Not Things, but Men."[10] In *The Genius,* Dreiser explains Eugene's period of commercial success as a function of his "electric" psychic force: "he radiated ideas and suggestions much as an electric generator radiates sparks. A psychometrist and delineator once told him that she could see waves of energy" about him (483). Striking mental powers extend to other characters as well. Angela uses "psychic interpretation" to discern the sort of woman her husband is having an affair with in Riverwood (378). Years later, Suzanne attracts Eugene because when "she touched his face with her fingers . . . he thrilled from head to toe; she looked into his eyes and something flashed or rather soothingly flowed out to him" (683).

One wonders what readers would have made of *The Genius* had it been published in 1911 as Dreiser initially wrote it. It is difficult to imagine reviewers finding it "a huge orgy of the flesh without the slightest touch of the divine," or concluding that Dreiser had "thrust his magic pen home into the heart of American Puritanism," as was said of *The "Genius"* of 1915. If Eugene Witla *is* Dreiser, as Robert Elias claims, then the Eugene of 1911 expresses a different incarnation of the novelist than does the Eugene of 1915.[11] The two versions of the novel reflect, in both subtle and dramatic ways, Dreiser's changing conceptions of himself and of the art and business of writing fiction.

The Genius *as Autobiography*

More than any other of Dreiser's novels, *The "Genius"* has been explored for its biographical value. The autobiographical underpinning of the novel is easily summarized. Eugene Witla is, like Dreiser, a small-town midwesterner who feels compelled to create artistically, to experiment sexually,

and to immerse himself in city life. Both do early work with newspapers and magazines. In his late teens, the character, like the novelist, leaves home and moves to Chicago, where he works at odd jobs. The lake city shapes Eugene's artistic ideals, as it had Dreiser's, before New York exerts an even stronger influence. After several early sexual relationships, Dreiser and Eugene become embroiled with passionate but conservative women (Sara "Jug" White and Angela Blue, respectively) who represent, as do the women's fathers, the continuing appeal of the midwestern heartland. Like his creator, Eugene enters into an ill-advised marriage that proves sexually strenuous and psychologically draining. Dreiser felt, as does Eugene, that his wife was too conventional, too controlling, and, especially, too insistent on monogamy. The siren song of other women lures both of these confirmed "varietists." Eugene's early artistic exposure, as well as the divided critical opinions on his work, approximates the events surrounding Dreiser's publication of *Sister Carrie* in 1900. A neurasthenic breakdown and recuperative period of manual labor on the railroad follows for both before Eugene's and Dreiser's phoenix-like re-emergence to commercial achievement in advertising and editing, respectively. In the novel as in the life, this period of worldly success ends with the introduction of a winsome eighteen-year-old. Suzanne Dale, like her prototype Thelma Cudlipp, is addressed by her older lover as "Honeypot," "Blue Bird," and "Divine Fire."[12] The romantic spark between them leads to a conflagration which marks the end of this period of Eugene's life, as it had Dreiser's, disrupting both marriage and career. Chastened, Eugene and Dreiser return to their art.

The parallels are intentional and indisputable. In reworking the raw material of his life, however, Dreiser made numerous incidental and several major changes. One significant alteration concerns Eugene's class background. Rather than the debilitating poverty of Dreiser's childhood, which caused his family to splinter several times into discrete units living in different towns, the Witlas are comfortably middle-class. Eugene's family is small and stable, unfamiliar with the poverty and disgrace that marked Dreiser's upbringing. The second major change is vocational. Dreiser retains his journalistic background for Eugene, but transforms the character into a painter. Making the protagonist a visual artist may have provided Dreiser some distance that was helpful in sorting through his thematic concerns; it also helped him to move his personal story into the larger realm of cultural myth. A third critical change involves the conclusion of marriages that had come to seem oppressive to the husbands. The end of the Theodore-Jug marriage, when she learned of his interest in Thelma, was neither sudden nor complete. A lengthy separation beginning in the fall of 1910

(Jug refused to grant him a divorce) was punctuated in its early years by intermittent rapprochements. Dreiser missed his wife, who had taken such good care of him; he returned to her periodically, even while embroiled in other relationships. But in *The Genius*, Angela dies from childbirth complications. Dreiser's invention of "Angela second," the baby, is itself a significant deviation from the life of the author, who had no children.

Dreiser had good reason to anticipate an audience eager for a fictionalized version of the breakup of his marriage. One of the titles he considered, "This Matter of Marriage, Now," indicates Dreiser's awareness that his personal experience had considerable cultural resonance. *The Genius* provides one of the most comprehensive and memorable portraits of marriage in American literature, which is all the more notable when we consider how much attention the subject drew. Contemporaneous fiction plumbing the "matter of marriage" includes Frank Norris's *The Pit* (1903), Henry James's *The Golden Bowl* (1904), Robert Herrick's *Together* (1908), Upton Sinclair's *Love's Pilgrimage* (1911), Mary Stewart Cutting's *Refractory Husbands* (1913), Edith Wharton's *The Custom of the Country* (1913), Sinclair Lewis's *Main Street* (1920), and a score of David Graham Phillips novels, including *Old Wives for New* (1908), *The Hungry Heart* (1909), and *The Husband's Story* (1910). Influential nonfiction such as Edward Carpenter's *Love's Coming-of-Age* (1896) and Ellen Key's *Love and Marriage* (1911) also anatomized marriage. *The Delineator* was among the popular magazines to launch a series joining, in the words of a 1910 contributor, the "general discussion of marriage and divorce which was looming large at this time."[13] The interest in marriage characteristic of Dreiser's generation reflects and contributed to a re-evaluation of what constituted public versus private experience; the sharp increase in and new visibility of divorce; women's changing expectations concerning sexual, employment, educational, and other decisions; and a host of other changes that would define the twentieth century.

In extrapolating the cultural significance of his marriage and other aspects of his life, Dreiser's extensive changes confirm that, however autobiographical the foundation of the novel, he is not Eugene and *The Genius* is fiction, not autobiography. In the most comprehensive study of the novel to date, Louis Oldani challenges what he calls "the global identification of Witla and Dreiser" and concludes that "Dreiser's steady transformation of the raw materials of reality for his fictional ends necessitates some qualification of the well-nigh unanimous opinion that *The 'Genius'* is autobiography thinly disguised with elements of fiction."[14] That this transformation occurred in distinct stages becomes newly visible with this edition of Dreiser's initial version of the novel.

American Art and Artists

Among Dreiser's many aims in *The Genius* was to explore the nature, function, and reception of art in America. His choice of a painter rather than a writer came naturally to him, both because he had a deep interest in visual arts and because, like many others in his generation, he believed that writers and painters shared a common aesthetic. His novel therefore provides an important index to the ideas about art and the artist's life that were prevalent in the generation that came to maturity in the 1890s and the first decade of the new century.

"If I were a painter," Dreiser begins an early sketch, "[o]ne of the first things I would paint would be one or another of the great railroad yards that abound in every city, those in New York and Chicago being as interesting as any."[15] *The Genius* provides detailed descriptions of the kind of art Dreiser might well have produced had he worked with brush rather than pen. Eugene Witla is inspired by the same urban-industrial scenes that move his creator, and likewise imbues them with great feeling. When visiting Ruby Kenny on a rainy Sunday in Chicago, Eugene finds the neighborhood "dreary" but pauses as

He crossed a great maze of black cindered car tracks where engines and cars stood in great masses, and speculated as usual on what magnificent, forceful drawings such scenes would make. After experimenting with charcoal, he had begun to think that maybe he could work these things out in crayon, with touches of color thrown in. These dreary car track scenes kept appealing to him as something wonderful—big black engines throwing up clouds of smoke and steam in gray, wet air; great mazes of parti-colored cars dank in the rain but lovely somehow. At night the switch-lights in these great masses of yards bloomed like flowers. He loved the sheer yellows, reds, greens, blues that burned like eyes. Here was the stuff that touched him magnificently. . . . How poor was the mind that could not feel the beauty of these things. (69)

In its picture of the American artist who captures the unexpected beauty of urban scenes that strike the casual observer as "dreary," *The Genius* thus provides an analogue to Dreiser's own practice as a realist.

This aesthetic suggests the work of the Ashcan School, which flourished in New York from the late 1890s through the 1910s. Eugene's canvases depict quintessential Ashcan subjects: "the empty canyon of Broadway at three o'clock in the morning; a long line of giant milk wagons, . . . a plunging parade of fire vehicles, the engines steaming smoke . . .; a crowd of polite society figures emerging from the opera; the bread line; an Italian boy throwing pigeons in the air" (229). A critic's description of the Ashcan method as "a reflection of our American life as it is today, crude, vehe-

ment, inconsiderate though not without tenderness" captures the spirit of Eugene's paintings.[16] As Dreiser remarks of Eugene, "Everything he touched seemed to have romance and beauty and yet it was real and mostly grim and shabby" (229).

The evocative term "Ashcan" was not in currency when Dreiser wrote *The Genius*, and indeed not so until 1934. Initial newspaper accounts, noting the shift from the bright palette of the Impressionists toward darker colors, used such monikers as "the revolutionary black gang" and the "apostles of ugliness" to describe the new painters.[17] More neutral names were The Eight or the New York Realists. The terms overlap with what later would be called the Ashcan School, but they are not identical. The Eight got their name when a group of that number exhibited together at Macbeth's Gallery in New York in 1908. Five of the painters (Robert Henri, George Luks, William Glackens, John Sloan, and Everett Shinn) specialized in gritty urban scenes similar to Eugene's. Art historians use the term "Ashcan" to include painters such as George Bellows, who did not show with the original Eight but who also adopted dark palettes, rough brushwork, and raw urban themes.[18]

There was good reason why Dreiser felt affinities to this group. A number of the Ashcan artists had, like Eugene Witla and Dreiser himself, begun their careers working for the newspapers. Before the development of the halftone printing process, papers relied on artists almost as much as writers to cover the news. Sloan, Luks, Glackens, and Shinn all worked as artist-reporters before turning to fine art. In *The Genius*, Eugene's first job after recovering from neurasthenia is with the *New York World*, the same paper that had employed Luks and Glackens from 1896 and Shinn from 1897. In 1894, Dreiser himself worked briefly at the *World* as a space-rate reporter. The immersion in journalism taught these artists, both visual and literary, not only what to observe in the city but also how to see urban life, fundamentally shaping their artistic goals. Like Dreiser, Shinn understood that the newspaper was where he and his associates "went to school, a school now lamentably extinct . . . a school that trained memory and quick perception."[19] Dreiser's urban realism, like that of the Ashcan artists, builds upon the journalist's close observation of particulars to produce detailed images of the city infused with the observer's personality.

Commentators at the time were keenly aware of the similarities between Dreiser's writing and the work of these painters. The influential critic James Gibbons Huneker, for one, saw Dreiser and The Eight as producing analogous work in different media. In his first of two reviews of the exhibition at Macbeth's, Huneker notes that "Luks, Sloan, Glackens, born illustrators, are realists, as are Gorky, the late Frank Norris in 'McTeague' and Theo-

dore Dreiser in 'Sister Carrie'. . . . they are not afraid of coal holes, wharf rats, street brats, the teeming East Side and the two rivers. They invest the commonest attitudes and gestures of life with the dignity of earnest art." Huneker extended the comparison in a personal note to Dreiser around the time he began work on *The Genius*, observing, "You belong to the men who paint real life."[20]

Dreiser shared a sense of camaraderie with individual members of The Eight. He was friendly with Luks and also with Shinn, whose work Dreiser used as illustrations in *Broadway Magazine*. In the 1890s he knew Glackens, who was commissioned to illustrate Dreiser's 1900 story "Whence the Song." Subsequently Glackens illustrated Dreiser's *A Traveler at Forty* (1913). Dreiser was also familiar with the work of Henri, the leader of the group as well as its most vocal spokesman. In a 1907 *Broadway Magazine* article, Dreiser recognized Henri as a fellow artist of the city: "if New York does not know Robert Henri the reverse cannot be said. Henri does know his New York." Dreiser also sought out John Sloan several months before he began writing *The Genius*. Dreiser's fondness for the work of George Bellows endured until at least the 1920s. In a 1925 article for *Vanity Fair*, the novelist paid tribute to Bellows's famous 1913 painting *The Cliff Dwellers*, praising this rendition of tenement life for being "so direct, so forthright. No pointed nuances. No hidden ones—any more than the broad, accurate face of life anywhere appears at a first glance to have any."[21]

The most discussed of Dreiser's affiliations with Ashcan painters concerns Everett Shinn, who has often been proposed as one of the models for Eugene Witla. Although at times Dreiser said there was no original for Witla, he told both Dorothy Dudley and Robert Elias that Shinn was the model for his fictional painter.[22] Shinn's Ashcan cityscapes from the 1890s through the early 1900s, such as *Street Scene* and *Ragpicker* (both before 1900) and *Under the Elevated* [undated, see illustration 9], undeniably resemble Dreiser's descriptions of Eugene's artwork. Moreover, Shinn's innovative use of pastel to capture urban life and his later turn to mural painting parallel the development of Eugene's career.[23]

There are other candidates for the original of Eugene Witla. John Sloan, who kept diaries of his early New York years (1906–1912) and later amassed extensive notes from his memories of the period, believed Eugene was a composite portrait. Sloan asserts that Eugene "was based on Everett Shinn, Dreiser, and two unknowns, of whom, as a person, I am not one." Given Sloan's well-advertised dislike of *The "Genius"*, he not surprisingly sought to disavow any personal association with Dreiser's character. While Sloan's desire to distance himself from Eugene is precisely the opposite of Shinn's wish to align himself with the character, a key similarity remains: Sloan also

felt that Dreiser had "described some of my paintings very accurately as works of his hero."[24] Sloan and Shinn could both find their artwork precisely captured in *The Genius* because in subject matter, philosophy, technique, and style, Eugene's paintings reflect the work of the entire Ashcan School, not a particular painter. Dreiser's comment in 1938—"I had no artist in mind when I wrote [*The Genius*], but a combination of circumstances in my own and other people's lives which interested and moved me"—is probably a more revealing assessment than his claim for any particular artist as his model.[25]

The city as the prime locus of this school of painters is reflected in Witla's work. Paeans to the city's distinctive aesthetic beauty run throughout Dreiser's writing, but in *The Genius* they become central to the plot and characterization.[26] When Eugene first arrives in New York, he finds it "strange and cold, and if he had not immediately fallen desperately in love with it as a spectacle he would have been unconscionably lonely and unhappy." He is "fascinated" by the "unchanging glamor" of the city: "'Such seething masses of people! Such whirlpools of life!' he thought" (100), and sets out to capture it on paper. George Bellows's *New York* [see illustration 13], painted the same year Dreiser composed *The Genius*, captures Eugene's sense of the city's seductive vitality. Soaring skyscrapers to the rear of the canvas seem to press forward on the bustling activity in the foreground—shoppers, walkers, workers, policemen, carriages. Vivid greens, yellows, and spots of red further enliven the painting that seems to burst with vitality. Bellows's canvas illustrates the Ashcan ideal, as articulated by Robert Henri in a 1907 piece for the *New York Sun:* "It is the fashion to say that skyscrapers are ugly. It is certain that any of the eight will tell you: 'No, the skyscraper is beautiful. Its twenty stories swimming toward you are typical of all that America means.'"[27] Like Dreiser and Eugene, The Eight sang the city electric.

Dreiser's descriptions of Eugene's technique and palette also owe much to the group's practice. Effective at minimizing form, Eugene's street scenes appear "forceful in the peculiar massings of their blacks, the unexpected, almost flashing, use of a streak of white at times. There was emotion in them, a sense of life and movement." As in the portraiture by Henri and Luks, Eugene "drew a man's coat with a single dash of his pen. He indicated a face by a spot. If you looked close there was scarcely any detail, frequently none at all" (98). The French gallery director, M. Anatole Charles, admires the "[r]aw reds, raw greens, dirt gray" of Eugene's palette (228), and the artist himself wonders if his paintings were not too "raw and sketchy, that they might not have sufficient human appeal, seeing that they concerned factory architecture at times, scows, tugs, engines, the elevated roads done in raw reds, yellows, and blacks" (219). This use of jarring color to create expressive, even dissonant, urban images typifies the Ashcan style. As

Huneker notes, Henri "does not fear the ugly; the ugly for him is always the expressive. . . . And then he never quails before paint. If a color jars, let it jar. [He is a] master of dissonances."[28] Likewise, in *The Genius* a reviewer of Eugene's work says, "The artist has a new, crude, raw, and almost rough method" (218).

Dreiser was intimately familiar with these sorts of reactions, since his own writing elicited similar comments. In much the same way readers would admit the power of Dreiser's writing even while complaining of its lack of elegance, observers of The Eight's cityscapes were both moved and disturbed by the rough vitality. The character in *The Genius* who most authoritatively remarks on the originality and authenticity of this style of realism is M. Charles, who reflects on Eugene's paintings:

Of whose work did it remind him—anybody's? Raw reds, raw greens, dirt gray paving stones—such faces! Why this thing fairly shouted its facts. It seemed to say, "I'm dirty, I am commonplace, I am grim, I am shabby, but I am life." And there was no apologizing for anything in it, no glossing anything over. Bang! Smash! Crack! came the facts one after another, with a bitter, brutal insistence on their so-ness. Why, on moody days when he felt sour and depressed, he had seen somewhere a street that looked like this, and here it was—dirty, sad, slovenly, immoral, drunken—anything, everything, but here it was.

"Thank God for a realist," Charles concludes (228). According to this model of realism, "shouting facts" trump conventional ideals of beauty and confirm the epistemological validity of the artwork. As an art editor in *The Genius* says of Eugene's sketches, they are "the real thing" (104). Eliciting such a response was The Eight's objective. One of their admirers who was also a friend of Dreiser's, Mary Fanton Roberts, commended them for "painting truth . . . with strength and fearlessness and individuality." Or, as Dreiser insisted, "True Art Speaks Plainly."[29]

Art in the Modern Marketplace

The Genius shows Dreiser's keen awareness of the difficult position of the modern artist—whether writer or painter—who must manage market values and pressures even while striving to fulfill more traditional romantic conceptions of the revolutionary and unconventional artist who seeks without compromise to express "truth" in his work. The early New York sections of *The Genius* detail Eugene's unsuccessful attempts to sell paintings to national magazines such as *Century*, *Harper's*, and *Scribner's*. His first real break comes when a weekly appropriately titled *Truth* purchases one of his drawings for seventy-five dollars and reproduces it as a double-page color

spread. It is only after Eugene's art has thus been validated by the market-place that he considers entering one of his works in a formal competition. When the painting is accepted, Eugene enjoys seeing the original hanging on a gallery wall almost as much as he had delighted in showing magazine reproductions to Angela and others. Later in the novel, he works in advertising and publishing as successfully as he does in pastel and paint. Dreiser's choice of an advertising firm to provide one of the turning points in Eugene's personal and professional life is particularly appropriate because advertising was, as the narrator remarks, "coming to be quite a business" (405) by the turn of the century. Moreover, an important factor in the explosion of advertising was the systematic use of art to sell products.[30]

That fine art must itself be marketed was a lesson familiar to Dreiser's generation. William Dean Howells proclaimed in 1893 that the "man of letters" must also be a "man of business," and few writers fulfill that mandate better than Dreiser. As he astutely said in a 1917 interview, "We all start out as artists, and we develop into propagandists, because instead of creating for a public, we have first to create a public for us." Dreiser's ongoing experiences concerning censorship of *The "Genius"* of 1915 likely prompted that insight. In any case, one of the closest analogues to Dreiser's appreciation of the role of publicity in validating modern art comes, again, with the Ashcan painters. Like Dreiser, they understood that public controversy about a new art form breeds excitement, and when the artist is lucky, even sales. The extensive publicity surrounding the 1908 inaugural exhibition of The Eight enticed seven thousand viewers to crowd into Macbeth Galleries on 450 Fifth Avenue. As Elizabeth Milroy sums up, "The Eight demonstrated that the independent exhibition was a viable form. . . . And they proved that the American public, so long maligned as uninterested in the visual arts, would indeed attend an art exhibition if its curiosity was whetted by a well-orchestrated and persuasive publicity campaign." To interest readers—and stimulate newspaper sales—the press exaggerated the so-called "revolutionary" qualities of the group. In particular, a group of critics friendly with The Eight who wrote for *The New York Sun* and the *Evening Sun* made strategic exaggerations to drum up interest.[31]

As *The Genius* demonstrates, Dreiser was well aware of this press coverage. In the novel he refers to the *Evening Sun* as "a most excellent medium for art opinion," and he imagines its favorable review of Witla's *Six O'Clock*:

"a pastel . . . which for directness, virility, sympathy, faithfulness to detail, and what for want of a better term we may call totality of spirit, is quite the best thing in the exhibition. It looks rather out of place surrounded by the weak and spindling interpretations of scenery and water, which so readily find a place in

the exhibitions of the Academy, but it is none the weaker for that. The artist has a new, crude, raw, and almost rough method but his canvas seems to say quite clearly what he sees and feels. Eugene Witla is an artist." (218)

This fictional review follows the content as well as the rhetoric of critics who supported The Eight. Champions routinely stressed the "virility and masculinity" of the artwork, "which they contrasted with the 'delicate sensibilities' characteristic of the society and academy artists." No longer a defect, roughness became a virtue, and a manly one. In the words of Samuel Swift, "There is virility in what [The Eight] have done, but virility without loss of tenderness; a manly strength that worships beauty."[32] In *The Genius*, M. Charles likewise thrills to Eugene's work because he finds it "astonishingly virile" (228).

Witla garners the above review through a group show sponsored by the National Academy of Design. An honorary organization founded in 1825 to promote American artists by sponsoring annual exhibitions, the National Academy was initially a progressive institution, but by the 1890s it had grown conservative. The Academy "placed a great brake upon American art, its self-perpetuating membership contriving to stifle nonconformism through a rigid system of election of members," which was especially damaging because the market for American art was so limited. There were few private galleries in New York at the turn of the century, and most of them specialized in European art. (One exception was Knoedler's, which promoted American art; Dreiser seems to have modeled his fictitious M. Kellner and Son on this distinguished gallery.) As Dreiser correctly notes in *The Genius*, for the most part, "American art . . . did not sell," because the collectors' "prejudice" was for European works (222). By the turn of the century, the Academy had become the *bête noir* of The Eight and other independents, many of whose paintings it refused. As John Sloan grumbled, the Academy was "no more national than the National Biscuit Company." The review in *The Genius* of Witla's *Six O'Clock* reflects Dreiser's accord with the belief of many artists that the Academy exercised a dangerous degree of control over the American art scene. Critics charged the Academy with preferring, in Dreiser's account, "weak and spindling" artwork, or, in the words of George Luks, canvases by "pink and white painters." When detractors were not content to vilify the Academy for effeminate weakness, they delighted in pronouncing it dead: "the morgue" was a common nickname for it, which Dreiser translates into Eugene's reflection on the Academy's preference for "dead-alive" paintings (216). The painter Arthur Dove encapsulates the American artist's frustration: *"Once upon a time the same ones could always take the same things to the same places and get the same welcome because the things*

were the same. . . . There was a great necessity for a live one because there were so many undertakers, and they all made their livings from the dead ones."[33]

Eugene's career reflects the tensions of shifting marketplace values, very much as Dreiser had experienced them as a novelist. Eugene's first one-man exhibition, at M. Kellner's, polarizes responses in the press, both sides of which could be pages torn out of contemporary responses to The Eight, as well as to Dreiser's novels. A critic claims that Eugene's subjects disqualify the work as art: "If we are to have ash cans and engines and broken down bus-horses thrust down our throats as art, heaven preserve us. We had better turn to commonplace photography at once and be done with it. Broken window shutters, dirty pavements, half-frozen ash cart drivers, overdrawn, heavily exaggerated figures of policeman, tenement harridans, beggars, panhandlers, sandwich men—of such is *Art* according to Eugene Witla" (234). Another critic finds in the same paintings evidence of Eugene's brave originality. The fictitious *Sun* critic praises the show in terms that recall those of the early advocates of *Sister Carrie*: "There is no fear here, no bowing to traditions, no recognition of any of the accepted methods. It is probable that he may not know what the accepted methods are. So much the better. We have a new method" (234). Such flouting of convention was often mentioned by champions of The Eight, as in a reviewer for *Studio Talk* who described Shinn's pastels as "somewhat raw" yet "vigorously executed," and approvingly concluded, "He disregards precedent and academic laws."[34]

Dreiser's familiarity with the Ashcan painters—their approach, style, and how their work was reviewed—reflects his considerable knowledge about the visual arts and his understanding of the politics of the marketplace. As a journalist in the 1890s, Dreiser had published some thirty articles about the arts, and in A *Traveler at Forty* he remarks that he had "knocked about sufficiently in my time in the showy chambers of American dealers."[35] In addition to Eugene's affiliation with various members of the Ashcan School, Dreiser drew considerable information—even descriptions of actual paintings—from two other urban artists, both of them personal friends: the painter William Louis Sonntag, Jr., and the pioneering photographer Alfred Stieglitz. Dreiser's experience with these men provided him with further insights into the business of art as well as important lessons about the aesthetic principles shared by writers and visual artists.

During the winter of 1895, Dreiser was editing the music magazine *Ev'ry Month*, and in this capacity he approached Sonntag for a business transaction, "on the lookout for interesting illustrations." Dreiser had seen some of the painter's night scenes and thought they would work well in the magazine. Dreiser was surprised to find that Sonntag, a professional who had learned the business end of his craft from his father, also a successful painter, was

a skillful negotiator. Dreiser was prepared to pay only $100, but Sonntag refused to part with a drawing for less than $150. Sonntag got the fee he wanted while also flattering Dreiser for his own business savvy, making him promise not to tell anyone how little he had paid.[36]

Dreiser got more than he had bargained for, since by his account in "W.L.S." (originally published in 1901 as "The Color of To-day"), Sonntag taught him to see the city through a painter's eye. Describing a walk they took together on a "drizzly autumn evening," Dreiser recalls,

When we reached Greeley Square (at that time a brilliant and almost sputtering spectacle of light and merriment), S—— took me by the arm.

"Come over here," he said. "I want you to look at it from here."

The artist urged Dreiser to train his eye to where several streets converged around throngs of people and vehicles. "Do you see the quality of that?" Sonntag asked. "Look at the blend of the lights and shadows in there under the L." The artist continued his instruction: "See, right here before us— that pool of water there—do you get that? Now, that isn't silver-colored, as it's usually represented. It's a prism. Don't you see the hundred points of light?" Under Sonntag's tutelage, Dreiser got it; he saw Greeley Square as a shimmering Impressionist canvas. Dreiser also attributes to Sonntag the lesson of seeing the city as a "'great spectacle,'" an approach that would characterize many of his novels.[37]

When Sonntag died in 1898 at the age of twenty-nine, probably from malaria contracted while covering the Spanish-American war as an illustrator, Dreiser was devastated. Death had trumped both the artist's talent and his ability to navigate the rough currents of the marketplace. *The Genius* pays quiet homage to an artist Dreiser admired and emulated. Eugene's painting of "Greeley Square in a drizzling rain" provides a fictionalized rendering of Sonntag's lesson about color and light:

Eugene by some mystery of his art had caught the exact texture of seeping water on gray stones in the glare of various electric lights. He had caught the values of various kinds of lights—those in cabs, those in cable cars, those in shop windows, those in the street lamp. The black shadows of the crowds and of the sky were excellent. The color work here was unmistakably good. It could not be the mere drama of the situation—night, crowd, and rain—for this surface of wet, light-struck stones was too difficult to handle without fine artistic perception. (224)

Some of Eugene's canvases suggest specific Sonntag paintings. Compare, for instance, Dreiser's account in "W.L.S." of "spectacular scenes . . . Madison Square in a drizzle; the Bowery lighted by a thousand lamps and crowded

with 'L' and surface cars; Sixth Avenue looking north from Fourteenth Street,"[38] with his description in *The Genius* of Eugene strolling about New York, struck by "[t]he Bowery by night; Fifth Avenue in a driving snow; a pilot tug with a tow of cars in the East River; Greeley Square in a wet drizzle—the pavements a glistening gray—all these things were fixing themselves in his brain as wonderful spectacles" (101). Dreiser may have had in mind Sonntag's 1895 watercolor *The Bowery at Night* [see illustration 14], which depicts an elevated train rushing forward at a sharp diagonal. The cool blues accentuate the beauty of the train, running on an elevated track above thronging theatergoers attending the Bowery Theater. Following the same path Sonntag and Dreiser had trod together, in *The Genius* Eugene enjoys "walk[ing] the streets in rain or fog or snow. The city appealed to him, wet or white, particularly the public squares. He saw Fifth Avenue once in a driving snow storm and under sputtering arc lights, and he hurried to his easel the next morning to see if he could not put it down in black and white" (101).

Dreiser's friendship with Alfred Stieglitz, the avant-garde photographer and proponent of modern art, also grew out of journalistic assignments. They met in June 1899 when Dreiser conducted for *Success* one of the first published interviews of Steiglitz.[39] At that time Stieglitz was concentrating on portraits and New York scenes such as the famous *Winter on Fifth Avenue* [1893; see illustration 15]. Slightly left of center in this photograph, a cab pulled by two horses pushes forward through heavy snow. A few scattered pedestrians stand to the right, while behind them buildings fade into the snow at the rear, and to the left rear stand two other lonely cabs. The freezing weather dominates the photograph, with snow emphasized by dark diagonals made by wheel tracks leading backward, dwarfing any signs of life. In writing about Stieglitz, Dreiser joined in the endorsement of the new photography and learned from the inside the importance of the media in promoting revolutionary works of art. Dreiser writes of *Winter on Fifth Avenue*, "It was said . . . that it was 'a lucky hit.' The driving sleet and the uncomfortable atmosphere issued out of the picture with uncomfortable persuasion. It had the tone of reality. But *lucky hit* followed *lucky hit*, until finally the accusation would explain no more, and then *talent* was substituted."[40]

Dreiser's endorsement of Stieglitz's famous photograph resurfaces, more than ten years later, in *The Genius*. The author has Witla paint the exact scene in the same weather and with the same spirit: "Fifth Avenue in a snow storm, the battered, shabby bus pulled by a team of lean, unkempt, bony horses," surrounded by "swirling, wind-driven snow. The emptiness of this thoroughfare, usually so crowded, the buttoned, huddled, hunched, withdrawn look of those who traversed it, the exceptional details of piles of snow

sifted onto window sills and ledges and into doorways and onto the windows of the bus itself" (224). Another of Witla's paintings—depicting "three engines entering the great freight yard abreast, the smoke of the engines towering straight up like tall, whitish-gray plumes in the damp, cold air, the sky lowering with blackish-gray clouds" (229)—shares visual elements, mood, and subject matter with Stieglitz's photographs of lonely trains, such as *Hand of Man* (1902) and *In the New York Central Yards* (1903).

Dreiser and Stieglitz both understood that successful art involved not only the creation of significant work but also publicity and marketing. Like the Ashcan paintings and the literary realism of Dreiser and his contemporaries, pictorial photography was frequently criticized for its roughness and ridiculed for its claim for recognition as an art. Stieglitz led the publicity campaign in favor of pictorial photography, and Dreiser makes an important contribution in his expanded portrait, strategically titled "A Remarkable Art: Alfred Stieglitz." Dreiser predicts this "new school of art" will soon compete with "pictures done in oil, water-color, chalk, pastelle, pen-and-ink and all the other known mediums."[41] Segments throughout *The Genius* detailing Eugene's transactions with galleries and dealers extend Dreiser's commentary on the necessary marketing of art.

Dreiser recognized Stieglitz as an artistic fellow traveler. He told the photographer that he had him in mind as an ideal reader for *Sister Carrie*. After Steiglitz had read the novel, he enthusiastically gave copies to a number of friends, thus reciprocating Dreiser's efforts by supporting the novelist in ways the two men understood as essential if their work was to succeed. As Dreiser noted of the photographs, "Truth in art is a watchword," much as it was for Eugene Witla, Dreiser himself, and the Ashcan painters. The photographer's triumph, as contemporaries saw it, was remaining honest despite a culture of lies. William Carlos Williams captures this quality when he says that Stieglitz's "photographic camera and what it could do were peculiarly well suited to a place where the immediate and the actual were under official neglect."[42] Dreiser captures this spirit in *The Genius*, when Eugene faces a public "which cannot stomach nature as it is," only life "cabled off" and prettified (232).

In addition to Dreiser's preoccupations with the opening of a market for a new aesthetic, he was fascinated with the public image of the artist. As illustrated by the phenomenal success of George du Maurier's *Trilby* (1894), mentioned several times in *The Genius*, the artist's lifestyle had by the turn of the century become a commodity the public was eager to consume. Like many of his contemporaries, Dreiser identifies the artist's eccentric mode of life with the studio, and *The Genius* conveys the power of this space through Angela's eyes. A triumphant Eugene brings his new wife to his Washington

Square South studio where a "soft waxen glow irradiated the place as he proceeded and then Angela saw old Chippendale chairs, a Hepplewhite writing table, a Flemish strong box containing used and unused drawings, the green stained fish net studded with bits of looking glass in imitation of scales, a square, gold framed mirror over the mantel, and one of Eugene's drawings." The studio provides an advertisement that the occupant *lives* art, its carefully selected appointments offering visitors an instantaneous visual lesson in the production of style. When Angela moves from Black Wood to Greenwich Village, she enters the portals of art, immediately grasping the distinction between "the tawdry gorgeousness of a commonplace hotel and this selection and arrangement of individual taste" (197).[43]

Most of Dreiser's early descriptions of studios emphasize furnishings and decorations. His exposure dates back to his stint as a reporter in St. Louis in the early 1890s. The sketch "Peter" in *Twelve Men* describes a St. Louis newspaper artist's "'studio' . . . decorated in the most . . . recherché or different manner possible." In *Newspaper Days* Dreiser describes himself at that time "so green in all that related to artists and studios," and elaborates on the décor of "*the* room, the studio" of another St. Louis artist friend, Richard Wood. In his initial description of Sonntag's studio (a segment not published in the *Twelve Men* sketch) Dreiser had written in the holograph, "His studio was decorated in the customary artistic fashion, having altogether somewhat of a Turkish air, in color and arrangement at least. There were sombre colored rugs, one or two divans, several archaic iron lamps suspended by chains, a fish net used as a wall drapery and pictures in profusion. In the middle of the room was his easel, on the floor great stacks of drawings." Robert Coltrane points out that Dreiser learned about bohemian decorating from a "Decorative Notes" column that appeared in an issue of *Ev'ry Month* under his editorship, and he speculates that the description of Sonntag's workspace derives from a photograph of Stanley Middleton's studio that accompanied Dreiser's article on artists' studios published in the June 1898 *Demorest's Family Magazine*.[44]

When Dreiser visited John Sloan's Sixth Avenue loft in July 1910, he evidently was conducting his own version of market research for *The Genius*. Such in any case was Sloan's conclusion. Van Wyck Brooks, Sloan's biographer and personal friend, recounts that the novelist "found none of the atmosphere that he was looking for. . . . As Sloan put it, Dreiser 'saw at a glance that I was not leading the right kind of artist-life for his purposes: no rich furnishings and none of the typical trappings like fish-nets and spinning-wheels which were the earmarks of the "studio."'" According to Sloan, The Eight did not favor the "long hair flowing tie" look that was popularized as artistic in novels and the mass media of the day.[45]

Dreiser may have been disappointed to find neither flowing tie nor fish-nets chez Sloan, but his expectations reflect potent cultural stereotypes. The studio was an essential part of the packaging for the modern artist. As Sarah Burns demonstrates in her study of the artist in Gilded Age Amer-ica, the bohemian artist was expected to behave in an adolescent manner, and even those who were professionally and commercially successful were understood to cultivate a memorably eccentric workspace.[46] Along with the composite portraits of actual artists that contribute to the character of Eugene, the studio is part of the general truth—and the myth—about a particular type of urban artist in America that had considerable market value in this period.

In Dreiser's hands, this myth has its regenerative aspects. Despite Eugene's neurasthenic breakdown, failed marriage, and considerable success in the business world, he does finally return to his artwork. By the end of *The Genius*, Eugene finally has achieved the ideal workspace; his Montclair bun-galow is "obviously of studio proportions and arrangement" (743). Dreiser now emphasizes the studio's requisite north light rather than its décor.

The concluding chapter also registers a shift in the type of art Eugene produces. As he tells Suzanne, "I have been busy . . . on public buildings—theatres and a bank. I'm going in for state capitols and libraries, I think" (742). Eugene admits "it sounds odd for me, doesn't it?" (742), but his move toward large, institutional paintings reflects a pervasive trend in Ameri-can art from the mid-1890s through the mid-1910s: the beaux arts murals designed initially for private homes but soon used to adorn public buildings of just the sort that Eugene mentions.

Before the grand mural tradition that flourished in the 1930s, largely under the auspices of the WPA, an earlier generation of artists popularized the form. One catalyst was the 1893 World's Columbian Exposition in Chi-cago, which featured numerous murals; another was the contemporaneous City Beautiful movement. An 1899 article in *Scribner's* counted nearly a hundred murals produced by thirty-six artists in the United States.[47] Unlike the often political (and to modern eyes more vibrant) murals of a later gen-eration, the beaux arts muralists emphasized classical ideals and favored the allegorical use of human figures. In *The Genius*, Hudson Dula, one-time art director of *Truth*, makes a passing reference to some of the most famous beaux arts murals—and incidentally gives the recovering neurasthenic a real boost—when he tells Eugene what a mistake the Boston Public Library made in not commissioning him for some of its panels (400). Eugene is understandably flattered: the muralists that architect Charles Follen McKim had selected were John Singer Sargent, Edwin Austin Abbey, and Puvis de Chavannes.

At the end of *The Genius*, Eugene has realized Dula's earlier faith in him: the "high panel" Eugene works on signifies, in the parlance of the day, a mural, and Dreiser emphasizes its monumental dimensions by having the artist, his clothes covered with paint, working from a "swinging bridge" (743). The subject Eugene is painting, however—"the Brooklyn Bridge with a vision of the bay beyond"—suggests he has not abandoned urban themes or completely turned to commercial work; his latest project seems to be a hybrid form, somewhere between beaux arts and Ashcan preoccupations.[48]

There are several reasons why this earlier generation of muralists on which Dreiser draws is so unfamiliar: many of their murals have been destroyed, their aesthetic seems alien to modern sensibilities, and the prestige that mural painting once held has eroded. The matter of prestige is especially suggestive: when Dreiser wrote *The Genius*, muralists such as John La Farge, Will H. Low, Edwin H. Blashfield, and Dreiser's friend Everett Shinn were commercially successful, even if not uniformly esteemed by other artists and critics. The public nature of the muralists' artwork, its emphasis on accessible and elevating messages, and its marketability all contributed to a degree of prestige that is unusual for American artists. Nor is it coincidental that financial institutions made ample use of murals. Much of this art was unabashedly commercial, as suggested by titles such as *Commerce and Agriculture Bringing Wealth to Detroit* (Detroit Savings Bank, painted by Thomas W. Dewing) or *Industry and Thrift Leading the People to Security* (Prudential Insurance Company in Newark, painted by Blashfield). Dreiser was aware by 1910 of murals used in the marketplace, for he discusses how struck he was when he saw Ellen Adams Wrynn's murals that year in "one of the large department stores of Philadelphia."[49]

Mural painting is a logical choice for the last glimpse Dreiser provides of Eugene's artwork because it provides a resolution, however tenuous, of the sometimes competing, sometimes overlapping pulls of art and the marketplace. At precisely the point in *The Genius* when Dreiser has Hudson Dula reappear with his encouraging words about the Boston Public Library, Eugene starts noticing how "certain artists, . . . the very successful ones," were becoming "quite commercial in their appearance" (398). Eugene accordingly changes his manner of dress, "abandoning the flowing tie and the rather indiscriminate manner he had of combing his hair" (398). When Eugene lunches with Dula, the editor clinches the point, saying the artist's "point of view is worth something"—not only "spiritually" but also "financially" (399). As the successful muralist Blashfield put it, "beauty is a tremendous commercial asset."[50] It is an idea Dreiser would surely approve. His protagonist, Eugene Witla, faces many problems—physical weakness,

moral confusion, sexual panic, financial worry, marital incompatibility—but his career shows no real difficulty in moving from art to business, nor from business back to art.

Notes

1. W. A. Swanberg, *Dreiser* (New York: Charles Scribner's Sons, 1965), 274.

2. Richard Lehan, *Theodore Dreiser: His World and His Novels* (Carbondale and Edwardsville: Southern Illinois University Press, 1969), 118; Ellen Moers, *Two Dreisers* (New York: The Viking Press, 1969), 139n.

3. *The Genius* is the first volume in the Dreiser Edition to have a title different from the version published during the author's lifetime. To avoid confusion, the title with quotation marks, *The "Genius"*, will be used only when discussing aspects unique to it, such as reactions to the first edition. Quotations are from the present edition except when designated "G", signaling a quotation from the 1915 text.

4. Dreiser maintained that Doubleday, Page and Company, after agreeing to publish *Sister Carrie*, had second thoughts and "suppressed" it. As Donald Pizer remarks, "Dreiser's controversy with Doubleday, Page and Company over the publication of *Sister Carrie* is one of the most frequently noted events in American literary history" (see Norton Critical Edition of *Sister Carrie* [New York: W. W. Norton, 1991], 443). See also the essay by James L. W. West III, "*Sister Carrie*: Manuscript to Print," in the Dreiser Edition of *Sister Carrie* (Philadelphia: University of Pennsylvania Press, 1981), 503–534.

5. Dorothy Dudley, *Forgotten Frontiers: Dreiser and the Land of the Free* (New York: Harrison Smith and Rat Haas, 1932), 350–51; H. L. Mencken to Theodore Dreiser (hereafter TD), 1 December 1920, *Dreiser-Mencken Letters: The Correspondence of Theodore Dreiser and H. L. Mencken, 1907–1945*, ed. Thomas P. Riggio, 2 vols. (1986), 2:411.

6. Floyd Dell, *Homecoming* (New York: Holt and Rinehart, 1933), 217.

7. See "The Composition of *The Genius*: The 1911 Version to Print" in this volume.

8. Before crossing it off in the holograph, Dreiser in fact used the phrase "New Woman," defining the figure as one who sought "to smash the traditions in regard to women's place in the universe" and who was "eager to get out in the world." Dreiser's understanding of the New Woman corresponds with that of recent commentators. As June Howard remarks, "Whether she attracted or repelled, the defining feature of the New Woman was that she had choices. She might marry, or not; she might have a career, or not; she might support reform and suffrage, or not—but in each case, she was understood to make up her own mind" (*Publishing the Family* [Durham, N.C.: Duke University Press, 2001], 158). On the New Woman, see also Carroll Smith-Rosenberg, *Disorderly Conduct: Visions of Gender in Victorian America* (New York: Alfred A. Knopf, 1985).

9. Thomas P. Riggio, "Another Two Dreisers: The Artist as 'Genius'," *Studies in the Novel* 9 (1977), 128.

10. Beryl Satter, *Each Mind a Kingdom: American Women, Sexual Purity, and the New Thought Movement, 1875–1920* (Berkeley and Los Angeles: University of California Press, 1999), 52.

11. "A Riot of Eroticism" [review from 1915 *St. Louis Post-Dispatch*], rpt. in Jack Salzman, ed., *Theodore Dreiser: The Critical Reception* (New York: David Lewis, 1972), 224;

The Scavenger, "The Dionysian Dreiser," *Little Review* 2 (October 1915), 209; Robert H. Elias, "Bibliography and the Biographer," *Theodore Dreiser Centenary* (Philadelphia: The Library Chronicle, University of Pennsylvania, 1971), 28.

12. See Dreiser's letters to Thelma Cudlipp, *The Letters of Theodore Dreiser*, ed. Robert H. Elias. 3 Vols. (Philadelphia: University of Pennsylvania Press, 1959) 1: 104–9. The most complete account of Dreiser's breakdown can be found in *An Amateur Laborer*, ed. Richard W. Dowell (Philadelphia: University of Pennsylvania Press, 1983). For further biographical information, see Robert Elias, *Theodore Dreiser: Apostle of Nature*. Emended edition (Ithaca, N.Y.: Cornell University Press, 1969); Swanberg, *Dreiser*; Richard Lingeman, *At the Gates of the City: 1871–1907* (New York: G. P. Putnam's Sons, 1986) and *An American Journey: 1908–1945* (New York: G. P. Putnam's Sons, 1990); Donald Pizer, *The Novels of Theodore Dreiser: A Critical Study* (Minneapolis: University of Minnesota Press, 1976); Moers, *Two Dreisers*.

13. Charles Hanson Towne, "Some Noted Contributors," *The Delineator* LXXVI (November 1910), 368.

14. Louis J. Oldani, "A Study of Theodore Dreiser's *The 'Genius'*" (dissertation, University of Pennsylvania, 1972), 18, 52.

15. Theodore Dreiser, "The Car Yard," rpt. in *The Color of a Great City*, rpt. (Syracuse, N.Y.: Syracuse University Press, 1996), 68. As Pizer notes in *Novels*, 139, these sketches mark Dreiser's attempts "to create in prose an effect similar to that achieved by a Shinn, Glackens, or Robert Henri street scene."

16. Quoted in Valerie Ann Leeds, *The Independents: The Ashcan School and Their Circle from Florida Collections* (Winter Park, Fla.: Rollins College, 1996), 8.

17. Elizabeth Milroy, *Painters of a New Century: The Eight and American Art*, with an essay by Gwendolyn Owens (Milwaukee: Milwaukee Art Museum, 1991), 16; Virginia M. Mecklenburg, "Manufacturing Rebellion: The Ashcan Artists and the Press," in *Metropolitan Lives: The Ashcan Artists and Their New York*, ed. Rebecca Zurier, Robert W. Snyder, and Virginia M. Mecklenburg (New York and London: National Museum of American Art in Association with W. W. Norton & Company, 1995), 191; Bennard B. Perlman, *Painters of the Ashcan School: The Immortal Eight* (New York: Dover, 1979), 152.

It is unclear who coined the term "The Eight." Mary Fanton Roberts claimed to have originated it, but Sloan believed that Charles FitzGerald and Frederick James Gregg, writers for *The Evening Sun*, instigated it (William Innes Homer, with the assistance of Violet Organ, *Robert Henri and His Circle* [Ithaca, N.Y.: Cornell University Press, 1969], 130). Initial coverage of the show, however, appeared in the morning *Sun* (see Milroy, *Painters*, 53–54, n. 36).

The Eight also included three non-Ashcan sorts of painters: Ernest Lawson painted lovely, controlled Impressionist landscapes; Maurice Prendergrast, a post-Impressionist, used rich colors applied in large blots; Arthur B. Davies painted dreamlike allegories. The broader attribution of "New York Realists" includes such painters as Edward Hopper, Glenn O. Coleman, Reginald Marsh, and Guy Pène DuBois.

18. Another artist affiliated with this group is Jerome Myers, brother of Gustavus, whose *History of the Great American Fortunes* (1909) would have such an impact on Dreiser's understanding of capitalism. Samuel Swift's important "Revolutionary Figures in American Art," *Harper's Magazine* 51 (13 April 1907), 534, describes Myers as one of the "school" including Henri, Sloan, Luks, and Glackens. See Grant Holcomb,

"The Forgotten Legacy of Jerome Myers, (1867–1940): Painter of New York's Lower East Side," *The American Art Journal* 9 (May 1977), 78–91. Myers is favorably discussed in Robert Henri's "The New York Exhibition of Independent Artists," *The Craftsman* 2 (May 1910), 162–63.

19. Milroy, *Painters*, 45; Everett Shinn, "Life on the Press," *Philadelphia Museum of Art Bulletin* 41 (November 1945), 9 (ellipsis in original). The school became "extinct" when the spread of the photograph and halftone eliminated the need for artists' illustrations.

20. James Gibbons Huneker, "Eight Painters: First Article," 1908, rpt. in *Americans in the Arts 1890–1920, Critiques by James Gibbons Huneker,* ed. Arnold T. Schwab (New York: AMS Press, 1985) 475; James Gibbons Huneker to TD, undated 1911, DPUP. Of Dreiser's portrait of the artist, Huneker said, "I enjoyed 'The "Genius,"'" yet do I wish that it were shorter. You can't see the trees because of the forest, in this instance" ("The Seven Arts," *Americans in the Arts,* 334).

21. On Dreiser's introduction to Glackens, see Henry Edward Rood to TD, June 1, 1900, DPUP; Dreiser's comment about Henri quoted in Joseph J. Kwiat, "Dreiser and the Graphic Artist," *American Quarterly* 3 (Summer 1951), 130; John Sloan to TD, 10 July 1910, DPUP; Theodore Dreiser, "'The Cliff Dwellers': A Painting by George Bellows," *Vanity Fair* 24:5 (December 1925), 55, 118 (reprinted in *Vanity Fair Facsimile Edition* [Ann Arbor, Mich.: University Microfilms, 1966]).

In 1915 Dreiser attempted to visit Sloan's studio again, this time bringing his lover Kirah Markham; see John Sloan [no salutation], February 1915, DPUP, and John Sloan to Kirah Markham, 28 March 1915, DPUP.

22. In *Forgotten Frontiers,* 328, Dudley says that Dreiser told her "[h]e had four men in mind when he wrote [*The "Genius"*], his young predecessor of the Delineator [*sic*]; the erotic illustrator, Everett Shinn; himself, especially as to outward circumstance, and a fourth unnamed." Dreiser's predecessor was Ralph Tilton, editor of *The Delineator* in 1906, about whom little is known. See also Elias, *Theodore Dreiser,* 155, 328 n. 12. Helen Dreiser mentions an unnamed "young art editor of the Butterick Publications, who had committed suicide," from whom Dreiser drew Eugene's "physical and nervous form" as well as his use of Shinn. See Helen Dreiser, *My Life with Dreiser* (Cleveland and New York: World Publishing Company, 1951), 81.

23. The connections have been elucidated most conclusively in Joseph J. Kwiat, "Dreiser's The '*Genius*' and Everett Shinn, The 'Ash-Can' Painter," *PMLA* 67:2 (March 1952), 15–31. This argument, however, relies largely on Shinn's own testimony—a dubious source since by the time Kwiat interviewed him, Shinn's reputation had faded while his desire to remain in the limelight had not. After a 1901 trip to Paris, Shinn's subject and style changed drastically. He moved away from Ashcan subjects and treatments in favor of more uptown and upbeat subjects executed in a lighter, more decorative, even rococo style that was easier to sell. But even as he became commercially successful, Shinn's reputation declined; from 1905 to 1943, he had only one solo exhibition. He remained, however, an opportunistic self-promoter and continued to trumpet his youthful affiliations with The Eight long after he had abandoned their aesthetic. (See, for example, Shinn's "Recollections of the Eight," written when the Brooklyn Museum launched a retrospective [in *The Eight* (Brooklyn Museum, 1943), 11–22].) By the time Kwiat interviewed Shinn, the glamorous notion that he was the "model" for Eugene Witla was probably the artist's biggest claim to fame, and one he was happy to exaggerate. One of the best overviews of Shinn's career is Sylvia L. Yount, "Consuming Drama: Everett Shinn and the Spectacular City," *American Art* 6:4 (Fall 1992), 87–109.

The tradition of associating Shinn with Eugene continues with Swanberg, *Dreiser* (who cites no documentation [183]), and Pizer, *Novels* (citing Kwiat [139–40]). Richard Lingeman adds a piquant biographical parallel by noting Shinn had a "string of wives" and "epitomized the Bohemian sexual freedom" that Dreiser "envied" (*American Journey* 37). Shinn was married four times, and his first divorce was a highly publicized affair, as his wife Flossie went to the papers with accusations of three counts of adultery. This occurred, however, in 1912—one year after Dreiser completed *The Genius*.

As art historian Mahonri Sharp Young pointedly states, "Too much has been made of Shinn's being the model for Dreiser's *The Genius* [sic], particularly by Shinn himself" (*The Eight* [New York: Watson-Guptil Publications, 1973], 152).

24. John Sloan notes, quoted in Edith De Shazo, *Everett Shinn 1876–1953: A Figure in His Time* (New York: Clarkson N. Potter, 1974), 147. Sloan's second wife, who has been highly instrumental in first recording and then archiving her husband's papers, remembers Sloan saying, "It bothers me that scholars . . . assume that I was influenced in my thinking and working habits by Stephen Crane or Theodore Dreiser. I never liked their idea about the artist needing to have experiences in order to understand or to gather subject matter from life" (quoted by Helen Farr Sloan, "Introduction" to *John Sloan's New York Scene from the Diaries, Notes, and Correspondence 1906–1913*, ed. Bruce St. John with an Introduction by Helen Farr Sloan [New York: Harper and Row, 1965], xx). Moers, *Two Dreisers*, 22, likewise notes that three of The Eight—Glackens, Luks, and Shinn—were "Dreiser's friends" and that "all three contributed something to" The "Genius". As Miles Orvell notes, Witla's paintings are "closer in spirit" to the urban scenes of Sloan than of Shinn ("Dreiser, Art, and the Museum," *The Cambridge Companion to Theodore Dreiser*, ed. Leonard Cassuto and Clare Virginia Eby [Cambridge: Cambridge University Press, 2004], 130).

25. TD to John Golden, 17 June 1938, *Letters* 3:797.

26. At first glance, the aesthetic sensitivity of Frank Cowperwood would seem to make *The Financier* and *The Titan* closest in spirit to *The Genius*. When he arrives in Chicago, Cowperwood, like Eugene, appreciates the city's "artistic subtlety" (*Titan* 11). Like Eugene, Cowperwood is especially drawn to industrial landscapes: "Between the street ends that abutted on it and connected the two sides of the city ran this amazing stream—dirty, odorous, picturesque, compact—of a heavy, delightful, constantly crowding and moving boat traffic. . . . It was lovely, human, natural, Dickensesque—a fit subject for a Daumier, a Turner, or a Whistler" (*Titan* 157). But as his artistic reference points suggest, Cowperwood's aesthetic looks backward and toward Europe.

27. Henri quoted in Homer, *Robert Henri*, 131.

28. James Gibbons Huneker, "Robert Henri and Others" (1907), rpt. in *Americans in the Arts*, 494.

29. Giles Edgerton [Mary Fanton Roberts], "The Younger American Painters: Are They Creating a National Art?" *Craftsman* XIII (February 1908), 521; Theodore Dreiser, "True Art Speaks Plainly," 1903, rpt. in *Documents of Modern Literary Realism*, ed. George J. Becker (Princeton, N.J.: Princeton University Press, 1963), 154.

30. For more on advertising and art, see Historical Notes for Chapter LXII.

31. William Dean Howells, "The Man of Letters as a Man of Business," *Scribner's Magazine* 14 (October 1983), 429–445; Milroy, *Painters*, 87; Dreiser quoted in Oldani, "A Study," 314; Milroy, *Painters*, 18. See also Mecklenburg, "Manufacturing," 191–213; John Loughery, "The *New York Sun* and Modern Art in America: Charles FitzGerald, Frederick James Gregg, James Gibbons Huneker, Henry McBride," *Arts Magazine* 59 (December 1984): 77–82.

Exaggerations about the group's "revolutionary" qualities suggest another important parallel with Dreiser, who strategically overstated tales of the "suppression" of *Sister Carrie*. Moreover, the Ashcan paintings, like Dreiser's novels, were eclipsed by more radical currents in modern art. At the 1913 New York Armory Show, which brought modern art to wide audiences in America, seven of The Eight exhibited in the American section—but it became obvious to the painters themselves, as well as to the general public, that their "revolution" had fizzled. (Shinn, who hated modern art, refused to submit anything to the Armory Show.) See Constance H. Schwartz, *The Shock of Modernism in America: The Eight and Artists of the Armory Show* (Roslyn Harbor, N. Y.: Nassau County Museum of Fine Art, 1984).

32. Mecklenburg, "Manufacturing," 203; Swift, "Revolutionary," 534.

33. Milton W. Brown, Sam Hunter, John Jacobus, Naomi Rosenblum, and David M. Sokol, *American Art* (New York: Harry N. Abrams, 1979), 338; John Sloan, quoted in Van Wyck Brooks, *John Sloan: A Painter's Life* (New York: E. P. Dutton & Co., 1955),72; George Luks, quoted in Perlman, *Painters*, 175; Arthur G. Dove, "A Different One," in *America and Alfred Stieglitz*, 121–22, italics in original. For more on Knoedler's, see Historical Notes, 811 and 816.

The Eight's first exhibition was organized in response to the Academy's refusal of paintings by several Henri students.

34. Quoted in Schwartz, *Shock*, 22.

35. Theodore Dreiser, *A Traveler at Forty*, ed. Renate von Bardeleben. Dreiser Edition. (Urbana: University of Illinois Press, 2004), 555. Most of Dreiser's writings on the arts have been reprinted in *Selected Magazine Articles of Theodore Dreiser: Life and Art in the American 1890s*, ed. Yoshinobu Hakutani (Rutherford, N.J.: Fairleigh Dickinson University Press, 1985), and *Art, Music, and Literature 1897–1902*, ed. Yoshinobu Hakutani (Urbana and Chicago: University of Illinois Press, 2001).

36. Theodore Dreiser, "W.L.S." *Twelve Men*, ed. Robert Coltrane. Dreiser Edition (Philadelphia: University of Pennsylvania Press, 1998), 344–46. The earlier version, "The Color of To-day" (14 December 1901), is reprinted in *Selected Magazine Articles*, 267–78.

37. Dreiser, "W.L.S.," 357.

38. Dreiser, "W.L.S.," 344.

39. Theodore Dreiser, "A Master of Photography," rpt. in *Selected Magazine Articles*, 248–53, later expanded into "The Camera Club of New York" and published in *Ainslee's* October 1899 (rpt. in *Art, Music, and Literature*, 80–92).

40. Dreiser, "Camera Club," 85.

41. Theodore Dreiser, "A Remarkable Art: Alfred Stieglitz," rpt. in *Art, Music, and Literature*, 112.

42. Alfred Stieglitz to Dorothy Dudley, 5 December 1932, copy at DPUP; Richard Whelan, *Alfred Stieglitz: Photography, Georgia O'Keeffe, and the Rise of the Avant-Garde in America* (Boston: Little, Brown and Co., 1955), 192–94; Dreiser, "Remarkable," 115; William Carlos Williams, "The American Background," in *America and Alfred Stieglitz: A Collective Portrait*, ed. Waldo Frank, Lewis Mumford, Dorothy Norman, Paul Rosenfeld, and Harold Rugg, new, revised edition (New York: Doubleday and Company, 1975), 26. According to Whelan, Dreiser and Stieglitz fell out of contact when Dreiser had his neurasthenic breakdown, and the men never reconnected.

In the catalogue for a 1921 exhibition of his photographs, Stieglitz famously declared, "I was born in Hoboken. I am an American. Photography is my passion. The search for Truth my obsession" (quoted in Whelan, *Alfred Stieglitz*, 419).

43. The location of the Witla studio, 61 Washington Square South, was one of the best-known rooming houses in the area, popular with people in the arts. William and Edith Glackens's studio was on number 50 of the same street. Dreiser identifies Eugene's first New York studio (shared with Smite and McHugh), as on Waverly Place. Everett and Florence Shinn occupied 112 Waverly Place, where they staged semiprofessional plays in their "Waverly Place Players."

44. Theodore Dreiser, "Peter," *Twelve Men*, 14; Theodore Dreiser, *Newspaper Days*, ed. T. D. Nostwich (Philadelphia: University of Pennsylvania Press, 1991), 167; Robert Coltrane, "Historical Notes" to *Twelve Men*, 421.

45. Brooks, *John Sloan*, 188, 76.

46. Sarah Burns, *Inventing the Modern Artist: Art and Culture in Gilded Age America* (New Haven, Conn.: Yale University Press, 1996), see especially 266–67 and 50–51. For a young Dreiser's reactions to artists' studios, see also *Newspaper Days*, 167–70. Some of the contemporaneous descriptions of high jinx at artists' studios match or exceed Dreiser's in *The Genius*. Ira Glackens (son of the painter) records the partying in Henri's studio (shared at various times with Sloan and Glackens) at 806 Walnut Street, Philadelphia: "Once a week 'the gang' met here, and the evening was devoted to discussions, games, beer and welsh rabbits, and sometimes skits" (Ira Glackens, *William Glackens and The Eight: The Artists Who Freed American Art* [New York: Horizon Press, 1957], 6). For more detailed accounts of the revels of The Eight—including a spaghetti dinner reminiscent of what Dreiser depicts in *The Genius*—see Perlman, *Painters*, ch. 5.

47. Bailey Van Hook, *The Virgin & the Dynamo: Public Murals in American Architecture, 1893–1917* (Athens: Ohio University Press, 2003), 36. This discussion of the first mural movement is greatly indebted to Van Hook. A useful contemporary account that emphasizes the pivotal role played by the Chicago World's Fair in both the production of and appreciation of murals is Pauline King, *American Mural Painting: A Study of the Important Decorations by Distinguished Artists in the United States* (Boston: Noyes, Platt & Company, 1902).

48. In the 1915 edition of *The "Genius"*, Eugene's murals are in Washington, three state capitols, and "two of the great public libraries of America" (reprinted here in Appendix 3, 903). Eugene's murals conform even more clearly to the beaux arts ideal: his "tall glowing panels . . . demonstrated . . . his dreams—in line, color, arrangement—a brooding suggestion of beauty that never was on land or sea. Here and there in them might have been detected a face, an arm, a cheek, an eye. If you had ever known Suzanne as she was you would have known the basis" (see Appendix 3, 904). For a reading of Eugene's murals as depicted in the 1915 edition as reminiscent of the work of Maxfield Parrish, see Orvell, "Dreiser, Art," 133.

49. Theodore Dreiser, "Ellen Adams Wrynn," *A Gallery of Women*, 2 vols. (New York: Horace Liveright, 1929), 144. Shinn's mural commissions included eighteen panels for Belasco's Stuyvesant Theatre (1907) and *Steel and Ceramic Industries* (1911) for the Trenton, N. J., City Hall.

50. Blashfield, quoted in Van Hook, *Virgin*, 114.

HISTORICAL NOTES

Notes identify persons, geographical locations, organizations, buildings, allusions, and other citations in the text that might be unfamiliar to modern readers. Dreiser's numerous references to specific artists and artworks are identified here. Readers interested in the art historical context of *The Genius* can consult the two relevant sections of "The Intellectual and Cultural Background to *The Genius*: The 1911 Version to Print." Slang and other words are defined only when usage is likely to be obscure. Full names and birth and death dates for people are given with the first entry. Dreiser's first reference for an item will be annotated. For subsequent references, readers can consult the index.

The page-line reference is followed by the glossed word or words in bold type, and then by the explanatory information. Entries preceded by an asterisk also have a textual note for the item.

The historical period of the novel can be calculated by certain chronological markers. The first paragraph identifies the action as beginning during 1884–1889, the date range apparently capturing Eugene's years in Alexandria, Illinois. He is sixteen early in the novel and has just turned seventeen when he begins working at the *Appeal* (10). Eugene was thus born around 1868. Eugene takes classes at the Chicago Art Institute before the "present impressive structure" (44) was built. Since the new building was erected in 1893, this places Eugene in Chicago by no later than the early 1890s. Chapter XLVIII mentions a subway under construction in New York (308); the New York subway was built in 1904, placing the events of this chapter shortly before that year. Suzanne Dale is eighteen years old when introduced in Chapter LXXVII; Eugene is "thirty-eight or thirty-nine" (626), making the year around 1906. In Chapter XC, Eugene tries to persuade Mrs. Dale that his love for Suzanne is justified because "[t]his is not fifty years ago, though, but the twentieth century" (619; curiously, the detail is changed in the 1915 text to read "nineteenth century," possibly to make the story seem more distant). When Eugene goes to a Christian Science practitioner in Chapter CII, he is "nearly forty" (626), and a "period of nearly four years" (737) passes before he re-encounters Suzanne. Their reunion thus occurs around 1910, the year Dreiser began to write the novel.

The following sources have been consulted in preparing the notes:

Baedeker, Karl, ed. *Baedeker's New York: Excursions in and around New York at the Turn of the Century, including Boston, Philadelphia, Baltimore and Washington.* New York: Hippocrene Books Inc., 1985. [Facsimile edition of parts of Baedeker's United States, Second Edition (1899)]

———. *Paris and Environs, with Routes from London to Paris; Handbook for Travellers.* Leipsic: K. Baedeker, 1898.

Baigell, Matthew. *Dictionary of American Art.* 1979. Reprinted with corrections, New York: Harper and Row, 1982.

Barnhart, Clarence L., ed. *New Century Cyclopedia of Names.* New York: Appleton-Century-Crofts, 1954.

Beard, George M. *American Nervousness: Its Causes and Consequences. A Supplement to Nervous Exhaustion (Neurasthenia).* New York: G. P. Putnam's Sons, 1881.

———. *Sexual Neurasthenia (Nervous Exhaustion). Its Hygiene, Causes, Symptoms, and Treatment, With a Chapter on Diet for the Nervous.* Edited by A. D. Rockwell from a posthumous manuscript. New York: E. B. Treat, 1884.

Benet's Reader's Encyclopedia. Third Edition. New York: Harper & Row, 1987.

Bénézit, E. *Dictionnaire critique et documentaire des peintres, sculpteurs, dessinateurs et graveurs de tous les temps et de tous les pays.* 14 volumes. Paris: Gründ, 1999.

The Bible, King James Version.

Biography and Genealogy Master Index. <http://galenet.galegroup.com>

Bordman, Gerald, ed. *The Oxford Companion to American Theatre.* Oxford: Oxford University Press, 1984.

Bowden, Henry Warner, ed. *Dictionary of American Religious Biography.* Westport, Conn.: Greenwood Press, 1993.

Burrows, Edwin G., and Mike Wallace. *Gotham: A History of New York City to 1898.* New York: Oxford University Press, 1999.

Chapman, Robert L. *New Dictionary of American Slang.* New York: Harper and Row, 1986.

Chilvers, Ian, and Harold Osborne, ed. *Oxford Dictionary of Art.* New York: Oxford University Press, 1997.

Condit, Carl W. *The Chicago School of Architecture: A History of Commercial and Public Building in the Chicago Area, 1875–1925.* Chicago: University of Chicago Press, 1964.

Condit, Carl W., and Hugh Dalziel Duncan. *Chicago's Famous Buildings: A Photographic Guide to the City's Architectural Landmarks and Other Notable Buildings.* Chicago: University of Chicago Press, 1965.

Craigie, Sir William, ed. *Dictionary of American English on Historical Principles.* 4 volumes. Chicago: University of Chicago Press, 1936–1944.

Dictionary of American Biography. New York, C. Scribner's Sons, 1928–1958.

Dakin, Edward Franden. *Mrs. Eddy: The Biography of a Virginal Mind.* New York: Charles Scribner's Sons, 1930.

Dreiser, Theodore. *An Amateur Laborer.* Edited by Richard W. Dowell, James L. W. West III, and Neda M. Westlake. Philadelphia: University of Pennsylvania Press, 1983.

———. *Art, Music, and Literature, 1897–1902.* Edited by Yoshinobu Hakutani. Urbana: University of Illinois Press, 2001.

———. *The Color of a Great City.* 1923. Syracuse, N.Y.: Syracuse University Press, 1996.

———. *Dawn.* New York: Horace Liveright, 1931.

———. *Jennie Gerhardt.* Edited by James L. W. West III. Dreiser Edition. Philadelphia: University of Pennsylvania Press, 1992.

———. *The Letters of Theodore Dreiser.* Edited by Robert H. Elias. 3 vols. Philadelphia: University of Pennsylvania Press, 1959.

————. *Newspaper Days*. Edited by T. D. Nostwich. Dreiser Edition. Philadelphia: University of Pennsylvania Press, 1991.

————. *Selected Magazine Articles of Theodore Dreiser: Life and Art in the American 1890s*. Edited by Yoshinobu Hakutani. Rutherford, N.J.: Fairleigh Dickinson University Press, 1985.

————. *Sister Carrie*. 1900. Edited by Donald Pizer. Norton Critical Edition. 2d edition. New York: Norton, 1991.

————. *Sister Carrie*. Edited by John C. Berkey, Alice M. Winters, James L. W. West III, and Neda M. Westlake. Dreiser Edition. Philadelphia: University of Pennsylvania Press, 1981.

————. *Theodore Dreiser Journalism*, vol. 1. *Newspaper Writings, 1892–1895*. Edited by T. D. Nostwich. Philadelphia: University of Pennsylvania Press, 1988.

————. *Twelve Men*. Edited by Robert Coltrane. Dreiser Edition. Philadelphia: University of Pennsylvania Press, 1998.

Dreiser, Theodore, and H. L. Mencken. *Dreiser-Mencken Letters: The Correspondence of Theodore Dreiser and H. L. Mencken*. Edited by Thomas P. Riggio. 2 vols. Philadelphia: University of Pennsylvania Press, 1986.

Eddy, Mary Baker. *Science and Health with Key to the Scriptures*. 1875. Reprint, Boston: The Writings of Mary Baker Eddy, 2000.

Elias, Robert. *Theodore Dreiser: Apostle of Nature* (original edition 1948). Emended edition. Ithaca, N.Y.: Cornell University Press, 1970.

Encyclopedia Britannica, 11th edition (1911). <http://www.1911encyclopedia.org/>

Federal Writers' Project. *The WPA Guide to New York City*. 1939. Reprint, New York: Pantheon, 1982.

Fierro, Alfred. *Historical Dictionary of Paris*. Translated by Jon Woronoff. Lanham, Md., and London: Scarecrow Press, 1998.

Foner, Eric, and John A. Garraty, ed. *The Reader's Companion to American History*. Boston: Houghton Mifflin, 1991.

Glackens, Ira. *William Glackens and The Eight: The Artists Who Freed American Art*, New York: Horizon Press, 1957.

Grove Art On-line. <http://www.groveart.com/>

Honderich, Ted. *The Oxford Companion to Philosophy*. Oxford and New York: Oxford University Press, 1995.

Jackson, Joseph. *Encyclopedia of Philadelphia*. 4 volumes. Harrisburg, Pa.: The National Historical Association, 1931, 1932, 1933.

Jackson, Kenneth T., ed. *The Encyclopedia of New York City*. New Haven, Conn.: Yale University Press, 1995.

Lears, Jackson. *Fables of Abundance: A Cultural History of Advertising in America*. New York: Basic Books, 1994.

Legassé, Paul, ed. *The Columbia Encyclopedia*. New York: Columbia University Press, 2000.

Lingeman, Richard. *Theodore Dreiser: An American Journey, 1908–1945*. New York: G. P. Putnam's Sons, 1990.

————. *Theodore Dreiser: At the Gates of the City, 1871–1907*. New York: G. P. Putnam's Sons, 1986.

May, Elaine Tyler. *Great Expectations: Marriage and Divorce in Post-Victorian America*. Chicago: University of Chicago Press, 1980.

Merriam Webster's Collegiate Dictionary. 10th edition. Springfield, Mass: Merriam-Webster, 1993.

Milroy, Elizabeth. *Painters of a New Century: The Eight & American Art.* With an essay by Gwendolyn Owens. Milwaukee: Milwaukee Art Museum, 1991.

Mott, Frank Luther. *American Journalism, A History: 1690–1960.* 3d edition. New York: Macmillan, 1962.

———. *A History of American Magazines, 1741–.* 5 volumes. New York: D. Appleton, 1930–1968.

National Cyclopedia of American Biography. New York: J. T. White, 1937.

The New York Times.

The New York Times Theater Reviews, 1870–1919. New York: New York Times.

Newlin, Keith, ed. *A Theodore Dreiser Encyclopedia.* Westport, Ct.: Greenwood Press, 2003.

Oxford English Dictionary (Compact Edition). Oxford: Oxford University Press, 1971.

Parry, Albert. *Garrets and Pretenders: A History of Bohemianism in America.* New York: Covici, Friede Publishers, 1933.

Partridge, Eric. *A Dictionary of Slang and Unconventional English.* New York: Macmillan, 1970.

Perkins, George, Barbara Perkins, and Phillip Leininger. *Benet's Reader's Encyclopedia of American Literature.* New York: Harper Collins, 1991.

Phillips, Roderick. *Putting Asunder: A History of Divorce in Western Society.* Cambridge: Cambridge University Press, 1988.

Pierce, Bessie Louise. *A History of Chicago.* Volume III. *The Rise of a Modern City 1871–1893.* New York: Knopf, 1937.

Pope, Daniel. *The Making of Modern Advertising.* New York: Basic Books, 1983.

Presbrey, Frank. *The History and Development of Advertising.* 1929. Reprint, New York: Greenwood Press, 1968.

Sadie, Stanley, ed., and John Tyrrell, exec. ed. *New Grove Dictionary of Music and Musicians.* 29 vols. New York: Grove, 2001.

Satter, Beryl. *Each Mind a Kingdom: American Women, Sexual Purity, and the New Thought Movement, 1875–1920.* Berkeley and Los Angeles: University of California Press, 1999.

Stern, Robert A. M., Gregory Gilmartin, and John Montague Massengale. *New York 1900: Metropolitan Architecture and Urbanism 1890–1915.* New York: Rizzoli International Publications, 1983.

Swanberg, W. A. *Dreiser.* New York: Charles Scribner's Sons, 1965.

Thième, Ulrich, et al. *Allgemeines Lexikon der bildenden Künstler von der Antike bis zur Gegenwart.* 37 vols. Leipzig: W. Engelmann, 1907–1950.

Thomas, Robert David. *"With Bleeding Footsteps": Mary Baker Eddy's Path to Religious Leadership.* New York: Alfred A. Knopf, 1994.

Tone, Andrea. *Devices and Desires: A History of Contraceptives in America.* New York: Hill and Wang, 2001.

Turner, Jane, ed. *The Dictionary of Art.* 34 volumes. New York: Grove, 1996.

Who's Who in America. Volume 1. Chicago: A. N. Marquis, 1899.

Who Was Who, 1897–1915. 5th edition. London: Adam and Charles Black, 1967.

Willms, Johannes. *Paris: From the Revolution to the Belle Epoque.* Translated by Eveline L. Kanes. New York and London: Holmes and Meier, 1997.

Young, Mahonri Sharp. *The Eight: The Realist Revolt in American Painting*. New York: Watson-Guptill Publications, 1973.

Zurier, Rebecca, Robert W. Snyder, and Virginia M. Mecklenburg. *Metropolitan Lives: The Ashcan Artists and Their New York*. New York: National Museum of American Art in Association with W. W. Norton & Company, 1995.

* * *

Fly leaf **"Eugene Witla, wilt thou have . . ."** From the Liturgy of Solemnizing Marriage in the Episcopalian *The Book of Common Prayer* (1559).

CHAPTER I

6.36 *Idylls of the King* (1859–1885) Series of poems based on Arthurian legend, by Victorian poet Alfred, Lord Tennyson (1809–1892).

7.20 **Dickens, Thackeray, Scott, and Poe** Charles Dickens (1812–1870) and William Makepeace Thackeray (1811–1863), popular Victorian novelists. Sir Walter Scott (1771–1832), Scottish novelist and poet of the romantic school.
Edgar Allan Poe (1809–1849), American poet and writer of horror stories.
Hippolyte Taine (1828–1893), French historian, critic, and philosopher.
Edward Gibbon (1737–1794), English historian.

8.6 **"beauty like a tightened bow"** From W. B. Yeats (1865–1939), "No Second Troy" (1910); Dreiser quotes the entire poem later, 714.
"thy hyacinth hair, thy classic face" From Edgar Allan Poe's "To Helen" (1831).
"a dancing shape, an image gay" From "She Was a Phantom of Delight" (1807) by William Wordsworth (1770–1850).

CHAPTER II

11.20 **"patent insides"** This means of filling newspaper space began during the 1860s, when editors of small weeklies near Milwaukee, having lost their printing assistants to the Civil War, asked the *Milwaukee Evening Wisconsin* for material. The practice of using material—both news and advertisements—from larger papers spread rapidly, and editors of country papers would set local items around the outside pages, printing the "insides" as they received them.

12.36 **Chicago *Tribune*** founded in 1847, this newspaper achieved national prominence during the Civil War.

15.5 **fragile and yet virile** When applied to women, "virile" had the now obsolete meaning of "nubile."

16.4 **stereotyped factory design** stamped with a decorative pattern.

17.38 **"the shining strands of hair"** unidentified.

18.24 *The Fair God* popular historical novel (1873) by Indiana-born author Lew Wallace (1827–1905).

18.28 *Ben Hur* another popular historical novel (1880) by Wallace.

CHAPTER III

22.15 **calf-love** youthful infatuation, puppy love.
24.31 **worked at his case** a divided tray that holds printing type.

CHAPTER IV

29.9 **Longfellow and Bryant** Henry Wadsworth Longfellow (1807–1882), and
William Cullen Bryant (1794–1878), American poets.
29.10 **"Thanatopsis" and of the "Elegy"** William Cullen Bryant's "Thanatopsis"
(1817) and "Elegy Written in a Country Churchyard" (1751) by Thomas Gray
(1716–1771) are poetic meditations on mortality.
29.28 **drew him like a magnet** Cf. the first chapter title in the Doubleday and Page
Sister Carrie: "The Magnet Attracting: A Waif Amid Forces."
29.31 **Goose Island** An island upstream from where the branches of the Chicago
River converge; an industrial site since the 1860s.

CHAPTER V

32.25 **Doré** Gustave Doré (1832–1883), French artist, best known as illustrator
for literary works such as Rabelais's *Gargantua and Pantagruel*, Balzac's *Droll
Stories*, and Dante's *Inferno*.

CHAPTER VI

36.27 **Bill Sikes** In Charles Dickens's *Oliver Twist* (1837–1839), Sikes is a brutal
murderer who tempts the title character to become a thief.
37.7 **dough face** perhaps as in "dough head," slang for a foolish person.
39.34 **Carlyle, Emerson, Thoreau, Whitman** Thomas Carlyle (1795–1881), Scot-
tish-born writer of often explosive Victorian prose.
Ralph Waldo Emerson (1803–1882), American transcendentalist, author of
philosophy and poetry with a strong prophetic edge.
Henry David Thoreau (1817–1862), transcendentalist best known for nature
writings and social criticism.
Walt Whitman (1819–1892), in addition to his realistic urban poetry, ful-
filled transcendental ideas in ecstatic, unconventional poetry written in free
verse.
39.35 **theosophists** followers of occult religion founded in 1875 by Helena Petrovna
Blavatsky (1831–1891) and Henry Steel Olcott (1832–1907). One of many
synthesizing philosophies of the Victorian era, theosophy sought the unifying
principles that linked the world's religions. Dreiser interviewed Annie Besant
(1847–1933), who assumed control of the Esoteric Section of theosophy fol-
lowing Blavatsky's death. See "Theosophy and Spiritualism," rpt. in *Theodore
Dreiser Journalism* vol. 1, 36–38.

CHAPTER VIII

44.29 **present impressive structure** The Chicago Academy of Design, founded
in 1866, initially located on Dearborn Street and then on W. Adams Street,
started giving classes in 1868, making it one of the four oldest art schools in
America. After the Academy went bankrupt following the Great Chicago
Fire of 1871, the Chicago Academy of Fine Arts was established in 1879. In
1882, it changed its name to the Art Institute of Chicago and soon occupied
a building designed by John Wellborn Root (1850–1891) built in 1886–87
on the corner of Michigan and Van Buren Avenues. The "present impres-
sive structure," an Italian Renaissance design, was built in 1893 by the firm
of Shepley, Rutan, and Coolidge, and still houses the museum and art school
on Grant Park facing Michigan Avenue.

44.36 **beginners who could not go abroad** Berlin and, especially, Paris were the
preferred destinations for studying art abroad. Competition to study at l'Ecole
des Beaux-Arts was fierce, and so many Americans studied at l'Academie
Julian.

45.24 **Verestchagin** Vasily Vasilievich Verestchagin, also spelled Vereschagin
(1842–1904), Russian painter of military subjects. Many of his paintings devi-
ate from the traditional glorification of military exploits, conveying instead
the barbarity of war. Verestchagin's work appeared in one-person exhibitions
in major European and American cities from 1870 to 1890. By the turn of the
century he was the most popular Russian artist abroad.

45.37 **Bouguereau** William (-Adolphe) Bouguereau (1825–1905), French painter
of religious, genre, and mythological subjects; his work idealizes forms while
accurately rendering details. He is best known for nudes that are at once sen-
timental, mythological, and erotic. Bouguereau's work was widely collected
by Europeans and Americans during his lifetime; his teaching at l'Ecole des
Beaux-Arts further extended his influence. Eugene later identifies the painting
he sees in Chicago as "Bouguereau's Venus" (219). Bouguereau produced sev-
eral paintings of the Roman goddess of beauty and love; Dreiser probably has
in mind *The Birth of Venus* [see illustration 7]. This painting features a stand-
ing nude with long hair arising from a shell in the water. She is surrounded by
cupids and other mythological figures whose swirling shapes accentuate her
sensuous curves. In comparison with the *Birth of Venus* by Sandro Botticelli
(1444–1510)—to which the French painting obviously alludes—Bouguereau's
goddess is more erotic, facing the viewer without modestly covering her nudity
as does Botticelli's figure. Like Eugene, Dreiser may have first seen a Bouguereau
in Chicago; three of his paintings were shown at the 1893 World's Columbian
Exposition, which Dreiser attended. It is likely that Dreiser saw another of
Bouguereau's paintings, *Nymphs and Satyrs*, in New York. This painting was
displayed at the Hoffman House Café in New York, where Dreiser went with
his brother Paul (see *Newspaper Days*, 577).

On Dreiser's disdain for popular recoil against such "daring portrayal of the
nude," see his 1898 article on the controversial Bacchante sculpture by Fred-
erick W. MacMonnies ("The Art of MacMonnies and Morgan," rpt. in *Selected
Magazine Articles*, 212).

47.11 **Rembrandt** Rembrandt Harmenszoon van Rijn (1606–1669), whose handling of light and profound studies of human character make him the master of the Dutch school of painting.

47.18 **antique class** art students practiced drawing from plaster casts of antique sculptures. This practice, which eliminated fees for live models (as well as the possibility of scandals associated with drawing from the nude), was considered by many instructors and students as stultifying. As the painter Edith Dimock (1876–1955), later the wife of William Glackens (1870–1938), described her experience at the Art Students League (see below, 805), "In a room innocent of ventilation, the job was to draw Venus (just the head) and her colleagues. . . . The dead white of plaster of Paris was a perfect inducer of eye-strain" (quoted in Ira Glackens, *William Glackens, 35*).

48.19 **National Academicians** members of an honorary association of American artists. The National Academy of Design was founded in 1825 by Rembrandt Peale (1778–1860), Thomas Cole (1801–1848), Samuel F. B. Morse (1791–1872), and others to "promote the fine arts in America through instruction and exhibition." Housed from 1865 to 1897 in a Venetian Gothic building on East Twenty-third Street designed by Peter Bonnet Wight (1838–1925), the Academy erected a temporary building on West 109th Street in 1899. Beginning in 1900, the prestigious spring exhibitions were held at the Fine Arts Building on West Fifty-seventh Street. It is now located at 1083 Fifth Avenue (at Eighty-ninth Street).

Initially a progressive organization, the Academy grew conservative over the decades. By the late nineteenth century, their annual shows favored works by other academicians or artists who followed closely in their paths, prompting the organization of several rival groups. The impetus for the 1908 showing of The Eight was the Academy's rejection of several paintings by Robert Henri (1865–1929) and some of his associates. The historic New York Armory show of 1913, which introduced modern art to America, was also staged in reaction to the Academy's conservative tendency. Dreiser refers to the Academy's reactionary bias when he mentions "contempt" for it coming from "certain quarters."

48.37 **camp stools** folding stools, often used by artists for *plein air* and other work.

CHAPTER IX

52.16 **Professor Swing** David Swing (1830–1894), Chicago Presbyterian pastor, tried for heresy but acquitted.

 Reverend H. W. Thomas Henry Washington Thomas (1832–1909), liberal pulpit orator who was expelled from the Methodist Church for associating with nondenominational ministers and atheists. In the early 1890s, Dreiser attended some of Thomas's sermons in Chicago at McVicker's Theatre.

 Reverend F. W. Gunsaulus Frank Wakely Gunsaulus (1856–1921), Chicago minister, educator, and founding president of Armour Institute of Technology (now called the Illinois Institute of Technology). Dreiser interviewed him in "A Leader of Young Mankind, Frank W. Gunsaulus," *Success* 2 (15 December 1898), 23–24.

Professor Saltus Probably the philosopher and novelist Edgar Saltus (1855–1921). Though neither a preacher nor a professor, Saltus "felt himself a pioneer, a vanguard, proponent of a new religion" (Claire Sprague, *Edgar Saltus* [New York: Twayne, 1968], 33). Before he turned to novels, Saltus's early work engaged theological questions: *The Philosophy of Disenchantment* (1885) asserts that "life to the Christian is a problem, to the Brahmin a burden, to the Buddhist a dream, and to the pessimist a nightmare" (quoted in Sprague 33). *The Anatomy of Negation* (1886) surveys what Saltus calls "anti-theism," and *The Lords of Ghostland* (1907) provides a comparative study of nine religions, displaying Saltus's strong interest in reincarnation.

53.2 **stockyards** After the Union Stock Yard and Transit Company was established in 1865, Chicago became the center of the U.S. meatpacking industry. Part of Chicago's industrial belt, the stockyards were in the southwestern part of the city.

54.30 **jarflies** locusts.

56.6 **not ultimately big** Dreiser often describes people (women as well as men) who have emotional, psychological, or intellectual depth as "big."

CHAPTER X

58.14 **"Ode on a Grecian Urn"** poem by John Keats (1795–1821), culminating in a sentiment that is relevant to Eugene's glorification of artistic "beauty": "'Beauty is truth, truth beauty,' that is all/Ye know on earth, and all ye need to know."

60.17 **Grand Opera** After the 1870s, the Grand Opera House featured shows with well-known traveling troupes. After the great fire of 1871, it reopened in 1880.

CHAPTER XI

64.37 **Sofroni's** Whether this was an actual establishment is undetermined. Italian restaurants were popular with artists, especially in Chicago and New York. In *Garrets and Pretenders*, 260, Albert Parry describes an Italian establishment which was "one of the first restaurants to set tables in the back yard and call it a garden in spite of the washings hanging on the lines overhead."

66.30 **in the altogether** this phrase meaning "nude" was popularized by the best-selling novel *Trilby* by George du Maurier, in which the eponymous character poses nude. According to Parry, *Garrets and Pretenders*, 105, "'The altogether' came to mean a model's nudity not unlike the nudity practiced by gay, brave Trilby."

66.34 **roached his hair** brushed back his hair so it arched upward.

CHAPTER XII

68.7 **The Fair** one of Chicago's prominent discount department stores, founded in 1875 by German American E. J. Lehmann (1849–1900), The Fair catered to the middle and working classes. In 1891 a huge eleven-story building with 286,000 square feet, designed by engineer-architect William Le Baron Jen-

ney (1832–1907), was built around the original store. It was located on the north side of Adams Street from State to Dearborn and has since been demolished.

68.39 **variable** although Dreiser may mean fickle or moody, he probably intends to refer primarily to Ruby's promiscuity (which he frequently referred to as "varietism"), while also suggesting her unconventional behaviors more generally. Conversely, Dreiser will describe Angela's disposition as "anything but variable" (75).

70.21 **Mr. Rose, Byam Jones, Walter Low, Manson Steele, Arthur Biggs, Finley Wood, Wilson Brooks** Apparently fictitious, though Dreiser may be using surnames of contemporary American artists such as Seth Corbett Jones (1853–1930), Hugh Bolton Jones (1848–1927), Alfred Jones (1819–1900), or Francis Coates Jones (1857–1932); Will Low (1853–1932); Theodore Clement Steele (1847–1926;); Ogden Wood (1851–1912), Thomas Waterman Wood (1823–1903), or George Bacon Wood, Jr. (1832–1910); Alden Brooks (1840–1931) or Nicholas Alden Brooks (1840–1904).

CHAPTER XIII

73.36 **Marguerite in *Faust*** The legend of Faust, who made a pact with Mephistopheles, is the subject of numerous literary works, most famously *Faust* (1808 and 1832) by Johann Wolfgang von Goethe (1749–1832). Here Dreiser is referring to the opera *Faust* (1859) by Charles Gounod (1818–1893).

73.41 **Chicago Opera House** The first Chicago Opera House was destroyed in the Great Fire of 1871. The new building, designed by Henry Ives Cobb (1859–1931) and Charles Sumner Frost (1856–1932), completed in 1884–85, was located on the corner of Clark and Washington. It was demolished in 1912.

74.1 ***The Crystal Slipper*** Based on the Cinderella story, *The Crystal Slipper; or, Prince Pettywitz and Little Cinderella. A Spectacular Burlesque in Three Acts and Fourteen Tableau* (1888) was a popular extravaganza by Fred J. Eustis (1851–1912).

74.12 **Central Music Hall** completed in 1879, its design by Dankmar Adler (1844–1900), the Central Music Hall had superb acoustics, as well as interior ornamentation by Louis Sullivan (1856–1924). The Central Music Hall, on the corner of Randolph and State Streets, hosted many "famous preachers," among them David Swing, Mary Baker Eddy, and the Reverend Dwight L. Moody (1837–1899). The building was demolished in 1901.

77.40 **"Down in the Lehigh Valley"** ballad about a man searching for the city slicker who seduced his girlfriend.

78.5 **"La Paloma"** Folksong composed by Sebastián de Iradier y Salaverri (1809–1865), who moved from Spain to Cuba in 1861. The song, a *habañera*, is based on Cuban dance rhythms.

CHAPTER XIV

79.5 **wash drawings** made with pen and ink and diluted ink (called wash), generally black and white.

82.26 **the Bridewell** named after its London predecessor, this Chicago jail housed

inmates on a short-term basis. It was built in 1852 on Polk and Wells Streets, near what was then the vice district.

83.5 **Jugend** founded in 1896, this Munich periodical was pacifist and anti-clerical and advocated artistic freedom. The name derives from the German *Jugendstil* (literally "youth style"), which refers to the decorative fin de siècle style known as Art Nouveau.

Simplicissimus a German satirical periodical, founded in 1896, that used vivid colors and modern graphics.

Pick-Me-Up a self-proclaimed "Literary and Artistic Tonic for the Mind," a periodical founded in 1888 in London.

83.6 **Steinlen** Théophile Alexandre Steinlen (1859–1923), Swiss-French painter, printmaker, and sculptor of the Art Nouveau school.

Van Ile unidentified.

Mucha Alphonse Maria Mucha (1860–1939), Czech artist, perhaps the best-known practitioner of the Art Nouveau style, known for magazine and calendar illustrations and posters.

CHAPTER XV

84.27 **Kinsley's** restaurant at 105 Adams Street.

85.2 **Jehane of Arthur's court** In Arthurian legend, Jehane is a beautiful young maiden who marries the faithful squire Robert, who later wrongly accuses her of infidelity. Jehane disguises herself as a boy and serves Robert faithfully, who finally realizes his error. After Robert's death, Jehane marries King Florus, to whom she also remains loyal.

85.6 **He understood—for words mean so little anyhow** Cf. Dreiser Edition of *Sister Carrie:* "How true it is that words are but vague shadows of the volumes we mean. . . ." (9); and "People in general attach too much importance to words. . . ." (118).

85.11 **Romeo, Juliet** the ill-fated lovers in *Romeo and Juliet* (c. 1596), by William Shakespeare (1564–1616).

85.26 **"Fifth Nocturne"** by French composer, Ignace Xavier Joseph Leybach (1817–1891); also called Opus 52.

86.32 **Kant, Hegel, Schlegel, Schopenhauer** German philosophers.

Immanuel Kant (1724–1804) proposed that the external world was knowable only to the knowing mind.

Georg Wilhelm Friedrich Hegel (1770–1831) maintained that mind or spirit, not the material world, was truly real. According to the Hegelian dialectic, a concept (or thesis) generates its opposite (the antithesis); the interaction between the two generates a new concept (the synthesis), and the cycle begins again.

Friedrich von Schlegel (1772–1829), proponent of romanticism.

Arthur Schopenhauer (1788–1860), a pessimist, maintained life consists of unsatisfied wants and pain; the only escape is through renouncing desire—or, temporarily, through art or philosophy.

86.34 **Pierre Loti** pseudonym of Julien Viaud (1850–1923), French novelist of romantic tales set in exotic locales.

Thomas Hardy (1840–1928) English novelist who typically depicts lower class characters living in a universe that is indifferent, if not hostile.

Maurice Maeterlinck (1862–1949) Belgian author, received the Nobel Prize for Literature in 1911.

Leo Tolstoy (1828–1910) Russian novelist and philosopher.

87.3 The *Daily Globe* a minor Chicago paper; the *Globe* employed Dreiser as a reporter in 1892.

87.22 **like a thief in the night** the second coming of Christ is described as arriving "like a thief in the night" (see especially 1 Thess. 5:2), making it a curious description for Eugene's nighttime visits to Ruby, which may be why the phrase was omitted from the 1915 edition.

88.11 **Rector's** a nightclub on Clark and Monroe Streets, also mentioned in the first paragraph of Chapter V in both Doubleday, Page and Dreiser Editions of *Sister Carrie*.

88.15 **the levee** a red-light district of gambling and prostitution in Chicago's First Ward, in the south side of the city.

88.17 **Whitechapel Club** press club founded in 1889 by Chicago newspapermen with literary inclinations, the club was named after the London district made notorious by Jack the Ripper. Members' drinking out of skulls has become legendary, although the club only lasted for five years.

CHAPTER XVI

91.15 **Rhine Maiden, Little Lorelei** Lorelei, a rock cliff that juts out into the Rhine, a hazard to boats. In "Die Lorelei" (1827), German poet Heinrich Heine (1797–1856) depicts Lorelei as a siren, luring ships to their destruction by her beguiling songs, thereby establishing an enduring legend.

91.16 **mermaid** half-fish, half-woman figure of folklore, aligned with sirens.

91.17 **Dutch Gretchen** Gretchen is the German diminutive for Marguerite.

94.32 **Jay Gould** (1836–1892) railroad financier and speculator. His involvement in the Erie Railroad scandal of 1867, the panic of "Black Friday" on 24 September 1869, and other predatory financial dealings made Gould among the most notorious of the robber barons.

Russell Sage (1815–1906) financier, banker, speculator. In association with Gould, Sage gained control of several western railroads and New York City's elevated railroad system. He reputedly left more than $100,000,000 to his descendants.

Vanderbilts descendants of financier Cornelius Vanderbilt (1794–1877), who became a millionaire before the age of fifty by promoting steamboats. A quintessential robber baron, "the Commodore" died the richest man in New York City, leaving the bulk of his estate to one of his thirteen children, William, and William's sons. Involved in reorganizing railroads during the 1880s, William Vanderbilt (1825–1885) succeeded his father as president of New York Central Railroad and added to the family fortune. Named after his grandfather, William's son Cornelius Vanderbilt (1843–1899) took over the family holdings and built the famous Newport, Rhode Island, estate known as The Breakers. Another of this generation, George Washington Vanderbilt (1862–1914), built Asheville, North Carolina's Biltmore Estate. Many oth-

ers from this wealthy family remained in the public eye, including Gertrude Vanderbilt Whitney (1875–1942), granddaughter of Cornelius, who was a sculptor and patron of the arts. She later opened the Whitney Museum of American Art in 1931.

Morgan J. Pierpont Morgan (1837–1913), banker and art collector. Involved in reorganizing railroads during the 1880s and 1890s, he then took over his father's New York firm, which he renamed J. P. Morgan and Company.

94.34 **Madison Square** probably the park located on Twenty-third and Broadway; or Dreiser may have in mind Madison Square Garden, at that time an elaborate entertainment complex on the block bounded by Madison and Fourth Avenues and Twenty-sixth and Twenty-seventh Streets. In 1891, architect Charles Follen McKim (1847–1909) rebuilt Madison Square Garden at this location (since demolished).

CHAPTER XVII

95.3 **Desbrosses Street ferry** operated by the Pennsylvania Railroad from 1862 to 1930, the ferry ran from Desbrosses Street (just below Canal Street) to Jersey City. When Dreiser visited his brother Paul in 1894, they took this ferry into Manhattan. See *Newspaper Days*, 563.

West Street north-south street in lower Manhattan, right along Hudson River; turns into Twelfth Avenue further north.

95.18 **lower Seventh Avenue** in Greenwich Village.

95.31 **City Hall** the original neoclassical building was constructed on Murray Street between Broadway and Park Row between 1803 and 1812, designed by John McComb (1763–1853) in collaboration with Joseph Mangin (fl. 1794–1818). By the 1880s, the city had outgrown the building. After some talk of demolition, the building was preserved, and competitions were held for ancillary buildings. McKim, Mead & White won a competition for the Municipal Building, erected 1909–1914.

95.33 **the Bowery** street in lower Manhattan which in the nineteenth century became known for dives, dance halls, and cheap theaters.

Riverside Drive one of New York's best-known residential addresses, runs along the Hudson River from West Seventy-second Street to West 181st Street.

the Battery area surrounding Castle Clinton in Battery Park, at lower tip of Manhattan, used initially as a fortress, later as an immigration center (before the opening of Ellis Island for this purpose in 1892) and a public entertainment center.

Central Park with 840 acres (land acquired by the city in 1856), the largest park in Manhattan, bordered by Fifty-ninth Street to the south, Fifth Avenue on the east, 110th Street on the north, and Eighth Avenue to the west. The park was laid out according to the plans of Frederick Law Olmsted (1822–1903) and Calvert Vaux (1824–1895).

lower East Side The area stretching from Fourteenth Street on the north down to Catherine Street on the south, and from Broadway on the west to the East River. At this time it was densely populated, largely by immigrant Germans, Irish, Italians, and eastern European Jews.

97.13 **"Dear Eugene,"** Ruby's farewell letter, including the postscript, is almost identical to the one Dreiser attributes to his Chicago girlfriend Lois Zahn in *Newspaper Days*, 158.

98.18 **Blue Island Avenue** in the Lower West Side of Chicago, built in 1854 as a plank road linking Western Avenue with downtown, Blue Island Avenue was known as "Black Road" because it was covered with cinders from nearby factories.

98.32 ***Century, Harper's, Scribner's*** leading nineteenth-century periodicals with wide circulations; all of them used extensive illustrations.

Century, founded in 1850, renamed *Century Illustrated Monthly Magazine* in 1881, liberally illustrated its fictional and nonfictional series.

Harper's Weekly, founded in 1857, specialized in current events, politics, serial fiction, and short stories and was also known for its superb illustrations. Or Dreiser may have in mind *Harper's Monthly Magazine* (founded in 1850 as *Harper's New Monthly Magazine*), a leading periodical in which novelist William Dean Howells (1837–1920) waged an influential campaign in behalf of literary realism. In 1913 it assumed its current title, *Harper's Magazine*.

Scribner's Monthly was founded in 1870. Five years after it was sold to the owners of *Century Magazine*, the new *Scribner's Magazine* appeared in 1887, featuring high-quality fiction, travel, criticism, biography, along with illustrations (wood engravings, followed by halftones and later full-color pieces) by distinguished artists.

98.36 **Brentano's** In *Newspaper Days*, Dreiser describes this establishment as "the famous booksellers, at 16th on the west side of Union Square" (576). Later a store was built on Fifth Avenue.

CHAPTER XVIII

99.33 **Washington Square** one of the focal points of Greenwich Village in lower Manhattan, the location of dignified private homes as well as New York University.

99.36 **MacDougal Alley** a blind alley one-half block north of Washington Square, consisting of stables converted into studios; tourists would later call it "Art Alley de Luxe."

100.3 **Salmagundi** celebrated artists' club, founded as a sketch club in 1871, located at 14 West Twelfth Street. In its first years the club was primarily social but in 1878 it began staging annual exhibitions. Dreiser became a member in December 1897 and lived there for a while in 1898.

Kit-Kat Club founded in 1881 and located on 20 W. Fifty-ninth Street. The club offered art classes without instructors; members critiqued each other's work.

Lotos founded in 1870, New York's foremost club devoted to the arts sponsored exhibitions. In 1909 the club moved from a converted townhouse to its new clubhouse at 110 W. Fifty-seventh Street.

101.24 **Greeley Square** triangular area at intersection of Broadway and Sixth Avenue at Thirty-fourth Street.

102.14 **Art Students League** influential art school founded in 1875, known for more progressive teaching than other New York academies. In 1892, the Fine Arts

Building on 215 W. Fifty-seventh Street was built to house the Art Students League, Society of American Artists, and Architectural League.

103.7 **William McConnell, Oren Benedict, Judson Cole** apparently fictitious, though Dreiser may be using the surnames of actual American artists, such as George McConnell (1852–1929); Joseph Foxcroft Cole (1837–1892), Walter Cole (1881–?), or Timothy Cole (1852–1931).

103.31 *Truth* A New York weekly founded in 1881, suspended in 1884, reorganized in 1886 and again in 1891. A society journal, *Truth* sported its first color cover in 1891; soon thereafter it regularly featured center spreads in brilliant color.

105.9 **Shanley's** restaurant in the Putnam Building, on the west side of Broadway between Forty-third and Forty-fourth Streets. In the 1900s Shanley's was, along with Chez Mouquin, Café Francis, and Petipas, a favorite late-night haunt of John Sloan (1871–1951), William Glackens, and other artists.

CHAPTER XIX

106.1 **Waverly Place** street running east and west on Washington Square North.

107.17 *The Red Badge of Courage* (1895) novel about the Civil War that made its young American author, Stephen Crane (1871–1900), internationally famous.

Trilby Launched as a serial by *Harper's* in January 1894 and subsequently published as a novel, this tale of three art students in Paris, written by English novelist and illustrator George du Maurier (1834–1896), centers on Trilby, an artist's model with an innocent heart who is unable to marry the man she loves because his family wrongly considers her disreputable. Trilby then falls under the influence of the sinister mesmerist Svengali, becomes a diva, and dies an early death. The best-selling novel (based on *Scènes de la vie de bohème* [1848] by Henri Murger [1822–1861]) popularized an enduring image of bohemian artist life. In *Newspaper Days*, 545–46, Dreiser describes the "profound emotional perturbation" he experienced upon reading *Trilby*.

Thomas Hardy (1840–1928) English novelist and poet whose works include the pastoral novel *The Woodlanders* (1887).

107.34 **the lake city** Chicago.

CHAPTER XX

114.7 **old Jotham Blue** The original for Jotham Blue is Archibald Herndon White; a similar portrait appears as "A True Patriarch" in *Twelve Men*.

114.18 **Plato and Socrates** Plato (c. 427–c. 347 B.C.) and Socrates (469–399 B.C.), Greek philosophers.

115.32 **war with Venezuela** the dispute between Great Britain and Venezuela over the boundaries of British Guiana peaked in the 1890s. President Cleveland declared American wishes paramount in the Western Hemisphere and insisted that Britain agree to arbitration.

115.33 **new leader in the Democratic Party** probably William Jennings Bryan (1860–1925), admired by Archibald Herndon White. Bryan was thrice nomi-

nated for president, first in 1896 after electrifying the Democratic convention with his "Cross of Gold" speech.

117.11 **Black Bay, Wanhesba, Koosa** fictitious names that sound similar to actual Wisconsin locations.

121.13 **Dante and Beatrice; Abélard and Hélöise** famous lovers from literature. Italian poet Dante Alighieri (1265–1321) reveals his idealized love for Beatrice (probably Beatrice Portinari, 1266–1290) in *La Vita Nuova* (c. 1293), and in the *Divine Comedy* (1321) he depicts her as the symbol of divine revelation. French philosopher Pierre Abélard (1079–1142) was hired as a tutor for Hélöise, who bore him a child. After Hélöise's enraged uncle had Abélard castrated, he became a monk and she a nun.

CHAPTER XXI

122.17 **squire of dames** Possibly an allusion to *Trilby*, by George du Maurier (Oxford: Oxford University Press, 1995), 154.

124.18 **Constantinople** Christian capital of the Roman Empire, center of the Byzantine Empire until it fell to the Turks in 1453, when it became the capital of the Ottoman Empire. Constantinople is now the Turkish city of Istanbul. **Mahomet** alternate spelling of Muhammad (from Arabic meaning "the praised one"; 570–632), the founder of Islam.

126.16 **Isaiah** Eighth-century B.C. Hebrew prophet. The Old Testament Book of Isaiah is attributed to him.

126,23 **Goldsmith's "Deserted Village" and "Traveller"** The fame of Irish-born English writer Oliver Goldsmith (1731–1774) began with his didactic poem "The Traveller" (1764); "The Deserted Village" (1770), a poem depicting rural depopulation in the latter part of the eighteenth century, is probably his best-known work.

CHAPTER XXII

130.30 *Craft* apparently fictitious, though Dreiser may have in mind *Craftsman*, founded in 1901 by Gustav Stickley (1858–1942), American furniture maker and proponent of the arts and crafts movement associated with William Morris (1834–1896) and John Ruskin (1819–1900). Beginning in 1904, *Craftsman* changed its scope to include articles on gardening and interior design. From 1906 to 1916, the journal was edited by Dreiser's friend Mary Fanton Roberts (1871–1956).

132.12 *Marius, the Epicurean* (1885) philosophical novel by British author Walter Pater (1839–1894), an advocate of "art for art's sake."
Wives of Men of Genius sketches by Alphonse Daudet (1840–1897). The copy in Dreiser's library (DPUP) is translated by Edward Wakefield (New York: Worthington Co., 1889). The first sketch, "Madame Heurtebise," opens, "That woman certainly was never to be the wife of a man of genius . . ." (21).
Story of My Heart (1883) autobiography by Victorian author Richard Jefferies (1848–1887). Dreiser quotes Jefferies at length in *Jennie Gerhardt*, 73–74.
"Aes Triplex" 1878 essay by Robert Louis Stevenson (1850–1894), Scottish author best known for adventure tales.

"The Kasidah" (1880) lengthy philosophical poem in couplets, purportedly translated from the Arabic of Hâjî Abdû El-Yezdî, but in fact written by Sir Richard Francis Burton (1821–1890), English explorer and author who brought eastern erotica such as *The Kama Sutra* to England.

The House of Life sonnet sequence written between 1848 and 1881 by Pre-Raphaelite poet and painter Dante Gabriel Rossetti (1828–1882).

Also sprach Zarathustra (1883–1892) philosophical narrative which develops the doctrine of *Übermensch* ("Superman"), by German poet and philosopher Friedrich Nietzsche (1844–1900).

133.19 *Harper's Bazar* one of America's earliest fashion magazines, first published in 1867 (spelled *Bazaar* since 1929).

133.26 **"Arabian Dance"** incidental music composed by Norwegian Edvard Hagerup Grieg (1843–1907) for the play *Peer Gynt* (1867) by Henrik Ibsen (1828–1906).

"Es war ein Traum" by Danish composer Eduard Lassen (1830–1904).

"Elegie" by French composer Jules Massenet (1842–1912), known for sensuous style.

"Otidi" by Davydoff probably by Karl Davydov (1838–1889), Russian composer, conductor, and cellist; or by Stephan Ivanovich Davydov (1777–1825), Russian composer and conductor.

"Nymphs and Shepherds" by English composer and organist Henry Purcell (1659–1695), appeared in *The Libertine* (1692), a play by Thomas Shadwell (c. 1642–1692).

Gluck Christoph Willibald von Gluck (1714–1787), German-born operatic composer.

Sgambati Giovanni Sgambati (1841–1914), Italian composer.

Rossini Gioacchino Antonio Rossini (1792–1868), Italian operatic composer whose masterpiece is *The Barber of Seville* (1816).

Tschaikowsky alternate spelling for Piotr Ilich Tchaikovsky (1840–1893), Russian composer of melodious, emotional music.

Wieniawski Henry Wieniawski (1835–1880), violinist.

Scarlatti probably Giuseppe Domenico Scarlatti (1685–1757), Italian composer of keyboard sonatas, or his father Alessandro Scarlatti (1660–1725), composer of more than 100 operas.

134.8 **"The Nightingale"** Though many songs have "nightingale" in the title, Dreiser may have in mind "Nightingale" by Pablo de Sarasate (1844–1908), a Spanish composer and violinist who became famous throughout Europe and in North and South America during 1869–71 and 1889–90 concert tours.

"The Lost Spring" unidentified.

CHAPTER XXIII

135.33 **Carmencita** Stage name of Carmen Dauset (1868–?), tempestuous and often risqué Spanish flamenco dancer who performed throughout Europe and in American cities on the East Coast, including in the studios of prominent artists. She was also a popular artistic subject, captured in portraits by William Merritt Chase (1849–1916) and John Singer Sargent (1856–1925), and also on film by Thomas Edison (1847–1931).

136.25 **Hylas, Adonis, Perseus** from Greek mythology, all of them popular subjects in Western art and literature. Hylas was a beautiful youth, dragged into a pool by water nymphs and never found again. Among other artists, John William Waterhouse (1849–1917) revisited the myth in his famous painting *Hylas and the Nymphs* (1896).

Adonis was beloved by Aphrodite and Persephone, both of whom claimed him after his death. Zeus settled the dispute by having Adonis spend six months above ground with Aphrodite and six in the underworld with Persephone. Perseus, a favorite of the gods, killed the Gorgon Medusa. He married Andromeda after rescuing her from a sea monster.

136.26 **G. F. Watts** George Frederic Watts (1817–1904), English painter and sculptor of allegorical subjects, influenced by Renaissance painting and Greek sculpture.

Millais Sir John Everett Millais (1829–1896), English painter with painstakingly detailed style. With Dante Gabriel Rossetti and William Holman Hunt (1827–1910), initiated Pre-Raphaelite movement, which turned away from the industrial present and embraced medieval subjects.

Burne-Jones Sir Edward Burne-Jones (1833–1898), English decorator and painter of often dreamlike medieval subjects; joined Pre-Raphaelite brotherhood.

Ford Madox Brown (1821–1893) English historical painter affiliated with Pre-Raphaelite movement (and grandfather of novelist Ford Madox Ford [1873–1939], whose name Dreiser mistakenly wrote in the holograph). "Men of Sir Arthur's court" appeared in works such as Rossetti's *King Arthur's Tomb* (1855–60) and Watts's *Galahad* (1860).

138.14 **New York Symphony Orchestra** founded in 1878 by German immigrant Leopold Damrosch (1832–1885), the New York Symphony Orchestra merged with the New York Philharmonic Orchestra in 1928, forming the New York Philharmonic-Symphony Orchestra.

138.27 **two kinds of greatness possible in an individual—intellectual and emotional** Cf. *Sister Carrie*, in which Hurstwood underestimates Carrie because "he did not understand the nature of emotional greatness. He had never learned that a person might be emotionally instead of intellectually great" (378).

138.29 **Sapho** title character in 1884 semiautobiographical novel by Daudet about a Parisian who falls under the spell of a courtesan; not to be confused with Greek lyric poet Sappho (b. 612 B.C.).

Mademoiselle Marguerite Gautier better known as Camille, beautiful courtesan in the play *La Dame aux camélias* (1852) by Alexandre Dumas, *fils* (1824–1895), first published as a novel (1848). The deathbed reunion of Camille and her lover Armand is a dramatic staple, as in the operatic version *La Traviata* (1853), by Giuseppe Verdi (1813–1901).

Manon Lescaut fascinating woman who practically ruins the brilliant young man who loves her, originally appearing in *L'Histoire du Chevalier des Grieux et de Manon Lescaut* (1731), by Antoine François Prévost d'Éxiles (1697–1763), known as Abbé Prévost. The story was later made into operas by Massenet in 1884 and by Giacomo Puccini (1858–1924) in 1893.

Carmen from story by Prosper Mérimée (1803–70), popularized in 1875 opera by that name by French composer Georges Bizet (1838–1875).

Fior d'Aliza "An Idyl of Italian Life," 1863 work by French poet, historian, and politician Alphonse de Lamartine (1790–1869).

Paul and Virginia from idyllic romance *Paul et Virginie* (1787), by French naturalist and author Jacques Henri Bernardin de Saint-Pierre (1737–1814). Their story is about two fatherless children who fall in love during adolescence, she dying within sight of her beloved.

138.35 **Sarah Bernhardt** stage name of popular French actress Henriette-Rosine Bernard (1844–1923). When she toured Europe and America, Bernhardt was acclaimed for her performances in such plays as *La Dame aux camélias*, mentioned above, 809. Bernhardt also founded her own theater at Place du Chatelet, where she acted until 1914.

139.12 *Town Topics* and *Vogue* society magazines.

In 1885, E. D. Mann (1855–1902) bought *American Queen* and renamed it *Town Topics*, revamping its image. The gossip and society magazine, which also published sophisticated fiction and nonfiction under the editorship of C. M. S. McLellan (1865–1916, later a playwright), ran until 1937.

Vogue was founded in 1892 as a society weekly, focusing on wealthy New-Yorkers. When reorganized in 1894, *Vogue* became a fashion journal. It moved to semimonthly format in 1910.

140.36 **"Che faro senza Euridice"** from *Orpheus and Eurydice* (1762) by Gluck.

141.1 **"Who is Sylvia?"** (1826) by Franz Schubert (1797–1828).

CHAPTER XXIV

142.14 **Balzac's story *Cousin Betty*** 1846 novel about a frustrated spinster who destroys a romance between her niece and a sculptor; part of *La Comédie Humaine* by Honoré de Balzac (1799–1850), French realistic novelist.

142.23 *four hundred* society leader Ward McAllister (1827–1895) coined this phrase in 1899, claiming this number comprised New York's elite. Anecdotally, the phrase also refers to the number of people who could fit into the ballroom of Caroline (Mrs. William) Astor (1830–1908).

142.41 **Verlaine** Paul Verlaine (1844–1896), French symbolist poet, whose tragic personal life included a prison sentence.

143.9 **"white light" district** so called because of the late-night establishments clustered around the hotels and theaters.

145.5 **Florizel** there is no Pennsylvania town by this name. Dreiser may have in mind Shakespeare's *The Winter's Tale* (c. 1611), in which Florizel falls in love with Perdita and flees with her to Sicilia.

145.36 **Philharmonic concerts** The New York Philharmonic Orchestra, founded in 1842, was America's first orchestra. From 1891 to 1962, it performed at Carnegie Hall. In 1928, the organization merged with the New York Symphony Orchestra.

Waldorf-Astoria luxury hotel, the grandest of those built in the 1890s, formed by joining the Waldorf (opened in 1893) and the Astoria (opened in 1897). It was the site of so many important functions that it was called New York's unofficial palace. The original hotel, located on Fifth Avenue between Thirty-third and Thirty-fourth Streets, was demolished when the Empire State Building was erected on this site; in 1931 the hotel opened at its new location

on 301 Park Avenue. In *Sister Carrie*, the title character's residence at the end of the novel is the old Waldorf.

Carnegie Hall concert hall on Seventh Avenue and Fifty-seventh Street, designed by William B. Tuthill (1855–1929) and featuring superb acoustics, opened in 1891. Under the encouragement of German-American conductor and composer Walter Damrosch (1862–1950), Andrew Carnegie (1835–1919) invested two million dollars in the project, hoping to secure profits that never materialized.

Arion Society German-American male chorus, founded 1854, the first American musical organization to tour in Europe. Their clubhouse was on Park Avenue at Fifty-ninth Street.

CHAPTER XXV

146.32 **Hayden Boyd in *The Signet*** The actor is unidentified. Dreiser might have in mind a play by this name (1884) about Queen Elizabeth, written by British dramatist David Pulliam Lloyd (1857–1931).
Elmina Deming unidentified.
Winslow Homer (1836–1910) American painter of landscapes and marine and genre subjects, and a Greenwich Village resident. Along with Thomas Eakins (1844–1916), Homer was the most admired American painter of the late nineteenth century, and a pioneer realist.
Knoedler's Knoedler & Co., established in 1857 at 366 Broadway, later occupying various locations on Fifth Avenue. The gallery helped create a market for American artists (including Homer) by exhibiting them alongside European artists. Knoedler's favored progressive and at times controversial art, leading to an 1887 raid by morals crusader Anthony Comstock (1844–1915) for displaying nudes. For more on Knoedler's, see 816.

149.29 **Villon** François Villon (1431–?), French poet of late Middle Ages who became popular in the nineteenth century as a rogue hero.

149.30 ***Rubáiyát of Omar Khayyám*** eleventh-century poems translated from Persian into English by Edward FitzGerald (1809–1883) in 1859; the translation was hailed as a major work of art in its own right. The quatrains urge that humans should relish earthly life as we know nothing of the afterlife.
London Voluntaries 1892 collection of poems (including acerbic descriptions of city life) by British writer William Ernest Henley (1849–1903), a pioneer of free verse.

150.2 ***First Principles*** (1862) philosophical tome by Herbert Spencer (1820–1903) that sought to synthesize all human knowledge, arguing that evolution proceeds from simple to complex forms. The British Social Darwinist had a huge American following. Dreiser uses almost identical language to describe his own response to reading Spencer (see *Newspaper Days* 610).
Marcus Aurelius Marcus Aurelius Antonius (121–180), Roman emperor and philosopher whose *The Meditations of Marcus Aurelius* lucidly presents Stoic philosophy.
Epictetus (fl. A.D. 100), emancipated slave and Stoic philosopher.
Spinoza Baruch Spinoza (1632–1677), Dutch philosopher and expounder of pantheism.

150.11 **natural history museum** Dreiser probably has in mind the Museum of Natural History, incorporated in 1869, which captured the era's fascination with science. The museum, located at Seventy-ninth Street and Central Park West, was formally opened in 1877 by President Hayes.

150.22 **Darwin** naturalist Charles Darwin (1809–1882), whose *The Origin of Species* (1859) articulated the theory of natural selection. This controversial bestseller transformed both scientific and popular thinking.

Huxley biologist Thomas Henry Huxley (1825–1895), called "Darwin's bulldog" for his defense of evolutionary theory, helped to popularize scientific thought.

Tyndall John Tyndall (1820–1893), British physicist, mathematician, geologist.

Lubbock Sir John Lubbock (1834–1913), British archaeologist, biologist, politician.

150.38 **"Gather ye rosebuds while ye may"** opening line of "To the Virgins, to Make Much of Time" (1648), by Robert Herrick (1591–1674). The poem urges women to marry while still young.

151.6 **dainty revolutionist's cap** probably the line of "Charlotte Corday" hats, named for the woman who killed Marat in his bath. In 1905, Sears sold the hat for $2.05, advertising it as "the rage of Paris and New York. It is a small dress shape with edge drooping in mushroom effects," enhanced by a "very large bell crown," and decorated with silk and velvet flowers (see David L. Cohn, *The Good Old Days: A History of American Morals and Manners as seen through the Sears, Roebuck Catalogs 1905 to the Present* [New York: Simon and Schuster, 1940], 331).

CHAPTER XXVI

152.20 **"Time and chance"** Ecclesiastes 9:11 reads, "but time and chance happeneth to them all."

CHAPTER XXVII

*158.29 **newer order of femininity** Dreiser has in mind the "New Woman"—a phrase he used, but then crossed out of the holograph, along with the explanation that these independent women were inclined "to smash the traditions in regard to women's place in the universe." The New Woman made her appearance in the 1880s and 1890s; typically, she was college-educated and affluent, and married late (if at all). A second generation of New Women, more radical than the first, flourished in the 1910s and 1920s. (See Carroll Smith-Rosenberg, *Disorderly Conduct: Visions of Gender in Victorian America* [New York: Alfred A. Knopf, 1985]; Martha Banta, *Imaging American Women: Ideas and Ideals in Cultural History* [New York: Columbia University Press, 1987].)

159.9 **"'fan'"** This slang word (by some accounts, short for fanatic) was in use by the 1890s to describe enthusiasts of a hobby or sport, particularly baseball.

159.17 **"The bird in the gilded cage"** perhaps alluding to the song, "She's Only a Bird in a Gilded Cage," popularized by operetta star Lillian Russell (stage name of Helen Louise Leonard, [1861–1922]).

CHAPTER XXVIII

166.22 **Eberhard Zang** probably fictitious.

CHAPTER XXIX

177.3 **Jackson Park** on the south side of Lake Michigan, the main site of the 1893 World's Fair. It was on a trip to the fair that Dreiser met Sara Osborne White, who became his first wife.

177.25 **Henner's maidens** Jean-Jacques Henner (1829–1905), French painter. His portraits of young women—both nude and clothed—often depict long, flowing, reddish hair that appears billowy; the effect resembles a halo or soft cloud.

CHAPTER XXX

180.33 **studio in Washington Square South** Dreiser later identifies the location as the third floor of number 61 (184), a popular boarding house. In 1910, more than 60 percent of the residents of 61 Washington Square South were artists, musicians, writers, and journalists (Gerald W. McFarland, *Inside Greenwich Village: A New York City Neighborhood, 1898–1918* [Amherst: University of Massachusetts Press, 2001], 171).

182.10 **Coney Island, Far Rockaway** amusement areas. Brooklyn's Coney Island is a sand bar including a six-mile beach on the Atlantic Ocean; Far Rockaway sits on the beginning of a narrow peninsula that juts off of South Queens.

*182.30 **Monet** Claude Monet (1840–1926), French landscape painter, a founder of Impressionism.
Manet Édouard Manet (1832–1883), French painter of figures and landscapes, a key influence on Impressionists and also on the artists who became known as "The Eight."
Ribera probably Jusepe de Ribera (1591–1652), Spanish baroque painter.
Fortuny Mariano José Bernardo Fortuny y Marsal (1838–1874), Spanish genre painter and etcher.
Van Hooge possibly Pieter de Hooch (c. 1629–after 1677), Dutch genre painter; or Romeyn de Hooghe (1645–1708), Dutch etcher, painter, sculptor, writer, best known for political caricature.
Fragonard Jean-Honoré Fragonard (1732–1806), French painter and engraver.
Watteau Jean-Antoine Watteau (1684–1721), French painter of Flemish descent.
Ruisdael Jacob van Ruisdael (1628–1682), Dutch landscape painter.
Mesdag H(endrik) W(illem) Mesdag, Dutch painter and collector (1831–1915), known especially for marine paintings.
Mancini Either Francesco Mancini (1679–1758), Italian painter of largely ecclesiastical subjects, or Antonio Mancini (1852–1930), painter whose early treatments of commonplace subjects such as street boys of Venice placed him at the forefront of the Verismo movement, the Italian variant of realism. Given the reference to Mancini later in the novel (253), Dreiser probably intends the latter.

182.35 **sea scene** Some elements of Dreiser's description of Smite's painting suggest *The Gulf Stream* (1899) by Winslow Homer. In the center of *The Gulf Stream* a small sailboat, its mast broken off, rocks in a choppy ocean. A shirtless black man lying on the boat looks away from the ravenous sharks circling in the foreground.

CHAPTER XXXI

185.24 **Gozzolo** It is unclear whether Gozzolo was an actual restaurateur, but the 1890s–1910s wave of Italian immigrants settling in Greenwich Village established several restaurants that became popular with artists. Maria's, located on MacDougal Street before moving uptown in 1907, offered a popular "spaghetti hour" featuring large servings at modest prices. Gonfarone's, on 179 MacDougal, became popular after Maria's departed. Other area Italian restaurants of the period include Galotti's (64 W. Tenth) and Renganeschi's (139 W. Tenth). A contemporary poem, "The Village Epic," commemorates "Way down South in Greenwich Village, / Where they eat Italian swillage . . ." (quoted in Egmont Erons, *The Little Book of Greenwich Village: A Handbook of Information Concerning New York's Bohemia with which is Incorporated a Map and Directory* [New York: Published by the author, 1918], 16).

191.7 **"When I Was a Lad I Went to Sea"** unidentified.

CHAPTER XXXII

195.2 **Iroquois Hotel** erected in 1889 on Main and Eagle Streets in Buffalo, demolished in 1940.

196.20 **Great White Way** the Broadway theater district, so called because of blazing electric lights.

196.31 **Washington Arch** This eighty-six-foot-high arch, commemorating the first inauguration of George Washington, was designed by Stanford White (1853–1906) and completed in 1895, at a cost of $128,000. It remains the focal point of Washington Park.

CHAPTER XXXIII

198.20 **"Lay not up for yourselves"** Matthew 6:19.

200.32 **witch of Endor** In 1 Samuel 28:7–22, Saul, seeking answers to questions about the future, has the witch of Endor conjure up from the dead the prophet Samuel.

201.29 **Titian hair** The female figures in many of the biblical and classical paintings by Venetian painter Tiziano Vecellio (1490–1576), better known as Titian, have auburn hair, often drawn back from the face. Some of his nudes, such as the famous reclining *Venus of Urbino* (1537), have long, loosely flowing, reddish-brown hair.

205.3 **broad and flowery path** Eugene may have in mind Matthew 7:13: "Enter in at the narrow gate; for wide is the gate, and broad is the way, that leadeth to destruction, and many there be who go in that way."

CHAPTER XXXIV

206.16 **survival of the fittest** often mistakenly attributed to Darwin, this concept is one of the signature ideas of Spencer.

206.26 **Jean Jacques Rousseau's *Confessions*** twelve-volume autobiography, written between 1766 and 1770, and published posthumously in 1781 and 1788, by French romantic author Jean Jacques Rousseau (1712–1778), who claimed to have put five illegitimate children in an orphanage.

208.5 **atmosphere of enthusiasm trailing (it seemed to Eugene) like a cloud of glory** allusion to "Ode: Intimations of Immortality from Recollections of Early Childhood," 1802–04 poem by Wordsworth. For a less puzzling allusion to this passage, see later in the text, 532.

CHAPTER XXXV

215.33 **"hung on the line"** Artists whose paintings were not so advantageously displayed complained of their work being "skied," or hung so high it could scarcely be seen.

216.10 **"dead-alive"** Critics of the National Academy shows frequently spoke of the selections as moribund and dismissed the Academy as "the morgue." This criticism was part of a wider disparaging of genteel culture in the 1890s. Lewis Mumford (1895–1990) captures the spirit of the decade's rebels: "The genteel standards that prevailed were worse than no standards at all: Dead objects, dead techniques, dead forms of worship, cast a morbid shadow on every enterprise, . . . causing vitality to seem somehow shameful" ("The Metropolitan Milieu," in *America and Alfred Stieglitz: A Collective Portrait*, ed. Waldo Frank, Lewis Mumford, Dorothy Norman, Paul Rosenfeld, and Harold Rugg, new, revised edition [New York: Aperture, 1979], 32).

216.16 **Impressionists . . . were being so ignored now** The Impressionists' formal and technical innovations, emphasis on personal response, and disregard of academic rules of composition had made them unpopular among conservative viewers, patrons, and critics in an earlier generation. American Impressionism lagged a full generation behind the French movement of the 1860s and 1870s, and the National Academy of Design in the 1890s recapitulated an earlier generation's discomfort with the new art. In 1897, a group of American painters inspired by Impressionism banded together as "The Ten" and resigned from the Academy and its offshoot, the Society of American Artists. The Ten included Childe Hassam (1859–1935), J. Alden Weir (1852–1919), and John Twachtman (1853–1902). Despite the Academy's conservatism, by the early 1890s both French and American Impressionists were much admired in America. In 1886, a major exhibition of European Impressionists was sponsored in New York by Paul Durand-Ruel; in 1893, American Impressionist exhibitors at the World's Columbian Exposition were acclaimed. By the 1890s, American Impressionists such as Hassam, Weir, and Twachtman were established and popular.

218.3 ***Evening Sun*** An offshoot of the *New York Sun*, the *Evening Sun* was launched in 1887. Sold for a penny, this popular and well-edited paper featured influential writing about the arts.

CHAPTER XXXVI

219.15 **Metropolitan Museum** incorporated in 1870, resulting from a movement to create national museums to benefit the general population. The first part of the permanent building (1874–1880), designed by Calvert Vaux (1824–1895) and Jacob Wrey Mould (1825–1886), located on Fifth Avenue and Eighty-second Street, opened in 1880.

Corot Jean-Baptiste Camille Corot (1796–1875), landscape and figure painter, among the most influential landscape painters for his celebrating without romanticizing the countryside.

Daubigny Charles-François Daubigny (1817–1878), French landscape painter, noted for atmospheric effects.

Detaille Jean-Baptiste Édouard Detaille (1848–1912), painter of military scenes, precise and realistic.

219.41 **Rossetti's "Blessed Damozel"** 1850 poem by Dante Gabriel Rossetti.

220.15 **The firm of M. Kellner and Son** Dreiser's description of this "one truly distinguished art trade[r]" seems to be loosely modeled on Knoedler's, which he mentions above by name (146). The origins of this prominent firm lie in the 1846 emigration of Michel Knoedler (?–1878) from Paris to manage the New York branch of Goupil, a French gallery. Michael (as he was later known) purchased Goupil in 1857, and the gallery was intermittently known by that name until 1889, when it became known exclusively as Knoedler's. The gallery established itself as one of the leading dealers of European and American art—selling to such clients as Jay Gould, John Jacob Astor (1864–1912), Cornelius Vanderbilt, and J. Pierpont Morgan. From early on, Knoedler's championed the work of contemporary Americans, including Inness, Homer, Sargent, and Whistler (all mentioned in *The Genius*). Knoedler's also granted group exhibitions to artists who had not yet achieved national prominence. Upon the 1878 death of Michael Knoedler, his son Roland F. Knoedler (1856–1932) ran the gallery until 1928, during which period it occupied several locations on Fifth Avenue. The gallery moved to its present location, 19 East Seventieth Street, in 1973.

220.23 **heavy spring rain in a grove of silver poplars by Winthrop** unidentified, though Dreiser may have in mind a painting by Frederick Winthrop Ramsdell (1865–1915), an American Impressionist who joined the group of Old Lyme artists in Connecticut around 1900. Ramsdell studied at the Art Students League and exhibited work at the 1893 World's Columbian Exposition, the Chicago Art Institute, and in various New York galleries.

220.27 **Aubrey Beardsley** (1872–1898) illustrator and writer, with an austere, flat, graphic style, known for high-contrast illustrations that combine large areas of solid black or white with intensely detailed areas. Many of his works have erotic themes, often with a perverse twist. The term "decadent," frequently applied to fin-de-siècle artists and authors such as Beardsley, refers to the deliberate artificiality of their work.

Helleu Paul-César Helleu (1859–1927), French painter and etcher, popular portraitist of the Belle Epoque. Most of his works are very detailed and accurate, while giving the effect of quick execution.

Rodin Auguste Rodin (1840–1917), French sculptor of monumental works, realistic yet romantic, such as *The Kiss* and *The Thinker*.

Thaulow Frits Thaulow (1847–1906), Norwegian painter and engraver, best known for realistic winter landscapes.

222.12 **Inness** George Inness (1825–1894), landscape painter, leading American in the Barbizon School. While his early work was in the grand manner of the Hudson River School and his later work more intimate, Inness consistently imbued landscape with romantic qualities. Dreiser was invited by the painter's son-in-law to assemble an album of Inness's work and write a biographical introduction, a project that did not materialize.

Blum Robert Frederick Blum (1857–1903), painter and illustrator.

Sargent John Singer Sargent, renowned for flattering and dramatic portraits, especially of society figures; considered for some time the greatest of all portrait painters.

Abbey Edwin Austin Abbey (1852–1911), illustrator and painter, specializing in landscapes and portraits. His reputation grew considerably while he worked for Harper & Brothers beginning in 1871; later he executed large public murals, including for the Boston Public Library.

Whistler James Abbott McNeill Whistler (1834–1903), painter, etcher. The style of this American expatriate evolved from an early realism to embrace the principles of the Aesthetic Movement, which cultivated art for art's sake. As M. Charles's preference in the novel indicates, these artists were among those rare Americans counted among the "living successful."

224.3 **Fifth Avenue in a snow storm** This description suggests the photograph *Winter on Fifth Avenue* (1893; see illustration 15) by Alfred Stieglitz (1864–1946). Similar scenes were frequently painted by the New York Realists, as in *Central Park, Winter* (1905, Metropolitan Museum) by Glackens.

224.22 **Greeley Square in a drizzling rain** The description of this painting derives from Dreiser's sketch of William Louis Sonntag, Jr. (1869–1898), "W.L.S.," in *Twelve Men*, 357.

CHAPTER XXXVII

227.25 **great ceilings in the new congressional library** Dreiser may have in mind the Library of Congress, which would fit the time frame depicted in the novel. Although established in 1800, the Library of Congress did not occupy a separate building until what is now known as the Thomas Jefferson Building was built from 1888 to 1897. Designed by the firm of Smithmeyer & Pelz, then placed under the direction of the chief of the Army Corps of Engineers, General Thomas Lincoln Casey (1831–1896), and finished by Edward Pearce Casey (1864–1940), the Library of Congress featured more than a hundred murals by nineteen artists. The ceiling mural in the reading room was the most discussed: *The Evolution of Civilization* (1896) by Edwin H. Blashfield (1848–1936), one of the pre-eminent muralists of the period. Dreiser may be basing this reference to the fictitious Temple Boyle on a combination of Blashfield and Kenyon Cox (1856–1919), another prominent muralist for the Library of Congress, and who had taught at the Art Institute of Chicago in 1911; both were National Academicians.

CHAPTER XXXVIII

234.12 **Millet** Jean-François Millet (1814–1875), French painter celebrated for the power and simplicity of his work. Because of the quiet dignity he attributes to peasant laborers in such paintings as the *Gleaners* and *Angelus*, Millet is often described as a social realist.
 Velázquez Diego Rodríguez de Silva y Velázquez (1599–1660), most celebrated painter of the Spanish school, especially known for court and religious paintings and for his masterful control of lights and darks.
 Turner Joseph Mallard William Turner (1775–1851), foremost English romantic landscape painter, a brilliant colorist whose work became increasingly abstract in his attempt to capture atmospheric effects.

236.14 **"Diana of the mountains"** Diana, Roman goddess identified with Artemis; the goddess of hunting, the moon, and woodlands.
 hama-dryad In classical mythology, a tree nymph who presides over a certain tree and dies when it dies; also called dryad.

CHAPTER XXXIX

236.33 **Water Color Society** A group of eleven painters in New York established The American Society of Painters in Water Color in 1866; the following year marked the society's first exhibit. In 1878 the organization's name was changed to The American Water Color Society; it was incorporated in 1903. William Louis Sonntag, Jr.—the "W.L.S." of Dreiser's sketch in *Twelve Men*—became a member in 1898. In the same year, Dreiser published an exhibition review, "The American Water-Color Society," in *Metropolitan* magazine (reprinted in *Art, Music, and Literature*, 16–19).

240.5 **Montmartre** village incorporated into Paris in 1860, bohemian and art center, and after the 1889 opening of the Moulin Rouge, a center of nightlife. Montmartre was the subject of many paintings by such French artists as Vincent Van Gogh (1853–1890), Édouard Vuillard (1868–1940), Camille Pissaro (1830–1903), and Henri de Toulouse-Lautrec (1864–1901).

240.18 **Hotel Métropole** large hotel popular with English-speaking visitors, on the Rue de Castiglione.

240.29 **Gare du Nord** train station, completed in 1866. The lead architect, Jacques Ignace Hittorff (1792–1867), combined neoclassical styling with modern metal structures.
 Notre Dame [de Paris] Gothic cathedral upon Ile de la Cité, a small island in the Seine. The cornerstone was laid in 1163 but the building was not completed until the early fourteenth century.
 Eiffel Tower monument made of fifteen thousand metal pieces, erected for the 1889 Paris exposition.

241.13 **Apache district** areas of Belleville and Charonne districts dominated by juvenile delinquents, called "Apaches" because their ferocity was believed to match that of the North American Indian tribe of that name.
 Versailles city that has become synonymous with the lavish classical palace and grounds built by Louis XIV (1638–1715), who moved his court there.

Saint-Cloud suburb west of Paris, on the Seine, a residential town and resort.

241.38 **pen of men and angels** Cf. 1 Corinthians 13:1: "Though I speak with the tongues of men and of angels. . . ."

CHAPTER XL

243.34 **Gérôme** Jean-Léon Gérôme (1824–1904), French historical and genre painter, whose style is almost photographic in its realism, while his subjects tend to the exotic. He moved to Paris in 1840.

245.21 **between Scylla and Charybdis** monsters in Homer's *Odyssey*. They endangered ships traveling through the Straits of Messina (between the mainland of Italy and Sicily), and so "Scylla and Charybdis" has come to mean working one's way between two great difficulties.

245.32 **skate** slang for a worn-out horse, a contemptible person, or a cheapskate. Dreiser may intend the latter sense of the word, for The Dreiser Collection contains a photocopy of a booklet called "The Complete Jingler," featuring poems by Dreiser illustrated with artwork by Thelma Cudlipp (1891–1983). One of them, titled "Lines to Bougereau" [*sic*], reads:

> "Oogle boogle six and eight
> Evry [*sic*] artist is a skate,
> "Evry artist that I know
> Rarely seems to have the dough" (DPUP, Folder 1337).

CHAPTER XLI

250.40 **the Plaza** This luxury hotel, named after the adjacent Grand Army Plaza at the southeast corner of Central Park, opened to the public in 1890. The first hotel, designed by Carl Pfeiffer and completed by McKim, Mead, and White, was redesigned by Henry J. Hardenbergh (1847–1918) and reopened in 1907. A 1921 addition moved the main entrance from Fifty-ninth Street to Fifth Avenue. In 1986, it became a National Historic Landmark.

Museum of Fine Arts there is no such museum in New York, though this is the name of a major Boston museum.

251.4 **Sèvres** delicate porcelain, featuring flowers and figures on white backgrounds, made in Sèvres, France, in potteries established by Louis XV (1710–1774).

251.18 **Milo in the Grecian Archipelago** Milo, a mountainous island in the Aegean Sea, was a center of early Aegean civilization. Of the many excavations there, the most famous find was the Venus of Milo, discovered in 1820.

253.5 **Ibsen** Henrik Ibsen (1828–1906), Norwegian dramatist and poet, acclaimed for depicting the struggles of nineteenth-century women.

Shaw George Bernard Shaw (1856–1950), Irish playwright and critic. His dramas about ideas—such as *Man and Superman* (1903), about a cerebral man who makes an unfortunate marriage—would win him the Nobel Prize in 1925.

Rossetti probably the painter and poet Dante Gabriel Rossetti, mentioned

several times in the text. Other famous Rossettis are his sister, writer Christina Rossetti (1830–1894), and their father, writer Gabriele Rossetti (1783–1854).

253.12 **Turgenieff** alternate spelling for Ivan Sergeyevich Turgenev (1818–1883), Russian writer and pioneer realist.

Wells H[erbert] G[eorge] Wells (1866–1946), English author of history, science fiction, and novels of ideas.

Madox Brown Ford Madox Brown. Again Dreiser wrote the name "Maddox Ford" on the holograph. Ford Madox Ford's novels did not begin to appear until 1901.

255.39 **Clara Morris** (1848–1925) American actress, acclaimed for her emotional roles of women in melodrama. Augustin Daly (1838–1899)—whose *Under the Gaslight* (1867) is the play in which *Sister Carrie's* title character debuts in Chicago—wrote *Article 47* for Morris to play the lead role.

256.26 **Mademoiselle de Maupin** title character in 1835 novel by Théophile Gautier.

CHAPTER XLII

259.29 **neurasthenia** This term was coined by American physician George M. Beard (1839–1883), who proclaimed in *American Nervousness* (1881) that "American nervousness is the product of American civilization." As Dreiser's account in the following paragraph indicates, neurasthenia was a catchall term for physical and mental illness, particularly conditions believed to have been brought on by the frenzied pace of modern life. Diagnosis and treatment of neurasthenia—believed to afflict persons of refined sensibilities—derived from the assumption that people have a fixed amount of "nerve force," or energy, which overuse could debilitate. One way in which the system could be overtaxed was through excessive sexual activity, and Beard devoted another volume, *Sexual Neurasthenia* (1884), to this variant of the disease. Neurasthenia was believed to afflict men and women differently, and so the prescribed cures diverged: soothing rest for women, vigorous exercise for men. Dreiser recounts his own neurasthenic breakdown in *An Amateur Laborer* and in the 1902–03 entries of *American Diaries 1902–1926*. He sketches the man who helped treat him for it, William Muldoon (1845–1933), in "Culhane, the Solid Man" (see *Twelve Men*). See also George Beard, *A Practical Treatise on Nervous Exhaustion (Neurasthenia) Its Symptoms, Nature, Sequences, Treatment* (1880); Tom Lutz, *American Nervousness, 1903: An Anecdotal History* (Ithaca, N.Y.: Cornell University Press, 1991), and, for the European context, Peter Gay, *The Bourgeois Experience: Victoria to Freud;* Vol. II, *The Tender Passion* (New York: Oxford University Press, 1986). Many authorities today consider Chronic Fatigue Syndrome (CFS) to be the same illness as neurasthenia.

260.6 **Saint Vitus' dance** chorea, a nervous disorder causing spasms and incoordination.

Locomotor ataxia tabes dorsalis, a syphilitic condition of the nervous system.

Paralysis loss of motion in, or function of, a body part.

Paresis partial paralysis.

260.12 **ills to which the flesh is heir** from *Hamlet* 3.1: "The heartache and the thousand shocks/That flesh is heir to."

CHAPTER XLIII

267.20 **Arcady** Arcadia, district in Greek Peloponnesus, believed to embody pastoral simplicity.

CHAPTER XLIV

280.17 **until the last farthing is paid** from the Sermon on the Mount: "Verily I say unto thee, thou shalt by no means come out from there, till thou hast paid the uttermost farthing" (Matthew 5:26).

283.3 **St. Paul's** London's baroque cathedral designed by Sir Christopher Wren (1632–1723) is the fifth structure to occupy the site; the first was built in the seventh century.

Thames Embankment The north bank of the Thames was pushed back with eight-foot walls to create space for sewers and underground trains; the embankments serve as promenades. Dreiser may have in mind the largest of them, the Victoria Embankment (built 1864–1870), often called simply "The Embankment."

Piccadilly exclusive London area, location of the Ritz, the Royal Academy, and fashionable shops. Or Dreiser may have in mind Piccadilly Circus, a tourist area where five of the West End arteries meet, and at the center of which stands a statue of Eros.

Blackfriars Bridge one of many London bridges crossing the Thames, completed in 1869 out of wrought iron arches sitting on granite pillars, on the site of an earlier bridge.

Whitechapel and the East End Whitechapel, part of the poorer section of London's East End, is the center of the Jewish ghetto and made infamous by the murders of Jack the Ripper.

285.2 **"sicklied o'er by the pale cast of thought"** from the "To be or not to be" soliloquy in *Hamlet*, 3.1.

285.33 ***Knights of the Round Table*** 1903 compilation of Arthurian tales, written and illustrated in vivid pen-and-inks by Howard Pyle (1853–1911), a talented American illustrator who worked for many years for Harper Brothers. The actual title is *The Story of King Arthur and His Knights*.

CHAPTER XLVI

293.33 **Gary Calkins** Gary N. Calkins (1869–1943), zoologist, author of *Marine Protozoa from Woods Hole* (1902), *Protozoa* (1910), and other works.

294.24 **"can honor set a leg?"** from *Hamlet* 5.1: "can honor set to a leg?"

294.25 **Machiavelli** Niccolò Machiavelli (1469–1527), Florentine political theorist and statesman and author of *The Prince* (1513). Machiavelli broke from the traditional emphasis on the morality of the state, inquiring instead how the state might best maintain its power.

294.35 **marriage of true minds** William Shakespeare's Sonnet CXVI begins, "Let me not to the marriage of true minds / Admit impediments."

294.37 **friendship of Damon and Pythias** According to Greek legend, when Dionysius condemned Pythias to death, Pythias obtained leave to return home under the condition that his friend Damon take his place, even to the point of being executed should Pythias not return. This display of friendship so impressed Dionysius that he allowed both to live.

299.5 **"a husband is property to a wife and family and to win him away is nothing short of stealing" was a matter of court record in the state of New Jersey** While the reference to New Jersey is elusive, the general idea is clear. The nineteenth-century ideal of husband as breadwinner would remain entrenched through most of the twentieth century. In the last two decades of the nineteenth century, a husband's failure to provide adequate support for his wife was seen in many states as grounds for her to divorce him.

299.10 **Suits for non-support, alienation of affection, abandonment, and alimony** laws establishing grounds for divorce varied considerably from state to state and also from decade to decade, but each of the items Dreiser mentions here could lead to a successful divorce. Dreiser is also correct about the divorce boom being newsworthy: from 1867 to 1929, the American population increased by 300 percent, the marriage rate increased by 400 percent, and the divorce rate soared by 2,000 percent (May, *Great Expectations*, 2). Alimony, however, remained more precarious than Dreiser suggests: according to the 1909 Bureau of Census, only one in eleven divorces resulted in alimony.

301.40 **"There are more things in heaven. . . ."** After seeing the ghost of his murdered father, Hamlet speaks these words to Horatio (*Hamlet* 1.5).

CHAPTER XLVII

304.4 **"one old cat"** ball game named according to the number of batters: one old cat for one batter, two old cat for two batters. This simplified version of baseball was also known as town ball.

CHAPTER XLVIII

307.5 **chemistry and physics . . . mind is all** The trend of modern physics has been to replace matter with energy and other abstract concepts. Dreiser may have in mind the 1905 special relativity theory of Albert Einstein (1879–1955), which implies the equivalence of matter and energy.

307.7 **"as a man thinketh so is he"** from Proverbs 23:7: "As he thinketh in his heart, so is he."

307.15 **wireless message** the image of "wireless" radios or telegraphs was commonly invoked by psychic researchers, theosophists, and spiritualists to describe psychic activity. The image persists in *Mental Radio*, the title of Upton Sinclair's 1929 book of research into psychic phenomena conducted with his second wife, Mary Craig Kimbrough.

308.21 **subway** The first subway was constructed in London, the first line opening in 1863. The subsequent expansion of the underground was in part financed

by Charles Tyson Yerkes (1837–1905), the model for Dreiser's Frank Cowperwood of *The Trilogy of Desire*. Following the first American subway in Boston (1898), New York's first segment opened in 1904.

308.22 **automobile** German and French manufacturers pioneered automobile production in the late nineteenth century, but making cars affordable would be an American achievement of the early twentieth century. The first successful American gas automobile was produced in 1893; by 1899, thirty American manufacturers were producing cars. General Motors was founded in 1908, the same year that Henry Ford (1863–1947) introduced the Model T. Ford Motor Company and led the way in producing affordable autos, such as the Model N (1906–1907, selling for $600) and the Model T ($825). Much of Ford's success derived from mass production, especially at the Detroit Highland Park plant (opened 1910; first assembly line 1913–14).

309.13 **North River** The section of the Hudson River in Manhattan.

310.37 **genre art** catchall term for paintings of unidealized, everyday subjects. The term can be applied to the peasant scenes of Pieter Bruegel (1525–1569), the middle-class interiors of Jan Vermeer (1632–1675), and to numerous works in the Impressionist and Ashcan schools, among many others.

CHAPTER XLIX

311.35 **Jacob Bergman, Henry La Rue, Pottle Frères** apparently fictitious.

317.36 **writer who had found himself nervously depressed** Dreiser might have himself in mind here; much of Eugene's ensuing work for the railroad is modeled on the author's own experience with the New York Central Railroad, as recorded in *An Amateur Laborer*.

CHAPTER L

320.36 **complete change of environment** Standard medical wisdom held that neurasthenics needed frequent changes of environment. (See Beard, *Sexual Neurasthenia*, 209.)

321.10 **Speonk** fictitious place, based on "Spike," railroad slang for Spuyten Duyvil, the village Dreiser records in *An Amateur Laborer*. (See *An Amateur Laborer* 187.)

CHAPTER LI

327.11 **Riverwood** fictitious, based on the town of Kingsbridge, New York, where Dreiser lived in the corresponding period of his life.

CHAPTER LII

334.31 **tushes** long pointed teeth.

335.26 **mokes** slang for easygoing person such as a "moocher," a black person, or a fool; Dreiser likely intends the latter.

CHAPTER LIII

339.38 **De Maupassant and Zola** Guy de Maupassant (1850–1893) and Émile Zola (1840–1902), French naturalist authors, both of whom tried objectively to depict subject matter that many critics considered sordid or even degenerate.

340.15 **Frans Hals** (1580–1666) Dutch painter of portraits and genre subjects.
Correggio Italian painter Antonio Alhegri (1494–1534), called Correggio after his birthplace.
Tintoretto Venetian painter Jacopo Robusti (1518–1594), called Tintoretto ("little dyer") after his father's craft.
The Noble Slav 1632 portrait by Rembrandt.
Cabanel Alexandre Cabanel (1823–1889), French painter of mythological scenes and figures, including a sensuous Venus similar to those of his contemporary, Bouguereau.

340.23 *Mona Lisa* the enigmatic smile of the woman (the wife of a Florentine merchant) in this portrait by Leonardo da Vinci (1452–1519) is famous.

342.30 **collarette** high-riched collar, originally of sixteenth-century design.

CHAPTER LIV

350.41 **Omar** The *Rubáiyát of Omar Khayyám*. This line does not appear in the FitzGerald translation; Dreiser may be recalling the twelfth quatrain:

> "'How sweet is mortal Sovranty!'"—think some:
> Others—'How blest the Paradise to come!'
> Ah, take the Cash in hand and waive the Rest;
> Oh, the brave Music of a distant Drum!"

CHAPTER LV

356.38 **Circe** in Greek mythology, an island-dwelling sorceress who turns the companions of Odysseus into swine.

CHAPTER LVII

368.6 **eggs and tasty meat juices** Besides meeting the Witlas' modest budget, this protein-rich diet follows that recommended for neurasthenics by George M. Beard. Reasoning from principles saturated in the evolutionary logic of Social Darwinism—"*as human constitution increases in sensitiveness through civilization or acquires sensitiveness through disease, the diet should correspond or be restricted mainly to that form of food which is nearest to man in development*"—Beard recommends a diet centering on "Beef, Mutton and lamb, Fowl, Eggs, Milk, Fish, Butter, Wheaten bread" (*Sexual Neurasthenia* 259, 250). The next paragraph makes clear that during her absence Angela has learned about sexual neurasthenia.

369.39 **Brahmanistic dogma of a psychic body** According to Brahmanism (classical Hinduism), each individual is composed of three parts or "bodies"—gross, subtle, and causal—and each of the parts, in turn, is composed of one or more

sheaths, rather like the coats of an onion. Since Dreiser identifies what he calls the "psychic body" as the "real self," he probably has in mind the causal body, which, in the words of one authority, "represents a sort of record-keeping link between the physical body and the soul, and stores the experience of all actions performed during this life. It goes out with the soul and conditions future existence, determining the form of birth in the next incarnation" (Benjamin Walker, *The Hindu World*, Vol. 1 [New York: Frederick A. Praeger, 1968], p. 163).

370.25 **weaknesses to which the flesh is heir** from *Hamlet* 3.1, the "To be or not to be" soliloquy: "and by a sleep to say we end / The heartache and the thousand natural shocks / That flesh is heir to,—'tis a consummation / Devoutly to be wish'd."

371.3 **the Cardiff Giant** a huge statue found in Cardiff, New York. In a famous 1869 hoax perpetrated by tobacconist and atheist George Hull (?–1902) following an argument with a minister about biblical references to giants once walking the earth (Gen. 6:4), Hull commissioned the construction of a ten-foot-tall human figure. After treating the sculpture to make it look ancient, Hull buried it. When the Cardiff Giant was discovered, experts quickly denounced the supposed fossil as a fraud, but some revivalists defended its veracity on scriptural grounds. Charging fifty cents per view, Hull made $30,000 on the sculpture that had cost him $2,600 to make. After an unsuccessful attempt to purchase the giant, P. T. Barnum (1810–1891) had his own copy made.

371.8 **"a little gay"** probably in the slang sense of impudent, sassy.

CHAPTER LIX

381.13 ***La Bohème* and *Rigoletto*** Italian operas. *La Bohème* (1896), by Giacomo Puccini (1858–1924) is set in 1830s Paris and based on Murger's *Scènes de la vie de bohème* (1849), which also inspired *Trilby*. *Rigoletto* (1851), by Verdi, is set in sixteenth-century Mantua and based on a play by Victor Hugo (1802–1885), *Le roi s'amuse* (1832).

381.15 **Timothy Deegan** Dreiser models this figure on Michael Burke (dates unknown), masonry foreman for the New York Central Railroad, on whose crew Dreiser worked from September through December 1903. He recorded this experience in various writings in addition to *The Genius: An Amateur Laborer*, "The Toil of the Laborer" (*New York Call*, 13 July 1913), "The Mighty Burke" (*McClure's*, May 1911), "The Mighty Rourke" (*Twelve Men*), and "The Irish Section Foreman Who Taught Me How to Live" (*Hearst's International*, August 1924).

CHAPTER LX

388.21 **St. Augustine** (354–430) Christian philosopher, bishop, and saint.

390.12 **as the Mormons might** that is, with multiple wives. The Church of Jesus Christ of Latter-day Saints was founded in 1830 by Joseph Smith (1805–1844); followers are called Mormons. The second leader, Brigham Young (1801–1877), formally announced "plural marriage" in 1852. This doctrine, widely discussed in the press, remained popularly associated with the faith for gen-

erations after Mormon president Wilford Woodruff (1807–1898) withdrew church sanction for polygamy in 1890. The custom diminished, but even today, self-styled "independent" Mormons, fundamentalists outside of the faith's main current, still practice polygamy.

CHAPTER LXI

396.5 **"a dancing shape, an image gay, to haunt, to startle and waylay"** from William Wordsworth, "She was a Phantom of Delight."

398.34 **Printing House Square** area surrounding Newspaper Row, New York's center of news publishing from the 1830s to the 1920s, in lower Manhattan. In *Newspaper Days*, Dreiser reports going to this square in 1894 and "gazing at the *Sun* and *World* and *Times* and *Tribune*, all facing City Hall Park, [and] sigh[ing] for the opportunities which they represented" (607–08).

398.40 **Hahn's** restaurant on Park Row.

400.6 **Boston Library, panels** the Boston Public Library, a beaux arts building designed by the firm of McKim, Mead & White (principal architect Charles Follen McKim [1847–1909]), William Rutherford Mead [1846–1928], and Stanford White), was erected in Copley Square from 1888 to 1895. The monumental effect was enhanced by extensive use of artwork, and in the parlance of the time, "panels" refers to murals. McKim, a pioneer in the use of mural decoration, commissioned leading artists as his muralists: Sargent, who completed his murals in three phases, from 1895 to 1919; Abbey, who finished his work in 1902; and the French painter Puvis de Chavannes (1824–1898), whose murals were installed in 1896.

400.14 **the World** The *New York World*, founded in 1860, was sold in 1882 to Joseph Pulitzer (1847–1911), whose revamping of the paper doubled its circulation within four months and soon made it the most profitable newspaper in existence at the time. Dreiser worked on the *World* briefly in 1894, shortly before George Luks (1866–1933), Everett Shinn (1876–1953), and Glackens were employed there as illustrators.

401.1 **Gramercy Place** Gramercy Park is an exclusive address running from Eighteenth to Twenty-third Streets and from Third to Fourth Avenues.

401.23 **Port Morris** in what is now called the South Bronx.

CHAPTER LXII

405.4 **development of art in advertising** The use of artwork in advertising took a quantum leap forward when Pears' Soap paid £2,300 for *Bubbles*—a painting by Sir John Millais (1829–1896) of his cherubic grandson blowing soap bubbles—and used it in an 1887 ad. Mellin's Food followed suit in 1893, reproducing *The Awakening of Cupid* by Leon Jean Basile Perrault (1832–1908) on the back page of the Chicago World's Fair edition of *Youth's Companion*—at a cost of over $14,000, a record advertising expenditure. Art posters, first used by bicycle manufacturers, brought such artists as Frederic Remington (1861–1909) and Maxfield Parrish (1870–1966) into American ads in the 1890s. In that decade, advertising journals and agency heads began urging the role of pictures in selling products. The 1890s also marked the appearance

of human interest trademark drawings, such as Aunt Jemima, the Cream of Wheat chef, and Uneeda Biscuit's boy in a slicker. By the first decade of the twentieth century, large American agencies had their own art departments.

405.12 **coming to be quite a business** The first American advertising agents appeared in the 1850s and 1860s, in lower Manhattan and other major cities. An 1869–70 New York City business directory lists forty-two ad agencies; by 1899, the number was over four hundred. But throughout the later decades of the nineteenth century, the primary role of agencies was selling space in publications; only around the turn of the century did the practice shift to composing ads to sell products. The first full-time copywriter of ads was hired in 1892, and by 1900, preparing copy became a standard aspect of agencies' services. At this time a Chicago agency introduced the "reason why" philosophy, urging that the mission of advertising was to provide consumers reasons for purchasing products.

Recognizably modern advertising began appearing in the 1880s (the decade when the longest-running and most influential trade journal, *Printer's Ink*, was founded by George Rowell [1838–1908]), as the development of national products created the need for broad marketing strategies to coordinate efforts in copy, layout, and art. Prior to that, the most widely advertised products had been patent medicines, and the intent of ads had been largely to inform (albeit conveying much dubious information) rather than to persuade. By the 1890s, a wider range of products was advertised—foremost among them food, soap, cosmetics, and durable consumer goods.

405.34 **art for art's sake** Although the idea sounds ironic here, Dreiser likely intends to invoke the notion that the aim of art is the perfection of expression, not the service of any moral or didactic end. This idea, associated with Romantic poets such as Poe and Samuel Taylor Coleridge (1772–1834), was further elaborated by French symbolist poets and other fin de siècle writers such as Oscar Wilde (1854–1900) and Walter Pater (1839–1894). Visual artists associated with the movement include Aubrey Beardsley and, particularly, the American expatriate James McNeill Whistler.

CHAPTER LXIII

408.15 **consumption** tuberculosis, called *consumption* before the discovery of the tubercle bacillus, because bodily tissues wasted away as if consumed.

409.35 **life of Napoleon** Napoleon I (1769–1821; family name Bonaparte), French emperor and military leader. As first consul of the Consulate, Napoleon's administrative reforms transformed France into a modern, efficient state. Ralph Waldo Emerson was one of many nineteenth-century commentators to interpret Napoleon as emblematic of the new breed of businessmen who "subordinat[e] all intellectual and spiritual forces into means to a material success." See "Napoleon; Or, The Man of the World," *Representative Men* (1850), rpt. New York: Mershon Company, n.d., 208.

411.26 **catch phrase such as "Have You Seen This New Soap" or "Do You Know Soresda?—It's Red"** In 1889, George Eastman's slogan for the Kodak camera—"You press the button; we do the rest"—made advertising history. Such slogans typified 1890s advertising, which marked the appearance of

such famous catch phrases as the *New York Times's* "All the news that's fit to print" and Ivory soap's "It floats." Many advertising agents had, like Eugene, backgrounds in journalism, and reporting was seen as excellent training for copywriting. At the turn of the century and for decades after, phrasing that sounded sincere, simple, and conversational, rather than "literary," was favored for ads, as in the "catch phrases" Dreiser depicts here.

411.35 **interesting phases of human psychology** Articles on the psychology of advertising began appearing as early as 1895. In 1903 a Northwestern University professor of advertising, Walter Dill Scott (1869–1955), began publishing articles that formed the basis of his influential book *The Psychology of Advertising* (1908).

CHAPTER LXV

420.12 **tropic** probably Dreiser means in the sense of biological tropism—turning or growing toward something, or an innate tendency. The theory of tropism was popularized by mechanistic physiologist Jacques Loeb (1859–1924), who greatly influenced Dreiser's thinking, though it would be later in the 1910s when Dreiser read deeply in Loeb.

425.15 **bear garden** full of confusion. The phrase comes from the Renaissance practice of keeping bears in gardens and baiting them for public amusement.

CHAPTER LXVI

428.40 **house telephone** The telephone was invented in 1876 but not widely used until the development of other technologies (such as the switchboard, underground cables, and long-distance line) over the next two decades. In 1879, New York City had only seventeen residential telephones, with another five in Brooklyn. During the telephone's third decade of existence, usage greatly expanded, becoming national by the early twentieth century. By 1910, America had seven million telephones—more than a quarter of them in farm houses (Herbert N. Casson, *The History of the Telephone*, 3d edition [Chicago: A. C. McClurg & Co., 1910], 168–69; Henry Collin Brown, ed. *Valentine's Manual of Old New York*. Number 5, New Series [New York: The Chauncey Hold Co., 1920]).

429.16 **Haviland china** fine china, originated by New York china importer David Haviland (1814–1879), after finding superb French china during a trip to Limoges. Haviland started a factory in France, designing wares for American tastes, and made his first export to America in 1842. Since 1936, Haviland china has been made in the U.S.

CHAPTER LXVII

431.25 **William Butler, Andrew Gillette, Mark Gorthwaite** apparently fictitious.

432.9 **Pullmans** sleeping cars on trains, named after their developer, George Mortimer Pullman (1831–1897), who founded the Pullman Palace Car Company in 1867. In addition to their association with luxury, Pullmans are also asso-

ciated with capitalist greed and the exploitation of labor; the 1894 Pullman strike is among the most infamous in American history.

433.6 **pooh-bah** a person in high position, after a character in *The Mikado* (1885) by Sir William Schwenk Gilbert (1836–1911) and Sir Arthur Seymour Sullivan (1842–1900).

CHAPTER LXVIII

439.5 **plunger** slang for reckless gambler, speculator.

441.15 **Union League** The Union Club (which Dreiser wrote in the holograph) was a University of Pennsylvania cricket team organized in 1843. He almost certainly means the Union League, a citadel of Philadelphia Republicans. The organization was founded in 1862 to help keep the Union intact during the Civil War. In 1865 the League moved from 1118 Chestnut to Broad and Samson Streets, just south of City Hall.

442.19 **Atlantic City, Spring Lake, and Shelter Island** entertainment and resort areas.
Atlantic City: on an Atlantic Ocean sandbar in southeastern New Jersey, settled around 1790. It was a fishing village until the 1854 construction of a railroad made Atlantic City desirable as a resort. The first of the city's signature boardwalks was built in 1870.
Spring Lake: upscale borough in eastern New Jersey, near the Atlantic Ocean and several lakes.
Shelter Island: island between two Long Island peninsulas, settled in the seventeenth century, a resort area since the 1870s.

442.39 **central station in Philadelphia** Broad Street Station, erected in 1880, an individualistic interpretation of Gothic architecture designed by the firm of Furness & Evans. Extensive additions were made in 1892–94.
Haverford district wealthy suburb, west of Philadelphia.

444.36 **absolute accuracy in statement** In the 1890s, the ethics of advertising became an issue, culminating in the truth-in-advertising campaigns of the 1910s, through which advertisers sought to legitimize themselves.

CHAPTER LXIX

448.35 **electroliers** chandeliers for electric lamps.

450.33 ***Boston Herald*** popular paper, founded in 1844, still extant.
New York Sun founded in 1833 as a breezy, one-penny paper, purchased by Charles A. Dana (1819–1897) in 1868, who boosted circulation while doubling the price. It was popular for its clever style and human interest stories.
Baltimore Sun founded in 1837 as a one-penny paper, still in circulation.

451.3 **Philadelphia Country Club** founded in 1890, the oldest in the Philadelphia area, the club is located on Spring Mill Road in Gladwyne.
Merion Cricket Club after electing its first president in 1865 and initially playing matches in Wynnewood and Ardmore, the club built its first clubhouse in 1892 on Montgomery Avenue and Gray's Lane in Haverford. After the first building burned down, a second clubhouse was built in 1896, designed by Furness, Evans & Company.

Tennis Club Tennis was not played in America before 1875, but by the 1890s it was popular throughout the country, including in Philadelphia. Dreiser may have in mind the Philadelphia Cricket Club at Wissahickon Heights, Chestnut Hill, or the Merion Cricket Club.

Rittenhouse and Markham Clubs The exclusive Rittenhouse Club, on 1811 Walnut Street, faces Center City's Rittenhouse Square. It was founded in 1875 as The Social Art Club. Another social organization, the Markham Club, was housed at 1405 Locust Street.

According to a contemporary account, "The characteristic clubs of Philadelphia, strong and long established, gray with age, are fortresses which hold in exclusiveness the exclusive people who unitedly make up what is really Philadelphia." The author maintains that membership figures are irrelevant; what matters is the clubs' "undisputed holding of authority; an authority never spokenly claimed but always unspokenly conceded" (Robert Shackleton, *The Book of Philadelphia* [Philadelphia: The Penn Publishing Co. 1918], 201.)

CHAPTER LXX

543.17 **Woodside Manor** resort hotel in Perkiomen region of Montgomery County.

453.22 **Manhattan Beach** on the east end of Coney Island, on the Atlantic Ocean.

459.36 **Baltusrol Golf Club** opened in 1895 in Springfield, New Jersey, on land once owned by a man named Baltus Roll.

Yere Tennis Club unidentified.

460.13 **Christian Science** religion founded by Mary Baker Eddy (1821–1910) and practiced by members of the Church of Christ, Scientist. As its name implies, Christian Science marks one of the nineteenth century's efforts to reconcile the claims of religion and science. Followers believe that God is the only reality, and He is all good; thus, evil, sin, illness, and even death are illusions that can be overcome by right thinking. The reasoning is syllogistic: as Eddy explains, "God, good, being ever present, it follows in divine logic that evil, the suppositional opposite of good, is never present" (*Science and Health* 72). The religion grew from twenty-six members in 1879 to 86,000 by 1906. It also launched many competitive movements, leading to Eddy's copyrighting the term "Christian Science" in the 1890s.

CHAPTER LXXI

461.22 **Single Tax theory of Henry George** Henry George (1839–97), American economist and reformer, believed that poverty increased at a rate greater than the rate of increase in national wealth. He attributed the acceleration of poverty to land rents, which profit the wealthy few at the expense of the many. George's proposed solution, a Single Tax on land, was outlined in his *Our Land and Land Policy* (1871) and in the international bestseller *Progress and Poverty* (1879).

Socialism political and economic theory advocating collective ownership of means of producing wealth.

463.31 **secure the stock on a long time consideration** to purchase securities with the expectation of a rise in price.

464.39 ***National Review, Swinton's Magazine, Scudder's Weekly*** fictitious, though Dreiser may have intended nods to William Swinton (1833–1892), a newspaperman who helped cover the Civil War for the *New York Times;* and Horace E. Scudder (1838–1902), an editor for the *Atlantic* from 1890 to 1898.

466.14 **literary and artistic primate** *Webster's* gives, as the second definition of "primate," "(archaic): first in authority; leader." Dreiser favored many archaic words, and so his eccentric way of phrasing "literary and artistic leader" has been retained.

466.26 **Hardware Club** Incorporated in 1892, this business and social club for members of the hardware trade, as well as men in other businesses, had headquarters in the Postal Telegraph and Cable Company building on Broadway and Murray Streets.

468.35 **Schuylkill** 130–mile river running from Schuylkill County in central Pennsylvania to the Delaware River in Philadelphia.
Monongahela 128–mile river formed at Fairmont, Virginia, flowing north into southwest Pennsylvania, where it joins the Allegheny River. The Monongahela was the first American river to be improved for navigation.

CHAPTER LXXII

472.3 **the tempter speaking to Jesus** Satan's temptation of Jesus, as recorded in Matthew 4:8–9 and Luke 4:5–7.

473.11 **Sherry's** one of Manhattan's most fashionable restaurants, at Fifth Avenue and Thirty-seventh Street. Carrie Meeber eats dinner there with the Vances and Bob Ames in Chapter XXXV of *Sister Carrie* (XXXII of the Doubleday, Page edition).

CHAPTER LXXIII

478.35 **Union Square** entertainment district, with theaters, shops, restaurants, and hotels; bordered by Fourteenth and Eighteenth Streets and Third and Sixth Avenues.

483.5 **psychometrist** a person who uses psychic skills to divine a person's qualities, often revealed, as here, in the size, shape, and color of a person's "aura."
delineator perhaps as in a horoscope delineator.

CHAPTER LXXIV

491.3 **Grant's Tomb** located in the south end of an oval formed where Riverside Drive forks at West 122nd Street, the tomb of General and President Ulysses S. Grant (1822–1885) and his wife Julia (1826–1902) sits on a hill overlooking the Hudson River. Designed by John H. Duncan (1855–1929) and dedicated in 1897, the neoclassical granite structure is the second tallest mausoleum in the Western Hemisphere and a popular tourist attraction.

492.5 **Nero** Nero Claudius Caesar (A.D. 37–A.D. 68), tyrannical Roman emperor, was infamous for evil deeds, including the murder of his mother, wife, and

countless Roman officials. He committed suicide in response to a revolt against him, and among his last words were, "What an artist the world is losing in me!"

492.7 **Appian Way** This most famous of the Roman roads, more than 350 miles long, was the chief highway to Greece and the East.

CHAPTER LXXVI

504.5 **William Dean Howells** (1837–1920), novelist, editor, critic. The leading figure in American literary realism in the generation before Dreiser's, Howells helped promote many younger writers. Dreiser's "The Real Howells," published in *Ainslee's* 5 (March 1900), 137–42, is based on an interview and reprinted in *Selected Magazine Articles of Theodore Dreiser*, ed. Yoshinobu Hakutani.
 Mark Twain pen name of Samuel Langhorne Clemens (1835–1910), humorist and novelist, who achieved both popular and critical fame. For Dreiser's views on Twain, see Theodore Dreiser, "Mark Twain: Three Contacts," *Esquire* 4 (October 1935), 22, 162, 162A–B.
 William James (1842–1910) pragmatist philosopher and psychologist, Harvard professor, and brother of the novelist Henry James.
 Sir A. Conan Doyle Sir Arthur Conan Doyle (1859–1930), English novelist, best known for Sherlock Holmes detective stories.

505.39 **Dives and Lazarus** in one of Jesus' parables (Luke 16:19–26), the pleas of the sick and sore-infested beggar, Lazarus, for crumbs from the table of the wealthy Dives are not answered. The gulf between the men remains after their deaths, but their respective positions reverse: Dives is sent to Hell, from where he begs for comfort that is not given him, while Lazarus is taken into the bosom of Abraham.

CHAPTER LXXVII

508.13 **Mephisto** Satan.

508.36 **noble restrictions** an early form of zoning. Deed restrictions control what property owners can and cannot do, thus maintaining property values and the character of the community. Dreiser may call the restrictions "noble" because they keep the area safe and clean.

509.11 **Gravesend Bay** arm of Lower New York Bay, in northeastern section.

509.23 **Jamaica Bay** shallow bay in southwest Long Island; Rockaway peninsula separates it from the Atlantic Ocean.

513.6 **Morristown, New Jersey** in Morris County, northern New Jersey, on the Whippany River.
 fashionable Grymes Hill on Staten Island hilly area in northeastern section of Staten Island, with spectacular views of New York harbor that made it popular with wealthy New Yorkers. Grymes Hill was named after an early resident who bought large tracts of land there and built a mansion which she named Capo di Monte.
 Lenox, Massachusetts town settled in 1750 in the Berkshires. A literary hub in the nineteenth century, later primarily a summer resort.

513.17 **Kill Van Kull** channel connecting Newark Bay and Upper New York Bay.

513.18 **Tompkinsville** on eastern shore of Staten Island.

513.23 **fashionable boarding school at Tarrytown** perhaps Hackley School, founded in 1899.

514.8 **"slings and arrows of Miss Fortune"** a play on "The slings and arrows of outrageous fortune," from the "To be or not to be" soliloquy in *Hamlet* 3.1.

516.5 **Arturo Schalcero, Bonavita** apparently fictitious.

518.6 **Royal Dresden** fine china, often with delicate floral patterns.

518.10 **"The Summer Winds Are Blowing, Blowing"** possibly from the 1854 song "Summer Wind, Summer Wind!" with music by "Miss C. M. C.," words by E. Fanny Haworth.

CHAPTER LXXVIII

524.35 **Fort Wadsworth** on Staten Island, the fort guarded the Narrows, the water gateway to Upper New York Bay. While the site had fortifications beginning in 1663, its first fort, built in 1812, was replaced in 1847.

525.12 **divided riding skirt** full culottes which have the appearance of a skirt but allow some of the freedom of movement of pants.

525.27 **pierced linen** in a decorative pattern, for instance, pierced with embroidery.

CHAPTER LXXIX

528.9 **practitioner** a Christian Science healer, who helps the patient understand that her disease is illusory as a way of allegedly curing the illness.

530.6 **government fortifications at the Narrows** New York City's harbor comprises the Lower Bay, the Upper Bay, and the Narrows, a strait which links the two bays. Fort Hamilton—originally known as the Narrows—completed in 1831, is located in Brooklyn, at the bottom of the strait. Across the strait is Fort Wadsworth.

532.5 **"trailing clouds of glory," "from God, who is our home."** From Wordsworth's "Ode: Intimations of Immortality," about the attempt to recapture the child's sense of immortality, wonder, and connection with God which is lost with the aging process. Stanza 5 includes the lines, "But trailing clouds of glory do we come / From God, who is our home: / Heaven lies about us in our infancy!"

532.12 **"See how the floor of heaven. . . ."** From Shakespeare's *Merchant of Venice* (c. 1595) 5.1: "look, how the floor of heaven / Is thick inlaid with patines of bright gold."

CHAPTER LXXX

537.34 **Palm Beach** resort on the Atlantic Ocean and Lake Worth in southeast Florida, was settled in the 1870s. It grew rapidly beginning with the 1893 arrival of the railroad and Standard Oil tycoon Henry Flagler (1830–1913), who developed the area.

538.11 **Monte Carlo** resort in principality of Monaco, on the Mediterranean Sea

and French Riviera, known for its scenery, gambling casino (built in 1858), and luxury hotels.

538.13 **Palm Beach, Old Point Comfort, Virginia Hot Springs, Newport, Shelter Island, Atlantic City, Tuxedo** resort areas.

Old Point Comfort on a peninsula in southeast Virginia on Chesapeake Bay, a boating and fishing resort since the 1830s.

Virginia Hot Springs mineral springs in the Allegheny Mountains, Bath County, in northwest Virginia.

Newport city in southeastern Rhode Island, founded in 1639, where nineteenth-century millionaires built lavish homes.

Tuxedo Tuxedo Park, an affluent village in southeast New York, on Tuxedo Lake in Ramapo Mountains. The Tuxedo Park colony, begun in 1886, was known for sports and society functions.

538.17 **Chamberlain at Old Point Comfort and the Royal Poinciana at Palm Beach** luxury hotels. The Chamberlain was begun by John Chamberlain (dates unknown) in 1890; he ran out of money and the hotel was not completed until 1896. The Chamberlain was the first American hotel to be illuminated entirely by electric lights. The original five-star hotel, which had 554 rooms, burned down in 1920 and was replaced in 1926.

The Royal Poinciana was Palm Beach's first resort hotel. When opened in 1894 by Henry Flagler, it was the only oceanfront hotel south of Daytona Beach.

538.32 **casino at Newport** built in 1879–80, a shingle-style building designed by the architectural firm of McKim, Mead, and White.

Bar Harbor on Mount Desert Island in southeast coastal Maine, settled in 1763; it became a popular resort in the nineteenth century.

539.3 **In St. Louis he had seen a mausoleum built after the theory of the Taj Mahal** Louis Sullivan (1856–1924) designed a domed mausoleum for a St. Louis millionaire, the brewer Ellis Wainwright (1850–1924), and his wife Charlotte. Located in the Bellefontaine Cemetery, the structure is known as the "Taj Mahal of Saint Louis" because of its resemblance to the elaborate mausoleum in northern India, completed in 1643, the ornate design of which evokes the Islamic conception of Paradise.

539.27 **common stock and . . . preferred** The latter is "preferred" in two respects. Holders of preferred stock receive dividends before holders of common stock; moreover, if a company is liquidated, holders of preferred stock (and bonds) receive precedence over holders of common stock.

CHAPTER LXXXI

541.20 **The Long Island Railroad** The third oldest railroad in the country, the Long Island Railroad ran its first train in 1836. Initially intended as part of a rail and water route between New York and Boston, by 1850, with the completion of an all-rail route to Boston, the Long Island Railroad became a local and commuter line. It was most successful from 1880 to 1914; during the 1890s the line transported more than thirteen million passengers per year. It operated between the shores of Long Island, carried local traffic between Jamaica and Flatbush Avenue, and took excursion traffic to Rockaway Beach, Aqueduct Park, and Belmont race tracks. The line was electrified in 1904, which

reduced travel time: in 1906, the trip from Flatbush Avenue to Jamaica was cut to twenty minutes from thirty-five (Carl Condit, *The Port of New York: A History of the Railroad and Terminal System from the Beginnings to Pennsylvania Station* [Chicago: University of Chicago Press, 1980]).

541.23 **Mr. Wiltsie** apparently fictitious.

542.9 **five-for-one-basis** That is, the three shares of common and two of preferred stock, as explained in previous chapter.

544.18 **Selah** "a term of uncertain meaning found in the Hebrew text of the Psalms and Habakkuk carried over untranslated into some English versions" (*Webster's*).

CHAPTER LXXXII

548.32 **Moorish, Spanish, and Old Mission styles of architecture** Unusual, even exotic, styles for the time and place.

Moorish: Inspired by mosques and other highly ornamental Moorish architecture, such as the Giralda that Dreiser mentions later in the novel.

Spanish: Spanish style by way of the American Southwest, characterized by stucco or stone walls, tiled low-pitched roofs, rounded doors and windows, and decorative tiles.

Old Mission: Generally called "Mission," originating in Southern California, inspired by Spanish mission churches. Many elements resemble Spanish style, such as the tiled roofs, stucco walls, and arched windows and doors. Mission style also features flourishes such as bell towers and roof parapets. It was especially popular from the 1890s through the 1920s.

548.40 **Giralda** tower in Seville, built in 1184–1198 as a minaret to the main mosque in the city, converted into a bell tower in 1568 by building an ornate Renaissance superstructure atop a square, Moorish tower.

*550.31 **Rossetti gallery. . . . portraits of the same woman** Dante Gabriel Rossetti made many drawings and watercolors featuring the face of Elizabeth (Lizzie) Siddel (or Siddall) (1829–1862), with whom he fell in love in 1853 and married in 1860. Dreiser probably has in mind, however, Rossetti's "many portraits," most of them in oil, of Jane Burden (1840–1914). Rossetti also fell in love with Burden, who married Pre-Raphaelite painter William Morris in 1859 and who embodied the Pre-Raphaelite ideal of female beauty. Rossetti captures Jane Burden in portraits both mystical and sensuous, frequently with a halo atop her long, auburn hair.

CHAPTER LXXXIII

556.16 **a cane rack to ring canes** In this amusement park game, the player tries to ring a hoop over one of a series of standing canes. The winner takes home the cane.

556.22 **Devil's Whirlpool** Similar names were popular for amusement park rides, such as Dreamland's "Hell Gate" (built in 1905, and the site where the park's 1911 fire originated), which took amusement seekers on a boat ride ending in a whirlpool, and "Dante's Inferno" (c. 1902–1905) at Steeplechase.

556.31 **Terra Marine [Inn]** lavish hotel on the beach in Huguenot Park, Staten Island.

CHAPTER LXXXIV

560.11 **"Roses of hell"** A Höllenrose is a She-Devil in German folklore. In *Parsifal* (1877), by Richard Wagner (1813–1883), Klingsor calls Kundry by this name.

560.23 **Tarrytown** residential suburb of New York City, on east bank of Hudson River in Westchester County, settled in the seventeenth century by the Dutch.

562.38 **Perth Amboy** harbor city in Middlesex County, northeastern New Jersey.

564.30 *Anna Karenina* novel (1873–1876), one of masterpieces by Tolstoy. The title character abandons her husband and child to have an affair; she ends up killing herself by leaping in front of a train.

567.18 **Jenny Lind** Swedish soprano (1820–1887), who toured the United States in 1850–1852 under the management of P. T. Barnum. "The Swedish Nightingale" was wildly popular.

 Allen Poe presumably Dreiser has in mind Edgar Allan Poe.

CHAPTER LXXXV

568.21 **her old time precautions** According to a recent study, "prolonged lactation, male withdrawal, abstinence, suppositories, and douching solutions made out of common household ingredients were the mainstays of birth control practice in preindustrial America" (Tone, *Devices*, 14). Abortifacients (ingested orally to induce miscarriage) included pennyroyal and savin, both of which grew wild. 1830s developments included domestically manufactured condoms (previously imported from Europe), diaphragms, "male caps" to cover the tip of the penis, and intrauterine devices. By the 1870s, Americans could purchase, by mail or in stores, a wide array of well-advertised contraceptives. But moralists such as Nicholas Cooke, in the anticontraceptive tract *Satan in Society* (1870), opined that the diaphragm was the "'invention of hell'" (quoted in Tone, *Devices*, 17). The 1873 Comstock Act criminalized contraceptives, as well as pornography and other printed matter pertaining to sex. The morals crusader Anthony Comstock was less worried over private and "natural" means of contraception (such as the rhythm method or withdrawal) than over the public commerce in sex. Nevertheless, manufacturers continued to advertise and sell contraceptives after 1873, simply adopting euphemisms. Led by such reformers as Emma Goldman (1869–1940) and especially Margaret Sanger (1879–1966), cities across the country would launch birth control leagues from 1914 to 1918. Under Sanger's leadership, between the 1920s and 1960s, contraception became legal, state by state.

569.27 **"Oh, That We Two Were Maying"** 1888 song by American composer and pianist Ethelbert W. Nevin (1862–1901).

 "Obstination" song by Henri de Fontenailles (dates unknown).

 "The Erlking" 1815 lied by Schubert, based on a ballad by Goethe, telling that everyone touched by Erlking (the King of Dwarves) must die.

570.32 **mater dolorosa** sorrowful mother; the term evokes the Virgin Mary weeping over the body of Christ.

CHAPTER LXXXVI

585.14 **"I'll try yet not to have one"** Angela might be speaking of taking an abortifacient or, more likely, of procuring an abortion. The latter would have been more effective, but likely difficult to arrange. Abortions had been common in America in the first half of the nineteenth century, but between 1821 and 1841, ten states criminalized the practice, for the first time in the country's history. The American Medical Association's opposition to abortion in the 1860s and 1870s drove the practice underground, although some women, especially immigrants, continued to have illegal abortions.

CHAPTER LXXXVII

586.30 **in whom it was well pleased** The phrase echoes Matthew 3:17: "And lo, a voice from heaven, saying, This is my beloved Son, in whom I am well pleased."

586.31 **those which surrounded and accomplished Macbeth's tragic end** In *Macbeth* (1606), the Weird Sisters appear before the title character does, their words anticipating his so as to cast doubt on whether he has any control over his actions. Macbeth turns several times to these witches and other supernatural beings for advice and prophecy, thereby entangling his fate with theirs. Dreiser also invokes the Weird Sisters in the final paragraph of *The Financier* (1912).

588.8 **bewrayed** probably in the archaic sense of "to reveal, expose, discover . . . the true character of" something (OED 3b).

588.10 **story in Matthew . . . "save by prayer and fasting"** In Matthew 17:14–21, the disciples are unable to exorcise a demon from a "lunatick" son, but Jesus succeeds. When they ask him why they failed, Jesus explains, "Because of your unbelief; for verily I say unto you, If ye have faith as a grain of mustard seed, ye shall say unto this mountain, Remove from here to yonder place; and it shall remove; and nothing shall be impossible unto you. Howbeit, this kind goeth not out but by prayer and fasting."

589.28 **Claremont Inn** located in the north end of an oval formed where Riverside Drive forks at West 122nd Street, above Grant's Tomb. Built c. 1793, the manor house was established as a restaurant before the Civil War and was especially popular for summertime dining.

591.24 **Helen! . . . Dianeme!**
Helen: Helen of Troy, from Greek mythology, an icon of female beauty invoked in countless literary texts. Her abduction by Paris instigated the Trojan War.
Dianeme: A poem by this name written by Robert Herrick appeared in the May 1882 issue of *Harper's New Monthly Magazine*. The poem advises a woman against excessive pride in her beauty.

593.31 ***The Bluebird:*** Dreiser may have in mind *L'Oiseau bleu* (1909) by Belgian dramatist Maeterlinck.

CHAPTER LXXXVIII

601.5 **St. Bartholomew's** Episcopal Church, founded in 1835, that accommodated one of Manhattan's wealthiest congregations. At this time it was housed in its second location, on Madison Avenue and Forty-fourth Street, in a Gothic building designed by James Renwick (1818–1895), to which a triple portal was added by Stanford White. In 1918 the parish moved to a new location on Park Avenue at Fiftieth Street, taking the White portal with it.

603.18 **visé** to endorse or sign as correct, as in to visé a passport (OED).

CHAPTER LXXXIX

605.21 **Callendar** in Scotland, a tourist resort on the edge of the highlands in the southern end of the Pass of Leny.

605.23 **Isle of Wight** island county in southern England, across the Solent and Spithead channels from Hampshire.

CHAPTER XC

614.17 **"yellow" newspapers** providing sensational stories, with faked interviews, lavish illustrations, and scare-head makeup in order to boost circulation. The phrase derives from the "Yellow Kid," a cartoon figure created by newspaper illustrator Richard F. Outcault (1863–1928) for the *New York World.* When Outcault was lured away to produce the "Yellow Kid" for the *New York Journal,* the *World* had George Luks produce its "Yellow Kid" comics, furthering the competition between the papers.

CHAPTER XCI

624.5 **"Bear ye one another's burdens"** Galatians 6:2.
"Love one another" John 15:12,17.

626.17 **The fatal age** The doctor's assessment—which speaks of social or psychological, rather than bodily, perils—has been confirmed by modern psychological studies, which place midlife crises predictably in patients in the very last years of their thirties to around age forty.

CHAPTER XCII

631.23 **E. L. Henry, F. Luis Mora, F. S. Church** American artists.
E[dward] L[amson] Henry (1841–1919), painted rural subjects, generally with human figures in the landscapes. He studied with Courbet, among others, and became a National Academician.
F[rancis] L[uis] Mora (aka Francesco Lluch Mora, 1874–1940), muralist, portrait painter, illustrator. Born in Uruguay, he spent most of his life in New York and Connecticut.
F[rederick] S[tuart] Church (1842–1924), a New York–based painter and illustrator specializing in elegant, idealized women, often placed in harmony with nature.

633.35 **Thousand Islands** group of more than 1,800 islands and 3,000 shoals in St. Lawrence River, along the U.S.-Canadian border, between northern New York and southern Ontario.

 country between Montreal and Québec along the St. Lawrence river in Québec province.

 Three Rivers Also Trois Rivières; about halfway between Montreal and Québec at the confluence of the St. Maurice and St. Lawrence Rivers.

CHAPTER XCIV

646.12 **to foreclose and take it over** that is, Winfield would get back the land he had mortgaged to the corporation, also retaining the mortgage payments he had received in the interval.

646.34 **receivership** When a company is being reorganized, it is managed by a person appointed as a receiver, thus placing it in receivership.

648.41 **Spartan boy who was gnawed by the fox** According to legend, a Spartan boy stole a fox and hid it inside his tunic. When questioned, the boy denied having seen a fox, even while it was eating into his stomach. The legend illustrates the greater disgrace in Spartan culture in being detected than in stealing.

CHAPTER XCV

652.31 **Grand Central Station** Along with Pennsylvania Station, one of Manhattan's two major railway terminals, between Lexington and Park Avenues on Forty-second Street. The first building on the site, Grand Central Depot, was built in 1869–71 while Cornelius Vanderbilt was in charge of the New York Central and Hudson River Railroad. The original depot, made up of three buildings, was connected during an 1898–1900 upgrade, at which point it was renamed the Grand Central Terminal. The building was replaced in 1913.

660.9 **"On such a night"** In *The Merchant of Venice* 5.1, an interchange between Lorenzo and Jessica repeatedly uses the phrase, "In such a night as this."

660.22 **Hebe** In Greek mythology, daughter of Zeus and Hera, the goddess of youth with the power to make the old young again.

CHAPTER XCVI

661.19 **Carlyle** Living in an age dominated by rationalism and materialism, Thomas Carlyle advocated idealism and mysticism. He first elaborated in *Sartor Resartus* (1833–34) the notion that the material world is an illusion, a projection of the real underlying spiritual order, and held to this idea throughout his writings. For evidence that Eddy in fact plagiarized from Carlyle (among others), see Dakin, *Mrs. Eddy*, 531–38, and Martin Gardner, *The Healing Revelations of Mary Baker Eddy: The Rise and Fall of Christian Science* (Buffalo, N.Y.: Prometheus Books, 1993), 145–48.

 Wallace Alfred Russel Wallace (1823–1913), British naturalist and proponent of evolution who maintained a strong interest in spiritualism. Wallace claimed that "the whole cumulative argument of my 'World of Life'"—a book

from which Dreiser quotes (see 709–12)—"Is that in its every detail it [the universe] calls for the agency of a mind" (quoted in James Marchand, *Alfred Russel Wallace: Letters and Reminiscences*. 1916. Reprint [New York: Arno Press, 1975], 413).

Mrs. Eddy, . . . Christian Science, . . . storm of sex, . . . male and female, . . . mortal mind, . . . vagaries of sex As Dreiser describes here, Mary Baker Eddy maintained that matter and evil are illusory; Divine Mind is the true reality, and it is good. Eddy's most influential book, *Science and Health with Key to the Scriptures,* discusses sexuality only in passing, but in a judgmental tone. "Sensualism is not bliss, but bondage," Eddy maintains, and she places "the lust of the flesh" under the definition of "Devil" (337, 584). She recommends the reader "conquer lust with chastity," and notes that lust can cause the erroneous belief that one is diseased (405, 419). Moreover, as Dreiser suggests here, Eddy considers gender difference itself something of an illusion: "Gender . . . is a quality, not of God, but a characteristic of mortal mind" (*Science and Health* 305; see also "mortal mind," identified in Eddy's cosmology with error, 687.31) To her, "Masculine, feminine, and neuter genders are human concepts," not to be confused with divine truths (*Science and Health* 516).

In this passage, Dreiser continues his practice, which can be traced back to *Sister Carrie,* of interrupting the narrative action to philosophize and editorialize on characters' actions. His conflation of Eddy, Carlyle, and Wallace begins with their related claims about the illusory nature of matter. Dreiser then moves to the tangentially related idea that the "storm of sex"—as a product of the bodies, hence of matter—does not represent ultimate reality either. If one could get beyond the "illusion of sex" (by which Dreiser seems to mean both gender difference and sexual desire) one would find calmness, peace, and unity. Dreiser's intent seems to be to provide a detached, philosophical perspective on the "vagaries of sex" currently so disruptive to Eugene.

669.13 **"I haven't any suitable grounds"** Many northeastern states liberalized divorce laws by the early nineteenth century, and divorces were on the rise throughout much of the country in the second half of the century. New York, however, maintained one of the most restrictive divorce laws until the 1960s. A 1787 New York law named adultery as the sole ground for divorce; moreover, until 1879, when this punitive provision of the law was repealed, the guilty party could not remarry. Beginning in 1813, women could obtain a separation, but not a divorce, in New York if the husband was deemed cruel and inhumane (and in 1824 the separation provision extended to men). The net result was that "New Yorkers had more limited access to divorce than the inhabitants of almost all other states during the nineteenth century" (Phillips, *Putting Asunder,* 445; see also May, *Great Expectations*).

CHAPTER XCVII

675.7 **"whom the gods would destroy they first make mad"** The saying has been variously attributed, including to Euripides (480 or 485–406 B.C.) and Longfellow.

680.11 **"Faded the flower . . ."** from "The Day is Gone, and all its Sweets are Gone," 1819 sonnet by Keats.

CHAPTER XCVIII

687.26 **divine science** synonym for Christian Science, as used by believers.

687.31 **mortal mind** According to Eddy, "In reality there is no *mortal* mind," which is an illusion, the primary source of error (such as misguided beliefs in evil and sickness). She continues, "The expression mortal mind is really a solecism, for Mind is immortal, and Truth pierces the error of mortality as a sunbeam penetrates the cloud. Because, in obedience to the immutable law of Spirit, this so-called mind is self-destructive, I name it mortal" (*Science and Health* 103).

687.32 **It will come out all right if we think right** This is perhaps the quintessential Christian Science belief. Eddy maintains that "[a]s a man thinketh, so is he" and that "human power" is "proportionate to its embodiment of right thinking" (*Science and Health* 166, 225).

688.30 **study law or trained nursing or domestic science** Although the number of women in legal fields increased from the late nineteenth to the early twentieth century, the figure remained minuscule. In 1910, women received 1.1 percent of legal degrees awarded in the United States (Nancy Cott, *The Grounding of Modern Feminism* [New Haven, Conn.: Yale University Press, 1987], 219). The other fields Eugene mentions were more likely for women: according to the 1900 census, 93.6 percent of nurses were female; domestic science (also called home economics), which sought to apply scientific ideas to improve nutrition, sanitation, and other domestic concerns, was practiced almost exclusively by women.

689.13 **"go over to New Jersey"** since New Jersey permitted divorce on the ground of desertion as well as adultery, Eugene is probably urging Angela to move there to sue for divorce on the ground of his deserting her. For Angela to charge Eugene with adultery, at least with Suzanne, would be to perjure herself.

691.6 **laws of the state of New York . . . not entitled to anything more than a very small fraction** From 1900 to 1922, the number of divorces resulting in alimony nearly doubled, but awards were still unusual. Between 1887 and 1906, alimony was received in less than 10 percent of American divorces. Factors increasing the probability of alimony included the presence of children and the perception that the husband was responsible for the failure of the marriage. When alimony was granted, often the award did not consider the husband's income; it also was generally discretionary and impermanent.

CHAPTER XCIX

692.10 **Kingsbridge** also known as Marble Hill, a neighborhood north of where the Harlem River curves east to meet the Hudson. Dreiser lived here in 1903, during his depression.

692.35 **"Go" and "Come"** Allusion to Luke 7:8, in which a centurion calls upon Jesus to heal one of his servants.

692.41 **These are the times that try men's souls** Opening line from *The American Crisis* (begun 1776), a series of pamphlets by Thomas Paine (1737–1809), referring to the beginning of the American Revolution.

693.11 **"Thus saith the Lord . . . given to the Medes and the Persians"** So speaks

the prophet Daniel to Belshazzar, king of Babylon, interpreting handwriting on the wall that perplexes the king's other interpreters (Daniel 5:23, 26–28).

693.27 **whited sepulchres shining to the sun** from Jesus' condemnation of the Pharisees: "Woe unto you, scribes and Pharisees, hypocrites! For ye are like whited sepulchers, which indeed appear beautiful outward, but are within full of dead men's bones, and of uncleanliness" (Matt. 23:27). Mary Baker Eddy also quotes this phrase early in *Science and Health* (8).

693.28 **providence which shapes our ends** A misquotation of "a divinity that shapes our ends" from *Hamlet* 5.2, perhaps mixed up with "there's a special providence in the fall of a sparrow" from the same act.

697.5 **no evil, only good** This premise is central to Christian Science. As Eddy maintains, "Evil has no reality. It is neither person, place, nor thing, but is simply a belief, an illusion of material sense" (*Science and Health* 71).

697.8 **sense of materiality** Angela presumably means that she has for so long believed in the illusions of the material world that she finds it difficult fully to embrace Christian Science.

CHAPTER C

699.31 **Lourdes, St. Anne de Beaupré** Catholic shrines visited for faith healing and religious renewal. At Lourdes, in southwest France, Saint Bernadette was reportedly visited several times by Our Lady of Lourdes. Beaupré is in southern Quebec; its patron saint is Anne, who was mother of the Virgin Mary, and upon whom women in childbirth frequently call.

699.36 **ovarian tumor, . . .** *Science and Health with Key to the Scriptures,* **. . . instantly cured** *Science and Health with Key to the Scriptures* (1875) is the scriptural text of Christian Science, authored by Mary Baker Eddy. (The book went through numerous "improved editions" during Eddy's life. It is impossible to know which version Dreiser read, and so all quotations here are from the most likely source, the final edition, copyrighted 1906.) Faith healing, probably the most familiar of Christian Science practices, is central to the religion, and follows from the assertion that mind is real and matter an illusion. It also follows from the founder's experience: in 1866, Eddy was severely injured (by some accounts, breaking her spine) when she fell on ice, but was spontaneously cured while reading an account of Jesus' healing of the sick. She would later describe this moment as when she "discovered" Christian Science. In *Science and Health,* she contends that Jesus' repeated curing of the sick, as recorded throughout the gospels, was not unique to his era or to his divine powers, but rather is the essence of Divine Science (or Christian Science).

700.12 **God is a principle, not a personality** Eddy repeatedly speaks against the notion of an anthropomorphic God, an error that she sees as a further instance of the tyranny of matter over mind.

700.19 **Matter becomes . . . illusions** *Science and Health* defines "Matter" as "Mythology; mortality; another name for mortal mind; illusion; . . . life resulting in death, and death in life; . . . the opposite of Truth; the opposite of Spirit; the opposite of God. . . ." (591).

700.31 **Lord Avebury** Sir John Lubbock Avebury (1834–1913), English statesman, banker, and naturalist.

Alfred Russel Wallace Dreiser may have in mind such writings as *On Miracles and Modern Spiritualism* (1875) and "The Scientific Aspect of the Supernatural" (1866), which attempted to place spiritualism on a scientific basis.

Sir Oliver Lodge Sir Oliver Joseph Lodge (1851–1940), English physicist and believer in spiritualism, sought to reconcile religion and science.

Sir William Crookes Sir William Crookes (1832–1919), English chemist and physicist, also interested in psychic research.

Emerson's "Over-Soul" 1841 essay about cosmic unity by Emerson, published in *Essays, First Series.*

Carl Snyder's *World Machine* Carl Snyder (1869–1946) published *The World Machine: The First Phase: The Cosmic Mechanism* in 1907. This work in cosmology opens with an epigraph from Nietzsche's *Genealogy of Morals:* "Since Copernicus, Man seems as if thrown upon an inclined plane, down which he is rolling, faster and ever faster—away from his central place in creation—Whither? Into Nothingness? Into a deep—penetrating sense of nothingness?"

Johnston's translation of the *Bhagavad Gita* This Hindu religious work, originally in Sanskrit, was translated in 1908 into English by Charles Johnston (1867–1931).

700.37 **Christ had said to the woman at the well in Samaria** In John 4, while traveling through Samaria, Jesus asks a woman for water from a well, promising her "living water"—that is, salvation—in exchange.

700.41 **Sermon on the Mount** The gospel of Matthew records one of the most beloved of Jesus' sermons, preached from atop a mountain. The Sermon on the Mount extends from Matthew 5–7 (cf. Luke 6: 17–49), but Dreiser probably has in mind the beatitudes, promising heavenly rewards for those who suffer on Earth (Matt. 5: 3–12).

701.6 **The Word—before it was made flesh** allusion to John 1:14: "And the Word was made flesh, and dwelt among us," signifying the incarnation of God's Word in Christ.

701.21 ***The History of Human Marriage*** published in 1891, by Edward Westermarck (1862–1934).

702.4 **right that he should cease to live with Angela** Myrtle may be speaking here more as a sister who longs for her brother's happiness than as a Christian Scientist. *Science and Health* maintains that "[i]nfidelity to the marriage covenant is the social scourge of all races" (56). At the same time, Eddy admits that "[d]ivorces should warn the age of some fundamental error in the marriage state" (65).

702.7 **"Seek ye first the Kingdom of God"** Matthew 6:33; cf. Luke 12:31.

702.25 **Fourth Church of Christ Scientist in New York** founded in 1896 by two students of Mary Baker Eddy, its first location was in a hall in West Eighty-second Street. In 1911 the congregation moved into the Ricker Building at Broadway and Eighty-first Street. From 1914 to 1918, a new building was built at Fort Washington Avenue and 178th Street, but the congregation was forced to leave in 1930 to make way for the George Washington Bridge. It then built a new building at Fort Washington Avenue and 185th Street.

703.5 **Bible says, to lust after her** From the Sermon on the Mount: "But I say

unto you that whosoever looketh on a woman to lust after her hath already committed adultery with her in his heart" (Matt. 5:28).

703.9 **dropsy** also called edema, an accumulation of fluid in tissue or cavity.

703.25 **"he who doeth his will in the army of the heavens"** Daniel 4:35.

703.30 **"He that believeth in me shall never die"** In John 3:16, Jesus tells Nicodemus, "For God so loved the world, that he gave his only begotten Son, that whosoever believeth in him should not perish, but have everlasting life." The famous promise is echoed in John 11:25; after raising Lazarus from the dead, Jesus promises Martha, "I am the resurrection, and the life; he that believeth in me, though he were dead, yet shall he live."

703.36 **"He is of eyes too pure to behold evil"** The prophet Habakkuk asked how God could use the wicked: "Thou art of purer eyes than to behold evil, and canst not look on iniquity; wherefore lookest thou upon them that deal treacherously . . .?" (Hab. 1:13).

CHAPTER CI

704.25 **statement concerning the rapid multiplication and increased violence of diseases since the flood** The preface of *Science and Health* notes "the reputed longevity of the Antediluvians, and the rapid multiplication and increased violence of diseases since the flood" (viii).

704.33 **evidences of the five physical senses** Eddy repeatedly urges that the five senses are the origins of human error.

similes based upon those evidences For instance we read in *Science and Health* that "[t]he manifestation of God through mortals is as light passing through the window-pane. The light and the glass never mingle, but as matter, the glass is less opaque than the walls" (295); "As frightened children look everywhere for the imaginary ghost, so sick humanity sees danger in every direction" (371); "As vapor melts before the sun, so evil would vanish before the reality of good" (480). Eddy herself mentions the incongruity of such comparisons, declaring that "like all other languages, English is inadequate to the expression of spiritual conceptions and propositions, because one is obliged to use material terms in dealing with spiritual ideas" (349).

705.11 **"Become conscious for a single moment"** Quotation from *Science and Health* 14.

705.16 **"God is a spirit"; ". . . in spirit and in truth"** John 4:24.

705.18 **"You will find yourself suddenly well"** (*Science and Health* 14).

"Sorrow is turned into joy" from the Lord's questions asked of Job (Job 41:22).

705.22 **immaculate conception of the Virgin Mary** Eddy does not mention this in *Science and Health*, but she published an article called "Immaculate Conception" in the November 1888 issue of *The Christian Science Journal*.

ultimate abolition of marriage A chapter in *Science and Health* describes marriage as the approved mechanism for the spiritual and physical joining of men and women—but clearly implies that the institution will be superseded when humans evolve into a fuller understanding of truth. As Eddy puts it, "the time cometh of which Jesus spake, when he declared that in the resurrection there should be no more marrying nor giving in marriage, but man

would be as the angels. Then shall Soul rejoice in its own, in which passion has no part" (*Science and Health* 64). But "until it is learned that God is the Father of all, marriage will continue" (*Science and Health* 64). In *Miscellaneous Writings*, Eddy says, "To abolish marriage at this period, and maintain morality and generation, would put ingenuity to ludicrous shifts; yet is this possible in *Science*, although it is today problematic" (quoted in Dakin, *Mrs. Eddy*, 124).

dematerialization of the body presumably the tenet that the material body is not the real person; only the Mind—a reflection of God—is real.

chemicalization The term is only vaguely defined in *Science and Health*: "By chemicalization I mean the process which mortal mind and body undergo in the change of belief from a material to a spiritual basis"; "*chemicalization* is the upheaval produced when immortal Truth is destroying erroneous mortal belief. Mental chemicalization brings sin and sickness to the surface, forcing impurities to pass away, as is the case with a fermenting fluid" (168–69, 401).

705.36 **its adherents multiplying** In 1879, Christian Science had twenty-six members; by 1906, it boasted 86,000 (Satter, *Each Mind*, 5).

705.39 **Mrs. Eddy . . . would never die** Eddy maintained that just as illness could be cured by right thinking, so would death ultimately be overcome. The reasoning follows the same loosely evolutionary path by which she contends that marriage will become unnecessary when humans accept the full Truth. One of Eddy's most influential minions, Augusta Stetson (?–1928), head of the New York church from the early 1890s until 1909 (when Eddy excommunicated her), took this idea literally and proclaimed that both she and Eddy were immortal.

705.41 **Christian Scientists were uniformly successful . . . material success** More often, the tendency of Christian Scientists to accumulate wealth was seen as discrediting the faith. In his famous assault on Mary Baker Eddy and her followers, Mark Twain, for instance, charged that "the Boston Christian-Science Trust gives nothing away; everything it has is for sale. And the terms are cash; and not only cash, but cash in advance. Its god is Mrs. Eddy first, then the Dollar. Not a spiritual Dollar, but a real one. From end to end of the Christian-Science literature not a single (material) thing in the world is conceded to be real, except the dollar" (*Christian Science*. 1907. New York: Oxford University Press, 1996, 68).

706.12 **Carlyle had once said that "matter itself . . . product due to man's mind"** see above, 839.

Carlyle's journal, from Froude's *Life of Carlyle* two-volume biography, *Thomas Carlyle: A History of His Life in London, 1834–1881* (1884) and *Thomas Carlyle: A History of the First Forty Years of His Life, 1795–1835* (1882), by James Anthony Froude (1818–1894).

706.24 **"Lay not up for yourselves . . ."** and **"For where your treasure is"** Matthew 6:20–21.

706.28 **Keats, . . . "beauty is truth"** see above, 800. Eddy remarks that "Beauty, as well as truth, is eternal; but the beauty of material things passes away" (*Science and Health* 247).

another, "truth is what is" Dreiser might have in his own proclamation in a 1903 manifesto: "Truth is what is; and the seeing of what is, the realization of

truth" (Dreiser, "True Art Speaks Plainly," reprinted in *Documents of Modern Literary Realism*, ed. George J. Becker (Princeton, N.J.: Princeton University Press, 1963), 155.

706.37 **maternity hospital** See explanatory note below, 847.

707.6 **Kent's *History of the Hebrews*** Charles Foster Kent (1867–1925) published numerous books on historical Judaism; Dreiser may have in mind *A History of the Hebrew People* (1896) or *History of the Jewish People during the Babylonian, Persian, and Greek Periods* (1899).

 Weininger's *Sex and Character* by Otto Weininger (1880–1903), translated from the German in 1906.

 Muzzey's *Spiritual Heroes* *Spiritual Heroes; A Study of the World's Prophets* (1902), by David Saville Muzzey (1870–1965).

 Huxley's *Science and Hebrew Tradition* and *Science and Christian Tradition* 1894 and 1896, respectively, by Thomas Huxley.

707.21 **Persian zealots, . . . feast of the tenth month** Some members of the Shiite sect of Muslims perform communal self-mutilation, as part of the process of lamentation for the martyrdom of a prophet, during the Muharrem fast.

707.26 **Isaiah eschewed clothing** Isaiah's going naked and barefoot for three years is not, in fact, mentioned in Is. 22:21, but rather in Is. 20:3.

 Jeremiah appeared . . . wooden The prophet says, "Thus saith the Lord to me, Make these bonds and yokes and put them upon thy head" (Jer. 27:8).

 Zedekiah came to King Ahab . . . horns of iron 1 Kings 22:11. Ahab was King of Israel for twenty-two years, during which time he repeatedly "did evil in the sight of the Lord" (1 Kings 16:30).

 prophet was called mad cf. Hosea 9:7: "The days of visitation are come, the days of recompense are come; Israel shall know it; the prophet is a fool, the spiritual man is mad . . ."

 Elisha, . . . Jehu as recorded in 2 Kings 9:1–3.

*708.1 **George M. Gould** George Milbry Gould (1848–1922), a Philadelphia ophthalmologist, compiled medical dictionaries, still used today under the title of *Blackiston's New Gould Medical Dictionary*. Here Dreiser splices together several quotations from Gould's *The Infinite Presence* (New York: Moffat, Yard and Company, 1910), 60–63.

708.20 **quotation in a Sunday newspaper . . . Edgar Lucien Larkin** Astronomer Edgar Lucien Larkin (1847–1925) frequently wrote for newspapers and magazines. Many of these pieces were combined in his book *Radiant Energy*, published in 1904.

*709.7 **Alfred Russel Wallace** In *The Novels of Theodore Dreiser*, 359, n. 37, Donald Pizer identifies the quotation as from the concluding chapter of Wallace's *The World of Life: A Manifestation of Creative Power, Directive Mind, and Ultimate Purpose* (New York, 1911).

710.24 **'cell souls' posited by Haeckel** Ernst Heinrich Haeckel (1834–1919), German biologist and philosopher, talks about this concept in *The Riddle of the Universe at the Close of the Nineteenth Century* (New York and London: Harper & Brothers, 1900): "The cell-soul (or cytopsyche): first state of phyletic psychogenesis. The earliest ancestors of man and all other animals were unicellular protozoa. This fundamental hypothesis of rational phylogeny is based, in virtue of the phylogenetic law, on the familiar embryological fact that every

man, like every other metazoon (i.e., every multicellular organism with tissues), begins his personal existence as a simple cell. . . . As this cell has a 'soul' from the commencement, so had also the corresponding unicellular ancestral forms" (151–52). Dreiser's copy of the book is heavily marked and annotated. His markings in this section on "cell souls" include Haeckel's discussion of the conclusions of Max Verworn in *Psycho-physiological Studies of the Protists:* "psychic processes are unconscious in all the protists. . . . Hence the psychic phenomena of the protists form a bridge that connects the chemical processes of the inorganic world with the psychic life of the highest animals; they represent the germ of the highest psychic phenomena of the metazoa and of man" (DPUP).

711.5 ***Man's Place in the Universe*** published 1903.

711.18 **vera causa** a cause in harmony with other known causes.

712.3 **"a little lower than the angels"** From Psalms 8:4–5: "What is man, that thou art mindful of him? And the son of man, that thou visitest him? For thou hast made him a little lower than the angels, and hast crowned him with glory and honor."

712.7 **Mrs. Eddy's contention that all was mind** A central tenet of the faith. For example, "Mind is All and matter is naught" (*Science and Health* 109).

712.13 **God was a principle, like a rule in mathematics** Eddy repeatedly asserts this point, often with mathematical analogies.

CHAPTER CII

712.30 **not a narrow dogmatic one** Christian Science maintains that its tenets, which return to the original message of Christ, lie beyond dogma. "Creeds, doctrines, and human hypotheses do not express Christian Science; much less can they demonstrate it," according to Eddy (*Science and Health* 98).

712.36 **mesmerism** A cosmological system which claims to promote healing, the brainchild of German physician Franz Anton Mesmer (1734–1815). Mesmer believed he had discovered an invisible ether or fluid that acted as a medium between physical and celestial bodies. Unobstructed flow of this fluid—also called animal magnetism—promoted health.

spiritism Also known as spiritualism, the belief that the dead communicate through a medium with the living. Believers maintain that death means not an end to existence but a change of wavelength, and that mediums can receive vibrations from the dead. The dead make contact both through psychic means (e.g., telepathy) and physical means (e.g., automatic writing). Modern American spiritualism dates back to 1848, when the Fox sisters claimed to hear rappings in their home in New York. By 1855, they had a million followers.

713.8 **sound and fury, signifying nothing** From Shakespeare's *Macbeth* 5.5, spoken by the title character upon hearing of Lady Macbeth's suicide.

713.13 **hospital in 110th Street** Woman's Hospital, founded in 1855, was displaced from its original location on Park and Lexington Avenues between Forty-ninth and Fiftieth Streets when Grand Central Terminal was enlarged. The hospital was rebuilt in 1904–1906 between 109th and 110th Streets, designed by the firm of Allen and Collens.

713.37 **Who's Who** This encyclopedia of notable people was founded in 1899, and Dreiser was among those listed in the first edition.

714.11 **Christian Science set aside marriage** see above, 844.

714.18 **"Helen** The poem, which Dreiser quotes in its entirety, is actually called "No Second Troy." Ostensibly about Helen of Troy, the poem in fact reflects Yeats's troubled relationship with Maud Gonne (1866–1953). The poem appeared with *The Green Helmet and Other Poems* (1910).

714.33 **"When in Disgrace"** Sonnet 29, in its entirety.

715.11 **Keats's "The Day is Gone"** Dreiser quotes four lines from this sonnet above, 840.

Alice Meynell's "Renouncement" Alice Thompson Meynell (1847–1922), English poet and essayist, wrote pious Catholic works such as the sonnet "Renouncement."

"Endurance" by Elizabeth Akers Allen Elizabeth Akers Allen (1832–1911), author of sentimental poems. "Endurance" bemoans, "How much the heart may bear and yet not break!"

"Tears" by Lizette Woodworth Reese Lizette Woodworth Reese (1856–1935), a Baltimore poet of intensely emotional verse. In her most popular poem, "Tears," a sonnet first published in *Scribner's* in 1899 and widely anthologized, she prays that clear vision will supplant weeping.

"The Eve of St. Agnes" by Keats sensuous 1819 poem based on the legend that maidens can glimpse their future husbands on the Eve of St. Agnes (21 January).

717.1 **Mrs. Micawber** devoted wife, sanguine in the face of hard times, in *David Copperfield* (1849–50), by Dickens.

718.9 **Isaiah's words** Isaiah 1:18.

718.22 **St. Paul says, 'I can** Philippians 4:13.

718.28 **St. Paul says, 'for the** 1 Corinthians 3:19.

'The Lord knoweth 1 Corinthians 3:20. Cf. Psalms 94:11: "The Lord knoweth the thoughts of man, that they are vanity."

718.32 **'Now then we** 2 Corinthians 5:20.

718.39 **fix his mind in meditation on the Lord's Prayer** Eddy criticizes long prayers, which she believes promote hypocrisy. She recommends the Lord's Prayer as "the prayer of Soul, not of material sense" (14). The first chapter of *Science and Health* ends with her interpretation of the Lord's Prayer.

719.4 **"He that dwelleth. . . ."** Psalm 91, in its entirety. This psalm is of especial importance to Christian Science.

720.9 **slough of their own despond** In the Christian allegory *The Pilgrim's Progress from This World to That Which Is to Come* (1678, 1684), by John Bunyan (1628–1688), the main character, Christian, is mired in the Slough of Despond because of the heaviness of his sin, until he is rescued by Help.

720.29 **these were not to be practised** Although nonbelievers are apt to see many parallels, and Eddy herself had been a student of New Hampshire mesmerist Phineas P. Quimby (1802–1866), she sought to disassociate Christian Science from mesmerism. Eddy describes mesmerism and hypnotism as instances of "half-way impertinent knowledge" which subscribe to the "false belief that mind is in matter" (*Science and Health* 103). She expressed her hostility to the mesmerists by referring to "Malicious Animal Magnetism"—"M.A.M.," as it was known to her inner circle.

721.12 **"a liar and the father of it"** Spoken of the devil (John 8:44). Eddy also quotes this biblical passage: "Jesus said of personified evil, that it was 'a liar, and the father of it'" (*Science and Health* 357).

721.24 **"When mortal man blends . . ."** Quotation from *Science and Health* 263.

721.31 **"'The good that I would . . .'"** Romans 7:19.

721.37 ***Evening Post*** founded in 1801 by Alexander Hamilton, this paper had a long history of supporting reform causes, most notably under the forty-nine-year editorship of William Cullen Bryant and, beginning in the 1890s, of the distinguished trio of German American Carl Schurz (1829–1906), Edwin Lawrence Godkin (1831–1902), and Horace White (1834–1916).

721.39 **Francis Thompson, . . . "The Hound of Heaven"** Francis Thompson (1859–1907), a devout Catholic poet. His most famous verse, "The Hound of Heaven," appears in *His Poems* (1893). Dreiser quotes liberally from the 182–line poem.

CHAPTER CIII

725.17 **"all-mother"** possibly derived from the Great Mother or Magna Mater—creator of the universe, Queen of Heaven, Mother of the gods. She is the counterpart of the Greek Rhea and the Roman Ops. Dreiser also uses the phrase in *Jennie Gerhardt*, 92.

725.29 **book on obstetrics** Many such books, a number of them published within a decade prior to the composition of *The Genius*, would have been available to Dreiser. His description of a 75 percent success rate with Caesarean operations suggests a volume published shortly before he composed *The Genius*, but a whole chapter on cephalotripsy (which Dreiser accurately describes later in the text) suggests an older work. Many obstetrics books were lavishly illustrated, such as J. Whitridge Williams's popular *Obstetrics: A Text-Book for the Use of Students and Practitioners* (New York and London: D. Appleton and Company, 1903). It is clear that Dreiser relied on his friend Dr. Leonard Keene Hirshberg for information on labor and delivery (see "The Composition of *The Genius*: The 1911 Version to Print," 751–52); which book or books he may also have consulted cannot be determined.

726.2 **Craniotomy** "all operations which bring about a decrease in the size of the foetal head, with a view to rendering its delivery easier" (Williams, *Obstetrics*, 418).
 Cephalotripsy, . . . cephalotribe accurately explained by Dreiser. Cephalotripsy killed the fetus, while craniotomy attempted to save it.

726.8 **hemostatic clamps** used to arrest the flow of blood.
 forceps, high and low used to extract the fetus when it emerges head first. According to Williams, *Obstetrics*, "Forceps operations are designed as low, mid, high, and floating, according to the position of the head. When the presenting part rests upon the perinaeum, or lies below the line joining the ischial spine, we speak of low forceps; . . . when the head has partially descended into the pelvic canal, but its greatest circumference has not passed the superior strait, high forceps" are used (359). Low forceps operations were considerably less risky than procedures requiring high forceps.

727.2 **think her through a thing like this** When Eddy founded her Massachusetts Metaphysical College, the prospectus described her as Professor of Obstetrics,

Metaphysics, and Christian Science. She conducted classes in obstetrics which taught the use of Christian Science principles to eliminate the "illusion" of labor pains. Early editions of *Science and Health* describe a Mrs. Miranda Rice undergoing a painless childbirth under the ministrations of Eddy, but this account was deleted from later editions (see Dakin, *Mrs. Eddy*, 118). The final edition of *Science and Health* tones down the idea to a vague paragraph on "the obstetrics taught by this [Christian] Science": "To attend properly the birth of the new child, or divine idea, you should so detach mortal thought from its material conceptions, that the birth will be natural and safe. Though gathering new energy, this idea cannot injure its useful surroundings in the travail of spiritual birth. A spiritual idea has not a single element of error, and this truth removes properly whatever is offensive. The new idea, conceived and born of Truth and Love, is clad in white garments. Its beginning will be meek, its growth sturdy, and its maturity undecaying. When this new birth takes place, the Christian Science infant is born of the Spirit, born of God, and can cause the mother no more suffering" (463).

730.33 **absent treatment** Because Christian Science healing was performed mentally—and generally silently, through the practitioner's thoughts—treatments could be performed without the practitioner and patient even seeing each other.

732.6 **holding a cone** for ether.

733.12 **lay figure** "a jointed model of the human body used by artists to show the disposition of drapery" (*Webster's*).

733.16 **Rembrandt's *The Night Watch*** Actually titled *The Company of Captain F. B. Cocq*, this group portrait of 1642 by Rembrandt is commonly called *The Night Watch*.

734.33 **hierarchies and powers, as Alfred Russel Wallace had pointed out** Beginning with his 1869 review of Lyell's *Principles of Geology*, Wallace affirmed that while natural selection explained man's evolution, a divine power must have been the engine behind evolution. His later writings would repeatedly show the influence of his embrace of spiritualism.

CHAPTER CIV

735.10 **eclampsia** For Dreiser's use in this section of material provided by Dr. Leonard Keene Hirshberg, see "The Composition of *The Genius*: The 1911 Version to Print," 751–52.

735.24 **"realize her identity with good"** According to Christian Science, all evil and sickness are illusions representing errors in understanding. To realize one's identity with good is to realize oneness with God, and thus to overcome the limits of the material and mortal world. In Eddy's words, "As vapor melts before the sun, so evil would vanish before the reality of good" (*Science and Health* 480).

737.24 **for he was very virile** On "virility" in the arts, see "The Intellectual and Cultural Background to *The Genius*," 778.

739.18 **two years** The time sequence in this section of the novel is confusing, since Dreiser several times uses the phrase "two years" as well as "four years." Apparently Eugene continues to dabble in Christian Science and otherwise work

things out philosophically for "two years" (739) and "two years later"—that is, two years after the first two years, he re-encounters Suzanne (741). At this point, Eugene reflects, "And it was four years!" (742).

740.8 **"'Beloved** 1 John 3:2.

740.36 **whales, . . . bugs and torturesome insects** Mrs. Johns's beliefs may derive from Eddy's gloss on Genesis. Eddy's interpretation of "And God created great whales, and every living creature that moveth, . . ." (Gen. 1:21) is that "Spirit is symbolized by strength, presence, and power. . . ." And she glosses "And God said, Let the earth bring forth the living creature after his kind, cattle, and creeping thing, . . ." (Gen. 1:24), by noting that "Spirit diversifies, classifies, and individualizes all thoughts. . . ." (*Science and Health* 512–513).

741.4 **as Carlyle had said, a state of mind** see above, 839.

741.10 **"There is no life. . . ."** Quotation from *Science and Health,* 468; Eddy terms it "the scientific statement of being."

744.36 **Bergson** Henri Bergson (1859–1941), French philosopher, known for theory of *élan vital* or the life force, which he expounds in *Creative Evolution* (1907) as a means of positing an evolutionary theory that accommodates religion.

*745.25 **Spencer's *Facts and Comments*** 1902 collection of essays by Herbert Spencer.

746.26 **"Yes, I'm coming, sweet"** For Chapter CV, which is included with the holograph but written at a later time, see Appendix 3.

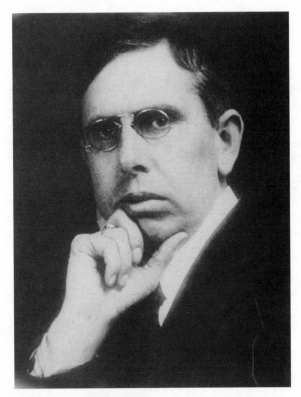

Theodore Dreiser, circa 1907
(Annenberg Rare Book and Manuscript Library,
University of Pennsylvania)

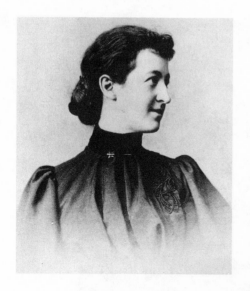

Sara Osborne White, known as
"Jug," Dreiser's first wife and the
model for Angela Blue
(Annenberg Rare Book and
Manuscript Library, University
of Pennsylvania)

Thelma Cudlipp, circa 1912,
the model for Suzanne Dale
(Annenberg Rare Book and
Manuscript Library, University
of Pennsylvania)

Mr. and Mrs. Theodore Dreiser
(Annenberg Rare Book and Manuscript Library, University of Pennsylvania)

The Genius

Alternative Titles

Will those who read this manuscript kindly indicate here any other title which may occur to them as appropriate and forceful. Or check the one which they prefer.

This matter of marriage, now.
The Glory of Eugene E.
Eugene Witla

The Hedonist
The Dreamer
The Sensualist.

The Genius holograph title page
(Annenberg Rare Book and Manuscript Library, University of Pennsylvania)

Enter Carlotta!

bewitching, ethereal—but so human!—in this instalment she plays her part in

Theodore Dreiser's

soul-searching novel

The Genius

Illustrations
by
Gerald Leake

Her Mother did not see Carlotta step out of Eugene's room, but she could scarcely have come from anywhere else

Characters previously introduced:—Eugene Witla, that dreamy, mysterious type of humanity, The Genius. After making good as a painter, his nerves go wrong and he has to hunt for rough jobs. In his struggle for mastery in Art, Life and Love, his path has crossed that of

Ruby, a model who loved and lost;

Christina, whose name wakes memories, and

Angela, the girl who became his wife—only to wonder whether that was the wise thing to do.

THE idea of appealing to the president of one of the great roads that entered into New York was not so difficult to execute, and after Eugene had made known his mission, he was given a letter to Mr. Jack Stix, foreman carpenter at Speonk, a point of land on the Hudson River above Riverwood. This letter was presented on a bright Friday afternoon, and brought him the advice to come Monday at seven A.M., and so Eugene saw a career as a day laborer stretching very conspicuously before him. The carpenter

29

"Enter Carlotta."
This illustration by Gerald Leake appeared in the serialized version of the novel published in 1923 in *Metropolitan Magazine*.
(Annenberg Rare Book and Manuscript Library, University of Pennsylvania)

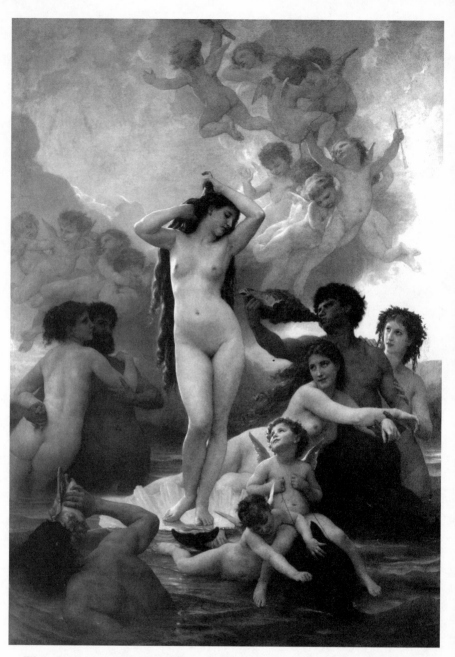

W. A. Bouguereau, *The Birth of Venus* (1879)
"These women stood up big in their sense of beauty and magnetism, the soft lure of desire in their eyes, their full lips parted, their cheeks naturally flushed with the blood of health. They were a notable call to motherhood and as such were anathema to the conservative and puritanical mind; the religious in temperament; the cautious in training or taste" (*The Genius*, 46) (Réunion des Musées Nationaux/Art Resource, N.Y.; Musee d'Orsay, Paris, France)

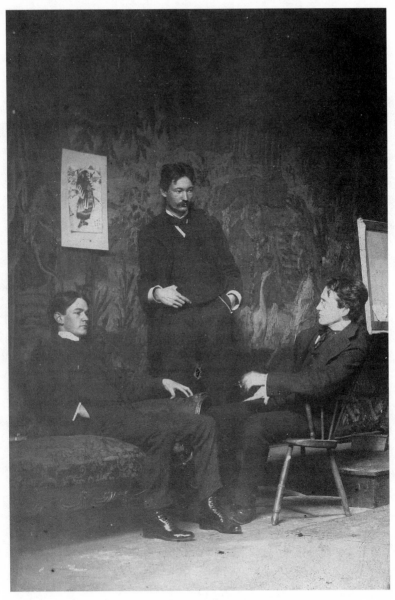

Photo of Everett Shinn, Robert Henri, and John Sloan (1896)
Three members of The Eight (the nucleus of what would later be called the
Ashcan School) relaxing in Henri's Philadelphia studio. Dreiser knew Shinn
and Sloan and was familiar with the career of Henri, the dynamic leader of
the group.
(Miscellaneous photographs, Archives of American Art, Smithsonian
Institution)

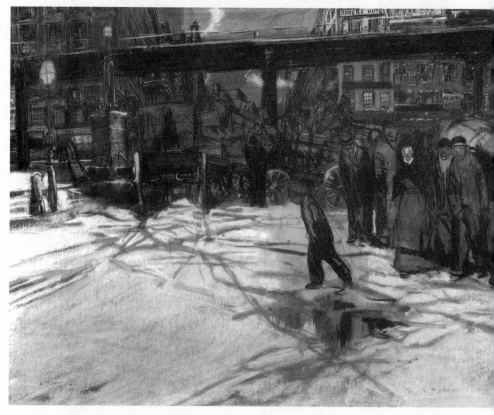

Everett Shinn, *Under the Elevated* (undated)
"He drew a man's coat with a single dash of his pen. He indicated a face by a
spot. If you looked close there was scarcely any detail, frequently none at all"
(*The Genius*, 98).
(Pastel and charcoal on paper. Collection of Whitney Museum of Art, New York;
Gift of Mr. and Mrs. Arthur G. Altschul)

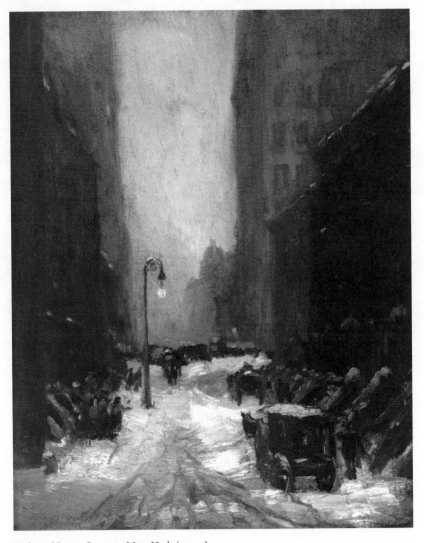

Robert Henri, *Snow in New York* (1902)
"Everything he touched seemed to have romance and beauty and yet it was real
and mostly grim and shabby" (*The Genius*, 229).
(Chester Dale Collection. Image © 2005 Board of Trustees, National Gallery of
Art, Washington, D.C.)

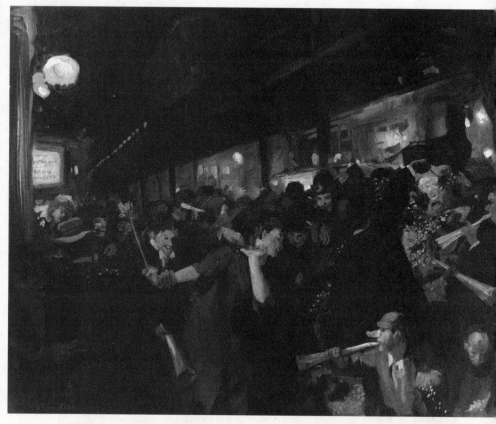

John Sloan, *Election Night in Herald Square* (1907)
"Why, on moody days when he felt sour and depressed, he had seen somewhere a street that looked like this, and here it was—dirty, sad, slovenly, immoral, drunken—anything, everything, but here it was" (*The Genius*, 228).
(Memorial Art Gallery of the University of Rochester; Marion Stratton Gould Fund)

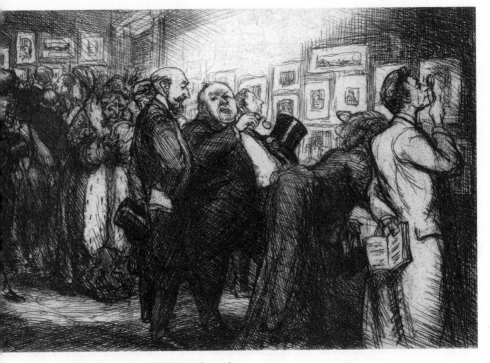

John Sloan, *Connoisseurs of Prints* (1905)
"People came and stared. Young society matrons, art dealers, art critics, the
literary element who were interested in art, some musicians, and because the
newspapers made especial mention of it, quite a number of those who run
wherever they imagine there is something interesting to see" (*The Genius*, 233).
(Delaware Art Museum)

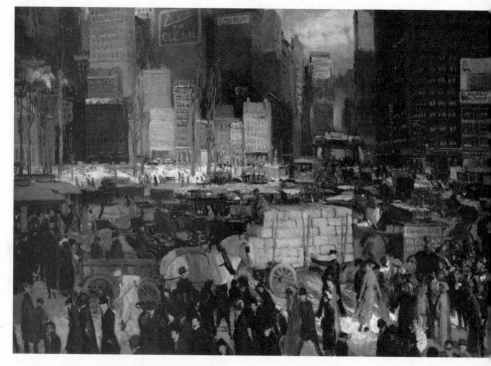

George Bellows, *New York* (1911)
"Such seething masses of people! Such whirlpools of life!" (*The Genius*, 100).
Bellows, a younger member of the Ashcan School, painted this scene of New
York the same year Dreiser wrote *The Genius*. (Collection of Mr. and Mrs. Paul
Mellon. Image © 2005 Board of Trustees, National Gallery of Art, Washington,
D.C.)

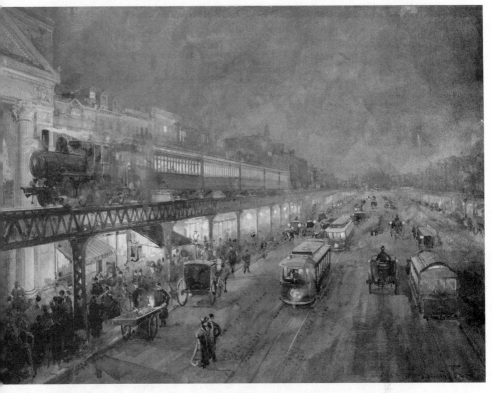

William Louis Sonntag Jr., *The Bowery at Night* (1895)
"The Bowery by night; Fifth Avenue in a driving snow; a pilot tug with a tow
of cars in the East River; Greeley Square in a wet drizzle—the pavements a
glistening gray—all these things were fixing themselves in his brain as wonderful
spectacles" (*The Genius*, 101).

Dreiser was devastated when Sonntag, who had taught him how to see the city
through a painter's eye, died at age twenty-nine.

(Photo reprinted with permission of the Museum of the City of New York.)

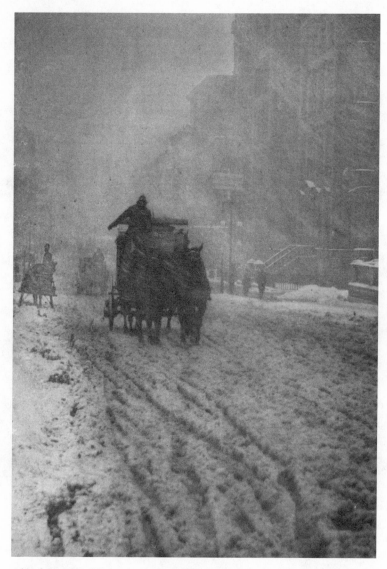

Alfred Stieglitz, *Winter on Fifth Avenue* (1893)
"[L]ooking at . . . Fifth Avenue in a snow storm, the battered, shabby
bus pulled by a team of lean, unkempt, bony horses, he paused, struck
by its force. He liked the delineation of swirling, wind-driven snow.
The emptiness of this thoroughfare, usually so crowded, the buttoned,
huddled, hunched, withdrawn look of those who traversed it, the
exceptional details of piles of snow sifted onto window sills and ledges
and into doorways and onto the windows of the bus itself, attracted his
attention" (*The Genius,* 224).
Dreiser was one of the first to interview pictorial photographer Alfred
Stieglitz, whose career he championed while the pioneering modernist
was under attack.
(Photo reprinted with permission of George Eastman House)

Textual Commentary

EDITORIAL PRINCIPLES AND COPY-TEXT

The editorial procedures underlying this edition follow the principles of the Dreiser Edition as articulated in the general editor's Preface. Accordingly, this edition is not offered as a definitive text of Dreiser's fourth published novel, *The "Genius"* of 1915. Rather, it is presented as an important version of Dreiser's book, a text that Dreiser named *The Genius* and completed in 1911, before the significant revisions that were incorporated in the novel published four years later. This edition thus presents Dreiser's novel as it existed at a crucial moment in its long history of composition.

The copy-text for the edition is the 1911 holograph manuscript in the Annenberg Rare Book and Manuscript Library at the University of Pennsylvania. This is the text Dreiser originally composed and from which he had copies typed in 1911. Because all typescripts from this period have been lost, and because all other relevant texts are the product of later stages of composition, the holograph has been chosen as the base text for this edition. The copy-text has been edited as a public document: it is presented as a clear text in which emendations have been made for typographical errors, hiatuses, misspelling, and unintelligible passages. Whenever possible, emendations are based on collations from existing documents—including extant typescripts and the 1915 edition of the novel—that have authorial sanction. Consequently, Typescript A, Typescript B, the Revised Typescript, and the 1915 edition of the novel have all been used as sources for emendations and textual notes. As a convenience to readers, whenever an emendation appears in the 1915 edition, that text has been given as the authority for the emendation. Readers can thus compare the present text with the readily available published edition.

In cases where there are no authorities beyond the copy-text, the editor has taken an active role and made emendations based on internal evidence and Dreiser's known habits of composition. There are two sets of emendations: (1) an abbreviated selection printed as part of the apparatus of this edition and (2) a comprehensive list of all emendations on file among the Dreiser Papers at the Annenberg Rare Book and Manuscript Library at the University of Pennsylvania.

Changes in Dreiser's hand have been allowed to stand. Wherever Dreiser wrote "stet" alongside a passage that had been crossed out, whether by himself or someone else, the passage has been retained. When Dreiser altered a passage, the original wording is remarked in a textual note only when the text contains material that has special significance.

Hyphenation of compound words was looser at the time of Dreiser's

writing, and he could be inconsistent—sometimes hyphenating, and at other times not hyphenating, compounds such as "real estate." When the inconsistency does not pose a problem to readers, Dreiser's preferences have been retained.

Silent emendations have been made for the following: changing "+" to "and"; adding terminal punctuation when Dreiser has left it off; adding or deleting apostrophes, quotation marks, commas, hyphens, and dashes; changing the position of terminal punctuation to appear before closing quotation marks; regularizing the format of titles; changing upper to lower case, or vice versa. Dreiser occasionally used a comma immediately before a dash, but more often used the dash alone, a feature which has been consistently retained.

TEXTUAL NOTES

Typescript A is abbreviated here as TSA, the Revised Typescript as Revised TS.

These notes make reference to what Dreiser had written in the 1911 holograph and subsequently changed. These references appear here unedited, with missing words, incomplete sentences, and other errors preserved. The only notation will be [*sic*] when a passage appears particularly obscure.

Before the first fly leaf: two pages appear in the holograph in Dreiser's hand; see Appendix 1.

CHAPTER I

5.22 **Alexandria was a city** Before altering this passage in the holograph, Dreiser originally had written "Bloomington," but crossed it out after several pages. The original name appears off and on over the first few chapters beneath Dreiser's cross-out marks.

6.5 **Eugene Tennyson Witla** Before altering this passage in the holograph, Dreiser originally had called him "Alfred Tennyson Witla," after his namesake Alfred, Lord Tennyson. The original name appears off and on over the first few chapters beneath Dreiser's cross-out marks in the holograph.

CHAPTER VIII

47.38 **even if he was a raw country boy** On the holograph, Dreiser's original verb, "were," has been crossed out and below the phrase a handwritten note penciled in: "was—not a supposition—a fact. D. V." The initials indicate Dreiser's typist Decima Vivian. Several changes in her handwriting are penciled in throughout this chapter, mostly toning down the more sexual connotations of Dreiser's prose. Because several other minor changes in this chapter appear in Dreiser's hand, some in pencil, and it is impossible to determine if he or she crossed out some other phrases, and because these changes were incorporated into TSA, they are adopted here.

CHAPTER IX

55.21 **"Black Wood," she laughed** In the holograph, Dreiser originally had written "Green Bay," then changed it to "Black Bay," and finally settled on "Black Wood."

CHAPTER X

57.6 **Miss Angela Blue** Before altering this passage in the holograph, Dreiser originally had called her "Miss Christine Blue."

CHAPTER XI

64.1 **He saw her strolling about, looking** In the holograph, Dreiser originally wrote, "He saw her strolling about, nude, looking." The word "nude" has been penciled out; it is impossible to determine if by Dreiser or by another hand. TSA retains the change, and so it is adopted here.

64.16 **"Good lord," he thought, "if I could only have her now."** In the holograph, this sentence was put in parentheses and underlined. TSA retains the phrase, and so it is adopted here.

CHAPTER XIV

83.20 **connection with Ruby Kenny** Before altering this passage in the holograph, Dreiser originally had called her "Ruby Winchell."

84.21 **her passion. She was sleeping as** Before altering this passage in the holograph, Dreiser originally had written, "her passion. He whispered to himself at times that if she were aroused to a true ~~meaning~~ understanding of the sexual relationship she would be wonderful, deadly. She was sleeping as"

CHAPTER XV

84.24 **weeks Angela came back** In the holograph, Dreiser originally had written, "weeks she came back"; above the "she" someone has penciled in "Angela." It is impossible to determine if the change was made by Dreiser or by another hand, but as TSA retains the change, it is adopted here.

CHAPTER XVI

91.24 **would have taken those customary liberties which were instinctive** Before altering this passage in the holograph, Dreiser originally had written that Eugene "would have felt her breasts and thighs."

CHAPTER XIX

107.10 **Chicago and Black Wood** Here and throughout the chapter, in the holograph Dreiser originally had called the latter "Green Bay" before changing it to "Black Wood."

112.15 **one brown suit** Dreiser ignored the suggestion of typist Decima Vivian, who objected to Eugene's clothing, leaving a penciled note on the holograph page reading, "Mr. D. Please make it blue—D.V."

CHAPTER XX

118.9 **in an exaggerated form,** through **said that he did** This page is numbered, in Dreiser's hand and in the same ink he used in the rest of the chapter, "21–22–23–34–25."

118.39 **delight which came with it** In the holograph, Dreiser originally had written, "delight which came with sex-gratification." Someone has penciled in

the change of "sex-gratification" to "it" on the holograph; it is impossible to determine if by Dreiser or by another hand. TSA retains the change, and so it is adopted here.

122.8 **her trim form. It was dainty. He had held her bosom in his arms** Before altering this passage in the holograph, Dreiser originally had written, "her trim leg. It was dainty. He had held her bosoms in his hand." Dreiser then changed "bosoms" to "breasts," and then decided on "bosom."

122.11 **He wished sincerely** Before altering this passage in the holograph, Dreiser originally had begun this paragraph, "But she was beautiful! Yes, she was intensely beautiful and passionate," but then crossed out those two sentences.

CHAPTER XXV

148.26 **"It is a difficult problem,"** through **expense of love?** Before altering these passages in the holograph, Dreiser originally had Eugene behaving "off hand[edly] and distantly," which Christina presumes is because "[h]e probably expected her to marry him."

148.31 **might be contemplating some radical step** through **her problem** Before altering this passage in the holograph, Dreiser originally had written that Christina "might not be virtuous—and that anyhow she was debating the wisdom of remaining so."

149.17 **for a magazine** Before altering this passage in the holograph, Dreiser originally had written "for McClures."

CHAPTER XXVI

152.2 **curious spiritual exaltation** Before altering this passage in the holograph, Dreiser originally had written, "A curious sexual exaltation."

153.5 **arrangement which need not be discussed here** through **possible with her** Before altering this passage in the holograph, Dreiser originally had written, "arrangement which gave Eugene the pleasure of her body while protecting her."

153.9 **those who know. By degrees** On the holograph, Dreiser crossed out a sentence between these two sentences that reads, "From holding her in his lap, fondling her form, stroking her neck and ~~arms~~ waist he had descended to those more subtle delights of the lover her sacred limbs and breasts."

154.13 **gladly, joyously** On the holograph, the phrase "whenever he wished" has been penciled out immediately after this phrase; it is impossible to determine if by Dreiser or by another hand. TSA retains the change, and so it is adopted here.

156.35 **well enough. [¶] Just before** through **"Now when you see me"** On the holograph, Dreiser crossed out a scene here. What remains is the beginning of the scene on holograph page 24 and its ending on holograph page 25. The fragmentary scene follows:

> "well enough.
>
> "There was one scene between him and Christina which rather rounded out his experiences here and brought them to a close. Despite

their very complete intimacy he had never seen her form in its totality except once when they were in bathing in the big swimming pool at the hotel. When she appeared in a chic bathing

"Just before he left to return to New York she said to him [new holograph page] He kissed her madly, passionately, knelt at her feet, carried her in his arms and finally after satisfying himself for quite the last time let her dress again.

"'Now,' she [illegible word] said as they came out of their trysting place, 'Now when you see me."

Because the number 28 is visible beneath the number 25 on the latter holograph page, the eliminated scene appears to have run for five holograph pages. Dreiser probably added the new transitional phrase, "Just before he left to return to New York she said to him," the final line at the bottom of holograph page 24, after eliminating the scene. The three missing holograph pages have not been discovered.

CHAPTER XXVII

157.23 **he had not thought** Before altering this passage in the holograph, Dreiser originally had written a word (it appears to be "recently") between "had" and "thought." After Dreiser crossed off the word, the passage reads "he had thought." Since the paragraph delineates Eugene's emotional disengagement from Angela, this reading has been adapted from the 1915 edition.

158.28 **not of the newer order of femininity, eager to get out in the world** Before altering this passage in the holograph, Dreiser originally had written, "not your 'new woman' eager to do (a phrase of the time indicative of the tendency then current—to smash the traditions in regard to women's place in the universe) eager to get out [*sic*] in the world."

CHAPTER XXVIII

166.29 **Greeley Square** Before altering this passage in the holograph, Dreiser originally had written, "Herald Square."

169.37 **fires of his sympathies** through **sense of emotion** Before altering this passage in the holograph, Dreiser originally had written, "fires of her nature. She tried to conceal her real feeling—to sham composure and indifference but her eyes spoke. Something roused in him now at her look—the governing lust of his body."

173.14 **How terrible it can be!"** On the holograph Dreiser crossed out a paragraph after this sentence that reads, "And Eugene in his room was drowsily speculating on what he should do now. What would Miriam think if he married Angela? And Norma? And as for Christina—would he not live to regret this? She might come back and want to marry him. Why in the name of the devil hadn't she taken him in the first place?"

CHAPTER XXIX

175.16 **should not yield. [¶] The Blue family** Dreiser crossed out from the holograph a paragraph between these two sentences that reads, "Angela, after her first trespass and because of fear would have desisted, but Eugene was insatiable. He had found her body, in its shapeliness, lovelier than he had anticipated. Her ~~legs~~ limbs were trim and beautifully rounded. Her ankles small. Her torso, waist, hips, a model for a sculptor. Her breasts were dainty cups of ivory. He found her unconsciously passionate, yielding in a delirium of affection—fearsome but eager withal. It roused him to persistence and excess, putting a strain on his nervous strength which was not easy to bear. His eyes and complexion quickly attested a weariness which affected to every muscle of his body."

175.41 **Already she was beginning to worry over the future. [¶] It so transpired** Before altering this passage in the holograph, Dreiser originally had written: "Already she was beginning to complain of peculiar sensations which might mean—probably did mean—pregnancy. He did not know that owing to a peculiar deformity of her womb it was not possible for her to have a child. He had not in this period of excitement set himself to protect her as he had Christine. He had tried to but he could not be sure."

176.5 **Her usual plan was to stay at her aunt's and she was going there now. [¶] On the way she asked over and over what he would think of her in the future** Before altering this passage in the holograph, Dreiser originally had written: "Her usual plan was to stay at her aunt's and she was going there now but Eugene proposed that she go to a hotel with him, during the afternoons at least long enough seeing how easy it was for him to register her as his wife in the first place. For he wished her to spend some time with him, in utter freedom, free beyond from [sic] possible espionage. She could come then, ostensibly to shop mornings or afternoons or both and spend the time with him. It was a Because of her love for It [sic] was a very simple arrangement and led to a number of hours of utmost joy for him. Because of her love for him and the fact that her fate was in his hands she Angela [sic] consented. She asked over and over what he would think of her in the future."

176.12 **feeling for him. [¶] Once she said** On the holograph Dreiser crossed out a paragraph appearing between these two sentences that reads: "Three days, they were three all told, were a continuation of that bliss which had begun for him in Black Wood. Because of the thought that the worst so far as conduct was concerned had been reached between them there was utter freedom now. For fear of discovery they remained in their room most of the time and here it was that all the depths of passion and gratification were sounded. Now he would stroll out into the city, feeling in advance the loneliness of the days when he would be without her. For this close communion of the flesh had superinduced a condition of mind once more in which he believed that he loved her. Her feeling now for him was so intense that it conveyed a part of itself to his own point of view. Such love as hers was worthy of a great reward, he thought. It would not be possible for him to leave her after this. He would have to return to New York and see about renting a studio for two."

176.41 **only alternative. [¶] One evening** On the holograph Dreiser crossed out a passage appearing between these two sentences that reads: "At the end of three

days it was necessary for her to return. She had not looked as thoroughly in the shops for the things she had wanted as she should but she had pretended to do so. It was taking her longer to find the things she was looking for she told her aunt. On two evenings, seeing that she had to remain at her aunts house Eugene called."

CHAPTER XXX

179.3 **that she was sure there was something wrong with her** On the holograph Dreiser crossed out this phrase and placed a dash above it, apparently intending to add an alternate explanation later, but he never did. TSA retains the phrase, and so it is adopted here.

179.4 **sincere enough, but based** Before altering this passage in the holograph, Dreiser originally had written, "sincere enough for the first six weeks, for delayed menstruation and curious sensations of change were alike based."

179.7 **to know. His lack** Before altering this passage in the holograph, Dreiser originally had written, "to know that a remedy for the first stages of pregnancy was not only possible but in use. His lack."

179.9 **that he would marry her** Before altering this passage in the holograph, Dreiser originally had written, "that she should be absolutely sure in which case he would marry her."

182.31 **Fortuny, Van Hooge, Fragonard, Watteau, and Ruisdael, Mesdag, Mancini came** In the holograph Dreiser left a long space between "Fortuny" and "came." "Van Hooge, Frogonard [sic], Watteau and Ruysdael" was added in another hand that has not been identified. Dreiser added the names "Mesdag, Mancini."

CHAPTER XXXII

197.41 **Then after a time they blew out the candles and retired for the night** Before altering this passage in the holograph, Dreiser originally had ended the chapter with these words: "Then after a sudden there came an upwelling of that feeling which is animal desire based upon superfluity and content. Their faces flushed and he began to undo the buttons of her traveling dress at the back. In a few moments they were once more in possession of each other enjoying that relationship for which in their transports then they insisted the world was made. Silly dreamers; victims of an illusion; as far from the substance of true content as darkness is from light and heat from eternal cold."

CHAPTER XXXIII

206.4 **or could it ever be remedied?** On the holograph Dreiser crossed out a paragraph after this sentence that reads: "He went to bed nursing that solemn thought. He took Angela in his arms without losing it. It was the fly in this pretty scented jar of ointment. He had made a mistake and now it could never readily be corrected—probably never."

CHAPTER XXXV

218.10 **The artist has** Before altering this passage in the holograph, Dreiser originally had written, "The author has."

CHAPTER XXXVI

223.13 **polished man, artistically superb** In the holograph an illegible word follows "man." The space was left blank in TSA; this reading is adapted from the 1915 edition.

CHAPTER XXXVII

226.4 **It was some little time before** On the holograph, Dreiser crossed out a sentence before this one that reads, "The triumph which this probable exhibit promised, though it was still nebulous and uncertain, was sufficient to exalt Eugene mentally to a great height, to keep him almost trembling with a sense of pleasure for days and weeks and months."

230.17 **I will loan you frames** In the holograph the word "loan" has been flagged and a penciled notation written on the page: "This is a noun D.V. [Decima Vivian]." TSA runs the verb as "loan," and *Webster's* approves the usage, so it has been retained.

CHAPTER XXXVIII

231.36 **but not many have the power** In the holograph, two illegible words fall between "not" and "the power." TSA runs the passage as "but love the power"; the 1915 edition picks it up as "but lack the power."

233.37 **to have seen several of the city's most distinguished social leaders looking** Before altering this passage in the holograph, Dreiser originally had written, "to have seen Mrs. John Jacob Astor, Mrs. A. P. Belmont, Mrs. Stuyvesant Fish looking."

CHAPTER XXXIX

238.27 **"The ruck of living,"** In the holograph, an illegible word follows "The." This reading is adapted from TSA.

240.5 **the Montmartre district** Before altering this passage in the holograph, Dreiser originally had written "the Latin Quarter."

240.18 **Hotel Métropole was a comfortable** In the holograph, Dreiser wrote, "hotel Metropole in the was," leaving a blank between "the" and "was," apparently intending to fill in a location later. The blanks were retained in TSA and in the 1915 edition.

 third floor of a house which In the holograph, Dreiser wrote, "third floor of a house in the Rue which," leaving a blank between "Rue" and "which," apparently intending to later fill in a location. The blanks were retained in TSA. This reading is adapted from the 1915 edition.

CHAPTER XL

242.1 **Unfortunately Angela** Five paragraphs that appear in the holograph are cut from this edition because the writing is confused and the ideas contradictory. However, they provide an important reflection of Dreiser's concerns at the time, and so are reproduced in their entirety in Appendix 2. These paragraphs were marked for removal in Revised TS, and do not appear in 1915.

248.10 **Too conventional. He wasn't going to** On the holograph Dreiser crossed out a section between these two sentences that reads: "Dear heaven, how little she knew of art life. How little of the artistic temperament. Why, if Norma Whitmore could hear this she would laugh. And yet he had to endure this. He had to adjust his actions and his attitude to this point of view from now on. He was married. He had taken her for better or worse. He had to keep his word. Why? God damn it! Such an attitude was silly. Still he was"

CHAPTER XLI

249.19 XLI: Dreiser stops numbering holograph pages with this chapter.

256.38 **Now, aren't you** In the holograph, a page ends with this phrase. The next ten holograph pages are clipped together with a small piece of paper on which is penciled in, in Dreiser's hand, "This might be cut." All of this material is retained in TSA, and so it is retained here.

CHAPTER XLIII

268.16 **"Dear Eugene," through "Ruby."** Ruby's letter has been edited to make it correspond with the first time it was quoted, Chapter XVII, 97.

275.15 **in a complimentary way** In the holograph, this phrase is only partially legible. This reading is adopted from TSA.

279.26 **take him on probation** On the holograph Dreiser crossed out the following at the end of the chapter:

> This shifty world, she thought. This traitorous matter of love. If only Eugene were morally impeccable. If only her love meant all to him. How was she to accomplish that? How? And how was she ever to be really happy again?
>
> How indeed?
>
> As for Eugene, he was wondering whether he was going to endure this forever. Couldn't she be made to change? Dear heaven, this was terrible. He couldn't stand it. He really couldn't. It would kill him. He wanted to get well.
>
> He brooded over it for days and then he decided that he made a mess of his whole life. His marriage was a failure. He wasn't happy. That's what he had received for being sympathetic—just that—unhappiness—nothing more.

CHAPTER XLVII

304.26　**no cause for criticism. [¶] There were no further grounds**　On the holograph Dreiser crossed out the following that appeared between these two sentences: "In the essential things she was a model wife. If it had not been for Eugene's abstract love of beauty, his restless, wandering, untiring type of mind, his craze for novelty and change he could have been comfortable and happy with her. He thought of this many times himself."

CHAPTER XLVIII

306.19　**Chapter XLVIII**　In the holograph, attached to the first page of the chapter, there is a typed note on a small piece of paper from Dreiser's typist that reads: "Memo for Mr. Dreiser[:] Judging by the notation at the beginning of this chapter, I take it that the parts queried, marked 'out', or simply lined out are to be cut. I trust I have done right in omitting them. [Signed] E.H.W. [Edna H. Westervelt]." The notation to which she refers appears, in Dreiser's hand, penciled at the top of the first holograph page of the chapter: "This + the next chapter appear too much. One could be dispensed with." That Dreiser considered not only general cuts here but also specific passages for deletion is confirmed by a number of passages marked in pencil for deletion throughout the chapter; but as the typist's note suggests, it is impossible to know his intentions on some of the marked passages. While his intent concerning text marked "out" seems clear, other passages are marked with a "?" and still others simply are bracketed by a long line penciled in at the left margin. Because Dreiser clearly intended for cuts to be made, because most of the marked passages repeat material amply covered elsewhere in the novel (and often covered elsewhere within the chapter), and in the interest of consistency, all the marked passages in this chapter have been deleted from this edition. None of the deleted passages appear in the typescripts or in the 1915 edition. These cuts comprise approximately 1,150 words; because of their bulk and largely repetitive content, the deletions have been silently accepted and are not reproduced in textual notes.

CHAPTER LIII

347.33　**to her again.**　On the holograph Dreiser crossed out the following at the end of the chapter: "There was union that night for them for after an hour [*sic*], and when she had left him for a few moments, she came silently to his room."

CHAPTER LIV

349.14　**were in her private room**　Before altering this passage in the holograph, Dreiser originally had written "were enjoying themselves in her private room."

CHAPTER LVII

375.15 **Hastily and by intuition** through **At the same** Before altering this passage in the holograph, Dreiser originally had written, "She looked at the sleeve ends where were little spots, then at the lining, then at the vest. It had a spot at the third button. She decided to get the gasoline and take it out then and there. Down came the coat and vest. At the same."

375.20 **she asked, all her suspicious nature on the qui vive for additional proof** Before altering this passage in the holograph, Dreiser originally had written, "she asked, curiously, wondering what it was"

CHAPTER LIX

282.39 **other voice. Eugene saw it** In the holograph, Dreiser originally had written "other voice. And Matt would pay no attention to that. Eugene saw it." The sentence beginning "And Matt" has been lightly penciled out. A penciled note on the left margin from Decima Vivian reads, "It looks as though you might have wanted this to come out. I couldn't tell—D.V." The sentence has been left out of TSA, and that emendation has been adopted here.

383.18 **overwrought sentimentalist. [¶] That night he went home to Angela** The holograph reads "overwrought sentimentalist. for assistance that had ever come to him [*sic*]. He was delighted to be able to help. That night he went home that night to Angela." Decima Vivian has flagged the phrase "for assistance that had ever come to him. He was delighted to be able to help" and penciled in, "I don't see where this comes in so have left it out." The passage has been left out of TSA, and that emendation has been retained here.

CHAPTER LX

390.32 **Her mind was fixed on the same thing his was—** through **Both had their advantages** Before altering this passage in the holograph, Dreiser originally had written, "Her mind was fixed on the same thing his was—or rather its correlative. He was in love with beauty. She was in love with love. And an over-mastering vein of self gratification ran through both."

391.1 **herself to ridicule. Also Angela's** between these sentences, a passage in the holograph reads, "She demanded to know of him point blank, time and again, but he refused to tell her. She charged him with continuing the relationship and he denied it strenuously but only as to particular days. He never admitted having been with her again. He was all muddled as to what the outcome would be and so was Carlotta." In the holograph, the passage is marked "out" in pencil, in what may be Dreiser's hand. The passage has been left out of TSA, and so that emendation has been retained here.

CHAPTER LXI

398.34 **One day Eugene** through **to see him.** Before altering this passage in the holograph, Dreiser originally had written, "There were six months of this drifting journalistic work in which, as in his railroad work he grew more and

more restless and there came a [words missing in holograph] he was doing very bad. [¶] One of the things that brought about a change was the meeting in Madison Avenue one day of Hudson Dula. Eugene was down town to get himself a new pair of shoes which he needed very badly."

398.40 **Hahn's** Before altering this passage in the holograph, Dreiser originally had written, "the Holland House."

402.35 **but she felt that he needed her to help him. Poor Eugene—if he only were not cursed with this weakness. Perhaps he would overcome it? So she mused** In the holograph, Dreiser originally had written, "but she could not better her condition and she could help him. Poor Eugene—if he only were not cursed with this weakness. So she mused." TSA retains the change, and so it is adopted here.

CHAPTER LXIV

416.31 **All day with the Wickham *Union*** In the margins of the Revised TS, in response to British editor Frederic Chapman's comment that this "idiom . . . hardly explains itself," Floyd Dell responded, "'All day' was succeeded in US by 'good night!'—meaning done for, dismissed."

CHAPTER LXVII

431.21 **dark clouds. [¶] For another thing,** On the holograph Dreiser crossed out the following paragraph that appeared between these two paragraphs: "The state of the Witla household had by this time considerably improved though they still were living in the little apartment they had taken in Port Morris for the simple reason that Angela wanted to save money. She was opposed or had been to their increasing their [words missing in holograph] be detailed later he was beginning to think that artists were mere nincompoops but he was not absolutely convinced of it as yet. His experiences with M. Charles and his exhibits in New York and Paris had left too deep an impress to make him change utterly but still he was beginning to waver."

CHAPTER LXIX

447.34 **Kalvin, as** through **charitable and sympathetic** Before altering this paragraph in the holograph, Dreiser originally had written, "Mr. Kalvin, as had Mr. Summerfield, liked his appearance. The latter had been most chagrinned at losing Eugene so suddenly but he was too much of a self-opinionated and vainglorious individualist to permit himself one pang on that score. Eugene might go. There were plenty of other men just as good. He would find them. He said to himself he was a little tired of Eugene anyhow and so they parted with hypocritical smiles on both sides, Eugene glad that he had been able to avoid the possible discharge that might eventually have [words missing in holograph]." Dreiser presumably deleted the passage to eliminate the idea that Summerfield had a soft spot for Eugene, thus maintaining the character of Summerfield as consistently "vainglorious."

450.3 **quite down. But as he** Before altering this passage in the holograph, Dreiser

originally had written, "quite down—and he felt that he could bring himself to walk in the straight and narrow path of moral rectitude if he tried. He was trying. But as he." This deleted passage reinforces the authority of conventional morality to Eugene, a tendency far more prevalent in the 1911 than the 1915 version of the novel.

CHAPTER LXXIII

480.28 **those he fancied. Vanity was** Before altering this passage in the holograph, Dreiser originally had written, "those he fancied. [words missing in holograph] even then Summerfield for he talked less and acted more. He had already done a number of ruthless things in his life time from throwing down dependent girls whom he lured into affectional relationships to ordering lockouts in mills in which he held a controlling interest. He was as hard as steel, but a smiling appearance and a delightful, whole hearted presence [*sic*]. Vanity was." Before crossing out the entire passage from the holograph, Dreiser wrote in, then crossed out, "but this did not sink into Eugene's consciousness sufficiently to worry him any. He fancied he was a strong man able to hold his own anywhere. When difficulties arose, if they did, his fertile imagination would get him out of them."

CHAPTER LXXV

495.19 **worth two whoops** through **axe suspended over him** Before altering this section in the holograph, Dreiser had used more emphatic language to describe Colfax. "two whoops to come" had read "two whoops in hell to come"; "is making a mistake" through "in print)," had read, "is a damn fool and can't do what he thinks he can do. I'm a stinking, God damned bastardly son-of-a-bitch and"; "and at the same time an axe suspended over him" had read, "and Colfax was the Holy Father."

CHAPTER LXXVII

518.40 **in his mind. [¶] "What are you thinking** On the holograph Dreiser crossed out the following that appeared between these two paragraphs: "[¶] And though he jested with her indifferently at leaving, and though he congratulated Mrs. Dale on having such a charming daughter in a far away tone of voice, and though he passed only the most indifferent comment on Suzanne's personality to Angela, she was constantly running in his mind. Those eyes, those lips, that smile, that heavenly youthful girl. [¶] Oh if life would only take him back to youth again. If he could be back in Alexandria as a boy in his father's town starting all over again. If he could only kneel on the ice to Stella Appleton or renew his love to this girl."

CHAPTER LXXXII

547.26 **but being a natural born leader** In the holograph, this phrase has been flagged, and a note penciled in above it: "I think you contradicted this D. V.

[Decima Vivian]." On the left margin, the note continues in the same hand, "Ref. from Chap. 81." While Dreiser's typist has a point about the contradiction, the passage remains in TSA and later versions, and so has been allowed to stand here. Dreiser's intent seems to be that while Eugene's charismatic personality makes him a "natural born leader," he lacks the ability to follow through.

550.31 **Rossetti gallery** In a note in the margin of the Revised TS, Frederic Chapman writes, "'The Rossetti gallery' is a purely figurative expression. There is not and never has been such a *place* or such a private collection that could be so styled" (DPUP, Box 164, Folder 8000). Dreiser then penciled in the margin, "Dell—make this point in another way," and Floyd Dell changed the passage to read, "Have you ever seen the Rossetti woman?" Dreiser's original wording in the holograph has been allowed to stand here, because Eugene's point is not about any particular gallery but rather the existence of the paintings in London. At the time Dreiser composed *The Genius*, he had not yet traveled to Europe. In an 1898 article, Dreiser mentions a Rossetti room in the Royal Academy of London ("Benjamin Eggleston, Painter," reprinted in *Selected Magazine Articles* 219).

CHAPTER LXXXIII

554.34 **poetic spirit. In the realm** On the holograph Dreiser crossed out a sentence between these two sentences that provides insight into what makes men attractive to Suzanne: "She like[d] their appearance in many cases but not their mental attitude."

CHAPTER LXXXVI

581.2 **this coming child's. [¶] "Oh, Eugene,"** On the holograph Dreiser crossed out in pencil, at the end of the former sentence, "his own innately evil disposition betraying him in the end."

CHAPTER LXXXVII

593.38 **"You've been spoiled. You're a bad boy. Mamá says that"** Before altering this section in the holograph, Dreiser wrote, "'You've been spoiled like a bad boy by Mrs. Witla. Mama says that.'"

CHAPTER XCI

630.18 **"Yes," she replied. through "Be reasonable. Remember your own sensations—"** Before altering this section in the holograph, Dreiser originally had written,

> "Yes," smiled Mrs. Dale.
> "And would like to be again no doubt?"
> "Oh, doctor! In this situation how can you?"
> "I can because life can. But what I was going to say. Remember your own sensations—"

CHAPTER XCV

654.12 **could consider the situation and signal Suzanne** In the holograph an illegible word follows "could" and "situation." This reading is adapted from TSA.

CHAPTER XCIX

696.32 **"at this home here and see how things are, and what binding influences children are** In the holograph, another hand, possibly Decima Vivian's, has penciled in corrections so the phrase would read "at homes where there are children and see what binding influences they are." TSA runs the passage as "at homes where there are children and see how things are, and what binding influences they are."

CHAPTER CI

708.1 **George M. Gould** Because Dreiser splices together several quotations from Gould's *The Infinite Presence* (New York: Moffat, Yard and Company, 1910), 60–63, quotation marks have been added to indicate Dreiser's use of the source. The word "organic" has also been changed to "inorganic," as it appears in the original.

709.6 **reflection in regard to the universe and its government by Alfred Russel Wallace which interested him** Before altering this passage in the holograph, Dreiser originally had written "reflection on space, quoted from Spencer which interested him greatly regard [*sic*] to the universe."

CHAPTER CIV

737.26 **seize on him.** On the holograph Dreiser crossed out the following that appeared at the end of this sentence: "It was useless for him to contend at times that there was no evil. He felt its power—its lure as much as he tried to overcome it."

745.6 **Curiously, in spite of their strange** through **peculiar ramifications—** Before altering this passage in the holograph, Dreiser originally had written, "It had often occurred to him that because of his age + her youth she would prove unfaithful but it was not so. Temperamentally they were much alike—rather happy-go-lucky and devil-may-care. There was a temperamental pull—each for the other. 'Oh you [words missing in holograph].'"

745.25 **Spencer's *Facts and Comments*** Dreiser quotes here from *Facts and Comments*, a collection of essays by Herbert Spencer (D. Appleton and Company, 1902), not *First Principles*, as he wrote in the holograph. The quotation appears at the end of the volume, in a chapter called "Ultimate Questions." Punctuation, spelling, and paragraphing have been changed here to conform to the original.

746.11 **I think it is full of kindly wisdom," and he closed the book.** through **"Yes, I'm coming, sweet."** Before altering this passage in the holograph, Dreiser originally ended the chapter several lines earlier. On the penultimate holograph page for this chapter (holograph page 48 of 49), "The End" has been

crossed off in pencil at the bottom of the page. Another sentence on this page has also been crossed off. Dreiser's original ending for the chapter appears to have been: "'I know what space is full of,'" and he closed the book. [¶] And so he arose and went to bed. [¶] The End."

746.16 **"There is a ruling power," he said. "It rules all—"** Before altering this passage in the holograph, Dreiser originally had written, "'There is a ruling God,' he said. 'He rules all—'"

Textual Apparatus

SELECTED EMENDATIONS

Each entry begins with a page-line reference to the location of the reading in this edition. The first reading in the entry is that which has been revised or emended by Dreiser or the editor, and which is printed in the text of this edition. There follows a bracket, which can be read "emended from." The second reading is that which has been rejected from the holograph copytext, and any errors have been retained. This reading is followed by a siglum that identifies its source. The following sigla are used: [1915], when emended from the first edition; [TSA], when emended from Typescript A; [cve], when supplied by the volume editor. The 1915 edition was accepted by Dreiser. Typescript A was also produced under his authority and contains revisions in his hand.

Entries preceded by an asterisk also have a textual and/or historical note for the item.

CHAPTER I

5.2 Alexandria, Illinois, between] Alexandria, between [1915]
5.33 with the general agency in that county of one of the best known and best selling sewing machines made.] with the control of sale or general agency of one the of the best known and best selling sewing machine completely in his charge for that county. and Mrs. Miriam Witla was a good wife to him. [1915]
6.29 Chicago. She had gone to Springfield as a very young girl, to see Lincoln buried, and once] Chicago, once as very young girl to see Lincoln buried at the former place and once [1915]
7.5 brown like her eyes; her face white as her hands.] brown and her eyes; her face white and her hands. [cve]
7.10 by two years.] by two years and like them dark. [1915]
7.15 Because he believed he had a weak stomach and a semi-anaemic condition, he did not appear as strong as he really was, though] Because of a belief in a weak stomach and a semi-anaemic condition of his blood he did not appear really as strong as he was, though [cve]

CHAPTER II

10.37 with one flat bed press and three job and printing presses] with the one 5000 per hour flat bed press and the three hand and foot job + printing presses [cve]
13.2 Eugene, because of his innate] Eugene, because of his seriousness and because of his innate [1915]
13.28 and in a game of "post-office" had enjoyed the wonder of a girl's arms around him in a dark room and of a girl's lips] and in a kissing game had enjoyed

the wonder of a girls arms around him in a dark room—(the game was "Post Office") and of a girls lips [1915]

14.40 but inexperience hindered her] but newness barred her [1915]

CHAPTER III

20.5 passing as it was—except] passing as it was (for unfortunately it did not endure) except [cve]

21.12 as ready for love as he had thought] as much for love as he thought [1915]

CHAPTER IV

26.8 deal. Eugene saw her walk with him now and then, saw her go skating] deal. She was seen to walk with him now and then by Eugene, to go skating [1915]

26.24 elite, on Wednesdays] elite near the court house on Wednesdays [1915]

26.34 was much older; only in the matter of years was he younger.] was years older. In the matter of time he was younger. [cve]

26.36 hurt him. [¶] Another] hurt him—principally because he did not correlate them—each in its proper attitude towards the other. [¶] Another [1915]

CHAPTER V

32.28 seemed as though he could do something here.] seemed as though something could be done here. [cve]

33.13 The door was] It was [1915]

CHAPTER VI

35.1 varied. He had walked] varied. His first place was as a clerk in a hardware store and that too in his own neighborhood (that of his room) after he had walked [cve]

35.42 bakery, in a candy store, in a dry-goods store.] bakery, a clerk in a candy store, a clerk in a dry-goods store. [1915]

39.3 and was anything but an uplifting influence on him. [¶] This] who was anything but an uplifting on him. This [cve]

39.36 the western world, and] the world and the west and [1915]
trifling with could not hold him. Of] trifling with was temporary. Of [1915]

40.13 you're ready you can have them. I'm willing."] your ready I'm willing. You can have them." [1915]

CHAPTER VII

41.21 study. After his quarrel with Margaret, he did not feel that his place with the laundry was quite as tenable. She was satisfied that he was slipping away. He knew the time would come when he would see her no more. [¶] The end finally] study. He did not feel—(After his quarrel with Margaret) that this place was quite as tenable, though their actual relationship did not cease until

sometime after he had left there. She was satisfied that he was slipping away from—was not dissatisfied that it should be so—he knew that he was going to reach the time when he would see her no more. It finally [cve]

42.25 notice.] notice and then leave, unless they wished it otherwise. [1915]

43.7 knew being] knew of more than really knew being [1915]

CHAPTER VIII

44.10 Eugene had] It was after Eugene had [1915]

44.35 like. In the basement were a number of rooms for the classes] like and, in the basement a number of class rooms for the accommodation of the classes [cve]

45.11 girl to get out] girl to do this thing—to get out [1915]

47.33 different world that he was entering now.] different world toward which he was drawing now. [cve]

48.27 the moving] the presence of a moving [1915]

CHAPTER IX

50.22 the unpaid bills certified.] the latter certified. [1915]

50.34 wished, and go] wished he might better go [1915]

54.23 called, and the three of them] called and with him and Myrtle Eugene [1915]

55.8 flounces at the] flounces which characterized the [1915]

55.27 it?" she cried. "At home I do wear white mostly. You see] it? I do mostly", she cried, "at home. It's the easiest thing to make. You see [1915]

56.2 "That's what happens to all of them.] "Thats the way they all do. [cve]

56.24 not, and Eugene gleaned from stray remarks that] not, for he gained from scraps that [1915]

CHAPTER X

57.7 to be. He] to be,—for he [1915]

57.15 knowing that it is so.] knowing or at worst admitting to itself that it is so. [cve]

57.20 at least many, of] at worst many of [1915]

57.30 meet; but] meet—just what this was, but [1915]

57.33 But it seemed now] But as I say, she deemed at times [1915]

57.33 were destined never] were over or never destined [1915]

58.7 emotions were not aroused by the same things as his.] emotion was not based on the same things his was. [cve]

58.21 these two were destined not to like the same people, except up to a certain point. After that, their paths, or to be exact their tastes in character, diverged.] these two people were destined not really to like the same people, in the same way or for the same reasons except up to a certain point or standard. Afterward their paths or to be exact their character tastes diverged. [cve]

58.30 black.] black, green. [1915]

60.13 instinct to do] instinct and her sense to do [1915]

60.39 was apparently not as passionate temperamentally as] was not passionate
 temperamentally (apparently only) as [1915]
61.14 wild firebrands like] wild peices of fire like [cve]
61.15 indifferent beauties like] indifferent peices of beauty like [1915]

CHAPTER XI

62.3 now, or thought] now—and quickly—or thought [1915]
62.9 south, from Chicago and St. Louis,] south and from Chicago St. Louis
 [1915]
62.18 millionaire. Facts of this kind appealed to Eugene, and he felt they gave the
 Art Institute an edge.] millionaire. These facts gave a sort of edge to the place
 to Eugene at least for facts of this kind appealed to his mind. [cve]
65.16 them hardly more than cost] them almost cost [1915]
65.20 treats.] treats which regularly preceded and followed it. [1915]
66.5 models said] models—the class did not always use the same model—said
 [1915]
66.33 which was very becoming to him.] which became him excellently. [cve]
66.34 and enviously mimicked the] and envied though he did not mock except in
 spirit, the [cve]
66.36 sort of god] sort of God [1915]

CHAPTER XII

68.4 four years.] four years and raised her. [1915]
*68.7 lead. She began life as a cash girl in The Fair and was spoiled of her virtue at
 fifteen. By reason of some defect of body she had escaped] lead. Spoiled of her
 virtue at fifteen—she began life as a cash girl in The Fair—she had by reason
 of some defect of organism escaped [cve]
68.10 also, because she attracted the rather superior, capable, self-protecting type
 of individual who is not afflicted with the horrors of sex contagion, she had
 also escaped disease. Ruby was] also disease had escaped her for her smartness
 attracted the rather superior, capable, self-protecting type of individual who
 is not afflicted with the horrors of sex contagion. Also she was [cve]
69.3 open spaces between] open spaces that existed between [1915]
69.5 masses, and speculated] masses to get here and had speculated [1915]
70.9 neighborhood. [¶] Ruby watched] neighborhood. [¶] Miss Kenny watched
 [1915]
72.1 him in the studio, looking] him, looking [1915]
72.9 customary in the men she knew.] customary. [1915]

CHAPTER XIII

73.28 better than anyone he had ever known.] better than he had ever heard any-
 one play whom he had known. [1915]
75.16 to endure and] to stick and [1915]
75.29 her. The very] her. There was that in the very [1915]
75.35 affection, for] affection that had not so much to do with sex for [1915]

76.24 clog dance,] clog, [1915]
76.39 dollars each way but] dollars for each direction but [1915]
78.6 much sought after.] much talked to. [1915]

CHAPTER XIV

80.12 one of whom posed] one of whom acted or posed [1915]
80.28 friends with] friends, partially with [1915]
81.33 things to draw, but these scenes stood] things but these stood [cve]
82.24 gave everything he wrote stability.] gave all his stuff stability. [1915]

CHAPTER XV

85.3 cheeks were rosy with the elation of the hour;] cheeks with the elation of the
 hour were rosy; [1915]
86.18 now living together] now doing together [1915]
87.19 candle under a red shade on a small table by her bed and] candle by her bed
 on a small table under a red shade and [1915]
88.8 the point where] the place where [1915]

CHAPTER XVI

90.10 this idea of New York was] this thought was [1915]
90.20 have Eugene off the paper but resentful of] have him off the paper but regret-
 ful of [cve]
90.33 art, but] art drawing but [1915]
90.34 Mathews.] Mathews intelligently who knew that Eugene could not mean it.
 [1915]
91.4 so easy.] so easy for his mind. [1915]
91.4 case he felt sympathy,] case it was sympathy, [cve]
91.10 since her return to tell him that she] since her promise to return and tell him
 whether she [1915]
92.9 and had never come back.] and never came back. [1915]
93.40 and sleeping towns succeeding one another.] and towns succeeding one the
 other, sleeping. [1915]
94.31 gulls, grasped in an emotional way the meaning of this great mass] gulls, real-
 ized emotionally the mass [cve]

CHAPTER XVII

97.39 introspective at] instropective or even calmly so at [1915]
98.10 spellbound. He would have run after them anywhere unless given] spell bound.
 The one meant the other to him outside of natural beauty. He would have
 run after it any where unless told to run, given [cve]
98.27 all. From the praise he had received] all. He was slowly, from the praise had
 received [1915]
98.35 the illustration world.] the illustrative world. [1915]

CHAPTER XVIII

99.22 unity.] unity—either collectively or separately taken. [1915]
103.6 the Institute—] the art students league—[1915]
103.16 yet had dealings with.] yet arranged with. [1915]
105.7 seen that looked anywhere close to what the slimness of his purse could accom-
 modate.] seen which looked anywhere near the slimness of his purse. [cve]

CHAPTER XIX

105.17 and later the appearance of the picture in] and its much more (in point of
 time) removed reproduction in [1915]
105.18 career had achieved a substantial foundation.] career had reached a substan-
 tial basis. [cve]
105.33 make anyone's opportunity for immediate distinction easy.] make any ones
 opourtunity for rapid advance into distinction common. [1915]
106.37 drawings, his street scenes, were hung here and there.] drawings, hung here
 and there, spoke volumes for life—his street scenes. [1915]
107.13 color and life.] color and go. [1915]
107.39 Little towns with white, yellow, and blue lumber cottages, nestling] Little lum-
 ber built towns with cottages of white and yellow and blue nestling [cve]
109.4 His heart sang] His brain sang [1915]
109.8 buzzard. [¶] As he rode, the] buzzard. [¶] He rode and as he did so and the
 [1915]
110.28 earnings spent to bring up the first three children to healthy adolescence.]
 earnings used to bring the first three children through to a healthy boy and
 girlhood. [cve]
113.14 worthwhile. Also what to her were his wonderful] worth while. Then his, to
 her, wonderful [1915]
113.38 extreme and most supreme of human emotions—] extreme and supreme of
 human emotions on earth— [cve]

CHAPTER XX

116.1 raised eight children.] raised eleven children. [1915]
118.40 be extraordinary because] be super-normal because [cve]
119.15 fairly made Eugene's soul ache.] fairly ached Eugene in his soul. [1915]
120.30 movement possible.] movement important or possible. [1915]
121.24 they had been a little] they were a little [1915]

CHAPTER XXI

123.18 groaned soulfully.] groaned in her soul. [cve]
126.12 farewell, moreover, to] farewell though in addition to [1915]

CHAPTER XXII

128.36 year, had gone] year when Eugene could not go home had gone [1915]
131.3 was a striking simplicity] was an artistic simplicity [1915]
131.38 Stella and Margaret and Ruby and even Angela had—] Stella Appleton and Margaret Duff and Ruby Winchell and even Angela Blue had—[1915]
*132.13 Richard Jefferies's *Story of My Heart,*] Richard Jeffreys "Heart" [cve]
132.34 present, made no objection to being neglected.] present seemed easily to be neglected. [1915]
132.35 He wanted her to admire] He helped her admire [1915]

CHAPTER XXIII

136.11 conclusions, what might be called her emotional] conclusions, her—what might be called—emotional [1915]
*136.27 and Ford Madox Brown.] and Maddox Ford. [1915]
138.7 characterized Miss Finch's studio] characterized the formers studio [1915]
138.19 in a New York opera.] in New York. [1915]
139.4 which evoked the] which brought back the [cve]

CHAPTER XXIV

142.12 to affluence.] to financial affluence. [1915]
143.11 the world of the newly rich middle class who] the world of middle class new rich who [cve]

CHAPTER XXV

147.12 In another way Christina] On the other hand Christina [1915]
*149.30 *The Rubáiyát of Omar Khayyám* was] The Rubaiyat of Omar was [cve]

CHAPTER XXVI

152.39 moonlight.] moonlight or no light. [1915]
157.5 she said.] she pleased. [1915]
157.12 all that he would with her.] all that would. [cve]

CHAPTER XXVII

158.15 the artifices of the dressmaker] the substitutes of the dress maker [1915]
159.28 Oren Benedict and Judson] Oren Root + Judson [cve]
162.14 the age of courtship, she] the philandering age she [1915]
162.19 not abandon herself to] not feel an abandon to [cve]
165.13 which she lived.] which he lived. [1915]
165.22 but not necessarily lovers nor eventually] but necessarily lovers or eventually [1915]

CHAPTER XXVIII

166.12 His interest] And by the way, in passing his interest [1915]
168.8 she replied.] she replied, referring to the suggestion of meeting him at Black Wood. [1915]
170.17 Angela's house, and which the Blues were wont to call home.] Angelas home and from which place the Blues were wont to say they were. [cve]

CHAPTER XXIX

176.9 credit, because of the] credit, the [cve]
176.29 yellow sandy shores.] yellow sands of shores. [1915]
176.36 not be present at it, they could at least know was taking place.] not participate they would at least be cognizant of. [1915]
177.33 would it be with her if] would be with him and with her if [1915]

CHAPTER XXX

179.3 that she was] that he was [cve]
180.21 ranked with this one for] ranked this for [cve]
182.14 At one time it] At one time or day it [1915]
182.16 On another day,] On another time or day [cve]
183.37 less expressive,] less expressive in extremes, [cve]

CHAPTER XXXI

185.29 "It's a good idea."] "It a good idea. I'll go you." [cve]

CHAPTER XXXII

193.35 intellectual or verbally] intellectual—verbally [cve]
194.8 of his days.] of his life. [1915]
194.19 as generously as] as joyously as [1915]
196.11 parade coincidentally provided] parade accidentally provided [cve]

CHAPTER XXXIII

198.18 It is because we lack the understanding of that peace] It is for the lack of understanding that peace [cve]
198.37 the latter.] the studio apartment and Washington Square. [1915]
199.12 rugged, hence more] rugged, newer more [TSA]
200.16 together (with Eugene] together (Eugene [1915]
204.39 at Black Wood, and Angela joined in.] at Black Bay in which Angela joined. [cve]

CHAPTER XXXIV

209.29 called. Richard] called (Marietta was out at the time) and still another on
which she came to dinner for Richard [1915]

210.7 disappointment.] disappointment or chagrin. [cve]

211.25 commented to herself on] commented intellectually on [1915]

CHAPTER XXXV

215.24 sent the original] sent, as indicated previously, the original [1915]

216.17 Later the National Academy would] Later they would [cve]

216.27 The picture was sent] It was sent [1915]

CHAPTER XXXVI

221.16 if he was going] if he were going [1915]

CHAPTER XXXVII

231.13 twenty-seven or thirty great pictures] twenty seven or twenty great pictures
[1915]

CHAPTER XXXVIII

233.9 can of mixed ashes, paper, and garbage to] can of ashes, paper, and garbage
mixed to [1915]

234.10 brutally. [¶] "Mr. Witla,"] brutally. "Mr. Witla," [1915]

234.14 master of draughtsmanship and] master of draughting and [cve]

CHAPTER XXXIX

238.13 She and Eugene discussed the interesting fact that all Englishmen] She Eugene
and discussed the fact as interesting that all Englishman [1915]

240.4 hear the language and pick] hear French, where he could pick [cve]

241.26 discolor his world, take scope from imagination, and hamper art with nervous
irritation. In the] discolor the aspect of the world for himself, take scope from
imagination, hamper art with nervous irritation, he was now doing. In the
[cve]

CHAPTER XL

243.27 her suspected insufficiency.] her suspected weakness of her own insuffiency.
[cve]

248.1 Disturbed, opposed, and irritated, Eugene listened to this semi-pleading, semi-
chastising harangue.] Eugene listened to this semi-pleading, semi-chastising
harangue with disturbed opposed and irritated ears. [cve]

249.12 a quiet, reserved,] a quite, reserved [TSA]

CHAPTER XLI

250.33 he—or rather she, for him and her—was] he or rather he for him and her was
 [TSA]
253.34 seemed to Angela to be intent on taking him from] seemed to to her to be
 intent on taking her husband from [cve]
255.6 How should he] How she he [TSA]

CHAPTER XLII

261.25 and a sensation as though] and as though [1915]
261.35 laid the brush down] laid it down [1915]
263.28 satyr, he could not have withstood these persistent assaults.] satyr they could
 not have withstood the persistent assaults he made upon them. [cve]
264.2 peculiar nervousness which] peculiar nervous which [1915]
264.18 consulted a practitioner of] consulted one of [1915]
265.12 which Angela had] which Marietta had [1915]
266.16 dollars. However, on] dollars, but on [1915]

CHAPTER XLIII

*268.19 is all right for I suppose it has] is allright I suppose. It has [cve]
272.25 to conceal from Angela the fact that he had been there.] to ignore the fact
 that he had been there to Angela. [1915]
275.18 good looking she was, how] good looking, how [1915]

CHAPTER XLIV

280.14 Since Eugene was morbid anyhow, this thought was doubly irritating to him.
 He] Being morbid anyhow this thought was doubly irritating. He [cve]
281.10 smiled and patted her] smiled and slapped her [1915]
282.19 was to be done, rather] was rather [1915]
282.36 enthusiasm.] enthusiasm not so much for things as for him. [1915]
284.18 dead. Roth lived] dead but who lived [cve]
286.4 Gawaine, Queen Guinevere."] Gawaine, Lady Guinevere [1915]

CHAPTER XLV

293.8 an inimical fate.] an enmitous fate. [1915]

CHAPTER XLVI

294.15 If he lost his treasure by resistance, what] If his treasure was in this and he
 lost it by resistance what [cve]
297.5 contact, her insistence] contact, his insistence [1915]
298.10 could not paint or illustrate anything new in his present state.] could paint
 or illustrate anything new in the state that he was. [1915]
298.38 property. Some women could see the fame, the labor, the mental capacity of

the husband—the former historic lord and master—as chattels] property and
and could see in the fame, the labor, the conditions which surrounded the
mental capacity of the former historic lord + master as chattels [cve]

299.15 controverted the vaguely recalled serfdom] controverted a vague recollection
of the serfdom [cve]

299.21 to the letter.] to the life. [1915]

299.40 her; to pose as being] her; as being [1915]

300.15 air of proprietorship which] air of propriety which [1915]

CHAPTER XLVII

303.34 over whatever seemed to require it.] over what seemed to require it and when.
[1915]

303.38 unaware of the fear] unaware of the sacrifice she was making, the fear
[1915]

CHAPTER XLVIII

307.11 light.] light even by those who may not know that it has burned out. [cve]

CHAPTER XLIX

312.9 pleased. It was the same with Henry] pleased. This was true of Henry
[1915]

313.38 no customers for] no custom for [cve]

CHAPTER L

319.33 would repent of] would repent him of [1915]

325.6 Since he had secured this position, he had taken out of his trunk a dark] Out
of his trunk, since he had secured this position he had taken a dark [cve]

CHAPTER LI

326.21 music. A slim, dapper, rather dandyish type of man with a lean, not thin but
tight-muscled face and a short black mustache, he was a buyer for one of the
large department stores and appeared] music. He was a buyer for one of the
large department stores (a slim, dapper, rather dandyish type of man with a
lean, not thin but tight-muscled face and a short black mustache) and appeared
[1915]

328.3 quite equal to doing it. He] quite able to do it. He [1915]

CHAPTER LII

333.10 higher mind as it was revealed to them.] higher mind to suit themselves and
as it was revealed to them. [cve]

333.31 engineer, with Joseph,] engineer, making friends with Joseph, [1915]

336.40 for one or several of the men in] for one of the men or several in [1915]

CHAPTER LIII

338.28 skills were in] skills and reliance was in [cve]
340.4 world than that in which] world in which [cve]
340.25 When someone suggested that she overdid the tolerance, she replied, "Why
 shouldn't I? I live in such a magnificent] When some one suggested that she
 was exceptionally the former she replied "why shouldn't I be. I live in such
 magnificent [1915]

CHAPTER LIV

353.15 lonely. Her return] lonely. On the other hand her return [1915]

CHAPTER LV

354.26 this ailment and] this lonliness and [1915]
355.10 and convict Carlotta of] and Carlotta was convicted of [1915]

CHAPTER LVI

361.41 only about noon the next morning when Eugene] only until noon the next
 morning before Eugene [1915]
365.17 and seeming injustices of] and injustices (seeming) of [1915]

CHAPTER LVII

370.1 have it acutely. They know] have the latter correctly. They know [cve]
370.6 from him she] from him at this time she [1915]
370.6 that she ought] that he ought [1915]
370.31 be sufficient. Bill] be sufficient and I will insert that one. Bill [cve]

CHAPTER LVIII

376.28 commiseration, and a brutal,] commiseration brutal, [1915]
377.3 Had she not laid] Had she laid [1915]
377.6 gone without friends,] gone with friends, [1915]
377.32 where she was] where he was [1915]
380.15 balcony and] balcony which was there and [cve]

CHAPTER LIX

381.8 the reason for his] the whyness of his [cve]
383.30 nice to Angela in] nice in [cve]
385.30 of bewildered innocence. "What] of nonplussed innocence. "What [1915]
386.25 now, I would kill] now I kill [1915]

CHAPTER LX

388.23 One is almost prepared to believe it when one contemplates the ramifica-
tions of evil, its fertile inventiveness, its seeming inability to turn from its
ways except by the pressure of difficulties which it alone creates.] When one
contemplates the ramifications of evil, its fertile inventiveness, its seeming
inability to turn from its ways except by the pressure of difficulties which it
alone creates one is almost prepared to believe it. [cve]

393.27 which Deegan could] which could [cve]

394.19 with Carlotta, Angela would] with her she would [cve]

CHAPTER LXI

402.7 affectionately as it rested on] affectionately on [1915]

402.25 Gramercy Place.] Gramercy Square. [1915]

CHAPTER LXII

407.8 I wouldn't put] I would put [1915]

CHAPTER LXIII

408.8 Alabama, his] Albama, (<u>here we rest</u> though rest was never connected with
him) his [1915]

410.9 vacancy, the latter] vacancy which really existed, the latter [cve]

410.40 When Eugene] As has been said when Eugene

413.5 Usually the] Usually and basically the [1915]

414.15 some psychological reason,] some psychologic reason [1915]

CHAPTER LXIV

416.18 "You mean," said Summerfield, "you never] "Yes maam", said Summerfield,
genially following up the alliteration. "You never [1915]

418.16 art products were] art department were [1915]

CHAPTER LXV

423.12 this and that man's shoulder, asking] this mans shoulder and that asking
[cve]

CHAPTER LXVI

427.14 was liked by in return; Mrs. Link] was in return liked by, Mrs. Link [cve]

427.17 in a neighboring apartment] in this apartment [1915]

428.26 Before long, because of his advice] Time went on and because of this advice
[1915]

429.29 would be cross at] would quarrel at [1915]

429.32 It appeared to be for her benefit as much as for his that he was working.] It
 was for her benefit as much as his that he appeared to be working. [cve]

CHAPTER LXVII

431.3 heartily together. [¶] Summerfield came bounding into Eugene's room] heart-
 ily together The latter came bounding into his room [cve]

CHAPTER LXVIII

440.5 dollars, Pottle Frères being the] dollars and Pottle Freres were the [1915]
*441.15 Union League in] Union Club in [cve]
443.3 house, where they arrived in time for dinner, and while they were getting
 ready for it, Mr.] house, arriving in time for dinner and while they were get-
 ting ready for the latter Mr. [1915]
445.19 machine to Mr. Fredericks's house—] machine with Mr. Fredericks to the lat-
 ters house [cve]

CHAPTER LXIX

447.17 they had been with the Summerfield Company, and the idea] they were with
 the Summerfield Company and the idea [1915]
447.22 the *Weekly*,] the weekly, [1915]

CHAPTER LXX

453.19 seen the poverty of] seen the pity of [cve]
456.3 Fittingly was he president] Fitly he was president [1915]
457.30 He did nothing desperate but weariness of this enforced conservative exis-
 tence was on him. [¶] "As though] Nevertheless he did nothing desperate
 but weariness of this enforced conservative existence was on him "As though
 [cve]
460.5 western relatives] western home relatives [cve]
460.19 now irrevocably engaged] now fatally engaged [1915]

CHAPTER LXXI

462.17 influential of these—] infuential—[1915]
462.37 rapidly as an executive that] rapidly executively that [cve]
464.12 only semi-articulate.] only semi-inarticulate. [1915]
467.36 the United Magazines] the American Magazines [1915]

CHAPTER LXXII

475.41 wanted Eugene to stay within the bounds of his own] wanted him to stay
 within bounds of his (Eugene's) own [cve]

CHAPTER LXXIII

480.32 Eugene seemed to] Eugene was seeming to [1915]
482.13 bully evolved into] bully evoluted into [1915]

CHAPTER LXXIV

487.19 them wholeheartedly as worthwhile, only as endurable and in some respects even enjoyable.] them whole heartedly as, if not worth while, at least endurable and in some of their many phases enjoyable. [cve]
490.14 forgotten. He was made to feel] forgotten and to feel [cve]

CHAPTER LXXV

495.37 That individual's commercial instincts were different.] That individuals instincts were different commercially. [cve]
497.41 of *Adventure Story Magazine* was] of short story magazine was [1915]

CHAPTER LXXVI

500.11 something which a successful person represents—whatever that may be,] something through those avenues which a successful person represents whatever they may be, [cve]
502.21 when he was] when they or rather he (Colfax) was [1915]
506.13 peace of mind, but] peace, but [1915]

CHAPTER LXXVII

509.38 guest—he] guest with his automobile—he [cve]
512.9 for himself and] for him (Eugene) and [1915]
513.10 at Morristown was] at Morris Park was [1915]
513.32 She was one of] One of [cve]
514.17 literary, studious of character.] literary, character-studious. [cve]
515.8 This intimacy, however, was never of a very definite character. When Mrs. Dale met Angela she liked her quite well as an] It was never of a very definite character though when Mrs. Dale met Angela she liked her well an an [1915]

CHAPTER LXXVIII

519.36 Suzanne to which Eugene] Suzanne that Eugene [cve]
520.1 differences, she] differences between them she [1915]

CHAPTER LXXIX

528.2 severe rheumatic attack, completely] severe attack of the former completely [1915]
532.15 onto the veranda.] onto this. [1915]

CHAPTER LXXX

534.35 While it] On the other hand while it [cve]
538.26 city where the lots should sell at] city which should sell lots at [1915]

CHAPTER LXXXI

545.22 Construction Company, which] Construction which [1915]

CHAPTER LXXXII

548.7 like to think that any one man] like think that anyone man [1915]
549.21 swing at Dalewood.] swing at Huguenot. [cve]

CHAPTER LXXXIII

553.33 in life. [¶] Had she] in life. Had she [1915]
554.12 and beliefs.] and beliefs as that person. [cve]
555.36 together. It was one of those semi-accidental, semi-voiceless series] together which though it was one of those semi-accidental, semi-voiceless but nevertheless not wholly thoughtless series [cve]
556.23 for by now Suzanne was caught in the persuasive subtlety of his emotion] for now Suzanne was caught in this persuasive subtlety of emotion [1915]

CHAPTER LXXXIV

562.8 which must have been very trying to her.] which to her must have been a very trying. [cve]

CHAPTER LXXXV

568.5 important. For Angela,] important and under the circumstances intense for Angela, [1915]
569.10 a tenor who had] a tenor—a baritone, who had [1915]
574.7 His response was] That was [cve]
575.27 wonderfully worthy of love—] wonderfully worth love— [1915]

CHAPTER LXXXVI

576.35 promise of one, that] promise of it that [cve]
578.17 were conservative.] were conservative men. [cve]
579.27 if she did, she wouldn't leave] if she didn't she would leave [1915]
580.37 blame me, Eugene?] blame Eugene. [1915]
581.11 close to me as a lover should, unless you had to or you couldn't avoid me.] close to as a lover should unless you had to or you couldn't avoid. [1915]
583.10 Suzanne without] Suzanne if she knows it without [cve]
583.27 What do you want to do with Mrs. Dale?] what you want to do with Suzanne? [1915]

CHAPTER LXXXVII

586.12 are under control. Passions have] are in control. They have [cve]
586.28 sent to revolutionize] sent in a way to revolutionize [1915]
588.24 enrapt by him in this first burst of affection that she] enwrapt by by him in
 this first burst of affection that her life had really known that she [1915]

CHAPTER LXXXVIII

595.37 for Suzanne. Since Suzanne was so generous, he proposed to insist, not to
 argue this point. He must] for Suzanne. He proposed now that Suzanne was
 so generous not to argue this point but to fight it out. He must [cve]
598.24 "I don't know what] "I cant think what [1915]
598.38 will have to, though.] will though. [1915]
600.30 way whereby] way—outside of her particular family remember—whereby
 [1915]

CHAPTER LXXXIX

605.10 been conjecturing, how,] been figuring, how, [1915]

CHAPTER XC

614.12 and possibly to members] and possibly, not probably to members [1915]
614.37 and got the same answer.] and it was equally so. [1915]
615.29 Suzanne, in case she refused to listen to the doctor's counsel, could be, force-
 fully or by some ruse, with his assistance spirited] Suzanne forcefully or by
 some ruse, with his assistance could be in case she refused to listen to his
 counsel which would be given in good part spirited [cve]
617.5 said at one point significantly,] said one place significantly [1915]
619.23 rewarded, however." [¶] Eugene merely] rewarded however." Eugene merely
 [1915]

CHAPTER XCI

624.14 his waistcoat were apt to be stained at times. He] his waist coat was apt to be
 stained at times—his wife was dead. He [cve]

CHAPTER XCII

631.4 she might not be in a mellower mood and to plead with her further for] she
 (Suzanne) might not be in a mellower mood and to plead with her more for
632.21 rosy, babyish way.] rosy, baby way. [cve]
633.23 divorce, and if Suzanne would wait, she would consent to a marriage on that
 basis rather than see Suzanne go this way.] divorce rather than see Suzanne
 go this way (and she would wait) she would consent to a marriage on that
 basis. [cve]

635.15 of her father the late Westfield Dale's estate] of the late Westfield Dales (her father) estate [1915]

635.25 that, what with her mother's] that what, in conjunction with her mothers [1915]

CHAPTER XCIII

639.33 a sallow complexion in spite of his constant exercise.] a—in spite of his constant exercise—sallow complexion. [cve]

642.14 to Kinroy, but she did not believe him.] to this but she did not believe it. [1915]

CHAPTER XCIV

644.12 her way. [¶] Meanwhile, Eugene, back] her way. [¶] This story might concern itself with the life at Wille Away best for the few days they were there but it has nothing to do with it. The main point was that Eugene back [1915]

644.32 too much. In the] too much if he really could do it but he had long fancied that he was merely substituting for the man who could and should do it—Colfax. In the [1915]

645.31 of the corporation.] of it—the corporation. [1915]

648.22 was successful. [¶] If Eugene had been] was successful. It is absolutely true that if he had been [cve]

CHAPTER XCV

653.31 volition, might see she was no longer available as a normal matrimonial candidate, and yield and say nothing. In this case] volition see she was no longer available as a normal matrimonial candidate might yeild and say nothing. In which case [cve]

660.41 stood by, white, tense. To think] stood standing by white, tense [¶] To think [1915]

CHAPTER XCVI

661.21 interpreting Christ's words, saw] interpreting Christ saw [cve]

664.15 of delay. After a] of delay and after a [1915]

664.27 might say, they] might be thinking or saying they [1915]

665.23 Angela, speaking of Mrs. Dale, interrupted him—"She] Angela interrupted with—speaking of Mrs. Dale "She [1915]

CHAPTER XCVII

671.21 way involving Suzanne. Having been] way involved Suzanne. Have been [1915]

CHAPTER XCVIII

682.30 because at the time there was a suggestion of effulgent dawn in the east, where] because of the at the time effulgent suggestion of dawn in the East where [cve]

689.35 they came. [¶] There was] they came. [¶] It would be useless to follow step by step this deary progress. There was [1915]

CHAPTER XCIX

693.22 who may, because of his deeds, be condemned] who may be by his deeds condemned [1915]

CHAPTER C

699.6 use of talking? I] use talking. I [1915]

700.2 medicines, of which there was quite a store, into the garbage pail, eschewed] medicines in the garbage pail, of which there was quite a store, eschewed [1915]

700.14 is His image] is his image [1915]

702.9 It seemed terribly silly at first to Eugene to be] All this seemed terribly silly at first to Eugene for him to be [cve]

CHAPTER CI

705.23 that they believed in the] that the [1915]

706.37 maternity hospital, whither] maternity whither [1915]

*708.6 our ends. "No inorganic] our ends. No organic [1915]

712.8 variety. The only] variety and that the only [cve]

CHAPTER CII

716.31 He did not see] He did see [1915]

721.32 not, that I do."] not, I do." [cve]

CHAPTER CIII

724.3 was the outward sign of her ability] was her ability [1915]

725.38 volume—it was by an eminent surgeon—he learned that] volume he learned it was by an eminent surgeon that [cve]

732.2 near Angela's feet, officiating] near Angelas head officiating [1915]

CHAPTER CIV

736.32 visited his old Christian] visited a Christian [1915]

738.20 was little Angela to] was Angela, second, to [cve]

740.3 the truth—could gainsay divine harmony. She] the truth that it was not in accordance with divine harmony and hence was not at all. She [1915]

743.18 The machine (a bright purple body) sped away, and] The machine sped away, a bright purple body, and [cve]

*744.37 Maeterlinck and Bergson with] Maeterlinck and Bergman with [cve]

*745.24 Spencer's *Facts and Comments*, which] Spencers "First Principles" which [cve]

Appendixes:
Deleted Passages

APPENDIX 1

Holograph Pages before the First Fly Leaf

Before the first fly leaf the holograph has two pages in Dreiser's hand. They read as follows:

Alternative Titles

Will those who read this manuscript kindly indicate here any other title which may occur to them as appropriate and forceful or check the one which they prefer.

This Matter of Marriage, Now.

The Hedonist

The Story of Eugene The Dreamer

Eugene Witla The Sensualist.

The Genius — Title Page

The Genius

By Theodore Dreiser
Author of Sister Carrie,
Jennie Gerhardt.

Note: The author would deem it a favor of those who read this story, or in whose hands, perchance, it may unwittingly fall, if they will see that it is not passed indiscriminately into the hands of the too young. Its psychology and philosophy should forefend it against general and immature reading but there are those who read only for suggestive incidents. And he would ask of the elders, offended perchance by the notable variations from current prejudice and conventions of religion, morality and philosophy, that they suspend judgement until the last page is reached when they may pass upon the work as a whole.

Holograph Material Deleted from the
Beginning of Chapter XL

On this material, see Textual Note, XL, 242.1.

The following five paragraphs appear in the holograph at the beginning of Chapter XL. The series of conflicting viewpoints about "sex-indulgence" presented in unedited prose demonstrates Eugene's (and apparently also Dreiser's) substantial confusion. Because considerable speculation about the author's intent would be necessary to render the prose comprehensible—and because that process would still not resolve the logical contradictions—the passage has been cut. However, it remains an important index of Eugene's and Dreiser's thinking, and in fact the confusions, indicating his intellectual turmoil and ethical searching, make the passage all the more suggestive. The range of intellectual authorities mentioned (ancient philosophers, Shakespeare, the Bible, religious leaders East and West), as well as the allusions to a range of influential contemporary movements (Christian Science, evolutionary thought, and sexual reformers both conservative and progressive), indicate Dreiser's considerable investment in ideas he has not yet sorted through. For these reasons the deleted passage is presented as an appendix.

Dreiser seems in the following paragraphs to gesture toward a number of groups, only vaguely defined, each with its own agenda concerning sexuality. The first paragraph contrasts an ideology that maintains sex is evil and destructive with the fact of increasing sexual freedom. In the second paragraph Dreiser identifies the antisex ideology as a "conspiracy of silence" and contrasts it with the work of sex educators. These educators are not, however, birth control advocates or other liberalizers; rather, Dreiser describes conservative instructors who instill fear about sexual dangers both to the individual and to the "race," for instance through disease and depletion of strength. Dreiser also mentions a "new religion," identified in the third paragraph as Christian Science. (For Christian Science views on marriage, sexuality, and divorce, see Historical Notes 844–45, 840, and 843.) In the fourth paragraph, Eugene sympathetically considers the conservative position that sexuality has its rightful place only in propagating a family. The fifth paragraph begins by commending chastity even while stating that Eugene could probably never maintain it. In several places throughout these paragraphs, Eugene tries to dissociate himself from antisex forces, but he is far from successful.

It is evident that Eugene is weighing different and contradictory atti-
tudes about sexuality, finding in each position something that seems valid.
It is also evident that his vacillation among competing positions—to say
nothing of his sex drive itself—"caused him both mental pain and confu-
sion," as the narrator remarks at the end of the passage. Dreiser seems to
be trying to offer cultural contexts for understanding Eugene's troubled
sexuality, in much the same way that he contextualizes Carrie Meeber's
longing for beautiful clothes in his "brief history of the department store"
early in *Sister Carrie*, or Frank Cowperwood's amorality by reference to the
Social Darwinist parable of the lobster and the squid at the beginning of
The Financier. That is, Eugene's problems of overindulgence are not simply
indicators of individual pathology. Much as Dreiser's description of Eugene's
neurasthenia in Chapter XLII insists that the malady is typical of the age,
so Eugene's confusion about the role of sexuality in a healthy life mirrors
contradictions within American culture.

What is practically absent from this tangle of references is sustained
allusion to the era's most radical sex theorists and educators. It is under-
standable that Dreiser does not mention Sigmund Freud (1856–1936), who
began publishing his works in the 1890s (though they were not translated
into English until 1909), for Dreiser did not read Freud until around 1918.
Yet other liberal sex theorists were widely familiar in the English-speaking
world of 1911, such as pioneer sexologist Havelock Ellis (1859–1937). The
first of Ellis's seven-volume *Studies in the Psychology of Sex* was published in
1897; this series was banned—as *The "Genius"* would be—on the charge
of obscenity. The authoritative *Psycopathia Sexualis* by Richard von Krafft-
Ebing (1840–1912) appeared in 1886 and was translated into English in
1892. Apart from sex theorists, many liberal sex reformers who worked on
practical fronts had been visible for years—for instance, advocates for birth
control. For example, in England in 1877, Charles Bradlaugh (1833–1891)
and Annie Besant (who later converted to theosophy and adopted an anti-
sex position) were tried for selling a pamphlet on contraception written by
an American.

It is also notable that while Eugene on several occasions distances him-
self from the forces urging chastity, the role of libertine is by no means easy
for him to assume. Moreover, evolutionary thinking emerges in this passage
not as something that clarifies his thinking, but rather "befogged the subject
for him." The passage as a whole suggests a Eugene—and a Dreiser—deeply
enmeshed in traditional and even puritanical views about sexuality, bear-
ing considerable guilt for desires that seem destructive, and struggling for
an ethical position that would allow him to make sense of erotic desire. If,
as Randolph Bourne famously declared, "Desire as Hero"[1] in Dreiser, this

passage confirms what the 1911 *The Genius* as a whole suggests: that desire could also be villain for Dreiser.

At the time that these events were transpiring in connection with Eugene's art the world was in a state of nervous apprehension regarding the passion of sex, lest somehow discussion of it, explanation of sex characteristics, understanding of sex functions, and the clearing up of the joint relationship existing between men and women should work some terrible disaster to the world at large, the morals of the race, and mayhap the divine spirit which created the universe itself. Unwitting that by some peculiar maladjustment of mortal consciousness the world of men and women of the time had left the primal, instinct-governed morality of the beasts far behind, and had entered upon a career of sex indulgence based solely on the capacity and endurance of the contracting individuals—the end being governed solely by surfeit, inability from weakness, lesion or disease—the race almost as a unit was opposing sex discussion, ostracizing its advocates, punishing its prophets by insisting on indifference to them.

This condition was described by some who were opposed to what they considered the immoral drift of the time, the danger of disaster to innocence and virtue by the presence of lust, disease, weakness, undue indulgence and so forth, as the conspiracy of silence, and societies for the spread of sex-knowledge, the prevention of sex-disease, by the enactment of restrictive legal measures and the understanding generally of the destructive character of over-indulgence, were already forming. The race was beginning to awaken dimly to a consciousness that under the shelter of matrimony as well as out of it might exist an aimless, destructive immorality which would undermine the character of the race, corrupt the normal effective workings of the home, make the desire for race progress lose itself in a mushy sybaritism where sense gratification would be the one and aim of existence but they did not know exactly what to do about it. There had arisen indeed a new religion, or rather a spiritual awakening to an older one, in which marriage itself was attacked, the sex relationship including marriage set aside as a function having no place in true spiritual existence and was it seeking [*sic*] by this doctrine to end the pointless inexplicable miseries and entanglements of material and mortal existence. The conclusion by this method of so-called mortal existence was, no less, the end in view, and the substitution therefore of a spiritual existence which should have no basis in gross material appetites but be of spiritual force and persistence solely was the end in view.

Eugene knew somewhat of these views at the time of his marriage. He was aware of Christian Science and some of its tenets though not of these peculiar teachings. His own feeling was that over indulgence in the sexual

relationship was the deadly rival of whiskey and the destructive opiates. But this feeling had no influence on his personal conduct. He believed that self-preservation was the only safe guiding instinct worth considering and he thought he had this. As for the various theories relating to morality and sex indulgence, he thought that universally the world talked one thing and did another. It was according to him right to take enjoyment in sex up to the limit of individual capacity and to talk anything less than this was silly nonsense. At the same time he was violently opposed to disease and weakness as being expressions of the inability of the individual to govern himself within the limits of self-preservation. So marriage spelled to him license within the limits of his strength, though it might have little in common as in his case with intellectual compatibility.

On the other hand there was in his mind the thought that the world had not begun to grasp the pathology of sex diseases nor to read the riddle of personality which on the physical side appeared to be so definitely bound up with the function of reproduction. It might be he thought that in chastity only was the safeguard against mental and moral deterioration, and that the dictum of the religionist, "conceived in sin and brought forth in iniquity,"[2] was not without its basis in spiritual truth in so far as the generation of the race was concerned. Only for purposes of race production—if that were desirable—was it either necessary or permissible for the sexes to meet and then only with the rearing and safeguarding of a family of children, raised in a similar understanding of the functions of life in view.

Every great spiritual upheaval in the past, he knew, had this one point in view. The teaching of Buddha, Jesus, the prophets, Confucius, Socrates, Epictetus, St. Paul, the Saints, and Luther had one cardinal point to emphasize—chastity. Adultery and lust, either legally sanctioned or otherwise, were seen to be, by the religionist at least, the foundation and incitement of hatred, variance, vain emulations, wrath, greed, murder—the whole host of sins and sicknesses of the soul and body which beset the world. To cut through this undergrowth of immorality and legalized sex indulgence and come out into the clear sunlight of chastity and so intellectual and spiritual peace, was, of course, the great thing to be desired—if one could. It would be, Eugene thought at times in his hours of remorse, like laying off a vague and torturesome dreams [sic]—Shakespeare's "fitful fever."[3] Still he did not see how he could do it. One had to be born differently. Modern scientific reading with its insistence on material, evolutionary ancestry had made him a fatalist. It befogged the subject for him. Yet this proposition as to permanent chastity might still be true. These thoughts did not occur to Eugene as concisely as they are put here, but they did occur to him and set over against his at times gross materiality caused him both mental pain and confusion.

APPENDIX 3

Dreiser's Alternate Ending

Dreiser composed Chapter CV, an alternate ending, no earlier than the fall of 1914. On the dating of this alternate ending, which is on file with the Dreiser Papers at the University of Pennsylvania, see "The Composition of *The Genius:* The 1911 Version to Print," 759n3. With minor revisions, this alternate ending would become the concluding chapter of the 1915 edition of *The "Genius"*. It is reprinted here as a convenience to the reader.

CHAPTER CV

The denouement of all this, as much as ever could be, was still two years off. By that time Suzanne was considerably more sobered, somewhat more intellectually cultivated, a little cooler—not colder exactly—and somewhat more critical. Men, when it came to her type of beauty, were a little too suggestive of their amorousness. After Eugene, their proffers of passion, adoration, undying love, were not so vital.

But one day, in New York on Fifth Avenue, there was a re-encounter. She was shopping with her mother, but their ways, for the moment, were divided. By now Eugene was once more in complete possession of his faculties. The old ache had subsided to a dim but colorful mirage of beauty that was always in the sky. Often he had thought what he should do if he saw Suzanne again—what say, if anything. Would he smile, bow—and if there were an answering light in her eye, begin his old courtship all over; or would he find her changed, cold, indifferent? Would he be indifferent, sneering? It would be hard on him perhaps—afterward—but it would pay her out and serve her right. If she really cared she ought to be made to suffer for being a waxy fool and tool in the hands of her mother. He did not know that she had heard of his wife's death—the presence of his child—and that she had composed and destroyed five separate letters, being afraid of reprisal, indifference, scorn.

She had heard of his rise to fame as an artist once more, for had not the exhibition finally come about, and with it great praise, brilliant acknowledgements of his supreme ability. Artists admired him most of all. They thought him strange, eccentric, but great. M. Charles had suggested to a great bank director that his new bank in the financial district be decorated by Eugene alone, and this was eventually done—nine great panels demonstrating his feeling for life. At Washington, in two of the great public libraries of America, and in three state capitols, were tall, glowing panels

which demonstrated with what fever and energy he could demonstrate his dreams—in line, color, arrangement—a brooding suggestion of beauty that never was on land or sea. Here and there in them might have been detected a face, an arm, a cheek, an eye. If you had ever known Suzanne as she was you would have known the basis—the tonic, fugitive spirit at the bottom of all of these things.

But in spite of that he now hated her, or told himself that he did. Under the heel of his intellectuality was the face, the beauty that he adored. He despised and yet loved it. Life had done him a vile trick—love—thus to frenzy his reason and then turn him out as mad. Now, never again, should love affect him, and yet the beauty of women was still his great lure—only he was the master.

And there were women—never believe otherwise. Not so many in actual contact as in approach and attempted union—drawn perhaps by certain wistfulness and loneliness in Eugene; quieted by tragedy for a little while, he was once more warming to the world. One after another they came, as his fame spread and his sorrow faded, and he could once more hold up his head. There were women who came via the drawing rooms to which he was invited—wives and daughters who sought to interest him in them and would scarcely have no for an answer. These were women of the stage, women artists like himself—women poetasters, varietists, critics, dreamers as to art. Does it sound like legion? There were not so many after all—only a passing few. From the many approaches—offers by letter and direct contact here and there—some two or three came into life for a time, only to go again, as others had before. Was he not changed then? Not much, no, only hardened intellectually and emotionally—better tempered for the work he had to do. There were scenes, too, violent ones, tears, separations, re-encounters, polite greetings—with little Angela always to one side, in Myrtle's care, as a kind of stay and consolation.

And then one day Suzanne appeared.

He scarcely recognized her—so sudden it was, and so quickly ended. She was crossing Fifth Avenue at Forty-second Street. He was coming out of a jeweler's with a birthday ring for little Angela. Then the eye of this girl, this pale look, a flash of something wonderful that he remembered, and then——

He stared curiously—not quite sure.

"He does not even recognize me," said Suzanne. "Or he hates me now. Oh! All in five years!"

"It is she, I believe," he said to himself, "though I am not sure. Well, if it is, she can go to the devil." His mouth hardened.

"I will cut her as she deserves to be cut," he thought to himself. "She shall never know that I care."

And so they passed—never to meet in this world—each always wishing, each defying, each folding a wraith of beauty to the heart.

L' ENVOI.

There appears to be in metaphysics a basis, or no basis save as the temperament and the experience of each shall incline him, for ethical or spiritual ease. Life sinks into the unknowable at every turn and only the temporary or historical scene remains as a guide—and that passes also. It may seem rather beside the mark that Eugene, in his moral and physical depression, should have inclined to various religious abstrusities for a time, but such is life and—any port in a storm. They constituted a refuge from himself, from his doubts and despairs as religious thought always does.

If I were to personally define religion, I should say that it is a bandage which man has invented to protect a soul made bloody by circumstance, an envelope to pocket him from the inescapable and unstable illimitable. We seek to think of things as permanent and see them so. Religion gives life a habitation and a name apparently—though it is an illusion.

So we are brought back to time and space and illimitable mind—as what? And we shall stand before them attributing to them all these things that we feel and cannot know. In Eugene you saw an artist who, pagan to the core, enjoyed to read the bible for the artistry of expression, and Schopenhauer, Nietzsche, Spinoza, and James for the mystery of things they suggested. In his child he found a charming personality as well as a study—one whom he could brood over with affectionate interest at times, seeing already something of himself and something of Angela, and wondering at the outcome. What would she be like? Would art have any interest for her? She was so daring, gay, self-willed, he thought.

"You've a tartar on your hands in her," Myrtle once said to him and he smiled as he replied,

"Just the same, I'll see if I can't keep up with her."

One of his occasional thoughts was that if he and little Angela eventually came to understand each other thoroughly, and she did not get married too soon, he could build a charming home around here. Perhaps her husband might not object to living with them.

The last scene of all may be taken from his studio in Montclair, where at present, with Myrtle and her husband as resident housekeepers, and Angela as his diversion, he was living and working. He was sitting in front of his fire place one night reading, when a thought in some history recalled Spencer's astonishing chapter on "the unknowable" in his *First Principles*,[4] and he arose to see if he could find it. Rummaging around in his books he extracted the volume and reread it with a kind of smack of intellectual

906 • *Historical Commentary*

agreement for it was so suited to his mood in regard to life in general and his own mental state in particular. Because it was so peculiarly related to his view point I quote it:

"Beyond the reach of our intelligence as are the mysteries of the objects known by our senses, those presented in this universal matrix are, if we may so say, still further beyond the reach of our intelligence, for whereas, those of the one kind may be, and are, thought of by many as explicable on the hypothesis of Creation, and by the rest on the hypothesis of Evolution, those of the other kind cannot by either be regarded as thus explicable. Theist and Agnostic must agree in recognizing the properties of Space as inherent, eternal, uncreated—as anteceding all creation, if creation has taken place.

"Hence, could we penetrate the mysteries of existence, there would still remain more transcendent mysteries. That which can be thought of neither as made nor evolved, presents us with fact, the origin of which, is even more remote from conceivability than is the origin of the facts presented by visible and tangible things. . . .

"The thought of this blank form of existence which, explored in all directions as far as imagination can reach, has, beyond that, an unexplored region compared with which the part imagination has traversed is but infinitesimal—the thought of a Space compared with which our immeasurable sidereal system dwindles to a point, is a thought too overwhelming to be dwelt upon. Of late years the consciousness that without origin or cause infinite Space has ever existed and must ever exist produces in me a feeling from which I shrink."

"Well," he said, turning as he thought he heard a slight noise, "that is certainly the sanest interpretation of the limitations of human thought that I have ever read"—and then seeing little Angela enter, clad in a baggy little sleeping suit which was not unrelated to a Harlequin costume, he smiled, for he knew her wheedling, shifty moods and tricks.

"Now what are you coming in here for?" he asked, mock severely. "You know you oughtn't be up so late. If Auntie Myrtle catches you——"

"But I can't sleep, Daddy," she replied trickily, anxious to be with him for a little while longer before the fire and tripping coaxingly across the floor. "Won't you take me?"

"Yes, I know all about your not being able to sleep, you scamp. You're coming in here to be cuddled. Well, you beat it."

"Oh no, daddy."

"All right then. Come here." And he gathered her up in his arms and reseated himself before the fire. "Now you go to sleep, or back you go to bed."

She snuggled down, her red head in his crooked elbow while he looked at her cheek, recalling the storm in which she arrived.

"Little flower girl," he said. "Sweet little kiddie."

His offspring made no reply. Presently he carried her asleep to her couch, tucked her in, and coming back went out on the brown lawn, where a late November wind rustled in the few still clinging brown leaves. Overhead were the stars—Orion's majestic belt and those mystic constellations that make dippers, bears and that remote cloudy formation known as the Milky Way.

"Where in all this—in substance," he thought, rubbing his lean hand through his hair, "is Angela? Where, in substance, will be that which is me? What a sweet welter life is—how rich, how tender, how grim, how artistic—how like a colorful symphony."

Great art dreams welled up into his soul as he viewed the sparkling deeps of space.

"The sound of the wind—how fine it is tonight," he said.

Then he went quietly back and closed the door.

THE END

1. Randolph Bourne, "Desire as Hero," rpt. in *Critical Essays on Theodore Dreiser*, ed. Donald Pizer (Boston: G. K. Hall & Co., 1981), 243.

2. **"conceived in sin and brought forth in iniquity"** derived from Psalms 5:5: "Behold, I was shaped in iniquity, and in sin did my mother conceive me."

3. **Shakespeare's "fitful fever"** from *Macbeth* 3.2.22–23: "Duncan is in his grave; / After life's fitful fever he sleeps well."

4. Dreiser in fact quotes here not from Spencer's *First Principles* (1862) but rather from *Facts and Comments* (1902).

INDEX

CLARE VIRGINIA EBY is Professor of English at the University of Connecticut. She is author of *Dreiser and Veblen, Saboteurs of the Status Quo*, editor of the Norton Critical Edition of Upton Sinclair's *The Jungle*, and coeditor of *The Cambridge Companion to Theodore Dreiser*.

The University of Illinois Press
is a founding member of the
Association of American University Presses.

Composed in 10.5/13 Goudy Old Style
by Jim Proefrock
at the University of Illinois Press
Manufactured by Sheridan Books, Inc.

University of Illinois Press
1325 South Oak Street
Champaign, IL 61820-6903
www.press.uillinois.edu